Contents

© Carson Ellis

© Jim Hunt.us

MARKETS

© 2004-7 Erik Rose/www.erikrose.com

© 2007 Sandy Oppenheimer

RESOURCES

INDEXES

© Nancy Flores/ArtEffect Designs Germany

From the Editor

If this is your first edition of *Artist's & Graphic Designer's Market*, you and I have something in common. If you're a seasoned reader, I hope you aren't too skeptical about the new name on this page.

When I was a kid, I wanted to be an artist. (Maybe this is something else we have in common.) For years I took watercolor painting lessons in the park, attended drawing classes and ceramics workshops, and entered art contests. As I grew and changed, I became interested in other arts like music, writing and photography, seldom practicing the drawing and painting I had spent so much time on as a child.

Karma stepped in when I was given the opportunity to work on this book. I began reading about the industry and discovered cool artists—like **Carson Ellis**, **Erik Rose** and **Natasha Wescoat**—who incited my passion and made me remember how I once *loved* to draw and paint. They inspired me to return to my old love so that I could genuinely connect with *AGDM*'s readers through the experience of being a freelance artist. I even designated the spare bedroom in my house—"the purple room"—as a creative sanctuary. (According to "color psychology," purple surroundings can promote artistic talent and creativity.)

Well, I haven't drawn or painted in months—but my excuse is that producing a great resource for serious working artists (you) became my priority. And, honestly, I'm not sure I have what it takes to turn my childhood hobby into a career. The most important thing I've learned from all the artists featured in these pages, is that even if you have talent as an artist or designer, you have to really *want* success and be simultaneously persistent and patient in order to achieve it.

Since you're reading this book, I'm guessing you *do* really want a successful career as an artist, which is why I've added lots of new resources to help you achieve that goal. Use the **geographic index** to look for opportunities in your region; apply for a **residency** or join an **online artists' community** to build a support network; contact **organizations** that offer financial and other assistance; learn from the featured artists' **success stories** about how to use this book to make your dreams come true.

Also check out www.artists-market.com and send me your feedback about the book. Share your stories of struggle and success—maybe I'll feature your work in a future edition so that *you* can be one of the "cool artists" who inspire the rest of us. In the meantime, I'll be in the purple room, with an ear to my muse and my hands covered in paint!

Erika O'Connell

Erika O'Connell
artdesign@fwpubs.com
www.artists-market.com

2008 Reader Survey:
Tell us about yourself!

1. How often do you purchase *Artist's & Graphic Designer's Market?*

○ every year
○ every other year
○ This is my first edition

2. Describe yourself and your artwork—and how you use *AGDM*.

3. What do you like best about *AGDM*?

4. Would you like to see an online version of *AGDM*?

○ Yes
○ No

Name: _____
Address: _____
City: _____ State: _____ Zip: _____
E-mail: _____
Web site: _____

Fax to Erika O'Connell at (513) 531-2686; mail to Artist's & Graphic Designer's Market, 4700 East Galbraith Road, Cincinnati, OH 45236; or e-mail artdesign@fwpubs.com.

How to Use This Book

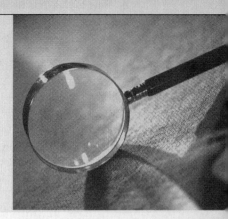

If you're picking up this book for the first time, you might not know quite how to start using it. Your first impulse might be to flip through and quickly make a mailing list, submitting to everyone with hopes that *someone* might like your work. Resist that urge.

First you have to narrow down the names in this book to those who need your particular art style. That's what this book is all about. We provide the names and addresses of art buyers along with plenty of marketing tips. You provide the hard work, creativity and patience necessary to hang in there until work starts coming your way.

Listings: the heart of this book

The book is divided into market sections, from galleries to art fairs. (See Table of Contents for complete list.) Each section begins with an introduction containing information and advice to help you break into the specific market.

Listings are the meat of this book. In a nutshell, listings are names, addresses and contact information for places that buy or commission artwork, along with a description of the type of art they need and their submission preferences.

Articles and Interviews

Throughout this book you will find helpful articles and interviews with working artists and experts from the art world. These articles give you a richer understanding of the marketplace by sharing the featured artists' personal experiences and insights. Their stories, and the lessons you can learn from other artists' feats and follies, give you an important edge over artists who skip the articles.

HOW *AGDM* WORKS

Following the instructions in the listings, we suggest you send samples of your work (not originals) to a dozen (or more) targeted markets. The more companies you send to, the greater your chances of a positive response. Establish a system to keep track of who you submit your work to and send follow-up mailings to your target markets at least twice a year.

How to read listings

The first thing you'll notice about many of the listings in this book is the group of symbols that appears before the name of each company. (You'll find a quick-reference key to the symbols on the front and back inside covers of the book.) Here's what each symbol stands for:

Getting Started

[N] Market new to this edition

[C] Canadian market

[⊕] International market

[♦] Market perfers to work with local artists/designers

Each listing contains a description of the artwork and/or services the company prefers. The information often reveals how much freelance artwork is used, whether computer skills are needed, and which software programs are preferred.

In some sections, additional subheads help you identify potential markets. Magazine listings specify needs for cartoons and illustrations. Galleries specify media and style.

Editorial comments, denoted by bullets (•), give you extra information about markets, such as company awards, mergers and insight into a company's staff or procedures.

It might take a while to get accustomed to the layout and language in the listings. In the beginning, you will encounter some terms and symbols that might be unfamiliar to you. Refer to the Glossary on page 562 to help you with terms you don't understand.

Working with listings

1. Read the entire listing to decide whether to submit your samples. Do *not* use this book simply as a mailing list of names and addresses. Reading listings carefully helps you narrow your mailing list and submit appropriate material.

2. Read the description of the company or gallery in the first paragraph of the listing. Then jump to the **Needs** or **Media** heading to find out what type of artwork is preferred. Is it the type of artwork you create? This is the first step to narrowing your target market. You should send your samples only to places that need the kind of work you create.

3. Send appropriate submissions. It seems like common sense to research what kind of samples a listing wants before sending off just any artwork you have on hand. But believe it or not, some artists skip this step. Many art directors have pulled their listings from *AGDM* because they've received too many inappropriate submissions. Look under the **First Contact & Terms** heading to find out how to contact the market and what to send. Some companies and publishers are very picky about what kinds of samples they like to see; others are more flexible.

What's an inappropriate submission? I'll give you an example. Suppose you want to be a children's book illustrator. Don't send samples of your cute animal art to *Business Law Today* magazine—they would rather see law-related subjects. Use the Niche Marketing Index on page 579 to find listings that accept children's illustrations. You'd be surprised how many illustrators waste their postage sending the wrong samples. And boy, does that alienate art directors. Make sure all your mailings are *appropriate* ones.

4. Consider your competition. Under the **Needs** heading, compare the number of freelancers who contact the company with the number they actually work with. You'll have a better chance with listings that use a lot of artwork or work with many artists.

5. Look for what they pay. In most sections, you can find this information under **First Contact & Terms**. Book Publishers list pay rates under headings pertaining to the type of work they assign, such as **Text Illustration** or **Book Design**.

At first, try not to be too picky about how much a listing pays. After you have a couple of assignments under your belt, you might decide to only send samples to medium- or high-paying markets.

6. Be sure to read the Tips. This is where art directors describe their pet peeves and give clues for how to impress them. Artists say the information within the **Tips** helps them get a feel for what a company might be like to work for.

These steps are just the beginning. As you become accustomed to reading listings, you

Frequently Asked Questions

1 **How do companies get listed in the book?** No company pays to be included—all listings are free. Every company has to fill out a detailed questionnaire about their art needs. All questionnaires are screened to make sure the companies meet our requirements. Each year we contact every company in the book and ask them to update their information.

2 **Why aren't other companies I know about listed in this book?** We may have sent these companies a questionnaire, but they never returned it. Or if they did return a questionnaire, we may have decided not to include them based on our requirements. If you know of a market you'd like to see in the book, send an e-mail request to artdesign@fwpubs.com.

3 **I sent some samples to a company that stated they were open to reviewing the type of work I do, but I have not heard from them yet, and they have not returned my materials. What should I do?** At the time we contacted the company they were open to receiving such submissions. However, things can change. It's a good idea to contact any company listed in this book to check on their policy before sending them anything. Perhaps they have not had time to review your submission yet. If the listing states that they respond to queries in one month, and more than a month has passed, you can send a brief e-mail or make a quick phone call to the company to inquire about the status of your submission. Some companies receive a large volume of submissions, so sometimes you must be patient. Never send originals when you are querying—always send copies. If for any reason your samples are never returned to you, you will not have lost forever the opportunity to sell an important image. It is a good idea to include a SASE (self-addressed, stamped envelope) with your submissions, even if the listing does not specifically request that you do so. This may facilitate getting your work back.

4 **A company says they want to publish my artwork, but first they will need a fee from me. Is this a standard business practice?** No, it is not a standard business practice. You should never have to pay to have your art reviewed or accepted for publication. If you suspect that a company may not be reputable, do some research before you submit anything or pay their fees. The exception to this rule is art fairs. Most art fairs have an application fee, and sometimes there is a fee for renting booth space. Some galleries may also require a fee for renting space to exhibit your work (see page 59 for more information).

will think of more ways to mine this book for your potential clients. Some of our readers tell us they peruse listings to find the speed at which a magazine pays its freelancers. In publishing, it's often a long wait until an edition or book is actually published, but if you are paid "on acceptance" you'll get a check soon after you complete the assignment and it is approved by the Art Director.

When looking for galleries, savvy artists often check to see how many square feet of space

Getting Started

are available and what hours the gallery is open. These details all factor in when narrowing down your search for target markets.

Pay attention to copyright information

It's also important to consider what **rights** companies buy. It is preferable to work with companies that buy first or one-time rights. If you see a listing that buys "all rights," be aware you may be giving up the right to sell that particular artwork in the future. See Copyright Basics on page 18 for more information.

Look for specialties and niche markets

Read listings closely. Most describe their specialties, clients and products within the first paragraph. If you hope to design restaurant menus, for example, target agencies that have restaurants for clients. If you prefer illustrating people, you might target ad agencies whose clients are hospitals or financial institutions. If you like to draw cars, look for agencies with clients in the automotive industry, and so on. Many book publishers specialize, too. Look for a publisher who specializes in children's books if that's the type of work you'd like to do. The Niche Marketing Index on page 579 lists possible opportunities for specialization.

Read listings for ideas

You'd be surprised how many artists found new niches they hadn't thought of by browsing the listings. One greeting card artist read about a company that produces mugs. Inspiration struck. Now this artist has added mugs to her repertoire, along with paper plates, figurines and rubber stamps—all because she browsed the listings for ideas!

Sending out samples

Once you narrow down some target markets, the next step is sending them samples of your work. As you create your samples and submission packets, be aware that your package or postcard has to look professional. It must be up to the standards art directors and gallery

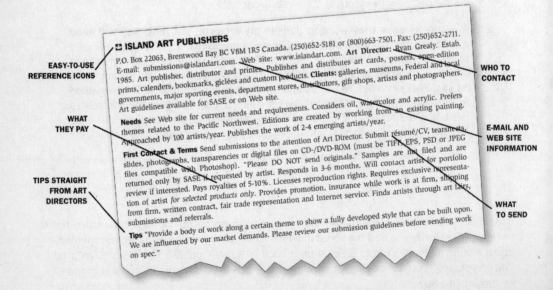

EASY-TO-USE
REFERENCE ICONS

WHAT
THEY PAY

TIPS STRAIGHT
FROM ART
DIRECTORS

WHO TO
CONTACT

E-MAIL AND
WEB SITE
INFORMATION

WHAT
TO SEND

ISLAND ART PUBLISHERS
P.O. Box 22063, Brentwood Bay BC V8M 1R5 Canada. (250)652-5181 or (800)663-7501. Fax: (250)652-2711. E-mail: submissions@islandart.com. Web site: www.islandart.com. **Art Director:** Ryan Grealy. Estab. 1985. Art publisher, distributor and printer. Publishes and distributes art cards, posters, open-edition prints, calenders, bookmarks, giclées and custom products. **Clients:** galleries, museums, Federal and local governments, major sporting events, department stores, distributors, gift shops, artists and photographers. Art guidelines available for SASE or on Web site.

Needs See Web site for current needs and requirements. Considers oil, watercolor and acrylic. Prefers themes related to the Pacific Northwest. Editions are created by working from an existing painting. Approached by 100 artists/year. Publishes the work of 2-4 emerging artists/year.

First Contact & Terms Send submissions to the attention of Art Director. Submit résumé/CV, tearsheets, slides, photographs, transparencies or digital files on CD-/DVD-ROM (must be TIFF, EPS, PSD or JPEG files compatible with Photoshop). "Please DO NOT send originals." Samples are not filed and are returned only by SASE if requested by artist. Responds in 3-6 months. Will contact artist for portfolio review if interested. Pays royalties of 5-10%. Licenses reproduction rights. Requires exclusive representation of artist *for selected products only.* Provides promotion, insurance while work is at firm, shipping from firm, written contract, fair trade representation and Internet service. Finds artists through art fairs, submissions and referrals.

Tips "Provide a body of work along a certain theme to show a fully developed style that can be built upon. We are influenced by our market demands. Please review our submission guidelines before sending work on spec."

dealers expect. There are examples throughout this book of some great samples sent out by other artists. Make sure your samples rise to that standard of professionalism.

See you next year

Use this book for one year. Highlight listings, make notes in the margins, fill it with Post-it notes. In November of 2008, our next edition—the *2009 Artist's & Graphic Designer's Market*—starts arriving in bookstores. By then, we'll have collected hundreds of new listings and changes in contact information. It is a career investment to buy the new edition every year. (And it's deductible! See page 13 for information on tax deductions.)

Join a professional organization

Artists who have the most success using this book are those who take the time to read the articles to learn about the bigger picture. In our interviews and Insider Reports, you'll learn what has worked for other artists and what kind of work impresses art directors and gallery dealers.

You'll find out how joining professional organizations such as the Graphic Artists Guild (www.gag.org) or the Society of Illustrators (www.societyillustrators.org) can jump start your career. You'll find out the importance of reading trade magazines such as *HOW* (www.howdesign.com), *PRINT* (www.printmag.com) and *Greetings etc.* (www.greetingsmagazine.com) to learn more about the industries you hope to approach. You'll learn about trade shows, art reps, shipping, billing, working with vendors, networking, self-promotion and hundreds of other details it would take years to find out about on your own. Perhaps most importantly, you'll read about how successful artists overcame rejection through persistence.

Hang in there!

Being professional doesn't happen overnight. It's a gradual process. It may take two or three years of using each successive year's edition of this book to gain enough information and experience to be a true professional in your field. So if you really want to be a professional artist, hang in there. Before long, you'll feel that heady feeling that comes from selling your work or seeing your illustrations on greeting cards or in magazines. If you really want it and you're willing to work for it, it *will* happen.

Complaint Procedure

Important

If you feel you have not been treated fairly by a company listed in *Artist's & Graphic Designer's Market*, we advise you to take the following steps:

- First, try to contact the company. Sometimes one phone call, e-mail or letter can quickly clear up the matter.

- Document all your correspondence with the company. If you write to us with a complaint, provide the details of your submission, the date of your first contact with the company, and the nature of your subsequent correspondence.

- We will enter your complaint into our files.

- The number and severity of complaints will be considered in our decision whether to delete the listing from the next edition.

How to Stay on Track and Get Paid

As you launch your artistic career, be aware that you are actually starting a small business. It is crucial that you keep track of the details, or your business will not last very long. The most important rule of all is to find a system to keep your business organized and stick with it.

YOUR DAILY RECORD-KEEPING SYSTEM

Every artist needs to keep a daily record of art-making and marketing activities. Before you do anything else, visit an office supply store and pick out the items listed below (or your own variations of these items). Keep it simple so you can remember your system and use it on automatic pilot whenever you make a business transaction.

What you'll need:
- A packet of colorful file folders or a basic Personal Information Manager on your computer or Palm Pilot.
- A notebook or legal pads to serve as a log or journal to keep track of your daily art-making and art marketing activities.
- A small pocket notebook to keep in your car to track mileage and gas expenses.

How to start your system
- Designate a permanent location in your studio or home office for two file folders and your notebook.
- Label one red file folder "Expenses."
- Label one green file folder "Income."
- Write in your daily log book each and every day.

Every time you purchase anything for your business, such as envelopes or art supplies, place the receipt in your red Expenses folder. When you receive payment for an assignment or painting, photocopy the check or place the receipt in your green Income folder.

Keep track of assignments

Whether you're an illustrator or fine artist, you should devise a system for keeping track of assignments and artworks. Most illustrators assign a job number to each assignment they receive and create a file folder for each job. Some arrange these folders by client name; others keep them in numerical order. The important thing is to keep all correspondence for each assignment in a spot where you can easily find it.

Pricing illustration and design

One of the hardest things to master is what to charge for your work. It's difficult to make blanket statements on this topic. Every slice of the market is somewhat different. Nevertheless, there is one recurring pattern: Hourly rates are generally only paid to designers working in house on a client's equipment. Freelance illustrators working out of their own studios are almost always paid a flat fee or an advance against royalties.

If you don't know what to charge, begin by devising an hourly rate, taking into consider-

Pricing Your Fine Art

Tips

There are no hard-and-fast rules for pricing your fine artwork. Most artists and galleries base prices on market value—what the buying public is currently paying for similar work. Learn the market value by visiting galleries and checking prices of works similar to yours. When you're starting out, don't compare your prices to established artists but to emerging talent in your region. Consider these factors when determining price:

- **Medium.** Oils and acrylics cost more than watercolors by the same artist. Price paintings higher than drawings.

- **Expense of materials.** Charge more for work done on expensive paper than for work of a similar size on a lesser grade paper.

- **Size.** Though a large work isn't necessarily better than a small one, as a rule of thumb you can charge more for the larger work.

- **Scarcity.** Charge more for one-of-a-kind works like paintings and drawings, than for limited editions such as lithographs and woodcuts.

- **Status of artist.** Established artists can charge more than lesser-known artists.

- **Status of gallery.** Prestigious galleries can charge higher prices.

- **Region.** Works usually sell for more in larger cities like New York and Chicago.

- **Gallery commission.** The gallery will charge from 30 to 50 percent commission. Your cut must cover the cost of materials, studio space, taxes and perhaps shipping and insurance, and enough extra to make a profit. If materials for a painting cost $25, matting and framing cost $37, and you spent five hours working on it, make sure you get at least the cost of material and labor back before the gallery takes its share. Once you set your price, stick to the same price structure wherever you show your work. A $500 painting by you should cost $500 whether it is bought in a gallery or directly from you. To do otherwise is not fair to the gallery and devalues your work.

As you establish a reputation, begin to raise your prices—but do so cautiously. Each time you graduate to a new price level, it will be that much harder to revert to former prices.

ation the cost of materials and overhead and what you think your time is worth. If you're a designer, determine what the average salary would be for a full-time employee doing the same job. Then estimate how many hours the job will take and quote a flat fee based on these calculations.

There is a distinct difference between giving the client a job estimate and a job quote. An estimate is a ballpark figure of what the job will cost but is subject to change. A quote is a set fee which, once agreed upon, is pretty much carved in stone. Make sure the client understands which you are negotiating. Estimates are often used as a preliminary step in itemizing costs for a combination of design services such as concepting, typesetting and printing. Flat quotes are generally used by illustrators, as there are fewer factors involved in arriving at fees.

For recommended fees for different services, refer to the *Graphic Artists Guild's Handbook of Pricing & Ethical Guidelines* (www.gag.org). Many artists' organizations have standard pay rates listed on their Web sites.

As you set fees, certain stipulations call for higher rates. Consider these bargaining points:

- **Usage (rights).** The more rights purchased, the more you can charge. For example, if the client asks for a "buyout" (to buy all rights), you can charge more, because by relinquishing all rights to future use of your work, you will be losing out on resale potential.
- **Turnaround time.** If you are asked to turn the job around quickly, charge more.
- **Budget.** Don't be afraid to ask about a project's budget before offering a quote. You won't want to charge $500 for a print ad illustration if the ad agency has a budget of $40,000 for that ad. If the budget is that big, ask for higher payment.
- **Reputation.** The more well known you are, the more you can charge. As you become established, periodically raise your rates (in small steps) and see what happens.

What goes in a contract?

Contracts are simply business tools to make sure everyone agrees on the terms of a project. Ask for one any time you enter into a business agreement. Be sure to arrange for the specifics in writing or provide your own. A letter stating the terms of agreement signed by both parties can serve as an informal contract. Several excellent books, such as *Legal Guide for the Visual Artist* and *Business and Legal Forms for Illustrators*, both by Tad Crawford (Allworth Press), contain negotiation checklists and tear-out forms and provide sample contracts you can copy. The sample contracts in these books cover practically any situation you might encounter.

The items specified in your contract will vary according to the market you're dealing with and the complexity of the project. Nevertheless, here are some basic points you'll want to cover:

Commercial contracts

- **A description of the service(s) you're providing.**
- **Deadlines for finished work.**
- **Rights sold.**
- **Your fee.** Hourly rate, flat fee or royalty.
- **Kill fee.** Compensatory payment received by you if the project is cancelled.
- **Changes fees.** Penalty fees to be paid by the client for last-minute changes.
- **Advances.** Any funds paid to you before you begin working on the project.
- **Payment schedule.** When and how often you will be paid for the assignment.
- **Statement regarding return of original art.** Unless you're doing work for hire, your artwork should always be returned to you.

Gallery contracts

- **Terms of acquisition or representation.** Will the work be handled on consignment? What is the gallery's commission?
- **Nature of the show(s).** Will the work be exhibited in group or solo shows or both?
- **Time frames.** If a work is sold, when will you be paid? At what point will the gallery return unsold works to you? When will the contract cease to be in effect?
- **Promotion.** Who will coordinate and pay for promotion? What does promotion entail? Who pays for printing and mailing of invitations? If costs are shared, what is the breakdown?
- **Insurance.** Will the gallery insure the work while it is being exhibited and/or while it is being shipped to or from the gallery?
- **Shipping.** Who will pay for shipping costs to and from the gallery?
- **Geographic restrictions.** If you sign with this gallery, will you relinquish the rights to show your work elsewhere in a specified area? If so, what are the boundaries of this area?

How to send invoices

If you're a designer or illustrator, you will be responsible for sending invoices for your services. Clients generally will not issue checks without them, so mail or fax an invoice as soon as you've completed the assignment. Illustrators are generally paid in full either upon receipt of illustration or on publication. Most graphic designers arrange to be paid in thirds, billing the first third before starting the project, the second after the client approves the initial roughs, and the third upon completion of the project.

Standard invoice forms allow you to itemize your services. The more you spell out the charges, the easier it will be for your clients to understand what they're paying for. Most freelancers charge extra for changes made after approval of the initial layout. Keep a separate form for change orders and attach it to your invoice.

If you're an illustrator, your invoice can be much simpler, as you'll generally be charging a flat fee. It's helpful, in determining your quoted fee, to itemize charges according to time, materials and expenses. (The client need not see this itemization; it is for your own purposes.)

Most businesses require your social security number or tax ID number before they can cut a check, so include this information in your bill. Be sure to put a due date on each invoice; include the phrase "payable within 30 days" (or other preferred time frame) directly on your invoice. Most freelancers ask for payment within 10-30 days.

Sample invoices are featured in *Business and Legal Forms for Illustrators* and *Business and Legal Forms for Graphic Designers*, both by Tad Crawford (Allworth Press).

If you're working with a gallery, you will not need to send invoices. The gallery should send you a check each time one of your pieces is sold (generally within 30 days). To ensure that you are paid in a timely manner, call the gallery periodically to touch base. Let the director or business manager know that you are keeping an eye on your work. When selling work independently of a gallery, give receipts to buyers and keep copies for your records.

Take advantage of tax deductions

You have the right to deduct legitimate business expenses from your taxable income. Art supplies, studio rent, printing costs and other business expenses are deductible against your gross art-related income. It is imperative to seek the help of an accountant or tax preparation service in filing your return. In the event your deductions exceed profits, the loss will lower your taxable income from other sources.

To guard against taxpayers fraudulently claiming hobby expenses as business losses, the IRS requires taxpayers to demonstrate a "profit motive." As a general rule, you must show

Getting Started

Can I Deduct My Home Studio?

Important

If you freelance full-time from your home and devote a separate area to your business, you may qualify for a home office deduction. If eligible, you can deduct a percentage of your rent or mortgage as well as utilities and expenses like office supplies and business-related telephone calls.

The IRS does not allow deductions if the space is used for purposes other than business. A studio or office in your home must meet three criteria:

- The space must be used exclusively for your business.
- The space must be used regularly as a place of business.
- The space must be your principle place of business.

The IRS might question a home office deduction if you are employed full time elsewhere and freelance from home. If you do claim a home office, the area must be clearly divided from your living area. A desk in your bedroom will not qualify. To figure out the percentage of your home used for business, divide the total square footage of your home by the total square footage of your office. This will give you a percentage to work with when figuring deductions. If the home office is 10% of the square footage of your home, deduct 10% of expenses such as rent, heat and air conditioning.

The total home office deduction cannot exceed the gross income you derive from its business use. You cannot take a net business loss resulting from a home office deduction. Your business must be profitable three out of five years; otherwise, you will be classified as a hobbyist and will not be entitled to this deduction.

Consult a tax advisor before attempting to take this deduction, as its interpretations frequently change.

For additional information, refer to IRS Publication 587, Business Use of Your Home, which can be downloaded at www.irs.gov or ordered by calling (800)829-3676.

a profit for three out of five years to retain a business status. If you are audited, the burden of proof will be on you to validate your work as a business and not a hobby.

The nine criteria the IRS uses to distinguish a business from a hobby are:

- the manner in which you conduct your business
- expertise
- amount of time and effort put into your work
- expectation of future profits
- success in similar ventures
- history of profit and losses
- amount of occasional profits
- financial status
- element of personal pleasure or recreation

If the IRS rules that you paint for pure enjoyment rather than profit, they will consider you a hobbyist. Complete and accurate records will demonstrate to the IRS that you take your business seriously.

Even if you are a "hobbyist," you can deduct expenses such as supplies on a Schedule A, but you can only take art-related deductions equal to art-related income. If you sold two $500 paintings, you can deduct expenses such as art supplies, art books and seminars only up to $1,000. Itemize deductions only if your total itemized deductions exceed your standard deduction. You will not be allowed to deduct a loss from other sources of income.

Figuring deductions

To deduct business expenses, you or your accountant will fill out a 1040 tax form (not 1040EZ) and prepare a Schedule C, which is a separate form used to calculate profit or loss from your business. The income (or loss) from Schedule C is then reported on the 1040 form. In regard to business expenses, the standard deduction does not come into play as it would for a hobbyist. The total of your business expenses need not exceed the standard deduction.

There is a shorter form called Schedule C-EZ for self-employed people in service industries. It can be applicable to illustrators and designers who have receipts of $25,000 or less and deductible expenses of $2,000 or less. Check with your accountant to see if you qualify.

Deductible expenses include advertising costs, brochures, business cards, professional group dues, subscriptions to trade journals and arts magazines, legal and professional services, leased office equipment, office supplies, business travel expenses, etc. Your accountant can give you a list of all 100-percent and 50-percent deductible expenses. Don't forget to deduct the cost of this book!

As a self-employed "sole proprieter," there is no employer regularly taking tax out of your paycheck. Your accountant will help you put money away to meet your tax obligations and may advise you to estimate your tax and file quarterly returns.

Your accountant also will be knowledgeable about another annual tax called the Social Security Self-Employment tax. You must pay this tax if your net freelance income is $400 or more.

The fees of tax professionals are relatively low, and they are deductible. To find a good accountant, ask colleagues for recommendations, look for advertisements in trade publications, or ask your local Small Business Association.

Whenever possible, retain your independent contractor status

Some clients automatically classify freelancers as employees and require them to file Form W-4. If you are placed on employee status, you may be entitled to certain benefits, but a portion of your earnings will be withheld by the client until the end of the tax year and you could forfeit certain deductions. In short, you may end up taking home less than you would if you were classified as an independent contractor.

The IRS uses a list of 20 factors to determine whether a person should be classified as an independent contractor or an employee. This list can be found in IRS Publication 937. Note, however, that your client will be the first to decide how you'll be classified.

Report all income to Uncle Sam

Don't be tempted to sell artwork without reporting it on your income tax. You may think this saves money, but it can do real damage to your career and credibility—even if you are never audited by the IRS. Unless you report your income, the IRS will not categorize you as a professional, and you won't be able to deduct expenses. And don't think you won't get caught if you neglect to report income. If you bill any client in excess of $600, the IRS requires the client to provide you with a Form 1099 at the end of the year. Your client must send one

Helpful Resources

Important

Most IRS offices have walk-in centers open year-round and offer over 90 free IRS publications to help taxpayers. Some helpful booklets include Publication 334—Tax Guide for Small Business, and Publication 505—Tax Withholding and Estimated Tax. Order by phone at (800)829-3676, or download from the official IRS Web site: www.irs.gov.

If you don't have access to the Internet, the booklet that comes with your tax return forms contains addresses of regional Forms Distribution Centers you can write to for information.

The U.S. Small Business Administration offers seminars and publications to help you launch your business. Check out their extensive Web site at www.sba.gov.

Arts organizations hold many workshops covering business management, often including detailed tax information. Inquire at your local arts council, arts organization or university to see if a workshop is scheduled.

The Service Corp of Retired Executives (SCORE) offers free business counseling via e-mail at their Web site: www.score.org.

copy to the IRS and a copy to you to attach to your income tax return. Likewise, if you pay a freelancer over $600, you must issue a 1099 form. This procedure is one way the IRS cuts down on unreported income.

Register with the state sales tax department

Most states require a two to seven percent sales tax on artwork you sell directly from your studio or at art fairs, or on work created for a client. You must register with the state sales tax department, which will issue you a sales permit or a resale number and send you appropriate forms and instructions for collecting the tax. Getting a sales permit usually involves filling out a form and paying a small fee. Reporting sales tax is a relatively simple procedure. Record all sales taxes on invoices and in your sales journal. Every three months, total the taxes collected and send it to the state sales tax department.

In most states, if you sell to a customer outside of your sales tax area, you do not have to collect sales tax. However, this may not hold true for your state. You may also need a business license or permit. Call your state tax office to find out what is required.

Save money on art supplies

As long as you have the above sales permit number, you can buy art supplies without paying sales tax. You will probably have to fill out a tax-exempt form with your permit number at the sales desk where you buy materials. The reason you do not have to pay sales tax on art supplies is that sales tax is only charged on the final product. However, you must then add the cost of materials into the cost of your finished painting or the final artwork for your client. Keep all receipts in case of a tax audit. If the state discovers that you have not collected sales tax, you will be liable for tax and penalties.

If you sell all your work through galleries, they will charge sales tax, but you still need a sales permit number to get a tax exemption on supplies.

Some states claim "creativity" is a non-taxable service, while others view it as a product

and therefore taxable. Be certain you understand the sales tax laws to avoid being held liable for uncollected money at tax time. Contact your state auditor for sales tax information.

Save money on postage

When you send out postcard samples or invitations to openings, you can save big bucks by mailing in bulk. Fine artists should send submissions via first class mail for quicker service and better handling. Package flat work between heavy cardboard or foam core, or roll it in a cardboard tube. Include your business card or a label with your name and address on the outside of the packaging material in case the outer wrapper becomes separated from the inner packing in transit.

Protect larger works—particularly those that are matted or framed—with a strong outer surface, such as laminated cardboard, masonite or light plywood. Wrap the work in polyfoam, heavy cloth or bubble wrap, and cushion it against the outer container with spacers to keep it from moving. Whenever possible, ship work before it is glassed. If the glass breaks en route, it may destroy your original image. If shipping large framed work, contact a museum in your area for more suggestions on packaging.

The U.S. Postal Service will not automatically insure your work, but you can purchase up to $600 worth of coverage. Artworks exceeding this value should be sent by registered mail. Certified packages travel a little slower but are easier to track.

Consider special services offered by the post office, such as Priority Mail, Express Mail Next Day Service and Special Delivery. For overnight delivery, check to see which air freight services are available in your area. Federal Express automatically insures packages for $100 and will ship art valued up to $500. Their 24-hour computer tracking system enables you to locate your package at any time.

The United Parcel Service automatically insures work for $100, but you can purchase additional insurance for work valued as high as $25,000 for items shipped by air (there is no limit for items sent on the ground). UPS cannot guarantee arrival dates but will track lost packages. It also offers Two-Day Blue Label Air Service within the U.S. and Next Day Service in specific zip code zones.

Before sending any original work, make sure you have a copy (photocopy, slide or transparency) in your files. Always make a quick address check by phone before putting your package in the mail.

Send us your business tips

If you've used a business strategy we haven't covered, please write to *Artist's & Graphic Designer's Market*, 4700 East Galbraith Road, Cincinnati OH 45236, or e-mail us at artdesign@ fwpubs.com. We may feature you and your work in a future edition.

Copyright Basics

As creator of your artwork, you have certain inherent rights over your work and can control how each one of your works is used, until you sell your rights to someone else. The legal term for these rights is called **copyright**. Technically, any original artwork you produce is automatically copyrighted as soon as you put it in tangible form.

To be automatically copyrighted, your artwork must fall within these guidelines:

- **It must be your *original* creation.** It cannot be a *copy* of somebody else's work.
- **It must be "pictorial, graphic, or sculptural."** Utilitarian objects, such as lamps or toasters, are not covered, although you can copyright an illustration featured on a lamp or toaster.
- **It must be fixed in "any tangible medium, now known or later developed."** Your work, or at least a representation of a planned work, must be created in or on a medium you can see or touch, such as paper, canvas, clay, a sketch pad or even a Web site. It can't just be an idea in your head. An idea cannot be copyrighted.

Copyright lasts for your lifetime plus seventy years

Copyright is *exclusive*. When you create a work, the rights automatically belong to you and nobody else but you until you sell those rights to someone else.

Works of art created on or after January 1978 are protected for your lifetime plus 70 years.

The artist's bundle of rights

One of the most important things you need to know about copyright is that it is not just a *singular* right. It is a *bundle* of rights you enjoy as creator of your artwork:

- **Reproduction right.** You have the right to make copies of the original work.
- **Modification right.** You have the right to create derivative works based on the original work.
- **Distribution rights.** You have the right to sell, rent or lease copies of your work.
- **Public performance right.** You have the right to play, recite or otherwise perform a work. (This right is more applicable to written or musical art forms than to visual art.)
- **Public display right.** You have the right to display your work in a public place.

This bundle of rights can be divided up in a number of ways, so that you can sell all or part of any of those exclusive rights to one or more parties. The system of selling parts of your copyright bundle is sometimes referred to as **"divisible" copyright**. Just as a land owner can divide up his property and sell it to many different people, the artist can divide up his rights to an artwork and sell portions of those rights to different buyers.

Divisible copyright: Divide and conquer

Why is divisible copyright so important? Because dividing up your bundle and selling parts of it to different buyers will help you get the most payment for each of your artworks. For any one of your artworks, you can sell your entire bundle of rights at one time (not advisable!) or divide each bundle pertaining to that work into smaller portions and make more money as a result. You can grant one party the right to use your work on a greeting card and sell another party the right to print that same work on T-shirts.

Clients tend to use legal jargon to specify the rights they want to buy. The terms below are commonly used in contracts to indicate portions of your bundle of rights. Some terms are vague or general, such as "all rights;" others are more specific, such as "first North American rights." Make sure you know what each term means before signing a contract.

Divisible copyright terms

- **One-time rights.** Your client buys the right to use or publish your artwork or illustration on a one-time basis. One fee is paid for one use. Most magazine and bookcover assignments fall under this category.
- **First rights.** This is almost the same as one-time rights, except that the buyer is also paying for the privilege of being the first to use your image. He may use it only once unless the other rights are negotiated.

 Sometimes first rights can be further broken down geographically. The buyer might ask to buy **first North American rights**, meaning he would have the right to be the first to publish the work in North America.
- **Exclusive rights.** This guarantees the buyer's exclusive right to use the artwork in his particular market or for a particular product. Exclusive rights are frequently negotiated by greeting card and gift companies. One company might purchase the exclusive right to use your work as a greeting card, leaving you free to sell the exclusive rights to produce the image on a mug to another company.
- **Promotional rights.** These rights allow a publisher to use an artwork for promotion of a publication in which the artwork appears. For example, if *The New Yorker* bought promotional rights to your cartoon, they could also use it in a direct mail promotion.
- **Electronic rights.** These rights allow a buyer to place your work on electronic media such as Web sites. Often these rights are requested with print rights.
- **Work for hire.** Under the Copyright Act of 1976, section 101, a "work for hire" is defined as "(1) a work prepared by an employee within the scope of his or her employment; or (2) a work specially ordered or commissioned for use as a contribution to a collective work, as part of a motion picture or other audiovisual work . . . if the parties expressly agree in a written instrument signed by them that the work shall be considered a work made for hire." When the agreement is "work for hire," you surrender all rights to the image and can never resell that particular image again. If you agree to the terms, make sure the money you receive makes it well worth the arrangement.
- **All rights.** Again, be aware that this phrase means you will relinquish your entire copyright to a specific artwork. Before agreeing to the terms, make sure this is an arrangement you can live with. At the very least, arrange for the contract to expire after a specified date. Terms for all rights—including time period for usage and compensation—should be confirmed in a written agreement with the client.

Since legally your artwork is your property, when you create an illustration for a magazine you are, in effect, temporarily "leasing" your work to the client for publication. Chances are you'll never hear an art director ask to lease or license your illustration, and he may not even

realize he is leasing, not buying, your work. But most art directors know that once the magazine is published, the art director has no further claims to your work and the rights revert back to you. If the art director wants to use your work a second or third time, he must ask permission and negotiate with you to determine any additional fees you want to charge. You are free to take that same artwork and sell it to another buyer.

However, if the art director buys "all rights," you cannot legally offer that same image to another client. If you agree to create the artwork as "work for hire," you relinquish your rights entirely.

What licensing agents know

The practice of leasing parts or groups of an artist's bundle of rights is often referred to as "**licensing**," because (legally) the artist is granting someone a "license" to use his work for a limited time for a specific reason. As licensing agents have come to realize, it is the exclusivity of the rights and the ability to divide and sell them that make them valuable. Knowing exactly what rights you own, which you can sell, and in what combinations, will help you negotiate with your clients.

Don't sell conflicting rights to different clients

You also have to make sure the rights you sell to one client don't conflict with any of the rights sold to other clients. For example, you can't sell the exclusive right to use your image on greeting cards to two separate greeting card companies. You *can* sell the exclusive greeting card rights to one card company and the exclusive rights to use your artwork on mugs to a separate gift company. You should always get such agreements in writing and let both companies know your work will appear on other products.

When to use the Copyright © and credit lines

A copyright notice consists of the word "Copyright" or its symbol ©, the year the work was created or first published, and the full name of the copyright owner. It should be placed where it can easily be seen, on the front or back of an illustration or artwork. It's also common to print your copyright notice on slide mounts or onto labels on the back of photographs.

Under today's laws, placing the copyright symbol on your work isn't absolutely necessary to claim copyright infringement and take a plagiarist to court if he steals your work. If you browse through magazines, you will often see the illustrator's name in small print near the illustration, *without* the Copyright ©. This is common practice in the magazine industry. Even though the © is not printed, the illustrator still owns the copyright unless the magazine purchased all rights to the work. Just make sure the art director gives you a credit line near the illustration.

Usually you will not see the artist's name or credit line next to advertisements for products. Advertising agencies often purchase all rights to the work for a specified time. They usually pay the artist generously for this privilege and spell out the terms clearly in the artist's contract.

How to register a copyright

To register your work with the U.S. Copyright Office, call the Copyright Form Hotline at (202) 707-9100 and ask for package 115 and circulars 40 and 40A. Cartoonists should ask for package 111 and circular 44. You can also write to the Copyright Office, Library of Congress, 101 Independence Ave. SE, Washington DC 20559, Attn: Information Publications, Section LM0455.

Whether you call or write, they will send you a package containing Form VA (for visual artists). You can also download forms from the Copyright Office Web site at www.copyright.gov. Registering your work costs $30.

After you fill out the form, return it to the Copyright Office with a check or money order for $30, a deposit copy or copies of the work, and a cover letter explaining your request. For almost all artistic works, deposits consist of transparencies (35mm or $2\frac{1}{4} \times 2\frac{1}{4}$) or photographic prints (preferably $8\frac{1}{2} \times 10$). Send one copy for unpublished works; two copies for published works.

You can register an entire collection of your work rather than one work at a time. That way you will only have to pay one $30 fee for an unlimited number of works. For example, if you have created a hundred works between 2005 and 2007, you can send a copyright form to register "the collected works of Jane Smith, 2005-2007." But you will have to send either slides or photocopies of each of those works.

Why register?

It seems like a lot of time and trouble to send in the paperwork to register copyrights for all your artworks. It may not be necessary or worth it to you to register every artwork you create. After all, a work is copyrighted the moment it's created anyway, right?

The benefits of registering are basically to give you additional clout in case an infringement occurs and you decide to take the offender to court. Without a copyright registration, it probably wouldn't be economically feasible to file suit, because you'd be entitled to only your damages and the infringer's profits, which might not equal the cost of litigating the case. If the works are registered with the U.S. Copyright Office, it will be easier to prove your case and get reimbursed for your court costs.

Likewise, the big advantage of using the Copyright © also comes when and if you ever have to take an infringer to court. Since the Copyright © is the most clear warning to potential plagiarizers, it is easier to collect damages if the © is in plain sight.

Register with the U.S. Copyright Office those works you fear are likely to be plagiarized before or shortly after they have been exhibited or published. That way, if anyone uses your work without permission, you can take action.

Deal swiftly with plagiarists

If you suspect your work has been plagiarized and you have not already registered it with the Copyright Office, register it immediately. You have to wait until it is registered before you can take legal action against the infringer.

Before taking the matter to court, however, your first course of action might be a well-phrased letter from your lawyer telling the offender to "cease and desist" using your work, because you have a registered copyright. Such a warning (especially if printed on your lawyer's letterhead) is often enough to get the offender to stop using your work.

Don't sell your rights too cheaply

Recently a controversy has been raging about whether or not artists should sell the rights to their works to stock illustration agencies. Many illustrators strongly believe selling rights to stock agencies hurts the illustration profession. They say artists who deal with stock agencies, especially those who sell royalty-free art, are giving up the rights to their work too cheaply.

Another pressing copyright concern is the issue of electronic rights. As technology makes it easier to download images, it is more important than ever for artists to protect their work against infringement.

Copyright Resources

Important

The U.S. Copyright Web site (www.copyright.gov), the official site of the U.S. Copyright Office, is very helpful and will answer just about any question you can think of. Information is also available by phone at (202)707-3000. Another great site, called The Copyright Website, is located at http://benedict.com.

A few great books on the subject are *Legal Guide for the Visual Artist* by Tad Crawford (Allworth Press); *The Rights of Authors, Artists, and other Creative People* by Kenneth P. Norwick and Jerry Simon Chasen (Southern Illinois University Press); *Electronic Highway Robbery: An Artist's Guide to Copyrights in the Digital Era* by Mary E. Carter (Peachpit Press); and *The Business of Being an Artist* by Daniel Grant (Allworth Press).

Log on to www.theispot.com and discuss copyright issues with your fellow artists. Join organizations that crusade for artists' rights, such as the Graphic Artists Guild (www.gag.org) or The American Institute of Graphic Arts (www.aiga.org). Volunteer Lawyers for the Arts (www.vlany.org) is a national network of lawyers who volunteer free legal services to artists who can't afford legal advice. A quick search of the Web will help you locate a branch in your state. Most branches offer workshops and consultations.

Promoting Your Work

So you're ready to launch your freelance art or gallery career. How do you let people know about your talent? One way is by introducing yourself to them by sending promotional samples. Samples are your most important sales tool, so put a lot of thought into what you send. Your ultimate success depends largely on the impression they make.

We divided this article into three sections, so whether you're a fine artist, illustrator or designer, check the appropriate heading for guidelines. Read individual listings and section introductions thoroughly for more specific instructions.

As you read the listings, you'll see the term SASE, short for self-addressed, stamped envelope. Enclose a SASE with your submissions if you want your material returned. If you send postcards or tearsheets, no return envelope is necessary. Many art directors want only nonreturnable samples, because they are too busy to return materials, even with SASEs. So read listings carefully and save stamps.

ILLUSTRATORS AND CARTOONISTS

You will have several choices when submitting to magazines, book publishers and other illustration and cartoon markets. Many freelancers send a cover letter and one or two samples in initial mailings. Others prefer a simple postcard showing their illustrations. Here are a few of your options:

Postcard. Choose one (or more) of your illustrations or cartoons that represent your style, then have the image(s) printed on postcards. Have your name, address, phone number, e-mail and Web site printed on the front of the postcard or in the return address corner. Somewhere on the card should be printed the word "Illustrator" or "Cartoonist." If you use one or two colors, you can keep the cost below $200. Art directors like postcards because they are easy to file or tack on a bulletin board. If the art director likes what she sees, she can always call you for more samples.

Promotional sheet. If you want to show more of your work, you can opt for an 8½×11 color or black and white photocopy of your work. No matter what size sample you send, never fold the page. It is more professional to send flat sheets, in a 9×12 envelope, along with a typed query letter, preferably on your own professional stationery.

Tearsheets. After you complete assignments, acquire copies of any printed pages on which your illustrations appear. Tearsheets impress art directors because they are proof that you are experienced and have met deadlines on previous projects.

Photographs. Some illustrators have been successful sending photographs, but printed or photocopied samples are preferred by most art directors. It is not practical or effective to send slides.

Query or cover letter. A query letter is a nice way to introduce yourself to an art director for the first time. One or two paragraphs stating your desire and availability for freelance work is all you need. Include your phone number and e-mail address.

E-mail submissions. E-mail is another great way to introduce your work to potential clients. When sending e-mails, provide a link to your Web site or JPEGs of your best work.

DESIGNERS AND COMPUTER ARTISTS

Plan and create your submission package as if it were a paying assignment from a client. Your submission piece should show your skill as a designer. Include one or both of the following:

Cover letter. This is your opportunity to show you can design a beautiful, simple logo or letterhead for your own business card, stationery and envelopes. Have these all-important pieces printed on excellent-quality bond paper. Then write a simple cover letter stating your experience and skills.

Sample. Your sample can be a copy of an assignment you've completed for another client, or a clever self-promotional piece. Design a great piece to show off your capabilities. For ideas and inspiration, browse through *Designers' Self-Promotion: How Designers and Design Companies Attract Attention to Themselves*, edited by Roger Walton (HBI).

Stand out from the crowd

You may have only a few seconds to grab art directors' attention as they make their way through the "slush pile" (an industry term for unsolicited submissions). Make yourself stand out in simple, effective ways:

Tie in your cover letter with your sample. When sending an initial mailing to a potential client, include a cover letter of introduction with your sample. Type it on a great-looking letterhead of your own design. Make your sample tie in with your cover letter by repeating a design element from your sample onto your letterhead. List some of your past clients within your letter.

Send artful invoices. After you complete assignments, a well-designed invoice (with one of your illustrations or designs strategically placed on it, of course) will make you look professional and help art directors remember you—and hopefully, think of you for another assignment.

Print and Mail Through the USPS

Tip

If you're looking for a convenient, timesaving and versatile service for printing and mailing promotional postcards, consider the U.S. Postal Service. USPS offers a postcard service through their Web site (www.usps.com). You can have promotional postcards printed on 4×6 or 6×9 glossy cardstock and buy as many or as little as you need.

One drawback of going through the USPS is that you can't order a certain amount of postcards to keep on hand—cards must be addressed through the Web site and are mailed out for you automatically. But you can essentially create a personal database and simply click on an address and mail a promo card whenever needed. You can upload different images to the site and create postcards that are geared to specific companies. (When you visit the site, click on "Send Cards, Letters & Flyers" in the Mailing Tools box.)

Follow up with seasonal promotions. Many illustrators regularly send out holiday-themed promo cards. Holiday promotions build relationships while reminding past and potential clients of your services. It's a good idea to get out your calendar at the beginning of each year and plan some special promos for the year's holidays.

Are portfolios necessary?

You do not need to send a portfolio when you first contact a market. But after buyers see your samples they may want to see more, so have a portfolio ready to show.

Many successful illustrators started their careers by making appointments to show their portfolios. But it is often enough for art directors to see your samples.

Some markets in this book have drop-off policies, accepting portfolios one or two days a week. You will not be present for the review and can pick up the work a few days later, after they've had a chance to look at it. Since things can get lost, include only duplicates that can be insured at a reasonable cost. Only show originals when you can be present for the review. Label your portfolio with your name, address and phone number.

Portfolio pointers

The overall appearance of your portfolio affects your professional presentation. It need not be made of high-grade leather to leave a good impression. Neatness and careful organization are essential whether you're using a three-ring binder or a leather case. The most popular portfolios are simulated leather with puncture-proof sides that allow the inclusion of loose samples. Choose a size that can be handled easily. Avoid the large, "student-size" books, which are too big to fit easily on an art director's desk. Most artists choose 11×14 or 18×24. If you're a fine artist and your work is too large for a portfolio, bring slides of your work and a few small samples.

- **Don't include everything you've done in your portfolio.** Select only your best work, and choose pieces relevant to the company you are approaching. If you're showing your book to an ad agency, for example, don't include greeting card illustrations.
- **Show progressives.** In reviewing portfolios, art directors look for consistency of style and skill. They sometimes like to see work in different stages (roughs, comps and finished pieces) to examine the progression of ideas and how you handle certain problems.
- **Your work should speak for itself.** It's best to keep explanations to a minimum and be available for questions if asked. Prepare for the review by taking along notes on each piece. If the buyer asks a question, take the opportunity to talk a little bit about the piece in question. Mention the budget, time frame and any problems you faced and solved. If you're a fine artist, talk about how the piece fits into the evolution of a concept and how it relates to other pieces you've shown.
- **Leave a business card.** Don't ever walk out of a portfolio review without leaving the buyer a sample to remember you by. A few weeks after your review, follow up by sending a small promo postcard or other sample as a reminder.

GUIDELINES FOR FINE ARTISTS

Send a 9×12 envelope containing whatever materials galleries request in their submission guidelines. Usually that means a query letter, slides and résumé, but check each listing for specifics. Some galleries like to see more. Here's an overview of the various components you can include:

- **Slides.** Send 8-12 slides of similar work in a plastic slide sleeve (available at art supply stores). To protect slides from being damaged, insert slide sheets between two pieces

of cardboard. Ideally, slides should be taken by a professional photographer, but if you must take your own slides, refer to *The Quick & Easy Guide to Photographing Your Artwork* by Roger Saddington (North Light Books) or *Photographing Your Artwork* by Russell Hart and Nan Star (Amherst Media). Label each slide with your name, the title of the work, media and dimensions of the work, and an arrow indicating the top of the slide. Include a list of titles and suggested prices gallery directors can refer to as they review slides. Make sure the list is in the same order as the slides. Type your name, address, phone number, e-mail and Web site at the top of the list. Don't send a variety of unrelated work. Send work that shows one style or direction.

- **Query letter or cover letter.** Type one or two paragraphs expressing your interest in showing at the gallery, and include a date and time when you will follow up.
- **Résumé or bio.** Your résumé should concentrate on your art-related experience. List any shows your work has been included in, with dates. A bio is a paragraph describing where you were born, your education, the work you do and where you have shown in the past.
- **Artist's statement.** Some galleries require a short statement about your work and the themes you're exploring. Your statement should show you have a sense of vision. It should also explain what you hope to convey in your work.
- **Portfolios.** Gallery directors sometimes ask to see your portfolio, but they can usually judge from your slides whether your work would be appropriate for their galleries. Never visit a gallery to show your portfolio without first setting up an appointment.
- **SASE.** If you need material returned to you, don't forget to include a SASE.

Motivational Tools of the Trade

Advice from an Experienced Freelancer

by Jim Hunt

Staying motivated is an issue every artist deals with, both creatively and on a business level. Regardless of whether you've just begun your career or you're an established veteran, finding ways to stay motivated can be a challenge—sometimes even more so in the case of the latter group. Trust me, I know more than a few established artists who have practically begun "phoning it in." For some, success leads to monotony; for others—it's motivating!

How do freelance artists stay motivated while trying to establish their careers? For me, it's quite simple. Since I began freelancing in 1989, I have never subscribed to traditional guidelines (or *Sports Illustrated* for that matter). One thing I knew early on, was that if I was going to succeed, I had to build on my strengths: salesmanship, "people skills," and my wife. Now lest you think that's simply a gratuitous plug to earn points on the home front, be aware that having a support system when getting established is a very important part of staying motivated. It can be emotional support and, in many cases, financial support. Usually, it's both. The point is, as you develop your business (and confidence), you'll need others along the way. And it's very rewarding when they also get to share in your success after having been there from the start!

Your artistic talent will develop as your business sense develops. That's the beauty of being an artist—you only get better as you get older. That very same principle applies to the marketing of your work. It becomes refined and, therefore, more effective. But in order to survive the early days, you'll need to sell yourself as much as the work. In fact, most art directors tell me they prefer to work with someone (even of lesser talent) who is professional in their handling of an assignment, and also a pleasure to work with. Remember, you are trying to build long-term relationships as a freelancer. Developing these qualities early on will carry you a long way. They are, in fact, your reputation.

Establishing a new client is very motivating. But continuing to find more and more clients is the challenge—a challenge that some (myself included) use as motivation each and every day. I've always viewed marketing my work as planting seeds or casting out fishing lines. Not a few lines, mind you, but one of those trawler boats with dozens of lines in the water at the same time. Watching a few "tugs and nibbles" (replies of interest, and telling you they'll keep your name and Web site on file) is encouraging. When a line gets a serious bite (request for a quote, or an assignment), that's even more encouraging—and definitely

JIM HUNT is a nationally recognized cartoonist whose clients include NASCAR, Hershey's, Eastman Kodak and Bank of America. Visit www.jimhunt.us to learn more about him and his work.

motivating! Of course, every once in a while you'll snag a tire or old shoe (assignment offer with a budget of $10). Just clean that hook and recast the line.

Why you *shouldn't* read about the industry

There are so many Web sites, blogs and publications that address the issues freelance artists want to keep up on. Those resources can be very helpful. But the one thing I find most *un*helpful, is the "doom and gloom" editorial in relation to opportunities for an artist. There will always be blogs that talk about how bad things are for freelancers. Who cares? Do you really want to base your career decisions on some frustrated artist's blog rant? Yes, there will always be certain areas where opportunities for work are fewer. But when a blog (authored by a struggling artist) tells you there's no work out there, I suggest you ignore that, and cast another line.

Why limit yourself?

For most of us, the style we work in is pretty specific. That doesn't suggest, however, that the client base needs to be as well. Even though my cartooning style is very specific, there are so many different applications for my work. When building a freelance business, it certainly makes sense to look for opportunities everywhere. I continue to do this, even after 18 years. One of the common outlets for a cartoonist's work is magazine illustration. There's always a call for sidebar and article spot illustrations, in certain publications. But after you've established that magazine client, why not introduce your work to the marketing manager of that publication? You never know what sorts of promotional pieces they may design. And in many cases, that magazine is owned by a publisher who also has several other magazines and possibly even book imprints. The marketing manager may in fact handle all of them.

This is one example of how the application of your work can vary. But that's just the tip of the example iceberg. When I'm in a casual, family-style or bar-and-grille type of restaurant, I immediately look at the menu. Does it have the type of design that spot cartoons or icons would fit with? If so, I make note of that (or take home a to-go menu to remind myself) and introduce my work to the restaurant owner at a later, more appropriate time. Don't forget the ever-popular "kids' coloring page," or even T-shirt designs.

If I'm flipping through a newspaper or magazine and I see an ad with clip art (or a spot cartoon that looks like it was drawn by their "brother's friend's nephew who likes to draw"), I introduce my work to that advertiser. It may take some digging and a few e-mails to find the right contact person, but it's worth it. I've even brought brochures home from the Department of Motor Vehicles that had clip art on them. Needless to say, I had plenty of time at the DMV to notice the various brochures and pamphlets lying about. The point of these examples is to show that your style may be the same, but the possibilities for work are limitless.

Panning for gold

I know I used the "casting out fishing lines" metaphor earlier, but when it comes to motivation, you can never invoke too many metaphors. I've always thought of having examples of my work out in the marketplace (via direct promotional pieces, or assignments) as panning for gold. In the case of a magazine assignment, my work is now in front of all of those magazine readers. Whether they're subscribers to that publication, or dental patients killing time in the waiting room, they have now seen my work. And since (in most cases) there will be a credit line associated with the illustration, if by chance they are in need of a cartoonist, they will immediately know how to find one.

Another benefit to having your work appear in a variety of outlets, is the likelihood that a prospective client may already be familiar with your work before contacting you. That establishes a credibility that goes a long way. And it's nice to refer to an example that they may have already seen. I was in a restaurant one day discussing this very topic with a friend

(he had asked me where I find work), and I said, "Ask that woman next to you if she'll hold up her shopping bag." It just so happened that the bag was from a local bookstore, and the front of the bag featured a cartoon I had drawn for that store. Certainly the timing of that woman's appearance was pure coincidence, but the impact of that example at that moment would have made quite an impression had I been meeting with a prospective client. And that moment was also quite motivating for me.

Let e-mails pound the pavement

There's nothing quite as motivating as a reply to an e-mail inquiry—even the ones that say "Thank you for thinking of us, but we don't use illustration," are welcome. Those replies often include a nice complimentary remark. Compliments never get old; they are like kindling for the motivational fire (yet another metaphor). And since freelance work is as much sales as it is creating the actual work, getting responses to your solicitations is what you want.

The great thing about an e-mail introduction of your work to a prospective client, is that it really is the "cold call" without the nervousness or pressure that comes with sales. And the better you get at targeting your brief introductory e-mails (which include a Web site link, of course) to the right prospects, the higher the percentage of replies that say either "Great work! We'll definitely keep you in mind . . ." or "Your timing is perfect! We just so happen to have a project that you can help us with."

Every job is about you

As a freelance artist, you are developing both your artistic and marketing skills at the same time. But in order to increase your chances of landing a new assignment, you need to back

© JimHunt.us

up the work that clients are already impressed with by being professional and easy to work with. Your motivation in this case is the hope that they will give you another assignment, and yet another. Once you establish a reputation as a solid professional, the work will continue to come in—assuming, of course, that your promotional and marketing efforts continue to go out! Remember, it's not just what's on paper that matters. If people like working with you, you'll have those clients (and others they refer to you) for life.

Conversely, even if you produce what is asked of you but make the experience a frustrating or difficult one for the client, you'll likely not be hearing from them again. I've had more than one art director tell me horror stories of artists who acted as if they just exhibited in The Louvre and shouldn't have to take art direction on an assignment.

Let them motivate you

So what about when the tables are turned? You're great to work with, deliver what a client asks for, but the client is never satisfied; or they're all over the map with their editing comments. Every freelance artist has, or will, run across these types at some point. If you're lucky, it's only going to happen a handful of times in your career. As you become more experienced (and don't need to take EVERY job that comes along), you will become more aware of certain red flags that present themselves when you're approached for a quote. You will get a sense that this may not be a person you'll want to collaborate with. This will normally not be an issue with an art director or an editor. It tends to be a problem with "non-professionals" who want to hire you for a project.

In my case, an example of this type of candidate would be the author who wants to self-publish their work. Most are very mindful of the fact that you are the professional and they are not; they defer to your judgment on the artwork being created (as long as you allow them to have *some* input). But others decide to micro-manage each line that is drawn. Unfortunately, you often have to persevere and finish the job, while griping to your spouse or friends about this "nightmare of a client." I have come to use those past experiences as motivation when moving ahead. I'm motivated to be more aware before agreeing to sign on to a project, and motivated to have more of an appreciation for the other 98% of the jobs that are enjoyable experiences.

Transcend doubt

There's one more very important thing I suggest you remind yourself of each morning when you go to your office: The fact that it is *your* office! Whether it's an office that also happens to be the laundry room in your home (my first workspace), or a private studio somewhere, you've just sat down at your desk, in your office, of your business. The way your day unfolds is determined by your outlook. You are in a position to be able to build a business, and to control your future.

To quote Thoreau, "If one advances confidently in the direction of his dreams and endeavors to live the life that he has imagined, he will meet with a success unexpected in common hours."

It may not be a day where you receive an assignment, or even a request for a price quote. But on those days, you stay motivated by remembering those fishing lines. Do an online search for a category of potential clients (T-shirt printers, magazine publishers, etc.), then grab a can of e-mail worms and start casting those new lines. You never know when or where that "big catch" will come from—the type of job that can carry you (both financially and motivationally) for months! Every e-mail or promo card you send can possibly lead to a job. How's that for motivation?

Self-Promotion in the Modern World

© Burton Morris Studios

by Maria Piscopo

Direct marketing can be an effective way for artists and designers to attract clients. The term "direct marketing" simply refers to sending self-promotion material—anything from postcards to brochures—to current and prospective clients with the goal of having them respond to you (and hopefully give you work).

"I think it's important to send out something that an art director or new client could hang up on their wall or give to someone to display that is unique in both image and design," says pop artist Burton Morris. "I send out e-mail postcards to generate interest in my Web site (www.burtonmorris.com), as well as printed postcards through the mail to attract new clients. Due to postcard mailings, I have gained attention and earned jobs creating signature artwork for the 76th Annual Academy Awards, the 2004 Summer Olympic Games, the 38th Montreux Jazz Festival, and the 2006 Major League Baseball All-Star Game."

But postcards are just the tip of the iceberg when it comes to contacting clients through direct mail. "Our best success story was a direct mail piece that was a quart-size paint can designed with a custom outer wrap," says designer Ron Leland. "Inside the can, we placed a paint swatch designed with 'hip' copy, where each shade of color featured on the card conveyed an element of the services we offer. The response from this mailing was tremendous, and much of the feedback pointed toward that proverbial 'Oh, it's way too cool to throw it away, so we're keeping it on our desk' sentiment."

Before you begin, says Burton, "write down your goals and think about who your target clients are. A strategic business/marketing plan is always a good idea, and focusing on what images you send out and why someone would hire you is crucial. Also, it is necessary to be consistent in your marketing efforts and send out mailers and e-mails quarterly to keep your work in front of potential clients."

When it comes to promoting design, "Target your audience," says Leland. "Share not only the results, but the process of design; tell a story visually, with text supporting those visuals; find a way to differentiate yourself; and close with a call to action."

MARIA PISCOPO (www.mpiscopo.com) has been an art/photo rep in California for 25 years. She writes magazine articles and columns for industry publications such as *Rangefinder, STEP inside design, Dynamic Graphics, Shutterbug* and *Communication Arts*. She is also the author of *Photographer's Guide to Marketing and Self-Promotion* and *Graphic Designer's and Illustrator's Guide to Marketing and Promotion* (both published by Allworth Press). She gives lectures, seminars and workshops on business and marketing for artists and designers around the world.

Design considerations

When you've put together a mailing list (see sidebar below for tips) and are ready to contact potential clients, it's time to think in terms of design. When creating direct mail pieces, choosing the right design is important if you want to attract potential clients in need of your talents—and entice them to contact you. "We like to call our direct marketing piece a 'Trojan Horse,' " says Leland. "It's the piece that's so compelling, the recipient can't help but take it in. Once we've gained attention, the message can be shared."

"Good design plays an important role in making a piece of direct mail stand out amongst the competition," says Fred Hernandez, Marketing Communications Manager at Modern

Assembling a Mailing List

Successful direct marketing always starts with a targeted list of prospective clients. In addition to creating mailing lists based on researching *Artist's & Graphic Designer's Market* listings and your own networking, some artists purchase industry-specific mailing lists or labels.

There are many industry-specific sources for your mailing lists. You can just buy the labels or e-mail addresses from these firms, but consider buying the database to use on your computer and make your own labels. Another option is to import the data if you are already using a compatible contact management software program for a database (e.g., *Filemaker Pro* or Microsoft *Access*). When buying data, look for individually prepared lists targeted to your marketing message.

Make sure the company updates their database at least two to three times a year. If you are buying the database, make sure you can add your own sales leads, contact names and even mail/merge for printing custom letters and envelopes. Check out the search and sort capabilities of the program before you buy so that you can search the data by company name, city, state, zip code, area code, type of client, contact name or any of the other popular fields of information used for mailing lists databases.

Here is a partial list of companies that sell targeted databases of clients that buy art and graphic design:

- ADBASE: www.adbase.com
- Adweek Directory: www.adweek.com/directories
- Agency Access: www.agencyaccess.com
- Agency ComPile: www.agencycompile.com
- ArtNetwork: www.artmarketing.com
- Bizjournal's *Book of Lists*: www.bizjournals.com/bookoflists
- Creative Access: www.bigroster.com/c1_cac.htm
- FRESH LIST: www.freshlists.com
- Gale Directory of Databases: www.galegroup.com
- The List: www.thelistinc.com
- Workbook Mailing Lists: www.workbook.com/mailing-lists

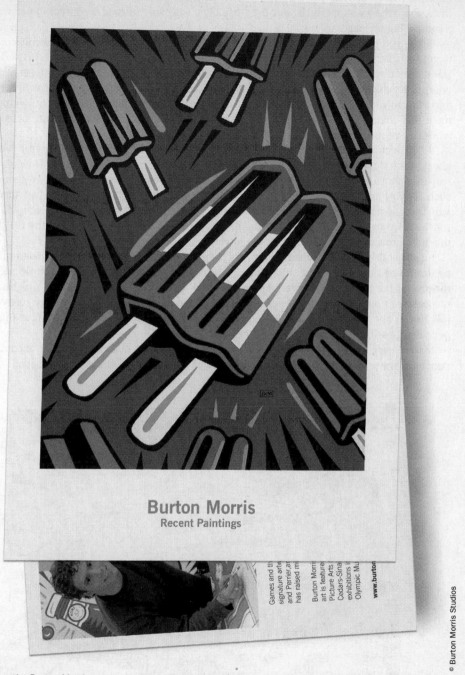

Burton Morris
Recent Paintings

Games and th
signature artw
and Perrier, a
has raised m

Burton Morri
art is feature
Picture Arts
Cedars-Sina
exhibitions i
Olympic Mu

www.burton

Pop artist Burton Morris sends out postcards such as this to attract new clients and update current clients on his latest projects.

Postcard (www.modernpostcard.com). "Every day our mailboxes are full of direct mail, but think about the ones that catch your eye—usually it's because of good design combined with a compelling message."

Before you begin designing, Hernandez says, be clear on your objective. "Are you trying to get a job, secure new clients, or simply stay in touch with your existing clients? Answering this question will determine the rest of the campaign," he says. "If you're trying to get a job, your mailer might include some résumé-type information along with samples of your work and a link to your portfolio or Web site. If you're prospecting, it will be more like an advertisement that could include an offer or promotion. A mailer to existing clients could focus on work you've just completed or an award that you've won."

When deciding on your design, also consider what kind of response you want from your client. What is it exactly that you want people to do when they receive your mail? How many response choices can you give them? These choices can range from a "low-risk" response, such as *Wait for our next mailing*, to a "high-risk" response such as *Call when you have a job!* There is no right or wrong response to use. However, the lower the risk to your client (or the more passive they get to be), the more people will respond. The higher the risk (or the more proactive they have to be), the lower the response.

Again, both will work, but which one is right for your direct marketing campaign must be determined by your overall marketing plan objectives. One factor to help you decide is the size of the mailing. For a very large volume of mail, you may want to use a high-risk response so you get just your serious clients to respond—that is, people who are ready to talk to you about an assignment. If your mailing list is very small, you may want as many people as possible to inquire, so lower the risk.

Make it easy for potential clients to respond by including the maximum number of contact options on the printed pieces. If you're sending material in envelopes, it's important that all your

"I think it's important to send out something that an art director or new client could hang up on their wall," says Burton Morris. His pop art paintings are ideal for this goal.

More Direct Marketing Tips

Fred Hernandez, Marketing Communications Manager at Modern Postcard (www.m odernpostcard.com), has worked with innumerable clients creating direct mail pieces for all kinds of direct marketing campaigns. Here he offers his checklist of tips that are generally true of any good campaign:

- **Have a clear objective.** Effective direct mail depends on having a specific purpose as opposed to other advertising, which is usually very general in nature. This step is crucial in setting up the rest of your campaign.

- **Know your audience.** A clear objective will usually determine who your audience will be. One of the strengths of direct mail is the ability to target only those prospects that are most likely to respond. For example, if you're marketing children's book illustration, you'll naturally only mail to companies who publish material for children.

- **Keep it short.** Resist the temptation of packing too many messages into one mailer. Remember your objective? That's the only topic you should be addressing in your mailer so that the reader is clear about what you are trying to tell them and what you want them to do.

- **Include a strong offer and call-to-action.** A crucial, and often forgotten, component of good direct mail is a compelling offer. Think about what will get a prospect to act. Discounts and the word *free* are always powerful offers. Also, you've gone through the trouble and expense to reach potential clients, so ask them to do something. Invite them to call, visit your Web site, view your portfolio, etc.

- **Don't forget your contact information.** Seems like a no-brainer, but you'd be surprised how often this happens. Burying your contact information is just as bad. Make it really easy for the recipient of your material to contact you— include your phone number, e-mail address and Web site prominently.

- **Test, test, test.** The ability to test smaller campaigns to evaluate effectiveness before you roll out a larger mailing is an important strength of direct mail. Test different elements of your mailers—creative, messaging, offers, audience—and determine what works best. This is where it really outshines other forms of advertising, which are usually all-or-nothing ventures.

contact information be on the promotional material itself so if the envelope gets thrown away, clients can still find all the information they need. Be sure to include your firm name if applicable, your name (so they know who to ask for when they call or e-mail), your full address with nine-digit zip code, phone and fax numbers with area code, e-mail address and Web site.

And make them an offer they can't refuse. The customary offer, *Call for a portfolio*, has become all too common. Clients would have to be really interested to accept that offer and respond. If you want a better response, be more interesting. The offer should be about the client and their needs, not about you. For example, in a message such as, *When you need a Web site designer to help promote your company, give us a call*, the "you" is the client.

Something else to keep in mind as you design promo pieces, are postal regulations, says

Hernandez. ''The U.S. Postal Service is very specific about postcard layout and how it needs to conform to their requirements in order for it to be mailed,'' he says. ''We provide handy templates for all major design programs that designers can use to make sure they are in compliance.''

Selecting images

Choosing the best—and most effective—images for your direct mail campaign materials is important. Be careful not to send too broad a message to your prospective clients. This means offering a narrow selection of images. You may want to consider a separate campaign for current clients that are used to seeing a broader selection of work.

Your marketing message dictates your image selection and is very narrow compared to the range of images you are actually capable of making. But your marketing message needs to focus on what you *want* to do—not necessarily what you've done in the past. If your marketing message is a visual style, then show it. Push it to the edge and show your style in as many situations as possible. Remember, style is not specific to any subject. But if your marketing message is a subject (for example, ''children's book illustration''), show that. Focus, focus, focus on the type of work you want to get.

Also, since you will most likely have more than one marketing message, look for crossover images for your direct marketing campaigns. Crossover images allow you to use the same image for more than one target market. For example, a photo-realistic illustration of a corporate executive may work in a campaign for both ''people'' illustration and ''annual report'' illustration.

Printing & mailing

Once your direct mail piece has been designed, you must consider printing. ''I always look for the best-quality printer to reproduce my artwork,'' says Morris. ''It's very important for me to make certain that whatever image I send out on a postcard or brochure catches the

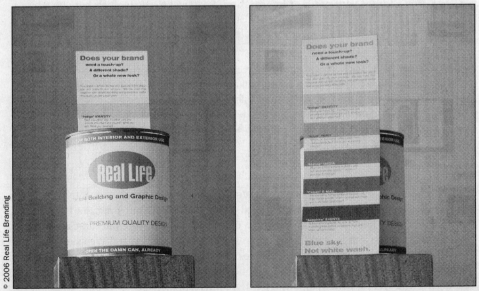

© 2006 Real Life Branding

Ron Leland is an art director at Real Life Brand Architecture (www.reallifebranding.com). He and his team created this unique direct mail piece—a quart-size paint can with a custom outer wrap displaying the company's name. Inside the can was a paint swatch; each color shade featured on the card described an element of the services offered by the company.

attention of anyone who receives it. I discovered Modern Postcard early in my career, and they've printed all of my postcards."

When you plan your direct mail campaigns, design them for staggered repetition and frequency. Be sure to schedule design and production timelines. Take out your calendar and create a timeline working backwards from the date you want the pieces to be mailed.

When you want to re-use past mailers, plan on re-packaging them in some way. For example, take leftover postcards, trim the images to fit, and bind them in some way (e.g., wire or plastic, ribbons or lace). This re-packaging of your direct marketing piece alters the client's perception and allows you to use the same piece twice.

Probably the biggest mistake artists can make in their direct mail marketing is the lack of consistency and quality of design and production. If you cannot do it well, don't do it. This does not mean spending a lot of money. It does mean getting a good design concept and quality production values. As soon as you have the concept, find out how much the entire campaign will cost and start setting that money aside. Plan a budget for your mailings by getting design, production and printing estimates in advance of needing to spend the money.

"A final important point for artists and designers is the idea of frequency," says Hernandez. "As with any form of marketing, a series of frequent and consistent mailings is far more powerful than one mailing. We see our top artist and designer clients send out as many as a dozen cards a year to their clients and prospects."

Articles & Interviews

Success Stories

Patience, Flexibility and Perseverance Pay

by Donya Dickerson

Congratulations, you are on the path to success. How do I know? Well, for starters you bought this book. That means you've taken the first crucial step toward your goal of becoming a published artist. Secondly, you're reading this article—which means you want to know how others were able to get art directors to not just notice them, but to actually *hire* them.

So, just what can you learn from the three success stories in this article? First, take note of how the artists work with vastly different markets, including comics, gifts and book publishing. And these represent only a small fraction of the places where you can send your work. This book is full of opportunities—ranging from magazines and galleries to advertising firms, poster publishers and more.

Next, recognize that by using their own research in addition to the listings in *Artist's & Graphic Designer's Market,* each individual had a strategy in place for approaching new markets. They've laid the groundwork for you. If you follow their proven methods, including researching art directors' specific needs and creating a knockout sample, you'll be one step closer to achieving your dream.

Finally, our featured artists—Troy Boyle, Michelle Shortt, and the husband and wife team of Hilary and Tyler Jenkins—provide invaluable insight about attracting the attention of art directors. Pay close attention to what they say; they speak from experience. Take some time to learn from them—and then go out and do it yourself. Find your own success!

Troy Boyle
(www.comicspace.com/t_boyle)

Yes. It's a word all artists long to hear. And for Troy Boyle, his first "yes" was truly unforgettable. "An artist's first published sale brings with it a huge sense of validation," he says. "For me, it was akin to having the outside world say, 'Yes, you *are* an artist!' " So what were the steps this comic artist and fine art painter took to achieve this initial thrill of success?

Boyle started by searching for markets in *AGDM,* specifically for publishers who had a need for editorial cartoons. "I can't remember not knowing about *AGDM,*" he says. "In both high school and college, we

were taught that this is an indispensable reference for anyone pursuing a creative career. I remember it was an exhaustive process. For each magazine and art director that I wanted to contact, I had to follow their submission guidelines exactly. Luckily, the proper contacts for discovering those guidelines are included in *AGDM*.''

To be taken seriously by any market, Boyle emphasizes the importance of paying close attention to its specific needs. ''You MUST follow the submission guidelines (including house style, media, content, delivery mechanism) published by the market you are attempting to enter,'' he says. ''Nothing will stop your career faster than arrogantly sending your artwork

© 2007 Troy Boyle

Troy Boyle used this image as a promotional piece for his new comics series ''Pinnacle,'' debuting in *Mysterious Visions Anthology* from Dimestore Productions (www.dimestore productions.com). The publisher purchased limited, first-run rights, and Boyle will receive 90% of the profits after production costs.

in the manner you're comfortable with, or that which is most convenient for you, rather than what the publisher or art director has specified."

The responses to Boyle's initial mailing started coming back almost immediately. "I first began hearing back from my original submissions about three weeks after I sent out a flurry of solicitations," he says. "Honestly, most of them were rejections." And while the news wasn't always good, Boyle also made his first two sales, which quickly became sources of inspiration for him as he thought about sending out more work. "One was from the local chapter of NOW, the National Organization for Women. They had accepted two of my editorial cartoons! It was my first published sale. I must have hoarded a couple dozen of the newsletters, and periodically I'd look at the cartoon on the front with my signature on it and just could not believe it was real."

Since those first assignments, Boyle's career has continued to flourish, and his illustrations have been published "in just about every arena you can name—magazines, newspapers, online publications, comic books, the recording industry, signs and logotypes," he says. Along the way, he's had some truly interesting opportunities. One that really stands out was being commissioned to paint "a one-hundred-foot-long glowing, fluorescent mural in a downtown nightclub." He believes that being flexible and willing to work with diverse styles is the key to developing long-term relationships with markets. "Once you've established a track record and a comfort level, you will find that you can submit illustration to almost any magazine, in any genre. It helps to be chameleonic."

These days, Boyle focuses his efforts on his real passion: comic books. "I am of the 'realist' school of comic art, first established by professionals such as Alex Raymond and Neal Adams. Although the faces and emotional content can be iconic, the treatment of anatomy, clothing, perspective, and especially shadowing, is very real." Being specialized has allowed Boyle to thrive in this extremely competitive marketplace. "It's been a busy year for me," he says. "I have several titles coming out that I'm quite proud of, including a short piece in Desperado Publishing's *Negative Burn*."

Boyle recognizes what it means to succeed in this difficult market. "Every year there are literally thousands of young kids trying to break into the business, but only a handful of real openings," he says. For any comic artist who wants to rise above the competition, he recommends making learning your craft a life-long pursuit. "Do not take shortcuts. Take the time to master anatomy, perspective, textures, light sourcing, and rotating a body in space. If you can't imagine or draw an object from every single angle, with any imaginable light source, accurately and convincingly, then you need more training. In fact, an artist's learning curve is never completed. You should be learning and striving to improve [throughout] your entire life. Even the masters—Van Gogh, Rembrandt, Michelangelo—were consumed by this idea of discovery and learning. The proof of that statement is apparent in the way that their output continually changed and evolved."

Finally, Boyle says, "Don't get discouraged. If you have talent and perseverance, you will succeed. I know that sounds like an empty platitude, but believe me, it's true. Having a career with longevity involves being adaptable enough to change with the times and being persistent enough to keep trying, regardless of how much resistance you encounter."

Michelle Shortt
(www.michelleshortt.com)

Before mailing out submissions, Michelle Shortt looked to the people she knew for opportunities to hone her craft. "Any work I had done was more on a local level and for family and

friends," she says. This included creating cards, wedding invitations, logos, illustrations for retail signage, and renderings for the interior design industry. "These small jobs can actually support your art," says Shortt. "Any money you earn can go right back into promotional efforts."

By gaining this invaluable experience, Shortt was able to get her first professional assignment, "illustrating scrapbook papers, which I loved," she says. This success encouraged her to do a mailing aimed at other markets that might be interested in her artwork.

To find more markets for her work, she did thorough research, ultimately compiling a list of about 450 leads—some from *AGDM*, some she found on her own. She took a very organized approach to contacting these markets by creating "an address book database on my e-mail program. From this database I created mailing labels." Her next move was deciding what to send. She created a full-color promotional postcard with "a simple design, which was an illustration of myself, and an introductory letter explaining a little bit about my artwork. I mailed all out at once, but to get some firm feedback, I included reply cards [self-addressed, stamped postcards] to 50 markets that represented a broad spectrum of types of companies."

All her careful research to target appropriate markets and her systematic mailing paid off.

<div style="text-align:right">Articles & Interviews</div>

© 2006 Michelle Shortt

Illustrator Michelle Shortt created this peacock image for a promotional mailing. "After sending out my promo," she says, "a few of my contacts requested a portfolio of my work (via reply cards)."

"I heard back within two weeks from particular art directors, which was very exciting," she says. "I had at least a ten-percent response, which was much higher than I predicted."

Based on the response she got from art directors, Shortt was able to quickly learn the types of markets for which her work is best suited. "My illustrations are very light, stylized and whimsical (nothing serious)," she explains. "I use mixed media, but usually end up with one cohesive style, which is very important. I like to use people and animals in my illustrations as well as bold, bright color." Because of this lively, often feminine style, she's had the most success in the gift, stationery, women's editorial, and advertising markets.

With all her successes, she's also faced rejection. This is typical for any artist who is sending work out into the world. But Shortt believes you can turn any "no" into a learning experience. "You will get an equal amount of negative response back if you ask for it. (I did this by sending out reply cards.) It's a little hard on the ego, but in the end it has only made me grow as an illustrator. Be patient and work really hard at sending your samples to the right companies."

To keep going through hard times, Shortt recommends that artists "take things in baby steps. It's not all going to happen at once, and if you think it will, you will only get overwhelmed. I have learned to reward myself for little things that, in the long run, are getting me closer to my dream of being a professional illustrator. I truly believe that hard work always pays off."

Blacksheep Studios
(www.blacksheepstudios.ca)

For artists out there who feel isolated, working as a member of a team is a great way to share ideas about art—and also markets. Hilary and Tyler Jenkins have certainly found this to be true. The husband and wife duo—who originally met while attending the Alberta College of Art and Design—together form Blacksheep Studios. While they don't often work on pieces together, their collaboration plays an important role when it comes to marketing their work.

Hilary and Tyler Jenkins

"No one person is good at everything, and having two people in the company allows us to focus on the parts we are best at," they explain. "The trick is to find a complimentary partner, one who is good at what you are not and is poor where you excel. It just so happens that the things that make our marriage successful also make our business strong. It doesn't matter, per se, that we are husband and wife, but that we operate as a team."

Although their work differs greatly, both Hilary and Tyler have found notable success in the publishing and editorial markets as well as in the game industry. Hilary works mostly in colored pencil and pencil, focusing specifically on illustrating work for children. Her goals for her work are "to create images that inspire kids, images that are completely at home in their imaginations, that make them laugh and want to go on grand adventures. I want to specialize in romantic images of innocence and fun."

Tyler, on the other hand, has found his niche in science fiction and fantasy as well as "modern day urban/street culture." He says his favorite kinds of work are "where I have a lot of room to move. I like having the opportunity to define a concept and then figure out the best way to represent that."

Another benefit of working so closely with someone is being able to "pool resources" when it comes to finding markets that want your work. "We market together," they say. "We've planned our business together, and we always have the invaluable second set of eyes to evaluate our work."

When they first formed their studio, Hilary and Tyler wanted to do a promotional campaign to make markets aware of their work. Together, they researched the best markets for unique styles. "As a new company, we weren't sure which markets would be the most receptive to our styles . . . so we actually contacted a wide cross section of the companies listed in *AGDM*. On top of this, we used the ideas of those markets to search the Internet for related companies."

They also carefully read the guidelines before sending out mailings. "We produced promotional material in the form of postcards to send to the companies that accepted mailed samples. We also included a letter of introduction as that is what a lot of companies in *AGDM* seemed to prefer." Because different companies have different needs, Hilary and Tyler produced their promotional material so that it could be sent in various formats—mailing postcards when appropriate, and sending e-mails to other markets.

When it comes to doing a mailing, they emphasize "professionalism and clarity" over

© 2007 Blacksheep Studios

Hilary Jenkins created this colored pencil image, "Gumboot Princess," as a self-promotion piece to target the children's book market.

everything else. As they say, "Make sure you do your research. You don't want to call a company that specifically says 'No phone calls.' You just look stupid and unprofessional. We made sure that each cover letter and envelope was addressed directly to the art director listed in *AGDM*, which makes things more personal."

This diligence and collaborative effort paid off. Within two months, the Jenkins team received positive response from a magazine called *Canadian Dimension*. "They hired us to do two full-page black and white illustrations for their Native issue. They had received one of our postcards in the mail and liked our pen and ink style. It was very exciting, of course. Receiving any new job or response to your work is always very exciting. We have since done a few more jobs for them." Hilary and Tyler have worked for several other companies as well, including Paizo, Fantasy Flight Games, Kenzer and Co., and Calgary publishers SkinnyFish Media and RedPoint Media Group.

For artists who are thinking about starting their own studio, keep in mind that "it's a full-time job," they say. "It's a lot of work, but it is absolutely worth it."

Scott McCloud

Comics Creator and Scholar
Shares Industry Theories

by Carol Pinchefsky

omic book artist Scott McCloud literally does it all. He draws his own comics, including the superhero parody *Zot!*; he writes books about comic books, their form and function; and he devises creative techniques for comic book artists to employ. Mc-Cloud doesn't just think outside the box: he invents new boxes.

Born in Boston and raised in Lexington, Massachusetts, McCloud has been drawing since he can remember, but he eschewed comic books until junior high school pal (now a professional artist himself) Kurt Busiek introduced him to the medium. He's been hooked ever since and has been working steadily in the comic book industry for about 25 years.

McCloud writes about comic books in comic book form, and he argues that comics are the perfect teaching medium. He may be right: his books show, with perfect clarity, why comic books are so compelling. He also makes visible the invisible transitions of time and space between panels, and the balance between words and pictures. Within a few pages of reading his books, the reader is thinking like a comic artist.

More importantly, McCloud ushers his audience into thinking about comics in a way that they have not done before. There's a depth to his analysis that rivals a dissertation, yet his books are written with humor and intelligence that make them accessible to every reader.

Artists who want to absorb the world of ink and word balloons should read McCloud's *Understanding Comics*, *Reinventing Comics* and *Making Comics*. Although each book can be enjoyed individually, they also work as a series: *Understanding Comics* describes the "inner life" of comics; *Reinventing Comics* discusses the fluid nature of the genre and how technology changes the dynamic between the artist, the reader and the art; *Making Comics* is more of a hands-on guide for artists looking to delve into the craft.

Here, McCloud talks about the series and offers advice on how to succeed in the comics industry.

What made you decide to write your three comic books about comics?

Understanding Comics came from quite a few notes I was jotting down about how the form worked. The idea of doing a comic book about comics occurred early on, probably within the first few years of my drawing comics professionally. I had the basic idea and kept taking more and more notes until the file folder I had started to sag off its hinges, and I decided it was time to make a book.

One inspiration was Larry Gonick's *The Cartoon History of the Universe*—the idea of a

CAROL PINCHEFSKY is a freelance writer who lives in New York City with her husband and their books.

narrator walking around explaining how things work. But years later I realized I was strongly influenced by the BBC TV host James Burke and his shows *Connections* and *The Day the Universe Changed*.

The passion that drove *Reinventing Comics* was my obsession with comics and digital media, which began pretty much as *Understanding Comics* came out. I was already falling in love with digital media. The fact that I wasn't able to put those ideas on paper right away was the source of a lot of frustration for me. I was ready to write *Reinventing Comics* earlier,

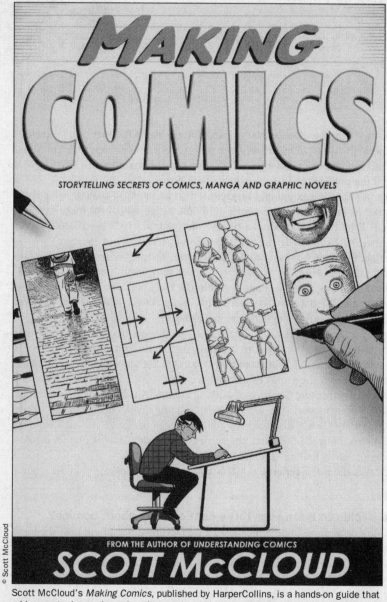

Scott McCloud's *Making Comics*, published by HarperCollins, is a hands-on guide that addresses topics such as choosing words and images that communicate together, mastering body language and facial expressions, framing actions and guiding the reader's eyes. McCloud recently completed a yearlong tour to promote the book. Visit www.scottmccloud.com to learn more about him and his work.

but for various reasons I had to get other things off my desk, and so *Reinventing Comics* was, in some ways, too late . . . and of course, it was far too early as well, because the Web was pretty primitive at the time.

The first half of the book is a catchall for other obsessions I've had over the years, and I don't think I managed to bring the same sense of urgency to them that I had in my first book. I believe in the message of *Reinventing Comics*—the principals regarding digital media and the importance of various revolutions I was chronicling—but I don't think it's as good a piece of rhetoric [as *Understanding Comics*].

Making Comics happened because I had begun teaching in 2002, and I discovered that I had a lot of ideas bottled up inside me that spilled out. I didn't realize how many ideas there were until I honed them in the classroom. I had a book within the first year or two.

I think we're at a juncture where good storytelling is important as comics are trying to diversify and create new readers. I think there are basic storytelling principals that cross all lines, that apply to comic books, manga, graphic novels, comic strips, and Web comics. [*Making Comics* addresses this.]

What methods of sequential art storytelling have you "invented"?

So far, probably the invention most people know me for, apart from the stuff in the books, is the 24-Hour Comic, which was a challenge for my friend Steve Bissette to do a 24-page comic in 24 hours. It has become something of a phenomenon. At this point, 2,000 to 3,000 artists have taken the challenge over the last few years, most notably in an annual celebration called 24-Hour Comics Day, where people from around the world attempt to meet that challenge, to scale the Mt. Everest of comics, as I call it. You can learn more about the day by going to www.24hourcomics.com.

I also like to invent little challenges to test creativity—pressure exercises, oddball things, like a card game [Five-Card Nancy] using panels from Ernie Bushmiller's *Nancy*, which is one of the sillier comic strips.

And I penned something called the Creator's Bill of Rights, which was an early attempt to publicize the rights of comic book artists to their own creations. So I am something of an inventor in that respect. Mostly I'm known for the various ideas I've introduced in *Understanding Comics* as to how comics work.

Is comic book art best when it's simple (for example, *Nancy*)?

No, not best. I think comic book art is best when it serves the story, the passions of the artist, or the entertainment of the reader. When I did *Understanding Comics*, we were at a stage in mainstream comics where it was important to stress the power of simplicity in art, because many had lost sight of that. I don't think that's true anymore. People are aware that simple art doesn't have to accompany simple-minded stories, because simple art can convey very complex ideas. That's commonly understood now, so I feel like our work is done on that front.

I never wanted to be pigeonholed as saying that simple art is "better." But simplicity has power, and it's a power worth understanding.

Are Web comics good for artists?

It depends on the artist, I suppose. They're good for some, and they've been really good for me. I've enjoyed experimenting in that realm; it's kept comics interesting for me. They have tremendous potential, some of it unfulfilled. There's some very good work on the Web, but it's all still very new, and I'm sure the best is yet to come as far as Web comics go.

What is the infinite canvas?

The infinite canvas is the notion of using the [computer] screen as a window, the idea that you don't have any limits on the size of your "pages," when you're creating comics on the

Web. You can create comics that sprawl out in any direction for as long as they need to be. Any comic that forces you to scroll all over creation, people just call an infinite canvas these days. A few artists that have followed this have created some really fascinating stuff.

If we can just call it an expanded canvas for a moment . . .

When you have an expanded format, you have the opportunity to allow your story to dictate the size and shape and rhythm of the panels in a way that you don't on the printed page. When you're trying to fit all of your panels on a printed page, that little rectangle has its own ideas about rhythm and space. But if you're able to spread out, you can plan your comic the way somebody plans a song. When it's time to change the rhythm and meter, you can do that. You have more freedom to select the right number of beats without worrying that you might land two-thirds down the page, just when it's time for a full-page spread. It's an opportunity to employ blank space between the panels, to regulate pacing; an opportunity for color, since screens have more of a gamut than the printed page; and of course an opportunity for multimedia, although that can be a bit like Pandora's box. You don't necessarily want to open that lid, but it's there if you think it's worthwhile.

What are trail-based comics?

Trails are a particular graphic device that I used in some of those "expanded canvas" comics, where the panels were connected. If you have a particularly unusual configuration of panels or set of reading directions, the trails make it easy to know which way to go next.

If you want to see it in action, there is a comic called *PoCom-UK-001* by Daniel Merlin Goodbrey (www.e-merl.com/pocom.htm) that uses trails in a particularly effective way.

I don't make any grandiose claims on it, but I think I was the first person to do [trail-based comics]. I did a number of them on my site, but I didn't use them for everything, because I like to try different devices, and in some cases it wouldn't have been appropriate.

In *Understanding Comics*, you write about icons. Are there any icons that you find overused or cliché?

The whole point of them is to overuse them. That's how they become a language: if they're used often enough, they become a kind of shorthand, like the bulging veins on the foreheads of Japanese comic characters. And the more they're used, the more they become like a word.

Story devices that are overused are tedious, and styles or stock characters that are overused are frustrating and boring. But symbols that are overused are just useful symbols. They drift from being simple pictures to representing a phenomenon the way words do. It's fun to watch.

Can you give us an example of an overused story device?

The various revenge fantasies and sexist power fantasies get overused in mainstream super-hero comics. Then there are gag structures that comic strip artists depend on like crutches, and lazy or static devices that Web comics use. Every type of comic has its dull, overused techniques for stories.

Can you describe any current trends in comic book art?

One of the most terrific trends right now is the fusion of Japanese and Western styles. We have a lot of young artists who were influenced by and passionate about Japanese manga and anime, but they're not just aping Japanese style. Their new styles are beginning to emerge, and they have their own stories to tell.

How is American comic art different from European and Asian forms?

European comics were dominated by a kind of world-building aesthetic that was pioneered by an artist named Hergé [the pen name of Belgian artist Georges Remi, who created *The*

Adventures of Tintin, one of the most popular European comics of the 20th century]. You can see throughout the generations, many European artists, as different as they were from Hergé, had that same basic impulse to create fully realized worlds.

And for many years in Japan, the common denominator in a lot of Japanese comics was about the reader experience—creating stories in which the reader becomes like a participant and not just an observer. There are techniques in manga that have contributed to that.

Here in North America, for many years the superhero aesthetic dominated. But there are other, more subtle aspects of the American approach that I think you can find running across different types of American comics, including a tendency to play to the reader a bit—that idea of character and backdrop and acknowledgement of the reader.

The idea of a theater in little boxes on the page is something that shows up in a lot of different types of comics. The differences are blurring a little [because of the] exchange of ideas between the cultures for much of the 20th century.

Can you explain why comics are now attracting a broader range of subjects beyond the usual superhero stories?

Each of the various new markets in comics are promoting new genres and new subject matter. And there are a few different ways in which genres of comics are exploding. On the Web comics side, you see the growth of niche markets and genres that didn't exist in print, like videogame-oriented comics, which are huge in the Web comics sphere. On the manga side, there's been a tremendous resurgence in comics for young girls—shojomanga, as they call it.

For the first time, graphic novels are outselling single-issue comic books. Why do you think this is?

There's a lot that goes into making great graphic novels. The format is capable of greatness, and it's capable of trash; it just depends on what you put into it. Fortunately there are people producing challenging, ambitious work in that format, and so graphic novels have come to be associated with that sort of artistic and literary ambition.

What are the differences between comic books and graphic novels?

In graphic novels, the push is mostly toward real-life subject matter (non-fiction, autobiography, stories about ordinary people and their relationships) and a drive to increase the depth of the literate worth of comics.

When people think of graphic novels, they think of Art Spiegelman's *Maus*, or stories of growing up in Iran during the Iranian revolution [like *Persepolis* by Marjane Satrapi]. Really, at the end of the day, it's just a format.

Any advice to artists looking to break into graphic novel writing?

It's harder than ever because you have more competition. There are plenty of opportunities out there, but there are about ten times as many talented artists as when I was starting. It's something of a meritocracy—if your work is really brilliant and you're offering it on the Web, people may indeed discover it.

It doesn't necessarily mean you'll make a living out of it, but if you want to get noticed and your work deserves to be noticed, you will be noticed. Going that extra step and figuring out how to make a living at it, that's not something we've really solved. It's still a struggle. It can be done, but there aren't many clear paths to financial independence. Doing the best work you can is still the best way to get a leg up on the competition. If anything, that's become even more true in recent years.

Articles & Interviews

Are there opportunities for comic book artists, besides creating comics and graphic novels?

You can become a storyboard artist for Hollywood, or a conceptual artist. Some [comic book artists] go into advertising, some go into moviemaking, some become prose authors. Being a comic book writer/artist is good preparation for any number of activities. In order to write and draw your own comic, you have to be director, cinematographer, costume designer, writer, actor and set designer. You have to do so many different things to effectively tell those stories visually that if you learn [how to create comic books], you may be set for life with an arsenal of skills in a number of professions.

IN NORTH AMERICA ALONE, THERE ARE **TWICE** AS MANY MARKETS TO CONSIDER AS WHEN I STARTED.

NONE OFFER AN EASY ROAD TO FAME OR FORTUNE, AND SOME ARE MORE CREATIVELY RESTRICTED THAN OTHERS, BUT MOST OFFER AT LEAST A FEW **SUCCESS STORIES**.

NEWSPAPER COMIC STRIPS

PERIODICAL COMIC BOOKS

GRAPHIC NOVELS

ALTERNATIVE / SMALL PRESS

MISCELLANEOUS PRINT

MANGA FORMAT

WEBCOMICS

OTHER NEW MEDIA

© Scott McCloud

McCloud created a cartoon image of himself to serve as the narrator of his books about comics, which depict sequential art in its own style. The cartoon analog walks readers through a series of explanations, such as this panel from the final chapter of *Making Comics*, which talks about professional opportunities in the comics industry.

With Great Power

*The Social Responsibility
of Political Cartoonists*

© Michel Kichka

by Lauren Mosko

T he phrase "with great power comes great responsibility" has been a maxim of American pop culture since Stan Lee penned a version of it in *Amazing Fantasy* #15, the first Spider-Man story, in 1962. So we expect to hear those words come from his mouth and the mouths of his characters—like Uncle Ben Parker in the 2002 *Spider-Man* movie—in superheroic fictional contexts. It may have seemed a little strange, however, to hear them uttered by Shashi Tharoor, Under-Secretary-General for Communications and Public Information for the United Nations, during a (very nonfictional) daylong seminar called "Cartooning for Peace: The Responsibility of Political Cartoonists," held in the UN's New York headquarters in October of 2006 (www.cartooningforpeace.org).

The seminar, originally the brainchild of French cartoonist Plantu (Jean Plantureux), was organized in response to the firestorm surrounding the Danish cartoons depicting the Prophet Muhammad and the resulting Iranian Holocaust cartoons, a clear indication that politically charged artwork is still viable, relevant—and potentially dangerous. During the seminar's opening address, Secretary-General Kofi Annan talked about cartoons' capacity to shape public opinion because of the powerful impact that images have on the brain. "Short of physical pain, few things can hurt you more directly than a caricature of yourself, of a group you belong to, or—perhaps worst—of a person you deeply respect," he said. With this in mind, he encouraged artists to "use their influence, not to reinforce stereotypes or inflame passions, but to promote peace and understanding." A superheroic responsibility, indeed.

It might, upon first thought, seem easy to boil an editorial cartoonist's code of ethics down to that of the one most associated with the medical profession: *First, do no harm.* In a world of corrupt government and business; economic, social, racial and gender inequality; and constant religious and political conflict, harm is always being done—and the job of the editorial cartoonist is to call attention to that harm. But how does one do that without inflaming someone else's passions? And how do you inflame the right passions, the good passions that move people to positive action, without contributing to the harm? The palette of the world is hardly black and white, and it's within the gray area that these artists work.

To discuss the social responsibility of today's political cartoonists and the climate in which they work are three artists who participated in the UN's "Cartooning for Peace" seminar. Cintia Bolio (http://purasevas.blogspot.com) is a self-taught cartoonist who lives and works in Mexico City and has been publishing cartoons since 1996. Much of her work focuses on feminist issues, class issues, and government corruption. Her cartoons have appeared in

LAUREN MOSKO is an editor at Writer's Digest Books.

newspapers such as *La Jornada, Milenio Diario, Milenio Diario de Monterrey* and *Uno Más Uno,* and magazines such as *El Chamuco, Conozca Más, Milenio Semanal, Expansión* and *Vértigo.* She is now a regular contributor to *El Chamuco* magazine and *El Centro* newspaper.

New Yorker **Jeff Danziger** (www.danzigercartoons.com) has been an independent cartoonist for 25 years, with cartoons appearing in *The New York Times, The Washington Post, Wall Street Journal, The Toronto Globe and Mail, Le Monde, The China Daily, Newsweek, Forbes* and *The New Yorker.* His work has covered election fraud, political figures and international affairs, and he was awarded the Herblock Prize for editorial cartooning in 2006 and the Overseas Press Award in 1993.

Jeff Danziger

Michel Kichka (www.israelcentersf.org/culture/profiles/michelkichka.shtml), a native Belgian who now resides in Israel, has lent his pen to editorial and political cartoons, as well as comic strips, children's books and advertising work, and he serves as a senior lecturer of illustration and comic art at the Bezalel Academy's Visual Communications Department in Jerusalem. His cartoons often focus on Middle East concerns.

What inspired you to become a political cartoonist?

Jeff Danziger: I loved the work of Herblock, Oliphant, Maudlin, and even Nast. My parents were both artists, so there were always pens and paper around the house.

Cintia Bolio: I decided to draw and make it my form of political and social participation, because I ain't no good doing anything else. (This is an old joke among colleagues here in Mexico, but it's very close to the truth: We used to be the little ones always making drawings of the teachers and other authority figures at school, and maybe it's like our common training road to become political cartoonists.) Drawing has always been part of my life; I've drawn since I was a child. I also make author comics and illustration, but the political humor has been my greatest pleasure, being born in this country where the government is so corrupt. So, I see my work as a kind of valve to let the social pressure come out through humor. I am inspired by the worst society has to offer: the political elite, the social inequality, the sexist culture. I do portray these people as corrupt, mean and ugly as they are. I see myself as a feminist, left-wing cartoonist. That is why I fight the creepy right-wing, ultra-conservative circles.

Cintia Bolio

Michel Kichka: When I was a little boy, my daddy, a survivor from Auschwitz, used to take me on his knees and draw me grotesque and ridiculous Nazis, with boxers and hairy legs, with pots on their heads, and with sticks instead of guns. It made me laugh to tears. Somewhere it made me understand that self-derision through cartoons is a wonderful way of self-healing and of self-expression. That is why I always looked at cartoons, trying sometimes to copy them to teach myself some basic know-how.

Is there an unspoken "cartooning code of ethics" within the field? If so, what do you think its tenets are? If not, what do you think its tenets should be?

Danziger: Not that I know of. It's an ungentlemanly art.

Bolio: Our job's nature is to be politically incorrect, but certainly, I make my drawings having in mind that I am doing a job of social commitment. These are some of the rules that

I follow: Not to laugh at the victims (I laugh at the aggressors and the oppressors); Not to feed any kind of hate or prejudices in our readers.

I have a didactic kind of style, so I try to promote free and tolerant thought. I draw about anything that can make our culture less sexist, and of course, sometimes I use my work as my own therapy to drive out my own demons.

Kichka: In our democratic societies, the unspoken and unwritten code of ethics is based on an unlimited freedom of expression dictated by self-consciousness, by personal limits of "good taste," levels of morality and of sensitivity to human beings. Everyone has his own taboos that draw his red lines. It's all between you and yourself, long before it comes to the editor's table. That freedom guarantees a healthy exercise of the cartooning profession. Cartooning is a combat for ideals and for ideas. As a cartoonist, you are totally exposed and you should be ready for controversy.

Photo by Tzur Kotzer

Michel Kichka

What do you, personally, think your responsibility to your audience is?

Kichka: My audience expects me to stay faithful to myself; to go on fighting for what I believe in; to make them react, smile, think, re-think, or even to piss them off sometimes.

Danziger: First to entertain, and at the same time to make people think about the politics they might ignore if they had to read a lot of dry political prose.

Bolio: As I mentioned before, knowing that this is, by nature, a job of commitment to freedom, equality and justice. We draw for the people; what we do comes from and belongs to the people, and I try to be the voice of it. Now, being a woman making political cartoons, I have a special commitment to my female readers, bringing to the discussion all the problems of being a woman in a sexist culture.

How much self-censorship do you have to do when you work?

Bolio: Long ago, they said, "Don't draw the Virgin of Guadalupe, because she is sacred. Don't draw the Army, because it is dangerous, and do not draw the President, because it is sacred, and dangerous." Our profession has taken giant steps. Time changes, like we say here. You can see the President every single day in our cartoons, and the army as well, since Calderón wrongly decided to send the army to the streets of many states to *fight crime*. And

I am sure that we would draw the Virgin too, if she was a congresswoman or part of Calderón's crew.

But, speaking of self-censorship, I prefer not to practice it, just because there is censorship in the newspapers; so I prefer to put my cartoons in the hands of my publisher, and he will decide, anyway, if the cartoon will see the light in the next edition or not. Now, I like to add that we cartoonists now have the Internet alternative: When one of my cartoons is censored, I can always post it on my blog. Thanks, Internet.

Kichka: Self-censorship is a natural reflex for a cartoonist, a sort of built-in

© Cintia Bolio

Cintia Bolio's self-caricature.

software. The proof is that you know exactly when you go too far, a tool you can use when you want to be more provocative for any reason.

Danziger: None, I work independently. Whether or not editors print them is their own decision.

Has your work ever been challenged by a particular group or individual? Whom? How did you handle it?

Kichka: First of all, a cartoonist must always be challenged by himself, which is not easy! I'm challenged by the cartoons of some of my colleagues and by the reactions of my audience who reply to me by mail as soon as they receive my work. Sometimes I try to have a look at

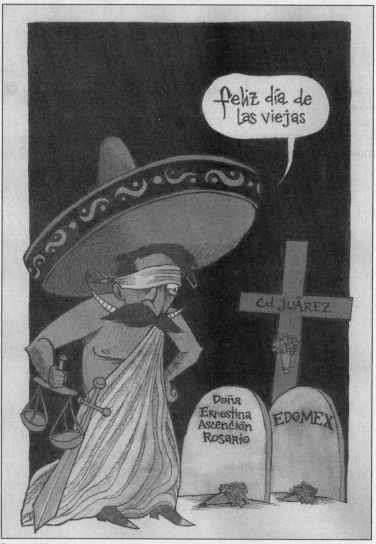

© Cintia Bolio

Recent killings of women in Mexico inspired Cintia Bolio to draw this cartoon, titled "March 8," for International Women's Day, an annual celebration of the economic, political and social achievements of women. "Mexico is one of the most sexist countries in the world," says Bolio. "That is why I portray Justice here not as a woman, but as a sexist man—a 'macho'—saying to the murdered females, 'Happy old ladies' day!'"

my colleagues' cartoons on delicate subjects, to understand how they themselves handle it. This comparison opens wide horizons in the cartoon field for me. The works I prefer are from Pat Oliphant, Jeff Danziger, Ann Telnaes, Patrick Chappatte, Plantu and others.

Danziger: Yes, the right wing and religious conservatives have mounted several campaigns. Didn't have much effect.

Bolio: I am not the most popular cartoonist among the sexist minds of my country, but I have received only two pieces of hate mail since my work began appearing in newspapers more than 10 years ago.

Government used to repress cartoonists in those days, put them in jail, etc.

Jeff Danziger's self-caricature.

Here I thank our greatest political cartoonists—Rius, Naranjo and Helioflores—for their braveness in the hard times of the 1960s and '70s. They fought for the freedom of expression now we all are having, and to our fortune they are working (and giving us the good example) still.

Now it is really rare to see a politician calling on the phone to protest some drawing in Mexico City. They do not complain these days just because they are so cynical that they take cartoons as a kind of tribute, and I do believe that this situation makes our work less powerful. But in the rest of the country, our colleagues still have to be careful with their drawings, because the local power is more primitive about it.

You all participated in the UN's "Cartooning for Peace" seminar in 2006. What did you take away from that experience? How beneficial did you feel the event was, and why?

Danziger: Internationally cartoons bridge the language barrier, and people all like to laugh at their leaders. I don't know whether peace is going to break out as a result, but, as a veteran of the Vietnam War, I can say that every little bit helps.

Bolio: I was so greatly honored to be invited to be part of this event representing my country. I still have a smile on my face. As I mentioned before, I do believe this is a work of commitment to the best causes, and one of them—the most important, internationally speaking—is the effort to draw for peace. It was important to see that the language of images can be used as a powerful tool, to make it a voice in the middle of every political conflict around the world, as well as how useful this language can be to bring the people and the cultures together to work for a better understanding. It was great, too, to see how deeply committed my colleagues are—humor is a serious thing.

I believe that when it comes to drawing about peace, we are all trying to be didactic and agitators (Plantu dixit) for a cause that needs the effort of everyone—drawing, writing or speaking. I enjoyed discovering the work of all of them, whom I admired so much.

I am following through the Internet the events of "Cartooning for Peace" [the traveling exhibition] in Europe. I hope that this reunion can encourage others to think about what everyone can do to make a world, maybe not better—I am not that optimistic—but a world

more conscious of the nonsense of what we call here *the savage capitalism* and other kinds of fundamentalist thought.

I congratulate Jean Plantu for being the creator and soul of this great and important idea-event, and everyone at the UN for their support and efforts, and of course, for the kindness they all showed to me. It is one of the greatest experiences I have lived as a cartoonist and as a woman, and this feeling will always be with me.

Kichka: "Cartooning for Peace" has been a unique experience. The highly symbolic states of the UN and of New York gave this gathering a deep and serious dimension that obliged me to make an introspection of my way of working and to put that in words in a structured and logical speech, which I'm not used to doing in my day-to-day life as a cartoonist. I had to focus on ethical and moral aspects of cartooning. It gave me an exceptional opportunity to listen to other cartoonists who came from other cultures and other religions. It made me understand better that there's a wide common ground that unifies us in our search for self-expression and in our struggle for a better understanding of the world. It gave me the feeling that we, the cartoonists, belong to a sort of global brotherhood.

What advice would you give to a young artist with aspirations of political cartooning?

Bolio: To be idealistic, even when it is more realistic to be a pessimist. To have a commitment to truth, to freedom, to equality, to justice, to tolerance . . . You must have the capacity to feel the pain of others to translate it to a drawing.

Our work is based in the language of humor, although I believe that our first duty is to

In this July 2007 cartoon by Michel Kichka, U.S. President George Bush is meeting with Mahmoud Abbas, the Fatah president of the Palestinian National Authority who fled to the West Bank after Hamas forces took control of the Gaza Strip. Bush asks, "To what bank do you want the U.S. financial help?" Abbas replies, "West Bank!" The day after Kichka drew this, the U.S. ended a 15-month economic and political embargo of the Palestinian Authority and resumed aid, attempting to strengthen Abbas's West Bank government.

be critical of everything that is not fair, so, if you cannot be humorous enough, or you decide that political incorrectness is your style, that's okay.

And last but not least, I think that the idea is more important than the beauty of the line; and it is much better when you can express it without words—but it's harder!

Kichka: My advice is: Check the news; search for better information; surf the Web; watch cables from other countries; learn languages; read papers; open yourself to cultures and civilizations, to history and to art; travel and meet people. In other words, become a sort of New Renaissance Man. Your cartoons will be deeper and richer, and you will be happier!

Danziger: Get a paying job, teaching or bartending. It will be a long time before any real money shows up.

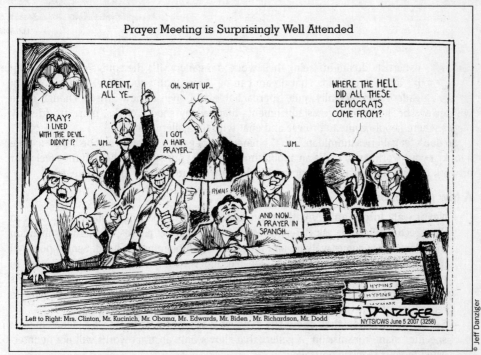

Jeff Danziger's cartoons are syndicated by the New York Times Syndicate. His observations during the early campaigning for the 2008 U.S. presidential election are humorously depicted in this June 2007 cartoon.

Galleries

Most artists dream of seeing their work in a gallery. It's the equivalent of "making it" in the art world. That dream can be closer than you realize. The majority of galleries are actually quite approachable and open to new artists. Though there will always be a few austere establishments manned by snooty clerks, most are friendly places where people come to browse and chat with the gallery staff.

So don't let galleries intimidate you. The majority of gallery curators will be happy to take a look at your work if you make an appointment or mail your slides to them. If they feel your artwork doesn't fit their gallery, most will steer you toward a more appropriate one.

A few guidelines

- **Never walk into a gallery without an appointment,** expecting to show your work to the director. When we ask gallery directors about their pet peeves, they always mention the talented newcomer walking into the gallery with paintings in hand. Send a polished package of about eight to 12 neatly labeled, mounted duplicate slides of your work in plastic slide sheets. (Refer to the listings for more specific information on each gallery's preferred submission method.) Do not send original slides, as you will need them to reproduce later. Send a SASE, but realize your packet may not be returned.
- **Seek out galleries that show the type of work you create.** Most galleries have a specific "slant" or mission. A gallery that shows only abstract works will not be interested in your realistic portraits.
- **Visit as many galleries as you can.** Browse for a while and see what type of work they sell. Do you like the work? Is it similar to yours in quality and style? What about the staff? Are they friendly and professional? Do they seem to know about the artists the gallery represents? Do they have convenient hours? If you're interested in a gallery outside your city and you can't manage a personal visit before you submit, read the listing carefully to make sure you understand what type of work is shown there. Check out the gallery's Web site to get a feel for what the space is like, or ask a friend or relative who lives in that city to check out the gallery for you.
- **Attend openings.** You'll have a chance to network and observe how the best galleries promote their artists. Sign each gallery's guest book or ask to be placed on galleries' mailing lists. That's also a good way to make sure the gallery sends out professional mailings to prospective collectors.

Showing in multiple galleries

Most successful artists show in several galleries. Once you've achieved representation on a local level, you might be ready to broaden your scope by querying galleries in other cities.

Types of Galleries

As you search for the perfect gallery, it's important to understand the different types of spaces and how they operate. The route you choose depends on your needs, the type of work you do, your long-term goals and the audience you're trying to reach.

Retail or commercial galleries. The goal of the retail gallery is to sell and promote the work of artists while turning a profit. Retail galleries take a commission of 40 to 50 percent of all sales.

Co-op galleries. Co-ops exist to sell and promote artists' work, but they are run by artists. Members exhibit their own work in exchange for a fee, which covers the gallery's overhead. Some co-ops also take a small commission of 20 to 30 percent to cover expenses. Members share the responsibilities of gallery-sitting, sales, housekeeping and maintenance.

Rental galleries. The rental gallery makes its profit primarily through renting space to artists and therefore may not take a commission on sales (or will take only a very small commission). Some rental spaces provide publicity for artists, while others do not. Showing in this type of gallery is risky. Rental galleries are sometimes thought of as "vanity galleries" and, consequently, do not have the credibility other galleries enjoy.

Nonprofit galleries. Nonprofit spaces will provide you with an opportunity to sell your work and gain publicity but will not market your work aggressively, because their goals are not necessarily sales-oriented. Nonprofits generally take a small commission of 20 to 30 percent.

Museums. Though major museums primarily show work by established artists, many small museums are open to emerging artists.

Art consultancies. Consultants act as liasions between fine artists and buyers. Most take a commission on sales (as would a gallery). Some maintain small gallery spaces and show work to clients by appointment.

Galleries

You may decide to be a "regional" artist and concentrate on galleries in surrounding states. Some artists like to have East Coast and West Coast representation.

If you plan to sell work from your studio, or from a Web site or other galleries, be up front with each gallery that shows your work. Negotiate commission arrangements that will be fair to you and all involved.

Pricing your fine art

A common question of beginning artists is "What do I charge for my paintings?" There are no hard and fast rules. The better known you become, the more collectors will pay for your work. Though you should never underprice your work, you must take into consideration what people are willing to pay. Also keep in mind that you must charge the same amount for a painting sold in a gallery as you would for work sold from your studio.

Juried shows, competitions and other outlets

It may take months, maybe years, before you find a gallery to represent you. But don't worry; there are plenty of other venues in which to show your work. Get involved with your local

art community. Attend openings and read the arts section of your local paper. You'll see there are hundreds of opportunities.

Enter group shows and competitions every chance you get. Go to the art department of your local library and check out the bulletin board, then ask the librarian to direct you to magazines that list "calls to artists" and other opportunities to exhibit your work. Subscribe to the Art Deadlines List, available in hard copy or online (www.artdeadlineslist.com). Join a co-op gallery and show your work in a space run by artists for artists.

Another opportunity to show your work is through local restaurants and retail shops that exhibit the work of local artists. Ask the managers how you can get your art on their walls. Become an active member in an arts group. It's important to get to know your fellow artists. And since art groups often mount exhibitions of their members' work, you'll have a way to show your work until you find a gallery to represent you.

Helpful Resources

For More Info

Look for lists of galleries and information about dealing with galleries in the following publications:

- *Art Calendar* (www.artcalendar.com)
- *Art in America* (www.artinamericamagazine.com; each August issue is an annual Guide to Museums, Galleries and Artists)
- *Art New England* (www.artnewengland.com; East Coast)
- *ART PAPERS* (www.artpapers.org)
- *The Artist's Magazine* (www.artistsmagazine.com)
- *ARTnews* (www.artnews.com)
- *Artweek* (www.artweek.com; West Coast)

A.R.C. GALLERY/EDUCATIONAL FOUNDATION

832 W. Superior St., #204, Chicago, IL 60622. (312)733-2787. E-mail: arcgallery@yahoo.com. Web site: www.arcgallery.org. **President:** Patricia Otto. Nonprofit gallery. Estab. 1973. Exhibits emerging, mid-career and established artists. 21 members review work for solo and group shows on an ongoing basis. Visit Web site for prospectus. Exhibited artists include Miriam Schapiro. Average display time: 1 month. Located in the West Town Neighborhood; 1,600 sq. ft. Clientele: 80% private collectors, 20% corporate collectors. Overall price range: $50-40,000; most work sold at $200-4,000.

Media Considers all media. Most frequently exhibits painting, sculpture (installation) and photography.

Style Exhibits all styles and genres. Prefers postmodern and contemporary work.

Terms There is a rental fee for space. Rental fee covers 1 month. No commission taken on sales. Gallery provides promotion; artist pays shipping costs. Prefers framed artwork.

Submissions See Web site (www.arcgallery.org/invitationals.html) for info or send e-mail query. Reviews are ongoing. Call for deadlines. Slides or digital images are accepted.

N ACA GALLERIES

529 W. 20th St., 5th Floor, New York NY 10011. (212)206-8080. Fax: (212)206-8498. E-mail: info@acagalleries.com. Web site: www.acagalleries.com. **Vice President:** Dorian Bergen. For-profit gallery. Estab. 1932. Exhibits mid-career and established artists. Approached by 200 artists/year; represents 35 artists/year. Exhibited artists include Faith Ringgold (painting, drawing, soft sculpture) and Jon Schueler (painting). Sponsors 8 exhibits/year. Average display time: 6-7 weeks. Open Tuesday through Saturday, 10:30-6. Closed last 2 weeks of August. Clients include local community, tourists, upscale. 25% of sales are to corporate collectors. Overall price range: $1,000-1,000,000.

Media Considers all media except photography. Most frequently exhibits acrylic, ceramics, collage, drawing, fiber, mixed media, oil, paper, pastel, pen & ink, sculpture, watercolor.

Style Considers all styles, all genres. Most frequently exhibits color field, expressionism, impressionism, postmodernism, surrealism.

Terms Artwork is accepted on consignment (10-50% commission). Retail price set by both artist and gallery. Gallery provides insurance, promotion, contract. Accepted work should be framed. Requires exclusive representation locally.

Submissions Send query letter with bio, artist's statement, résumé, brochure, photocopies, photographs, slides, reviews and SASE. Mail portfolio for review. Returns material with SASE. Responds to queries in 1-2 months.

ACADEMY GALLERY

8949 Wilshire Blvd., Beverly Hills CA 90211. (310)247-3000. Fax: (310)247-3610. E-mail: gallery @oscars.org. Web site: www.oscars.org. **Contact**: Ellen Harrington. Nonprofit gallery. Estab. 1992. Exhibitions focus on all aspects of the film industry and the filmmaking process. Sponsors 3-5 exhibitions/year. Average display time: 3 months. Open all year; Tuesday-Friday, 10-5; weekends, 12-6. Gallery begins in building's Grand Lobby and continues on the 4th floor. Total square footage is approx. 8,000. Clients include students, senior citizens, film aficionados and tourists.

Submissions Call or write to arrange a personal interview to show portfolio of photographs, slides and transparencies. Must be film process or history related.

N ADDISON/RIPLEY FINE ART

1670 Wisconsin Ave. NW, Washington DC 20007. (202)338-5180. Fax: (202)338-2341. E-mail: romyaddisonrip@aol.com. Web site: www.addisonripleyfineart.com. **Assistant Director:** Romy

Silverstein. For-profit gallery and art consultancy. Estab. 1981. Approached by 100 artists/year. Represents 25 emerging, mid-career and established artists. Sponsors 13 exhibits/year. Average display time: 6 weeks. Open all year; Tuesday-Saturday, 11-6. Closed end of summer. Clients include local community, tourists and upscale. 20% of sales are to corporate collectors. Overall price range: $500-80,000; most work sold at $2,500-5,000.

Media Considers acrylic, ceramics, collage, drawing, fiber, glass, installation, mixed media, oil, paper, pastel, sculpture and watercolor. Most frequently exhibits oil and acrylic. Types of prints include etchings, linocuts, lithographs, mezzotints, photography and woodcuts.

Style Considers all styles and genres. Most frequently exhibits painterly abstraction, color field and expressionism.

Terms Retail price set by the gallery and the artist. Gallery provides insurance, promotion and contract. Accepted work should be framed, mounted and matted. No restrictions regarding art or artists.

Submissions Mail portfolio for review. Send query letter with artist's statement, bio, photocopies, résumé and SASE. Returns material with SASE. Responds in 1 month. Finds artists through word of mouth, submissions, and referrals by other artists.

Tips "Submit organized, professional-looking materials."

AGORA GALLERY

530 W. 25th St., New York NY 10001. (212)226-4151, ext. 206. Fax: (212)966-4380. E-mail: Angela@Agora-Gallery.com. Web site: www.Agora-Gallery.com. **Director:** Angela Di Bello. For-profit gallery. Estab. 1984. Approached by 1,500 artists/year. Exhibits 100 emerging, mid-career and established artists. Sponsors 10 exhibits/year. Average display time: 3 weeks. Open all year; Tuesday-Saturday, 11-6. Closed national holidays. Located in Soho between Prince and Spring; landmark building with 2,000 sq. ft. of exhibition space; exclusive gallery block. Clients include upscale. 10% of sales are to corporate collectors. Overall price range: $550-10,000; most work sold at $3,500-6,500.

Media Considers acrylic, collage, digital, drawing, mixed media, oil, pastel, photography, sculpture, watercolor.

Style Considers all styles.

Terms There is a representation fee. There is a 35% commission to the gallery; 65% to the artist. Retail price set by the gallery and the artist. Gallery provides insurance and promotion.

Submissions Guidelines available on Web site (www.agora-gallery.com/artistinfo/GalleryRepres entation.aspx). Send 5-15 slides or photographs with cover letter, artist's statement, bio and SASE; include Portfolio Submission form from Web site, or submit all materials through online link. Responds in 3 weeks. Files bio, slides/photos and artist statement. Finds artists through word of mouth, submissions, portfolio reviews, art exhibits, Internet and referrals by other artists.

Tips "Follow instructions!"

ALASKA STATE MUSEUM

395 Whittier St., Juneau AK 99801-1718. (907)465-2901. Fax: (907)465-2976. E-mail: bruce_kato @eed.state.ak.us. Web site: www.museums.state.ak.us/asmhome.html. **Chief Curator:** Bruce Kato. Museum. Estab. 1900. Approached by 40 artists/year; exhibits 4 emerging, mid-career and established artists. Sponsors 10 exhibits/year. Average display time: 6-10 weeks. Downtown location—3 galleries exhibiting temporary exhibitions.

Media Considers all media. Most frequently exhibits painting, photography and mixed media. Considers engravings, etchings, linocuts, lithographs, mezzotints, serigraphs and woodcuts.

Style Considers all styles.

Submissions Finds Alaskan artists through submissions and portfolio reviews every two years.

Register for e-mail notification at: http://list.state.ak.us/guest/RemoteListSummary/Museum_Ex hibits_Events_Calendar.

THE ALBUQUERQUE MUSEUM OF ART & HISTORY

2000 Mountain Rd. NW, Albuquerque NM 87104. (505)243-7255. E-mail: dfairfield@cabq.gov. Web site: www.cabq.gov/museum. **Curator of Art:** Douglas Fairfield. Nonprofit museum. Estab. 1967. Sponsors 7-10 exhibits/year. Average display time: 3-4 months. Open Tuesday-Sunday, 9-5. Closed Mondays and city holidays. Located in Old Town, west of downtown.

Style Mission is to collect, promote, and showcase art and artifacts from Albuquerque, the state of New Mexico, and the Southwest. Sponsors mainly group shows and work from the permanent collection.

Submissions Artists may send portfolio for exhibition consideration: slides, photos, disk, artist statement, résumé, SASE.

ALEX GALLERY

2106 R St. NW, Washington DC 20008. (202)667-2599. E-mail: Alexartint@aol.com. Web site: www.alexgalleries.com. **Contact:** Victor Gaetan. Retail gallery and art consultancy. Estab. 1986. Represents 20 emerging and mid-career artists. Exhibited artists include Willem de Looper, Gunter Grass and Olivier Debre. Sponsors 8 shows/year. Average display time: 1 month. Open all year. Located in the heart of a "gallery" neighborhood; "two floors of beautiful turn-of-the-century townhouse; a lot of exhibit space." Clientele: diverse; international and local. 50% private collectors; 50% corporate collectors. Overall price range: $1,500-60,000.

Media Considers oil, acrylic, watercolor, pastel, mixed media, collage, sculpture, photography, original handpulled prints, lithographs, linocuts and etchings. Most frequently exhibits painting, sculpture and works on paper.

Style Exhibits expressionism, abstraction, color field, impressionism and realism; all genres. Prefers abstract and figurative work.

Terms Accepts artwork on consignment. Retail price set by gallery and artist. Gallery provides insurance, promotion and contract; shipping costs are shared.

Submissions Send query letter with résumé, slides, bio, SASE and artist's statement. Write for appointment to show portfolio, which should include slides and transparencies. Responds in 2 months.

CHARLES ALLIS ART MUSEUM

1801 N. Prospect Ave., Milwaukee WI 53202. (414)278-8295. Fax: (414)278-0335. E-mail: shabers troh@cavtmuseums.org. Web site: www.cavtmuseums.org. **Manager of Exhibitions & Collections:** Sarah Haberstroh. Museum. Estab. 1947. Approached by 20 artists/year. Represents 6 emerging, mid-career and established artists that have lived or studied in Wisconsin. Exhibited artists include Anne Miotke (watercolor); Evelyn Patricia Terry (pastel, acrylic, multi-media). Sponsors 6-8 exhibits/year. Average display time: 2 months. Open all year; Wednesday-Sunday, 1-5. Located in an urban area, historical home, 3 galleries. Clients include local community, students and tourists. 10% of sales are to corporate collectors. Overall price range: $200-6,000; most work sold at $300.

Media Considers acrylic, collage, drawing, installation, mixed media, oil, pastel, pen & ink, sculpture, watercolor and photography. Print types include engravings, etchings, linocuts, lithographs, serigraphs and woodcuts. Most frequently exhibits acrylic, oil and watercolor.

Style Considers all styles and genres. Most frequently exhibits realism, impressionism and minimalism.

Terms Artwork is accepted on consignment. Artwork can be purchased during run of an exhibition. There is a 30% commission. Retail price set by the artist. Museum provides insurance,

promotion and contract. Accepted work should be framed. Does not require exclusive representation locally. Accepts only artists from or with a connection to Wisconsin.

Submissions Send query letter with artist's statement, bio, business card, résumé, reviews, SASE and slides. Material is returned if the artist is not chosen for exhibition. Responds to queries in 1 year. Finds artists through art exhibits, referrals by other artists, submissions and word of mouth.

Tips "All materials should be typed. Slides should be labeled and accompanied by a complete checklist."

ALVA GALLERY

54 State St., New London CT 06320. (860)437-8664. Fax: (860)437-8665. E-mail: Alva@Alvagallery.com. Web site: www.alvagallery.com. For-profit gallery. Estab. 1999. Approached by 50 artists/year. Represents 30 emerging, mid-career and established artists. Exhibited artists include Maureen McCabe (assemblage), Sol LeWitt (gouaches) and Judith Cotton (paintings). Average display time: 6 weeks. Open all year; Tuesday-Saturday, 11-5. Closed between Christmas and New Year and last 2 weeks of August. Clients include local community, tourists and upscale. 5% of sales are to corporate collectors. Overall price range: $250-10,000; most work sold at $1,500.

Media Considers acrylic, collage, drawing, fiber, glass, mixed media, oil, paper, pastel, pen & ink, sculpture and watercolor. Most frequently exhibits oil, photography and mixed media. Considers all types of prints.

Style Considers all styles and genres.

Terms Artwork is accepted on consignment, and there is a 50% commission. Retail price set by the artist. Gallery provides insurance and promotion. Does not require exclusive representation locally.

Submissions Mail portfolio for review. Responds in 2 months. Finds artists through word of mouth, portfolio reviews and referrals by other artists.

THE AMERICAN ART COMPANY

1126 Broadway Plaza, Tacoma WA 98402. (253)272-4327. E-mail: craig@americanartco.com. Web site: www.americanartco.com. **Director:** Craig Radford. Retail gallery. Estab. 1889. Represents/exhibits 150 emerging, mid-career and established artists/year. Exhibited artists include Art Hansen, Michael Ferguson, Danielle Desplan, Doug Granum, Oleg Koulikov, Yoko Hara and Warren Pope. Sponsors 10 shows/year. Open all year; Tuesday-Friday, 10-5:30; Saturday, 10-5. Located downtown; 3,500 sq. ft. 60% of space for special exhibitions; 40% of space for gallery artists. Clientele: local community. 90% private collectors, 10% corporate collectors. Overall price range: $500-15,000; most work sold at $1,800.

Media Considers oil, fiber, acrylic, sculpture, glass, watercolor, mixed media, quilt art, pastel, collage, woodcuts, wood engravings, linocuts, engravings, mezzotints, etchings, lithographs, serigraphs, contemporary baskets, contemporary sculptural wood. Most frequently exhibits contemporary wood sculpture and original paintings.

Style Exhibits all styles. Genres include landscapes, Chinese and Japanese.

Terms Artwork is accepted on consignment (50% commission) or bought outright for 50% of retail price; net 30 days. Retail price set by the gallery and the artist. Gallery provides insurance and promotion; shipping costs are shared. Prefers artwork unframed.

Submissions Send query letter with résumé, slides, bio and SASE. Write for appointment to show portfolio of slides. Responds in 3 weeks. Finds artists through word of mouth, referrals by other artists, visiting art fairs and exhibitions, submissions.

AMERICAN PRINT ALLIANCE

302 Larkspur Turn, Peachtree City GA 30269-2210. E-mail: director@printalliance.org. Web site: www.printalliance.org. **Director:** Carol Pulin. Nonprofit arts organization with online gallery and

exhibitions, travelling exhibitions, and journal publication; Print Bin: a place on Web site that is like the unframed, shrink-wrapped prints in a bricks-and-mortar gallery's "print bin." Estab. 1992. Approached by hundreds of artists/year; represents dozens of artists/year. "We only exhibit original prints, artists' books and paperworks." Usually sponsors 2 travelling exhibits/year—all prints, paperworks and artists' books. Most exhibits travel for 2 years. Hours depend on the host gallery/museum/arts center. "We travel exhibits throughout the U.S. and occasionally to Canada." Overall price range for Print Bin: $150-3,200; most work sold at $300-500.

Media Considers and exhibits original prints, paperworks, artists' books. Also all original prints including any combination of printmaking techniques; no reproductions/posters.

Style Considers all styles, genres and subjects; the decisions are made on quality of work.

Terms Individual subscription: $30-37. Print Bin is free with subscription. "Subscribers have free entry to juried travelling exhibitions but must pay for framing and shipping to and from our office." Gallery provides promotion.

Submissions Subscribe to journal, *Contemporary Impressions* (www.printalliance.org/alliance/al_subform.html). Send one slide and signed permission form (www.printalliance.org/gallery/printbin_info.html). Returns slide if requested with SASE. Usually does not respond to queries from non-subscribers. Files slides and permission forms. Finds artists through submissions to the gallery or Print Bin, and especially portfolio reviews at printmakers conferences. "Unfortunately, we don't have the staff for individual portfolio reviews, though we may—and often do—request additional images after seeing one work, often for journal articles. Generally about 100 images are reproduced per year in the journal."

Tips "See the Standard Forms area of our Web site (www.printalliance.org/library/li_forms.html) for correct labels on slides and much, much more about professional presentation."

⊠ AMERICAN SOCIETY OF ARTISTS, INC.

P.O. Box 1326, Palatine IL 60078. (847)991-4748 or (312)751-2500. E-mail: asoa@webtv.net. Web site: www.americansocietyofartists.org. **Membership Chair:** Helen Del Valle.

Terms Members and nonmembers may exhibit. "Our members range from internationally known artists to unknown artists—quality of work is the important factor." Accepted work should be framed, mounted or matted.

Submissions Send SASE and 4 slides/photographs that represent your work; request membership information and application. Responds in 2 weeks. Accepted members may participate in lecture and demonstration service. Member publication: *ASA Artisan.*

⊠ ANDERSON-SOULE GALLERY

Two Capital Plaza, N. Main St., Concord NH 03301. E-mail: art@anderson-soulegallery.com. Web site: www.anderson-soulegallery.com. **Director:** Trish Soule. For-profit gallery, rental gallery, art consultancy. Estab. 2002. Exhibits the work of emerging, mid-career and established artists. Approached by 15 artists/year; represents or exhibits 20+ artists. Average display time: 6 weeks. Open Tuesday-Saturday, 10-4. Clients include local community, tourists, upscale. Overall price range: $100-8,000; most work sold at $1,000.

Media Considers acrylic, ceramics, collage, drawing, glass, mixed media, oil, pastel, sculpture, watercolor. Most frequently exhibits oil, mixed media, sculpture. Considers all types of prints.

Style Exhibits color field, expressionism, pattern painting and painterly abstraction. Genres include figurative, florals and landscapes.

Terms Artwork is accepted on consignment (50% commission). Retail price set by gallery and artist. Gallery provides insurance, promotion, contract. Accepted work should be framed, mounted, matted. Requires exclusive representation locally. Accepts only artists from Northeastern U.S.

Submissions Mail portfolio for review. Send query letter with artist's statement, bio, résumé,

photocopies, CD for PC, SASE. Returns material with SASE. Responds to queries within 4 weeks, only if interested. Finds artists through portfolio reviews, referrals by other artists.

Tips "Provide *all* requested materials."

[N] ARNOLD ART

210 Thames, Newport RI 02840. (401)847-2273. E-mail: info@arnoldart.com. Web site: www.arn oldart.com. **President:** William Rommel. Retail gallery. Estab. 1870. Represents 40 emerging, mid-career and established artists. Exhibited artists include John Mecray, Willard Bond. Sponsors 4 exhibits/year. Average display time: 1 month. Open Monday-Saturday, 9:30-5:30; Sunday, 12-5. Clientele: local community, students, tourists and Newport collectors. 1% of sales are to corporate clients. Overall price range: $100-35,000; most work sold at $600.

Media Considers oil, acrylic, watercolor, pastel, pen & ink, drawings, mixed media. Most frequently exhibits oil and watercolor.

Style Genres include marine sailing, classic yachts, America's cup, yachting/sailing.

Terms Accepts work on consignment (40% commission). Retail price set by artist. Exclusive area representation not required. Gallery provides promotion.

Submissions Send e-mail. Call or e-mail for appointment to show portfolio of originals. Returns materials with SASE.

Tips To make your submissions professional you must "Frame them well."

ART ENCOUNTER

3979 Spring Mountain Rd., Las Vegas NV 89102. (702)227-0220. Fax: (702)227-3353. E-mail: sharon@artencounter.com. Web site: www.artencounter.com. **Director of Artist Relations:** Sharon Darcy. Gallery Director: Rod Maly. Retail gallery. Estab. 1992. Represents 100 emerging and established artists/year. Exhibited artists include Jennifer Main, Jan Harrison and Vance Larson. Sponsors 4 shows/year. Open all year; Tuesday-Friday, 10-6; Saturday and Monday, 12-5. Located near the famous Las Vegas strip; 13,000 sq. ft. Clients include upscale tourists, locals, designers and casino purchasing agents. 95% of sales are to private collectors, 5% corporate collectors. Overall price range: $200-20,000; most work sold at $500-2,500.

Media Considers all media and all types of prints. Most frequently exhibits watercolor, oil, acrylic, and sculpture.

Style Exhibits all styles and genres.

Terms Rental fee for space; covers 6 months. Retail price set by the gallery and artist. Gallery provides promotion and contract; artist pays for shipping. Prefers artwork framed.

Submissions E-mail JPEGs or mail photographs and SASE. Appointments will be scheduled according to selection of juried artists. Responds within 2 weeks, only if interested. Files artist bios and résumés. Finds artists by advertising in *The Artist's Magazine* and *American Artist*, art shows and word of mouth.

Tips "Poor visuals, attempted walk-in without appointment, and no SASE are common mistakes."

THE ART EXCHANGE

539 E. Town St., Columbus OH 43215. (614)464-4611. Fax: (614)464-4619. E-mail: kristin@theart exchangeltd.com. Web site: www.theartexchangeltd.com. **Principal:** Kristin Meyer. Art consultancy. Estab. 1978. Represents 150+ emerging, mid-career and established artists/year. Exhibited artists include LaVon Van Williams, Frank Hunter, Mary Beam and Carl Krabill. Open all year; Monday-Friday, 9-5. Located near downtown; historic neighborhood; 4,000 sq. ft.; showroom located in Victorian home. 100% of space for gallery artists. Clientele: corporate leaders; 20% private collectors; 80% corporate collectors. "We work directly with interior designers and architects." Overall price range: $150-8,000; most work sold at $1,000-4,000.

Media Considers oil, acrylic, watercolor, pastel, mixed media, collage, sculpture, ceramics, fiber,

glass, photography and all types of prints. Most frequently exhibits oil, acrylic, watercolor.

Style Exhibits painterly abstraction, urban landscapes, impressionism, realism, folk art. Genres include florals and landscapes. Prefers impressionism, painterly abstraction, urban landscapes, realism.

Terms Accepts work on consignment. Retail price set by the gallery and the artist.

Submissions Send query letter or e-mail with résumé and CD, slides or photographs. Write for appointment to show portfolio. Responds in 2 weeks. Files CD, slides or photos and artist information. Finds artists through word of mouth, referrals by other artists, visiting art fairs and exhibitions, submissions.

Tips "Our focus is to provide high-quality artwork and consulting services to the corporate, design and architectural communities. Our works are represented in corporate offices, healthcare facilities, hotels, restaurants and private collections throughout the country."

ART SHOWS

P.O. Box 245, Spokane WA 99210-0245. (509)922-4545. E-mail: info@artshows.net. Web site: www.artshows.net. **President:** Don Walsdorf. Major art show producer. Estab. 1988. Sponsors large group shows. Clientele: collectors, hotel guests and tourists; 70% private collectors, 30% corporate collectors. Overall price range: $200-250,000; most work sold at $500-3,000.

Media Considers all media except craft.

Style Interested in all genres.

Submissions Send query letter with bio, brochure and photographs. "This information is retained in our permanent files." Portfolio review requested if interested in artist's work.

Tips "Selecting quality art shows is important. Read all the prospectus materials. Then re-read the information to make certain you completely understand the requirements, costs and the importance of early responses. Respond well in advance of any suggested deadline dates. Producers cannot wait until 60 days in advance of a show, due to contractual requirements for space, advertising, programming etc. If you intend to participate in a quality event, seek applications a year in advance for existing events. Professional show producers are always seeking to upgrade the quality of their shows. Seek new marketing venues to expand your horizons and garner new collectors. List your fine art show events with info@artshows.net by providing name, date, physical location, full contact information of sponsor or producer. This is a free database at www.artshows.net. Any time you update a brochure, biography or other related materials, be certain to date the material. Outdated material in the hands of collectors works to the detriment of the artist."

ART SOURCE L.A., INC.

2801 Ocean Park Blvd., #7, Santa Monica CA 90405. (310)452-4411. Fax: (310)452-0300. E-mail: info@artsourcela.com. Web site: www.artsourcela.com. **Artist Liason:** Patty Levert. Estab. 1980. Submission guidelines available on Web site.

• See additional listing in the Artists' Reps section.

Media Considers fine art in all media, including works on paper/canvas, sculpture, giclée and a broad array of accessories handmade by American artists. Considers all types of prints.

Terms Artwork is accepted on consignment (50% commission). No geographic restrictions.

Submissions "Send minimum of 20 slides or photographs (laser copies are not acceptable) clearly labeled with your name, title and date of work, size and medium. Catalogs and brochures of your work are welcome. Also include a résumé, price list and SASE. We will not respond without a return envelope." Also accepts e-mail submissions. Responds in 6-8 weeks. Finds artists through art fairs/exhibitions, submissions, referrals by other artists, portfolio reviews and word of mouth.

Tips "Be professional when submitting visuals. Remember, first impressions can be critical! Submit a body of work that is consistent and of the highest quality. Work should be in excellent

condition and already photographed for your records. Framing does not enhance presentation to the client.''

ART WITHOUT WALLS, INC.

P.O. Box 341, Sayville NY 11782. Phone/fax: (631)567-9418. E-mail: artwithoutwalls@webtv.net. **Executive Director:** Sharon Lippman. Nonprofit gallery. Estab. 1985. Approached by 300 artists/ year. Represents 100 emerging, mid-career and established artists. Sponsors 10 exhibits/year. Average display time: 1 month. Open daily, 9-5. Closed December 22-January 5 and Easter week. Overall price range: $1,000-25,000; most work sold at $3,000-5,000.

Media Considers all media and all types of prints. Most frequently exhibits painting, sculpture and drawing.

Style Considers all styles and genres. Most frequently exhibits impressionism, expressionism, postmodernism.

Terms Artwork is accepted on consignment (20% commission). Retail price set by the artist. Gallery provides promotion and contract. Accepted work should be framed, mounted and matted.

Submissions Mail portfolio for review. Send query letter with artist's statement, brochure, photographs, résumé, reviews, SASE and slides. Returns material with SASE. Responds in 1 month. Files artist résumé, slides, photos and artist's statement. Finds artists through submissions, portfolio reviews and art exhibits.

Tips "Work should be properly framed with name, year, medium, title and size."

⬛ ART-AGENT.COM

Web site: www.art-agent.com. Commission-free, electronic broker of fine art; online gallery. "There are no commissions, no signup fees, no service charges, and no subscriptions to pay. The only thing that is requred is a free community account at our sister site, WetCanvas.com. If you are a visual artist and are interested in selling your works via Art-Agent.com, please visit www.wetcanvas.com for more information on creating your account and getting started marketing and selling your art through our network."

🌐 ART@NET INTERNATIONAL GALLERY

(617)495-7451 or (++359)98448132. Fax: (617)495-7049 or (++359)251-2838. E-mail: artnetg @yahoo.com. Web site: www.designbg.com. **Director:** Yavor Shopov. For-profit Internet gallery. Estab. 1998. Approached by 150 artists/year. Represents 20 emerging, mid-career and established artists. Exhibited artists include Nicolas Roerich (paintings) and Yavor Shopov (photography). Sponsors 15 exhibits/year. Average display time: permanent. Open all year; Monday-Sunday, 24 hours. "Internet galleries like ours have a number of unbelievable advantages over physical galleries and work far more efficiently, so they are expanding extremely rapidly and taking over many markets held by conventional galleries for many years. Our gallery exists only online, giving us a number of advantages both for our clients and artists. Our expenses are reduced to the absolute minimum, so we charge our artists lowest commission in the branch (only 10%) and offer to our clients lowest prices for the same quality of work. Unlike physical galleries, we have over 100 million potential Internet clients worldwide and are able to sell in over 150 countries without need to support offices or representatives everywhere. We mount cohesive shows of our artists, which are unlimited in size and may be permanent. Each artist has individual 'exhibition space' divided to separate thematic exhibitions along with bio and statement. We are just hosted in the Internet space, otherwise our organization is the same as of a traditional gallery." Clients include collectors and business offices worldwide; 30% corporate collectors. Overall price range: $150-50,000.

Media Considers ceramics, crafts, drawing, oil, pastel, pen & ink, sculpture and watercolor. Most frequently exhibits photos, oil and drawing. Considers all types of prints.

Style Considers expressionism, geometric abstraction, impressionism and surrealism. Most frequently exhibits impressionism, expressionism and surrealism. Also considers Americana, figurative work, florals, landscapes and wildlife.

Terms Artwork is accepted on consignment, and there is a 10% commission and a rental fee for space of $1/image per month or $5/image per year (first 6 images are displayed free of rental fee). Retail price set by the gallery or the artist. Gallery provides promotion. Accepted work should be matted. Does not require exclusive representation locally. "Every exhibited image will contain your name and copyright as watermark and cannot be printed or illegally used, sold or distributed anywhere."

Submissions E-mail portfolio for review. E-mail attached scans of 900×1200 pixels (300 dpi for prints or 900 dpi for 36mm slides) as JPEG files for IBM computers. "We accept only computer scans; no slides, please." E-mail artist's statement, bio, résumé, and scans of the work. Cannot return material. Responds in 6 weeks. Finds artists through submissions, portfolio reviews, art exhibits, art fairs, and referrals by other artists.

Tips "E-mail us or send a disk or CD with a tightly edited selection of less than 20 scans of your best work. All work must be very appealing and interesting, and must force any person to look over it again and again. Main usage of all works exhibited in our gallery is for limited edition (photos) or original (paintings) wall decoration of offices and homes. Photos must have the quality of paintings. We like to see strong artistic sense of mood, composition, light and color, and strong graphic impact or expression of emotions. We exhibit only artistically perfect work in which value will last for decades. We would like to see any quality work facing these requirements on any media, subject or style. No distractive subjects. For us only quality of work is important, so new artists are welcome. Before you send us your work, ask yourself, 'Who and why will someone buy this work? Is it appropriate and good enough for this purpose?' During the exhibition, all photos must be available in signed limited edition museum quality 8×10 or larger matted prints."

ARTISIMO UNLIMITED

(formerly Artisimo Artspace), P.O. Box 28044, Scottsdale AZ 85255. (480)949-0433. Fax: (480)214-5776. E-mail: artisimo@artisimogallery.com. Web site: www.artisimogallery.com. **Owner:** Julia Ohman. For-profit gallery. Estab. 1991. Approached by 30 artists/year. Represents 20 emerging, mid-career and established artists. Exhibited artists include Carolyn Gareis (mixed media) and Phyllis Brooks (acrylic). Sponsors 3 exhibits/year. Average display time: 5 weeks. Clients include local community, upscale, designers, corporations, restaurants. Overall price range: $200-4,000; most work sold at $2,500.

Media Considers all media and all types of prints.

Style Exhibits geometric abstraction and painterly abstraction. Genres include figurative work, florals, landscapes and abstract.

Terms "Available art is displayed on the Artisimo Web site. Artisimo will bring desired art to the client's home or business. If art is accepted, it will be placed on the Web site." There is a 50% commission upon sale of art. Retail price set by the artist. Gallery provides insurance and promotion.

Submissions Send query e-mail with artist's statement, bio, photographs, résumé or link to Web site. Responds in 3 weeks. Files photographs and bios. Finds artists through submissions, portfolio reviews, art fairs and exhibits, word of mouth and referrals by other artists.

N ARTISTS LAIR

2766 Janitell Rd. S., Colorado Springs CO 80906. (719)576-5247. Fax: (719)579-9070. E-mail: PagiArtistsLair@aol.com. Web site: www.artistslair.net. **Gallery Consultant:** Ernie Ferguson. For-profit gallery. Estab. 2006. Exhibits emerging, mid-career and established artists. Average

display time: 2-4 weeks. Open Tuesday, Thursday and Friday, 10:30-5; Wednesday, 12:30-7:30; Saturday, 12-5. Closed Sunday, Monday and some holidays. Located in an emerging retail area; 3,000 sq. ft. Clients include local community, students, tourists. 25% of sales are to corporate collectors. Overall price range: $60-3,000; most work sold at $400-800.

Media Considers all media and all types of prints.

Style Exhibits all styles and genres.

Terms Artwork is accepted on consignment (35% commission). Retail price set by artist. Gallery provides promotion and contract. Accepted work should be framed, mounted, matted.

Submissions Send query letter with artist's statement, bio, brochure, business card, résumé, photocopies, photographs, slides, reviews, SASE. E-mail query letter with JPEG samples or link to Web site. Call or write to arrange a personal interview to show portfolio of photographs, slides, transparencies. Mail portfolio for review. Returns material with SASE. Responds in 3 weeks. Keeps CDs on file. Finds artists through submissions, portfolio reviews, art fairs and exhibits, word of mouth and referrals by other artists. "We also have a call for entries."

ARTISTS' COOPERATIVE GALLERY

405 S. 11th St., Omaha NE 68102. (402)342-9617. Web site: www.artistsco-opgallery.com. Estab. 1974. Sponsors 11 exhibits/year. Average display time: 1 month. Gallery sponsors all-member exhibits and outreach exhibits; individual artists sponsor their own small group exhibits throughout the year. Overall price range: $100-500.

Media Considers oil, acrylic, watercolor, pastel, drawings, mixed media, collage, paper, sculpture, ceramic, fiber, glass, photography, woodcuts, serigraphs. Most frequently exhibits sculpture, acrylic, oil and ceramic.

Style Exhibits all styles and genres.

Terms Charges no commission. Reviews transparencies. Accepted work should be framed work only. "Artist must be willing to work 13 days per year at the gallery. We are a member-owned-and-operated cooperative. Artist must also serve on one committee."

Submissions Send query letter with résumé, SASE. Responds in 2 months.

Tips "Write for membership application. Membership committee screens applicants August 1-15 each year. Responds by September 1. New membership year begins October 1. Members must pay annual fee of $325. Our community outreach exhibits include local high school photographers and art from local elementary schools."

ARTQUOTE INTERNATIONAL, LLC

4653 Chelsea Lane, Bloomfield Hills MI 48301. (248)851-6091. Fax: (248)851-6090. E-mail: artquote@bigfoot.com. **Contact:** M. Burnstein. Art consultancy; for-profit, wholesale gallery; corporate art and identity programs. Estab. 1985. Exhibits established artists. Exhibited artists include Andy Warhol (screenprints) and Bill Mack (sculpture). Clients include local community. Most sales are to corporate collectors. Does not sell art at retail prices. Supplier to Fortune 100 corporations (global).

Submissions Depends on corporate client. Finds artists through "established network of channels."

N THE ARTS COMPANY

215 Fifth Ave., Nashville TN 37219. (615)254-2040. Fax: (615)254-9289. E-mail: art@theartscompany.com. Web site: www.theartscompany.com. **Owner:** Anne Brown. Art consultancy, for-profit gallery. Estab. 1996. Over 6,000 sq. ft. of gallery space on 2 floors. Overall price range: $10-35,000; most work sold at $300-3,000.

Media Considers all media. Most frequently exhibits painting, photography and sculpture.

Style Exhibits all styles and genres. Frequently exhibits contemporary outsider art.

Terms Artwork is accepted on consignment. Gallery provides insurance and contract. Accepted work should be framed. Requires exclusive representation locally.

Submissions "We prefer an initial info packet via e-mail." Send query letter with artist's statement, bio, brochure, business card, photocopies, résumé, reviews, SASE, CD. Returns material with SASE. Finds artists through word of mouth, art fairs/exhibits, submissions, referrals by other artists.

Tips "Provide professional images on a CD along with a professional bio, résumé."

N I ARTS ON DOUGLAS

123 Douglas St., New Smyrna Beach FL 32168. (386)428-1133. Fax: (386)328-5008. E-mail: mail@ artsondouglas.net. Web site: www.artsondouglas.net. **Gallery Director:** Meghan Martin. For-profit gallery. Estab. 1996. Represents 56 professional Florida artists and exhibits 12 established artists/year. Average display time: 1 month. Open all year; Tuesday-Friday, 11-6; Saturday, 10-2. 5,000 sq. ft. of exhibition space. Clients include local community, tourists and upscale. Overall price range: varies.

Media Considers all media except installation.

Style Considers all styles and genres.

Terms Artwork is accepted on consignment (50% commission). Retail price set by the artist. Gallery provides insurance and promotion. Accepted work should be framed. Requires exclusive representation locally. Accepts only professional artists from Florida.

Submissions Returns material with SASE. Files slides, bio and résumé. Artists may want to call gallery prior to sending submission package—not always accepting new artists.

Tips "We want current bodies of work—please send slides of what you're presently working on."

N ARTWORKS GALLERY

811 Race St., Cincinnati OH 45202. (513)333-0388. Fax: (513)333-0799. E-mail: allen@artworksci ncinnati.com. Web site: www.ArtWorksCincinnati.com. **Coordinator:** Allen Cochran. Alternative space; cooperative, nonprofit, rental gallery. Estab. 2003. Exhibits emerging, mid-career and established artists. Approached by 75-100 artists/year; represents or exhibits 50-75 artists. Exhibited artists include Brian Joiner (painting), Tiffany Owenby (sculpture, doll art), Pam Kravetz (fiber) and Frank Herrmann (painting). Sponsors 11-12 exhibits/year. Average display time: 4 weeks or 1½ months. Open Monday-Friday, 9-5; also by appointment. "Generally we are closed during the month of January." Located in downtown Cincinnati; 1,500 sq. ft.; available for event rentals and small private parties. Clients include local community, students, tourists, upscale. 20% of sales are to corporate collectors. Overall price range: $200-15,000; most work sold at $500-1,200.

Media Considers all media. Most frequently exhibits painting, drawing and small sculpture. Considers all types of prints.

Style Considers all styles and genres. Most frequently exhibits abstract, realistic and figurative work.

Terms Artwork is accepted on consignment (30% commission). Retail price set by both artist and gallery. Gallery provides promotion and contract. Accepted work should be "finished and exhibition ready. We have the right to jury the works coming into the space."

Submissions Call or mail portfolio for review. Send query letter with résumé, artist's statement, slides or digital images via CD or e-mail. Cannot return material; "We hold on to materials for future exhibition opportunities. We have many opportunities beyond just exhibiting in our gallery." Responds to queries in 3-4 weeks. Finds artists through submissions, art fairs/exhibits, portfolio reviews, art competitions, referrals by other artists, word of mouth.

Tips "ArtWorks is looking for strong artists who are not only talented in terms of their ability to

make and create, but who also can professionally present themselves and show a genuine interest in the exhibition of their artwork. In regards to this, ArtWorks is looking for concise statements that the artists themselves have written about their own work, as well as résumés of exhibitions to help back up their written statements. We do ask that communication is top on the list. Artists and interested parties should continue to communicate with us beyond exhibitions and further down the line just to let us know what they're up to or how they've grown.''

⚜ ARTWORKS GALLERY, INC.

233 Pearl St., Hartford CT 06103. (860)247-3522. E-mail: artworks.gallery@snet.net. Web site: www.artworksgallery.org. **Executive Director:** Francesca Verblen. Cooperative nonprofit gallery. Estab. 1976. Exhibits emerging, mid-career and established artists. Sponsors 12 shows/year. Average display time: 1 month. Open Wednesday-Friday, 11-5; Saturday, 12:30-3:30; also by appointment. Located in downtown Hartford; 1,300 sq. ft.; large, first floor, store front. 20% of space for special exhibitions; 80% of space for gallery artists. Clientele: 80% private collectors; 20% corporate collectors. Overall price range: $200-5,000; most work sold at $200-1,000.
Media Considers all media and all types of prints. Most frequently exhibits paintings, photography and sculpture. No crafts or jewelry.
Style Exhibits all styles and genres, especially contemporary.
Terms Co-op membership fee plus a donation of time. There is a 30% commission. Retail price set by artist. Offers customer discounts and payment by installments. Gallery provides insurance, promotion and contract. Artist pays for shipping costs. Accepts only artists from Connecticut for membership. Accepts artists from New England and New York for juried shows.
Submissions For membership, send query letter with résumé, slides, bio and $25 application fee. E-mail 10 JPEG file attachments to apply@artworksgallery.org. Membership Committee will contact artist for interview. Responds in 1 month. Finds artists through submissions, visiting exhibitions, various art publications and sourcebooks, art collectors' referrals, but mostly through word of mouth and 2 juried shows/year.

ASHLAND ARTS/ICON STUDIOS

1205 W. Pierce St., Phoenix AZ 85007. Phone/fax: (602)257-8543. **Director:** David Cook. Estab. 1986. Represents emerging, mid-career and established artists. Sponsors 6 exhibits/year. Average display time: 2 months. One juried show in spring and fall of each year ''for adults only.'' Annual anniversary exhibition in spring (call for information—$25 fee, 3 slides, SASE). Overall price range: $100-500; most work sold at $150.
Media Considers all media and all types of prints. Most frequently exhibits photography, painting, mixed media and sculpture.
Style Exhibits all styles, preferably conceptualism, minimalism and neo-expressionism.
Terms Accepts work on consignment (25% commission); rental fee for space covers 2 months. Retail price set by artist. Artist pays for shipping.
Submissions Send query letter with résumé, samples, SASE. Responds in 2 weeks.
Tips ''Sincerely look for a venue for your art and follow through. Search for traditional and nontraditional spaces. Treat your work with care and make slides if possible for easy presentation.''

⚜ SARAH BAIN GALLERY

411 W. Broadway, Suite C, Anaheim CA 92805. (714)758-0545. E-mail: sarahbain@aol.com. Web site: www.sarahbaingallery.com. For-profit gallery. Exhibits emerging and mid-career artists. Approached by 200 artists/year; represents or exhibits 24 artists. Sponsors 12 total exhibits/year. Average display time: 1 month. Clients include local community, students, tourists and upscale. Overall price range: $700-15,000; most work sold at $4,000.

Media Considers acrylic, drawing, mixed media, oil. Most frequently exhibits drawing, mixed media, paintings in representational or figurative style.

Style Exhibits representational or figurative.

Terms Artwork is accepted on consignment. Retail price set by the gallery. Gallery provides promotion. Accepted work should be framed and mounted. Prefers only representational or figurative art.

Submissions Mail portfolio for review. Send query letter with slides. Returns material with SASE. Responds to queries in 1 month.

Tips "Show a consistent, comprehensive body of work as if it were its own show ready to be hung."

BARUCCI GALLERY

8101 Maryland Ave., St. Louis MO 63105. (314)727-2020. E-mail: baruccigallery@dellmail.com. Web site: www.baruccigallery.com. **Owner/Director:** Shirley Taxman Schwartz. Retail gallery and art consultancy specializing in hand-blown glass by national juried artists. Estab. 1977. Represents 40 artists. Interested in emerging and established artists. Sponsors 3-4 solo and 4 group shows/year. Average display time: 6 weeks. Located in an "affluent, young area;" corner location featuring 3 large display windows. 70% private collectors, 30% corporate clients. Overall price range: $100-10,000; most work sold at $1,000.

Media Considers oil, acrylic, watercolor, pastel, collage and works on paper. Most frequently exhibits watercolor, oil, acrylic and hand-blown glass.

Style Exhibits painterly abstraction and impressionism. Currently seeking contemporary works; abstracts in acrylic and fiber; some limited edition serigraphs.

Terms Accepts work on consignment (50% commission). Retail price set by gallery or artist. Sometimes offers payment by installment. Gallery provides contract.

Submissions Send query letter with résumé, slides and SASE. Portfolio review requested if interested in artist's work. Slides, bios and brochures are filed.

Tips "More clients are requesting discounts or longer pay periods."

SETH JASON BEITLER FINE ARTS

250 NW 23rd St., Suite 202, Miami FL 33127. (305)438-0218. Fax: (800)952-7026. E-mail: info@sethjason.com. Web site: www.sethjason.com. **Owner:** Seth Beitler. For-profit gallery, art consultancy. Estab. 1997. Approached by 300 artists/year. Represents 40 mid-career, established artists. Exhibited artists include Florimond Dufoor, oil paintings; Terje Lundaas, glass sculpture. Sponsors 5 exhibits/year. Average display time: 2-3 months. Clients include local community and upscale. 5-10% of sales are to corporate collectors. Overall price range: $2,000-300,000; most work sold at $5,000.

Media Considers acrylic, glass, mixed media, sculpture, drawing, oil. Most frequently exhibits sculpture, painting, photography. Considers etchings, linocuts, lithographs.

Style Exhibits color field, geometric abstraction and painterly abstraction. Most frequently exhibits geometric sculpture, abstract painting, photography. Genres include figurative work and landscapes.

Terms Artwork is accepted on consignment, and there is a 50% commission. Retail price set by the gallery. Gallery provides insurance, promotion and contract. Accepted work should be mounted.

Submissions Write to arrange personal interview to show portfolio of photographs, slides, transparencies. Send query letter with artist's statement, bio, photographs, résumé, SASE. Returns material with SASE. Responds to queries in 2 months. Files photos, slides, transparencies. Finds artists through art fairs, portfolio reviews, referrals by other artists and word of mouth.

Tips Send "easy to see photographs. E-mail submissions for quicker response."

MARY BELL GALLERIES

740 N. Franklin, Chicago IL 60610. (312)642-0202. Fax: (312)642-6672. Web site: www.marybell. com. **President:** Mary Bell. Retail gallery. Estab. 1975. Represents mid-career artists. Interested in seeing the work of emerging artists. Exhibited artists include Mark Dickson. Sponsors 4 shows/ year. Average display time: 6 weeks. Open all year. Located downtown in gallery district; 5,000 sq. ft. 25% of space for special exhibitions. Clientele: corporations, designers and individuals. 50% private collectors, 50% corporate collectors. Overall price range: $500-15,000.

Media Considers oil, acrylic, pastel, mixed media, collage, paper, sculpture, ceramic, fiber, glass, original handpulled prints, offset reproductions, woodcuts, engravings, lithographs, pochoir, posters, wood engravings, mezzotints, serigraphs, linocuts and etchings. Most frequently exhibits canvas, unique paper and sculpture.

Style Exhibits expressionism, painterly abstraction, impressionism, realism and photorealism. Genres include landscapes and florals. Prefers abstract, realistic and impressionistic styles. Does not want "figurative or bizarre work."

Terms Accepts artwork on consignment (50% commission). Retail price set by gallery and artist. Offers customer discounts and payment by installments. Gallery provides insurance and contract; shipping costs are shared. Prefers artwork unframed.

Submissions Send query letter with slides and SASE. Portfolio review requested if interested in artist's work. Portfolio should include slides or photos.

CECELIA COKER BELL GALLERY

Coker College, Hartsville, SC 29550. (843)383-8156. E-mail: lmerriman@pascal.coker.edu. Web site: www.coker.edu/art/gallery.html. **Director:** Larry Merriman. "A campus-located teaching gallery that exhibits a variety of media and styles to expose students and the community to the breadth of possibility for expression in art. Exhibits include regional, national and international artists with an emphasis on quality and originality. Shows include work from emerging, mid, and late career artists." Sponsors 5 solo shows/year, with a 4-week run for each show.

Media Considers all media including installation and graphic design. Most frequently exhibits painting, photograpy, sculpture/installation and mixed media.

Style Considers all styles. Not interested in conservative/commercial art.

Terms Retail price set by artist (sales are not common). Exclusive area representation not required. Gallery provides insurance, promotion and contract; shipping costs are shared.

Submissions Send résumé, 10 slides (or JPEGs on CD), and SASE by October 15. Visits by artists are welcome; however, the exhibition committee will review and select all shows from the slides and JPEGs submitted by the artists.

N BELL STUDIO

3428 N. Southport Ave., Chicago IL 60657. Web site: www.bellstudio.net. **Director:** Paul Therieau. For-profit gallery. Estab. 2001. Approached by 60 artists/year; represents or exhibits 10 artists. Sponsors 10 exhibits/year. Average display time: 6 weeks. Open all year; Monday-Friday, 12-7; weekends, 12-5. Located in brick storefront with high traffic; 750 sq. ft. of exhibition space. Overall price range: $150-3,500; most work sold at $600.

Media Considers acrylic, collage, drawing, mixed media, oil, paper, pastel, pen & ink and watercolor. Considers all types of prints except posters. Most frequently exhibits watercolor, oils and photography.

Style Exhibits minimalism, postermodernism and painterly abstraction. Genres include figurative work and landscapes.

Terms Artwork is accepted on consignment (50% commission). Retail price set by the gallery. Gallery provides insurance, promotion and contract. Accepted work should be framed. Requires exclusive representation locally.

Submissions Write to arrange a personal interview to show portfolio; include bio and résumé. Responds to queries within 3 months, only if interested. Finds artists through referrals by other artists, submissions, word of mouth.

Tips "Type submission letter and include your show history, résumé and a SASE."

BENNETT GALLERIES

5308 Kingston Pike, Knoxville TN 37919. (865)584-6791. Fax: (865)588-6130. Web site: www.ben nettgalleries.com. **Director:** Marga Hayes. Owner: Rick Bennett. Retail gallery. Represents emerging and established artists. Exhibited artists include Richard Jolley, Carl Sublett, Scott Duce, Andrew Saftel and Tommie Rush, Akira Blount, Scott Hill, Marga Hayes Ingram, John Boatright, Grace Ann Warn, Timothy Berry, Cheryl Warrick, Dion Zwirne. Sponsors 10 shows/year. Average display time: 1 month. Open all year; Monday-Thursday, 10-6; Friday-Saturday, 10-5:30. Located in West Knoxville. Clientele: 80% private collectors, 20% corporate collectors. Overall price range: $200-20,000; most work sold at $2,000-8,000.

Media Considers oil, acrylic, watercolor, pastel, drawing, mixed media, works on paper, sculpture, ceramic, craft, photography, glass, original handpulled prints. Most frequently exhibits painting, ceramic/clay, wood, glass and sculpture.

Style Exhibits contemporary works in abstraction, figurative, narrative, realism, contemporary landscape and still life.

Terms Accepts artwork on consignment (50% commission). Retail price set by the gallery and the artist. Sometimes offers customer discounts and payment by installments. Gallery provides insurance on works at the gallery, promotion and contract. Prefers artwork framed. Shipping to gallery to be paid by the artist.

Submissions Send query letter with résumé, no more than 10 slides, bio, photographs, SASE and reviews. Finds artists through agents, visiting exhibitions, word of mouth, various art publications, sourcebooks, submissions/self-promotions and referrals.

Ⓝ SYBIL BERG CONTEMPORARY ART

444 E. 82nd St., Suite 6T, New York NY 10028. E-mail: mgyerman@verizon.net. Web site: www.s ybilbergca.com. **Curator:** Marcia G. Yerman. Estab. 2004. "Sybil Berg Contemporary Art is a consultancy that focuses on the work of women artists. We file JPEGs of artwork by women for projects, lectures and exhibits."

Media Considers all media.

Submissions E-mail JPEGs to be kept on file. Responds in 4 weeks.

MONA BERMAN FINE ARTS

78 Lyon St., New Haven CT 06511. (203)562-4720. Fax: (203)787-6855. E-mail: info@monaberma nfinearts.com. Web site: www.monabermanfinearts.com. **Director:** Mona Berman. Art consultant. Estab. 1979. Represents 100 emerging and mid-career artists. Exhibited artists include Tom Hricko, David Dunlop, Pierre Dardignac and S. Wind-Greenbaum. Sponsors 1 show/year. Open all year by appointment. Located near downtown; 1,400 sq. ft. Clientele: 25% private collectors, 75% corporate collectors. Overall price range: $200-20,000; most artwork sold at $500-5,000.

Media Considers all media except installation. Shows very little sculpture. Considers all limited edition prints except posters and photolithography. Also considers limited and carefully selected, well-priced, high-quality digital media. Most frequently exhibits works on paper, painting, relief and ethnographic arts.

Style Exhibits most styles. Prefers abstract, landscape and transitional. Little figurative, little still life.

Terms Accepts work on consignment (50% commission; net 30 days). Retail price is set by gallery and artist. Retail prices must be consistent regardless of venue. Customer discounts and payment

by installment are available. Gallery provides insurance; artist pays for shipping. Prefers artwork unframed.

Submissions Accepts digital submissions by e-mail and links to Web sites; or send query letter, résumé, CD, bio, SASE, reviews and "retail price list." Portfolios are reviewed only after images have been reviewed. Responds in 1 month. Include e-mail address for faster response. CDs and supporting material returned only if SASE is included. Finds artists through word of mouth, art publications and sourcebooks, submissions and self-promotions and other professionals' recommendations.

Tips "We will not carry artists who do not maintain consistent retail pricing. We are not a gallery, although we do a few exhibits; so please do not submit if you are looking for an exhibition venue. We are primarily art consultants. We continue to be busy selling high-quality art and related services to the corporate, architectural, design and private sectors. A follow-up e-mail is preferable to a phone call."

⑤ BERTONI GALLERY

1392 Kings Hwy., Sugar Loaf NY 10981. (845)469-0993. Fax: (845)469-6808. E-mail: bertoni@opt online.net. Web site: www.bertonigallery.com. **Owner:** Rachel Bertoni. For-profit gallery, rental gallery, art consultancy. Estab. 2000. Exhibits emerging, mid-career and established artists. Approached by 15 artists/year; represents 5 artists/year. Exhibited artists include Mae Bertoni (watercolor) and Mike Jarosko (oil). Sponsors 5 exhibits/year. Average display time: 2 months. Open Thursday-Sunday, 11-6. Clients include local community, tourists. 10% of sales are to corporate collectors. Overall price range: $100-1,500; most work sold at $400.

Media Considers all media. Most frequently exhibits watercolor, oil, mixed media. Considers all types of prints

Style Exhibits all styles and genres.

Terms Artwork is accepted on consignment (40% commission); or artwork is bought outright for 50% of retail price. There is a co-op membership fee plus a donation of time (30% commission). There is a rental fee for space; rental fee covers 2 months. Retail price set by the artist. Accepted work should be framed, mounted, matted.

Submissions Send query letter with artist's statement, résumé and photographs. Returns material with SASE. Responds to queries in 2 weeks. Finds artists through word of mouth and referrals by other artists.

Tips "Submit materials in a neat manner with SASE for easy return."

TOM BINDER FINE ARTS

825 Wilshire Blvd. #708, Santa Monica CA 90401. (310)822-1080. Fax: (310)822-1580. E-mail: info@artman.net. Web site: www.artman.net. **Owner:** Tom Binder. For-profit gallery. Exhibits established artists. Also has a location in Marina Del Rey. Clients include local community, tourists and upscale. Overall price range: $200-2,000.

• See additional listing in the Posters & Prints section.

Media Considers all media; types of prints include etchings, lithographs, posters and serigraphs.

Style Considers all styles and genres.

Terms Artwork is accepted on consignment or bought outright. Retail price set by the gallery. Gallery provides insurance. Accepted work should be mounted.

Submissions Write to arrange a personal interview to show portfolio. Returns material with SASE. Responds in 2 weeks.

⑤ BLUE SPIRAL 1

38 Biltmore Ave., Asheville NC 28801. (828)251-0202. Fax: (828)251-0884. E-mail: info@bluespir al1.com. Web site: www.bluespiral1.com. **Director:** John Cram. Retail gallery. Estab. 1991. Rep-

resents emerging, mid-career and established artists living in the Southeast. Over 100 exhibited artists including Julyan Davis, John Nickerson, Suzanne Stryk, Greg Decker and Will Henry Stephens. Sponsors 15-20 shows/year. Average display time: 6-8 weeks. Open all year; Monday-Saturday, 10-6; Sunday, 12-5 (May-October). Located downtown; 15,000 sq. ft.; historic building. 50% of space for special exhibitions; 50% of space for gallery artists. Clientele: "across the range;" 90% private collectors, 10% corporate collectors. Overall price range: less than $100-50,000; most work sold at $100-2,500.

Media Considers all media. Most frequently exhibits painting, clay, sculpture and glass.

Style Exhibits all styles, all genres.

Terms Accepts work on consignment (50% commission). Retail price set by the artist. Gallery provides insurance, promotion and contract; artist pays shipping costs to and from gallery. Prefers framed artwork.

Submissions Accepts only artists from Southeast. Send query letter with résumé, slides, prices, statement and SASE. Responds in 3 months. Files slides, name and address. Finds artists through word of mouth, referrals and travel.

Tips "Work must be technically well executed and properly presented."

BOCA RATON MUSEUM OF ART

501 Plaza Real, Boca Raton FL 33432. (561)392-2500. Fax: (561)391-6410. E-mail: info@bocamus eum.org. Web site: www.bocamuseum.org. **Executive Director:** George S. Bolge. Museum. Estab. 1950. Represents established artists. 5,500 members. Exhibits change every 2-3 months. Open all year; Tuesday, Thursday and Friday, 10-5; Wednesday, 10-9; Saturday and Sunday, 12-5. Located one mile east of I-95 in Mizner Park; 44,000 sq. ft.; national and international temporary exhibitions and impressive second-floor permanent collection. Three galleries—one shows permanent collection, two are for changing exhibitions. 66% of space for special exhibitions.

Media Considers all media. Exhibits modern masters including Braque, Degas, Demuth, Glackens, Klee, Matisse, Picasso and Seurat; 19th and 20th century photographers; Pre-Columbian and African art; contemporary sculpture.

Submissions "Contact executive director in writing."

Tips "Photographs of work of art should be professionally done if possible. Before approaching museums, an artist should be well-represented in solo exhibitions and museum collections. Their acceptance into a particular museum collection, however, still depends on how well their work fits into that collection's narrative and how well it fits with the goals and collecting policies of that museum."

⊕ BRACKNELL GALLERY; MANSION SPACES

South Hill Park Arts Centre, Berkshire RG12 7PA United Kingdom. (44)(0)1344-416240. E-mail: outi.remes@southhillpark.org.uk. Web site: www.southhillpark.org.uk. **Visual Arts & Exhibitions Officer:** Dr. Outi Remes. Alternative space/nonprofit gallery. Estab. 1991. Approached by at least 50 artists/year; exhibits several shows of emerging, mid-career and established artists. "Very many artists approach us for the Mansion Spaces; all applications are looked at." Exhibited artists include Billy Childish (painting), Paul Russell (photography) and Matt Sherratt (ceramic). Average display time: 2 months. Open all year; call or check Web site for hours. Located "within a large arts centre that includes theatre, cinema, studios, workshops and a restaurant; one large room and one smaller with high ceilings, plus more exhibiting spaces around the centre." Clients include local community and students.

Media Considers all media. Most frequently exhibits painting, sculpture, live art, installations, group shows, video-digital works, craftwork (ceramics, glasswork, jewelry). Considers all types of prints.

Style Considers all styles and genres.

Terms Artwork is accepted on consignment, and there is a 20% commission. Retail price set by the artist. Gallery provides insurance, promotion and contract.

Submissions Send query letter with artist's statement, bio and photographs. Returns material with SAE. Responds to queries only if interested. Files all material "unless return of slides/photos is requested." Finds artists through invitations, art exhibits, referrals by other artists, submissions and word of mouth.

Tips "We have a great number of applications for exhibitions in the Mansion Spaces. Make yours stand out! Exhibitions at the Bracknell Gallery are planned 2-3 years in advance."

N RENA BRANSTEN GALLERY

77 Geary St., San Francisco CA 94108. (415)982-3292. Fax: (415)982-1807. E-mail: leigh@renabra nstengallery.com. Web site: www.renabranstengallery.com. **Director:** Leigh Markopoulos. For-profit gallery. Estab. 1974. Exhibits emerging, mid-career and established artists. Approached by 200 artists/year. Exhibits 12-15 artists/year. Average display time: 4-5 weeks. Open Tuesday-Friday, 10:30-5:30; Saturday, 11-5; usually closed the last week of August and the first week of September.

Media Considers all media except craft and fiber. Considers all types of prints.

Style Considers all styles of contemporary art.

Term Retail price set by the gallery and the artist.

Submissions Send JPEGs or Web site link via e-mail. Mailed submissions must include SASE if return of materials is required. Files cover letter from artist. Finds artists through art fairs and exhibits, portfolio reviews, referrals by curators and other artists, studio visits and word of mouth.

BRENAU UNIVERSITY GALLERIES

500 Washington St. SE, Gainesville GA 30501. (770)534-6263. Fax: (770)538-4599. E-mail: gallery @lib.brenau.edu. Web site: www.brenau.edu. **Gallery Director:** Tonya Cribb. Nonprofit gallery. Estab. 1980s. Exhibits emerging, mid-career and established artists. Sponsors 7-9 shows/year. Average display time: 6-8 weeks. Open all year; Tuesday-Friday, 10-4; Sunday, 2-5 during exhibit dates. "Please call for Summer hours." Located near downtown; 3,958 sq. ft., 3 galleries—the main one in a renovated 1914 neoclassic building, another in an adjacent renovated Victorian building dating from the 1890s, the third is in the new center for performing arts. 100% of space for special exhibitions. Clientele: tourists, upscale, local community, students. "Although sales do occur as a result of our exhibits, we do not currently take any percentage, except in our invitational exhibitions. Our purpose is primarily educational."

Media Considers all media.

Style Exhibits wide range of styles. "We intentionally try to plan a balanced variety of media and styles."

Terms Retail price set by the artist. Gallery provides insurance and promotion; shipping costs are shared, depending on funding for exhibits. Prefers artwork framed. "Artwork must be framed or otherwise ready to exhibit."

Submissions Send query letter with résumé, 10-20 slides, photographs and bio. Write for appointment to show portfolio of slides and transparencies. Responds within months if possible. Artist should call to follow up. Files one or two slides or photos with a short résumé or bio if interested. Remaining material returned. Finds artists through referrals, direct viewing of work and inquiries.

Tips "Be persistent, keep working, be organized and patient. Take good slides and develop a body of work. Galleries are limited by a variety of constraints—time, budgets, location, taste—and rejection does not mean your work may not be good; it may not 'fit' for other reasons at the time of your inquiry."

⃞N⃞ BREW HOUSE SPACE 101

2100 Mary St., Pittsburgh PA 15203. (412)381-7767. Fax: (412)390-1977. E-mail: thebrewhouse@ gmail.com. Web site: www.brew-house.org. Alternative space; cooperative, nonprofit, rental gallery. Estab. 1993. Average display time: 1 month. Open Wednesday and Thursday, 6-9; Saturday, 12-6. Located in Pittsburgh's historic south side; 1,360 sq. ft. with 23-ft.-high ceilings.

Media Considers all media and all types of prints. Most frequently exhibits sculpture, painting and installation.

Style Considers all styles and genres.

Terms Artwork is accepted through juried selection. Gallery provides insurance, promotion, contract. Accepted work should be framed.

Submissions Mail portfolio for review. Responds in 3 months. Finds artists through submissions.

BROOKFIELD CRAFT CENTER

286 Whisconier Rd., Brookfield CT 06804-0122. E-mail: info@brookfieldcraftcenter.org. Web site: www.brookfieldcraftcenter.org. **Contact:** Gallery Director. Nonprofit gallery. Estab. 1954. Exhibits emerging, mid-career and established artists. Approached by 100 artists/year; represents 400+ artists.

Media Considers ceramics, craft, drawing, glass, mixed media and paper. Most frequently exhibits clay, glass, metal, wood. Considers all types of prints.

Style Exhibits color field and impressionism. Considers all genres.

Terms Artwork is accepted on consignment (40% commission) or bought outright for 50% of retail price; net 30 days. Retail price of the art set by the artist. Gallery provides insurance, promotion and contract. Accepted work should be framed.

Submissions Write to arrange personal interview to show portfolio of photographs and slides. Send query letter with brochure. Returns material with SASE. Responds to queries in 2 weeks to 1 month. Finds artists through art fairs/exhibits, portfolio reviews, referrals by other artists, submissions and word of mouth.

BROOKLYN BOTANIC GARDEN—STEINHARDT CONSERVATORY GALLERY

1000 Washington Ave., Brooklyn NY 11225. (718)623-7200. Fax: (718)622-7839. E-mail: emilycar son@bbg.org. Web site: www.bbg.org. **Public Programs Associate:** Emily Carson. Nonprofit botanic garden gallery. Estab. 1988. Represents emerging, mid-career and established artists. 20,000 members. Sponsors 10-12 shows/year. Average display time: 4-6 weeks. Open all year; Tuesday-Sunday, 10-4. Located near Prospect Park and Brooklyn Museum; 1,200 sq. ft.; part of a botanic garden, gallery adjacent to the tropical, desert and temperate houses. Clients include BBG members, tourists, collectors. 100% of sales are to private collectors. Overall price range: $75-7,500; most work sold at $75-500.

Media Considers all media and all types of prints. Most frequently exhibits watercolor, oil and photography.

Style Exhibits all styles. Genres include landscapes, florals and wildlife.

Terms Accepts work on consignment (20% commission). Retail price set by the artist. Gallery provides insurance, promotion and contract; artist pays shipping costs to and from gallery. Artwork must be framed or ready to display unless otherwise arranged. Artists hang and remove their own shows.

Submissions Work must reflect the natural world. Send query letter with résumé, slides, bio, brochure, photographs, SASE, business card and reviews for review.

Tips "Artists' groups contact me by submitting résumé and slides of artists in their group. We favor seasonal art which echoes the natural events going on in the garden. Large format, colorful works show best in our multi-use space."

N BRUNNER GALLERY

215 N. Columbia St., Covington LA 70433. (985)893-0444. Fax: (985)893-4332. E-mail: submissions@brunnergallery.com. Web site: www.brunnergallery.com. **Owner/Director:** Susan Brunner. For-profit gallery. Estab. 1997. Approached by 400 artists/year. Exhibits 45 emerging, mid-career and established artists. Sponsors 10-12 exhibits/year. Average display time: 1 month. Open all year; Tuesday-Saturday, 10-5; weekends, 10-5. Closed major holidays. Located 45 minutes from metropolitan New Orleans, one hour from capital of Baton Rouge and Gulf Coast; 2,500 sq. ft. Building designed by Rick Brunner, artist and sculptor, and Susan Brunner, designer. Clients include local community, tourists, upscale and professionals. 20% of sales are to corporate collectors. Overall price range: $200-10,000; most work sold at $1,500-3,000.

Media Considers all media. Types of prints include etchings and monoprints.

Style Considers all styles and genres. Most frequently exhibits abstraction, expressionism and conceptualism.

Terms Artwork is accepted on consignment (50% commission) or bought outright for 90-100% of retail price (net 30 days). Retail price set by the gallery and the artist. Gallery provides insurance, promotion and contract. Accepted work should be framed. Requires exclusive representation locally.

Submissions Preliminary review: E-mail artist's statement, bio, résumé, 3 JPEG files (no larger than 72 dpi) or URL. Submissions are reviewed quarterly. Will contact for portfolio review if interested. (See Web site for additional information regarding ''secondary review'' guidelines.) Finds artists through word of mouth, submissions, portfolio reviews, art fairs/exhibits, and referrals by other artists.

Tips ''In order for us to offer representation to an artist, it is necessary for us to consider whether the artist will be a good fit for the private and corporate collectors who make up our client base. We request that each image include not only the title, dimensions and medium, but also the retail price range.''

BUNNELL STREET GALLERY

106 W. Bunnell, Suite A, Homer AK 99603. (907)235-2662. Fax: (907)235-9427. E-mail: bunnell@xyz.net. Web site: www.bunnellstreetgallery.org. **Director:** Asia Freeman. Nonprofit gallery. Estab. 1990. Approached by 50 artists/year. Represents 35 emerging, mid-career and established artists. Sponsors 12 exhibits/year. Average display time: 1 month. Open Monday-Saturday, 10-6; Sunday, 12-4 (summer only). Closed January. Located on corner of Main and Bunnell Streets, Old Town, Homer; 30×25 exhibition space; good lighting, hardwood floors. Clients include local community and tourists. 10% of sales are to corporate collectors. Overall price range: $50-2,500; most work sold at $500.

Media Considers all media. Most frequently exhibits painting, ceramics and installation. No prints; originals only.

Style Considers all styles and genres. Most frequently exhibits painterly abstraction, impressionism, conceptualism.

Terms Artwork is accepted on consignment, and there is a 35% commission. A donation of time is requested. Gallery provides insurance, promotion and contract. Accepted work should be framed. Does not require exclusive representation locally.

Submissions Call or write to arrange a personal interview to show portfolio of slides or mail portfolio for review. Returns material with SASE. Responds in 1 month. Finds artists through word of mouth, submissions, art exhibits and referrals by other artists.

N CADEAUX DU MONDE

26 Mary St., Newport RI 02835. (401)848-0550. Fax: (401)849-3225. E-mail: info@cadeauxdumonde.com. Web site: www.cadeauxdumonde.com. **Owners:** Jane Dyer and Katie Dyer. Retail gal-

lery. Estab. 1987. Represents emerging, mid-career and established artists. Exhibited artists include John Lyimo and A.K. Paulin. Sponsors 7 changing shows and 1 ongoing show/year. Average display time: 3-4 weeks. Open all year; daily, 10-6 and by appointment. Located in "the Anna Pell House (circa 1840), recently restored with many original details intact including Chiswick tiles on the fireplace and an outstanding back stairway 'Galerie Escalier' (the servant's staircase), which has rotating exhibitions from June to December;" historic, commercial district; 1,300 sq. ft. 15% of space for special exhibitions; 85% of space for gallery artists. Clients include tourists, upscale, local community and students. 95% of sales are to private collectors, 5% corporate collectors. Overall price range: $20-5,000; most work sold at $100-300.

Media Considers all media suitable for display in a stairway setting for special exhibitions. No prints.

Style Exhibits folk art. "Style is unimportant; quality of work is deciding factor. We look for unusual, offbeat and eclectic."

Terms Accepts work on consignment (30% commission). Retail price set by the artist. Gallery provides insurance. Artist pays shipping costs and promotional costs of opening. Prefers framed artwork.

Submissions Send query letter with résumé, 10 slides, bio, photographs and business card. Call for appointment to show portfolio of photographs or slides. Responds within 2 weeks, only if interested. Finds artists through submissions, word of mouth, referrals by other artists, visiting art fairs and exhibitions.

Tips Artists who want gallery representation should "present themselves professionally; treat their art and the showing of it like a small business; arrive on time and be prepared; and meet deadlines promptly."

THE CANTON MUSEUM OF ART

1001 Market Ave. N., Canton OH 44702. (330)453-7666. Fax: (330)453-1034. E-mail: al@cantonart.org. Web site: www.cantonart.org. **Executive Director:** M. Joseph Albacete. Nonprofit gallery. Estab. 1935. Represents emerging, mid-career and established artists. "Although primarily dedicated to large-format touring and original exhibitions, the CMA occasionally sponsors solo shows by local and original artists, and one group show every 2 years featuring its own 'Artists League.' " Average display time: is 6 weeks. Overall price range: $50-3,000; few sales above $300-500.

Media Considers all media. Most frequently exhibits oil, watercolor and photography.

Style Considers all styles. Most frequently exhibits painterly abstraction, post-modernism and realism.

Terms "While every effort is made to publicize and promote works, we cannot guarantee sales, although from time to time sales are made, at which time a 25% charge is applied." One of the most common mistakes in presenting portfolios is "sending too many materials. Send only a few slides or photos, a brief bio and a SASE."

Tips There seems to be "a move back to realism, conservatism and support of regional artists."

N Ψ CAPITOL ARTS ALLIANCE GALLERIES

416 E. Main St., Bowling Green KY 42101-2241. (270)782-2787. E-mail: gallery@capitolarts.com. Web site: www.capitolarts.com. **Gallery Director:** Lynn Robertson. Nonprofit gallery. Approached by 30-40 artists/year. Represents 16-20 emerging, mid-career and established artists. Sponsors 10 exhibits/year. Average display time: 3-4 weeks. Open daily, 9-4. Closed Christmas-New Year's Day. Clients include local community and tourists.

Media Considers all media except crafts; all types of prints except posters.

Style Considers all styles.

Terms Artwork is accepted on consignment (20% commission). Retail price set by the artist.

Gallery provides promotion and contract. Accepted work should be framed. Accepts only artists within a 100-mile radius.

Submissions Contact Capitol Arts to be added to Call to Artists List. Finds artists through submissions and word of mouth.

CARNEGIE ARTS CENTER

P.O. Box 375, 204 W. Fourth St., Alliance NE 69301. Phone/Fax: (308)762-4571. E-mail: carnegieartscenter@bbc.net. Web site: www.carnegieartscenter.com. **Director:** Peggy Weber. Visual art gallery. Estab. 1993. Represents 300 emerging, mid-career and established artists/year. 350 members. Exhibited artists include Liz Enyeart (functional pottery) and Silas Kern (handblown glass). Sponsors 12 shows/year. Average display time: 6 weeks. Open all year; Tuesday-Saturday, 10-4; Sunday, 1-4. Located downtown; 2,346 sq. ft.; renovated Carnegie library built in 1911. Clients include tourists, upscale, local community and students. 90% of sales are to private collectors; 10% corporate collectors. Overall price range: $10-2,000; most work sold at $10-300.

Media Considers all media and all types of prints. Most frequently exhibits pottery, blown glass, 2D, acrylics, bronze sculpture, watercolor, oil and silver jewelry.

Style Exhibits all styles and genres. Most frequently exhibits realism, modern realism, geometric, abstraction.

Terms Accepts work on consignment (35% commission). Retail price set by the artist. Gallery provides promotion. Shipping costs negotiated. Prefers framed artwork.

Submissions Accepts only quality work. Send query. Write for appointment to show portfolio of photographs, slides or transparencies. Responds within 1 month, only if interested. Files résumé and contracts. Finds artists through submissions, word of mouth, referrals by other artists, visiting art fairs and exhibitions.

Tips "Presentations must be clean, 'new' quality—that is, ready to meet the public. Two-dimensional artwork must be nicely framed with wire attached for hanging. Unframed prints need protective wrapping in place."

JOAN CAWLEY GALLERY, LTD.

7135 E. Main St., Scottsdale AZ 85251. (602)947-3548. Fax: (602)947-7255. E-mail: karinc@jcgltd.com. Web site: www.jcgltd.com. **President:** Kevin P. Cawley. Director: Karin Cawley. Retail gallery and print publisher. Estab. 1974. Represents 20 emerging, mid-career and established artists/year. Exhibited artists include Carol Grigg, Adin Shade. Sponsors 5-10 shows/year. Average display time: 2-3 weeks. Open all year; Monday-Saturday, 10-5; Thursday, 7-9. Located in art district, center of Scottsdale; 2,730 sq. ft. (about 2,000 for exhibiting); high ceilings, glass frontage and interesting areas divided by walls. 50% of space for special exhibitions; 75% of space for gallery artists. Clientele: tourists, locals. 90% private collectors. Overall price range: $100-12,000; most work sold at $3,500-5,000.

 • Joan Cawley also runs an art licensing company: Joan Cawley Licensing, 1410 W. 14th St., Suite 101, Tempe AZ 85281. (800)835-0075.

Media Considers all media except fabric or cast paper; all graphics. Most frequently exhibits acrylic on canvas, watercolor, pastels and chine colle.

Style Exhibits expressionism, painterly abstraction, impressionism. Exhibits all genres. Prefers Southwestern and contemporary landscapes, figurative, wildlife.

Terms Accepts work on consignment (50% commission.) Gallery provides promotion and contract; shipping costs are shared. Prefers artwork framed.

Submissions Prefers artists from west of Mississippi. Send query letter with bio and at least 12 slides or photos. Call or write for appointment to show portfolio of photographs, slides or transparencies. Responds as soon as possible.

Tips "We are a contemporary gallery in the midst of traditional Western galleries. We are inter-

ested in seeing new work always." Advises artists approaching galleries to "check out the direction the gallery is going regarding subject matter and media. Also always make an appointment to meet with the gallery personnel. We always ask for a minimum of five to six paintings on hand. If the artist sells for the gallery, we want more, but a beginning is about six paintings."

CEDARHURST CENTER FOR THE ARTS

Richview Road, Mt. Vernon IL 62864. (618)242-1236. Fax: (618)242-9530. E-mail: mitchellmuseu m@cedarhurst.org. Web site: www.cedarhurst.org. **Director of Visual Arts:** Kevin Sharp. Museum. Estab. 1973. Exhibits emerging, mid-career and established artists. Average display time: 6 weeks. Open all year; Tuesday through Saturday, 10-5; Sunday, 1-5; closed Mondays and federal holidays.

Submissions Call or send query letter with artist's statement, bio, résumé, SASE and slides.

[N] [T] CENTRAL BANK GALLERY

P.O. Box 1360, Lexington KY 40588. Fax: (606)253-6432. **Curator:** John G. Irvin. Estab. 1987. Sponsors 12 exhibits/year. Average display time: 3 weeks. Overall price range: $75-1,500.

- • Considers Kentucky artists only.

Media Considers all media. Most frequently exhibits oils, watercolor, sculpture.

Style Exhibits all styles. "Please, no nudes."

Terms Retail price set by the artist; "100% of proceeds go to artist." Gallery provides insurance and promotion; artist pays for shipping.

Submissions Call or write for appointment.

Tips "Don't be shy; call us. We enjoy encouraging artists."

CENTRAL MICHIGAN UNIVERSITY ART GALLERY

Wightman 132, Art Department, Mt. Pleasant MI 48859. (989)774-3800. Fax: (989)774-2278. E-mail: julia.morrisroe@cmich.edu. Web site: www.uag.cmich.edu. **Director:** Julia Morrisroe. Nonprofit gallery. Estab. 1970. Approached by 250 artists/year. Represents 40 emerging, mid-career and established artists. Exhibited artists include Ken Fandell, Jan Estep, Sang-Ah-Choi, Amy Yoes, Scott Anderson, Richard Shaw. Sponsors 7 exhibits/year. Average display time: 1 month. Open all year; Monday, Tuesday, Thursday and Friday, 10-5; Wednesday, 12-8; Saturday, 12-5. Clients include local community, students and tourists. Overall price range: $200-5,000.

Media Considers all media and all types of prints. Most frequently exhibits sculpture, painting and photography.

Style Considers all styles.

Terms Buyers are referred to the artist. Gallery provides insurance, promotion and contract. Accepted work should be framed. Does not require exclusive representation locally.

Submissions Write to arrange a personal interview to show portfolio of slides. Mail portfolio for review. Send query letter with artist's statement, bio, résumé, reviews, SASE and slides. Returns material with SASE. Responds within 2 months, only if interested. Files resume, reviews, photocopies and brochure. Finds artists through word of mouth, submissions, portfolio reviews, art exhibits, and referrals by other artists.

[N] THE CHAIT GALLERIES DOWNTOWN

218 E. Washington St., Iowa City IA 52240. (319)338-4442. Fax: (319)338-3380. E-mail: info@theg alleriesdowntown.com. Web site: www.thegalleriesdowntown.com. **Director:** Benjamin Chait. For-profit gallery. Estab. 2003. Approached by 300 artists/year. Represents 50 emerging, mid-career and established artists. Exhibited artists include Doug Russell (mixed media), Corrine Smith (painting), Gretchen Caracas-Rogovin (painting), Justine Zimmer (sculpture) and Syed Ahmad (dichroic glass). Sponsors 12 exhibits/year. Average display time: 90 days. Open all year;

Monday-Friday, 11-6; Saturday, 11-5; Sunday by chance or appointment. Located in a downtown building restored to its original look (circa 1882), with 14-ft. molded ceiling and original 9-ft. front door. Professional museum lighting and scamozzi-capped columns complete the elegant gallery. Clients include local community, students, tourists, upscale. Overall price range: $50-10,000; most work sold at $500-1,000.

Media/Style Considers all media, all types of prints, all styles and all genres. Most frequently exhibits painting, sculpture and ceramic.

Terms Artwork is accepted on consignment, and there is a 50% commission. Retail price set by the gallery and the artist. Gallery provides insurance, promotion and contract. Accepted work should be framed. Requires exclusive representation locally.

Submissions Call; mail portfolio for review. Returns material with SASE. Responds to queries in 2 weeks. Finds artists through art fairs, exhibits, portfolio reviews and referrals by other artists.

CHAPELLIER FINE ART

128 Cabernet Dr., Chapel Hill NC 27516. (919)656-5258. E-mail: chapellier@earthlink.net. Web site: www.chapellier.com. **Director:** Shirley C. Lally. Retail gallery. Estab. 1916. Represents 3 established artists/year. Exhibited artists include Mary Louise Boehm, Elsie Dinsmore Popkin. Sponsors 3-4 shows/year. Average display time: 6-8 weeks. Open all year; Monday-Saturday by appointment. 1,000 sq. ft. 75% of space for special exhibitions; 25% of space for gallery artists. Clientele: upscale. 90% private collectors, 10% corporate collectors. Overall price range: $500-90,000; most work sold at $3,000-10,000.

Media Considers oil, acrylic, watercolor, pastel, pen & ink, drawing, mixed media, paper, sculpture (limited to small pieces) and all types of prints. Most frequently exhibits oil, watercolor, pastel.

Style Exhibits impressionism and realism. Exhibits all genres. Prefers realism and impressionism. Inventory is primarily 19th and early 20th century American art.

Terms Accepts work on consignment (50% commission). Retail price set by the gallery. Gallery provides insurance, promotion and contract; shipping costs are shared. Prefers artwork framed.

Submissions Accepts only artists from America. Send query letter with résumé, slides, bio or photographs, price list and description of works offered, exhibition record. Write for appointment to show portfolio of photographs, transparencies or slides. Responds in 1 month. Files material only if interested. Finds artists through word of mouth, visiting art fairs and exhibitions.

Tips ''Gallery owner and artist must be compatible and agree on terms of representation.''

N. CHAPMAN FRIEDMAN GALLERY

624 W. Main St., Louisville KY 40202. E-mail: friedman@imagesol.com. Web site: www.chapman friedmangallery.com;www.imagesol.com. **Owner:** Julius Friedman. For-profit gallery. Estab. 1992. Approached by 100 or more artists/year. Represents or exhibits 25 artists. Sponsors 7 exhibits/year. Average display time: 1 month. Open Wednesday-Saturday, 10-5. Closed during August. Located downtown; approximately 3,500 sq. ft. with 15-ft. ceilings and white walls. Clients include local community and tourists. 5% of sales are to corporate collectors. Overall price range: $75-10,000; most work sold at more than $1,000.

Media Considers all media except craft. Types of prints include engravings, etchings, lithographs, posters, serigraphs and woodcuts. Most frequently exhibits painting, ceramics and photography.

Style Exhibits color field, geometric abstraction, primitivism realism, painterly abstraction. Most frequently exhibits abstract, primitive and color field.

Terms Artwork is accepted on consignment (50% commission). Retail price set by the artist. Gallery provides insurance, promotion and contract. Accepted work should be framed. Requires exclusive representation locally.

Submissions Send query letter with artist's statement, bio, brochure, photographs, résumé, slides

and SASE. Returns material with SASE. Responds to queries in 1 month. Finds artists through portfolio reviews and referrals by other artists.

CINCINNATI ART MUSEUM

953 Eden Park Dr., Cincinnati OH 45202. (513)639-2995. Fax: (513)639-2888. E-mail: information @cincyart.org. Web site: www.cincinnatiartmuseum.org. **Deputy Director:** Anita J. Ellis. Estab. 1881. Exhibits 6-10 emerging, mid-career and established artists/year. Sponsors 20 exhibits/year. Average display time: 3 months. Open all year; Tuesday-Sunday, 11-5 (Wednesday open until 9). Closed Mondays, Thanksgiving, Christmas, New Year's Day and Fourth of July. General art museum with a collection spanning 6,000 years of world art. Over 100,000 objects in the collection with exhibitions on view annually. Clients include local community, students, tourists and up-scale.

Media Considers all media and all types of prints. Most frequently exhibits paper, mixed media and oil.

Style Considers all styles and genres.

Submissions Send query letter with artist's statement, photographs, reviews, SASE and slides.

CLAMPART

531 W. 25th Street, New York NY 10001. E-mail: info@clampart.com. Web site: www.clampart.c om. **Director:** Brian Paul Clamp. For-profit gallery. Estab. 2000. Approached by 1200 artists/year. Represents 15 emerging, mid-career and established artists. Exhibited artists include Arthur Tress (photography), and John Dugdale (photography). Sponsors 6-8 exhibits/year. Average display time: 5 weeks. Open Tuesday-Saturday from 11 to 6; closed last two weeks of August. Located on the ground floor on Main Street in Chelsea. Small exhibition space. Clients include local community, tourists and upscale. 5% of sales are to corporate collectors. Overall price range: $300-50,000; most work sold at $2,000.

Media Considers acrylic, collage, drawing, mixed media, oil, paper, pastel, pen & ink and water-color. Considers all types of prints. Most frequently exhibits photo, oil and paper.

Style Exhibits conceptualism, geometric abstraction, minimalism and postmodernism. Considers genres including figurative work, florals, landscapes and portraits. Most frequently exhibits post-modernism, conceptualism and minimalism.

Terms Artwork is accepted on consignment, and there is a 50% commission. Retail price set by the gallery. Gallery provides insurance, promotion and contract. Accepted work should be framed, mounted and matted. Does not require exclusive representation locally.

Submissions E-mail query letter with artist's statement, bio and JPEGs. Cannot return material. Responds to queries in 2 weeks. Finds artists through portfolio reviews, referrals by other artists and submissions.

Tips "Include a bio and well-written artist statement. Do not submit work to a gallery that does not handle the general kind of work you produce."

⊠ CLAY CENTER'S AVAMPATO DISCOVERY MUSEUM

One Clay Square, 300 Leon Sullivan Way, Charleston WV 25301. (304)561-3570. Fax: (304)561-3598. E-mail: info@theclaycenter.org. Web site: www.theclaycenter.org. **Curator:** Ric Ambrose. Museum gallery. Estab. 1974. Represents emerging, mid-career and established artists. Sponsors 6 shows/year. Average display time: 2-3 months. Open all year; contact for hours. Located inside the Clay Center for the Arts & Sciences—West Virginia.

Media Considers oil, acrylic, watercolor, pastel, pen & ink, drawings, mixed media, collage, works on paper, sculpture, installations, photography and prints.

Style Considers all styles and genres.

Terms Retail price set by artist. Gallery pays shipping costs. Prefers framed artwork.

Submissions Send query letter with bio, résumé, brochure, slides, photographs, reviews and SASE. Write for appointment to show portfolio of slides. Responds within 2 weeks, only if interested. Files everything or returns in SASE.

THE CLAY PLACE

1 Walnut St., Suite #2, Carnegie PA 15106. (412)682-3737. Fax: (412)682-3239. E-mail: clayplace1 @aol.com. Web site: www.clayplace.com. **Director:** Elvira Peake. Retail gallery. Estab. 1973. Represents 50 emerging, mid-career and established artists. Exhibited artists include Jack Troy and Kirk Mangus. Sponsors 7 shows/year. Open all year. Located in small shopping area; "second level of modern building with atrium." 1,200 sq. ft. 50% of space for special exhibitions. Overall price range: $10-2,000; most work sold at $40-100.
Media Considers ceramic, sculpture, glass and pottery. Most frequently exhibits clay, glass and enamel.
Terms Accepts artwork on consignment (50% commission) or buys outright for 50% of retail price (net 30 days). Retail price set by artist. Sometimes offers customer discounts and payment by installments. Gallery provides insurance, promotion and shipping costs from gallery.
Submissions Prefers only clay, some glass and enamel. Send query letter with résumé, slides, photographs, bio and SASE. Write for appointment to show portfolio. Portfolio should include actual work rather than slides. Responds in 1 month. Does not reply when busy. Files résumé. Does not return slides. Finds artists through visiting exhibitions and art collectors' referrals.
Tips "Functional pottery sells well. Emphasis on form, surface decoration. Some clay artists have lowered quality in order to lower prices. Clientele look for quality, not price."

🏺 COAST GALLERIES

P.O. Box 223519, Carmel CA 93922. (831)625-8688. Fax: (831)625-8699. E-mail: gary@coastgalleries.com. Web site: www.coastgalleries.com. **Owner:** Gary Koeppel. Retail galleries. Estab. 1958. Represents 300 emerging, mid-career and established artists. Sponsors 3-4 shows/year. Open daily, all year. Locations in Big Sur, Carmel and Pebble Beach, California; Hana, Hawaii (Maui). "No two Coast Galleries are alike. Each gallery was designed specifically for its location and clientele. The Hawaii gallery features Hawaiiana; our Big Sur gallery is constructed of redwood water tanks and features Central California Coast artists and imagery." Square footage of each location varies from 1,500 to 3,000 sq. ft. 100% of space for special exhibitions. Clientele: 90% private collectors, 10% corporate collectors. Overall price range: $25-60,000; most work sold at $400-4,000.
Media Considers all media; engravings, lithographs, posters, etchings, wood engravings and serigraphs. Most frequently exhibits bronze sculpture, limited edition prints, watercolor and oil on canvas.
Style Exhibits impressionism and realism. Genres include landscape, marine and wildlife.
Terms Accepts fine art and master crafts on consignment (commission varies), or buys master crafts outright (net 30 days). Retail price set by gallery. Gallery provides insurance, promotion and contract; artist pays for shipping. Requires framed artwork.
Submissions Accepts only artists from Hawaii for Hana gallery; coastal and wildlife imagery for California galleries; California painting and American crafts for Carmel gallery; Central California Coast imagery for Pebble Beach gallery. Send query letter with résumé, slides, bio, brochure, photographs, business card and reviews; SASE mandatory if materials are to be returned. Write for appointment to show portfolio of photographs, slides and transparencies. Responds in 2 weeks.

COLEMAN FINE ART

79 Church St., Charleston SC 29401. (843)853-7000. Fax: (843)722-2552. E-mail: info@colemanfineart.com. Web site: www.colemanfineart.com. **Gallery Director:** Katherine Wright. Retail gal-

lery; gilding, frame making and restoration. Estab. 1974. Represents 8 emerging, mid-career and established artists/year. Exhibited artists include John Cosby, Marc Hanson, Glenna Hartmann, Joe Paquet, Jan Pawlowski, Don Stone, George Strickland, Mary Whyte. Hosts 2 shows/year. Average display time: 1 month. Open all year; Monday, 10-4; Tuesday-Saturday, 10-6, and by appointment. "Both a fine art gallery and restoration studio, Coleman Fine Art has been representing regional and national artists for over 30 years. Located on the corner of Church and Tradd streets, the gallery reinvigorates one of the country's oldest art studios." Clientele: tourists, upscale and locals. 95-98% private collectors, 2-5% corporate collectors. Overall price range: $1,000-50,000; most work sold at $3,000-8,000.

Media Considers oil, watercolor, pastel, pen & ink, drawing, mixed media, sculpture. Most frequently exhibits watercolor, oil and sculpture.

Style Exhibits expressionism, impressionism, photorealism and realism. Genres include portraits, landscapes, still lifes and figurative work. Prefers figurative work/expressionism, realism and impressionism.

Terms Accepts work on consignment (45% commission); net 30 days. Retail price set by the gallery and the artist. Gallery provides promotion and contract. Shipping costs are shared. Prefers artwork framed.

Submissions Send query letter with brochure, 20 slides/digital CD of most recent work, reviews, bio and SASE. Write for appointment to show portfolio of photographs, slides and transparencies. Responds within 1 month, only if interested. Files slides. Finds artists through submissions.

Tips "Do not approach gallery without an appointment."

THE COLONIAL ART GALLERY & CO.

1336 NW First St., Oklahoma City OK 73106. (405)232-5233. Fax: (405)232-6607. E-mail: info@colonialart.com. Web site: www.colonialart.com. **Owner:** Willard Johnson. Estab. 1919.

- See listing in the Posters & Prints section.

ⓝ ⓘ CONTEMPORARY ART WORKSHOP

542 W. Grant Place, Chicago IL 60614. (773)472-4004. Fax: (773)472-4505. E-mail: info@contemporaryartworkshop.org. Web site: www.contemporaryartworkshop.org. **Director:** Lynn Kearney. Nonprofit gallery. Estab. 1949. Average display time: 1 month. Gallery open Tuesday-Friday, 12:30-5:30; Saturday, 12-5. Closed holidays. "The CAW is located in Chicago's Lincoln Park neighborhood. It is housed in a converted dairy that was built in the 1800s." Includes over 21 artists' studios as well as 2 galleries that show (exclusively) emerging Chicago-area artists.

Media Considers oil, acrylic, mixed media, works on paper, sculpture, installations and original handpulled prints. Most frequently exhibits paintings, sculpture, works on paper and fine art furniture.

Style "Any high-quality work" is considered.

Terms Accepts work on consignment (30% commission). Retail price set by gallery or artist. Gallery provides insurance and promotion. Accepts artists from Chicago area only.

Submissions Send query letter with artist's statement, bio, résumé, reviews, samples (slides, photos or JPEGs on CD), SASE. Responds in 2 months. Finds artists through word of mouth, submissions, art exhibits, referrals by other artists.

CONTEMPORARY ARTS COLLECTIVE

231 W. Charleston Blvd., Suite 110, Las Vegas NV 89102. (702)382-3886. Fax: (702)598-3886. E-mail: info@lasvegascac.org. Web site: www.lasvegascac.org. **Contact:** Natalia Ortiz. Nonprofit gallery. Estab. 1989. Sponsors more than 9 exhibits/year. Average display time: 1 month. Gallery open Tuesday-Saturday, 12-4. Closed Thanksgiving, Christmas, New Year's Day. 1,200 sq. ft. Clients include tourists, local community and students. 75% of sales are to private collectors,

25% corporate collectors. Overall price range: $200-4,000; most work sold at $400.

Media Considers all media and all types of prints. Most frequently exhibits painting, photography and mixed media.

Style Exhibits conceptualism, group shows of contemporary fine art. Genres include all contemporary art/all media.

Terms Artwork is accepted through annual call for proposals of self-curated group shows; there is a 30% requested donation. Gallery provides insurance, promotion, contract.

COOS ART MUSEUM

235 Anderson Ave., Coos Bay OR 97420. (541)267-3901. E-mail: info@coosart.org. Web site: www.coosart.org. Not-for-profit corporation; 3rd-oldest art museum in Oregon. Estab. 1950. Mounts 4 juried group exhibitions/year of 85-150 artists; 20 curated single/solo exhibits/year of established artists; and 6 exhibits/year from the Permanent Collection. 5 galleries allow for multiple exhibits mounted simultaneously, averaging 6 openings/year. Average display time: 6-9 weeks. Open Tuesday-Friday, 10-4; Saturday, 1-4. Closed Sunday, Monday and all major holidays. Free admission during evening of 2nd Thursday (Art Walk), 5-8. Clients include local community, students, tourists and upscale.

Media For curated exhibition, considers all media including print, engraving, litho, serigraph. Posters and giclées not considered. Most frequently exhibits paintings (oil, acrylic, watercolor, pastel), sculpture (glass, metal, ceramic), drawings, etchings and prints.

Style Considers all styles and genres. Most frequently exhibits primitivism, realism, postmodernism and expressionism.

Terms No gallery floor sales. All inquiries are referred directly to the artist. Retail price set by the artist. Museum provides insurance, promotion and contract. Accepted work should be framed, mounted and matted. Accepts only artists from Oregon or Western United States.

Submissions Send query letter with artist's statement, bio, résumé, SASE, slides or digital files on CD or links to Web address. Responds to queries in 6 months. Never send 'only copies' of slides, résumés or portfolios. Exhibition committee reviews 2 times/year—schedule exhibits 2 years in advance. Files proposals. Finds artists through portfolio reviews and submissions.

Tips "Have complete files electronically on a Web site or CD. Have a written positioning statement and proposal of show as well as letter(s) of recommendation from a producer/curator/gallery of a previous curated exhibit. Do not expect us to produce or create exhibition. You should have all costs figured ahead of time and submit only when you have work completed and ready. We do not develop artists. You must be professional."

CORBETT GALLERY

Box 339, 459 Electric Ave. B, Bigfork MT 59911. (406)837-2400. E-mail: corbett@digisys.net. Web site: www.corbettgallery.com. **Director:** Jean Moore. Retail gallery. Estab. 1993. Represents 20 mid-career and established artists. Exhibited artists include Cynthia Fisher. Sponsors 2 shows/year. Average display time: 3 weeks. Open all year; Sunday-Friday, 10-7 summer, 10-5 winter. Located downtown; 2,800 sq. ft. Clients include tourists and upscale. 90% of sales are to private collectors. Overall price range: $250-10,000; most work sold at $2,400.

Media Considers all media; types of prints include engravings, lithographs, serigraphs and etchings. Most frequently exhibits oil, watercolor, acrylic and pastels.

Style Exhibits photorealism. Genres include western, wildlife, southwestern and landscapes. Prefers wildlife, landscape and western.

Terms Accepts work on consignment (40% commission). Retail price set by the artist. Gallery provides insurance, promotion and contract. Shipping costs are shared. Prefers artwork framed.

Submissions Send query letter with slides, brochure and SASE. Call for appointment to show

portfolio of photographs or slides. Responds in 1 week. Files brochures and bios. Finds artists through art exhibitions and referrals.

Tips "Don't show us only the best work, then send mediocre paintings that do not equal the same standard."

CORPORATE ART SOURCE

2960-F Zelda Rd., Montgomery AL 36106. (334)271-3772. E-mail: casjb@mindspring.com. Web site: casgallery.com. For-profit gallery, art consultancy. Estab. 1985. Exhibits mid-career and established artists. Approached by 40 artists/year; exhibits 50 artists/year. Exhibited artists include George Taylor and Lawrence Mathis. Open Monday-Friday, 10-5:30; closed weekends. Located in an upscale shopping center; small gallery walls, but walls are filled; 50-85 pieces on display. Clients include corporate clients. Overall price range: $200-40,000; most work sold at $1,000.

Media Considers all media and all types of prints. Most frequently exhibits paintings, glass and watercolor.

Style Considers all styles and genres. Most frequently exhibits painterly abstraction, impressionism and realism.

Terms Artwork is accepted on consignment (50% commission). Retail price set by artist.

Submissions Call, e-mail, or write to arrange a personal interview to show portfolio of photographs, slides, transparencies or CD, résumé and reviews. Returns material with SASE.

Tips "Have good photos of work, as well as Web sites with enough work to get a feel for the overall depth and quality."

CUESTA COLLEGE ART GALLERY

P.O. Box 8106, San Luis Obispo CA 93403-8106. (805)546-3202. Fax: (805)546-3904. E-mail: tanderso@cuesta.edu. Web site: academic.cuesta.cc.ca.us/finearts/gallery.htm. **Director:** Tim Anderson. Nonprofit gallery. Estab. 1965. Exhibits the work of emerging, mid-career and established artists. Exhibited artists include Italo Scanga and JoAnn Callis. Sponsors 8 shows/year. Average display time: 4½ weeks. Open all year. Space is 1,300 sq. ft.; 100% of space for special exhibitions. Overall price range: $250-5,000; most work sold at $400-1,200.

Media Considers all media and all types of prints. Most frequently exhibits painting, sculpture and photography.

Style Exhibits all styles, mostly contemporary.

Terms Accepts work on consignment (20% commission). Retail price set by artist. Customer payment by installment available. Gallery provides insurance, promotion and contract; shipping costs are shared. Prefers artwork framed.

Submissions Send query letter with artist statement, slides, bio, brochure, SASE and reviews. Call for appointment to show portfolio. Responds in 6 months. Finds artists mostly by reputation and referrals, sometimes through slides.

Tips "We have a medium budget, thus cannot pay for extensive installations or shipping. Present your work legibly and simply. Include reviews and/or a coherent statement about the work. Don't be too slick or too sloppy."

N ☑ DALES GALLERY

537 Fisgard St., Victoria BC V8W 1R3 Canada. Fax: (250)383-1552. E-mail: dalesgallery@shaw.ca. Web site: www.dalesgallery.ca. **Contact:** Alison Trembath. Museum, retail shop. Estab. 1976. Approached by 6 artists/year; represents 40 emerging, mid-career and established artists/year. Exhibited artists include Grant Fuller and Graham Clarke. Sponsors 2-3 exhibits/year. Average display time: 2 weeks. Open all year; Monday-Saturday, 10-5:30; Sunday, 12-4. Gallery situated in Chinatown (Old Town); approximately 650 sq. ft. of space—one side brick wall. Clients include

local community, students, tourists and upscale. Overall price range: $100-4,600; most work sold at $350.

Media Considers most media except photography. Most frequently exhibits oils, etching and watercolor. Considers all types of prints.

Style Exhibits expressionism, impressionism, postmodernism, primitivism, realism and surrealism. Most frequently exhibits impressionism, realism and expressionism. Genres include figurative, florals, landscapes, humorous whimsical.

Terms Accepts work on consignment (40% commission) or buys outright for 50% of retail price (net 30 days). Retail price set by both gallery and artist. Gallery provides promotion. Accepted work should be framed by professional picture framers. Does not require exclusive representation locally.

Submissions Call to arrange a personal interview to show portfolio of photographs or slides or send query letter with photographs. Portfolio should include résumé, reviews, contact number and prices. Responds within 2 months, only if interested. Finds artists through word of mouth, art exhibits, submissions, art fairs, portfolio reviews and referral by other artists.

N THE DALLAS CENTER FOR CONTEMPORARY ART

2801 Swiss Ave., Dallas TX 75204. (214)821-2522. Fax: (214)821-9103. E-mail: info@thecontemporary.net. Web site: www.thecontemporary.net. **Director:** Joan Davidow. Nonprofit gallery. Estab. 1981. Sponsors 10 exhibits/year. Average display time: 6-8 weeks. Gallery open Tuesday-Saturday, 10-5.

Media Considers all media.

Style Exhibits all styles and genres.

Terms Charges no commission. "Because we are nonprofit, we do not sell artwork. If someone is interested in buying art in the gallery, they get in touch with the artist. The transaction is between the artist and the buyer."

Submissions Reviews slides/CDs. Send material by mail for consideration; include SASE. Responds October 1 annually.

Tips "We offer a lot of information on grants, commissions and exhibitions available to Texas artists. We are gaining members as a result of our in-house resource center and non-lending library. Our Business of Art seminar series provides information on marketing artwork, presentation, museum collection, tax/legal issues and other related business issues. Memberships available starting at $50. See our Web site for info and membership levels."

DALLAS MUSEUM OF ART

1717 N. Harwood St., Dallas TX 75201. (214)922-1200. Fax: (214)922-1350. Web site: www.dallasmuseumofart.org. Museum. Estab. 1903. Exhibits emerging, mid-career and established artists. Average display time: 3 months. Open Tuesday-Sunday, 11-5; open until 9 on Thursday. Closed Monday, Thanksgiving, Christmas and New Year's Day. Clients include local community, students, tourists and upscale.

Media Exhibits all media and all types of prints.

Style Exhibits all styles and genres.

Submissions Does not accept unsolicited submissions.

MARY H. DANA WOMEN ARTISTS SERIES

Douglass Library, Rutgers, 8 Chapel Dr., New Brunswick NJ 08901. E-mail: olin@rci.rutgers.edu. Web site: www.libraries.rutgers.edu/rul/exhibits/dana_womens.shtml. **Curator:** Dr. Ferris Olin. Alternative space for juried exhibitions of works by women artists. Estab. 1971. Sponsors 4 shows/year. Average display time: 5-6 weeks. Located on college campus in urban area. Clients include students, faculty and community.

© Lori McElrath-Eslick

Lori McElrath-Eslick painted "Van Gogh's Dog," a canine tribute to Vincent van Gogh, for a compilation book edited by Michael J. Rosen called *21st Century Dog, A Visionary Compendium* (Stewart, Tabori & Chang). After the book's publication, Rosen arranged for the original dog portraits to be available for sale at the Dallas Museum of Art gift shop. "When the museum was to host an exhibition of original Van Gogh art, the curator had the idea to print this illustration as a poster," says McElrath-Eslick. She later created promo postcards using the image and has gotten a good response from her mailing list.

Media Considers all media.

Style Exhibits all styles and genres.

Terms Retail price by the artist. Gallery provides insurance and promotion; arranges transportation.

Submissions Does not accept unsolicited submissions. Write or e-mail with request to be added to mailing list.

HAL DAVID FINE ART

P.O. Box 411213, St. Louis MO 63141. (314)409-7884. E-mail: mscharf@sbcglobal.net. Web site: www.maxrscharf.com. **Director:** Max Scharf. For-profit gallery. Estab. 1991. Exhibits established artists. Approached by 30 artists/year; represents 3 artists/year. Exhibited artists include Max R. Scharf (acrylic on canvas) and Sandy Kaplan (terra cotta sculpture). Sponsors 3 exhibits/year. Average display time: 2 months. Open all year. Clients include upscale. 30% sales are to corporate collectors. Overall price range: $2,000-30,000; most work sold at $10,000.

Style Exhibits expressionism, impressionism, painterly abstraction. Most frequently exhibits impressionism and expressionism.

Terms Artwork is accepted on consignment, and there is a 50% commission. Retail price set by the artist. Accepted work should be framed. Does not require exclusive representation locally.

Submissions Returns material with SASE. Responds to queries in 3 weeks. Finds artists through referrals by other artists.

Tips "Have a good Web site to look at."

DELAWARE CENTER FOR THE CONTEMPORARY ARTS

200 S. Madison St., Wilmington DE 19801. (302)656-6466. Fax: (302)656-6944. E-mail: info@thed cca.org. Web site: www.thedcca.org. **Executive Director:** Neil Watson. Alternative space, non-profit gallery, museum retail shop. Estab. 1979. Approached by more than 800 artists/year; exhibits 50 artists. Sponsors 30 exhibits/year. Average display time: 6 weeks. Open Tuesday, Thursday and Friday, 10-6; Wednesday, 12-5; Saturday, 10-5; Sunday, 12-5. Closed major holidays. Seven galleries located along rejuvenated Wilmington riverfront; very versatile. Overall price range: $500-50,000.

Media Considers all media, including contemporary crafts.

Style Exhibits contemporary, abstract, figurative, conceptual, representational and nonrepresentational, painting, sculpture, installation and contemporary crafts.

Terms Accepts work on consignment (35% commission). Retail price is set by the gallery and the artist. Gallery provides insurance and promotion; shipping costs are shared. Prefers contemporary art.

Submissions Send query letter with artist's statement, bio, SASE, 10 slides. Returns material with SASE. Responds within 6 months. Finds artists through word of mouth, submissions, portfolio reviews, art exhibits, referrals by other artists.

DOLPHIN GALLERIES

230 Hana Highway, Suite 12, Kahalui HI 96732. (800)669-5051, ext. 207. Fax: (808)873-0820. E-mail: ChristianAdams@DolphinGalleries.com. Web site: www.dolphingalleries.com. **Director of Sales:** Christian Adams. For-profit galleries. Estab. 1976. Exhibits emerging, mid-career and established artists. Exhibited artists include Alexandra Nechita, Pino and Thomas Pradzynski. Sponsors numerous exhibitions/year, "running at all times through 9 separate fine art or fine jewelry galleries." Average display time: "varies from one-night events to a 30-day run." Open 7 days/week, 9 a.m. to 10 p.m. Located in upscale, high-traffic tourist locations throughout Hawaii. On Oahu, Dolphin has galleries at the Hilton Hawaiian Village. On Big Island they have galleries located at the Kings Shops at Waikoloa. Clients include local community and upscale tourists. Overall price range: $100-100,000; most work sold at $1,000-5,000.

• The above address is for Dolphin Galleries' corporate offices. Dolphin Galleries has 9 locations throughout the Hawaiian islands.

Media Considers all media. Most frequently exhibits oil and acrylic paintings and limited edition works of art. Considers all types of prints.

Style Most frequently exhibits impressionism, figurative and abstract art. Considers American landscapes, portraits and florals.

Terms Artwork is accepted on consignment with negotiated commission, promotion and contract. Retail price set by the gallery. Gallery provides insurance, promotion and contract. Accepted work should be framed, mounted and matted. Requires exclusive representation locally.

Submissions E-mail submissions to ChristianAdams@DolphinGalleries.com. Finds artists mainly through referrals by other artists, art exhibits, submissions, portfolio reviews and word of mouth.

THE DONOVAN GALLERY

3895 Main Rd., Tiverton Four Corners RI 02878. (401)624-4000. E-mail: kd@donovangallery.com. Web site: www.donovangallery.com. **Owner:** Kris Donovan. Retail gallery. Estab. 1993. Represents 50 emerging, mid-career and established artists/year. Average display time: 1 month. Open all year; Monday-Saturday, 10-5; Sunday, 12-5; shorter winter hours. Located in a rural shopping area; 1750s historical home; 2,000 sq. ft. 100% of space for gallery artists. Clientele: tourists, upscale, local community and students. 90% private collectors, 10% corporate collectors. Overall price range: $100-6,500; most work sold at $250-800.

Media Considers oil, acrylic, watercolor, pastel, mixed media, collage, paper, ceramics, some craft, fiber and glass; and limited edition prints. Most frequently exhibits watercolors, oils and pastels.

Style Exhibits conceptualism, impressionism, photorealism and realism. Exhibits all genres. Prefers realism, impressionism and representational.

Terms Accepts work on consignment (45% commission). Retail price set by the artist. Gallery provides limited insurance, promotion and contract; artist pays for shipping. Prefers artwork framed.

Submissions Accepts only artists from New England. Send query letter with résumé, 6 slides, bio, brochure, photographs, SASE, business card, reviews and artist's statement. Call or write for appointment to show portfolio of photographs or slides or transparencies. Responds in 1 week. Files material for possible future exhibition. Finds artists through networking and submissions.

Tips "Do not appear without an appointment. Be professional, make appointments by telephone, be prepared with résumé, slides and (in my case) some originals to show. Don't give up. Join local art associations and take advantage of show opportunities there."

DOT FIFTYONE GALLERY

51 NW 36 St., Miami FL 33127. Phone/fax: (305)573-3754. E-mail: dot@dotfiftyone.com. Web site: www.dotfiftyone.com. **Directors:** Isaac Perelman and Alfredo Guzman. For-profit gallery. Estab. 2004. Approached by 40+ artists/year. Represents or exhibits 10 artists. Sponsors 9 exhibits/year. Average display time: 40 days. Open Monday-Friday, 12-7; Saturdays and private viewings available by appointment. Located in the Wynwood Art District; approximately 7,000 sq. ft.; 2 floors. Overall price range: $600-30,000; most work sold at $6,000.

Media Considers all media, serigraphs and woodcuts; most frequently exhibits acrylic, installation, mixed media and oil.

Style Exhibits color field, conceptualism, expression, geometric abstraction, minimalism. Exhibits all genres including figurative work.

Terms Artwork is accepted on consignment (50% commission). Retail price set by the gallery and the artist. Gallery provides promotion and contract. Requires exclusive representation locally.

Submissions E-mail link to Web site. Write to arrange a personal interview to show portfolio.

Mail portfolio for review. Finds artists through art fairs, portfolio reviews, referrals by other artists.

Tips "Have a good presentation. Contact the gallery first by e-mail. Never try to show work during an opening, and never show up at the gallery without an appointment."

DURHAM ART GUILD

120 Morris St., Durham NC 27701-3242. (919)560-2713. E-mail: artguild1@yahoo.com. Web site: www.durhamartguild.org. **Gallery Director:** Lisa Morton. Gallery Assistant: Diane Amato. Non-profit gallery. Estab. 1948. Represents/exhibits 500 emerging, mid-career and established artists/year. Sponsors more than 20 shows/year, including an annual juried art exhibit. Average display time: 6 weeks. Open all year; Monday-Saturday, 9-9; Sunday, 1-6. Free and open to the public. Located in center of downtown Durham in the Arts Council Building; 3,600 sq. ft.; large, open, movable walls. 100% of space for special exhibitions. Clientele: general public; 80% private collectors, 20% corporate collectors. Overall price range: $100-14,000; most work sold at $200-1,200.

Media Considers all media. Most frequently exhibits painting, sculpture and photography.

Style Exhibits all styles, all genres.

Terms Artwork is accepted on consignment (30-40% commission). Retail price set by the artist. Gallery provides insurance and promotion. Artist installs show. Prefers artwork framed.

Submissions Artists must be 18 years or older. Send query letter with résumé, slides and SASE. "We accept slides for review by February 1 for consideration of a solo exhibit or special projects group show." Finds artists through word of mouth, referral by other artists, call for slides.

Tips "Before submitting slides for consideration, be familiar with the exhibition space to make sure it can accommodate any special needs your work may require."

N PAUL EDELSTEIN GALLERY

P.O. Box 80012, Memphis TN 38108. (901)454-7105. E-mail: henrygrove@yahoo.com. Web site: www.pauledelstein.com. **Director/Owner:** Paul R. Edelstein. Estab. 1985. "Shows are presented continually throughout the year." Overall price range: $300-10,000; most work sold at $1,000.

Media Considers all media and all types of prints. Most frequently exhibits oil, watercolor and prints.

Style Exhibits hard-edge geometric abstraction, color field, painterly abstraction, minimalism, postmodern works, feminist/political works, primitivism, photorealism, expressionism and neo-expressionism. Genres include florals, landscapes, Americana and figurative. Most frequently exhibits primitivism, painterly abstraction and expressionism.

Terms Charges 50% commission. Accepted work should be framed or unframed, mounted or unmounted, matted or unmatted work. There are no size limitations.

Submissions Send query letter with résumé, 20 slides, bio, brochure, photographs, SASE and business card. Cannot return material. Responds in 3 months. Finds artists mostly through word of mouth, *Art in America*, and also through publications like *Artist's & Graphic Designer's Market*.

Tips "Most artists do not present enough slides or their biographies are incomplete. Professional artists need to be more organized when presenting their work."

N EMEDIALOFT.ORG

55 Bethune St., A-269, New York NY 10014-2035. E-mail: abc@emedialoft.org. Web site: www.eMediaLoft.org. **Co-Director:** Barbara Rosenthal. Alternative space. Estab. 1982. Exhibits mid-career artists. Sponsors 4 exhibits/year. Average display time: 3 months. Open by appointment. Located in the West Village of New York City. Overall price range: $5-50,000; most work sold at $500-2,000.

Media Considers installation, mixed media, oil, watercolor. Most frequently exhibits performance

videos, artists' books, photography. Considers Xerox, offset, digital prints ("if used creatively").

Style Exhibits conceptualism, primitivism realism, surrealism. Genres include Americana, figurative work, landscapes.

Terms Artwork is accepted on consignment (50% commission). Accepts work from artists over age 30.

Submissions E-mail 250 words and 5 JPEGs (72 dpi max, 300 px on longest side). Or send query letter with "anything you like, but no SASE—sorry, we can't return anything. We may keep you on file, but please do not telephone." Responds to queries only if interested.

Tips "Create art from your subconscious, even if it ooks like something recognizable; don't illustrate ideas. No political art. Be sincere and probably misunderstood. Be hard to categorize. Show me art that nobody 'gets,' but please, nothing 'psychadelic.' Intrigue me: Show me something I really haven't seen in anything like your way before. Don't start your cover letter with 'my name is . . .' Take a hard look at the artists' pages on our Web site before you send anything."

FAR WEST GALLERY

2817 Montana Ave., Billings MT 59101. (406)245-2334. Fax: (406)245-0935. E-mail: farwest@180 com.net. Web site: www.farwestgallery.com. **Manager:** Sondra Daly. Retail gallery. Estab. 1994. Represents emerging, mid-career and established artists. Exhibited artists include Joe Beeler, Dave Powell, Kevin Red Star and Stan Natchez. Sponsors 4 shows/year. Average display time: 6-12 months. Open all year; 9-6. Located in downtown historic district in a building built in 1910. Clientele: tourists. Overall price range: $1-9,500; most work sold at $300-700.

Media Considers all media and all types of prints. Most frequently exhibits Native American beadwork, oil and craft/handbuilt furniture.

Style Exhibits all styles. Genres include western and Americana. Prefers Native American beadwork, western bits, spurs, memorabilia, oil, watercolor and pen & ink.

Terms Buys outright for 50% of retail price. Retail price set by the gallery and the artist. Gallery provides insurance and promotion.

FARMINGTON VALLEY ARTS CENTER'S FISHER GALLERY

25 Arts Center Lane, Avon CT 06001. (860)678-1867. Fax: (860)674-1877. E-mail: info@fvac.net. Web site: www.fvac.net. **Executive Director:** Marie Dalton-Meyer. Nonprofit gallery. Estab. 1972. Exhibits the work of 100 emerging, mid-career and established artists. Open all year; Wednesday-Saturday, 11-5; Sunday, 12-5; extended hours November-December. Located in Avon Park North just off Route 44; 600 sq. ft.; "in a beautiful 19th-century brownstone factory building once used for manufacturing." Clientele: upscale contemporary craft buyers. Overall price range: $35-500; most work sold at $50-100.

Media Considers "primarily crafts," also some mixed media, works on paper, ceramic, fiber, glass and small-size prints. Most frequently exhibits jewelry, ceramics and fiber.

Style Exhibits contemporary, handmade craft.

Terms Accepts artwork on consignment (50% commission). Retail price set by the artist. Gallery provides promotion and contract; shipping costs are shared. Requires artwork framed where applicable.

Submissions Send query letter with résumé, bio, slides, photographs, SASE. Responds only if interested. Files a slide or photo, résumé and brochure.

ⓝ FINE ARTS CENTER GALLERIES—UNIVERSITY OF RHODE ISLAND

105 Upper College Rd., Kingston RI 02881-0820. (401)874-2627. Fax: (401)874-2007. E-mail: jtolnick@uri.edu. Web site: www.uri.edu/artgalleries. **Director:** Judith Tolnick Champa. Nonprofit galleries. Estab. 1968. Sponsors 15-20 exhibits/year. Average display time: 1-3 months. There are 3 exhibition spaces: The Main and Photography Galleries, open Tuesday-Friday, 12-4

and weekends, 1-4; The Corridor Gallery, open daily, 9-9. Clients include local community, students, tourists and upscale. Exhibitions are curated from a national palette and regularly reviewed in the local press. Unsolicited proposals (slides or CD with SASE are reviewed as needed).
Media Considers all types of prints.
Style Considers all styles and genres.
Terms Retail price set by the artist. Gallery provides insurance. Accepted work should be framed.
Submissions Mail portfolio for review. Returns material with SASE. Responds in 1 month. Finds artists through word of mouth, submissions, art exhibits and referrals by other artists.

[N] 5 + 5 GALLERY

111 Front St., Suite 210, Brooklyn NY 11201. (718)488-8383. E-mail: gallery1@fodde.com. Web site: www.5plus5gallery.com. **Director:** Raphael Foddé. For-profit gallery. Estab. 1996. Exhibits emerging and established artists. Approached by 50 artists/year; exhibits 6 artists/year. Average display time: 60 days. Open daily. Closed Federal and religious holidays. Overall price range: $300-15,000; most work sold at $1,200.
Media Exhibits paper, pastel, pen & ink, watercolor.
Terms Artwork is accepted on consignment (50% commission).
Submissions E-mail attachments only. Finds artists through submissions.
Tips "Submit a very simple, short and to-the-point artist's statement and CV."

FLORIDA ART CENTER & GALLERY

208 First St. NW, Havana FL 32333. (850)539-1770. E-mail: drdox@juno.com. **Executive Director:** Dr. Kim Doxey. Retail gallery, studio and art school. Estab. 1993. Represents 30 emerging, mid-career and established artists. Interested in seeing the work of emerging artists. Open all year. Located in a small but growing town just outside Tallahassee, Florida; 2,100 st. ft.; housed in a large renovated 50-year-old building with exposed rafters and beams. Clientele: 100% private collectors.
Media Considers all media including original handpulled prints, sculpture, jewelry, and ceramics.
Style Exhibits all styles, prefers traditional styles. Genres include landscapes and portraits.
Terms Accepts work on consignment (45% commission). Retail price set by gallery and artist. Gallery provides insurance, promotion and contract.
Submissions Send query letter with slides. Call or write for appointment.
Tips "Prepare a professional presentation for review, (i.e. quality work, good slides, clear, concise and informative backup materials). Include size, medium, price and framed condition of painting. In order to effectively express your creativity and talent, you must be a master of your craft, including finishing and presentation."

THE FLYING PIG LLC

N6975 State Hwy. 42, Algoma WI 54201. (920)487-9902. Fax: (920)487-9904. E-mail: theflyingpig @charterinternet.com. Web site: www.theflyingpig.biz. **Owner/Member:** Susan Connor. For-profit gallery. Estab. 2002. Exhibits approximately 150 artists. Open Thursday-Sunday, 10-5 (winter); daily, 9-6 (May 1st-October 31st). Clients include local community, tourists and upscale. Overall price range: $5-3,000; most work sold at $300.
Media Considers all media.
Style Exhibits impressionism, minimalism, painterly abstraction and primitivism realism. Most frequently exhibits primitivism realism, impressionism and minimalism. Genres include outsider and visionary.
Terms Artwork is accepted on consignment, and there is a 40% commission; or artwork is bought outright for 50% of retail price, net 15 days. Retail price set by the artist. Gallery provides insur-

ance, promotion and contract. Accepted work should be framed. Does not require exclusive representation locally.

Submissions Send query letter with artist's statement, bio and photographs. Returns material with SASE. Responds to queries in 3 weeks. Files artist's statement, bio and photographs if interested. Finds artist's through art fairs and exhibitions, referrals by other artsts, submissions, word of mouth and Online.

FOCAL POINT GALLERY

321 City Island Ave., City Island NY 10464. (718)885-1403. Fax: (718)885-1451. E-mail: RonTerner@aol.com. Web site: www.FocalPointGallery.com. **Contact:** Ron Terner. Retail gallery and alternative space. Estab. 1974. Interested in emerging and mid-career artists. Exhibited artists include Marguerite Chadwick-Juner (watercolor). Sponsors 2 solo and 6 group shows/year. Average display time: 3-4 weeks. Open Tuesday-Sunday, 12-7 with additional evening hours; Friday and Saturday, 7:30-9. Clients include locals and tourists. Overall price range: $175-750; most work sold at $300-500.

Media Considers all media. Most frequently exhibits photography, watercolor, oil. Also considers etchings, giclée, color prints, silver prints.

Style Exhibits all styles. Most frequently exhibits painterly abstraction, conceptualism, expressionism. Genres include figurative work, florals, landscapes, portraits. Open to any use of photography.

Terms Accepts work on consignment (40% commission). Exclusive area representation required. Customer discounts and payment by installment are available. Gallery provides promotion. Prefers artwork framed.

Submissions "Please call for submission information. Do not include résumés. The work should stand by itself. Slides should be of high quality."

Tips "Care about your work."

N FOUNDRY GALLERY

1314 18th St. NW, 1st Floor, Washington DC 20036. (202)463-0203. E-mail: president@foundrygallery.org. Web site: www.foundry_gallery.org. **President:** Steve Nordinger. Cooperative gallery and alternative space. Estab. 1971. Sponsors 10-20 solo and 2-3 group shows/year. Average display time: 1 month. Open Wednesday-Sunday, 12-6. Clientele: 80% private collectors; 20% corporate clients. Overall price range: $100-5,000; most work sold at $100-1,000.

Media Considers oil, acrylic, watercolor, pastel, pen & ink, drawings, mixed media, collage, paper, sculpture, ceramic, fiber, glass, installation, photography, woodcuts, engravings, mezzotints, etchings, pochoir and serigraphs. Most frequently exhibits painting, sculpture, paper and photography.

Style Exhibits "serious artists in all mediums and styles." Prefers nonobjective, expressionism and neo-geometric. "Founded to encourage and promote Washington area artists and to foster friendship with artists and arts groups outside the Washington area. The Foundry Gallery is known in the Washington area for its promotion of contemporary works of art."

Terms Co-op membership fee plus donation of time required; 30% commission. Retail price set by artist. Offers customer discounts and payment by installments. Exclusive area representation not required. Gallery provides insurance, promotion, contract and Web site presence.

Submissions See Web site for membership application. Send query letter with 10 PDF images or slides. Local artists drop off 6 pieces of actual work. Portfolio reviews every third Wednesday of the month. Finds artists through submissions.

Tips "Have a coherent body of work, a minimum of 10 actual, finished works. Show your very best, strongest work. Build your résumé by submitting your artwork at juried shows. Visit gallery to ascertain whether the work fits in."

ⓝ THE FRASER GALLERY

7700 Wisconsin Ave., Suite E, Bethesda MD 20814. (301)718-9651. E-mail: info@thefrasergallery. com. Web site: www.thefrasergallery.com. **Director:** Catriona Fraser. For-profit gallery. Estab. 1996. Approached by 500 artists/year; represents 25 artists and sells the work of an additional 75 artists. Average display time: 1 month. Open Tuesday-Saturday, 11:30-6. Closed Sunday and Monday except by appointment. Overall price range: $200-20,000; most work sold at under $5,000.

Media Considers acrylic, drawing, mixed media, oil, paper, pastel, pen & ink, sculpture and watercolor. Most frequently exhibits oil, photography and drawing. Types of prints include engravings, etchings, linocuts, mezzotints and woodcuts.

Style Most frequently exhibits contemporary realism. Genres include figurative work and surrealism.

Terms Artwork is accepted on consignment (50% commission). Gallery provides insurance, promotion, contract. Accepted work should be framed, matted to full conservation standards. Requires exclusive representation locally.

Submissions Send query letter with bio, reviews, slides or CD-ROM, SASE. Responds in 1 month. Finds artists through submissions, portfolio reviews, art fairs/exhibits.

Tips "Research the background of the gallery, and apply to galleries that show your style of work. All work should be framed or matted to full museum standards."

ⓖ GALERÍA VÉRTICE

Lerdo de Tejada #2418 Col. Laffayette, C.P. 44140, Guadalajara, Jalisco, México. (5233) 36160078. Fax: (5233) 33160079. E-mail: grjsls@mail.udg.mx. Web site: www.verticegaleria.com. **Director:** Luis Garca Jasso. Estab. 1988. Approached by 20 artists/year; exhibits 12 emerging, mid-career and established artists/year. Sponsors 10 exhibitions/year. Average display time: 20 days. Open all year. Clients include local community, students and tourists. Overall price range: $5,000-100,000.

Media Considers all media except installation. Considers all types of prints.

Style Considers all styles. Most frequently exhibits abstraction, new-figurativism and realism. Considers all genres.

Terms Artwork is accepted on consignment (40% commission). Retail price set by the gallery. Gallery provides insurance, promotion and contract. Accepted work should be framed. Requires exclusive representation locally.

Submissions Mail portfolio for review or send artist's statement, bio, brochure, photocopies, photographs and résumé. Responds to queries in 3 weeks. Finds artists through art fairs, art exhibits and portfolio reviews.

ⓝ GALERIE ARTSOURCE

401 N. Brand Blvd., Glendale CA 91203. (818)244-0066. E-mail: artsource_online@yahoo.com. **Managing Director:** Ripsime Marashian. For-profit gallery. Estab. 1997. Exhibits mostly established artists. Sponsors 4 exhibits/year. Average display time: 3 months. Located in downtown Glendale, on the 9th floor of a historical building; 1,500-sq.-ft. showroom with 3,000-sq.-ft. patio offering a spectacular view of the city skyline and surrounding mountains. Clients include established and beginning collectors. 80% of sales are to private collectors; 20% to corporate clients. Overall price range: $500-60,000; most work sold at $3,500-35,000.

● See also listing for ArtSource International Inc. in the Posters & Prints section.

Media Considers all media. Most frequently exhibits oils, watercolors, pastel, mixed media, handblown glass and sculpture.

Style Exhibits all styles, all genres.

Terms Accepts artwork on consignment (50% commission). Retail price set by gallery and artist.

Gallery provides insurance, promotion and contract; artist pays shipping costs to and from gallery.
Submissions Send query letter with résumé, slides and SASE. Accepts e-mail introductions with referrals or invitations to Web sites; no attachments. Portfolio review requested if interested in artist's work.
Tips "Art must be outstanding, professional quality."

GALERIE BONHEUR

10046 Conway Rd., St. Louis MO 63124. (314)993-9851. Fax: (314)993-9260. E-mail: gbonheur@a ol.com. Web site: www.galeriebonheur.com. **Owner:** Laurie Griesedieck Carmody. Private retail and wholesale gallery. Focus is on international folk art. Estab. 1980. Represents 60 emerging, mid-career and established artists/year. Exhibited artists include Milton Bond and Justin McCarthy. Sponsors 6 shows/year. Average display time: 1 year. Open all year; by appointment. Located in Ladue (a suburb of St. Louis); 3,000 sq. ft.; art is displayed all over very large private home. 75% of sales to private collectors. Overall price range: $25-25,000; most work sold at $50-1,000.
Media Considers oil, acrylic, watercolor, pastel, pen & ink, drawing, mixed media, collage, paper, sculpture, ceramics and craft. Most frequently exhibits oil, acrylic and metal sculpture.
Style Exhibits expressionism, primitivism, impressionism, folk art, self-taught, outsider art. Genres include landscapes, florals, Americana and figurative work. Prefers genre scenes and figurative.
Terms Accepts work on consignment (50% commission). Retail price set by the gallery and the artist. Gallery provides promotion; artist pays shipping costs to and from gallery. Prefers artwork framed.
Submissions Prefers only self-taught artists. Send query letter with bio, photographs and business card. Write for appointment to show portfolio of photographs. Responds within 6 weeks, only if interested. Finds artists through agents, visiting exhibitions, word of mouth, art publications, sourcebooks and submissions.
Tips "Be true to your inspirations. Create from the heart and soul. Don't be influenced by what others are doing; do art that you believe in and love and are proud to say is an expression of yourself. Don't copy; don't get too sophisticated or you will lose your individuality!"

ROBERT GALITZ FINE ART & ACCENT ART

166 Hilltop Court, Sleepy Hollow IL 60118. (847)426-8842. Fax: (847)426-8846. E-mail: robert@ga litzfineart.com. Web site: www.galitzfineart.com. **Owner:** Robert Galitz. Wholesale representation to the trade. Makes portfolio presentations to corporations. Estab. 1986. Represents 40 emerging, mid-career and established artists. Exhibited artists include Marko Spalatin and Jack Willis. Open by appointment.

• See additional listings in the Posters & Prints and Artists' Reps sections.

Media Considers oil, acrylic, watercolor, mixed media, collage, ceramic, fiber, original hand-pulled prints, engravings, lithographs, pochoir, wood engravings, mezzotints, serigraphs and etchings. "Interested in original works on paper."
Style Exhibits expressionism, painterly abstraction, surrealism, minimalism, impressionism and hard-edge geometric abstraction. Interested in all genres. Prefers landscapes and abstracts.
Terms Accepts artwork on consignment (variable commission), or artwork is bought outright (25% of retail price; net 30 days). Retail price set by artist. Customer discounts and payment by installment are available. Gallery provides promotion and shipping costs from gallery. Prefers unframed artwork only.
Submissions Send query letter with SASE and submission of art. Will request portfolio review if interested.
Tips "Do your thing and seek representation—don't drop the ball! Keep going—don't give up!"

N GALLERY 110 COLLECTIVE

110 S. Washington St., Seattle WA 98104. E-mail: director@gallery110.com. Web site: www.gallery110.com. **Director:** Molly Norris. Not-for-profit, cooperative gallery. Estab. 2002. Represents 60 artists. "Our exhibits change monthly and consist of either two solo shows or group/thematic exhibits. We also display intimate solo shows in our Loft Space." Open Wednesday-Saturday, 12-5; hosts receptions every First Thursday of the month, 6-8 pm. Located in the historic gallery district of Pioneer Square, the gallery has 2 side-by-side storefront spaces. Overall price range: $125-3,000; most work sold at $500-800.

Media Considers all media.

Style Exhibits all styles and genres.

Terms Artwork is accepted on consignment (50% commission); or artwork is bought outright for 50% commission (net 60 days). Gallery provides insurance, promotion, contract (nonexclusive).

Submissions Call or write to arrange a personal interview to show portfolio of slides or CD. Send query letter with artist's statement, bio, résumé, SASE, and "the reasons you've chosen us." Finds artists through word of mouth, art exhibits, submissions, referrals by other artists.

Tips "I want to know that the artist has researched us. I want to see art I've never seen before that shows the artist is aware of other art/history."

N GALLERY 1988: LOS ANGELES

7020 Melrose Ave., Los Angeles CA 90038. E-mail: gallery1988@aol.com. Web site: www.gallery1988.com. For-profit gallery. Estab. 2004. Exhibits emerging artists. Approached by 300 artists/year; represents or exhibits 100 artists. Sponsors 15 exhibits/year. Average display time: 3 weeks. Open Tuesday-Sunday, 11-6. Closed Monday and national holidays. Located in the heart of Hollywood; 1,250 sq. ft. with 20-ft.-high walls. Clients include local community, students, upscale. Overall price range: $75-15,000; most work sold at $750.

- Second location: 1173 Sutter St., San Francisco CA 94109. E-mail: gallery1988sf@gmail.com. Open Tuesday-Saturday, 12-7. Closed Sunday and Monday.

Media Considers acrylic, drawing, oil, paper, pen & ink. Most frequently exhibits acrylic, oil, pen & ink. Types of prints include limited edition giclées.

Style Exhibits surrealism and illustrative work. Prefers character-based works.

Terms Artwork is accepted on consignment. Retail price set by both the artist and gallery. Gallery provides insurance, promotion, contract. Accepted work should be framed.

Submissions Accepts e-mail submissions only. Send query e-mail (subject line: "submission") with link to Web site or 3-4 JPEG samples. Keeps Web site addresses on file. Cannot return material. Responds to queries within 4 weeks, only if interested. Finds artists through art exhibits, submissions, referrals by other artists, word of mouth.

Tips "Keep your e-mail professional and include prices. Stay away from trying to be funny, which you'd be surprised to know happens a *lot*. We are most interested in the art."

GALLERY 400

College of Architecture and the Arts, University of Illinois at Chicago, 400 S. Peoria St. (MC 034), Chicago IL 60607. (312)996-6114. Fax: (312)355-3444. E-mail: lorelei@uic.edu. Web site: http://gallery400.aa.uic.edu. **Director:** Lorelei Stewart. Nonprofit gallery. Estab. 1983. Approached by 500 artists/year; exhibits 80 artists. Sponsors 6 exhibits/year. Average display time: 4-6 weeks. Open Tuesday-Friday, 10-6; Saturday, 12-6. Clients include local community, students, tourists and upscale.

Media Considers drawing, installation, mixed media and sculpture. Most frequently exhibits sculpture, drawing and installation.

Style Exhibits conceptualism, minimalism and postmodernism. Most frequently exhibits contemporary conceptually based artwork.

Terms Gallery provides insurance and promotion.

Submissions Send query letter with SASE for guidelines. Responds in 5 months. Finds artists through word of mouth, art exhibits, referrals by other artists.

Tips "Check our Web site for guidelines for proposing an exhibition and follow those proposal guidelines. Please do not e-mail, as we do not respond to e-mails."

GALLERY 54, INC.

54 Upham, Mobile AL 36607. (251)473-7995. E-mail: gallery54art1@aol.com. **Owner:** Leila Hollowell. Retail gallery. Estab. 1992. Represents 35 established artists/year. May be interested in seeing the work of emerging artists in the future. Exhibited artists inlcude Charles Smith and Lee Hoffman. Sponsors 5 shows/year. Average display time: 1 month. Open all year; Tuesday-Saturday, 11-4:30. Located in midtown, about 560 sq. ft. Clientele: local; 70% private collectors, 30% corporate collectors. Overall price range: $20-6,000; most work sold at $200-1,500.

Media Considers oil, acrylic, watercolor, pastel, pen & ink, drawing, mixed media, collage, sculpture, ceramics, glass, photography, woodcuts, serigraphs and etchings. Most frequently exhibits acrylic/abstract, watercolor and pottery.

Style Exhibits expressionism, painterly abstraction, impressionism and realism. Prefers realism, abstract and impressionism.

Terms Accepts work on consignment (40% commission) or buys outright for 50% of retail price (net 30 days). Retail price set by the artist. Gallery provides contract. Artist pays shipping costs. Prefers framed artwork.

Submissions Southern artists preferred (mostly Mobile area). "It's easier to work with artist's work on consignment." Send query letter with slides and photographs. Write for appointment to show portfolio of photographs and slides. Responds in 2 weeks. Files information on artist. Finds artists through art fairs, referrals by other artists and information in mail.

Tips "Don't show up with work without calling and making an appointment."

GALLERY 72

2709 Leavenworth St., Omaha NE 68105-2399. (402)345-3347. Fax: (402)348-1203. E-mail: gallery72@novia.net. **Director:** Robert D. Rogers. Estab. 1972. Represents or exhibits 6 artists. Sponsors 4 solo and 4 group shows/year. Average display time: 3-4 weeks. Open Monday-Saturday, 10-5; Sunday, 12-5. One large room, one small room.

Media Considers oil, acrylic, digital, watercolor, pastel, pen & ink, drawings, mixed media, collage, sculpture, ceramic, installation, photography, original handpulled prints and posters. Most frequently exhibits paintings, prints and sculpture.

Style Exhibits hard-edge geometric abstraction, color field, minimalism, impressionism and realism. Genres include landscapes and figurative work. Most frequently exhibits color field/geometric, impressionism and realism.

Terms Artwork is accepted on consignment (50% commission). Gallery provides insurance, promotion. Requires exclusive representation locally. "No Western art."

Submissions Call or write to arrange personal interview to show portfolio. Send query letter with artist's statement, brochure, photocopies, résumé. Accepts digital images. Finds artists through word of mouth, submissions, art exhibits.

THE GALLERY AT 910

910 Santa Fe Dr., Denver CO 80204. (303)815-1779. Fax: (303)333-9762. E-mail: info@thegalleryat910.com. Web site: www.thegalleryat910.com. **Curator:** Michele Renée Ledoux. Alternative space; for-profit gallery; nonprofit gallery; rental gallery; community educational outreach. Estab. 2007. Exhibits emerging, mid-career and established artists. Sponsors 6 exhibits/year in main gallery; 6/year in community; 2/year in sculpture garden. Average display time: 2 months in

gallery/community; 6 months in sculpture garden. Open Tuesday-Friday, 12-6; Saturday, 10-2; Monday by appointment. "Gallery hours may vary. Hours as listed unless otherwise posted. Please check Web site." Located in Denver's Art District on Santa Fe at Nine10Arts, Denver's only green-built creative artist community; 1,300 sq. ft.; 105 linear ft.; additional 76 linear ft. of movable walls. Clients include local community, students, tourists, upscale.

Media Considers all media, including performance art. Considers all types of prints except posters.

Style Considers all styles and genres.

Terms Artwork is accepted on consignment (35% commission); or there is a rental fee for space. Retail price set by the artist. Gallery provides insurance, promotion, contract.

Submissions See Web site or contact for guidelines. Responds to queries "as soon as possible." Cannot return material. Keeps all submitted materials on file if interested. Finds artists through submissions, art fairs/exhibits, portfolio reviews, art competitions, referrals by other artists, word of mouth.

Tips "Adhere to submission guidelines. Visit Web site prior to submitting to ensure work fits gallery's mission."

GALLERY BERGELLI

483 Magnolia Ave., Larkspur CA 94939. (415)945-9454. Fax: (415)945-0311. E-mail: rcritelli@bergelli.com. Web site: www.gallerybergelli.com. **Owner:** Robin Critelli. For-profit gallery. Estab. 2000. Approached by 200 artists/year; exhibits 15 emerging artists/year. Exhibited artists include Jeff Faust and James Leonard (acrylic painting). Sponsors 8-9 exhibits/year. Average display time: 6 weeks. Open daily, 10-4. "We're located in affluent Marin County, just across the Golden Gate Bridge from San Francisco. The Gallery is in the center of town, on the main street of Larkspur, a charming village known for its many fine restaurants. It is spacious and open with 2,500 square feet of exhibition space with large window across the front of the building. Moveable hanging walls (see the home page of our Web site) give us great flexibility to customize the space to best show the current exhibition." Clients include local community, upscale in the Marin County & Bay Area. Overall price range is $2,000-26,000; most work sold at $4,000-10,000. Also publishes Jeff Faust through Bergelli Limited. Seeking other artists for publishing: www.bergellilimited.com.

Media Considers acrylic, collage, mixed media, oil, pastel, sculpture. Most frequently exhibits acrylic, oil and sculpture.

Style Exhibits geometric abstraction, imagism, new-expressionism, painterly abstraction, post-modernism, surrealism. Most frequently exhibits painterly abstraction, imagism and neo-expressionism.

Terms Artwork is accepted on consignment, and there is a 50% commission. Retail price set by the artist with gallery input. Gallery provides insurance and promotion. Accepted work should be matted, stretched, unframed and ready to hang. Requires exclusive representation locally. Artwork evidencing geographic and cultural differences is viewed favorably.

Submissions Mail portfolio for review or send query letter with artist's statement, bio, brochure, business card, photographs, résumé, reviews, SASE and slides. Returns material with SASE. Responds to queries in 1 month. Files material not valuable to the artist (returns slides) that displays artist's work. Finds artists through art exhibits, portfolio reviews, referrals by other artists, submissions and word of mouth.

Tips "Your submission should be about the artwork, the technique, the artist's accomplishments, and perhaps the artist's source of creativity. Many artist's statements are about the emotions of the artist, which is irrelevant when selling paintings."

GALLERY M

2830 E. Third Ave., Denver CO 80206. (303)331-8400. Fax: (303)331-8522. E-mail: newartists@ga llerym.com. Web site: www.gallerym.com. **Contact:** Managing Partner. For-profit gallery. Estab. 1996. Average display time: 6-12 weeks. Overall price range: $1,000-75,000.

Media Considers acrylic, collage, drawing, glass, installation, mixed media, oil, paper, pastel, pen & ink, watercolor, engravings, etchings, linocuts, lithographs, mezzotints, serigraphs, woodcuts, photography and sculpture.

Style Exhibits color field, expressionism, geometric abstraction, neo-expressionism, postmodernism, primitivism, realism and surrealism. Considers all genres.

Terms Retail price set by the gallery and the artist. Gallery provides insurance and promotion. Requires exclusive local and regional representation.

Submissions "Artists interested in showing at the gallery should visit the Artist Submissions section of our Web site (under Site Resources). The gallery provides additional services for both collectors and artists, including our quarterly newsletter, *The Art Quarterly*."

GALLERY NAGA

67 Newbury St., Boston MA 02116. (617)267-9060. Fax: (617)267-9040. E-mail: mail@gallerynaga .com. Web site: www.gallerynaga.com. **Director:** Arthur Dion. Retail gallery. Estab. 1977. Represents 30 emerging, mid-career and established artists. Sponsors 9 shows/year. Average display time: 1 month. Open Tuesday-Saturday, 10-5:30. Closed during August. Located on "the primary street for Boston galleries;" housed in a 1,500-sq.-ft historic neo-gothic church. Clientele: 90% private collectors, 10% corporate collectors. Overall price range: $500-60,000; most work sold at $2,000-10,000.

Media Considers oil, acrylic, mixed media, photography, studio furniture. Most frequently exhibits painting and furniture.

Style Exhibits expressionism, painterly abstraction, postmodern works and realism. Genres include landscapes, portraits and figurative work. Prefers expressionism, painterly abstraction and realism.

Terms Accepts work on consignment (50% commission). Retail price set by gallery and artist. Gallery provides insurance and promotion; artist pays for shipping. Prefers artwork framed.

Submissions "Not seeking submissions of new work at this time." See Web site for updates.

Tips "We focus on Boston and New England artists. We exhibit the most significant studio furniture makers in the country. Become familiar with any gallery to see if your work is appropriate before you make contact."

THE FANNY GARVER GALLERY

230 State St., Madison WI 53703. (608)256-6755. E-mail: art@fannygarvergallery.com. Web site: www.fannygarvergallery.com. **President:** Jack Garver. Retail Gallery. Estab. 1972. Represents 100 emerging, mid-career and established artists/year. Exhibited artists include Lee Weiss, Jaline Pol. Sponsors 11 shows/year. Average display time: 1 month. Open all year; Monday-Thursday, 10-6; Friday, 10-8; Saturday, 10-6; Sunday, 12-4 (closed Sundays Jan-April). Located downtown; 3,000 sq. ft.; older refurbished building in unique downtown setting. 33% of space for special exhibitions; 95% of space for gallery artists. Clientele: private collectors, gift-givers, tourists. 40% private collectors, 10% corporate collectors. Overall price range: $100-10,000; most work sold at $100-1,000.

Media Considers oil, pen & ink, paper, fiber, acrylic, drawing, sculpture, glass, watercolor, mixed media, ceramics, pastel, collage, craft, woodcuts, wood engravings, linocuts, engravings, mezzotints, etchings, lithographs and serigraphs. Most frequently exhibits watercolor, oil and glass.

Style Exhibits all styles. Prefers landscapes, still lifes and abstraction.

Terms Accepts work on consignment (50% commission) or buys outright for 50% of retail price

(net 30 days). Retail price set by gallery. Gallery provides promotion and contract, artist pays shipping costs both ways. Prefers artwork framed.

Submissions Send query letter with résumé, 8 slides, bio, brochure, photographs and SASE. Write for appointment to show portfolio, which should include originals, photographs and slides. Responds within 1 month, only if interested. Files announcements and brochures.

Tips "Don't take it personally if your work is not accepted in a gallery. Not all work is suitable for all venues."

Ⓝ GERING & LÓPEZ GALLERY

730 Fifth Ave., New York NY 10019. (646)336-7183. Fax: (646)336-7185. E-mail: info@geringlope z.com. Web site: www.geringlopez.com. **Partner:** Sandra Gering. For-profit gallery. Estab. 2006. Exhibits emerging, mid-career and established artists. Open Tuesday-Saturday, 10-6 (June 22 through Labor Day: Tuesday-Friday, 10-6; Saturday and Monday by appointment). Located in the historic Crown Building.

● This is a new gallery created through the partnership of Sandra Gering (formerly of Sandra Gering Gallery, New York) and Javier López (formerly of Galería Javier López, Madrid).

Media Considers mixed media, oil, sculpture and digital. Most frequently exhibits computer-based work, electric (light) sculpture and video/DVD.

Style Exhibits geometric abstraction. Most frequently exhibits cutting edge.

Terms Artwork is accepted on consignment.

Submissions Send e-mail query with link to Web site and JPEGs. Cannot return material. Responds within 6 months, only if interested. Finds artists through word of mouth, art fairs/exhibits, and referrals by other artists.

Ⓝ HALLWALLS CONTEMPORARY ARTS CENTER

341 Delaware Ave., Buffalo NY 14202. (716)854-1694. Fax: (716)854-1696. E-mail: john@hallwall s.org. Web site: www.hallwalls.org. **Visual Arts Curator:** John Massier. Nonprofit multimedia organization. Estab. 1974. Sponsors 10 exhibits/year. Average display time: 6 weeks.

Media Considers all media.

Style Exhibits all styles and genres. "Contemporary cutting edge work which challenges traditional cultural and aesthetic boundaries."

Terms Retail price set by artist. "Sales are not our focus. If a work does sell, we suggest a donation of 15% of the purchase price." Gallery provides insurance.

Submissions Send material by mail for consideration. Work may be kept on file for additional review for 1 year.

Ⓝ THE HARWOOD MUSEUM OF ART

238 Ledoux St., Taos NM 87571-6004. (505)758-9826. Fax: (505)758-1475. E-mail: harwood@un m.edu. Web site: www.harwoodmuseum.org. **Curator:** Margaret Bullock. Estab. 1923. Approached by 100 artists/year; represents or exhibits more than 200 artists. Sponsors 10 exhibits/year. Average display time: 3 months. Open Tuesday-Saturday, 10-5; Sunday, 12-5. Consists of 7 galleries, 2 of changing exhibitions. Clients include local community, students and tourists. 1% of sales are to corporate collectors. Overall price range: $1,000-5,000; most work sold at $2,000.

Media Considers all media and all types of prints.

Style Considers all styles and genres.

Terms Artwork is accepted on consignment (40% commission). Gallery provides insurance, contract. Accepted work should be framed, mounted, matted. "The museum exhibits work by Taos, New Mexico, artists as well as major artists from outside our region."

Submissions Mail portfolio for review. Send query letter with artist's statement, bio, brochure,

résumé, reviews, SASE, slides. Responds in 3 months. Finds artists through word of mouth, submissions, art exhibits, referrals by other artists.

Tips "The gift shop accepts some art on consignment, but the museum itself does not."

▣ WILLIAM HAVU GALLERY

1040 Cherokee St., Denver CO 80204 (303)893-2360. Fax: (303)893-2813. E-mail: bhavu@mho.n et. Web site: www.williamhavugallery.com. **Owner:** Bill Havu. Gallery Administrator: Nick Ryan. For-profit gallery. Estab. 1998. Exhibits 50 emerging, mid-career and established artists. Exhibited artists include Emilio Lobato (painter and printmaker) and Amy Metier (painter). Sponsors 7-8 exhibits/year. Average display time: 6-8 weeks. Open all year; Tuesday-Friday, 10-6; Saturday, 11-5. Closed Sundays, Christmas and New Year's Day. Located in the Golden Triangle Arts District of downtown Denver; the only gallery in Denver designed as a gallery; 3,000 sq. ft., 18-ft.-high ceilings, 2 floors of exhibition space; sculpture garden. Clients include local community, students, tourists, upscale, interior designers and art consultants. Overall price range: $250-18,000; most work sold at $1,000-4,000.

Media Considers acrylic, ceramics, collage, drawing, mixed media, oil, paper, pastel, pen & ink, sculpture and watercolor. Most frequently exhibits painting, prints. Considers etchings, linocuts, lithographs, mezzotints, woodcuts, monotypes, monoprints and silkscreens.

Style Exhibits expressionism, geometric abstraction, impressionism, minimalism, postmodernism, surrealism and painterly abstraction. Most frequently exhibits painterly abstraction and expressionism.

Terms Artwork is accepted on consignment (50% commission). Retail price set by the gallery and the artist. Gallery provides insurance, promotion and contract. Accepted work should be framed. Primarily accepts only artists from Rocky Mountain/Southwestern region.

Submissions Mail portfolio for review. Send query letter with artist's statement, bio, brochure, résumé, SASE and slides. Returns material with SASE. Files slides and résumé, if interested in the artist. Responds within 1 month, only if interested. Finds artists through word of mouth, submissions and referrals by other artists.

Tips "Always mail a portfolio packet. We do not accept walk-ins or phone calls to review work. Explore our Web site or visit gallery to make sure work would fit with the gallery's objective. Archival-quality materials play a major role in selling fine art to collectors. We only frame work with archival-quality materials and feel its inclusion in work can 'make' the sale."

▣ MARIA HENLE STUDIO

55 Company St., Christiansted, St. Croix VI 00820. E-mail: mariahenle@earthlink.net. Web site: www.mariahenlestudio.com. **Owner:** Maria Henle. For-profit gallery. Estab. 1993. Exhibits mid-career and established artists. Approached by 4 artists/year; represents or exhibits 7 artists. Sponsors 4 exhibits/year. Average display time: 1 month. Open Monday-Friday, 11-5; weekends, 11-3. Closed part of September/October. Located in an 18th-century loft space in historical Danish West Indian town; 750 sq. ft. Clients include local community, tourists, upscale. 10% of sales are to corporate collectors. Overall price range: $600-6,000; most work sold at $600.

Media Considers all media. Most frequently exhibits painting, photography, printmaking. Types of prints include etchings, mezzotints.

Style Considers all styles. Most frequently exhibits realism, primitive realism, impressionism. Genres include figurative work, landscapes, Caribbean.

Terms Artwork is accepted on consignment (40% commission). Retail price set by the artist. Gallery provides promotion. Accepted work should be matted. Requires exclusive representation locally.

Submissions Call or send query letter with artist's statement, bio, brochure. Returns material

with SASE. Responds in 4 weeks. Files promo cards, brochures, catalogues. Finds artists through art exhibits, referrals by other artists, submissions.

Tips "Present good slides or photos neatly presented with a clear, concise bio."

Ⓝ THE HENRY ART GALLERY

15th Ave. NE and NE 41st St., Seattle WA 98195-1410. (206)543-2280. Fax: (206)685-3123. E-mail: info@henryart.org. Web site: www.henryart.org. **Curatorial Assistant:** Karen Bangsund. Museum. Estab. 1927. Exhibits emerging, mid-career and established artists. Sponsors 18 exhibits/year. Open Tuesday-Sunday, 11-5; Thursday, 11-8. Located "on the western edge of the University of Washington campus. Parking is often available in the underground Central Parking garage at NE 41st St. On Sundays, free parking is usually available. The Henry Art Gallery can be reached by over twenty bus routes. Call Metro at (206)553-3000 (http://transit.metroke.gov) or Community Transit at (425)778-2785 for additional information." Clients include local community, students, tourists and upscale.

Media Considers all media. Most frequently exhibits painting, photography and video. Exhibits all types of prints.

Style Exhibits all styles and genres.

Terms Does not require exclusive representation locally.

Submissions Send query letter with artist's statement, résumé, reviews, SASE, slides and transparencies. Returns material with SASE. Responds to queries quarterly. "If we are interested in an artist we will send them an informational letter and ask to keep their materials on file. The materials could include résumé, bio, reviews, slides, photographs, or transparencies." Finds artist's through art exhibits, exhibition announcements, individualized research, periodicals, portfolio reviews, referrals by other artists, submissions and word of mouth.

Ⓝ MARTHA HENRY INC. FINE ART

400 E. 57th St., Suite 7L, New York NY 10022. (212)308-2759. Fax: (212)754-4419. E-mail: info@ marthahenry.com. Web site: www.marthahenry.com or www.artnet.com/marthahenry.html. **President:** Martha Henry. Estab. 1987. Art consultancy. Exhibits emerging, mid-career and established artists, specializing in art by African Americans. Approached by over 200 artists/year; exhibits over 12 artists/year. Exhibited artists include Jan Muller (oil paintings), Mr. Imagination (sculpture), JAMA (acrylic paintings) and Bob Thompson (oil paintings). Sponsors 6 exhibits/year. Average display time: 4 days to 6 weeks. Open all year; by appointment only. Located in a private gallery in an apartment building. 5% of sales are to corporate collectors. Overall price range: $5,000-200,000; most work sold under $50,000.

Terms Accepts all artists, with emphasis on African-American artists.

Submissions Mail portfolio for review or send query letter with artist's statement, bio, photocopies, photographs, slides and SASE. Returns material with SASE. Responds in 3 months. Files slides, bio or postcard. Finds artists through art fairs and exhibits, portfolio reviews, referrals by other artists, submissions, word of mouth and press.

Ⓝ HENRY STREET SETTLEMENT/ABRONS ART CENTER

466 Grand St., New York NY 10002. (212)598-0400. Fax: (212)505-8329. E-mail: mdust@henrystr eet.org. Web site: www.henrystreet.org. **Visual Arts Coordinator:** Martin Dust. Estab. 1970. Alternative space, nonprofit gallery, community center. Sponsors 5-6 exhibits/year. Average display time: 1-2 months. Open Monday-Friday, 9-6; weekends, 12-6. Closed major holidays.

Media Considers all media and all types of prints. Most frequently exhibits mixed media, sculpture and painting.

Style Considers all styles and genres.

Terms Artwork is accepted on consignment (20% commission). Gallery provides insurance and contract.

Submissions Send query letter with artist's statement, résumé and SASE. Returns material with SASE. Files résumés. Finds artists through word of mouth, submissions and referrals by other artists.

HERA EDUCATIONAL FOUNDATION AND ART GALLERY

P.O. Box 336, Wakefield RI 02880. (401)789-1488. E-mail: info@heragallery.org. Web site: www. heragallery.org. **Director:** Chelsea Heffner. Cooperative gallery. Estab. 1974. Sponsors 9-10 shows/year. Average display time: 6 weeks. Open Wednesday-Friday, 1-5; Saturday, 10-4. Closed during January. Sponsors openings; provides refreshments and entertainment or lectures, demonstrations and symposia for some exhibits. Overall price range: $100-10,000.

Media Considers all media and original handpulled prints.

Style Exhibits installations, conceptual art, expressionism, neo-expressionism, painterly abstraction, surrealism, conceptualism, postmodern works, realism and photorealism, basically all styles. "We are interested in innovative, conceptually strong, contemporary works that employ a wide range of styles, materials and techniques." Prefers "a culturally diverse range of subject matter which explores contemporary social and artistic issues important to us all."

Terms Co-op membership. Gallery charges 25% commission. Retail price set by artist. Sometimes offers customer discount and payment by installments. Gallery provides promotion; artist pays for shipping and shares expenses such as printing and postage for announcements. Works must fit inside a 6'6"×2'6" door.

Submissions Inquire about membership and shows. Responds in 6 weeks. Membership guidelines and application available on Web site or mailed on request. Finds artists through word of mouth, advertising in art publications, and referrals from members.

Tips "Hera exhibits a culturally diverse range of visual and emerging artists. Please follow the application procedure listed in the Membership Guidelines. Applications are welcome at any time of the year."

GERTRUDE HERBERT INSTITUTE OF ART

506 Telfair St., Augusta GA 30901-2310. (706)722-5495. Fax: (706)722-3670. E-mail: ghia@ghia.org. Web site: www.ghia.org. **Executive Director:** Kim Overstreet. Nonprofit gallery. Estab. 1937. Exhibits emerging, mid-career and established artists; 5 solo/group shows annually; approx. 40 artists. Exhibited artists include Andrew Crawford, sculpture; Roger Shimomura, prints. Sponsors 5 exhibits/year. Average display time: 6-8 weeks. Open Tuesday-Friday, 10-5; Saturdays by advance appointment only; closed first week in August, December 20-31. Located in historic 1818 Ware's Folly mansion. Clients include local community, tourists and upscale. Approx. 5% of sales are to corporate collectors. Overall price range: $100-5,000; most work sold at $500.

Media Considers all media except craft. Considers all types of prints.

Style Exhibits all styles.

Terms Artwork is accepted on consignment, and there is a 35% commission. Retail price set by the artist. Gallery provides insurance and promotion. Accepted works on paper must be framed and under Plexiglass. Does not require exclusive representation locally.

Submissions Send query letter with artist statement, bio, brochure, résumé, reviews, SASE, slides or CD of current work. Returns material with SASE. Responds to queries quarterly after expeditions review committee meets. Finds artists through art exhibits, referrals by other artists and submissions.

THE HIGH MUSEUM OF ART

1280 Peachtree St. NE, Atlanta GA 30309. (404)733-4473. Fax: (404)733-4529. E-mail: highmuseum@woodruffcenter.org. Web site: www.high.org. Museum. Estab. 1905. Exhibits emerging, mid-career and established artists. Has over 11,000 works of art in its permanent collection. The

museum has an extensive anthology of 19th and 20th century American art; significant holdings of European paintings and decorative art; a growing collection of African-American art; and burgeoning collections of modern and contemporary art, photography and African art. Open Tuesday, Wednesday, Friday, Saturday, 10-5; Thursday, 10-8; Sunday, 12-5; closed Mondays and national holidays. Located in Midtown Atlanta. The Museum's building, designed by noted architect Richard Meier, opened to worldwide acclaim in 1983 and has received many design awards, including 1991 citation from the American Institute of Architects as one of the ''ten best works of American architecture of the 1980s.'' Meier's 135,000-sq.-ft. facility tripled the Museum's space, enabling the institution to mount more comprehensive displays of its collections. In 2003, to celebrate the twentieth anniversary of the Richard Meier-designed building, the High unveiled enhancements to its galleries and interior, and a new, chronological installation of its permanent collection. Three new buildings, designed by Italian architect Renzo Piano, more than double the Museum's size to 312,000 sq. ft. This allows the High to display more of its growing collection, increase educational and exhibition programs, and offer new visitor amenities to address the needs of larger and more diverse audiences. The expansion will strengthen the High's role as the premier art museum in the Southeast and allow the Museum to better serve its growing audiences in Atlanta and from around the world. Clients include local community, students, tourists and upscale.

Media Considers all media and prints.

Style Considers all styles and genres.

Terms Retail price is set by the gallery and the artist. Gallery provides insurance, promotion and contract.

Submissions Call, e-mail or write to arrange a personal interview to show portfolio of slides, artist's statement, bio, résumé and reviews. Returns materials with SASE.

ICEBOX QUALITY FRAMING & GALLERY

1500 Jackson St. NE, Suite 443, Minneapolis MN 55413. (612)788-1790. Fax: (612)788-6947. E-mail: icebox@bitstream.net. Web site: www.iceboxminnesota.com. **Owner:** Howard M. Christopherson. Exhibition, promotion and sales gallery. Estab. 1988. Represents photographers and fine artists in all media, predominantly photography. ''A sole proprietorship gallery, Icebox sponsors installations and exhibits in the gallery's 1,700-sq.-ft. space in the Minneapolis Arts District.'' Overall price range: $200-1,500; most work sold at $200-800.

Media Considers photography and all fine art with some size limitations.

Style Exhibits photos of multicultural, enviromental, landscapes/scenics, rural, adventure, travel and fine art photographs from artists with serious, thought-provoking work. Interested in alternative process, documentary, erotic, historical/vintage.

Terms Charges 50% commission.

Submissions ''Send letter of interest telling why and what you would like to exhibit at Icebox. Include only materials that can be kept at the gallery and updated as needed. Check Web site for more details about entry and gallery history.''

Tips ''Be more interested in the quality and meaning of your artwork than in a way to make money.''

⊞ ILLINOIS STATE MUSEUM CHICAGO GALLERY

100 W. Randolph, Suite 2-100, Chicago IL 60601. (312)814-5322. Fax: (312)814-3471. E-mail: jstevens@museum.state.il.us. Web site: www.museum.state.il.us. **Assistant Administrator:** Jane Stevens. Museum. Estab. 1985. Exhibits emerging, mid-career and established artists. Sponsors 2-3 shows/year. Average display time: 5 months. Open all year. Located ''in the Chicago loop, in the James R. Thompson Center designed by Helmut Jahn.'' 100% of space for special exhibitions.

Media All media considered, including installations.

Style Exhibits all styles and genres, including contemporary and historical work.

Terms "We exhibit work; do not handle sales." Gallery provides insurance and promotion; artist pays for shipping. Prefers artwork framed.

Submissions Accepts only artists from Illinois. Send résumé, 10 high-quality slides or CD, bio and SASE.

INDIANAPOLIS ART CENTER

820 E. 67th St., Indianapolis IN 46220. (317)255-2464. Fax: (317)254-0486. E-mail: exhibs@indpls artcenter.org. Web site: www.indplsartcenter.org. **Director of Exhibitions:** David Kwasigroh. Estab. 1934. Nonprofit art center. Prefers emerging artists. Sponsors 10-15 exhibits/year. Average display time: 8 weeks. Overall price range: $50-5,000; most work sold at $500.

Media Considers all media and all types of original prints. Most frequently exhibits painting, sculpture installations and fine crafts.

Style Exhibits all styles. "In general, we do not exhibit genre works. We do maintain a referral list, though." Prefers postmodern works, installation works, conceptualism, large-scale outdoor projects.

Terms Charges 35% commission. One-person show: $300 honorarium; 2-person show: $200 honorarium; 3-person show: $100 honorarium; plus $0.32/mile travel stipend (one way). Accepted work should be framed (or other finished-presentation formatted). Prefers artists who live within 250 miles of Indianapolis.

Submissions Send minimum of 20 digital images with résumé, reviews, artist's statement and SASE between July 1 and December 31.

Tips "Research galleries thoroughly; get on their mailing lists, and visit them in person at least twice before sending materials. Find out the 'power structure' of the targeted galleries and use it to your advantage. Most artists need to gain experience exhibiting in smaller or nonprofit spaces before approaching a traditional gallery. Work needs to be of consistent, dependable quality. Have slides done by a professional if possible. Stick with one style—no scattershot approaches. Have a concrete proposal with installation sketches (if it's never been built). We book two years in advance—plan accordingly. Do not call. Put me on your mailing list one year before sending application so I can be familiar with your work and record. Ask to be put on my mailing list so you know the gallery's general approach. It works!"

INSLEY ART GALLERY

1000 Bourbon St. #373, New Orleans LA 70116. (504)701-8852. Fax: (504)949-1909. E-mail: insleyartgallery@aol.com. Web site: www.insleyart.com and www.neworleansinsleyart.com. **Director:** Charlene Insley. For-profit gallery. Estab. 2004. Exhibits mid-career, established artists. Approached by 50 artists/year; represents 7-45 artists/year. Clients include local community, tourists, upscale. Overall price range: $350-6,000; most work sold at $3,000.

Media Considers acrylic, ceramics, collage, drawing, glass, mixed media, oil, sculpture. Considers giclées.

Style Exhibits conceptualism, surrealism, painterly abstraction, sculpture and original photography.

Terms Artwork is accepted on consignment, and there is a 30-50% commission. Retail price set by the artist. Gallery provides insurance, promotion, contract. Accepted work should be framed or ready for display. "We now only carry New Orleans area artists." Requires exclusive representation locally.

Submissions Send query letter with bio, photocopies, SASE or by e-mail. Materials cannot be returned. Finds artists through art exhibits, portfolio reviews, referrals by other artists.

JESSEL GALLERY

1019 Atlas Peak Rd., Napa CA 94558. (707)257-2350. E-mail: jessel@napanet.net. Web site: www.jesselgallery.com. **Owner:** Jessel Miller. Retail gallery. Represents 5 major artists. Exhibited artists include Clark Mitchell, Timothy Dixon and Jessel Miller. Sponsors 2-6 shows/year. Average display time: 1 month. Open all year; 7 days/week, 10-5. Located 1 mile out of town; 9,000 sq. ft. 20% of space for special exhibitions; 50% of space for gallery artists. Clientele: upper income collectors. 95% private collectors, 5% corporate collectors. Overall price range: $25-10,000; most work sold at $2,000-3,500.

Media Considers oil, acrylic, watercolor, pastel, collage, sculpture, ceramic and craft. Most frequently exhibits acrylic, watercolor and pastel.

Style Exhibits painterly abstraction, photorealism, realism and traditional. Genres include landscapes, florals and figurative work. Prefers figurative, landscape and abstract.

Terms Accepts work on consignment (50% commission). Retail price set by gallery. Gallery provides promotion; artist pays for shipping costs. Prefers artwork framed.

Submissions Send query letter with résumé, slides, bio, SASE and reviews. Call (after sending slides and background info) for appointment to show portfolio of photographs or slides. Responds in 1 month.

N STELLA JONES GALLERY

201 St. Charles Ave., New Orleans LA 70170. (504)568-9050. Fax: (504)568-0840. E-mail: jones6941@aol.com. Web site: www.stellajones.com. **Contact:** Stella Jones. For-profit gallery. Estab. 1996. Approached by 40 artists/year. Represents 121 emerging, mid-career and established artists. Exhibited artists include Elizabeth Catlett (prints and sculpture), Richard Mayhew (paintings). Sponsors 7 exhibits/year. Average display time: 6-8 weeks. Open all year; Monday-Friday, 11-6; Saturday, 12-5. Located in downtown New Orleans, one block from French Quarter. Clients include local community, tourists and upscale. 10% of sales are to corporate collectors. Overall price range: $500-150,000; most work sold at $1,000-5,000.

Media Considers all media. Most frequently exhibits oil and acrylic. Considers all types of prints except posters.

Style Considers all styles. Most frequently exhibits postmodernism and geometric abstraction. Exhibits all genres.

Terms Artwork is accepted on consignment, and there is a 50% commission. Retail price set by the artist. Gallery provides insurance, promotion and contract. Accepted work should be framed. Requires exclusive representation locally.

Submissions To show portfolio of photographs, slides and transparencies, mail for review. Send query letter with artist's statement, bio, brochure, business card, photocopies, photographs, résumé, reviews, SASE and slides. Returns material with SASE. Responds in 1 month. Finds artists through word of mouth, submissions, portfolio reviews, art exhibits, and referrals by other artists.

Tips "Send organized, good visuals."

MARIA ELENA KRAVETZ ART GALLERY

San Jerónimo 448, 5000 Córdoba Argentina. (54)351 4221290. Fax: (54)351 4271776. E-mail: mek@mariaelenakravetzgallery.com. Web site: www.mariaelenakravetzgallery.com. **Director:** Maria Elena Kravetz. For-profit gallery. Estab. 1998. Approached by 30 artists/year; exhibits 16 emerging and mid-career artists/year. Exhibited artists include Sol Halabi (paintings) and Paulina Ortiz (fiber art). Average display time: 25 days. Open Monday-Friday, 4:30pm-8:30pm; Saturday, 10am-1pm. Closed Sunday. Closed January and February. Located in the main downtown of Córdoba city; 170 square meters, 50 spotlights and white walls. Clients include local community and tourists. Overall price range: $500-10,000; most work sold at $1,500-5,000.

Media Considers all media. Most frequently exhibits glass sculpture and mixed media. Considers etchings, linocuts, lithographs and woodcuts.

Style Considers all styles. Most frequently exhibits new-expressionism and painterly abstraction. Considers all genres.

Terms Artwork is accepted on consignment, and there is a 30% commission. Retail price set by the artist. Requires exclusive representation locally. Prefers only artists from South America and emphasizes sculptors.

Submissions Mail portfolio for review. Cannot return material. Responds to queries in 1 month. Finds artists through art fairs and exhibits, portfolio reviews, referrals by other artists, submissions and word of mouth.

Tips Artists "must indicate a Web page to make the first review of their works, then give an e-mail address to contact them if we are interested in their work."

MARGEAUX KURTIE MODERN ART

39 Yerba Buena, P.O. Box 39, Cerrillos NM 87010. (505)473-2250. E-mail: mkma@att.net. Web site: www.mkmamadrid.com. **Director:** Jill Alikas St. Thomas. Art consultancy. Estab. 1996. Approached by 200 artists/year. Represents 13 emerging, mid-career and established artists. Exhibited artists include Thomas St. Thomas (mixed media painting and sculpture) and Gary Groves (color infrared film photography). Sponsors 8 exhibits/year. Average display time: 5 weeks. Located in a historic adobe home, 18 miles southeast of Santa Fe; 5,000 sq. ft. Clients include local community, students and tourists. 5% of sales are to corporate collectors. Overall price range: $500-15,000; most work sold at $2,800.

Media Considers acrylic, glass, mixed media, paper, sculpture. Most frequently exhibits acrylic on canvas, oil on canvas, photography.

Style Exhibits conceptualism, pattern painting. Most frequently exhibits narrative/whimsical, pattern painting, illussionistic. Genres include figurative work, florals.

Terms Artwork is accepted on consignment (50% commission). Retail price set by the gallery. Gallery provides insurance. Accepted work should be framed, mounted or matted. Requires exclusive representation locally.

Submissions Criteria for review process listed on Web site. Send query letter with artist's statement, bio, résumé, reviews, SASE, slides, $25 review fee (check payable to gallery). Returns material with SASE. Responds to queries in 1 month. Finds artists through art fairs/exhibits, portfolio reviews, referrals by other artists, submissions, word of mouth.

Tips "Label all slides: medium, size, title and retail price. Send only works that are available."

LA ARTISTS GALLERY

6650 Franklin Ave., Hollywood CA 90028. (323)461-0047. Fax: (323)960-3357. E-mail: susan100art@yahoo.com. Web site: www.laartists.com. **Director:** Susan Anderson. Alternative space. Estab. 2000. Approached by 25 artists/year. Represents 25 mid-career artists. Exhibited artists include Dan Shupe, Esau Andrade. Gallery not open to walk-ins. Open by appointment. Clients include upscale dealers, designers, private clients. 10% of sales are to corporate collectors. Overall price range: $1,500-5,000.

Media Considers collage, oil, sculpture, watercolor. Most frequently exhibits oil on canvas. Considers all types of prints.

Style Exhibits neo-expressionism, postmodernism, figurative, contemporary, folk. Most frequently exhibits figurative/contemporary.

Terms Artwork is accepted on consignment, and there is a 10-50% commission. Retail price set by the artist.

Submissions Write to arrange personal interview to show portfolio of photographs. Mail portfolio for review. Returns material with SASE. Does not reply to queries.

Tips "Keep submissions really short and enclose photographs, not slides."

⬚ LAKE GEORGE ARTS PROJECT/COURTHOUSE GALLERY

1 Amherst St., Lake George NY 12845. (518)668-2616. E-mail: mail@lakegeorgearts.org. Web site: www.lakegeorgearts.org. **Gallery Director:** Laura Von Rosk. Alternative space; nonprofit gallery. Estab. 1986. Exhibits emerging, mid-career and established artists. Approached by 200 artists/year; exhibits 8-15 artists/year. Average display time: 5 weeks. Open Tuesday-Friday, 12-5; Saturday, 12-4.

Media "We show work in any media."

Style Considers all styles.

Terms Artwork is accepted on consignment (25% commission). Retail price set by the artist. Gallery provides insurance, promotion, contract.

Submissions Annual deadline for open call is January 31. Send artist's statement, résumé, 10-12 images (slides or CD), image script and SASE. Guidelines available on Web site. Returns material with SASE. Finds artists through art exhibits, portfolio reviews, referrals by other artists, submissions, word of mouth.

Tips Do not send e-mail submissions or links to Web sites. Do not send original art. Review guidelines on Web site.

⬚ LANDING GALLERY

7956 Jericho Turnpike, Woodbury NY 11797. (516)364-2787. Fax: (516)364-2786. E-mail: landing gallery@aol.com. **President:** Bruce Busko. For-profit gallery. Estab. 1985. Approached by 40 artists/year. Exhibits 50 emerging, mid-career and established artists. Exhibited artists include Bruce Busko, mixed media; Edythe Kane, watercolor. Sponsors 2 exhibits/year. Average display time: 2-3 months. Open all year; Monday-Saturday, 10-6; Sunday, 11-4. Closed Tuesdays all year, Sundays in summer. Located in the middle of Long Island's affluent North Shore communities, 30 miles east of New York City. 3,000 sq. ft. on 2 floors with 19-ft. ceilings. The brick building is on the corner of a major intersection. Clients include local community, tourists and upscale. 5% of sales are to corporate collectors. Overall price range: $100-12,000; most work sold at $1,500-2,000.

Media Considers all media. Most frequently exhibits paintings, prints and sculpture. Considers engravings, etchings, lithographs, mezzotints and serigraphs.

Style Considers all styles. Most frequently exhibits realism, abstract and impressionism. Considers figurative work, florals and landscapes.

Terms Artwork is accepted on consignment, and there is a 50% commission. Retail price set by the gallery. Gallery provides insurance, promotion and contract. Accepted work should be framed. Requires exclusive representation locally.

Submissions Call to arrange a personal interview to show portfolio of photographs, slides and transparencies. Mail portfolio for review. Send query letter with artist's statement, bio, brochure, business card, photocopies, photographs, résumé, reviews, SASE and slides. Returns material with SASE. Responds in 2 weeks. Files photos, slides, photocopies and information. Finds artists through word of mouth, submissions, portfolio reviews, art exhibits, art fairs and referrals by other artists.

Tips "Permanence denotes quality and professionalism."

DAVID LEONARDIS GALLERY

217 W. Huron St. #5, Chicago IL 60610. (312)863-9045. E-mail: david@dlg-gallery.com. Web site: www.dlg-gallery.com. **Owner:** David Leonardis. For-profit gallery. Estab. 1992. Approached by 100 artists/year. Represents 12 emerging, mid-career and established artists. Exhibited artists include Kristen Thiele and Christopher Makos. Average display time: 30 days. Open all year; Monday-Friday, 12-6; Saturday, 12-4. Clients include local community, tourists, upscale. 10% of sales are to corporate collectors. Overall price range: $50-5,000; most work sold at $500.

• Second location at 1346 N. Paulina St., Chicago IL 60622. (773)278-3058. Fax: (773)278-3068. Open by appointment.

Media Most frequently exhibits painting, photography and lithography. Considers lithographs and serigraphs.

Style Exhibits pop. Most frequently exhibits contemporary, pop, folk, photo. Genres include figurative work and portraits.

Terms Artwork is accepted on consignment, and there is a 50% commission. Retail price set by the gallery and the artist. Gallery provides promotion. Accepted work should be framed. Does not require local representation. Prefers artists who are professional and easy to deal with.

Submissions E-mail. Responds only if interested. E-mails and JPEGs are filed. Finds artists through word of mouth, art exhibits, and referrals by other artists.

N ✠ LEOPOLD GALLERY

324 W. 63rd St., Kansas City MO 64113. E-mail: email@leopoldgallery.com. Web site: www.leopoldgallery.com. For-profit gallery. Estab. 1991. Approached by 100+ artists/year; represents or exhibits 50 artists. Sponsors 8 exhibits/year. Average display time: 3 weeks. Open Monday-Friday, 10-6; Saturday, 10-5; Sunday, 12-4. Closed holidays. Located in Brookside, a charming retail district built in 1920 with more than 70 shops. The gallery has 2 levels of exhibition space. Clients include H&R Block, Kauffman Foundation, local community, tourists. 65% of sales are to corporate collectors. Overall price range: $50-25,000+; most work sold at $1,500.

Media Considers all media. Most frequently exhibits oil, glass, ceramic, stainless steel. Considers all types of prints.

Style Considers all styles and genres. Most frequently exhibits abstraction, impressionism, conceptual.

Terms Artwork is accepted on consignment (50% commission). Retail price set by the gallery and artist. Gallery provides insurance, promotion, contract. Requires exclusive representation locally. Accepts only artists from Kansas City region.

Submissions E-mail query letter with JPEG samples or link to Web site. Mail query letter with bio, artist's statement, résumé, business card, brochure, reviews, SASE and disc with images. Returns material with SASE. Responds to queries in 2 months. Finds artists through submissions, art fairs/exhibits, portfolio reviews, referrals by other artists, word of mouth.

RICHARD LEVY GALLERY

514 Central Ave. SW, Albuquerque NM 87102. (505)766-9888. E-mail: info@levygallery.com. Web site: www.levygallery.com. **Director:** Viviette Hunt. Estab. 1992. Open Tuesday-Saturday, 11-4. Closed during art fairs (always noted on voice message). Located on Central Ave. between 5th and 6th. Clients include upscale.

Media Considers all media. Most frequently exhibits paintings, prints and photography.

Style Contemporary art.

Submissions Submissions by e-mail preferred. "Please include images and any other pertinent information (artist's statment, bio, etc.). When sending submissions by post, please include slides or photographs and SASE for return of materials."

Tips "Portfolios are reviewed at the gallery by invitation or appointment only."

LIMITED EDITIONS & COLLECTIBLES

697 Haddon Ave., Collingswood NJ 08108. (856)869-5228. Fax: (856)869-5228. E-mail: jdl697ltd @juno.com. Web site: www.ltdeditions.net. **Owner:** John Daniel Lynch, Sr. For-profit gallery. Estab. 1997. Approached by 24 artists/year. Exhibited artists include Richard Montmurro, James Allen Flood and Gino Hollander. Open all year. Located in downtown Collingswood; 700 sq. ft. Overall price range: $190-20,000; most work sold at $450.

Media Considers all media and all types of prints. Most frequently exhibits acrylic, watercolors and oil.

Style Considers all styles and genres.

Terms Artwork is accepted on consignment, and there is a 30% commission. Retail price set by the artist. Gallery provides insurance, promotion and contract. Accepted work should be framed, mounted and matted. Does not require exclusive representation locally.

Submissions Call or write to arrange a personal interview to show portfolio. Send query letter with bio, business card and résumé. Responds in 1 month. Finds artists through word of mouth, portfolio reviews, art exhibits, and referrals by other artists.

LIZARDI/HARP GALLERY

P.O. Box 91895, Pasadena CA 91109. (626)791-8123. Fax: (626)791-8887. E-mail: lizardiharp@ea rthlink.net. **Director:** Grady Harp. Retail gallery and art consultancy. Estab. 1981. Represents 15 emerging, mid-career and established artists/year. Exhibited artists include Wes Hempel, Gerard Huber, Wade Reynolds, Robert Peterson and William Fogg. Sponsors 4 shows/year. Average display time: 2 months. Open all year; Tuesday-Saturday by appointment only. 80% private collectors, 20% corporate collectors. Overall price range: $900-80,000; most work sold at $2,000-15,000.

Media Considers oil, acrylic, watercolor, pastel, pen & ink, drawing, mixed media, sculpture, installation, photography, lithographs, and etchings. Most frequently exhibits works on paper and canvas, sculpture, photography.

Style Exhibits representational art. Genres include landscapes, figurative work—both portraiture and narrative, and still life. Prefers figurative, landscapes and experimental.

Terms Accepts work on consignment (50% commission). Retail price set by the gallery and the artist. Gallery provides insurance, promotion, contract; artist pays shipping costs.

Submissions Send query letter with artist's statement, résumé, 20 slides, bio, photographs, SASE and reviews. Write for appointment to show portfolio of photographs, slides and transparencies. Responds in 1 month. Files all interesting applications. Finds artists through studio visits, group shows, submissions.

Tips "Timelessness of message is a plus (rather than trendy). Our emphasis is on quality or craftsmanship, evidence of originality . . . and maturity of business relationship concept." Artists are encouraged to send an artist's statement with application and at least one 4×5 or print along with 20 slides. Whenever possible, send images over the Internet via e-mail.

LOS ANGELES ART ASSOCIATION/GALLERY 825

825 N. La Cienega Blvd., Los Angeles CA 90069. (310)652-8272. Fax: (310)652-9251. E-mail: gallery825@laaa.org. Web site: www.laaa.org. **Executive Director:** Peter Mays. Artistic Director: Sinead Finnerty-Pyne. Nonprofit gallery. Estab. 1925. Sponsors 16 exhibits/year. Average display time: 4-5 weeks. Open Tuesday-Saturday, 10-5. Overall price range: $200-5,000; most work sold at $600.

 • Also displays exhibitions at LAAA South, The Mike Napoliello Gallery, 936 Hermosa Beach Ave., #105, Hermosa Beach CA 90254.

Media Considers all media and original handpulled prints. "Fine art only. No crafts." Most frequently exhibits mixed media, oil/acrylic and watercolor.

Style Exhibits all styles.

Terms Requires $225 annual membership fee plus entry fees or 6 hours volunteer time. Charges 40% commission. Retail price set by artist. Gallery provides promotion. Works are limited to 100 lbs.

Submissions Submit 2 pieces during screening date. Responds immediately following screening. Call for screening dates.

Tips ''Bring work produced in the last three years. No commercial work (i.e., portraits/advertisements).''

MACNIDER ART MUSEUM

303 Second St. SE, Mason City IA 50401. (641)421-3666. E-mail: macnider@macniderart.org. Web site: www.macniderart.org. **Director:** Shelia Perry. Nonprofit gallery. Estab. 1966. Exhibits 1-10 emerging, mid-career and established artists. Sponsors 10-15 exhibits/year. Average display time: 3 months. Open all year; Tuesday and Thursday, 9-9; Wednesday, Friday and Saturday, 9-5; Sunday, 1-5. Closed Mondays. Large gallery space with track system for hanging works on monofiliment line. Smaller gallery items are hung or mounted on the wall. Clients include local community, students, tourists and upscale. Overall price range: $50-2,500; most work sold at $200-$500.

Media Considers all media and all types of prints.

Style Considers all styles and genres.

Terms Artwork is accepted on consignment, and there is a 40% commission. Retail price set by the artist. Gallery provides insurance, promotion and contract. Accepted work should be framed. Does not require exclusive representation locally.

Submissions For retail shop or exhibition: mail portfolio for review. Returns material with SASE. Responds within 3 months, only if interested. Finds artists through word of mouth, submissions, portfolio reviews, art exhibits, art fairs and referrals by other artists.

Tips Opportunities include exhibition in 2 different gallery spaces, entry into competitive exhibits (1 fine craft exhibit open to Iowa artists, 1 photography show open to artists living in Cerro Gordo County, 1 school art show, and 1 all media open to artists within 100 miles of Mason City Iowa), features in museum shop on consignment, booth space in Festival Art Market in June.

[N] MAIN AND THIRD FLOOR GALLERIES

Department of Visual Arts, Northern Kentucky University, Highland Heights KY 41099. (859)572-5148. Fax: (859)572-6501. E-mail: knight@nku.edu. Web site: www.nku.edu/~art/galleries.ht ml. **Director of Exhibitions and Collections:** David Knight. University galleries. Program established 1975. Represents emerging, mid-career and established artists. Sponsors 10 shows/year. Average display time: 1 month. Open Monday-Friday, 9-9 or by appointment; closed major holidays and between Christmas and New Year's. Located 8 miles from downtown Cincinnati; 3,000 sq. ft.; 2 galleries—one small and one large space with movable walls. 100% of space for special exhibitions. 90% private collectors, 10% corporate collectors. Overall price range: $25-50,000; most work sold at $25-2,000.

Media Considers all media and all types of prints. Most frequently exhibits painting, printmaking and photography.

Style Exhibits all styles, all genres.

Terms Retail price set by the artist. Gallery provides insurance, promotion and contract; shipping costs are shared. Prefers framed artwork, ''but we are flexible.'' Commission rate is 20%.

Submissions ''Proposals from artists must go through our art faculty to be considered.'' Unsolicited submissions/proposals from outside the NKU Department of Visual Arts are not accepted. Unsolicited submissions will be returned to sender.

MAIN STREET GALLERY

105 Main Street, P.O. Box 161, Groton NY 13073. (607)898-9010. E-mail: maingal@localnet.com. Web site: www.mainstreetgal.com. **Directors:** Adrienne Smith and Roger Smith. For-profit gallery, art consultancy. Estab. 2003. Exhibits 15 emerging, mid-career and established artists. Sponsors 7 exhibits/year. Average display time: 5-6 weeks. Open all year; Thursday/Saturday 12-6; Sunday 1-5; closed January and February. Located in the village of Groton in the Finger Lakes

Region of New York, 20 minutes to Ithaca; 900 sq. ft. Clients include local community, tourists, upscale. Overall price range: $120-5,000.

Media Considers all media. Considers prints, including engravings, etchings, linocuts, lithographs, mezzotints and woodcuts. Most frequently exhibits painting, sculpture, ceramics, prints.

Style Considers all styles and genres.

Terms Artwork is accepted on consignment, and there is a 40% commission. Retail price set by the artist. Gallery provides insurance, promotion and contract. Accepted work should be framed, mounted and matted. Requires exclusive representation locally.

Submissions Write to arrange personal interview to show portfolio of photographs and slides. Send query letter with artist's statement, bio, brochure, photographs, résumé, reviews, SASE and slides. Returns material with SASE. Responds to queries in 4 weeks, only if interested. Finds artists through art exhibits, portfolio reviews, referrals by other artists, submissions and word of mouth.

MALTON GALLERY

2643 Erie Ave., Cincinnati OH 45208. (513)321-8614. Fax: (513)321-8716. E-mail: info@maltonart gallery.com. Web site: www.maltonartgallery.com. **Director:** Penelope Gamel. Retail gallery. Estab. 1974. Represents about 100 emerging, mid-career and established artists. Exhibits 20 artists/year. Exhibited artists include Carol Henry, Mark Chatterley, Terri Hallman and Esther Levy. Sponsors 7 shows/year (2-person shows alternate with display of gallery artists). Average display time: 1 month. Open all year; Tuesday-Saturday, 11-5. Located in high-income neighborhood shopping district; 2,500 sq. ft. Clientele: private and corporate. Overall price range: $250-10,000; most work sold at $400-2,500.

Media Considers oil, acrylic, drawing, sculpture, watercolor, mixed media, pastel, collage and original handpulled prints.

Style Exhibits all styles. Genres include contemporary landscapes, figurative and narrative and abstractions work.

Terms Accepts work on consignment (50% commission). Retail price set by artist (sometimes in consultation with gallery). Gallery provides insurance, promotion, contract and shipping costs from gallery; artist pays shipping costs to gallery. Prefers framed works for canvas; unframed works for paper.

Submissions Send query letter with résumé, slides or photographs, reviews, bio and SASE. Responds in 4 months. Files résumé, review or any printed material. Slides and photographs are returned.

Tips "Never drop in without an appointment. Be prepared and professional in presentation. This is a business. Artists themselves should be aware of what is going on, not just in the 'art world,' but with everything."

N ☙ MARKEIM ART CENTER

Lincoln Ave. and Walnut St., Haddonfield NJ 08033. (856)429-8585. Fax: (856)429-8585. E-mail: markeim@verizon.net. Web site: www.markeimartcenter.org. **Executive Director:** Elizabeth Madden. Nonprofit gallery. Estab. 1956. Sponsors 10-11 exhibits/year. Average display time: 4 weeks. Overall price range: $75-1,000; most work sold at $350.

Media Considers all media. Must be original. Most frequently exhibits paintings, photography and sculpture.

Style Exhibits all styles and genres.

Terms Charges 30% commission. Accepted work should be framed, mounted or unmounted, matted or unmatted. "Artists from New Jersey and Delaware Valley region are preferred. Work must be professional and high quality."

Submissions Send slides by mail for consideration. Include SASE, résumé and letter of intent. Responds in 1 month.

Tips "Be patient and flexible with scheduling. Look not only for one-time shows, but for opportunities to develop working relationships with a gallery. Establish yourself locally and market yourself outward."

Ⓝ MARLBORO GALLERY

Prince George's Community College, Largo MD 20774-2199. (301)322-0965. Fax: (301)808-0418. E-mail: tberault@pgcc.edu. Web site: http://academic.pg.cc.md.us. **Curator/Director:** Thomas A. Berault. Nonprofit gallery. Estab. 1976. Interested in emerging, mid-career and established artists. Sponsors 4 solo and 4 group shows/year. Average display time: 1 month. Seasons for exhibition: September-May. 2,100 sq. ft. with 10-ft. ceilings and 25-ft. clear story over 50% of spacetrack lighting (incandescent) and daylight. Clientele: 100% private collectors. Overall price range: $200-10,000; most work sold at $500-700.

Media Considers all media. Most frequently exhibits acrylics, oils, photographs, watercolors and sculpture.

Style Exhibits mainly expressionism, neo-expressionism, realism, photorealism, minimalism, primitivism, painterly abstraction, conceptualism and imagism. Exhibits all genres. "We are open to all serious artists and all media. We will consider all proposals without prejudice."

Terms Accepts artwork on consignment. Retail price set by artist. Exclusive area representation not required. Gallery provides insurance. Artist pays for shipping. Prefers artwork ready for display.

Submissions Send query letter with résumé, slides, SASE, photographs, artist's statement and bio. Portfolio review requested if interested in artist's work. Portfolio should include slides and photographs. Responds every 6 months. Files résumé, bio and slides. Finds artists through word of mouth, visiting exhibitions and submissions.

Tips Impressed by originality. "Indicate if you prefer solo shows or will accept inclusion in group show chosen by gallery."

MAYANS GALLERIES, LTD.

601 Canyon Rd., Santa Fe NM 87501. (505)983-8068. E-mail: arte2@aol.com. Web site: www.artn et.com/mayans.html. **Director:** Ernesto Mayans. Retail gallery and art consultancy. Estab. 1977. Publishes books, catalogs and portfolios. Overall price range: $200-5,000.

Media Considers oil, acrylic, watercolor, pastel, pen & ink, drawings, mixed media, sculpture, photography and original handpulled prints. Most frequently exhibits oil, photography, and lithographs.

Style Exhibits 20th century American and Latin American art. Genres include landscapes and figurative work.

Terms Accepts work on consignment (50% commission). Retail price set by gallery and artist. Exclusive area representation required. Size limited to 11×20 maximum.

Submissions Arrange a personal interview to show portfolio. Send query by mail with SASE for consideration. Responds in 2 weeks.

Tips "Please call before submitting."

MCMURTREY GALLERY

3508 Lake St., Houston TX 77098. (713)523-8238. Fax: (713)523-0932. E-mail: info@mcmurtreyg allery.com. **Owner:** Eleanor McMurtrey. Retail gallery. Estab. 1981. Represents 20 emerging and mid-career artists. Exhibited artists include Robert Jessup and Jenn Wetta. Sponsors 10 shows/year. Average display time: 1 month. Open all year. Located near downtown; 2,600 sq. ft. Clients include corporations. 75% of sales are to private collectors, 25% corporate collectors. Overall price range: $400-17,000; most work sold at $1,800-6,000.

Media Considers oil, acrylic, pastel, drawings, mixed media, collage, works on paper, photography and sculpture. Most frequently exhibits mixed media, acrylic and oil.

Style Exhibits figurative, narrative, painterly abstraction and realism.

Terms Accepts work on consignment (50% commission). Retail price set by gallery and artist. Prefers artwork framed.

Submissions Send query letter with résumé, slides and SASE. Call for appointment to show portfolio of originals and slides.

Tips "Be aware of the work the gallery exhibits and act accordingly. Please make an appointment."

☒ MERIDIAN MUSEUM OF ART

628 25th Ave., Meridian MS 39302. (601)693-1501. E-mail: meridianmuseum@aol.com. Web site: www.meridianmuseum.org. **Director:** Terence Heder. Museum. Estab. 1970. Represents emerging, mid-career and established artists. Interested in seeing the work of emerging artists. Exhibited artists include Jere Allen, Patt Odom, James Conner, Bonnie Busbee, Charlie Busler, Terry Cherry, Alex Loeb and Hugh Williams. Sponsors 15 shows/year. Average display time: 5 weeks. Open all year; Tuesday-Sunday, 1-5. Located downtown; 1,750 sq. ft.; housed in renovated Carnegie Library building, originally constructed 1912-13. 50% of space for special exhibitions. Clientele: general public. Overall price range: $150-2,500; most work sold at $300-1,000.

• Sponsors annual Bi-State Art Competition for Mississippi and Alabama artists.

Media Considers all media. Most frequently exhibits oils, watercolors and sculpture.

Style Exhibits all styles, all genres.

Terms Work available for sale during exhibitions (25% commission). Retail price set by the artist. Gallery provides insurance and promotion; shipping costs are shared. Prefers framed artwork.

Submissions Prefers artists from Mississippi, Alabama and the Southeast. Send query letter with résumé, slides, bio and SASE. Responds in 3 months. Finds artists through submissions, referrals, work included in competitions and visiting exhibitions.

THE MEXICAN MUSEUM

Fort Mason Center, Bldg. D, San Francisco CA 94123. (415)202-9700. Fax: (415)441-7683. E-mail: info@mexicanmuseum.org; victormarquezesq@aol.com. Web site: www.mexicanmuseum.org. **Chairman:** Victor Marquez. Estab. 1975. Represents Mexican and Latino artists. Sponsors 3 exhibits/year. Average display time: 3 months. Clients include local community, students, tourists and upscale.

Media Considers all media and all types of art.

Style Considers all styles. Most frequently exhibits modernist, popular and pre-conquest.

Submissions Send query letter with artist's statement, bio, brochure, business card, photocopies, photographs, résumé, reviews and slides. Responds within 6 months, only if interested.

☒ MEYERS ART GALLERY

7173 E. Main St., Scottsdale AZ 85251. E-mail: ken@meyersartgallery.com. Web site: www.meyersartgallery.com. **President:** Ken Meyers. For-profit gallery. Estab. 1994. Exhibits established artists. Approached by 150 artists/year; represents 25 artists/year. Sponsors 12 exhibits/year. Average display time: 2 weeks. Open Monday-Saturday, 10-5. Located in Old Town Scottsdale; 2,200 sq. ft. Clients include local community, tourists and upscale. Overall price range: $900-20,000; most work sold at $1,500.

Media Considers acrylic, craft, drawing, fiber, mixed media, oil, paper, pastel, watercolor. Most frequently exhibits oil, pastel and watercolor.

Style Considers all styles and genres. Most frequently exhibits traditional and contemporary.

Terms Artwork is accepted on consignment (60% commission). Retail price is set by the artist.

Gallery provides insurance, promotion and contract. Accepted work must be framed, mounted or matted. Requires exclusive representation locally.

Submissions Call or write to arrange a personal interview to show portfolio of photographs, slides, transparencies or actual examples of work. Returns materials with SASE. Responds to queries in 1 week. Finds artists through art fairs, art exhibits, portfolio reviews and submissions.

Tip "Be prepared to submit at least two examples of work. Slides and photos are not trustworthy."

MILL BROOK GALLERY & SCULPTURE GARDEN

236 Hopkinton Rd., Concord NH 03301. (603)226-2046. E-mail: artsculpt@mindspring.com. Web site: www.themillbrookgallery.com. For-profit gallery. Estab. 1996. Exhibits 70 artists. Sponsors 7 exhibits/year. Average display time: 6 weeks. Open Tuesday-Saturday, 11-5 (April 1 to December 24); open by appointment December 25 to March 31. Outdoor juried sculpture exhibit; 3 rooms inside for exhibitions; 1,800 sq. ft. Overall price range: $8-30,000; most work sold at $500-1,000.

Media Considers acrylic, ceramics, collage, drawing, glass, mixed media, oil, pastel, sculpture, watercolor, etchings, mezzotints, serigraphs and woodcuts. Most frequently exhibits oil, acrylic and pastel.

Style Considers all styles. Most frequently exhibits color field/conceptualism, expressionism. Genres include landscapes. Prefers more contemporary art.

Terms Artwork is accepted on consignment (50% commission). Retail price set by the artist. Gallery provides insurance, promotion and contract. Accepted work should be framed and matted.

Submissions Write to arrange a personal interview to show portfolio of photographs, slides. Send query letter with artist's statement, bio, photocopies, photographs, résumé, slides, SASE. Responds within 1 month, only if interested. Finds artists through word of mouth, submissions, art exhibits, referrals by other artists.

MULTIPLE IMPRESSIONS, LTD.

41 Wooster St., New York NY 10013. (212)925-1313. Fax: (212)431-7146. E-mail: info@multiplei mpressions.com. Web site: www.multipleimpressions.com. **Contact:** Director. Estab. 1972. For-profit gallery. Approached by 100 artists/year. Represents 50 emerging, mid-career and established artists. Sponsors 5 exhibits/year. Average display time: 2 weeks. Open Tuesday-Saturday, 11-6:30; closed December 30-January 8. Located in the center of Soho, street level. Clients: local community, tourists and upscale. 10% of sales are to corporate collectors. Overall price range: $500-40,000; most work sold at $1,500.

Media Considers oil, pastel, engravings, etchings, lithographs and mezzotints. Most frequently exhibits etchings and oils.

Styles Exhibits imagism and painterly abstraction. Genres include figurative work, landscapes and abstract.

Terms Artwork is accepted on consignment, and there is a 50% commission. Retail price set by the gallery and the artist. Requires exclusive representation locally.

Submissions Send query letter with artist's statement, bio, résumé, photocopies, photographs, slides, price list and SASE. Returns material with SASE. Responds to queries in 1 week. Finds artists through art fairs, portfolio reviews, referrals by other artists, submissions, word of mouth and travel.

THE CATHERINE G. MURPHY GALLERY

The College of St. Catherine, Visual Arts Bldg., 2004 Randolph Ave., St. Paul MN 55105. (651)690-6637. E-mail: kmdaniels@stkate.edu. Web site: www.stkate.edu/gallery. **Director:** Kathleen M. Daniels. Nonprofit gallery. Estab. 1973. Represents emerging, mid-career and nationally and

regionally established artists. Sponsors 5 shows/year. Average display time: 4-5 weeks. Open September-May; Monday-Friday, 8-8; weekends, 12-6. Located in the Visual Arts Building on the campus of the College of St. Catherine; 1,480 sq. ft.

● Gallery shows 75% women's art since it is part of an all-women's undergraduate program.

Media Considers a wide range of media for exhibition.

Style Considers a wide range of styles.

Terms Artwork is loaned for the period of the exhibition. Gallery provides insurance. Shipping costs are shared. Prefers artwork framed.

Submissions Send query letter with résumé, bio, artist's statement, slides and checklist of slides (title, size, medium, etc.). Include SASE for return of materials. Responds in 6 weeks. Files résumé and cover letters. Serious consideration is given to artists who do group proposals under one inclusive theme.

MUSEO ITALOAMERICANO

Fort Mason Center, Bldg. C, San Francisco CA 94123. (415)673-2200. Fax: (415)673-2292. E-mail: sfmuseo@sbcglobal.net. Web site: www.museoitaloamericano.org. Museum. Estab. 1978. Approached by 80 artists/year. Exhibits 15 emerging, mid-career and established artists/year. Exhibited artists include Sam Provenzano. Sponsors 7 exhibits/year. Average display time: 3-4 months. Open all year; Tuesday-Sunday, 12-4. Closed major holidays. Located in the San Francisco Marina District with beautiful view of the Golden Gate Bridge; 3,500 sq. ft. of exhibition space. Clients include local community, students, tourists, upscale and members. Free admission.

Media Considers all media and all types of prints. Most frequently exhibits mixed media, paper, photography, oil, sculpture and glass.

Style Considers all styles and genres. Most frequently exhibits primitivism realism, geometric abstraction, figurative and conceptualism; 20th century and contemporary art.

Terms "The museum sells pieces in agreement with the artist; and if it does, it takes 25% of the sale." Gallery provides insurance and promotion. Accepted work should be framed, mounted and matted. Accepts only Italian or Italian-American artists.

Submissions Submissions accepted with artist's statement, bio, brochure, photography, résumé, reviews, SASE and slides or CDs. Returns material with SASE. Responds in 2 months. Files 2 slides, bio and artist's statement for each artist. Finds artists through word of mouth and submissions.

Tips Looks for "good-quality slides and clarity in statements and résumés. Be concise."

N NEVADA MUSEUM OF ART

160 W. Liberty St., Reno NV 89501. (775)329-3333. Fax: (775)329-1541. Web site: www.nevadaart.org. **Curator:** Ann Wolfe. Estab. 1931. Sponsors 12-15 exhibits/year. Average display time: 2-3 months.

Media Considers all media.

Style Exhibits all styles and genres.

Terms Acquires art "by committee following strict acquisition guidelines per the mission of the institution."

Submissions Send query letter with slides. Write to schedule an appointment to show a portfolio. "No phone calls, please."

Tips "The Nevada Museum of Art is a private, nonprofit institution dedicated to providing a forum for the presentation of creative ideas through its collections, educational programs, exhibitions and community outreach. We specialize in art addressing the environment and the altered landscape."

A NEW LEAF GALLERY
Cornerstone Gardens, 23588 Arnold Dr. (Hwy. 121), Sonoma CA 95476. (707)933-1300. E-mail: info@sculpturesite.com. Web site: www.sculpturesite.com. **Curator:** Brigitte Micmacker. Retail gallery. Estab. 1990. Represents 100 emerging, mid-career and established artists. Sponsors 10 sculpture shows/year. Average display time: 3-4 months. Open daily, 10-6. Clients include local community, upscale. Overall price range: $1,000-100,000; most work sold at $5,000-20,000.
Media Considers sculpture, mixed media, ceramic and glass. Most frequently exhibits sculpture. No crafts. "No paintings or works on paper, please."
Style Exhibits only contemporary abstract and abstract figurative.
Terms Accepts artwork on consignment. Retail price set by artist in cooperation with gallery. Gallery provides insurance. Exclusive area representation required.
Submissions Digital images are best; or send e-mail link to your Web site for review. Responds 2-3 times per year.
Tips "We suggest artists visit us if possible; and, in any case, check Web site before submitting."

N. NEW VISIONS GALLERY, INC.
1000 N. Oak Ave., Marshfield WI 54449. (715)387-5562. E-mail: newvisions.gallery@verizon.net. Web site: www.newvisionsgallery.org. **Executive Director:** Mary Peck. Nonprofit educational gallery. Represents emerging, mid-career and established artists. Organizes a variety of group and thematic shows, sponsors Marshfield Art Fair and "Biennial" every two years; "Culture and Agriculture" annual invitational exhibit of art with agricultural themes. Does not represent artists on a continuing basis but does accept exhibition proposals. Average display time: 6 weeks. Open all year; Monday-Friday, 9-5:30; Saturday 11-3. 1,500 sq. ft. Price range varies with exhibit. Small gift shop with original jewelry, notecards and crafts at $10-50. "We do not show 'country crafts.' "
Media Considers all media.
Style Exhibits all styles and genres.
Terms Accepts work on consignment (35% commission). Retail price set by artist. Gallery provides insurance and promotion. Prefers artwork framed.
Submissions Send query letter with résumé, high-quality slides or digital images and SASE. Label slides with size, title, media.
Tips "Meet deadlines, read directions, make appointments—in other words, respect yourself and your work by behaving as a professional."

NEXUS/FOUNDATION FOR TODAYS ART
1400 N. American St., Suite 102, Philadelphia PA 19122. (215)629-1103. E-mail: info@nexusphila delphia.org. Web site: www.nexusphiladelphia.org. **Executive Director:** Nick Cassway. Alternative space, cooperative gallery, nonprofit gallery. Estab. 1975. Approached by 40 artists/year. Represents 20 emerging and mid-career artists. Exhibited artists include Matt Pruden (illegal art extravaganza). Sponsors 10 exhibits/year. Average display time: 1 month. Open Wednesday-Sunday from 12 to 6 p.m.; closed July and August. Clients include local community, students, tourists and upscale. Overall price range: $75-1,200; most work sold at $200-400.
Media Considers acrylic, ceramics, collage, craft, drawing, fiber, glass, installation, mixed media, oil, paper, pen & ink and sculpture. Most frequently exhibits installation and mixed media.
Style Exhibits conceptualism, expressionism, neo-expressionism, postmodernism and surrealism. Most frequently exhibits conceptualism, expressionism and postmodernism.
Terms There is no commission for artwork sold by member artists; 30% commission on sales by artists outside of the organization.
Submissions Membership reviews are held twice a year in September and February. Artists may submit an applicaton at any time throughout the year. Incomplete applications will not be considered for review. Notification of results will be made within one week of the scheduled

review. Applicants cannot be presently enrolled in school and must live within a 50-mile radius of Philadelphia. Go to www.nexusphiladelphia.org/images/memberapp.pdf for an application form.

Tips ''Get great slides made by someone who knows how to take professional slides. Learn how to write a cohesive and understandable artist statement.''

⚏ NORTHWEST ART CENTER

Minot State University, 500 University Ave. W., Minot ND 58707. (701)858-3264. Fax: (701)858-3894. E-mail: nac@minotstateu.edu. Web site: www.minotstateu.edu/nac. **Director:** Avis R. Veikley. Nonprofit gallery. Estab. 1970. Represents emerging, mid-career and established artists. Sponsors 18-20 shows/year. Average display time: 4-6 weeks. Open all year. Two galleries—Hartnett Hall Gallery: Monday-Friday, 8-4:30; The Library Gallery: Sunday-Thursday, 8-9. Located on university campus; 1,000 sq. ft. 100% of space for special exhibitions. 100% private collectors. Overall price range: $100-40,000; most work sold at $100-4,000.

Media Considers all media. Emphasis on contemporary works on paper.

Style Exhibits all styles, all genres.

Terms Retail price set by the artist. 30% commission. Gallery provides insurance, promotion and contract; shipping costs are shared. Prefers framed artwork.

Submissions Send query letter with résumé, bio, artist's statement, slides and SASE. Sponsors 2 national juried shows each year; prospectus available on Web site. Call for appointment to show portfolio of originals, photographs, slides and transparencies. Responds in 4 months. Files all material. Finds artists through submissions, visiting exhibitions, word of mouth.

NOYES ART GALLERY

119 S. Ninth St., Lincoln NE 68508. (402)475-1061. E-mail: julianoyes@aol.com. Web site: www.noyesartgallery.com. **Director:** Julia Noyes. For-profit gallery. Estab. 1992. Exhibits 150 emerging artists. Has 25 members. Average display time: 1 month minimum. (''If mutually agreeable this may be extended or work exchanged.'') Open all year. Located downtown, near historic Haymarket District; 3,093 sq. ft.; renovated 128-year-old building. 25% of space for special exhibitions. Clientele: private collectors, interior designers and decorators. 90% private collectors, 10% corporate collectors. Overall price range: $100-5,000; most work sold at $200-750.

Media Considers oil, acrylic, watercolor, pastel, pen & ink, drawings, mixed media, collage, paper, sculpture, ceramic, fiber, glass and photography; original handpulled prints, woodcuts, wood engravings, linocuts, engravings, mezzotints, etchings, lithographs and serigraphs. Most frequently exhibits oil, watercolor and mixed media.

Style Exhibits expressionism, neo-expressionism, impressionism, realism, photorealism. Genres include landscapes, florals, Americana, wildlife, figurative work. Prefers realism, expressionism, photorealism.

Terms Accepts work on consignment (10-35% commission). Retail price set by artist (sometimes in conference with director). Gallery provides promotion and contract; artist pays for shipping. Prefers artwork framed.

Submissions Send query letter with résumé, slides, bio, SASE; label slides concerning size, medium, price, top, etc. Submit at least 6-8 slides. Reviews submissions monthly. Responds in 1 month. Files résumé, bio and slides of work by accepted artists (unless artist requests return of slides). All materials are returned to artists whose work is declined.

⚎ OPENING NIGHT FRAMING SERVICES & GALLERY

2836 Lyndale Ave. S., Minneapolis MN 55408-2108. (612)872-2325. Fax: (612)872-2385. E-mail: deen@onframe-art.com. Web site: www.onframe-art.com. **Contact:** Deen Braathen. Estab. 1974. Exhibits 15 emerging and mid-career artists. Sponsors 4 exhibits/year. Open all year; Monday-Friday, 8:30-5; Saturday, 10:30-4.

Media Considers acrylic, ceramics, collage, drawing, fiber, glass, oil, paper, sculpture and water-color.

Style Exhibits local and regional art.

Terms Artwork is accepted on consignment, and there is a 50% commission. Retail price set by the gallery. Gallery provides insurance, promotion and contract.

Submissions "E-mail Deen with cover letter, artist statement, and visuals."

OPUS 71 FINE ARTS, HEADQUARTERS

(formerly Opus 71 Galleries, Headquarters), 4115 Carriage Dr., Villa P-2, Misty Oaks, Pompano Beach FL 33069. (954)974-4739. E-mail: lionxsx@aol.com. **Co-Directors:** Charles Z. Candler III and Gary R. Johnson. Retail and wholesale private gallery, alternative space, art consultancy and salon style organization. Estab. 1969. Represents 40 (15-20 on regular basis) emerging, mid-career and established artists/year. Open by appointment only. Clientele: upscale, local, international and regional. 75% private collectors; 25% corporate collectors. Overall price range: $200-85,000; most work sold at $500-7,500.

- This gallery is a division of The Leandros Corporation. Other divisions include The Alexander Project and Opus 71 Art Bank.

Media Considers oil, acrylic, pastel, pen & ink, drawing, mixed media, collage, sculpture and ceramics; types of prints include woodcuts and wood engravings. Most frequently exhibits oils or acrylic, bronze and marble sculpture and pen & ink or pastel drawings.

Style Exhibits expressionism, neo-expressionism, primitivism, painterly abstraction, surrealism, conceptualism, minimalism, color field, postmodern works, impressionism, photorealism, hard-edge geometric abstraction (paintings), realism and imagism. Exhibits all genres. Prefers figural, objective and nonobjective abstraction and realistic bronzes (sculpture).

Terms Accepts work on consignment or buys outright. Retail price set by "consulting with the artist initially." Gallery provides insurance (with limitations), promotion and contract; artist pays for shipping to gallery and for any return of work. Prefers artwork framed, unless frame is not appropriate.

Submissions Telephone call is important. Call for appointment to show portfolio of photographs and actual samples. "We will not look at slides." Responds in 2 weeks. Files résumés, press clippings and some photographs. "Artists approach us from a far flung area. We currently have artists from about 12 states and 4 foreign countries. Most come to us. We approach only a handful of artists annually."

Tips "Know yourself . . be yourself . . . ditch the jargon. Quantity of work available not as important as quality and the fact that the presenter is a working artist. We don't want hobbyists."

ORANGE COUNTY CENTER FOR CONTEMPORARY ART

117 N. Sycamore St., Santa Ana CA 92701. (714)667-1517. E-mail: grau@prodigy.net. Web site: www.occca.org. **Exhibitions Director:** Pamela Grau Twena. Cooperative, nonprofit gallery. Exhibits emerging and mid-career artists. 26 members. Sponsors 12 shows/year. Average display time: 1 month. Open all year; Thursday and Sunday, 12-5; Friday and Saturday, 12-9; Monday-Wednesday by appointment. Opening receptions first Saturday of every month, 7-10 pm. Gallery space: 5,500 sq. ft. 25% of time for special exhibitions; 75% of time for gallery artists. Membership fee: $30/month.

Media Considers all media—contemporary work.

Terms Co-op membership fee plus a donation of time. Retail price set by artist.

Submissions Accepts artists generally in and within 50 miles of Orange County. Send query letter with SASE. Responds in 1 week.

Tips "This is an artist-run nonprofit. Send SASE for application prospectus. Membership involves 10 hours per month of volunteer work at the gallery or gallery-related projects."

THE PARTHENON

Centennial Park, Nashville TN 37201. (615)862-8431. Fax: (615)880-2265. E-mail: susan@parthenon.org. Web site: www.parthenon.org. **Curator:** Susan E. Shockley. Nonprofit gallery in a full-size replica of the Greek Parthenon. Estab. 1931. Exhibits the work of emerging to mid-career artists. Sponsors 10-12 shows/year. Average display time: 3 months. Clientele: general public, tourists. Overall price range: $300-2,000. "We also house a permanent collection of American paintings (1765-1923)."

Media Considers "nearly all" media.

Style "Interested in both objective and non-objective work. Professional presentation is important."

Terms "Sale requires a 20% commission." Retail price set by artist. Gallery provides a contract and limited promotion. The Parthenon does not represent artists on a continuing basis.

Submissions Send 20 well-organized slides, résumé and artist's statement addressed to curator.

Tips "We plan our gallery calendar at least one year in advance."

PENTIMENTI GALLERY

145 N. Second St., Philadelphia PA 19106. (215)625-9990. Fax: (215)625-8488. E-mail: mail@pentimenti.com. Web site: www.pentimenti.com. **Director:** Christine Pfister. Commercial gallery. Estab. 1992. Represents 20-30 emerging, mid-career and established artists. Sponsors 7-9 exhibits/year. Average display time: 4-6 weeks. Open all year; Wednesday-Friday, 11-5; weekends, 12-5. Closed Sundays, August, Christmas and New Year. Located in the heart of Old City Cultural district in Philadelphia. Overall price range: $250-12,000; most work sold at $1,500-7,000.

Media Considers all media. Most frequently exhibits paintings of all media.

Style Exhibits conceptualism, minimalism, postmodernism, painterly abstraction, and representational works. Most frequently exhibits postmodernism, minimalism and conceptualism.

Terms Artwork is accepted on consignment, and there is a 50% commission. Retail price set by the gallery and the artist. Gallery provides insurance and promotion. Requires exclusive representation locally.

Submissions Send query letter with artist's statement, bio, brochure, photographs, résumé, SASE and slides. Returns material with SASE. Responds in 3 months. Finds artists through word of mouth, submissions, portfolio reviews, art exhibits, art fairs and referrals by other artists.

THE PHOENIX GALLERY

210 11th Ave. at 25th St., Suite 902, New York NY 10001. (212)226-8711. E-mail: info@phoenix-gallery.com. Web site: www.phoenix-gallery.com. **Director:** Linda Handler. Nonprofit gallery. Estab. 1958. 32 members. Exhibits the work of emerging, mid-career and established artists. Exhibited artists include Gretl Bauer and Jae Hi Ahn. Sponsors 10-12 shows/year. Average display time: 1 month. Open Tuesday-Saturday, 11:30-6. Located in Chelsea; 180 linear ft. "We have a movable wall that can divide the gallery into two large spaces." 100% of space for special exhibitions. 75% of sales are to private collectors, 25% corporate clients, also art consultants. Overall price range: $50-20,000; most work sold at $300-10,000.

- The Phoenix Gallery actively reaches out to the members of the local community, scheduling juried competitions, dance programs, poetry readings, book signings, plays, artists speaking on art panels and lectures. A special exhibition space, The Project Room, has been established for guest-artist exhibits.

Media Considers oil, acrylic, watercolor, pastel, pen & ink, drawings, mixed media, collage, works on paper, sculpture, ceramic, photography, original handpulled prints, woodcuts, engravings, wood engravings, linocuts, etchings and photographs. Most frequently exhibits oil, acrylic and watercolor.

Style Exhibits painterly abstraction, minimalism, realism, photorealism, hard-edge geometric abstraction and all styles.

Terms Co-op membership fee plus donation of time for active members, not for inactive or associate members (25% commission). Retail price set by gallery. Offers customer discounts and payment by installment. Gallery provides promotion and contract; artist pays for shipping. Prefers framed artwork.

Submissions Send query letter with résumé, slides and SASE. Call for appointment to show portfolio of slides. Responds in 1 month. Only files material of accepted artists. The most common mistakes artists make in presenting their work are "incomplete résumés, unlabeled slides and an application that is not filled out properly. We find new artists by advertising in art magazines and art newspapers, word of mouth, and inviting artists from our juried competition to be reviewed for membership."

Tips "Come and see the gallery—meet the director."

🅽 PIERRO GALLERY OF SOUTH ORANGE

Baird Center, 5 Mead St., South Orange NJ 07079. (973)378-7755, ext. 3. Fax: (973)378-7833. E-mail: pierrogallery@southorange.org. Web site: www.pierrogallery.org. **Director:** Judy Wukitsch. Nonprofit gallery. Estab. 1994. Approached by 75-185 artists/year; represents or exhibits 25-50 artists. Average display time: 7 weeks. Open Friday-Sunday, 1-4; by appointment. Closed mid-December through mid-January and during August. Overall price range: $100-10,000; most work sold at $800.

Media Considers all media and prints, except posters—must be original works. Most frequently exhibits painting, mixed media/collage/sculpture.

Style Considers all styles and genres.

Terms Artwork is accepted on consignment (15% commission). Retail price set by the artist. Gallery provides insurance, promotion and contract. Accepted work should be framed.

Submissions Mail portfolio for review; 3 portfolio reviews/year: January, June, October. Send query letter with artist's statement, résumé, slides. Responds in 2 months from review date. Finds artists through word of mouth, submissions, portfolio reviews, referrals by other artists.

Tips "Send legible, clearly defined, properly identified slides."

🅽 POLK MUSEUM OF ART

800 E. Palmetto St., Lakeland FL 33801-5529. (863)688-7743. Fax: (863)688-2611. E-mail: info@polkmuseumofart.org. Web site: www.polkmuseumofart.org. **Curator of Art:** Todd Behrens. Estab. 1966. Approached by 75 artists/year; represents or exhibits 3 artists. Sponsors 15 exhibits/year. Open Tuesday-Saturday, 10-5; Sunday, 1-5. Closed major holidays. Four different galleries of various sizes and configurations.

Media Considers all media. Most frequently exhibits prints, photos and paintings. Considers all types of prints except posters.

Style Considers all styles and genres, provided the artistic quality is very high.

Terms Gallery provides insurance, promotion and contract. Accepted work should be framed.

Submissions Mail portfolio for review. Send query letter with artist's statement, bio, résumé and SASE. Returns material with SASE. Reviews 2-3 times/year and responds shortly after each review. Files slides and résumé.

PORTFOLIO ART GALLERY

2007 Devine St., Columbia SC 29205. (803)256-2434. E-mail: artgal@portfolioartgal.com. Web site: www.portfolioartgal.com. **Owner:** Judith Roberts. Retail gallery and art consultancy. Estab. 1980. Represents 40-50 emerging, mid-career and established artists. Exhibited artists include Juko Ono Rothwell, Sigmund Abeles and Shannon Bueker. Sponsors 3 shows/year. Average

display time: 3 months. Open all year. Located in a 1930s shopping village, 1 mile from downtown; 2,000 sq. ft.; features 12-ft. ceilings. 100% of space for work of gallery artists. "A unique feature is glass shelves where matted and small to medium pieces can be displayed without hanging on the wall." Clientele: professionals, collectors, corporations; 70% professionals and collectors, 30% corporate. Overall price range: $150-12,500; most work sold at $600-$3,000.

Media Considers oil, acrylic, watercolor, pastel, mixed media, collage, works on paper, sculpture, ceramic, glass, original handpulled prints, woodcuts, wood engravings, linocuts, engravings, mezzotints, etchings, lithographs and serigraphs. Most frequently exhibits oils, acrylics, ceramics and sculpture, and original jewelry.

Style Exhibits neo-expressionism, painterly abstraction, imagism, minimalism, color field, impressionism, and realism. Genres include landscapes and figurative work. Prefers landscapes/seascapes, painterly abstraction and figurative work. "I especially like mixed media pieces, original prints and oil paintings. Pastel medium and watercolors are also favorites, as well as kinetic sculpture and whimsical clay pieces."

Terms Accepts work on consignment (40% commission). Retail price set by gallery and artist. Offers payment by installments. Gallery provides insurance, promotion and contract; artist pays for shipping. Artwork may be framed or unframed.

Submissions Send query letter with bio and images via e-mail, CD or slides. Write for appointment to show portfolio of originals, slides, photographs and transparencies. Responds within 1 month, only if interested. Files tearsheets, brochures and slides. Finds artists through visiting exhibitions and referrals.

Tips "The most common mistake beginning artists make is showing all the work they have ever done. I want to see only examples of recent best work—unframed, originals (no copies)—at portfolio reviews."

Ⓝ POSNER FINE ART

13234 Fuji Way, Suite G, Marina del Rey CA 90292. (310)822-2600. Fax: (310)578-8501. E-mail: info@posnerfineart.com. Web site: www.posnerfineart.com. **Director:** Judith Posner. Retail gallery and art publisher. Estab. 1994. Represents 200 emerging, mid-career and established artists. Sponsors 5 shows/year. Average display time: 6 weeks. Open all year; Tuesday-Saturday, 10-6; Sunday, 12-5 or by appointment. Clientele: upscale and collectors; 50% private collectors, 50% corporate collectors. Overall price range: $25-50,000; most work sold at $500-10,000.

● See additional listing in the Posters & Prints section.

Media Considers oil, acrylic, watercolor, pastel, mixed media, collage, works on paper, sculpture, ceramics, original handpulled prints, engravings, etchings, lithographs, posters and serigraphs. Most frequently exhibits paintings, sculpture and original prints.

Style Exhibits painterly abstraction, minimalism, impressionism, realism, photorealism, pattern painting and hard-edge geometric abstraction. Genres include florals and landscapes. Prefers abstract, trompe l'oeil, realistic.

Terms Accepts work on consignment (50% commission). Retail price set by the gallery. Gallery provides insurance and promotion; shipping costs are shared. Prefers unframed artwork.

Submissions Send query letter with résumé, slides and SASE. Portfolio should include slides. Responds in 2 weeks, only if interested. Finds artists through submissions and art collectors' referrals.

Tips "We are looking for artists for corporate collections."

THE PRINT CENTER

1614 Latimer St., Philadelphia PA 19103. (215)735-6090. Fax: (215)735-5511. E-mail: info@printc enter.org. Web site: www.printcenter.org. Nonprofit gallery. Estab. 1915. Exhibits emerging, mid-career and established artists. Approached by 500 artists/year. Sponsors 11 exhibits/year.

Average display time: 2 months. Open all year; Tuesday-Saturday, 11-5:30. Closed December 22-January 2. Gallery houses 3 exhibit spaces as well as a separate Gallery Store. Located in historic Rittenhouse area of Philadelphia. Clients include local community, students, tourists and high end collectors. 30% of sales are to corporate collectors. Overall price range: $15-15,000; most work sold at $200.

Media Considers all forms of printmaking, photography and digital printing. Accepts original artwork only—no reproductions.

Style Considers all styles and genres.

Terms Accepts artwork on consignment, and there is a 50% commission. Retail price set by the artist. Gallery provides insurance, promotion and contract. Accepted work should be framed and matted for exhibitions; unframed for Gallery Store. Does not require exclusive representation locally. Only accepts prints and photos.

Submissions Must be member to submit work—member's work is reviewed by Curator and Gallery Store Manager. See Web site for membership application. Finds artists through submissions, art exhibits and membership.

⚏ PUMP HOUSE CENTER FOR THE ARTS

P.O. Box 1613, Chillicothe OH 45601. Phone/fax: (740)772-5783. E-mail: pumpart@bright.net. Web site: www.pumphouseartgallery.com. **Director:** Priscilla V. Smith. Nonprofit gallery. Estab. 1991. Approached by 6 artists/year; represents or exhibits more than 50 artists. Sponsors 8 exhibits/year. Average display time: 6 weeks. Open Tuesday-Friday, 11-4; weekends, 1-4. Closed Mondays and major holidays. Overall price range: $150-600; most work sold at $300. Facility is also available for rent (business meetings, reunions, weddings, wedding receptions or rehearsals, etc.).

Media Considers all media and all types of prints. Most frequently exhibits oil, acrylic and watercolor.

Style Considers all styles and genres.

Terms Artwork is accepted on consignment (30% commission). Gallery provides insurance and promotion. Accepted work should be framed, matted and wired for hanging. The Pump House reserves the right to reject any artwork deemed inappropriate.

Submissions Call or stop in to show portfolio of photographs, slides, originals or prints. Send query letter with bio, photographs, SASE and slides. Returns material with SASE. Responds in 1 month. Finds artists through word of mouth, submissions, portfolio reviews, art fairs/exhibits, and referrals by other artists.

Tips "All artwork must be original designs, framed, ready to hang (wired—no sawtooth hangers)."

⚏ QUEENS COLLEGE ART CENTER

Benjamin S. Rosenthal Library, Queens College, Flushing NY 11367-1597. (718)997-3770. Fax: (718)997-3753. E-mail: suzanna.simor@qc.cuny.edu. Web site: www.qc.cuny.edu. **Director:** Suzanna Simor. Curator: Alexandra de Luise. Estab. 1955. Average display time: 6 weeks. Overall price range: $200-600.

Media Considers all media.

Style Open to all styles and genres; decisive factor is quality.

Terms Charges 40% commission. Accepted work can be framed or unframed, mounted or unmounted, matted or unmatted. Sponsors openings. Artist is responsible for providing/arranging refreshments and cleanup.

Submissions Send query letter with résumé, samples and SASE. Responds in 1 month.

⚡ MARCIA RAFELMAN FINE ARTS

10 Clarendon Ave., Toronto ON M4V 1H9 Canada. (416)920-4468. Fax: (416)968-6715. E-mail: info@mrfinearts.com. Web site: www.mrfinearts.com. **President:** Marcia Rafelman. Gallery Director: Meghan Richardson. Semi-private gallery. Estab. 1984. Average display time: 1 month. Gallery is centrally located in Toronto; 2,000 sq. ft. on 2 floors. Clients include local community, tourists and upscale. 40% of sales are to corporate collectors. Overall price range: $800-25,000; most work sold at $1,500.

Media Considers all media. Most frequently exhibits photography, painting and graphics. Considers all types of prints.

Style Exhibits geometric abstraction, minimalism, neo-expressionism, primitivism and painterly abstraction. Most frequently exhibits high realism paintings. Considers all genres except Southwestern, Western and wildlife.

Terms Artwork is accepted on consignment (50% commission); net 30 days. Retail price set by the gallery and the artist. Gallery provides insurance, promotion and contract. Requires exclusive representation locally.

Submissions Mail or e-mail portfolio for review; include bio, photographs, reviews. Responds within 2 weeks, only if interested. Finds artists through word of mouth, submissions, art fairs, referrals by other artists.

RAIFORD GALLERY

1169 Canton St., Roswell GA 30075. (770)645-2050. Fax: (770)992-6197. E-mail: raifordgallery@mindspring.com. Web site: www.raifordgallery.com. For-profit gallery. Estab. 1996. Approached by many artists/year. Represents 400 mid-career and established artists. Exhibited artists include Cathryn Hayden (collage, painting and photography) and Richard Jacobus (metal). Sponsors 4 exhibits/year. Average display time: 4 weeks. Open all year; Tuesday-Friday, 10-6; Saturday, 10-5. Located in historic district of Roswell; 4,500 sq. ft. in an open 2-story timber-frame space. Clients include local community, tourists and upscale. Overall price range: $10-2,000; most work sold at $200-300.

Media Considers all media except installation. Most frequently exhibits painting, sculpture and glass.

Style Exhibits contemporary American art & craft.

Terms Artwork is accepted on consignment, and there is a 50% commission. Retail price set by the artist. Gallery provides insurance, promotion and contract. Accepted work should be framed. Requires exclusive representation locally.

Submissions Call or write to arrange a personal interview to show portfolio of photographs, slides and originals. Send query letter with artist's statement, bio, brochure, photocopies, photographs, SASE. Returns material with SASE. Finds artists through submissions, portfolio reviews, art exhibits and art fairs.

⚡ THE RALLS COLLECTION INC.

1516 31st St. NW, Washington DC 20007. (202)342-1754. Fax: (202)342-0141. E-mail: maralls@aol.com. Web site: www.rallscollection.com. **Owner:** Marsha Ralls. For-profit gallery. Estab. 1991. Approached by 125 artists/year; represents or exhibits 60 artists. Sponsors 10 exhibits/year. Average display time: 1 month. Open Tuesday-Saturday, 11-4 and by appointment. Closed Thanksgiving and Christmas. Clients include local community and tourists. 30% of sales are to corporate collectors. Overall price range: $1,500-50,000; most work sold at $2,500-5,000.

Media Considers acrylic, collage, drawing, mixed media, oil, sculpture and watercolor. Most frequently exhibits photography, oil and acrylic. Considers lithographs.

Style Exhibits geometric abstraction, neo-expressionism and painterly abstraction. Most frequently exhibits painterly abstraction.

Terms Artwork is accepted on consignment (50% commission). Retail price set by the gallery and the artist. Gallery provides insurance, promotion and contract. Accepted work should be framed and matted. Requires exclusive representation locally. Accepts only American artists.
Submissions Mail portfolio for review. Send query letter with artist's statement, bio, brochure, business card, photocopies, photographs, résumé, reviews, slides, SASE. Responds in 2 months. Finds artists through word of mouth, submissions, portfolio reviews, art fairs/exhibits, referrals by other artists.

RAMSAY MUSEUM

1128 Smith St., Honolulu HI 96817. (808)537-ARTS. Fax: (808)531-MUSE. E-mail: ramsay@lava.n et. Web site: www.ramsaymuseum.org. **CEO:** Ramsay. Gallery, museum shop, permanent exhibits and artists' archive documenting over 200 exhibitions including 500 artists of Hawaii. Estab. 1981. Open all year; Monday-Friday, 10-5; Saturday, 10-4. Located in downtown historic district; 5,000 sq. ft.; historic building with courtyard. Displaying permanent collection of Ramsay quill & ink originals spanning 50 years. Clientele: 50% tourist, 50% local; 25% private collectors, 75% corporate collectors.
Media Especially interested in ink.
Style Currently focusing on the art of tattoo.
Terms Accepts work on consignment. Retail price set by the artist.
Submissions Send query letter with résumé, bio, 20 slides, SASE. Write for appointment to show portfolio of original art. Responds within 1 month, only if interested. Files all material that may be of future interest.
Tips "Keep a record of all artistic endeavors for future use, and to show your range to prospective commissioners and galleries. Prepare your gallery presentation packet with the same care that you give to your art creations. Quality counts more than quantity. Show samples of current work with an exhibit concept in writing."

ALICE C. SABATINI GALLERY

1515 SW 10th Ave., Topeka KS 66604-1374. (785)580-4516. Fax: (785)580-4496. E-mail: sbest@m ail.tscpl.org. Web site: www.tscpl.org. **Gallery Director:** Sherry Best. Nonprofit gallery. Estab. 1976. Exhibits emerging, mid-career and established artists. Sponsors 6-8 shows/year. Average display time: 6 weeks. Open all year; Monday-Friday, 9-9; Saturday, 9-6; Sunday, 12-9. Located 1 mile west of downtown; 2,500 sq. ft.; security, track lighting, plex top cases; 5 moveable walls. 100% of space for special exhibitions and permanent collections. Overall price range: $150-$5,000.
Media Considers oil, fiber, acrylic, sculpture, glass, watercolor, mixed media, ceramic, pastel, collage, metal work, woodcuts, wood engravings, linocuts, engravings, mezzotints, etchings, lithographs, photography, and installation. Most frequently exhibits ceramic, oil and watercolor.
Style Exhibits neo-expressionism, painterly abstraction, postmodern works and realism. Prefers painterly abstraction, realism and neo-expressionism.
Terms Retail price set by artist. Gallery provides insurance; artist pays for shipping costs. Prefers artwork framed. Does not handle sales.
Submissions Usually accepts regional artists. Send query letter with résumé and 12-24 images. Call or write for appointment to show portfolio. Responds in 2 months. Files résumé. Finds artists through visiting exhibitions, word of mouth and submissions.
Tips "Find out what each gallery requires from you and what their schedule for reviewing artists' work is. Do not go in unannounced. Have good, quality images. If reproductions are bad, they probably will not be looked at. Have a dozen or more to show continuity within a body of work. Your entire body of work should be at least 50 pieces. Competition gets heavier each year. We look for originality."

SAN DIEGO ART INSTITUTE (SDAI: Museum of the Living Artist, San Diego Art Dept. & COVA: Combined Organizations for the Visual Arts)

1439 El Prado, San Diego CA 92101. (619)236-0011. Fax: (619)236-1974. E-mail: admin@sandiego-art.org. Web site: www.sandiego-art.org. **Executive Director:** Timothy J. Field. Administrative Director: Kerstin Robers. Art Director: K.D. Benton. Nonprofit gallery. Estab. 1941. Represents 600 emerging and mid-career member/artists. 2,400 artworks juried into shows each year. Sponsors 11 all-media exhibits/year. Average display time: 4-6 weeks. Open Tuesday-Saturday, 10-4; Sunday 12-4. Closed major holidays and all Mondays. 10,000 sq. ft., located in the heart of Balboa Park. Clients include local community, students and tourists. 10% of sales are to corporate collectors. Overall price range: $100-4,000; most work sold at $800.

Media Considers all media and all types of prints. Most frequently exhibits oil, mixed media, pastel, digital.

Style Considers all styles and genres. No craft or installations.

Terms Artwork is accepted on consignment, and there is a 40% commission. Membership fee: $125/year. Retail price set by the artist. Accepted work should be framed. Work must be carried in by hand for each monthly show, except for annual international show juried by slides.

Submissions Request membership packet and information about juried shows. Membership not required for submission in monthly juried shows, but fee required. Returns material with SASE. Finds artists through word of mouth and referrals by other artists.

Tips "All work submitted must go through jury process for each monthly exhibition. Work required to be framed in professional manner."

SAPER GALLERIES

433 Albert Ave., East Lansing MI 48823. (517)351-0815. E-mail: roy@sapergalleries.com. Web site: www.sapergalleries.com. **Director:** Roy C. Saper. Retail gallery. Estab. in 1978; in 1986 designed and built new location. Displays the work of 150 artists, mostly mid-career, and artists of significant national prominence. Exhibited artists include Picasso, Peter Max, Rembrandt. Sponsors 2 shows/year. Average display time: 2 months. Open all year. Located downtown; 5,700 sq. ft. 50% of space for special exhibitions. Clients include students, professionals, experienced and new collectors. 80% of sales are to private collectors, 20% corporate collectors. Overall price range: $100-100,000; most work sold at $1,000.

Media Considers oil, acrylic, watercolor, pastel, drawings, mixed media, collage, paper, sculpture, ceramic, craft, glass and original handpulled prints. Considers all types of prints except offset reproductions. Most frequently exhibits intaglio, serigraphy and sculpture. "Must be of highest professional quality."

Style Exhibits expressionism, painterly abstraction, surrealism, postmodern works, impressionism, realism, photorealism and hard-edge geometric abstraction. Genres include landscapes, florals, southwestern and figurative work. Prefers abstract, landscapes and figurative. Seeking extraordinarily talented, outstanding artists who will continue to produce exceptional work.

Terms Accepts work on consignment (negotiable commission); or buys outright for negotiated percentage of retail price. Retail price set by the artist. Offers payment by installments. Gallery provides insurance, promotion and contract; shipping costs are shared. Prefers artwork unframed (gallery frames).

Submissions Prefers digital pictures e-mailed to roy@sapergalleries.com. Call for appointment to show portfolio of originals or photos of any type. Responds in 1 week. Files any material the artist does not need returned. Finds artists mostly through New York Art Expo.

Tips "Present your very best work to galleries that display works of similar style, quality and media. Must be outstanding, professional quality. Student quality doesn't cut it. Must be great. Be sure to include prices and SASE."

[N] SECOND STREET GALLERY

115 Second St. SE, Charlottesville VA 22902. (434)977-7284. Fax: (434)979-9793. E-mail: director @secondstreetgallery.org. Web site: www.secondstreetgallery.org. **Director:** Leah Stoddard. Estab. 1973. Sponsors approximately 8 exhibits/year. Average display time: 1 month. Open Tuesday-Saturday, 11-6; 1st Friday of every month, 6-8, with Artist Talk at 6:30. Overall price range: $300-2,000.

Media Considers all media, except craft. Most frequently exhibits sculpture, paintings, prints and photographs.

Style Exhibits the best of contemporary artistic expression.

Terms Artwork is accepted on consignment (30% commission).

Submissions Reviews slides/CDs in fall; $10 processing fee. Submit 10 slides or a CD for review; include artist's statement, cover letter, bio/résumé, and most importantly, a SASE. Responds in 2 months.

Tips Looks for work that is "cutting edge, innovative, unexpected."

[N] SELECT ART

1025 E. Levee St., Dallas TX 75207. (214)521-6833. Fax: (214)521-6344. E-mail: selart@swbell.n et. **Owner:** Paul Adelson. Private art gallery. Estab. 1986. Represents 25 emerging, mid-career and established artists. Exhibited artists include Barbara Elam and Larry Oliverson. Open all year; Monday-Saturday, 9-5 by appointment only. Located in North Dallas; 2,500 sq. ft. "Mostly I do corporate art placement." Clientele: 15% private collectors, 85% corporate collectors. Overall price range: $200-7,500; most work sold at $500-1,500.

Media Considers oil, fiber, acrylic, sculpture, glass, watercolor, mixed media, ceramic, pastel, collage, photography, woodcuts, linocuts, engravings, etchings and lithographs. Prefers monoprints, paintings on paper and photography.

Style Exhibits photorealism, minimalism, painterly abstraction, realism and impressionism. Genres include landscapes. Prefers abstraction, minimalism and impressionism.

Terms Accepts work on consignment (50% commission). Retail price set by consultant and artist. Sometimes offers customer discounts. Provides contract (if the artist requests one). Consultant pays shipping costs from gallery; artist pays shipping to gallery. Prefers artwork unframed.

Submissions "No florals or wildlife." Send query letter with résumé, slides, bio and SASE. Call for appointment to show portfolio of slides. Responds within 1 month, only if interested. Files slides, bio, price list. Finds artists through word of mouth and referrals from other artists.

Tips "Be timely when you say you are going to send slides, artwork, etc., and neatly label slides."

[N] PAUL SHARPE CONTEMPORARY ART

547 W. 27th St., 5th Floor, New York NY 10001. E-mail: paulsharpe1@msn.com. Web site: www.paulsharpegallery.com. **Director:** Paul Sharpe. Art gallery and consulting. Exhibits emerging and established artists. Exhibited artists include Gloria Garfinkel (painting, prints, sculpture) and Lenore RS Lim (prints). Sponsors 8-10 exhibits/year. Average display time: 4-5 weeks. Open Tuesday-Saturday, 11-6. Overall price range: $1,000-50,000.

Media Considers all media; mostly paintings and conceptual art.

Style Most frequently exhibits abstract and abstract landscape.

Terms Artwork is accepted on consignment and commission.

Submissions Send color copies of work, bio, statement and SASE. Finds artists through referrals by other artists and word of mouth.

SOUTH DAKOTA ART MUSEUM

South Dakota State University, Box 2250, Brookings SD 57007. (605)688-5423 or (866)805-7590. Fax: (605)688-4445. Web site: www.SouthDakotaArtMuseum.com. **Curator of Exhibits:** John

Rychtarik. Estab. 1970. Sponsors 15 exhibits/year. Average display time: 4 months. Open Monday-Friday, 10-5; Saturday, 10-4; Sunday, 12-4. Closed state holidays. Six galleries offer 26,000 sq. ft. of exhibition space. Overall price range: $200-6,000; most work sold at $500.

Media Considers all media and all types of prints. Most frequently exhibits painting, sculpture and fiber.

Style Considers all styles.

Terms Artwork is accepted on consignment (30% commission). Retail price set by the artist. Gallery provides insurance and promotion. Accepted 2D work must be framed and ready to hang.

Submissions Send query letter with artist's statement, bio, résumé, slides, SASE. Responds within 3 months, only if interested. Finds artists through word of mouth, portfolio reviews, art exhibits, referrals by other artists.

SPACES

2220 Superior Viaduct, Cleveland OH 44113. (216)621-2314. E-mail: info@spacesgallery.org. Web site: www.spacesgallery.org. Artist-run alternative space. Estab. 1978. "Exhibitions feature artists who push boundaries by experimenting with new forms of expression and innovative uses of media, presenting work of emerging artists and established artists with new ideas. SPACELab offers the same opportunity for younger artists and college students. The SPACES World Artist Program gives visiting national and international artists the opportunity to create new work and interact with the Northeast Ohio community." Sponsors 5-6 shows/year. Average display time: 6 weeks. Open all year; Tuesday-Sunday. Located in downtown Cleveland; 6,000 sq. ft.; "warehouse space with row of columns."

Media Considers all media. Most frequently exhibits installation, painting, video and sculpture.

Style "Style not relevant; presenting challenging new ideas is essential."

Terms Artists are provided honoraria, and 20% commission is taken on work sold. Gallery provides insurance, promotion and contract.

Submissions Contact SPACES for deadline and application. Also seeking curators interested in pursuing exhibition idea.

Tips "Present yourself professionally and don't give up."

SPAIGHTWOOD GALLERIES, INC.

P.O. Box 1193, Upton MA 01568-6193. (508)529-2511. E-mail: sptwd@verizon.net. Web site: www.spaightwoodgalleries.com. **President:** Sonja Hansard-Weiner. Vice President: Andy Weiner. For-profit gallery. Estab. 1980. Exhibits mostly established artists. "See 'Artists' page on our Web site: http://spaightwoodgalleries.com/Pages/Artists.html (9,000 works from late 15th century to present in inventory)." Sponsors 6 exhibits/year. Average display time: 2 months. Open by appointment. "We are located in a renovated ex-Unitarian Church; basic space is 90×46 ft; ceilings are 25 ft. high at center, 13 ft. at walls. See http://spaightwoodgalleries.com/Pages/Upton.html for views of the gallery. Clients include mostly Internet and visitors drawn by Internet; we are currently trying to attract visitors from Boston and vicinity via advertising and press releases." 2% of sales are to corporate collectors. Overall price range: $175-125,000; most work sold at $1,000-4,000.

Media Considers all media except installations, photography, glass, craft, fiber. Most frequently exhibits oil, drawing and ceramic sculpture. Considers all types of prints.

Style Exhibits old master to contemporary; most frequently impressionist and post-impressionist (Cassatt, Renoir, Cezanne, Signac, Gauguin, Bonnard), Fauve (Matisse, Rouault, Vlaminck, Derain) modern (Picasso, Matisse, Chagal, Miroó, Giacometti), German Expressionist (Heckel, Kollwitz, Kandinsky, Schmidt-Rottluff), Surrealist (Miroó, Fini, Tanning, Ernst, Lam, Matta); COBRA (Alechinsky, Appel, Jorn), Abstract Expressionist (Tàpies, Tal-Coat, Saura, Llèdos, Bird, Mitchell, Frankenthaler, Olitski), Contemporary (Claude Garache, Titus-Carmel, Joan Snyder, John Him-

melfarb, Manel Llèdos, Jonna Rae Brinkman). Most frequently exhibits modern, contemporary, impressionist and post-impressionist. "Most work shown is part of our inventory; we buy mostly at auction. In the case of some artists, we buy directly from the artist or the publisher; in others we have works on consignment."

Terms Retail price set by both artist and gallery. Accepted work should be unmatted and unframed. Requires exclusive representation locally.

Submissions Prefers link to Web site with bio, exhibition history and images. Returns material with SASE. Responds to queries only if interested. Finds artists through art exhibits (particularly museum shows), referrals by other artists, books.

Tips "Make high-quality art."

N T THE STATE MUSEUM OF PENNSYLVANIA

300 North St., Harrisburg PA 17120-0024. (717)783-9904. Fax: (717)783-4558. E-mail: nstevens@ state.pa.us. Web site: www.statemuseumpa.org. **Senior Curator of Art Collections:** N. Lee Stevens. Museum established in 1905; current Fine Arts Gallery opened in 1993. Number of exhibits varies. Average display time: 2 months. Overall price range: $50-3,000.

Media Considers all media and all types of prints.

Style Exhibits all styles and genres.

Terms Work is sold in gallery, but not actively. Connects artists with interested buyers. No commission. Accepted work should be framed. Art must be created by a native or resident of Pennsylvania, or contain subject matter relevant to Pennsylvania.

Submissions Send material by mail for consideration; include SASE. Responds in 1 month.

Tips "Have the best visuals possible. Make appointments. Remember most curators are also overworked, underpaid and on tight schedules."

N STATE OF THE ART

120 W. State St., Ithaca NY 14850. (607)277-1626 or (607)277-4950. E-mail: gallery@soag.org. Web site: www.soag.org. Cooperative gallery. Estab. 1989. Sponsors 12 exhibits/year. Average display time: 1 month. Open Wednesday-Friday, 12-6; weekends, 12-5. Located in downtown Ithaca; 2 rooms; about 1,100 sq. ft. Overall price range: $100-6,000; most work sold at $200-500.

Media Considers all media and all types of prints. Most frequently exhibits sculpture, paintings, mixed media.

Style Considers all styles and genres.

Terms There is a co-op membership fee plus a donation of time. There is a 10% commission for members, 30% for nonmembers. Retail price set by the artist. Gallery provides promotion and contract. Accepted work must be ready to hang.

Submissions Write for membership application. Finds artists through word of mouth, submissions, portfolio reviews, art exhibits, referrals by other artists.

STATE STREET GALLERY

1804 State St., La Crosse WI 54601. (608)782-0101. E-mail: ssg1804@yahoo.com. Web site: www. statestreetartgallery.com. **President:** Ellen Kallies. Retail gallery. Estab. 2000. Approached by 15 artists/year. Represents 40 emerging, mid-career and established artists. Exhibited artists include Diane French, Phyllis Martino, Michael Martino and Barbara Hart Decker. Sponsors 6 exhibits/ year. Average display time: 4-6 months. Open all year; Tuesday-Friday, 10-4; Saturday, 10-2; closed Saturdays in July. Located across from the University of Wisconsin/La Crosse on one of the main east/west streets. "We are next to a design studio; parking behind gallery." Clients include local community, tourists, upscale. 40% of sales are to corporate collectors, 60% to private collectors. Overall price range: $150-25,000; most work sold at $500-5,000.

Media Considers acrylic, collage, drawing, glass, mixed media, oil, pastel, sculpture, watercolor

and photography. Most frequently exhibits oil, dry pigment, drawing, watercolor and mixed media collage. Considers all types of prints.

Style Considers all styles and genres. Most frequently exhibits contemporary representational, realistic watercolor, collage.

Terms Artwork is accepted on consignment, and there is a 40% commission. Retail price set by the gallery and the artist. Gallery provides insurance, promotion, contract. Accepted work should be framed and matted.

Submissions Call to arrange a personal interview or mail portfolio for review. Send query letter with artist's statement, photographs or slides. Returns material with SASE. Responds in 1 month. Finds artists through word of mouth, art exhibits, art fairs, and referrals by other artists.

Tips "Be organized; be professional in presentation; be flexible! Most collectors today are savvy enough to want recent works on archival-quality papers/boards, mattes, etc. Have a strong and consistant body of work to present."

STETSON UNIVERSITY DUNCAN GALLERY OF ART

421 N. Woodland Blvd., Unit 8252, DeLand FL 32723. (386)822-7264. E-mail: dgunderson@stetson.edu. **Gallery Director:** Dan Gunderson. Nonprofit university gallery. Approached by 20 artists/year. Represents emerging and established artists. Sponsors 4-6 exhibits/year. Average display time: 4-5 weeks. Open September-April; Monday-Friday, 10-4; weekends, 1-4. Approximately 2,400 sq. ft. Clients include local community, students, tourists, school groups and elder hostelers.

Media Considers acrylic, ceramics, drawing, installation, mixed media, oil, acrylic, sculpture. Most frequently exhibits oil/acrylic, sculpture and ceramics.

Style Most frequently exhibits contemporary.

Terms 30% of price is returned to gallery. Retail price set by the artist. Gallery provides insurance. Accepted work should be framed, mounted and matted.

Submissions Send query letter with artist's statement, bio, letter of proposal, résumé, reviews, SASE and 20 slides. Returns material with SASE. May respond, but artist should contact by phone. Files "whatever is found worthy of an exhibition—even if for future." Finds artists through word of mouth, submissions, art exhibits, and referrals by other artists.

Tips Looks for "professional-quality slides, good letter of proposal."

ELIZABETH STONE GALLERY

1127 King St., Suite 201, Alexandria VA 22314. (703)706-0025. Fax: (703)706-0027. E-mail: elizabeth@elizabethstonegallery.com. Web site: www.elizabethstonegallery.com. **Owner:** Elizabeth Stone. Art consultancy. Estab. 1989. Approached by more than 50 artists/year; represents 100 established artists/year. Exhibited artists include Wendell Minor (watercolor/acrylic) and Lynn Munsinger (watercolor). Sponsors 12 exhibits/year. Average display time: 1 month. Open all year; Tuesday-Saturday, 11-6; Sunday, 12-5. Clients include local community, tourists and upscale. 25% of sales are to corporate collectors. Overall price range: $100-7,500; most work sold at $500-1,000.

Media Considers acrylic, ceramics, collage, fiber, mixed media, oil, paper, pastel, pen & ink, sculpture, watercolor. Most frequently exhibits watercolor, collage and mixed media. Considers limited edition prints by giclée reproduction and limited editions by offset reproduction.

Style Exhibits children's book illustration; specialist and consultant. Most frequently exhibits watercolor, collage and mixed media. Considers all genres.

Terms Artwork is accepted on consignment, and there is a 50% commission. Retail price of the art set by the gallery and the artist. Gallery provides insurance, promotion and contract. Accepted work does not have to be framed or matted. Does not require exclusive representation locally. Accepts art only from children's book illustrators.

Submissions Call or e-mail request. Cannot return material. Responds to queries in 1 month.

Files children's books. Finds artists through referrals by other artists, word of mouth, children's book submissions.

Tips "A phone call or e-mail with intent to me is enough. Provide quality book information of your published books."

⊞ SWORDS INTO PLOWSHARES PEACE CENTER AND GALLERY

33 E. Adams Ave., Detroit MI 48226. (313)963-7575. Fax: (313)963-2569. E-mail: swordsintoplow shares@prodigy.net. Web site: www.swordsintoplowshares.org. **Administrative Assistant:** Tina Mangum. Nonprofit peace center and gallery. "Our theme is Peace and Justice!" Estab. 1985. Presents 3-4 major shows/year. Open all year; Tuesday, Thursday and Saturday, 11-3. Located in downtown Detroit in the Theater District; 2,881 sq. ft.; 1 large gallery, 3 small galleries. 100% of space for special exhibitions. Clients include walk-in, church, school and community groups. 100% of sales are to private collectors. Overall price range: $75-6,000; most work sold at $75-700.

Media Considers all media and all types of prints.

Terms Retail price set by the artist. Gallery provides insurance and promotion.

Submissions Accepts artists primarily from Michigan and Ontario. Send query letter with statement on how work relates to theme. Responds in 2 months. Finds artists through lists from Michigan Council of the Arts and Windsor Council of the Arts.

ℕ SYNCHRONICITY FINE ARTS

106 W. 13th St., New York NY 10011. (646)230-8199. Fax: (646)230-8198. E-mail: synchspa@best web.net. Web site: www.synchronicityspace.com. Nonprofit gallery. Estab. 1989. Approached by several hundred artists/year. Exhibits 12-16 emerging and established artists. Sponsors 6 exhibits/year. Average display time: 1 month. Open Tuesday-Saturday, 12-6. Closed for 2 weeks in August. Clients include local community, students, tourists and upscale. 20% of sales are to corporate collectors. Overall price range: $1,500-10,000; most work sold at $3,000-5,000.

Media Considers acrylic, collage, drawing, mixed media, oil, paper, pastel, pen & ink, sculpture, watercolor, engravings, etchings, mezzotints and woodcuts. Most frequently exhibits oil, sculpture and photography.

Style Exhibits color field, expressionism, impressionism, postmodernism and painterly abstraction. Most frequently exhibits semi-abstract and semi-representational abstract. Genres include figurative work, landscapes and portraits.

Terms Retail price set by the gallery. Gallery provides insurance, promotion and contract. Accepted work should be framed, mounted and matted.

Submissions Write or call to arrange a personal interview to show portfolio of photographs, slides and transparencies. Send query letter with photocopies, photographs, résumé, SASE and slides. Returns material with SASE. Responds in 3 weeks. Files materials unless artist requests return. Finds artists through submissions, portfolio reviews, art exhibits and referrals by other artists.

JILL THAYER GALLERIES AT THE FOX

1700 20th St., Bakersfield CA 93301-4329. (661)328-9880. E-mail: jill@jillthayer.com. Web site: www.jillthayer.com. **Director:** Jill Thayer. For profit gallery. Estab. 1994. Represents 25+ emerging, mid-career and established artists of regional and international recognition. Features 6-8 exhibits/year. Average display time: 6 weeks. Open Friday-Saturday, 1-4 or by appointment. Closed holidays. Located at the historic Fox Theater, built in 1930. Thayer renovated the 400-sq.-ft. space in 1994. The gallery features large windows, high ceilings, wood floor and bare wire, halogen lighting system. Clients include regional and southern California upscale. 25% of sales are to corporate collectors. Overall price range: $250-10,000; most work sold at $2,500.

Media Considers all media, originals only. Exhibits painting, drawing, photography, sculpture, assemblage, glass.

Style Exhibits contemporary, abstract, and representational work.

Terms Artwork is accepted on consignment for duration of exhibit with 50% commission. Artist pays all shipping and must provide insurance. Retail price set by the gallery and the artist. Gallery provides marketing, mailer design, and partial printing. Artist shares cost of printing, mailings and receptions.

Submissions Send query letter with artist's statement bio, résumé, exhibition list, reviews, SASE and 12 slides. Responds in 1 month if interested. Finds artists through submissions and portfolio reviews.

Tips "When submitting to galleries, be concise, professional, send up-to-date package (art and info) and slide sheet of professionally documented work."

NATALIE AND JAMES THOMPSON ART GALLERY

School of Art Design, San Jose CA 95192-0089. (408)924-4723. Fax: (408)924-4326. E-mail: thompsongallery@cadre.sjsu.com. Web site: www.sjsu.edu. **Director:** Jo Farb Hernandez. Nonprofit gallery. Approached by 100 artists/year. Sponsors 6 exhibits/year of emerging, mid-career and established artists. Average display time: 1 month. Open during academic year; Tuesday, 11-4, 6-7:30; Monday, Wednesday-Friday, 11-4. Closed semester breaks, summer and weekends. Clients include local community, students and upscale.

Media Considers all media and all types of prints.

Style Considers all styles and genres.

Terms Retail price set by the artist. Gallery provides insurance, transportation and promotion. Accepted work should be framed and/or ready to display. Does not require exclusive representation locally.

Submissions Send query letter with artist's statement, bio, résumé, reviews, SASE and slides. Returns material with SASE.

TIBOR DE NAGY GALLERY

724 Fifth Ave., New York NY 10019. (212)262-5050. Fax: (212)262-1841. **Owners:** Andrew H. Arnot and Eric Brown. Retail gallery. Estab. 1950. Represents emerging and mid-career artists. Exhibited artists include Jane Freilicher, Robert Berlind, George Nick, David Kapp. Sponsors 12 shows/year. Average display time: 1 month. Closed August. Located midtown; 3,500 sq. ft. 100% of space for work of gallery artists. 60% private collectors, 40% corporate collectors. Overall price range: $1,000-100,000; most work sold at $5,000-20,000.

● The gallery focus is on painting within the New York School traditions, and photography.

Media Considers oil, pen & ink, paper, acrylic, drawings, sculpture, watercolor, mixed media, pastel, collage, etchings, and lithographs. Most frequently exhibits oil/acrylic, watercolor and sculpture.

Style Exhibits representational work as well as abstract painting and sculpture. Genres include landscapes and figurative work. Prefers abstract, painterly realism and realism.

Submissions Gallery is not looking for submissions at this time.

N J. TODD GALLERIES

572 Washington St., Wellesley MA 02482. (781)237-3434. E-mail: fineart@jtodd.com. Web site: www.jtodd.com. **Owner:** Jay Todd. Retail gallery. Estab. 1980. Represents 55 emerging, mid-career and established artists. Sponsors 2-3 shows/year. Average display time: 1 month. Open all year; Tuesday-Saturday, 10-5:30; Sunday, 1-5, October through April only; closed Sundays, May through September. Located "in Boston's wealthiest suburb"; 4,000 sq. ft.; vast inventory, professionally displayed. 30% of space for special exhibitions; 70% of space for gallery artists.

Clientele: residential and corporate; 75% private collectors, 25% corporate collectors. Overall price range: $500-40,000; most work sold at $1,000-15,000.

Media Considers oil, acrylic, watercolor, pen & ink, drawing, mixed media, woodcuts, engravings, lithographs, wood engravings, mezzotints, serigraphs, linocuts and etchings. Most frequently exhibits oils, woodcuts and etchings. "We do not accept pastels, giclées or sculpture."

Style Exhibits primitivism, modern, contemporary, postmodern works, impressionism and realism. Genres include landscape, seascape, nautical, urban scenes, abstracts, interiors, florals, figurative work and still life. Prefers landscapes, abstracts, figures and still lifes.

Terms Accepts work on consignment (negotiable commission). Retail price set by the artist. Gallery provides promotion. Prefers unframed artwork.

Submissions "Currently looking for contemporary and abstract. Send work via our Web site. Click on 'For Artists' and follow the outlined procedure." Files "all that is interesting to us." Finds artists through agents, submissions, visiting exhibitions, word of mouth, art publications and sourcebooks.

Tips "Give us a minimum of six works that are new and considered to be your BEST (maximum size 30" × 40")."

[N] TRI-ART GALLERY

2815 Van Giesen St., Richland WA 99354-4932. (509)551-3360. Fax: (509)942-0310. E-mail: dave @triartgallery.com. Web site: www.triartgallery.com. **Owner:** Dave Mitchell. For-profit gallery. Estab. 2005. Exhibits emerging, mid-career and established artists. Approached by 50 artists/year; represents or exhibits 25 artists. Exhibited artists include Jud Turner (welded steel) and Tom McClelland (bronze, stainless steel). Sponsors 12 exhibits/year. Average display time: 30 days for exhibits; 1 year for represented sculpture. Open Friday-Saturday, 10-6. Outdoor retail sculpture gallery on 2 riverfront acres; 1 indoor exhibition space (18×11 ft.) for indoor sculpture and 2D work. Clients include local community, students, tourists, upscale, public art. 25% of sales are to corporate collectors. Overall price range: $250-31,000; most work sold at $1,200.

Media Considers ceramics, collage, craft, glass, installation, mixed media, sculpture. Most frequently exhibits sculpture, collage, mixed media. "The majority of the work sold/represented is sculpture."

Style Considers all styles and genres.

Terms Artwork is accepted on consignment (negotiated commission). Retail price set by the artist. Gallery provides insurance, promotion, contract. Requires exclusive representation locally.

Submissions Prefers digital images. "The best way for artists to contact the gallery is with an e-mail query that includes a few digital photos of their work, or a link to their Web site so we can see their entire portfolio." Send query letter with artist's statement, bio, business card, reviews and SASE. Returns material with SASE. Responds to queries in 3 weeks. Files "any information the artist wants us to retain for future commissions/exhibitions." Finds artists through art exhibits, portfolio reviews, referrals by other artists, submissions, word of mouth.

Tips "Research the type of work exhibited in a given gallery before submitting to the gallery. Check the gallery's Web site to see if your work is compatible with the type of work shown there. Think ahead and make sure your pricing will be consistent between your own studio sales and gallery sales."

TRINITY GALLERY

315 E. Paces Ferry Rd., Atlanta GA 30305. (404)237-0370. Fax: (404)240-0092. E-mail: info@trinitygallery.com. Web site: www.trinitygallery.com. **President:** Alan Avery. Retail gallery and corporate sales consultants. Estab. 1983. Represents/exhibits 67 mid-career and established artists and old masters/year. Exhibited artists include Roy Lichtenstein, Jim Dine, Robert Rauschenberg, Andy Warhol, Larry Gray, Ray Donley, Robert Marx, Lynn Davison and Russell Whiting. Sponsors

6-8 shows/year. Average display time: 6 weeks. Open all year; Tuesday-Friday, 10-6; Saturday, 11-5 and by appointment. Located mid-city; 6,700 sq. ft.; 25-year-old converted restaurant. 50-60% of space for special exhibitions; 40-50% of space for gallery artists. Clientele: upscale, local, regional, national and international. 70% private collectors, 30% corporate collectors. Overall price range: $2,500-100,000; most work sold at $2,500-5,000.

Media Considers all media and all types of prints. Most frequently exhibits painting, sculpture and work on paper.

Style Exhibits expressionism, conceptualism, color field, painterly abstraction, postmodern works, realism, impressionism and imagism. Genres include landscapes, Americana and figurative work. Prefers realism, abstract and figurative.

Terms Artwork is accepted on consignment (negotiable commission). Retail price set by gallery. Gallery pays promotion and contract. Shipping costs are shared. Prefers framed artwork.

Submissions Send query letter with résumé, at least 20 slides, bio, prices, medium, sizes and SASE. Reviews every 6 weeks. Finds artists through submissions, word of mouth and referrals by other artists.

Tips "Be as complete and professional as possible in presentation. We provide submittal process sheets listing all items needed for review. Following this sheet is important."

▣ TURNER CARROLL GALLERY

725 Canyon Rd., Santa Fe NM 87501. (505)986-9800. Fax: (505)986-5027. E-mail: tcgallery@aol.com. Web site: www.turnercarrollgallery.com. **Owner:** Tonya Turner Carroll. Art consultancy; for-profit gallery. Estab. 1991. Exhibits established artists. Approached by more than 50 artists/year; represents or exhibits approximately 15 artists. Exhibited artists include Michael Bergt (egg tempura, bronze) and Igor Melnikov (oil on canvas). Sponsors approximately 11 exhibits/year. Average display time: 4-6 weeks. Open daily, 10-6 (Friday until 7). Closed Christmas Day. Gallery includes 3 salon rooms; 1,200 sq. ft. Clients include local community, tourists, upscale, private national collectors. Less than 10% of sales are to corporate collectors. Overall price range: $1,000-40,000; most work sold at $4,000-5,000.

Media Considers all media except glass, ceramics, fiber. Most frequently exhibits oil on canvas, acrylic, egg tempura. Considers all types of prints except posters.

Style Considers all genres. Most frequently exhibits contemporary figurative art and masterworks.

Terms Artwork is accepted on consignment (50% commission). Retail price set by the gallery. Gallery provides insurance and contract. Accepted work should be framed. Requires exclusive representation locally. Accepts only museum track artists.

Submissions Accepts submissions via e-mail only. Send query letter with artist's statement, bio, résumé and digital images. Responds to queries within 3 months, only if interested. Finds artists through art fairs.

▣ THE U GALLERY

221 E. Second St., New York NY 10009. (212)995-0395. E-mail: ugallery@ugallery.org. Web site: www.ugallery.org. **Contact:** Darius. Alternative space, for-profit gallery, art consultancy and rental gallery. Estab. 1989. Approached by 100 artists/year. Represents 3 emerging and established artists. Sponsors 2 exhibits/year. Open all year. Located in Manhattan; 500 sq. ft.

Media Considers acrylic, drawing, oil, paper, pastel, sculpture and watercolor. Considers all types of prints.

Style Exhibits conceptualism, geometric abstraction, impressionism, minimalism and surrealism. Genres include figurative work, landscapes, portraits and wildlife.

Submissions Write to arrange a personal interview to show portfolio of photographs and slides. Send query letter with artist's statement, photocopies, photographs and slides. Cannot return material. Finds artists through word of mouth and portfolio reviews.

ULRICH MUSEUM OF ART

Wichita State University, 1845 Fairmount St., Wichita KS 67260-0046. (316)978-3664. Fax: (316)978-3898. E-mail: ulrich@wichita.edu. Web site: www.ulrich.wichita.edu. **Director:** Dr. Patricia McDonnell. Estab. 1974. Wichita's premier venue for modern and contemporary art. Presents 6-8 shows/year. Open Tuesday-Friday, 11-5; Saturday and Sunday, 1-5; closed Mondays and major holidays. Admission is always free.

Media "Exhibition program includes all range of media."

Style "Style and content of exhibitions aligns with leading contemporary trends."

Submissions "For exhibition consideration, send cover letter with artist's statement, bio, sample printed material and visuals, SASE." Responds in 3 months.

N UNIVERSITY ART GALLERY IN THE D.W. WILLIAMS ART CENTER

New Mexico State University, MSC 3572, P.O. Box 30001, Las Cruces NM 88003-8001. (505)646-2545. Fax: (505)646-5207. E-mail: artglry@nmsu.edu. Web site: www.nmsu.edu/~artgal. **Interim Director:** John Lawson. Estab. 1973. Sponsors 5-6 exhibits/year. Average display time: 2 months. Overall price range: $300-2,500.

Media Considers all media and all types of prints.

Style Exhibits all styles and genres.

Terms Accepts work on consignment (33% commission). Retail price set by the artist. Shipping costs are paid by the gallery. Prefers artwork framed or ready to hang.

Submissions Arrange a personal interview to show portfolio. Submit portfolio for review. Send query letter with samples. Send material by mail with SASE by end of October for consideration. Responds in 3 months.

Tips "The gallery does mostly curated, thematic exhibitions; very few one-person exhibitions. Tenacity is a must."

VALE CRAFT GALLERY

230 W. Superior St., Chicago IL 60610. (312)337-3525. Fax: (312)337-3530. E-mail: peter@valecra ftgallery.com. Web site: www.valecraftgallery.com. **Owner:** Peter Vale. Retail gallery. Estab. 1992. Represents 100 emerging, mid-career artists/year. Exhibited artists include Tana Acton, Mark Brown, Tina Fung Holder, John Neering and Kathyanne White. Sponsors 4 shows/year. Average display time: 3 months. Open all year; Tuesday-Friday, 10:30-5:30; Saturday, 11-5. Located in River North gallery district near downtown; 2,100 sq. ft.; lower level of prominent gallery building; corner location with street-level windows provides great visibility. Clientele: private collectors, tourists, people looking for gifts, interior designers and art consultants. Overall price range: $50-2,000; most work sold at $100-500.

Media Considers paper, sculpture, ceramics, craft, fiber, glass, metal, wood and jewelry. Most frequently exhibits fiber wall pieces, jewelry, glass, ceramic sculpture and mixed media.

Style Exhibits contemporary craft. Prefers decorative, sculptural, colorful, whimsical, figurative, and natural or organic.

Terms Accepts work on consignment (50% commission). Retail price set by the artist. Gallery provides insurance, promotion, contract and shipping costs from gallery; artist pays shipping costs to gallery.

Submissions Accepts only craft media. No paintings, prints, or photographs. By mail: send query letter with résumé, bio or artist's statement, reviews if available, 10-20 slides, CD of images (in JPEG format) or photographs (including detail shots if possible), price list, record of previous sales, and SASE if you would like materials returned to you. By e-mail: include a link to your Web site or send JPEG images, as well as any additional information listed above. Call for appointment to show portfolio of originals and photographs. Responds in 2 months. Files résumé (if

interested). Finds artists through submissions, art and craft fairs, publishing a call for entries, artists' slide registry and word of mouth.

Tips "Call ahead to find out if the gallery is interested in showing the particular type of work that you make. Try to visit the gallery ahead of time or check out the gallery's Web site to find out if your work fits into the gallery's focus. I would suggest you have at least 20 pieces in a body of work before approaching galleries."

N VIENNA ARTS SOCIETY—ART CENTER

115 Pleasant St., Vienna VA 22180. (703)319-3971. E-mail: teresa@tlcillustration.com. Web site: www.viennaartssociety.org. **Director:** Teresa Ahmad. Nonprofit rental gallery and art center. Estab. 1969. Exhibits emerging, mid-career and established artists. Approached by 100-200 artists/year; exhibits 50-100 artists. "Anyone to become a member of the Vienna Arts Society has the opportunity to exhibit their work." Sponsors 3 exhibits/year. Average display time: 3-4 weeks. Open Tuesday-Saturday, 10-4. Closed Federal holidays. Located off Route 123, approximately 3 miles south of Beltway 495; historic building in Vienna; spacious room with modernized hanging system; 3 display cases for 3D, glass, sculpture, jewelry, etc. Clients include local community, students and tourists. Overall price range: $100-1,500; most work sold at $200-500.

Media Considers all media except basic crafts. Most frequently exhibits watercolor, acrylic and oil.

Style Considers all styles.

Terms Artwork is accepted on consignment, and there is a 20% commission. There is a rental fee that covers 1 month, "based on what we consider a 'featured artist' exhibit." Gallery handles publicity with the artist. Retail price set by the artist. Gallery provides promotion and contract. Accepted work must be framed or matted. "We do accept 'bin pieces' matted and shrink wrapped." VAS members can display at any time. Non-members will be asked for a rental fee when space is available.

Submissions Call. Responds to queries in 2 weeks. Finds artists through art fairs and exhibits, referrals by other artists and membership.

N VILLA JULIE COLLEGE GALLERY

1525 Green Spring Valley Rd., Stevenson MD 21153. (443)334-2163. Fax: (410)486-3552. E-mail: dea-dian@mail.vjc.edu. Web site: www.vjc.edu. **Contact:** Diane DiSalvo. College/university gallery. Estab. 1997. Approached by many artists/year. Represents numerous emerging, mid-career and established artists. Sponsors 14 exhibits/year. Average display time: 8 weeks. Open all year; Monday-Tuesday and Thursday-Friday, 11-5; Wednesday, 11-8; Saturday, 1-4. Located in the Greenspring Valley, 5 miles north of downtown Baltimore; beautiful space in renovated academic center and student center. "We do not take commission; if someone is interested in an artwork we send them directly to the artist."

Media Considers all media and all types of prints except posters. Most frequently exhibits painting, sculpture, photography and works on paper.

Style Considers all styles and genres.

Terms Artwork is accepted on consignment, and there is no commission. Retail price set by the artist. Gallery provides insurance. Does not require exclusive representation locally. Has emphasis on mid-Atlantic regional artists but does not set geographic limitations.

Submissions Write to arrange a personal interview to show portfolio of slides. Send query letter with artist's statement, bio, résumé, reviews, SASE and slides. Returns material with SASE. Responds in 3 months. Files bio, statement, reviews, letter, but will return slides. Finds artists through word of mouth, submissions, portfolio reviews, art exhibits, and referrals by other artists.

Tips "Be clear and concise, and have good slides or representative media."

VIRIDIAN ARTISTS, INC.

530 W. 25th St., #407, New York NY 10001. (212)414-4040. Fax: (212)414-4040. E-mail: info@viridianartists.com. Web site: www.viridianartists.com. **Director:** Barbara Neski. Estab. 1968. Sponsors 11 exhibits/year. Average display time: 4 weeks. Overall price range: $175-10,000; most work sold at $1,500.

Media Considers oil, acrylic, watercolor, pastel, pen & ink, drawings, mixed media, collage, works on paper, sculpture, installation, photography and limited edition prints. Most frequently exhibits works on canvas, sculpture, mixed media, works on paper and photography.

Style Exhibits hard-edge geometric abstraction, color field, painterly abstraction, conceptualism, postmodern works, primitivism, photorealism, abstract, expressionism, and realism. "Eclecticism is Viridian's policy. The only unifying factor is quality. Work must be of the highest technical and aesthetic standards."

Terms Accepts work on consignment (30% commission). Retail price set by gallery and artist. Sometimes offers customer discounts and payment by installment. Gallery provides promotion, contract and representation.

Submissions Will review transparencies and CDs only if submitted as part of membership application for representation with SASE. Request information for representation via phone or e-mail, or check Web site.

Tips "Artists often don't realize that they are presenting their work to an artist-owned, professionally run gallery. They must pay each month to maintain their representation. We feel a need to demand more of artists who submit work. Because of the number of artists who submit work, our criteria for approval has increased as we receive stronger work than in past years, due to commercial gallery closings."

WAILOA CENTER

Division of State Parks, Department of Land & Natural Resources, State of Hawaii, P.O. Box 936, Hilo HI 96721. (808)933-0416. Fax: (808)933-0417. E-mail: wailoa@yahoo.com. **Director:** Codie M. King. Nonprofit gallery and museum. Focus is on propagation of the culture and arts of the Hawaiian Islands and their many ethnic backgrounds. Estab. 1968. Represents/exhibits 300 emerging, mid-career and established artists. Interested in seeing work of emerging artists. Sponsors 36 shows/year. Average display time: 1 month. Open all year; Monday, Tuesday, Thursday and Friday, 8:30-4:30; Wednesday, 12-4:30; closed weekends and state holidays. Located downtown; 10,000 sq. ft.; 4 exhibition areas. Clientele: tourists, upscale, local community and students. Overall price range: $25-25,000; most work sold at $1,500.

Media Considers all media and most types of prints. No giclée prints; original artwork only. Most frequently exhibits mixed media.

Style Exhibits all styles. "We cannot sell, but will refer buyer to artist." Gallery provides some promotion. Artist pays for shipping, invitation, and reception costs. Artwork must be framed.

Submissions Send query letter with résumé, slides, photographs and reviews. Call for appointment to show portfolio of photographs and slides. Responds in 3 weeks. Finds artists through word of mouth, referrals by other artists, visiting art fairs and exhibitions, submissions.

Tips "We welcome all artists, and try to place them in the best location for the type of art they create. Drop in and let us review what you have."

WASHINGTON COUNTY MUSEUM OF FINE ARTS

P.O. Box 423, Hagerstown MD 21741. (301)739-5727. Fax: (301)745-3741. E-mail: info@wcmfa.org. Web site: www.wcmfa.org. **Contact:** Curator. Estab. 1929. Approached by 30 artists/year. Average display time: 6-8 weeks. Open Tuesday-Friday, 9-5; Saturday, 9-4; Sunday, 1-5. Closed legal holidays. Overall price range: $50-7,000.

Media Considers all media except installation and craft. Most frequently exhibits oil, watercolor and ceramics. Considers all types of prints except posters.

Style Exhibits impressionism. Genres include florals, landscapes, portraits and wildlife.

Terms Museum provides artist's contact information to potential buyers. Accepted work should not be framed.

Submissions Write to show portfolio of photographs, slides. Mail portfolio for review. Responds in 1 month. Finds artists through word of mouth, portfolio reviews, art exhibits, referrals by other artists.

MARCIA WEBER/ART OBJECTS, INC.

1050 Woodley Rd., Montgomery AL 36106. (334)262-5349. Fax: (334)567-0060. E-mail: weberart @mindspring.com. Web site: www.marciaweberartobjects.com. **Owner:** Marcia Weber. Retail, wholesale gallery. Estab. 1991. Represents 21 emerging, mid-career and established artists/year. Exhibited artists include Woodie Long, Jimmie Lee Sudduth, Michael Banks, Mose Tolliver, Mary Whitfield, Malcah Zeldis. Open all year by appointment or by chance, weekday afternoons. Located in Old Cloverdale near downtown in older building with hardwood floors. 100% of space for gallery artists. Clientele: tourists, upscale. 90% private collectors, 10% corporate collectors. Overall price range: $300-20,000; most work sold at $300-4,000.

 • This gallery owner specializes in the work of self-taught, folk, or outsider artists. Marcia Weber moves the gallery to New York's Soho district 3 weeks each winter and routinely shows in the Atlanta area.

Media Considers all media except prints. Must be original one-of-a-kind works of art. Most frequently exhibits acrylic, oil, found metals, found objects and enamel paint.

Style Exhibits genuine contemporary folk/outsider art, self-taught art and some Southern antique original works.

Terms Accepts work on consignment (variable commission) or buys outright. Gallery provides insurance, promotion and contract if consignment is involved. Prefers artwork unframed so the gallery can frame it.

Submissions "Folk/outsider artists usually do not contact dealers. They have a support person or helper, who might write or call, send query letter with photographs, artist's statement." Call or write for appointment to show portfolio of photographs, original material. Finds artists through word of mouth, other artists and "serious collectors of folk art who want to help an artist get in touch with me." Gallery also accepts consignments from collectors.

Tips "An artist is not a folk artist or an outsider artist just because their work resembles folk art. They have to *be* folks who began creating art without exposure to fine art. Outsider artists live in their own world outside the mainstream and create art. Academic training in art excludes artists from this genre." Prefers artists committed to full-time creating.

⊞ WEST END GALLERY

5425 Blossom, Houston TX 77007. (713)861-9544. E-mail: kpackl1346@aol.com. **Owner:** Kathleen Packlick. Retail gallery. Estab. 1991. Exhibits emerging and mid-career artists. Open all year. Located 5 mintues from downtown Houston; 800 sq. ft.; "The gallery shares the building (but not the space) with West End Bicycles." 75% of space for special exhibitions; 25% of space for gallery artists. Clientele: 100% private collectors. Overall price range: $30-2,200; most work sold at $300-600.

Media Considers oil, pen & ink, acrylic, drawings, watercolor, mixed media, pastel, collage, woodcuts, wood engravings, linocuts, engravings, mezzotints, etchings, lithographs and serigraphs. Prefers collage, oil and mixed media.

Style Exhibits conceptualism, minimalism, primitivism, postmodern works, realism and imagism. Genres include landscapes, florals, wildlife, portraits and figurative work.

Terms Accepts work on consignment (40% commission). Retail price set by artist. Payment by installment is available. Gallery provides promotion; artist pays shipping costs. Prefers framed artwork.

Submissions Accepts only artists from Houston area. Send query letter with slides and SASE. Portfolio review requested if interested in artist's work.

▓ WALTER WICKISER GALLERY

210 11th Ave., Suite 303, New York NY 10001. (212)941-1817. Fax: (212)625-0601. E-mail: wwick iserg@aol.com. Web site: www.walterwickisergallery.com. For-profit gallery. Shows only established artists.

THE WING GALLERY

13632 Ventura Blvd., Sherman Oaks CA 91423. (818)981-WING and (800)422-WING. Fax: (818)981-ARTS. E-mail: robin@winggallery.com. Web site: www.winggallery.com. **Director:** Robin Wing. Retail gallery. Estab. 1975. Represents 100+ emerging, mid-career and established artists. Exhibited artists include Doolittle and Wysocki. Sponsors 6 shows/year. Average display time: 2 weeks-3 months. Open all year. Located on a main boulevard in a charming freestanding building, carpeted; separate frame design area. 60% of space for special exhibitions. Clientele: 90% private collectors, 10% corporate collectors. Overall price range: $50-$50,000; most work sold at $150-$5,000.

Media Considers oil, acrylic, watercolor, pen & ink, drawings, sculpture, ceramic, craft, glass, original handpulled prints, offset reproductions, engravings, lithographs, monoprints and serigraphs. Most frequently exhibits offset reproductions, watercolor and sculpture.

Style Exhibits primitivism, impressionism, realism and photorealism. Genres include landscapes, Americana, Southwestern, Western, wildlife and fantasy.

Terms Accepts work on consignment (40-50% commission). Retail price set by gallery and artist. Sometimes offers customer discounts and payment by installments. Gallery provides insurance, promotion and contract; shipping costs are shared. Prefers unframed artwork.

Submissions Send query letter with résumé, slides, bio, brochure, photographs, SASE, reviews and price list. "Send complete information with your work regarding price, size, medium, etc., and make an appointment before dropping by." Portfolio reviews requested if interested in artist's work. Responds in 2 months. Files current information and slides. Finds artists through agents, by visiting exhibitions, word of mouth, various publications, submissions and referrals.

Tips Artists should have a "professional presentation" and "consistent quality."

▓ WOMEN & THEIR WORK ART SPACE

1710 Lavaca St., Austin TX 78701. (512)477-1064. Fax: (512)477-1090. E-mail: info@womenandt heirwork.org. Web site: www.womenandtheirwork.org. **Program Director:** Katherine McQueen. Alternative space and nonprofit gallery. Estab. 1978. Approached by more than 200 artists/year. Sponsors 8-10 solo and seasonal juried shows of emerging and mid-career Texas women. Exhibited artists include Margarita Cabrera, Misty Keasler, Karyn Olivier, Angela Fraleigh and Liz Ward. Average display time: 5 weeks. Open Monday-Friday, 9-6; Saturday, 12-5. Closed holidays. Located downtown; 2,000 sq. ft. Clients include local community, students, tourists and upscale. 10% of sales are to corporate collectors. Overall price range: $500-5,000; most work sold at $800-1,000.

Media Considers all media. Most frequently exhibits photography, sculpture, installation and painting.

Style Exhibits contemporary. Most frequently exhibits minimalism, conceptualism and imagism.

Terms Selects artists through an Artist Advisory Panel and Curatorial/Jury process. Pays artists to exhibit. Takes 25% commission if something is sold. Retail price set by the gallery and the

artist. Gallery provides insurance, promotion and contract. Accepted work should be framed, mounted and matted. Accepts Texas women in solo shows only; all other artists, male or female, in one annual curated show. See Web site for more information.

Submissions See Web site for current Call for Entries. Returns materials with SASE. Filing of material depends on artist and if he/she is a member. Online Slide Registry on Web site for members. Finds artists through submissions and annual juried process.

Tips Send quality slides/digital images, typed résumé, and clear statement with artistic intent. 100% archival material required for framed works.

N Z WOMEN'S CENTER ART GALLERY

University of California at Santa Barbara, Student Resource Building 1220, Santa Barbara CA 93106-7190. (805)893-3778. Fax: (805)893-3289. E-mail: sharon.hoshida@sa.ucsb.edu. Web site: www.sa.ucsb.edu/women'scenter. **Program Director:** Sharon Hoshida. Nonprofit gallery. Estab. 1973. Approached by 200 artists/year; represents or exhibits 50 artists. Sponsors 4 exhibits/year. Average display time: 11 weeks. Open Monday-Thursday, 10-9; Friday, 10-5. Closed UCSB campus holidays. Exhibition space is roughly 750 sq. ft. Clients include local community and students. Overall price range: $10-1,000; most work sold at $300.

Media Considers all media and all types of prints. Most frequently exhibits acrylic, mixed media and photography.

Style Considers all styles and genres. Most frequently exhibits post modernism, feminist art and abstraction.

Terms Artwork is accepted on consignment (no commission). Retail price set by the artist. Gallery provides insurance and promotion. Accepted work should be framed. Preference given to residents of Santa Barbara County.

Submissions Mail portfolio for review. Send query letter with artist's statement, bio, photocopies, photographs, résumé, slides, SASE. Responds within 3 months, only if interested. Finds artists through word of mouth, portfolio reviews, art exhibits, e-mail and promotional calls to artists.

Tips "Complete your submission thoroughly and include a relevent statement pertaining to the specific exhibit."

N WOODWARD GALLERY

133 Eldridge St., Ground Floor, New York NY 10002. (212)966-3411. Fax: (212)966-3491. E-mail: art@woodwardgallery.net. Web site: www.woodwardgallery.net. **Director:** John Woodward. For-profit gallery. Estab. 1994. Exhibits emerging, mid-career and established artists. Approached by more than 2,000 artists/year; represents 10 artists/year. Exhibited artists include Cristina Vergano (oil on canvas/wood panel), Charles Yoder (oil on canvas; works on paper) and Margaret Morrison (oil on canvas/wood panel and paper). Also features work by Andy Warhol, Richard Hambleton, Jean-Michel Basquiat and Robert Indiana. Sponsors 6 exhibits/year. Average display time: 2 months. Open Tuesday-Saturday, 11-6; August by private appointment only. Clients include local community, tourists, upscale, and other art dealers. 20% of sales are to corporate collectors. Overall price range: $3,000-5,000,000; most work sold at $10-100,000.

Media Considers acrylic, collage, drawing, mixed media, oil, paper, pastel, pen & ink, sculpture, watercolor. Most frequently exhibits canvas, paper and sculpture. Considers all types of prints.

Style Most frequently exhibits realism/surrealism, pop, abstract and landscapes. Genres include figurative work, florals, landscapes and portraits.

Terms Artwork is bought outright (net 30 days) or consigned. Retail price set by the gallery.

Submissions Call before sending anything. Send query letter with artist's statement, bio, brochure, photocopies, photographs, reviews and SASE. Returns material with SASE. Finds artists through referrals or submissions.

Tips "An artist must follow our artist review criteria, which is available every new year (first or second week of January) with updated policy from director."

WORLD FINE ART GALLERY

511 W. 25th St., #803, New York NY 10001-5501. (646)336-1677. Fax: (646)336-6090. E-mail: info@worldfineart.com. Web site: www.worldfineart.com. **Director:** O'Delle Abney. Cooperative gallery. Estab. 1992. Approached by 1,500 artists/year; represents or exhibits 50 artists. Average display time: 1 month. Open Tuesday-Saturday, 12-6. Closed during August. Located in Chelsea, NY; 1,000 sq. ft. Overall price range: $500-5,000; most work sold at $1,500.

Media Considers all media. Most frequently exhibits acrylic, oil and mixed media. Types of prints include lithographs, serigraphs and woodcuts.

Style Exhibits color field. Considers all styles and genres. Most frequently exhibits painterly abstraction, color field and surrealism.

Terms There is a rental fee for space that covers 1 month or 1 year. Retail price set by the artist. Gallery provides insurance, promotion and contract. Accepted work should be framed; must be considered suitable for exhibition.

Submissions Write to arrange a personal interview to show portfolio, or e-mail JPEG images. Responds to queries in 1 week. Finds artists through the Internet.

Tips "Have Web site available for review."

☒ YEISER ART CENTER INC.

200 Broadway, Paducah KY 42001-0732. (270)442-2453. E-mail: info@theyeiser.org. Web site: www.yeiserartcenter.com. **Contact:** Ms. Catie Bates, gallery specialist, or Ms. Landee Bryant, administrative specialist. Nonprofit gallery. Estab. 1957. Exhibits emerging, mid-career and established artists. 450 members. Sponsors 8-10 shows/year. Average display time: 6-8 weeks. Open all year. Located downtown; 1,800 sq. ft.; "in historic building that was farmer's market." 90% of space for special exhibitions. Clientele: professionals and collectors. 90% private collectors. Overall price range: $200-8,000; most artwork sold at $200-1,000.

Media Considers all media. Prints considered include original handpulled prints, woodcuts, wood engravings, linocuts, mezzotints, etchings, lithographs and serigraphs.

Style Exhibits all styles and genres.

Terms Gallery takes 40% commission on all sales (60/40 split), and expenses are negotiated.

Submissions Send résumé, slides, bio, SASE and reviews. Responds in 3 months.

Tips "Do not call. Give complete information about the work—media, size, date, title, price. Have good-quality slides of work, indicate availability, and include artist statement. Presentation of material is important."

YELLOWSTONE GALLERY

216 W. Park St., P.O. Box 472, Gardiner MT 59030. (406)848-7306. E-mail: jckahrs@aol.com. Web site: yellowstonegallery.com. **Owner:** Jerry Kahrs. Retail gallery. Estab. 1985. Represents 20 emerging and mid-career artists/year. Exhibited artists include Mary Blain and Nancy Glazier. Sponsors 2 shows/year. Average display time: 2 months. Located downtown; 3,000 sq. ft. 25% of space for special exhibitions; 50% of space for gallery artists. Clientele: tourist and regional. 90% private collectors, 10% corporate collectors. Overall price range: $25-8,000; most work sold at $75-600.

Media Considers oil, acrylic, watercolor, ceramics, craft and photography; types of prints include wood engravings, serigraphs, etchings and posters. Most frequently exhibits watercolors, oils and limited edition, signed and numbered reproductions.

Style Exhibits impressionism, photorealism and realism. Genres include Western, wildlife and landscapes. Prefers wildlife realism, Western and watercolor impressionism.

Terms Accepts work on consignment (45% commission). Retail price set by the artist. Gallery provides contract; artist pays for shipping. Prefers artwork framed.

Submissions Send query letter with brochure or 10 slides. Write for appointment to show portfolio of photographs. Responds in 1 month. Files brochure and biography. Finds artists through word of mouth, regional fairs and exhibits, mail and periodicals.

Tips "Don't show up unannounced without an appointment."

⟨N⟩ ZENITH GALLERY

413 Seventh St. NW, Washington DC 20004. E-mail: art@zenithgallery.com. Web site: www.zenit hgallery.com. **Owner/Director:** Margery E. Goldberg. For-profit gallery. Estab. 1978. Exhibits emerging, mid-career and established artists. Open Tuesday-Friday, 11-6; Saturday, 11-7; Sunday, 12-5. Three rooms; 2,400 sq. ft. of exhibition space. Clients include local community, tourists and upscale. 50% of sales are to corporate collectors. Overall price range: $5,000-10,000.

Media Considers all media.

Terms Requires exclusive representation locally for solo exhibitions.

Submissions Send query letter with artist's statement, bio, résumé, reviews, brochures, images on CD, SASE. Returns material with SASE. Responds to most queries. Finds artists through art fairs/exhibits, portfolio reviews, referrals by other artists, submissions and word of mouth.

Tips "The review process can take anywhere from one month to one year. Please be patient and do not call the gallery for acceptance information." Visit Web site for detailed submission guidelines before sending any materials.

Magazines

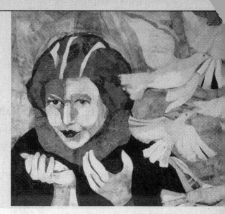

Magazines are a major market for freelance illustrators. The best proof of this fact is as close as your nearest newsstand. The colorful publications competing for your attention are chock-full of interesting illustrations, cartoons and caricatures. Since magazines are generally published on a monthly or bimonthly basis, art directors look for dependable artists who can deliver on deadline and produce quality artwork with a particular style and focus.

Art that illustrates a story in a magazine or newspaper is called editorial illustration. You'll notice that term as you browse through the listings. Art directors look for the best visual element to hook the reader into the story. In some cases this is a photograph, but often, especially in stories dealing with abstract ideas or difficult concepts, an illustration makes the story more compelling. A whimsical illustration can set the tone for a humorous article, or an edgy caricature of movie stars in boxing gloves might work for an article describing conflicts within a film's cast. Flip through a dozen magazines in your local drugstore and you will quickly see that each illustration conveys the tone and content of articles while fitting in with the magazine's "personality."

The key to success in the magazine arena is matching your style to appropriate publications. Art directors work to achieve a synergy between art and text, making sure the artwork and editorial content complement each other.

TARGET YOUR MARKETS

Read each listing carefully. Knowing how many artists approach each magazine will help you understand how stiff your competition is. (At first, you might do better submitting to art directors who aren't swamped with submissions.) Look at the preferred subject matter to make sure your artwork fits the magazine's needs. Note the submission requirements and develop a mailing list of markets you want to approach.

Visit newsstands and bookstores. Look for magazines not listed in *Artist's & Graphic Designer's Market*. Check the cover and interior; if illustrations are used, flip to the masthead (usually a box in one of the beginning pages) and note the art director's name. The circulation figure is also relevant; the higher the circulation, the higher the art director's budget (generally). When art directors have a good budget, they tend to hire more illustrators and pay higher fees.

Look at the credit lines next to each illustration. Notice which illustrators are used often in the publications you wish to work with. You will see that each illustrator has a very definite style. After you have studied dozens of magazines, you will understand what types of illustrations are marketable.

Although many magazines can be found at a newsstand or library, some of your best markets may not be readily available. If you can't find a magazine, check the listing in *Artist's & Graphic Designer's Market* to see if sample copies are available. Keep in mind that many magazines also provide artists' guidelines on their Web sites.

CREATE A PROMO SAMPLE

Focus on one or two *consistent* styles to present to art directors in sample mailings. See if you can come up with a style that is different from every other illustrator's style, if only slightly. No matter how versatile you may be, limit styles you market to one or two. That way, you'll be more memorable to art directors. Choose a style or two that you enjoy and can work in relatively quickly. Art directors don't like surprises. If your sample shows a line drawing, they expect you to work in that style when they give you an assignment. It's fairly standard practice to mail nonreturnable samples: either postcard-size reproductions of your work, photocopies or whatever is requested in the listing. Some art directors like to see a résumé; some don't.

MORE MARKETING TIPS

- **Don't overlook trade magazines and regional publications.** While they may not be as glamorous as national consumer magazines, some trade and regional publications are just as lavishly produced. Most pay fairly well, and the competition is not as fierce. Until you can get some of the higher-circulation magazines to notice you, take assignments from smaller magazines. Alternative weeklies are great markets as well. Despite their modest payment, there are many advantages to working with them. You learn how to communicate with art directors, develop your signature style, and learn how to work quickly to meet deadlines. Once the assignments are done, the tearsheets become valuable samples to send to other magazines.

- **Develop a spot illustration style in addition to your regular style.** "Spots"—illustrations that are half-page or smaller—are used in magazine layouts as interesting visual cues to lead readers through large articles or to make filler articles more appealing. Though the fee for one spot is less than for a full layout, art directors often assign five or six spots within the same issue to the same artist. Because spots are small in size, they must be all the more compelling. So send art directors a sample showing a few powerful small pieces along with your regular style.

- **Invest in a fax machine, e-mail and graphics software.** Art directors like to work with illustrators who have fax machines and e-mail, because they can quickly fax or e-mail a layout with a suggestion. The artist can send back a preliminary sketch or "rough" for the art director to approve. They also appreciate it if you can e-mail digital files of your work.

- **Get your work into competition annuals and sourcebooks.** The term "sourcebook" refers to the creative directories published annually to showcase the work of freelancers. Art directors consult these publications when looking for new styles. Many listings mention if an art director uses sourcebooks. Some directories like *The Black Book*, *American Showcase* and *RSVP* carry paid advertisements costing several thousand dollars per page. Other annuals, like the *PRINT Regional Design Annual* or *Communication Arts Illustration Annual*, feature award winners of various competitions. An entry fee and some great images can put your work in a competition directory and in front of art directors across the country.

- **Consider hiring a rep.** If after working successfully on several assignments you decide to make magazine illustration your career, consider hiring an artists' representative to market your work for you. (See the Artists' Reps section, beginning on page 486.)

Helpful Resources

For More Info

- A great source for new magazine leads is in the business section of your local library. Ask the librarian to point out the business and consumer editions of the *Standard Rate and Data Service (SRDS)* and *Bacon's Magazine Directory*. These huge directories list thousands of magazines and will give you an idea of the magnitude of magazines published today. Another good source is a yearly directory called *Samir Husni's Guide to New Consumer Magazines*, also available in the business section of the public library and online at www.mrmagazine.com. *Folio* magazine provides information about new magazine launches and redesigns.

- Each year the Society of Publication Designers sponsors a juried competition, the winners of which are featured in a prestigious exhibition. For information about the annual competition, contact the Society of Publication Designers at (212)223-3332 or visit their Web site at www.spd.org.

- Networking with fellow artists and art directors will help you find additional success strategies. The Graphic Artists Guild (www.gag.org), The American Institute of Graphic Artists (www.aiga.org), your city's Art Directors Club (www.adcglobal.org) or branch of the Society of Illustrators (www.societyillustrators.org) hold lectures and networking functions. Attend one event sponsored by each organization in your city to find a group you are comfortable with, then join and become an active member.

AARP THE MAGAZINE

601 E St. NW, Washington DC 20049. (202)434-2277. Fax: (202)434-6451. Web site: www.aarpmagazine.org. **Design Director:** Eric Seidman. Art Director: Courtney Murphy-Price. Estab. 2002. Bimonthly 4-color magazine emphasizing health, lifestyles, travel, sports, finance and contemporary activities for members 50 years and over. Circ. 21 million.

Illustration Approached by 200 illustrators/year. Buys 30 freelance illustrations/issue. Assigns 60% of illustrations to well-known or "name" illustrators; 30% to experienced but not well-known illustrators; 10% to new and emerging illustrators. Works on assignment only. Considers digital, watercolor, collage, oil, mixed media and pastel.

First Contact & Terms Samples are filed "if I can use the work." Do not send portfolio unless requested. Portfolio can include original/final art, tearsheets, slides and photocopies and samples to keep. Originals are returned after publication. Buys first rights. Pays on completion of project: $700-3,500.

Tips "We generally use people with strong conceptual abilities. I request samples when viewing portfolios."

ABA BANKING JOURNAL

American Bankers Association, 345 Hudson St., 12th Floor, New York NY 10014-4502. (212)620-7256. Fax: (212)633-1165. E-mail: wwilliams@sbpub.com. Web site: www.ababj.com. **Creative**

Director: Wendy Williams. Associate Creative Director: Phil Desiere. Estab. 1908. Monthly association journal; 4-color with contemporary design. Emphasizes banking for middle and upper level banking executives and managers. Circ. 31,440.

Illustration Buys 4-5 illustrations/issue from freelancers. Features charts & graphs, computer, humorous and spot illustration. Assigns 20% of illustrations to new and emerging illustrators. Themes relate to stories, primarily financial, from the banking industry's point of view; styles vary, realistic, surreal. Uses full-color illustrations. Works on assignment only.

First Contact & Terms Illustrators: Send finance-related postcard sample and follow-up samples every few months. To send a portfolio, send query letter with brochure and tearsheets, promotional samples or photographs. Negotiates rights purchased. **Pays on acceptance**: $250-950 for color cover; $250-450 for color inside; $250-450 for spots. Accepts previously published material. Returns original artwork after publication.

Tips Must have experience illustrating for business or financial publications.

ACTIVE LIFE

Windhill Manor, Leeds Rd., Shipley, W. Yorkshire BD18 1BP United Kingdom. 0800-560900. E-mail: info@activelife.co.uk. Web site: www.activelife.co.uk. **Managing Editor:** Helene Hodge. Estab. 1990. Bimonthly consumer magazine emphasizing lively lifestyle for people over age 50. Circ. 240,000.

Illustration Approached by 200 illustrators/year. Buys 12 illustrations/issue. Features humorous illustration. Prefers family-related themes, pastels and bright colors. Assigns 20% of illustration to well-known or "name" illustrators; 60% to experienced, but not well-known illustrators; 20% to new and emerging illustrators.

First Contact & Terms Send nonreturnable samples. Accepts Mac-compatible disk submissions. Samples are filed. Responds within 1 month. Will contact artist for portfolio review if interested. Buys all rights. Pays on publication. Finds illustrators through promotional samples.

Tips "We use all styles, but more often 'traditional' images."

ADVANSTAR LIFE SCIENCES

123 Tice Blvd., Woodcliff Lake NJ 07677. (201)690-5300. E-mail: mec.art@advanstar.com. Web site: www.advanstar.com. Estab. 1909. Publishes 9 health-related publications and special products. Uses freelance artists for "most editorial illustration in the magazines."

Cartoons Prefers general humor topics (workspace, family, seasonal); also medically related themes. Prefers single-panel b&w drawings and washes with gagline.

Illustration Interested in all media, including 3D, electronic and traditional illustration. Needs editorial and medical illustration that varies "but is mostly on the conservative side." Works on assignment only.

First Contact & Terms Cartoonists: Send unpublished cartoons only with SASE to Jeanne Sabatie, cartoon editor. Pays $115. Buys first world publication rights. Illustrators: Send samples to Sindi Price. Samples are filed. Responds only if interested. Write for portfolio review. Buys nonexclusive worldwide rights. Pays $1,000-1,500 for color cover; $250-800 for color inside; $200-600 for b&w. Accepts previously published material. Originals are returned at job's completion.

ADVENTURE CYCLIST

150 E. Pine St., Missoula MT 59802. (406)721-1776. Fax: (406)721-8754. E-mail: gsiple@adventurecycling.org. Web site: www.adventurecycling.org. **Art Director:** Greg Siple. Estab. 1974. Journal of adventure travel by bicycle, published 9 times/year. Circ. 43,000.

Illustration Buys 1 illustration/issue. Has featured illustrations by Margie Fullmer, Ludmilla Tomova and Anita Dufalla. Works on assignment only.

First Contact & Terms Illustrators: Send printed samples. Samples are filed. Will contact artist

for portfolio review if interested. Pays on publication, $50-350. Buys one-time rights. Originals are returned at job's completion.

⒩ ADVOCATE, PKA'S PUBLICATION

1881 Co. Rt. 2, Prattsville NY 12468. (518)299-3103. **Art Editor:** C.J. Karlie. Estab. 1987. Bimonthly b&w literary tabloid. *"Advocate* provides aspiring artists, writers and photographers the opportunity to see their works published and to receive byline credit toward a professional portfolio so as to promote careers in the arts." The Gaited Horse Association Newsletter is published within the pages of *Advocate*. Circ. 10,000. Sample copies with guidelines available for $4 with SASE.

Cartoons Open to all formats.

Illustration Buys 10-15 illustrations/issue. Considers pen & ink, charcoal, linoleum-cut, woodcut, lithograph, pencil or photos, "either black & white or color prints (no slides). We are especially looking for horse-related art and other animals." Also needs editorial and entertainment illustration.

First Contact & Terms Cartoonists: Send query letter with SASE and submissions for publication. Illustrators: Send query letter with SASE and photos of artwork (b&w or color prints only). "Good-quality photocopy or stat of work is acceptable as a submission." No simultaneous submissions. Samples are not filed and are returned by SASE. Portfolio review not required. Responds in 6 weeks. Buys first rights. Pays cartoonists/illustrators in contributor's copies. Finds artists through submissions and from knowing artists and their friends.

Tips "No postcards are acceptable. Many artists send us postcards to review their work. They are not looked at. Artwork should be sent in an envelope with a SASE."

AGING TODAY

833 Market St., San Francisco CA 94103. (415)974-9619. Fax: (415)974-0300. Web site: www.asaging.org. **Editor:** Paul Kleyman. Estab. 1979. *"Aging Today* is the bimonthly black & white newspaper of The American Society on Aging. It covers news, public policy issues, applied research and developments/trends in aging." Circ. 10,000. Accepts previously published artwork. Originals are returned at job's completion if requested. Sample copies available on request.

Cartoons Approached by 50 cartoonists/year. Buys 1-2 cartoons/issue. Prefers political and social satire cartoons; single, double or multiple panel with or without gagline, b&w line drawings. Samples are returned by SASE. Responds only if interested. Buys one-time rights.

Illustration Approached by 50 illustrators/year. Buys 1 illustration/issue. Works on assignment only. Prefers b&w line drawings and some washes. Considers pen & ink. Needs editorial illustration.

First Contact & Terms Cartoonists: Send query letter with brochure and roughs. Illustrators: Send query letter with brochure, SASE and photocopies. Pays cartoonists $25, with fees for illustrations; $25-50 for b&w covers or inside drawings. Samples are not filed and are returned by SASE. Responds only if interested. To show portfolio, artist should follow up with call and/or letter after initial query. Buys one-time rights.

Tips "Send brief letter with two or three applicable samples. Don't send hackneyed cartoons that perpetuate ageist stereotypes."

AIM: AMERICA'S INTERCULTURAL MAGAZINE

P.O. Box 390, Milton WA 98354-0390. (253)815-9030. E-mail: apiladoone@aol.com. Web site: www.aimmagazine.org. **Contact:** Ruth Apilado. Estab. 1973. Quarterly b&w magazine with 2-color cover. Readers are those "wanting to eliminate bigotry and desiring a world without inequalities in education, housing, etc." Circ. 7,000. Sample copy available for $5; art submission guidelines free for SASE.

Cartoons Approached by 12 cartoonists/week. Buys 10-15 cartoons/year. Uses 1-2 cartoons/issue. Prefers themes related to education, environment, family life, humor in youth, politics and retirement; single-panel with gagline. Especially needs "cartoons about the stupidity of racism."

Illustration Approached by 4 illustrators/week. Uses 4-5 illustrations/issue; half from freelancers. Prefers pen & ink. Subjects include current events, education, environment, humor in youth, politics and retirement.

First Contact & Terms Cartoonists: Send samples with SASE. Illustrators: Provide brochure to be kept on file for future assignments. Samples are not returned. Responds in 3 weeks. Buys all rights on a work-for-hire basis. Pays on publication. Pays cartoonists $5-15 for b&w line drawings. Pays illustrators $25 for b&w cover illustrations. Accepts previously published, photocopied and simultaneous submissions.

Tips "We could use more illustrations and cartoons with people from all ethnic and racial backgrounds in them. We also use material of general interest. Artists should show a representative sampling of their work and target the magazine's specific needs. Nothing on religion."

ALASKA MAGAZINE
301 Arctic Slope Ave., Suite 300, Anchorage AK 99518-3035. (907)272-6070. Fax: (907)275-2117. Web site: www.alaskamagazine.com. **Art Director:** Tim Blum. Estab. 1935. Monthly 4-color regional consumer magazine featuring Alaskan issues, stories and profiles exclusively. Circ. 200,000.

Illustration Approached by 200 illustrators/year. Buys 1-4 illustrations/issue. Has featured illustrations by Bob Crofut, Chris Ware, Victor Juhaz and Bob Parsons. Features humorous and realistic illustrations. Works on assignment only. Assigns 50% to new and emerging illustrators. 50% of freelance illustration demands knowledge of Illustrator, Photoshop and QuarkXPress.

First Contact & Terms Send postcard or other nonreturnable samples. Accepts Mac-compatible disk submissions. Samples are not returned. Responds only if interested. Will contact artist for portfolio review if interested. Buys first North American serial rights and electronic rights; rights purchased vary according to project. Pays on publication. Pays illustrators $125-300 for color inside; $400-600 for 2-page spreads; $125 for spots.

Tips "We work with illustrators who grasp the visual in a story quickly and can create quality pieces on tight deadlines."

ALTERNATIVE THERAPIES IN HEALTH AND MEDICINE
InnoVision Communications, LLC, 2995 Wilderness Place, Suite 205, Boulder CO 80301. (303)440-7402. Fax: (303)440-7446. E-mail: lee.dixson@innerdoorway.com. Web site: www.alternative-therapies.com. **Creative Director:** Lee Dixson. Estab. 1995. Bimonthly trade journal. "*Alternative Therapies* is a peer-reviewed medical journal established to promote integration between alternative and cross-cultural medicine with conventional medical traditions." Circ. 20,000. Sample copies available.

Illustration Buys 6 illustrations/year. "We purchase fine art for the covers, not graphic art."

First Contact & Terms Send query letter with slides. Samples are filed. Responds in 10 days. Will contact artist for portfolio review if interested. Portfolio should include photographs and slides. Buys one-time and reprint rights. Pays on publication; negotiable. Accepts previously published artwork. Originals are returned at job's completion. Finds artists through agents, sourcebooks and word of mouth.

AMERICA
106 W. 56th St., New York NY 10019. (212)581-1909. Fax: (212)399-3596. Web site: www.americamagazine.org. **Associate Editor:** James Martin. Estab. 1904. Weekly Catholic national magazine published by U.S. Jesuits. Circ. 46,000.

Illustration Buys 3-5 illustrations/issue. Has featured illustrations by Michael O'Neill McGrath, William Hart McNichols, Tim Foley, Stephanie Dalton Cowan. Features realistic illustration and spot illustration. Assigns 45% of illustrations to new and emerging illustrators. Considers all media.

First Contact & Terms Illustrators: Send printed samples and tearsheets. Buys first rights. Pays on publication: $300 for color cover; $150 for color inside.

Tips "We look for illustrators who can do imaginative work for religious, educational or topical articles. We will discuss the article with the artist and usually need finished work in two to three weeks. A fast turnaround is extremely valuable."

AMERICAN AIRLINES NEXOS

4333 Amon Carter Blvd., Ft. Worth TX 76155. (817)967-1804. Fax: (817)963-9976. E-mail: marco.r osales@aa.com. Web site: www.nexosmag.com. **Art Director**: Marco Rosales. Bimonthly inflight magazine published in Spanish and Portuguese that caters to "the affluent, highly-educated Latin American frequent traveler residing in the U.S. and abroad." Circ. 270,400.

Illustration Approached by 300 illustrators/year. Buys 50 illustrations/year. Features humorous and spot illustrations of business and families.

First Contact & Terms Send postcard sample. After introductory mailing, send follow-up postcard sample every 6 months. Pays $100-250 for color inside. Pays on publication. Buys one-time rights. Finds freelancers through submissions.

AMERICAN FITNESS

15250 Ventura Blvd., Suite 200, Sherman Oaks CA 91403. (818)905-0040, ext. 200. Fax: (818)990-5468. E-mail: americanfitness@afaa.com. Web site: www.americanfitness.com; www.afaa.com. **Editor:** Meg Jordan. Bimonthly magazine for fitness and health professionals. Official publication of the Aerobics and Fitness Association of America, the world's largest fitness educator. Circ. 42,900.

Illustration Approached by 12 illustrators/month. Assigns 2 illustrations/issue. Works on assignment only. Prefers "very sophisticated" 4-color line drawings. Subjects include fitness, exercise, wellness, sports nutrition, innovations and trends in sports, anatomy and physiology, body composition.

First Contact & Terms Send promotional postcard sample. Acquires one-time rights. Accepts previously published material. Original artwork returned after publication.

Tips "Excellent source for never-before-published illustrators who are eager to supply full-page lead artwork."

THE AMERICAN GARDENER

7931 E. Boulevard Dr., Alexandria VA 22308. (703)768-5700. Fax: (703)768-7533. E-mail: editor@ahs.org. Web site: www.ahs.org. **Editor:** David J. Ellis. Estab. 1922. Bimonthly, 4-color magazine for advanced and amateur gardeners and horticultural professionals who are members of the American Horticultural Society. Circ. 35,000. Sample copies available for $5.

Illustration Rarely uses illustrations. Works on assignment only. "Botanical accuracy is important for some assignments. All media used; digital media welcome."

First Contact & Terms Send query letter with résumé, tearsheets, slides and photocopies. Samples are filed. "We will call artist if their style matches our need." To show a portfolio, mail b&w and color tearsheets and slides. Buys one-time rights. Pays on publication: $150-300 for color inside.

Tips "Prefers art samples depicting plants and gardens or gardening."

AQUARIUM FISH INTERNATIONAL

(formerly *Aquarium Fish Magazine*), P.O. Box 6050, Mission Viejo CA 92690. (949)855-8822. Fax: (949)855-3045. E-mail: aquariumfish@bowtieinc.com. Web site: www.aquariumfish.com.

Editor: Russ Case. Estab. 1988. Monthly magazine covering fresh and marine aquariums and garden ponds. Guidelines available for SASE with first-class postage or on Web site.

Cartoons Approached by 30 cartoonists/year. Themes should relate to aquariums and ponds.

First Contact & Terms Buys one-time rights. Pays $35 for b&w and color cartoons.

THE ARTIST'S MAGAZINE

F + W Publications, Inc., 4700 E. Galbraith Rd., Cincinnati OH 45236. E-mail: tamedit@fwpubs.c om. Web site: www.artistsmagazine.com. **Art Director:** Daniel Pessell. 4-color magazine emphasizing the techniques of working artists for the serious beginning, amateur and professional artist. Published 10 times/year. Circ. 180,000. Sample copy available for $4.99 U.S., $7.99 Canadian or international; remit in U.S. funds.

• Sponsors annual contest. Send SASE for more information.

Cartoons Buys 3-4 cartoons/year. Must be related to art and artists.

Illustration Buys 2-3 illustrations/year. Has featured illustrations by Susan Blubaugh, Sean Kane, Jamie Hogan, Steve Dininno and Kathryn Adams. Features humorous and realistic illustration. Works on assignment only.

First Contact & Terms Cartoonists: Contact Cartoon Editor. Send query letter with brochure, photocopies, photographs and tearsheets to be kept on file. Prefers photostats or tearsheets as samples. Samples not filed are returned by SASE. Buys first rights. **Pays on acceptance.** Pays cartoonists $65. Pays illustrators $350-1,000 for color inside, $100-500 for spots. Occasionally accepts previously published material. Returns original artwork after publication.

Tips "Research past issues of publication and send samples that fit the subject matter and style of target publication."

ASCENT MAGAZINE

837 Rue Gilford, Montreal QC H2J 1P1 Canada. (514)499-3999. Fax: (514)499-3904. E-mail: assist ant_editor@ascentmagazine.com. Web site: www.ascentmagazine.com. **Assistant Editor:** Luna Allison. Estab. 1999. Quarterly consumer magazine focusing on yoga and engaged spirituality; b&w with full-color cover. Circ. 7,500. Sample copies are available for $7. Art guidelines available on Web site or via e-mail (design@ascentmagazine.com).

Illustration Approached by 20-40 illustrators/year. Prefers b&w, or color artwork that will reproduce well in b&w. Assigns 50% to new and emerging illustrators. 50% of freelance illustration demands knowledge of Illustrator, InDesign and Photoshop.

First Contact & Terms Send postcard sample or query letter with b&w photocopies, samples, URL. Accepts e-mail submissions with link to Web site or image file. Prefers Mac-compatible TIFF files. Samples are filed. Responds in 2 months. Will contact artist for portfolio review if interested. Portfolio should include b&w and color, finished art, photographs and tearsheets. Pays $200-500 for color cover; $50-350 for b&w inside. Pays on publication. Buys first rights, electronic rights. Original artwork returned upon request. Finds freelancers through agents, submissions, magazines and word of mouth.

Tips "We encourage artwork that is abstract, quirky and unique. It should connect with the simplicity of the magazine's design, and be accessible and understandable to our readers, who vary greatly in age and artistic appreciation. For commissioned artwork, the piece should relate to the narrative style of the article it will illustrate."

AUTOMOBILE MAGAZINE

120 E. Liberty St., 2nd Floor, Ann Arbor MI 48104-4193. (734)994-3500. Web site: www.automobi lemag.com. **Art Director:** Molly Jean. Estab. 1986. Monthly 4-color automobile magazine for upscale lifestyles. Circ. 650,000. Art guidelines are specific for each project.

Illustration Buys illustrations mainly for spots and feature spreads. Works with 5-10 illustrators/

year. Buys 2-5 illustrations/issue. Works on assignment only. Considers airbrush, mixed media, colored pencil, watercolor, acrylic, oil, pastel and collage. Needs editorial and technical illustrations.

First Contact & Terms Send query letter with brochure showing art style, résumé, tearsheets, slides, photographs or transparencies. Show automobiles in various styles and media. "This is a full-color magazine; illustrations of cars and people must be accurate." Samples are returned only if requested. "I would like to keep something in my file." Responds to queries/submissions only if interested. Buys first rights and one-time rights. Pays $200 and up for color inside. Pays $2,000 maximum depending on size of illustration. Finds artists through mailed samples.

Tips "Send samples that show cars drawn accurately with a unique style and imaginative use of medium."

BABYBUG®

Cricket Magazine Group, Carus Publishing, 70 E. Lake St., Suite 300, Chicago IL 60601. Web site: www.cricketmag.com. **Contact:** Art Submissions Coordinator. Managing Art Director: Suzanne Beck. Estab. 1994. A listening and looking magazine for infants and toddlers ages 6 months to 2 years. Published monthly except for combined May/June and July/August issues. Art guidelines available on Web site.

● See also listings in this section for other magazines published by the Cricket Magazine Group: *LADYBUG*, *SPIDER*, *CRICKET* and *CICADA*.

Illustration Buys 23 illustrations/issue. Works on assignment only.

First Contact & Terms Send photocopies, photographs or tearsheets to be kept on file. Samples are returned by SASE if requested. Responds in 3 months. Buys all rights. **Pays 45 days after acceptance**: $750 for color cover; $250 for color full page; $100 for color spots; $50 for b&w spots.

Tips "Before attempting to illustrate for *BABYBUG*, be sure to familiarize yourself with this age group, and read several issues of the magazine. Please do not query first."

BACKPACKER MAGAZINE

Rodale, Inc., 33 E. Minor St., Emmaus PA 18098. (610)967-8296. E-mail: mbates@backpacker.com. Web site: www.backpacker.com. **Art Director:** Matthew Bates. Estab. 1973. Consumer magazine covering nonmotorized wilderness travel. Circ. 306,500.

Illustration Approached by 200-300 illustrators/year. Buys 10 illustrations/issue. Considers all media. 60% of freelance illustration demands knowledge of FreeHand, Photoshop, Illustrator, QuarkXPress.

First Contact & Terms Send query letter with printed samples, photocopies and/or tearsheets. Send follow-up postcard sample every 6 months. Accepts disk submissions compatible with QuarkXPress, Illustrator and Photoshop. Samples are filed and are not returned. Art director will contact artist for portfolio review of color photographs, slides, tearsheets and/or transparencies if interested. Buys first rights or reprint rights. Pays on publication. Finds artists through submissions and other printed media.

Tips *Backpacker* does not buy cartoons. "Know the subject matter, and know *Backpacker Magazine*."

BALTIMORE JEWISH TIMES

Alter Communications, Inc., 1040 Park Ave., Suite 200, Baltimore MD 21201. (410)752-3504. Fax: (443)451-0702. E-mail: artdirector@jewishtimes.com. Web site: www.jewishtimes.com. **Editorial Designer:** Lisa Drobek. Weekly b&w tabloid with 4-color cover. Emphasizes special interests to the Jewish community for largely local readership. Circ. 13,000. Sample copies available.

● Alter Communications also publishes *Style*, a Baltimore lifestyle magazine; *Chesapeake Life*,

which covers lifestyle topics in southern Maryland and the Eastern Shore; and *PaperDoll*, Baltimore's first magazine devoted exclusively to shopping. See www.alteryourview.com for more information on these publications.

Illustration Approached by 50 illustrators/year. Buys 4-6 illustrations/year. Works on assignment only. Prefers high-contrast, b&w illustrations.

First Contact & Terms Illustrators: Send query letter with brochure showing art style or tearsheets and photocopies. Samples not filed are returned by SASE. Responds if interested. To show a portfolio, mail appropriate materials or write/call to schedule an appointment. Portfolio should include original/final art, final reproduction/product and color tearsheets and photostats. Buys first rights. Pays on publication: $500 for b&w or color cover; $50-100 for b&w inside. Accepts previously published artwork. Returns original artwork after publication, if requested.

Tips Finds artists through word of mouth, self-promotions and sourcebooks. Sees trend toward "more freedom of design integrating visual and verbal."

BALTIMORE MAGAZINE

1000 Lancaster St., Suite 400, Baltimore MD 21202-4382. (410)752-4200. Fax: (410)625-0280. E-mail: wamanda@baltimoremag.com. Web site: www.baltimoremagazine.net. **Art Director:** Amanda White-Iseli. Editorial Design Assistant: Kathryn Swartz. Estab. 1908. Monthly city magazine featuring news, profiles and service articles. Circ. 57,000. Sample copies available for $2.50 each.

Illustration Approached by 60 illustrators/year. Buys 4 illustrations/issue. Works on assignment only. Considers all media, depending on assignment. 10% of freelance work demands knowledge of QuarkXPress, FreeHand, Illustrator or Photoshop, or any other program that is saved as a TIFF or PICT file.

First Contact & Terms Illustrators: Send postcard sample. Accepts disk submissions. Samples are filed. Will contact for portfolio review if interested. Originals are returned at job's completion. Buys one-time rights. Pays on publication: $250-600 for color inside; 60 days after invoice. Finds artists through sourcebooks, publications, word of mouth, submissions.

Tips All art is freelance—humorous front pieces, feature illustrations, etc. Does not use cartoons.

BARTENDER MAGAZINE

P.O. Box 158, Liberty Corner NJ 07938-0158. (908)766-6006. Fax: (908)766-6607. E-mail: barmag @aol.com. Web site: www.bartender.com. **Art Director:** Doug Swenson. Editor: Jackie Foley. Estab. 1979. Quarterly 4-color trade journal emphasizing restaurants, taverns, bars, bartenders, bar managers, owners, etc. Circ. 150,000.

Cartoons Approached by 10 cartoonists/year. Buys 3 cartoons/issue. Prefers bar themes; single-panel.

Illustration Approached by 5 illustrators/year. Buys 1 illustration/issue. Works on assignment only. Prefers bar themes. Considers any media.

First Contact & Terms Cartoonists: Send query letter with finished cartoons. Buys first rights. Illustrators: Send query letter with brochure. Samples are filed. Negotiates rights purchased. Pays on publication. Pays cartoonists $50 for b&w and $100 for color inside. Pays illustrators $500 for color cover.

BAY WINDOWS

46 Plympton St., 5th Floor, Boston MA 02118. (617)266-6670, ext. 204. Fax: (617)266-5973. E-mail: mmaguire@baywindows.com. Web site: www.baywindows.com. **Editorial Design Manager:** Matt Maguire. Estab. 1983. Weekly newspaper "targeted to politically-aware lesbians, gay men and other political allies publishing non-erotic news and features"; b&w with 2-color cover. Circ. 60,000. Sample copies available.

Cartoons Approached by 25 cartoonists/year. Buys 1-2 cartoons/issue. Buys 50 cartoons/year. Preferred themes include politics and lifestyles. Prefers double and multiple panel, political and editorial cartoons with gagline; b&w line drawings.

Illustration Approached by 60 illustrators/year. Buys 1 illustration/issue. Buys 50 illustrations/year. Works on assignment only. Preferred themes include politics; "humor is a plus." Considers pen & ink and marker drawings. Needs computer illustrators familiar with Illustrator or FreeHand.

First Contact & Terms Cartoonists: Send query letter with roughs. Samples are returned by SASE if requested by artist. Illustrators: Send query letter with photostats and SASE. Samples are filed. Responds in 6 weeks, only if interested. Portfolio review not required. Rights purchased vary according to project. Pays on publication. Pays cartoonists $50-100 for b&w only. Pays illustrators $100-125 for cover; $75-100 for b&w inside; $75 for spots. Accepts previously published artwork. Original artwork returned after publication.

THE BEAR DELUXE

P.O. Box 10342, Portland OR 97296. (503)242-1047. E-mail: bear@orlo.org. Web site: www.orlo.org. **Art Director:** Kristin Rogers. Editor-in-Chief: Tom Webb. Estab. 1993. Quarterly consumer magazine emphasizing environmental writing and visual art. Circ. 46,000. Sample copies available for $3. Art guidelines for SASE with first-class postage.

Cartoons Approached by 50 cartoonists/year. Buys 5 cartoons/issue. Prefers work related to environmental, outdoor, media, arts. Prefers single panel, political, humorous, b&w line drawings.

Illustration Approached by 50 illustrators/year. Has featured illustrations by Matt Wuerker, Ed Fella, Eunice Moyle and Ben Rosenberg. Caricature of politicians, charts & graphs, natural history and spot illustration. Assigns 30% of illustrations to new and emerging illustrators. 30% of freelance illustration demands knowledge of Illustrator, Photoshop and FreeHand.

First Contact & Terms Cartoonists: Send query letter with b&w photocopies and SASE. Samples are filed or returned by SASE. Responds in 4 months. Illustrators: Send postcard sample and nonreturnable samples. Accepts Mac-compatible disk submissions. Send EPS or Tiff files. Samples are filed or returned by SASE. Responds only if interested. Portfolios may be dropped off by appointment. Buys first rights. Pays on publication. Pays cartoonists $10-50 for b&w. Pays illustrators $200 for b&w or color cover; $15-75 for b&w or color inside; $15-75 for 2-page spreads; $20 for spots. Finds illustrators through word of mouth, gallery visits and promotional samples.

Tips "We are actively seeking new illustrators and visual artists, and we encourage people to send samples. Most of our work (besides cartoons) is assigned as editorial illustration or independent art. Indicate whether an assignment is possible for you. Indicate your fastest turnaround time. We sometimes need people who can work with 2-3 week turnaround or faster."

BIRD WATCHER'S DIGEST

P.O. Box 110, Marietta OH 45750. (740)373-5285. Fax: (740)373-8443. E-mail: editor@birdwatchersdigest.com. Web site: www.birdwatchersdigest.com. Estab. 1978. Bimonthly magazine covering birds and bird watching for bird watchers and birders (backyard and field; veteran and novice). Circ. 90,000. Sample copies available for $3.99. Art guidelines available on Web site or free for SASE.

Illustration Buys 1-2 illustrations/issue. Has featured illustrations by Julie Zickefoose, Tom Hirata, Kevin Pope and Jim Turanchik. Assigns 15% of illustrations to new and emerging illustrators.

First Contact & Terms Send samples or tearsheets. Responds in 2 months. Buys one-time rights. Pays $50 minimum for b&w; $100 minimum for color. Previously published material OK. Original work returned after publication.

BIRMINGHAM PARENT

Evans Publishing LLC, 115-C Hilltop Business Dr., Pelham AL 35124. (205)739-0090. Fax: (205)739-0073. E-mail: carol@birminghamparent.com. Web site: www.birminghamparent.com. Estab. 2004. Monthly magazine serving parents of families in Central Alabama/Birmingham with news pertinent to them. Circ. 40,000 + . Art guidelines free with SASE or on Web site.

Cartoons Approached by 2-3 cartoonists/year. Buys 12 cartoons/year. Prefers fun, humorous, parenting issues, nothing controversial. Format: single panel. Media: color washes.

Illustration Approached by 2 illustrators/year. Assigns 5% of illustrations to new and emerging illustrators. 95% of freelance work demands computer skills. Freelancers should be familiar with InDesign, QuarkXPress, Photoshop.

First Contact & Terms E-mail submissions accepted with link to Web site. Portfolio not required. Pays cartoonists $0-25 for b&w or color cartoons. Pays on publication. Buys electronic rights, first North American serial rights.

Tips "We do very little freelance artwork. We are still a small publication and don't have space or funds for it. Our art director provides the bulk of our needs. It would have to be outstanding for us to consider purchasing right now."

Ⓝ BITCH: Feminist Response to Pop Culture

2904 NE Alberta St. #N, Portland OR 97211-7034. E-mail: bitch@bitchmagazine.com. Web site: www.bitchmagazine.com. **Contact:** Art Director. Estab. 1996. Quarterly b&w magazine "devoted to incisive commentary on our media-driven world. We examine popular culture in all its forms for women and feminists of all ages." Circ. 80,000.

Illustration Approached by 300 illustrators/year. Buys 3-7 illustrations/issue. Features caricatures of celebrities, conceptual, fashion and humorous illustration. Work on assignment only. Prefers b&w ink drawings and photo collage. Assigns 90% of illustrations to experienced but not well-known illustrators; 8% to new and emerging illustrators; 2% to well-known or "name" illustrators.

First Contact & Terms Send postcard sample, nonreturnable samples. Accepts Mac-compatible disk submissions. Samples are filed and are not returned. Will contact artist for portfolio review if interested. Finds illustrators through magazines and word of mouth.

Tips "We have a couple of illustrators we work with regularly, but we are open to others. Our circulation has been doubling annually, and we are distributed internationally. Read our magazine and send something we might like."

BOTH SIDES NOW

10547 State Hwy. 110 N., Tyler TX 75704-3731. (903)592-4263. E-mail: bothsidesnow@prodigy.net. Web site: www.bothsidesnow.info. **Editor/Publisher:** Elihu Edelson. Alternative zine covering the interface between spirituality and politics from a New Age perspective. Quarterly, computer-printed publication. Circ. 200. Accepts previously published material. Original artwork returned by SASE. Sample copy available for $2.

Cartoons Prefers fantasy, political satire, spirituality, religion and exposure of hypocrisy as themes. Prefers single- or multi-panel b&w line drawings.

Illustration Prefers fantasy, surrealism, spirituality and realism as themes. Color work will be reproduced in grayscale.

First Contact & Terms Cartoonists: Send query letter or e-mail with typical examples. Illustrators: Send query letter or e-mail with résumé and examples. Samples not filed are returned by SASE. Responds in 3 months. Pays cartoonists/illustrators on publication in copies and subscription.

Tips "Pay close attention to listing and Web site FAQ page. Do not send angst-laden downers, please."

© 2007-2008 Cindy Chung

Cindy Chung painted "Butterfly" in watercolor. "The amount of detail and the well-defined shapes are designed to be reminiscent of stained glass windows," she says. "The enclosed shapes and bold colors allow for easy reproduction on mugs, T-shirts, logos, and other promotional items." Originally conceived as a graphic to be used on promotional material for a nature park, Chung's image was later published in *Both Sides Now* magazine after she sent the editor some tearsheets from her portfolio.

☘ BREWERS ASSOCIATION

736 Pearl St., Boulder CO 80302. (303)447-0816, ext. 127. Fax: (303)447-2825. E-mail: kelli@brew ersassociation.org. Web site: www.beertown.org. **Magazine Art Director:** Kelli Gomez. Estab. 2005 (merger of the Association of Brewers and the Brewers' Assocation of America). "Our nonprofit organization hires illustrators for two magazines, *Zymurgy* and *The New Brewer*, each published bimonthly. *Zymurgy* is the journal of the American Homebrewers Association. The goal of the AHA division is to promote public awareness and appreciation of the quality and variety of beer through education, research and the collection and dissemination of information." Circ. 10,000. "*The New Brewer* is the journal of the Brewers Association. It offers practical insights and advice for breweries that range in size from less than 500 barrels per year to more than 500,000. Features articles on brewing technology and problem solving, pub and restaurant man-

Magazines

agement, and packaged beer sales and distribution, as well as important industry news and industry sales and market share performance." Circ. 3,000.

Illustration Approached by 50 illustrators/year. Buys 3-6 illustrations/year. Prefers beer and homebrewing themes. Considers all media.

Design Prefers local freelancers with experience in Photoshop, QuarkXPress, Illustrator.

First Contact & Terms Illustrators: Send postcard sample or query letter with printed samples, photocopies, tearsheets; follow-up sample every 3 months. Accepts disk submissions with EPS, TIFF or JPEG files. "We prefer samples we can keep." No originals accepted; samples are filed. Responds only if interested. Art director will contact artist for portfolio review if interested. Buys one-time rights. Pays 60 days net on acceptance. Pays illustrators $700-800 for color cover; $200-300 for b&w inside; $200-400 for color inside. Pays $150-300 for spots. Finds artists through agents, sourcebooks and magazines (Society of Illustrators, *Graphis*, *PRINT*, *Colorado Creative*), word of mouth, submissions. Designers: Send query letter with printed samples, photocopies, tearsheets.

Tips "Keep sending promotional material for our files. Anything beer-related for subject matter is a plus. We look at all styles."

ⓝ BUCKMASTERS WHITETAIL MAGAZINE

10350 Hwy. 80 E., Montgomery AL 36117-6064. (334)215-3337. Fax: (334)215-3535. E-mail: lunge r@buckmasters.com. Web site: www.buckmasters.com. **Creative Director:** Laura Unger. Art Director: Jacob Dunn. Estab. 1987. Seasonal magazine covering whitetail deer hunting; published 6 times/year. Circ. 400,000. Sample copies and art guidelines available.

 • Also publishes *Rack* (www.rackmag.com; Art Director: Tim Martin) and *Buckmasters Gun-Hunter* (www.gunhuntermag.com; Art Director: Ryan Noffsinger).

Cartoons Approached by 5 cartoonists/year. Buys 1 cartoon/issue (*Rack* only).

Illustrations Approached by 5 illustrators/year. Buys 1 illustration/issue. Works on assignment only. Considers all media. Prefers realistic styles. 80% of freelance work demands knowledge of Illustrator, QuarkXPress, Photoshop or InDesign.

First Contact & Terms Cartoonists: Send query letter with brochure and photos of originals. Illustrators: Send postcard sample. Accepts submissions on disk. Samples are filed. Responds in 3 months. Call or write for appointment to show portfolio. Portfolio should include final art, slides and photographs. Rights purchased vary according to project. Pays on publication. Pays cartoonists $25 for b&w. Pays illustrators $500 for color cover; $150 for color inside. Accepts previously published artwork. Originals are not returned.

Tips "Send samples related to whitetail deer or turkeys."

BULLETIN OF THE ATOMIC SCIENTISTS

6042 S. Kimbark Ave., Chicago IL 60637-2898. (773)702-2555. Fax: (773)702-0725. E-mail: joy@t hebulletin.org. Web site: www.thebulletin.org. **Managing Editor:** John Rezek. Art Director: Joy Olivia Miller. Estab. 1945. Bimonthly magazine of international affairs and nuclear security. Circ. 15,000.

Cartoons Approached by 15-30 cartoonists/year. Buys 2 cartoons/issue. Prefers single panel, humor related to global security, b&w/color washes and line drawings.

Illustration Approached by 30-40 illustrators/year. Buys 2-3 illustrations/issue.

First Contact & Terms Send postcard sample and photocopies. Buys one-time and digital rights. Responds only if interested. **Pays on acceptance.**

Tips "We're eager to see cartoons that relate to our editorial content, so it's important to take a look at the magazine before submitting items."

BUSINESS LAW TODAY

321 N. Clark St., 20th Floor, Chicago IL 60610. (312)988-5000. Fax: (312)988-5444. E-mail: tedha msj@staff.abanet.org. Web site: www.abanet.org/buslaw/blt. **Art Director:** Jill Tedhams. Estab. 1992. Bimonthly magazine covering business law. Circ. 60,291. Art guidelines not available.

Cartoons Buys 20-24 cartoons/year. Prefers business law themes. Prefers single panel, humorous, b&w line drawings with gaglines. Use of women and persons of color in contemporary settings is important. Prefers cartoons submitted electronically by e-mail.

Illustration Buys 6-9 illustrations/issue. Has featured illustrations by Sean Kane, Max Licht and Jim Starr. Features whimsical, realistic and computer illustrations. Assigns 10% of illustrations to new and emerging illustrators. Prefers editorial illustration. Considers all media. 10% of freelance illustration demands knowledge of Photoshop, Illustrator and QuarkXPress.

First Contact & Terms Cartoonists: Send to tedhamsj@staff.abanet.org or palmerj@staff.abanet. org. Responds only if interested. Illustrators: "We will accept work compatible with QuarkXPress version 4.04. Send JPEG, EPS or TIFF files." Samples are filed and are not returned. Responds only if interested. Buys one-time rights. Pays on publication. Pays cartoonists $150 minimum for b&w. Pays illustrators $850 for color cover; $520 for b&w inside; $650 for color inside; $175 for b&w spots.

Tips "Although our payment may not be the highest, accepting jobs from us could lead to other projects, since we produce many publications at the ABA. Sending samples (three to four pieces) works best to get a sense of your style; that way I can keep them on file."

N BUSINESS TRAVEL NEWS

770 Broadway, New York NY 10003. (646)654-4439. Fax: (646)654-4455. E-mail: ewong@btnonli ne.com. Web site: www.btnonline.com. **Art Director:** Eric Wong. Estab. 1984. Bimonthly 4-color trade publication focusing on business and corporate travel news/management. Circ. 50,000.

Illustration Approached by 300 illustrators/year. Buys 4-8 illustrations/month. Features charts & graphs, computer illustration, conceptual art, informational graphics and spot illustrations. Preferred subjects: business concepts, electronic business and travel. Assigns 30% of illustrations to well-known, experienced and emerging illustrators.

First Contact & Terms Illustrators: Send postcard or other nonreturnable samples. Samples are filed. Buys first rights. **Pays on acceptance:** $600-900 for color cover; $250-350 for color inside. Finds illustrators through promotional material and sourcebooks.

Tips "Send your best samples. We look for interesting concepts and print a variety of styles. Please note we serve a business market."

CAT FANCY

P.O. Box 6050, Mission Viejo CA 92690-6050 (for UPS or overnight deliveries: 3 Burroughs Dr., Irvine CA 92618). (949)855-8822. E-mail: catsupport@catchannel.com. Web site: www.catchann el.com. **Contact:** Art Editor. Monthly 4-color consumer magazine dedicated to the love of cats. Circ. 290,000. Sample copy available for $5.50. Art guidelines available for SASE or on Web site.

Cartoons Occasionally uses single-panel cartoons as filler. Cartoons must feature a cat or cats and should fit single-column width ($2^1/4$) or double-column width ($4^1/2$).

Illustration Needs editorial, medical and technical illustration and images of cats. Works on assignment only.

First Contact & Terms Send query letter with brochure, high-quality photocopies (preferably color), tearsheets and SASE. Responds in 6-8 weeks. Buys one-time rights. Pays on publication. Pays cartoonists $35 for b&w line drawings. Pays illustrators $35-75 for spots; $75-150 for color inside; more for packages of multiple illustrations.

Tips "Seeking creative and innovative illustrators that lend a modern feel to our magazine. Please review a sample copy of the magazine before submitting your work to us."

CATHOLIC FORESTER

P.O. Box 3012, Naperville IL 60566-7012. (630)983-4900. Fax: (630)983-4057. E-mail: magazine@ catholicforester.com. Web site: www.catholicforester.com. **Contact:** Art Director. Estab. 1883. National quarterly 4-color magazine. Circ. under 100,000. "We are a fraternal insurance company but use general-interest articles, art and photos. Audience is middle-class, many small town as well as big-city readers, patriotic, Catholic and traditionally conservative." Accepts previously published material. Sample copy available for 9 × 12 SASE with 3 first-class stamps.

Illustration Buys and commissions editorial illustration. No longer accepts gag or panel cartoons.

First Contact & Terms Illustrators: Will contact for portfolio review if interested. Requests work on spec before assigning job. Buys one-time rights, North American serial rights or reprint rights. Pays on publication. Pays $30 for b&w, $75-300 for color inside.

Tips "Know the audience you're drawing for; always read the article and don't be afraid to ask questions. Pick the art director's brain for ideas and be timely."

CED (COMMUNICATIONS, ENGINEERING & DESIGN MAGAZINE)

Advantage Business Media, 6041 S. Syracuse Way, Suite 310, Greenwood Village CO 80111-9402. (973)920-7709. E-mail: don.ruth@advantagemedia.com. Web site: www.cedmagazine.com. **Senior Art Director:** Don Ruth. Estab. 1978. Monthly trade journal; "the premier magazine of broadband technology." Circ. 25,000. Sample copies and art guidelines available.

Illustration Buys 1 illustration/issue. Works on assignment only. Features caricatures of celebrities; realistic illustration; charts and graphs; informational graphics and computer illustrations. Prefers cable TV industry themes. Considers watercolor, airbrush, acrylic, colored pencil, oil, charcoal, mixed media, pastel, computer disk formatted in Photoshop, Illustrator or FreeHand. Assigns 10% of illustrations to new and emerging illustrators.

First Contact & Terms Contact only through artist rep. Samples are filed. Call for appointment to show portfolio. Portfolio should include final art, b&w/color tearsheets, photostats, photographs and slides. Rights purchased vary according to project. **Pays on acceptance.** Pays illustrators $400-800 for color cover; $125-400 for b&w and color inside; $250-500 for 2-page spreads; $75-175 for spots. Accepts previously published work. Original artwork not returned at job's completion.

Tips "Be persistent; come in person if possible. Be willing to change in mid course; be willing to have finished work rejected. Make sure you can draw and work fast."

CHARLOTTE MAGAZINE

127 W. Worthington Ave., Suite 208, Charlotte NC 28203-4474. (704)335-7181. Fax: (704)335-3739. E-mail: carrie.campbell@charlottemagazine.com. Web site: www.charlottemagazine.com. **Art Director:** Carrie Campbell. Estab. 1995. Monthly 4-color city-based consumer magazine for Charlotte and surrounding areas. Circ. 40,000. Sample copy free for #10 SAE with first-class postage.

Illustration Approached by many illustrators/year. Buys 1-5 illustrations/issue. Features caricatures of celebrities and politicians; computer illustration; humorous illustration; natural history, realistic and spot illustration. Prefers wide range of media/conceptual styles. Assigns 20% of illustrations to new and emerging illustrators.

First Contact & Terms Illustrators: Send postcard sample and follow-up postcard every 6 months. Send non-returnable samples. Accepts e-mail submissions. Send EPS or TIFF files. Samples are filed. Responds only if interested. Portfolio review not required. Finds illustrators through promotional samples and sourcebooks.

Tips "We are looking for diverse and unique approaches to illustration. Highly creative and conceptual styles are greatly needed. If you are trying to get your name out there, we are a great avenue for you."

CHESAPEAKE BAY MAGAZINE

1819 Bay Ridge Ave., Annapolis MD 21403. (410)263-2662. Fax: (410)267-6924. E-mail: kashley@ cbmmag.net. Web site: www.cbmmag.net. **Art Director:** Karen Ashley. Estab. 1972. Monthly 4-color magazine focusing on the boating environment of the Chesapeake Bay—including its history, people, places, events, environmental issues and ecology. Circ. 45,000. Original artwork returned after publication upon request. Sample copies free for SASE with first-class postage. Art guidelines available.

Illustration Approached by 12 illustrators/year. Buys 2-3 technical and editorial illustrations/ issue. Has featured illustrations by Jim Paterson, Kim Harroll, Jan Adkins, Tamzin B. Smith, Marcy Ramsey, Peter Bono, Stephanie Carter and James Yang. Assigns 50% of illustrations to new and emerging illustrators. Considers pen & ink, watercolor, collage, acrylic, marker, colored pencil, oil, charcoal, mixed media and pastel; also digital. Usually prefers watercolor or acrylic for 4-color editorial illustration. "Style and tone are determined by the artist after he/she reads the story."

First Contact & Terms Illustrators: Send query letter with résumé, tearsheets and photographs. Samples are filed. Make sure to include contact information on each sample. Responds only if interested. Publication will contact artist for portfolio review if interested. Portfolio should include "anything you've got." No b&w photocopies. Buys one-time rights. "Price decided when contracted." Pays illustrators $100-300 for quarter-page or spot illustrations; up to $1,200 for spreads.

Tips "Our magazine design is relaxed, fun, oriented toward people who enjoy recreation on the water. Boating interests remain the same. But for the Chesapeake Bay boater, water quality and the environment are more important now than in the past. Colors are brighter. We like to see samples that show the artist can draw boats and understands our market environment. Send tearsheets or Web site information. We're always looking. Artist should have some familiarity with the appearance of different types of boats, boating gear and equipment."

CHESS LIFE

P.O. Box 3967, Crossville TN 38557. (931)787-1234. Fax: (931)787-1200. Web site: www.uschess. org. **Editor:** Daniel Lucas. Estab. 1939. Official publication of the United States Chess Federation. Contains news of major chess events with special emphasis on American players, plus columns of instruction, general features, historical articles, personality profiles, tournament reports, cartoons, quizzes, humor and short stories. Monthly b&w with 4-color cover. Design is "text-heavy with chess games." Circ. 70,000/month. Accepts previously published material and simultaneous submissions. Sample copy for SASE with 6 first-class stamps; art guidelines for SASE with first-class postage.

- Also publishes children's magazine, *Chess Life For Kids* every other month. Same submission guidelines apply.

Cartoons Approached by 5-10 cartoonists/year. Buys 0-12 cartoons/year. All cartoons must be chess related. Prefers single panel with gagline; b&w line drawings.

Illustration Approached by 10-20 illustrators/year. Works with 4-5 illustrators/year from freelancers. Buys 8-10 illustrations/year. Uses artists mainly for cartoons and covers. All must have a chess motif. Works on assignment, but will also consider unsolicited work.

First Contact & Terms Cartoonists: Send query letter with brochure showing art style. Material kept on file or returned by SASE. Illustrators: Send query letter with samples or e-mail Dan Lucas at dlucas@uschess.org. Responds in 2 months. Negotiates rights purchased. Pays on publication. Pays cartoonists $25. Pays illustrators $150 for b&w cover; $300 for color cover; $25 inside.

CHRISTIAN HOME & SCHOOL

3350 E. Paris Ave. SE, Grand Rapids MI 49512. (616)957-1070. Fax: (616)957-5022. E-mail: rogers @csionline.org. Web site: www.csionline.org. **Senior Editor:** Roger W. Schmurr. Quarterly 4-

color magazine emphasizing current, crucial issues affecting the Christian home for parents who support Christian education. Circ. 66,000. Sample copy for 9×12 SASE with 4 first-class stamps; art guidelines for SASE with first-class postage.

Cartoons Prefers family and school themes.

Illustration Buys approximately 2 illustrations/issue. Has featured illustrations by Patrick Kelley, Rich Bishop and Pete Sutton. Features humorous, realistic and computer illustration. Assigns 75% of illustrations to experienced but not well-known illustrators; 25% to new and emerging illustrators. Prefers pen & ink, charcoal/pencil, colored pencil, watercolor, collage, marker and mixed media. Prefers family or school life themes. Works on assignment only.

First Contact & Terms Illustrators: Send query letter with résumé, tearsheets, photocopies or photographs. Show a representative sampling of work. Samples are returned by SASE, or "send one or two samples art director can keep on file." Will contact if interested in portfolio review. Buys first rights. Pays on publication. Pays cartoonists $75 for b&w. Pays illustrators $300 for 4-color full-page inside. Finds most artists through references, portfolio reviews, samples received through the mail and art reps.

CHRISTIAN RESEARCH JOURNAL

CRI International, P.O. Box 8500, Charlotte NC 28271-8500. (704)887-8200. Fax: (704)887-8299. E-mail: submissions@equip.org. Web site: www.equip.org. **Managing Editor:** Melanie Cogdill. Estab. 1977. Religion and theology journal that probes "today's religious movements, promoting doctrinal discernment and critical thinking, and providing reason for Christian faith and ethics." Published 6 times/year by the Christian Research Institute. Circ. 20,000.

Illustration Features caricatures of celebrities/politicians, realistic illustrations of men and women and related to subjects of articles. Assigns 5% of illustrations to new and emerging illustrators.

First Contact & Terms Send postcard sample. Accepts e-mail submissions with link to Web site. Prefers JPEG files. Responds only if interested. Will contact artist for portfolio review if interested. Pays on completion of assignment. Buys first rights. Finds freelancers through submissions, word of mouth and art reps.

CICADA®

Cricket Magazine Group, Carus Publishing, 70 E. Lake St., Suite 300, Chicago IL 60601. Web site: www.cricketmag.com. **Contact:** Art Submissions Coordinator. Managing Art Director: Suzanne Beck. Estab. 1998. Bimonthly literary magazine for teenagers. Art guidelines available on Web site.

● See also listings in this section for other magazines published by the Cricket Magazine Group: *BABYBUG, LADYBUG, SPIDER* and *CRICKET*.

First Contact & Terms "We at The Cricket Magazine Group know that teenagers' interests and tastes constantly evolve, and we want *CICADA* to evolve with them. Therefore we are re-examining the scope, focus, and format of *CICADA*, and are no longer accepting submissions for the magazine in its current format. Please check our Web site periodically for updates on our submission guidelines."

CINCINNATI CITYBEAT

811 Race St., 5th Floor, Cincinnati OH 45202. (513)665-4700. Fax: (513)665-4369. E-mail: shughes @citybeat.com. Web site: www.citybeat.com. **Art Director:** Sean Hughes. Estab. 1994. Weekly alternative newspaper emphasizing issues, arts and events. Circ. 50,000.

● Please research alternative weeklies before contacting this art director. He reports receiving far too many inappropriate submissions.

Cartoons Approached by 30 cartoonists/year. Buys 1 cartoon/year.

Illustration Buys 1-3 illustrations/issue. Features caricatures of celebrities and politicians, computer and humorous illustration. Prefers work with a lot of contrast. Assigns 40% of illustrations to new and emerging illustrators. 10% of freelance illustration demands knowledge of Illustrator, Photoshop, FreeHand, QuarkXPress.

First Contact & Terms Cartoonists: Send query letter with samples. Illustrators: Send postcard sample or query letter with printed samples and follow-up postcard every 4 months. Accepts Mac-compatible disk submissions. Send EPS, TIFF or PDF files. Samples are filed. Responds in 2 weeks, only if interested. Buys one-time rights. Pays on publication. Pays cartoonists $10-100 for b&w, $30-100 for color, $10-35 for comic strips. Pays illustrators $75-150 for b&w cover, $150-250 for color cover, $10-50 for b&w inside, $50-75 for color inside, $75-150 for 2-page spreads. Finds illustrators through word of mouth and artists' samples.

CINCINNATI MAGAZINE

200 Carew Tower, 441 Vine St., Cincinnati OH 45202. (513)421-4300. Fax: (513)562-2746. E-mail: gsaunders@cintimag.emmis.com. Web site: www.cincinnatimagazine.com. **Assistant Art Director:** Grace Saunders. Estab. 1960. Monthly 4-color lifestyle magazine for the city of Cincinnati. Circ. 30,000.

Illustration Approached by 200 illustrators/year. Works on assignment only.

First Contact & Terms Send samples. Samples are filed or returned by SASE. Responds only if interested. Buys one-time rights or reprint rights. Accepts previously published artwork. Original artwork returned at job's completion. Pays on publication: $500-800 for features; $200-450 for spots.

Tips Prefers traditional media with an interpretive approach. No cartoons or mass-market computer art.

CIRCLE K MAGAZINE

Kiwanis International, 3636 Woodview Trace, Indianapolis IN 46268. (317)875-8755. Fax: (317)879-0204. E-mail: magazine@kiwanis.org. Web site: www.circlek.org. **Art Director:** Maria Malandrakis. Estab. 1968. Magazine published 3 times/year for college-age students, emphasizing service, leadership, etc. Circ. 12,000. Free sample copy for SASE with 3 first-class postage stamps.

• Kiwanis International also publishes *Kiwanis* and *Key Club* magazines; see separate listings in this section.

Illustration Approached by more than 30 illustrators/year. Buys 1-2 illustrations/issue. Works on assignment only. Needs editorial illustration. "We look for variety."

First Contact & Terms Send query letter with photocopies, photographs, tearsheets and SASE. Samples are filed. Will contact for portfolio review if interested. Portfolio should include tearsheets and slides. Originals and sample copies returned to artist at job's completion. **Pays on acceptance:** $100 for b&w cover; $250 for color cover; $50 for b&w inside; $150 for color inside.

CITY & SHORE MAGAZINE

200 E. Las Olas Blvd., Ft. Lauderdale FL 33301-2299. (954)356-4685. Fax: (954)356-4612. E-mail: gcarannante@sun-sentinel.com. Web site: www.cityandshore.com. **Art Director:** Greg Carannante. Estab. 2000. Bimonthly "luxury lifestyle magazine published for readers in South Florida." Circ. 42,000. Sample copies available for $4.95.

Illustration "Rarely use illustrations, but when we do, we prefer sophisticated, colorful styles, with lifestyle-oriented subject matter. We do not use illustration whose style is dark or very edgy."

First Contact & Terms Accepts e-mail submissions with image file.

CLARETIAN PUBLICATIONS

205 W. Monroe, Chicago IL 60606. (312)236-8682. Fax: (312)236-8207. E-mail: wrightt@claretian s.org. **Art Director:** Tom Wright. Estab. 1960. Monthly magazine ''covering the Catholic family experience and social justice.'' Circ. 40,000. Sample copies and art guidelines available.

Illustration Approached by 20 illustrators/year. Buys 4 illustrations/issue. Considers all media.

First Contact & Terms Illustrators: Send postcard sample and query letter with printed samples and photocopies or e-mail with an attached Web site link. Accepts disk submissions compatible with EPS or TIFF. Samples are filed. Responds only if interested. Art director will contact artist for portfolio review if interested. Negotiates rights purchased. **Pays on acceptance:** $100-400 for color inside.

Tips ''We like to employ humor in our illustrations and often use clichés with a twist. We appreciate getting art in digital form.''

THE CLERGY JOURNAL

6160 Carmen Ave. E., Inver Grove Heights MN 55076-4422. (800)328-0200. Fax: (888)852-5524. E-mail: sfirle@logosstaff.com. Web site: www.logosproductions.com. **Editor:** Sharon Firle. Magazine for professional clergy and church business administrators; 2-color with 4-color cover. Monthly (except June, August and December). Circ. 4,000.

● This publication is one of many published by Logos Productions and Woodlake Books.

Cartoons Buys cartoons from freelancers on religious themes.

First Contact & Terms Cartoonists: Send SASE. Responds in 1 month. Pays $25 on publication. Original artwork returned after publication if requested.

CLEVELAND MAGAZINE

1422 Euclid Ave., Suite 730, Cleveland OH 44115. (216)771-2833. Fax: (216)781-6318. E-mail: sluzewski@clevelandmagazine.com. Web site: www.clevelandmagazine.com. **Contact:** Gary Sluzewski. Monthly city magazine with 4-color cover, emphasizing local news and information. Circ. 45,000.

Illustration Approached by 100 illustrators/year. Buys 3-4 editorial illustrations/issue on assigned themes. Sometimes uses humorous illustrations. 40% of freelance work demands knowledge of InDesign, Illustrator or Photoshop.

First Contact & Terms Illustrators: Send postcard sample with brochure or tearsheets. Accepts e-mail and disk submissions. ''Please include application software.'' Call or write for appointment to show portfolio of printed samples, final reproduction/product, color tearsheets and photographs. Pays $300-700 for color cover; $75-300 for b&w inside; $150-400 for color inside; $75-350 for spots.

Tips ''Artists are used on the basis of talent. We use many talented college graduates just starting out in the field. We do not publish gag cartoons but do print editorial illustrations with a humorous twist. Full-page editorial illustrations usually deal with local politics, personalities and stories of general interest. Generally, we are seeing more intelligent solutions to illustration problems, and better techniques. The economy has drastically affected our budgets; we pick up existing work as well as commissioning illustrations.''

COBBLESTONE, DISCOVER AMERICAN HISTORY

Cobblestone Publishing, Inc., 30 Grove St., Suite C, Peterborough NH 03458-1438. (603)924-7209. Fax: (603)924-7380. E-mail: anndillon@yahoo.com. Web site: www.cobblestonepub.com. **Art Director:** Ann Dillon. Monthly magazine emphasizing American history; features nonfiction, supplemental nonfiction, fiction, biographies, plays, activities and poetry for children ages 8-14. Circ. 38,000. Accepts previously published material and simultaneous submissions. Sample copy $4.95 with 8×10 SASE; art guidelines on Web site. Material must relate to theme of issue; subjects

and topics published in guidelines for SASE. Freelance work demands knowledge of Illustrator, Photoshop and QuarkXPress.

- Other magazines published by Cobblestone include *Calliope* (world history), *Dig* (archaeology for kids), *Faces* (cultural anthropology), *Odyssey* (science), all for kids ages 8-15, and *Appleseeds* (social studies), for ages 7-9.

Illustration Buys 2-5 illustrations/issue. Prefers historical theme as it pertains to a specific feature. Works on assignment only. Has featured illustrations by Annette Cate, Beth Stover, David Kooharian. Features caricatures of celebrities and politicians, humorous, realistic illustration, informational graphics, computer and spot illustration. Assigns 15% of illustrations to new and emerging illustrators.

First Contact & Terms Send query letter with brochure, résumé, business card and b&w photocopies or tearsheets to be kept on file or returned by SASE. Write for appointment to show portfolio. Buys all rights. Pays on publication: $20-125 for b&w inside; $40-225 for color inside.

Tips "Study issues of the magazine for style used. Send update samples once or twice a year to help keep your name and work fresh in our minds. Send nonreturnable samples we can keep on file; we're always interested in widening our horizons."

COLLEGE PARENT MAGAZINE

P.O. Box 888, Liberty Corner NJ 07938-0888. (908)580-1271. Fax: (908)580-0761. E-mail: kbruzen ak@collegeparentmagazine.com. Web site: www.collegeparentmagazine.com. **Art Director:** Ken Bruzenak. Estab. 2003. Bimonthly consumer magazine written by parents of college and college-bound students. Circ. 100,000. Guidelines available on Web site.

Cartoons Approached by 100 cartoonists/year. Buys 10 cartoons/year. Prefers college themes; single-panel.

Illustration Approached by 100 illustrators/year. Buys 20 illustrations/year. Features teens, college students and parents; caricatures of celebrities/politicians; humorous illustration and spot illustrations. Assigns 10% to new and emerging illustrators.

First Contact & Terms Cartoonists: Send photocopies. Illustrators: Send postcard sample with URL. Responds only if interested. Pays cartoonists $50-100 for b&w. Pays illustrators $100-200 for color inside. Pays on publication. Buys one-time rights. Finds freelancers through submissions.

N ⬛ COMMON GROUND

#204-4381 Fraser St., Vancouver BC V5V 4G4 Canada. (604)733-2215. Fax: (604)733-4415. E-mail: admin@commonground.ca. Web site: www.commonground.ca. **Contact:** Art Director. Estab. 1982. Monthly consumer magazine focusing on health and cultural activities and holistic personal resource directory. Circ. 70,000. Accepts previously published artwork and cartoons. Original artwork is returned at job's completion. Sample copies for SASE with first-class Canadian postage or International Postage Certificate.

Illustration Approached by 20-40 freelance illustrators/year. Buys 1-2 freelance illustrations/issue. Prefers all themes and styles. Considers cartoons, pen & ink, watercolor, collage and marker.

First Contact & Terms Illustrators: Send query letter with brochure, photographs, SASE and photocopies. Samples are filed or are returned by SASE if requested by artist. Responds only if interested. Buys one-time rights. Payment varies.

Tips "Send photocopies of your top three inspiring works in black & white or color—all three on one sheet of $8^1/_2 \times 11$ paper or all in one color copy. I can tell from that if I am interested."

CONFRONTATION: A LITERARY JOURNAL

English Department, C.W. Post Campus, Long Island University, Brookville NY 11548. (516)299-2720. Fax: (516)299-2735. E-mail: martin.tucker@liu.edu. **Editor-in-Chief:** Martin Tucker. Estab.

1968. Semiannual literary magazine devoted to short stories and poems, for a literate audience open to all forms, new and traditional. Circ. 2,000. Sample copies available for $3 each.

Illustration Approached by 10-15 illustrators/year. Buys 2-3 illustrations/issue. Considers pen & ink and collage. Works on assignment only. 20% of freelance work demands computer skills.

First Contact & Terms Send query letter with SASE and photocopies. Samples are not filed and are returned by SASE. Responds in 2 months, only if interested. Rights purchased vary according to project. Pays on publication: $50-100 for b&w cover; $100-250 for color cover; $25-50 for b&w inside; $50-75 for color inside; $25-75 for spots.

ℕ CONSTRUCTION EQUIPMENT OPERATION AND MAINTENANCE

Construction Publications, Inc., P.O. Box 1689, Cedar Rapids IA 52406. (319)366-1597. E-mail: chuckparks@constpub.com. Web site: www.constructionpublications.com. **Editor-in-Chief:** Chuck Parks. Estab. 1948. Bimonthly b&w tabloid with 4-color cover. Covers heavy construction and industrial equipment for contractors, machine operators, mechanics and local government officials involved with construction. Circ. 67,000. Free sample copy.

Cartoons Buys 8-10 cartoons/issue. Interested in themes "related to heavy construction industry" or "cartoons that make contractors and their employees 'look good' and feel good about themselves"; single-panel.

First Contact & Terms Cartoonists: Send finished cartoons and SASE. Responds in 2 weeks. Original artwork not returned after publication. Buys all rights, but may reassign rights to artist after publication. Pays $50 for b&w. Reserves right to rewrite captions.

DAVID C. COOK

(formerly Cook Communications Ministries), 4050 Lee Vance View, Colorado Springs CO 80918-7100. (719)536-0100. Web site: www.cookministries.org. **Design Manager:** Jeff Barnes. Publisher of teaching booklets, books, take-home papers for Christian market, "all age groups." Art guidelines available for SASE with first-class postage only.

Illustration Buys about 10 full-color illustrations/month. Has featured illustrations by Richard Williams, Chuck Hamrick and Ron Diciani. Assigns 5% of illustrations to new and emerging illustrators. Features realistic illustration, Bible illustration, computer and spot illustration. Works on assignment only.

First Contact & Terms Illustrators: Send tearsheets, color photocopies of previously published work; include self-promo pieces. No samples returned unless requested and accompanied by SASE. **Pays on acceptance:** $400-700 for color cover; $250-400 for color inside; $150-250 for b&w inside; $500-800 for 2-page spreads; $50-75 for spots. Considers complexity of project, skill and experience of artist, and turnaround time when establishing payment. Buys all rights.

Tips "We do not buy illustrations or cartoons on speculation. Do *not* send book proposals. We welcome those just beginning their careers, but it helps if the samples are presented in a neat and professional manner. Our deadlines are generous but must be met. Fresh, dynamic, the highest of quality is our goal; art that appeals to everyone from preschoolers to senior citizens; realistic to humorous, all media."

COSMOGIRL!

300 W. 57th St., New York NY 10019. Web site: www.cosmogirl.com. **Contact:** Art Department. Estab. 1996. Monthly 4-color consumer magazine designed as a cutting-edge lifestyle publication exclusively for teenage girls. Circ. 1.5 million.

Illustration Approached by 350 illustrators/year. Buys 6-10 illustrations/issue. Features caricatures of celebrities and music groups, fashion, humorous and spot illustration. Preferred subject is teens. Assigns 10% of illustrations to well-known or "name" illustrators; 80% to experienced but not well-known illustrators; 10% to new and emerging illustrators.

First Contact & Terms Send postcard sample and follow-up postcard every 6 months. Samples are filed. Responds only if interested. Buys first rights. **Pays on acceptance.** Pay varies. Finds illustrators through sourcebooks and samples.

COSMOPOLITAN

300 W. 57th St., New York NY 10019-3741. E-mail: jlanuza@hearst.com. Web site: www.cosmopolitan.com. **Art Director:** John Lanuza. Estab. 1886. Monthly 4-color consumer magazine for contemporary women covering a broad range of topics including beauty, health, fitness, fashion, relationships and careers. Circ. 3,021,720.

Illustration Approached by 300 illustrators/year. Buys 10-12 illustrations/issue. Features beauty, humorous and spot illustration. Preferred subjects include women and couples. Prefers trendy fashion palette. Assigns 5% of illustrations to new and emerging illustrators.

First Contact & Terms Send postcard sample and follow-up postcard every 4 months. Samples are filed. Responds only if interested. Buys first North American serial rights. **Pays on acceptance:** $1,000 minimum for 2-page spreads; $450-650 for spots. Finds illustrators through sourcebooks and promotional samples.

CRICKET®

Cricket Magazine Group, Carus Publishing, 70 E. Lake St., Suite 300, Chicago IL 60601. Web site: www.cricketmag.com. **Contact:** Art Submissions Coordinator. Senior Art Director: Karen Kohn. Estab. 1973. Monthly literary magazine for young readers, ages 9-14. Art guidelines available on Web site.

- See also listings in this section for other magazines published by the Cricket Magazine Group: *BABYBUG*, *LADYBUG*, *SPIDER* and *CICADA*.

Illustration Works with 75 illustrators/year. Buys 600 illustrations/year. Considers pencil, pen & ink, watercolor, acrylic, oil, pastels, scratchboard, and woodcut. "While we need humorous illustration, we cannot use work that is overly caricatured or 'cartoony.' We are always looking for strong realism. Many assignments will require artist's research into a particular scientific field, world culture, or historical period." Works on assignment only.

First Contact & Terms Send photocopies, photographs or tearsheets to be kept on file. Samples are returned by SASE if requested. Responds in 3 months. Buys all rights. Pays 45 days after acceptance: $750 for color cover; $250 for color full page; $100 for color spots; $50 for b&w spots.

Tips "Before attempting to illustrate for *CRICKET*, be sure to familiarize yourself with this age group, and read several issues of the magazine. Please do not query first."

DAKOTA COUNTRY

P.O. Box 2714, Bismark ND 58502. (701)255-3031. Fax: (701)255-5038. E-mail: dcmag@btinet.net. Web site: www.dakotacountrymagazine.com. **Publisher:** Bill Mitzel. Estab. 1979. Monthly hunting and fishing magazine with readership in North and South Dakota. Features stories on all game animals and fish and outdoors. Circ. 14,200. Accepts previously published artwork. Original artwork is returned after publication. Sample copies for $2; art guidelines for SASE with first-class postage.

Cartoons Likes to buy cartoons in volume. Prefers outdoor themes, hunting and fishing. Prefers multiple or single panel with gagline; b&w line drawings.

Illustration Features humorous and realistic illustration of the outdoors. Portfolio review not required.

First Contact & Terms Send query letter with samples of style. Samples not filed are returned by SASE. Responds to queries/submissions within 2 weeks. Negotiates rights purchased. **Pays on acceptance.** Pays cartoonists $10-20 for b&w. Pays illustrators $20-25 for b&w inside; $12-30 for spots.

Tips "Always need good-quality hunting and fishing line art and cartoons."

DAKOTA OUTDOORS

P.O. Box 669, Pierre SD 57501-0669. (605)224-7301. Fax: (605)224-9210. E-mail: dakotaoutdoors @capjournal.com. **Editor:** Lee Harstad. Estab. 1978. Monthly outdoor magazine covering hunting, fishing and outdoor pursuits in the Dakotas. Circ. 7,500. Accepts previously published artwork. Original artwork is returned at job's completion. Sample copies and art guidelines for SASE with first-class postage.

Cartoons Approached by 10 cartoonists/year. Buys 1-2 cartoons/issue. Prefers outdoor, hunting and fishing themes. Prefers cartoons with gagline.

Illustration Approached by 2-10 illustrators/year. Buys 1 illustration/issue. Features spot illustration. Prefers outdoor, hunting/fishing themes, depictions of animals and fish native to the Dakotas. Prefers pen & ink. Accepts submissions on disk compatible with Macintosh in Illustrator, FreeHand and Photoshop. Send TIFF, EPS and PICT files.

First Contact & Terms Cartoonists: Send query letter with appropriate samples and SASE. Illustrators: Send postcard sample or query letter with tearsheets, SASE and copies of line drawings. Samples are not filed and are returned by SASE. Responds in 2 months. To show a portfolio, mail ''high-quality line art drawings.'' Rights purchased vary according to project. Pays on publication. Pays cartoonists $5 for b&w. Pays illustrators $5-50 for b&w inside; $5-25 for spots.

DERMASCOPE

Geneva Corporation, 2611 N. Belt Line Rd., Suite 101, Sunnyvale TX 75182. (972)226-2309. Fax: (972)226-2339. E-mail: saundra@dermascope.com. Web site: www.dermascope.com. **Production Manager:** Saundra Brown. Estab. 1978. Monthly magazine/trade journal for aestheticians, plastic surgeons and stylists. Circ. 15,000. Sample copies and art guidelines available.

Illustration Approached by 5 illustrators/year. Prefers illustrations of ''how-to'' demonstrations. Considers digital media. 100% of freelance illustration demands knowledge of Photoshop, Illustrator, InDesign, Fractil Painter.

First Contact & Terms Accepts disk submissions. Samples are not filed. Responds only if interested. Rights purchased vary according to project. Pays on publication.

Ⓝ DISCOVERIES

923 Troost Ave., Kansas City MO 64109. (816)931-1900. Fax: (816)412-8306. E-mail: kdadams@w ordaction.com. **Editor:** Virginia L. Folsom. Estab. 1974. Weekly 4-color story paper; ''for 8- to 10-year-olds of the Church of the Nazarene and other holiness denominations. Material is based on everyday situations with Christian principles applied.'' Circ. 40,000. Originals are not returned at job's completion. Sample copies and guidelines for SASE with first-class postage.

Cartoons Approached by 15 cartoonists/year. Buys 52 cartoons/year. ''Cartoons need to be humor for children—not about them.'' Spot cartoons only. Prefers artwork with children and animals; single panel.

First Contact & Terms Cartoonists: Send finished cartoons. Samples not filed are returned by SASE. Responds in 2 months. Buys all rights. Pays $15 for b&w.

Tips No ''fantasy or science fiction situations or children in situations not normally associated with Christian attitudes or actions.''

THE EAST BAY MONTHLY

1301 59th St., Emeryville CA 94608. (510)658-9811. Fax: (510)658-9902. E-mail: artdirector@the monthly.com. Web site: www.themonthly.com. **Art Director:** Andreas Jones. Estab. 1970. Monthly consumer tabloid; b&w with 4-color cover. Editorial features are general interests (art, entertainment, business owner profiles) for an upscale audience. Circ. 80,000. Sample copy and guidelines available for SASE with 5 oz. first-class postage.

Cartoons Approached by 75-100 cartoonists/year. Buys 3 cartoons/issue. Prefers single-panel, b&w line drawings; ''any style, extreme humor.''

Illustration Approached by 150-200 illustrators/year. Buys 2 illustrations/issue. Prefers pen & ink, watercolor, acrylic, colored pencil, oil, charcoal, mixed media and pastel. No nature or architectural illustrations.

Design Occasionally needs freelancers for design and production. 100% of freelance design requires knowledge of PageMaker, Macromedia FreeHand, Photoshop, QuarkXPress, Illustrator and InDesign.

First Contact & Terms Cartoonists: Send query letter with finished cartoons. Illustrators: Send postcard sample or query letter with tearsheets and photocopies. Designers: Send query letter with résumé, photocopies or tearsheets. Accepts submissions on disk, Mac-compatible with Macromedia FreeHand, Illustrator, Photoshop, PageMaker, QuarkXPress or InDesign. Samples are filed or returned by SASE. Responds only if interested. Write for appointment to show portfolio of thumbnails, roughs, b&w tearsheets and slides. Buys one-time rights. Pays 15 days after publication. Pays cartoonists $35 for b&w. Pays illustrators $100-200 for b&w inside; $25-50 for spots. Pays for design by the project. Accepts previously published artwork. Originals are returned at job's completion.

EMERGENCY MEDICINE MAGAZINE

7 Century Dr., Suite 302, Parsippany NJ 07054-4603. (973)206-3434. Web site: www.emedmag.com. **Art Director:** Karen Blackwood. Estab. 1969. Emphasizes emergency medicine for emergency physicians, emergency room personnel, medical students. Monthly. Circ. 80,000. Returns original artwork after publication. Art guidelines not available.

Illustration Works with 10 illustrators/year. Buys 1-2 illustrations/issue. Has featured illustrations by Scott Bodell, Craig Zuckerman and Steve Oh. Features realistic, medical and spot illustration. Assigns 70% of illustrations to well-known or "name" illustrators; 30% to experienced, but not well-known illustrators. Works on assignment only.

First Contact & Terms Send postcard sample or query letter with brochure, photocopies, photographs, tearsheets to be kept on file. Samples not filed are not returned. Accepts disk submissions. To show a portfolio, mail appropriate materials. Responds only if interested. Buys first rights. Pays $1,200-1,700 for color cover; $200-500 for b&w inside; $500-800 for color inside; $250-600 for spots.

F+W PUBLICATIONS, INC.

4700 E. Galbraith Rd., Cincinnati OH 45236. Web site: www.fwpublications.com. Publishes special interest magazines and books in a broad variety of consumer enthusiast categories. Also operates book clubs, conferences, trade shows, Web sites and education programs—all focused on the same consumer hobbies and enthusiast subject areas in which the magazines and book publishing programs specialize.

● Magazines published by F+W include *The Artist's Magazine, Horticulture, HOW, PRINT, Watercolor Artist* and *Writer's Digest*. See separate listings in this section as well as F+W's listing in the Book Publishers section for more information and specific guidelines.

FAMILY TIMES PUBLICATIONS

P.O. Box 16422, St. Louis Park MN 55416. (952)922-6186. Fax: (952)922-3637. E-mail: aobrien@familytimesinc.com. Web site: www.familytimesinc.com. **Editor/Art Director:** Annie O'Brien. Estab. 1991. Publishes *Family Times, Best of Times, Grandparent Times* and *Baby Times*. Sample copies available for SASE. Art guidelines available—call for guidelines.

Illustration Approached by 6 illustrators/year. Buys 33 illustrations/year. Preferred subjects: children, families, teens. Assigns 2% of illustrations to new and emerging illustrators. Freelancers should be familiar with Illustrator, Photoshop. E-mail submissions accepted with link to Web site, or image file at 72 dpi. Prefers Mac-compatible JPEGs. Samples are filed. Responds only if

interested. Portfolio not required. Company will contact artist for portfolio review if interested. Pays illustrators $300 for color cover, $100 for b&w inside, $225 for color inside. Pays on publication. Buys one-time rights, electronic rights. Finds freelancers through submissions, sourcebooks, online.

First Contact & Terms Illustrators: Send query letter with b&w/color photocopies or e-mail.

Tips "Looking for fresh, family-friendly styles and creative sense of interpretation of editorial."

FANTAGRAPHICS BOOKS, INC.

7563 Lake City Way NE, Seattle WA 98115. (206)524-1967. Fax: (206)524-2104. E-mail: fbicomix @fantagraphics.com. Web site: www.fantagraphics.com. **Contact:** Submissions Editor. Estab. 1976. Publishes comic books and graphic novels—all genres except superheroes. Recent titles: *Love and Rockets*; *Hate*; *Eightball*; *Black Hole*; *Blab*; *Penny Century*. Circ. 8,000-30,000. Sample copy: $3; free catalog. Art submission guidelines available on Web site.

• See additional listing in the Book Publishers section.

Cartoons Approached by 500 cartoonists/year. "Fantagraphics is looking for artists who can create an entire product or who can work as part of an established team." Most titles are b&w.

First Contact & Terms Send query letter with photocopies that display storytelling capabilities, or submit a complete package. All artwork is creator-owned. Buys one-time rights. Payment terms vary.

Tips "We prefer not to see illustration work unless there is some accompanying comics work. We also do not want to see unillustrated scripts. Be sure to include basic information like name, address, phone number, etc. Also include SASE. In comics, I see a trend toward more personal styles. In illustration in general, I see more and more illustrators who got started in comics, appearing in national magazines."

FASHION ACCESSORIES

P.O. Box 859, Mahwah NJ 07430. (201)684-9222. Fax: (201)684-9228. **Publisher:** Sam Mendelson. Estab. 1951. Monthly trade journal emphasizing costume jewelry and accessories. Circ. 9,500. Accepts previously published artwork. Original artwork is returned to the artist at the job's completion. Sample copies for $3.

Illustration Works on assignment only. Needs editorial illustration. Prefers mixed media.

First Contact & Terms Illustrators: Send query letter with brochure and photocopies. Samples are filed. Responds in 1 month. Portfolio review not required. Rights purchased vary according to project. **Pays on acceptance:** $50-100 for b&w cover; $100-150 for color cover; $50-100 for b&w inside; $100-150 for color inside.

N FEDERAL COMPUTER WEEK

3141 Fairview Park Dr., Suite 777, Falls Church VA 22042. (703)876-5131. Fax: (703)876-5126. E-mail: jeffrey_langkau@fcw.com. Web site: www.fcw.com. **Creative Director:** Jeff Langkau. Estab. 1987. Trade publication for federal, state and local government information technology professionals. Circ. 120,000.

Illustration Approached by 50-75 illustrators/year. Buys 5-6 illustrations/month. Features charts & graphs, computer illustrations, informational graphics, spot illustrations of business subjects. Assigns 5% of illustrations to well-known or "name" illustrators; 85% to experienced but not well-known illustrators; 10% to new and emerging illustrators.

First Contact & Terms Send postcard or other nonreturnable samples. Accepts Mac-compatible disk submissions. Samples are filed. Will contact artist for portfolio review if interested. Rights purchased vary according to project. Pays $800-1,200 for color cover; $600-800 for color inside; $200 for spots. Finds illustrators through samples and sourcebooks.

Tips "We look for people who understand 'concept' covers and inside art, and very often have them talk directly to writers and editors."

N **THE FINAL EDITION**

P.O. Box 294, Rhododendron OR 97049. (503)622-4798. **Publisher:** Michael P. Jones. Estab. 1985. Monthly b&w investigative journal that deals with "a variety of subjects—environment, wildlife, crime, etc., for professional and blue-collar people who want in-depth reporting." Circ. 1,500. Art guidelines available for #10 SASE with 1 first-class stamp.

Cartoons Buys 1-18 cartoons/issue. Prefers single, double, multi-panel, b&w line drawings, b&w or color washes with or without gagline.

Illustration Buys 10 illustrations/issue. Works with 29 illustrators/year. Prefers editorial, technical and medical illustration in pen & ink, airbrush, pencil, marker, calligraphy and computer illustration.

Design Needs freelancers for design and production. 50% of freelance work demands computer skills.

First Contact & Terms Cartoonists: Send query letter with samples of style, roughs or finished cartoons. Illustrators: Send query letter with brochure showing art style or résumé and tearsheets, transparencies, photocopies, slides or photographs. Designers: Send brochure, résumé, photocopies, photographs, SASE, slides, tearsheets or transparencies. Samples not filed are returned by SASE. Responds in 2 months, "depending upon work load." Cannot return phone calls because of large volume. Request portfolio review in original query. Portfolio should include thumbnails, roughs, printed samples, final reproduction/product, color or b&w tearsheets, photostats and photographs. Accepts previously published material. Original artwork is returned after publication. Acquires one-time rights. Pays cartoonists/illustrators in copies. Finds artists primarily through sourcebooks and also through word of mouth.

Tips "We are really looking for artists who can sketch covered wagons, pioneers, Native Americans and mountain men. Everything is acceptable just as long as it doesn't advocate sex and violence and destroying our environment. We are looking for illustrators who can illustrate in black & white. Pen & ink is a plus. We want to work with an illustrator who wants to be published. Due to the great many requests we are receiving each day, illustrators should include a SASE for a timely response."

FIRST FOR WOMEN

270 Sylvan Ave., Englewood Cliffs NJ 07632. (201)569-6699. Fax: (201)569-6264. E-mail: dearpaige@firstforwomen.com. Web site: www.firstforwomen.com. **Creative Director:** Francois Baron. Estab. 1988. Mass market consumer magazine for younger women, published every 3 weeks. Circ. 1.4 million. Sample copies and art guidelines available upon request.

Cartoons Buys 10 cartoons/issue. Prefers humorous cartoons; single-panel b&w washes and line drawings. Prefers themes related to women's issues.

Illustration Approached by 100 illustrators/year. Buys 1 illustration/issue. Works on assignment only. Preferred themes are humorous, sophisticated women's issues. Considers all media.

First Contact & Terms Cartoonists: Send query letter with photocopies. Illustrators: Send query letter with any sample or promo that can be kept on file. Samples are filed and will be returned by SASE only if requested. Responds only if interested. Will contact artist for portfolio review if interested. Buys one-time rights. **Pays on acceptance.** Pays cartoonists $150 for b&w. Pays illustrators $200 for b&w; $300 for color. Originals are returned at job's completion. Finds artists through promo mailers and sourcebooks.

Tips Uses humorous or conceptual illustrations for articles where photography won't work. "Use the mail—no phone calls, please."

FOREVER YOUNG

467 Speers Rd., Oakville ON L6K 3S4 Canada. (905)815-0017. Fax: (905)337-5571. E-mail: dwall@haltonsearch.com. Web site: www.foreveryoungnews.com. **Editor:** Don Wall. Estab. 1980.

Monthly magazine for mature readers (age 50 +). Features current information on entertainment, health, housing, travel and finance, as well as calendars of local events and advertising offers that are geared to their needs and interests. Circ. 525,000.

Illustration Approached by 50 illustrators/year. Buys 10 illustrations/year. Features children, families, pets, men and women ages 50 or older; humorous illustration and spot illustrations. Assigns 10% to new and emerging illustrators.

First Contact & Terms Send postcard sample with URL. After introductory mailing, send follow-up postcard sample every 6 months. Responds only if interested. Pays $75-250 for color inside. Pays on publication. Buys one-time rights. Find freelancers through submissions.

GEORGIA MAGAZINE

P.O. Box 1707, Tucker GA 30085-1707. (770)270-6950. Fax: (770)270-6995. E-mail: ann.orowski @georgiaemc.com. Web site: www.georgiamagazine.org. **Editor:** Ann Orowski. Estab. 1945. Monthly consumer magazine promoting electric co-ops (largest read publication by Georgians for Georgians). Circ. 460,000 members.

Cartoons Approached by 10 cartoonists/year. Buys 2 cartoons/year. Prefers electric industry themes. Prefers single-panel, humorous, b&w washes and line drawings.

Illustration Approached by 10 illustrators/year. Prefers electric industry themes. Considers all media. 50% of freelance illustration demands knowledge of Illustrator and QuarkXPress.

Design Uses freelancers for design and production. Prefers local designers with magazine experience. 80% of design demands knowledge of Photoshop, Illustrator, QuarkXPress and InDesign.

First Contact & Terms Cartoonists: Send query letter with photocopies. Samples are filed and not returned. Illustrators: Send postcard sample or query letter with photocopies. Designers: Send query letter with printed samples and photocopies. Accepts disk submissions compatible with QuarkXPress 7.5. Samples are filed or returned by SASE. Responds in 2 months if interested. Rights purchased vary according to project. **Pays on acceptance.** Pays cartoonists $50 for b&w, $50-100 for color. Pays illustrators $50-100 for b&w, $50-200 for color. Finds illustrators through word of mouth and submissions.

GIRLFRIENDS MAGAZINE

PMB 30, 3181 Mission St., San Francisco CA 94110-4515. E-mail: staff@girlfriendsmag.com. Web site: www.girlfriendsmag.com. **Contact:** Art Director. Estab. 1994. Monthly magazine for lesbians. Circ. 30,000. Sample copies available for $4.95. Art guidelines available for #10 SASE with first-class postage.

Illustration Approached by 50 illustrators/year. Buys 3-4 illustrations/issue. Features caricatures of celebrities and realistic, computer and spot illustration. Considers all media and styles. Assigns 40% of illustrations to new and emerging illustrators. 10% of freelance illustration demands knowledge of Illustrator, QuarkXPress.

First Contact & Terms Send query letter with printed samples, tearsheets, résumé, SASE and color copies. Accepts disk submissions compatible with QuarkXPress (JPEG files). Samples are filed or returned by SASE on request. Responds in 6-8 weeks. To show portfolio, artist should follow up with call and/or letter after initial query. Portfolio should include color, final art, tearsheets, transparencies. Rights purchased vary according to project. Pays on publication: $50-200 for color inside; $150-300 for 2-page spreads; $50-75 for spots. Finds illustrators through word of mouth and submissions.

Tips "Read the magazine first. We like colorful work; ability to turn around in two weeks."

GLASS FACTORY DIRECTORY

P.O. Box 2267, Hempstead NY 11551. (516)481-2188. E-mail: manager@glassfactorydir.com. Web site: www.glassfactorydir.com. **Manager:** Liz Scott. Annual listing of glass manufacturers in U.S., Canada and Mexico.

Cartoons Receives an average of 1 submission/month. Buys 5-10 cartoons/issue. Cartoons should pertain to glass manufacturing (flat glass, fiberglass, bottles and containers; no mirrors). Prefers single and multiple panel b&w line drawings with gagline. Prefers roughs or finished cartoons. "We do not assign illustrations. We buy from submissions only."

First Contact & Terms Send SASE. Usually gets a review and any offer back to you within a month. Buys all rights. **Pays on acceptance:** $30.

Tips "We don't use cartoons about broken glass, future, past or present. We can't use stained glass cartoons—there is a stained glass magazine. We will not use any cartoons with any religious theme. Since our directory is sold worldwide, caption references should consider that we do have an international readership."

THE GOLFER

516 Fifth Ave., Suite 304, New York NY 10036-7510. (212)867-7070. Fax: (212)867-8550. E-mail: webmaster@thegolfermag.com. Web site: www.thegolfermag.com. **Contact:** Art Director. Estab. 1994. Bimonthly "sophisticated golf magazine with an emphasis on travel and lifestyle." Circ. 254,865.

Illustration Approached by 200 illustrators/year. Buys 6 illustrations/issue. Considers all media.

First Contact & Terms Send postcard sample. "We will accept work compatible with QuarkX-Press 3.3. Send EPS files." Samples are not filed and are not returned. Responds only if interested. Rights purchased vary according to project. Pays on publication. Payment to be negotiated.

Tips "I like sophisticated, edgy, imaginative work. We're looking for people to interpret sport, not draw a picture of someone hitting a ball."

GOLFWEEK

1500 Park Center Dr., Orlando FL 32835. Fax: (407)563-7077. E-mail: smiller@golfweek.com. Web site: www.golfweek.com. **Art Director:** Scott Miller. Weekly golf magazine for the accomplished golfer. Covers the latest golfing news and all levels of competitive golf from amateur and collegiate to juniors and professionals. Includes articles on golf course architecture as well as the latest equipment and apparel. Circ. 119,000.

Illustration Approached by 200 illustrators/year. Buys 20 illustrations/year. Has featured illustrations by Roger Schillerstrom. Features caricatures of golfers and humorous illustrations of golf courses and golfers. Assigns 20% to new and emerging illustrators. 5% of freelance illustration demands knowledge of Photoshop.

First Contact & Terms Send postcard sample. After introductory mailing, send follow-up postcard sample every 3-6 months. Accepts e-mail submissions with link to Web site. Prefers JPEG files. Samples are filed. Responds only if interested. Pays illustrators $400-1,000 for color cover; $400-500 for color inside. Pays on publication. Buys one-time rights. Finds freelancers through submissions and sourcebooks.

Tips "Look at our magazine. Know golf."

GREENPRINTS

P.O. Box 1355, Fairview NC 28730. (828)628-1902. E-mail: patstone@atlantic.net. Web site: www.greenprints.com. **Editor:** Pat Stone. Estab. 1990. Quarterly magazine "that covers the personal, not the how-to, side of gardening." Circ. 13,000. Sample copy for $5; art guidelines available on Web site or free for #10 SASE with first-class postage.

Illustration Approached by 46 illustrators/year. Works with 15 illustrators/issue. Has featured illustrations by Claudia McGehee, P. Savage, Marilynne Roach and Jean Jenkins. Assigns 30% of illustrations to emerging and 5% to new illustrators. Prefers plants and people. Considers b&w only.

First Contact & Terms Illustrators: Send query letter with photocopies, SASE and tearsheets.

Samples accepted by U.S. mail only. Accepts e-mail queries without attachments. Samples are filed or returned by SASE. Responds in 2 months. Buys first North American serial rights. Pays on publication: $250 maximum for color cover; $100-125 for b&w inside; $25 for spots. Finds illustrators through word of mouth, submissions.

Tips "Read our magazine and study the style of art we use. Can you do both plants and people? Can you interpret as well as illustrate a story?"

GUIDEPOSTS PUBLICATIONS

16 E. 34th St., New York NY 10016. Fax: (212)684-1311. E-mail: fmessina@guideposts.org. Web site: www.guidepostsmag.com. **Creative Director:** Francesca Messina. Mangaging Art Director: Donald Partyka. Estab. 1995. Art guidelines posted on Web site.

• Publishes 3 titles out of New York office: *Guideposts*, a monthly magazine with a circulation of 2.6 million; *Angels On Earth*, a bimonthly magazine with a circulation of 500,000; a new lifestyle and spirituality magazine, *Positive Thinking*.

Illustration Approached by 500 illustrators/year. Buys 5-10 illustrations/issue. Features computer, whimsical, humorous, conceptual, realistic and spot illustration. Assigns 40% of illustrations to well-known or "name" illustrators; 40% to experienced but not well-known illustrators; 20% to new and emerging illustrators. Prefers conceptual/realistic, "soft" styles. Considers all media.

First Contact & Terms Illustrators: Send nonreturnable promotional materials, slides or tearsheets. Accepts disk submissions compatible with Photoshop, Illustrator. Samples are filed. Send *only* nonreturnable samples. Art director will contact artist for portfolio review of color slides and transparencies if interested. Rights purchased vary. **Pays on acceptance:** $500-2,500 for color cover; $500-2,000 for 2-page spreads; $300-500 for spots. For more information, see Web site. Finds artists through reps, *American Showcase*, *Society of Illustrators Annual*, submissions and Web sites.

Tips "Please study our magazine and be familiar with the content presented."

Ⓝ GUITAR PLAYER

1111 Bayhill Dr., Suite 125, San Bruno CA 94066. (650)238-0300. Fax: (650)238-0261. E-mail: phaggard@musicplayer.com. Web site: www.guitarplayer.com. **Art Director:** Paul Haggard. Estab. 1975. Monthly 4-color magazine focusing on technique, artist interviews, etc. Circ. 150,000.

Illustration Approached by 15-20 illustrators/week. Buys 5 illustrations/year. Works on assignment only. Features caricatures of celebrities; realistic, computer and spot illustration. Assigns 33% of illustrations to new and emerging illustrators. Prefers conceptual, "outside, not safe" themes and styles. Considers pen & ink, watercolor, collage, airbrush, digital, acrylic, mixed media and pastel.

First Contact & Terms Send query letter with brochure, tearsheets, photographs, photocopies, photostats, slides and transparencies. Accepts disk submissions compatible with Mac. Samples are filed. Responds only if interested. Will contact artist for portfolio review if interested. Buys first rights. Pays on publication: $200-400 for color inside; $400-600 for 2-page spreads; $200-300 for spots.

HARPER'S MAGAZINE

666 Broadway, 11th Floor, New York NY 10012. (212)420-5720. Fax: (212)228-5889. E-mail: stacey@harpers.org. **Art Director:** Stacey D. Clarkson. Estab. 1850. Monthly 4-color literary magazine covering fiction, criticism, essays, social commentary and humor.

Illustration Approached by 250 illustrators/year. Buys 5-10 illustrations/issue. Has featured illustrations by Ray Bartkus, Steve Brodner, Tavis Coburn, Hadley Hooper, Ralph Steadman, Raymond Verdaguer, Andrew Zbihlyj, Danijel Zezelj. Features intelligent concept-oriented illustration. Pre-

ferred subjects: literary, artistic, social, fiction-related. Prefers intelligent, original thought and imagery in any media. Assigns 25% of illustrations to new and emerging illustrators. 10% of freelance illustration demands knowledge of Photoshop.

First Contact & Terms Illustrators: Send nonreturnable samples. Accepts Mac-compatible disk submissions. Samples are filed and are not returned. Will contact artist for portfolio review if interested. Portfolios may be dropped off for review the last Wednesday of any month. Buys first North American serial rights. Pays on publication: $250-400 for b&w inside; $450-1,000 for color inside; $450 for spots. Finds illustrators through samples, annuals, reps, other publications.

Tips "Intelligence, originality and beauty in execution are what we seek. A wide range of styles is appropriate; what counts most is content."

N HEAVY METAL

100 N. Village Rd., Suite 12, Rookville Center NY 11570. Web site: www.metaltv.com. **Contact:** Submissions. Estab. 1977. Consumer magazine. "*Heavy Metal* is the oldest illustrated fantasy magazine in U.S. history."

• See listing in the Book Publishers section.

N HIEROGLYPHICS MAGAZINE

24272 Sunnybrook Circle, Lake Forest CA 92630-3853. (949)215-4319. Fax: (949)215-4792. E-mail: hieroglyphic@cox.net. **President:** Deborah Boldt. Estab. 2007. Monthly and online literary magazine. "*Hieroglyphics* is a new and developing children's educational, science, and history magazine. It's mission is to present Africa's ancient history from the pre-written history period forward, traveling back and forth through time and history. *Hieroglyphics* is dedicated to children and empowering them with a positive self image. Our readers can explore achievements in science and history through wholesome adventure stories that will develop reading skills and increase critical thinking skills." Sample copies and art submission guidelines available for SASE.

Cartoons Buys 20-30 cartoons/year. Needs 4-6 cartoons/issue. Interested in "upbeat, positive vocabulary for children ages 2-12; cartoons involving concepts of black children, family life, science and historical Egypt/Africa, modern science, and morality." Prefers humorous cartoons; single or multiple panel color washes.

Illustration Buys more than 200 illustrations/year. Features realistic, scientific and natural history illustrations, "from child's point of view; more graphic than cartoon; upbeat." Subjects include children, families, pets, games and puzzles, "black characters (especially children) within a background environment in ancient Africa/Egypt, science, sailing, carpentery, hunting, fishing, farming, mining and the arts; also in modern times." Prefers watercolor, pen & ink, colored pencil, mixed media. 15% of assignments are given to new and emerging illustrators.

First Contact & Terms Cartoonists: Send samples, photocopies, roughs, SASE. Illustrators: Send query letter with photocopies, tearsheets, SASE. After introductory mailing, send follow-up post-card every 4 months. Accepts e-mail submissions with link to Web site or Windows-compatible image files (JPEG or TIFF). Samples are kept on file or are returned by SASE. Responds in 2 months. Will contact artist for portfolio review if interested. Portfolio should include original, finished art. Pays cartoonists $20-100 for color cartoons; $50-500 for comic strips. Pays illustrators $600-2,000 for color cover; $50-2,000 for color inside. **Pays on acceptance.** Buys all rights (work for hire basis). Finds freelancers through submissions, word of mouth, magazines and Internet.

Tips "We look for professional-level drawing and the ability to interpret a juvenile story. Drawings of children are especially needed. We like attention to detail. Please research history for details and ideas."

HIGH COUNTRY NEWS

119 Grand Ave., P.O. Box 1090, Paonia CO 81428-1090. (970)527-4898. Fax: (970)527-4897. E-mail: cindy@hcn.org. Web site: www.hcn.org. **Art Director:** Cindy Wehling. Estab. 1970. Bi-

weekly nonprofit newspaper covering environmental, public lands and community issues in the 10 western states. Circ. 24,000. Art guidelines at www.hcn.org/about/guidelines.jep.

Cartoons Buys 1 editorial cartoon/issue. Only issues affecting Western environment. Prefers single panel, political, humorous on topics currently being covered in the paper. Color or b&w. Professional quality only.

Illustration Considers all media if reproducible.

First Contact & Terms Cartoonists: Send query letter with finished cartoons and photocopies. Illustrators: Send query letter with printed samples and photocopies. Accepts e-mail and disk submissions compatible with QuarkXPress and Photoshop. Samples are filed or returned by SASE. Responds only if interested. Rights purchsed vary according to project. Pays on publication. Pays cartoonists $50-125 depending on size used. Pays illustrators $100-200 for color cover; $35-100 for inside. Finds illustrators through magazines, newspapers and submissions.

HIGHLIGHTS FOR CHILDREN

803 Church St., Honesdale PA 18431. (570)253-1080. Fax: (570)253-0179. E-mail: eds@highlights-corp.com. Web site: www.highlights.com. **Art Director:** Cynthia Faber Smith. Editor-in-Chief: Christine French Clark. Monthly 4-color magazine for children ages 2-12. Circ. approx. 2 million. Art guidelines available for SASE with first-class postage.

Cartoons Receives 20 submissions/week. Buys 2-4 cartoons/issue. Interested in upbeat, positive cartoons involving children, family life or animals; single or multiple panel. ''One flaw in many submissions is that the concept or vocabulary is too adult, or that the experience necessary for its appreciation is beyond our readers. Frequently, a wordless self-explanatory cartoon is best.''

Illustration Buys 30 illustrations/issue. Works on assignment only. Prefers ''realistic and stylized work; upbeat, fun, more graphic than cartoon.'' Pen & ink, colored pencil, watercolor, marker, cut paper and mixed media are all acceptable. Discourages work in fluorescent colors.

First Contact & Terms Cartoonists: Send roughs or finished cartoons and SASE. Illustrators: Send query letter with photocopies, SASE and tearsheets. Samples are kept on file. Responds in 10 weeks. Buys all rights on a work-for-hire basis. **Pays on acceptance.** Pays cartoonists $20-40 for line drawings. Pays illustrators $1,200 for color front and back covers; $50-$700 for color inside. ''We are always looking for good hidden pictures. We require a picture that is interesting in itself and has the objects well-hidden. Usually an artist submits pencil sketches. In no case do we pay for any preliminaries to the final hidden pictures. Hidden pictures should be submitted to Juanita Galuska.''

Tips ''We have a wide variety of needs, so I would prefer to see a representative sample of an illustrator's style.''

HISPANIC MAGAZINE

6355 NW 36th St., Virginia Gardens FL 33166. (305)774-3550. Fax: (305)774-3578. E-mail: tailer.senior@page1media.com. Web site: www.hispanicmagazine.com. **Art Director:** Tailer Senior. Estab. 1987. Monthly 4-color consumer magazine for Hispanic Americans. Circ. 250,000.

Illustration Approached by 100 illustrators/year. Buys 5 illustrations/issue. Has featured illustrations by Will Terry, A.J. Garces and Sonia Aguirre. Features caricatures of politicians, humorous illustrations, realistic illustrations, charts & graphs, spot illustrations and computer illustration. Prefers business subjects, men and women. Prefers pastel and bright colors. Assigns 80% of illustrations to experienced, but not well-known illustrators; 20% to new and emerging illustrators.

First Contact & Terms Illustrators: Send nonreturnable postcard samples. Accepts Mac-compatible disk submissions. Send EPS or TIFF files. Samples are filed. Responds only if interested. Will contact artist for portfolio review if interested. Buys one-time rights. Pays on publication: $500-

1,000 for color cover; $800 maximum for color inside; $300 maximum for b&w inside; $250 for spots.

Tips "Concept is very important—to take an idea or a story and to be able to find a fresh perspective. I like to be surprised by the artist."

HORSE ILLUSTRATED

Bowtie, Inc., 3 Burroughs, Irvine CA 92618. (949)855-8822. E-mail: horseillustrated@bowtieinc.com. Web site: www.horseillustrated.com. **Editor:** Elizabeth Moyer. Estab. 1976. Monthly consumer magazine providing "information for responsible horse owners." Circ. 192,000. Art guidelines available on Web site.

Cartoons Approached by 200 cartoonists/year. Buys 1 or 2 cartoons/issue. Prefers satire on horse ownership ("without the trite clichés"); single-panel b&w line drawings with gagline.

Illustration Approached by 60 illustrators/year. Buys 1 illustration/issue. Prefers realistic, mature line art; pen & ink spot illustrations of horses. Assigns 10% of illustrations to new and emerging illustrators.

First Contact & Terms Cartoonists: Send query letter with brochure, roughs and finished cartoons. Illustrators: Send query letter with SASE and photographs. Samples are not filed and are returned by SASE. Responds in 6 weeks. Portfolio review not required. Buys first rights or one-time rights. Pays on publication. Pays cartoonists $40 for b&w. Finds artists through submissions.

Tips "We only use spot illustrations for breed directory and classified sections. We do not use much, but if your artwork is within our guidelines, we usually do repeat business. *Horse Illustrated* needs illustrators who know equine anatomy, as well as human anatomy, with insight into the horse world."

HORTICULTURE MAGAZINE

98 N. Washington St., Boston MA 02114. (617)742-5600. Fax: (617)367-6364. E-mail: sara.begg@fwpubs.com. Web site: www.hortmag.com. **Contact:** Art Director. Estab. 1904. Monthly magazine for all levels of gardeners (beginners, intermediate, highly skilled). "*Horticulture* strives to inspire and instruct avid gardeners of every level." Circ. 300,000. Art guidelines available.

Illustration Approached by 75 freelance illustrators/year. Buys 10 illustrations/issue. Works on assignment only. Features realistic illustration; informational graphics; spot illustration. Assigns 20% of illustrations to new and emerging illustrators. Prefers tight botanicals; garden scenes with a natural sense to the clustering of plants; people; hands and "how-to" illustrations. Considers all media.

First Contact & Terms Send query letter with brochure, résumé, SASE, tearsheets, slides. Samples are filed or returned by SASE. Art Director will contact artist for portfolio review if interested. Buys one-time rights. Pays 1 month after project completed. Payment depends on complexity of piece; $800-1,200 for 2-page spreads; $150-250 for spots. Finds artists through word of mouth, magazines, submissions/self-promotions, sourcebooks, agents/reps, art exhibits.

Tips "I always go through sourcebooks and request portfolio materials if a person's work seems appropriate and is impressive."

[N] HOUSE BEAUTIFUL

300 W. 57th St., 23rd Floor, New York NY 10019-3741. Web site: www.housebeautiful.com. **Contact:** Art Director. Estab. 1896. Monthly consumer magazine about interior decorating. Emphasis is on classic and contemporary trends in decorating, architecture and gardening. The magazine is aimed at both the professional and nonprofessional interior decorator. Circ. 1.3 million. Sample copies available.

Illustration Approached by 75-100 illustrators/year. Buys 2-3 illustrations/issue. Works on assignment only. Prefers contemporary, conceptual, interesting use of media and styles. Considers all media.

First Contact & Terms Send postcard-size sample. Samples are filed only if interested and are not returned. Will contact artist for portfolio review of final art, photographs, slides, tearsheets and good quality photocopies if interested. Buys one-time rights. Pays on publication: $600-700 for color inside; $600-700 for spots (99% of illustrations are done as spots).

Tips "We find most of our artists through submissions of either portfolios or postcards. Sometimes we will contact an artist whose work we have seen in another publication. Some of our artists are found through reps and annuals."

N HOW MAGAZINE

F+W Publications, Inc., 4700 E. Galbraith Rd., Cincinnati OH 45236. E-mail: editorial@howdesign.com. Web site: www.howdesign.com. Estab. 1985. Bimonthly trade journal covering creativity, business and technology for graphic designers. Circ. 40,000. Sample copy available for $8.50.
- Sponsors 2 annual conferences for graphic artists, as well as annual Promotion, International, Interactive and In-House Design competitions. See Web site for more information.

Illustration Approached by 100 illustrators/year. Buys 4-8 illustrations/issue. Works on assignment only. Considers all media, including photography and computer illustration.

First Contact & Terms Illustrators: Send nonreturnable samples. Accepts disk submissions. Responds only if interested. Buys first rights or reprint rights. Pays on publication: $350-1,000 for color inside. Original artwork returned at job's completion.

Tips "Send good samples that reflect the style and content of illustration commonly featured in the magazine. Be patient; art directors get a lot of samples."

HR MAGAZINE

1800 Duke St., Alexandria VA 22314. (703)535-6860. Fax: (703)548-9140. E-mail: janderson@shrm.org. Web site: www.shrm.org. **Art Director:** John Anderson Jr. Estab. 1948. Monthly trade journal dedicated to the field of human resource management. Circ. 200,000.

Illustration Approached by 70 illustrators/year. Buys 6-8 illustrations/issue. Prefers people, management and stylized art. Considers all media.

First Contact & Terms Illustrators: Send query letter with printed samples. Accepts disk submissions. Illustrations can be attached to e-mails. *HR Magazine* is Macintosh based. Samples are filed. Art director will contact artist for portfolio review if interested. Rights purchased vary according to project. Requires artist to send invoice. Pays within 30 days. Pays $700-2,500 for color cover; $200-1,800 for color inside. Finds illustrators through sourcebooks, magazines, word of mouth and submissions.

IDEALS MAGAZINE

A division of Guideposts, 535 Metroplex Dr., Suite 250, Nashville TN 37211. (615)333-0478. Fax: (888)815-2759. Web site: www.idealspublications.com. **Editor:** Melinda Rathjen. Estab. 1944. 4-color quarterly general interest magazine featuring poetry and text appropriate for the family. Circ. 25,000. Sample copy: $4. Art guidelines free for #10 SASE with first-class postage or on Web site.

Illustration Approached by 100 freelancers/year. Buys 4 or less illustrations/issue. Uses freelancers mainly for flowers, plant life, wildlife, realistic people illustrations and botanical (flower) spot art. Prefers seasonal themes. Prefers watercolors. Assigns 90% of illustrations to experienced illustrators; 10% to new and emerging illustrators. "We are not interested in computer generated art. No electronic submissions."

First Contact & Terms Illustrators: Send nonreturnable samples or tearsheets. Samples are filed. Responds only if interested. Do not send originals. Buys artwork "for hire." Pays on publication; payment negotiable.

Tips "In submissions, target our needs as far as style is concerned, but show representative subject matter. Artists are strongly advised to be familiar with our magazine before submitting samples of work."

THE INDEPENDENT WEEKLY
P.O. Box 2690, Durham NC 27715. (919)286-1972. Fax: (919)286-4274. E-mail: mbshain@indywe ek.com. Web site: www.indyweek.com. **Art Director:** Maria Bilinski Shain. Estab. 1982. Weekly b&w with 4-color cover tabloid; general interest alternative. Circ. 50,000. Original artwork is returned if requested. Sample copies available for SASE with first-class postage.
Illustration Buys 10-15 illustrations/year. Prefers local (North Carolina) illustrators. Has featured illustrations by Tyler Bergholz, Keith Norvel, V. Cullum Rogers, Nathan Golub. Works on assignment only. Considers pen & ink; computer-generated art.
First Contact & Terms Samples are filed or are returned by SASE if requested. Responds only if interested. E-mail for appointment to show portfolio or mail tearsheets. Pays on publication: $150 for cover illustrations; $25-$50 for inside illustrations.
Tips "Have a political and alternative 'point of view.' Understand the peculiarities of newsprint. Be easy to work with. No prima donnas."

ISLANDS
460 N. Orlando Ave., Suite 200, Winter Park FL 32789. (407)628-4802. Fax: (407)628-7061. E-mail: editorial@islands.com. Web site: www.islands.com. **Art Director:** Mike Bessire. Estab. 1981. 4-color travel magazine "exclusively about islands," published 8 times/year. Circ. 225,000.
Illustration Buys 0-1 illustrations/issue. Needs editorial illustration. Considers all media.
First Contact & Terms Illustrators: Send query letter with tearsheets. Samples are filed. Responds only if interested. Buys first rights or one-time rights. **Pays on acceptance:** $100-400 per image inside. Original artwork returned after publication.

JOURNAL OF ACCOUNTANCY
AICPA, 220 Leigh Farm Rd., Durham NC 27707. (919)402-4449. E-mail: rrosen@aicpa.org. Web site: www.aicpa.org. **Managing Editor:** Rocky Rosen. Monthly 4-color magazine of the American Institute of Certified Public Accountants that focuses on the latest news and developments related to the field of accounting for CPAs; corporate/business format. Circ. 400,000.
Illustration Approached by 200 illustrators/year. Buys 2-6 illustrations/issue. Prefers business, finance and law themes. Accepts mixed media, pen & ink, airbrush, colored pencil, watercolor, acrylic, oil, pastel and digital. Works on assignment only. 35% of freelance work demands knowledge of Illustrator, QuarkXPress and FreeHand.
First Contact & Terms Send query letter with brochure showing art style. Samples not filed are returned by SASE. Portfolio should include printed samples and tearsheets. Buys first rights. Pays on publication: $1,200 for color cover; $200-600 for color inside. Accepts previously published artwork. Original artwork returned after publication. Finds artists through submissions/self-promotions, sourcebooks and magazines.
Tips "We look for indications that an artist can turn the ordinary into something extraordinary, whether it be through concept or style. In addition to illustrators, I also hire freelancers to do charts and graphs. In portfolios, I like to see tearsheets showing how the art and editorial worked together."

JOURNAL OF ASIAN MARTIAL ARTS
Via Media Publishing, 941 Calle Mejia #822, Santa Fe NM 87501. (814)455-9517. Fax: (814)455-2726. E-mail: md@goviamedia.com. Web site: www.goviamedia.com. **Publisher:** Michael A. DeMarco. Estab. 1991. Quarterly journal covering all historical and cultural aspects of Asian martial arts. Interdisciplinary approach. College-level audience. Circ. 10,000. Accepts previously

Erik Rose

*Art direction from
both sides of the fence*

If you're familiar with the humor/arts/entertainment magazine *Tastes Like Chicken* (www.tlchicken.com), you already know the work of Erik Rose. His alter-ego, Night Watchman, is an art director, editor and writer for the now internationally-distributed quarterly that began as a free, student-run newspaper at the Columbus College of Art & Design in Columbus, Ohio. Rose graduated from CCAD with a BFA in Illustration nearly five years ago, and he's been working as a successful freelance illustrator/designer ever since. His client list includes Cartoon Militia, Chron X, Image Comics, The Limited, *Dime Magazine*, *Futures Mystery Anthology Magazine* and Troma Films.

Although he studied art in high school, Rose's small hometown of Bryan, Ohio, didn't offer much in the way of creative inspiration (other than being home to the Ohio Art Company, manufacturer of the popular Etch A Sketch). Fortunately, he was raised in an artistic family that nurtured and supported him with inspiration. "I really don't remember a time that I wasn't drawing," says Rose. "My grandfather painted and sculpted, my aunt is an amazingly talented artist, my mom drew and painted, and even my dad used to color in the comic strips; so the inspiration was always there." Rose spent much of his youth drawing Spider-Man, Superman and Kiss, which led to making comic books with his friends. "After that it was yearbook covers and designing posters for plays and dances in high school."

Currently residing in Chicago, Rose is a film buff and an avid music fan. He played guitar and sang in a band for about seven or eight years between graduating from high school and attending CCAD. He now looks to hobbies such as these for artistic stimulation. "I'm probably one of the easiest people to inspire," he says. "It's everywhere for me—movies, music, books and architecture. The environment you live in can be a huge inspiration. A city like Chicago has all kinds of amazing sights every day."

It's obvious from looking at Rose's work that he's also a fan of comic books and graphic novels. "There are so many amazing artists in that field alone," he says. "There are guys like Tony Harris, Lee Bermejo and Duncan Fegredo who are just the most amazing draftsmen ever—these guys can draw anything from any angle, and it always has such power."

Originally hooked on comics by artists like Bill Sienkiewicz and Dave McKean, Rose still finds them the most inspiring. But he also admires the new crop of artists who have "reinvented" comics (Greg Ruth, Teddy Kristiansen, Scott Morse and Danijel Zezelj), as well as classic illustrators like Bob Peak, Bernie Fuchs, Martin French, Robert McGinnis and Ralph Steadman. "Throw in some great fine artists like Kathie Kollwitz, Egon Schiele, Jenny Saville, Joel Peter-Witkin and J.W. Waterhouse, and you can just imagine how big my library is."

In addition to his ongoing role at *TLC*, Rose has written and illustrated a graphic novel

called *Downstairs*, due for release in mid-2008. "It's a dark, voyeuristic thriller," he says. "It's the first of several graphic novel ideas I have in the works." He's also been working on a pitch for a comic called . . . *the know* with a writer in New York. "If that gets picked up, it's going to be a long project—at least 12 issues." Rose says he hopes to be able to do more magazine portrait/editorial illustration work in the next couple years. "I've been working on a bunch of my own stuff and miss the pace and challenge of doing regular magazine work."

Here Rose talks about his journey as an artist and offers guidance for those who wish to follow a similar path.

Were you blessed with natural talent, or did you have to work hard to learn the basics?

I think I had a little artistic talent passed down through the genes, but the rest of it was just practice and more practice. It never really felt like work until I reached a certain point; I think it's that point where most people give up. I wanted my drawings to look like this artist or that illustrator and was frustrated that the marks I was making didn't match up. Little did I know that those marks I was making were my very own "style." It took a long time to get comfortable with my own marks once I reached that stage where you start comparing yourself to everyone else. A few years of not doing anything with art went by until finally I couldn't ignore it anymore. I reached a point where I felt like I wanted to go to college to fill in the blanks in my self-taught education, and it did wonders—not just in my ability to draw, but in being able to see and analyze what I was looking at.

Do you think your art/design skills would be as refined at this point if you had never gone to art school and simply practiced on your own?

I don't think so. One of the biggest things that art school taught me was time management. I had tried to do many projects for myself before going through college but never finished them. I didn't have a real deadline, or I was always waiting for the muse to hit me. Then the pace alone of a school like CCAD made me have to work harder than I ever had before. I got projects done. I learned how to estimate how long projects would take me, and how to come up with design ideas on the spot instead of waiting for inspiration to strike. That made all the difference in the world for me.

I think if you are a very motivated person you could go through a foundations program at a college (color theory, 2D design, drawing, anatomy, painting, perspective), and the rest is just practicing those skills. *If* you could push yourself, by yourself, you could do pretty well. But you would be missing out on some of those wonderful interactions: critiques with fellow artists and instructors. The people you meet at school are so incredibly important to your development. I probably wouldn't be doing what I'm doing without the people I met while going for my degree.

How did you land your first paying job as a freelance artist?

It was through a friend at school. He had been doing some work for a small magazine, and they were looking for some new artists. It was about female skateboarders, and I think I made 20 dollars plus a copy of the magazine. But as soon as I saw my stuff in print, there was no turning back. To this day my work doesn't seem real (especially work done on the computer) until it's been printed. Around the same time, I won a poster design contest in

one of my classes and made a few hundred bucks, so that really made me want to do much more freelance while still in school.

In what ways has the ''art world'' changed and evolved over the years since you've been working as a freelance artist?
I think there has steadily been more and more work available for illustrators again in the past four to five years. It's definitely changed from a lot of the things they were telling us in college. A lot of old-school illustrators were saying the field was dead, that there was

Erik Rose drew this portrait of Walter from the movie *The Big Lebowski* along with two other characters, Maude and The Dude, to be used for self-promo pieces. It's possible one of the portraits will end up on a poster for Lebowski Fest (http://lebowskifest.com) in the near future. ''I've had a lot of exposure from this image and got quite a few commissions because of it,'' says Rose. ''This piece is a great example of the motto *Do the kind of work you want to be known for*, as it shows what I do best: icon images, celebrity portraits, and pop-subculture.''

no more work. (Just what you want to hear when you've gone tens of thousands of dollars in debt.) But it wasn't dead; it was just changing. Sure there wasn't as much print or magazine work anymore, but now there was the Web. There was the combination of a lot of different disciplines—graphic design, illustration, Web design, and photo manipulation. It became much more about finding your own niche.

As far as how the process for creating art has changed, the Web and instant e-mail contact have made a huge difference in the way people do business. No more faxing sketches; no more mailing out original artwork—it's all e-mailed or uploaded. Of course, with that you find that sometimes the deadlines are much, much tighter, but you learn to adapt. As a designer or illustrator your primary talent is not making type look good or drawing a really cool character; it's about problem solving. Anticipate the changes and find a way to make them work for you, and you'll always have work.

Are you able to make a respectable living from your freelance work, or do you have to supplement with a "real" job?

I could make a living doing nothing but illustration if I took on any job that came my way. But I've found that to make a steady living on illustration alone I'd have to do a lot of work that is just not me. Can I draw the 10 biggest U.S. Bank buildings in the United States? Sure. Does it represent the kind of work I want to be known for? No. I have a lot of interests—a lot of areas where I can work on interesting stuff, but it doesn't always pay the most. I take my work seriously. I really enjoy doing it, but if I am not engaged by a project I know I'm not giving it my all. So I teach [at Harrington College of Design], and I really love it. I love the interaction and seeing that process of discovery. I vividly remember what it was like to be a college student, maybe because I went a little later in life, and I think a lot of instructors forget that. They forget what it was like to be sitting there learning this stuff for the first time.

With teaching, my bills are paid. I don't have to miss paying rent because some company doesn't cut checks until three months after you've done a job for them. I can accept only the jobs that are the kind of work I want to do, which keeps my passion for illustration up and the quality of my work up to a certain level. I know that you have to toil in the trenches to get your stuff out there, and I just want to make sure that anything people see with my name in the credit is something I'm proud of.

What's your favorite medium/style to work in?

I really like pen and ink; just the physical act of creating with it is an amazing Zen-like experience. I've experimented with using nothing but the computer, but I feel a little too separated from the final project, so most of my work is pen and ink in the physical world and color and painting done on the computer. Most of my work is very similar in style. What you would call that style is another matter. Neo-realist comicism? I don't know—it's just "my stuff."

Is it easy to jump from one medium to another (e.g., learning to paint if you're a skilled sketch artist)?

I think success in one area makes it easier to transition into another. I actually learned a lot about how to physically paint by painting on the computer. A few years ago I started experimenting with drawing straight into the computer using a Wacom tablet. At first I didn't tell anyone and asked if there was anything different about the result, and most people couldn't tell the difference. I'm always learning new things in one medium and applying them in different ways to another medium. It's nice to understand those different ways of thinking so you can pull them up if you need them for a certain effect or a new approach.

Other than using *Artist's & Graphic Designer's Market* (of course), how can artists find the right markets/clients for their particular talent/style?

It really depends on what you're interested in doing. I love doing magazine work, so I'll just go to the newsstand of some big bookstore and flip though different magazines to see what kind of work they're buying. Even if you're using *AGDM*, you should go seek out physical examples of the magazines to make sure you could see your work in there. I always do the *Could I do better illustrations than this?* test while flipping through. If so, I'll get the art director's info and send them some samples.

If you're in school or planning to go to school, take advantage of those job postings and internships. You should be getting freelance work while you're in school if you can; you will learn so much from it that will help augment your coursework. Go to gallery openings, alumni functions, and pass out business cards—anything you can do to get your name and artwork out there in front of people. You never know who is looking or who knows someone that could get you work doing exactly what you've always wanted to be doing.

From your experience, what are the best ways for an artist to promote his/her work to appropriate markets?

Today you simply have to have a Web site. The days of people reviewing your portfolios one-on-one are pretty much gone. Go out and meet people; make contacts at gallery openings, online—there are lots of great online artist communities. Find out what's going on in your own neighborhood. Don't be afraid to do a few "freebies" to get your work out there, and don't forget the old standbys: send out postcards; go to conventions; set up at an art fair. Any place is a good place to start. I've done live painting in clubs, selling all the stuff I do that night to the crowds; you pass out some business cards and suddenly you have some freelance gigs or commissions.

Rose created this piece for a section he launched at www.tlchicken.com called Sketchbook. "We had so many great artists involved with the magazine; I came up with Sketchbook as a way to showcase them," says Rose. "Each month I send out a word or phrase to a bunch of artists, and they send back their interpretation. There is no pay involved, just exposure." Rose has sold quite a few prints of this piece over the years, and he says it's a very important one for him. "I was really starting to hit my stride," he says. "I was churning out three to six pieces a month for *Tastes Like Chicken*, plus other freelance work, and I was really growing with each piece I did. I love those pieces that you surprise yourself with—how well they turn out—and this was definitely one of them."

© 2004-07 Erik Rose / www.erikrose.com

How much of an impact has your Web site had on your success?

It's been an amazing tool to get the word out about my work. It is also very rewarding because I get to hear from so many people that like what I'm doing. A lot of times as an illustrator you only get feedback from a handful of people—the peers that you trust to tell you whether your work sucks or not, and maybe from the art director that you do the work for, if they're not too busy—that's usually about it. The Web is just a great marketing tool. I've gotten so many jobs from having an easily accessible portfolio, and I'm constantly getting commission work from private collectors.

How do you stay motivated/find time to keep up with the demand of all your assignments, commissions, etc.?

In college I was working full-time and going to school full-time, so I got very used to the concept of using my time wisely. I don't think of the week as five days of working and two days off—every day is a workday. To me, illustration is a lifestyle, not a nine-to-five job. As far as staying motivated, I just try to choose those kinds of projects that challenge me and allow me to investigate the things I'm most interested in. I work really quickly and am very aware of how long it takes me to do a project, so I am also honest with myself as far as how much I can take on at one time. I'm never going to overextend myself to the point where I might miss a deadline—that's just not an option. Having the right music to listen to is also a great motivator.

As an art director, what do you expect (in terms of professionalism, quality, etc.) from other freelance artists?

Deadlines are number one. If you can't get something to me on time, get out of this business. There are a hundred other people that are waiting for their opportunity who will get it in on time. I've had to tell really good friends that I wouldn't hire them again because they couldn't get something in on time.

Stay in contact, but don't be annoying—it's a real fine line, but figure out where that line is. If I don't hear from someone for a really long time, I forget to offer them jobs; it's as simple as that. Send some new images of things you've been working on every couple months.

Don't send me an amazing thumbnail and then turn in a final that is a totally different idea. Even if you hit it out of the park with the new version, I'll start to wonder if you're able to deliver what I need when I say yes to a sketch.

Oh, and did I mention deadlines?

What can artists do to stay motivated and ensure that their work remains fresh and interesting (especially if faced with rejection)?

The truth is, either you need to do this because you *need* to do this, or maybe you should go find something a little easier to do for a living. Because there is always someone else out there who does *need* to do this, and it shows in the work they do. Always be looking at both new and old art. Find things that inspire you. Do some work for yourself and send that out there to try to scare up some contacts. It's much, much easier to do work you want to do than having to mimic a bunch of other artists' styles to try to make a living.

Be willing to listen to anyone who is willing to critique your work. You don't have to take their advice, but sometimes we become so wrapped up in what's in front of us that we need a new set of eyes to see through. Above all, keep moving forward—art, illustration and design are all things that take lifetimes to master, so keep pushing yourself and never allow your work to drop below a certain level. If you stay true to yourself and your ideals, the rejections won't hurt as much.

Do you have any other advice for aspiring freelance artists?

If you have a passion for this, it doesn't matter how many rejections you get; just be honest with your own set of skills. It's never too late to go back and learn something you missed out on. (I didn't end up in college until eight years after I graduated from high school.) And of course, do the work you want to do—not the kind of work you think would sell. The rest of it is just working hard.

—*Erika O'Connell*

published artwork. Sample copies available for $10. Art guidelines for SASE with first-class postage.

Illustration Buys 150 illustrations/issue. Has featured illustrations by Oscar Ratti, Jon Parr, Guy Junker and Michael Lane. Features realistic and medical illustration. Assigns 10% of illustrations to new and emerging illustrators.

First Contact & Terms Illustrators: Send query letter with brochure, résumé, SASE and photocopies. Accepts disk submissions compatible with PageMaker, QuarkXPress and Illustrator. Samples are filed. Responds in 6 weeks. Publication will contact artist for portfolio review if interested. Portfolio should include b&w roughs, photocopies and final art. Buys first rights and reprint rights. Pays on publication: $100-300 for color cover; $10-100 for b&w inside; $100-150 for 2-page spreads.

Tips "Artists should see our journal and our Web site for reference, because it is unlike other martial art magazines. We can be found in bookstores, libraries or in listings of publications. Areas most open to freelancers are illustrations of historic warriors, weapons, castles, battles—any subject dealing with the martial arts of Asia. If artists appreciate aspects of Asian martial arts and/or Asian culture, we would appreciate seeing their work and discuss the possibilities of collaboration."

JUDICATURE

2700 University Ave., Des Moines IA 50311. E-mail: drichert@ajs.org. Web site: www.ajs.org. **Contact:** David Richert. Estab. 1917. Journal of the American Judicature Society. 4-color bimonthly publication. Circ. 6,000. Accepts previously published material and computer illustration. Original artwork returned after publication. Sample copy for SASE with $1.59 postage; art guidelines not available.

Cartoons Approached by 10 cartoonists/year. Buys 1-2 cartoons/issue. Interested in "sophisticated humor revealing a familiarity with legal issues, the courts and the administration of justice."

Illustration Approached by 20 illustrators/year. Buys 1-2 illustrations/issue. Has featured illustrations by Estelle Carol, Mary Chaney, Jerry Warshaw and Richard Laurent. Features humorous and realistic illustration; charts & graphs; computer and spot illustration. Works on assignment only. Interested in styles from "realism to light humor." Prefers subjects related to court organization, operations and personnel. Freelance work demands knowledge of Quark and FreeHand.

Design Needs freelancers for design. 100% of freelance work demands knowledge of Quark and FreeHand.

First Contact & Terms Cartoonists: Send query letter or e-mail with samples of style and SASE. Responds in 2 weeks. Illustrators: Send query letter, SASE, photocopies, tearsheets or brochure showing art style (can be sent electronically). Publication will contact artist for portfolio review if interested. Portfolio should include roughs and printed samples. Wants to see "black & white and color, along with the title and synopsis of editorial material the illustration accompanied." Buys one-time rights. Negotiates payment. Pays cartoonists $35 for unsolicited b&w cartoons.

© 2007 JonParr.com

"Dragon Spirit" by Jon Parr was created to illustrate an article for the *Journal of Asian Martial Arts*. It appeared on the cover of the Fall 2006 issue and has also been sold as prints to individual collectors. Parr says the magazine's editor found him through his Web site and online promotions. After publishing some of Parr's existing imagery in previous issues, the editor commissioned this piece for one-time use. "I love to receive new problems to solve, leaving my comfort zone to learn something new," says Parr.

Pays illustrators $250-375 for 2-, 3- or 4-color cover; $250 for b&w full page, $175 for b&w half page inside; $75-100 for spots. Pays designers by the project.
Tips "Show a variety of samples, including printed pieces and roughs."

KALEIDOSCOPE: Exploring the Experience of Disability Through Literature and the Fine Arts
701 S. Main St., Akron OH 44311-1019. (330)762-9755. E-mail: mshiplett@udsakron.org. Web site: www.udsakron.org **Editor-in-Chief:** Gail Willmott. Estab. 1979. Black & white with 4-color cover. Semiannual. "Elegant, straightforward design. Explores the experiences of disability through lens of the creative arts. Specifically seeking work by artists with disabilities. Work by artists without disabilities must have a disability focus." Circ. 1,500. Accepts previously published artwork. Sample copy: $6; art guidelines free for SASE with first-class postage.
Illustration Freelance art occasionally used with fiction pieces. More interested in publishing art that stands on its own as the focal point of an article. Approached by 15-20 artists/year. Has featured illustrations by Dennis J. Brizendine, Deborah Vidaver Cohen and Sandy Palmer. Features humorous, realistic and spot illustration.
First Contact & Terms Illustrators: Send query letter with résumé, photocopies, photographs, SASE and slides. Do not send originals. Prefers high contrast, b&w glossy photos, but will also review color photos or 35mm slides. Include sufficient postage for return of work. Samples are

not filed. Publication will contact artist for portfolio review if interested. Acceptance or rejection may take up to a year. Pays $25-100 for color covers; $10-25 for b&w or color insides. Rights revert to artist upon publication. Finds artists through submissions/self-promotions and word of mouth.

Tips "Inquire about future themes of upcoming issues. Considers all mediums, from pastels to acrylics to sculpture. Must be high-quality art."

KANSAS CITY MAGAZINE

7101 College Blvd., 4th Floor, Overland Park KS 66210. (913)894-6923. E-mail: cbrooks@kcmag.com. Web site: www.kcmag.com. **Editor:** Chadwick Brooks. Estab. 1994. Monthly lifestyle-oriented magazine, celebrating living in Kansas City. "We try to look at things from a different angle and show the city through the eyes of the people." Sample copies available for SASE with first-class postage.

Illustration Approached by 100-200 illustrators/year. Buys 3-5 illustrations/issue. Works on assignment only. Prefers conceptual editorial style. Considers all media. 25% of freelance illustration demands knowledge of Illustrator and Photoshop.

Design Needs freelancers for design and production. Prefers local freelancers only. 100% of freelance work demands knowledge of Photoshop, Illustrator and QuarkXPress.

First Contact & Terms Illustrators: Send postcard-size sample or query letter with tearsheets, photocopies and printed samples. Designers: Send query letter with printed samples, photocopies, SASE and tearsheets. Accepts disk submissions compatible with Macintosh files (EPS, TIFF, Photoshop, etc.). Samples are filed. Will contact artist for portfolio review if interested. **Pays on acceptance:** $500-800 for color cover; $50-200 for b&w, $150-300 for color inside; $50-150 for spots. Finds artists through sourcebooks, word of mouth, submissions.

Tips "We have a high-quality, clean, cultural, creative format. Look at magazine before you submit."

KENTUCKY LIVING

P.O. Box 32170, Louisville KY 40232. (502)451-2430. Fax: (502)459-1611. E-mail: e-mail@kentuckyliving.com. Web site: www.kentuckyliving.com. **Editor:** Paul Wesslund. Monthly 4-color magazine emphasizing Kentucky-related and general feature material for Kentuckians living outside metropolitan areas. Circ. 500,000. Sample copies available.

Cartoons Approached by 10-12 cartoonists/year.

Illustration Buys occasional illustrations. Works on assignment only. Prefers b&w line art.

First Contact & Terms Illustrators: Send query letter with résumé and samples. Samples not filed are returned only if requested. Buys one-time rights. **Pays on acceptance.** Pays cartoonists $30 for b&w. Pays illustrators $50 for b&w inside. Accepts previously published material. Original artwork returned after publication if requested.

KEY CLUB MAGAZINE

(formerly *Keynoter*), Kiwanis International, 3636 Woodview Trace, Indianapolis IN 46268. (317)875-8755. Fax: (317)879-0204. E-mail: magazine@kiwanis.org. Web site: www.keyclub.org. **Art Director:** Maria Malandrakis. Quarterly 4-color magazine with "contemporary design for mature teenage audience." Circ. 170,000. Free sample copy for SASE with 3 first-class postage stamps.

- Kiwanis International also publishes *Circle K* and *Kiwanis* magazines; see separate listings in this section.

Illustration Buys 3 editorial illustrations/issue. Works on assignment only.

First Contact & Terms Include SASE. Responds in 2 weeks. "Freelancers should call our Production and Art Department for interview." Previously published, photocopied and simultaneous

submissions OK. Original artwork is returned after publication by request. Buys first rights. **Pays on receipt of invoice**: $100 for b&w cover; $250 for color cover; $50 for b&w inside; $150 for color inside.

KIPLINGER'S PERSONAL FINANCE

1729 H St. NW, Washington DC 20006. (202)887-6416. Fax: (202)331-1206. E-mail: ccurrie@kipli nger.com. Web site: www.kiplinger.com. **Art Director:** Cynthia L. Currie. Estab. 1947. Monthly 4-color magazine covering personal finance issues such as investing, saving, housing, cars, health, retirement, taxes and insurance. Circ. 800,000.

Illustration Approached by 350 illustrators/year. Buys 4-6 illustrations/issue. Works on assignment only. Has featured illustrations by Dan Adel, Tim Bower, Michael Paraskevas and Edwin Fotheringham. Features computer, conceptual editorial and spot illustration. Assigns 5% of illustrations to new and emerging illustrators. Interested in editorial illustration in new styles, including computer illustration.

First Contact & Terms Illustration: Send postcard samples. Accepts Mac-compatible CD submissions. Samples are filed or returned by SASE if requested by artist. Will contact artist for portfolio review if interested. Buys one-time rights. Pays on publication: $400-1,200 for color inside; $250-500 for spots. Finds illustrators through reps, online, magazines, *Workbook* and award books. Originals are returned at job's completion.

KIWANIS MAGAZINE

Kiwanis International, 3636 Woodview Trace, Indianapolis IN 46268. (317)875-8755. Fax: (317)879-0204. E-mail: magazine@kiwanis.org. Web site: www.kiwanis.org. **Art Director:** Maria Malandrakis. Estab. 1918. Bimonthly 4-color magazine emphasizing civic and social betterment, business, education and domestic affairs for business and professional persons. Circ. 240,000. Free sample copy for SASE with 4 first-class postage stamps.

• Kiwanis International also publishes *Circle K* and *Key Club* magazines; see separate listings in this section.

Illustration Buys 1-2 illustrations/issue. Assigns themes that correspond to themes of articles. Works on assignment only. Keeps material on file after in-person contact with artist.

First Contact & Terms Illustration: Include SASE. Responds in 2 weeks. To show a portfolio, mail appropriate materials (out of town/state) or call or write for appointment. Portfolio should include roughs, printed samples, final reproduction/product, color and b&w tearsheets, photostats and photographs. Original artwork returned after publication by request. Buys first rights. **Pays on acceptance:** $600-1,000 for cover; $400-800 for inside; $50-75 for spots. Finds artists through talent sourcebooks, references/word of mouth and portfolio reviews.

Tips "We deal direct—no reps. Have plenty of samples, particularly those that can be left with us. Too many student or unassigned illustrations in many portfolios."

L.A. PARENT MAGAZINE

443 E. Irving Dr., Suite A, Burbank CA 91504-2447. (818)846-0400. Fax: (818)841-4964. E-mail: carolyn.graham@parenthood.com. Web site: www.laparent.com. **Editor:** Carolyn Graham. Estab. 1979. Monthly regional magazine for parents. 4-color throughout; "bold graphics and lots of photos of kids and families." Circ. 120,000. Accepts previously published artwork. Originals are returned at job's completion.

Illustration Buys 2 freelance illustrations/issue. Assigns 50% of illustrations to experienced but not well-known illustrators; 50% to new and emerging illustrators. Works on assignment only.

First Contact & Terms Send postcard sample. Accepts disk submissions compatible with Illustrator 5.0 and Photoshop 3.0. Samples are filed or returned by SASE. Responds in 2 months. To show a portfolio, mail thumbnails, tearsheets and photostats. Buys one-time rights or reprint rights. Pays on publication: $300 color cover; $75 for b&w inside; $50 for spots.

Tips "Show an understanding of our publication. Since we deal with parent/child relationships, we tend to use fairly straightforward work. Also looking for images and photographs that capture an L.A. feel. Read our magazine and find out what we're all about."

LADIES' HOME JOURNAL

125 Park Ave., New York NY 10017. (212)455-1293. Fax: (212)455-1313. E-mail: lhj@meredith.com. Web site: www.lhj.com. **Art Director**: Donni Alley. Estab. 1883. Monthly consumer magazine celebrating the rich values of modern family life. Topics include beauty, fashion, nutrition, health, medicine, home decorating, parenting, self-help, personalities and current events. Circ. 412,087.

Illustration Features caricatures of celebrities, humorous illustration and spot illustrations of families, women and pets.

First Contact & Terms Send postcard sample with URL. After introductory mailing, send follow-up postcard sample every 3-6 months. Samples are filed. Responds only if interested. Pays $200-500 for color inside. Buys one-time rights. Finds freelancers through submissions and sourcebooks.

LADYBUG®

Cricket Magazine Group, Carus Publishing, 70 E. Lake St., Suite 300, Chicago IL 60601. Web site: www.cricketmag.com. **Contact:** Art Submissions Coordinator. Managing Art Director: Suzanne Beck. Estab. 1990. Monthly 4-color magazine emphasizing literature and activities for children ages 2-6. Circ. 140,000. Art guidelines available on Web site.

• See also listings in this section for other magazines published by the Cricket Magazine Group: *BABYBUG, SPIDER, CRICKET* and *CICADA*.

Illustration Buys 200 illustrations/year. Prefers realistic styles (animal, wildlife or human figure); occasionally accepts caricatures. Works on assignment only.

First Contact & Terms Send photocopies, photographs or tearsheets to be kept on file. Samples are returned by SASE if requested. Responds in 3 months. Buys all rights. **Pays 45 days after acceptance**: $750 for color cover; $250 for color full page; $100 for color spots; $50 for b&w spots.

Tips "Before attempting to illustrate for *LADYBUG*, be sure to familiarize yourself with this age group, and read several issues of the magazine. Please do not query first."

THE LOOKOUT

8805 Governor's Hill Dr., Suite 400, Cincinnati OH 45249. (513)728-6866. Fax: (513)931-0950. E-mail: lookout@standardpub.com. Web site: www.lookoutmag.com. **Administrative Assistant:** Sheryl Overstreet. Weekly 4-color magazine for conservative Christian adults and young adults. Circ. 85,000. Sample copy available for $1.

Illustration Prefers both humorous and serious, stylish illustrations featuring Christian families. "We no longer publish cartoons."

First Contact & Terms Illustrators: Send postcard or other nonreturnable samples.

Tips Do not send e-mail submissions.

THE LUTHERAN

8765 W. Higgins Rd., Chicago IL 60631-4101. (773)380-2540. Fax: (773)380-2409. E-mail: lutheran@thelutheran.org. Web site: www.thelutheran.org. **Art Director:** Michael D. Watson. Estab. 1988. Monthly general interest magazine of the Evangelical Lutheran Church in America; 4-color, "contemporary" design. Circ. 400,000. Previously published work OK. Original artwork returned after publication on request. Free sample copy for 9×12 SASE and 5 first-class stamps. Freelancers should be familiar with Illustrator, QuarkXPress or Photoshop. Art guidelines available.

Cartoons Approached by 100 cartoonists/year. Buys 2 cartoons/issue from freelancers. Interested in humorous or thought-provoking cartoons on religion or about issues of concern to Christians; single panel b&w washes and line drawings with gaglines. Prefers finished cartoons.

Illustration Buys 6 illustrations/year from freelancers. Has featured illustrations by Rich Nelson, Jimmy Holder, Michael D. Watson. Assigns 30% of illustrations to well-known or "name" illustrators; 70% to experienced but not well-known illustrators. Works on assignment. Does not use spots.

First Contact & Terms Cartoonists: Send query letter with photocopies of cartoons and SASE. Illustrators: Send query letter with brochure and tearsheets to keep on file for future assignments. Buys one-time usage of art. Will return art if requested. Responds usually within 2 weeks. Accepts disk submississions compatible with Illustrator 5.0. Samples are returned by SASE if requested. Portfolio review not required. Pays on publication. Pays cartoonists $50-100 for b&w line drawings and washes. Pays illustrators $600 for color cover; $150-350 for b&w, $500 for color inside. Finds artists mainly through submissions.

Tips "Include your phone number with submission. Send samples that can be retained for future reference. We are partial to computer illustrations. Would like to see samples of charts and graphs. Want professional-looking work, contemporary, not too wild in style."

N MAIN LINE TODAY

4699 W. Chester Pike, Newtown Square PA 19703. (610)325-4630. Fax: (610)325-5215. Web site: www.mainlinetoday.com. **Art Director:** Ingrid Hansen-Lynch. Estab. 1996. Monthly consumer magazine providing quality information to the Main Line and western surburbs of Philadelphia. Circ. 40,000. Sample copy available for #10 SASE with first-class postage.

Illustration Approached by 100 illustrators/year. Buys 3-5 illustrations/issue. Considers acrylic, charcoal, collage, color wash, mixed media, oil, pastel and watercolor.

First Contact & Terms Send postcard sample or query letter with printed samples and tearsheets. Send follow-up postcard sample every 3-4 months. Samples are filed and are not returned. Responds only if interested. Buys one-time and reprint rights. Pays on publication: $400 maximum for color cover; $125-250 for b&w or color inside; $125 for spots. Finds illustrators by word of mouth and submissions.

N MANY MOUNTAINS MOVING

3775 W. 25th St., #F202, Greeley CO 80634-4162. E-mail: mmm@mmminc.org. Web site: www.mmminc.org. **Contact:** Art Director. Estab. 1994. Quarterly literary magazine featuring poetry and fine art. Circ. 3,000.

Illustration Approached by 100 illustrators/year. Buys 8-10 illustrations/issue.Features fine art and photography. Open to all subject matter and styles. Prefers b&w for inside art; b&w or color for cover. Assigns 30% of illustrations to well-known or "name" illustrators; 35% to experienced but not well-known illustrators; 35% to new and emerging illustrators.

First Contact & Terms Send query letter with SASE and photocopies. Responds in 2 months. Will contact artist for portfolio review if interested. Buys first North American serial rights. Pays on publication: $10 for b&w or color cover; $5 for b&w or color inside; $10 for 2-page spreads. Finds illustrators through promotional samples, word of mouth, gallery exhibitions and magazine articles.

N MASSAGE MAGAZINE

P.O. Box 887, Boulder Creek CA 95006-0887. E-mail: kmenehan@massagemag.com. Web site: www.massagemag.com. **Editor:** Karen Menehan. Estab. 1986. Bimonthly trade magazine for practitioners and their clients in the therapeutic massage and allied healing arts and sciences (acupuncture, aromatherapy, chiropractic, etc.). Circ. 45,000.

Illlustration Buys 6-10 illustrations/year. Features medical illustration representing mind/body/spirit healing. Themes/styles range from full-color/spiritually moving to business-like line art. Considers all media. All art must be scanable. Assigns 100% of illustrations to experienced but not well-known illustrators.

First Contact & Terms Send postcard sample and query letter with printed samples or photocopies. Accepts e-mail submissions. Prefers Mac-compatible files saved in EPS, PDF, PSD or TIFF format. Responds only if interested. Rights purchased vary according to project. Pays on publication: $75-200 for inside color illustration. Finds illustrators through word of mouth and submissions.

Tips "I'm looking for quick, talented artists with an interest in the healing arts and sciences."

MEDICAL ECONOMICS

123 Tice Blvd., Suite 300, Woodcliff Lake NJ 07677-7671. (201)690-5300. Fax: (201)690-5420. E-mail: cwilson@advanstar.com. Web site: www.memag.com. **Art Director:** Christie Wilson. Semimonthly trade publication for physicians in office, group and managed care practices. Circ. 168,000.

Illustration Buys 10 illustrations/year. Features spot illustrations of families, doctors, nurses and assistants.

First Contact & Terms Cartoonists: Send b&w photocopies. Illustrators: Send postcard sample. After introductory mailing, send follow-up postcard sample every 6 months. Buys one-time rights. Finds freelancers through submissions and sourcebooks.

N: MEETINGS WEST

550 Montgomery St., Suite 750, San Francisco CA 94111. (415)788-2005. Fax: (415)788-0301. Web site: www.meeting411.com. **Art Director:** Scott Kambic. Designer: Shirin Ardakani. Monthly 4-color tabloid/trade publication for meeting planners covering the 14 western United States, plus western Canada and Mexico. Circ. 30,000.

Illustration Approached by 5 illustrators/year. Buys more than 1 illustration/issue. Features computer illustration, humorous and spot illustration. Prefers subjects portraying business and business travel subjects. Prefers colorful, fun computer illustration. Assigns 20% of illustration to experienced, but not well-known illustrators; 80% to new and emerging illustrators.

First Contact & Terms Illustrators: Send postcard sample. Accepts Mac-compatible disk submissions. Samples are filed or returned by SASE. Will contact artist for portfolio review if interested. Buys first rights. Pays on publication: $700-1,000 for color cover; $50-300 for color inside. Finds illustrators through word of mouth, recommendations by colleagues, promo samples.

Tips "We are always open to new interpretations. All must be able to work fast and have a flexible style."

METROKIDS

4623 S. Broad St., Philadelphia PA 19112. (215)291-5560, ext. 102. Fax: (215)291-5563. E-mail: editor@metrokids.com. Web site: www.metrokids.com. **Executive Editor:** Tom Livingston. Estab. 1990. Monthly resource magazine for parents and children in the Delaware Valley. Circ. 130,000. Sample copy free for 3 first-class stamps. Art guidelines free for SASE with first-class postage.

Cartoons Approached by 12 cartoonists/year. Buys 1 cartoon/issue. Prefers parenting issues or kids' themes; single-panel b&w line drawings.

Illustration Approached by 50 illustrators/year. Buys 100 illustrations/year. Prefers parenting issues or kids' themes. Considers pen & ink.

First Contact & Terms Send query letter with tearsheets, photocopies and SASE. Samples are filed or returned by SASE if requested by artist. Responds in 3 months. Portfolio review not

required. Buys reprint rights. Pays on publication. Pays cartoonists $25 for b&w. Pays illustrators $50 for color cover; $25 for b&w inside.

MGW NEWSMAGAZINE
Guess What Media, LLC, 1123-21st St., Suite 200, Sacramento CA 95811-4225. (916)441-6397. Fax: (916)441-6422. E-mail: info@mgwnews.com. Web site: www.mgwnews.com. **Editorial Director:** Matthew Burlingame. Estab. 1978. Bimonthly publication featuring politics and commentary, interviews, local and national news, feature articles and investigative pieces. Highlighting the West Coast's progressive lifestyle are sections on automotive, gardening, home improvement, fashion, entertainment, travel and technology, as well as reviews of restaurants, theater, opera, film, art, books and music. "With a continued focus on quality of reporting and writing, *MGW* is the place to read about the issues that affect one's local community as well as the greater society in which we live." Circ. 21,000. Sample copies available for SASE and first-class postage.
Cartoons Approached by 15 cartoonists/year. Buys 5 cartoons/issue. Prefers gay/lesbian themes. Prefers single and multiple panel, political and humorous b&w line drawings with gagline. Pays cartoonists $5-50 for b&w.
Illustration Approached by 10 illustrators/year. Buys 3 illustrations/issue. Features caricatures of celebrities; humorous, realistic and spot illustration. Prefers gay/lesbian themes. Considers pen & ink. Assigns 50% of illustration to new and emerging illustrators. 50% of freelance illustration demands knowledge of PageMaker.
Design Needs freelancers for design and production. Prefers local designers. 100% of freelance work demands knowledge of PageMaker 6.5, QuarkXPress, Photoshop, Freehand, InDesign.
First Contact & Terms Cartoonists: Send query letter with photocopies and SASE. Illustrators: Send query letter with photocopies. Art director will contact artist for portfolio review of b&w photostats if interested. Rights purchased vary according to project. Pays on publication: $100 for b&w or color cover; $10-100 for b&w or color inside; $300 for 2-page spreads; $25 for spots. Finds illustrators through word of mouth and submissions.
Tips "Send us copies of your ideas that relate to gay/lesbian issues—serious and humorous."

⊠ MUSCLEMAG INTERNATIONAL
5775 McLaughlin Rd., Mississauga ON L5R 3P7 Canada. (905)507-3545. E-mail: editorial@emuscl emag.com. Web site: www.emusclemag.com. **Contact:** Robert Kennedy. Estab. 1974. Monthly consumer magazine emphasizing bodybuilding for men and women. Circ. 300,000. Sample copies available for $5; art guidelines not available.
Illustration Approached by 200 illustrators/year. Buys 130 illustrations/year. Has featured illustrations by Eric Blais, Mark Collins and Gino Edwards. Features caricatures of celebrities; charts & graphs; humorous, medical and computer illustrations. Assigns 20% of illustrations to new and emerging illustrators. Prefers bodybuilding themes. Considers all media.
First Contact & Terms Cartoonists: Send photocopy of your work. Illustrators: Send query letter with photocopies. Samples are filed. Responds in 1 month. Portfolio review not required. Buys all rights. **Pays on acceptance.** Pays cartoonists $50-100. Pays illustrators $100-150 for b&w inside; $250-1,000 for color inside. "Higher pay for high-quality work." Finds artists through "submissions from artists who see our magazine."
Tips Needs line drawings of bodybuilders exercising. "Study the publication. Work to improve by studying others. Don't send out poor-quality stuff. It wastes editor's time."

NA'AMAT WOMAN
350 Fifth Ave., Suite 4700, New York NY 10118. (212)563-5222. Fax: (212)563-5710. E-mail: judith@naamat.org. Web site: www.naamat.org. **Editor:** Judith Sokoloff. Estab. 1926. Quarterly magazine for Jewish women, covering a wide variety of topics that are of interest to the Jewish

community. Affiliated with NA'AMAT USA (a nonprofit organization). Sample copies available for $1 each.

Illustration Approached by 30 illustrators/year. Buys 2-3 illustrations/issue (b&w for inside; color cover). Has featured illustrations by Julie Delton, Ilene Winn-Lederer, Avi Katz and Yevgenia Nayberg.

First Contact & Terms Illustrators: Send query letter with tearsheets. Samples are filed or are returned by SASE if requested by artist. Responds only if interested. Will contact artist for portfolio review if interested. Portfolio should include b&w tearsheets and final art. Rights purchased vary according to project. Pays on publication. Pays illustrators $150-2 50 for cover; $75-100 for inside. Finds artists through sourcebooks, publications, word of mouth, submissions. Originals are returned at job's completion.

Tips "Give us a try! We're small, but nice."

THE NATION

33 Irving Place, 8th Floor, New York NY 10003. (212)209-5400. Fax: (212)982-9000. E-mail: studio@stevenbrowerdesign.com. Web site: www.thenation.com. **Art Director:** Steven Brower. Estab. 1865. Weekly journal of "left/liberal political opinion, covering national and international affairs, literature and culture." Circ. 100,000. Sample copies available.

- *The Nation*'s art director works out of his design studio at Steven Brower Design. You can send samples to *The Nation* and they will be forwarded.

© 2007 Sandy Oppenheimer

This studio piece by Sandy Oppenheimer not only sold in a show, but was also used as a cover illustration for Amy Shuman's book, *Other People's Stories* (University of Illinois Press), and as an illustration for an article in *Na'amat Woman*. "This piece is about letting go of the fears that keep us in our personal prisons," says Oppenheimer. "Letting Go" was an ideal image to accompany the *Na'amat* article, titled "Aging: To Defy, Accept or Celebrate?" Oppenheimer was paid $100 for the magazine publication and $500 for the cover use.

Illustration Approached by 50 illustrators/year. Buys 3-4 illustrations/issue. Works with 25 illustrators/year. Has featured illustrations by Robert Grossman, Luba Lukora, Igor Kopelnitsky and Karen Caldecott. Buys illustrations mainly for spots and feature spreads. Works on assignment only. Considers pen & ink, airbrush, mixed media and charcoal pencil; b&w only.

First Contact & Terms Illustrators: Send query letter with tearsheets and photocopies. "On top of a defined style, artist must have a strong and original political sensibility." Samples are filed or are returned by SASE. Responds only if interested. Buys first rights. Pays $100-150 for b&w inside; $175 for color inside. Originals are returned after publication upon request.

NATIONAL GEOGRAPHIC

P.O. Box 98199, Washington DC 20090. E-mail: ngm@nationalgeographic.com. Web site: www.nationalgeographic.com. **Art Director:** Chris Sloan. Estab. 1888. Monthly. Circ. 9 million.

- *National Geographic* receives up to 30 inquiries a day from freelancers, most of which are not appropriate to their needs. Please make sure you have studied several issues before you submit. They have a roster of artists they work with on a regular basis, and it's difficult to break in, but if they like your samples they will file them for consideration for future assignments.

Illustration Works with 20 illustrators/year. Contracts 50 illustrations/year. Interested in "full-color renderings of historical and scientific subjects. Nothing that can be photographed is illustrated by artwork. No decorative, design material. We want scientific geological cut-aways, maps, historical paintings, prehistoric scenes." Works on assignment only.

First Contact & Terms Send color copies, postcards, tearsheets, proofs or other appropriate samples. Art director will contact for portfolio review if interested. Samples are returned by SASE. **Pays on acceptance:** varies according to project.

Tips "Do your homework before submitting to any magazine. We only use historical and scientific illustrations—ones that are very informative and very accurate. No decorative, abstract or portraits."

N NATIONAL LAMPOON

8228 Sunset Blvd., Los Angeles CA 90046-2414. (310)474-5252. Fax: (310)474-1219. E-mail: srubin@nationallampoon.com. Web site: www.nationallampoon.com. **Art Director:** Joe Oesterle. Editor-in-chief: Scott Rubin. Estab. 1971. Online consumer magazine of humor and satire.

Cartoon Approached by 50 cartoonists/year. Buys 6 cartoons/issue. Prefers satire, humor; b&w line drawings.

Illustration Approached by 10 illustrators/year. Buys 30 illustrations/issue. Considers all media.

First Contact & Terms Cartoonists: Send photocopies and SASE. E-mail submissions are preferred. Illustrators: Send e-mail with JPEG images or query letter with photocopies and SASE. Samples are filed. Responds only if interested. Rights purchased vary according to project. Payment negotiable.

Design Needs freelancers for design and production. Prefers local designers. 100% of freelance work demands knowledge of Photoshop and QuarkXPress.

Tips "Since we are a Web-based publication, I prefer artists who are experienced with JPEG images and who are familiar with e-mailing their work. I'm not going to discount some brilliant artist who sends traditional samples, but those who send e-mail samples have a better chance."

NATURALLY

(formerly *Travel Naturally*), P.O. Box 317, Newfoundland NJ 07435. (973)697-3552. Fax: (973)697-8313. E-mail: naturally@internaturally.com. Web site: www.internaturally.com. **Publisher/Editor:** Bernard Loibl. Director of Operations: Brian J. Ballone. Estab. 1981. Quarterly magazine covering family nudism/naturism and nudist resorts and travel. Circ. 35,000. Sample

copies available for $8.95 and $4.50 postage; art guidelines for #10 SASE with first-class postage.

Cartoons Approached by 10 cartoonists/year. Buys approximately 3 cartoons/issue. Prefers nudism/naturism.

Illustration Approached by 10 illustrators/year. Buys approximately 3 illustrations/issue. Prefers nudism/naturism. Considers all media.

First Contact & Terms Cartoonists: Send query letter with finished cartoons. Illustrators: Contact directly. Accepts all digital formats or hard copies. Samples are filed. Always responds. Buys one-time rights. Pays on publication. Pays cartoonists $20-80. Pays illustrators $200 for cover; $80/page inside. Fractional pages or fillers are prorated.

NECROLOGY MAGAZINE

P.O. Box 510232, St. Louis MO 63151. (314)315-5200. E-mail: editor@necrologymag.com. Web site: www.necrologymag.com. **Editor:** John Ferguson. Estab. 2006. Quarterly consumer magazine of horror, science fiction, fantasy and ''dark Lovecraftian-type fiction.'' Circ.: 1,000 readers; 3,500 online visits/month. Sample copies available for $5 each. Art guidelines available for SASE or on Web site.

Cartoons Approached by 4-6 cartoonists/year. Buys 8-10 cartoons/year. Prefers horror, science fiction and fantasy themes; humorous, single-panel, b&w drawings and washes.

Illustration Approached by 2-3 illustrators/year. Buys 4-6 illustrations/year. Prefers horror, science fiction and fantasy themes. Assigns 50% of work to new and emerging illustrators. 100% of freelance work demands computer skills. Artists should be familiar with Photoshop.

First Contact & Terms Accepts e-mail submissions with image files or link to Web site; also accepts digital files on CD-ROM. Prefers Windows-compatible JPEG or GIF files. Samples are not filed and are returned by SASE only if requested. Responds within 2 months. Portfolio review not required. Pays cartoonists $5-15 for b&w cartoons. Pays illustrators $10-20 for b&w cover or b&w inside. **Pays on acceptance.** Buys one-time rights. Finds freelancers through submissions and word of mouth.

Tips ''Artwork should relate to the type of fiction we publish. E-mail and CD-ROM are the only methods of submission we accept.''

NERVE COWBOY

P.O. Box 4973, Austin TX 78765-4973. Web site: www.jwhagins.com/nervecowboy.html. **Editors:** Joseph Shields and Jerry Hagins. Estab. 1995. Biannual literary journal of poetry, short fiction and b&w artwork. Art guidelines free for #10 SASE with first-class postage.

Illustration Approached by 400 illustrators/year. Buys work from 20 illustrators/issue. Has featured illustrations by James Dankert, Wayne Hogan and Greta Shields. Features unusual illustration and creative b&w images. Strongly prefers b&w. ''Color will be considered if a black & white half-tone can reasonably be created from the piece.'' Assigns 60% of illustrations to new and emerging illustrators.

First Contact & Terms Illustrators: Send printed samples, photocopies, SASE. Samples are returned by SASE. Responds in 3 months. Portfolio review not required. Buys first North American serial rights. Pays on publication: 3 copies of issue in which art appears on cover, or 1 copy if art appears inside.

Tips ''We are always looking for new artists with an unusual view of the world.''

NEW HAMPSHIRE MAGAZINE

150 Dow St., Manchester NH 03101. (603)624-1442. Fax: (603)624-1310. E-mail: slaughlin@nh.com. Web site: www.nhmagazine.com. **Creative Director:** Susan Laughlin. Estab. 1990. Monthly 4-color magazine emphasizing New Hampshire lifestyle and related content. Circ. 26,000.

Illustration Approached by 300 illustrators/year. Has featured illustrations by Brian Hubble and

Stephen Sauer. Features lifestyle illustration, charts & graphs and spot illustration. Prefers conceptual illustrations to accompany articles. Assigns 50% to experienced but not well-known illustrators; 50% to new and emerging illustrators.

First Contact & Terms Send postcard sample and follow-up postcard every 3 months. Samples are filed. Portfolio review not required. Negotiates rights purchased. Pays on publication. Pays $75-250 for color inside; $150-500 for 2-page spreads; $125 for spots.

Tips "Lifestyle magazines want 'uplifting' lifestyle messages, not dark or disturbing images."

NEW MOON: The Magazine for Girls and Their Dreams

2 W. First St. #101, Duluth MN 55802. (218)728-5507. Fax: (218)728-0314. E-mail: girl@newmoon.org. Web site: www.newmoon.org. **Executive Editor:** Kate Freeborn. Estab. 1992. Bimonthly 4-color cover, 4-color inside consumer magazine. Circ. 30,000. Sample copies are $7.00.

Illustration Buys 3-4 illustrations/issue. Has featured illustrations by Andrea Good, Liza Ferneyhough, Liza Wright. Features realistic illustrations, informational graphics and spot illustrations of children, women and girls. Prefers colored work. Assigns 30% of illustrations to new and emerging illustrators.

First Contact & Terms Illustrators: Send postcard sample or other nonreturnable samples. Final work can be submitted electronically or as original artwork. Send EPS files at 300 dpi or greater, hi-res. Samples are filed. Responds only if interested. Portfolio review not required. Buys onetime rights. Pays on publication: $400 maximum for color cover; $200 maximum for inside.

Tips "Be very familiar with the magazine and our mission. We are a magazine for girls ages 8-14 and look for illustrators who portray people of all different shapes, sizes and ethnicities in their work. Women and girl artists preferred. See cover art guidelines at www.newmoon.org.

⬛ THE NEW RENAISSANCE

26 Heath Rd., Apt. 11, Arlington MA 02174-3645. E-mail: umichaud@gwi.net. **Editor:** Louise T. Reynolds. Co-editor/Art Editor: Michal Anne Kuchauki. Estab. 1968. Biannual (spring and fall) magazine emphasizing literature, arts and opinion for "the general, literate public"; b&w with 4-color cover, 6×9. Circ. 1,400. Originals are only returned after publication if SASE is enclosed. Sample copy available for $6.50.

Cartoons Approached by 35-45 freelance cartoonists/year. Cartoons used only every 4-5 issues.

Illustration Buys 6-8 illustrations/issue from freelancers and "occasional supplementary artwork (2-4 pages)" mainly on assignment. Has featured illustrations by Phoebe McKay and Barry Nolan. Features expressive, realistic illustrations and symbolism. Assigns 25% or more illustrations to new and emerging illustrators.

First Contact & Terms Illustrators: Send résumé, samples, photos and SASE. DO NOT send postcards. Responds in 4 months. Publication will contact artist for portfolio review if interested, "but only if artist has enclosed SASE." Portfolio should include roughs, b&w photographs and SASE. Buys one-time rights. Pays after publication. Pays $15-30 for b&w plus 1 copy. Pays illustrators $25-30 for b&w inside; $18-25 for drop-in art.

Tips "Buy a back issue to see if your work fits in with our mission. We like realistic or symbolic, expressionistic interpretations. Only interested in b&w. We want artists who understand a 'quality' (or 'serious' or 'literary') piece of fiction. Study our past illustrations. We are receiving work that is appropriate for a newsletter, newsprint, or alternative-press magazines, but not for us. We will consider only work that is submitted with a SASE."

NEW WRITER'S MAGAZINE

P.O. Box 5976, Sarasota FL 34277. Phone/fax: (941)953-7903. E-mail: newriters@aol.com. **Editor/Publisher:** George J. Haborak. Estab. 1986. Bimonthly b&w magazine. "Forum where all writers can exchange thoughts, ideas and their own writing. It is focused on the needs of the

aspiring or new writer." Circ. 5,000. Rarely accepts previously published artwork. Original artwork returned after publication if requested. Sample copies available for $3 each; art guidelines available for SASE with first-class postage.

Cartoons Approached by 15 cartoonists/year. Buys 1-3 cartoons/issue. Features spot illustration. Assigns 80% of illustrations to new and emerging illustrators. Prefers cartoons "that reflect the joys or frustrations of being a writer/author"; single panel b&w line drawings with gagline.

Illustration Buys 1 illustration/issue. Works on assignment only. Prefers line drawings. Considers watercolor, mixed media, colored pencil and pastel.

First Contact & Terms Cartoonists: Send query letter with samples of style. Illustrators: Send postcard sample. Samples are filed or returned by SASE if requested. Responds in 1 month. To show portfolio, mail tearsheets. Buys first rights or negotiates rights purchased. Pays on publication. Payment negotiated.

THE NEW YORKER

4 Times Square, New York NY 10036. (212)286-5400. Fax: (212)286-5735. E-mail: toon@cartoonbank.com. Web site: www.cartoonbank.com. Emphasizes news analysis and lifestyle features. Circ. 938,600.

Cartoons Buys b&w cartoons. Receives 3,000 cartoons/week. Cartoon editor is Bob Mankoff, who also runs Cartoon Bank, a stock cartoon agency that features *New Yorker* cartoons.

Illustration All illustrations are commissioned. Portfolios may be dropped off Wednesdays (10-6) and picked up on Thursdays. Art director is Caroline Mailhot.

First Contact & Terms Cartoonists: Accepts unsolicited submissions only by mail. Reviews unsolicited submissions every 1-2 weeks. Photocopies only. Strict standards regarding style, technique, plausibility of drawing. Especially looks for originality. Pays $575 minimum for cartoons. Contact cartoon editor. Illustrators: Mail samples, no originals. "Because of volume of submissions we are unable to respond to all submissions. No calls please." Emphasis on portraiture. Contact illustration department.

Tips "Familiarize yourself with *The New Yorker*."

✠ NORTH CAROLINA LITERARY REVIEW

English Dept., Greenville NC 27858-4353. E-mail: bauerm@ecu.edu. **Editor:** Margaret Bauer. Estab. 1992. Annual literary magazine of art, literature, culture having to do with North Carolina. Circ. 500. Samples available for $10 and $15; art guidelines for SASE with first-class postage or e-mail address. North Carolina artists/art only.

Illustration Considers all media by North Carolina artists/photographers/graphic designers.

First Contact & Terms Illustrators: Send postcard sample or send query letter with printed samples, SASE and tearsheets. Send follow-up postcard sample every 2 months. Samples are not filed and are returned by SASE. Responds in 2 months. Art director will contact artist for portfolio review of b&w, color slides and transparencies if interested. Rights purchased vary according to projects. Pays on publication: $100-250 for cover; $50-250 for inside; $25 for spots. Finds illustrators through magazines and word of mouth.

Tips "Read our magazine. Artists, photographers, and graphic designers have to have North Carolina connections."

NOTRE DAME MAGAZINE

535 Grace Hall, Notre Dame IN 46556. (574)631-4630. Web site: www.nd.edu/~ndmag. **Design & Art Director:** Don Nelson. Estab. 1971. Quarterly 4-color university magazine that publishes essays on cultural, spiritual and ethical topics, as well as news of the university for Notre Dame alumni and friends. Circ. 155,000. Accepts previously published artwork. Original artwork returned after publication.

Illustration Buys 5-8 illustrations/issue. Has featured illustrations by Ken Orvidas, Earl Keleny, Vivienne Fleshner, Darren Thompson and James O'Brien. Works on assignment only.

First Contact & Terms "Don't send submissions—only tearsheets or samples." Tearsheets, photographs, brochures and photocopies OK for samples. Samples are returned by SASE if requested. Buys first rights.

Tips "Create images that can communicate ideas. Looking for noncommercial-style editorial art by accomplished, experienced editorial artists. Conceptual imagery that reflects the artist's awareness of fine art ideas and methods is the kind of thing we use. Sports action illustrations not used. Cartoons not used."

NURSEWEEK

6860 Santa Teresa Blvd., San Jose CA 95119. (408)249-5877. Fax: (408)574-1207. E-mail: youngk @nurseweek.com. Web site: www.nurseweek.com. **Art Director:** Young Kim. *"Nurseweek* is a biweekly 4-color tabloid mailed free to registered nurses nationwide. Combined circulation of all publications is over 1 million. *Nurseweek* provides readers with nursing-related news and features that encourage and enable them to excel in their work and that enhance the profession's image by highlighting the many diverse contributions nurses make. In order to provide a complete and useful package, the publication's article mix includes late-breaking news stories, news features with analysis (including in-depth bimonthly special reports), interviews with industry leaders and achievers, continuing education articles, career option pieces (Spotlight, Entrepreneur) and reader dialogue (Letters, Commentary, First Person)." Sample copy: $3. Art guidelines not available. Needs computer-literate freelancers for production. 90% of freelance work demands knowledge of Quark, PhotoShop, Illustrator, Adobe Acrobat.

Illustration Approached by 10 illustrators/year. Buys 1 illustration/year. Prefers pen & ink, watercolor, airbrush, marker, colored pencil, mixed media and pastel. Needs medical illustration.

Design Needs freelancers for design. 90% of design demands knowledge of Photoshop CS, QuarkXPress 6.0. Prefers local freelancers. Send query letter with brochure, résumé, SASE and tearsheets.

First Contact & Terms Illustrators: Send query letter with brochure, tearsheets, photographs, photocopies, photostats, slides and transparencies. Samples are not filed and are returned by SASE if requested by artist. Publication will contact artist for portfolio review if interested. Portfolio should include final art samples, photographs. Buys all rights. Pays on publication: $150 for b&w, $250 for color cover; $100 for b&w, $175 for color inside. Finds artists through sourcebooks.

NUTRITION HEALTH REVIEW

P.O. Box 406, Haverford PA 19041. (610)896-1853. Fax: (610)896-1857. **Publisher:** A. Rifkin. Estab. 1975. Quarterly newspaper covering nutrition, health and medical information for the consumer. Circ. 285,000. Sample copies available for $3. Art guidelines available.

Cartoons Prefers single panel, humorous, b&w drawings.

Illustration Features b&w humorous, medical and spot illustrations pertaining to health.

First Contact & Terms Cartoonists/Illustrators: Send query letter with b&w photocopies. After introductory mailing, send follow-up postcard every 3-6 months. Samples are filed or returned by SASE. Responds in 6 months. Company will contact artist for portfolio review if interested. Pays cartoonists $20 maximum for b&w. Pays illustrators $200 maximum for b&w cover; $30 maximum for b&w inside. **Pays on acceptance.** Buys first rights, one-time rights, reprint rights. Finds freelancers through agents, submissions, sourcebooks.

O&A MARKETING NEWS

Kal Publications, 559 S. Harbor Blvd., Suite A, Anaheim CA 92805-4525. (714)563-9300. Fax: (714)563-9310. Web site: www.kalpub.com. **Editor:** Kathy Laderman. Estab. 1966. Bimonthly

b&w trade publication about the service station/petroleum marketing industry. Circ. 8,000. Sample copies for 11×17 SASE with 10 first-class stamps.

Cartoons Approached by 10 cartoonists/year. Buys 1-2 cartoons/issue. Prefers humor that relates to service station industry. Prefers single panel, humorous, b&w line drawings.

First Contact & Terms Cartoonists: Send b&w photocopies, roughs or samples and SASE. Samples are returned by SASE. Responds in 1 month. Buys one-time rights. **Pays on acceptance:** $10 for b&w.

Tips "We run a cartoon (at least one) in each issue of our trade magazine. We're looking for a humorous take on business—specifically the service station/petroleum marketing/carwash/quick lube industry that we cover."

OCP (OREGON CATHOLIC PRESS)

5536 NE Hassalo, Portland OR 97213-3638. E-mail: gust@ocp.org. Web site: www.ocp.org. **Creative Director:** Gus Torres. Estab. 1988. Quarterly liturgical music planner in both Spanish and English with articles, photos and illustrations specifically for but not exclusive to the Roman Catholic market.

- OCP (Oregon Catholic Press) is a nonprofit publishing company, producing music and liturgical publications used in parishes throughout the United States, Canada, England and Australia. See additional listings in the Book Publishers and Record Labels sections.

Illustration Approached by 10 illustrators/year. Buys 20 illustrations/issue. Has featured illustrations by John August Swanson and Steve Erspamer. Assigns 50% of illustrations to new and emerging illustrators.

First Contact & Terms Illustrators: Send query letter with printed samples, photocopies, SASE. Does not return samples. Prefers to see samples on artist's Web site. Portfolio review not required. Rights purchased vary according to project. **Pays on acceptance:** $100-250 for color cover; $30-50 for b&w spot art.

Ⓝ OFFICEPRO MAGAZINE

IAAP, P.O. Box 20404, Kansas City MO 64195. (816)891-6600. Fax: (816)891-9118. E-mail: aensminger@iaap-hq.org. Web site: www.iaap-hq.org. **Editor:** Aaron Ensminger. Estab. 1945. Trade journal published 8 times/year. Official publication of the International Association of Administrative Professionals. Emphasizes workplace issues, trends and technology. Circ. 40,000. Sample copies available; contact subscription office at (816)891-6600, ext. 2236.

Illustration Approached by 50 illustrators/year. Buys 20 or fewer illustrations/year. Works on assignment and purchases stock art. Prefers communication, travel, meetings and international business themes. Considers pen & ink, airbrush, colored pencil, mixed media, collage, charcoal, watercolor, acrylic, oil, pastel, marker and computer.

First Contact & Terms Illustrators: Send postcard-size sample or send query letter with brochure, tearsheets and photocopies. Samples are filed. Responds only if interested. Will contact artist for portfolio review if interested. Portfolio should include final art and tearsheets. Accepts previously published artwork. Originals are returned at job's completion upon request only. Usually buys one-time rights, but rights purchased vary according to project. Pays $500-600 for color cover; $200-400 for color inside; $60-150 for b&w inside; $60 for b&w spots. Finds artists through word of mouth and artists' samples.

ON EARTH

40 W. 20th St., New York NY 10011. (212)727-2700. Fax: (212)727-1773. E-mail: OnEarth@nrdc.org. Web site: www.nrdc.org. **Art Director:** Gail Ghezzi. Associate Art Director: Irene Huang. Estab. 1979. Quarterly "award-winning environmental magazine exploring politics, nature, wildlife, science and solutions to problems." Circ. 140,000.

Illustration Buys 4 illustrations/issue. Prefers 4-color.

First Contact & Terms Illustrators: Send postcard sample. "We will accept work compatible with QuarkXPress, Illustrator 8.0, Photoshop 5.5 and below." Responds only if interested. Buys one-time rights. Also may ask for electronic rights. Pays $100-300 for b&w inside. Payment for spots varies. Finds artists through sourcebooks and submissions.

Tips "Our illustrations are often conceptual, thought-provoking, challenging. We enjoy thinking artists, and we encourage ideas and exchange."

THE OPTIMIST

4494 Lindell Blvd., St. Louis MO 63108-2404. (314)371-6000. Fax: (314)371-6006. E-mail: nickrent a@optimist.org. Web site: www.optimist.org. **Graphics Coordinator:** Andrea Nickrent. Quarterly 4-color magazine with 4-color cover that emphasizes activities relating to Optimist clubs in U.S. and Canada (civic-service clubs). "Magazine is mailed to all members of Optimist clubs. Average age is 42; most are management level with some college education." Circ. 120,000. Sample copy available for SASE.

Cartoons Buys 2 cartoons/issue. Has featured cartoons by Martin Bucella, Randy Glasbergen and Randy Bisson. Prefers themes of general interest, family-orientation, sports, kids, civic clubs. Prefers color, single-panel, with gagline. No washes.

First Contact & Terms Send query letter with samples. Send art on a disk if possible (Macintosh compatible). Submissions returned by SASE. Buys one-time rights. **Pays on acceptance:** $30 for b&w or color.

Tips "Send clear cartoon submissions, not poorly photocopied copies."

🅽 ORANGE COAST MAGAZINE

3701 Birch St., Suite 100, Newport Beach CA 92660. (949)862-1133. Fax: (949)862-0133. E-mail: ckassebaum@orangecoastmag.com. Web site: www.orangecoast.com. **Art Director:** Cindy Kassebaum. Estab. 1970. Monthly 4-color local consumer magazine with celebrity covers. Circ. 50,000.

Illustration Approached by 100 illustrators/year. Has featured illustrations by Cathi Mingus, Gweyn Wong, Scott Lauman, Santiago Veeda, John Westmark, Robert Rose, Nancy Harrison. Features computer, fashion and editorial illustrations featuring children and families. Prefers serious subjects; some humorous subjects. Assigns 10% of illustrations to well-known or "name" illustrators; 40% to experienced but not well-known illustrators; 50% to new and emerging illustrators. 40% of freelance illustration demands knowledge of Illustrator or Photoshop.

First Contact & Terms Illustrators: Send postcard or other nonreturnable samples. Accepts Mac-compatible disk submissions. Send EPS files. Samples are filed. Responds in 1 month. Will contact artist for portfolio review if interested. **Pays on acceptance:** $175 for b&w or color inside; $75 for spots. Finds illustrators through promotional samples.

Tips "Looking for fresh and unique styles. We feature approximately four illustrators per publication. I've developed great relationships with all of them."

OREGON QUARTERLY

130 Chapman Hall, 5228 University of Oregon, Eugene OR 97403-5228. (541)346-5048. Fax: (541)346-5571. E-mail: quarterly@uoregon.edu. Web site: www.oregonquarterly.com. **Art Director:** Tim Jordan. Editor: Guy Maynard. Estab. 1919. Quarterly 4-color alumni magazine. Emphasizes regional (Northwest) issues and events as addressed by University of Oregon faculty members and alumni. Circ. 91,000. Sample copies available for SASE with first-class postage.

Illustration Approached by 25 illustrators/year. Buys 1-2 illustrations/issue. Prefers story-related themes and styles. Interested in all media.

First Contact & Terms Illustrators: Send query letter with résumé, SASE and tearsheets. Samples

are filed unless accompanied by SASE. Responds only if interested. Portfolio review not required. Buys one-time rights for print and electronic versions. **Pays on acceptance:** rates negotiable. Accepts previously published artwork. Originals are returned at job's completion.

Tips "Send postcard or URL, not portfolio."

OREGON RIVER WATCH

P.O. Box 294, Rhododendron OR 97049. (503)622-4798. **Editor:** Michael P. Jones. Estab. 1985. Quarterly b&w books published in volumes emphasizing "fisheries, fishing, camping, rafting, environment, wildlife, hiking, recreation, tourism, mountain and wilderness scenes and everything that can be related to Oregon's waterways." Circ. 2,000. Accepts previously published material. Original artwork returned after publication. Art guidelines available for SASE with first-class postage.

Cartoons Approached by 400 cartoonists/year. Buys 1-25 cartoons/issue. Cartoons need to be straightforward, about fish and wildlife/environmental/outdoor-related topics. Prefers single, double or multiple panel b&w line drawings, b&w or color washes with or without gagline.

Illustration Approached by 600 illustrators/year. Works with 100 illustrators/year. Buys 225 illustrations/year. Needs editorial, humorous and technical illustration related to the environment. "We need black & white pen & ink sketches. We look for artists who are not afraid to be creative, rather than those who merely go along with trends."

Design Needs freelancers for design and production.

First Contact & Terms Cartoonists: Send query letter with SASE, samples of style, roughs or finished cartoons. Illustrators: Send query letter with brochure, résumé, photocopies, SASE, slides, tearsheets and transparencies. "Include enough to show me your true style." Designers: Send brochure, photocopies, SASE, tearsheets, résumé, photographs, slides and transparencies. Samples not filed are returned by SASE. Responds in 2 months. Buys one-time rights. Pays in copies.

Tips "Freelancers must be patient. We have a lot of projects going on at once but cannot always find an immediate need for a freelancer's talent. Being pushy doesn't help. I want to see examples of the artist's expanding horizons, as well as their limitations. Make it really easy for us to contact you. Remember, we get flooded with letters and will respond faster to those with a SASE."

ORGANIC GARDENING

22 E. Second St., Emmaus PA 18098. (610)967-5171. Fax: (610)967-7846. E-mail: gavin.robinson @rodale.com. Web site: www.organicgardening.com. **Art Director:** Gavin Robinson. Bimonthly magazine emphasizing gardening. Circ. 306,079. Sample copies available for SASE.

Illustration Buys 10 illustrations/issue. Works on assignment only.

First Contact & Terms Illustrators: Send tearsheets. Samples are filed or are returned by SASE only. Occasionally needs technical illustration. Buys first rights or one-time rights.

Tips "Our emphasis is 'how-to' gardening; illustrators with experience in the field will have a greater chance of being published. Detailed and fine rendering quality is essential."

ORLANDO MAGAZINE

801 N. Magnolia Ave., 201, Orlando FL 32803. (407)423-0618. Fax: (407)237-6258. E-mail: jason.j ones@orlandomagazine.com. Web site: www.orlandomagazine.com. **Art Director:** Jason Jones. Estab. 1946. "We are a monthly city/regional magazine covering the Central Florida area—local issues, sports, home and garden, business, entertainment and dining." Circ. 40,000. Accepts previously published artwork. Originals are returned at job's completion. Sample copies available.

Illustration Buys 2-3 illustrations/issue. Has featured illustrations by T. Sirell, Rick Martin, Mike Wright, Jon Krause. Assigns 100% of illustrations to experienced, but not necessarily well-known illustrators. Works on assignment only. Needs editorial illustration.

Design Needs freelancers for design and production.

First Contact & Terms Illustrators: Send postcard, brochure or tearsheets. Samples are filed and are not returned. Responds only if interested with a specific job. Portfolio review not required. Buys first rights, one-time rights or all rights (rarely). Pays for design by the project.

Tips "Send appropriate samples. Most of my illustration hiring is via direct mail. The magazine field is still a great place for illustration. Have several ideas ready after reading editorial to add to or enhance our initial concept."

OUR STATE: DOWN HOME IN NORTH CAROLINA

P.O. Box 4552, Greensboro NC 27404. (336)286-0600. Fax: (336)286-0100. E-mail: art_director@o urstate.com. Web site: www.ourstate.com. **Art Director:** Shay Sprinkles. Estab. 1933. Monthly 4-color consumer magazine featuring travel, history and culture of North Carolina. Circ. 130,000. Art guidelines free for #10 SASE with first-class postage.

Illustration Approached by 6 illustrators/year. Buys 12 illustrations/issue. Features "cartoon-y" maps of towns in North Carolina. Prefers "watercolor, pastel and bright colors." Assigns 100% to new and emerging illustrators. 100% of freelance illustration demands knowledge of Illustrator.

First Contact & Terms Illustrators: Send postcard sample or nonreturnable samples. Samples are not filed and are not returned. Portfolio review not required. Buys one-time rights. Pays on publication: $400-600 for color cover; $75-350 for b&w inside; $75-350 for color inside; $350 for 2-page spreads. Finds illustrators through word of mouth.

N OUT OF THE BOXX

Phone/fax: (650)755-4827. E-mail: outoftheboxx@earthlink.net. Web site: www. outoftheboxx.l ookscool.com. **Editor:** Joy Miller. Art Director/Publisher: L.A. Miller. Estab. 2007. Monthly trade journal for cartoonists, humor writers, art collectors. Sample copy available for $3.50 ($6 foreign). Art guidelines available for #10 SASE with first-class postage.

Cartoons Buys 3-4 cartoons/issue (inside and front cover). Prefers single- or multi-panel; caption-less for front cover; b&w line drawings, no washes; humorous themes (avoid vulgarity).

Illustration Buys 1-2 illustrations/issue. Has featured work by Jack Cassady, Steve Langille, Art McCourt, Thom Bluemel and Brewster Allison. Considers pen & ink, mixed media.

First Contact & Terms Send query letter with business card, promo sheet, photocopied samples, SASE. Include all contact information (name, postal mail & e-mail addresses, URL, phone/fax numbers). Samples are filed. Responds in 1-2 months. Buys reprint rights. Works on assignment only. **Pays on acceptance.** Pays cartoonists $20/front cover, $15/inside spots; pays illustrators $20-30.

Tips "Please study a few sample issues to grasp the styles we accept."

OUTER DARKNESS

1312 N. Delaware Place, Tulsa OK 74110. E-mail: odmagazine@aol.com. **Editor:** Dennis Kirk. Estab. 1994. Quarterly digest/zine of horror and science fiction, poetry and art. Circ. 500. Sample copy available for $3.95 plus $1 postage. Sample illustrations free for 6×9 SASE and 2 first-class stamps. Art guidelines free for #10 SASE with first-class postage.

Cartoons Approached by 15-20 cartoonists/year. Buys 3-5 cartoons/year. Prefers horror/science fiction slant, but not necessary. Prefers single-panel, humorous, b&w line drawings.

Illustration Approached by 60-70 illustrators/year. Buys 5-7 illustrations/issue. Has featured illus-trations by Steve Rader, Popeye Wong, Bob Bryson and Erika McGinnis. Features realistic science fiction and horror illustrations, b&w, pencil or ink. Assigns 20% of illustrations to new and emerging illustrators.

First Contact & Terms Cartoonists: Send query letter with b&w photocopies, samples, SASE. Samples are returned. Illustrators: Send query letter with photocopies, SASE. Responds in 2

weeks. Buys one-time rights. Pays on publication in contributor's copies. Finds illustrators through magazines and submissions.

Tips "Send samples of your work, along with a cover letter. Let me know a little about yourself. I enjoy learning about artists interested in *Outer Darkness*. The magazine is continuing to grow at an incredible rate; it's presently available through both Project Pulp and Shocklines. It's also available in two out-of-state bookstores, and I'm working to get it in more."

OVER THE BACK FENCE MAGAZINE

2947 Interstate Pkwy., Brunswick OH 44212. (330)220-2483. Fax: (330)220-3083. E-mail: rockya @longpointmedia.com. Web site: www.backfencemagazine.com. **Creative Director:** Rocky Alten. Estab. 1994. Quarterly consumer magazine emphasizing southern Ohio topics. Circ. 15,000. Sample copy available for $5; illustrator's guidelines can be found on the Web site.

Illustration Features humorous and realistic illustration; informational graphics and spot illustration. Assigns 50% of illustration to experienced but not well-known illustrators; 50% to new and emerging illustrators.

First Contact & Terms Illustrators: Send query letter with photocopies, tearsheets and SASE. See guidelines on Web site. Samples are occasionally filed or returned by SASE. Responds in 3 months. Creative director will contact artist for portfolio review if interested. Buys one-time rights. Pays $100 for b&w and color covers; $25-100 for b&w and color inside; $25-200 for 2-page spreads; $25-100 for spots. Finds illustrators through word of mouth and submissions.

Tips "Our readership enjoys our warm, friendly approach. The artwork we select will possess the same qualities."

ℕ 🖼 PALO ALTO WEEKLY

703 High St., Palo Alto CA 94302. (650)326-8210. Fax: (650)326-3928. E-mail: chubenthal@pawe ekly.com. Web site: www.paloaltoonline.com/weekly/index2.shtml. **Design Director:** Carol Hubenthal. Estab. 1979. Semiweekly newspaper. Circ. 45,000. Accepts previously published artwork. Originals are returned at job's completion. Sample copies available.

Illustration Works on assignment only. Considers all media. Uses mostly photos and very few illustrations.

First Contact & Terms Illustrators: Send query letter with brochure, résumé, SASE, tearsheets, photographs and photocopies. Samples are filed. Publication will contact artist for portfolio review if interested. Pays on publication: $200 for color cover; $100 for b&w inside; $125 for color inside.

Tips Uses freelance illustration for covers and cover story, special section covers such as restaurant guides. Looking for San Francisco Bay area artists only.

ℕ PARADE MAGAZINE

711 Third Ave., New York NY 10017-4014. (212)450-7000. Fax: (212)450-7284. E-mail: ira_yoffe @parade.com. Web site: www.parade.com. **Creative Director:** Ira Yoffe. Weekly emphasizing general-interest subjects. Circ. 36 million (readership is 75 million). Sample copy available. Art guidelines for SASE with first-class postage.

Illustration Works on assignment only.

Design Needs freelancers for design. 100% of freelance work demands knowledge of Photoshop, Illustrator, InDesign and QuarkXPress. Prefers local freelancers.

First Contact & Terms Illustrators: Send query letter with brochure, résumé, business card, postcard and/or tearsheets to be kept on file. Designers: Send query letter with résumé. Call or write for appointment to show portfolio. Responds only if interested. Buys first rights, occasionally all rights. Pays for design by the project, by the day or by the hour, depending on assignment.

Tips "Provide a good balance of work."

Ⓝ PARENTS' PRESS

1454 Sixth St., Berkeley CA 94710-1431. (510)524-1602. Fax: (510)524-0912. E-mail: parentsprs@ aol.com. **Art Director:** Ann Skram. Estab. 1980. Monthly tabloid-size newspaper "for parents in the San Francisco Bay area." Circ. 75,000.

Illustration Buys occasional 4-color cover illustrations. Prefers parenting and child related. Considers all media, must be suitable for reproduction on newsprint. E-mail query with URL for online samples; no e-mail attachments.

First Contact & Terms "We will accept work compatible with QuarkXPress 4.1, Photoshop and Illustrator." Responds only if interested. Art director will contact artist for portfolio review of b&w and color slides if interested. Buys one-time rights. Pays on publication; negotiable.

PC MAGAZINE

Ziff Davis Media, 28 E. 28th St., 11th Floor, New York NY 10016. (212)503-3500. Fax: (212)503-5580. Web site: www.pcmag.com. **Art Director:** Richard Demler. Senior Associate Art Director: Michael St. George. Estab. 1983. Bimonthly consumer magazine featuring comparative lab-based reviews of current PC hardware and software. Circ. 750,000. Sample copies available.

Illustration Approached by 100 illustrators/year. Buys 5-10 illustrations/issue. Considers all media.

First Contact & Terms Send postcard sample and/or printed samples, photocopies, tearsheets. Accepts CD or e-mail submissions. Samples are filed. Portfolios may be dropped off and should include tearsheets and transparencies; art department keeps for one week to review. **Pays on acceptance.** Payment negotiable for cover and inside; $350 for spots.

PENNSYLVANIA LAWYER

Pennsylvania Bar Association, 100 South St., Harrisburg PA 17108-0186. (717)238-6715. E-mail: editor@pabar.org. Web site: www.pabar.org. **Editor:** Geoff Yuda. Bimonthly association magazine "featuring nuts and bolts articles and features of interest to lawyers." Circ. 30,000. Sample copies for #10 SASE with first-class postage. Art guidelines available.

Illustration Approached by 80 illustrators/year. Buys 2-3 illustrations/year. Considers all media.

First Contact & Terms Illustrators: Send query letter with samples. Samples are filed or returned by SASE. Art director will contact artist for portfolio review if interested. Negotiates rights purchased. **Pays on acceptance:** $300-500 for color cover; $100 for inside; $25-50 for spots. Finds illustrators through word of mouth and submissions.

Tips "Artists must be able to interpret legal subjects. Art must have fresh, contemporary look. Read articles you are illustrating. Provide three or more roughs in timely fashion."

PERSIMMON HILL

Published by the National Cowboy & Western Heritage Museum, 1700 NE 63rd St., Oklahoma City OK 73111. (405)478-6404. Fax: (405)478-4714. E-mail: editor@nationalmuseum.org. Web site: www.nationalcowboymuseum.org. **Director of Publications:** M.J. Van Deventer. Estab. 1970. Quarterly 4-color journal of Western heritage "focusing on both historical and contemporary themes. It features nonfiction articles on notable persons connected with pioneering the American West; art, rodeo, cowboys, floral and animal life; or other phenomena of the West of today or yesterday. Lively articles, well written, for a popular audience. Contemporary design follows style of *Architectural Digest* and *European Travel and Life*. Circ. 15,000. Original artwork returned after publication. Sample copy for $10.50.

Illustration Fine art only.

First Contact & Terms Send query letter with tearsheets, SASE, slides and transparencies. Samples are filed or returned by SASE if requested. Publication will contact artist for portfolio review if interested. Portfolio should include original/final art, photographs or slides. Buys first rights.

Requests work on spec before assigning job. Payment varies. Finds artists through word of mouth and submissions.

Tips "We are a Western museum publication. Most illustrations are used to accompany articles. Work with our writers, or suggest illustrations to the editor that can be the basis for a freelance article or a companion story. More interest in the West means we have to provide more contemporary photographs and articles about what people in the West are doing today. Study the magazine first—at least four issues."

PHI DELTA KAPPAN

P.O. Box 789, Bloomington IN 47402. (812)339-1156. Fax: (812)339-0018. Web site: www.pdkintl .org/kappan/kappan.htm. **Design Director:** Carol Bucheri. "The journal covers issues in education, policy, research findings and opinion. Readers include members of the education organization Phi Delta Kappa as well as non-member subscribers—school administrators, teachers, and policy makers." Published 10 times/year, September-June. Circ. 50,000. Sample copy available for $7 plus $5.50 S&H. "The journal is available in most public and university libraries."

Cartoons Approached by over 100 cartoonists/year. Looks for "finely drawn cartoons that reflect our multi-racial, multi-ethnic, non-gender-biased world." Cartoon content must be related to education. Submit packages of 10-25 cartoons, 1 per $8^{1}/_{2} \times 11$ sheet, with SASE. Allow 2 months for review. Do not send submissions April 1-May 30. "We do not accept electronic submissions of cartoons."

Illustration Approached by over 100 illustrators/year. "We have moved away from using much original illustration and now rely primarily on stock illustration to supplement an increased use of photography." Send plain-text e-mail with link to your online portfolio. "We look for serious conceptual art to illustrate complex and often abstract themes. We also use humorous illustrations." Purchases royalty-free stock and one-time print and electronic rights for original work. Submission guidelines available online at www.pdkintl.org/kappan/khome/khpsubmi.htm.

PLANNING

American Planning Association, 122 S. Michigan Ave., Suite 1600, Chicago IL 60603. (312)431-9100. Fax: (312)431-9985. Web site: www.planning.org. **Art Director:** Richard Sessions. Editor and Publisher: Sylvia Lewis. Monthly 4-color magazine for urban and regional planners interested in land use, housing, transportation and the environment. Circ. 42,000. Free sample copy and artist's guidelines available. "Enclose $1.82 in postage for sample magazine—stamps only, no cash or checks, please."

Cartoons Buys 2 cartoons/year. Themes include the environment, city/regional planning, energy, garbage, transportation, housing, power plants, agriculture and land use. Prefers single-panel with gagline ("provide outside of cartoon body if possible").

Illustration Buys 20 illustrations/year. Themes include the environment, city/regional planning, energy, garbage, transportation, housing, power plants, agriculture and land use.

First Contact & Terms Cartoonists: Include SASE. Illustrators: Send samples of style to be kept on file. If you want a response, enclose SASE. Responds in 2 weeks. Buys all rights. Pays on publication. Pays cartoonists $50 minimum for b&w line drawings. Pays illustrators $250 maximum for b&w cover drawings; $100 minimum for b&w line drawings inside. Previously published work OK. Original artwork returned after publication, upon request.

Tips "Don't send portfolio. No corny cartoons. Don't try to figure out what's funny to planners. All attempts seen so far are way off base. Your best chance is to send samples of any type of illustration—cartoons or other—that we can keep on file. If we like your style we will commission work from you."

PN/PARAPLEGIC NEWS

2111 E. Highland Ave., Suite 180, Phoenix AZ 85016-4702. (602)224-0500. Fax: (602)224-0507. E-mail: anngarvey@pnnews.com. Web site: www.pn-magazine.com. **Art Director:** Ann Garvey. Estab. 1947. Monthly 4-color magazine emphasizing wheelchair living for wheelchair users, rehabilitation specialists. Circ. 30,000. Accepts previously published artwork. Sample copy free for large-size SASE with $3 postage.

Cartoons Buys 3 cartoons/issue. Prefers line art with wheelchair theme. Prefers single panel b&w line drawings with or without gagline.

Illustration Prefers wheelchair living or medical and financial topics as themes. 50% of freelance work demands knowledge of QuarkXPress, Photoshop or Illustrator.

First Contact & Terms Cartoonists: Send query letter with finished cartoons to be kept on file. Responds only if interested. Buys all rights. **Pays on acceptance:** $10 for b&w. Illustrators: Send postcard sample. Accepts disk submissions compatible with Illustrator 10.0 or Photoshop 7.0. Send EPS, TIFF or JPEG files. Samples not filed are returned by SASE. Publication will contact artist for portfolio review if interested. Portfolio should include final reproduction/product, color and b&w tearsheets, photostats, photographs. Pays on publication. Pays illustrators $250 for color cover; $25 for b&w inside; $50 for color inside.

Tips "When sending samples, include something that shows a wheelchair user. We regularly purchase cartoons that depict wheelchair users."

POCKETS

P.O. Box 340004, Nashville TN 37203-0004. (615)340-7333. Fax: (615)340-7267. E-mail: pockets @upperroom.org. Web site: www.pockets.org. **Editor:** Lynn W. Gilliam. Devotional magazine for children ages 6-12. Monthly except January/February. Circ. 100,000. Accepts one-time previously published material. Original artwork returned after publication. Sample copy for 9×12 or larger SASE with 4 first-class stamps.

Illustration Approached by 50-60 illustrators/year. Features humorous, realistic and spot illustration. Assigns 15% of illustrations to new and emerging illustrators. Uses variety of styles; 4-color, traditional art or digital, appropriate for children. Realistic, fable and cartoon styles.

First Contact & Terms Illustrators: Send postcard sample, brochure, photocopies, SASE and tearsheets. No fax submissions accepted. Samples not filed are returned by SASE. "No response without SASE." Buys one-time or reprint rights. **Pays on acceptance:** $600 flat fee for 4-color covers; $75-350 for color inside.

Tips "Assignments made in consultation with out-of-house designer. Send samples to Chris Schechner, Schechner & Associates, 408 Inglewood Dr., Richardson, TX 75080."

PRAIRIE JOURNAL OF CANADIAN LITERATURE

P.O. Box 61203, Brentwood Postal Services, Calgary AB T2L 2K6 Canada. E-mail: prairiejournal@ yahoo.com. Web site: www.geocities.com/prairiejournal. **Contact:** Editor (by mail). Estab. 1983. Biannual literary magazine. Circ. 600. Sample copies available for $6 each; art guidelines on Web site.

Illustration Approached by 25 illustrators/year. Buys 6 illustrations/year. Has featured illustrations by Hubert Lacey, Rita Diebolt and Lucie Chan. Considers artistic/experimental b&w line drawings or screened prints.

First Contact & Terms Illustrators: Send postcard sample or query letter with b&w photocopies. Samples are filed. Responds only if interested. Portfolio review not required. Acquires one-time rights. Pays $50 maximum (Canadian) for b&w cover and $25 maximum for inside drawings. Pays on publication. Finds freelancers through unsolicited submissions and queries.

Tips "We are looking for black & white line drawings that are easily reproducable, and camera-ready copy. Never send originals through the mail."

ℕ PRINT MAGAZINE

F + W Publications, Inc., 38 E. 29th St., 3rd Floor, New York NY 10016. (212)447-1400. Fax: (212)447-5231. E-mail: kristina.dimatteo@printmag.com. Web site: www.printmag.com. **Art Director:** Kristina DiMatteo. Estab. 1940. Bimonthly professional magazine for "art directors, designers and anybody else interested in graphic design." Circ. 55,000. Art guidelines available.

First Contact & Terms Illustrators/Designers: Send postcard sample, printed samples and tearsheets. Samples are filed. Responds only if interested. Art director will contact artist for portfolio review if interested. Portfolios may be dropped off every Wednesday, and artists are responsible for retrieving them. Buys first rights. Pays on publication. Finds illustrators through agents, sourcebooks, word of mouth and submissions.

Tips "Read the magazine: We showcase design, typography, illustration and photography. We're also interested in individual creative approaches to design problems. Note: We have themed issues; please ask to see our editorial calendar."

⊠ PRISM INTERNATIONAL

University of British Columbia, Buchanan E462, 1866 Main Mall, Vancouver BC V6T 1Z1 Canada. (604)822-2514. Fax: (604)822-3616. E-mail: prism@interchange.ubc.ca. Web site: www.prism.arts.ubc.ca. Estab. 1959. Quarterly literary magazine. "We use cover art for each issue." Circ. 1,200. Sample copies available for $10 each; art guidelines free for SASE with first-class Canadian postage.

Illustration Buys 1 cover illustration/issue. Has featured illustrations by Mark Ryden, Mark Mothersbaugh, Annette Allwood, The Clayton Brothers, Maria Capolongo, Mark Korn, Scott Bakal, Chris Woods, Kate Collie and Angela Grossman. Features representational and nonrepresentational fine art. Assigns 50% of illustrations to experienced but not well-known illustrators; 50% to new and emerging illustrators. "Most of our covers are full-color artwork and sometimes photography; on occasion we feature a black & white cover."

First Contact & Terms Illustrators: Send postcard sample. Accepts submissions on disk compatible with CorelDraw 5.0 (or lower) or other standard graphical formats. Most samples are filed; those not filed are returned by SASE if requested by artist. Responds in 6 months. Portfolio review not required. Buys first rights. "Image may also be used for promotional purposes related to the magazine." Pays on publication: $250 Canadian and 4 copies of magazine. Original artwork is returned to the artist at job's completion. Finds artists through word of mouth and going to local exhibits.

Tips "We are looking for fine art suitable for the cover of a literary magazine. Your work should be polished, confident, cohesive and original. Please send postcard samples of your work. As with our literary contest, we will choose work that is exciting and which reflects the contemporary nature of the magazine."

PROGRESSIVE RENTALS

1504 Robin Hood Trail, Austin TX 78703. (512)794-0095. Fax: (512)794-0097. E-mail: nferguson@aprovision.org. Web site: www.rtohq.org. **Art Director:** Neil Ferguson. Estab. 1983. Bimonthly publication for members of the Association of Progressive Rental Organizations, the national association of the rental-purchase industry. Circ. 6,000. Sample copy free for catalog-size SASE with first-class postage.

Illustration Buys 2-3 illustrations/issue. Has featured illustrations by Barry Fitzgerald, Aletha St. Romain, A.J. Garces, Edd Patton and Jane Marinsky. Features conceptual illustration. Assigns 15% of illustrations to new and emerging illustrators. Prefers cutting edge; nothing realistic; strong editorial qualities. Considers all media. "Accepts computer-based illustrations (Photoshop, Illustrator).

First Contact & Terms Illustrators: Send postcard sample, query letter with printed samples,

photocopies or tearsheets. Accepts disk submissions. (Must be Photoshop-accessible high-resolution EPS files or Illustrator files.) Samples are filed or returned by SASE. Responds in 1 month if interested. Rights purchased vary according to project. Pays on publication: $300-450 for color cover; $250-350 for color inside. Finds illustrators mostly through submissions; some from other magazines.

Tips "Must have a strong conceptual ability—that is, must be able to illustrate for editorial articles dealing with business/management issues. We are looking for cutting-edge styles and unique approaches to illustration. I am willing to work with new, lesser-known illustrators."

PSM: INDEPENDENT PLAYSTATION MAGAZINE

Future US, Inc., 4000 Shoreline Court, Suite 400, South San Francisco CA 94080. (650)872-1642. Web site: www.psmonline.com; www.futurenetworkusa.com. **Contact:** Art Director. Estab. 1997. Monthly 4-color consumer magazine focused on PlayStation video games for youth (preteens and older). Style is "comic booky." Circ. 400,000. Free sample copies available.

Cartoons Prefers multiple-panel, humorous b&w line drawings; manga/comic book style.

Illustration Approached by 20-30 illustrators/year. Buys 24 illustrations/issue. Has featured illustrations by Joe Madureira, Art Adams, Adam Warren, Hajeme Soroyana, Royo, J. Scott Campbell and Travis Charest. Features comic-book style, computer, humorous, realistic and spot illustration. Preferred subject: video game characters. Assigns 80% of illustrations to well-known or "name" illustrators; 10% to experienced, but not well-known, illustrators; and 10% to new and emerging illustrators. 50% of freelance illustration demands knowledge of Illustrator and Photoshop.

First Contact & Terms Cartoonists: Send query letter with b&w and color photocopies and samples. Illustrators: Send postcard sample or nonreturnable samples; send query letter with printed samples, photocopies and tearsheets. Accepts Mac-compatible disk submissions. E-mail JPEG and/or Web link (preferred method). Samples are filed. Responds only if interested. Will contact artist for portfolio review if interested. Buys all rights. Pays on publication. Finds illustrators through magazines and word of mouth.

Tips "If you're an artist, confident that your vision is unique, your quality is the best, ever evolving, send us samples!"

QUILL & QUIRE

111 Queen St. E., 3rd Floor, Toronto ON M5C 1S2 Canada. (416)364-3333, ext. 3112. Fax: (416)595-5415. E-mail: gcampbell@quillandquire.com. Web site: www.quillandquire.com. **Art Director:** Gary Campbell. Estab. 1935. Monthly magazine of the Canadian book trade. Features book news and reviews for publishers, booksellers, librarians, writers, students and educators.

Illustration Approached by 25 illustrators/year. Buys 3 illustrations/issue. Assigns 100% of illustrations to experienced but not well-known illustrators. Considers pen & ink and collage. 10% of freelance illustration requires knowledge of Photoshop, Illustrator and QuarkXPress.

First Contact & Terms Send postcard sample. Accepts disk submissions. Samples are filed. Responds only if interested. Negotiates rights purchased. **Pays on acceptance:** $200-300 for cover; $100-200 for inside. Finds illustrators through word of mouth, submissions.

READER'S DIGEST

Reader's Digest Rd., Pleasantville NY 10570-7000. (914)238-1000. Fax: (914)244-5098. Web site: www.rd.com. **Design Director:** Hannu Laakso. Art Director: Dean Abatemarco. Estab. 1922. Monthly consumer magazine for the general interest reader. Content features articles from various sources on a wide range of topics published in 23 languages in more than 60 countries. Circ. 10,000,000 U.S.; 34,000,000 worldwide.

Cartoons Approached by 500 cartoonists/year. Buys approx. 10 cartoons/issue. Prefers single panel, b&w line drawings with or without color wash.

Illustration Approached by 500 illustrators/year. Buys 7-8 illustrations/issue. Has featured illustrations by Christoph Niemann, David Roth, Lou Beach, Kevin Irby, Ingo Fast and Edmund Guy. Assigns 80% of illustrations to well-known or "name" illustrators; 15% to experienced, but not well-known illustrators; 5% to new and emerging illustrators.

First Contact & Terms Cartoonists: Send b&w or color photocopies. Illustrators: Send postcard sample or small packet of 4-5 samples. Samples are filed. Responds only if interested. Will contact artist for portfolio review if interested. Buys one-time world rights for 1 year. **Pays on acceptance:** $750 minimum for color inside; $300 for spots. Finds illustrators through sourcebooks, reps, Internet.

Tips "More than anything else we're looking for a certain level of sophistication, whether that's in humorous or conceptual illustration. There are a lot of artists who send samples, but we look for that undefinable element that makes them stand out. Talent is talent. When you see someone with it, it's undeniable. Our job is to spot that talent, encourage it and use it."

ℕ REDMOND DEVELOPER NEWS

(formerly *Application Development Trends*), 9121 Oakdale Ave., Suite 101, Chatsworth CA 91311. (818)734-1520. Fax: (818)734-1526. E-mail: msingh@1105media.com. Web site: http://reddevnews.com. **Art Director:** Michele Singh. Estab. 1990. Twice-monthly 4-color trade publication for corporate software managers. Circ. 50,000.

Illustration Approached by 40 illustrators/year. Features charts & graphs, informational graphics, spot illustrations and computer illustration of business subjects. Has featured illustrations by Ryan Etter and Greg Mably. Assigns 50% of illustrations to experienced, but not well-known illustrators; 50% to new and emerging illustrators.

First Contact & Terms E-mail submissions or PDF files. Samples are filed. Responds in 1 month. Portfolio review not required. Pays $400 for spots.

Tips "Illustrate technology concepts in a unique way."

REFORM JUDAISM

633 Third Ave., 7th Floor, New York NY 10017-6778. (212)650-4240. Fax: (212)650-4249. E-mail: rjmagazine@urj.org. Web site: www.reformjudaismmag.org. **Managing Editor:** Joy Weinberg. Estab. 1972. Quarterly magazine. "The official magazine of the Reform Jewish movement. It covers developments within the movement and interprets world events and Jewish tradition from a Reform perspective." Circ. 310,000. Accepts previously published artwork. Originals are returned at job's completion. Sample copies available for $3.50.

Cartoons Prefers political themes tying into editorial coverage.

Illustration Buys 8-10 illustrations/issue. Works on assignment. 10% of freelance work demands computer skills.

First Contact & Terms Cartoonists: Send query letter with finished cartoons. Illustrators: Send query letter with brochure, résumé, SASE and tearsheets. Samples are filed. Responds in 1 month. Publication will contact artist for portfolio review if interested. Portfolio should include tearsheets, slides and final art. Rights purchased vary according to project. Pays on publication; varies according to project. Finds artists through sourcebooks and submissions.

RESIDENT & STAFF PHYSICIAN

Ascend Media Healthcare, 103 College Rd. E., Suite 300, Princeton NJ 08540. (609)524-9540. E-mail: smatthews@ascendmedia.com. Web site: www.residentandstaff.com. **Assistant Editor:** Sara Matthews. Editor: Dalia Buffery. Monthly publication emphasizing hospital medical practice from clinical, educational, economic and human standpoints, for hospital physicians, interns and residents. Circ. 100,000.

Illustration "We commission qualified freelance medical illustrators to do covers and inside material."

First Contact & Terms Send query letter with brochure showing art style or résumé, tearsheets, photostats, photocopies, slides and photographs. Call or write for appointment to show portfolio of color and b&w final reproduction/product and tearsheets. **Pays on acceptance:** $800 for color cover; payment varies for inside work.

Tips "We like to look at previous work to give us an idea of the artist's style. Since our publication is clinical, we require highly qualified technical artists who are very familiar with medical illustration. Sometimes we have use for nontechnical work. We like to look at everything. We need material from the *doctor's* point of view, *not* the patient's."

RESTAURANT HOSPITALITY

1300 E. Ninth St., Cleveland OH 44114. (216)931-9942. Fax: (216)696-0836. E-mail: croberto@penton.com. **Group Creative Director:** Chris Roberto. Estab. 1919. Monthly trade publication emphasizing restaurant management ideas, business strategies and foodservice industry trends. Readers are independent and chain restaurant operators, executives and chefs. Circ. 123,000.

Illustration Approached by 150 illustrators/year. Buys 3-5 illustrations/issue (combined assigned and stock). Prefers food- and business-related illustration in a variety of styles. Has featured illustrations by Mark Shaver, Paul Watson and Brian Raszka. Assigns 10% of illustrations to well-known or "name" illustrators; 60% to experienced but not well-known illustrators; and 30% to new and emerging illustrators. Welcomes stock submissions.

First Contact & Terms Illustrators: Postcard samples preferred. Send follow-up card every 3-6 months. Buys one-time rights. **Pays on acceptance:** $300-350 quarter-page; $250-350 for spots. Finished illustrations must be delivered as high-res digital. E-mail or FTP preferred.

Tips "I am always open to new approaches—contemporary, modern visuals that explore various aspects of the restaurant industry and restaurant experience. Please include a Web address on your sample so I can view an online portfolio."

RHODE ISLAND MONTHLY

280 Kinsley Ave., Providence RI 02903-4161. (401)277-8280. Fax: (401)277-8080. Web site: www.rimonthly.com. **Art Director:** Ellen Dessloch. Estab. 1988. Monthly 4-color magazine focusing on life in Rhode Island. Provides in-depth reporting, service and entertainment features as well as dining and calendar listings. Circ. 40,000.

- Also publishes a bridal magazine and tourism-related publications.

Illustration Approached by 200 freelance illustrators/year. Buys 2-4 illustrations/issue. Works on assignment. Considers all media.

First Contact & Terms Illustrators: Send self-promotion postcards or samples. Accepts previously published artwork. Samples are filed and not returned. Buys one-time rights. Pays on publication: $300 minimum for color inside, depending on the job. Pays $800-1,000 for features. Finds artists through submissions/self-promotions and sourcebooks.

Tips "Although we use a lot of photography, we are using more illustration, especially smaller, spot or quarter-page illustrations for our columns in the front of the magazine. If we see a postcard we like, we'll log on to the illustrator's Web site to see more work."

RURAL HERITAGE

Dept. AGDM, 281 Dean Ridge Lane, Gainesboro TN 38562-5039. (931)268-0655. Fax: (931)268-5884. E-mail: editor@ruralheritage.com. Web site: www.ruralheritage.com. **Editor:** Gail Damerow. Estab. 1976. Bimonthly farm magazine "published in support of modern-day farming and logging with draft animals (horses, mules, oxen)." Circ. 8,000. Sample copy available for $8 postpaid; art guidelines not available.

- Editor stresses the importance of submitting cartoons that deal only with farming and logging using draft animals.

Cartoons Approached by "not nearly enough cartoonists who understand our subject." Buys 2 or more cartoons/issue. Prefers bold, clean, minimalistic draft animals and their relationship with the teamster. "No unrelated cartoons!" Prefers single panel, humorous, b&w line drawings with or without gagline.

First Contact & Terms Cartoonists: Send query letter with finished cartoons and SASE. Samples accepted by U.S. mail only. Samples not filed are returned by SASE. Responds in 2 months. Buys first North American serial rights or all rights (rarely). Pays on publication: $10 for one-time rights; $20 for all rights.

Tips "Know draft animals (horses, mules, oxen, etc.) well enough to recognize humorous situations intrinsic to their use or that arise in their relationship to the teamster. Our best contributors read *Rural Heritage* and get their ideas from the publication's content."

THE SCHOOL ADMINISTRATOR

801 N. Quincy St., Suite 700, Arlington VA 22203-1730. (703)875-0753. Fax: (703)528-2146. E-mail: lgriffin@aasa.org. Web site: www.aasa.org. **Managing Editor:** Liz Griffin. Monthly association magazine focusing on education. Circ. 22,000.

Cartoons Approached by 75 editorial cartoonists/year. Buys 11 cartoons/year. Prefers editorial/ humorous, b&w/color washes or b&w line drawings. "Humor should be appropriate to a CEO of a school system, not a classroom teacher."

Illustration Approached by 60 illustrators/year. Buys 2-3 illustrations/issue. Has featured illustrations by Ralph Butler, Paul Zwolak, Heidi Younger and Claudia Newell. Features spot and computer illustrations. Assigns 50% of illustrations to experienced but not well-known illustrators; 50% to well-known or "name" illustrators. Considers all media.

First Contact & Terms Cartoonists: Send photocopies and SASE. Buys one-time rights. **Pays on acceptance.** Illustrators: Send nonreturnable samples. Samples are filed and not returned. Responds only if interested. Rights purchased vary according to project. Pays on publication. Pays illustrators $800 for color cover. Finds illustrators through word of mouth, stock illustration sources and sourcebooks.

Tips "I like work that takes a concept and translates it into a simple, powerful image. Check out our Web site. Send artwork to Jeff Roberts, Auras Design, 8435 Georgia Ave., Silver Spring MD 20910."

SCIENTIFIC AMERICAN

415 Madison Ave., New York NY 10017-1111. (212)754-0550. Fax: (212)755-1976. Web site: www.sciam.com. **Art Director:** Edward Bell. Monthly 4-color consumer magazine emphasizing scientific information for educated readers, covering geology, astronomy, medicine, technology and innovations. Circ. 675,000 worldwide (20 international editions, some of which create additional art).

Illustration Approached by 100+ illustrators/year. Buys 15-30 illustrations/issue, mostly science-related, but there are oppurtunities for editorial art in all media. Assigns illustrations to specialized science illustrators, to well-known editorial illustrators, and to relative newcomers in both areas.

First Contact & Terms Illustrators: Send postcard sample or e-mail with link to Web site; follow up in 6 months. Responds only if interested. Portfolio reviews done as time allows. **Pays on acceptance:** $750-2,000 for color inside; $350-750 for spots.

Tips "We use all styles of illustration. You do not have to be an expert in science, although some understanding certainly helps. The art directors at *Scientific American* are highly skilled at computer programs, have a broad-based knowledge of science, and closely guide the process. Editors are experts in their field and help with technical backup material. One caveat: content is heavily vetted here for accuracy, so a huge plus on the part of our illustrators is their ability to make changes and corrections cheerfully and in a timely fashion."

SCRAP

1615 L St. NW, Suite 600, Washington DC 20036-5610. (202)662-8547. Fax: (202)626-0947. E-mail: kentkiser@scrap.org. Web site: www.scrap.org. **Publisher:** Kent Kiser. Estab. 1987. Bimonthly 4-color trade publication that covers all aspects of the scrap recycling industry. Circ. 11,300.

Cartoons "We occasionally run single-panel cartoons that focus on the recycling theme/business."

Illustration Approached by 100 illustrators/year. Buys 0-2 illustrations/issue. Features realistic illustrations, business/industrial/corporate illustrations and international/financial illustrations. Assigns 10% of illustrations to new and emerging illustrators.

First Contact & Terms Illustrators: Send postcard sample. Samples are filed. Responds in 2 weeks. Portfolio review not required. Buys first North American serial rights. **Pays on acceptance:** $1,200-2,000 for color cover; $300-1,000 for color inside. Finds illustrators through creative sourcebooks, mailed submissions, referrals from other editors, and "direct calls to artists whose work I see and like."

Tips "We're always open to new talent and different styles. Our main requirement is the ability and willingness to take direction and make changes if necessary. No prima donnas, please. Send a postcard to let us see what you can do."

[N] SELF-EMPLOYED AMERICA

P.O. Box 612067, DFW Airport, Dallas TX 75261-2067. (817)310-4365. Fax: (817)310-4100. Web site: www.nase.org. **Art Director:** Patty Harkins. Bimonthly 4-color trade publication for owners of small businesses. Circ. 200,000.

Illustration Approached by 200 illustrators/year. Buys 2 illustrations/issue. Features men's and women's home business or small business-related illustrations.

First Contact & Terms Send postcard sample. Samples are filed. Buys one-time rights. Payment varies.

[N] [I] SHOW-ME PUBLISHING, INC.

2049 Wyandotte St., Kansas City MO 64108. E-mail: msweeney@ingramsonline.com. Web site: www.ingramsonline.com or www.destinationkansascity.com. **Senior Vice President:** Michelle Sweeney. "We publish a regional business magazine (*Ingram's*) and several business-to-business publications and Web sites covering Kansas and Missouri. We require all freelancers to allow us full usage and resale of all work done for our publications and Web sites." Has occasional use for graphic designers. Prefers local talent.

First Contact & Terms Send cover letter, résumé, references and samples of work to HR Department. Portfolios are not returned. Do not send original work; send digital files on CD. Pays $50/image; $20/hour for Web design.

SIERRA MAGAZINE

85 Second St., 2nd Floor, San Francisco CA 94105-3441. (415)977-5572. Fax: (415)977-5794. E-mail: sierra.letters@sierraclub.org. Web site: www.sierraclub.org. **Art Director:** Martha Geering. Bimonthly consumer magazine featuring environmental and general interest articles. Circ. 750,000.

Illustration Buys 8 illustrations/issue. Considers all media. 10% of freelance illustration demands computer skills.

First Contact & Terms Send postcard samples or printed samples, SASE and tearsheets. Samples are filed and are not returned. Responds only if interested. Art director will contact artist for portfolio review if interested. Buys one-time rights. Finds illustrators through illustration and design annuals, illustration Web sites, sourcebooks, submissions, magazines, word of mouth.

SKILLSUSA CHAMPIONS

14001 SkillsUSA Way, P.O. Box 3000, Leesburg VA 20177. (703)777-8810. Fax: (703)777-8999. E-mail: thall@skillsusa.org. Web site: www.skillsusa.org. **Editor:** Tom Hall. Estab. 1965. Quarterly 4-color magazine. *"SkillsUSA Champions* is primarily a features magazine that provides motivational content by focusing on successful members. SkillsUSA is an organization of 285,000 students and teachers in technical, skilled and service careers." Circ. 289,000. Sample copies available.

Illustration Approached by 4 illustrators/year. Works on assignment only. Prefers positive, youthful, innovative, action-oriented images. Considers pen & ink, watercolor, collage, airbrush and acrylic.

Design Needs freelancers for design. 100% of freelance work demands knowledge of Adobe CS.

First Contact & Terms Illustrators: Send postcard sample. Designers: Send query letter with brochure. Accepts disks compatible with FreeHand 5.0, Illustrator CS3, PageMaker 7.0 and InDesign CS3. Send Illustrator, FreeHand and EPS files. Portfolio should include printed samples, b&w and color tearsheets and photographs. Accepts previously published artwork. Originals are returned at job's completion (if requested). Rights purchased vary according to project. **Pays on acceptance.** Pays illustrators $200-300 for color; $100-300 for spots. Pays designers by the project.

Tips "Send samples or a brochure. These will be kept on file until illustrations are needed. Don't call! Fast turnaround helpful. Due to the unique nature of our audience, most illustrations are not reusable; we prefer to keep art."

SKIPPING STONES

P.O. Box 3939, Eugene OR 97403-0939. (541)342-4956. E-mail: editor@SkippingStones.org. Web site: www.SkippingStones.org. **Editor:** Arun Toke. Estab. 1988. Bimonthly b&w (with 4-color cover) consumer magazine. International nonprofit multicultural awareness and nature education magazine for today's youth. Circ. 2,000 (and on the Web). Art guidelines are free for SASE with first-class postage. Sample copy available for $5.

Cartoons Prefers multicultural, social issues, nature/ecology themes. Requests b&w washes and line drawings. Featured cartoons by Lindy Wojcicki of Florida. Prefers cartoons by youth under age 19.

Illustration Approached by 100 illustrators/year. Buys 10-20 illustrations/year. Has featured illustrations by Sarah Solie, Wisconsin; Alvina Kong, California; Elizabeth Wilkinson, Vermont; Inna Svjatova, Russia; Jon Bush, Massachusetts. Features humorous illustration, informational graphics, natural history and realistic, authentic illustrations. Prefers pen & ink. Assigns 80% of work to new and emerging illustrators.

First Contact & Terms Cartoonists: Send b&w photocopies and SASE. Illustrators: Send nonreturnable photocopies and SASE. Samples are filed or returned by SASE. Responds in 3 months if interested. Portfolio review not required. Buys first rights, reprint rights. Pays on publication: 1-4 copies. Finds illustrators through word of mouth, samples.

Tips "We are a gentle, non-glossy, ad-free magazine not afraid to tackle hard issues. We are looking for work that challenges the mind, charms the spirit, warms the heart; handmade, nonviolent, global, for youth ages 8-15 with multicultural/nature content. Please, no aliens or unicorns. We are especially seeking work by young artists under 19 years of age! People of color and international artists are especially encouraged."

SMALL BUSINESS TIMES

1123 N. Water St., Milwaukee WI 53202. (414)277-8181. Fax: (414)277-8191. Web site: www.biztimes.com. **Art Director:** Shelly Paul. Estab. 1995. Biweekly newspaper/magazine business-to-business publication for southeast Wisconsin. Circ. 15,000.

Illustration Approached by 80 illustrators/year. Uses 3-5 illustrations/year. Has featured illustra-

Skipping Stones

Vol. 19, No. 2 An Award Winning Multicultural Magazine March-April 2007
U.S.: $5; CAN: $6

Nature * From Boys to Men Worldwide

Jon Bush
06

Jon Bush found *Skipping Stones* in *Artist's & Graphic Designer's Market* and submitted work to editor Arun Toke, with whom he has since developed a deep bond. "To have artwork on the cover of a magazine is simply an indescribable feeling," says Bush. "I paint and draw from what I know. I seek the emotion." The sign language in this image was inspired by a deaf friend of his.

Although he's had some success, Bush still takes art classes. "There always seems to be more to learn," he says. Bush advises artists to "do what pleases you, always send your very best stuff, and use common sense about the market you are approaching."

tions by Milan Zori, Marla Campbell, Dave Crosland. Features charts & graphs, computer, humorous illustration, informational graphics, realistic and b&w spot illustrations. Prefers business subjects in simpler styles that reproduce well on newsprint. Assigns 75% of work to new and emerging illustrators.

First Contact & Terms Illustrators: Send postcard sample and follow-up postcard every year. Accepts Mac-compatible disk submissions. Send EPS or TIFF files at 300 dpi. Will contact artist for portfolio review if interested. Buys one-time rights. Pays illustrators $200-400 for color cover; $80-100 for inside. **Pays on acceptance.**

Tips "Conceptual work wanted! Audience is business men and women in southeast Wisconsin. Need ideas relative to today's business issues/concerns (insurance, law, banking, commercial real estate, health care, manufacturing, finance, education, technology, retirement). One- to two-week turnaround."

SPIDER®

Cricket Magazine Group, Carus Publishing, 70 E. Lake St., Suite 300, Chicago IL 60601. Web site: www.cricketmag.com. **Contact:** Art Submissions Coordinator. Managing Art Director: Suzanne Beck. Estab. 1994. Monthly literary and activity magazine for children ages 6-9. Circ. 70,000. Art guidelines available on Web site.

- See also listings in this section for other magazines published by the Cricket Magazine Group: *BABYBUG, LADYBUG, CRICKET* and *CICADA*.

Illustration Buys 20 illustrations/issue; 240 illustrations/year. Uses color artwork only. Works on assignment only.

First Contact & Terms Send photocopies, photographs or tearsheets to be kept on file. Samples are returned by SASE if requested. Responds in 3 months. Buys all rights. Pays 45 days after acceptance: $750 for color cover; $250 for color full page; $100 for color spots; $50 for b&w spots.

Tips "Before attempting to illustrate for *SPIDER*, be sure to familiarize yourself with this age group, and read several issues of the magazine. Please do not query first."

SPITBALL: THE LITERARY BASEBALL MAGAZINE

5560 Fox Rd., Cincinnati OH 45239. (513)385-2268. E-mail: spitball5@hotmail.com. Web site: www.angelfire.com/oh5/spitball. **Editor:** Mike Shannon. Estab. 1981. Quarterly 2-color magazine emphasizing baseball, exclusively for "well-educated, literate baseball fans." *Spitball* has a regular column called "Brushes with Baseball" that features one artist and his/her work. Chooses artists for whom baseball is a major theme/subject. Prefers to buy at least one work from the artist to keep in its collection. Sometimes prints color material in b&w on cover. Returns original artwork after publication if the work is donated; does not return if purchased. Sample copy available for $6.

Cartoons Prefers single-panel b&w line drawings with or without gagline. Prefers "old fashioned *Sport Magazine/New Yorker* type. Please, . . . make them funny, or what's the point?"

Illustration "We need two types of art illustration (for a story, essay or poem; filler). All work must be baseball-related." Prefers pen & ink, airbrush, charcoal/pencil and collage. Interested artists should write to find out needs for specific illustration. Buys 3 or 4 illustrations/issue.

First Contact & Terms Cartoonists: Query with samples of style, roughs and finished cartoons. Illustrators: Send query letter with b&w illustrations or slides. Target samples to magazine's needs. Samples not filed are returned by SASE. Responds in 1 week. Negotiates rights purchased. **Pays on acceptance.** Pays cartoonists $10 minimum. Pays illustrators $20-40 for b&w inside.

Tips "Usually artists contact us and if we hit it off, we form a long-lasting mutual admiration society. Please, you cartoonists out there, drag your bats up to the *Spitball* plate! We like to use a variety of artists."

STONE SOUP, The Magazine by Young Writers and Artists

P.O. Box 83, Santa Cruz CA 95063. (831)426-5557. E-mail: editor@stonesoup.com. Web site: www.stonesoup.com. **Editor:** Gerry Mandel. Quarterly 4-color magazine with "simple and conservative design" emphasizing writing and art by children. Features adventure, ethnic, experimental, fantasy, humorous and science fiction articles. "We only publish writing and art by children through age 13. We look for artwork that reveals that the artist is closely observing his or her world." Circ. 20,000. Sample copies available for $4 each. Art guidelines available for SASE with first-class postage.

Illustration Buys 12 illustrations/issue. Prefers complete and detailed scenes from real life. All art must be by children ages 8-13.

First Contact & Terms Illustrators: Send query letter with photocopies. Samples are filed or are returned by SASE. Responds in 1 month. Buys all rights. Pays on publication: $75 for color cover; $25 for color inside; $15 for spots.

STUDENT LAWYER

321 N. Clark St., Chicago IL 60610. (312)988-6042. E-mail: kulcm@staff.abanet.org. **Art Director:** Mary Anne Kulchawik. Estab. 1972. Trade journal emphasizing legal education and social/legal issues. "*Student Lawyer* is a legal affairs magazine published by the Law Student Division of the American Bar Association. It is not a legal journal. It is a features magazine, competing for a share of law students' limited spare time—so the articles we publish must be informative, lively, good reads. We have no interest whatsoever in anything that resembles a footnoted, academic article. We are interested in professional and legal education issues, sociolegal phenomena, legal career features, and profiles of lawyers who are making an impact on the profession." Monthly (September-May). Circ. 35,000. Original artwork is returned to the artist after publication.

Illustration Approached by 20 illustrators/year. Buys 8 illustrations/issue. Has featured illustrations by Sean Kane and Jim Starr. Features realistic, computer and spot illustration. Assigns 50% of illustrations to experienced but not well-known illustrators; 50% to new and emerging illustrators. Needs editorial illustration with an "innovative, intelligent style." Works on assignment only. Needs computer-literate freelancers for illustration. "No cartoons, please."

First Contact & Terms Send postcard sample, brochure, tearsheets and printed sheet with a variety of art images (include name and phone number). Samples are filed. Call for appointment to show portfolio of final art and tearsheets. Buys one-time rights. **Pays on acceptance:** $500-800 for color cover; $450-650 for color inside; $150-350 for spots.

Tips "In your samples, show a variety of styles with an emphasis on editorial work."

⟨⟩ SUB-TERRAIN MAGAZINE

P.O. Box 3008, MPO, Vancouver BC V6B 3X5 Canada. (604)876-8710. Fax: (604)879-2667. E-mail: subter@portal.ca. Web site: www.subterrain.ca. **Editor:** Brian Kaufman. Estab. 1988. Published 3 times/year. Literary magazine featuring contemporary literature of all genres. Art guidelines available for SASE with first-class postage.

Cartoons Prefers single-panel cartoons.

Illustration Assigns 50% of illustrations to new and emerging illustrators.

First Contact & Terms Send query letter with photocopies. Samples are filed. Responds if interested. Portfolio review not required. Buys first rights, first North American serial rights, one-time rights or reprint rights. Pays $35-100 (Canadian), plus contributor copies.

Tips "Take the time to look at an issue of the magazine to get an idea of the kind of material we publish."

⟨⟩ SWINDLE MAGAZINE

3780 Wilshire Blvd., Suite 210, Los Angeles CA 90010. E-mail: submissions@swindlemagazine.com. Web site: www.swindlemagazine.com. Estab. 2003. Published bimonthly, *Swindle* is a "thor-

ough pop culture magazine that derives a unique social commentary with timeless articles." Circ. 80,000. Sample copies available on request.

Cartoons Approached by 13 cartoonists/year. Buys 6 cartoons/year. Prefers political, humorous, single-panel color washes, b&w drawings.

Illustration Approached by 130 illustrators/year. Buys 65 illustrations/year. Has featured illustrations by Tim Gough, Shepard Fairey, Allison Cole. Features realistic, fashion, humorous, spot and computer illustrations and informational graphics. Assigns 30% of work to new and emerging illustrators. 85% of freelance work demands computer skills. Artists should be familiar with Illustrator, InDesign, Photoshop, QuarkXPress.

First Contact & Terms Send query letter with samples. After introductory mailing, send follow-up postcard sample every 6 months. Accepts e-mail submissions with image file or link to Web site. Prefers Mac-compatible JPEG files. Samples are not filed and are not returned. Responds only if interested. Will contact artist for portfolio review if interested. Portfolio should include color, b&w, original art, photographs, tearsheets, thumbnails. Pays on acceptance or publication. Rights purchased vary according to project. Finds freelancers through agents/reps, sourcebooks, submissions, word of mouth, magazines and Internet.

TAMPA BAY MAGAZINE

2531 Landmark Dr., Clearwater FL 33761. (727)791-4800. **Editor:** Aaron Fodiman. Estab. 1986. Bimonthly local lifestyle magazine with upscale readership. Circ. 40,000. Accepts previously published artwork. Sample copy available for $4.50. Art guidelines not available.

Cartoons Approached by 30 cartoonists/year. Buys 6 cartoons/issue. Prefers single-panel color washes with gagline.

Illustration Approached by 100 illustrators/year. Buys 5 illustrations/issue. Prefers happy, stylish themes. Considers watercolor, collage, airbrush, acrylic, marker, colored pencil, oil and mixed media.

First Contact & Terms Cartoonists: Send query letter with finished cartoon samples. Illustrators: Send query letter with photographs and transparencies. Samples are not filed and are returned by SASE if requested. To show a portfolio, mail color tearsheets, slides, photocopies, finished samples and photographs. Buys one-time rights. Pays on publication. Pays cartoonists $15 for b&w; $20 for color. Pays illustrators $150 for color cover; $75 for color inside.

TECHNICAL ANALYSIS OF STOCKS & COMMODITIES

Technical Analysis, Inc., 4757 California Ave. SW, Seattle WA 98116-4499. (206)938-0570. Fax: (206)938-1307. E-mail: cmorrison@traders.com. Web site: www.traders.com. **Art Director:** Christine Morrison. Estab. 1982. Monthly traders' magazine for stocks, bonds, futures, commodities, options, mutual funds. Circ. 66,000. Sample copies available for $5 each. Art guidelines on Web site.

- Parent company also publishes *Working Money*, a general interest financial magazine with similar cartoon and illustration needs. (See also listing for Technical Analysis, Inc., in the Book Publishers section.)

Cartoons Approached by 10 cartoonists/year. Buys 1-4 cartoons/issue. Prefers humorous, single-panel b&w line drawings with gagline.

Illustration Approached by 100 illustrators/year. Buys 6 illustrations/issue. Works on assignment only. Features humorous, realistic, computer (occasionally) and spot illustrations.

First Contact & Terms Cartoonists: Send query letter with finished cartoons (non-returnable copies only). Illustrators: Send e-mail JPEGs, brochure, tearsheets, photographs, photocopies, photostats, slides. Accepts disk submissions compatible with any Adobe products (TIFF or EPS files). Samples are filed and are not returned. Art director will contact artist for portfolio review if interested. Portfolio should include b&w and color tearsheets, slides, photostats, photocopies,

final art and photographs. Buys one-time rights and reprint rights. Pays on publication. Pays cartoonists $35 for b&w. Pays illustrators $135-350 for color cover; $165-220 for color inside; $105-150 for b&w inside. Accepts previously published artwork.

Tips ''Looking for creative, imaginative and conceptual types of illustration that relate to articles' concepts. Also interested in caricatures with market charts and computers. Send a few copies of black & white and color work with or without cover letter. If I'm interested, I will call.''

TEXAS PARKS & WILDLIFE

3000 S. IH 35, Suite 120, Austin TX 78704-6536. (512)912-7000. Fax: (512)707-1913. E-mail: magazine@tpwd.state.tx.us. Web site: www.tpwmagazine.com. **Art Director:** Andres Carrasw. Estab. 1942. Monthly magazine ''containing information on state parks, wildlife conservation, hunting and fishing, environmental awareness.'' Circ. 180,000. Sample copies available for #10 SASE with first-class postage.

Illustration 100% of freelance illustration demands knowledge of QuarkXPress.

First Contact & Terms Illustrators: Send postcard sample. Samples are not filed and are not returned. Responds only if interested. Buys one-time rights. Pays on publication; negotiable. Finds illustrators through magazines, word of mouth, submissions.

Tips ''Read our magazine.''

TIKKUN MAGAZINE

2342 Shattuck Ave., #1200, Berkeley CA 94704. (510)644-1200. Fax: (510)644-1255. E-mail: maga zine@tikkun.org. Web site: www.tikkun.org. **Managing Editor:** David Belden. Estab. 1986. Bi-monthly ''Jewish critique of politics, culture and society; includes articles regarding Jewish and non-Jewish issues, left-of-center politically.'' Circ. 70,000. Sample copies available for $6 plus $2 postage.

Illustration Approached by 50-100 illustrators/year. Buys 10-12 illustrations/issue. Has featured illustrations by Julie Delton, David Ball and Jim Flynn. Features symbolic and realistic illustration. Assigns 90% of illustrations to experienced, but not well-known illustrators; 10% to new and emerging illustrators. Prefers line drawings.

First Contact & Terms Send brochure, résumé, tearsheets, photostats, photocopies; slides and photographs for color artwork only. Do not send originals; unsolicited artwork will not be returned. Accepts previously published material. ''Often we hold onto line drawings for last-minute use.'' Pays on publication: $150 for color cover; $50 for b&w inside. Buys one-time rights.

Tips ''No sculpture, heavy religious content. Read the magazine—send us a sample illustration of an article we've printed, showing how you would have illustrated it.''

TIME

Attn: Art Dept., 1271 Avenue of the Americas, Rockefeller Center, New York NY 10020-1393. (212)522-1212. Fax: (212)522-0936. Web site: www.time.com. **Art Director:** Arthur Hochstein. Estab. 1923. Weekly magazine covering breaking news, national and world affairs, business news, societal and lifestyle issues, culture and entertainment. Circ. 4,034,000.

Illustration Considers all media.

First Contact & Terms Send postcard sample, printed samples, photocopies or other appropriate samples. Accepts disk submissions. Samples are filed. Responds only if interested. Buys first North American serial rights. Payment is negotiable. Finds artists through sourcebooks and illustration annuals.

Ⓝ TRAINING MAGAZINE

770 Broadway, Suite 200, New York NY 10003-9556. (646)654-4497. E-mail: lorri.freifeld@nielse n.com. Web site: www.trainingmag.com. **Executive Editor:** Lorri Freifeld. Estab. 1964. Monthly

4-color trade journal covering job-related training and education in business and industry, both theory and practice, for audience training directors, personnel managers, sales and data processing managers, general managers, etc. Circ. 45,000. Sample copies available for SASE with first-class postage.

Illustration Works on assignment only. Prefers themes that relate directly to business and training. Styles are varied. Considers pen & ink, airbrush, mixed media, watercolor, acrylic, oil, pastel and collage.

First Contact & Terms Send postcard sample, tearsheets or photocopies. Accepts disk submissions. Samples are filed. Responds only if interested. Buys first rights or one-time rights. **Pays on acceptance.** Pays illustrators $1,500-2,000 for color cover; $800-1,200 for color inside; $100 for spots.

Tips "Show a wide variety of work in different media and with different subject matter. Good renditions of people are extremely important."

ℕ TRAINS

P.O. Box 1612, 21027 Crossroads Circle, Waukesha WI 53187. (262)796-8776. Fax: (262)796-1778. E-mail: tdanneman@kalmbach.com. Web site: www.trains.com. **Art Director:** Thomas G. Danneman. Estab. 1940. Monthly magazine about trains, train companies, tourist RR, latest railroad news. Circ. 133,000. Art guidelines available.

• Published by Kalmbach Publishing, who also publishes *Classic Toy Trains, Astronomy, Finescale Modeler, Model Railroader, Model Retailer, Classic Trains, Bead and Button, Birder's World.*

Illustration 100% of freelance illustration demands knowledge of Photoshop CS 5.0, Illustrator CS 8.0.

First Contact & Terms Illustrators: Send query letter with printed samples, photocopies and tearsheets. Accepts disk submissions (opticals) or CDs, using programs above. Samples are filed. Art director will contact artist for portfolio review of color tearsheets if interested. Buys one-time rights. Pays on publication.

Tips "Quick turnaround and accurately built files are a must."

TRAVEL & LEISURE

Dept. AM, 1120 Sixth Ave., 10th Floor, New York NY 10036-6700. (212)382-5600. Fax: (212)382-5877. Web site: www.travelandleisure.com. **Creative Director:** David Heasty. Art Director: Nora Sheehan. Monthly magazine emphasizing travel, resorts, dining and entertainment. Circ. 1 million. Original artwork returned after publication. Art guidelines for SASE.

Illustration Approached by 250-350 illustrators/year. Buys 1-15 illustrations/issue. Interested in travel and leisure-related themes. "Illustrators are selected by excellence and relevance to the subject." Works on assignment only.

First Contact & Terms Provide samples and business card to be kept on file for future assignment. Responds only if interested.

Tips No cartoons.

ℕ TREASURY & RISK

475 Park Ave. S., Room 601, New York NY 10016-6901. E-mail: hdevine@treasuryandrisk.com. Web site: www.treasuryandrisk.com. **Creative Director:** Heather Devine. Monthly trade publication for financial/CFO-treasurers. Circ. 50,000. Sample copies available on request.

Illustration Buys 45-55 illustrations/year. Features business computer illustration, humorous illustration and spot illustrations. Prefers electronic media. Assigns 25% of illustrations to new and emerging illustrators. Freelance artists should be familiar with Illustrator and Photoshop.

First Contact & Terms Send postcard sample. After introductory mailing, send follow-up postcard

sample every 3 months. Accepts e-mail submissions with link to Web site and image file. Prefers Mac-compatible JPEG files. Responds only if interested. Will contact artist for portfolio review if interested. Portfolio should include color and tearsheets. Pays illustrators $1,000-1,200 for color cover; $400 for spots; $500 for ½-page color inside; $650 for full page; $800 for spread. Buys first rights, one-time rights, reprint rights and all rights. Finds freelancers through agents, submissions, magazines and word of mouth.

TURTLE MAGAZINE

Children's Better Health Institute, 1100 Waterway Blvd., Indianapolis IN 46202-0567. (317)636-8881. Fax: (317)684-8094. Web site: www.turtlemag.org. **Art Director:** Bart Rivers. Estab. 1979. Emphasizes health, nutrition, exercise and safety for children ages 2-5. Published 6 times/year; 4-color. Circ. 300,000.

Illustration Approached by 100 illustrators/year. Works with 20 illustrators/year. Buys 15-30 illustrations/issue. Interested in "stylized, humorous, realistic and cartooned themes; also nature and health." Works on assignment only. Needs computer-literate freelancers familiar with Macromedia FreeHand and Photoshop for illustrations.

First Contact & Terms Illustrators: Send query letter with good photocopies and tearsheets. Accepts disk submissions. Samples are filed or are returned by SASE. Responds only if interested. Portfolio review not required. Buys all rights. Pays on publication: $275 for color cover; $35-90 for b&w inside; $70-155 for color inside; $35-70 for spots. Finds most artists through samples received in mail.

Tips "Familiarize yourself with our magazine and other children's publications before you submit any samples. The samples you send should demonstrate your ability to support a story with illustration."

UNMUZZLED OX

105 Hudson St., New York NY 10013. (212)226-7170. Fax: (718)448-3395. E-mail: MAndreOX@aol.com. **Editor:** Michael Andre. Emphasizes poetry, stories, some visual arts (graphics, drawings, photos) for poets, writers, artists, musicians and interested others; b&w with 2-color cover and "classy" design. Circ. varies depending on format (5,000-20,000). Sample copy available for $14 (book-quality paperback format).

Illustration Uses "several" illustrations/issue. Themes vary according to issue.

First Contact & Terms Cartoonists: Send query letter with copies. No payment for cartoons. Illustrators: Send query letter and "anything you care to send" to be kept on file for possible future assignments. Return of original artwork after publication "depends on work; artist should send SASE." Responds in 10 weeks.

Tips Magazine readers and contributors are "highly sophisticated and educated"; artwork should be geared to this market. "Really, *Ox* is part of the New York art world. We publish 'art,' not illustration."

🄽 UPDATE

New York Academy of Sciences, 250 Greenwich St., 40th Floor, New York NY 10007-2157. (212)298-8646. E-mail: publications@nyas.org. Web site: www.nyas.org. **Vice President, Publishing & Communications:** Bill Silberg. Estab. 2001. Newsletter of science- and health-related articles for members of nonprofit New York Academy of Sciences. Circ. 25,000. Sample copies available for SASE.

Illustration Buys 4-5 illustrations/year. Features science/health-related charts & graphs, computer illustration, informational graphics, realistic illustration, medical illustration, spot illustrations. Assigns 2% of illustration to new and emerging illustrators. 80% of freelance illustration demands knowledge of QuarkXPress, Photoshop.

First Contact & Terms Send query letter with photographs, résumé, SASE and slides. Accepts e-mail submissions with TIFF files. Samples are not filed but are returned by SASE. Responds only if interested. Will contact artist for portfolio review if interested. Pays illustrators $600 maximum. Pays on publication. Buys electronic rights, reprint rights. Rights purchased vary according to project. Finds freelancers through sourcebooks and word of mouth.

Tips "We are nonprofit, working on tight budgets, and rarely purchase original illustrations. We sometimes receive works by well-known illustrators, such as Marshall Arisman, at little or no cost to the Academy. We sometimes purchase medical illustrations or stock photography that relates to or creates added interest in articles on various developments in science and medicine."

UROLOGY TIMES

7500 Old Oak Blvd., Cleveland OH 44130. (440)891-3108. Fax: (440)891-2735. E-mail: pseltzer@advanstar.com. Web site: www.urologytimes.com. **Art Director:** Peter Seltzer. Estab. 1972. Monthly trade publication. The leading news source for urgologists. Circ. 10,000. Art guidelines available.

Illustration Buys 6 illustrations/year. Assigns 25% of illustrations to new and emerging illustrators. 90% of freelance work demands computer skills. Freelancers should be familiar with Illustrator, Photoshop.

First Contact & Terms E-mail submissions accepted with link to Web site. Prefers TIFF, JPEG, GIF, EPS. Samples are filed. Art director will contact artist for portfolio review if interested. Portfolio should include finished art and tearsheets. Pays on publication. Buys multiple rights. Finds freelancers through submissions.

ⓝ US AIRWAYS MAGAZINE

Pace Communications, 1301 Carolina St., Greensboro NC 27401. (336)383-5708. E-mail: art@usairwaysmag.com. Web site: www.usairwaysmag.com. **Art Director:** Holly Holliday. Estab. 2006 (merger of *Attaché* and *America West Airlines Magazine*). Inflight magazine for national airline. Circ. 125,000.

Illustration Approached by 100 illustrators/year. Buys 5 illustrations/issue from freelancers. Buys illustrations for spots, columns and feature spreads. Uses freelancers mainly for features and columns. Works on assignment only. Prefers editorial illustration in airbrush, mixed media, colored pencil, watercolor, acrylic, oil, pastel, collage and calligraphy. Needs computer-literate illustrators familiar with Photoshop, Illustrator, QuarkXPress and FreeHand. Assigns 95% of illustrations to experienced, but not well-known illustrators.

First Contact & Terms Send query letter with color brochure showing art style and tearsheets. Looks for the "ability to intelligently grasp idea behind story and illustrate it. Likes crisp, clean colorful styles." Accepts disk submissions of EPS files. Samples are filed. Will contact artist for portfolio review if interested. Sometimes requests work on spec. Buys one-time rights. Pays on publication.

Tips "Send lots of good-looking color tearsheets that we can keep on hand for reference. If your work interests us, we will contact you. In your portfolio, show examples of editorial illustration for other magazines, good conceptual illustrations and a variety of subject matter. Often artists don't send enough of a variety of illustrations; it's much easier to determine if an illustrator is right for an assignment if we have a complete grasp of the full range of abilities. Send high-quality illustrations and show specific interest in our publication."

UTNE

12 N. 12th St., #400, Minneapolis MN 55403. (612)338-5040. Fax: (612)338-6043. Web site: www.utne.com. **Art Director:** Stephanie Glaros. Estab. 1984 by Eric Utne. Bimonthly digest featuring articles and reviews from the best of alternative media: independently published maga-

zines, newsletters, books, journals and Web sites. Topics covered include national and international news, history, art, music, literature, science, education, economics and psychology. Circ. 250,000.

First Contact & Terms "We are always on the lookout for skilled artists with a talent for interpreting editorial content, and welcome examples of your work for consideration. Because of our small staff, busy production schedule, and the volume of samples we receive, however, we ask that you read and keep in mind the following guidelines. We ask that you not call or e-mail seeking feedback, or to check if your package has arrived. We wish we could be more generous in this regard, but we simply don't have the staff or memory capacity to recall what has come in (SASEs and reply cards will be honored). Send samples that can be quickly viewed and tacked onto a bulletin board. Single-sided postcards are preferred. Make sure to include a link to your online portfolio so we can easily view more samples of your work. DO NOT SEND cover letters, résumés, or exhibition lists. Be assured, if your art strikes us as a good fit for the magazine, we will keep you in mind for assignments. Clearly mark your full name, address, phone number, Web site address and e-mail address on everything you send. Please do not send original artwork or original photographs of any kind."

VALLUM: CONTEMPORARY POETRY

P.O. Box 48003, Montreal QC H2V 4S8 Canada. E-mail: info@vallummag.com. Web site: www.vallummag.com. **Editors:** Joshua Auerbach and Helen Zisimatos Auerbach. Estab. 2001. Poetry/fine arts magazine published twice/year. Publishes exciting interplay of poets and artists. Circ. 3,200. Sample copies available for $9 Canadian/$7.95 U.S. Submission guidelines available on Web site.

Illustration Seeking exciting color cover art for magazine with international distribution. Has featured illustrations by Danielle Borisoff, Allen Martian-Vandever, Barbara Legowski, Sandy Wheaton, Charles Weiss and others. Interested in b&w art for inside the magazine, though color art is also accepted.

First Contact & Terms Send art submissions or query letter with brochure, photographs, résumé, samples. After introductory mailing, send follow-up postcard every 6 months. Material is not filed but is returned by SASE. Pays honorarium upon publication. Buys first North American serial rights.

VANCOUVER MAGAZINE

2608 Granville St., Suite 560, Vancouver BC V6H 3V3 Canada. (604)877-7732. Fax: (604)877-4823. E-mail: rwatson@vancouvermagazine.com. Web site: www.vancouvermagazine.com. **Art Director:** Randall Watson. Monthly 4-color city magazine. Circ. 50,000.

Illustration Approached by 100 illustrators/year. Buys 4 illustrations/issue. Has featured illustrations by Melinda Beck, Jordin Isip, Geoffrey Grahn, Craig Larotonda, Christopher Silas Neal, Nate Williams and Juliette Borda. Features editorial and spot illustrations. Prefers conceptual, modern, alternative, bright and graphic use of color and style. Assigns 10% of work to new and emerging illustrators.

First Contact & Terms Illustrators: Send e-mail with Web site and contact link. Send postcard or other nonreturnable samples and follow-up samples every 3 months. Samples are filed. Responds only if interested. Portfolio may be dropped off every Tuesday and picked up the following day. Buys one-time and Internet rights. Finds illustrators through magazines, agents, *Showcase*.

Tips "We stick to tight deadlines. Aggressive, creative, alternative solutions encouraged. No phone calls, please."

VEGETARIAN JOURNAL

P.O. Box 1463, Baltimore MD 21203-1463. (410)366-8343. E-mail: vrg@vrg.org. Web site: www.vrg.org. **Editor:** Debra Wasserman. Estab. 1982. Quarterly nonprofit vegetarian magazine that

examines the health, ecological and ethical aspects of vegetarianism. "Highly educated audience including health professionals." Circ. 20,000. Accepts previously published artwork. Originals are returned at job's completion upon request. Sample copies available for $3.

Cartoons Approached by 4 cartoonists/year. Buys 1 cartoon/issue. Prefers humorous cartoons with an obvious vegetarian theme; single-panel b&w line drawings.

Illustration Approached by 20 illustrators/year. Buys 6 illustrations/issue. Works on assignment only. Prefers strict vegetarian food scenes (no animal products). Considers pen & ink, watercolor, collage, charcoal and mixed media.

First Contact & Terms Cartoonists: Send query letter with roughs. Illustrators: Send query letter with photostats. Samples are not filed and are returned by SASE if requested by artist. Responds in 2 weeks. Portfolio review not required. Rights purchased vary according to project. **Pays on acceptance.** Pays cartoonists $25 for b&w. Pays illustrators $25-50 for b&w/color inside. Finds artists through word of mouth and job listings in art schools.

Tips Areas most open to freelancers are recipe section and feature articles. "Review magazine first to learn our style. Send query letter with photocopy sample of line drawings of food."

VERMONT MAGAZINE

P.O. Box 900, Arlington VT 05250-0900. E-mail: editor@vermontmagazine.com. Web site: www.vermontmagazine.com. **Editor-in-Chief:** Joseph Healy. Estab. 1989. Bimonthly regional publication "aiming to explore what life in Vermont is like—its politics, social issues and scenic beauty." Circ. 50,000. Sample copies and art guidelines available for SASE with first-class postage.

Illustration Approached by 100-150 illustrators/year. Buys 2-3 illustrations/issue. Works on assignment only. Features humorous, realistic, computer and spot illustration. "Particularly interested in creativity and uniqueness of approach." Considers pen & ink, watercolor, colored pencil, oil, charcoal, mixed media and pastel. Assigns 50% of illustrations to experienced but not well-known illustrators; 50% to new and emerging illustrators.

First Contact & Terms Send query letter with tearsheets, "something I can keep." Materials of interest are filed. Will contact artist for portfolio review if interested. Portfolio should include final art and tearsheets. Buys one-time rights. Considers buying second rights (reprint rights) to previously published work. Pays $400 maximum for color cover; $75-150 for b&w inside; $75-350 for color inside; $300-500 for 2-page spreads; $50-75 for spots. Finds artists mostly through submissions/self-promos and from other art directors.

WASHINGTONIAN MAGAZINE

1828 L St. NW, Suite 200, Washington DC 20036. (202)296-3600. E-mail: ecrowson@washingtonian.com. Web site: www.washingtonian.com. **Design Director:** Eileen O'Tousa Crowson. Estab. 1965. Monthly 4-color consumer lifestyle and service magazine. Circ. 185,000.

Illustration Approached by 200 illustrators/year. Buys 2-3 illustrations/issue. Has featured illustrations by Pat Oliphant, Chris Tayne and Richard Thompson. Features caricatures of celebrities, caricatures of politicians, humorous illustration, realistic illustration, spot illustration, computer illustrations and photo collage. Assigns 20% of illustrations to new and emerging illustrators. 20% of freelance illustration demands knowledge of Photoshop.

First Contact & Terms Illustrators: Send postcard sample and follow-up postcard every 6 months. Send nonreturnable samples. Accepts Mac-compatible submissions. Send EPS or TIFF files. Responds only if interested. Will contact artist for portfolio review if interested. Buys first rights. **Pays on acceptance:** $900-1,200 for color cover; $200-800 for b&w, $400-900 for color inside; $900-1,200 for 2-page spreads; $400 for spots. Finds illustrators through magazines, word of mouth, promotional samples, sourcebooks.

Tips "We like caricatures that are fun, not mean and ugly. We want a well-developed sense of color, not just primaries."

WATERCOLOR ARTIST

(formerly *Watercolor Magic*), 4700 E. Galbraith Rd., Cincinnati OH 45236. (513)531-2690. Fax: (513)531-2902. E-mail: wcmedit@aol.com. Web site: www.watercolormagic.com. **Art Director:** Cindy Rider. Editor: Kelly Kane. Estab. 1995. Bimonthly 4-color consumer magazine to ''help artists explore and master watermedia.'' Circ. 92,000. Art guidelines free for #10 SASE with first-class postage.

First Contact & Terms Illustration: Pays on publication. Finds illustrators through word of mouth, visiting art exhibitions, unsolicited queries, reading books.

Tips ''We are looking for watermedia artists who are willing to teach special aspects of their work and their techniques to our readers.''

WEEKLY READER

Weekly Reader Publishing, 1 Reader's Digest Rd., Pleasantville NY 10570-7000. (914)242-4000. Web site: www.weeklyreader.com. **Creative Director:** Amy Gery. Estab. 1928. Publishes educational periodicals, posters and books. ''*Weekly Reader* teaches the news to kids pre-K through high school age. The philosophy is to connect students to the world.'' Publications are 4-color. Sample copies are available.

James Lyle found the listing for Weekly Reader in the 2004 *Artist's & Graphic Designer's Market* and sent sample work to the creative director. Proof that good promotional material will eventually pay off, a few months later Lyle was contacted about doing this illustration for *Current Health 1*, one of Weekly Reader's magazines. He has since been commissioned for more assignments for a variety of Weekly Reader publications. ''One good client can result in a lot of business,'' says Lyle, ''but be prepared to do a good job, quickly, when the break comes.''

Illustration Needs editorial and technical illustration. Style should be "contemporary and age-level appropriate for the juvenile audience." Buys more than 50 illustrations/week. Works on assignment only. Uses computer and reflective art.

First Contact & Terms Illustrators: Send brochure, tearsheets, SASE and photocopies. Samples are filed or are returned by SASE if requested by artist. Accepts previously published artwork. Original artwork is returned at job's completion. Payment is usually made within 3 weeks of receiving the invoice. Finds artists through submissions/self-promotions, sourcebooks, agents and reps. Some periodicals need quick turnarounds.

Tips "Our primary focus is the children's and young adult marketplace. Art should reflect creativity and knowledge of audience's needs. Our budgets are tight, and we have very little flexibility in our rates. We need artists who can work with our budgets. Avoid using fluorescent dyes. Use clear, bright colors. Work on flexible board."

WESTWAYS
3333 Fairview Rd., A327, Costa Mesa CA 92808. (714)885-2396. Fax: (714)885-2335. E-mail: vaneyke.eric@aaa-calif.com. **Art Director:** Eric Van Eyke. Estab. 1918. Bimonthly lifestyle and travel magazine. Circ. 3,000,000. Sample copies and art guidelines available for SASE.

Illustration Approached by 20 illustrators/year. Buys 2-6 illustrations/year. Works on assignment only. Preferred style is "arty—tasteful, colorful." Considers pen & ink, watercolor, collage, airbrush, acrylic, colored pencil, oil, mixed media and pastel.

First Contact & Terms Illustrators: Send e-mail with link to Web site or query letter with brochure, tearsheets and samples. Samples are filed. Responds only if interested; "could be months after receiving samples." Buys first rights. **Pays on acceptance of final art:** $250 minimum for color inside. Original artwork returned at job's completion.

Ⓝ WILDLIFE ART
947 D St., Ramona CA 92065. (760)788-9453. Fax: (760)788-9454. E-mail: graphics@wildlifeartmag.com. Web site: www.wildlifeartmag.com. **Graphics:** Beth Edwards. Estab. 1982. Bimonthly 4-color trade journal with award-winning design. Many 2-page color art spreads. "The largest magazine in wildlife art originals, prints, duck stamps, artist interviews and industry information." Circ. 35,000. Sample copy available for $6.95; art guidelines available for SASE with first-class postage.

Illustration Approached by 100 artists/year. Works on assignment only. Prefers nature/animal themes and landscapes. Considers pen & ink and charcoal.

First Contact & Terms Send postcard sample or query letter. Accepts Mac-compatible disk submissions in QuarkXPress, Illustrator and Photoshop. Send EPS files. Samples are not filed and are returned by SASE if requested by artist. Responds in 2 months. To show a portfolio, mail color tearsheets, slides and photocopies. Accepts previously published artwork. Original artwork returned to artist at job's completion. Buys first rights.

Tips "Interested wildlife artists should send SASE, three to seven clearly-marked slides or transparencies, short biography; and be patient!"

WOODENBOAT MAGAZINE
P.O. Box 78, Brooklin ME 04616-0078. (207)359-4651. Fax: (207)359-8920. E-mail: olga@woodenboat.com. Web site: www.woodenboat.com. **Art Director:** Olga Lange. Estab. 1974. Bimonthly magazine for wooden boat owners, builders and designers. Circ. 106,000. Previously published work OK. Sample copy available for $6. Art guidelines free for SASE with first-class postage.

Illustration Approached by 10-20 illustrators/year. Buys 2-10 illustrations/issue on wooden boats or related items.

First Contact & Terms Illustrators: Send postcard sample or query letter with printed samples

and tearsheets. Samples are filed. Does not respond. Artist should follow up with call. Pays on publication. Pays illustrators $50-$400 for spots.

Tips "We work with several professionals on an assignment basis, but most of the illustrative material we use in the magazine is submitted with a feature article. When we need additional material, however, we will try to contact a good freelancer in the appropriate geographic area."

ℕ WRITER'S DIGEST

F + W Publications, Inc., 4700 E. Galbraith Rd., Cincinnati OH 45236. E-mail: writersdig@fwpubs. com. Web site: www.writersdigest.com. **Art Director:** Kathleen DeZarn. Editor: Maria Schneider. Bimonthly magazine emphasizing freelance writing for freelance writers. Circ. 140,000. Art guidelines free for SASE with first-class postage.

- Submissions are also considered for inclusion in annual *Writer's Yearbook* and other one-shot publications.

Illustration Buys 2-4 feature illustrations/issue. Theme: the writing life. Works on assignment only. Send postcard or any printed/copied samples to be kept on file (no larger than 8½ × 11).

First Contact & Terms Prefers postal mail submissions to keep on file. Final art may be sent via e-mail. Prefers EPS, TIFF or JPEG files, 300 dpi. Buys one-time rights. **Pays on acceptance:** $500-1,000 for color cover; $100-800 for color inside.

Tips "I like having several samples to look at. Online portfolios are great."

ℕ WY'EAST HISTORICAL JOURNAL

P.O. Box 294, Rhododendron OR 97049. (503)622-4798. Fax: (503)622-4798. **Publisher:** Michael P. Jones. Estab. 1994. Quarterly historical journal. "Our readers love history and nature, and this is what we are about. Subjects include America, Indians, fur trade, Oregon Trail, etc., with a focus on the Pacific Northwest." Circ. 2,500. Accepts previously published artwork. Originals are returned at job's completion if accompanied by SASE. Sample copy: $10. Art guidelines available for SASE with first-class postage. 50% of freelance work demands computer skills.

Cartoons Approached by 50 cartoonists/year. Buys 6 cartoons/issue. Prefers Northwest Indians, Oregon Trail, wildlife; single panel.

Illustration Approached by 100 illustrators/year. Buys 10 illustrations/issue. Prefers Northwest Indians, Oregon Trail, fur trade, wildlife. Considers pen & ink, airbrush and charcoal.

Design Needs freelancers for design and production.

First Contact & Terms Cartoonists: Send query letter with brochure, roughs and finished cartoons. Buys reprint rights. Illustrators/Designers: Send query letter with brochure, résumé, SASE, tearsheets, photographs, photocopies, slides and transparencies. Samples are filed or are returned by SASE if requested by artist. Responds in 2 weeks. Publication will contact artist for portfolio review if interested. Portfolio should include b&w and color thumbnails, tearsheets, slides, roughs, photostats, photocopies, final art and photographs. Buys first rights. Pays in copies. Finds artists through submissions, sourcebooks and word of mouth.

Tips Uses freelancers for "feature articles in need of illustrations. However, we will consider doing a feature on the artist's work. Artists find us. Send us a good selection of your samples, even if they are not what we are looking for. Once we see what you can do, we will give an assignment. We are specifically seeking illustrators who know how to make black & white illustrations come alive."

Book Publishers

Walk into any bookstore and start counting the number of images you see on books and calendars. The illustrations you see on covers and within the pages of books are, for the most part, created by freelance artists. Publishers rarely have enough artists on staff to generate such a vast array of styles. If you like to read and work creatively to solve problems, the world of book publishing could be a great market for you.

The artwork appearing on a book cover must grab readers' attention and make them want to pick up the book. It must show at a glance what type of book it is and who it is meant to appeal to. In addition, the cover has to include basic information such as title, the author's name, the publisher's name, blurbs and price.

Most assignments for freelance work are for jackets/covers. The illustration on the cover, combined with typography and the layout choices of the designer, announce to the prospective readers at a glance the style and content of a book. Suspenseful spy novels tend to feature stark, dramatic lettering and symbolic covers. Fantasy and science fiction novels, as well as murder mysteries and historical fiction, might show a scene from the story on their covers. Visit a bookstore and then decide which kinds of books interest you and would be best for your illustration style.

Book interiors are also important. The page layouts and illustrations direct readers through the text and complement the story, particularly in children's books and textbooks. Many publishing companies hire freelance designers with computer skills to design interiors on a contract basis. Look within each listing for the subheading Book Design to find the number of jobs assigned each year and how much is paid per project.

Finding your best markets

The first paragraph of each listing describes the types of books each publisher specializes in. You should submit only to publishers who specialize in the types of books you want to illustrate or design. There's no use submitting to a publisher of literary fiction if you want to illustrate children's picture books.

The publishers in this section are just the tip of the iceberg. You can find additional publishers by visiting bookstores and libraries and looking at covers and interior art. When you find covers you admire, write down the name of the books' publishers in a notebook. If the publisher is not listed in *Artist's & Graphic Designer's Market*, go to your public library and ask to look at a copy of *Literary Market Place*, also called *LMP*, published annually by Information Today, Inc. The cost of this large directory is prohibitive to most freelancers, but you should become familiar with it if you plan to work in the book publishing industry. Though it won't tell you how to submit to each publisher, it does give art directors' names. Also be sure to visit publishers' Web sites—many offer artist's guidelines.

Publishing Terms to Know

Important

- **Mass market** paperbacks are sold at supermarkets, newsstands, drugstores, etc. They include romance novels, diet books, mysteries and novels by popular authors like Stephen King.

- **Trade books** are the hardcovers and paperbacks found only in bookstores and libraries. The paperbacks are larger than those on the mass market racks, and are printed on higher-quality paper and often feature matte-paper jackets.

- **Textbooks** contain plenty of illustrations, photographs and charts to explain their subjects.

- **Small press** books are produced by small, independent publishers. Many are literary or scholarly in theme and often feature fine art on their covers.

- **Backlist titles** or **reprints** refer to publishers' titles from past seasons that continue to sell year after year. These books are often updated and republished with freshly designed covers to keep them up to date and attractive to readers.

How to submit

Send one to five nonreturnable samples along with a brief letter. Never send originals. Most art directors prefer samples that can fit in file drawers. Bulky submissions are considered a nuisance. After sending your initial introductory mailing, you should follow up with postcard samples every few months to keep your name in front of art directors. If you have an e-mail account and can send TIFF or JPEG files, check the publishers' preferences to see if they will accept submissions via e-mail.

Getting paid

Payment for design and illustration varies depending on the size of the publisher, the type of project and the rights purchased. Most publishers pay on a per-project basis, although some publishers of highly illustrated books (such as children's books) pay an advance plus royalties. Small, independent presses may only pay in copies.

Children's book illustration

Working in children's books requires a specific set of skills. You must be able to draw the same characters in a variety of poses and situations. Many publishers are expanding their product lines to include multimedia projects. While a number of children's book publishers are listed in this book, *Children's Writer's & Illustrator's Market*, also published by Writer's Digest Books, is an invaluable resource if you enter this field. See page 556 for more information, or visit www.fwbookstore.com to order the most recent edition. You may also want to consider joining the Society of Children's Book Writers and Illustrators (www.scbwi.org), an international organization that offers support, information, and lots of networking opportunities.

Book Publishers

Helpful Resources

For More Info

If you decide to focus on book publishing, become familiar with *Publishers Weekly*, the trade magazine of the industry. Its Web site, www.publishers weekly.com, will keep you abreast of new imprints, publishers that plan to increase their title selection, and the names of new art directors. You should also look for articles on book illustration and design in *HOW* (www. howdesign.com), *PRINT* (www.printmag.com) and other graphic design magazines. Helpful books include *By Its Cover: Modern American Book Cover Design* (Princeton Architectural Press), *Front Cover: Great Book Jacket and Cover Design* (Mitchell Beazley), and *Jackets Required: An Illustrated History of American Book Jacket Design, 1920-1950* (Chronicle Books).

HARRY N. ABRAMS, INC.

115 W. 18th St., New York NY 10011. (212)206-7715. Fax: (212)519-1210. Web site: www.hnaboo ks.com. **Director, Art and Design:** Mark LaRiviere. Estab. 1951. Publishes hardcover originals, trade paperback originals and reprints. Types of books include fine art and illustrated books. Publishes 240 titles/year. 60% require freelance design. Visit Web site for art submission guidelines.

Needs Uses freelance designers to design complete books including jackets and sales materials. Uses illustrators mainly for maps and occasional text illustration. 100% of freelance design and 50% of illustration demands knowledge of Illustrator, InDesign or QuarkXPress and Photoshop. Works on assignment only.

First Contact & Terms Send query letter with résumé, tearsheets, photocopies. Accepts disk submissions or Web address. Samples are filed "if work is appropriate." Samples are returned by SASE if requested by artist. Portfolio should include printed samples, tearsheets and/or photocopies. Originals are returned at job's completion, with published product. Finds artists through word of mouth, submissions, attending art exhibitions and seeing published work.

Book Design Assigns several freelance design jobs/year. Pays by the project.

ACROPOLIS BOOKS, INC.

201 Olivia Lane #7, Barnesville GA 30204-4404. E-mail: acropolisbooks@mindspring.com. Web site: www.acropolisbooks.com. **Vice President Operations:** Christine Lindsey. Imprints include Awakening. Publishes hardcover originals and reprints; trade paperback originals and reprints. Types of books include mysticism and spiritual. Specializes in books of higher consciousness. Recent titles: *The Journey Back to the Fathers Home* and *Showing Forth the Presence of God* by Joel S. Goldsmith. Publishes 4 titles/year. 30% require freelance design. Catalog available.

Needs Approached by 7 illustrators and 5 designers/year. Works with 2-3 illustrators and 2-3 designers/year. Knowledge of Photoshop and QuarkXPress useful in freelance illustration and design.

First Contact & Terms Designers: Send brochure and résumé. Illustrators: Send query letter with

photocopies and résumé. Samples are filed. Responds in 2 months. Will contact artist for portfolio review if interested. Buys all rights.

Book Design Assigns 3-4 freelance design jobs/year. Pays by the project.

Jackets/Covers Assigns 3-4 freelance design jobs/year. Pays by the project.

Tips "We are looking for people who are familiar with our company and understand our focus."

ADAMS MEDIA

F + W Publications, Inc., 57 Littlefield St., Avon MA 02322. (508)427-7100. Fax: (508)427-6790. E-mail: frank.rivera@adamsmedia.com. Web site: www.adamsmedia.com. **Art Director:** Frank Rivera. Estab. 1980. Publishes hardcover originals; trade paperback originals and reprints. Types of books include biography, business, gardening, pet care, cookbooks, history, humor, instructional, New Age, nonfiction, reference, self-help and travel. Specializes in business and careers. Recent titles: *101 Things You Didn't Know About Da Vinci*; *Tales from the Scales*; *The 10 Women You'll Be Before You're 35*. Publishes 260 titles/year. 20% require freelance illustration. Book catalog free by request.

● Imprints include Polka Dot Press, Platinum Press and Provenance Press. See also separate listing for F + W Publications, Inc., in this section.

Needs Works with 8 illustrators and 7-10 designers/year. Buys less than 100 freelance illustrations/year. Uses freelancers mainly for jacket/cover illustration, text illustration and jacket/cover design. 100% of freelance work demands computer skills. Freelancers should be familiar with InDesign, Illustrator and Photoshop.

First Contact & Terms Send postcard sample of work. Samples are filed. Art director will contact artist for portfolio review if interested. Portfolio should include tearsheets. Rights purchased vary according to project, but usually buys all rights.

Jackets/Covers Assigns 50 freelance design jobs/year. Pays by the project, $700-1,200.

Text Illustration Assigns 30 freelance illustration jobs/year.

N I ALLYN & BACON PUBLISHERS

75 Arlington St., Suite 300, Boston MA 02116. (617)848-7328. E-mail: linda.knowles@ablongman .com. Web site: www.ablongman.com. **Art Director:** Linda Knowles. Estab. 1868. Publishes more than 300 hardcover and paperback college textbooks/year. 60% require freelance cover designs. Subject areas include education, psychology and sociology, political science, theater, music and public speaking. Recent titles: *Criminal Justice*; *Including Students with Special Needs*; *Social Psychology*.

Needs Designers must be strong in book cover design and contemporary type treatment. 50% of freelance work demands knowledge of Illustrator, Photoshop and FreeHand.

Jackets/Covers Assigns 100 design jobs and 2-3 illustration jobs/year. Pays for design by the project, $500-1,000. Pays for illustration by the project, $500-1,000. Prefers sophisticated, abstract style in pen & ink, airbrush, charcoal/pencil, watercolor, acrylic, oil, collage and calligraphy.

Tips "Keep stylistically and technically up to date. Learn *not* to over-design. Read instructions and ask questions. Introductory letter must state experience and include at least photocopies of your work. If I like what I see, and you can stay on budget, you'll probably get an assignment. Being pushy closes the door. We primarily use designers based in the Boston area."

I AMERICAN JUDICATURE SOCIETY

2700 University Ave., Des Moines IA 50311. (515)271-2281. Fax: (515)279-3090. E-mail: drichert @ajs.org. Web site: www.ajs.org. **Editor:** David Richert. Estab. 1913. Publishes journals and books. Specializes in courts, judges and administration of justice. Publishes 5 titles/year; 75% require freelance illustration. Catalog available free for SASE.

Needs Approached by 20 illustrators and 6 designers/year. Works with 3-4 illustrators and 1

designer/year. Prefers local designers. Uses freelancers mainly for illustration. 100% of freelance design demands knowledge of PageMaker, FreeHand, Photoshop and Illustrator. 10% of freelance illustration demands knowledge of QuarkXPress, FreeHand, Photoshop and Illustrator.

First Contact & Terms Designers: Send query letter with photocopies. Illustrators: Send query letter with photocopies and tearsheets. Send follow-up postcard every 3 months. Samples are not filed and are returned by SASE. Responds in 1 month. Will contact artist for portfolio review of photocopies, roughs and tearsheets if interested. Buys one-time rights.

Book Design Assigns 1-2 freelance design jobs/year. Pays by the project, $500-1,000.

Text Illustration Assigns 10 freelance illustration jobs/year. Pays by the project, $75-375.

ANDREWS MCMEEL PUBLISHING, LLC

Andrews McMeel Universal, 4520 Main St., Kansas City MO 64111-7701. (816)932-6700. Fax: (816)932-6781. E-mail: tlynch@amuniversal.com. Web site: www.andrewsmcmeel.com. **Art Director:** Tim Lynch. Estab. 1972. Publishes hardcover originals and reprints; trade paperback originals and reprints. Types of books include humor, gift, instructional, nonfiction, reference, cooking. Specializes in calendars and comic strip collection books. Recent titles include *ModMex*, *Nobu West*, *The Blue Day Book* and *Complete Calvin and Hobbes*. Publishes 200 titles/year. 10% require freelance illustration; 80% require freelance design.

- See also listings for Universal Press Syndicate and uclick (other divisions of Andrews McMeel Universal) in the Syndicates & Cartoon Features section.

Needs Prefers freelancers experienced in book jacket design. Freelance designers must have knowledge of Illustrator, Photoshop, QuarkXPress, or InDesign. Food photographers experienced in cook book photography.

First Contact & Terms Send sample sheets and Web address or contact through artists' rep. Samples are filed and not returned. Responds only if interested. Portfolio review not required. Rights purchased vary according to project.

Book Design Assigns 60 freelance design jobs and 20 illustration jobs/year. Pays $600-3,000 for design.

Tips "We want designers who can read a manuscript and design a concept for the best possible cover. Communicate well and be flexible with design." Designer portfolio review once a year in New York City.

ART DIRECTION BOOK CO. INC.

456 Glenbrook Rd., Glenbrook CT 06906. (203)353-1441. Fax: (203)353-1371. **Production Manager:** Karyn Mugmon. Publishes hardcover and paperback originals on advertising design and photography. Titles include *Scan This Book* and *Most Happy Clip Art* (disks), *101 Absolutely Superb Icons* (book and disk) and *American Corporate Identity #11*. Publishes 10-12 titles/year. Book catalog free on request.

Needs Works with 2-4 freelance designers/year. Uses freelancers mainly for graphic design.

First Contact & Terms Send query letter to be filed and arrange to show portfolio of 4-10 tearsheets. Portfolios may be dropped off Monday-Friday. Samples returned by SASE. Buys first rights. Originals are returned to artist at job's completion. Advertising design must be contemporary. Finds artists through word of mouth.

Book Design Assigns 8 freelance design jobs/year. Pays $350 maximum.

Jackets/Covers Assigns 8 freelance design jobs/year. Pays $350 maximum.

ARTIST'S & GRAPHIC DESIGNER'S MARKET

Writer's Digest Books, F+W Publications, Inc., 4700 E. Galbraith Rd., Cincinnati OH 45236. E-mail: artdesign@fwpubs.com. Web site: www.artists-market.com. **Editor:** Erika O'Connell. Annual directory of markets for illustrators, cartoonists, graphic designers and fine artists.

Needs Buys 10-30 illustrations/year. "I need examples of art that have been sold to the listings in *Artist's & Graphic Designer's Market*. Look through this book for examples. The art must have been freelanced; it cannot have been done as staff work. Include the name of the listing that purchased or exhibited the work, what the art was used for, and (if possible) the payment you received. Bear in mind that interior art is reproduced in black & white, so the higher the contrast, the better. I also need to see promo cards, business cards and tearsheets."

First Contact & Terms Send e-mail with JPEG files (at least 300 dpi), or mail printed samples or tearsheets. "Because *Artist's & Graphic Designer's Market* is published only once a year, submissions are kept on file for the upcoming edition until selections are made. Material is then returned by SASE if requested." Buys one-time rights. Pays $75 to the owner of reproduction rights, as well as a free copy of *Artist's & Graphic Designer's Market* when published.

ATHENEUM BOOKS FOR YOUNG READERS
Imprint of Simon & Schuster Children's Publishing Division, 1230 Avenue of the Americas, New York NY 10020. (212)698-7000. Fax: (212)698-2798. Web site: www.simonsayskids.com. **Executive Art Director:** Ann Bobco. Publishes hardcover originals, picture books for young kids, nonfiction for ages 8-12, and novels for middle-grade and young adults. Types of books include biography, historical fiction, history, nonfiction. Recent titles: *Olivia Saves the Circus* by Ian Falconer; *Zeely* by Virginia Hamilton. Publishes 60 titles/year. 100% require freelance illustration. Book catalog free by request.

Needs Approached by hundreds of freelance artists/year. Works with 40-50 illustrators/year. "We are interested in artists of varying media and are trying to cultivate those with a fresh look appropriate to each title."

First Contact & Terms Send postcard sample of work or send query letter with tearsheets, résumé and photocopies. Samples are filed. Responds only if interested. Art Director will contact artist for portfolio review if interested. Portfolio should include final art if appropriate, tearsheets, and folded and gathered sheets from any picture books you've had published. Rights purchased vary according to project. Originals are returned at job's completion. Finds artists through submissions, magazines ("I look for interesting editorial illustrators."), word of mouth.

Jackets/Covers Assigns 20 freelance illustration jobs/year. Pays by the project, $1,200-1,800. "I am not interested in generic young adult illustrators."

Text Illustration Pays by the project, $500-2,000.

Ⓝ ATLAS GAMES
885 Pierce Butler, St. Paul MN 55104. (651)638-0077. Fax: (651)638-0084. E-mail: info@atlas-games. com. Web site: www.atlas-games.com. **Contact:** Art Director. Estab. 1990. Publishes roleplaying game books, game/trading cards and board games. Main style/genre of games: fantasy, horror, historical (medieval). Uses freelance artists mainly for b&w interior illustrations. Game/product lines include *Unknown Armies; Ars Magica; Penumbra; Feng Shui*. Publishes 12 titles or products/year. Art guidelines available on Web site or by request.

Needs Approached by 100 illustrators and 10 designers/year. Works with 6 illustrators and 1 designer/year. 100% of freelance design demands knowledge of Photoshop and QuarkXPress.

First Contact & Terms Not currently accepting submissions; check Web site for updates.

Visual Design Assigns 1 freelance design job/year.

Book Covers/Posters/Cards Assigns 4 illustration jobs/year. Pays $200-300 for cover art. Pays for design by the project, $100-300.

Text Illustration Assigns 20 freelance text illustration jobs/year. Pays by the full page, $40-50; by the half page, $20-25.

BAEN BOOKS

P.O. Box 1403, Riverdale NY 10471. (919)570-1640. Fax: (919)570-1644. E-mail: artdirector@bae n.com. Web site: www.baen.com. **Art Director:** Toni Weisskopf. Estab. 1983. Publishes science fiction and fantasy. Recent titles include *1634: The Baltic War* and *By Slanderous Tongues*. Publishes 60-70 titles/year; 90% require freelance illustration/design. Book catalog free on request.

Needs Approached by 500 freelancers/year. Works with 10 illustrators and 3 designers/year. 50% of work demands computer skills.

First Contact & Terms Designers: Send query letter with résumé, color photocopies, color tearsheets and SASE. Illustrators: Send query letter with color photocopies, slides, color tearsheets and SASE. Samples are filed. Originals are returned to artist at job's completion. Buys exclusive North American book rights.

Jackets/Covers Assigns 64 design and 64 illustration jobs/year. Pays by the project. Pays designers $200 minimum; pays illustrators $1,000 minimum.

Tips Wants to see samples within science fiction/fantasy genre only. "Do not send black & white illustrations or surreal art. Please do not waste our time and your postage with postcards. Serious submissions only."

⟨N⟩ BECKER&MAYER!

11120 NE 33rd Place, Suite 101, Bellevue WA 98004-1444. (425)827-7120. Fax: (425)828-9659. E-mail: infobm@beckermayer.com. Web site: www.beckermayer.com. Estab. 1973. Publishes nonfiction biography, humor, history and coffee table books. Recent titles: *The Art of Wine Tasting*; *Stan Lee's Amazing Marvel Universe*; *World War II Aircraft*; *The Secret World of Fairies*; *Disney Trivia Challenge*. Publishes 100+ titles/year. 10% require freelance design; 75% require freelance illustration. Book catalog available on Web site.

- becker&mayer! is spelled in all lower case letters with an exclamation mark. Publisher requests that illustration for children's books be sent to Juvenile Submissions. All other illustration should be sent to Adult Submissions.

Needs Works with 6 designers and 20-30 illustrators/year. Freelance design work demands skills in FreeHand, InDesign, Illustrator, Photoshop, QuarkXPress. Freelance illustration demands skills in FreeHand, Illustrator, Photoshop.

First Contact & Terms Designers: Send query letter with résumé and tearsheets. Illustrators: Send query letter, nonreturnable postcard sample, résumé and tearsheets. After introductory mailing, send follow-up postcard every 6 months. Does not accept e-mail submissions. Samples are filed. Responds only if interested. Will request portfolio review of color finished art, roughs, thumbnails and tearsheets, only if interested. Rights purchased vary according to project.

Text illustration Assigns 30 freelance illustration jobs a year. Pays by the project.

Tips "Our company is divided into adult and juvenile divisions; please send samples to the appropriate division. No phone calls!"

⟨N⟩ ⟨Ⓣ⟩ BLOOMSBURY CHILDREN'S BOOKS USA

104 Fifth Ave., 7th Floor, New York NY 10011. (212)727-8300. Fax: (212)727-0984. E-mail: bloom sbury.kids@bloomsburyusa.com. Web site: www.bloomsburyusa.com. **Senior Designer:** Lizzy Bromley. Estab. 2001. Publishes hardcover and trade paperback originals and reprints. Types of books include children's picture books, fantasy, humor, juvenile and young adult fiction. Recent titles: *Ruby Sings the Blues*; *The Last Burp of Mac McGerp*. Publishes 50 titles/year. 50% require freelance design; 100% require freelance illustration. Book catalog not available.

Needs Works with 5 designers and 20 illustrators/year. Prefers local designers. 100% of freelance design work demands knowledge of Illustrator, QuarkXPress and Photoshop.

First Contact & Terms Designers: Send postcard sample or query letter with brochure, résumé, tearsheets. Illustrators: Send postcard sample or query letter with brochure, photocopies and

SASE. After introductory mailing, send follow-up postcard sample every 6 months. Samples are filed or returned by SASE. Responds only if interested. Will contact artist for potfolio review if interested. Buys all rights. Finds freelancers through word of mouth.
Jackets/Covers Assigns 5 freelance cover illustration jobs/year.

▪.BLUE DOLPHIN PUBLISHING, INC.
P.O. Box 8, Nevada City CA 95959. (530)477-1503. Fax: (530)477-8342. E-mail: bdolphin@bluedo lphinpublishing.com. Web site: www.bluedolphinpublishing.com. **President:** Paul M. Clemens.

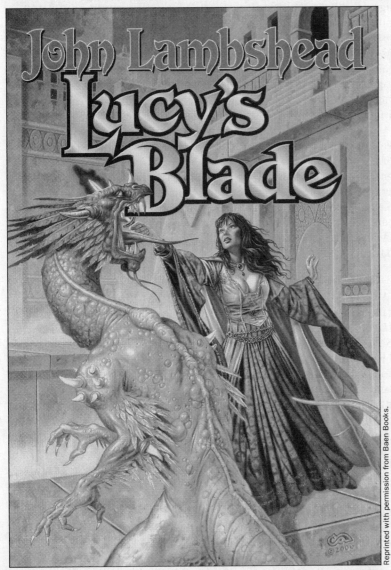

Reprinted with permission from Baen Books.

Artist Clyde Caldwell and designer Carol Russo created the cover of *Lucy's Blade* from Baen Books using a combination of action and composition to draw the reader in. This cover is successful because the monster is terrible, but the painting is beautiful, and the relationship between monster and woman is dynamic. "Clyde Caldwall has worked for Baen Books for a long time," says editorial assistant Kayt Hensley. "He perfectly captures the dynamic, romantic realism that is the hallmark of our covers."

Estab. 1985. Publishes hardcover and trade paperback originals. Types of books include biography, cookbooks, humor and self-help. Specializes in comparative spiritual traditions, lay psychology and health. Recent titles include *The Art of Energy Healing, Your Mind Knows More Than You Do, Consciousness Is All* and *The Fifth Gospel*. Publishes 20 titles/year. 25% require freelance illustration; 30% require freelance design. Books are "high quality on good paper, with laminated dust jacket and color covers." Book catalog free upon request.

Needs Works with 5-6 freelance illustrators and designers/year. Uses freelancers mainly for book cover design; also for jacket/cover and text illustration. "More hardcovers and mixed media are requiring box design as well." 50% of freelance work demands knowledge of PageMaker, QuarkXPress, FreeHand, Illustrator, Photoshop, CorelDraw, InDesign and other IBM-compatible programs. Works on assignment only.

First Contact & Terms Send postcard sample or query letter with brochure and photocopies. Samples are filed or are returned by SASE if requested. Responds "whenever work needed matches portfolio." Originals are returned to artist at job's completion. Sometimes requests work on spec before assigning job. Considers project's budget when establishing payment. Negotiates rights purchased. Considers buying second rights (reprint rights) to previously published work.

Book Design Assigns 3-5 jobs/year. Pays by the hour, $10-15; or by the project, $300-900.

Jackets/Covers Assigns 5-6 design and 5-6 illustration jobs/year. Pays by the hour, $10-15; or by the project, $300-900.

Text Illustration Assigns 1-2 jobs/year. Pays by the hour, $10-15; or by the project, $300-900.

Tips "Send query letter with brief sample of style of work. We usually use local people, but are always looking for something special. Learning good design is more important than designing on the computer, but we are very computer-oriented. Basically we look for original artwork of any kind that will fit the covers for the subjects we publish. Please see our online catalog of over 250 titles to see what we have selected so far."

Ⓝ BOOK DESIGN

P.O. Box 193, Moose WY 83012-0193. Phone/fax: (307)733-6248. **Art Director:** Robin Graham. Specializes in high-quality hardcover and paperback originals. Recent titles: *Tales of the Wolf; Wildflowers of the Rocky Mountains; Mattie: A Woman's Journey West; Cubby in Wonderland; Windswept; The Iron Shirt*. Publishes more than 12 titles/year.

Needs Works with 20 freelance illustrators and 10 designers/year. Works on assignment only. "We are looking for top-notch quality only." 90% of freelance work demands knowledge of PageMaker and FreeHand for electronic submissions.

First Contact & Terms Send query letter with "examples of past work and one piece of original artwork that can be returned." Samples not filed are returned by SASE if requested. Responds in 20 days. Originals are not returned. Write for appointment to show portfolio. Negotiates rights purchased.

Book Design Assigns 6 freelance design jobs/year. Pays by the project, $50-3,500.

Jackets/Covers Assigns 2 freelance design and 4 illustration jobs/year. Pays by the project, $50-3,500.

Text Illustration Assigns 26 freelance jobs/year. Prefers technical pen illustration, maps (using airbrush, overlays etc.), watercolor illustration for children's books, calligraphy and lettering for titles and headings. Pays by the hour, $5-20; or by the project, $50-3,500.

BOYDS MILLS PRESS

815 Church St., Honesdale PA 18431. (570)253-1164. Fax: (570)253-0179. Web site: www.boyds millspress.com. **Art Director:** Tim Gillner. Estab. 1990. Trade division of Highlights for Children, Inc. Publishes hardcover originals and reprints. Types of books include fiction, nonfiction, picture books and poetry. Recent titles: *A Splendid Friend, Indeed* by Suzanne Bloom; *Wings of Light:*

The Migration of the Yellow Butterfly by Stephen R. Swinburne (illustrated by Bruce Hiscock); *All Aboard! Passenger Trains Around the World* by Karl Zimmermann (photographs by the author). Publishes 50 titles/year. 25% require freelance illustration/design.

Needs Works with 25-30 freelance illustrators and 5 designers/year. Prefers illustrators with book experience, but also uses illustrators of all calibers of experience. Uses freelancers mainly for picture books, poetry books, and jacket art. Works on assignment only.

First Contact & Terms Send sample tearsheets, color photocopies, postcards, or electronic submissions. If electronic samples are submitted, low-res JPEGs or links to Web sites are best. Samples are not returned. Samples should include color and b&w. Rights purchased vary according to project. Originals are returned at job's completion. Finds artists through submissions, sourcebooks, agents, Internet and other publications.

Book Design Assigns 2-3 design/illustration jobs/year. Pays by the project.

Jackets/Covers Assigns 2-3 design/illustration jobs/year. Pays by the project.

Text Illustration Pays by the project.

Tips "Please don't send samples that need to be returned."

CACTUS GAME DESIGN, INC.

751 Tusquittee St., Hayesville NC 28904. (828)389-1536. Fax: (828)389-1534. E-mail: rob@cactus gamedesign.com. Web site: www.cactusgamedesign.com. **Art Director:** Doug Gray. Estab. 1995. Publishes comic books, game/trading cards, posters/calendars, CD-ROM/online games and board games. Main style/genre of games: science fiction, fantasy and Biblical. Recent products: *Outburst Bible Edition*; *Redemption 2nd Edition*; *Gil's Bible Jumble*. Publishes 2-3 titles or products/year. 100% require freelance illustration; 25% require freelance design.

Needs Approached by 100 illustrators and 10 designers/year. Works with 10 illustrators and 1 designer/year. Prefers freelancers experienced in fantasy and Biblical art. 100% of freelance design demands knowledge of Illustrator and Photoshop.

First Contact & Terms Send query letter with résumé and photocopies. Accepts disk submissions in Windows format. Send via CD, floppy disk, Zip as TIFF, GIF or JPEG files. Samples are filed. Responds only if interested. Portfolio review not required. Rights purchased vary according to project. Finds freelancers through submissions and word of mouth.

Visual Design Assigns 30-75 freelance design jobs/year. Pays for design by the hour, $20.

Book Covers/Posters/Cards Pays for illustration by the project, $25-250. "Artist must be aware of special art needs associated with Christian retail environment."

Tips "We like colorful action shots."

CANDLEWICK PRESS

2067 Massachusetts Ave., Cambridge MA 02140. (617)661-3330. Fax: (617)661-0565. Web site: www.candlewick.com. **Art Acquisitions:** Anne Moore. Estab. 1992. Publishes hardcover, trade paperback children's books. Publishes 200 titles/year. 100% require freelance illustration.

Needs Works with 170 illustrators and 1-2 designers/year. 100% of freelance design demands knowledge of Photoshop, Illustrator or QuarkXPress.

First Contact & Terms Designers: Send query letter with résumé. Illustrators: Send query letter with photocopies. Accepts nonreturnable disk submissions from illustrators. Samples are filed and are not returned. Will contact artist for portfolio review of artwork and tearsheets if interested. Rights purchased vary according to project.

Text Illustration Finds illustrators through agents, sourcebooks, word of mouth, submissions, art schools.

Tips "We generally use illustrators with prior trade book experience."

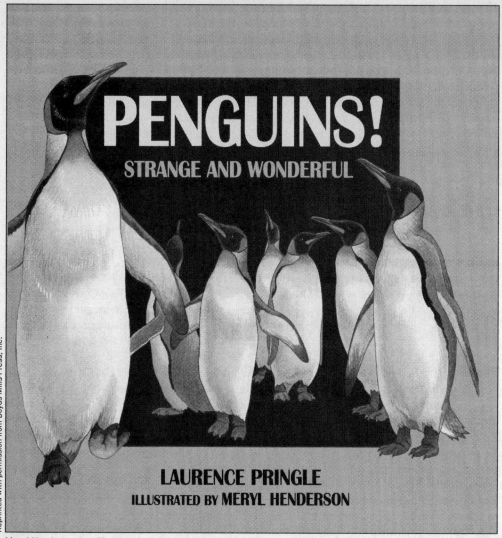

Meryl Henderson has illustrated numerous books for children, including Laurence Pringle's *Penguins! Strange and Wonderful*, from Boyds Mills Press, Inc. Henderson and Pringle have worked together on most of the books in the Strange and Wonderful series, which is intended to introduce young readers to the behaviors and lifestyles of different species. The back cover of *Penguins!* can be seen at the beginning of this section, as well as in the Artists' Reps section near the listing for Asciutto Art Reps, Inc. (Henderson's agent).

CENTERSTREAM PUBLISHING

P.O. Box 17878, Anaheim Hills CA 92817-7878. (714)779-9390. Fax: (714)779-9390. E-mail: center strm@aol.com. Web site: www.centerstream-usa.com. **Production:** Ron Middlebrook. Estab. 1978. Publishes DVDs, audio tapes, and hardcover and softcover originals. Types of books include music reference, biography, music history and music instruction. Recent titles include *Melodic Lines for the Intermediate Guitarist* (book/CD pack), *The Banjo Music of Tony Ellis*, *The Early Minstrel Banjo* and *More Dobro* (DVD). Publishes 10-20 titles/year; 100% require freelance illustration. Book catalog free for 6×9 SAE with 2 first-class stamps.

Needs Approached by 12 illustrators/year. Works with 3 illustrators/year.

First Contact & Terms Illustrators: Send postcard sample or tearsheets. Accepts Mac-compatible disk submissions. Samples are not filed and are returned by SASE. Responds only if interested. Rights purchased vary according to project.

N T CHATHAM PRESS

P.O. Box 677, Old Greenwich CT 06870. (203)531-7755. Fax: (718)359-8568. **Art Director:** Arthur G.D. Mark. Estab. 1971. Publishes hardcover originals and reprints, trade paperback originals and reprints. Types of books include coffee table books, cookbooks, history, nonfiction, self-help, travel, western, political, Irish and photographic. Publishes 12 titles/year. 5% require freelance illustration; 5% require freelance design; 5% require freelance art direction.

Needs Approached by 16 illustrators and 16 designers/year. Works with 2 illustrators, 2 designers and 2 art directors/year. Seeks b&w photographs of maritime and New England-oriented coastal scenes.

First Contact & Terms Send query letter with photocopies and SASE. Samples are not filed and are returned by SASE. Responds in 2 months. Will contact artist for portfolio review if interested. Negotiates rights purchased. Finds freelancers through word of mouth and individual contacts. Prefers local illustrators and designers.

Jackets/Covers Assigns 4 freelance design jobs and 1 illustration job/year. Pays for design by the project. Pays for illustration by the project.

Tips "We accept and look for contrast (black & whites rather than grays), simplicity in execution, and immediate comprehension (i.e., not cerebral, difficult-to-quickly-understand). We have one-tenth of a second to capture our potential customer's eyes—book jacket art must help us do that."

N T CHILDREN'S BOOK PRESS

965 Mission St., Suite 425, San Francisco CA 94103-2961. (866)935-2665. Fax: (415)543-2665. E-mail: submissions@childrensbookpress.org. Web site: www.childrensbookpress.org. **Contact:** Submissions. Estab. 1975. Nonprofit publishing house that "promotes cooperation and understanding through multicultural and bilingual literature, offering children a sense of their culture, history and importance." Publishes hardcover originals and trade paperback reprints. Types of books include juvenile picture books only. Specializes in multicultural. Publishes 4 titles/year. 100% require freelance illustration and design.

Needs Approached by 1,000 illustrators and 20 designers/year. Works with 2 illustrators and 2 designers/year. Prefers local freelancers experienced in QuarkXPress (designers) and previous children's picture book experience (illustrators). Uses freelancers for 32-page picture book design. 100% of freelance design demands knowledge of Photoshop, Illustrator and QuarkXPress.

First Contact & Terms Send query letter with color photocopies, résumé, bio and SASE. Responds in 8-10 weeks, only if interested or if SASE is included. Will contact artist for portfolio review if interested. Buys all rights.

Book Design Assigns 2 freelance design jobs/year. Pays by the project.

Text Illustration Assigns 2 freelance illustration jobs/year. Pays royalties.

Tips "We look for a multicultural experience. We are especially interested in the use of bright colors and non-traditional instructive approach."

N CHOWDER BAY BOOKS

P.O. Box 5542, Lake Worth FL 33466-5534. E-mail: acquisitions@chowderbaybooks.com. Web site: www.chowderbaybooks.com. **Acquisitions Editor:** Anna Valencia. Estab. 2007. Publishes hardcover originals, trade paperback originals and reprints. Types of books include mainstream fiction, experimental fiction, fantasy, humor, juvenile, young adult, preschool, instructional, biography. Publishes 8-10 titles/year. 100% require freelance design and illustration. Book catalog available on Web site.

• See also listing for Pinestein Press in this section.

Needs Approached by 200 designers and 480 illustrators/year. Works with 2 designers and 4 illustrators/year. 80% of freelance design work demands skills in Photoshop and QuarkXPress. 80% of freelance illustration work demands skills in FreeHand and Photoshop.

First Contact & Terms Send postcard sample with URL. Accepts e-mail submissions with link to Web site. Prefers Windows-compatible JPEG, TIFF or GIF files. Samples are filed and are not returned. Responds only if interested. Rights purchased vary according to project. Finds freelancers through submissions, word of mouth, magazines, Internet.

Jackets/Covers Assigns 8 illustration jobs/year. Pays by the project; varies.

Text Illustration Assigns 4 illustration jobs/year. Pays by the project; varies.

Tips "We're always willing to look at online portfolios. The best way to direct us there is via a simple postcard with URL. We are a young company with serious goals and a focus on creativity. While we are unable to respond directly to all inquiries or submissions, we do review everything that hits our inboxes (both e-mail and snail mail). Look for us at industry exhibits and conferences. We often seek new talent at industry events."

N I CHURCH PUBLISHING, INC.

(formerly Morehouse Publishing Group), 475 Linglestown Rd., Harrisburg PA 17112. (212)592-6414. Fax: (717)541-8136. E-mail: morehouse@morehousepublishing.org. Web site: www.morehousepublishing.org. Estab. 1884. Publishes trade paperback and hardcover originals and reprints. Books are religious. Specializes in spirituality, Christianity/contemporary issues. Publishes 30 titles/year. Recent titles include *A Wing and a Prayer* by Katharine Jefferts Schori; *God of the Sparrow* by Jaroslau Vajda, illustrated by Preston McDaniels. Book catalog free by request.

Needs Works with 1-2 illustrators/year. Prefers freelancers with experience in religious (particularly Christian) topics. Works on assignment only.

First Contact & Terms Send query letter with résumé and photocopies. Samples are filed. Portfolio review not required. Usually buys one-time rights. Finds artists through freelance submissions, *Literary Market Place* and word of mouth.

Text Illustration Assigns 1-2 freelance illustration jobs/year.

Tips "Prefer using freelancers who are located in central Pennsylvania and are available for meetings when necessary."

CRC PRODUCT SERVICES

2850 Kalamazoo Ave. SE, Grand Rapids MI 49560. (616)224-0780. Fax: (616)224-0834. Web site: www.crcna.org. **Art Director:** Dean Heetderks. Estab. 1866. Publishes hardcover and trade paperback originals and magazines. Types of books include instructional, religious, young adult, reference, juvenile and preschool. Specializes in religious educational materials. Publishes 8-12 titles/year. 85% require freelance illustration. 5% require freelance art direction.

Needs Approached by 30-45 freelancers/year. Works with 12-16 freelance illustrators/year. Prefers freelancers with religious education, cross-cultural sensitivities. Uses freelancers for jacket/cover and text illustration. Works on assignment only.

First Contact & Terms Send query letter with brochure, résumé, tearsheets, photographs, photocopies, slides and transparencies. Submissions will not be returned. Illustration guidelines are available on Web site. Samples are filed. Portfolio should include thumbnails, roughs, finished samples, color slides, tearsheets, transparencies and photographs. Buys one-time rights.

Jackets/Covers Assigns 2-3 freelance illustration jobs/year. Pays by the project, $200-1,000.

Text Illustration Assigns 50-100 freelance illustration jobs/year. Pays by the project, $75-100. "This is high-volume work. We publish many pieces by the same artist."

Tips "Be absolutely professional. Know how people learn and be able to communicate a concept clearly in your art."

N CREATIVE WITH WORDS PUBLICATIONS

P.O. Box 223226, Carmel CA 93922. E-mail: geltrich@mbay.net. Web site: http://members.tripod .com/CreativeWithWords. **Editor-in-Chief:** Brigitta Geltrich. Nature Editor: Bert Hower. Estab. 1975. Publishes mass market paperback originals. Types of books include adventure, children's picture books, history, humor, juvenile, preschool, travel, young adult and folklore. Specializes in anthologies. Publishes 10-12 titles/year. Recent titles: *Folkhumor*; *We are Writers, Too!* Books are listed on Web site.

Needs Approached by 5 illustrators/month. Works with 6-12 illustrators/year. Prefers freelancers experienced in b&w drawings. Does not want computer art.

First Contact & Terms Send postcard sample and follow-up postcard every 3 months, or query letter with printed samples, photocopies, SASE. Samples are filed or returned by SASE. Responds in 2 weeks if SASE enclosed. Will contact artist for portfolio review if interested. Buys one-time rights and sometimes negotiates rights purchased.

Book Design Assigns 12-14 freelance design jobs/year. Pays for design by the project, $2-20.

Jackets/Covers Assigns 10-12 illustration jobs/year. Pays for illustration by the project, $2-20. Prefers folklore themes, general-public appeal.

Text Illustration Assigns 10-12 freelance illustration jobs/year. Pays by the project, $2-20. Prefers b&w sketches.

Tips "We aim for a folkloristic slant in all of our publications. Therefore, we always welcome artists who weave this slant into our daily lives for a general (family) public. We also like to have the meanings of a poem or prose expressed in the sketch."

N CRUMB ELBOW PUBLISHING

P.O. Box 294, Rhododendron OR 97049. **Publisher:** Michael P. Jones. Estab. 1979. Publishes juvenile, educational, environmental, nature, historical, multicultural, travel and guidebooks. Publishes 40 titles/year. 75% require freelance illustration; 75% require freelance design.

Needs Approached by 250 freelancers/year. Works with 200 illustrators and 10 designers/year. Uses freelancers for jacket/cover design and illustration, text illustration, book and catalog design, calendars, prints, note cards. 50% of freelance work demands computer skills. Works on assignment only.

First Contact & Terms Send query letter with brochure, SASE, tearsheets and photocopies. Samples are filed or returned by SASE if requested by artist. Responds in 1 month. Request portfolio review in original query. Portfolio should include book dummy, final art, photographs, roughs, slides and tearsheets. Buys one-time rights. Originals are returned at job's completion.

Book Design Assigns 200 freelance cover illustrations/year. Pays by the project, $50-250 or in published copies.

Jackets/Covers Assigns 35 freelance design and 60 illustration jobs/year. Pays by the project, $50-250 or in published copies.

Text Illustration Assigns 40 freelance illustration jobs/year. Pays by the project, $50-250 or in published copies. Prefers pen & ink.

Tips "We find talented individuals to illustrate our projects any way we can. Generally artists hear about us and want to work with us. We are a very small company that gives beginners a chance to showcase their talents in a book project; and yet, more established artists are in touch with us because our projects are interesting (like American Indian mythology, The Oregon Trail, wildlife, etc.)."

DARK HORSE

10956 SE Main, Milwaukie OR 97222. E-mail: dhcomics@darkhorse.com. Web site: www.darkho rse.com. **Contact:** Submissions. Estab. 1986. Publishes mass market and trade paperback originals. Types of books include comic books and graphic novels. Specializes in comic books. Recent

titles include: *B.P.R.D.: The Universal Machine #2* by Mike Mignola; *Star Wars: Knights of the Old Republic #4* by John Jackson Miller; *Usagi Yojimbo #93* by Stan Sakai. Book catalog available on Web site.

First Contact & Terms Send photocopies (clean, sharp, with name, address and phone number written clearly on each page). Samples are not filed and not returned. Responds only if interested. Company will contact artist for portfolio review interested.

Tips "If you're looking for constructive criticism, show your work to industry professionals at conventions."

JONATHAN DAVID PUBLISHERS, INC.
68-22 Eliot Ave., Middle Village NY 11379. (718)456-8611. Fax: (718)894-2818. E-mail: submissions@jdbooks.com. Web site: www.jdbooks.com. **Contact:** Editorial Review. Estab. 1948. Publishes hardcover and paperback originals. Types of books include biography, religious, young adult, reference, juvenile and cookbooks. Specializes in Judaica. Titles include *Drawing a Crowd* and *The Presidents of the United States & the Jews*. Publishes 25 titles/year. 50% require freelance illustration; 75% require freelance design.

Needs Approached by numerous freelancers/year. Works with 5 freelance illustrators and 5 designers/year. Prefers freelancers with experience in book jacket design and jacket/cover illustration. 100% of design and 5% of illustration demand computer literacy. Works on assignment only.

First Contact & Terms Designers: Send query letter with résumé and photocopies. Illustrators: Send postcard sample and/or query letter with photocopies, résumé. Samples are filed. Production coordinator will contact artist for portfolio review if interested. Portfolio should include color final art and photographs. Buys all rights. Originals are not returned. Finds artists through submissions.

Book Design Assigns 15-20 freelance design jobs/year. Pays by the project.

Jackets/Covers Assigns 15-20 freelance design and 4-5 illustration jobs/year. Pays by the project.

Tips First-time assignments are usually book jackets, mechanicals and artwork.

DIAL BOOKS FOR YOUNG READERS
Penguin Group USA, 345 Hudson St., New York NY 10014. (212)414-3412. Fax: (212)414-3398. Web site: http://us.penguingroup.com. **Art Director:** Lily Malcom. Specializes in juvenile and young adult hardcover originals. Recent titles: *Snowmen at Night* by Caralyn and Mark Buchner; *The Surprise Visitor* by Juli Kangas. Publishes 50 titles/year. 100% require freelance illustration.

Needs Approached by 400 freelancers/year. Works with 40 freelance illustrators/year. Prefers freelancers with some book experience. Works on assignment only.

First Contact & Terms Send query letter with photocopies, tearsheets and SASE. Samples are filed or returned by SASE. Responds only if interested. Considers complexity of project, skill and experience of artist and project's budget when establishing payment. Rights purchased vary.

Jackets/Covers Assigns 8 illustration jobs/year. Pays by the project.

Text Illustration Assigns 40 freelance illustration jobs/year. Pays by the project.

Tips "Never send original art. Never send art by e-mail, fax or CD. Please do not phone, fax or e-mail to inquire after your art submission."

⊞ EDWARD ELGAR PUBLISHING INC.
9 Dewey Court, Northampton MA 01060-3815. (413)584-5551. Fax: (413)584-9933. E-mail: submissions@e-elgar.com. Web site: www.e-elgar.com. Estab. 1986. Publishes hardcover originals and textbooks. Types of books include instructional, nonfiction, reference, textbooks, academic monographs, references in economics and business and law. Recent titles: *Asia-Specific Geopoli-*

tics; *Climate and Trade Policy*; *Corporate Culture and Environmental Practice*. Publishes 200 titles/ year.

• This publisher uses only freelance designers. Its academic books are produced in the United Kingdom. Direct Marketing material is done in U.S. There is no call for illustration.

Needs Approached by 2-4 designers/year. Works with 2 designers/year. Prefers local designers experienced in direct mail and academic publishing. 100% of freelance design demands knowledge of Photoshop, InDesign.

First Contact & Terms Send query letter with printed samples. Accepts Mac-compatible disk submissions. Samples are filed. Will contact artist for portfolio review if interested. Rights purchased vary according to project. Finds freelancers through word of mouth, local sources (i.e., phone book, newspaper, etc.).

F+W PUBLICATIONS, INC.

4700 E. Galbraith Rd., Cincinnati OH 45236. Web site: www.fwpublications.com. **Art Directors:** Grace Ring, Marissa Bowers, Wendy Dunning. Publishes 120 books/year for writers, artists, graphic designers and photographers, plus selected trade (humor, lifestyle, home improvement) titles. Books are heavy on type-sensitive design.

• Imprints include Writer's Digest Books, TOW Books, HOW Books, Betterway Books, North Light Books, IMPACT Books, Popular Woodworking Books, Memory Makers Books, Adams Media, David & Charles, Krause Publications. See separate listings for Adams, IMPACT and North Light in this section for recent titles and specific guidelines. See also F+W's listing in the Magazines section.

Needs Works with 10-20 freelance illustrators and less than 5 designers/year. Uses freelancers for jacket/cover design and illustration, text illustration, direct mail and book design. Works on assignment only.

First Contact & Terms Send nonreturnable photocopies of printed work to be kept on file. Art director will contact artist for portfolio review if interested. Considers buying second rights (reprint rights) to previously published illustrations. "We like to know where art was previously published." Finds illustrators and designers through word of mouth and submissions/self-promotions.

Book Design Pays by the project, $600-1,000.

Jackets/Covers Pays by the project, $750.

Text Illustration Pays by the project, $100 minimum.

Tips "Don't call. Send appropriate samples we can keep. Clearly indicate what type of work you are looking for."

FANTAGRAPHICS BOOKS, INC.

7563 Lake City Way NE, Seattle WA 98115. (206)524-1967. Fax: (206)524-2104. E-mail: fbicomix @fantagraphics.com. Web site: www.fantagraphics.com. **Contact:** Submissions Editor. Estab. 1976. Publishes hardcover and trade paperback originals and reprints. Types of books include contemporary, experimental, mainstream, historical, humor and erotic. "All our books are comic books or graphic stories." Recent titles: *Love & Rockets*; *Hate*; *Eightball*; *Acme Novelty Library*; *The Three Paradoxes*. Publishes 100 titles/year. 10% require freelance illustration. Book catalog free by request. Art submission guidelines available on Web site.

• See additional listing in the Magazines section.

Needs Approached by 500 freelancers/year. Works with 25 freelance illustrators/year. Must be interested in and willing to do comics. Uses freelancers for comic book interiors and covers.

First Contact & Terms Send query letter addressed to Submissions Editor with résumé, SASE, photocopies and finished comics work. Samples are not filed and are returned by SASE. Responds only if interested. Call or write for appointment to show portfolio of original/final art and b&w

samples. Buys one-time rights or negotiates rights purchased. Originals are returned at job's completion. Pays royalties.

Tips "We want to see completed comics stories. We don't make assignments, but instead look for interesting material to publish that is pre-existing. We want cartoonists who have an individual style, who create stories that are personal expressions."

FORT ROSS INC.

26 Arthur Place, Yonkers NY 10701. (914)375-6448. E-mail: fortross@optonline.net or vkartsev2000@yahoo.com. Web site: www.fortrossinc.com. **Executive Director:** Dr. Vladimir P. Kartsev. Represents leading Russian, Polish, Spanish, etc., publishing companies in the U.S. and Canada. Estab. 1992. Publishes hardcover originals, mass market paperback originals and reprints, and trade paperback reprints. Types of books include adventure, fantasy, horror, romance, science fiction. Specializes in romance, science fiction, fantasy, mystery. Publishes 5 titles/year. Represents 500 titles/year. Recent titles: translations of *Judo* by Vladamir Putin; *The Redemption* by Howard Fast.

Needs Approached by 100 illustrators/year. Works with 40 illustrators/year. Prefers freelancers experienced in romance, science fiction, fantasy, mystery cover art.

First Contact & Terms Illustrators: Send query letter with printed samples, photocopies, SASE, tearsheets. Accepts Windows-compatible disk submissions. Send EPS files. Samples are filed. Will contact artist for portfolio review if interested. Buys secondary rights. Finds freelancers through agents, networking events, sourcebooks.

Jackets/Covers Buys up to 1,000 illustrations/year. Pays for illustration by the project, $50-150 for secondary rights (for each country). Prefers experienced romance, mystery, science fiction, fantasy cover illustrators.

Tips "Fort Ross is the best place for experienced cover artists to sell secondary rights for their images in Russia, Poland, Spain, Czech Republic, countries of the former USSR, Central and Eastern Europe. We prefer realistic, thoroughly executed expressive images on our covers."

FULCRUM PUBLISHING

16100 Table Mountain Parkway #300, Golden CO 80403. (303)277-1623. Fax: (303)279-7111. Web site: www.fulcrum-books.com. **Contact:** Art Director. Estab. 1984. Publishes hardcover originals and trade paperback originals and reprints. Types of books include biography, Native American, reference, history, self help, children's, teacher resource books, travel, humor, gardening and nature. Specializes in history, nature, teacher resource books, travel, Native American, environmental and gardening. Recent titles: *Broken Trail* by Alan Geaffrion; *Anton Wood: The Boy Murderer* by Dick Kreck. Publishes 50 titles/year. 15% require freelance illustration; 15% require freelance design. Book catalog free by request.

Needs Uses freelancers mainly for cover and interior illustrations for gardening books; also for other jackets/covers, text illustration and book design. Works on assignment only.

First Contact & Terms Send query letter with tearsheets, photographs, photocopies and photostats. Samples are filed. Responds to artist only if interested. To show portfolio, mail b&w photostats. Buys one-time rights. Originals are returned at job's completion.

Book Design Pays by the project.

Jackets/Covers Pays by the project.

Text Illustration Pays by the project.

Tips Previous book design experience a plus.

GALISON BOOKS/MUDPUPPY PRESS

28 W. 44th St., New York NY 10036. (212)354-8840. Fax: (212)391-4037. E-mail: carole@galison.com. Web site: www.galison.com. **Art Director:** Carole Otypka. Publishes note cards, journals, stationery, children's products. Publishes 120 titles/year.

• See additional listing in the Greeting Cards, Gifts & Products section.

Needs Works with 20 illustrators. Assigns 5-10 freelance cover illustrations/year. Some freelance design demands knowledge of Photoshop, Illustrator and QuarkXPress.

First Contact & Terms Illustrators: Send photocopies, printed samples, tearsheets or e-mail with link to Web site. Samples are filed or returned by SASE. Will contact artist for portfolio review if interested. Rights purchased vary according to project.

GEM GUIDES BOOK CO.

315 Cloverleaf Dr., Suite F, Baldwin Park CA 91706. (626)855-1611. Fax: (626)855-1610. E-mail: gembooks@aol.com. Web site: www.gemguidesbooks.com. **Editors:** Kathy Mayerski and Nancy Fox. Estab. 1964. Book publisher and wholesaler of trade paperback originals and reprints. Types of books include rocks and minerals, guide books, travel, history and regional (western U.S.). Specializes in travel and local interest (western Americana). Recent titles include *Geodes: Nature's Treasures* by Brad L. Cross and June Culp Zeither, *Baby's Day Out in Southern California: Fun Places to Go with Babies and Toddlers* by Jobea Holt, *Fee Mining and Rockhounding Adventures in the West 2/E* by James Martin and Jeannette Hathaway Monaco, and *Moving to Arizona 5/E* by Dorothy Tegeler. Publishes 7 titles/year; 100% require freelance cover design.

Needs Approached by 12 freelancers/year. Works with 1 designer/year. Uses freelancers mainly for covers. 100% of freelance work demands knowledge of Quark, Illustrator, Photoshop. Works on assignment only.

First Contact & Terms Send query letter with brochure, résumé and SASE; or e-mail. Samples are filed. Editor will contact artist for portfolio review if interested. Requests work on spec before assigning a job. Buys all rights. Originals are not returned. Finds artists through word of mouth and "our files."

Jackets/Covers Pays by the project.

GIBBS SMITH, PUBLISHER

P.O. Box 667, Layton UT 84041. (801)544-9800. Fax: (801)546-8853. E-mail: staylor@gibbs-smith.com. Web site: www.gibbs-smith.com. **Contact:** Suzanne Taylor. Estab. 1969. Imprints include Sierra Book Club for Children. Company publishes hardcover and trade paperback originals and textbooks. Types of books include children's picture books, coffee table books, cookbooks, humor, juvenile, nonfiction textbooks, western. Recent titles include *Batter Up Kids Delicious Desserts*; *Lost Coast Stories from the Surf*. Publishes 60 titles/year. 10% require freelance illustration; 90% require freelance design. Book catalog free for $8^1/_2 \times 11$ SASE with $1.24 postage.

Needs Approached by 250 freelance illustrators and 50 freelance designers/year. Works with 5 freelance illustrators and 15 designers/year. Designers may be located anywhere with Broadband service. Uses freelancers mainly for cover design and book layout, cartoon illustration, children's book illustration. 100% of freelance design demands knowledge of QuarkXPress. 70% of freelance illustration demands knowledge of Photoshop, Illustrator and FreeHand and/or InDesign.

First Contact & Terms Designers: Send samples for file. Illustrators: Send printed samples and photocopies. Samples are filed. Responds only if interested. Finds freelancers through submission packets and illustration annuals.

Book Design Assigns 50 freelance design jobs/year. Pays by the project, $10-15/page.

Jackets/Covers Assigns 50-60 freelance design jobs and 5 illustration jobs/year. Pays for design by the project, $500-800. Pays for illustration by the project.

Text Illustration Assigns 1 freelance illustration job/year. Pays by the project.

THE GRADUATE GROUP

P.O. Box 370351, West Hartford CT 06137-0351. (860)233-2330. E-mail: graduategroup@hotmail.com. Web site: www.graduategroup.com. **President:** Mara Whitman. Estab. 1967. Publishes

trade paperback originals. Types of books include instructional and reference. Specializes in internships and career planning. Recent titles include *Create Your Ultimate Résumé, Portfolio, and Writing Samples: An Employment Guide for the Technical Communicator* by Mara W. Cohen Ioannides. Publishes 35 titles/year; 10% require freelance illustration and design. Book catalog free by request.

Needs Approached by 20 freelancers/year. Works with 1 freelance illustrator and 1 designer/ year. Prefers local freelancers only. Uses freelancers for jacket/cover illustration and design; direct mail, book and catalog design. 5% of freelance work demands computer skills. Works on assignment only.

First Contact & Terms Send query letter with brochure and résumé. Samples are not filed. Responds only if interested. Write for appointment to show portfolio.

GREAT QUOTATIONS PUBLISHING

8102 Lemont Rd., #300, Woodridge IL 60517. (630)390-3580. Fax: (630)390-3585. **Contact:** Melanie Moorhouse. Estab. 1985. Imprint of Greatime Offset Printing. Publishes hardcover, trade paperback and mass market paperback originals. Types of books include humor, inspiration, motivation and books for children. Specializes in gift books. Recent titles: *Only a Sister Could Be Such a Good Friend*; *Words From the Coach*. Publishes 50 titles/year. 50% require freelance illustration and design. Book catalog available for $3 with SASE.

Needs Approached by 100 freelancers/year. Works with 20 designers and 20 illustrators/year. Uses freelancers to illustrate and/or design books and catalogs. 50% of freelance work demands knowledge of QuarkXPress and Photoshop. Works on assignment only.

First Contact & Terms Send letter of introduction and sample pages. Name, address and telephone number should be clearly displayed on the front of the sample. All appropriate samples will be placed in publisher's library. Design Editor will contact artist under consideration, as prospective projects become available. Rights purchased vary according to project.

Jackets/Covers Assigns 20 freelance cover illustration jobs/year. Pays by the project, $300-3,000.

Text Illustration Assigns 30 freelance text illustration jobs/year. Pays by the project, $100-1,000.

Tips "We're looking for bright, colorful cover design on a small-size book cover (around 6×6). Outstanding humor or motivational titles will be most in demand."

GROUP PUBLISHING BOOK PRODUCT

1515 Cascade Ave., Loveland CO 80539. (970)669-3836. Fax: (970)292-4391. Web site: www.group.com. **Art Directors:** Jeff Storm (children's/women's books), Michael Paustian (curriculum), Lisa Harris (Vacation Bible School). Company publishes books, Bible curriculum products (including puzzles, posters, etc.), clip art resources and audiovisual materials for use in Christian education for children, youth and adults. Publishes 35-40 titles/year. Recent titles: *Group's Scripture Scrapbook Series*, *The Dirt on Learning*; *Group's Hands-On Bible Curriculum*; *Group's Treasure Serengeti Trek Vacation Bible School*; *Faith Weaver Bible Curriculum*.

Needs Uses freelancers for cover illustration and design. 100% of design and 50% of illustration demand knowledge of InDesign CS2, Photoshop 7.0, Illustrator 9.0. Occasionally uses cartoons in books and teacher's guides. Uses b&w and color illustration on covers and in product interiors.

First Contact & Terms Send query letter with nonreturnable b&w or color photocopies, slides, tearsheets or other samples. Accepts disk submissions. Samples are filed; additional samples may be requested prior to assignment. Responds only if interested. Rights purchased vary according to project.

Jackets/Covers Assigns minimum 15 freelance design and 10 freelance illustration jobs/year. Pays $250-1,200 for design; pays $250-1,200 for illustration.

Text Illustration Assigns minimum 20 freelance illustration projects/year. **Pays on acceptance:**

$40-200 for b&w (from small spot illustrations to full page). Fees for color illustration and design work vary and are negotiable. Prefers b&w line or line and wash illustrations to accompany lesson activities.

Tips "We prefer contemporary, nontraditional styles appropriate for our innovative and upbeat products and the creative Christian teachers and students who use them. We seek experienced designers and artists who can help us achieve our goal of presenting biblical material in fresh, new and engaging ways. Submit design/illustration on disk. Self-promotion pieces help get you noticed. Have book covers/jackets, brochure design, newsletter or catalog design in your portfolio. Include samples of Bible or church-related illustration."

GRYPHON PUBLICATIONS

P.O. Box 209, Brooklyn NY 11228-0209. Web site: www.gryphonbooks.com. Estab. 1983. Publishes hardcover originals, trade paperback originals and reprints, reference books and magazines. Types of books include science fiction, mystery and reference. Specializes in crime fiction and bibliography. Recent titles: *Difficult Lives* by James Salli; *Vampire Junkies* by Norman Spinrad. Publishes 20 titles/year. 40% require freelance illustration; 10% require freelance design. Book catalog free for #10 SASE.

- Also publishes *Hardboiled*, a quarterly magazine of noir fiction, and *Paperback Parade*, a magazine for paperback readers and collectors.

Needs Approached by 75-200 freelancers/year. Works with 10 freelance illustrators and 1 designer/year. Prefers freelancers with "professional attitude." Uses freelancers mainly for book and magazine cover and interior illustrations; also for jacket/cover, book and catalog design. Works on assignment only.

First Contact & Terms Send query letter with résumé, SASE, tearsheets or photocopies. Samples are filed. Responds in 2 weeks, only if interested. Buys one-time rights. "I will look at reprints if they are of high quality and cost effective." Originals are returned at job's completion if requested. Send b&w samples only.

Jackets/Covers Assigns 2 freelance design and 5-6 illustration jobs/year. Pays by the project, $25-150.

Text Illustration Assigns 2 freelance jobs/year. Pays by the project, $10-100. Prefers b&w line drawings.

Tips "It is best to send photocopies of your work with an SASE and query letter. Then we will contact on a freelance basis."

GUERNICA EDITIONS

11 Mount Royal Ave., Toronto ON M6H 2S2 Canada. (416)658-9888. Fax: (416)657-8885. E-mail: guernicaeditions@cs.com. Web site: www.guernicaeditions.com. **Publisher/Editor:** Antonio D'Alfonso. Estab. 1978. Book publisher and literary press specializing in translation. Publishes trade paperback originals and reprints. Types of books include contemporary and experimental fiction, biography and history. Specializes in ethnic/multicultural writing and translation of European and Quebecois writers into English. Recent titles include *Peace Tower* by F.G. Paci (artist Hono Lulu) and *Medusa Subway* by Clara Blackwood (artist Normand Cousineau). Publishes 20-25 titles/year; 40-50% require freelance illustration. Book catalog available for SAE; include IRC if sending from outside Canada.

Needs Approached by 6 freelancers/year. Works with 6 freelance illustrators/year. Uses freelancers mainly for jacket/cover illustration.

First Contact & Terms Send query letter with résumé, SASE (or SAE with IRC), tearsheets, photographs and photocopies. Samples are filed or are returned by SASE if requested by artist. Responds only if interested. To show portfolio, mail photostats, tearsheets and dummies. Buys one-time rights. Originals are not returned at job completion.

Carson Ellis

*Living her dream, through
a series of fortunate events*

© Carson Ellis

Carson Ellis remembers drawing constantly as a child. "I loved horses and spent hours laboriously copying and labeling drawings from my horse books, sketching my model horse collection, and drawing comics about ponies." Although her obsession with horses has faded over time, Ellis is still "moved to draw" the same types of things that appealed to her as a child—plants, animals, houses, people, the woods. "I'm inspired by an infinite number of things," she says. Early photography, folk art, botanical drawings, Russian literature, old printing motifs and typography are just a few of her stimuli.

Ellis was born in Vancouver, British Columbia, and grew up in suburban New York. She went to college at the University of Montana in Missoula and spent a semester at an art school in the South of France. After graduating with a BFA in painting, she lived in Minneapolis, Vermont and San Francisco before settling in Portland, Oregon. She is currently represented by Motel Gallery (www.motelgallery.com) in Portland, but Ellis is best known for her work with the rock band The Decemberists—a detour of sorts that actually paved the way to realizing her original ambition as an artist: to be a children's book illustrator.

"I did get sidetracked in college from my dream to be a children's book illustrator," says Ellis, "but only because the school I went to didn't have an illustration program; I chose to study painting instead." It was at the University of Montana that she met current boyfriend Colin Meloy, lead singer of The Decemberists. "After college I was making a go of it as an oil painter for three or four years before I started making album art for The Decemberists, which eventually led to illustration work. So, if anything, the band artwork sidetracked me from my short-lived dream to be a painter."

Either way, Ellis doesn't regret her work with the band. "Most art editors and book people found me through the stuff I'd done for The Decemberists," she says. "I don't think I was ready to work as a book illustrator five years ago, and I've learned a lot doing all that stuff—album art, T-shirt designs, Web site illustration, stage backdrops and photo shoot sets—it's been way more work than I did in my five years of college. Also, I really love working for the band. I still find it totally inspiring and fun."

Ellis and Meloy recently celebrated the birth of son Henry, who will surely be a source of inspiration for mom as she navigates her way through the world of children's book publishing. In addition to illustrating Trenton Lee Stewart's recent release from Little, Brown Books for Young Readers, *The Mysterious Benedict Society*, Ellis has projects underway with HarperCollins, Hyperion and Harcourt. "Right now I'm illustrating *The Composer Is Dead* by Lemony Snicket; it's a picture book that comes with a CD of an original score with narration, like *Peter and the Wolf*. After that I'm working on a book with Colin about our cat." Ellis worked with HarperCollins editor Susan Rich on both these titles.

Other upcoming projects include *Stagecoach Sal* by Deborah Hopkinson for Hyperion; *Dillweed* by Florence Parry Heide for Harcourt; and a storybook of Greek myths adapted by Cynthia Rylant, also for Harcourt.

Here, Ellis talks about her work and offers advice for aspiring illustrators.

How did you land the job with Little, Brown to illustrate Trenton Lee Stewart's *The Mysterious Benedict Society*?

My agent set up a meeting for me when I was in New York a couple of years ago, just to introduce myself and show them my portfolio. I guess they liked it because they hired me not long after.

Do you think it's necessary for a freelance artist to have an agent?

It's probably not necessary to have an agent, though mine has done wonders for my career. I felt like I was doing splendidly without one, and when Steven Malk (of Writers House) contacted me to ask if I'd like to work with him, I was actually leery of the idea and initially turned him down. I was working on a book at the time, tentatively for an editor at Harper-

Carson Ellis illustrated Trenton Lee Stewart's first novel for children, published by Little, Brown Books for Young Readers. *The Mysterious Benedict Society* was also Ellis's first children's book, but others are soon to follow.

Collins, but without any contract or advance, or any kind of guarantee that it would be published. I didn't really care because I was just so excited for the opportunity. I told Steven about it and he said, "Would you like a contract and an advance for that book?" I said, "Yes . . . can you do that?" And that's how we started working together. He's a wonderful guy—really nice to talk to, and savvy and supportive and ecstatic about book illustration. He's helped make my professional life a lot simpler, so it was a good decision.

Also, I was doing mostly editorial and band artwork before we started working together, and I felt pretty comfortable negotiating for myself. I didn't bother with contracts most of the time and typically felt like I was being paid fairly. Book illustration jobs are so much more complicated: advance amounts run the gamut; contracts are 50 pages long; you work with your editor for months and months. I think it could be overwhelming without someone on your side to advise you and keep the whole process running smoothly, especially if you're just starting out and don't always know what you're doing.

What have you done to promote your artwork?

I've made a couple of promotional postcards on Steven's urging; he mails them to publishers. I also have a MySpace account (www.myspace.com/carsonellis), though I wasn't

necessarily thinking of promotion when I started it. Really, The Decemberists have turned out to be a better promotional tool than anything else imaginable.

How much of an impact has your Web site had on your success?

It's hard to say, but I am glad I have one (www.carsonellis.com). I feel like everyone should have one if they have work they're proud of and want people to be able to get in touch with them about it. And if not a Web site, then a blog (www.littlelittlegreenhouse.blogspot.com) or a MySpace page or *something*. Having some kind of Internet presence will always make it easier for artists to find work.

How did you get your work into the Motel Gallery?

Motel's owner and director, Jenn Armbrust, contacted me to ask if I'd like to work with her. Portland's a pretty small town, so it wasn't hard for us to find each other. Motel is a special place. It's little, but really charming, and I think Jenn's got great taste. I'm always very proud to be involved with it.

Tell me about your fascination with Russia.

I like Russia because it's at once exotic and familiar. Their cultural history is similar to ours and easy to relate to. Russian literature, painting, music, dance and theatre have followed a lot of the same trends as American arts and, especially in the 19th and early 20th centuries, were almost always more amazing, I think. But the context that they were

© Carson Ellis

Ellis created this fine art piece, titled "Otter Joins the Seminary," for a show of ink and watercolor drawings she had a few years ago. Another piece from the show, "Irkutsky Dom" (which means Irkutskian House in Russian), can be seen on the Contents page at the front of this book. "It's from a sketch I did when I was in Irkutsk, Siberia," says Ellis.

made in was so different—Tsardom, Socialism, Orthodoxy, post-Soviet chaos, Siberian towns sprung from penal colonies, Gulags, Bolshevik uprisings, Napoleonic wars, Gypsy and Coassack encampments. It's been a wild and turbulent place through much of its existence but has also managed to be very civilized and culturally brilliant somehow. I find that contrast really interesting.

What kinds of emotions do you try to evoke with your illustrations?
Dreaminess, eeriness, coziness, melancholy, nostalgia, recklessness.

© Carson Ellis

This graphite drawing by Ellis was used in a glossary of horror terminology called *The Darkening Garden* by John Clute, published by Payseur and Schmidt. "A different artist illustrated each entry," says Ellis. "Mine was 'Holocaust Fiction.' "

Do you have any words of advice for aspiring freelance artists/illustrators?

My advice to aspiring artists is to take your time. It takes forever to develop an illustrative style that's confident and sincere, and that learning stage doesn't necessarily end when you graduate from college. I recently found some of my sketchbooks from around the time I graduated, and I remembered that I'd copied a bunch of drawings from them to send to the *San Francisco Bay Guardian* in hopes of getting some editorial work. I remember that it was a big deal making the color copies and buying a decent-looking book to put them in because I was broke. I even remember biking to the *Guardian* and dropping it all off in person, hoping it might make a good impression. No one ever hired me or even responded to my letter, and I was totally confused by it at the time because I thought I was a shoo-in. It's kind of heartbreaking to think about.

But now I look at those drawings and I know exactly why no one called me: they weren't awful, but they were sort of awkward and unsubtle, and I hadn't found a medium I was comfortable working in yet. In short, I wasn't ready to work as an artist. I was 22 and had four or five more years of experimenting, absorbing stuff, and constant drawing and painting before I was ready. So my advice is to be patient with yourself and take all the time you need to become a brilliant artist. Work hard and be persistent; if things aren't working out, don't see it as a sign of abject failure so much as a sign that you just need to work more.

—*Erika O'Connell*

Jackets/Covers Assigns 10 freelance illustration jobs/year. Pays by the project, $150-200.

Tips "We really believe that the author should be aware of the press they work with. Try to see what a press does and offer your own view of that look. We are looking for strong designers. We have three new series of books, so there is a lot of room for artwork."

HARVEST HOUSE PUBLISHERS

990 Owen Loop N., Eugene OR 97402. (541)343-0123. Fax: (541)242-8819. **Contact:** Cover Coordinator. Specializes in hardcover and paperback editions of Christian evangelical adult fiction and nonfiction, children's books, gift books and youth material. Publishes 100-125 titles/year. Recent titles: *Why is the Sky Blue?*; *Power of a Praying Teen*; *Discovering Your Divine Assignment*; *My Little Angel*.

Needs Works with 1-2 freelance illustrators and 4-5 freelance designers/year. Uses freelance artists mainly for cover art; also for text illustration. Works on assignment only.

First Contact & Terms Send query letter with brochure, résumé, tearsheets and photographs. Art director will contact artist for portfolio review if interested. Requests work on spec before assigning a job. Originals may be returned at job's completion. Buys all rights. Finds artists through word of mouth and submissions/self-promotions.

Book Design Pays by the project.

Jackets/Covers Assigns 100-125 design and less than 5 illustration jobs/year. Pays by the project.

Text Illustration Assigns less than 5 jobs/year. Pays by the project.

HAY HOUSE, INC.

P.O. Box 5100, Carlsbad CA 92018-5100. (760)431-7695 or (800)431-7695. Fax: (760)431-6948. E-mail: csalinas@hayhouse.com. Web site: www.hayhouse.com. **Art Director:** Christy Salinas. Publishes hardcover originals and reprints, trade paperback originals and reprints, CDs, DVDs and VHS tapes. Types of books include self-help, mind-body-spirit, psychology, finance, health and fitness, nutrition, astrology. Recent titles: *Inspiration, Your Ultimate Calling* by Wayne Dyer; *If You Could See What I See* by Sylvia Browne; *Left to Tell* by Immaculee Illibagiza. Publishes 175 titles/year. 40% require freelance illustration; 30% require freelance design.

• Hay House is also looking for people who design for the gift market.

Needs Approached by 50 illustrators and 5 designers/year. Works with 20 illustrators and 2-5 designers/year. Uses freelancers mainly for cover design and illustration. 80% of freelance design demands knowledge of Photoshop, Illustrator, QuarkXPress. 20% of titles require freelance art direction.

First Contact & Terms Send e-mail to csalinas@hayhouse.com or send non-returnable samples to the address above. Art director will contact if interested. Buys all rights. Finds freelancers through word of mouth and submissions.

Illustrations Purchases 200+ illustrations/year. A project such as an illustrated card deck with affirmations may have 50 original illustrations. Illustrators must have a strong ability to conceptualize.

Tips "We look for freelancers with experience in graphic design, desktop publishing, printing processes, production, and illustrators with strong ability to conceptualize."

[N] HEAVY METAL

100 N. Village Rd., Suite 12, Rookvill Center NY 11570. Web site: www.metaltv.com. **Contact:** Submissions. Estab. 1977. Publishes trade paperback originals. Types of books include comic books, fantasy and erotic fiction. Specializes in fantasy. Recent titles: *The Universe of Cromwell*; *Serpieri Clone*. Art guidelines available on Web site.

• See additional listing in the Magazines section.

First Contact & Terms Send contact information (mailing address, phone, fax, e-mail), photocopies, photographs, SASE, slides. Samples are returned only by SASE. Responds in 3 months.

Tips "Please look over the kinds of work we publish carefully so you get a feel for what we are looking for."

[logo] HEMKUNT PUBLISHERS PVT. LTD.

A-78, Naraina Industrial Area Phase I, New Delhi 110028 India. 011-91-11 2579-2083, 2579-0032 or 2579-5079. E-mail: hemkunt@ndf.vsnl.net.in. Web site: www.hemkuntpublishers.com. **Chief Executive:** Mr. G.P. Singh. Director of Marketing: Arvinder Singh. Director of Production: Deepinder Singh. Specializes in educational text books, illustrated general books for children, and books for adults on various subjects. Subjects include religion, history, etc. Recent titles: *More Tales of Birbal and Akbar*; *Whiz Kid General Knowledge*; *Bedtime Stories from Around the World*; *Benaras—Visions of a Living Ancient Tradition*. Publishes 30-50 new titles/year.

Needs Works with 30-40 illustrators and 3-5 designers/year. Uses freelancers mainly for illustration and cover design; also for jacket/cover illustration. Works on assignment only.

First Contact & Terms Send query letter with résumé and samples to be kept on file. Prefers photographs and tearsheets as samples. Samples not filed are not returned. Art director will contact artist for portfolio review if interested. Requests work on spec before assigning a job. Originals are not returned. Considers complexity of project, skill and experience of artist and project's budget when establishing payment. Buys all rights. Interested in buying second rights (reprint rights) to previously published artwork.

Book Design Assigns 40-50 freelance design jobs/year. Payment varies.

Jackets/Covers Assigns 30-40 freelance design jobs/year. Pays $20-50.

Text Illustration Assigns 30-40 freelance jobs/year. Pays by the project.

HIPPOCRENE BOOKS INC.

171 Madison Ave., Suite 1602, New York NY 10016. (212)685-4371. Fax: (212)779-9338. Web site: www.hippocrenebooks.com. **Editor:** Priti Gress. Estab. 1971. Publishes hardcover originals and trade paperback reprints. Types of books include cookbooks, history, nonfiction, reference, travel, dictionaries, foreign language, bilingual. Specializes in dictionaries, cookbooks. Publishes

60 titles/year. Recent titles: *Hippocrene Children's Illustrated Foreign Language Dictionaries*; *St. Patrick's Secrets*; *American Proverbs*.

Needs Approached by 150 illustrators and 50 designers/year. Works with 2 illustrators and 3 designers/year. Prefers local freelancers experienced in line drawings.

First Contact & Terms Designers: Send query e-mail with small attachment or Web site link.

Jackets/Covers Assigns 4 freelance design and 2 freelance illustration jobs/year. Pays by the project.

Text Illustration Assigns 4 freelance illustration jobs/year. Pays by the project.

Tips "We prefer traditional illustrations appropriate for gift books and cookbooks."

N HOLIDAY HOUSE

425 Madison Ave., New York NY 10017. (212)688-0085. Fax: (212)421-6134. Web site: www.holi dayhouse.com. **Director of Art and Design:** Claire Counihan. Editor-in-Chief: Regina Griffin. Specializes in hardcover children's books. Recent titles: *Jazz* by Walter Dean Myers; *Freedom Walkers* by Russell Freedman; *Traveling Tom and the Leprechaun* by Teresa Bateman. Publishes 70 titles/year. 75% require illustration. Art submission guidelines available on Web site.

Needs Accepts art suitable for children and young adults only. Works on assignment only.

First Contact & Terms Send cover letter with photocopies and SASE. Samples are filed or are returned by SASE. Request portfolio review in original query. Responds only if interested. Originals are returned at job's completion. Finds artists through submissions and agents.

Jackets/Covers Assigns 5-10 freelance illustration jobs/year. Pays by the project, $900-1,200.

Text Illustrations Assigns 35 freelance jobs/year (picture books). Pays royalties.

N HOLLOW EARTH PUBLISHING

P.O. Box 51480, Boston MA 02205. (617)249-0161. Fax: (617)249-0161. E-mail: yvettegr@hotmail .com. **Publisher:** Helian Yvette Grimes. Estab. 1983. Publishes hardcover, trade paperback and mass market paperback originals and reprints, textbooks, electronic books and CD-ROMs. Types of books include contemporary, experimental, mainstream, historical and science fiction, instruction, fantasy, travel and reference. Specializes in mythology, photography, computers (Macintosh). Recent titles: *Norse Mythology*; *The Legend of the Nibelungenlied*. Publishes 5 titles/year. 50% require freelance illustration; 50% require freelance design. Book catalog free for #10 SAE with 1 first-class stamp.

Needs Approached by 250 freelancers/year. Prefers freelancers with experience in computer graphics. Uses freelancers mainly for graphics; also for jacket/cover design and illustration, text illustration, book design and multimedia projects. 100% of freelance work demands knowledge of Illustrator, QuarkXPress, Photoshop, FreeHand, Director or rendering programs. Works on assignment only.

First Contact & Terms Send e-mail queries only. Responds in 1 month. Art director will contact artist for portfolio review if interested. Portfolio should include color thumbnails, roughs, tearsheets and photographs. Buys all rights. Originals are returned at job's completion. Finds artists through submissions and word of mouth.

Book Design Assigns 12 book and magazine covers/year. Pays by the project, $100 minimum.

Jackets/Covers Assigns 12 freelance design and 12 illustration jobs/year. Pays by the project, $100 minimum.

Text Illustration Assigns 12 freelance illustration jobs/year. Pays by the project, $100 minimum.

Tips Recommends being able to draw well. First-time assignments are usually article illustrations; covers are given to "proven" freelancers.

N HOMESTEAD PUBLISHING

P.O. Box 193, Moose WY 83012. Phone/fax: (307)733-6248. Web site: www.homesteadpublishin g.net. **Contact:** Art Director. Estab. 1980. Publishes hardcover and paperback originals. Types of

books include art, biography, history, guides, photography, nonfiction, natural history, and general books of interest. Recent titles: *Cubby in Wonderland*; *Windswept*; *Banff-Jasper Explorer's Guide*. Publishes more than 6 print, 100 online titles/year. 75% require freelance illustration. Book catalog free for SAE with 4 first-class stamps.

Needs Works with 20 freelance illustrators and 10 designers/year. Prefers pen & ink, airbrush, pencil and watercolor. 25% of freelance work demands knowledge of PageMaker or FreeHand. Works on assignment only.

First Contact & Terms Send query letter with printed samples to be kept on file or write for appointment to show portfolio. For color work, slides are suitable; for b&w, technical pen, photostats. Samples not filed are returned by SASE only if requested. Responds in 10 days. Rights purchased vary according to project. Originals are not returned.

Book Design Assigns 6 freelance design jobs/year. Pays by the project, $50-3,500.

Jackets/Covers Assigns 2 freelance design and 4 illustration jobs/year. Pays by the project, $50-3,500.

Text Illustration Assigns 50 freelance illustration jobs/year. Prefers technical pen illustration, maps (using airbrush, overlays, etc.), watercolor illustrations for children's books, calligraphy and lettering for titles and headings. Pays by the hour, $5-20; or by the project, $50-3,500.

Tips "We are using more graphic, contemporary designs and looking for exceptional quality."

IDEALS PUBLICATIONS INC.

A division of Guideposts, 535 Metroplex Dr., Suite 250, Nashville TN 37211. (615)333-0478. Web site: www.idealsbooks.com. **Publisher:** Patricia Pingry. Art Director: Eve DeGrie. Estab. 1944. Imprints include: Candy Cane Press, Williamson Books. Company publishes hardcover originals and *Ideals* magazine. Specializes in nostalgia and holiday themes. Publishes 100 book titles and 6 magazine issues/year. 50% require freelance illustration. Guidelines free for #10 SASE with 1 first-class stamp or on Web site.

Needs Approached by 100 freelancers/year. Works with 10-12 freelance illustrators/year. Prefers freelancers with experience in illustrating people, nostalgia, botanical flowers. Uses freelancers mainly for flower borders (color), people and spot art; also for text illustration, jacket/cover and book design. Works on assignment only.

First Contact & Terms Send tearsheets to be filed. Responds only if interested. Buys all rights. Finds artists through submissions.

Text Illustration Assigns 75 freelance illustration jobs/year. Pays by the project. Prefers watercolor or gouache.

Tips "Looking for illustrations with unique perspectives, perhaps some humor, that not only tell the story but draw the reader into the artist's world. We accept all styles."

IMAGE COMICS

1942 University Ave., Suite 305, Berkeley CA 94704. E-mail: info@imagecomics.com. Web site: www.imagecomics.com. **Contact:** Erik Larsen. Estab. 1992. Publishes comic books, graphic novels. Recent titles: *Athena Inc.*; *Noble Causes Family Secrets #2*; *Powers #25*. See this company's Web site for detailed guidelines.

Needs "We are looking for good, well-told stories and exceptional artwork that run the gamut in terms of both style and genre."

First Contact & Terms Send proposals only. See Web site for guidelines. No e-mail submissions. All comics are creator-owned. Image only wants proposals for comics, not "art submissions." Proposals/samples not returned. Do not include SASE. Responds as soon as possible.

Tips "Please do not try to 'impress' us with all the deals you've lined up or testimonials from your Aunt Matilda. We are only interested in the comic."

IMPACT BOOKS

F+W Publications, Inc., 4700 E. Galbraith Rd., Cincinnati OH 45236. (513)531-2690. Fax: (513)531-2686. E-mail: pam.wissman@fwpubs.com. Web site: www.impact-books.com. **Aquisitions Editor:** Pam Wissman. Publishes trade paperback originals. Specializes in illustrated art instruction books. Recent titles: *DragonArt* by Jessica Peffer; *Comic Artist's Photo Reference: People and Poses* by Buddy Scalera; *Face Off* by Harold Hamernik; *Girl to Grrrl Manga* by Colleen Doran. Publishes 10 titles/year. Book catalog free with 9×12 SASE (6 first-class stamps).

 • IMPACT Books publishes titles that emphasize illustrated how-to-draw-comics and fantasy art instruction. Currently emphasizing traditional superhero and American comics styles, including humor; Japanese-style (manga and anime); and fantasy art. This market is for experienced comic-book artists who are willing to work with an IMPACT editor to produce a step-by-step how-to book about the artist's creative process. See also separate listing for F+W Publications, Inc., in this section.

Needs Approached by 30 author-artists/year. Works with 10 author-artists/year.

First Contact & Terms Send query letter or e-mail; digital art, tearsheets, photocopies, photographs, transparencies or slides; résumé, SASE and URL. Accepts Mac-compatible e-mail submissions (TIFF or JPEG). Samples may be filed but are usually returned. Responds only if interested. Company will contact artist for portfolio review of color finished art, digital art, roughs, photographs, slides, tearsheets and/or transparencies if interested. Buys all rights. Finds freelancers through submissions, conventions, Internet and word of mouth.

Tips Submission guidelines available online at www.impact-books.com/submit_work.asp.

INNER TRADITIONS INTERNATIONAL/BEAR & COMPANY

One Park St., Rochester VT 05767. (802)767-3174. Fax: (802)767-3726. E-mail: peri@innertraditions.com. Web site: www.innertraditions.com. **Art Director:** Peri Champine. Estab. 1975. Publishes hardcover originals and trade paperback originals and reprints. Types of books include self-help, psychology, esoteric philosophy, alternative medicine, Eastern religion, and art books. Recent titles: *The Virgin Mary Conspiracy*, *Strength Training on the Ball* and *The Discovery of the Nag Hammadi*. Publishes 60 titles/year. 25% require freelance illustration; 25% require freelance design. Book catalog free by request.

Needs Works with 8-9 freelance illustrators and 3-4 freelance designers/year. 100% of freelance design demands knowledge of QuarkXPress, InDesign or Photoshop. Uses freelancers for jacket/cover illustration and design. Works on assignment only.

First Contact & Terms Send query letter with résumé, tearsheets, photocopies, photographs, slides and SASE. Accepts disc submissions. Samples are filed if interested; returned by SASE if requested by artist. Responds only if interested. To show portfolio, mail tearsheets, photographs, slides and transparencies. Rights purchased vary according to project. Originals are returned at job's completion. Pays by the project.

Jackets/Covers Assigns approximately 25 design and illustration jobs/year. Pays by the project.

INTERCULTURAL PRESS, INC.

20 Park Plaza, Suite 1115A, Boston MA 02116-4303. (617)523-3801. Fax: (617)523-3708. E-mail: books@interculturalpress.com. Web site: www.interculturalpress.com. **Production Manager:** Erika Heilman. Estab. 1982. Publishes paperback originals. Types of books include text and reference. Specializes in intercultural and multicultural. Recent titles: *Kids Like Me* by Judith Blohm and Terri Lapinski; *Islam & Muslims* by Mark Sedgwick. Publishes 12 titles/year. 10% require freelance illustration. Book catalog free by request.

Needs Approached by 20 freelancers/year. Works with 2-3 freelance illustrators/year. Prefers freelancers with experience in trade books, multicultural field. Uses freelancers mainly for jacket/cover design and illustration. 80% of freelance work demands knowledge of PageMaker or Illus-

trator. "If a freelancer is conventional (i.e., not computer driven) they should understand production and pre-press."

First Contact & Terms Send query letter with brochure, tearsheets, résumé and photocopies. Samples are filed or are returned by SASE if requested by artist. Will contact artist for portfolio review if interested. Portfolio should include b&w final art. Buys all rights. Originals are not returned. Finds artists through submissions and word of mouth.

Jackets/Covers Assigns 6 freelance illustration jobs/year. Pays by the project, $300-500.

Text Illustration Assigns 1 freelance illustration job/year. Pays "by the piece, depending on complexity." Prefers b&w line art.

Tips First-time assignments are usually book jackets only; book jackets with interiors (complete

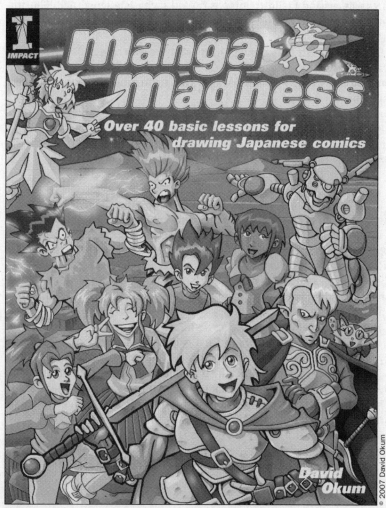

David Okum found illustrating the cover of *Manga Madness* from IMPACT Books a challenge because of the variety of characters depicted and the need to feature the many drawing styles taught within the book. But as a high school visual arts teacher, Okum is able to stay in touch with the world of manga and other material that interests his students. "Maintain a strong Internet presence and surround yourself with fellow artists," he advises. "Join an online community. Network, network, network."

projects) are given to "proven" freelancers. "We look for artists who have flexibility with schedule and changes to artwork. We appreciate an artist who will provide artwork that doesn't need special attention by pre-press in order for it to print properly. For black & white illustrations, keep your lines crisp and bold. For color illustrations, keep your colors pure and saturated."

JIREH PUBLISHING COMPANY

P.O. Box 1911, Suisun City CA 94585-1911. (510)276-3322. E-mail: jaholman@jirehpublishing.com. Web site: www.jirehpublishing.com. **Editor:** J. Holman. Publishes CD-ROMs, hardcover and trade paperback originals. Types of books include adventure and religious (fiction); instructional, religious and e-books (nonfiction). Recent titles: *Accessible Bathroom Design* and *The Art of Seeking God*. Publishes 2 titles/year. 85% require freelance design; 50% require freelance illustration. Book catalog not available; see Web site for current titles.

Needs Approached by 15 designers and 12 illustrators/year. Works with 2 designers and 1 illustrator/year. 85% of design work and 75% of illustration work demands knowledge of Corel Draw, Illustrator and Photoshop.

First Contact & Terms Designers/Illustrators: Send postcard samples with résumé, URL. Samples are filed. Responds only if interested. Will contact artist for portfolio review if interested. Portfolio should include color finished art. Rights purchased vary according to project. Finds freelancers through art reps, submissions and Internet.

Jackets/Covers Assigns 2 freelance cover illustration jobs/year. Pays for illustration by the project, $1,000 minimum. Prefers experienced Christian cover designers.

Text Illustration Assigns 1 freelance illustration job/year. Pays $50 minimum/hour.

Tips "Be experienced in creating Christian cover designs for fiction and nonfiction titles."

KAEDEN BOOKS

P.O. Box 16190, Rocky River OH 44116. (440)617-1400. Fax: (440)617-1403. E-mail: curmston@kaeden.com. Web site: www.kaeden.com. **Publisher:** Craig Urmston. Estab. 1989. Publishes children's books. Types of books include picture books and early juvenile. Specializes in elementary educational content. Recent titles: *Adventures of Sophie Bean: The Red Flyer Roller Coaster*, *Ethel the Emu*, *Miss Flutter Remembers* and *Zamboni's Bath*. Publishes 8-20 titles/year; 90% require freelance illustration. Book catalog available upon request.

- Kaeden Books is now providing content for ThinkBox.com and the TAE KindlePark Electronic Book Program.

Needs Approached by 100-200 illustrators/year. Works with 5-10 illustrators/year. Prefers freelancers experienced in juvenile/humorous illustration and children's picture books. Uses freelancers mainly for story illustration.

First Contact & Terms Designers: Send query letter with brochure and résumé. Illustrators: Send postcard sample or query letter with photocopies, photographs, printed samples or tearsheets, no larger than 8½×11. Samples are filed and not returned. Responds only if interested. Art director will contact artist for portfolio review if interested. Buys all rights.

Text Illustration Assigns 8-20 jobs/year. Pays by the project. Looks for a variety of styles.

Tips "We look for professional-level drawing and rendering skills, plus the ability to interpret a juvenile story. There is a tight correlation between text and visual in our books, plus a need for attention to detail. Drawings of children are especially needed. Please send only samples that pertain to our market."

KIRKBRIDE BIBLE CO. INC.

Kirkbride Bible & Technology, 335 W. Ninth St., Indianapolis IN 46202-0606. (317)633-1900. Fax: (317)633-1444. E-mail: gage@kirkbride.com. Web site: www.kirkbride.com. **Director of Production and Technical Services:** Michael B. Gage. Estab. 1915. Publishes hardcover originals,

CD-ROMs and many styles and translations of the Bible. Types of books include reference and religious. Specializes in reference and study material. Publishes 6 main titles/year. 5% require freelance illustration; 20% require freelance design. Catalog available.

Needs Approached by 1-2 designers/year. Works with 1-2 designers/year. Prefers freelancers experienced in layout and cover design. Uses freelancers mainly for artwork and design. 100% of freelance design and most illustration demands knowledge of PageMaker, FreeHand, Photoshop, Illustrator and QuarkXPress. 5-10% of titles require freelance art direction.

First Contact & Terms Designers: Send query letter with photostats, printed samples and résumé. Illustrators: Send query letter with photostats, printed samples and résumé. Accepts disk submissions compatible with QuarkXPress or Photoshop files, 4.0 or 3.1. Samples are filed. Responds only if interested. Rights purchased vary according to project.

Book Design Assigns 1 freelance design job/year. Pays by the hour, $100 minimum.

Jackets/Covers Assigns 1-2 freelance design jobs and 1-2 illustration jobs/year. Pays for design by the project, $100-1,000. Pays for illustration by the project, $100-1,000. Prefers modern with traditional text.

Text Illustration Assigns 1 freelance illustration/year. Pays by the project, $100-1,000. Prefers traditional. Finds freelancers through sourcebooks and references.

Tips "Quality craftsmanship is our top concern, and it should be yours also!"

DENIS KITCHEN PUBLISHING CO., LLC

P.O. Box 2250, Amherst MA 01004-2250. (413)259-1627. Fax: (413)259-1812. E-mail: publishing @deniskitchen.com. Web site: www.deniskitchenpublishing.com. **Contact:** Denis Kitchen or Steven Krupp. Estab. 1999 (previously Kitchen Sink Press, 1969-1999). Publishes hardcover originals and trade paperback originals. Types of books include art prints, coffee table books, graphic novels, illustrated books, postcard books, and boxed trading cards. Specializes in comix and graphic novels. Recent titles: *Heroes of the Blues* by R. Crumb, *Grasshopper & Ant* by Harvey Kurtzman and *Mr. Natural Postcard Book* by R. Crumb. Publishes 4-6 titles/year. 50% require freelance design; 10% require freelance illustration. Book catalog not available.

Needs Approached by 50 illustrators and 100 designers/year. Works with 6 designers and 2 illustrators/year. Prefers local designers. 90% of freelance design work demands knowledge of QuarkXPress and Photoshop. Freelance illustration demands QuarkXPress, Photoshop and sometimes old-fashioned brush and ink.

First Contact & Terms Send postcard sample with SASE, tearsheets, URL and other appropriate samples. After introductory mailing, send follow-up postcard sample every 6 months. Samples are filed or returned by SASE. Responds in 4-6 weeks. Portfolio not required. Finds freelancers through submissions, art exhibits/fairs and word of mouth.

Jackets/Covers Assigns 2-3 freelance cover illustrations/year. Prefers "comic book" look where appropriate.

B. KLEIN PUBLICATIONS

P.O. Box 6578, Delray Beach FL 33482. (561)496-3316. Fax: (561)496-5546. **Editor:** Bernard Klein. Estab. 1955. Publishes reference books, such as the *Guide to American Directories*. Publishes approximately 15-20 titles/year. 25% require freelance illustration; 25% require freelance art direction. Book catalog free on request.

Needs Works with 1-3 freelance illustrators and 1-3 designers/year. Uses freelancers for jacket design and direct mail brochures.

First Contact & Terms Submit résumé and samples. Pays $50-300.

▣ PETER LANG PUBLISHING, INC.

29 Broadway, Room 1800, New York NY 10006-3221. Web site: www.peterlangusa.com. **Contact:** Creative Director. Publishes humanities textbooks and monographs. Publishes 300 titles/year. Book catalog available on request or on Web site.

Needs Works with a small pool of designers/year. Prefers local freelance designers experienced in scholarly book covers. Most covers will be CMYK. 100% of freelance design demands knowledge of Illustrator, Photoshop and QuarkXPress.

First Contact & Terms Send query letter with printed samples, photocopies and SASE. Accepts disk submissions. Samples are filed. Responds only if interested. Will contact artist for portfolio review if interested. Finds freelancers through referrals.

Jackets/Covers Assigns 100 freelance design jobs/year. Only accepts Quark electronic files. Pays for design by the project.

LAREDO PUBLISHING CO./RENAISSANCE HOUSE DBA

9400 Lloydcrest Dr., Beverly Hills CA 90210. (310)860-9930. Fax: (310)860-9902. E-mail: laredo@ renaissancehouse.net. Web site: renaissancehouse.net. **Art Director:** Sam Laredo. Estab. 1991. Publishes juvenile and preschool textbooks. Specializes in Spanish texts, educational/readers. Recent titles: *Legends of America* (series of 21 titles), *Extraordinary People* (series of 6 titles) and *Breast Health with Nutribionics*. Publishes 16 titles/year.

Needs Approached by 10 illustrators and 2 designers/year. Works with 2 designers/year. Uses freelancers mainly for book development. 100% of freelance design demands knowledge of Photoshop, Illustrator, QuarkXPress. 20% of titles require freelance art direction.

First Contact & Terms Designers: Send query letter with brochure, photocopies. Illustrators: Send photocopies, photographs, résumé, slides, tearsheets. Samples are not filed and are returned by SASE. Responds only if interested. Portfolio review required for illustrators. Art director will contact artist for portfolio review if interested. Portfolio should include book dummy, photocopies, photographs, tearsheets and artwork portraying children. Buys all rights or negotiates rights purchased.

Book Design Assigns 5 freelance design jobs/year. Pays for design by the project.

Jacket/Covers Pays for illustration by the project, page.

Text Illustration Pays by the project, page.

LEE & LOW BOOKS

95 Madison Ave., #1205, New York NY 10016-7801. (212)779-4400. Fax: (212)532-6035. E-mail: general@leeandlow.com. Web site: www.leeandlow.com. **Editor-in-Chief:** Louise May. Estab. 1991. Publishes hardcover originals and reprints for the juvenile market. Specializes in multicultural children's books. Titles include *Rent Party Jazz* by William Miller; *Where On Earth Is My Bagel?* by Frances Park and Ginger Park; and *Love to Mama*, edited by Pat Mora. Publishes 12-15 titles/year. 100% require freelance illustration and design. Book catalog available.

Needs Approached by 100 freelancers/year. Works with 12-15 freelance illustrators and 4-5 designers/year. Uses freelancers mainly for illustration of children's picture books. 100% of design work demands computer skills. Works on assignment only.

First Contact & Terms Contact through artist rep or send query letter with brochure, résumé, SASE, tearsheets or photocopies. Samples of interest are filed. Art director will contact artist for portfolio review if interested. Portfolio should include color tearsheets and dummies. Rights purchased vary according to project. Originals are returned at job's completion.

Book Design Pays by the project.

Text Illustration Pays by the project.

Tips "We want an artist who can tell a story through pictures and who is familiar with the children's book genre. We are now also developing materials for older children, ages 8-12, so we are interested in seeing work for this age group, too. Lee & Low Books makes a special effort to work with writers and artists of color and encourages new talent. We prefer filing samples that feature children, particularly from diverse backgrounds."

N LEISURE BOOKS; LOVE SPELL

Divisions of Dorchester Publishing Co., Inc., 200 Madison Ave., Suite 2000, New York NY 10016. (212)725-8811. Web site: www.dorchesterpub.com. Estab. 1970. Publishes paperback originals and reprints. Specializes in mass market category fiction—romance, western, adventure, horror, thriller, chick lit. Publishes 200 titles/year. View covers on Web site. Art submission guidelines available on Web site.

Needs Works with 24 freelance illustrators and 6 designers/year for covers. Prefers digital, oil or acrylic. Works on assignment only.

First Contact & Terms Send samples by mail, marked ATTN: Art Department. Send nonreturnable tearsheets. No e-mail or fax submissions. Complexity of project will determine payment. Usually buys first rights, but rights purchased vary according to project. Interested in buying second rights (reprint rights) to previously published work for romances and westerns only.

Jackets/Covers Pays by the project.

Tips "Talented new artists welcome. Be familiar with the kind of artwork we use on our covers."

LERNER PUBLISHING GROUP

241 First Ave. N., Minneapolis MN 55401. (612)332-3344. Fax: (612)332-7615. E-mail: info@lernerbooks.com. Web site: www.lernerbooks.com. **Art Director:** Zach Marell. Estab. 1959. Publishes educational books for young people. Subjects include animals, biography, history, geography, science and sports. Publishes 200 titles/year. 100% require freelance illustration. Recent titles: *Colorful Peacocks*; *Ethiopia in Pictures*. Book catalog free on request. Art submission guidelines available on Web site.

Needs Uses 10-12 freelance illustrators/year. Uses freelancers mainly for book illustration; also for jacket/cover design and illustration, book design and text illustration.

First Contact & Terms Send bio/résumé with slides, JPEG or PDF files on disk, photocopies or tearsheets showing skill in children's book illustration. Samples are kept on file or are returned by SASE. Responds in 2 weeks, only if SASE included. Considers skill and experience of artist and turnaround time when establishing payment. Pays by the project, $500-3,000 average, or advance plus royalty. Considers buying second rights (reprint rights) to previously published artwork.

Tips "Send samples showing active children, not animals or still life. Don't send original art. Look at our books to see what we do."

MITCHELL LANE PUBLISHERS, INC.

P.O. Box 196, Hockessin DE 19707. (302)234-9426. Fax: (302)234-4742. Web site: www.mitchelllane.com. **Publisher:** Barbara Mitchell. Estab. 1993. Publishes library bound originals. Types of books include biography. Specializes in multicultural biography for young adults. Recent titles: *Disaster in the Indian Ocean* and *Tsunami 2004*. Publishes 85 titles/year. 50% require freelance illustration; 50% require freelance design.

Needs Approached by 20 illustrators and 5 designers/year. Works with 2 illustrators/year. Prefers freelancers experienced in illustrations of people. Looks for cover designers and interior book designers.

First Contact & Terms Send query letter with printed samples, photocopies. Interesting samples are filed and are not returned. Will contact artist for portfolio review if interested. Buys all rights.

Jackets/Covers Prefers realistic portrayal of people.

MODERN PUBLISHING

155 E. 55th St., New York NY 10022. (212)826-0850. Fax: (212)758-4166. E-mail: ntocco@modernpublishing.com. Web site: www.modernpublishing.com. **Executive Editor:** Nicole Tocco. Specializes in children's coloring and activity books, novelty books, hardcovers, paperbacks (both

generic and based on licensed characters). Recent titles: Fisher Price books, Care Bears books, The Wiggles books, Bratz and Lil' Bratz books. Publishes approximately 200 titles/year.

Needs Approached by 15-30 freelancers/year. Works with 25-30 freelancers/year. Works on assignment and royalty.

First Contact & Terms Send query letter with résumé and samples. Samples are not filed and are returned by SASE only if requested. Responds only if interested. Originals are not returned. Considers turnaround time, complexity of work and rights purchased when establishing payment.

Jackets/Covers Pays by the project, $100-250/cover, usually 2-4 books/series.

Text Illustration Pays by the project, $35-75/page; line art, 24-384 pages per book, usually 2-4 books/series. Pays $50-125/page; full-color art.

Tips "Research our books at bookstores or on our Web site to get a good feel for our product line; do not submit samples that do not reflect the styles we use."

MORGAN KAUFMANN PUBLISHERS

30 Corporate Dr., Suite 400, Burlington MA 01803-4252. (781)313-4700. Fax: (781)221-1615. E-mail: mkp@mkp.com. Web site: www.mkp.com. Estab. 1984. Publishes computer science books for academic and professional audiences in paperback, hardback and book/CD-ROM packages. Publishes 60 titles/year. 75% require freelance interior illustration; 100% require freelance text and cover design; 15% require freelance design and production of 4-color inserts.

• Morgan Kaufmann is now part of Elsevier (www.elsevier.com).

Needs Approached by 150-200 freelancers/year. Works with 10-15 freelance illustrators and 10-15 designers/year. Uses freelancers for covers, text design and technical and editorial illustration, design and production of 4-color inserts. 100% of freelance work demands knowledge of at least one of the following Illustrator, QuarkXPress, Photoshop, Ventura, Framemaker, or laTEX (multiple software platform). Works on assignment only.

First Contact & Terms Send query letter with samples. Samples must be nonreturnable or with SASE. "No calls, please." Samples are filed. Production editor will contact artist for portfolio review if interested. Portfolio should include final printed pieces. Buys interior illustration on a work-for-hire basis. Buys first printing and reprint rights for text and cover design. Finds artists primarily through word of mouth and submissions.

Book Design Assigns freelance design jobs for 40-50 books/year. Pays by the project. Prefers Illustrator and Photoshop for interior illustration and QuarkXPress for 4-color inserts.

Jackets/Covers Assigns 40-50 freelance design; 3-5 illustration jobs/year. Pays by the project. Uses primarily stock photos. Prefers designers take cover design through production to film and MatchPrint. "We're interested in a look that is different from the typical technical publication." For covers, prefers modern, clean, spare design, with emphasis on typography and high-impact imagery.

Tips "Although experience with book design is an advantage, sometimes artists from another field bring a fresh approach, especially to cover design."

MOUNTAIN PRESS PUBLISHING CO.

P.O. Box 2399, Missoula MT 59806. (406)728-1900. Fax: (406)728-1635. E-mail: info@mtnpress.com. Web site: www.mountain-press.com. **Design and Production:** Kim Ericsson and Jeannie Painter. Estab. 1960s. Company publishes trade paperback originals and reprints; some hardcover originals and reprints. Types of books include western history, geology, natural history/nature. Specializes in geology, natural history, history, horses, western topics. Publishes 20 titles/year. Recent titles: *From Angels to Hellcats: Legendary Texas Women*, and regional photographic field guides. Book catalog free by request.

Needs Approached by 100 freelance artists/year. Works with 2-5 freelance illustrators/year. Buys 5-10 freelance illustrations/year. Prefers artists with experience in book illustration and design,

book cover illustration. Uses freelance artists for jacket/cover illustration, text illustration and maps. 100% of design work demands knowledge of InDesign, Photoshop, Illustrator. Works on assignment only.

First Contact & Terms Send query letter with résumé, SASE and any samples. Samples are filed or are returned by SASE. Responds only if interested. Project editor will contact artist for portfolio review if interested. Buys one-time rights or reprint rights depending on project. Originals are returned at job's completion. Finds artists through submissions, word of mouth, sourcebooks and other publications.

Book Design Pays by the project.

Jackets/Covers Assigns 0-1 freelance design and 3-6 freelance illustration jobs/year. Pays by the project.

Text Illustration Assigns 0-1 freelance illustration jobs/year. Pays by the project.

Tips First-time assignments are usually book cover/jacket illustration or map drafting; text illustration projects are given to "proven" freelancers.

ⓝ NEW ENGLAND COMICS (NEC PRESS)

732 Washington St., Norwood MA 02062-3548. (781)769-3470. Fax: (781)769-2853. E-mail: office @newenglandcomics.com. Web site: www.newenglandcomics.com. Publishes comic books and games. Book catalog available on Web site.

Needs Seeking pencillers and inkers. Not currently interested in new stories.

First Contact & Terms Send SASE and 2 pages of pencil or ink drawings derived from the submissions script posted on Web site. Responds in 2 weeks (with SASE only).

Tips Visit Web site for submissions script. Do not submit original characters or stories. Do not call.

NORTH LIGHT BOOKS

F+W Publications, Inc., 4700 E. Galbraith Rd., Cincinnati OH 45236. (513)531-2690. Fax: (513)531-2686. E-mail: jamie.markle@fwpubs.com. Web site: www.fwpublications.com. **Publisher:** Jamie Markle. Publishes trade paperback and hardback originals. Specializes in fine art, craft and decorative painting instruction books. Recent titles: *Acrylic Revolution*; *Drawing with Your Artist's Brain*; *The Watercolor Bible*; *Domiknitrix*; *Plush You!*; *Mixed-Media Mosaics*. Publishes 75 titles/year. Book catalog available for SASE with 6 first-class stamps.

• This market is for experienced fine artists who are willing to work with a North Light editor to produce a step-by-step how-to book about the artist's creative process. See also separate listing for F+W Publications, Inc., in this section.

Needs Approached by 100 author-artists/year. Works with 30 artists/year.

First Contact & Terms Send query letter with photographs, slides or digital images. Accepts e-mail submissions. Samples are not filed and are returned. Responds only if interested. Company will contact artist for portfolio review of color slides if interested. Buys all rights. Finds freelancers through art competitions, art exhibits, submissions, Internet and word of mouth.

Tips "Include 30 examples of artwork, book idea, outline and a step-by-step demonstration. Submission guidelines posted on Web site at www.fwpublications.com/authorguidelines.asp."

ⓝ NORTHWOODS PRESS

Conservatory of American Letters, P.O. Box 298, Thomaston ME 04861. (207)226-7528. E-mail: cal@americanletters.org. Web site: www.americanletters.org. **Editor:** Robert Olmsted. Estab. 1972. Specializes in hardcover and paperback originals of poetry. Publishes approximately 6 titles/year. 10% require freelance illustration. Book catalog for SASE.

• The Conservatory of American Letters publishes the *Northwoods Journal*, a quarterly literary

magazine. They're seeking cartoons and line art and pay cash on acceptance. Get guidelines from Web site.

Needs Approached by 40-50 freelance artists/year. Works with 1-2 illustrators/year. Uses freelance artists mainly for cover illustration. Rarely uses freelance artists for text illustration.

First Contact & Terms Send query letter to be kept on file. Art Director will contact artist for portfolio review if interested. Sometimes requests work on spec before assigning a job. Considers complexity of project, skill and experience of artist, project's budget, turnaround time and rights purchased when establishing payment. Buys one-time rights and occasionally all rights. Originals are returned at job's completion.

Book Design Pays by the project, $10-100.

Jackets/Covers Assigns 2-3 design jobs and 4-5 illustration jobs/year. Pays by the project, $10-100.

Text Illustration Pays by the project, $5-20.

Tips Portfolio should include "art suitable for book covers—contemporary, usually realistic."

OCP (OREGON CATHOLIC PRESS)

5536 NE Hassalo, Portland OR 97213-3638. E-mail: gust@ocp.org. Web site: www.ocp.org. **Creative Director:** Gus Torres. Division estab. 1997. Publishes religious and liturgical books specifically for, but not exclusively to, the Roman Catholic market. Publishes 2-5 titles/year; 30% require freelance illustration. Book catalog available for 9×12 SASE with first-class postage.

● OCP (Oregon Catholic Press) is a nonprofit publishing company, producing music and liturgical publications used in parishes throughout the United States, Canada, England and Australia. See additional listings in the Magazines and Record Labels sections.

Tips "I am always looking for appropriate art for our projects. We tend to use work already created on a one-time-use basis, as opposed to commissioned pieces. I look for tasteful, not overtly religious art."

OCTAMERON PRESS

1900 Mount Vernon Ave., Alexandria VA 22301. (703)836-5480. Fax: (703)836-5650. Web site: www.octameron.com. **Editorial Director:** Karen Stokstod. Estab. 1976. Publishes paperback originals. Specializes in college financial and college admission guides. Recent titles: *College Match*; *The Winning Edge*. Publishes 9 titles/year.

Needs Approached by 25 freelancers/year. Works with 1-2 freelancers/year. Works on assignment only.

First Contact & Terms Send query letter with brochure showing art style or résumé and photocopies. Samples not filed are returned if SASE is included. Considers complexity of project and project's budget when establishing payment. Rights purchased vary according to project.

Jackets/Covers Works with 1-2 designers and illustators/year on 15 different projects. Pays by the project, $500-1,000.

Text Illustration Works with variable number of artists/year. Pays by the project, $35-75. Prefers line drawings to photographs.

Tips "The look of the books we publish is friendly! We prefer humorous illustrations."

THE OVERLOOK PRESS

141 Wooster St., New York NY 10012. (212)965-8400. Fax: (212)965-9834. Web site: www.overlookpress.com. **Contact:** Art Director. Estab. 1970. Publishes hardcover originals. Types of books include contemporary and experimental fiction, health/fitness, history, fine art and children's books. Publishes 90 titles/year. 60% require freelance illustration; 40% require freelance design. Book catalog free for SASE.

Needs Approached by 10 freelance artists/year. Works with 4 freelance illustrators and 4 free-

lance designers/year. Buys 5 freelance illustrations/year. Prefers local artists only. Uses freelance artists mainly for jackets. Works on assignment only.

First Contact & Terms Send query letter with printed samples or other nonreturnable material. Samples are filed. To show a portfolio, mail tearsheets and slides. Buys one-time rights. Originals are returned to artist at job's completion.

Jackets/Covers Assigns 10 freelance design jobs/year. Pays by the project, $250-350.

PALACE PRESS

(formerly Mandala Publishing), 17 Paul Dr., San Rafael CA 94903. (415)526-1370. Fax: (415)884-0500. E-mail: lisa@palacepress.com. Web site: www.insighteditions.com. **Contact:** Lisa Fitzpatrick. Estab. 1987. Publishes art and photography books, calendars, journals, postcards and greeting card box sets. Types of books include pop culture, fine art, photography, spiritual, philosophy, art, biography, coffee table books, cookbooks, instructional, religious, travel, and nonfiction. Specializes in art books, spiritual. Publishes 12 titles/year. 100% require freelance design and illustration. Book catalog free on request.

Needs Approached by 50 illustrators/year. Works with 12 designers and 12 illustrators/year. Location of designers/illustrators not a concern.

First Contact & Terms Send photographs and résumé. Accepts disk submissions. Prefers Mac-compatible TIFF and JPEG files. Samples are filed. Responds only if interested. Company will contact artist for portfolio review if interested. Rights purchased vary according to project. Finds freelancers through submissions and word of mouth.

Jackets/Covers Assigns 3 freelance cover illustration jobs/year. Pays for illustration by the project.

Text Illustration Assigns 2 freelance illustration jobs/year. Pays by the project.

Tips "Look at our published books and understand what we represent and how your work could fit."

PAPERCUTZ

40 Exchange Place, Suite 1308, New York NY 10005. (800)886-1223. Fax: (212)643-1545. E-mail: salicrup@papercutz.com. Web site: www.papercutz.com. **Editor-in-Chief:** Jim Salicrup. Estab. 2005. "Independent publisher of graphic novels based on popular existing properties aimed at the teen and tween market." Publishes hardcover and paperback originals, distributed by Holtzbrinck Publishers. Recent titles: *Nancy Drew*; *The Hardy Boys*; *Tales from the Crypt*. Publishes 10+ titles/year. Book catalog free upon request.

Needs Uses licensed characters/properties aimed at teen/tween market. Not looking for original properties at this time. "Looking for professional comics writers able to write material for teens and tweens without dumbing down the work, and comic book artists able to work in animated or manga styles." Also has a need for inkers, colorists, letterers.

First Contact & Terms Send low-res files of comic art samples or a link to Web site. Attends New York comic book conventions, as well as the San Diego Comic-Con, and will review portfolios if time allows. Responds in 1-2 weeks. Pays an advance against royalties.

Tips "Be familiar with our titles—that's the best way to know what we're interested in publishing. If you are somehow attached to a successful teen or tween property and would like to adapt it into a graphic novel, we may be interested."

PATHWAY BOOK SERVICE

4 White Brook Rd., Gilsum NH 03448. (800)345-6665. Fax: (603)357-2073. E-mail: pbs@pathwaybook.com. Web site: www.pathwaybook.com; www.stemmer.com. **President/Publisher:** Ernest Peter. Specializes in design resource originals, children's nonfiction and nature/environmental books in series format or as individual titles. Recent titles: *Designs of Tonga, Art Deco Designs*,

Arts & Crafts Patterns & Designs and *I Hear the Wind*. Publishes 6-8 titles/year. 10% require freelance design; 75% require freelance illustration.

Needs Approached by more than 200 freelancers/year. Works with 4 freelance illustrators and 1 designer/year. Works on assignment only.

First Contact & Terms Designers: Send query letter with brochure, tearsheets, SASE, photocopies. Illustrators: Send postcard sample or query letter with brochure, photocopies, photographs, SASE, slides and tearsheets. Do not send original work. Material not filed is returned by SASE. Call or write for appointment to show portfolio. Responds in 6 weeks. Works on assignment only. Originals are returned to artist at job's completion on request. Negotiates rights purchased.

Book Design Assigns 1 freelance design and 2 illustration projects/year. Pays by the project.

Jackets/Covers Assigns 4 freelance design jobs/year. Prefers paintings. Pays by the project.

Text Illustration Assigns 3 freelance jobs/year. Prefers full-color artwork for text illustrations. Pays by the project.

Tips Looks for "draftmanship, flexibility, realism, understanding of the printing process." Books are "rich in design quality and color, stylized while retaining realism; not airbrushed. We prefer noncomputer. Review our books. No picture book illustrations considered currently."

PAULINE BOOKS & MEDIA

50 Saint Paul's Ave., Boston MA 02130-3491. (617)522-8911. Fax: (617)541-9805. E-mail: design @paulinemedia.com. Web site: www.pauline.org. **Art Director:** Sr. Mary Joseph Peterson. Estab. 1932. Publishes hardcover and trade paperback originals. Types of books include instructional, biography, reference, history, self-help, prayer and religious, for children of all ages and adults. Specializes in religious topics. "We also produce music and spoken recordings." Publishes 30-40 titles/year. Art guidelines available. Send requests and art samples with SASE using first-class postage.

Needs Approached by 50 freelancers/year. Works with 10-20 freelance illustrators/year. Knowledge and use of QuarkXPress, InDesign, Illustrator, Photoshop, etc., is valued.

First Contact & Terms Send query letter with résumé, SASE, tearsheets and photocopies. Accepts disk submissions compatible with Mac. Send JPEG, EPS, TIFF or GIF files. Samples are filed or returned by SASE. Responds in 3 months, only if interested. Rights purchased vary according to project.

Jackets/Covers Assigns 3-4 freelance illustration jobs/year. Pays by the project.

Text Illustration Assigns 6-10 freelance illustration jobs/year. Pays by the project.

PAULIST PRESS

997 Macarthur Blvd., Mahwah NJ 07430. (201)825-7300. Fax: (201)825-8345. E-mail: pmcmahon @paulistpress.com. Web site: www.paulistpress.com. **Managing Editor:** Paul McMahon. Estab. 1869. Publishes hardcover and trade paperback originals, juvenile and textbooks. Types of books include religion, theology, and spirituality including biography. Speacializes in academic and pastoral theology. Recent titles: *How to Read a Church, Traveling with the Saints in Italy* and *Child's Guide to the Seven Sacraments*. Publishes 90 titles/year. 5% require freelance illustration; 5% require freelance design.

 • Paulist Press distributes the general trade imprint HiddenSpring.

Needs Works with 5 illustrators and 10 designers/year. Prefers local freelancers, particulary for juvenile titles. Prefers knowledge of QuarkXPress. Works on assignment only.

First Contact & Terms Send query letter with brochure, résumé and tearsheets. Samples are filed. Portfolio review not required. Negotiates rights purchased. Originals are returned at job's completion if requested.

Book Design Assigns 8 freelance design jobs/year.

Jackets/Covers Assigns 30 freelance design jobs/year. Pays by the project, $400-800.
Text Illustration Assigns 5 freelance illustration jobs/year. Pays by the project.

PEACHTREE PUBLISHERS
1700 Chattahoochee Ave., Atlanta GA 30318. (404)876-8761. Fax: (404)875-2578. E-mail: hello@peachtree-online.com. Web site: www.peachtree-online.com. **Art Director:** Loraine Joyner. Production Manager: Melanie McMahon Ives. Estab. 1977. Publishes hardcover and trade paperback originals. Types of books include children's picture books, young adult fiction, early reader fiction, juvenile fiction, parenting, regional. Specializes in children's and young adult titles. Publishes 24-30 titles/year. 100% require freelance illustration. Call for catalog.
Needs Approached by 750 illustrators/year. Works with 15-20 illustrators. "If possible, send samples that show your ability to depict subjects or characters in a consistent manner. See our Web site to view styles of artwork we utilize."
First Contact & Terms Illustrators: Send query letter with photocopies, SASE, tearsheets. "Prefer not to receive samples from designers." Accepts Mac-compatible disk submissions, but not preferred. Samples are returned by SASE. Responds only if interested. Will contact artist for portfolio review if interested. Rights purchased vary according to project. Finds freelancers through submission packets, agents and sourcebooks, including *Directory of Illustration* and *Picturebook*.
Jackets/Covers Assigns 18-20 illustration jobs/year. Prefers acrylic, watercolor or mixed media on flexible material. Pays for illustration by the project.
Text Illustration Assigns 4-6 freelance illustration jobs/year. Pays by the project.
Tips "We are an independent, high-quality house with a limited number of new titles per season; therefore each book must be a jewel. We expect the illustrator to bring creative insights which expand the readers' understanding of the storyline through visual clues not necessarily expressed within the text itself."

PENGUIN GROUP (USA) INC.
375 Hudson St., New York NY 10014. (212)366-2000. Fax: (212)366-2666. Web site: www.penguingroup.com. **Art Director:** Paul Buckley. Publishes hardcover and trade paperback originals.
Needs Works with 100-200 freelance illustrators and 100-200 freelance designers/year. Uses freelancers mainly for jackets, catalogs, etc.
First Contact & Terms Send query letter with tearsheets, photocopies and SASE. Rights purchased vary according to project.
Book Design Pays by the project; amount varies.
Jackets/Covers Pays by the project; amount varies.

N PENNY-FARTHING PRESS, INC.
2000 W. Sam Houston Pkwy. S., Suite 550, Houston TX 77042-3652. (713)780-0300. Fax: (713)780-4004. E-mail: corp@pfpress.com. Web site: www.pfpress.com. **Contact:** Submissions Editor. Publishes hardcover and trade paperback originals. Types of books include adventure, comic books, fantasy, science fiction. Specializes in comics and graphic novels. Recent titles: *Captain Gravity*; *The Victorian Act II*; *Self-Immolation*. Book catalog and art guidelines available on Web site.
First Contact & Terms Pencillers: Send 3-5 penciled pages "showing story-telling skills and versatility. Do not include dialogue or narrative boxes." Inkers: Send at least 3-5 samples (full-sized and reduced to letter-sized) showing interior work. "Include copies of the pencils." Illustrators: Send color photocopies. "Please do not send oversized copies." Samples are returned by SASE ONLY. Submissions in the form of URLs may be e-mailed to submissions@pfpress.com with PFP Art Submission as the subject line. See Web site for specific instructions. Responds in several months. Do not call to check on status of your submission.
Tips "Do not send originals."

PEREGRINE

40 Seymour Ave., Toronto ON M4J 3T4 Canada. (416)461-9884. Fax: (416)461-4031. E-mail: peregrine@peregrine-net.com. Web site: www.peregrine-net.com. **Creative Director:** Kevin Davies. Estab. 1993. Publishes role-playing game books, audio music, and produces miniatures supplements. Game styles/genres include science fiction, cyberpunk, mythology, fantasy, military, horror and humor. Game/product lines include *Murphy's World* (role-playing game); *Bob, Lord of Evil* (role-playing game); *Adventure Areas* (miniatures supplements); *Grit Multi-Genre Miniatures Rules*; *Adventure Audio*. Publishes 1-2 titles or products/year. 90% require freelance illustration; 10% require freelance design. Art guidelines available on Web site.

Needs Approached by 20 illustrators and 2 designers/year. Works with 2-5 artists/year. Uses freelance artists mainly for interior art (b&w, grayscale) and covers (color). Prefers freelancers experienced in anatomy, structure, realism, cartoon and grayscale. 100% of freelance design demands knowledge of Illustrator, Photoshop, InDesign and QuarkXPress.

First Contact & Terms Send query letter with résumé, business card. Illustrators: Send photocopies and/or tearsheets (5-10 samples). Accepts digital submissions in Mac format via CD or e-mail attachment as EPS, TIFF or JPEG files at 72-150 ppi (for samples) and 300 ppi (for finished work). Paper and digital samples are filed and are not returned. Responds only if interested. Send self-promotion photocopy and follow-up postcard every 9-12 months. Portfolio review not required. Rights purchased vary according to project. Finds freelancers through conventions, Internet and word of mouth.

Book Covers/Posters/Cards Assigns 1-2 illustration jobs/year. Pays for illustration by the project.

Text Illustration Assigns 1-5 illustration jobs/year (grayscale/b&w). Pays $50-100 for full page; $10-25 for half page. "Payment varies with detail of image required and artist's experience."

Tips "Check out our existing products on our Web site. Make sure at least half of the samples you submit reflect the art styles we're currently publishing. Other images can be provided to demonstrate your range of capability."

PINESTEIN PRESS

Imprint of Chowder Bay Books, P.O. Box 5542, Lake Worth FL 33466-5534. E-mail: acquisitions@pinestein.com. Web site: www.pinestein.com. **Acquisitions Editor:** Valerie Kensington. Estab. 2007. Publishes hardcover originals, trade paperback originals and reprints. Types of books include juvenile, young adult, preschool, instructional. Publishes 6-8 titles/year. 100% require freelance design and illustration. Book catalog available on Web site.

● See also listing for Chowder Bay Books in this section.

Needs Approached by 200 designers and 480 illustrators/year. Works with 2 designers and 4 illustrators/year. 80% of freelance design work demands skills in Photoshop and QuarkXPress. 80% of freelance illustration work demands skills in FreeHand and Photoshop.

First Contact & Terms Send postcard sample with URL. Accepts e-mail submissions with link to Web site. Prefers Windows-compatible JPEG, TIFF or GIF files. Samples are filed and are not returned. Responds only if interested. Rights purchased vary according to project. Finds freelancers through submissions, word of mouth, magazines, Internet.

Jackets/Covers Assigns 8 illustration jobs/year. Pays by the project; varies.

Text Illustration Assigns 4 illustration jobs/year. Pays by the project; varies.

Tips "We're always willing to look at online portfolios. The best way to direct us there is via a simple postcard with URL. We are a young company with serious goals and a focus on creativity. While we are unable to respond directly to all inquiries or submissions, we do review everything that hits our inboxes (both e-mail and snail mail). Work that catches our eye is unique in style, bold in execution, and has age-appropriate kid appeal (from preschool to young adult)."

N̄ PIPPIN PRESS

229 E. 85th St., P.O. Box 1347, Gracie Station, New York NY 10028. (212)288-4920. Fax: (732)225-1562. **Publisher/Editor-in-Chief:** Barbara Francis. Estab. 1987. Publishes hardcover juvenile originals. Recent titles: *Abigail's Drum*; *A Visit from the Leopard: Memories of a Ugandan Childhood*. Publishes 4-6 titles/year. 100% require freelance illustration; 100% require freelance design. Book catalog free for SAE with 2 first-class stamps.

Needs Approached by 50-75 freelance artists/year. Works with 6 freelance illustrators and 2 designers/year. Prefers artists with experience in juvenile books for ages 4-10. Uses freelance artists mainly for book illustration; also for jacket/cover illustration and design and book design.

First Contact & Terms Send query letter with résumé, tearsheets, photocopies. Samples are filed "if they are good," and are not returned. Responds in 2 weeks. Portfolio should include selective copies of samples and thumbnails. Buys all rights. Originals are returned at job's completion.

Book Design Assigns 3-4 freelance design jobs/year.

Text Illustration All text illustration assigned to freelance artists.

Tips Finds artists "through exhibits of illustration and looking at recently published books in libraries and bookstores. Aspiring illustrators should be well acquainted with work of leading children's book artists. Visit children's rooms at local libraries to examine these books. Prepare a sketchbook showing animals and children in a variety of action drawings (running, jumping, sitting, etc.) and with a variety of facial expressions. Create scenes perhaps by illustrating a well-known fairytale. Know why you want to illustrate children's books."

PLAYERS PRESS

P.O. Box 1132, Studio City CA 91614. (818)789-4980. E-mail: playerspress@att.net. **Associate Editor:** Jean Sommers. Specializes in plays and performing arts books. Recent titles: *Costumes and Settings: v3, v4, & v5*; *Principles of Stage Combat*; *Choreographing the Stage Musical*; *Scenery, Design and Fabrication*.

Needs Works with 3-15 illustrators and 1-3 designers/year. Uses freelancers mainly for play covers; also for text illustration. Works on assignment only.

First Contact & Terms Send query letter with brochure showing art style or résumé and samples. Samples are filed or are returned by SASE. Request portfolio review in original query. Art director will contact artist for portfolio review if interested. Portfolio should include thumbnails, final reproduction/product, tearsheets, photographs and "as much information as possible." Sometimes requests work on spec before assigning a job. Buys all rights. Considers buying second rights (reprint rights) to previously published work, depending on usage. "For costume books this is possible."

Book Design Pays by the project, rate varies.

Jackets/Covers Pays by the project, rate varies.

Text Illustration Pays by the project, rate varies.

Tips "Supply what is asked for in the listing and don't waste our time with calls and unnecessary cards. We usually select from those who submit samples of their work which we keep on file. Keep a permanent address so you can be reached."

PRAKKEN PUBLICATIONS, INC.

832 Phoenix Dr., P.O. Box 8623, Ann Arbor MI 48107. (734)975-2800. Fax: (734)975-2787. Web site: www.techdirections.com or http://eddigest.com. **Art/Design/Production Manager:** Sharon K. Miller. Estab. 1934. Publishes 2 magazines: *The Education Digest* and *Tech Directions*; text and reference books for technology and career/technical education. Specializes in vocational, technical, technology and general education. Recent titles: *Technology's Past*; *More Technology Projects for the Classroom*. Book catalog free by request.

Needs Rarely uses freelancers. 50% of freelance work demands knowledge of PageMaker. Works on assignment only.

First Contact & Terms Send samples. Samples are filed or are returned by SASE if requested by artist. Responds only if interested. Art director will contact artist for portfolio review if interested. Portfolio should include b&w and color final art and tearsheets.

PRO LINGUA ASSOCIATES

P.O. Box 1348, Brattleboro VT 05302-1348. (802)257-7779. Fax: (802)257-5117. E-mail: andy@Pr oLinguaAssociates.com. Web site: www.ProlinguaAssociates.com. **President:** Arthur A. Burrows. Estab. 1980. Publishes textbooks. Specializes in language textbooks. Recent titles: *Writing Strategies*; *Dictations for Discussion*. Publishes 3-8 titles/year. Most require freelance illustration. Book catalog free by request.

Needs Approached by 10 freelance artists/year. Works with 2-3 freelance illustrators/year. Uses freelance artists mainly for pedagogical illustrations of various kinds; also for jacket/cover and text illustration. Works on assignment only.

First Contact & Terms Send postcard sample and/or query letter with brochure, photocopies and photographs. Samples are filed. Responds in 1 month. Portfolio review not required. Buys all rights. Originals are returned at job's completion if requested. Finds artists through word of mouth and submissions.

Text Illustration Assigns 5 freelance illustration jobs/year. Pays by the project, $200-1,200.

PUSSYWILLOW

1212 Punta Gorda St. #13, Santa Barbara CA 93103. (805)899-2145. E-mail: bandanna@cox.net. **Publisher:** Birdie Newborn. Estab. 2002. Publishes fiction and poetry trade paperback originals. Types of books include erotic classics in translation for the connoisseur. Recent titles: *Wife of Bath* and *Aretino's Sonnetti Lussuriosi*.

Needs Sensual art.

First Contact & Terms Send samples, not originals. Responds in 2 months, only if interested.

Jackets/Covers Pays at least $200.

Text Illustration Pays by the project.

Tips "Send samples we can keep on file."

G.P. PUTNAM'S SONS, BOOKS FOR YOUNG READERS

Penguin Group USA, 345 Hudson St., 14th Floor, New York NY 10014-3657. (212)366-2000. Web site: http://us.penguingroup.com. **Art Director:** Cecilia Yung. Publishes hardcover juvenile books. Publishes 84 titles/year. Free catalog available.

Needs Illustration on assignment only.

First Contact & Terms Provide flier, tearsheet, brochure and photocopy to be kept on file for possible future assignments. Samples are returned by SASE only. "We take drop-offs on Tuesday mornings before noon and return them to the front desk after 4 p.m. the same day. Please call Ryan Thomann in advance with the date you want to drop of your portfolio. Do not send samples via e-mail or CDs."

Jackets/Covers Uses full-color illustrations with realistic painterly style.

Text Illustration Uses a wide cross section of styles for story and picture books.

QUITE SPECIFIC MEDIA GROUP LTD.

7373 Pyramid Place, Hollywood CA 90046. (323)851-5797. Fax: (323)851-5798. E-mail: info@quit especificmedia.com. Web site: www.quitespecificmedia.com. **President:** Ralph Pine. Estab. 1967. Publishes hardcover originals and reprints, trade paperback reprints and textbooks. Specializes in costume, fashion, theater and performing arts books. Recent titles: *Understanding Fashion*

History; *The Medieval Tailor's Assistant*. Publishes 12 titles/year. 10% require freelance illustration; 60% require freelance design.

- Imprints of Quite Specific Media Group Ltd. include Drama Publishers, Costume & Fashion Press, By Design Press, EntertainmentPro and Jade Rabbit.

Needs Works with 2-3 freelance designers/year. Uses freelancers mainly for jackets/covers; also for book, direct mail and catalog design and text illustration. Works on assignment only.

First Contact & Terms Send query letter with brochure and tearsheets. Samples are filed. Responds only if interested. Rights purchased vary according to project. Originals are not returned. Pays by the project.

RAINBOW BOOKS, INC.

P.O. Box 430, Highland City FL 33846-0430. (863)648-4420. Fax: (863)647-5951. E-mail: rbibooks @aol.com. Web site: www.rainbowbooksinc.com. **Media Buyer:** Betsy A. Lampe. Estab. 1979. Publishes hardcover and trade paperback originals. Types of books include instruction, adventure, biography, travel, self-help, mystery and reference. Specializes in nonfiction, self-help, mystery fiction, and how-to. Recent titles: *How to Handle Bullies and Teasers and Other Meanies* and *Bahamas West End Is Murder*. Publishes 20 titles/year.

Needs Approached by hundreds of freelance artists/year. Works with 2 illustrators/year. Prefers freelancers with experience in cover design and line illustration. Uses freelancers for jacket/cover illustration/design and text illustration. Needs computer-literate freelancers for design, illustration and production. 90% of freelance work demands knowledge of draw or design software programs. Works on assignment only.

First Contact & Terms Send brief query, tearsheets, photographs and book covers or jackets. Samples are not returned. Responds in 2 weeks. Art director will contact artist for portfolio review if interested. Portfolio should include b&w and color tearsheets, photographs and book covers or jackets. Rights purchased vary according to project. Originals are returned at job's completion.

Jackets/Covers Assigns 10 freelance illustration jobs/year. Pays by the project, $250-1,000.

Text Illustration Pays by the project. Prefers pen & ink or electronic illustration.

Tips "Nothing Betsy Lampe receives goes to waste. After consideration for Rainbow Books, Inc., artists/designers are listed for free in her newsletter (Florida Publishers Association *Sell More Books!* Newsletter), which goes out to over 100 independent presses. Then, samples are taken to the art department of a local school to show students how professional artists/designers market their work. Send samples (never originals); be truthful about the amount of time needed to complete a project; learn to use the computer. Study the competition (when doing book covers); don't try to write cover copy; learn the publishing business (attend small-press seminars, read books, go online, make friends with the local sales reps of major book manufacturers). Pass along what you learn. Do not query via e-mail attachment."

RAINBOW PUBLISHERS

P.O. Box 261129, San Diego CA 92196. (800)331-7337. Fax: (800)331-0297. E-mail: rbpub@earthli nk.net. **Creative Director:** Sue Miley. Estab. 1979. Publishes trade paperback originals. Types of books include religious books, reproducible Sunday School books for children ages 2-12, and Bible teaching books for children and adults. Recent titles: *Favorite Bible Children*; *Make It Take It Crafts*; *Worship Bulletins for Kids*; *Cut, Color & Paste*; *God's Girls*; *Gotta Have God*; *God and Me*. Publishes 20 titles/year. Book catalog available for SASE with 2 first-class stamps.

Needs Approached by hundreds of illustrators and 50 designers/year. Works with 5-10 illustrators and 5-10 designers/year. 100% of freelance design and illustration demands knowledge of Illustrator, Photoshop and QuarkXPress.

First Contact & Terms Send query letter with printed samples, SASE and tearsheets. Samples

are filed or returned by SASE. Responds only if interested. Will contact artist for portfolio review if interested. Finds freelancers through samples and personal referrals.

Book Design Assigns 25 freelance design jobs/year. Pays for design by the project, $350 minimum. Pays for art direction by the project, $350 minimum.

Jackets/Covers Assigns 25 freelance design jobs and 25 illustration jobs/year. "Prefers computer-generated, high-energy style with bright colors appealing to kids." Pays for design and illustration by the project, $350 minimum. "Prefers designers/illustrators with some Biblical knowledge."

Text Illustration Assigns 20 freelance illustration jobs/year. Pays by the project, $500 minimum. "Prefers black & white line art, preferably computer generated with limited detail yet fun."

Tips "We look for illustrators and designers who have some Biblical knowledge and excel in working with a fun, colorful, high-energy style that will appeal to kids and parents alike. Designers must be well versed in Quark, Illustrator and Photoshop, know how to visually market to kids and have wonderful conceptual ideas!"

RANDOM HOUSE CHILDREN'S BOOKS

Random House, Inc., 1745 Broadway, 10th Floor, New York NY 10019. (212)782-9000. Fax: (212)782-9452. Web site: www.randomhouse.com/kids. Largest English-language children's trade book publisher. Specializes in books for preschool children through young adult readers, in all formats from board books to activity books to picture books and novels. Recent titles: *How Many Seeds in a Pumpkin?*; *How Not to Start Third Grade*; *Spells & Sleeping Bags*; *The Power of One*. Publishes 250 titles/year. 100% require freelance illustration.

- The Random House publishing divisions hire their freelancers directly. To contact the appropriate person, send a cover letter and résumé to the department head at the publisher as follows: "Department Head" (e.g., Art Director, Production Director), "Publisher/Imprint" (e.g., Knopf, Doubleday, etc.), 1745 Broadway New York, NY 10019. See http://www.random house.com/kids/about/imprints.html for details of imprints.

Needs Works with 100-150 freelancers/year. Works on assignment only.

First Contact & Terms Send query letter with résumé, tearsheets and printed samples; no originals. Samples are filed. Negotiates rights purchased.

Book Design Assigns 5 freelance design jobs/year. Pays by the project.

Text Illustration Assigns 150 illustration jobs/year. Pays by the project.

☑ RED DEER PRESS

1800 Fourth St. SW, #1512, Calgary AB T2S 2S5 Canada. (403)509-0800. Fax: (403)228-6503. E-mail: rdp@reddeerpress.com. Web site: www.reddeerpress.com. **Publisher:** Dennis Johnson. Estab. 1975. Publishes hardcover and trade paperback originals. Types of books include contemporary and mainstream fiction, fantasy, biography, preschool, juvenile, young adult, humor and cookbooks. Specializes in contemporary adult and juvenile fiction, picture books and natural history for children. Recent titles: *The Queen's Feet* and *Roundup at the Palace*. 100% of titles require freelance illustration; 30% require freelance design. Book catalog available for SASE with Canadian postage.

Needs Approached by 50-75 freelance artists/year. Works with 10-12 freelance illustrators and 2-3 freelance designers/year. Buys 50 freelance illustrations/year. Prefers artists with experience in book and cover illustration. Also uses freelance artists for jacket/cover and book design and text illustration. Works on assignment only.

First Contact & Terms Send query letter with résumé, tearsheets, photographs and slides to Erin Woodward. Samples are filed. To show a portfolio, mail b&w slides and dummies. Rights purchased vary according to project. Originals are returned at job's completion.

Book Design Assigns 3-4 design and 6-8 illustration jobs/year. Pays by the project.

Jackets/Covers Assigns 6-8 design and 10-12 illustration jobs/year. Pays by the project, $300-1,000 Canadian.

Text Illustration Assigns 3-4 design and 4-6 illustration jobs/year. Pays by the project. May pay advance on royalties.

Tips Looks for freelancers with a proven track record and knowledge of Red Deer Press. "Send a quality portfolio, preferably with samples of book projects completed."

RED WHEEL/WEISER

500 Third St., Suite 230, San Francisco CA 94107. (415)978-2665. Fax: (415)869-1022. E-mail: dlinden@redwheelweiser.com. Web site: www.redwheelweiser.com. **Creative Director:** Donna Linden. Publishes trade hardcover and paperback originals and reprints. Imprints: Red Wheel (spunky self-help); Weiser Books (metaphysics/oriental mind-body-spirit/esoterica); Conari Press (self-help/inspirational). Publishes 50 titles/year.

Needs Uses freelancers for jacket/cover design and illustration.

First Contact & Terms Designers: Send résumé, photocopies and tearsheets. Illustrators: Send photocopies, photographs, SASE and tearsheets. "We can use art or photos. I want to see samples I can keep." Samples are filed or are returned by SASE only if requested by artist. Responds only if interested. Originals are returned to artist at job's completion. To show portfolio, mail tearsheets, color photocopies or slides. Considers complexity of project, skill and experience of artist, project's budget, turnaround time and rights purchased when establishing payment. Buys one-time nonexclusive rights. Finds most artists through references/word of mouth, portfolio reviews and samples received through the mail.

Jackets/Covers Assigns 20 design jobs/year. Prefers a variety of media—depends entirely on project. Pays by the project, $100-500.

Tips "Send samples by mail, preferably in color. We work electronically and prefer digital artwork or scans. Do not send drawings of witches, goblins and demons for Weiser Books; we don't put those kinds of images on our covers. Please take a moment to look at our books before submitting anything; we have characteristic looks for all three imprints."

Ⓝ SOUNDPRINTS

353 Main Ave., Norwalk CT 06851-1552. (203)846-2274. Fax: (203)846-1776. E-mail: soundprints @soundprints.com. Web site: www.soundprints.com. **Art Director:** Meredith Campbell Britton. Estab. 1989. Publishes hardcover originals. Types of books include juvenile. Specializes in wildlife, worldwide habitats, social studies and history. Recent titles: *Screech Owl at Midnight Hollow* by Drew Lamm, *Koala Country* by Deborah Dennand, *Box Turtle at Silver Pond Lane* by Susan Korman. Publishes 30 titles/year; 100% require freelance illustration. Book catalog available for 9×12 SASE with $1.21 postage.

Needs Works with 8-10 illustrators/year. Prefers freelancers with experience in realistic wildlife illustration and children's books. Heavy visual research required of artists. Uses freelancers for illustrating children's books (covers and interiors).

First Contact & Terms Send query letter with samples, tearsheets, résumé and SASE. Samples are filed or returned by SASE if requested by artist. Responds in 1 month. Art director will contact artist for portfolio review if interested. Portfolio should include color final art and tearsheets. Rights purchased vary according to project. Originals are returned at job's completion. Finds artists through agents, sourcebooks, referrals, unsolicited submissions.

Text Illustration Assigns 12-14 freelance illustration jobs/year.

Tips "We want realism, not cartoons. Animals illustrated are not anthropomorphic. Artists who love to produce realistic, well-researched wildlife and habitat illustrations, and who care deeply about the environment, are most welcome."

Ⓝ THE SPEECH BIN, INC.

P.O. Box 922668, Norcross GA 30010-2668. (770)449-5700. Fax: (770)510-7290. E-mail: info@spe echbin.com. Web site: www.speechbin.com. **Senior Editor:** Jan J. Binney. Estab. 1984. Publishes textbooks and educational games and workbooks for children and adults. Specializes in tests and materials for treatment of individuals with all communication disorders. Recent titles: *I Can Say R*; *I Can Say S*; *R & L Stories Galore*. Publishes 20-25 titles/year. 50% require freelance illustration; 50% require freelance design. Book catalog available on Web site.

Needs Works with 8-10 freelance illustrators and 2-4 designers/year. Buys 1,000 illustrations/ year. Work must be suitable for handicapped children and adults. Uses freelancers mainly for instructional materials, cover designs, gameboards, stickers; also for jacket/cover and text illustration. Occasionally uses freelancers for catalog design projects. Works on assignment only.

First Contact & Terms Send query letter with SASE, tearsheets and photocopies. Samples are filed or are returned by SASE if requested by artist. Responds only if interested. Do not send portfolio; query only. Usually buys all rights. Considers buying second rights (reprint rights) to previously published work. Finds artists through ''word of mouth, our authors, and submissions by artists.''

Book Design Pays by the project.

Jackets/Covers Assigns 10-12 freelance design jobs and 10-12 illustration jobs/year. Pays by the project.

Text Illustration Assigns 6-10 freelance illustration jobs/year. Prefers b&w line drawings. Pays by the project.

TORAH AURA PRODUCTIONS; ALEF DESIGN GROUP

4423 Fruitland Ave., Los Angeles CA 90058. (323)585-7312. Fax: (323)585-0327. E-mail: misrad@ torahaura.com. Web site: www.torahaura.com. **Art Director:** Jane Golub. Estab. 1981. Publishes hardcover and trade paperback originals, textbooks. Types of books include children's picture books, cookbooks, juvenile, nonfiction and young adult. Specializes in Judaica titles. Recent titles: *S'fatai Tiftan (Open My Lips)*; *I Have Some Questions About God*. Publishes 15 titles/year. 85% require freelance illustration. Book catalog free for 9×12 SAE with 10 first-class stamps.

Needs Approached by 50 illustrators and 20 designers/year. Works with 5 illustrators/year.

First Contact & Terms Illustrators: Send postcard sample and follow-up postcard every 6 months, printed samples, photocopies. Accepts Windows-compatible disk submissions. Samples are filed. Will contact artist for portfolio review if interested. Rights purchased vary according to project. Finds freelancers through submission packets.

Jackets/Covers Assigns 6-24 illustration jobs/year. Pays by the project.

Ⓝ 🔖 TORMONT PUBLICATIONS INC.

5532 St. Patrick, Montreal QC H4E 1A8 Canada. (514)954-1441. Fax: (514)954-1443. E-mail: sherry.segal@tormont.ca. **Publishing Director:** Sherry Segal. Estab. 1986. Specializes in children's books and stationery products. Publishes 60+ titles/year.

Needs Looking for creative and professional freelance illustrators, layout artists and graphic designers with experience in children's publishing. Must be able to work on strict deadlines with Illustrator, QuarkXPress and Photoshop.

First Contact & Terms Send portfolio by e-mail or postal mail. Art Director will contact artist only if there is interest. Buys all rights. Does not pay royalties.

Tips Tormont produces children's books that target the 3- to 7-year age group.

TREEHAUS COMMUNICATIONS, INC.

906 W. Loveland Ave., P.O. Box 249, Loveland OH 45140. (513)683-5716. Fax: (513)683-2882. E-mail: treehaus@treehaus1.com. Web site: www.treehaus1.com. **President:** Gerard Pottebaum.

Estab. 1973. Publisher. Specializes in books, periodicals, texts, TV productions. Product specialties are social studies and religious education. Recent titles: *The Stray*; *Rosanna The Rainbow Angel* (for children ages 4-8).

Needs Approached by 12-24 freelancers/year. Works with 2 or 3 freelance illustrators/year. Prefers freelancers with experience in illustrations for children. Works on assignment only. Uses freelancers for all work. 5% of work is with print ads. Needs computer-literate freelancers for illustration.

First Contact & Terms Send query letter with résumé, transparencies, photocopies and SASE. Samples are sometimes filed or returned by SASE if requested by artist. Responds in 1 month. Art director will contact artist for portfolio review if interested. Portfolio should include final art, tearsheets, slides, photostats and transparencies. Pays for design and illustration by the project. Rights purchased vary according to project. Finds artists through word of mouth, submissions and other publisher's materials.

Tips "We are looking for original style that is developed and refined. Whimsy helps."

TYNDALE HOUSE PUBLISHERS, INC.

351 Executive Dr., Carol Stream IL 60188. E-mail: talindaiverson@tyndale.com. Web site: www.tyndale.com. **Art Buyer:** Talinda Iverson. Estab. 1962. Publishes hardcover and trade paperback originals. Specializes in children's books on "Christian beliefs and their effect on everyday life." Publishes 150 titles/year. 20% require freelance illustration.

Needs Approached by 200-250 freelance artists/year. Works with 5-10 illustrators.

First Contact & Terms Send query letter and tearsheets. Samples are filed or are returned by SASE. Responds only if interested. Considers complexity of project, skill and experience of artist, project's budget and rights purchased when establishing payment. Negotiates rights purchased. Originals are returned at job's completion, except for series logos.

Jackets/Covers Assigns 5-10 illustration jobs/year. Prefers progressive but friendly style. Pays by the project.

Text Illustration Assigns 1-5 jobs/year. Prefers progressive but friendly style. Pays by the project.

Tips "Only show your best work. We are looking for illustrators who can tell a story with their work and who can draw the human figure in action when appropriate."

THE UNIVERSITY OF ALABAMA PRESS

P.O. Box 870380, Tuscaloosa AL 35487-0380. (205)348-5180 or (205)348-1571. Fax: (205)348-9201. E-mail: rcook@uapress.ua.edu. Web site: www.uapress.ua.edu. **Production Manager:** Rick Cook. Designer: Michele Myatt Quinn. Specializes in hardcover and paperback originals and reprints of academic titles. Publishes 75-85 titles/year. 35% require freelance design.

Needs Works with 5-6 freelancers/year. Requires book design experience, preferably with university press work. Works on assignment only. 100% of freelance design demands knowledge of Photoshop, QuarkXPress, InDesign.

First Contact & Terms Send query letter with résumé, tearsheets and slides. Accepts disk submissions if compatible with Macintosh versions of above programs, provided that a hard copy that is color accurate is also included. Samples not filed are returned only if requested. Responds in a few days. To show portfolio, mail samples, final reproduction/product or e-mail. Considers project's budget when establishing payment. Buys all rights. Originals are not returned.

Book Design Assigns 4-5 freelance jobs/year. Pays by the project, $600 minimum.

Jackets/Covers Assigns about 50 freelance design jobs/year. Pays by the project, $600 minimum.

Tips Has a limited freelance budget. "We often need artwork that is abstract or vague rather than very pointed or focused on an obvious idea. For book design, our requirements are that they be classy."

N: VOYAGEUR PRESS

MBI Publishing Company, 380 Jackson St., Suite 200, St. Paul MN 5510-3885. (651)287-5000. Fax: (651)287-5001. E-mail: mlabarre@mbipublishing.com. Web site: www.mbipublishing.com; www.voyageurpress.com. **Contact:** Publishing Assistant. Estab. 1972. Publishes hardcover originals and reprints. Subjects include regional history, nature, popular culture, travel, wildlife, Americana, collectibles, lighthouses, quilts, tractors, barns and farms. Specializes in natural history, travel and regional subjects. Recent titles: *Legendary Route 66: A Journey Through Time Along America's Mother Road*; *Illinois Central Railroad*; *Birds in Love: The Secret Courting & Mating Rituals of Extraordinary Birds*; *Backroads of New York*; *How to Raise Cattle*; *Knitknacks*; *Much Ado About Knitting*; *Farmall: The Red Tractor that Revolutionzed Farming*; *Backroads of Ohio*; *Farmer's Wife Baking Cookbook*; *John Deere Two-Cylinder Tractor Encyclopedia*. Publishes 50 titles/year. 10% require freelance illustration; 10% require freelance design. Book catalog free by request.

Needs Approached by 100 freelance artists/year. Works with 2-5 freelance illustrators and 2-5 freelance designers/year. Prefers artists with experience in maps and book and cover design. Uses freelance artists mainly for cover and book design; also for jacket/cover illustration and direct mail and catalog design. 100% of design requires computer skills. Works on assignment only.

First Contact & Terms Send postcard sample and/or query letter with brochure, photocopies, tearsheets, list of credits and samples of work that need not be returned. Samples are filed. Responds only if interested. "We do not review portfolios unless we have a specific project in mind. In that case, we'll contact artist for a portfolio review." Usually buys first rights. Originals are returned at job's completion.

Book Design Assigns 2-5 freelance design jobs and 2-5 freelance illustration jobs/year.

Jackets/Covers Assigns 2-5 freelance design and 2-5 freelance illustration jobs/year.

Text Illustration Assigns 2-5 freelance design and 2-5 design illustration jobs/year.

Tips "We use more book designers than artists or illustrators, since most of our books are illustrated with photographs."

WEIGL EDUCATIONAL PUBLISHERS LIMITED

6325-10th St. SE, Calgary AB T2H 2Z9 Canada. (403)233-7747. Fax: (403)233-7769. E-mail: linda @weigl.com. Web site: www.weigl.com. **Contact:** Managing Editor. Estab. 1979. Textbook and library series publisher catering to juvenile and young adult audience. Specializes in social studies, science-environmental, life skills, multicultural American and Canadian focus. Titles include: *The Love of Sports*; *A Guide to American States*; *20th Century USA*. Publishes over 100 titles/year. Book catalog free by request.

Needs Approached by 300 freelancers/year. Uses freelancers only during peak periods. Prefers freelancers with experience in children's text illustration in line art/watercolor. Uses freelancers mainly for text illustration or design; also for direct mail design. Freelancers should be familiar with QuarkXPress 5.0, Illustrator 10.0 and Photoshop 7.0.

First Contact & Terms Send résumé for initial review prior to selection for interview. Limited freelance opportunities. Graphic designers required on site. Extremely limited need for illustrators. Samples are returned by SASE if requested by artist. Responds only if interested. Write for appointment to show portfolio of original/final art (small), b&w photostats, tearsheets and photographs. Rights purchased vary according to project.

Text Illustration Pays on per-project basis, depending on job. Prefers line art and watercolor appropriate for elementary and secondary school students.

WHALESBACK BOOKS

P.O. Box 9546, Washington DC 20016. (202)333-2182. Fax: (202)333-2184. E-mail: hhi@ix.netco m.com. **Publisher:** W. D. Howells. Estab. 1988. Imprint of Howells House. Company publishes

hardcover and trade paperback originals and reprints. Types of books include biography, history, art, architecture, social and human sciences. Publishes 4 print, 2 online titles/year. 80% require freelance illustration; 80% require freelance design.

Needs Approached by 6-8 freelance artists/year. Works with 1-2 freelance illustrators and 1-3 freelance designers/year. Buys 10-20 freelance illustrations/job. Prefers local artists with experience in color and desktop. Uses freelance artists mainly for illustration and book/jacket design. Also uses freelance artists for jacket/cover illustration and design; text, direct mail, book and catalog design. 20-40% of freelance work demands knowledge of PageMaker, Illustrator or QuarkXPress. Works on assignment only.

First Contact & Terms Send query letter with brochure, SASE and photocopies. Samples are not filed and are returned by SASE if requested by artist. Responds only if interested. Art Director will contact artist for portfolio review if interested. Portfolio should include b&w roughs and photostats. Rights purchased vary according to project.

Book Design Assigns 2-4 freelance design jobs/year. Pays by the project.

Jackets/Covers Assigns 2-4 freelance design jobs/year. Pays by the project.

Text Illustration Assigns 6-8 freelance illustration jobs/year. Pays by the project.

WHITE MANE PUBLISHING COMPANY, INC.

73 W. Burd St., P.O. Box 708, Shippensburg PA 17257. (717)532-2237. Fax: (717)532-6110. Web site: www.whitemane.com. **Vice President:** Harold Collier. Estab. 1987. Publishes hardcover originals and reprints, trade paperback originals and reprints. Types of books include historical biography, biography, history, juvenile, nonfiction and young adult. Publishes 70 titles/year. 10% require freelance illustration. Book catalog free with SASE.

Needs Works with 2-3 illustrators and 2 designers/year.

First Contact & Terms Send query letter with printed samples. Samples are filed. Interested only in historic artwork. Responds only if interested. Will contact artist for portfolio review if interested. Rights purchased vary according to project. Finds freelancers through submission packets and postcards.

Jackets/Covers Assigns 8 illustration jobs/year. Pays for design by the project.

Tips Uses art for covers only—historical scenes for young adults.

ALBERT WHITMAN & COMPANY

6340 Oakton, Morton Grove IL 60053-2723. (847)581-0033. Fax: (847)581-0039. E-mail: mail@aw hitmanco.com. Web site: www.albertwhitman.com. **Art Director:** Carol Gildar. Publishes hardcover originals. Specializes in juvenile fiction and nonfiction—many picture books for young children. Recent titles: *Mabella the Clever* by Margaret Read MacDonal; *Bravery Soup* by Maryann Cocca-Leffle. Publishes 35 titles/year; 100% require freelance illustration.

Needs Prefers working with artists who have experience illustrating juvenile trade books. Works on assignment only.

First Contact & Terms Illustrators: Send postcard sample and tearsheets. "One sample is not enough. We need at least three. Do *not* send original art through the mail." Accepts disk submissions. Samples are not returned. Responds "if we have a project that seems right for the artist. We like to see evidence that an artist can show the same children and adults in a variety of moods, poses and environments." Rights purchased vary. Original work returned at job's completion.

Cover/Text Illustration Cover assignment is usually part of text illustration assignment. Assigns 2-3 covers per year. Prefers realistic and semi-realistic art. Pays by flat fee for covers; royalties for picture books.

Tips Books need "a young look—we market to preschoolers and children in grades 1-3." Especially looks for "an artist's ability to draw people (especially children) and to set an appropriate mood for the story. Please do NOT submit cartoon art samples or flat digital illustrations."

WILSHIRE BOOK CO.
9731 Variel Ave., Chatsworth CA 91311. E-mail: mpowers@mpowers.com. Web site: www.mpo wers.com. **President:** Melvin Powers. Publishes trade paperback originals and reprints. Types of books include Internet marketing, humor, instructional, New Age, psychology, self-help, inspirational and other types of nonfiction. Recent titles: *Think Like a Winner!*, *The Dragon Slayer with a Heavy Heart* and *The Knight in Rusty Armor*. Publishes 25 titles/year; 100% require freelance design.

Needs Uses freelancers mainly for book covers.

First Contact & Terms Send query letter with fee schedule, tearsheets, photostats, photocopies (copies of previous book covers).

Book Design Assigns 25 freelance design jobs/year.

Jackets/Covers Assigns 25 cover jobs/year.

Greeting Cards, Gifts & Products

© Janet Stever

The companies listed in this section contain some great potential clients for you. Although greeting card publishers make up the bulk of the listings, you'll also find many businesses that need images for all kinds of other products. We've included manufacturers of everyday items such as paper plates, napkins, banners, shopping bags, T-shirts, school supplies, personal checks and calendars, as well as companies looking for fine art for limited edition collectibles.

TIPS FOR GETTING STARTED

1. Read the listings carefully to learn exactly what products each company makes and the specific styles and subject matter they use.

2. Browse store shelves to see what's out there. Take a notebook and jot down the types of cards and products you see. If you want to illustrate greeting cards, familiarize yourself with the various categories of cards and note which images tend to appear again and again in each category.

3. Pay attention to the larger trends in society, such as diversity, patriotism, and the need to feel connected to others. Fads such as reality TV and scrapbooking, as well as popular celebrities, often show up in images on cards and gifts. Trends can also be spotted in movies and on Web sites.

GUIDELINES FOR SUBMISSION

- Do *not* send originals. Companies want to see photographs, photocopies, printed samples, computer printouts, tearsheets or slides. Many also accept digital files on disc or via e-mail.
- Artwork should be upbeat, brightly colored, and appropriate to one of the major categories or niches popular in the industry.
- Make sure each sample is labeled with your name, address, phone number, e-mail address and Web site.
- Send three to five appropriate samples of your work to the contact person named in the listing. Include a brief cover letter with your initial mailing.
- Enclose a self-addressed, stamped envelope if you need your samples back.
- Within six months, follow up with another mailing to the same listings and additional card and gift companies you have researched.

Don't overlook the collectibles market

Limited edition collectibles, such as ornaments, figurines and collector plates, appeal to a wide audience and are a lucrative niche for artists. To do well in this field, you have to be

Greeting Card Basics

Important

- **Approximately 7 billion** greeting cards are purchased annually, generating more than $7.5 billion in retail sales.

- **Women** buy more than 80% of all greeting cards.

- **Seasonal cards** express greetings for more than 20 different holidays, including Christmas, Easter and Valentine's Day. Christmas cards account for 60% of seasonal greeting card sales.

- **Everyday cards** express nonholiday sentiments. The "everyday" category includes get well cards, thank you cards, sympathy cards, and a growing number of person-to-person greetings. There are cards of encouragement that say "Hang in there!" and cards to congratulate couples on staying together, or even getting divorced! There are cards from "the gang at the office" and cards to beloved pets. Check store racks for possible "everyday" occasions.

- **Categories** are further broken down into the following areas: **traditional**, **humorous** and **alternative**. "Alternative" cards feature quirky, sophisticated or offbeat humor.

- **There are more than 2,000 greeting card publishers in America,** ranging from small family businesses to major corporations.

flexible enough to take suggestions. Companies test-market products to find out which images will sell the best, so they will guide you in the creative process. For a collectible plate, for example, your work must fit into a circular format or you'll be asked to extend the painting out to the edge of the plate.

Popular themes for collectibles include animals (especially kittens and puppies), children, dolls, TV nostalgia, and patriotic, Native American, wildlife, religious (including madonnas and angels), gardening, culinary and sports images.

E-cards

If you are at all familiar with the Internet, you know that electronic greeting cards are very popular. Many can be sent for free, but they drive people to Web sites and can, therefore, be a smart marketing tool. The most popular e-cards are animated, and there is an increasing need for artists who can animate their own designs for the Web, using Flash animation. Search the Web and visit sites such as www.hallmark.com, www.bluemountain.com and www.americangreetings.com to get an idea of the variety of images that appear on e-cards. Companies often post their design needs on their Web sites.

PAYMENT AND ROYALTIES

Most card and product companies pay set fees or royalty rates for design and illustration. Card companies almost always purchase full rights to work, but some are willing to negotiate for other arrangements, such as greeting card rights only. If the company has ancillary plans

in mind for your work (calendars, stationery, party supplies or toys), they will probably want to buy all rights. In such cases, you may be able to bargain for higher payment. For more tips, see Copyright Basics on page 18.

Helpful Resources

For More Info

Greetings etc. (www.greetingsmagazine.com) is the official publication of the **Greeting Card Association** (www.greetingcard.org). Subscribe online, and sign up for a free monthly e-newsletter.

Party & Paper is a trade magazine focusing on the party niche. Visit www.partypaper.com for industry news and subscription information.

The National Stationery Show is the "main event" of the greeting card industry. Visit www.nationalstationeryshow.com to learn more.

Greeting Cards & Gifts

Ⓝ KURT S. ADLER, INC.
7 W. 34th St., Suite 100, New York NY 10001-3019. (212)924-0900. Fax: (212)807-0575. E-mail: info@kurtadler.com. Web site: www.kurtadler.com. **President:** Howard Adler. Estab. 1946. Manufacturer and importer of Christmas ornaments and giftware products. Produces collectible figurines, decorations, gifts, ornaments.
Needs Prefers freelancers with experience in giftware. Considers all media. Will consider all styles appropriate for Christmas ornaments and giftware. Produces material for Christmas, Halloween.
First Contact & Terms Send query letter with brochure, photocopies, photographs. Responds within 1 month. Will contact for portfolio review if interested. Payment negotiable.
Tips "We rely on freelance designers to give our line a fresh, new approach and innovative new ideas."

ALLPORT EDITIONS
2337 NW York St., Portland OR 97210-2112. (503)223-7268. Fax: (503)223-9182. E-mail: art@allport.com. Web site: www.allport.com. **Contact:** Creative Director. Estab. 1983. Produces greeting cards and stationery. Specializes in fine art, humor, florals, animals and collage. Art guidelines available on Web site.
Needs Approached by 200 freelancers/year. Works with 5-10 freelancers/year. Licenses 80 freelance designs and illustrations/year. Prefers art scaleable to card size. Produces material for all holidays and seasons, birthdays and everyday. Submit seasonal material 1 year in advance.
First Contact & Terms Send query letter with photocopies or photographs and SASE. Accepts submissions on disk compatible with PC-formatted TIFF or JPEG files with Illustrator, Photoshop or Quark document. Samples are filed or returned by SASE. Responds in 3-5 months, "if response is requested." Rights purchased vary according to project. All contracts on royalty basis. Pays for illustration by the project. Finds freelancers through submissions and SURTEX in New York.
Tips "Submit enough samples for us to get a feel for your style/collection. Two is probably too few; forty is too many."

AMCAL, INC.

MeadWestvaco Consumer & Office Products, 4751 Hempstead Station Dr., Kettering OH 45429. (937)495-6323. Fax: (937)495-3192. E-mail: calendars@meadwestvaco.com. Web site: www.amc alart.com or www.meadwestvaco.com. Publishes calendars, note cards, Christmas cards and other stationery items and books. Markets to a broad distribution channel, including better gifts, books, department stores and larger chains throughout U.S. Some sales to Europe, Canada and Japan. "We look for illustration and design that can be used in many ways: calendars, note cards, address books and more, so we can develop a collection. We license art that appeals to a widely female audience."

Needs Prefers work in horizontal format. No gag humor or cartoons. Art guidelines available for SASE with first-class postage or on Web site.

First Contact & Terms Send query letter with brochure, résumé, photographs, slides, tearsheets and transparencies. Include a SASE for return of material. Responds within 6 weeks. Will contact artist for portfolio review if interested. Pays for illustration by the project, advance against royalty.

Tips "Research what is selling and what's not. Go to gift shows and visit lots of stationery stores. Read all the trade magazines. Talk to store owners."

AMERICAN GREETINGS CORPORATION

One American Rd., Cleveland OH 44144. (216)252-7300. Fax: (216)252-6778. E-mail: dan.weiss@ amgreetings.com. Web site: www.corporate.americangreetings.com. Estab. 1906. Produces greeting cards, stationery, calendars, paper tableware products, giftwrap and ornaments. Also recruiting for AG Interactive.

Needs Prefers designers with experience in illustration, graphic design, surface design and calligraphy. Also looking for skills in motion graphics, Photoshop, animation and strong drawing skills. Usually works from a list of 100 active freelancers.

First Contact & Terms Apply online. "Do not send samples." Pays $300 and up based on complexity of design. Does not offer royalties.

Tips "Get a BFA in graphic design with a strong emphasis on typography."

ANW CRESTWOOD; THE PAPER COMPANY; PAPER ADVENTURES

501 Ryerson Rd., Lincoln Park NJ 07035. (973)406-5000. Fax: (973)709-9494. E-mail: katey@anw crestwood.com. Web site: www.anwcrestwood.com. **Creative Department Contact:** Katey Franceschini. Estab. 1901. Produces stationery, scrapbook and paper crafting. Specializes in stationery, patterned papers, stickers and related paper products.

Needs Approached by 100 freelancers/year. Works with 20 freelancers/year. Buys or licenses 150 freelance illustrations and design pieces/year. Prefers freelancers with experience in illustration/fine art, stationery design/surface design. Works on assignment only. Considers any medium that can be scanned.

First Contact & Terms Mail or e-mail nonreturnable color samples. Company will call if there is a current or future project that is relative. Accepts Mac-compatible disk and e-mail submissions. Samples are filed for future projects. Will contact artist for more samples and to discuss project. Pays for illustration by the project, $100 and up. Also considers licensing for complete product collections. Finds freelancers through trade shows and *Artist's & Graphic Designer's Market*.

Tips "Research the craft and stationery market and send only appropriate samples for scrapbooking, cardcrafting and stationery applications. Send lots of samples, showing your best, neatest and cleanest work with a clear concept."

APPLEJACK ART PARTNERS

P.O. Box 1527, Historic Rt. 7A, Manchester Center VT 05255. (802)362-3662. Fax: (802)362-3286. E-mail: jess@applejackart.com. Web site: www.applejackart.com. **Manager of Art Sourcing and**

Artist Support: Jess Rogers. Licenses art for balloons, bookmarks, calendars, CD-ROMs, collectible figurines, decorative housewares, decorations, games, giftbags, gifts, giftwrap, greeting cards, limited edition plates, mugs, ornaments, paper tableware, party supplies, personal checks, posters, prints, school supplies, stationery, T-shirts, textiles, toys, wallpaper, etc.

- Long-established poster companies Bernard Fine Art, Hope Street Editions and Rose Selavy of Vermont are divisions of Applejack Art Partners. See separate listings in the Posters & Prints section.

Needs Seeking extensive artwork for use on wide cross section of product categories. Looking for variety of styles and subject matter. Art guidelines free for SASE with first-class postage. Considers all media and all styles. Produces material for all holidays.

First Contact & Terms Send brochure, photocopies, photographs, tearsheets, CD-ROM. No e-mail submissions. Accepts disk submissions compatible with Photoshop, Quark or Illustrator. Samples are filed or returned by SASE only. Responds in 1 month. Will contact artist for portfolio review if interested. Portfolio should include color final art, photographs, photostats, roughs and tearsheets.

AR-EN PARTY PRINTERS, INC.

8225 N. Christiana Ave., Skokie IL 60076. (847)673-7390. Fax: (847)673-7379. E-mail: info@ar-en.net. Web site: www.ar-en.com. **Owner:** Gary Morrison. Estab. 1978. Produces stationery and paper tableware products. Makes personalized party accessories for weddings and all other affairs and special events.

Needs Works with 1-2 freelancers/year. Buys 10 freelance designs and illustrations/year. Works on assignment only. Uses freelancers mainly for new designs; also for calligraphy. Looking for contemporary and stylish designs, especially b&w line art (no grayscale) to use for hot stamping dyes. Prefers small (2×2) format.

First Contact & Terms Send query letter with brochure, résumé and SASE. Samples are filed or returned by SASE if requested by artist. Responds in 2 weeks. Will contact artist for portfolio review if interested. Rights purchased vary according to project. Pays by the hour, $40 minimum; by the project, $750 minimum.

Tips "My best new ideas always evolve from something I see that turns me on. Do you have an idea/style that you love? Market it. Someone out there needs it."

ART LICENSING INTERNATIONAL INC.

7350 S. Tamiami Trail #227, Sarasota FL 34231. (941)966-8912. Fax: (941)966-8914. E-mail: artlicensing@comcast.net. Web site: www.out-of-the-blue.us. **President:** Michael Woodward. Licenses art and photography for fine art prints, wall decor, calendars, paper products and greeting cards.

- See additional listings for this company in the Posters & Prints and Artists' Reps sections. See also listing for Out of the Blue in this section.

ARTFUL GREETINGS

P.O. Box 52428, Durham NC 27717. (919)484-0100. Fax: (919)484-3099. E-mail: myw@artfulgree tings.com. Web site: www.artfulgreetings.com. **Vice President of Operations:** Marian Whittedalderman. Estab. 1990. Produces bookmarks, greeting cards, T-shirts and magnetic notepads. Specializes in multicultural subject matter, all ages.

Needs Approached by 200 freelancers/year. Works with 10 freelancers/year. Buys 20 freelance designs and illustrations/year. No b&w art. Uses freelancers mainly for cards. Considers bright color art, no photographs. Looking for art depicting people of all races. Prefers a multiple of 2 sizes: 5×7 and $5^1/_2 \times 8$. Produces material for Christmas, Mother's Day, Father's Day, graduation, Kwanzaa, Valentine's Day, birthdays, everyday, sympathy, get well, romantic, thank you,

woman-to-woman and multicultural. Submit seasonal material 1 year in advance.

First Contact & Terms Designers: Send photocopies, SASE, slides, transparencies (call first). Illustrators: Send photocopies (call first). May send samples and queries by e-mail. Samples are filed. Artist should follow up with call or letter after initial query. Will contact for portfolio review of color slides and transparencies if interested. Negotiates rights purchased. Pays for illustration by the project, $50-100. Finds freelancers through word of mouth, NY Stationery Show.

Tips "Don't sell your one, recognizable style to all the multicultural card companies."

ARTVISIONS™

Web site: www.artvisions.com. Licensing agency. "Not currently seeking new talent. However, we are always willing to view the work of top-notch established artists. For details and contact information, please see our listing in the Artists' Reps section."

BARTON-COTTON INC.

1405 Parker Rd., Baltimore MD 21227. (410)247-4800. Fax: (410)247-3681. E-mail: carol.bell@bar toncotton.com. Web site: www.bartoncotton.com. **Art Buyer:** Carol Bell. Produces religious greeting cards, commercial all-occasion, Christmas cards, wildlife designs and spring note cards. Licenses wildlife art, photography, traditional Christmas art for note cards, Christmas cards, calendars and all-occasion cards.

Needs Buys 150-200 freelance illustrations/year. Submit seasonal work any time. Free art guidelines for SASE with first-class postage and sample cards; specify area of interest (religious, Christmas, spring, etc.).

First Contact & Terms Send query letter with résumé, tearsheets, photocopies or slides. Submit full-color work only (watercolor, gouache, pastel, oil and acrylic). Previously published work and simultaneous submissions accepted. Responds in 1 month. Pays by the project. Pays on acceptance.

Tips "Good draftsmanship is a must. Spend some time studying current market trends in the greeting card industry. There is an increased need for creative ways to paint traditional Christmas scenes with up-to-date styles and techniques."

BERGQUIST IMPORTS, INC.

1412 Hwy. 33 S., Cloquet MN 55720. (218)879-3343. Fax: (218)879-0010. E-mail: bbergqu106@ao l.com. Web site: www.bergquistimports.com. **President:** Barry Bergquist. Estab. 1948. Produces paper napkins, mugs and tile. Wholesaler of mugs, decorator tile, plates and dinnerware.

 ● See additional listing in the Posters & Prints section.

Needs Approached by 25 freelancers/year. Works with 5 freelancers/year. Buys 50 designs and illustrations/year. Prefers freelancers with experience in Scandinavian designs. Works on assignment only. Also uses freelancers for calligraphy. Produces material for Christmas, Valentine's Day and everyday. Submit seasonal material 6-8 months in advance.

First Contact & Terms Send query letter with brochure, tearsheets and photographs. Samples are returned, not filed. Responds in 2 months. Request portfolio review in original query. Artist should follow up with a letter after initial query. Portfolio should include roughs, color tearsheets and photographs. Rights purchased vary according to project. Originals are returned at job's completion. Requests work on spec before assigning a job. Pays by the project, $50-300; average flat fee of $100 for illustration/design; or royalties of 5%. Finds artists through word of mouth, submissions/self-promotions and art fairs.

BLUE MOUNTAIN ARTS

P.O. Box 1007, Boulder CO 80306. (303)417-6513. Fax: (303)447-0939. E-mail: jkauflin@sps.com. Web site: www.sps.com. **Art Director:** Jody Kauflin. Estab. 1970. Produces books, bookmarks,

calendars, greeting cards, mugs and prints. Specializes in handmade-looking greeting cards, calendars and books with inspirational or whimsical messages accompanied by colorful hand-painted illustrations.

Needs Art guidelines free with SASE and first-class postage or on Web site. Uses freelancers mainly for hand-painted illustrations. Considers all media. Product categories include alternative cards, alternative/humor, conventional, cute, inspirational and teen. Submit seasonal material 10 months in advance. Art size should be 5×7 vertical format for greeting cards.

First Contact & Terms Send query letter with photocopies, photographs, SASE and tearsheets. Send no more than 5 illustrations initially. No phone calls, faxes or e-mails. Samples are filed or are returned by SASE. Responds in 2 months. Portfolio not required. Buys all rights. Pays freelancers flat rate: $150-250/illustration if chosen. Finds freelancers through submissions and word of mouth.

Tips "We are an innovative company, always looking for fresh and unique art styles to accompany our sensitive or whimsical messages. We also welcome illustrated cards accompanied with your own editorial content. We strive for a handmade look. We love color! We don't want photography! We don't want slick computer art! Do in-store research to get a feel for the look and content of our products. We want illustrations for printed cards, NOT E-CARDS! We want to see illustrations that fit with our existing looks, and we also want fresh, new and exciting styles and concepts. Remember that people buy cards for what they say. The illustration is a beautiful backdrop for the message."

BLUE SKY PUBLISHING

6595 Odell Place, Suite C, Boulder CO 80301. (303)530-4654. E-mail: bspinfo@blueskypublishing. net. Web site: www.blueskypublishing.net. **Contact:** Robert Marqueen. Estab. 1989. Produces greeting cards. "At Blue Sky Publishing, we are committed to producing contemporary fine art greeting cards that communicate reverence for nature and all creatures of the earth, that express the powerful life-affirming themes of love, nurturing and healing, and that share different cultural perspectives and traditions, while maintaining the integrity of our artists' work. Our mainstay is our photographic card line of Winter in the West and other breathtaking natural scenes. We use well known landmarks in Arizona, New Mexico, Colorado and Utah for cards that businesses in the West purchase as their corporate holiday greeting cards."

Needs Approached by 500 freelancers/year. Works with 3 freelancers/year. Licenses 10 fine art pieces/year. Works with freelancers from all over U.S. Prefers freelancers with experience in fine art media: oils, oil pastels, acrylics, calligraphy, vibrant watercolor and fine art photography. Art guidelines available for SASE. "We primarily license existing pieces of art or photography. We rarely commission work." Looking for colorful, contemporary images with strong emotional impact. Art guidelines available for SASE with first-class postage. Produces cards for all occasions. Submit seasonal material 1 year in advance.

First Contact & Terms Send query letter with SASE, slides or transparencies. Samples are filed or returned if SASE is provided. Responds in 4 months if interested. Transparencies are returned at job's completion. Pays royalties of 3% with a $150 advance against royalties. Buys greeting card rights for 5 years (standard contract; sometimes negotiated).

Tips "We're interested in seeing artwork with strong emotional impact. Holiday cards are what we produce in biggest volume. We are looking for joyful images; cards dealing with relationships, especially between men and women, with pets, with Mother Nature and folk art. Vibrant colors are important."

[N] ASHLEIGH BRILLIANT ENTERPRISES

117 W. Valerio St., Santa Barbara CA 93101. (805)682-0531. **President:** Ashleigh Brilliant. Publishes postcards.

• See additional listing in the Syndicates & Cartoon Features section.

Needs Buys up to 300 designs/year. Freelancers may submit designs for word-and-picture postcards, illustrated with line drawings.

First Contact & Terms Submit $5^{1}/_{2} \times 3^{1}/_{2}$ horizontal b&w line drawings and SASE. Responds in 2 weeks. Buys all rights. Pays $60 minimum.

Tips "Since our approach is very offbeat, it is essential that freelancers first study our line. Otherwise, you will just be wasting our time and yours. We supply a catalog and sample set of cards for $2 plus SASE."

BRISTOL GIFT CO., INC.

P.O. Box 425, Washingtonville NY 10992. (845)496-2821. Fax: (845)496-2859. E-mail: bristol6@frontiernet.net. Web site: www.bristolgift.net. **President:** Matthew Ropiecki. Estab. 1988. Specializes in framed pictures for inspiration and religious markets. Art guidelines available for SASE.

Needs Approached by 5-10 freelancers/year. Works with 2 freelancers/year. Buys 15-30 freelance designs and illustrations/year. Works on assignment only. Uses freelancers mainly for design; also for calligraphy, P-O-P displays, Web design and mechanicals. Prefers 16×20 or smaller. 10% of design and 60% of illustration require knowledge of PageMaker or Illustrator. Produces material for Christmas, Mother's Day, Father's Day and graduation. Submit seasonal material 6 months in advance.

First Contact & Terms Send query letter with brochure and photocopies. Samples are filed or returned. Responds in 2 weeks. Will contact artist for portfolio review if interested. Portfolio should include roughs. Requests work on spec before assigning a job. Originals are not returned. Pays by the project, $30-50 or royalties of 5-10%. Rights purchased vary according to project. Interested in buying second rights (reprint rights) to previously published artwork.

BRUSH DANCE INC.

165 N. Redwood Dr., Suite 200, San Rafael CA 94903. (800)531-7445. Fax: (415)491-4938. E-mail: lkalloch@brushdance.com. Web site: www.brushdance.com. **Art Director:** Liz Kalloch. Estab. 1989. Produces greeting cards, stationery, blank journals, illustrated journals, boxed notes, calendars, holiday cards and magnets. "The line of Brush Dance products is inspired by the interplay of art and words. We develop products that combine powerful and playful words and images that act as daily reminders to inspire, connect, challenge and support."

Needs Approached by 200 freelancers/year. Works with 3-5 freelancers/year. Uses freelancers for illustration, photography and calligraphy. Looking for nontraditional work conveying emotion or message. "We are also interested in artists who are using both images and original words in their work."

First Contact & Terms Check Web site for guidelines. Send query letter and tearsheets or color copies of your work. "Please don't send us transparencies, and never send originals." Samples are filed or returned by SASE. Pays on a royalty basis with percentage depending on product. Finds artists through word of mouth, submissions, art shows.

Tips "*Please* do your research, and look at our Web site to be sure your work will fit into our line of products."

▣ CARAVAN INTERNATIONAL, INC.

4699 Nautilus Court, Suite 205, Boulder CO 80301. (303)516-0700. **President:** Dale E. Byars. Estab. 1985. Produces bookmarks, gifts, magnets, multicultural greeting cards, stationery, T-shirts.

Needs Uses freelancers mainly for new images; also for calligraphy, P-O-P. Looking for Celtic, Hispanic, African-American, Farsi, French, German, Native American, Asian, multicultural and calligraphy. 10% of freelance work demands computer skills. Produces material for Christmas,

Rosh Hashana, Kwanzaa, Hannukkah, New Year, birthdays and everyday. Submit seasonal material 4 months in advance, and all others by July 15.

First Contact & Terms Send query letter with photocopies, slides and transparencies. Samples are filed or returned by SASE. Responds within 3 months. Will contact artist for portfolio review of slides and transparencies if interested. Rights purchased vary according to project. Pays by the project, $50-350; royalties of 2-5% for licensed sales.

CARDMAKERS
P.O. Box 236, Lyme NH 03768. Phone/fax: (603)795-4422. E-mail: info@cardmakers.com. Web site: www.cardmakers.com. **Principal:** Peter Diebold. Estab. 1978. Produces greeting cards. "We produce cards for special interests and greeting cards for businesses—primarily Christmas. We also publish everyday cards for stockbrokers and boaters."

- CardMakers requests if you send submissions via e-mail, please keep files small. When sending snail mail, please be aware they will only respond if SASE is included.

Needs Approached by more than 300 freelancers/year. Works with 5-10 freelancers/year. Buys 20-40 designs and illustrations/year. Prefers professional-caliber artists. Art guidelines available on Web site only. "Please do not e-mail us for same." Works on assignment only. Uses freelancers mainly for greeting card design and calligraphy. Considers all media. "We market 5×7 cards designed to appeal to individual's specific interest—boating, building, cycling, stocks and bonds, etc." Prefers an upscale look. Submit seasonal ideas 6-9 months in advance.

First Contact & Terms Designers: Send brief sample of work. Illustrators: Send postcard sample or query letter with brief sample of work. "One good sample of work is enough for us. A return postcard with boxes to check off is wonderful. Phone calls are out; fax is a bad idea." Samples are filed. Responds only if interested. Portfolio review not required. Pays flat fee of $100-300, depending on many variables. Rights purchased vary according to project. Interested in buying second rights (reprint rights) to previously published work, if not previously used for greeting cards. Finds artists through word of mouth, exhibitions and *Artist's & Graphic Designer's Market* submissions.

Tips "We like to see new work in the early part of the year. It's important that you show us samples *before* requesting submission requirements. Getting published and gaining experience should be the main objective of freelancers entering the field. We favor fresh talent (but do also feature seasoned talent). PLEASE be patient waiting to hear from us! Make sure your work is equal to or better than that which is commonly found in use presently. Go to a large greeting card store. If you think you're as good or better than the artists there, continue!"

N CAROLE JOY CREATIONS, INC.
1087 Federal Rd., Unit #8, Brookfield CT 06804. Fax: (203)740-4495. Web site: www.carolejoy.com. **President:** Carole Gellineau. Estab. 1985. Produces greeting cards. Specializes in cards, notes and invitations for people who share an African heritage.

Needs Approached by 200 freelancers/year. Works with 5-10 freelancers/year. Buys 100 freelance designs, illustrations and calligraphy/year. Will license design where appropriate. Also interested in licensing 12 coordinated images for calendars. Prefers artists "who are thoroughly familiar with, educated in and sensitive to the African-American culture." Works on assignment only. Uses freelancers mainly for greeting card art; also for calligraphy. Considers full color only. Looking for realistic, traditional, Afrocentric, colorful and upbeat style. Prefers 11×14. 20% of freelance design work demands knowledge of Illustrator, Photoshop and QuarkXPress. Produces of material for Christmas, Easter, Mother's Day, Father's Day, graduation, Kwanzaa, Valentine's Day, birthdays and everyday; also for sympathy, get well, romantic, thank you, serious illness and multicultural cards. Submit seasonal material 1 year in advance.

First Contact & Terms Send query letter with brochure, photocopies, photographs and SASE. No

phone calls or slides. No e-mail addresses. Responds to street address only. Calligraphers: send samples and compensation requirements. Samples are not filed and are returned with SASE only within 6 months. Responds only if interested. Portfolio review not required. Buys all rights. Pays for illustration by the project. Does not pay royalties; will license at one-time flat rate.

Tips "Excellent illustration skills are necessary, and designs should be appropriate for African-American social expression. Writers should send verse that is appropriate for greeting cards and avoid lengthy, personal experiences. Verse and art should be uplifting. We need coordinated themes for calendars."

CASE STATIONERY CO., INC.

179 Saw Mill River Rd., Yonkers NY 10701-6616. (914)965-5100. Fax: (914)965-2362. E-mail: case@casestationery.com. Web site: www.casestationery.com. **President:** Jerome Sudnow. Vice President: Joyce Blackwood. Estab. 1954. Produces stationery, notes, memo pads and tins for mass merchandisers in stationery and housewares departments.

Needs Approached by 10 freelancers/year. Buys 50 freelance designs/year. Works on assignment only. Buys design and/or illustration mainly for stationery products. Uses freelancers for mechanicals and ideas. Produces materials for Christmas; submit 6 months in advance. Likes to see youthful and traditional styles, as well as English and French country themes. 10% of freelance work requires computer skills.

First Contact & Terms Send query letter with résumé, tearsheets, photostats, photocopies, slides and photographs. Samples not filed are returned. Responds ASAP. Call or write for appointment to show portfolio. Original artwork is not returned. Pays by the project. Buys first rights or one-time rights.

Tips "Find out what we do. Get to know us. We are creative and know how to sell a product."

◙ CATCH PUBLISHING, INC.

456 Penn St., Yeadon PA 19050. (484)521-0132. Fax: (610)626-2778. **Contact:** Michael Markowicz. Produces greeting cards, stationery, giftwrap, blank books, posters and calendars. Art guidelines available for SASE with first-class postage.

Needs Approached by 200 freelancers/year. Works with 5-10 freelancers/year. Buys 25-50 freelance designs and illustrations/year. Uses freelancers mainly for design. Considers all media. Produces material for Christmas, New Year and everyday. Submit seasonal material 1 year in advance.

First Contact & Terms Send query letter with brochure, tearsheets, résumé, slides, computer disks and SASE. Samples are not filed and are returned by SASE if requested by artist. Responds in 6 months. Will contact artist for portfolio review if interested. Portfolio should include final art, slides or large-format transparencies. Rights purchased vary according to project. Originals are returned at job's completion. Pays royalties of 10-12% (may vary according to job).

CENTRIC CORP.

6712 Melrose Ave., Los Angeles CA 90038. (323)936-2100. Fax: (323)936-2101. E-mail: centric@juno.com. Web site: www.centriccorp.com. **President:** Sammy Okdot. Estab. 1986. Produces celebrity licensed products such as watches, pens, T-shirts, pillows, clocks, mugs and frames for ages 15-65.

Needs Looking for freelancers who know Photoshop, QuarkXPress and Illustrator well.

First Contact & Terms Send samples of your work and rate range. Pays when project is completed.

Tips "Research the demographics of buyers who purchase Elvis, Lucy, Marilyn Monroe, James Dean, Betty Boop and Bettie Page products to know how to 'communicate a message' to the buyer."

N CLASSIC OILS

P.O. Box 33, Flushing NY 11367. (347)342-8378. **Contact:** Roy Sicular. Estab. 1978. Produces greeting cards and posters.

Needs Approached by 5 freelancers/year. Works with 0-1 freelancer/year. Buys 0-1 freelance design or illustration/year. Considers all media. "I publish scenes of New York City—watercolor, collages, black & white."

First Contact & Terms Send query letter with photocopies. Samples are not filed and are returned. Responds only if interested. Portfolio review not required. Originals are returned at job's completion. Pays $100-300 for reproduction rights. Buys reprint rights.

COMSTOCK CARDS, INC.

600 S. Rock Blvd., Suite 15, Reno NV 89502. (775)856-9400. Fax: (775)856-9406. E-mail: production@comstockcards.com. Web site: www.comstockcards.com. **Contact:** Production Assistant. Estab. 1986. Produces greeting cards, giftbags and invitations. Styles include alternative and adult humor, outrageous and shocking themes. Art guidelines available for SASE with first-class postage.

Needs Approached by 250-350 freelancers/year. Works with 30-35 freelancers/year. "Especially seeking artists able to produce outrageous adult-oriented cartoons." Uses freelancers mainly for cartoon greeting cards. No verse or prose. Gaglines must be brief. Prefers 5×7 final art. Produces material for all occasions. Submit holiday concepts 6 months in advance.

First Contact & Terms Send query letter with SASE, tearsheets or photocopies. Samples are not usually filed and are returned by SASE if requested. Responds only if interested. Portfolio review not required. Originals are not returned. Pays royalties of 5%. Pays by the project, $50-150 minimum; may negotiate other arrangements. Buys all rights.

CONCORD LITHO

92 Old Turnpike Rd., Concord NH 03301. (603)225-3328 or (800)258-3662. Fax: (603)225-6120. E-mail: info@concordlitho.com. Web site: www.concordlitho.com. **Contact:** Art Librarian. Estab. 1958. Produces greeting cards, stationery, posters, giftwrap, specialty paper products for non-profit direct mail fundraising.

Needs Licenses artwork, illustration and photography. Considers all media but prefers watercolor. Art needs range from all-occasion and holiday greeting cards to religious subjects, wildlife, florals, nature, scenics, cute and whimsical. Always looking for traditional religious art. Produces printed material for Christmas, Valentine's Day, Mother's Day, Father's Day, Easter, Thanksgiving, New Year, birthdays, everyday and other religious dates. Submit seasonal material minimum 6-8 months in advance.

Specs Accepts images in digital format, original artwork and transparencies on rare occasions. Requires digital files via CD/DVD at 300 dpi (TIFF, EPS, JPEG).

First Contact & Terms Send introductory letter with with nonreturnable photographs, samples, or photocopies of work. Will keep samples that have strong potential for use on file. Also accepts submissions on disk. "Indicate whether work is for style only and if it is available." Responds in 3 months. Portfolio review not required. Rights purchased vary according to project. Pays by the project, $200-800. "No phone calls, please."

Tips Send quality samples or copies.

COURAGE CARDS

3915 Golden Valley Rd., Minneapolis MN 55422. (888)413-3323. E-mail: artsearch@courage.org. Web site: www.couragecards.org. **Art and Production Manager:** Laura Brooks. Estab. 1970. Courage Cards are holiday cards that are produced to support the programs of Courage Center, a nonprofit provider of rehabilitation services that helps people with disabilities live more independently.

Needs Seeking holiday art appropriate for greeting cards—including traditional, winter, nostalgic, religious, ethnic and world peace designs. Features artists with disabilities, but all artists are encouraged to enter the annual Courage Card Art Search. Submission guidelines available on Web site.

First Contact & Terms Call or e-mail with name and address to receive Art Search guidelines, which are mailed in early May for the July 31 entry deadline. Artist retains ownership of the art. Pays $400 licensing fee in addition to nationwide recognition through distribution of more than 500,000 catalogs and promotional pieces, Internet, TV, radio and print advertising.

Tips "Do not send originals. Entries should be sent with a completed Art Search guidelines form. The Selection Committee chooses art that will reproduce well as a card. We need colorful contemporary and traditional images for holiday greetings. Participation in the Courage Cards Art Search is a wonderful way to share your talents and help people live more independently."

SUZANNE CRUISE CREATIVE SERVICES, INC.

7199 W. 98th Terrace, #110, Overland Park KS 66212. (913)648-2190. Fax: (913)648-2110. E-mail: artagent@cruisecreative.com. Web site: www.cruisecreative.com. **President:** Suzanne Cruise. Estab. 1990. Art agent representing artists for licensing in categories such as calendars, craft papers, decorative housewares, fabric giftbags, gifts, giftwrap, greeting cards, home decor, keychains, mugs, ornaments, prints, scrap booking, stickers, tabletop, and textiles. "We are a full-service licensing agency, as well as a full-service creative agency representing both licensed artists and freelance artists. Our services include, but are not limited to, screening manufacturers for quality and distribution, negotiating rights, overseeing contracts and payments, sending artists' samples to manufacturers for review, and exhibiting artists' work at major trade shows annually." Art guidelines available on Web site.

Needs Seeks established and emerging artists with distinctive styles suitable for the ever-changing consumer market. Looking for artists that manufacturers cannot find in their own art staff or in the freelance market, or who have a style that has the potential to become a classic license. "We represent a wide variety of freelance artists, and a few select licensed artists, offering their work to manufacturers of goods such as gifts, textiles, home furnishings, bedding, book publishing, social expression, puzzles, rubber stamps, etc. We look for art that has popular appeal. It can be traditional, whimsical, cute, humorous, seasonal or everyday, as long as it is not 'dated'."

First Contact & Terms Send query letter with color photocopies, tearsheets or samples. No originals. Samples are returned only if accompanied by SASE. Responds only if interested. Portfolio required. Request portfolio review in original query.

Tips "Walk a few trade shows and familiarize yourself with the industries you want your work to be in. Attend a few of the panel discussions that are put on during the shows to get to know the business a little better."

Ⓝ CURRENT, INC.

1005 E. Woodmen Rd., Colorado Springs CO 80920. (719)594-4100. Fax: (719)531-2564. Web site: www.currentcatalog.com. **Creative Business Manager:** Dana Grignano. Estab. 1950. Produces bookmarks, calendars, collectible plates, decorative housewares, decorations, giftbags, gifts, giftwrap, greeting cards, mugs, ornaments, school supplies, stationery, T-shirts. Specializes in seasonal and everyday social expressions products.

Needs Works with hundreds of freelancers/year. Buys 700 freelance designs and illustrations/year. Prefers freelancers with experience in greeting cards and textile industries. Uses freelancers mainly for cards, wraps, calendars, gifts, calligraphy. Considers all media. Product categories include business, conventional, cute, cute/religious, juvenile, religious, teen. Freelancers should be familiar with Photoshop, Illustrator and FreeHand. Produces material for all holidays and seasons and everyday. Submit seasonal material year-round.

First Contact & Terms Send query letter with photocopies, tearsheets, brochure and photographs. Samples are filed. Responds only if interested. Will contact artist for portfolio review if interested. Buys all rights. Pays by the project, $50-500. Finds freelancers through agents, submissions, sourcebooks.

Tips "Review Web site or catalog prior to sending work."

CUSTOM STUDIOS INC.

4353 N. Lincoln Ave., Chicago IL 60618. (773)665-2226. Fax: (773)665-2228. E-mail: customstudios123@yahoo.com. Web site: www.custom-studios.com. **President:** Gary Wing. Estab. 1966. "We specialize in designing and screen printing custom T-shirts for schools, business promotions, fundraising and for our own line of stock." Also manufactures coffee mugs, bumper stickers, balloons and over 1,000 other products.

Needs Works with 7 freelance illustrators/year. Assigns 10 freelance jobs/year. Needs b&w illustrations (some original and some from customer's sketch). Uses artists for direct mail and brochures/fliers, but mostly for custom and stock T-shirt designs. "We are open to new stock design ideas the artist may have."

First Contact & Terms Send query letter with résumé, photostats, photocopies or tearsheets. Mail b&w or color tearsheets or photostats to be kept on file. "We will not return originals or samples." Responds in 1 month. Pays for design and illustration by the hour, $15-35; by the project, $50-150. Considers turnaround time and rights purchased when establishing payment. For designs submitted to be used as stock T-shirt designs, pays 5-10% royalty. Rights purchased vary according to project.

Tips "Send 5-10 good copies of your best work. We would like to see more illustrations or copies, not originals. Do not get discouraged if your first designs sent are not accepted."

DALOIA DESIGN

100 Norwich E., West Palm Beach FL 33417. (561)697-4739. E-mail: daloiades@aol.com. **Owner/ Designer:** Peter Daloia. Estab. 1983. Produces art for stationery and gift products such as magnets, photo frames, coasters, bookmarks, home decor, etc.

Needs Approached by 20-30 freelancers/year. Uses freelancers for product art. Freelancers must know software appropriate for project, including PageMaker, Photoshop, QuarkXPress, Illustrator or "whatever is necessary."

First Contact & Terms Send samples of your work. Samples are filed and are not returned. Responds only if interested. Payment "depends on project and use." Negotiates rights purchased.

Tips "Keep an open mind, strive for excellence, push limitations."

⚏ DCI STUDIOS

8010 State Line Rd., Suite 200, Leawood KS 66208. E-mail: jim@dcistudios.com. Web site: www.dcistudios.com; www.redtreestudios.com. **Creative Coordinator:** Jim. Estab. 1991. Produces greeting cards, e-cards, stationery, calendars, decorative housewares, party supplies, gifts, textiles. "DCI Studios specializes in social sentiment using humor, inspirational and traditional writing. Our cards, calendars, and stationery are sold in the mass market and are targeted toward men and women of any age. Our decorative housewares are designed for the gift market, appealing mostly to women ages 30-50." Art guidelines available for SASE.

Needs Approached by 100-200 freelancers/year. Prefers freelancers with experience in mass market retail. Product categories include counter humor, alternative/humor, inspirational and conventional. Produces material for all holidays and seasons. Submit seasonal material 6-8 months in advance. Final art size should be under 5MB. 100% of freelance work demands computer skills. Freelance artists should be familiar with InDesign, Illustrator, QuarkXPress, Photoshop.

First Contact & Terms Send query letter with brochure, résumé, photocopies, URL. Prefers Mac-compatible JPEG files. Samples are filed and are not returned. Responds only if interested. Company will contact artist for portfolio review if interested. Portfolio should include color finished art; a variety of illustrations. Pays by the project. Finds freelancers through submissions.

Tips "We're interested in artists who have experience working for mass market retail. Artists should have exceptional depth of design and styles, and be able to work with different materials and computer programs. Experience with 3D illustration and construction of prototypes is a plus."

DIMENSIONS, INC.

1801 N. 12th St., Reading PA 19604. (610)939-9900. Fax: (610)939-9666. E-mail: pam.keller@dimensions-crafts.com. Web site: www.dimensions-crafts.com. **Designer Relations Coordinator:** Pamela Keller. Produces craft kits, including, but not limited to, needlework, stained glass, paint-by-number, kids bead crafts and memory products. "We are a craft manufacturer with emphasis on sophisticated artwork and talented designers. Products include needlecraft kits, paint-by-number, and baby products. Primary market is anyone who does crafts."

Needs Approached by 50-100 freelancers/year. Works with 200 freelancers/year. Develops more than 400 freelance designs and illustrations/year. Uses freelancers mainly for the original artwork for each product. Art guidelines available for SASE with first-class postage. In-house art staff adapts for needlecraft. Considers all media. Looking for fine art, realistic representation, good composition, more complex designs than some greeting card art; fairly tight illustration with good definition; also whimsical, fun characters. Produces material for Christmas, everyday, birth, wedding and anniversary records. Majority of products are everyday decorative designs for the home.

First Contact & Terms Send cover letter with CD, color brochure, tearsheets, photographs or photocopies. Samples are filed "if artwork has potential for our market." Samples are returned by SASE only if requested by artist. Responds in 1 month. Portfolio review not required. Originals are returned at job's completion. Pays by project, royalties of 2-5%; sometimes purchases outright. Finds artists through magazines, trade shows, word of mouth, licensors/reps.

Tips "Current popular subjects in our industry include florals, wildlife, garden themes, ocean themes, celestial, cats, birds, Southwest/Native American, juvenile/baby and whimsical."

KRISTIN ELLIOTT, INC.

10 Industrial Way, Amesbury MA 01913. (978)526-7126. Fax: (978) 834- 0700. E-mail: kristinelliott@verizon.net. Web site: www.kristinelliott.com. **Creative Director:** Barbara Elliott. Publishes greeting cards and stationery products.

Needs Works with 25 freelance artists/year. Uses illustrations and graphic design. Prefers watercolor and gouache. Produces Christmas and everyday stationery products, including boxed notes, imprintables and photo cards.

First Contact & Terms Send published samples, color copies, tearsheets or photos. Include SASE for return of materials. Payment negotiable.

Tips "Crisp, clean colors preferred. Best submission time is May through August."

N EPIC PRODUCTS INC.

2801 S. Yale St., Santa Ana CA 92704. (800)548-9791. Fax: (714)641-8217. E-mail: mdubow@epicproductsinc.com. Web site: www.epicproductsinc.com. Estab. 1978. Produces paper tableware products and wine and spirits accessories. "We manufacture products for the gourmet/housewares market; specifically products that are wine-related. Many have a design printed on them."

Needs Approached by 50-75 freelance artists/year. Works with 10-15 freelancers/year. Buys 25-50 designs and illustrations/year. Prefers artists with experience in gourmet/housewares, wine and spirits, gifts and stationery.

First Contact & Terms Send query letter with résumé and photocopies. Samples are filed. Write for appointment to show portfolio. Portfolio should include thumbnails, roughs, final art, b&w and color. Buys all rights. Originals are not returned. Pays by the project.

EVERYTHING METAL IMAGINABLE (EMI)

P.O. Box 3127, Visalia CA 93278-3127. (559)732-8126. Fax: (559)732-5961. E-mail: marketing@artbronze.com. Web site: www.artbronze.com. Estab. 1967. Wholesale manufacturer. "We manufacture lost wax bronze sculpture." Clients: wholesalers, premium incentive consumers, retailers, auctioneers, corporations.

Needs Approached by 10 freelance artists/year. Works with 20 freelance designers/year. Assigns 5-10 jobs to freelance artists/year. Prefers artists that understand centrifugal casting, bronze casting and the principles of mold-making. Uses artists for figurine sculpture and model-making.

First Contact & Terms Send query letter with brochure or résumé, tearsheets, photostats, photocopies and slides. Samples not filed are returned only if requested. Responds only if interested. Call for appointment to show portfolio of original/final art and photographs "or any samples." Pays for design by the project, $500-20,000. Buys all rights.

Tips "Artists must be conscious of detail in their work, be able to work expediently and under time pressure, and be able to accept criticism of work from client. Price of program must include completing work to satisfaction of customers. Trends include children at play."

FANTAZIA MARKETING CORP.

65 N. Chicopee St., Chicopee MA 01020. (413)534-7323. Fax: (413)534-4572. E-mail: fantazia@charter.net. Web site: www.fantaziamarketing.com. **President:** Joel Nulman. Estab. 1979. Produces toys and high-end novelty products (lamps, banks and stationery items in over-sized form).

Needs Will review anything. Prefers artists with experience in product development. "We're looking to increase our molded products." Uses freelancers for P-O-P displays, paste-up, mechanicals, product concepts. 50% of design work requires computer skills.

First Contact & Terms Send query letter with résumé. Samples are filed. Responds in 2 weeks. Call for appointment to show portfolio. Portfolio should include roughs and dummies. Originals are not returned. Rights purchased vary according to project. Pays by the project. Royalties negotiable.

FIDDLER'S ELBOW

101 Fiddler's Elbow Rd., Middle Falls NY 12848. (518)692-9665. Fax: (518)692-9186. E-mail: info@fiddlerselbow.com. Web site: www.fiddlerselbow.com. **Art and Licensing Coordinator:** Christy Phelan. Estab. 1974. Produces decorative housewares, gifts, pillows, totes, soft sculpture, flags and doormats.

Needs Introduces 100+ new products/year. Currently uses freelance designs and illustrations. Looking for adult contemporary, traditional, dog, cat, horse, botanical and beach themes. Main images with supporting art helpful in producing collections.

First Contact & Terms Send digital or hardcopy submissions by mail. Samples are filed or returned by SASE. Responds generally within 4 months if interested. "Please, no phone calls."

Tips "Please visit Web site first to see if art is applicable to current lines and products."

GAGNE WALLCOVERING, INC.

2035 Calumet St., Clearwater FL 33765-1308. (727)461-1812. Fax: (727)447-6277. E-mail: info@gagnewall.com. Web site: www.gagnewall.com. **Studio Director:** Linda Vierk. Estab. 1977. Produces wall murals and wallpaper. Specializes in residential and commercial wallcoverings, borders and murals encompassing a broad range of styles and themes for all age groups.

Needs Approached by 12-20 freelancers/year. Works with 20 freelancers/year. Buys 150 freelance

designs and/or illustrations/year. Considers oils, watercolors, pastels, colored pencil, gouache, acrylic—"just about anything two-dimensional." Artists should check current wallcovering collections to see the most common techniques and media used.

First Contact & Terms Send brochure, color photocopies, photographs, slides, tearsheets, "actual painted or printed sample of artist's hand if possible." Samples are filed. Responds only if interested. Portfolio not required. "We usually buy all rights to a design, but occasionally consider other arrangements." Pays by the project, $500-1,200. Finds freelancers through magazines, licensing agencies, trade shows and word of mouth.

Tips "We are usually looking for traditional florals, country/folk art, juvenile and novelty designs. We do many borders and are always interested in fine representational art. Panoramic borders and murals are also a special interest. Be aware of interior design trends, both in style and color. Visit a wallcovering store and see what is currently being sold. Send us a few samples of your best quality, well-painted, detailed work."

GALISON/MUDPUPPY PRESS

28 W. 44th St., Suite 1411, New York NY 10036. (212)354-8840. Fax: (212)391-4037. E-mail: carole@galison.com. Web site: www.galison.com. **Art Director:** Carole Otypka. Estab. 1978. Produces boxed greeting cards, stationery, puzzles, address books, specialty journals and fine paper gifts. Many projects are done in collaboration with museums around the world.

Needs Works with 10-15 freelancers/year. Buys 20 designs and illustrations/year. Works on assignment only. Uses freelancers mainly for illustration. Considers all media. Also produces material for holidays (Christmas, Hanukkah and New Year). Submit seasonal material 1 year in advance.

First Contact & Terms Send postcard sample, photocopies, tearsheets (no unsolicited original artwork), résumé, and SASE. Accepts submissions on disk compatible with Photoshop, Illustrator or QuarkXPress (but not preferred). Samples are filed. Responds only if interested. Request portfolio review in original query. Art Director will contact artist for portfolio review if interested. Portfolio should include color photostats, slides, tearsheets and dummies. Originals are returned at job's completion. Pays by the project. Rights purchased vary according to project. Finds artists through word of mouth, magazines and artists' reps.

Tips "Looking for great presentation and artwork we think will sell and be competitive within the gift market. Please visit our Web site to see if your style is compatible with our design aesthetic."

GALLANT GREETINGS CORP.

4300 United Pkwy., Franklin Park IL 60131. (847)671-6500. Fax: (847)233-2499. E-mail: joanlacko uitz@gallantgreetings.com. Web site: www.gallantgreetings.com. **Vice President of Product Development:** Joan Lackouitz. Estab. 1966. Creator and publisher of seasonal and everyday greeting cards, gift wrap and gift bags as well as stationery products.

First Contact & Terms Samples are filed or returned. Will respond within 3 weeks if interested. Do not send originals.

GREAT AMERICAN PUZZLE FACTORY INC.

16 S. Main St., South Norwalk CT 06854. (203)838-4240. Fax: (203)838-2065. E-mail: pduncan@g reatamericanpuzzle.com. Web site: www.greatamericanpuzzle.com. **President:** Pat Duncan. Estab. 1975. Produces jigsaw puzzles and games for adults and children. Licenses various illustrations for puzzles.

Needs Approached by 200 freelancers/year. Works with 80 freelancers/year. Buys 70 designs and illustrations/year. Uses freelancers mainly for puzzle material. Looking for "fun, busy and colorful" work. 100% of graphic design work requires knowledge of QuarkXPress, Illustrator or Photoshop.

First Contact & Terms Send postcard sample and/or 3 representative samples via e-mail. Do not send seasonal material. Do not send originals or transparencies. Samples are filed or are returned. Art director will contact artist for portfolio review if interested. Original artwork is returned at job's completion. Pays flat fee of $600-1,000 (work for hire); royalties of 5-6% for licensed art (existing art only). Interested in buying second rights (reprint rights) to previously published work.

Tips "All artwork should be *bright*, cheerful and eye-catching. 'Subtle' is not an appropriate look for our market. Decorative motifs are not appropriate. Visit stores and Web sites to check appropriateness of your art. No black & white. Looking for color, detail and emotion.''

GREAT ARROW GRAPHICS

2495 Main St., Suite 457, Buffalo NY 14214. (716)836-0408. Fax: (716)836-0702. E-mail: design@greatarrow.com. Web site: www.greatarrow.com. **Art Director:** Lisa Samar. Estab. 1981. Produces greeting cards and stationery. "We produce silkscreened greeting cards—seasonal and everyday—to a high-end design-conscious market.''

Needs Approached by 150 freelancers/year. Works with 75 freelancers/year. Buys 350-500 images/year. Art guidelines can be downloaded at www.greatarrow.com/guidelines.asp. Prefers freelancers with experience in silkscreen printing process. Uses freelancers for greeting card design only. Considers all 2D media. Looking for sophisticated, classic, contemporary or cutting edge styles. Requires knowledge of Illustrator or Photoshop. Produces material for all holidays and seasons. Submit seasonal material 1 year in advance.

First Contact & Terms Send query letter with photocopies. Accepts submissions on disk compatible with Illustrator or Photoshop, or e-mail JPEGs. Samples will not be returned; do not send originals until the images are accepted. Responds in 6 weeks if interested. Art director will contact artist for portfolio review if interested. Portfolio should include color roughs, final art, photographs and transparencies. Originals are returned at job's completion. Pays royalties of 5% of net sales. Rights purchased vary according to project.

Tips "We are interested in artists familiar with the assets and limitations of screenprinting, but we are always looking for fun new ideas and are willing to give help and guidance in the silkscreen process. Be original; be complete with ideas. Don't be afraid to be different . . . forget the trends . . . do what you want. Make your work as complete as possible at first submission. The National Stationery Show in New York City is a great place to make contacts.''

HALLMARK CARDS, INC.

P.O. Box 419580, Kansas City MO 64141-6580. Web site: www.hallmark.com. Estab. 1931.
- Because of Hallmark's large creative staff of full-time employees and their established base of freelance talent capable of fulfilling their product needs, they do not accept unsolicited freelance submissions.

HARLAND CLARKE

(formerly Clarke American), P.O. Box 460, San Antonio TX 78292-0460. (210)694-1473. Fax: (210)558-9265. E-mail: acollins@clarkeamerican.com. Web site: www.clarkeamerican.com. **Product Marketing Manager:** Ashley Collins. Estab. 1874. Produces checks and other products and services sold through financial institutions. "We're a national printer seeking original works for check series, consisting of one, three or five scenes. Looking for a variety of themes, media and subjects for a wide market appeal.''

Needs Uses freelancers mainly for illustration and design of personal checks. Considers all media and a range of styles. Prefers to see art at twice the size of a standard check.

First Contact & Terms Send postcard sample or query letter with résumé and brochure (or Web address if work is online). "Indicate whether the work is available; do not send original art.''

Samples are filed and are not returned. Responds only if interested. Rights purchased vary according to project. Payment for illustration varies by the project.

Tips "Keep red and black in the illustration to a minimum for image processing."

HOFFMASTER SOLO CUP COMPANY

2920 N. Main St., Oshkosh WI 54903. (920)235-9330. Fax: (920)235-1642. **Art and Marketing Services Manager:** Paul Zuehlke. Produces decorative paper tableware, placemats, plates, table-cloths and napkins for institutional and consumer markets. Printing includes up to 6-color flexo-graphic napkin printing.

Needs Approached by 20-30 freelancers/year. Works with 5-10 freelancers/year. Prefers freelancers with experience in paper tableware products. Art guidelines and specific design needs based on current market are available from Creative Managers. Looking for trends and traditional styles. Prefers 9" round artwork with coordinating 6.5" square image. Produces material for all holidays and seasons and everyday. Special need for seasonal material.

First Contact & Terms Send query letter with photocopies, résumé, appropriate samples by mail or fax only. Ideas may be sent in a color rough sketch. Accepts disk submissions compatible with Illustrator and FreeHand. Samples are filed or returned by SASE if requested by artist. Responds in 90 days, only if interested. "Will provide feedback to artists whose designs could be adapted but are not currently acceptable for use without additional work and a resubmission." Creative Manager will contact artist for portfolio review if interested. Portfolio should include thumbnails, roughs, finished art samples, color photostats, tearsheets, photographs and dummies. Prefers to buy artwork outright. Rights purchased vary according to project. Pays by the project: $350-1,500. Amounts vary according to project. May work on a royalty arrangement for recognized properties. Finds freelancers through art fairs and artists' reps.

Tips Looking for new trends and designs appropriate for plates and napkins.

THE IMAGINATION ASSOCIATION/THE FUNNY APRON COMPANY

P.O. Box 1780, Lake Dallas TX 75065-1780. (940)498-3308. Fax: (940)498-1596. E-mail: ellice@funnyaprons.com. Web site: www.funnyaprons.com. **Creative Director:** Ellice Lovelady. Estab. 1992. "Our primary focus is on our subdivision, The Funny Apron Company, that manufactures humorous culinary-themed aprons and T-shirts for the gourmet marketplace."

Needs Works with 6 freelancers/year. Artists must be fax/e-mail accessible and able to work on fast turnaround. "Check Web site to determine if your style fits our art direction." 100% of freelance work demands knowledge of Illustrator, Corel Draw, or programs with ability to electronically send vector-based artwork. (Photoshop alone is not sufficient.) Currently not accepting text or concepts.

First Contact & Terms Send query letter with brochure, photographs, SASE and photocopies. E-mail inquiries must include a link to a Web site to view artwork. Do not send unsolicited attachments, they are automatically deleted. Samples are filed or returned by SASE if requested by artist. Company will contact artist if interested. Negotiates rights and payment terms. Finds artists via word of mouth from other freelancers or referrals from publishers.

Tips Looking for artists "with a style we feel we can work with and a professional attitude. Understand that sometimes we require several revisions before final art, and all under tight deadlines. Even if we can't use your style, be persistent! Stay true to your creative vision and don't give up!"

N ⊞ INCOLAY STUDIOS INCORPORATED

12927 S. Budlong Ave., Gardena CA 90247. (800)462-6529. E-mail: info@incolayusa.com. Web site: www.incolayusa.com. **Art Director:** Louise Hartwell. Estab. 1966. Manufacturer. "We reproduce antiques in Incolay Stone, all handcrafted here at the studio."

Needs Prefers local artists with experience in carving bas relief. Uses freelance artists mainly for carvings; also for product design and model making.

First Contact & Terms Send query letter with résumé, or call to discuss. Samples not filed are returned. Responds in 1 month. Call for appointment to show portfolio. Pays 5% of net sales. Negotiates rights purchased.

Tips "Let people know that you are available and want work. Do the best you can. Discuss the concept and see if it is right for your talent."

INNOVATIVE ART

(formerly Portal Publications, Ltd.), 100 Smith Ranch Rd., Suite 210, San Rafael CA 94903. (415)884-6200 or (800)227-1720. Fax: (415)382-3377. Web site: www.portalpub.com. **Senior Art Director:** Andrea Smith. Estab. 1954. Publishes greeting cards, calendars, posters, wall decor, framed prints. Art guidelines available for SASE or on Web site.

● See additional listing in the Posters & Prints section.

Needs Approached by more than 1,000 freelancers/year. Offers up to 400 or more assignments/ year. Works on assignment only. Considers any media. Looking for "beautiful, charming, provocative, humorous images of all kinds." 90% of freelance design work demands knowledge of the most recent versions of Illustrator, QuarkXPress and Photoshop. Submit seasonal material 1 year in advance.

First Contact & Terms "No submission will be considered without a signed guidelines form, available on our Web site at www.portalpub.com/contact/ArtistSubmissionForm.pdf; or contact Robin O'Conner at (415)526-6362."

Tips "Ours is an increasingly competitive business, so we look for the highest quality and most unique imagery that will appeal to our diverse market of customers."

INTERCONTINENTAL GREETINGS LTD.

176 Madison Ave., New York NY 10016. (212)683-5830. Fax: (212)779-8564. E-mail: art@inter continental-ltd.com. Web site: www.intercontinental-ltd.com. **Creative Director:** Jerra Parfitt. Estab. 1967. Sells reproduction rights of designs to manufacturers of multiple products around the world. Represents artists in 50 different countries. "Our clients specialize in greeting cards, giftware, giftwrap, calendars, postcards, prints, posters, stationery, paper goods, food tins, playing cards, tabletop, bath and service ware and much more."

● See additional listing in the Posters & Prints section.

Needs Approached by several hundred artists/year. Seeking creative, decorative art in traditional and computer media (Photoshop preferred; some Illustrator work accepted). Prefers artwork previously made with few or no rights pending. Graphics, sports, occasions (i.e., Christmas, baby, birthday, wedding), humorous, "soft touch," romantic themes, animals. Accepts seasonal/ holiday material any time. Prefers artists/designers experienced in greeting cards, paper products, tabletop and giftware.

First Contact & Terms Query with samples. Send unsolicited CDs or DVDs by mail. "Please do not send original artwork." Upon request, submit portfolio for review. Provide résumé, business card, brochure, flier, tearsheets or slides to be kept on file for possible future assignments. "Once your art is accepted, we require original color art—Photoshop files on disc (Mac, TIFF, 300 dpi); 4×5, 8×10 transparencies; 35mm slides. We will respond only if interested (will send back nonaccepted artwork in SASE if provided)." Pays on publication. No credit line given. Offers advance when appropriate. Sells one-time rights and exclusive product rights. Simultaneous submissions and previously published work OK. "Please state reserved rights, if any."

Tips Recommends the annual New York SURTEX and Licensing shows. In portfolio samples, wants to see "a neat presentation, thematic in arrangement, consisting of a series of interrelated

images (at least 6). In addition to having good drawing/painting/designing skills, artists should be aware of market needs and trends.''

THE INTERMARKETING GROUP

29 Holt Rd., Amherst NH 03031. (603)672-0499. **President:** Linda Gerson. Estab. 1985. Licensing agent for all categories of consumer goods, including greeting cards, stationery, calendars, posters, paper products, tabletop, dinnerware, giftwrap, giftware, toys, needlecrafts, home furnishings and apparel.

● See additional listing in the Artists' Reps section.

Needs Approached by 100 freelancers/year. Works with 6 freelancers/year. Licenses work as developed by clients. Prefers freelancers with experience in full-color illustration. Uses freelancers mainly for tabletop, cards, giftware, calendars, paper tableware, toys, bookmarks, needlecraft, apparel, housewares. Will consider all media forms. ''My firm generally represents illustrated works and illustrations for direct product applications. All works are themed.'' Prefers 5×7 or 8×10 final art. Produces material for all holidays and seasons and everyday. Submit seasonal material 6 months in advance.

First Contact & Terms Send query letter with brochure, tearsheets, résumé, slides or color copies, SASE. Samples are not filed and are returned by SASE. Responds in 3 weeks. Requests work on spec before assigning a job. Originals are returned at job's completion. Pays royalties of 2-7% plus advance against royalties. Buys all rights. Considers buying second rights (reprint rights) to previously published work. Finds new artists ''mostly by referrals and via submissions. I do review trade magazines and attend art shows and other exhibits to locate suitable clients.''

Tips ''Companies today seem to be leaning towards a fresh, trendy look in the art approach. Companies are selective in their licenses. A well-organized presentation is very helpful. Be aware of the market. See what is selling in stores and focus on specific products that would incorporate your art well. Get educated on market conditions and trends.''

Ⓝ JILLSON & ROBERTS

3300 W. Castor St., Santa Anna CA 92704-3908. (714)424-0111. Fax: (714)424-0054. E-mail: shawn@jillsonroberts.com. Web site: www.jillsonroberts.com. **Creative Director:** Shawn K. Doll. Estab. 1974. Specializes in giftwrap, totes, printed tissues and accessories using recycled/recyclable products. Art guidelines available on Web site.

Needs Works with 10 freelance artists/year. Prefers artists with experience in giftwrap design. Considers all media. ''We are looking for colorful graphic designs as well as humorous, sophisticated, elegant or contemporary styles.'' Produces material for Christmas, Valentine's Day, Hanukkah, Halloween, graduation, birthdays, baby announcements and everyday. Submit seasonal material 3-6 months before holiday.

First Contact & Terms Send color copies or photocopies. Samples are kept on file. Responds in up to 2 months. Simultaneous submissions to other companies is acceptable. ''If your work is chosen, we will contact you to discuss final art preparation, procedures and payment.''

Tips ''We are particularly interested in baby shower and wedding shower designs.''

KEMSE AND COMPANY

P.O. Box 14334, Arlington TX 76094. (888)656-1452. Fax: (817)446-9986. E-mail: kim@kemseand company.com. Web site: www.kemseandcompany.com. **Contact:** Kimberly See. Estab. 2003. Produces stationery. Specializes in multicultural stationery and invitations.

Needs Approached by 10-12 freelancers/year. Works with 5-6 freelancers/year. Buys 15-20 freelance designs and/or illustrations/year. Considers all media. Product categories include African-American and Hispanic. Produces material for all holidays and seasons, birthday, graduation and woman-to-woman. Submit seasonal material 8 months in advance. 75% of freelance work demands knowledge of FreeHand, Illustrator, QuarkXPress and Photoshop.

First Contact & Terms Send query letter with photocopies, résumé and SASE. Accepts e-mail submissions with image file. Prefers Windows-compatible, JPEG files. Samples are filed. Responds only if interested. Company will contact artist for portfolio review if interested. Portfolio should include color, finished art, roughs and thumbnails. Buys all rights and reprint rights. Pays freelancers by the project. Finds freelancers through submissions.

☀ KENZIG KARDS, INC.

2300 Julia Goldbach Ave., Ronkonkoma NY 11779-6317. (631)737-1584. Fax: (631)737-8341. E-mail: kenzigkards@aol.com. **President:** Jerry Kenzig. Estab. 1999. Produces greeting cards and stationery. Specializes in greeting cards (seasonal and everyday) for a high-end, design-conscious market (all ages).

Needs Approached by 75 freelancers/year. Works with 3 freelancers/year. Prefers local designers/illustrators, but will consider freelancers working anywhere in the U.S. Art guidelines free with SAE and first-class postage. Uses freelancers mainly for design and calligraphy. Considers watercolor, colored pencils; most media. Product categories include alternative/humor, business and cute. Produces material for baby congrats, birthday, cards for pets, Christmas, congratulations, everyday, get well, sympathy, Valentine's Day and wedding/anniversary. Submit seasonal material 6 months in advance. Art size should be 5×7 or $5^{3}/_{4} \times 5^{3}/_{4}$ square. 20% of freelance work demands knowledge of Illustrator, QuarkXPress and Photoshop.

First Contact & Terms Send query letter with brochure, résumé and tearsheets. After introductory mailing, send follow-up postcard sample every 6 months. Samples are filed. Responds in 2 weeks. Company will contact artist for portfolio review if interested. Portfolio should include color, original art, roughs and tearsheets. Buys one-time rights and reprint rights for cards and mugs. Negotiates rights purchased. Pays freelancers by the project, $150-350; royalties (subject to negotiation). Finds freelancers through industry contacts (Kenzig Kards, Inc., is a member of the Greeting Card Association), submissions and word of mouth.

Tips "We are open to new ideas and different approaches within our niche (i.e., dog- and cat-themed designs, watercolor florals, etc.). We look for bright colors and cute, whimsical art. Floral designs require crisp colors."

KID STUFF MARKETING

University Blvd. at Essex Entrance, Topeka KS 66619-0235. (785)862-3707. Fax: (785)862-1424. E-mail: michael@kidstuff.com. Web site: www.kidstuff.com. **Senior Creative Director:** Michael Oden. Estab. 1982. Produces collectible figurines, toys, kids' meal sacks, edutainment activities and cartoons for restaurants and entertainment venues worldwide.

Needs Approached by 50 freelancers/year. Works with 10 freelancers/year. Buys 30-50 freelance designs and illustrations/year. Works on assignment only. Uses freelancers mainly for illustration, activity or game development and sculpting toys. Considers all media. Looking for humorous, child-related styles. Freelance illustrators should be familiar with Photoshop, Illustrator, FreeHand and QuarkXPress. Produces material for Christmas, Easter, Halloween, Thanksgiving, Valentine's Day and everyday. Submit seasonal material 3 months in advance.

First Contact & Terms Illustrators and Cartoonists: Send query letter with photocopies or e-mail JPEG files. Sculptors, calligraphers: Send photocopies. Samples are filed or returned by SASE. Responds only if interested. Portfolio review not required. Pays by the project, $250-5,000 for illustration or game activities. Finds freelancers through word of mouth and submissions.

THE LANG COMPANIES

514 Wells St., Delafield WI 53018. (262)646-3399. Web site: www.lang.com. **Product Development Coordinator:** Yvonne Moroni. Estab. 1982. Produces high-quality linen-embossed greeting cards, stationery, calendars, boxes and gift items. Art guidelines available for SASE.

Needs Approached by 300 freelance artists/year. Works with 40 freelance artists/year. Uses freelancers mainly for card and calendar illustrations. Considers all media and styles. Looking for traditional and nonabstract country-inspired, folk, contemporary and fine art styles. Produces material for Christmas, birthdays and everyday. Submit seasonal material 6 months in advance.

First Contact & Terms Send query letter with SASE and brochure, tearsheets, photostats, photographs, slides, photocopies or transparencies. Samples are returned by SASE if requested by artist. Responds in 6 weeks. Pays royalties based on net wholesale sales. Rights purchased vary according to project.

Tips "Research the company and submit compatible art. Be patient awaiting a response."

THE LOLO COMPANY

6755 Mira Mesa Blvd., Suite 123-410, San Diego, CA 92121. (800)760-9930. Fax: (800)234-6540. E-mail: products@lolofun.com. Web site: www.lolofun.com. **Creative Director:** Robert C. Paul. Estab. 1995. Publishes board games. Recent games include "Bucket Blast," "It-DAH-gan," "Run Around Fractions" and "You're It."

Needs Approached by 1 illustrator and 1 designer/year. Works with 2 illustrators and 2 designers/year. Prefers humorous work. Uses freelancers mainly for product design and packaging. 100% of freelance design and illustration demands knowledge of Illustrator, Photoshop and QuarkXPress.

First Contact & Terms Preferred submission package is a self-promotional postcard sample. Send 5 printed samples or photographs. Accepts disk submissions in Windows format; send via Zip as EPS. Samples are filed. Will contact artist for portfolio review if interested. Portfolio should include artwork of characters in sequence, color photocopies, photographs, transparencies of final art and roughs. Rights purchased vary according to project. Finds freelancers through word of mouth and Internet.

LPG GREETINGS, INC.

813 Wisconsin St., Walworth WI 53184. (262)275-5600. Fax: (262)275-5609. E-mail: judy@lpggreetings.com. Web site: www.lpggreetings.com. **Creative Director:** Judy Cecchi. Estab. 1992. Produces greeting cards. Specializes in boxed Christmas cards.

Needs Approached by 50-100 freelancers/year. Works with 20 freelancers/year. Buys 70 freelance designs and illustrations/year. Art guidelines free for SASE with first-class postage. Uses freelancers mainly for original artwork for Christmas cards. Considers any media. Looking for traditional and humorous Christmas designs. Greeting cards can be vertical or horizontal; 5×7 or 6×8. Usually prefers 5×7. Submit seasonal material 1 year in advance.

First Contact & Terms Send query letter with photocopies. Samples are filed if interested or returned by SASE. Portfolio review not required. Will contact artist for portfolio if interested. Rights purchased vary according to project. Pays for design by the project. Pays flat fee for illustration. Finds freelancers through word of mouth and submissions. Do not send unsolicited samples via e-mail; they will not be considered.

Tips "Be creative with fresh new ideas."

MADISON PARK GREETINGS

1407 11th Ave., Seattle WA 98122-3901. (206)324-5711. Fax: (206)324-5822. E-mail: info@madpark.com. Web site: www.madisonparkgreetings.com. **Art Director:** Glen Biely. Estab. 1977. Produces greeting cards, stationery, notepads, frames.

Needs Approached by 3,000 freelancers/year. Works with 30 freelancers/year. Buys 200 freelance designs and illustrations/year. Art guidelines available free for SASE. Works on assignment only. Uses freelancers mainly for greeting cards; also for calligraphy, reflective art. Considers all paper-related media. Produces material for Christmas, Easter, Mother's Day, Father's Day, graduation, New Year, Valentine's Day, birthdays, everyday, sympathy, get well, anniversary, baby congratu-

lations, wedding, thank you, expecting, friendship. "We are interested in floral and whimsical imagery, as well as humor." Submit seasonal material 10 months in advance.

First Contact & Terms Designers: Send photocopies. Illustrators: Send postcard sample or photocopies. Accepts submissions on disk. Send JPEG or PDF files. Samples are not returned. Will contact artist for portfolio review of color, final art, roughs if interested. Rights purchased and royalties vary according to project.

MILLIMAC LICENSING CO.

188 Michael Way, Santa Clara CA 95051. (408)984-0700. E-mail: clamkinman@comcast.net. Web site: www.clamkinman.com. **Owner:** Bruce Ingrassia. Estab. 1978. Produces collectible figurines, mugs, T-shirts and textiles. Produces a line of cartoon characters called the Clamkin® Family, directed towards "children and adults young at heart."

Needs Approached by 10 freelancers/year. Works with 2-3 freelancers/year. Buys 30-40 freelance designs and illustrations/year. Prefers freelancers with experience in cartooning. Works on assignment only. Uses freelancers mainly for line art, color separation, Mac computer assignments. Looking for humorous, clever, "off the wall," cute animals. 50% of freelance design/illustration demands knowledge of Photoshop, Illustrator, FreeHand (pencil roughs OK). "Computer must be Mac or PC." Produces material for everyday.

First Contact & Terms Designers/Cartoonists: Send query letter with photocopies. Sculptors: Send photos of work. Accepts e-mail submissions compatible with Mac Adobe Illustrator files or PDF. Samples are filed. Will contact artist for portfolio review if interested. Rights purchased and pay rates vary according to project. Finds freelancers through submissions. "I also find a lot of talent around town at fairs, art shows, carnivals, schools—I'm always on the lookout."

Tips "Get a computer—learn Adobe Illustrator and Photoshop. Be clever, creative, open minded and responsible, and never give up. Quitters never get there."

MIXEDBLESSING

P.O. Box 97212, Raleigh NC 27624-7212. (919)847-7944. Fax: (919)847-6429. E-mail: mixedblessing@earthlink.com. Web site: www.mixedblessing.com. **President:** Elise Okrend. Licensing: Philip Okrend. Estab. 1990. Produces interfaith greeting cards combining Jewish and Christian as well as multicultural images for all ages. Licenses holiday artwork for wrapping paper, tote bags, clothing, paper goods and greeting cards.

Needs Approached by 10 freelance artists/year. Works with 10 freelancers/year. Buys 20 designs and illustrations/year. Provides samples of preferred styles upon request. Works on assignment only. Uses freelancers mainly for card illustration. Considers watercolor, pen & ink and pastel. Prefers final art 5×7. Produces material for Christmas and Hanukkah. Submit seasonal material 10 months in advance.

First Contact & Terms Send nonreturnable samples for review. Samples are filed. Responds only if interested. Originals are returned at job's completion. Sometimes requests work on spec before assigning a job. Pays flat fee of $125-500 for illustration/design. Buys all rights. Finds artists through visiting art schools.

Tips "I see growth ahead for the industry. Go to and participate in the National Stationery Show."

N-M LETTERS, INC.

662 Bullocks Point Ave., Riverside RI 02915. (401)433-0040. Fax: (800)989-2051. E-mail: help@nmletters.com. Web site: www.nmletters.com. **President:** Judy Mintzer. Estab. 1982. Produces announcements and invitations that are "sweet and sassy, cool and sophisticated, playful and edgy."

Needs Approached by 2-5 freelancers/year. Works with 2 freelancers/year. Prefers local artists only. Works on assignment only. Produces material for parties, weddings and Bar/Bat Mitzvahs. Submit seasonal material 6 months in advance.

First Contact & Terms Send query letter with résumé. Responds in 1 month, only if interested. Call for appointment to show portfolio of b&w roughs. Original artwork is not returned. Pays by the project.

ℕ 🆈 NATIONAL DESIGN CORP.

16885 Via Del Campo Court, Suite 300, San Diego CA 92127-1700. (858)674-6040. Fax: (858)674-4120. Web site: www.nationaldesign.com. **Creative Director:** Christopher Coats. Estab. 1985. Produces gifts, writing instruments and stationery accoutrements. Markets include gift/souvenir and premium markets.

Needs Works with 3-4 freelancers/year. Buys 3 freelance designs and illustrations/year. Prefers local freelancers only. Works on assignment only. Uses freelancers mainly for design illustration; also for prepress production on Mac. Considers computer renderings to mimic traditional medias. Prefers children's and contemporary styles. 100% of freelance work demands knowledge of Illustrator and InDesign, Freehand and Photoshop. Produces material for Christmas and everyday.

First Contact & Terms Send query letter with photocopies, résumé, SASE. Accepts submissions on disk. "Contact by phone for instructions." Samples are filed and are returned if requested. Company will contact artist for portfolio review of color, final art, tearsheets if interested. Rights purchased vary according to project. Payments depends on complexity, extent of project(s).

Tips "Must be well traveled to identify with gift/souvenir markets internationally. Fresh ideas always of interest."

NOBLE WORKS

P.O. Box 1275, Hoboken NJ 07030. (201)420-0095. Fax: (201)420-0679. E-mail: info@nobleworks inc.com. Web site: www.nobleworksinc.com. **Contact:** Art Department. Estab. 1981. Produces greeting cards, notepads, gift bags and gift products. Specializes in trend-oriented, hip urban greeting cards. "Always pushing the envelope, our cards redefine the edge of sophisticated, sassy, and downright silly fun." Art guidelines available for SASE with first-class postage.

Needs Approached by 100-200 freelancers/year. Works with 50 freelancers/year. Buys 250 freelance designs and illustrations/year. Looking for humorous, "off-the-wall" adult contemporary and editorial illustration. Produces material for Christmas, Mother's Day, Father's Day, graduation, Halloween, Valentine's Day, birthdays, thank you, anniversary, get well, astrology, sympathy, etc. Submit seasonal material 18 months in advance.

First Contact & Terms Designers: Send query letter with photocopies, SASE, tearsheets, transparencies. Illustrators and Cartoonists: Send query letter with photocopies, tearsheets, SASE. After introductory mailing, send follow-up postcard sample every 8 months. Responds in 1 month. Buys reprint rights. Pays for design and illustration by the project. Finds freelancers through sourcebooks, illustration annuals, referrals.

NOVO CARD PUBLISHERS INC.

3630 W. Pratt Ave., Lincolnwood IL 60712. (847)763-0077. Fax: (847)763-0022. E-mail: art@novo card.net. Web site: www.novocard.net. Estab. 1927. Produces all categories of greeting cards.

Needs Approached by 200 freelancers/year. Works with 30 freelancers/year. Buys 300 or 400 pieces/year from freelance artists. Art guidelines free for SASE with first-class postage. Uses freelancers mainly for illustration and text; also for calligraphy. Considers all media. Prefers crop size $5 \times 7^3/_4$, bleed $5^1/_4 \times 8$. Knowledge of Photoshop, Illustrator and QuarkXPress helpful. Produces material for all holidays and seasons and everyday. Submit seasonal material 8 months in advance.

First Contact & Terms Designers: Send brochure, photocopies, photographs and SASE. Illustrators and Cartoonists: Send photocopies, photographs, tearsheets and SASE. Calligraphers: Send b&w copies. Accepts disk submissions compatible with Macintosh QuarkXPress 4.0 and Windows

Kirsten Ulve (www.kirstenulve.com) began her career as a graphic designer and part-time illustrator in Chicago, then relocated to New York in 1996 to devote herself to illustration full-time. Currently represented in the U.S. by Holly Hahn + Co. (www.hollyhahn.com), her digital illustration style was influenced by early obsessions with Lite Brite, puppets, fashion and discotheques. "Always draw what excites you," she advises. "I try to put feeling into everything I draw." Ulve created these commissioned images for NobleWorks Inc. (www.nobleworksinc.com). "New Mom" (left) was used as a Mother's Day card; "Lovebirds" (right) as a Valentine's Day card.

95. Art samples are not filed and are returned by SASE only. Written samples retained on file for future assignment with writer's permission. Responds in 2 months. Pays for design and illustration by the project, $75-200.

OATMEAL STUDIOS

P.O. Box 138, Rochester VT 05767. (802)767-3171. Fax: (802)767-9890. E-mail: sales@oatmealstu dios.com. Web site: www.oatmealstudios.com. **Creative Director:** Helene Lehrer. Estab. 1979. Publishes humorous greeting cards and notepads, creative ideas for everyday cards. Art guidelines available for SASE with first-class postage.

Needs Approached by approximately 300 freelancers/year. Buys 100-150 freelance designs and illustrations/year. Considers all media.

First Contact & Terms Write for art guidelines; send query letter with slides, roughs, printed pieces or brochure/flyer to be kept on file. "If brochure/flyer is not available, we ask to keep one slide or printed piece; color or b&w photocopies also acceptable for our files." Samples are returned by SASE. Responds in 6 weeks. No portfolio reviews. Negotiates payment.

Tips "We're looking for exciting and creative, humorous (not cutesy) illustrations and single-panel cartoons. If you can write copy and have a humorous cartoon style all your own, send us your ideas! We do accept artwork without copy, too."

ONTARIO FEDERATION OF ANGLERS AND HUNTERS

P.O. Box 2800, Peterborough ON K9J 8L5 Canada. (705)748-6324. Fax: (705)748-9577. Web site: www.ofah.org. **Graphic Designer:** Deborah Carew. Estab. 1928. Produces calendars, greeting cards, limited edition prints. "We are a nonprofit, conservation organization that publishes a

high-quality wildlife art calendar and a series of four Christmas cards each year. We also commission two paintings per year that we produce in limited edition prints.'' Art guidelines free by mail, e-mail or on Web site.

Needs Approached by 60 freelancers/year. Works with 6-12 freelancers/year. Buys 12 freelance designs and illustrations/year. Prefers wildlife artists. Uses freelancers mainly for calendar/cards. Considers any media that gives realistic style. ''We find talent through a yearly wildlife art calendar contest. Our criteria is specific to the wildlife art market with a slant towards hunting and fishing activities. We can only consider North American species found in Ontario. We welcome scenes involving sportsmen and women in the outdoors; also sporting dogs. All art must be fine art quality, realistic, full color, with backgrounds. Any medium that gives these results is acceptable. No illustrative or fantasy-type work, please. Look to successful wildlife artists like Robert Bateman or Michael Dumas for the style we're seeking.'' Prefers minimum 9×12 final art. No wording required.

First Contact & Terms ''Contact through contest only, please.'' Samples are filed or returned. Responds following contest. Portfolio review not required. Buys one-time rights. Pays $150/calendar piece plus extras.

OUT OF THE BLUE

7350 S. Tamiami Trial #227, Sarasota FL 34231. (941)966-4042. Fax: (941)966-8914. E-mail: outoftheblue.us@mac.com. Web site: www.out-of-the-blue.us. **President:** Michael Woodward. ''We specialize in creating 'Art Brands.' We are looking for decorative art that we can license for product categories such as posters and fine art prints, limited edition giclées, greeting cards, calendars, stationery, gift products and the home decor market. We specialize particulary in the fine art print/poster market.''

• This company is a division of Art Licensing International, Inc. See separate listings in the Posters & Prints and Artists' Reps sections as well as in this section.

Needs Collections of art, illustrations or photography that have wide consumer appeal. ''CD or e-mail presentations preferred, but photocopies/flyers are acceptable. Keep files to 250K or below.''

First Contact & Terms Send samples on CD (JPEG files), short bio, color photocopies and SASE. E-mail submissions also accepted. ''Terms are 50/50 with no expense to artist as long as artist can provide high-res scans if we agree on representation.'' Submission guidelines are available on Web site at www.out-of-the-blue.us/submissions.html.

Tips ''Pay attention to trends and color palettes. Artists need to consider actual products when creating new art. Look at products in retail outlets and get a feel for what is selling well. Get to know the markets you want to sell your work to.''

PAPER MAGIC GROUP INC.

401 Adams Ave., Scranton PA 18510. (570)961-3863. Fax: (570)348-8389. E-mail: careers@paper magic.com. Web site: www.papermagic.com. **Creative Director:** Don French. Estab. 1984. Produces greeting cards, stickers, vinyl wall decorations, 3D paper decorations. ''We publish seasonal cards and decorations for the mass market. We use a wide variety of design styles.''

Needs Works with 60 freelance artists/year. Prefers artists with experience in greeting cards. Work is by assignment; or send submissions on spec. Designs products for Christmas and Valentine's Day. Also uses freelancers for lettering and art direction.

First Contact & Terms Send query letter with résumé, samples (color photocopies) and SASE. Samples are filed or are returned by SASE if requested by artist. Responds in 2 months. Originals are not returned. Pays by the project, $350-2,000 average. Buys all rights.

Tips ''Please, experienced illustrators only.''

PORTERFIELD'S FINE ART LICENSING

5 Mountain Rd., Concord NH 03301-5479. (800)660-8345 or (603)228-1864. Fax: (603)228-1888. E-mail: information@porterfieldsfineart.com. Web site: www.porterfieldsfineart.com. **President:** Lance J. Klass. Licenses representational, Christmas, holiday, seasonal, Americana, and many other subjects. "We're a major, nationally recognized full-service licensing agency." Estab. 1994. Functions as a full-service licensing representative for individual artists wishing to license their work into a wide range of consumer-oriented products. "We are one of the fastest growing art licensing agencies in North America, as well as the best-known art licensing site on the Internet, rated #1 in art licensing by Google for over 8 years, and recently #1 on MSN, Yahoo and Ask.com as well. Stop by our site for more information about how to become a Porterfield's artist and have us represent you and your work for licenses in wall and home decor, home fabrics, stationery and all paper products, crafts, giftware and many other fields."

Needs Approached by more than 800 artists/year. Licenses many designs and illustrations/year. Prefers commercially oriented artists "who can create beautiful pieces of art that people want to look at again and again, and that will help sell products to the core consumer—that is, women over 30 who purchase 85% of all consumer goods in America." Art guidelines listed on Web

© Janet Stever, represented by Porterfield's Fine Art Licensing

This snowman painting "was one of the first images Janet Stever made available to Porterfield's for license," says Lance Klass, President of Porterfield's Fine Art Licensing. "It opened the door to a number of licenses for the artist in a wide variety of home decor, paper, stationery and giftware products." Thus far Stever's painting has been reproduced on mugs, stocking holders, cookie jars, trays, votives, plates, boxes, and even fabric products. Klass recommends watching the market for similar art that is being used on commercial products and noting not only what is selling, but what is not.

site. Considers existing works first. Considers any media—oil, pastel, watercolor, acrylics, digital. "We are seeking artists who have exceptional artistic ability and commercial savvy, who study the market for trends, and who would like to have their art and their talents introduced to the broad public. Artists must be willing to work hard to produce art for the market."

First Contact & Terms Visit company's Web site to read needs and submission guidelines. E-mail JPEG files or your URL, or send query letter with tearsheets, photographs, photocopies. SASE required for return of materials. Responds in several weeks. Will contact for further review if interested. Licenses primarily on a royalty basis.

Tips "We are impressed first and foremost by level of ability, even if the subject matter is not something we would use. Thus, a demonstration of competence is the first step; hopefully the second would be that demonstration using subject matter that we believe would be commercially marketable onto a wide and diverse array of consumer products. We work with artists to help them with the composition of their pieces for particular media. We treat artists well, and actively represent them to potential licensees. Instead of trying to reinvent the wheel yourself and contact everyone 'cold,' we suggest you look at getting a licensing agent or rep whose particular abilities complement your art. We specialize in the application of art to home decor and accessories, home fabrics, prints and wall decor, and also print media such as cards, stationery, calendars, and many other products. The trick is to find the right rep whom you feel you can work with— someone who really loves your art (whatever it is), who is interested in investing financially in promoting your work, and whose specific contacts and abilities can help further your art in the marketplace."

THE PRINTERY HOUSE OF CONCEPTION ABBEY

P.O. Box 12, Conception MO 64433. (660)944-3110. Fax: (660)944-3116. E-mail: art@printeryhouse.org. Web site: www.printeryhouse.org. **Art Director:** Brother Michael Marcotte, O.S.B. Creative Director: Ms. Lee Coats. Estab. 1950. Publishes religious greeting cards. Licenses art for greeting cards and wall prints. Specializes in religious Christmas and all-occasion themes for people interested in religious, yet contemporary, expressions of faith. "Card designs are meant to speak to the heart. They feature strong graphics, calligraphy and other appropriate styles."

Needs Approached by 100 freelancers/year. Works with 40 freelancers/year. Art guidelines and technical specifications available on Web site. Uses freelancers for product illustration and lettering. Looking for dignified styles and solid religious themes. Has preference for high-quality broad-edged pen lettering with simple backgrounds/illustrations. Produces seasonal material for Christmas and Easter as well as birthday, get well, sympathy, thank you, etc. Digital work is accepted in Photoshop or Illustrator format.

First Contact & Terms Send query letter with résumé, photocopies, CDs, photographs, slides or tearsheets. Calligraphers: send samples of printed or finished work. Nonreturnable samples preferred or else samples with SASE. Accepts disk submissions compatible with Photoshop or Illustrator. Send TIFF or EPS files. Usually responds within 3-4 weeks. To show portfolio, mail appropriate materials only after query has been answered. "Generally, we continue to work with artists once we have accepted their work." Pays flat fee of $300-$500 for illustration/design, and $100-$200 for calligraphy. Usually buys exclusive reproduction rights for a specified format, but artist retains copyright for any other usage.

Tips "Remember that our greeting cards need to have a definite Christian/religious dimension but not overly sentimental. It must be good, quality artwork. We sell mostly via catalogs, so artwork has to reduce well for catalog."

PRIZM INC.

P.O. Box 1106, Manhattan KS 66505-1106. (785)776-1613. Fax: (785)776-6550. E-mail: michele@prizm-inc.com. **President of Product Development:** Michele Johnson. Produces and markets

figurines, decorative housewares, gifts and ornaments. Manufacturer of exclusive figurine lines.
Needs Approached by 20 freelancers/year. Art guidelines free for SASE with first-class postage. Works on assignment only. Uses freelancers mainly for figurines, home decor items; also for calligraphy. Considers all media. Looking for traditional, old world style, sentimental, folk art. Produces material for Christmas, Mother's Day, everyday. Submit seasonal material 1 year in advance.
First Contact & Terms Send query letter with photocopies, résumé, SASE, slides, tearsheets. Samples are filed. Responds in 2 months if SASE is included. Will contact for portfolio review of color, final art, slides. Rights purchased vary according to project. Pays royalties plus payment advance; negotiable. Finds freelancers through submissions, decorative painting industry.
Tips "People seem to be more family oriented—therefore more wholesome and positive images are important. We are interested in looking for new artists and lines to develop. Send a few copies of your work with a concept."

⚅ PRUDENT PUBLISHING

65 Challenger Rd., Ridgefield Park NJ 07660. (201)641-7900. Fax: (201)641-9356. Web site: www.gallerycollection.com. **Creative Coordinator:** Marian Francesco. Estab. 1928. Produces greeting cards. Specializes in business/corporate all-occasion and holiday cards. Art guidelines available.
Needs Buys calligraphy. Uses freelancers mainly for card design, illustrations and calligraphy. Considers traditional media. Prefers no cartoons or cute illustrations. Prefers $5^{1}/_{2} \times 7^{7}/_{8}$ horizontal format (or proportionate). Produces material for Christmas, Thanksgiving, birthdays, everyday, sympathy, get well and thank you.
First Contact & Terms Designers, illustrators and calligraphers: Send query letter with brochure, photostats, photocopies, tearsheets. Samples are filed or returned by SASE if requested. Responds ASAP. Portfolio review not required. Buys all rights. No royalty or licensing arrangements. Payment is negotiable. Finds freelancers through submissions, magazines, sourcebooks, agents and word of mouth.
Tips "No cartoons."

RECYCLED PAPER GREETINGS INC.

3636 N. Broadway, Chicago IL 60613. (773)348-6410. Fax: (773)281-1697. Web site: www.recycled.com. **Art Directors:** Gretchen Hoffman, John LeMoine. Publishes greeting cards, adhesive notes and imprintable stationery.
Needs Buys 1,000-2,000 freelance designs and illustrations/year. Considers b&w line art and color—"no real restrictions." Looking for "great ideas done in your own style with messages that reflect your own slant on the world." Prefers 5×7 vertical format for cards. "Our primary interest is greeting cards." Produces seasonal material for all major and minor holidays including Jewish holidays. Submit seasonal material 18 months in advance; everyday cards are reviewed throughout the year.
First Contact & Terms Send SASE to the Art Department or view Web site for guidelines. "Please do not send slides, CDs or tearsheets. We're looking for work done specifically for greeting cards." Responds in 2 months. Portfolio review not required. Originals returned at job's completion. Sometimes requests work on spec before assigning a job. Pays average flat fee of $250 for illustration/design with copy; some royalty contracts. Buys card rights.
Tips "Remember that a greeting card is primarily a message sent from one person to another. The art must catch the customer's attention, and the words must deliver what the front promises. We are looking for unique points of view and manners of expression. Our artists must be able to work with a minimum of direction and meet deadlines. There is a renewed interest in the use of recycled paper; we have been the industry leader in this for over three decades."

RIGHTS INTERNATIONAL GROUP, LLC

500 Paterson Plank Rd., Union City NJ 07030. (201)239-8118. Fax: (201)222-0694. E-mail: rhazaga @rightsinternational.com. Web site: www.rightsinternational.com. **Contact:** Robert Hazaga. Estab. 1996. Agency for cross licensing. Licenses images for manufacturers/publishers of giftware, stationery, posters and home furnishings.

● See additional listing in the Posters & Prints section.

Needs Approached by 50 freelancers/year. Uses freelancers mainly for creative, decorative art for the commercial and designer market; also for textile art. Considers oil, acrylic, watercolor, mixed media, pastels and photography.

First Contact & Terms Send brochure, photocopies, photographs, SASE, slides, tearsheets or transparencies. Accepts disk submissions compatible with PC format. Responds in 1 month. Will contact for portfolio review if interested. Negotiates payment and rights purchased.

RITE LITE LTD., THE JACOB ROSENTHAL JUDAICA COLLECTION

333 Stanley Ave., Brooklyn NY 11207. (718)498-1700. Fax: (718)498-1251. E-mail: products@rit iteltd.com. Web site: www.riteliteltd.com. Estab. 1948. Manufacturer and distributor of a full range of Judaica. Clients include department stores, galleries, gift shops, museum shops and jewelry stores.

Needs Looking for new menorahs, mezuzahs, children's Judaica, Passover and matza plates. Works on assignment only. Must be familiar with Jewish ceremonial objects or design. Also uses artists for brochure and catalog design, illustration and layout mechanicals, and product design. Most of freelance work requires knowledge of Illustrator and Photoshop. Produces material for Hannukkah, Passover and other Jewish Holidays. Submit seasonal material 1 year in advance.

First Contact & Terms Designers: Send query letter with brochure or résumé and photographs. Illustrators: Send photocopies. Do not send originals. Samples are filed. Responds in 1 month, only if interested. Art Director will contact for portfolio review if interested. Portfolio should include color tearsheets, photographs and slides. Pays flat fee per design. Buys all rights. Finds artists through word of mouth.

Tips ''Be open to the desires of the consumers. Don't force your preconceived notions on them through the manufacturers. Know that there is one retail price, one wholesale price, and one distributor price.''

ROCKSHOTS GREETING CARDS

20 Vandam St., 4th Floor, New York NY 10013-1274. (212)243-9661. Fax: (212)604-9060. Web site: www.rockshots.com. **Art Director:** Bob Vesce. Estab. 1979. Produces calendars, giftbags, giftwrap, greeting cards, mugs. ''Rockshots is an outrageous, sometimes adult, always hilarious card company. Our themes are sex, birthdays, sex, holidays, sex, all-occasion and sex. Our images are mainly photographic, but we also seek out cartoonists and illustrators.'' Art guidelines free for SASE with first-class postage.

Needs Approached by 10-20 freelancers/year. Works with 5-6 freelancers/year. Buys 10 freelance designs and illustrations/year. ''We like a line that has many different facets to it, encompassing a wide range of looks and styles. We are outrageous, adult, witty, off-the-wall, contemporary and sometimes shocking.'' Prefers any size that can be scaled on a greeting card to 5 inches by 7 inches. 10% of freelance illustration demands computer skills. Produces material for Christmas, New Year, Valentine's Day, birthdays, everyday, get well, woman-to-woman (''some male bashing allowed'') and all adult themes.

First Contact & Terms Send photocopies, photographs and photostats. Samples are filed. Responds only if interested. Portfolio review not required. Buys first rights. Pays per image.

Tips ''As far as trends go in the greeting card industry, we've noticed that 'retro' refuses to die. Vintage-looking cards and images still sell very well. People find comfort in the nostalgic look of

yesterday. Sex also is a huge seller. Rockshots is looking for illustrators that can come up with something a little out of mainstream. Our look is outrageous, witty, adult and sometimes shocking. Our range of style starts at cute and whimsical and runs the gamut all the way to totally wacky and unbelievable. Rockshots cards definitely stand out from the competition. For our line of illustrations, we look for a style that can convey a message, whether through a detailed 'elaborate colorful piece of art or a simple 'gesture' drawing. Characters work well, such as the ever-present wisecracking granny to the nerdy 'everyman' guy. It's always good to mix sex and humor, as sex always sells. As you can guess, we do not shy away from much. Be creative, be imaginative, be funny, but most of all, be different.''

ROMAN, INC.
472 Brighton Dr., Bloomingdale IL 60108-3100. (630)705-4600. Fax: (630)705-4601. E-mail: dswetz@roman.com. Web site: www.roman.com. **Vice President:** Julie Puntch. Estab. 1963. Produces collectible figurines, decorative housewares, decorations, gifts, limited edition plates, ornaments. Specializes in collectibles and giftware to celebrate special occasions.
Needs Approached by 25-30 freelancers/year. Works with 3-5 freelancers/year. Uses freelancers mainly for graphic packaging design, illustration. Considers variety of media. Looking for traditional-based design; also has an inspirational niche. 80% of freelance design and illustration demands knowledge of Photoshop, QuarkXPress, Illustrator. Produces material for Christmas, Mother's Day, graduation, Thanksgiving, birthdays, everyday. Submit seasonal material 1 year in advance.
First Contact & Terms Send query letter with photocopies. Samples are filed or returned by SASE. Responds in 2 months if artist requests a reply. Portfolio review not required. Pays by the project. Finds freelancers through submissions and word of mouth.

RUBBERSTAMPEDE
2690 Pellisier Place, City of Industry CA 90601. (562)695-7969. Fax: (800)546-6888. E-mail: psmith@deltacreative.com. Web site: www.deltacreative.com. **Director of Marketing:** Peggy Smith. Estab. 1978. Produces art and novelty rubber stamps, kits, glitter pens, ink pads, papers, stickers, scrapbooking products.
Needs Approached by 30 freelance artists/year. Works with 10-20 freelance artists/year. Buys 200-300 freelance designs and illustrations/year. Uses freelance artists for calligraphy, P-O-P displays, and original art for rubber stamps. Considers pen & ink. Looks for whimsical, feminine style and fashion trends. Produces material for Christmas, Valentine's Day, Easter, Hanukkah, Thanksgiving, Halloween, birthdays and everyday (includes wedding, baby, travel, and other life events). Submit seasonal material 9 months in advance.
First Contact & Terms Send nonreturnable samples. Samples are filed. Responds only if interested. Pays by the hour, $15-50; by the project, $50-1,000. Rights purchased vary according to project. Originals are not returned.

ℕ ⊕ SANGHAVI ENTERPRISES PVT. LTD.
D-24, M.I.D.C., Satpur, Nashik 422 007 India. (91)(253)235-0181. Fax: (91)(253)235-1381. E-mail: seplnsk@sancharnet.in. **Managing Director:** H.L. Sanghavi. Estab. 1974. Produces greeting cards, calendars, stationery and school supplies. Art guidelines available on request.
Needs Approached by 50-60 freelancers/year. Buys 50 designs/year. Uses freelancers mainly for greeting cards and calendars. Prefers flowers, landscapes, wildlife and other general themes.
First Contact & Terms Send query letter and photocopies to be kept on file. ''Prefer nonreturnable copies; no originals, please.'' Responds in 1 month. Pays on publication. Pays flat fee of $25 for design. Buys reprint rights.

SANGRAY GIFTS BY PDI

2828 Granada Blvd., Pueblo CO 81005. (719)564-3408. Fax: (719)564-0956. E-mail: sales@pdipueblo.com. Web site: www.sangray.com. **Licensing:** Thomas Luchin. Estab. 1971. Licenses art for gift and novelty markets. Produces refrigerator magnets and other gift products using full-color art. Art guidelines available for SASE with first-class postage.

Needs Approached by 30-40 freelancers/year. Works indirectly with 6-7 freelancers/year. Buys 25-30 freelance designs and illustrations/year. Open to all themes and styles. Uses freelancers mainly for fine art for products. Considers all media. Prefers 7×7 size, or digital. Submit seasonal material 15 months in advance.

First Contact & Terms Send query letter with examples of work in any media. Samples are filed. Responds in 1 month. Will contact artist for portfolio review if interested. Buys first rights. Pays by the project, or royalty. Originals are returned at job's completion. Finds artists through submissions and design studios.

Tips "Try to get a catalog of the company products and send art that closely fits the style the company tends to use."

SOURIRE

P.O. Box 1659, Old Chelsea Station, New York NY 10113. (718)573-4624. E-mail: greetings@cardsorbust.com. Web site: www.cardsorbust.com. **Contact:** Submissions. Estab. 1998. Specializes in exclusive greeting card designs for cultural holidays and occasions. Target market is African-American and multi-ethnic men and women between ages 20 and 60.

Needs Approached by 50 freelancers/year. Licenses up to 20 freelance designs and/or illustrations/year. Art guidelines available on Web site or for SASE with first-class postage. Considers all media. Product categories include wedding, women, babies, historical, handcrafted. Produces material for all cultured holidays and occasions. Submit material 6 months in advance.

First Contact & Terms Send query letter with samples. Samples are returned by SASE or else discarded. Responds in 3 months. Portfolio review not required. Rights purchased vary. Finds freelancers through submissions and word of mouth.

SPARROW & JACOBS

6701 Concord Park Dr., Houston TX 77040. (713)329-9400. Fax: (713)744-8799. E-mail: sparrowart@gabp.com. **Contact:** Product Merchandiser. Estab. 1986. Produces calendars, greeting cards, postcards and other products for the real estate industry.

Needs Buys up to 200 freelance images/year including illustrations for postcards and greeting cards. Considers all media. Looking for new product ideas featuring residential front doors, flowers, landscapes, animals, holiday themes and much more. "Our products range from, but are not limited to, humorous illustrations and comical cartoons to classical drawings and unique paintings, to striking photography." Produces material for Christmas, Easter, Mother's Day, Father's Day, Halloween, New Year, Thanksgiving, Valentine's Day, birthdays, everyday, time change. Submit seasonal material 1 year in advance.

First Contact & Terms Send query letter with color photocopies, photographs or tearsheets. Also accepts e-mail submissions of low-resolution images. "If sending slides, do not send originals. We are not responsible for slides lost or damaged in the mail. Samples are filed or returned in your SASE."

SPENCER GIFTS, LLC

6826 Black Horse Pike, Egg Harbor Twp. NJ 08234-4197. (609)645-5526. Fax: (609)645-5797. E-mail: james.stevenson@spencergifts.com. Web site: www.spencersonline.com. **Contact:** James Stevenson. Licensing: Carl Franke. Estab. 1965. Retail gift chain located in approximately 750 stores in 43 states, including Hawaii and Canada. Includes new retail chain stores named Spirit Halloween Superstores.

● Products offered by store chain include posters, T-shirts, games, mugs, novelty items, cards, 14K jewelry, neon art, novelty stationery. Spencer's is moving into a lot of different product lines, such as custom lava lights and Halloween costumes and products. Visit a store if you can to get a sense of what they offer.

Needs Assigns 10-15 freelance jobs/year. Prefers artists with professional experience in advertising design. Uses artists for illustration (hard line art, fashion illustration, airbrush). Also needs product and fashion photography (primarily jewelry), as well as stock photography. Uses a lot of freelance computer art. 50% of freelance work demands knowledge of InDesign, Illustrator, Photoshop and QuarkXPress. Also needs color separators, production and packaging people. "You don't necessarily have to be local for freelance production."

First Contact & Terms Send postcard sample or query letter with *nonreturnable* brochure, résumé and photocopies, including phone number where you can be reached during business hours. Accepts submissions on disk. James Stevenson will contact artist for portfolio review if interested. Will contact only upon job need. Considers buying second rights (reprint rights) to previously published work. Finds artists through sourcebooks.

Tips "Become proficient in as many computer programs as possible."

STARFISH & DREAMS

(formerly NRN Designs, Inc.), 3291 Industry Way, Signal Hill CA 90755. (562)985-0608. Fax: (888)978-2734. E-mail: sales@starfishanddreams.com. Web site: www.starfishanddreams.com. **Art Director:** Linda Braun. Produces high-end invitations and announcements, photocards, and calendars.

Needs Looking for freelance artists with innovative ideas and formats for invitations and scrap-booking products. Works on assignment only. Produces stickers and other material for Christmas, Easter, graduation, Halloween, Hanukkah, New Year, Thanksgiving, Valentine's Day, birthdays, everyday (sympathy, get well, etc.). Submit seasonal material 1 year in advance.

First Contact & Terms E-mail query with link to your Web site or mail photocopies or other nonreturnable samples. Responds only if interested. Portfolios required from designers. Company will contact artist for portfolio review if interested. Rights purchased vary according to project. Pays for design by the project.

SUNSHINE ART STUDIOS, INC.

270 Main St., Agawan MA 01001. (413)82-8700. Fax: (413)821-8701. E-mail: aorsi@sunshinecards.com. Web site: sunshinecards.com. **Art Director:** Alicia Orsi. Estab. 1921. Produces greeting cards, stationery and calendars that are sold in own catalog, appealing to all age groups.

Needs Works with 50 freelance artists/year. Buys 100 freelance designs and illustrations/year. Prefers artists with experience in greeting cards. Art guidelines available for SASE with first-class postage. Works on assignment only. Uses freelancers for greeting cards, stationery and gift items; also for calligraphy. Considers all media. Looking for traditional or humorous images. Produces material for Christmas, birthdays and everyday. Submit seasonal material 6-8 months in advance.

First Contact & Terms Send query letter with brochure, résumé, SASE, tearsheets and slides. Samples are filed or are returned by SASE if requested by artist. Responds only if interested. Portfolio should include finished art samples and color tearsheets and slides. Originals are not returned. Pays by the project, $450-700. Pays $100-150/piece for calligraphy and lettering. Buys all rights.

SYRACUSE CULTURAL WORKERS

P.O. Box 6367, Syracuse NY 13217. (315)474-1132. Fax: (877)265-5399. E-mail: karenk@syracuseculturalworkers.com. Web site: www.syracuseculturalworkers.com. **Art Director:** Karen Kerney. Estab. 1982. Produces posters, note cards, postcards, greeting cards, T-shirts and calendars that

are feminist, progressive, radical, multicultural, lesbian/gay allied, racially inclusive and honoring of elders and children. Publishes and distributes peace and justice resources through their Tools For Change catalog.

• See additional listing in the Posters & Prints section.

Needs Approached by many freelancers/year. Works with 50 freelancers/year. Buys 40-50 freelance fine art images and illustrations/year. Considers all media (in slide form). Art guidelines available on Web site or free for SASE with first-class postage. Specifically seeking artwork celebrating peace-making diverstiy, people's history and community building. "Our mission is to help sustain a culture that honors diversity and celebrates community; that inspires and nurtures justice, equality and freedom; that respects our fragile Earth and all its beings; that encourages and supports all forms of creative expression." Themes include environment, positive parenting, positive gay and lesbian images, multiculturalism and cross-cultural adoption.

First Contact & Terms Send query letter with slides, brochures, photocopies, photographs, tearsheets, transparencies and SASE. Samples are filed or returned by SASE. Responds in 1 month with SASE. Will contact for portfolio review if interested. Buys one-time rights. Pays flat fee, $85-450; royalties of 4-6% gross sales. Finds artists through submissions and word of mouth.

Tips "Please do NOT send original art or slides. Rather, send photocopies, printed samples or duplicate slides. Also, one postcard sample is not enough for us to judge whether your work is right for us. Include return postage if you would like your artwork/slides returned. December and January are major art selection months."

TJ'S CHRISTMAS

7101 College Blvd., Overland Park KS 66210. (913)888-8338. Fax: (913)888-8350. E-mail: ed@imit chell.com. Web site: www.imitchell.com. **Creative Coordinator:** Edward Mitchell. Estab. 1983. Produces figurines, decorative accessories, ornaments and other Christmas adornments. Primarily manufactures and imports Christmas ornaments, figurines and accessories. Also sells some Halloween, Thanksgiving, gardening, 3D art (woodcarving and sculptures) and everyday home decor items. Clients: higher-end floral, garden, gift and department stores.

Needs Uses freelancers mainly for unique and innovative designs. Considers most media. "Our products are often nostalgic, bringing back childhood memories. They also should bring a smile to your face. We are looking for traditional designs that fit with our motto, 'Cherish the Memories.'" Produces material for Christmas, Halloween, Thanksgiving and everyday. Submit seasonal material 18 months in advance.

First Contact & Terms Send query letter with résumé, SASE and photographs. Will accept work on disk. Portfolios may be dropped off Monday-Friday. Samples are not filed and are returned by SASE. Responds in 2 months. Negotiates rights purchased. Pays advance on royalties of 5%. Terms are negotiated. Finds freelancers through magazines, word of mouth and artists' reps.

Tips "We typically stay away from selling mass markets. To succeed requires something different and better. Try richer color combinations and new twists on traditional concepts. Inspirational and humorous wording can help differentiate product, too."

VAGABOND CREATIONS INC.

2560 Lance Dr., Dayton OH 45409. (937)298-1124. E-mail: sales@vagabondcreations.net. Web site: www.vagabondcreations.net. **Art Director:** George F. Stanley, Jr. Publishes stationery and greeting cards with contemporary humor; also a line of coloring books. 99% of artwork used is provided by staff artists working with the company.

Needs Works with 3 freelancers/year. Buys 6 finished illustrations/year. Seeking line drawings, washes and color separations. Material should fit in standard-size envelope. Submit Christmas, Valentine's Day, everyday and graduation material at any time.

First Contact & Terms Query. Samples are returned by SASE. Responds in 2 weeks. Originals are returned only upon request. Payment negotiated.

Tips "Important! Currently we are *not* looking for additional freelance artists because we are very satisfied with the work submitted by those individuals working directly with us. Our current artists are very experienced and have been associated with us in some cases for over 30 years. We do not in any way wish to offer false hope to anyone, but it would be foolish on our part not to give consideration."

ⓝ VILLAGE NOTE CARDS

742 Elmhurst Circle, Claremont CA 91711-2946. (909)437-0808. Fax: (206)339-3765. E-mail: cards @villagenotecards.com. Web site: www.villagenotecards.com. **Owner:** Diane Cooley. Estab. 2007. Produces fine art note cards—blank inside, suitable for all occasions. "All cards are custom printed and assembled by hand." Art guidelines available on Web site.

Needs Considers all media. "We especially like illustrations and watercolor. Special consideration is given to art that portrays subjects or scenes related to Claremont, California." Final art size should be up to 8×10; "We will digitally scale art to card size."

First Contact & Terms Send photographs, photocopies, transparencies, URL or CD formatted for PC (with files in TIFF or JPEG format). Does not accept e-mail submissions, except URL link. Samples are not filed and are not returned. Responds only if interested. Buys electronic and reprint rights for cards. Pays in merchandise and offers Internet exposure with credit line. Finds freelancers through submissions, word of mouth, Internet.

Tips "We are open to artists who are new to the market. Mail submissions of 4-10 samples that are similar in style (we sell cards in matched sets as well as individually). Query is not necessary. Current needs include, but are not limited to, color illustrations of botanicals and herbs. Please e-mail questions rather than calling."

ⓝ WARNER PRESS, INC.

1201 E. Fifth St., Anderson IN 46012. (800)741-7721. Web site: www.warnerpress.org. **Creative Director:** Curtis Corzine. Estab. 1884. Warner Press is the publication board for the Church of God. Produces church bulletins and church supplies such as postcards and children's materials. "We produce products for the Christian market. Our main markets are the Church and Christian bookstores. We provide products for all ages." Art submission guidelines on Web site.

Needs Approached by 50 freelancers/year. Works with 15-20 freelancers/year. Buys 200 freelance designs and illustrations/year. Works on assignment only. Uses freelancers for all products, including bulletins and coloring books. Considers all media and photography. 100% of production work demands knowledge of Photoshop, Illustrator and InDesign.

First Contact & Terms Send postcard or query letter with samples. Do not send originals. Creative Director will contact artist for portfolio review if interested. Samples are filed or returned if SASE included. Pays by the project. Buys all rights (occasionally varies).

Tips "Subject matter must be appropriate for Christian market. Most of our art purchases are for children's materials."

ⓝ ZITI PUBLISHING

601 S. Sixth St., St. Charles MO 63301. E-mail: mail@zitipublishing.com. Web site: www.zitipubli shing.com. **Owner:** Salvatore Venture. Estab. 2006. Produces greeting cards. Specializes in architectural holiday cards for design professionals. Art guidelines available via e-mail.

Needs Buys 3 freelance designs and/or illustrations/year. Uses freelancers for architectural-related illustrations. Considers all media. Produces material for greeting cards, mainly Christmas and Thanksgiving. Submit seasonal material at any time. Final art size should be "proportional to and at least" 5×7 inches.

First Contact & Terms Accepts e-mail submissions with Windows-compatible image files or link to Web site. "E-mail attachments are preferred, but anything that accurately shows the work is fine." After introductory mailing, send follow-up postcard sample every 6 months. Samples are filed or returned by SASE if requested. Responds only if interested. "We purchase exclusive rights for the use of illustrations/designs on greeting cards and do not prevent artists from using images on other non-greeting card items. Artist retains all copyrights and can end the agreement for any reason." Pays $50 advance and 5% royalties at the end of the season. Finds freelancers through submissions.

Tips "We need unusual and imaginative illustrations that relate to architecture for general greeting cards and especially the Christmas holiday season—architecture plus snow, holiday decorations/colors/symbols, etc. Present your ideas for cards if your portfolio does not include such work. We will consider your card ideas in terms of your style, and we will consider any media and any style."

Posters & Prints

© Natasha Wescoat

Have you ever noticed, perhaps at the opening of an exhibition or at an art fair, that though you have many paintings on display, everybody wants to buy the same one? Do friends, relatives and co-workers ask you to paint duplicates of work you've already sold? Many artists turn to the print market because they find certain images have a wide appeal and will sell again and again. This section lists publishers and distributors who can produce and market your work as prints or posters. It is important to understand the difference between the terms "publisher" and "distributor" before you begin your research. Art *publishers* work with you to publish a piece of your work in print form. Art *distributors* assist you in marketing a pre-existing poster or print. Some companies function as both publisher and distributor. Look in the first paragraph of each listing to determine if the company is a publisher, distributor or both.

RESEARCH THE MARKET

Some listings in this section are fine art presses, and others are more commercial. Read the listings carefully to determine which companies create editions for the fine art market or for the decorative market. Visit galleries, frame shops, furniture stores and other retail outlets that carry prints to see where your art fits in. You may also want to visit designer showrooms and interior decoration outlets.

To further research this market, check each company's Web site or send for their catalog. Some publishers will not send their catalogs because they are too expensive, but you can often ask to see one at a local poster shop, print gallery, upscale furniture store or frame shop. Examine the colors in the catalogs to make sure the quality is high.

What to send

To approach a publisher, send a brief query letter, a short bio, a list of galleries that represent your work, and five to 10 slides or whatever samples they specify in their listing. It helps to send printed pieces or tearsheets as samples, as these show publishers that your work reproduces well and that you have some understanding of the publication process. Most publishers will accept digital submissions via e-mail or CD.

Signing and numbering your editions

Before you enter the print arena, follow the standard method of signing and numbering your editions. You can observe how this is done by visiting galleries and museums and talking to fellow artists.

If you are creating a limited edition—with a specific, set number of prints—all prints

Your Publishing Options

Important

1. **Working with a commercial poster manufacturer or art publisher.** If you don't mind creating commercial images and following current trends, the decorative market can be quite lucrative. On the other hand, if you work with a fine art publisher, you will have more control over the final image.

2. **Working with a fine art press.** Fine art presses differ from commercial presses in that press operators work side by side with you every step of the way, sharing their experience and knowledge of the printing process. You may be charged a fee for the time your work is on the press and for the expert advice of the printer.

3. **Working at a co-op press.** Instead of approaching an art publisher, you can learn to make your own hand-pulled original prints—such as lithographs, monoprints, etchings or silk-screens. If there is a co-op press in your city, you can rent time on a press and create your own editions. It can be rewarding to learn printing skills and have the hands-on experience. You also gain total control of your work. The drawback is you have to market your images yourself by approaching galleries, distributors and other clients.

4. **Self-publishing.** Several national printing companies advertise heavily in artists' magazines, encouraging artists to publish their own work. If you are a saavy marketer who understands the ins and outs of trade shows and direct marketing, this is a viable option. However, it takes a large investment up front, whether you work with a printing company or choose to do everything on your own. If you contract with a printer, you could end up with a thousand prints taking up space in your basement. On the other hand, if you are a good marketer, you could end up selling them all and making a much larger profit than if you had gone through an art publisher or poster company.

 Another option is to create the prints yourself, from your computer, using a high-quality digital printer and archival paper. You can make the prints as needed, which will save money. (See the Insider Report on page 332 for more information.)

5. **Marketing through distributors.** If you choose the self-publishing route but don't have the resources to market your prints, distributors will market your work in exchange for a percentage of sales. Distributors have connections with all kinds of outlets like retail stores, print galleries, framers, college bookstores and museum shops.

should be numbered, such as 35/100. The largest number is the total number of prints in the edition; the smaller number is the sequential number of the actual print. Some artists hold out ten percent as artist's proofs and number them separately with AP after the number (e.g., 5/100 AP). Many artists sign and number their prints in pencil.

Types of prints

Original prints. Original prints may be woodcuts, engravings, linocuts, mezzotints, etchings, lithographs or serigraphs (see Glossary on page 562 for definitions). What distinguishes them is that they are produced by hand by the artist (and consequently often referred to as hand-pulled prints). In a true original print, the work is created specifically to be a print. Each print is considered an original because the artist creates the artwork directly on the plate, woodblock, etching stone or screen. Original prints are sold through specialized print galleries, frame shops and high-end decorating outlets, as well as fine art galleries.

Offset reproductions and posters. Offset reproductions, also known as posters and image prints, are reproduced by photochemical means. Since plates used in offset reproductions do not wear out, there are no physical limits on the number of prints that can be made. Quantities, however, may still be limited by the publisher in order to add value to the edition.

Giclée prints. As color-copier technology matures, inkjet fine art prints, also called giclées, are gaining popularity. Iris prints, images that are scanned into a computer and output on oversized printers, are even showing up in museum collections.

Canvas transfers. Canvas transfers are becoming increasingly popular. Instead of, and often in addition to, printing an image on paper, the publisher transfers the image onto canvas so the work has the look and feel of a painting. Some publishers market limited editions of 750 prints on paper, along with a smaller edition of 100 of the same image on canvas. The edition on paper might sell for $150 per print, while the canvas transfer would be priced higher, perhaps selling for $395.

Pricing criteria for limited editions and posters

Because original prints are always sold in limited editions, they command higher prices than posters, which are not numbered. Since plates for original prints are made by hand, and as a result can only withstand a certain amount of use, the number of prints pulled is limited by the number of impressions that can be made before the plate wears out. Some publishers impose their own limits on the number of impressions to increase a print's value. These limits may be set as high as 700 to 1,000 impressions, but some prints are limited to just 250 to 500, making them highly prized by collectors.

A few publishers buy work outright for a flat fee, but most pay on a royalty basis. Royalties for hand-pulled prints are usually based on retail price and range from 5 to 20 percent, while percentages for posters and offset reproductions are lower (from $2\frac{1}{2}$ to 5 percent) and are based on the wholesale price. Be aware that some publishers may hold back royalties to cover promotion and production costs; this is not uncommon.

Prices for prints vary widely depending on the quantity available; the artist's reputation; the popularity of the image; the quality of the paper, ink and printing process. Because prices for posters are lower than for original prints, publishers tend to select images with high-volume sales potential.

Negotiating your contract

As in other business transactions, ask for a contract and make sure you understand and agree to all the terms before you sign. Make sure you approve the size, printing method, paper, number of images to be produced, and royalty terms. Other things to watch for include insurance terms, marketing plans, and a guarantee of a credit line or copyright notice.

Always retain ownership of your original work. Negotiate an arrangement in which you're selling publication rights only. You'll also want to sell rights only for a limited period of time. That way you can sell the image later as a reprint or license it for other use (e.g., as a calendar or note card). If you are a perfectionist about color, make sure your contract gives you final approval of your print. Stipulate that you'd like to inspect a press proof prior to the print run.

MORE INDUSTRY TIPS

Find a niche. Consider working within a specialized subject matter. Prints with Civil War themes, for example, are avidly collected by Civil War enthusiasts. But to appeal to Civil War buffs, every detail, from weapons and foliage in battlefields to uniform buttons, must be historically accurate. Signed limited editions are usually created in a print run of 950 or so and can average about $175-200; artist's proofs sell from between $195-250, with canvas transfers selling for $400-500. The original paintings from which images are taken often sell for thousands of dollars to avid collectors.

Sport art is another lucrative niche. There's a growing trend toward portraying sports figures from football, basketball and racing (both sports car and horse racing) in prints that include both the artist's and the athlete's signatures. Movie stars and musicians from the 1950s (such as James Dean, Marilyn Monroe and Elvis) are also cult favorites, but any specialized style (such as science fiction/fantasy or wildlife art) can be a marketable niche. See the index starting on page 579 for more ideas.

Work in a series. It is easier to market a series of small prints exploring a single theme than to market single images. A series of similar prints works well in long hospital corridors, office meeting rooms or restaurants. "Paired" images also are rather profitable. Hotels often purchase two similar prints for each of their rooms.

Study trends. If you hope to get published by a commercial art publisher or poster company, realize your work will have a greater chance of acceptance if you use popular colors and themes.

Attend trade shows. Many artists say it's the best way to research the market and make contacts. It's also a great way for self-published artists to market their work. DECOR Expo is held each year in four cities: Atlanta, New York, Orlando and Los Angeles. For more information, call (888)608-5300 or visit www.decor-expo.com. Artexpo is held every spring in New York, and now also every fall in Las Vegas. The SOLO Independent Artists' Pavilion, a special section of Artexpo dedicated to showcasing the work of emerging artists, is the ultimate venue for artists to be discovered. See www.artexpos.com for more information.

Insider Tips

Tips

- Read industry publications, such as *DECOR* magazine (www.decormagazine.com) and *Art Business News* (www.artbusinessnews.com), to get a sense of what sells.

- To find out what trade shows are coming up in your area, check the event calendars in industry trade publications. Many shows, such as the DECOR Expo (www.decor-expo.com), coincide with annual stationery or gift shows, so if you work in both the print and greeting card markets, be sure to take that into consideration. Remember, traveling to trade shows is a deductible business expense, so don't forget to save your receipts!

- Consult *Business and Legal Forms for Fine Artists*, by Tad Crawford (Allworth Press) for sample contracts.

ACTION IMAGES INC.

7148 N. Ridgeway, Lincolnwood IL 60712. (847)763-9700. Fax: (847)763-9701. E-mail: actionim @aol.com. Web site: www.actionimagesinc.com. **President:** Tom Green. Estab. 1989. Art publisher of sport art. Publishes limited edition prints, open edition posters as well as direct printing on canvas. Specializes in sport art prints for events such as the Super Bowl, Final Four, Stanley Cup, etc. Clients include retailers, distributors, sales promotion agencies.

Needs "Ideally seeking sport artists/illustrators who are accomplished in both traditional and computer-generated artwork as our needs often include tight deadlines, exacting attention to detail and excellent quality. Primary work relates to posters and T-shirt artwork for retail and promotional material for sporting events." Considers all media. Artists represented include Cheri Wenner, Andy Wenner, Ken Call, Konrad Hack and Alan Studt. Approached by approximately 25 artists/year.

First Contact & Terms Send JPEG or PDF files via e-mail or mailed disk, compatible with Mac, and color printouts. Samples are filed. Responds only if interested. If interested in samples, will ask to see more of artist's work. Pays flat fee: $1,000-2,000. Buys exclusive reproduction rights. Rarely acquires original painting. Provides insurance while work is at firm and outbound in-transit insurance. Promotional services vary depending on project. Finds artists through recommendations from other artists, word of mouth and submissions.

Tips "If you're a talented artist/illustrator and know your PhotoShop/Illustrator software, you have great prospects."

ARNOLD ART STORE & GALLERY

210 Thames St., Newport RI 02840. (401)847-2273 or (800)352-2234. Fax: (401)848-0156. E-mail: info@arnoldart.com. Web site: www.arnoldart.com. **Owner:** Bill Rommel. Estab. 1870. Poster company; art publisher/distributor; gallery specializing in marine art. Publishes/distributes limited and unlimited editions, fine art prints, offset reproductions and posters.

Needs Seeking creative, fashionable, decorative art for the serious collector, commercial and designer markets. Considers oil, acrylic, watercolor, mixed media, pastel, pen & ink, sculpture. Prefers sailing images—Americas Cup or other racing images. Artists represented include Kathy Bray, Thomas Buechner and James DeWitt. Editions are created by working from an existing painting. Approached by 100 artists/year. Publishes/distributes the work of 10-15 established artists/year.

First Contact & Terms Send query letter with 4-5 photographs. Samples are filed or returned by SASE. Call to arrange portfolio review. Pays flat fee, royalties or consignment. Negotiates rights purchased; rights purchased vary according to project. Provides advertising and promotion. Finds artists through word of mouth.

▨ ART EMOTION CORP.

1758 S. Edgar St., Palatine IL 60067. (847)397-9300. E-mail: gperez@artcom.com. **President:** Gerard V. Perez. Estab. 1977. Art publisher and distributor. Publishes and distributes limited editions. Clients: corporate/residential designers, consultants and retail galleries.

Needs Seeking decorative art. Considers oil, watercolor, acrylic, pastel and mixed media. Prefers representational, traditional and impressionistic styles. Editions are created by working from an existing painting. Approached by 50-75 artists/year. Publishes and distributes the work of 2-5 artists/year.

First Contact & Terms Send query letter with slides or photographs. "Supply a SASE if you want materials returned to you." Samples are filed. Does not always respond. Pays royalties of 10%.

Tips "Send visuals first."

ART IMPRESSIONS, INC.

23586 Calabasas Rd., Suite 210, Calabasas CA 91302. (818)591-0105. Fax: (818)591-0106. E-mail: info@artimpressionsinc.com. Web site: www.artimpressionsinc.com. **Creative Director:** Jennifer Ward. Estab. 1990. Licensing agent. Clients: major manufacturers worldwide. Current clients include Tripp NYC, Lounge Fly, Random House, Springs Industries, 3M and Mead West-vaco.

Needs Seeking art for the commercial market, "especially art geared towards fashion/streetwear market." Considers oil, acrylic, mixed media, pastel and photography. No abstracts or nudes. Artists represented include Skelanimals, Corky Mansfield, Jessica Louise, Schim Schimmel, Valerie Tabor-Smith, Celine Dion and Josephine Wall. Approached by over 70 artists/year.

First Contact & Terms Send query letter with photocopies, photographs, slides, transparencies or tearsheets and SASE. Accepts disk submissions. Samples are not filed and are returned by SASE. Responds in 2 months. Will contact artist for portfolio review if interested. Artists are paid percentage of licensing revenues generated by their work. No advance. Requires exclusive representation of artist. Provides advertising, promotion, written contract and legal services. Finds artists through art exhibitions, word of mouth, publications and submissions.

Tips "Artists should have at least 25 images available and be able to reproduce new collections several times a year. Artwork must be available on disc and be of reproduction quality."

Ⓝⓒ ART IN MOTION

2000 Brigantine Dr., Coquitlam BC V3K 7B5 Canada. (604)525-3900 or (800)663-1308. Fax: (604)525-6166 or (877)525-6166. E-mail: artistrelations@artinmotion.com. Web site: www.artin motion.com. **Contact:** Artist Relations. Publishes, licenses and distributes open edition reproductions. Licenses all types of artwork for all industries, including wallpaper, fabric, stationery and calendars. Clients: galleries, high-end retailers, designers, distributors (worldwide) and picture frame manufacturers.

Needs "Our collection of imagery reflects today's interior decorating tastes; we publish a wide variety of techniques. View our collection online before submitting. However, we are always interested in new looks, directions and design concepts." Considers oil and mixed media.

First Contact & Terms Submit portfolio for review. Pays royalties of 10%. Royalties paid monthly. "Art In Motion covers all associated costs to reproduce and promote your artwork."

Tips "We are a world leader in fine art publishing with distribution in over 72 countries. The publishing process utilizes the latest technology and state-of-the-art printing equipment and uses the finest inks and papers available. Artist input and participation are highly valued and encouraged at all times. We warmly welcome artist inquiries. Contact us via e-mail, or direct us to your Web site; also send slides or color copies of your work (all submissions will be returned)."

ART LICENSING INTERNATIONAL INC.

7350 S. Tamiami Trail #227, Sarasota FL 34231. (941)966-8912. Fax: (941)966-8914. E-mail: artlicensing@comcast.net. Web site: www.out-of-the-blue.us. **President:** Michael Woodward. Estab. 1986. Licenses images internationally for a range of products—particularly fine art posters and prints for interior design industry, as well as greeting cards and stationery.

• See additional listings for this company in the Greeting Cards, Gifts & Products and Artists' Reps sections. See also listing for Out of the Blue in the Greeting Cards, Gifts & Products section.

First Contact & Terms Send a CD and photocopies or e-mail JPEGs or a link to your Web site. Send SASE for return of material. Commission rate is 50%.

Tips "Concepts for prints and posters should be in pairs or sets of four or more, with regard for trends and color palettes related to the home decor market."

THE ART PUBLISHING GROUP

165 Chubb Ave., Lyndhurst NJ 07071. (201)842-8500 or (800)760-3058. Fax: (201)842-8546. E-mail: submitart@theartpublishinggroup.com. Web site: www.theartpublishinggroup.com. **Contact:** Artist Submissions. Estab. 1973. Publisher and distributor of limited editions, open editions, and fine art prints and posters. Clients: galleries and custom frame shops worldwide.

- Divisions of The Art Publishing Group include APG Collection, Front Line Art Publishing, Modernart Editions and Scafa Art. See Web site for details of each specific line. Submission guidelines are the same for all.

Needs Seeking decorative art for the commercial and designer markets. Considers oil, watercolor, mixed media, pastel and acrylic. Prefers fine art, abstract and contemporary, floral, representational, still life, decorative, collage, mixed media. Size: 16×20. Editions are created by collaborating with the artist or by working from an existing painting. Approached by 200 artists/year. Publishes the work of 10-15 emerging artists/year. Distributes the work of 100 emerging artists/year.

First Contact & Terms Submit no more than 4 JPEGs (maximum 300KB each) via e-mail. Also accepts CDs, color copies, photographs "or any any other medium that best represents your art. DO NOT send original art, transparencies or slides. If you want your samples returned, be sure to include a SASE." Responds in 6 weeks. Will contact artist for portfolio review if interested. Pays flat fee of $200-300 or royalties of 10%. Offers advance against royalties. Provides insurance while work is at firm, shipping to firm and written contract.

Tips "If you want your submission to be considered for a specific line within The Art Publishing Group, please indicate that in your cover letter."

ART SOURCE

210 Cochrane Dr., Unit 3, Markham ON L3R 8E6 Canada. (905)475-8181. Fax: (905)479-4966. E-mail: lou@artsource.ca. Web site: www.artsource.ca. **President:** Lou Fenninger. Estab. 1979. Poster company and distributor. Publishes/distributes hand-pulled originals, limited editions, unlimited editions, canvas transfers, fine art prints, monoprints, monotypes, offset reproductions and posters. Clients: galleries, decorators, frame shops, distributors, corporate curators, museum shops and gift shops.

Needs Seeking creative, fashionable and decorative art for the designer market. Considers oil, acrylic, watercolor, mixed media, pastel and pen & ink. Editions are created by collaborating with the artist and by working from an existing painting. Approached by 50 artists/year. Publishes the work of 5 emerging, 5 mid-career and 10 established artists/year. Distributes the work of 5 emerging, 5 mid-career and 10 established artists/year.

First Contact & Terms Send query letter with brochure, photocopies, photographs, photostats, résumé, SASE, slides, tearsheets and transparencies. Accepts low-resolution submissions via e-mail. "Please keep e-mail submissions to a maximum of 10 images." Responds in 2 weeks. Company will contact artist for portfolio review if interested. Portfolios may be dropped off every Monday and Tuesday. Portfolio should include color photographs, photostats, roughs, slides, tearsheets, thumbnails and transparencies. Artist should follow up with letter after initial query. Pays royalties of 6-12%; flat fee is optional. Payment is negotiable. Offers advance when appropriate. Negotiates rights purchased. Rights purchased vary according to project. Sometimes requires exclusive representation of artist. Provides advertising, promotion and written contract.

Tips "We are looking for more original art for our distribution."

ARTEFFECT DESIGNS

Roggenstrasse 28, Weeze 47652 Germany. (49)(2837)668260. Fax: (49)(2837)6682618. E-mail: william@arteffectdesigns.de. Web site: www.arteffectdesigns.de. **Manager:** William F. Cupp. Product development, art licensing and representation of European publishers.

Needs Seeking creative, decorative art for the commercial and designer markets. Considers oil, acrylic, mixed media. Interested in all types of design. Artists represented include Nathalie Boucher, James Demmick, Hedy, Henriette Schaeffers, Jasper, Gertrud Schweser, Nancy Flores and Reint Withaar. Editions are created by working from an existing painting.

First Contact & Terms Send brochure, photographs, slides. Responds only if interested. Company will contact artist for portfolio review of transparencies if interested. Pays flat fee or royalties. No advance. Rights purchased vary according to project. Provides advertising and representation at international trade shows.

ARTSOURCE INTERNATIONAL INC.

1081 E. Santa Anita Ave., Burbank CA 91501. (818)558-5200. Fax: (818)567-1414. E-mail: artsour ce_online@aol.com. **Managing Director:** Ripsime Marashian. Estab. 1997. Publisher of fine art; business management consultant. Handles fine art originals, limited editions. Clients: private upscale clientele, corporate buyers, interior designers, frame shops, distributors and galleries.

• See also listing for Galerie ArtSource in the Galleries section.

Needs Any art of exceptional quality. ''We prefer artwork with creative expression—museum-quality landscape, figurative, still life, decorative art.'' Approached by 50 artists/year. Works with 3-4 emerging and established artists/year.

First Contact & Terms Send query letter, brochure, SASE, digital files, résumé. Accepts e-mail submissions. Prefers JPEGs. Samples are returned by SASE. Responds only if interested. Negotiates rights purchased according to project. Requires exclusive representation of artist. Provides

Painting what she knows and loves, Nancy Flores used her dog Napoleon as a model for this lovely beach piece. ''Napoleon'' (also called ''Best Friend'') has been issued as open edition prints by Viva Prints (www.vivaprints.org), a Spanish publisher represented by ArtEffect Designs. ''This image is beautiful, has the right soft colors, and is painted in a style that sells very well,'' says Monique van den Hurk of ArtEffect Designs. She advises artists interested in the print market to buy magazines on home decoration and pay attention to the colors.

© Nancy Flores / ArtEffect Designs Germany

advertising, written contract, promotion and exhibitions. Finds artists through submissions, art exhibits, other galleries.

Tips "Provide a body of work along a certain theme to show a fully developed style that can be built upon. We offer services to artists who are serious about their career, individuals who want to become professional artist representatives, galleries and dealers who want to target new artists."

ARTVISIONS™

Web site: www.artvisions.com. Licensing agency. "Not currently seeking new talent. However, we are always willing to view the work of top-notch established artists. For details and contact information, please see our listing in the Artists' Reps section."

ASHLAND ART

797 Andover Village Dr., Lexington KY 40519. Phone/fax: (859)264-7366. **Owner:** Bob Coffey. Estab. 1974. Art publisher/distributor. Publishes/distributes hand-pulled originals, monoprints, monotypes, original art. Clients: art consultants, corporate curators, decorators, distributors, frame shops, galleries.

Needs Seeking decorative art for the commercial and designer markets. Considers acrylic, mixed media, oil, watercolor, serography, etchings. Editions are created by collaborating with the artist and working with the needs of the customer. Approached by over 25 artists/year. Publishes work of 6-8 emerging artists/year. Distributes the work of over 60 emerging artists/year.

First Contact & Terms Send photographs, slides and transparencies. Samples are not filed but are returned. Responds in 2 weeks. Portfolios not required. Request portfolio review in original query. Will contact artist for portfolio review if interested. Portfolio should include color art, "in whatever presentation is easiest for artist." Pays on consignment basis. Firm receives variable commission. No advance. Rights purchased vary according to project. Requires regional exclusive representation of artist. Provides insurance while work is at firm, shipping from firm, all sales expenses. Finds artists through submissions and referrals.

BANKS FINE ART

1231 Dragon St., Dallas TX 75207. (214)352-1811. Fax: (214)352-6360. E-mail: mb@banksfineart. com. Web site: www.banksfineart.com. **Owner:** Bob Banks. Estab. 1980. Distributor; gallery of original oil paintings. Clients: galleries, decorators.

Needs Seeking decorative, traditional and impressionistic art for the serious collector and the commercial market. Considers oil, acrylic. Prefers traditional and impressionistic styles. Artists represented include Joe Sambataro, Jan Bain and Marcia Banks. Approached by 100 artists/year. Publishes/distributes the work of 2 emerging artists/year.

First Contact & Terms Send photographs. Samples are returned by SASE. Responds in 1 week. Offers advance. Rights purchased vary according to project. Provides advertising, in-transit insurance, insurance while work is at firm, promotion, shipping from firm, written contract.

Tips Needs Paris and Italy street scenes. Advises artists entering the poster and print market to attend Artexpo, the industry's largest trade event, held in New York City every spring (and now also in Las Vegas every fall). Also recommends reading *Art Business News*.

BENTLEY PUBLISHING GROUP

1410 Lesnick Lane, Walnut Creek CA 94597. (925)935-3186. Fax: (925)935-0213. E-mail: harriet@ bentleypublishinggroup.com. Web site: www.bentleypublishinggroup.com. **Product Development Coordinator:** Harriet Rinehart. Estab. 1986. Art publisher of open and limited editions of offset reproductions and canvas replicas; also agency for licensing of artists' images worldwide. Licenses florals, contemporary, landscapes, wildlife and Christmas images to appear on puzzles, tapestry products, doormats, stitchery kits, giftbags, greeting cards, mugs, tiles, wall coverings,

resin and porcelain figurines, waterglobes and various other gift items. Clients: framers, galleries, distributors and framed picture manufacturers.

● Divisions of this company include Bentley House, Rinehart Fine Arts, and Bentley Licensing Group. See separate listing for Rinehart Fine Arts in this section.

Needs Seeking decorative fine art for the designer, residential and commercial markets. Considers oil, watercolor, acrylic, pastel, mixed media and photography. Artists represented include Sherry Strickland, Lisa Chesaux and Andre Renoux. Editions are created by collaborating with the artist or by working from an existing painting. Approached by 1,000 artists/year.

First Contact & Terms Submit JPEG images via e-mail or send query letter with brochure showing art style or résumé, advertisements, slides and photographs. Samples are filed or are returned by SASE if requested by artist. Responds in 6 weeks. Pays royalties of 10% net sales for prints monthly plus 50 artist proofs of each edition. Pays 40% monies received from licensing. Obtains all reproduction rights. Usually requires exclusive representation of artist. Provides national trade magazine promotion, a written contract, worldwide agent representation, 5 annual trade show presentations, insurance while work is at firm and shipping from firm.

Tips "Bentley is looking for experienced artists with images of universal appeal."

BERGQUIST IMPORTS INC.

1412 Hwy. 33 S., Cloquet MN 55720. (218)879-3343. Fax: (218)879-0010. E-mail: bbergqu106@aol.com. Web site: www.bergquistimports.com. **President:** Barry Bergquist. Estab. 1948. Distributor. Distributes unlimited editions. Clients: gift shops.

● See additional listing in the Greeting Cards, Gifts & Products section.

Needs Seeking creative and decorative art for the commercial market. Considers oil, watercolor, mixed media and acrylic. Prefers Scandinavian or European styles. Artists represented include Jacky Briggs, Dona Douma and Suzanne Toftey. Editions are created by collaborating with the artist or by working from an existing painting. Approached by 20 artists/year. Publishes the work of 2-3 emerging, 2-3 mid-career and 2 established artists/year. Distributes the work of 2-3 emerging, 2-3 mid-career and 2 established artists/year.

First Contact & Terms Send brochure, résumé and tearsheets. Do not send art attached to e-mail. Will not download from unknown sources. Samples are returned, not filed. Responds in 2 months. Artist should follow up. Portfolio should include color thumbnails, final art, photostats, tearsheets and photographs. Pays flat fee of $50-300; royalties of 5%. Offers advance when appropriate. Negotiates rights purchased. Provides advertising, promotion, shipping from firm, and written contract. Finds artists through art fairs.

Tips Suggests artists read *Giftware News Magazine*.

BERKSHIRE ORIGINALS

2 Prospect Hill, Stockbridge MA 01263. (413)298-3691. Fax: (413)298-1293. E-mail: clevesque@marian.org. Web site: www.marian.org. **Administrator/Senior Designer:** Catherine M. LeVesque. Estab. 1991. Art publisher and distributor of offset reproductions and greeting cards.

Needs Seeking creative art for the commercial market. Considers oil, watercolor, acrylic, pastel and pen & ink. Prefers religious themes, but also considers florals, holiday and nature scenes, line art and border art.

First Contact & Terms Send query letter with brochure showing art style or other art samples. Samples are filed or are returned by SASE if requested by artist. Responds in 1 month. Write for appointment to show portfolio of slides, color tearsheets, transparencies, original/final art and photographs. Pays flat fee: $100-1,000. Buys all rights.

Tips "Good draftsmanship is a must, particularly with figures and faces. Colors must be harmonious and clearly executed."

BERNARD FINE ART

P.O. Box 1528, Manchester Center VT 05255. (802)362-3662. Fax: (802)362-3286. E-mail: publishi
ng@applejackart.com. Web site: www.applejackart.com. Art publisher. Publishes open edition
prints and posters. Clients: picture frame manufacturers, distributors, manufacturers, galleries
and frame shops.

- This company is a division of Applejack Art Partners, along with the high-end poster lines
 Hope Street Editions and Rose Selavy of Vermont. See separate listings for Hope Street Editions
 and Rose Selavy of Vermont in this section, and Applejack Art Partners in the Greeting Cards,
 Gifts & Products section.

Needs Seeking creative, fashionable, and decorative art and photography for commercial and
designer markets. Considers all media, including oil, watercolor, acrylic, pastel, mixed media
and printmaking (all forms). Editions are created by collaborating with the artist or by working
from an existing painting. Artists and photographers represented include Reed Baxter, Shelly
Rasche and Jack Wemp. Approached by hundreds of artists/year. Publishes the work of 8-10
emerging, 10-15 mid-career and 100-200 established artists.

First Contact and Terms Send query letter with brochure showing art style and/or résumé,
tearsheets, photocopies, photographs. Samples are returned by SASE only. Responds only if
interested. Pays royalties. Offers an advance when appropriate. Usually requires exclusive repre-
sentation of artist. Provides in-transit insurance, insurance while work is at firm, promotion,
shipping from firm, and a written contract. Finds artists through submissions, sourcebooks,
agents, art shows, galleries and word of mouth.

Tips "We look for subjects with a universal appeal. Some subjects that would be appropriate are
florals, still lifes, wildlife, religious themes, landscapes and contemporary images/abstracts.
Please send enough examples of your work so we can see a true representation of your style and
technique."

TOM BINDER FINE ARTS

825 Wilshire Blvd. #708, Santa Monica CA 90401. (800)332-4278. Fax: (800)870-3770. E-mail:
info@artman.net. Web site: www.artman.net and www.alexanderchen.com. **Owner:** Tom
Binder. Wholesaler of hand-pulled originals, limited editions and fine art prints. Clients: galleries
and collectors.

- See additional listing in the Galleries section.

Needs Seeking art for the commercial market. Considers acrylic, mixed media, giclée and pop
art. Artists represented include Alexander Chen, Ken Shotwell and Elaine Binder. Editions are
created by working from an existing painting.

First Contact & Terms Send brochure, photographs, photostats, slides, transparencies and tear-
sheets. Accepts disk submissions if compatible with Illustrator 5.0. Samples are not filed and are
returned by SASE. Does not reply; artist should contact. Offers advance when appropriate. Rights
purchased vary according to project. Provides shipping. Finds artists through New York Artexpo
and World Wide Web.

THE BLACKMAR COLLECTION

P.O. Box 537, Chester CT 06412. Phone/fax: (860)526-9303. E-mail: carser@mindspring.com.
Web site: www.theblackmarcollection.com. Estab. 1992. Art publisher. Publishes offset repro-
duction and giclée prints. Clients: individual buyers.

Needs "We are not actively recruiting at this time." Artists represented include DeLos Blackmar,
Blair Hammond, Gladys Bates and Keith Murphey. Editions are created by working from an
existing painting. Approached by 24 artists/year. Publishes the work of 3 established artists/
year. Provides advertising, in-transit insurance, insurance while work is at firm. Finds artists
through personal contact. All sales have a buy back guarantee.

BON ART™ & ARTIQUE™

Divisions of Art Resources International, Ltd., 129 Glover Ave., Norwalk CT 06850-1311. (800)228-2989 or (203)845-8888. Fax: (203)846-6849. E-mail: sales@fineartpublishers.com. Web site: www.fineartpublishers.com; www.artiq.com. **Creative Director:** R. Bonnist. Estab. 1980. Art publisher; poster company; licensing and design studio. Publishes/distributes fine art prints, canvas transfers, unlimited editions, offset reproductions and posters. Clients: Internet purveyors of art, picture frame manufacturers, catalog companies, distributors.

Needs Seeking decorative and fashionable art for the commercial and designer markets. Considers oil, acrylic, pastel, watercolor and mixed media. Artists represented include Tom Butler, Mid Gordon, Martin Wiscombe, Julia Hawkins, Gloria Ericksen and Tina Chaden. Editions are created by collaborating with the artist or by working from an existing painting. Approached by 500 artists/year. Publishes/distributes the work of 30 emerging artists/year.

First Contact & Terms E-mail or send query letter with brochure, samples, photographs, URL. Accepts e-mail submissions with image files or link to Web site. Prefers JPEG or TIFF files. Samples are kept on file or returned by SASE if requested. Responds only if interested. Will contact artist for portfolio review if interested. Portfolio should include b&w, color, finished art, roughs, photographs. Pays flat fee or royalties. Offers advance when appropriate. Rights purchased vary according to project; negotiated. Requires exclusive representation. Provides insurance while work is at firm, shipping from firm, promotion and written contract. Finds artists through agents/reps, submissions, portfolio reviews, art fairs/exhibits, word of mouth, referrals by other artists, magazines, sourcebooks, Internet.

Tips "Bon Art and Artique welcome submissions from a wide range of international artists. As leaders in the field of fine art publishing for the past 27 years, we believe in sharing our knowledge of the trends, categories and styles with our artists. Although interested in working with veterans of our industry, we actively recruit and encourage all accomplished artists to submit their portfolios—preferably by e-mail with links to images."

CLASSIC COLLECTIONS FINE ART

1 Bridge St., Irvington NY 10533. (914)591-4500. Fax: (914)591-4828. E-mail: info@classiccollecti ons.com. Web site: www.classiccollections.com. **Acquisition Manager:** Larry Tolchin. Estab. 1990. Art publisher. Publishes unlimited editions and offset reproductions. Clients: galleries, interior designers, hotels. Licenses florals, landscapes, animals for kitchen/bath textiles, rugs, tabletop.

Needs Seeking decorative art for the commercial and designer markets. Considers oil, acrylic, watercolor, mixed media and pastel. Prefers landscapes, still lifes, florals. Artists represented include Harrison Rucker, Roger Duvall, Sid Willis, Martha Collins, Judy Shelby and Henry Peeters. Editions are created by collaborating with the artist and by working from existing painting. Approached by 100 artists/year. Publishes the work of 6 emerging, 6 mid-career and 6 established artists/year.

First Contact & Terms Mail color copies or send JPEGs via e-mail. Samples are filed. Responds in 3 months. Will contact artist for portfolio review if interested. Offers advance when appropriate. Buys first and reprint rights. Provides advertising, insurance while work is at firm, and written contract. Finds artists through art fairs, exhibitions and competitions.

Ⓝ CLAY STREET PRESS, INC.

1312 Clay St., Cincinnati OH 45202. (513)241-3232. E-mail: mpginc@iac.net. Web site: www.pats fallgraphics.com. **Owner:** Mark Patsfall. Estab. 1981. Art publisher and contract printer. Publishes fine art prints, hand-pulled originals, limited editions. Clients: architects, corporate curators, decorators, galleries and museum print curators.

Needs Seeking serious artists. Prefers conceptual/contemporary. Editions are created by collaborating with the artist. Publishes the work of 2-3 emerging artists/year.

First Contact & Terms Contact only through artist rep. Accepts e-mail submissions with image files. Prefers Mac-compatible JPEG files. Responds in 1 week. Negotiates payment. Negotiates rights purchased. Services provided depend on contract. Finds artists through reps, galleries and word of mouth.

⬛ CLEARWATER PUBLISHING

161 MacEwan Ridge Circle NW, Calgary AB T3K 3W3 Canada. (403)295-8885. Fax: (403)295-8981. E-mail: clearwaterpublishing@shaw.ca. Web site: www.clearwater-publishing.com. **Contact:** Laura Skorodenski. Estab. 1989. Fine art publisher. Handles giclées, canvas transfers, fine art prints and offset reproductions. Clients: decorators, frame shops, gift shops, galleries and museum shops.

Needs Seeking artwork for the serious collector and commercial market. Considers acrylic, watercolor, mixed media and oil. Prefers high realism or impressionistic works. Artists represented can be seen on Web site.

First Contact & Terms Accepts e-mail submissions with link to Web site and image file; Windows-compatible. Prefers JPEGs. Samples are not filed or returned. Responds only if interested. Company will contact artist for portfolio review if interested. Portfolio should include slides. No advance. Requires exclusive representation of artist.

THE COLONIAL ART GALLERY & CO.

1336 NW First St., Oklahoma City OK 73106. (405)232-5233. Fax: (405)232-6607. E-mail: info@colonialart.com. Web site: www.colonialart.com. **Owner:** Willard Johnson. Estab. 1919. Publisher and distributor of offset reproductions for galleries. Clients: retail and wholesale. Current clients include Osburns, Grayhorse and Burlington.

Needs Prefers realism and expressionism—emotional work. Publishes the work of 2-3 emerging, 2-3 mid-career and 3-4 established artists/year. Distributes the work of 10-20 emerging, 30-40 mid-career and hundreds of established artists/year.

First Contact & Terms Send sample prints. Samples not filed are returned only if requested by artist. Will contact artist for portfolio review if interested. Pays negotiated flat fee, royalties, or on a consignment basis (firm receives 33% commission). Offers an advance when appropriate. Considers buying second rights (reprint rights) to previously published work.

Tips "The current trend in art publishing is an emphasis on quality."

⬛ CUPPS OF CHICAGO, INC.

77 S. Evergreen Ave., Unit 1103, Arlington Heights IL 60005-1493. (847)593-5655. Fax: (847)593-5550. E-mail: cuppsofchicago@aol.com. **President:** Gregory Cupp. Estab. 1967. Art publisher and distributor of limited and open editions, offset reproductions and posters, and original paintings. Clients: galleries, frame shops, designers and home shows.

Needs Seeking creative and decorative art for the commercial and designer markets. Editions are created by collaborating with the artist or by working from an existing painting. Considers oil and acrylic paintings in "almost any style—only criterion is that it must be well done." Prefers individual works of art. Approached by 150-200 artists/year. Publishes and distributes the work of 25-50 emerging artists/year.

First Contact & Terms Send query letter with résumé, photographs, photocopies and tearsheets. Samples are filed or are returned by SASE if requested. Responds only if interested. Will contact artist for portfolio review of color photographs if interested. Negotiates payment. Rights purchased vary according to project. Provides advertising, promotion, shipping from firm, insurance while work is at firm.

Tips Pay attention to contemporary/popular colors when creating work for this design-oriented market. "Please send photos, original work, prints and photocopies in CD form."

DARE TO MOVE

1117 Broadway, Suite 301, Tacoma WA 98402. (253)284-0975. Fax: (253)284-0977. E-mail: dareto move@aol.com. Web site: www.daretomove.com. **President:** Steve W. Sherman. Estab. 1987. Art publisher, distributor. Publishes/distributes limited editions, unlimited editions, canvas transfers, fine art prints, offset reproductions. Licenses aviation and marine art for puzzles, note cards, bookmarks, coasters, etc. Clients include art galleries, aviation museums, frame shops and interior decorators.

- This company has expanded from aviation-related artwork to work encompassing most civil service areas. Steve Sherman likes to work with artists who have been painting for 10-20 years. He usually starts off distributing self-published prints. If prints sell well, he will work with artist to publish new editions.

Needs Seeking naval, marine, firefighter, civil service and aviation-related art for the serious collector and commercial market. Considers oil and acrylic. Represented artists include John Young, Ross Buckland, Mike Machat, James Dietz, Jack Fellows, William Ryan and Patrick Haskett. Editions are created by collaborating with the artist or working from an existing painting. Approached by 15-20 artists/year. Publishes the work of 1 emerging, 2-3 mid-career and established artists/year. Distributes the work of 9 emerging and 2-3 established artists/year.

First Contact & Terms Send query letter with photographs, slides, tearsheets and transparencies. Samples are filed or sometimes returned by SASE. Artist should follow up with call. Portfolio should include color photographs, transparencies and final art. Pays royalties of 10% commission of wholesale price on limited editions; 5% commission of wholesale price on unlimited editions. Buys one-time or reprint rights. Provides advertising, in-transit insurance, insurance while work is at firm, promotion, shipping from firm, and written contract.

Tips "Present your best work—professionally."

DELJOU ART GROUP, INC.

1616 Huber St., Atlanta GA 30318. (404)350-7190. Fax: (404)350-7195. E-mail: submit@deljouart group.com. Web site: www.deljouartgroup.com. **Contact:** Art Director. Estab. 1980. Art publisher, distributor and gallery of limited editions (maximum 250 prints), hand-pulled originals, monoprints/monotypes, sculpture, fine art photography, fine art prints and paintings on paper and canvas. Clients: galleries, designers, corporate buyers and architects. Current clients include Coca Cola, Xerox, Exxon, Marriott Hotels, General Electric, Charter Hospitals, AT&T and more than 3,000 galleries worldwide, "forming a strong network throughout the world."

Needs Seeking creative, fine and decorative art for the designer market and serious collectors. Considers oil, acrylic, pastel, sculpture and mixed media and photography. Artists represented include Yunessi, T.L. Lange, Michael Emani, Vincent George, Nela Soloman, Alterra, Ivan Reyes, Mindeli, Sanford Wakeman, Niro Vessali, Lee White, Alexa Kelemen, Bika, Kamy, Craig Alan, Roya Azim, Jian Chang, Elya DeChino, Antonio Dojer, Emanuel Mattini and Mia Stone. Editions are created by collaborating with the artist. Approached by 300 artists/year. Publishes the work of 10 emerging, 20 mid-career artists and 20 established artists/year.

First Contact & Terms Send query letter with photographs, slides, brochure, photocopies, tearsheets, SASE and transparencies. Prefers contact and samples via e-mail. Samples not filed are returned only by SASE. Responds in 6 months. Will contact artist for portfolio review if interested. Payment method is negotiated. Offers an advance when appropriate. Negotiates rights purchased. Requires exclusive representation. Provides promotion, a written contract and advertising. Finds artists through visiting galleries, art fairs, word of mouth, World Wide Web, art reps, submissions, art competitions and sourcebooks. Pays highest royalties in the industry.

Tips "We need landscape artists, 3D wall art (any media), strong figurative artists, sophisticated abstracts and soft-edge abstracts. We are also beginning to publish sculptures and are interested in seeing slides of such. We also have the largest gallery in the country. We have added a poster division and need images in different categories for our poster catalogue as well."

DODO GRAPHICS, INC.

145 Cornelia St., P.O. Box 585, Plattsburgh NY 12901. (518)561-7294. Fax: (518)561-6720. E-mail: dodographics@aol.com. **Manager:** Frank How. Art publisher of offset reproductions, posters and etchings for galleries and frame shops.

Needs Considers pastel, watercolor, tempera, mixed media, airbrush and photographs. Prefers contemporary themes and styles. Prefers individual works of art, 16×20 maximum. Publishes the work of 5 artists/year.

First Contact & Terms Send query letter with brochure showing art style or photographs, slides or CD-ROM. Samples are filed or are returned by SASE. Responds in 3 months. Write for appointment to show portfolio of original/final art and slides. Payment method is negotiated. Offers an advance when appropriate. Buys all rights. Requires exclusive representation of the artist. Provides written contract.

Tips "Do not send any originals unless agreed upon by publisher."

DOLICE GRAPHICS

649 E. Ninth St., Suite C2, New York NY 10009. (212)529-2025. Fax: (212)260-9217. E-mail: joe@dolice.com. Web site: www.dolice.com. **President:** Joe Dolice. Estab. 1968. Art publisher. Publishes fine art prints, limited editions, offset reproductions, unlimited editions. Clients: architects, corporate curators, decorators, distributors, frame shops, galleries, gift shops and museum shops. Current clients include Bloomingdale's (Federated Dept. Stores).

Needs Seeking decorative, representational, antiquarian "type" art for the commercial and designer markets. Considers acrylic, mixed media, pastel, pen & ink, prints (intaglio, etc.) and watercolor. Prefers traditional, decorative, antiquarian type. Editions are created by collaborating with the artist and working from an existing painting. Approached by 12-20 artists/year.

First Contact & Terms Send query letter with color photocopies, photographs, résumé, SASE, slides and transparencies. Samples are returned by SASE only. Responds only if interested. Will contact artist for portfolio review if interested. Negotiates payment. Buys all rights on contract work. Rights purchased vary according to project. Provides free Web site space, promotion and written contract. Finds artists through art reps and submissions.

Tips "We publish replicas of antiquarian-type art prints for decorative arts markets and will commission artists to create 'works for hire' in the style of pre-century artists and occasionally to color black & white engravings, etchings, etc. Artists interested should be well schooled and accomplished in traditional painting and printmaking techniques."

FAIRFIELD ART PUBLISHING

87 35th St., 3rd Floor, Brooklyn NY 11232. (800)835-3539. Fax: (718) 832-8432. E-mail: cyclopete @aol.com. **Vice President:** Peter Lowenkron. Estab. 1996. Art publisher. Publishes posters, unlimited editions and offset reproductions. Clients: galleries, frame shops, museum shops, decorators, corporate curators, gift shops, manufacturers and contract framers.

Needs Decorative art for the designer and commercial markets. Considers collage, oil, watercolor, pastel, pen & ink, acrylic. Artists represented include Daniel Pollera, Roger Vilarchao, Yves Poinsot.

First Contact & Terms Send query letter with slides and brochure. Samples are returned by SASE if requested by artist. Responds only if interested. Pays flat fee, $400-2,500 maximum, or royalties of 7-15%. Offers advance when appropriate. Rights purchased vary according to project. Interested in buying second rights (reprint rights) to previously published artwork.

Natasha Wescoat

Self-taught artist becomes
Internet marketing maven

Many young artists dream of the day when they can live entirely off the money they make from their art sales. Some never realize this dream; others who do typically get there after years of hard work and lean times. Very few artists experience this type of success early in their careers.

Natasha Wescoat is one of the few who, at a young age, has been able to achieve her dream of becoming a professional artist. At 25, she has experienced the kind of success that most artists work a lifetime to achieve, supporting herself entirely with sales generated by her work. Wescoat's success is largely due to the broad appeal of her acrylic paintings. The artist's lively style, which has been compared to Miro and Klimt, seems to have struck a chord with a far-ranging clientele that includes individuals of all ages and from all walks of life. However, many artists who are producing great work fail to get the notice that Wescoat has received in such a short time. It often takes years of exposure through local galleries and exhibitions before most artists attain the high level of public recognition that Wescoat has since she started selling her work in 2004.

The difference between Wescoat and other fine artists, is that this tech-savvy artist has learned how to tap into the Web as a means of marketing her work. Through podcasting, videoblogging and online journaling, Wescoat is using the Internet to generate interest and excitement about her art. She uses auction sites such as eBay, and her own Web site (www.natashawescoat.com), as venues for posting and selling her work.

Humble beginnings

Wescoat grew up in a family where she was encouraged to draw and paint. She was inspired by her grandmother, whose whimsical bird and flower paintings hung in the bedroom of her home. At an early age Wescoat created her own comic characters, inspired by the comics she read in the Sunday papers. By the time she reached age seven, Wescoat had entered her first art competition and won first place. Other competitions followed in which Wescoat won additional awards. At the age of 10, she sent samples of her work to Disney Studios and Oprah Winfrey. "I received letters from Disney and Oprah encouraging me to work hard for my dreams," Wescoat recalls.

By the time she enrolled at Delta College in her hometown of Saginaw, Michigan, in 2002, Wescoat had won many awards for her paintings in both local and national competitions. In spite of the recognition she had received as a fine artist, Wescoat began her education with the intention of earning a degree in graphic design. "I did some research and found that graphic design is a growing field where you can make pretty good money,"

she says. At the time, earning a good living with her degree was important to Wescoat because she had a nine-month-old son to support.

Wescoat worked on her degree for the next two years, but when her second son was born in 2004, she found herself struggling to make ends meet. To raise some extra cash, she decided to sell some of her paintings on eBay, posting digital photos of her work in a section of the site that features emerging artists. "I wasn't sure if I would be successful," says Wescoat. "I had watched other artists and how they were selling their art. One of the things that seemed to be working for them was selling their work on auction sites like eBay." To Wescoat's surprise, the paintings sold for much more than she expected. "I was hoping to get $20 to $50 to cover supplies. At my first auction I sold a painting for $70. At the second auction, I sold a painting for $200. That was really a shock for me," she says.

"Blossoms and Blackbirds," painted in acrylic on a 16 × 20-inch canvas, is from Wescoat's Garden Series. "With this painting, I approached my usual blossoms and bird compositions with more detail and whimsy," she says. "I wanted to improve upon my previous concept and make it really pop. This is one of my favorite works I've done yet."

Online success

Wescoat's success on eBay encouraged her to continue posting her work on online auctions. Two months after her eBay sales, she created her own Web site so that potential customers could learn more about her work. "I posted some of my old work as examples of what I do to give people an idea of my style," she says. As a graphic design major and Web enthusiast, Wescoat's knowledge of HTML coding and page design was put to good use in developing her site. She also did some research and found other auction possibilities beyond eBay. "I found many directories and artist communities where I could list my Web site," she says.

It wasn't long before Wescoat's sales grew to the point where she was so busy filling orders she needed to take a break from school and devote herself full-time to maintaining the site and responding to customers. It soon became clear that Wescoat needed to return to painting in order to create more work to sell online.

As business grew and Web technology evolved, Wescoat posted additional work on her site and added other features to facilitate sales. In addition to offering original paintings from her Web site, Wescoat decided to include fine art prints of her original works. She makes the 8 × 10-inch reproductions herself by printing them from her digital printer on archival paper.

Since launching her site in 2004, Wescoat has developed it into a sophisticated marketing tool. The site is broken down into topic categories that make it easy to navigate. Customers are directed to separate sections for original paintings or fine art prints. Thumb-

nail-sized images of Wescoat's work make it easy for visitors to view several images at once. From there, they can enlarge each image to view details. Online purchases are facilitated through the site's shopping cart feature and a link to PayPal. The site also features a section where Wescoat lists her prices for commissioned paintings according to size.

Wescoat says that developing a state-of-the-art Web site is extremely important for artists wanting to sell their work online. In a traditional gallery or studio setting, artists or their representatives can talk to potential customers about their work. But in today's online marketplace it's important for artists to maintain a Web site to establish a personal connection with potential customers. "Selling online can be a challenge," says Wescoat. "You want to make the customers comfortable about purchasing from you by allowing them to learn about your art and your process." On her Web site, Wescoat includes details about the sizes of her paintings and prints as well as the media and materials she uses.

In addition to learning about Wescoat and making online purchases, visitors to the site can sign up for a free e-mail newsletter to find out about upcoming exhibitions and other events featuring Wescoat's work. Links to the artist's blog and other sites, including online retailers and auction sites, create a network of promotional and marketing opportunities for Wescoat and her art.

Wescoat stresses the importance of these links for artists considering the Web as an outlet for their work. "Make sure you find some online communities or networks where

© Natasha Wescoat

Wescoat is seen here painting "Windy Forest," from her Jeweled Tree Series, in acrylic on a 24 × 30-inch canvas. "This piece is one of my most popular art prints sold," she says. Wescoat sells 8 × 10-inch prints of her paintings for $17.99 on her Web site, but prints are also available in a variety of sizes and formats at Art.com. "I offer limited edition giclées and lithographs there," she says.

you can get your name out there or post your art," she advises. In addition to eBay, another auction site that features Wescoat's work is Overstock.com. Other online retailers carrying her work include Absolutearts.com, Ebsqart.com, Sistino.com and Art.com. In some cases, Wescoat represents herself; other sites (such as Art.com, which features framed and unframed posters and fine art prints of Wescoat's originals) require membership.

On the sites where Wescoat represents herself, she posts her work using a template she created in Dreamweaver. (Prior to using Dreamweaver, she used Microsoft's FrontPage.) "I make sure to include enough information—when and how each painting was made, the size and how much it would cost to ship—so that people who don't know me will have some of the information they need at the auction site," she says. In addition to offering her work, each of these retail and auction sites also includes the URL for Wescoat's Web site. "It's a great way to advertise my site," she says. "I get a lot of traffic and gain a lot of new customers in these places."

Infinite possibilities

Wescoat's business grew by leaps and bounds in fall 2006 when her paintings appeared on *Extreme Makeover Home Edition*. "They found me on eBay," she says. "One of the producers of the show bought a piece from me." From there, the producer commissioned Wescoat to create some original paintings for one of the houses they were remodeling. "My business climbed steadily after that."

Wescoat estimates that she makes about $3,000-4,000 per month from online auctions and an equivalent amount in royalties from Art.com. In addition to the income she makes from these online resources and purchases from her Web site, commissions for original work comprise a sizable chunk of her sales. "I just finished six pieces for an orthodontist's office," she says. "They designed the entire office around the paintings." At this point, Wescoat says she has over 1,000 original paintings, commissioned and purchased from auctions, hanging in private and corporate collections worldwide, including France, Japan, Belgium, Australia, Portugal, Germany, Finland, Greece, Italy and Great Britain.

The demand for Wescoat's art has recently extended beyond fine art prints and paintings. A line of T-shirts bearing her imagery is being offered as "Sunshine Gear" at Cafepress.com. "I'm hoping to continue to license my work on merchandise," says Wescoat, who is currently working with Pure Country Weavers (www.purecountry.com) on a line of tapestries that feature her art. She says royalty arrangements for merchandise can be very lucrative, with the artist receiving 10-15% of every sale.

Wescoat has also written a book: *Secrets of Powerselling Artists on Ebay*, available at Lulu.c om. "It's a small e-guide for artists wanting to sell their work through online art auctions," she says. Wescoat is taking advantage of every income-producing opportunity available while her work is in high demand. She is well aware of how easy it is for an artist to fall quickly from fame. She has returned to school with the goal of earning a master's degree in Art History so that she can teach college classes. "The art business can be so fickle," she says. "I want something I can fall back on."

—Poppy Evans

Posters & Prints

FLYING COLORS, INC.

26943 Ruether Ave., Suite S, San Clarita CA 91351. (661)424-0545. Fax: (661)299-5586. E-mail: joe@flying-colors.net. Web site: www.flying-colors.net. **President:** Joe McCormick. Estab. 1993. Poster company and art publisher. Publishes unlimited editions, fine art prints, posters. Clients: galleries, frame shops, distributors, museum shops, gift shops, mail order, end-users, retailers, chains, direct mail.

Needs Seeking decorative art for the commercial market. Considers oil, acrylic, watercolor, mixed media, pastel. Prefers multicultural, religious, inspirational, wildlife, Amish, country, scenics, still life, American culture. Also needs freelancers for design. Prefers designers who own Mac computers. Artists represented include Greg Gorman and Deidre Madsen. Editions are created by collaborating with the artist or by working from an existing painting. Approached by 200 artists/year. Publishes the work of 20 emerging, 5-10 mid-career, 1-2 established artists/year.

First Contact & Terms May contact via e-mail or send photocopies, photographs, SASE, slides, transparencies. Accepts disk submissions if compatible with SyQuest, Dat, Jazzy, ZIP, QuarkX-Press, Illustrator, Photoshop or FreeHand. Samples are filed or returned by SASE. Responds only if interested. Artist should follow-up with call to show portfolio. Portfolio should include color, photographs, roughs, slides, transparencies. Negotiates payment. Offers advance when appropriate. Negotiates rights purchased; all rights preferred. Provides advertising, promotion, written contract. Finds artists through art exhibitions, art fairs, word of mouth, submissions, clients, local advertisements.

Tips "Ethnic and inspirational/religious art is very strong. Watch the furniture industry. Come up with themes, sketches and series of at least two pieces. Art has to work on 8×10, 16×20, 22×28, 24×36, greeting cards and other possible mediums."

FORTUNE FINE ART

2908 Oregon Court, Suite G3, Torrance CA 90503. (310)618-1231. Fax: (310)618-1232. E-mail: carolv@fortunefa.com. Web site: www.fortunefa.com. **President:** Carol J. Vidic. Licensing: Peter Iwasaki. Publishes fine art prints, hand-pulled serigraphs, originals, limited editions, offset reproductions, posters and unlimited editions. Clients: art galleries, dealers and designers.

Needs Seeking creative art for the serious collector. Considers oil on canvas, acrylic on canvas, mixed media on canvas and paper. Artists represented include John Powell, Daniel Gerhartz, Marilyn Simandle and Don Hatfield. Publishes and distributes the work of a varying number of emerging artists/year.

First Contact & Terms Send query letter with résumé, slides, photographs, transparencies, biography and SASE. Samples are not filed. Responds in 1 month. To show a portfolio, mail appropriate materials. Payment method and advances are negotiated. Prefers exclusive representation of artist. Provides in-transit insurance, insurance while work is at firm, promotion and written contract.

Tips "Establish a unique style, look or concept before looking to be published."

FUNDORA ART STUDIO

100 Bahama Rd., Key Largo FL 33047. (305)852-1516. E-mail: thomasfund@aol.com. **Director:** Thomas Fundora. Estab. 1987. Art publisher/distributor/gallery. Publishes limited edition fine art prints. Clients: galleries, decorators, frame shops. Current clients include Ocean Reef Club, Paul S. Ellison.

Needs Seeking creative and decorative art for the serious collector. Considers oil, watercolor, mixed media. Prefers nautical, maritime, tropical. Artists represented include Thomas Fundora, Gaspel, Juan A. Carballo and Carlos Sierra. Editions are created by collaborating with the artist and working from an existing painting. Approached by 15 artists/year. Publishes/distributes the work of 2 emerging, 1 mid-career and 3 established artists/year.

First Contact & Terms Send query letter with brochure, photographs, slides or printed samples. Samples are filed. Will contact artist for portfolio review if interested. Pays royalties. Buys first rights. Requires exclusive representation of artist in U.S. Provides advertising and promotion. Also works with freelance designers.

Tips "Trends to watch: tropical sea and landscapes."

GALAXY OF GRAPHICS, LTD.

20 Murray Hill Pkwy., Suite 160, East Rutherford NJ 07073-2180. (201)806-2100. Fax: (201)806-2050. E-mail: susan.murphy@kapgog.com. Web site: www.galaxyofgraphics.com. **Art Director:** Colleen Buchweitz. Estab. 1983. Art publisher and distributor of unlimited editions. Licensing handled by Christine Gaccione. Clients: galleries, distributors and picture frame manufacturers.

Needs Seeking creative, fashionable and decorative art for the commerical market. Artists represented include Richard Henson, Betsy Brown, Elaine Lane, Charlene Olson, Vivian Flasch, Joyce Combs, Igor Lerashov, Ruane Manning and Carol Robinson. Editions are created by collaborating with the artist or by working from an existing painting. Considers any media. "Any currently popular and generally accepted themes." Art guidelines free for SASE with first-class postage. Approached by several hundred artists/year. Publishes and distributes the work of 20 emerging and 20 mid-career and established artists/year.

First Contact & Terms Send query letter with résumé, tearsheets, slides, photographs and transparencies. Samples are not filed and are returned by SASE. Responds in 2 weeks. Call for appointment to show portfolio. Pays royalties of 10%. Offers advance. Buys rights only for prints and posters. Provides insurance while material is in-house and while in transit from publisher to artist/photographer. Provides written contract to each artist.

Tips "There is a trend of strong jewel-tone colors and spice-tone colors. African-American art very needed."

ROBERT GALITZ FINE ART & ACCENT ART

166 Hilltop Lane, Sleepy Hollow IL 60118-1816. (847)426-8842. Fax: (847)426-8846. E-mail: robert@galitzfineart.com. Web site: www.galitzfineart.com. **Owner:** Robert Galitz. Estab. 1986. Distributor of fine art prints, handpulled originals, limited editions, monoprints, monotypes and sculpture. Clients: architects and galleries.

• See additional listings in the Galleries and Artists' Reps sections.

Needs Seeking creative, decorative art for the commercial and designer markets. Considers acrylic, mixed media, oil, sculpture and watercolor.

First Contact & Terms Send query letter with brochure, SASE, slides and photographs. Samples are not filed and are returned by SASE. Responds in 1 month. Will contact artist for portfolio review if interested. Pays flat fee. No advance. Rights purchased vary according to project. Finds artists through art fairs and submissions.

GUILDHALL, INC.

P.O. Box 136550, Fort Worth TX 76136. (800)211-0305. Fax (817)236-0015. E-mail: westart@guildhall.com. Web site: www.guildhall.com. **President:** John M. Thompson III. Art publisher/distributor of limited and unlimited editions, offset reproductions and hand-pulled originals for galleries, decorators, offices and department stores. Current clients include over 500 galleries and collectors nationwide.

Needs Seeking creative art for the serious and commercial collector and designer market. Considers pen & ink, oil, acrylic, watercolor, and bronze and stone sculptures. Prefers historical Native American, Western, equine, wildlife, landscapes and religious themes. Prefers original works of art. Over past 25 years has represented over 50 artists in printing and licensing work. Editions are created by collaborating with the artist and by working from existing art. Approached by 150 artists/year.

First Contact & Terms Send query letter with résumé, tearsheets, photographs, slides and 4×5 transparencies or electronic file, preferably cowboy art in photos or printouts. Samples are not filed and are returned only if requested. Responds in 1 month. Payment options include paying a flat fee for a single use; paying 10-20% royalties for multiple images; paying 35% commission on

consignment. Negotiates rights purchased. Requires exclusive representation for contract artists. Provides insurance while work is at firm.

Tips ''The new technologies in printing are changing the nature of publishing. Self-publishing artists have flooded the print market. Printing is the easy part. Selling it is another problem. Many artists, in order to sell their work, have to price it very low. In many markets this has caused a glut. Some art would be best served if it was only one of a kind. There is no substitute for scarcity and quality.''

HADLEY HOUSE PUBLISHING

4816 Nicollet Ave. S., Minneapolis MN 55419-5511. (886)619-2324. Fax: (952)943-8098. E- mail: borcd@hadleyco.com. Web site: www.hadleylicensing.com or www.hadleyhouse.com. **Vice President—Publishing/Licensing:** Deborah Borchardt. Estab. 1974. Art publisher, distributor. Publishes and distributes canvas transfers, fine art prints, giclées, limited and unlimited editions, offset reproductions and posters. Licenses all types of flat art. Clients: wholesale and retail.

Needs Seeking artwork with creative artistic expression and decorative appeal. Considers oil, watercolor, acrylic, pastel and mixed media. Prefers florals, landscapes, figurative and nostalgic Americana themes and styles. Art guidelines free for SASE with first-class postage. Artists represented include Nancy Howe, Steve Hamrick, Sueellen Ross, Collin Bogle, Lee Bogle and Bruce Miller. Editions are created by collaborating with artist and by working from an existing painting. Approached by 200-300 artists/year. Publishes the work of 3-4 emerging, 15 mid-career and 8 established artists/year. Distributes the work of 1 emerging and 4 mid-career artists/year.

First Contact & Terms Send query letter with brochure showing art style or résumé and tearsheets, slides, photographs and transparencies. Samples are filed or are returned. Responds in 2 months. Call for appointment to show portfolio of slides, original final art and transparencies. Pays royalties. Requires exclusive representation of artist and/or art. Provides insurance while work is at firm, promotion, shipping from firm, a written contract and advertising through dealer showcase.

Tips ''Build a market for your originals by affiliating with an art gallery or two. Never give away your copyrights! When you can no longer satisfy the overwhelming demand for your originals, *that* is when you can hope for success in the reproduction market.''

Ⓝ HOPE STREET EDITIONS

P.O. Box 1528, Manchester Center VT 05255. (802)362-3662. Fax: (802)362-1082. E-mail: publishing@applejackart.com. Web site: www.applejackart.com. Publishes/distributes unlimited edition fine art prints. Clients: galleries, decorators, frame shops, distributors, architects, corporate curators, museum shops and gift shops.

- This company is a division of Applejack Art Partners (see separate listing in the Greeting Cards, Gifts & Products section).

Needs Seeking decorative art for the serious collector, commercial and designer markets. Considers oil, acrylic, watercolor, mixed media and pastel. Prefers contemporary art, folk art, antique, traditional and botanical. Artists represented include Robin Anderson, Kevin Daniel and Nancy Overton. Editions are created by collaborating with the artist or by working from an existing painting.

First Contact & Terms Send query letter with brochure, photocopies, photographs and tearsheets; or send e-mail query with JPEGs. Samples are not filed and are returned by SASE only. Responds only if interested. Will contact artist for portfolio review if interested. Offers advance when appropriate. Usually requires exclusive representation of artist. Provides promotion and written contract. Finds artists through art fairs and exhibitions.

IMAGE CONNECTION

456 Penn St., Yeadon PA 19050. (610)626-7770. Fax: (610)626-2778. E-mail: sales@imageconnect ion.biz. Web site: www.imageconnection.biz. **President:** Michael Markowicz. Estab. 1988. Publishes and distributes limited editions and posters. Represents several European publishers.

Needs Seeking fashionable and decorative art for the commercial market. Considers oil, pen & ink, watercolor, acrylic, pastel and mixed media. Prefers contemporary and popular themes, realistic and abstract art. Editions are created by collaborating with the artist and by working from an existing painting. Approached by 200 artists/year.

First Contact & Terms Send query letter with brochure showing art style or résumé, slides, photocopies, photographs, tearsheets and transparencies. Accepts e-mail submissions with link to Web site or Mac-compatible image file. Samples are not filed and are returned by SASE. Responds in 2 months. Will contact artist for portfolio review if interested. Portfolio should include b&w and color finished, original art, photographs, slides, tearsheets and transparencies. Payment method is negotiated. Offers advance when appropriate. Negotiates rights purchased. Requires exclusive representation of artist for product. Finds artists through art competitions, exhibits/fairs, reps, submissions, Internet, sourcebooks and word of mouth.

▣ IMAGE SOURCE INTERNATIONAL

630 Belleville Ave., New Bedford MA 02745. (508)999-0090. Fax: (508)999-9499. E-mail: pdownes @isiposters.com. Web site: www.isiposters.com. **Contact:** Patrick Downes. Art Editor: Kevin Miller. Licensing: Patrick Downes. Art Director: Bob Downs. Estab. 1992. Poster company, art publisher, distributor, foreign distributor. Publishes/distributes unlimited editions, fine art prints, offset reproductions, posters. Clients: galleries, decorators, frame shops, distributors, architects, corporate curators, museum shops, gift shops, foreign distributors (Germany, Holland, Asia, South America).

● Image Source International is one of America's fastest-growing publishers.

Needs Seeking fashionable, decorative art for the designer market. Considers oil, acrylic, pastel. Artists represented include Micarelli, Kim Anderson, Bertram Bahner, Juarez Machado, Anthony Watkins, Rob Brooks and Karyn Frances Gray. Editions are created by collaborating with the artist or by working from an existing painting. Approached by hundreds of artists/year. Publishes the work of 6 emerging, 2 mid-career and 2 established artists/year. Distributes the work of 50 emerging, 25 mid-career, 50 established artists/year.

First Contact & Terms Send query letter with brochure, photocopies, photographs, résumé, slides, tearsheets, transparencies, postcards. Samples are filed and are not returned. Responds only if interested. Company will contact artist for portfolio review if interested. Pays flat fee "that depends on artist and work and risk." Buys all rights. Requires exclusive representation of artist.

Tips Notes trends as sports art, neo-classical, nostalgic, oversize editions. "Think marketability. Watch the furniture market."

▣ IMCON

68 Greene St., Oxford NY 13830. (607)843-5130. E-mail: imcon@mkl.com. **President:** Fred Dankert. Estab. 1986. Fine art printer of hand-pulled originals. "We invented the waterless litho plate, and we make our own inks." Clients: galleries, distributors.

Needs Seeking creative art for the serious collector. Editions are created by collaborating with the artist, "who must produce image on my plate. Artist will be given proper instruction."

First Contact & Terms Call or send query letter with résumé, photographs and transparencies.

Tips "Artists should be willing to work with me to produce original prints. We do *not* reproduce; we create new images. Artists should have market experience."

INNOVATIVE ART

(formerly Portal Publications, Ltd.), 100 Smith Ranch Rd., Suite 210, San Rafael CA 94903. (415)884-6200 or (800)227-1720. Fax: (415)382-3377. Web site: www.portalpub.com. **Senior Art Director:** Andrea Smith. Estab. 1954. Publishes greeting cards, calendars, posters, wall decor, framed prints. Art guidelines available for SASE or on Web site.

● See additional listing in the Greeting Cards, Gifts & Products section.

Needs Approached by more than 1,000 freelancers artists/year. Offers up to 400 or more assignments/year. Works on assignment only. Considers any media. Looking for "beautiful, charming, provocative, humorous images of all kinds." 90% of freelance design demands knowledge of the most recent versions of Illustrator, QuarkXPress and Photoshop. Submit seasonal material 1 year in advance.

First Contact & Terms "No submission will be considered without a signed guidelines form, available on our Web site at www.portalpub.com/contact/ArtistSubmissionForm.pdf; or contact Robin O'Conner at (415)526-6362."

Tips "Ours is an increasingly competitive business, so we look for the highest quality and most unique imagery that will appeal to our diverse market of customers."

INSPIRATIONART & SCRIPTURE, INC.

P.O. Box 5550, Cedar Rapids IA 52406. (319)365-4350. Fax: (319)861-2103. E-mail: charles@inspirationart.com. Web site: www.inspirationart.com. **Creative Director:** Charles R. Edwards. Estab. 1993 (incorporated 1996). Produces Christian posters. "We create and produce jumbo-sized (24×36) posters targeted at pre-teens (10-14), teens (15-18) and young adults (18-30). A Christian message appears on every poster. Some are fine art and some are very commercial. We prefer very contemporary images." Art guidelines available on Web site or for SASE with first-class postage.

Needs Approached by 150-200 freelance artists/year. Works with 10-15 freelancers/year. Buys 10-15 designs, photos, illustrations/year. Christian art only. Uses freelance artists for posters. Considers all media. Looking for "something contemporary or unusual that appeals to teens or young adults and communicates a Christian message."

First Contact & Terms Send query letter with SASE, photographs, slides or transparencies. Accepts submissions on disk (call first). Samples are filed or are returned by SASE. Responds in 30 days. Will contact artist for portfolio review if interested. Portfolio should include color roughs, final art, photographs and transparencies. "We need to see the artist's range. It is acceptable to submit 'secular' work, but we also need to see work that is Christian-inspired." Originals are returned at job's completion. Pays by the project, $50-250. Pays royalties of 5% "only if the artist has a body of work that we are interested in purchasing in the future." Rights purchased vary according to project.

Tips "The better the quality of the submission, the better we are able to determine if the work is suitable for our use (slides are best). The more complete the submission (i.e., design, art layout, scripture, copy), the more likely we are to see how it may fit into our poster line. We do accept traditional work but are looking for work that is more commercial and hip (think MTV with values). A poster needs to contain a Christian message that is relevant to teen and young adult issues and beliefs. Understand what we publish before submitting work. Visit our Web site to see what it is that we do. We are not simply looking for beautiful art, but rather we are looking for art that communicates a specific scriptural passage."

N INTERCONTINENTAL GREETINGS LTD.

176 Madison Ave., New York NY 10016. (212)683-5830. Fax: (212)779-8564. E-mail: art@intercontinental-ltd.com. Web site: www.intercontinental-ltd.com. **Art Director:** Jerra Parfitt. Estab. 1967. Sells reproduction rights of designs to publishers/manufacturers in 50 countries around

the world. Specializes in greeting cards, gift bags, stationery and novelty products, ceramics, textile, bed and bath accessories, and kitchenware.

• See additional listing in the Greeting Cards, Gifts & Products section.

Needs Seeking creative, commercial and decorative art in traditional and computer media and photography. Accepts seasonal and holiday material at any time. Animals, children, babies, fruits/wine, sports, scenics, international cities and Americana themes are highly desirable.

First Contact & Terms Send query letter with brochure, tearsheets, CDs or DVDs. "Please do not send original artwork." Samples are filed or returned by SASE if requested. Artist is paid a percentage once work is published. No credit line given. Sells one-time rights and exclusive product rights. Simultaneous submissions and previously published work okay. "Please state reserved rights, if any."

Tips Recommends the annual New York SURTEX Show. "In addition to having good painting/designing skills, artists should be aware of market needs and trends. We're looking for artists who possess a large collection of designs, and we are interested in series of interrelated images."

INTERNATIONAL GRAPHICS

Walmsley GmbH, Junkersring 11, Eggenstein DE-76344 Germany. (49)(721)978-0620. Fax: (49)(721)978-0651. E-mail: LW@ig-team.de. Web site: www.international-graphics com. **President:** Lawrence Walmsley. Publishing Assistant: Anita Cieslar. Estab. 1981. Poster company, art publisher/distributor. Publishes/distributes limited edition monoprints, monotypes, offset reproductions, posters, original paintings and silkscreens. Clients: galleries, framers, department stores, gift shops, card shops and distributors. Current clients include Art.com, Windsor Art, Intercontinental Art, Balangier and Bombay stores.

Needs Seeking creative, fashionable and decorative art for the commercial and designer markets. Also seeking Americana art for gallery clients. Considers oil, acrylic, watercolor, mixed media, pastel and photos. Prefers landscapes, florals, still lifes. Art guidelines free for SASE with first-class postage. Artists represented include Christian Choisy, Benevolenza, Ona, Thiry, Magis, Marthe and Mansart. Editions are created by working from an existing painting. Approached by 100-150 artists/year. Publishes the work of 10-20 emerging artists/year. Distributes the work of 10-20 emerging artists/year.

First Contact & Terms Send query letter with brochure, photocopies, photographs, photostats, résumé, slides, tearsheets. Accepts disc submissions for Mac or Windows. Samples are filed and returned. Responds in 2 months. Will contact artist for portfolio review if interested. Negotiates payment on basis of per-piece-sold arrangement. Offers advance when appropriate. Buys first rights. Provides advertising, promotion, shipping from firm, and contract. Also works with free-lance designers. Prefers local designers. Finds artists through exhibitions, word of mouth, submissions.

Tips "Pastel landscapes and still life pictures are good at the moment. Earthtones are popular—especially lighter shades. At the end of the day, we seek the unusual, that has not yet been published."

ISLAND ART PUBLISHERS

P.O. Box 22063, Brentwood Bay BC V8M 1R5 Canada. (250)652-5181 or (800)663-7501. Fax: (250)652-2711. E-mail: submissions@islandart.com. Web site: www.islandart.com. **Art Director:** Ryan Grealy. Estab. 1985. Art publisher, distributor and printer. Publishes and distributes art cards, posters, open-edition prints, calenders, bookmarks, giclées and custom products. Clients: galleries, museums, Federal and local governments, major sporting events, department stores, distributors, gift shops, artists and photographers. Art guidelines available on Web site.

Needs See Web site for current needs and requirements. Considers oil, watercolor and acrylic. Prefers themes related to the Pacific Northwest. Editions are created by working from an existing

© 2007 Andy Everson

"Heritage" by Andy Everson (www.andyeverson.com) is distributed by Island Art Publishers as a limited edition print/giclée, a 6×9-inch art card, and in wall, desktop and perpetual calendars. Driven by the traditions of his Native American relatives and ancestors, Everson strives to maintain a balance between age-old customs and modern technology. The ability to create and print most of his own work has allowed him to explore and express his ancestral concepts in a number of contemporary ways.

painting. Approached by 100 artists/year. Publishes the work of 2-4 emerging artists/year.

First Contact & Terms Send submissions to the attention of Art Director. Submit résumé/CV, tearsheets, slides, photographs, transparencies or digital files on CD-/DVD-ROM (must be TIFF, EPS, PSD or JPEG files compatible with Photoshop). "Please DO NOT send originals." Samples are not filed and are returned only by SASE if requested by artist. Responds in 3-6 months. Will contact artist for portfolio review if interested. Pays royalties of 5-10%. Licenses reproduction rights. Requires exclusive representation of artist *for selected products only*. Provides promotion, insurance while work is at firm, shipping from firm, written contract, fair trade representation and Internet service. Finds artists through art fairs, submissions and referrals.

Tips "Provide a body of work along a certain theme to show a fully developed style that can be built upon. We are influenced by our market demands. Please review online, or ask for, our submission guidelines before sending work on spec."

LESLI ART, INC.

20558 Chatsboro Dr., Woodland Hills CA 91364. (818)999-9228. E-mail: lesliart@adelphia.net. Web site: www.lesliart.com. **President:** Stan Shevrin. Estab. 1965. Artist agent handling paintings for art galleries and the trade. Open by appointment only.

● See additional listing in the Artists' Reps section.

Needs Considers oil paintings and acrylic paintings. Prefers realism and impressionism—figures costumed with narrative content, landscapes, still lifes and florals. Works with 20 artists/year.

First Contact & Terms E-mail visuals, or mail color photos or slides. Send 6-12 images to the attention of Stan Shevrin. Responds in 1 week. Offers an advance and written agreement. Confers with artist on pricing schedule. Provides marketing and merchandising on national level.

Tips "We consider only those artists who are serious about having their work exhibited in important galleries throughout the United States and Europe."

LESLIE LEVY FINE ART PUBLISHING

7137 Main St., Scottsdale AZ 85251. (480)947-2925. Fax: (480)945-1518. E-mail: art@leslielevy.com. Web site: www.leslielevy.com. **President:** Leslie Levy. Estab. 1976. Publisher of fine art posters and open editions. Clients: frame shops, galleries, designers, framed art manufacturers, distributors and department stores.

• This company is a division of Bentley Publishing Group (see separate listing in this section).

Needs Seeking creative and decorative art for the residential, hospitality, health care, commercial and designer markets. Artists represented include Steve Hanks, Terry Isaac, Stephen Morath, Kent Wallis, Cyrus Afsary and Raymond Knaub. Considers oil, acrylic, pastel, watercolor, tempera and mixed media. Prefers florals, landscapes, wildlife, semi-abstract, nautical, figurative works and b&w photography. Approached by hundreds of artists/year.

First Contact & Terms Send query letter with résumé, slides or photos and SASE. Samples are returned by SASE. "Portfolio will not be seen unless interest is generated by the materials sent in advance. Please do not send limited editions, transparencies or original works." Pays royalties quarterly based on wholesale price. Insists on acquiring reprint rights for posters. Requires exclusive representation of artist. Provides promotion and written contract.

Tips "Please, don't call us. After we review your materials, we will contact you or return materials within one month. If you are a beginner, do not go through the time and expense of sending materials."

LOLA LTD./LT'EE

1817 Egret St. SW, Shallotte NC 28470-5433. (910)754-8002. E-mail: lolaltd@yahoo.com. **Owner:** Lola Jackson. Distributor of limited editions, offset reproductions, unlimited editions, hand-pulled originals, antique prints and etchings. Clients: art galleries, architects, picture frame shops, interior designers, major furniture and department stores, industry and antique gallery dealers.

• This distributor also carries antique prints, etchings and original art on paper and is interested in buying/selling to trade.

Needs Seeking creative and decorative art for the commercial and designer markets. "Hand-pulled graphics are our main area." Considers oil, acrylic, pastel, watercolor, tempera or mixed media. Prefers unframed series, up to 30×40 maximum. Artists represented include Buffet, White, Brent, Jackson, Mohn, Baily, Carlson, Coleman. Approached by 100 artists/year. Publishes the work of 5 emerging, 5 mid-career and 5 established artists/year. Distributes the work of 40 emerging, 40 mid-career and 5 established artists/year.

First Contact & Terms Send query letter with samples. Samples are filed or are returned only if requested. Responds in 2 weeks. Payment method is negotiated. "Our standard commission is 50%, less 50% off retail." Offers an advance when appropriate. Provides insurance while work is at firm, shipping from firm and written contract.

Tips "We find we cannot sell black & white only. Leave wide margins on prints. Send all samples before end of May each year as our main sales are targeted for summer. We do a lot of business with birds, botanicals, boats and shells—anything nautical."

▧ MAPLE LEAF PRODUCTIONS

391 Steelcase Rd. W., Unit 24, Markham ON L3R 3V9 Canada. (905)940-9229. Fax: (905)940-9761. E-mail: ssillcox@ca.inter.net. Web site: www.mapleleafproductions.com. **President:** Scott Sillcox. Estab. 1993. Art publisher. Publishes sports art (historical), limited editions, posters, unlimited editions. Clients: distributors, frame shops, gift shops and museum shops.

Needs Considers watercolor. See Web site for themes and styles. Artists represented include Tino

Paolini, Nola McConnan, Bill Band. Approached by 5 artists/year. Publishes/distributes the work of 1 emerging artist/year.

First Contact & Terms Send e-mail. Accepts e-mail submissions with link to Web site. Prefers TIFF, JPEG, GIF, EPS files. Responds in 1 week. Negotiates payment. Offers advance when appropriate. Buys all rights. Provides written contract. Finds artists through word of mouth.

Tips "We require highly detailed watercolor artists, especially those with an understanding of sports and the human body. Attention to small details is a must."

BRUCE MCGAW GRAPHICS, INC.

389 W. Nyack Rd., West Nyack NY 10994. (845)353-8600. Fax: (845)353-8907. E-mail: acquisitions@bmcgaw.com. Web site: www.bmcgaw.com. **Product Development:** Katy Murphy. Clients: poster shops, galleries, frame shops.

Needs Artists represented include Romero Britto, David Doss, Ray Hendershot, Jacques Lamy, Eve Shpritser, Beverly Jean, Peter Sculthorpe, Bob Timberlake, Robert Bateman, Michael Kahn, Albert Swayhoover and P.G. Gravele. Other important fine art poster licenses include Disney, Andy Warhol, MOMA, New York and others. Publishes the work of 30 emerging and 30 established artists/year. Publishes nearly 300 images/year.

First Contact & Terms Send slides, disks (10-15 JPEGs), transparencies or any other visual material that shows the work in the best light. "We review all types of two-dimensional art with no limitation on media or subject. Review period is one month, after which time we will contact you with our decision. If you wish the material to be returned, enclose a SASE. If forwarding material electronically, send easily opened JPEG files for initial review consideration only. Referrals to artists' Web sites will not be addressed. Contractual terms are discussed if work is accepted for publication."

Tips "Simplicity is very important in today's market (yet there still needs to be 'a story' to the image). Form and palette are critical to our decision process. We have a tremendous need for decorative pieces, especially new abstracts, landscapes and florals. Decorative still life images are very popular, whether painted or photographed, and much needed as well. There are a lot of prints and posters being published these days. Market your best material! Review our catalog at your neighborhood gallery or poster shop, or visit our Web site before submitting. Send your best."

MILL POND PRESS COMPANIES

310 Center Court, Venice FL 34285. (800)535-0331. Fax: (941)497-6026. E-mail: ellen@millpond.com. Web site: www.millpond.com. **Public Relations Director:** Ellen Collard. Licensing: Linda Schaner. Estab. 1973. Publishes limited editions, unlimited editions, offset reproductions and giclées on paper and on canvas. Divisions include Mill Pond Press, Visions of Faith, Mill Pond Art Licensing and NextMonet. Clients: galleries, frame shops and specialty shops, Christian book stores, licensees. Licenses various genres on a range of quality products.

Needs Seeking creative, decorative art. Open to all styles, primarily realism. Considers oil, acrylic, watercolor and mixed media. Prefers wildlife, spiritual, figurative, landscapes and nostalgic. Artists represented include Paul Calle, Kathy Lawrence, Jane Jones, John Seerey-Lester, Robert Bateman, Carl Brenders, Nita Engle, Luke Buck and Maynard Reece. Editions are created by collaborating with the artist or by working from an existing painting. Approached by 250-300 artists/year. Publishes the work of 1-2 emerging, 1-2 mid-career and 6-8 established artists/year. The company has a program to assist independent artists who want to self-publish.

First Contact & Terms Send query letter with photographs, résumé, SASE, slides or transparencies, and description of artwork. Samples are not filed and are returned by SASE. Responds in 1 year. Will contact artist for portfolio review if interested. Pays royalties. Rights purchased vary according to project. Requires exclusive representation of artist. Provides promotion, in-transit

insurance, insurance while work is at firm, shipping to and from firm, and written contract. Finds artists through art exhibitions, submissions and word of mouth.

Tips "We continue to expand the genre published. Inspirational art has been part of expansion. Realism is our base, but we are open to looking at all art."

N MUSEUM MASTERS INTERNATIONAL

185 E. 85th St., Suite 27B, New York NY 10028. (212)360-7100. Fax: (212)360-7102. E-mail: mmimarilyn@aol.com. Web site: www.museummasters.com. **President:** Marilyn Goldberg. Licensing agent for international artists and art estates. Distributor of limited editions, posters, tapestry and sculpture for galleries, museums and gift boutiques. Current clients include the Boutique/Galeria Picasso in Barcelona, Spain, and The Hakone Museum in Japan.

Needs Seeking artwork with decorative appeal for the designer market. Considers oil, acrylic, pastel, watercolor and mixed media. Artists for whom merchandise has been developed include Pablo Picasso, Salvador Dali, Andy Warhol, Keith Haring, Ed Heck, Jacques Tang.

First Contact & Terms E-mail with sample download of artwork offered. Samples are filed or returned. Call or write for appointment to show portfolio or mail slides and transparencies. Payment method is negotiated. Offers advance when appropriate. Negotiates rights purchased. Exclusive representation is not required. Provides insurance while work is at firm, shipping to firm and a written contract.

NEW YORK GRAPHIC SOCIETY

129 Glover Ave., Norwalk CT 06850-1311. (800)677-6947. Fax: (203)846-2105. E-mail: donna@nygs.com. Web site: www.nygs.com. **Vice President of Publishing:** Donna Lavan. Estab. 1925. Specializes in fine art reproductions, prints, posters. Clients: galleries, frame shops and museums shops. Current clients include major retailers throughout the country.

Needs Considers oil, acrylic, pastel, watercolor, mixed media and colored pencil drawings. Art submission guidelines available on Web site.

First Contact & Terms Send query letter with transparencies, color copies, digital files or link to Web site. Responds in 8-12 weeks. All submissions returned to artists by SASE after review. Pays royalties of 10%. Buys all print reproduction rights. Provides in-transit insurance from firm to artist, insurance while work is at firm, promotion, shipping from firm and a written contract; provides insurance for art if requested. Finds artists through submissions/self-promotions, magazines, art fairs/exhibitions.

Tips "We publish a broad variety of styles and themes. We actively seek all sorts of fine decorative art."

N NOVA MEDIA INC.

1724 N. State St., Big Rapids MI 49307-9073. (231)796-4637. E-mail: trund@netonecom.net. Web site: www.novamediainc.com. **President:** Thomas J. Rundquist. Estab. 1981. Specializes in CD-ROMs, CDs/cassettes, games, limited edition plates, posters, school supplies, T-shirts. Licenses e-prints.

Needs Seeking creative art for the serious collector. Considers oil, acrylic. Prefers expressionism, impressionism, abstract. Editions are created by collaborating with the artist or by working from an existing painting. Approached by 14 artists/year. Publishes/distributes the work of 2 emerging, 2 mid-career and 1 established artists/year. Also needs freelancers for design. Prefers local designers.

First Contact & Terms Send query letter with samples. Accepts e-mail submissions. Responds in 1 month. Keeps samples on file; does not return material. Simultaneous submissions and previously published work OK. Pays royalties of 10% or negotiates payment. No advance. Rights purchased vary according to project. Provides promotion.

Tips "The most effective way to contact us is by e-mail or regular mail. Visit our Web site."

OLD GRANGE GRAPHICS

450 Applejack Rd., Manchester Center VT 05255. (800)282-7776. Fax: (802)362-3286. E-mail: greg@denunzio.com. Web site: www.oldgrangegraphics.com. **Sales Vice President:** Gregory Panjian. CEO/President: Jack Appelman. Estab. 1976. Distributor/canvas transfer studio. Publishes/distributes canvas transfers and posters. Clients: galleries, frame shops, museum shops, publishers, artists.

Needs Seeking decorative art for the commercial and designer markets. Considers lithographs. Prefers prints of artworks that were originally oil paintings. Editions are created by working from an existing painting. Approached by 100 artists/year.

First Contact & Terms Send query letter with brochure. Samples are not filed and are returned. Responds in 1 month. Will contact artist for portfolio review of tearsheets if interested. Negotiates payment. Rights purchased vary according to project. Provides promotion and shipping from firm. Finds artists through art publications.

Tips Recommends Galeria, Artorama and ArtExpo shows in New York, and *Decor*, *Art Trends*, *Art Business News* and *Picture Framing* as tools for learning about the current market.

ON A POSITIVE NOTE dba MACH1

P.O. Box 4871, Lafayette IN 47903. (800)955-6224. **Vice President of Marketing:** James Gordon. Estab. 1987. Art publisher. Publishes unlimited and limited editions and posters. Clients: museums, galleries, frame shops and mail order customers. Current clients include the Smithsonian Museum, the Intrepid Museum, Deck the Walls franchisers and Sky's The Limit.

Needs Seeking creative and decorative art for the commercial and designer markets. Considers mixed media. Editions are created by collaborating with the artist or by working from an existing painting. Publishes the work of 2-3 emerging, 2-3 mid-career and 2-3 established artists/year.

First Contact & Terms Send query letter with résumé, slides and photographs. Samples are not filed and are returned. Responds in 1 month. To show a portfolio, mail slides and photographs. Pays royalties. Offers an advance when appropriate. Requires exclusive representation of artist. Provides promotion, shipping to and from firm, and a written contract.

PENNY LANE PUBLISHING INC.

1791 Dalton Dr., New Carlisle OH 45344. (937)849-1101. Fax: (937)849-9666. E-mail: info@Penn yLanePublishing.com. Web site: www.PennyLanePublishing.com. **Art Coordinators:** Kathy Benton and Stacey Hoenie. Licensing: Renee Franck and Sara Elliott. Estab. 1993. Art publisher. Publishes limited editions, unlimited editions, offset reproductions. Clients: galleries, frame shops, distributors, decorators.

Needs Seeking creative, decorative art for the commercial market. Considers oil, acrylic, watercolor, mixed media, pastel. Artists represented include Linda Spivey, Donna Atkins, Lisa Hilliker, Pat Fischer, Annie LaPoint, Fiddlestix and Mary Ann June. Editions are created by collaborating with the artist or working from an existing painting. Approached by 40 artists/year. Publishes the work of 10 emerging, 15 mid-career and 6 established artists/year.

First Contact & Terms Send query letter with brochure, résumé, photographs, slides, tearsheets. Samples are filed or returned by SASE. Responds in 2 months. Will contact artist for portfolio review of color, final art, photographs, slides and tearsheets, if interested. Pays royalties. Buys first rights. Requires exclusive representation of artist. Provides advertising, shipping from firm, promotion, written contract. Finds artists through art fairs and exhibitions, submissions, decorating magazines.

Tips "Be aware of current color trends, and work in a series. Please review our Web site to see the style of artwork we publish."

⊞ PGM ART WORLD

Carl-von-Linde-Str. 33, Garching 85748 Germany. (49)(89)320-02-170. Fax: (49)(89)320-02-270. E-mail: info@pgm.de. Web site: www.pgm.de. **Production Manager:** Andrea Kuborn. Estab. 1969. International fine art publisher, distributor, gallery. Publishes/distributes limited and unlimited editions, offset reproductions, art prints, giclées, art cards and originals. Worldwide supplier to galleries, framers, distributors, decorators.

- PGM publishes around 180 images/year and distributes more than 6,000 images. The company also operates 3 galleries in Munich.

Needs Seeking creative, fashionable and decorative art for the commercial and designer markets. Considers oil, acrylic, watercolor, mixed media, pastel, pen & ink, photography and digital art. Considers any accomplished work of any theme or style. Artists represented include Renato Casaro, Marianne Bernhardt, Elena Filatov, Madjid, Vladimir Gorsky, Erika Heinemann and others. Editions are created by working from an existing painting or high-resolution digital data. Approached by more than 420 artists/year.

First Contact & Terms Send query letter with photographs, slides, color copies, color prints or work in digital format (JPEG) on CD-ROM/DVD. "Sent documentation will be returned." Responds within 1 month. Will contact artist for portfolio review if interested. Pays royalties per copies sold; negotiable. Requires exclusive representation of artist. Provides promotion of prints in catalogs and promotional material, presentation of artists (biography & photo) on Web site.

Tips "Get as much worlwide exposure as possible at art shows and with own Web site."

Ⓝ ⊞ PORTER DESIGN—EDITIONS PORTER

Court Farm House, Wello, Bath BA2 8PU United Kingdom. (866)293-2079. Fax: (01144)1225-849156. E-mail: service@porter-design.com. Web site: www.porter-design.com. **Partners:** Henry Porter and Mary Porter. Estab. 1985. Publishes limited and unlimited editions and offset productions and hand-colored reproductions. Clients: international distributors, interior designers and hotel contract art suppliers. Current clients include Devon Editions, Top Art, Harrods and Bruce McGaw.

Needs Seeking fashionable and decorative art for the designer market. Considers watercolor. Prefers 16th-19th century traditional styles. Artists represented include Victor Postolle, Joseph Hooker and Adrien Chancel. Editions are created by working from an existing painting. Approached by 10 artists/year. Publishes and distributes the work of 10-20 established artists/year.

First Contact & Terms Send query letter with brochure showing art style or résumé and photographs. Accepts disk submissions compatible with QuarkXPress on Mac. Samples are filed or are returned. Responds only if interested. To show portfolio, mail photographs. Pays flat fee or royalties. Offers an advance when appropriate. Negotiates rights purchased.

PORTFOLIO GRAPHICS, INC.

P.O. Box 17437, Salt Lake City UT 84117. (801)424-2574. E-mail: info@portfoliographics.com. Web site: www.nygs.com. **Creative Director:** Kent Barton. Estab. 1986. Publishes and distributes open edition prints, posters and hand-embellished canvas reproductions. Clients: galleries, designers, poster distributors (worldwide) and framers. Licensing: Most artwork is available for license for large variety of products. Portfolio Graphics works with a large licensing firm that represents all of their imagery.

Needs Seeking creative, fashionable and decorative art for commercial and designer markets. Considers oil, watercolor, acrylic, pastel, mixed media and photography. Publishes 100+ new works/year. Editions are created by working from an existing painting, transparency or high-resolution digital file.

First Contact & Terms Send query letter with résumé, bio and the images you are submitting via photos, transparencies, tearsheets or gallery booklets. "Please be sure to label each item. Please

do no send original artwork. Make sure to include a SASE for any materials you would like returned." Samples are not filed. Responds in 3 months. Pays royalties of 10%. Provides promotion and a written contract.

Tips "We find artists through galleries, magazines, art exhibits and submissions. We're looking for a variety of artists and styles/subjects."

POSNER FINE ART

13234 Fiji Way, Suite G, Marina Del Rey CA 90292. (310)318-8622. Fax: (310)578-8501. E-mail: info@posnerfineart.com. Web site: www.posnerfineart.com. **President:** Judith Posner. Estab. 1994. Art distributor and gallery. Distributes fine art prints, monoprints, sculpture and paintings. Clients: galleries, frame shops, distributors, architects, corporate curators, museum shops. Current clients include Renaissance Hollywood Hotel, NWQ Co., Royal Specialty.

• See additional listing in the Galleries section.

Needs Seeking creative art for the serious collector and commercial market. Considers oil, acrylic, watercolor, mixed media, sculpture. Prefers very contemporary style. Artists represented include Robert Indiana, Greg Gummersall and Michael Gallagher. Editions are created by collaborating with the artist. Approached by hundreds of artists/year. Distributes the work of 5-10 emerging, 5 mid-career and 200 established artists/year. Art guidelines free for SASE with first-class postage.

First Contact & Terms Send slides. "Must enclose self-addressed, stamped return envelope." Samples are filed or returned. Responds in a few weeks. Pays on consignment basis; firm receives 50% commission. Buys one-time rights. Provides advertising, promotion, insurance while work is at firm. Finds artists through art fairs and exhibitions, word of mouth, submissions, art reps.

Tips "Know color trends of design market. Look for dealer with same style in gallery. Send consistent work."

◫ POSTERS INTERNATIONAL

1180 Caledonia Rd. North York ON M6A 2W5 Canada. (416)789-7156. Fax: (416)789-7159. E-mail: art@postersinternational.net. Web site: www.postersinternational.net. **President:** Esther Cohen-Bartfield. Licensing: Andrew Cohen. Estab. 1976. Poster company, art publisher. Publishes fine art posters and giclée prints. Licenses for gift and stationery markets. Clients: galleries, designers, art consultants, framing, manufacturers, distributors, hotels, restaurants, etc., around the world. Current clients include Holiday Inn and Bank of Nova Scotia.

Needs Seeking creative, fashionable art for the commercial market. Considers oil, acrylic, watercolor, mixed media, b&w and color photography. Prefers landscapes, florals, abstracts, photography, vintage, collage and tropical imagery. Editions are created by collaborating with the artist or by working from an existing painting. Approached by 100 artists/year. Art guidelines free for SASE with first-class postage or IRC.

First Contact & Terms Send query letter or e-mail with attachment, brochure, photographs, slides, transparencies. Responds in 2 months. Company will contact artist for portfolio review of photographs, photostats, slides, tearsheets, thumbnails, transparencies if interested. Pays flat fee or royalties of 10%. Offers advance when appropriate. Rights purchased vary according to project. Provides advertising, promotion, shipping from firm, written contract. Finds artists through art fairs, art reps, submissions.

Tips "Be aware of current color trends and always work in a series of two or more. Visit framing stores to see what's popular before submitting artwork."

ℕ PRESTIGE ART INC.

3909 W. Howard St., Skokie IL 60076. (847)679-2555. E-mail: prestige@prestigeart.com. Web site: www.prestigeart.com. **President:** Louis Schutz. Estab. 1960. Publisher/distributor/art gallery. Represents a combination of 18th and 19th century work and contemporary material. Pub-

lishes and distributes hand-pulled originals, limited and unlimited editions, canvas transfers, fine art prints, offset reproductions, posters, sculpture. Licenses artwork for note cards, puzzles, album covers and posters. Clients: galleries, decorators, architects, corporate curators.

- Company president Louis Shutz does consultation for new artists on publishing and licensing their art in various media.

Needs Seeking creative and decorative art. Considers oil, acrylic, mixed media, sculpture, glass. Prefers figurative art, impressionism, surrealism/fantasy, photo realism. Artists represented include Jean-Paul Avisse. Editions are created by collaborating with the artist or by working from an existing painting. Approached by 15 artists/year. Publishes the work of 2 emerging artists/year. Distributes the work of 5 emerging artists/year.

First Contact & Terms Send query letter with résumé and tearsheets, photostats, slides, photographs and transparencies. Accepts IBM-compatible disk submissions. Samples are not filed and are returned by SASE. Responds only if interested. Company will contact artist for portfolio review of tearsheets if interested. Pays flat fee. Offers an advance when appropriate. Rights purchased vary according to project. Provides insurance in-transit and while work is at firm, advertising, promotion, shipping from firm and written contract.

Tips "Be professional. People are seeking better quality, lower-sized editions, fewer numbers per edition—1/100 instead of 1/750."

RIGHTS INTERNATIONAL GROUP, LLC

500 Paterson Plank Rd., Union City NJ 07030. (201)239-8118. Fax: (201)222-0694. E-mail: rhazaga @rightsinternational.com. Web site: www.rightsinternational.com. **Contact:** Robert Hazaga. Estab. 1996. Agency for cross licensing. Represents artists for licensing into publishing, stationery, posters, prints, calendars, giftware, home furnishing. Clients: publishers of giftware, stationery, posters, prints, calendars, wallcoverings and home decor.

- See additional listing in the Greeting Cards, Gifts & Products section.

Needs Seeking creative, decorative art for the commercial and designer markets. Also looking for "country/Americana with a fresh interpretation of country with more of a cottage influence. Think Martha Stewart, *Country Living* magazine; globally inspired artwork." Considers all media. Prefers commercial style. Approached by 50 artists/year. See Web site for artists represented.

First Contact & Terms Send brochure, photocopies, photographs, SASE, slides, tearsheets, transparencies, JPEGs, CD-ROM. Accepts disk submissions compatible with PC platform. Samples are not filed and are returned by SASE. Responds in 8 weeks. Will contact artist for portfolio review if interested. Negotiates payment.

Tips "Check our Web site for trend, color and style forecasts!"

RINEHART FINE ARTS

A division of Bentley Publishing Group, 290 West End Ave. #2d, New York NY 10023. (212)595-6862. Fax: (212)595-5837. E-mail: harriet@bentleypublishinggroup.com. Web site: www.bentley publishinggroup.com. Poster/open edition print publisher and product licensing agent. **President:** Harriet Rinehart. Licenses 2D artwork for posters. Clients include large chain stores and wholesale framers, furniture stores, decorators, frame shops, museum shops, gift shops and substantial overseas distribution.

- See also listing for Bentley Publishing Group in this section.

Needs Seeking creative, fashionable and decorative art. Considers oil, acrylic, watercolor, mixed media, pastel. Images are created by collaborating with the artist or working from an existing painting. Approached by 200-300 artists/year. Publishes the work of 50 new artists/year.

First Contact & Terms Send query letter with SASE, photographs, slides, tearsheets, transparencies, JPEGs or "whatever the artist has that represents artwork best." Samples are not filed. Responds in 3 months. Portfolio review not required. Pays royalties of 8-10%. Rights purchased

vary according to project. Provides advertising, promotion, written contract and substantial over-seas exposure.

Tips "Submit work in pairs or groups of four. Work in standard sizes. Visit high-end furniture store chains for color trends."

ROSE SELAVY OF VERMONT

P.O. Box 1528, Manchester Center VT 05255. (802)362-3662. Fax: (802)362-1082. E-mail: publishing@applejackart.com. Web site: www.applejackart.com. Publishes/distributes unlimited edition fine art prints. Clients: galleries, decorators, frame shops, distributors, architects, corporate curators, museum shops and gift shops.

- This company is a division of Applejack Art Partners (see separate listing in the Greeting Cards, Gifts & Products section).

Needs Seeking decorative art for the serious collector, commercial and designer markets. Considers oil, acrylic, watercolor, mixed media and pastel. Prefers contemporary art, folk art, antique, traditional and botanical. Artists represented include Lisa Audit, Edward Lowe and Sylvia Weinberg. Editions are created by collaborating with the artist or by working from an existing painting.

First Contact & Terms Send query letter with brochure, photocopies, photographs and tearsheets; or send e-mail query with JPEGs. Samples are not filed and are returned by SASE only. Responds only if interested. Will contact artist for portfolio review if interested. Offers advance when appropriate. Usually requires exclusive representation of artist. Provides promotion and written contract. Finds artists through art fairs and exhibitions.

⊕ FELIX ROSENSTIEL'S WIDOW & SON LTD.

33-35 Markham St., London SW3 3NR United Kingdom. (44)207-352-3551. Fax: (44)207-351-5300. E-mail: sales@felixr.com. Web site: www.felixr.com. **Contact:** Ms. Anna Smithson. Licensing: Mr. Francis Blake. Estab. 1880. Publishes art prints and posters, both limited and open editions. Licenses all subjects on any quality product. Art guidelines on Web site.

Needs Seeking decorative art for the serious collector and the commercial market. Considers oil, acrylic, watercolor, mixed media and pastel. Prefers art suitable for homes or offices. Editions are created by collaborating with the artist or by working from an existing painting. Approached by 200-500 artists/year.

First Contact & Terms Send query letter with photographs. Samples are not filed and are returned by SASE. Responds in 2 weeks. Company will contact artist for portfolio review of final art and transparencies if interested. Negotiates payment. Offers advance when appropriate. Rights purchased vary according to project.

Tips "We publish decorative, attractive, contemporary art."

Ⓝ ⊕ SCANDECOR MARKETING AB

Box 656, 751 27 Uppsala Sweden. E-mail: mariekadestam@scandecor-marketing.se. Web site: www.scandecor-marketing.se. **Contact:** Marie Kadestam. Poster company, art publisher/distributor. Publishes/distributes fine art prints and posters. Clients include gift and stationery stores, craft stores and frame shops.

Needs Seeking fashionable, decorative art. Considers acrylic, watercolor and pastel. Themes and styles vary according to current trends. Editions are created by working from existing painting. Approached by 150 artists/year. Publishes the work of 5 emerging, 10 mid-career and 10 established artists/year. Also uses freelance designers. 25% of products require freelance design.

First Contact & Terms Send query letter with brochure, photocopies, photographs, slides, tearsheets, CDs, transparencies and SASE. Samples not filed are returned by SASE in 2 months. Company will contact artist for portfolio review if interested. Portfolio should include color photographs, slides, tearsheets and/or transparencies. Pays flat fee, $250-1,000. Rights vary according

to project. Provides written contract. Finds artists through art exhibitions, art and craft fairs, art reps, submissions and looking at art already in the marketplace in other forms (e.g., collectibles, greeting cards, puzzles).

SCHIFTAN INC.

1300 Steel Rd. W., Suite 4, Morrisville PA 19067. (215)428-2900 or (800)255-5004. Fax: (215)295-2345. E-mail: schiftan@erols.com. Web site: www.schiftan.com. **President:** Harvey S. Cohen. Estab. 1903. Art publisher/distributor. Publishes/distributes unlimited editions, fine art prints, offset reproductions, posters and hand-colored prints. Distributes unusual ready-made frames. Clients: galleries, decorators, frame shops, architects, wholesale framers to the furniture industry.
Needs Seeking fashionable, decorative art for the commercial market. Considers watercolor, mixed media. Editions are created by collaborating with the artist. Approached by 15-20 artists/year. Also needs freelancers for design.
First Contact & Terms Send query letter with transparencies. Samples are not filed and are returned. Responds in 1 week. Company will contact artist for portfolio review of final art, roughs, transparencies if interested. Pays flat fee or royalties. Offers advance when appropriate. Negotiates rights purchased. Provides advertising and written contract. Finds artists through art exhibitions, art fairs, submissions.

SEGAL FINE ART

11955 Teller St., Unit C, Broomfield CO 80020-2823. (800)999-1297 or (303)926-6800. Fax: (303)926-0340. E-mail: carrie@segalfineart.com. Web site: www.segalfineart.com; www.motorcycleart.com. **Art Director:** Carrie Russell. Owner: Ron Segal. Estab. 1986. Art publisher. Publishes limited edition serigraphs, mixed media pieces and posters. Clients: galleries and Harely-Davidson dealerships.
Needs Seeking creative and fashionable art for the serious collector and commercial market. Considers oil, watercolor, mixed media and pastel. Artists represented include David Mann, Scott Jacobs and Motor Marc Lacourciere.
First Contact & Terms Send query letter with slides or résumé, bio and photographs. Samples are not filed and are returned by SASE. Responds in 2 months. To show portfolio, mail slides, color photographs, bio and résumé. Offers advance when appropriate. Negotiates payment method and rights purchased. Requires exclusive representation of artist. Provides promotion.
Tips Advises artists to "remain connected to their source of inspiration."

SOMERSET FINE ART

29366 McKinnon Rd., P.O. Box 869, Fulshear TX 77441. (866)742-2215. Fax: (713)465-6062. E-mail: sallen@somersethouse.com. Web site: www.somersethouse.com. **Executive Vice President:** Stephanie Allen. Licensing: Pat Thomas. Estab. 1972. Art publisher of fine art limited editions: giclées, canvas transfers and reproductions on paper. Clients include independent galleries in U.S. and Canada.
Needs Seeking fine art for the serious collector. Considers oil, acrylic, watercolor, mixed media, pastel. Also has a line of religious art. Artists represented include G. Harvey, Larry Dyke, Rod Chase, Nancy Glazier, Martin Grelle, James E. Seward, Kyle Sims, Mark Laguë, Suanna Wamsley, Gearge Hallmark, Bob Wygant, Bruce Greene, Bill Anton, David Mann, Ragan Gennusa and Andy Thomas. Editions are created by collaborating with the artist or by working from an existing painting. Approached by 1,500 artists/year. Publishes the work of 4 emerging, 4 mid-career and 7 established artists/year.
First Contact & Terms Send query letter accompanied by 10-12 slides or photos representative of work with SASE. Do not send transparencies until requested. Will review art on artist's Web site or submitted digital files in JPEG format. Samples are filed for future projects unless return

is requested. Responds in 1-2 months. Publisher will contact artist for portfolio review if interested. Pays royalties. Rights purchased vary according to project. Artist retains painting and copyrights for other uses such as books. Company provides advertising and promotion, in-transit insurance, shipping and written contract.

Tips ''Considers mature, full-time artists. Special consideration given to artists with originals selling above $20,000 and who are open to some direction.''

JACQUES SOUSSANA GRAPHICS

37 Pierre Koenig St., Jerusalem 91041 Israel. (972)(2)6782678. Fax: (972)(2)6782426. E-mail: info@soussanart.com. Web site: www.soussanart.com. Estab. 1973. Art publisher. Publishes hand-pulled originals, limited editions, sculpture. Clients: galleries, decorators, frame shops, distributors, architects. Current clients include Royal Beach Hotel, Moriah Gallery, LCA, foreign ministry.

Needs Seeking decorative art for the serious collector and designer market. Considers oil, watercolor and sculpture. Artists represented include Adriana Naveh, Gregory Kohelet, Edwin Salomon, Samy Briss and Calman Shemi. Editions are created by collaborating with the artist. Approached by 20 artists/year. Publishes/distributes the work of 5 emerging artists/year.

First Contact & Terms Send query letter with brochure, slides. To show portfolio, artist should follow up with letter after initial query. Portfolio should include color photographs.

SYRACUSE CULTURAL WORKERS

P.O. Box 6367, Syracuse NY 13217. (315)474-1132. Fax: (877)265-5399. E-mail: karenk@syracuse culturalworkers.com. Web site: www.syracuseculturalworkers.com. **Art Director:** Karen Kerney. Produces posters, notecards, postcards, greeting cards, T-shirts and calendars that are feminist, multicultural, lesbian/gay allied, racially inclusive and honoring of elders and children (environmental and social justice themes).

● See additional listing in the Greeing Cards, Gifts & Products section.

Needs Art guidelines free for SASE with first-class postage; also available on Web site.

First Contact & Terms Pays flat fee, $85-400; royalties of 6% of gross sales.

Tips ''View our Web site to get an idea of appropriate artwork for our company.''

TELE GRAPHICS

161 E. Lake Brantley Dr., Longwood FL 32779-4407. (407)682-5643. Fax: (407)682-2913. E-mail: ronrybak@telegraphicsonline.com. Web site: www.telegraphicsonline.com. **President:** Ron Rybak. Art publisher/distributor handling original mixed media and hand-pulled originals. Clients: galleries, picture framers, interior designers and regional distributors.

Needs Seeking decorative art for the serious collector. Artists represented include Beverly Crawford, Diane Lacom, Joy Broe and Ursala Brenner. Editions are created by collaborating with the artist or by working from an existing painting. Approached by 30-40 artists/year. Publishes the work of 1-3 emerging artists/year.

First Contact & Terms Send query letter with résumé and samples. Samples are not filed and are returned only if requested. Responds in 1 month. Call or write for appointment to show portfolio of original/final art. Pays by the project. Considers skill and experience of artist and rights purchased when establishing payment. Offers advance. Negotiates rights purchased. Requires exclusive representation. Provides promotion, shipping from firm and written contract.

Tips ''Be prepared to show as many varied examples of work as possible. Show transparencies or slides plus photographs in a consistent style. We are not interested in seeing only one or two pieces.''

VARGAS FINE ART PUBLISHING, INC.

Enterprise Office Park, 9470 Annapolis Rd., Suite 313, Lanham MD 20706. (301)731-5175. Fax: (301)731-5712. E-mail: vargasfineart@aol.com. Web site: www.vargasfineart.com and www.blackartoriginals.com. **President:** Elba Vargas. Estab. 1987. Art publisher and worldwide distributor of originals, serigraphs, limited and open edition offset reproductions, etchings, sculpture, collector plates, calendars, canvas transfers and figurines. Clients: galleries, frame shops, museums, decorators, movie sets and TV.

Needs Seeking creative art for the serious collector and commercial market. Considers oil, watercolor, acrylic, pastel, pen & ink and mixed media. Prefers ethnic themes. Artists represented include Joseph Holston, Kenneth Gatewood, Betty Biggs, Sylvia Walker, Ted Ellis, Leroy Campbell, William Tolliver, Sylvia Walker, Wayne Still and Paul Awuzie. Approached by 100 artists/year. Publishes/distributes the work of about 80 artists.

First Contact & Terms Send query letter with résumé, slides and/or photographs. Samples are filed. Responds only if interested. To show portfolio, mail photographs. Payment method is negotiated. Requires exclusive representation.

Tips "Continue to hone your craft with an eye towards being professional in your industry dealings."

VIBRANT FINE ART

3931 W. Jefferson Blvd., Los Angeles CA 90016. (323)766-0818. Fax: (323)737-3128. E-mail: vibrantfineart@hotmail.com. **Art Director:** Phylise Stevens. Design Coordinator: Jackie Stevens. Licensing: Tom Nolen. Estab. 1990. Art publisher and distributor. Publishes and distributes fine art prints, limited and unlimited editions and offset reproductions. Licenses ethnic art to appear on ceramics, gifts, textiles, miniature art, stationery and notecards. Clients: galleries, designers, gift shops, furniture stores and film production companies.

Needs Seeking decorative and ethnic art for the commercial and designer markets. Considers oil, watercolor, mixed media and acrylic. Prefers African-American, Native American, Latino themes. Artists represented include Sonya A. Spears, Van Johnson, Momodou Ceesay, William Crite and Darryl Daniels. Editions are created by collaborating with the artist or by working from an existing painting. Approached by 40 artists/year. Publishes the work of 5 emerging, 5 mid-career and 2 established artists/year. Distributes the work of 5 emerging, 5 mid-career and 2 established artists/year. Also needs freelancers for design. 20% of products require design work. Designers should be familiar with Illustrator and Mac applications. Prefers local designers only.

First Contact & Terms Send query letter with brochure, tearsheets and slides. Also accepts PDF or JPEG files. Samples are filed or are returned by SASE. Will contact artist for portfolio review if interested. Pays royalties of 10%. Rights purchased vary according to project. Provides advertising, insurance while work is at firm, promotion, written contract and shipping from firm. Finds artists through art exhibitions, referrals, sourcebooks, art reps, submissions.

Tips "Ethnic art is hot. The African-American art market is expanding. I would like to see more submissions from artists that include slides of ethnic imagery, particularly African-American, Latino and Native American. We desire contemporary, cutting edge, fresh and innovative art. Artists should familiarize themselves with the technology involved in the printing process. They should possess a commitment to excellence and understand how the business side of the art industry operates."

WILD WINGS LLC

2101 S. Highway 61, Lake City MN 55041. (651)345-5355. Fax: (651)345-2981. E-mail: info@wildwings.com. Web site: www.wildwings.com. **Marketing & Artist Relation Manager:** Jennifer A. White. Estab. 1968. Art publisher/distributor and gallery. Publishes and distributes limited editions and offset reproductions. Clients: retail and wholesale.

Needs Seeking artwork for the commercial market. Considers oil, watercolor, mixed media, pastel and acrylic. Prefers wildlife. Artists represented include David Maass, Lee Kromschroeder, Ron Van Gilder, Robert Abbett, Michael Sieve and Persis Clayton Weirs. Editions are created by working from an existing painting. Approached by 300 artists/year. Publishes the work of 36 artists/year. Distributes the work of numerous emerging artists/year.

First Contact & Terms Send query letter with digital files, color printouts or slides and résumé. Samples are filed and held for 6 months, then returned. Responds in 3 weeks if uninterested; 6 months if interested. Will contact artist for portfolio review if interested. Pays royalties for prints. Accepts original art on consignment and takes 40% commission. No advance. Buys first rights or reprint rights. Requires exclusive representation of artist. Provides in-transit insurance, promotion, shipping to and from firm, insurance while work is at firm and a written contract.

WINN DEVON ART GROUP

110-6311 Westminster Hwy., Richmond BC V7C 4V4 Canada. (604)276-4551. Fax: (604)276-4552. E-mail: artsubmissions@encoreartgroup.com. Web site: www.winndevon.com. Art publisher. Publishes open and limited editions, offset reproductions, giclées and serigraphs. Clients: mostly trade, designer, decorators, galleries, retail frame shops. Current clients include Pier 1, Z Gallerie, Intercontinental Art, Chamton International, Bombay Co.

Needs Seeking decorative art for the designer market. Considers oil, watercolor, mixed media, pastel, pen & ink and acrylic. Artists represented include Buffet, Lourenco, Jardine, Hall, Goerschner, Lovelace, Bohne, Romeu and Tomao. Editions are created by working from an existing painting. Approached by 300-400 artists/year. Publishes and distributes the work of 0-3 emerging, 3-8 mid-career and 8-10 established artists/year.

First Contact & Terms Send query letter with brochure, slides, photocopies, résumé, photostats, transparencies, tearsheets or photographs. Samples are returned by SASE if requested by artist. Responds in 4-6 weeks. Publisher will contact artist for portfolio review if interested. Portfolio should include "whatever is appropriate to communicate the artist's talents." Payment is based on royalties. Copyright remains with artist. Provides written contract. Finds artists through art exhibitions, agents, sourcebooks, publications, submissions.

Tips Advises artists to attend WCAF Las Vegas and DECOR Expo Atlanta. "I would advise artists to attend just to see what is selling and being shown, but keep in mind that this is not a good time to approach publishers/exhibitors with your artwork."

YOGA LIFE STYLE

(formerly Raymond L. Greenberg Art Publishing), 116 Costa Rd., Highland NY 12528. (845)883-4220. Fax: (845)883-4122. E-mail: info@yogalifestyle.com. Web site: www.yogalifestyle.com. **Owner:** Ray Greenberg. Estab. 1995. Publishes wall decor for the yoga and new age spiritual market.

Needs Art on a spiritual/yoga theme. Artists represented include Nancy Van Kangegan, Kyer Wiltshire and Pieter Weltevrede. Editions are created by collaborating with the artist and/or working from an existing painting. Approached by 10 artists/year. Publishes the work of 1 artist/year.

First Contact & Terms Send query letter with photographs, slides, SASE; "any good, accurate representation of your work." Samples are filed or returned by SASE. Responds in 6 weeks. Will contact artist for portfolio review if interested. Pays flat fee: $50-200; or royalties of 10%. Offers advance against royalties when appropriate. Buys all rights. Prefers exclusive representation. Provides insurance, promotion, contract and shipping from firm. Finds artists through word of mouth.

Tips "Artists who are making things accessible to the market can do well with us."

Advertising, Design & Related Markets

This section offers a glimpse at one of the most lucrative markets for artists. Because of space constraints, the companies listed are just the tip of the proverbial iceberg. There are thousands of advertising agencies and public relations, design and marketing firms across the country and around the world. All rely on freelancers. Look for additional firms in industry directories such as *The Black Book* and *Workbook*. Find local firms in the yellow pages and your city's business-to-business directory. You can also pick up leads by reading *Adweek, HOW, PRINT, STEP inside design, Communication Arts* and other design and marketing publications.

Find your best clients

Read listings carefully to identify firms whose clients and specialties are in line with the type of work you create. (You'll find clients and specialties in the first paragraph of each listing.) For example, if you create charts and graphs, contact firms whose clients include financial institutions. Fashion illustrators should approach firms whose clients include department stores and catalog publishers. Sculptors and modelmakers might find opportunities with firms specializing in exhibition design.

Payment and copyright

You will most likely be paid by the hour for work done on the firm's premises (in-house), and by the project if you take the assignment back to your studio. Most checks are issued 40-60 days after completion of assignments. Fees depend on the client's budget, but most companies are willing to negotiate, taking into consideration the experience of the freelancer, the lead time given, and the complexity of the project. Be prepared to offer an estimate for your services, and ask for a purchase order (P.O.) before you begin an assignment.

Some art directors will ask you to provide a preliminary sketch on speculation or "on spec," which, if approved by the client, can land you a plum assignment. If you are asked to create something "on spec," be aware that you may not receive payment beyond an hourly fee for your time if the project falls through. Be sure to ask upfront about payment policy before you start an assignment.

If you're hoping to retain usage rights to your work, you'll want to discuss this upfront, too. You can generally charge more if the client is requesting a buyout. If research and travel are required, make sure you find out ahead of time who will cover these expenses.

⚑ A.T. ASSOCIATES

63 Old Rutherford Ave., Charlestown MA 02129. (617)242-6004. **Partner:** Annette Tecce. Estab. 1976. Specializes in annual reports, industrial, interior, product and graphic design, model making, corporate identity, signage, display and packaging. Clients: nonprofit companies, high tech, medical, corporate clients, small businesses and ad agencies. Client list available upon request.

Needs Approached by 20-25 freelance artists/year. Works with 3-4 freelance illustrators and 2-3 freelance designers/year. Prefers local artists; some experience necessary. Uses artists for posters, model making, mechanicals, logos, brochures, P-O-P display, charts/graphs and design.

First Contact & Terms Send résumé and nonreturnable samples. Samples are filed or are returned by SASE if requested by artist. Responds only if interested. Call to schedule an appointment to show a portfolio, which should include a "cross section of your work." Pays for design and illustration by the hour or by the project. Rights purchased vary according to project.

THE AD AGENCY

P.O. Box 470572, San Francisco CA 94147. **Creative Director:** Michael Carden. Estab. 1972. Ad agency; full-service multimedia firm. Specializes in print, collateral, magazine ads. Client list available upon request.

Needs Approached by 120 freelancers/year. Works with 120 freelance illustrators and designers/year. Uses freelancers mainly for collateral, magazine ads, print ads; also for brochure, catalog and print ad design and illustration, mechanicals, billboards, posters, TV/film graphics, multimedia, lettering and logos. 60% of freelance work is with print ads. 50% of freelance design and 45% of illustration demand computer skills.

First Contact & Terms Send query letter with brochure, photocopies and SASE. Samples are filed or returned by SASE. Responds in 1 month. Portfolio should include color final art, photostats and photographs. Buys first rights or negotiates rights purchased. Finds artists through word of mouth, referrals and submissions.

Tips "We are an eclectic agency with a variety of artistic needs."

Ⓝ ADVANCED DESIGNS CORPORATION

1169 W. Second St., Bloomington IN 47403. (812)333-1922. Fax: (812)333-2030. Web site: www.d oprad.com. **President:** Matt McGrath. Estab. 1982. AV firm. Specializes in TV news broadcasts. Product specialties are the Doppler Radar and Display Systems.

Needs Prefers freelancers with experience. Works on assignment only. Uses freelancers mainly for TV/film (weather) and cartographic graphics. Needs computer-literate freelancers for production. 100% of freelance work demands skills in ADC Graphics.

First Contact & Terms Send query letter with résumé and SASE. Samples are not filed and are returned by SASE. Pays for design and illustration by the hour, $7 minimum. Will contact artist for portfolio review if interested. Rights purchased vary according to project. Finds artists through classifieds.

⚑ THE ADVERTISING CONSORTIUM

10536 Culver Blvd., Suite D, Culver City CA 90232. (310)287-2222. Fax: (310)287-2227. E-mail: theadco@pacbell.net. **Contact:** Kim Miyade. Estab. 1985. Ad agency; full-service, multimedia firm. Specializes in print, collateral, direct mail, outdoor, broadcast, packaging, PR/Events. Current clients include Bernini, Davante, Westime, Modular Communication Systems, Indulge-A-Bath.

Needs Works with 1 illustrator and 2 art directors/month. Prefers local artists only. Works on assignment only. Uses freelance artists and art directors for everything (none on staff), including brochure, catalog and print ad design and illustration and mechanicals and logos. 80% of work

is with print ads. 100% of freelance work demands knowledge of PageMaker, QuarkXPress, FreeHand, Illustrator and Photoshop.

First Contact & Terms Send postcard sample or query letter with brochure, tearsheets, photocopies, photographs and anything that does not have to be returned. Samples are filed. Write for appointment to show portfolio. "No phone calls, please." Portfolio should include original/final art, b&w and color photostats, tearsheets, photographs, slides and transparencies. Pays for design by the hour, $60-75. Pays for illustration by the project, based on budget and scope.

Tips Looks for "exceptional style."

ADVERTISING DESIGNERS, INC.

7087 Snyder Ridge Rd., Mariposa CA 95338-9029. (209)742-6704. E-mail: ad@yosemite.net. **President:** Tom Ohmer. Estab. 1947. Number of employees: 2. Specializes in annual reports, corporate identity, ad campaigns, package and publication design and signage. Clients: corporations.

First Contact & Terms Send query letter with postcard sample. Samples are filed. Does not reply. Artist should call. Write for appointment to show portfolio.

⚓ AM/PM ADVERTISING, INC.

345 Claremont Ave., Suite 26, Montclair NJ 07402. (973)824-8600. Fax: (973)824-6631. E-mail: mpt4220@aol.com. **President:** Robert Saks. Estab. 1962. Number of employees: 130. Approximate annual billing: $24 million. Ad agency; full-service multimedia firm. Specializes in national TV commercials and print ads. Product specialties are health and beauty aids. Current clients include J&J, Bristol Myers, Colgate Palmolive. Client list available upon request. Professional affiliations: AIGA, Art Directors Club, Illustration Club.

Needs Approached by 35 freelancers/year. Works with 3 freelance illustrators and designers/month. Prefers to work with local freelancers with experience in animation, computer graphics, film/video production, multimedia, Macintosh. Works only with artists' reps. Works on assignment only. Uses freelancers mainly for illustration and design; also for brochure design and illustration, storyboards, slide illustration, animation, technical illustration, TV/film graphics, lettering and logos. 30% of work is with print ads. 50% of work demands knowledge of PageMaker, QuarkXPress, FreeHand, Illustrator or Photoshop.

First Contact & Terms Send postcard sample and/or query letter with brochure, résumé and photocopies. Samples are filed or returned. Responds in 10 days. Portfolios may be dropped off every Friday. Artist should follow up after initial query. Portfolio should include b&w and color thumbnails, roughs, final art, tearsheets, photographs and transparencies. Pays by the hour, $35-100; by the project, $300-5,000; or royalties, 25%. Rights purchased vary according to project.

Tips "When showing work, give time it took to do job and costs."

ANDERSON STUDIO, INC.

2609 Grissom Dr., Nashville TN 37204. (615)255-4807. Fax: (615)255-4812. **Contact:** Andy Anderson. Estab. 1976. Specializes in T-shirts (designing and printing of art on T-shirts for retail/wholesale promotional market). Clients: business, corporate retail, gift and specialty stores.

Needs Approached by 20 freelancers/year. Works with 1-2 freelance illustrators and 1-2 designers/year. "We use freelancers with realistic (photorealistic) style. Works on assignment only. We need artists for automotive-themed art; also motorcycle designs as seen in the current line of shirts produced for Orange County Choppers of the Discovery Channel. We're also in need of Hot Rod art and designs for T-shirts along with graphic work and logo designs of the same."

First Contact & Terms Send postcard sample or query letter with color copies, brochure, photocopies, photographs, SASE, slides, tearsheets and transparencies. Samples are filed and are returned by SASE if requested by artist. Portfolio should include slides, color tearsheets, transparencies and color copies. Sometimes requests work on spec before assigning a job. Pays for design

and illustration by the project, $300-1,000; or in royalties per piece of printed art. Negotiates rights purchased. Considers buying second rights (reprint rights) to previously published work. **Tips** "Be flexible in financial/working arrangements. Most work is on a commission or flat buyout. We work on a tight budget until product is sold. Art-wise, the more professional the better." Advises freelancers entering the field to "show as much work as you can. Even comps or ideas for problem solving. Let art directors see how you think. Don't send disks—they take too long to review. Most art directors like hard copy art."

ASHCRAFT DESIGN

821 N. Nash St., El Segundo CA 90245. (310)640-8330. Fax: (310)640-8333. E-mail: information@ ashcraftdesign.com. Web site: www.ashcraftdesign.com. Estab. 1986. Specializes in corporate identity, display and package design and signage. Client list available upon request.

Needs Approached by 2 freelance artists/year. Works with 1 freelance illustrator and 2 freelance designers/year. Works on assignment only. Uses freelance illustrators mainly for technical illustration. Uses freelance designers mainly for packaging and production. Also uses freelance artists for mechanicals and model making.

First Contact & Terms Send query letter with tearsheets, résumé and photographs. Samples are filed and are not returned. Responds only if interested. To show a portfolio, e-mail samples or mail color copies. Pays for design and illustration by the project. Rights purchased vary according to project.

ASHER AGENCY

535 W. Wayne St., Fort Wayne IN 46802. (260)424-3373. Fax: (260)424-0848. E-mail: webelieve@ asheragency.com. Web site: www.asheragency.com. **Creative Director:** Matt Georgi. Estab. 1974. Approximate annual billing: $12 million. Full service ad agency and PR firm. Clients: automotive firms, financial/investment firms, area economic development agencies, health care providers, fast food companies, gaming companies and industrial.

Needs Works with 5-10 freelance artists/year. Assigns 25-50 freelance jobs/year. Prefers local artists. Works on assignment only. Uses freelance artists mainly for illustration; also for design, brochures, catalogs, consumer and trade magazines, retouching, billboards, posters, direct mail packages, logos and advertisements.

First Contact & Terms Send query letter with brochure showing art style or tearsheets and photocopies. Samples are filed or are returned by SASE. Responds only if interested. Will contact artist for portfolio review if interested. Portfolio should include roughs, original/final art, tearsheets and final reproduction/product. Pays for design by the hour, $40 minimum. Pays for illustration by the project, $40 minimum. Finds artists usually through word of mouth.

AURELIO & FRIENDS, INC.

14971 SW 43 Terrace, Miami FL 33185. (305)225-2434. Fax: (305)225-2121. E-mail: aurelio97@ao l.com. **President:** Aurelio Sica. Vice President: Nancy Sica. Estab. 1973. Number of employees: 3. Specializes in corporate advertising and graphic design. Clients: corporations, retailers, large companies, hotels and resorts.

Needs Approached by 4-5 freelancers/year. Works with 1-2 freelance illustrators and 3-5 designers/year. Uses freelancers for ad design and illustration, brochure, catalog and direct mail design, and mechanicals. 50% of freelance work demands knowledge of Adobe Ilustrator, Photoshop and QuarkXPress.

First Contact & Terms Send brochure and tearsheets. Samples are filed. Will contact artist for portfolio review if interested. Portfolio should include b&w and color final art, photographs, roughs and transparencies. Pays for design and illustration by the project. Buys all rights.

AVANCÉ DESIGNS, INC.

1775 Broadway, Suite 720, New York NY 10019. (212)380-1827. E-mail: info@avance-designs.c om. Web site: www.avance-designs.com. Estab. 1986. Specializes in visual communications. ''We maintain our role by managing multiple design disciplines from print and information design, to Web site design and interactive media.'' Clients include The DMC Corporation, Solar FX and Wedding.com.

Needs Seeking designers and Web designers strong in Photoshop, Illustrator; programmers in PHC, ASP, DHTML, Java-Script and Java.

First Contact & Terms Send query letter. Samples of interest are filed and are not returned. Responds only if interested.

BACKBEAT ADVERTISING

428 Fore St., Portland ME 04101. (207)775-5100, ext. 125. Fax: (207)775-5147. E-mail: info@back beatadvertising.com. Web site: www.backbeatadvertising.com. **Creative Director:** Frank Laurino. Production Manager: Dana Williams. Estab. 1985. Number of employees: 6. Full-service ad agency.

Needs Works with freelancers for illustration, occasionally for design.

First Contact & Terms Send samples for review. Accepts work via disk in Mac-compatible formats only. Samples are filed. Responds only if interested. Pays for design by the hour or by the project; pays for illustration by the project.

THE BAILEY GROUP, INC.

200 W. Germantown Pike, Plymouth Meeting PA 19462. (610)940-9030. Web site: www.baileygp. com. **Creative Director:** David Fiedler. Estab. 1985. Number of employees: 38. Specializes in package design, brand and corporate identity, sales promotion materials, corporate communications and signage systems. Clients: corporations (food, drug, health and beauty aids). Current clients include Aetna, Johnson & Johnson Consumer Products Co., Wills Eye Hospital and Welch's. Professional affiliations: AIGA, PDC, APP, AMA, ADC.

Needs Approached by 10 freelancers/year. Works with 3-6 freelance illustrators and 3-6 designers/year. Uses illustrators mainly for editorial, technical and medical illustration and final art, charts and airbrushing. Uses designers mainly for freelance production (*not* design), or computer only. Also uses freelancers for mechanicals, brochure and catalog design and illustration, P-O-P illustration and model-making.

First Contact & Terms Send query letter with brochure, résumé, tearsheets and photographs. Samples are filed. Responds only if interested. Will contact for portfolio review if interested. Portfolio should include finished art samples, color tearsheets, transparencies and artist's choice of other materials. May pay for illustration by the hour, $10-15; by the project, $300-3,000. Rights purchased vary according to project.

Tips Finds artists through word of mouth, self-promotions and sourcebooks.

AUGUSTUS BARNETT ADVERTISING/DESIGN

P.O. Box 197, Fox Island WA 98333. (253)549-2396. Fax: (253)549-4707. E-mail: charlieb@august usbarnett.com. Web site: www.augustusbarnett.com. **President/Creative Director:** Charlie Barnett. Estab. 1981. Approximate annual billing: $1.2 million. Specializes in food/beverage, financial, agricultural, corporate identity, package design. Clients: corporations, manufacturers. Current clients include Tree Top, Inc.; Nunhems USA; VOLTA. Client list available upon request.

Needs Approached by more than 50 freelancers/year. Works with 2-4 freelance illustrators and 2-3 designers/year. Prefers freelancers with experience. Works as consultant, on assignment and retainer.

First Contact & Terms Send query letter with samples, résumé and photocopies. Samples are

filed. Responds in 1 month. Pays for design by the hour, negotiable. Pays for illustration by project/use and buyouts. Rights purchased vary according to project.

⚒ BARNSTORM VISUAL COMMUNICATIONS, INC.

530 E. Colorado Ave., Colorado Springs CO 80903. (719)630-7200. Fax: (719)630-3280. Web site: www.barnstormcreative.biz. **Owner:** Becky Houston. Estab. 1975. Specializes in corporate identity, brochure design, publications, Web design and Internet marketing. Clients: high-tech corporations, nonprofit fundraising, business-to-business and restaurants. Current clients include Liberty Wire and Cable, Colorado Springs Visitors Bureau and Billiard Congress of America.

Needs Works with 2-4 freelance artists/year. Prefers local, experienced (clean, fast and accurate) artists with experience in TV/film graphics and multimedia. Works on assignment only. Uses freelancers mainly for editorial and technical illustration and production. Needs computer-literate freelancers for production. 90% of freelance work demands knowledge of Illustrator, QuarkX-Press, Photoshop, Macromedia FreeHand, InDesign and Flash.

First Contact & Terms Send query letter with résumé and samples to be kept on file. Prefers "good originals or reproductions, professionally presented in any form" as samples. Samples not filed are returned by SASE. Responds only if interested. Call or write for appointment to show portfolio. Pays for design by the hour, $15-40. Pays for illustration by the project, $500 minimum for b&w. Considers client's budget, skill and experience of artist, and turnaround time when establishing payment.

Tips "Portfolios should reflect an awareness of current trends. We try to handle as much inhouse as we can, but we recognize our own limitations (particularly in illustration). Do not include too many samples in your portfolio."

BASIC/BEDELL ADVERTISING & PUBLISHING

P. O. Box 6068, Ventura CA 93006. (805)650-1565. E-mail: barriebedell@earthlink.net. **President:** Barrie Bedell. Specializes in advertisements, direct mail, how-to books, direct response Web sites and manuals. Clients: publishers, direct response marketers, retail stores, software developers, Web entrepreneurs, plus extensive self-promotion of proprietary advertising how-to manuals.

 • This company's president is seeing "a glut of 'graphic designers,' and an acute shortage of 'direct response' designers."

Needs Uses artists for publication and direct mail design, book covers and dust jackets, and direct response Web sites. Especially interested in hearing from professionals experienced in e-commerce and in converting printed training materials to electronic media, as well as designers of direct response Web sites.

First Contact & Terms Portfolio review not required. Pays for design by the project, $100-2,500 and up, and/or royalties based on sales.

Tips "There has been a substantial increase in use of freelance talent and increasing need for true professionals with exceptional skills and responsible performance (delivery as promised and 'on target'). It is very difficult to locate freelance talent with expertise in design of advertising, advertising, direct mail and Web sites with heavy use of type. E-mail query with Web site link/URL or contact with personal letter and photocopy of one or more samples of work that needn't be returned."

THE BASS GROUP

Dept. AM, 102 Willow Ave., Fairfax CA 94930. (415)455-8090. **Producer:** Herbert Bass. Number of employees: 2. Approximate annual billing: $300,000. "A multimedia, full-service production company providing corporate communications to a wide range of clients. Specializes in video and special events productions."

Needs Approached by 30 freelancers/year. Works with a variety of freelance illustrators and

designers/year. Prefers solid experience in multimedia and film/video production. Works on assignment only. Uses freelancers for logos, charts/graphs and multimedia designs. Needs graphics, meeting theme logos, electronic speaker support and slide design. Needs computer-literate freelancers for design, illustration and production. 90% of freelance work demands skills in QuarkXPress, FreeHand, Illustrator and Photoshop.

First Contact & Terms Send résumé and slides. Samples are filed and are not returned. Responds in 1 month if interested. Will contact artist for portfolio review if interested. Sometimes requests work on spec before assigning a job. Pays by the project. Considers turnaround time, skill and experience of artist, and how work will be used when establishing payment. Rights purchased vary according to project. Finds illustrators and designers mainly through word of mouth recommendations.

Tips "Send résumé, samples, rates. Highlight examples in speaker support—both slide and electronic media—and include meeting logo design."

BBDO NEW YORK

1285 Avenue of the Americas, New York NY 10019. (212)459-5000. Fax: (212)459-6645. E-mail: mark.goldstein@bbdo.com. Web site: www.bbdo.com. Estab. 1891. Number of employees: 850. Annual billing: $50,000,000. Ad agency; full-service multimedia firm. Specializes in business, consumer advertising, sports marketing and brand development. Clients include Texaco, Frito Lay, Bayer, Campbell Soup, FedEx, Pepsi, Visa and Pizza Hut.

● BBDO Art Director told our editors he is always open to new ideas and maintains an open drop-off policy. If you call and arrange to drop off your portfolio, he'll review it, and you can pick it up in a couple days.

![] BEDA DESIGN

38663 Thorndale Place, Lake Villa IL 60046. Phone/fax (847)245-8939. **President:** Lynn Beda. Estab. 1971. Number of employees: 2-3. Approximate annual billing: $250,000. Design firm. Specializes in packaging, publishing, film and video documentaries. Current clients include business-to-business accounts, producers to writers, directors and artists.

Needs Approached by 6-12 illustrators and 6-12 designers/year. Works with 6 illustrators and 6 designers/year. Prefers local freelancers. Uses freelancers for retouching, technical illustration and production. 50% of work is with print ads. 75% of design demands skills in Photoshop, QuarkXPress, Illustrator, Premiere, Go Live.

First Contact & Terms Designers: Send query letter with brochure, photocopies and résumé. Illustrators: Send postcard samples and/or photocopies. Samples are filed and are not returned. Will contact for portfolio review if interested. Payments are negotiable. Buys all rights. Finds artists through word of mouth.

BELYEA

1809 Seventh Ave., Suite 1250, Seattle WA 98101. (206)682-4895. Fax: (206)623-8912. Web site: www.belyea.com. Estab. 1988. Design firm. Specializes in brand and corporate identity, marketing collateral, in-store P-O-P, direct mail, packages and publication design. Clients: corporate, manufacturers, retail. Current clients include PEMCO Insurance, Genie Industries, and Weyerhaeuser. Client list available upon request.

Needs Approached by 20-30 freelancers/year. Works with 3 freelance illustrators/photographers and no designers/year. Works on assignment only. Uses illustrators for "any type of project." 100% of design and 70% of illustration demands skills in Adobe CS.

First Contact & Terms Send postcard sample and résumé. Samples are filed. Responds only if interested. Pays for illustration by the project. Rights purchased vary according to project. Finds artists through submissions by mail and referrals by other professionals.

Tips ''Designers must be computer-skilled. Illustrators must develop some styles that make them unique in the marketplace. When pursuing potential clients, send something (one or more) distinctive. Follow up. Be persistent (it can take one or two years to get noticed) but not pesky. Always do the best work you can—exceed everyone's expectations.''

BERSON, DEAN, STEVENS

P.O. Box 3997, Thousand Oaks CA 91359. (818)713-0134. Fax: (818)713-0417. E-mail: info@bersondeanstevens.com. Web site: www.bersondeanstevens.com. **Owner:** Lori Berson. Estab. 1981. Specializes in annual reports, brand and corporate identity, collateral, direct mail, trade show booths, promotions, Web sites, packaging, and publication design. Clients: manufacturers, professional and financial service firms, ad agencies, corporations and movie studios. Professional affiliation: L.A. Ad Club.

Needs Approached by 50 freelancers/year. Works with 10-20 illustrators and 10 designers/year. Works on assignment only. Uses illustrators mainly for brochures, packaging, and comps; also for catalog, P-O-P, ad and poster illustration, mechanicals retouching, airbrushing, lettering, logos and model-making. 90% of freelance work demands skills in Illustrator, QuarkXPress, Photoshop, as well as Dreamweaver, Flash/HTML, CGI, Java, etc.

First Contact & Terms Send query letter with tearsheets and photocopies. Samples are filed. Will contact artist for portfolio review if interested. Pays for design and illustration by the project. Rights purchased vary according to project. Considers buying second rights (reprint rights) to previously published work. Finds artists through word of mouth, submissions/self-promotions, sourcebooks and agents.

BFL MARKETING COMMUNICATIONS

2000 Sycamore St., 4th Floor, Cleveland OH 44113. (216)875-8860. Fax: (216)875-8870. E-mail: dpavan@bflcom.com. Web site: www.bflcom.com. **President:** Dennis Pavan. Estab. 1955. Number of employees: 12. Approximate annual billing: $6.5 million. Marketing communications firm; full-service multimedia firm. Specializes in new product marketing, Web site design, interactive media. Product specialty is consumer home products. Client list available upon request. Professional affiliations: North American Advertising Agency Network, BPAA.

Needs Approached by 20 freelancers/year. Works with 5 freelance illustrators and 5 designers/year. Prefers freelancers with experience in advertising design. Uses freelancers mainly for graphic design, illustration; also for brochure and catalog design and illustration, lettering, logos, model making, posters, retouching, TV/film graphics. 80% of work is with print ads. Needs computer-literate freelancers for design, illustration, production and presentation. 50% of freelance work demands knowledge of FreeHand, Photoshop, QuarkXPress, Illustrator.

First Contact & Terms Send postcard-size sample of work or send query letter with brochure, photostats, tearsheets, photocopies, résumé, slides and photographs. Samples are filed or returned by SASE. Responds in 2 weeks. Artist should follow up with call and/or letter after initial query. Will contact artist for portfolio review if interested. Portfolio should include b&w and color final art, photographs, photostats, roughs, slides and thumbnails. Pays by the project, $200 minimum.

Tips Finds artists through *Creative Black Book, Illustration Annual, Communication Arts*, local interviews. ''Seeking specialist in Internet design, CD-ROM computer presentations and interactive media.''

BIGGS-GILMORE

261 E. Kalamazoo Ave., Suite 300, Kalamazoo MI 49007-3990. (269)349-7711. Fax: (269)349-9657. E-mail: mpuhalj@biggs-gilmore.com. Web site: www.biggs-gilmore.com. **Creative Director:** Marino Puhalj. Estab. 1973. Ad agency; full-service multimedia firm. Specializes in traditional

advertising (print, collateral, TV, radio, outdoor), branding, strategic planning, e-business development, and media planning and buying. Product specialties are consumer, business-to-business, marine and healthcare. Clients include Morningstar Farms, Pfizer, Kellogg Company, Zimmer, Beaner's Coffee, United Way.

Needs Approached by 10 artists/month. Works with 1-3 illustrators and designers/month. Works both with artist reps and directly with artist. Prefers artists with experience with client needs. Works on assignment only. Uses freelancers mainly for completion of projects needing specialties; also for brochure, catalog and print ad design and illustration, storyboards, mechanicals, retouching, billboards, posters, TV/film graphics, lettering and logos.

First Contact & Terms Send query letter with brochure, photocopies and résumé. Samples are filed. Responds only if interested. Call for appointment to show portfolio. Portfolio should include all samples the artist considers appropriate. Pays for design and illustration by the hour and by the project. Rights purchased vary according to project.

SAM BLATE ASSOCIATES LLC

10331 Watkins Mill Dr., Montgomery Village MD 20886-3950. (301)840-2248. Fax: (301)990-0707. E-mail: info@writephotopro.com. Web site: www.writephotopro.com. **President:** Sam Blate. Number of employees: 2. Approximate annual billing: $120,000. AV and editorial services firm. Clients: business/professional, U.S. government, private.

Needs Approached by 6-10 freelancers/year. Works with 1-5 freelance illustrators and 1-2 designers/year. Prefers to work with freelancers in the Washington, DC, metropolitan area. Works on assignment only. Uses freelancers for cartoons (especially for certain types of audiovisual presentations), editorial and technical illustrations (graphs, etc.), 35mm and digital slides, pamphlet and book design. Especially important are "technical and aesthetic excellence and ability to meet deadlines." 80% of freelance work demands knowledge of PageMaker, Photoshop, and/or Powerpoint for Windows.

First Contact & Terms Send query letter with résumé and Web site, tearsheets, brochure, photocopies, slides, transparencies or photographs to be kept on file. Accepts disk submissions compatible with Photoshop and PageMaker; IBM format only. "No original art." Samples are returned only by SASE. Responds only if interested. Pays by the hour, $20-50. Rights purchased vary according to project, "but we prefer to purchase first rights only. This is sometimes not possible due to client demand, in which case we attempt to negotiate a financial adjustment for the artist."

Tips "The demand for technically-oriented artwork has increased."

BLOCK & DECORSO

3 Clairidge Dr., Verona NJ 07044. (973)857-3900. Fax: (973)857-4041. E-mail: kdeluca@blockdec orso.com. Web site: www.blockdecorso.com. **Senior VP/Creative Director:** Karen DeLuca. Senior Art Director: Jay Baumann. Studio Manager: John Murray. Art Director: Marguerite Nastasi. Estab. 1939. Number of employees: 25. Approximate annual billing: $12 million. Product specialties are food and beverage, education, finance, home fashion, giftware, healthcare and industrial manufacturing. Professional affiliations: Ad Club of North Jersey.

Needs Approached by 100 freelancers/year. Works with 25 freelance illustrators and 25 designers/year. Prefers to work with "freelancers with at least 3-5 years experience as Mac-compatible artists and 'on premises' work as Mac artists." Uses freelancers for "consumer friendly" technical illustration, layout, lettering, mechanicals and retouching for ads, annual reports, billboards, catalogs, letterhead, brochures and corporate identity. Needs computer-literate freelancers for design and presentation. 90% of freelance work demands knowledge of QuarkXPress, Illustrator, Type-Styler and Photoshop.

First Contact & Terms To show portfolio, mail appropriate samples and follow up with a phone

call. E-mail résumé and samples of work, or mail the same. Responds in 2 weeks. Pays for design by the hour, $20-60. Pays for illustration by the project, $250-5,000 or more.

Tips "We are fortunately busy—we use four to six freelancers daily. Be familiar with the latest versions of QuarkXpress, Illustrator and Photoshop. We like to see sketches of the first round of ideas. Make yourself available occasionally to work on premises. Be flexible in usage rights!"

BOB BOEBERITZ DESIGN

247 Charlotte St., Asheville NC 28801. (828)258-0316. E-mail: bobb@main.nc.us. Web site: www .bobboeberitzdesign.com. **Owner:** Bob Boeberitz. Estab. 1984. Number of employees: 1. Approximate annual billing: $80,000. Specializes in graphic design, corporate identity and package design. Clients: retail outlets, hotels and restaurants, dot com companies, record companies, publishers, professional services. Majority of clients are business-to-business. Current clients include Para Research Software, SalesVantage.com, AvL Technologies, Southern Appalachian Repertory Theatre, Billy Edd Wheeler (Songwriter/Playwright), Shelby Stephenson (poet), and High Windy Audio. Professional affiliations: AAF, NARAS, Asheville Freelance Network, Asheville Creative Services Group, Public Relations Association of WNC.

Needs Approached by 50 freelancers/year. Works with 2 freelance illustrators/year. Works on assignment only. Uses freelancers primarily for technical illustration and comps. Prefers pen & ink, airbrush and acrylic. 50% of freelance work demands knowledge of PageMaker, Illustrator, Photoshop or CorelDraw.

First Contact & Terms Send query letter with résumé, brochure, SASE, photographs, slides and tearsheets. "Anything too large to fit in file" is discarded. Accepts disk submissions compatible with IBM PCs. Send EPS, PDF, JPEG, GIF, HTML and TIFF files. Samples are returned by SASE if requested. Responds only if interested. Will contact artist for portfolio review if interested. Portfolio should include thumbnails, roughs, final art, b&w and color slides and photographs. Sometimes requests work on spec before assigning a job. Pays for design and illustration by the project, $50 minimum. Rights purchased vary according to project. Will consider buying second rights to previously published artwork. Finds artists through word of mouth, submissions/self-promotions, sourcebooks, agents.

Tips "Show sketches. Sketches help indicate how an artist thinks. The most common mistake freelancers make in presenting samples or portfolios is not showing how the concept was developed, what their role was in it. I always see the final solution, but never what went into it. In illustration, show both the art and how it was used. Portfolios should be neat, clean and flattering to your work. Show only the most memorable work, what you do best. Always have other stuff, but don't show everything. Be brief. Don't just toss a portfolio on my desk; guide me through it. A 'leave-behind' is helpful, along with a distinctive-looking résumé. Be persistent but polite. Call frequently. I don't recommend cold calls (you rarely ever get to see anyone), but it is an opportunity for a 'leave behind.' I recommend using the mail. E-mail is okay, but it isn't saved. Asking people to print out your samples to save in a file is asking too much. I like postcards. They get noticed, maybe even kept. They're economical. And they show off your work. And you can do them more frequently. Plus you'll have a better chance to get an appointment. After you've had an appointment, send a thank you note. Say you'll keep in touch and do it!"

BOOKMAKERS LTD.

P.O. Box 1086, Taos NM 87571. (505)776-5435. Fax: (505)776-2762. E-mail: gayle@bookmakerslt d.com. Web site: www.bookmakersltd.com. **President:** Gayle McNeil. Estab. 1975. Full-service design and production studio. "We provide design and production services to the publishing industry. We also represent a group of the best children's book illustrators in the business. We welcome authors who are interested in self-publishing."

- This company is also listed in the Artists' Reps section.

First Contact & Terms Send query letter with samples. Include SASE if samples need to be returned. E-mail inquiries preferred.

Tips The most common mistake illustrators make in presenting samples or portfolios is "too much variety, not enough focus."

BOXER DESIGN

548 State St., Brooklyn NY 11216-1619. (718)802-9212. Fax: (718)802-9213. E-mail: eileen@boxer design.com. Web site: www.boxerdesign.com. **Contact:** Eileen Boxer. Estab. 1986. Approximate annual billing: $250,000. Design firm. Specializes in books and catalogs for art institutions; announcements and conceptual design primarily, but not exclusively, for cultural institutions. Current clients include Ubu Gallery, Guggenheim Museum, The American Federation of Arts, The Menil Collection, Dallas Museum of Fine Arts.

- This firm received AIGA Awards of Excellence in 1997 (*Graphic Design USA 18*) and 2005 (*AIGA Year in Design 26*).

Needs Design work demands intelligent and mature approach to design; knowledge of Photoshop, Illustrator, QuarkXPress, InDesign.

First Contact & Terms Send e-mail with written and visual credentials. Accepts disk submissions compatible with Adobe PDFs, InDesign, Photoshop, Illustrator—all Mac. Responds in 3 weeks if interested. Artist should follow up with call after initial query. Pays by the project. Rights purchased vary according to project.

BOYDEN & YOUNGBLUTT ADVERTISING & MARKETING

120 W. Superior St., Fort Wayne IN 46802. (260)422-4499. Fax: (260)422-4044. E-mail: info@b-y.net. Web site: www.b-y.net. **Vice President:** Jerry Youngblutt. Estab. 1990. Number of employees: 24. Ad agency; full-service, multimedia firm. Specializes in magazine ads, collateral, Web, media, television.

Needs Approached by 10 freelancers/year. Works with 3-4 freelance illustrators and 5-6 designers/year. Uses freelancers mainly for collateral layout and Web; also for annual reports, billboards, brochure design and illustration, logos and model-making. 25% of work is with print ads, 25% Web, 25% media, and 25% TV. Needs computer-literate freelancers for design. 100% of freelance work demands knowledge of FreeHand, Photoshop, Adobe Ilustrator, Web Weaver and InDesign.

First Contact & Terms Send query letter with photostats and résumé. Samples are filed. Will contact artist for portfolio review if interested. Portfolio should include b&w and color final art. Pays for design and illustration by the project. Buys all rights.

Tips Finds artists through sourcebooks, word of mouth and submissions. "Send a precise résumé with what you feel are your 'best' samples—less is more."

BRAGAW PUBLIC RELATIONS SERVICES

800 E. Northwest Hwy., Palatine IL 60074. (847)934-5580. Fax: (847)934-5596. E-mail: info@brag awpr.com. Web site: www.bragawpr.com. **President:** Richard S. Bragaw. Number of employees: 3. PR firm. Specializes in newsletters and brochures. Clients: professional service firms, associations, public agencies and industry. Current clients available on Web site.

Needs Approached by 12 freelancers/year. Works with 2 freelance illustrators and 2 designers/year. Prefers local freelancers only. Works on assignment only. Uses freelancers for direct mail packages, newsletters, brochures, signage, AV presentations and press releases. 90% of freelance work demands knowledge of PageMaker. Needs editorial and medical illustration.

First Contact & Terms E-mail query with Web site link, or mail query. Send query letter with brochure to be kept on file. Responds only if interested. Pays by the hour, $25-75 average.

Considers complexity of project, skill and experience of artist, and turnaround time when establishing payment. Buys all rights.

Tips "We do not spend much time with portfolios."

BRAINWORKS DESIGN GROUP, INC.
5 Harris Court, Building T, Monterey CA 93940. (831)657-0650. Fax: (831)657-0750. E-mail: mail@brainwks.com. Web site: www.brainwks.com. **President:** Alfred Kahn. Marketing Director: Christina Buckman. Estab. 1970. Number of employees: 8. Specializes in ERC (Emotional Response Communications), graphic design, corporate identity, direct mail and publication. Clients: colleges, universities, nonprofit organizations; majority are colleges and universities. Current clients include City College of New York, Manhattanville, University of South Carolina-Spartanburg, Queens College, Manhattan College, Nova University, American International College, Teachers College Columbia, University of Rochester.

Needs Approached by 100 freelancers/year. Works with 4 freelance illustrators and 10 designers/year. Prefers freelancers with experience in type, layout, grids, mechanicals, comps and creative visual thinking. Works on assignment only. Uses freelancers mainly for mechanicals and calligraphy; also for brochure, direct mail and poster design; mechanicals; lettering; and logos. 100% of design work demands knowledge of QuarkXPress, Illustrator, Photoshop and InDesign.

First Contact & Terms Send brochure or résumé, photocopies, photographs, tearsheets and transparencies. Samples are filed. Artist should follow up with call and/or letter after initial query. Will contact artist for portfolio review if interested. Portfolio should include thumbnails, roughs, final reproduction/product and b&w and color tearsheets, photostats, photographs and transparencies. Pays for design by the project, $200-2,000. Considers complexity of project and client's budget when establishing payment. Rights purchased vary according to project. Finds artists through sourcebooks and self-promotions.

Tips "Creative thinking and a positive attitude are a plus." The most common mistake freelancers make in presenting samples or portfolios is that the "work does not match up to the samples they show." Would like to see more roughs and thumbnails.

BRANDLOGIC
15 River Rd., Wilton CT 06897-4080. (203)834-0087. E-mail: klh@brandlogic.com. Web site: www.brandlogic.com. **Assistant Creative Director:** Karen Lukas-Hardy. Specializes in annual reports, corporate brand identity, Web site design, publications. Current clients include IBM, Siemens, Texaco, Wyeth.

Needs Works with 30 artists/year. Works on assignment only. Uses artists for editorial illustration. Needs computer-literate freelancers for illustration. 30% of freelance work demands knowledge of Illustrator.

First Contact & Terms "*No* phone calls!" Send query letter with tearsheets, slides, photostats or photocopies. Samples not kept on file are returned by SASE only. Responds only if interested. Pays for illustration by the project, $300-3,500 average. Considers client's budget, skill and experience of artist, and how work will be used when establishing payment.

LEO J. BRENNAN, INC.
2359 Livernois, Troy MI 48083-1692. (248)362-3131. Fax: (248)362-2355. E-mail: lbrennan@ljbrennan.com. Web site: www.ljbrennan.com. **President:** Leo Brennan. Estab. 1969. Number of employees: 3. Ad, PR and marketing firm. Clients: industrial, electronics, robotics, automotive, chemical, tooling, B2B.

Needs Works with 2 illustrators and 2 designers/year. Prefers experienced artists. Uses freelancers for design, technical illustration, brochures, catalogs, retouching, lettering, keylining and typesetting; also for multimedia projects. 50% of work is with print ads. 100% of freelance work demands knowledge of IBM software graphics programs.

First Contact & Terms Send query letter with résumé and samples. Samples not filed are returned only if requested. Responds only if interested. Call for appointment to show portfolio of thumbnails, roughs, original/final art, final reproduction/product, color and b&w tearsheets, photostats and photographs. Payment for design and illustration varies. Buys all rights.

ℕ BRIGHT IDEAS

A.W. Peller and Associates, Inc., 116 Washington Ave., Hawthorne NJ 07507. (800)451-7450. Fax: (973)423-5569. E-mail: awpeller@optonline.net. Web site: www.awpeller.com. **Art Director:** Karen Birchak. Estab. 1973. Number of employees: 12. AV producer. Serves clients in education. Produces children's educational materials—videos, sound filmstrips, read-along books, cassettes and CD-ROMs.

Needs Works with 1-2 freelance illustrators/year. "While not a requirement, a freelancer living in the same geographic area is a plus." Works on assignment only, "although if someone had a project already put together, we would consider it." Uses freelancers mainly for illustrating children's books; also for artwork for filmstrips, sketches for books and layout work. 50% of freelance work demands knowledge of QuarkXPress and Photoshop.

First Contact & Terms Send query letter with résumé, tearsheets, SASE, photocopies and photographs. Will contact artist for portfolio review if interested. "Include child-oriented drawings in your portfolio." Requests work on spec before assigning a job. Pays for design and illustration by the project, $20 minimum. Buys all rights. Finds artists through submissions.

BRIGHT LIGHT PRODUCTIONS, INC.

602 Main St., Suite 810, Cincinnati OH 45202. (513)721-2574. Fax: (513)721-3329. E:mail: info@brightlightusa.com. Web site: www.brightlightusa.com. **Contact:** Ken Sharp. Estab. 1976. "We are a full-service film/video communications firm producing TV commercials and corporate communications."

Needs Works on assignment only. Uses artists for editorial, technical and medical illustration and brochure and print ad design, storyboards, slide illustration, animatics, animation, TV/film graphics and logos. Needs computer-literate freelancers for design and production. 50% of freelance work demands knowledge of Photoshop, Illustrator and After Effects.

First Contact & Terms Send query letter with brochure and résumé. Samples not filed are returned by SASE only if requested by artist. Request portfolio review in original query. Portfolio should include roughs and photographs. Pays for design and illustration by the project. Negotiates rights purchased. Finds artists through recommendations.

Tips "Our need for freelance artists is growing."

🌐 BROMLEY COMMUNICATIONS

401 E. Houston St., San Antonio TX 78205. (210)244-2000. Fax: (210)244-2442. E-mail: info@bromcomm.com. Web site: www.bromleyville.com. **Chief Creative Officer:** Cat Lopez. Number of employees: 80. Approximate annual billing: $80 million. Estab. 1986. Full-service, multimedia ad agency and PR firm. Specializes in TV, radio and magazine ads, etc. Specializes in consumer service firms and Hispanic markets. Current clients include BellSouth, Burger King, Circuit City, Continental Airlines, Nestlé, Procter & Gamble.

Needs Approached by 3 artists/month. Prefers local artists only. Works on assignment only. Uses freelancers for storyboards, slide illustration, new business presentations and TV/film graphics and logos. 35% of work is with print ads. 25% of freelance work demands knowledge of PageMaker, QuarkXPress and Illustrator.

First Contact & Terms Send query letter with brochure and résumé. Samples are not filed and are returned by SASE only if requested by artist. Responds only if interested. Write for appointment to show portfolio.

BROWNING ADVERTISING

1 Browning Place, Morgan UT 84050. (801)876-2711. Fax: (801)876-3331. Web site: www.browning.com. **Contact:** Senior Art Director. Estab. 1878. Distributor and marketer of outdoor sports products, particularly firearms. Inhouse agency for 3 main clients. Inhouse divisions include non-gun hunting products, firearms and accessories.

Needs Approached by 50 freelancers/year. View Web site for any upcoming freelance opportunites. Prefers freelancers with experience in outdoor sportshunting, shooting, fishing. Works on assignment only. Uses freelancers occasionally for design, illustration and production; also for advertising and brochure layout, catalogs, product rendering and design, signage, P-O-P displays, and posters.

First Contact & Terms Send query letter with résumé and tearsheets, slides, photographs and transparencies. Samples are not filed and are not returned. Responds only if interested. To show portfolio, mail photostats, slides, tearsheets, transparencies and photographs. Pays for design by the hour, $50-75. Pays for illustration by the project. Buys all rights or reprint rights.

BRYANT, LAHEY & BARNES ADVERTISING & MARKETING

5300 Foxridge Dr., Mission KS 66202. (913)262-7075. Fax: (913)262-2049. E-mail: advertising@blbadv.com. Web site: www.blbadv.com. **Contact:** Art Director. Estab. 1976. Ad agency. Clients: agriculture and veterinary firms.

Needs Local freelancers only. Uses freelancers for illustration and production, via Mac format only; keyline and paste-up; consumer and trade magazines and brochures/flyers.

First Contact & Terms Query by phone. Send business card and résumé to be kept on file for future assignments. Originals not returned. Negotiates payment.

BUTWIN & ASSOCIATES ADVERTISING

8700 Westmoreland Lane, Minneapolis MN 55426. (952)545-3886. **President:** Ron Butwin. Estab. 1977. "We are a full-line ad agency working with both consumer and industrial accounts on advertising, marketing, public relations and meeting planning." Clients: financial institutions, restaurants, retail stores, entertainment, corporations and a "full range of retail and service organizations."

- This agency offers some unique services to clients, including uniform design, interior design and display design.

Needs Works with 10-15 illustrators and 10-12 designers/year. Prefers local artists when possible. Uses freelancers for design and illustration of brochures, catalogs, newspapers, consumer and trade magazines, P-O-P displays, retouching, animation, direct mail packages, motion pictures and lettering. 20% of work is with print ads. Prefers realistic pen & ink, airbrush, watercolor, marker, calligraphy, computer, editorial and medical illustration. Needs computer-literate freelancers for design and illustration. 40% of freelance work demands computer skills.

First Contact & Terms Send brochure or resume, tearsheets, photostats, photocopies, slides and photographs. Samples are filed or are returned only if SASE is enclosed. Responds only if interested. Call for appointment to show portfolio. Pays for design and illustration by the project: $25-3,000. Considers client's budget, skill and experience of artist, and how work will be used when establishing payment. Buys all rights.

Tips "Portfolios should include layouts and finished project." A problem with portfolios is that "samples are often too weak to arouse enough interest."

CAHAN & ASSOCIATES

171 Second St., 5th Floor, San Francisco CA 94105. (415)621-0915. Fax: (415)621-7642. E-mail: billc@cahanassociates.com. Web site: www.cahanassociates.com. **President:** Bill Cahan. Estab. 1984. Specializes in annual reports, corporate identity, package design, signage, business and business collateral. Clients: public and private companies (real estate, finance and biotechnology). Client list available upon request.

Needs Approached by 50 freelance artists/year. Works with 5-10 freelance illustrators and 3-5 freelance designers/year. Works on assignment only. Uses freelance illustrators mainly for annual reports. Uses freelance designers mainly for overload cases. Also uses freelance artists for brochure design.

First Contact & Terms Send query letter with brochure, tearsheets, photostats, résumé, photographs, and photocopies. Samples are filed and are not returned. Responds only if interested. To show a portfolio, mail thumbnails, roughs, tearsheets, and transparencies. Pays for design or illustration by the hour or by the project. Negotiates rights purchased.

THE CALIBER GROUP

(formerly Boelts/Stratford Associates), 345 E. University Blvd., Tucson AZ 85705-7848. (520)792-1641. Fax: (520)792-9720. E-mail: creative@calibergrp.com. Web site: www.calibergrp.com. **Principal/Creative Director:** Kerry Stratford. Estab. 1997. Specializes in annual reports, brand identity, corporate identity, display design, direct mail design, environmental graphics, package design, publication design and signage. Client list available upon request.

• The creative team has won over 500 international, national and local awards.

Needs Approached by 100 freelance artists/year. Works with 10 freelance illustrators and 5-10 freelance designers/year. Works on assignment only. Uses designers and illustrators for brochure, poster, catalog, P-O-P and ad illustration, mechanicals, retouching, airbrushing, charts/graphs and audiovisual materials.

First Contact & Terms Send query letter with PDF samples and résumé. Samples are filed. Responds only if interested. Call to schedule an appointment to show portfolio. Portfolio should include roughs, original/final art. Pays for design by the hour and by the project. Pays for illustration by the project. Negotiates rights purchased.

Tips When presenting samples or portfolios, designers and illustrators "sometimes mistake quantity for quality. Keep it short and show your best work."

CARNASE, INC.

1577 Bay Rd. #205, Miami Beach FL 33139-2280. E-mail: carnase@carnase.com. Web site: www.carnase.com. **President:** Tom Carnase. Estab. 1978. Specializes in annual reports, brand and corporate identity, display, landscape, interior, direct mail, package and publication design, signage and technical illustration. Clients: agencies, corporations, consultants. Current clients include Brooks Brothers, Fortune Magazine, Calvin Klein, Saks Fifth Avenue.

Needs Approached by 60 freelance artists/year. Works with 2 illustrators and 1 designer/year. Prefers artists with 5 years experience. Works on assignment only. Uses artists for brochure, catalog, book, magazine and direct mail design and brochure and collateral illustration. Needs computer-literate freelancers. 50% of freelance work demands skills in QuarkXPress or Illustrator.

First Contact & Terms Send query letter with brochure, résumé and tearsheets. Samples are filed. Responds in 10 days. Will contact artist for portfolio review if interested. Portfolio should include photostats, slides and color tearsheets. Negotiates payment. Rights purchased vary according to project. Finds artists through word of mouth, magazines, submissions/self-promotions, sourcebooks and agents.

THE CHESTNUT HOUSE GROUP, INC.

2121 St. Johns Ave., Highland Park IL 60035. (847)432-3273. Fax: (847)432-3229. E-mail: chestnuthouse@comcast.net. Web site: www.chestnuthousegroup.com. **President:** Miles Zimmerman. Clients: major educational publishers, small publishers, and selected self-publishers.

Needs Needs computer-literate freelancers with educational publishing experience. Uses experienced freelancers only. Uses freelancers mainly for illustration, layout and electronic page production. Freelancers should be familiar with QuarkXPress and various drawing and painting programs for illustrators.

First Contact & Terms Submit samples. Pays for production by the hour. Pays for illustration by the project.

CINE DESIGN FILMS

Box 6495, Denver CO 80206. (303)777-4222. E-mail: jghusband@aol.com. Web site: www.cinede signfilms.com. **Producer/Director:** Jon Husband. AV firm. Clients: documentary productions. **Needs** Works with 3-20 freelancers/year. Works on assignment only. Uses freelancers for layout, titles, animation and still photography. Clear concept ideas that relate to the client in question are important.

The Caliber Group commissioned this illustration by Géraldine Charette to be used as publicity for one of their clients, a company that distributes natural emollients to hair care and skin care product manufacturers. ''The buyer saw my illustration in the 2006 edition of the AIIQ (Association des illustrateurs et illustratrices du Québec) guide and contacted me,'' says Charette. By creating a modern image with nostalgic features like the dressing table, Charette was able to capture a unique balance between the past and present, an appealing quality for any cutting-edge company.

First Contact & Terms E-mail query with Web site links, or mail query with sample DVD/CD. "We like to see completed works as samples in DVD/CD form." Responds only if interested. Pays by the project. Considers complexity of project, client's budget and rights purchased when establishing payment. Rights purchased vary according to project.

CLEARVUE & SVE, INC.

P.O. Box 5027, Florence KY 41022-6027. E-mail: custserv@clearvue.com. Web site: www.clearvu e.com. **President:** Mark Ventling. Curriculum-oriented multimedia provider.

Needs Works with 1-2 freelance artists/year. Works on assignment only. Uses freelance artists mainly for catalog layout.

First Contact & Terms Send query letter with SASE to be kept on file. Responds in 10 days. Write for appointment to show portfolio.

Tips "Have previous layout skills."

CLIFF & ASSOCIATES

10061 Riverside Dr. #808, Toluca Lake CA 91602. (626)799-5906. Fax: (626)799-9809. E-mail: design@cliffassoc.com. Web site: www.cliffassoc.com. **Owner:** Greg Cliff. Estab. 1984. Number of employees: 10. Approximate annual billing: $1 million. Specializes in annual reports, corporate identity, direct mail, publication design and signage. Clients: Fortune 500 corporations and performing arts companies. Current clients include BP, IXIA, WSPA, IABC, Capital Research and ING.

Needs Approached by 50 freelancers/year. Works with 30 illustrators and 10 designers/year. Prefers local freelancers and Art Center graduates. Uses freelancers mainly for brochures; also for technical, "fresh" editorial and medical illustration, mechanicals, lettering, logos, catalog/book/magazine design, P-O-P and poster design and illustration, and model making. Needs computer-literate freelancers for design and production. 90% of freelance work demands knowledge of QuarkXPress, FreeHand, Illustrator, Photoshop, etc.

First Contact & Terms Send query letter with résumé and a nonreturnable sample of work. Samples are filed. Will contact artist for portfolio review if interested. Portfolio should include thumbnails, b&w photostats and printed samples. Pays for design by the hour, $25-35. Pays for illustration by the project, $50-3,000. Buys one-time rights. Finds artists through sourcebooks.

COAKLEY HEAGERTY ADVERTISING & PUBLIC RELATIONS

1155 N. First St., Suite 201, San Jose CA 95112-4925. (408)275-9400. Fax: (408)995-0600. E-mail: info@coakley-heagerty.com. Web site: www.coakley-heagerty.com. **Director of Digital Marketing:** Brian Behl. Estab. 1961. Number of employees: 35. Full-service ad agency and PR firm. Clients: real estate, consumer, senior care, banking/financial, insurance, automotive, telcom, public service. Professional affiliation: MAGNET (Marketing and Advertising Global Network).

Needs Approached by 50 freelancers/year. Works with 3 freelance illustrators and 5 designers/year. "We want freelancers with digital and/or Web site experience." Works on assignment only. Uses freelancers for illustration, retouching, animation, lettering, logos and charts/graphs. Freelance work demands skills in InDesign, Illustrator, Photoshop or QuarkXPress.

First Contact & Terms E-mail PDF files showing art style, or e-mail link to Web site. Responds only if interested. Call for an appointment to show portfolio. Pays for design and illustration by the project, $600-5,000.

COLOR PLAY STUDIO

P.O. Box 5855, Eugene OR 97405-0855. (541)687-8262. Fax: (541)687-8576. **President/Creative Director:** Gary Schubert. Media Director/VP: Gwen Schubert. Estab. 2005. Ad agency. "We pro-

vide full-service advertising to a wide variety of regional and national accounts. Our specialty is print media, serving predominantly industrial and business-to-business advertisers." Product specialties are forest products, heavy equipment, software, sporting equipment, food and medical.

Needs Works with approximately 4 freelance illustrators and 2 designers/year. Works on assignment only. Uses freelancers mainly for specialty styles; also for brochure and magazine ad illustration (editorial, technical and medical), retouching, animation, films and lettering. 80% of work is with print ads. 80% of freelance work demands knowledge of Illustrator, QuarkXPress, FreeHand, Director, Photoshop, multimedia program/design.

First Contact & Terms Send query letter, brochure, résumé, slides and photographs. Samples are filed or are returned by SASE if requested. Responds only if interested. Write for appointment to show portfolio. Pays for design and illustration and by the hour, $25-100. Rights purchased vary according to project.

Tips "We're busy. So follow up with reminders of your specialty, current samples of your work, and the convenience of dealing with you. We are looking at more electronic illustration. Find out what the agency does most often and produce a relative example for indication that you are up for doing the real thing! Follow up after initial review of samples. Do not send fine art, abstract subjects."

COMMUNICATIONS ELECTRONICS, INC.

Dept. AM, Box 2797, Ann Arbor MI 48106-2797. (734)996-8888. E-mail: cei@usascan.com. **Editor:** Ken Ascher. Estab. 1969. Number of employees: 38. Approximate annual billing: $5 million. Manufacturer, distributor and ad agency (13 company divisions). Specializes in marketing. Clients: electronics, computers.

Needs Approached by 500 freelancers/year. Works with 40 freelance illustrators and 40 designers/year. Uses freelancers for brochure and catalog design, illustration and layout, advertising, product design, illustration on product, P-O-P displays, posters and renderings. Needs editorial and technical illustration. Prefers pen & ink, airbrush, charcoal/pencil, watercolor, acrylic, marker and computer illustration. 30% of freelance work demands skills in PageMaker or QuarkXPress.

First Contact & Terms Send query letter with brochure, résumé, business card, samples and tearsheets to be kept on file. Samples not filed are returned by SASE. Responds in 1 month. Will contact artist for portfolio review if interested. Pays for design and illustration by the hour, $10-120; by the project, $10-15,000; by the day, $40-800.

COMPASS MARKETING, INC.

175 Northshore Place, Gulf Shores AL 36542. (251)968-4600. Fax: (251)968-5938. E-mail: jpking @compassbiz.com. Web site: www.compassbiz.com. **Editor:** Mark A. Newman. Estab. 1988. Number of employees: 25-30. Approximate annual billing: $4 million. Integrated marketing communications agency and publisher. Specializes in tourism products and programs. Product specialties are business and consumer tourism. Current clients include Alabama Bureau of Tourism and Alabama Gulf Coast CVB. Client list available upon request.

Needs Approached by 5-20 designers/year. Works with 4-6 designers/year. Prefers freelancers with experience in magazine work. Uses freelancers mainly for sales collateral, advertising collateral and illustration. 5% of work is with print ads. 100% of design demands skills in Photoshop 7.0 and InDesign.

First Contact & Terms Designers: Send query letter with photocopies, résumé and tearsheets. Samples are filed and are not returned. Responds in 1 month. Art director will contact artist for portfolio review of slides and tearsheets if interested. Pays by the project, $100 minimum. Rights

purchased vary according to project. Finds artists through sourcebooks, networking and print.
Tips ''Be fast and flexible. Have magazine experience.''

COUSINS DESIGN
330 E. 33rd St., New York NY 10016. (212)685-7190. E-mail: info@cousinsdesign.com. Web site: www.cousinsdesign.com. **President:** Michael Cousins. Number of employees: 4. Specializes in packaging and product design. Clients: marketing and manufacturing companies. Professional affiliation: IDSA.

Needs Occassionally works with freelance designers. Prefers local designers. Works on assignment only.

First Contact & Terms Send nonreturnable postcard sample or e-mail Web site link. Samples are filed. Responds in 2 weeks, only if interested. Write for appointment to show portfolio of roughs, final reproduction/product and photostats. Pays for design by the hour or flat fee. Considers skill and experience of artist when establishing payment. Buys all rights.

Tips ''Send great work that fits our direction.''

CREATIVE COMPANY, INC.
726 NE Fourth St., McMinnville OR 97128. (866)363-4433. Fax: (503)883-6817. E-mail: jlmorrow @creativeco.com. Web site: www.creativeco.com. **President/Owner:** Jennifer Larsen Morrow. Specializes in branding, marketing-driven corporate identity, collateral, direct mail, packaging and ongoing marketing campaigns. Product specialties are food, financial services, colleges, manufacturing, pharmaceutical, medical, agricultural products.

Needs Works with 6-10 freelance designers and 3-7 illustrators/year. Prefers local artists. Works on assignment only. Uses freelancers for design, illustration, computer production (Mac), retouching and lettering. ''Looking for clean, fresh designs!'' 100% of design and 60% of illustration demand skills in InDesign, FreeHand, Illustrator and Photoshop.

First Contact & Terms Send query letter with brochure, résumé, business card, photocopies and tearsheets to be kept on file. Samples returned by SASE only if requested. Will contact for portfolio review if interested. ''We require a portfolio review. Years of experience not important if portfolio is good. We prefer one-on-one review to discuss individual projects/time/approach.'' Pays for design by the hour or project, $50-90. Pays for illustration by the project. Considers complexity of project and skill and experience of artist when establishing payment.

Tips Common mistakes freelancers make in presenting samples or portfolios are ''1) poor presentation, samples not mounted or organized; 2) not knowing how long it took them to do a job to provide a budget figure; 3) not demonstrating an understanding of the audience, the problem or printing process, and how their work will translate into a printed copy; 4) just dropping in without an appointment; 5) not following up periodically to update information or a résumé that might be on file.''

CREATIVE CONSULTANTS
2608 W. Dell Dr., Spokane WA 99208-4428. (509)326-3604. Fax: (509)327-3974. E-mail: ebruneau @creativeconsultants.com. Web site: www.creativeconsultants.com. **President:** Edmond A. Bruneau. Estab. 1980. Approximate annual billing: $300,000. Ad agency and design firm. Specializes in collateral, logos, ads, annual reports, radio and TV spots. Product specialties are business and consumer. Client list available upon request.

Needs Approached by 20 illustrators and 25 designers/year. Works with 10 illustrators and 15 designers/year. Uses freelancers mainly for animation, brochure, catalog and technical illustration, model-making and TV/film graphics. 36% of work is with print ads. Designs and illustration demands skills in Photoshop and QuarkXPress.

First Contact & Terms Designers: Send query letter. Illustrators: Send postcard sample of work

and e-mail. Accepts disk submissions if compatible with Photoshop, QuarkXPress, PageMaker and FreeHand. Samples are filed. Responds only if interested. Pays by the project. Buys all rights. Finds artists through Internet, word of mouth, reference books and agents.

THE CRICKET CONTRAST
29505 N. 146th St., Scottsdale AZ 85262. (602)258-6149. Fax: (602)391-2199. E-mail: cricket@the cricketcontrast.com. Web site: www.thecricketcontrast.com. **Owner:** Kristie Bo. Estab. 1982. Specializes in providing solutions for branding, corporate identity, Web page design, advertising, package and publication design, and traditional online printing. Clients: corporations. Professional affiliations: AIGA, Scottsdale Chamber of Commerce, Phoenix Society of Communicating Arts, Phoenix Art Museum, Phoenix Zoo.
Needs Approached by 25-50 freelancers/year. Works with 5 freelance illustrators and 5 designers/year. Uses freelancers for ad illustration, brochure design and illustration, lettering and logos. Needs computer-literate freelancers for design and production. 100% of freelance work demands knowledge of Illustrator, Photoshop, InDesign, and QuarkXPress.
First Contact & Terms Send photocopies, photographs and résumé via e-mail. Will contact artist for portfolio review if interested. Pays for design and illustration by the project. Negotiates rights purchased. Finds artists through self-promotions and sourcebooks.
Tips "Beginning freelancers should send all info through e-mail."

▣ JO CULBERTSON DESIGN, INC.
939 Pearl St., Denver CO 80203. (303)861-9046. Fax: (303)861-4383. E-mail: joculdes@aol.com. **President:** Jo Culbertson. Estab. 1976. Number of employees: 1. Approximate annual billing: $75,000. Specializes in direct mail, packaging, publication and marketing design, annual reports, corporate identity, and signage. Clients: corporations, not-for-profit organizations. Current clients include Love Publishing Company, Gabby Krause Foundation, Jace Management Services, Vitamin Cottage, Sun Gard Insurance Systems. Client list available upon request.
Needs Approached by 10 freelancers/year. Works with 2 freelance illustrators/year. Prefers local freelancers only. Works on assignment only. Uses illustrators mainly for corporate collateral pieces, illustration and ad illustration. 50% of freelance work demands knowledge of QuarkXPress, Photoshop, CorelDraw.
First Contact & Terms Send query letter or e-mail with résumé, tearsheets and photocopies. Samples are filed. Responds only if interested. Artist should follow up with call. Portfolio should include b&w and color thumbnails, roughs and final art. Pays for design by the project, $250 minimum. Pays for illustration by the project, $100 minimum. Finds artists through file of résumés, samples, interviews.

▣ CUTRO ASSOCIATES, INC.
47 Jewett Ave., Tenafly NJ 07670. (201)569-5548. Fax: (201)569-8987. E-mail: cutroassoc@optonl ine.net. **Manager:** Ronald Cutro. Estab. 1961. Number of employees: 2. Specializes in annual reports, brochures, corporate identity, direct mail, fashion, package and publication design, technical illustration and signage. Clients: corporations, business-to-business, consumer.
Needs Approached by 5-10 freelancers/year. Works with 2-3 freelance illustrators/year and 2-3 designers/year. Prefers local artists only. Uses illustrators mainly for wash drawings, fashion, specialty art. Uses designers for comp layout. Also uses freelancers for ad and brochure design and illustration, airbrushing, catalog and P-O-P illustration, direct mail design, lettering, mechanicals, and retouching. Needs computer-literate freelancers for design, illustration and production. 98% of freelance work demands knowledge of Illustrator, QuarkXPress and Photoshop.
First Contact & Terms Send postcard sample of work. Samples are filed. Will contact artist for portfolio review if interested. Portfolio should include final art and photocopies. Pays for design and illustration by the project. Buys all rights.

⚡ DAIGLE DESIGN INC.

921 Hildebrande Lane NE, Suite 230, Bainbridge Island WA 98110. (206)842-5356. Fax: (206)331-4222. E-mail: candace@daigle.com. Web site: www.daigledesign.com. **Creative Director:** Candace Daigle. Estab. 1987. Number of employees: 6. Approximate annual billing: $450,000. Design firm. Specializes in brochures, catalogs, logos, magazine ads, trade show display and Web sites. Product specialties are telecommunications, furniture, real estate development, aviation, yachts, restaurant equipment and automotive.

Needs Approached by 10 illustrators and 20 designers/year. Works with 5 illustrators and 5 designers/year. Prefers local designers with experience in Photoshop, Illustrator, DreamWeaver, Flash and FreeHand. Uses freelancers mainly for concept and production; also for airbrushing, brochure design and illustration, lettering, logos, multimedia projects, signage, technical illustration and Web page design. 50% of work is with print. 50% of design demands skills in Photoshop, Illustrator and FreeHand. 50% of illustration demands skills in Photoshop, Illustrator.

First Contact & Terms Designers: Send query letter with résumé. Illustrators: Send query letter with photocopies. Accepts disk submissions. Send JPEG files. Samples are filed and are not returned. Responds only if interested. Will contact for portfolio review of b&w, color, final art, slides and tearsheets if interested. Pays for design by the hour, $25; pays for illustration by the project, $150-3,000. Buys all rights. Finds artists through submissions, reps, temp agencies and word of mouth.

DEFOREST CREATIVE

300 W. Lake St., Elmhurst IL 60126. (630)834-7200. Fax: (630)834-0908. E-mail: info@deforestgroup.com. Web site: www.deforestgroup.com. **Art Director:** Nick Chapman. Estab. 1965. Number of employees: 15. Marketing solutions, graphic design and digital photography firm.

Needs Approached by 50 freelance artists/year. Works with 3-5 freelance designers/year. Prefers artists with experience in PhotoShop, Illustrator and InDesign.

First Contact & Terms Send query letter with résumé and samples. Samples are filed or returned by SASE if requested by artist. To arrange for portfolio review artist should fax or e-mail. Pays for production by the hour, $25-75. Finds designers through word of mouth and submissions.

Tips "Be hardworking, honest, and good at your craft."

DENTON DESIGN ASSOCIATES

491 Arbor St., Pasadena CA 91105. (626)792-7141. **President:** Margi Denton. Estab. 1975. Specializes in annual reports, corporate identity and publication design. Clients: nonprofit organizations and corporations. Recent clients include California Institute of Technology, University of Southern California, Yellowjackets and SETI Institute.

Needs Approached by 12 freelance graphic artists/year. Works with roughly 5 freelance illustrators and 2 freelance designers/year. Prefers local designers only. "We work with illustrators from anywhere." Works with designers and illustrators for brochure design and illustration, lettering, logos and charts/graphs. Demands knowledge of QuarkXPress, Photoshop and Illustrator.

First Contact & Terms Send résumé, tearsheets and samples (illustrators, just send samples). Samples are filed and are not returned. Responds only if interested. Art director will contact artist for portfolio review if interested. Pays for design by the hour. Pays for illustration by the project. Rights purchased vary according to project. Finds artists through sourcebooks, AIGA, *PRINT*, *CA*, *Folio Planet* and other Internet sources.

DESIGN + AXIOM

P.O. Box 7000, #211, Rolling Hills Estates CA 90274. (310)377-0207. E-mail: tschorer@aol.com. **President:** Thomas Schorer. Estab. 1973. Specializes in graphic, environmental and architectural design, product development and signage.

Needs Approached by 100 freelancers/year. Works with 3 freelance illustrators and 5 designers/year. Works on assignment only. Uses designers for all types of design. Uses illustrators for editorial and technical illustration. 50% of freelance work demands knowledge of PageMaker or QuarkXPress.

First Contact & Terms Send query letter with appropriate samples. Will contact artist for portfolio review if interested. Portfolio should include appropriate samples. Pays for design and illustration by the project. Finds artists through word of mouth, self-promotions, sourcebooks and colleges.

DESIGN 2 MARKET

909 Weddell Court, Sunnyvale CA 94089. (408)744-6671. Fax: (408)744-6686. E-mail: info@design2marketinc.com. Web site: www.design2marketinc.com. **Production Manager:** Jean Philavong. Estab. 1980. Specializes in corporate identity, trade show exhibit design and coordination, displays, direct mail, print advertising, publication design, Web design, signage and marketing. Clients: high technology, government and business-to-business. Clients include NEC, OKI Semiconductor, IDEC, Saver Glass and City College of San Francisco. Client list available upon request.

Needs Approached by 6 freelancers/year. Works with 3 freelance illustrators and 2 designers/year. Works on assignment only. Uses illustrators mainly for 4-color, airbrush and technical work. Uses designers mainly for logos, layout and production. Also uses freelancers for brochure, catalog, ad, P-O-P and poster design and illustration; mechanicals; retouching; lettering; book, magazine, model-making; direct mail design; charts/graphs; AV materials; multimedia projects (Director SuperCard). Needs editorial and technical illustration. 100% of design and 75% of illustration demand knowledge of InDesign, QuarkXPress, Dreamweaver, Illustrator, Model Shop, Strata, Sketchup, Flash, MMDir or Photoshop.

First Contact & Terms Send postcard sample or query letter with brochure and tearsheets. Accepts disk submissions compatible with Illustrator, QuarkXPress, Photoshop, Sketchup, Flash and Strata. Samples are filed. Will contact artist for portfolio review if interested. Portfolio should include thumbnails, roughs, b&w and color photostats, tearsheets, photographs, slides and transparencies. Sometimes requests work on spec before assigning a job. Pays for design by the hour, $25-50. Pays for illustration by the project, $300-3,000. Rights purchased vary according to project. Finds artists through self-promotions.

Tips Would like to see more images for advertising purposes as well as the ability to reproduce in all media.

DESIGN ASSOCIATES GROUP, INC.

1828 Asbury Ave., Evanston IL 60201-3504. (847)425-4800. E-mail: info@designassociatesinc.com. Web site: www.designassociatesinc.com. **Contact:** Paul Uhl. Estab. 1986. Number of employees: 5. Specializes in text and trade book design, annual reports, corporate identity, Web site development. Clients: corporations, publishers and museums. Client list available upon request.

Needs Approached by 10-20 freelancers/year. Works with 100 freelance illustrators and 2 designers/year. Uses freelancers for design and production. 100% of freelance work demands knowledge of Illustrator, Photoshop and InDesign.

First Contact & Terms Send query letter with samples that best represent work. Accepts disk submissions. Samples are filed. Will contact artist for portfolio review if interested. Portfolio should include b&w and color samples.

🏠 DESIGN COLLABORATIVE

1617 Lincoln Ave., San Rafael CA 94901-5400. (415)456-0252. Fax: (415)479-2001. E-mail: mail@designco.com. Web site: www.designco.com. **Creative Director:** Bob Ford. Estab. 1987. Number of employees: 7. Approximate annual billing: $350,000. Ad agency/design firm. Specializes in publication design, package design, environmental graphics. Product specialty is consumer. Cur-

rent clients include B of A, Lucas Film Ltd., Broderbund Software. Client list available upon request. Professional affiliations: AAGD, PINC, AAD.

Needs Approached by 20 freelance illustrators and 60 designers/year. Works with 15 freelance illustrators and 20 designers/year. Prefers local designers with experience in package design. Uses freelancers mainly for art direction/production; also for brochure design and illustration, mechanicals, multimedia projects, signage, Web page design. 25% of work is with print ads. 80% of design and 85% of illustration demand skills in PageMaker, FreeHand, Photoshop, Quark-XPress, Illustrator, PageMill.

First Contact & Terms Designers: Send query letter with photocopies, résumé, color copies. Illustrators: Send postcard sample and/or query letter with photocopies and color copies. After introductory mailing send follow up postcard samples. Accepts disk submissions. Send EPS files. Samples are filed or returned. Responds in 1 week. Artist should call. Portfolio review required if interested in artist's work. Portfolios of final art and transparencies may be dropped off every Monday. Pays for design by the hour, $40-80. Pays for illustration by the hour, $40-100. Buys first rights. Rights purchased vary according to project. Finds artists through creative sourcebooks.

Tips "Listen carefully and execute well."

DESIGN CONCEPTS

137 Main St., Unadilla NY 13849. (607)369-4709. **Owner:** Carla Schroeder Burchett. Estab. 1972. Specializes in annual reports, brand identity, design and package design. Clients: corporations, individuals. Current clients include American White Cross and Private & Natural.

Needs Approached by 6 freelance graphic artists/year. Works with 2 freelance illustrators and designers/year. Prefers artists with experience in packaging, photography, interiors. Uses freelance artists for mechanicals, poster illustration, P-O-P design, lettering and logos.

First Contact & Terms Send query letter with tearsheets, brochure, photographs, résumé and slides. Samples are filed or are returned by SASE if requested by artist. Artists should follow up with letter after initial query. Portfolio should include thumbnails and b&w and color slides. Pays for design by the hour, $30 minimum. Negotiates rights purchased.

Tips "Artists and designers are used according to talent; team cooperation is very important. If a person is interested and has the professional qualification, he or she should never be afraid to approach us—small or large jobs."

DESIGN RESOURCE CENTER

424 Fort Hill Dr., Suite 118, Naperville IL 60540. (630)357-6008. Fax: (630)357-6040. E-mail: info@drcchicago.com. Web site: www.drcchicago.com. **President:** John Norman. Estab. 1990. Number of employees: 14. Approximate annual billing: $1,500,000. Specializes in package design and display, brand and corporate identity. Clients include corporations, manufacturers, private labels.

Needs Approached by 5-10 freelancers/year. Works with 5-10 freelance designers and production artists and 5-10 designers/year. Uses designers mainly for Macintosh or concepts. Also uses freelancers for P-O-P design and illustration, lettering, logos and package design. Needs computer-literate freelancers for design, illustration and production. 100% of freelance work demands knowledge of Illustrator, QuarkXPress and Photoshop.

First Contact & Terms Send query letter with brochure, photocopies, photographs and résumé. Samples are filed. Artist should follow up. Portfolio review sometimes required. Portfolio should include b&w and color final art, photographs, roughs and thumbnails. Pays for design by the hour, $15-40. Pays for illustration by the project. Buys all rights. Finds artists through word of mouth and referrals.

DEVER DESIGNS

14203 Park Center Dr., Suite 308, Laurel MD 20707. (301)776-2812. Fax: (301)953-1196. E-mail: info@deverdesigns.com. Web site: www.deverdesigns.com. **President:** Jeffrey Dever. Marketing Director: Holly Hagen. Estab. 1985. Number of employees: 8. Specializes in annual reports, corporate identity and publication design. Clients: corporations, museums, government agencies, associations, nonprofit organizations.

Needs Approached by 100 freelance illustrators/year. Works with 30-50 freelance illustrators/ year. Prefers artists with experience in editorial illustration. Uses illustrators mainly for publications.

First Contact & Terms Send postcard, samples or query letter with photocopies, résumé and tearsheets. Accepts PDFs and disk submissions compatible with Photoshop, Illustrator or InDesign, but prefers hard copy samples, which are filed. Will contact artist for portfolio review if interested. Portfolio should include b&w and/or color photocopies for files. Pays for illustration by the project. Rights purchased vary according to project. Finds artists through referrals and sourcebooks.

Tips Impressed by "uniqueness and consistent quality."

⚙ ANTHONY DI MARCO

301 Aris Ave., Metairie LA 70005. (504)833-3122. Fax: (504)833-3122. **Creative Director:** Anthony Di Marco. Estab. 1972. Number of employees: 1. Specializes in illustration, sculpture, costume design, art and photo restoration and retouching. Current clients include Audubon Institute, Louisiana Nature and Science Center, Fair Grounds Race Course. Client list available upon request. Professional affiliations: Art Directors Designers Association, Entergy Arts Council, Louisiana Crafts Council, Louisiana Alliance for Conservation of Arts.

Needs Approached by 50 or more freelancers/year. Works with 5-10 freelance illustrators and 5-10 designers/year. Seeks "local freelancers with ambition. Freelancers should have substantial portfolios and an understanding of business requirements." Uses freelancers mainly for fill-in and finish design, illustration, mechanicals, retouching, airbrushing, posters, model-making, charts/ graphs. Prefers highly polished, finished art in pen & ink, airbrush, charcoal/pencil, colored pencil, watercolor, acrylic, oil, pastel, collage and marker. 25% of freelance work demands computer skills.

First Contact & Terms Send query letter with résumé, business card, slides, brochure, photocopies, photographs, transparencies and tearsheets to be kept on file. Samples not filed are returned by SASE. Responds in 1 week if interested. Call or write for appointment to show portfolio. Pays for illustration by the hour or by the project, $100 minimum.

Tips "Keep professionalism in mind at all times. Put forth your best effort. Apologizing for imperfect work is a common mistake freelancers make when presenting a portfolio. Include prices for completed works (avoid overpricing). Three-dimensional works comprise more of our total commissions than before."

DICCICCO BATTISTA COMMUNICATIONS

655 Business Center Dr., Suite 100, Horsham PA 19044. (215)957-0300 Fax (215) 672-9373. E-mail: ccorbet@dbcommunications.net. Web site: www.dbcommunications.net. **Executive Creative Director:** Carol Corbett. Estab. 1967. Full-service, multimedia, business-to-business ad agency. Specializes in food and business-to-business. Current clients include Hatfield Meats, Primavera, Hallowell and Caulk Dental Supplies.

Needs Works with 10 freelance illustrators and 25 freelance designers/month. Uses freelance artists mainly for paste-up and mechanicals, illustration, photography and copywriting; also for brochure design, slides, print ads, animatics, animation, retouching, TV/film grapics, lettering and logos. 60% of work is with print ads.

First Contact & Terms Send query letter with brochure, résumé, tearsheets, photostats, photocopies, photographs, slides and SASE. Samples are filed or are returned by SASE if requested by artist. Responds only if interested. Write to schedule an appointment to show a portfolio, which should include roughs, original/final art, tearsheets, final reproduction/product, photographs, slides; include color and b&w samples. Pays for design by the hour, $15-50. Pays for illustration by the project. Rights purchased vary according to project.

NORMAN DIEGNAN & ASSOCIATES

3 Martens Rd., Lebanon NJ 08833. (908)832-7951. Fax: (908)832-9650. Web site: www.diegnan-associates.com. **President:** N. Diegnan. Estab. 1977. Number of employees: 5. Approximate annual billing: $1 million. PR firm. Specializes in magazine ads. Product specialty is industrial.

Needs Approached by 10 freelancers/year. Works with 20 freelancers illustrators/year. Works on assignment only. Uses freelancers for brochure, catalog and print ad design and illustration, storyboards, slide illustration, animatics, animation, mechanicals, retouching and posters. 50% of work is with print ads. Needs editorial and technical illustration.

First Contact & Terms Send query letter with brochure and tearsheets. Samples are filed and not returned. Responds in 1 week. To show portfolio, mail roughs. Pays for design and illustration by the project. Rights purchased vary according to project.

DITTMANN DESIGN

P.O. Box 31387, Seattle WA 98103-1387. (206)523-4778. E-mail: dittdsgn@nwlink.com. **Owner/Designer:** Martha Dittmann. Estab. 1981. Number of employess: 2. Specializes in brand and corporate identity, display and package design and signage. Clients: corporations. Client list available upon request. Professional affiliations: AIGA.

Needs Approached by 50 freelancers/year. Works with 5 freelance illustrators and 2 designers/year. Uses illustrators mainly for corporate collateral and packaging. Uses designers mainly for color brochure layout and production. Also uses freelancers for brochure and P-O-P illustration, charts/graphs and lettering. Needs computer-literate freelancers for design, illustration, production and presentation. 75% of freelance work demands knowledge of Illustrator, Photoshop, InDesign and Acrobat.

First Contact & Terms Send postcard sample of work or brochure and photocopies. Samples are filed. Will contact artist for portfolio review if interested. Portfolio should include final art, roughs and thumbnails. Pays for design by the hour, $65-150. Pays for illustration by the project, $500-7,500. Rights purchased vary according to project. Finds artists through sourcebooks, agents and submissions.

Tips Looks for "enthusiasm and talent."

DLD CREATIVE

620 E. Oregon Rd., Lititz PA 17543. (717)569-6568. Fax: (717)569-7410. E-mail: dave@dldcreative.com. Web site: www.dldcreative.com. **President/Creative Director:** Dave Loose. Estab. 1986. Number of employees: 12. Full-service design firm. Specializes in branding and corporate communications. Client list available upon request.

Needs Approached by 4 illustrators and 12 designers/year. Works with 4 illustrators/year. Uses freelancers mainly for illustration; also for animation, catalog, humorous and technical illustration and TV/film graphics. 10% of work is with print ads. 50% of design demands skills in Photoshop, QuarkXPress, Illustrator.

First Contact & Terms Designers: Send query letter with photocopies, résumé and tearsheets. Illustrators: Send postcard sample of work. Accepts e-mail submissions. Samples are filed. Responds only if interested. No calls. Portfolio should include color final art and concept roughs. Pays for design and illustration by the project. Buys all rights. Finds artists through *American Showcase*, postcard mailings, word of mouth.

Tips "Be conscientious of deadlines, willing to work with hectic schedules. Must be top talent and produce highest-quality work."

DOWLING & POPE ADVERTISING

311 W. Superior St., Chicago IL 60610. (800)432-8993. E-mail: salesinfo@dowlingadv.com. Web site: www.dowlingadv.com. Estab. 1988. Number of employees: 22. Approximate annual billing: $17 million. Ad agency; full-service multimedia firm. Specializes in magazine ads and collateral. Product specialty is recruitment.

Needs Approached by 6-12 freelance artists/year. Works with 6 freelance illustrators and 72 designers/year. Uses freelancers mainly for collateral; also for annual reports, multimedia, brochure design and illustration, catalog illustration, lettering and posters. 80% of work is with print ads. 80% of design and 50% of illustration demand knowledge of FreeHand, Photoshop and Illustrator.

First Contact & Terms Designers: Send postcard sample with brochure, résumé, photocopies and photographs. Illustrators: Send postcard sample with brochure and résumé. Accepts submissions on disk. Samples are filed. Responds in 2 weeks. Will contact artist for portfolio review if interested. Portfolio should include b&w and color final art. Pays for design and illustration by the project. Negotiates rights purchased. Finds artists through *The Black Book*, *Workbook* and *Chicago Source Book*.

☒ ☒ DRAFTFCB

(formerly Foote, Cone & Belding), 17600 Gillette Ave., Irvine CA 92614. (949)851-3050. Fax: (949)567-9465. Web site: www.draftfcb.com. **Art Buyer:** Karl Gore. Estab. 1950. Ad agency; full-service multimedia firm. Product specialties are package goods, toys, entertainment and retail.

Needs Approached by 15-20 freelance artists/month. Works with 3-4 freelance illustrators and 2-3 freelance designers/month. Prefers local artists with experience in design and sales promotion. Designers must be able to work in-house and have Mac experience. Uses freelance artists for brochure, catalog and print ad design and illustration, storyboards, mechanicals, retouching, lettering, logos and computer (Mac). 30% of work is with print ads.

First Contact & Terms Designers: Send query letter with résumé, photocopies and tearsheets. Illustrators: Send postcard, color photocopies, tearsheets or other nonreturnable samples. Samples are filed. Responds only if interested. Write to schedule an appointment to show a portfolio. Portfolio should include roughs and color. Pays for design based on estimate of project from concept to mechanical supervision. Pays for illustration by the project. Rights purchased vary according to project.

☒ DYKEMAN ASSOCIATES INC.

4115 Rawlins, Dallas TX 75219. (214)528-2991. Fax: (214)528-0241. E-mail: adykeman@airmail. net. Web site: www.dykemanassociates.com. **Contact:** Alice Dykeman. PR/marketing firm. Specializes in business, industry, hospitality, sports, environmental, energy, health.

Needs Works with 5 illustrators and designers/year. Local freelancers preferred. Uses freelancers for editorial and technical illustration, brochure design, exhibits, corporate identification, POS, signs, posters, ads and all design and finished artwork for graphics and printed materials. PC or Mac.

First Contact & Terms Request portfolio review in original query. Pays by the project, $250-3,000. "Artist makes an estimate; we approve or negotiate."

Tips "Be enthusiastic. Present an organized portfolio with a variety of work. Portfolio should reflect all that an artist can do. Don't include examples of projects for which you only did a small part of the creative work. Have a price structure, but be willing to negotiate per project. We prefer to use artists/designers/illustrators who will work with barter (trade) dollars and join one of our trade exchanges. We see steady growth ahead."

EDDINS MADISON CREATIVE

6487 Overlook Dr., Alexandria VA 22312. (703)795-3069. E-mail: steve@em-creative.com. Web site: www.em-creative.com. **President:** Stephen R. Madison. Estab. 1983. Number of employees: 5. Specializes in brand and corporate identity and publication design. Clients: corporations, associations and nonprofit organizations. Current clients include Apex Home Loans, CBS, Library of Congress, Nextel, Sallie Mae. Client list available upon request.

Needs Approached by 20-25 freelancers/year. Works with 4-6 freelance illustrators and 2-4 designers/year. Uses only artists with experience in Macintosh. Uses illustrators mainly for publications and brochures. Uses designers mainly for simple design and Mac production. Also uses freelancers for airbrushing, brochure and poster design and illustration, catalog design, charts/graphs. Needs computer-literate freelancers for design, production and presentation. 100% of freelance work demands knowledge of Illustrator, Photoshop, and QuarkXPress.

First Contact & Terms Send postcard sample of work or send query letter with photocopies and résumé. Samples are filed. Will contact artist for portfolio review if interested. Rights purchased vary according to project. Finds artists through sourcebooks, design/illustration annuals and referrals.

Tips Impressed by "great technical skills, nice cover letter, good/clean résumé and good work samples."

⚡ EJW ASSOCIATES, INC.

Crabapple Village Office Park, Alpharetta GA 30004. (770)664-9322. Fax: (770)664-9324. E-mail: advertise@ejwassoc.com. Web site: www.ejwassoc.com. **President:** Emil Walcek. Estab. 1982. Ad agency. Specializes in space ads, corporate ID, brochures, show graphics. Product specialty is business-to-business.

Needs Works with 2-4 freelance illustrators and designers/year. Prefers local freelancers with experience in Mac computer design/illustration and Photoshop expertise. Works on assignment only. Uses freelancers for brochure, Web site development, catalog and print ad design and illustration, editorial, technical illustration and logos. 50% of work is with print ads. 75% of freelance work demands skills in FreeHand, Photoshop, Web coding, Flash.

First Contact & Terms Send query letter with résumé, photostats, slides and Web site. Samples are filed or are returned by SASE if requested by artist. Responds only if interested. Pays for design by the hour, $40-80; by the day, $300-600; or by the project. Buys all rights.

Tips Looks for "experience in non-consumer, industrial or technology account work. Visit our Web site first, then e-mail or call. Do not send e-mail attachments."

THE EMERY GROUP

1519 Montana Ave., El Paso TX 79902. (888)651-8888. E-mail: emery@emerygroup.com. Web site: www.emerygroup.com. **Contact:** Art Director. Estab. 1977. Number of employees: 18. Ad agency. Specializes in automotive and retail firms, banks and restaurants. Current clients include Texas National Bank and Horizon Company Ltd.

● Second location: 8100 Paseo Del Ocaso, La Jolla CA 92037. (800)770-0099.

Needs Approached by 3-4 freelancers/year. Works with 2-3 freelance illustrators and 4-5 designers/year. Uses freelancers mainly for design, illustration and production. Needs technical illustration and cartoons.

First Contact & Terms Works on assignment only. Send query letter with résumé and samples to be kept on file. Prefers tearsheets as samples. Samples not filed are returned by SASE. Will contact artist for portfolio review if interested. Sometimes requests work on spec before assigning a job. Pays for design by the hour, $15 minimum; by the project, $100 minimum; by the day, $300 minimum. Pays for illustration by the hour, $15 minimum; by the project, $100 minimum.

Considers complexity of project, client's budget and turnaround time when establishing payment. Rights purchased vary according to project.

Tips Especially looks for "consistency and dependability, high creativity, familiarity with retail, Southwestern and Southern California look."

ERICKSEN ADVERTISING & DESIGN, INC.

12 W. 37th St., 9th Floor, New York NY 10018. (212)239-3313. Web site: www.eadcom.com. **Director:** Robert Ericksen. Art Director: Magno Parada. Full-service ad agency providing all promotional materials and commercial services for clients. Product specialties are promotional, commercial and advertising material. Current clients include BBC, National Geographic, CBSTV and Prudential.

Needs Works with several freelancers/year. Assigns several jobs/year. Works on assignment only. Uses freelancers mainly for advertising, packaging, brochures, catalogs, trade, P-O-P displays, posters, lettering and logos. Prefers composited and computer-generated artwork.

First Contact & Terms Contact through artist's agent or send query letter with brochure or tearsheets and slides. Samples are filed and are not returned unless requested with SASE; unsolicited samples are not returned. Responds in 1 week if interested, or when artist is needed for a project. Does not respond to all unsolicited samples. "Only on request should a portfolio be sent." Pays for illustration by the project, up to $5,000. Buys all rights, and retains ownership of original in some situations. Finds artists through word of mouth, magazines, submissions and sourcebooks.

Tips "Advertising artwork is becoming increasingly 'commercial' in response to very tightly targeted marketing. The artist has to respond to increased creative team input. Must be experienced in computer softwares: Quark, Photoshop, Acrobat, Illustrator, MS Office, Dreamweaver, and other design/Web programs."

ERVIN-BELL MARKETING COMMUNICATIONS

2134 Michelson Dr., Irvine CA 92612. (949)251-1166. Fax: (949)417-2239. E-mail: mervin@ervin bell.com. Web site: www.ervinbell.com. **Contact:** Mike Ervin. Estab. 1981. Specializes in annual reports, branding and brand management, corporate identity, retail, direct mail, package and publication design. Clients: corporations, malls, financial firms, industrial firms and software publishers. Current clients include Kodak, Nutro Pet Foods, Ropak Corporation. Client list available upon request.

Needs Approached by 100 freelancers/year. Works with 10 freelance illustrators and 6 designers/year. Works on assignment only. Uses illustrators mainly for package designs, annual reports. Uses designers mainly for annual reports, special projects. Also uses freelancers for brochure design and illustration, P-O-P and ad illustration, mechanicals, audiovisual materials, lettering and charts/graphs. Needs computer-literate freelancers for production. 100% of freelance work demands knowledge of QuarkXPress or Photoshop.

First Contact & Terms Send résumé and photocopies. Samples are filed and are not returned. Responds only if interested. Request portfolio review in original query. Portfolio should include color roughs, tearsheets and transparencies. Pays for design by the hour, $15-30; by the project (rate varies); by the day, $120-240. Pays for illustration by the project (rate varies). Buys all rights.

Tips Finds artists through sourcebooks, submitted résumés, mailings.

EVENSON DESIGN GROUP

4445 Overland Ave., Culver City CA 90230. (310)204-1995. Fax: (310)204-4879. E-mail: edgmail@ evensondesign.com. Web site: evensondesign.com. **Principal:** Stan Evenson. Estab. 1976. Specializes in annual reports, brand and corporate identity, display design, direct mail, package

design, Web site design, and signage. Clients: ad agencies, hospitals, corporations, law firms, entertainment companies, record companies, publications, PR firms. Current clients include ActiVision, Disney, Universal Studios, NSL Properties, Co-Op Network, University of Southern California, Warner Brothers, Yokohama.

Needs Approached by 75-100 freelance artists/year. Works with 10 illustrators and 15 designers/year. Prefers artists with production experience as well as strong design capabilities. Works on assignment only. Uses illustrators mainly for covers for corporate brochures. Uses designers mainly for logo design, page layouts, all overflow work. Also uses freelancers for brochure, catalog, direct mail, ad, P-O-P and poster design and illustration, mechanicals, lettering, logos and charts/graphs. 100% of design work demands skills in InDesign, FreeHand, Photoshop or Illustrator.

First Contact & Terms Send query letter with résumé and samples, or send samples via e-mail. Responds only if interested. Portfolio should include b&w and color photostats and tearsheets and 4×5 or larger transparencies.

Tips "Be efficient in the execution of design work, producing quality designs over the quantity of designs. Professionalism, as well as a good sense of humor, will prove you to be a favorable addition to any design team."

EVENTIV

10116 Blue Creek N., Whitehouse OH 43571. E-mail: jan@eventiv.com. Web site: www.eventiv.com. **President/Creative Director:** Janice Robie. Agency specializing in graphics, promotions and tradeshow marketing. Product specialties are industrial, consumer.

Needs Assigns 30 freelance jobs/year. Works with 5 illustrators/year and 20 designers/year. Works on assignment only. Uses freelancers for consumer and trade magazines, brochures, catalogs, P-O-P displays, AV presentations, posters and illustrations (technical and/or creative). 100% of design and 50% of illustration requires computer skills. Also needs freelancers experienced in electronic authoring, animation, Web design, programming and design.

First Contact & Terms Send query letter with résumé and slides, photographs, photostats or printed samples. Accepts disk submissions compatible with Mac or Windows. Samples returned by SASE if not filed. Responds only if interested. Write for appointment to show portfolio, which should include roughs, finished art, final reproduction/product and tearsheets. Pays by the hour, $25-80; or by the project, $100-2,500. Considers client's budget and skill and experience of artist when establishing payment. Negotiates rights purchased.

Tips "We are interested in knowing your specialty."

F.A.C. MARKETING

P.O. Box 782, Burlington IA 52601. (319)752-9422. Fax: (319)752-7091. E-mail: roger@facmarketing.com. Web site: www.facmarketing.com. **President:** Roger Sheagren. Estab. 1952. Number of employees: 8. Approximate annual billing: $500,000. Ad agency; full-service, multimedia firm. Specializes in newspaper, television, direct mail. Product specialty is funeral home to consumer.

Needs Approached by 30 freelancers/year. Works with 1-2 freelance illustrators and 4-6 designers/year. Prefers freelancers with experience in newspaper and direct mail. Uses freelancers mainly for brochure and direct mail; also for brochure design and illustration, logos, signage and TV/film graphics. Freelance work demands knowledge of PageMaker, Photoshop, CorelDraw and QuarkXPress.

First Contact & Terms E-mail Web site links or mail query letter with brochure, SASE, tearsheets and photocopies. Samples are filed or returned by SASE if requested by artist. Request portfolio review in original query. Portfolio should include b&w photostats, tearsheets and thumbnails. Pays by the project, $100-500. Rights purchased vary according to project.

FLAGLER ADVERTISING/GRAPHIC DESIGN

P.O. Box 280, Brookline MA 02446. (617)566-6971. Fax: (617)566-0073. E-mail: sflag@aol.com. **President/Creative Director:** Sheri Flagler. Specializes in corporate identity, brochure design, ad campaigns and package design. Clients: finance, real estate, high-tech and direct mail agencies, infant/toddler manufacturers.

Needs Works with 10-20 freelancers/year. Works on assignment only. Uses freelancers for illustration, photography, retouching, airbrushing, charts/graphs and lettering.

First Contact & Terms Send résumé, business card, brochures, photocopies or tearsheets to be kept on file. Call or write for appointment to show portfolio. Samples are filed and are not returned. Responds only if interested. Pays for design and illustration by the project, $150-2,500. Considers complexity of project, client's budget and turnaround time when establishing payment.

Tips "Send a range and variety of styles showing clean, crisp and professional work."

FLEXSTEEL INDUSTRIES, INC.

P.O. Box 877, Dubuque IA 52004. (563)585-8294. E-mail: jmills@flexsteel.com. Web site: www.fl exsteel.com. **Advertising Administrator:** Justin Mills. Estab. 1893. Full-service multimedia firm; manufacturer with full-service in-house agency. Specializes in furniture advertising layouts, price lists, etc. Product specialty is consumer-upholstered furniture.

Needs Approached by 1 freelance artist/month. Works with 2-4 illustrators/month. Prefers artists who can do both wash and line illustration of upholstered furniture. Uses freelance artists for catalog and print ad illustration, retouching, billboards and posters. Works on assignment only. 25% of work is with print ads.

First Contact & Terms Send query letter with résumé, tearsheets and samples. Samples are filed or are returned by SASE if requested by artist. Responds only if interested. To show a portfolio, mail thumbnails, roughs and b&w tearsheets. Pays for design and illustration by the project. Buys all rights.

FLINT COMMUNICATIONS

101 N. 10th St., Suite 300, Fargo ND 58102. (701)237-4850. Fax: (701)234-9680. E-mail: gerril@fli ntcom.com. Web site: www.flintcom.com. **Creative Director:** Gerri Lien. Art Directors: Dawn Koranda, Jeff Reed, Curt Grant, Frank Stegmaier. Estab. 1947. Number of employees: 60. Approximate annual billing: $14 million. Ad agency; full-service multimedia firm. Product specialties are agriculture, manufacturing, healthcare, insurance, tourism and banking. Professional affiliations: AIGA, MN Ad Fed.

● See also listing for Simmons/Flint Advertising in this section.

Needs Approached by 50 freelancers/year. Works with 6-10 freelance illustrators and 3-4 designers/year. Uses freelancers for annual reports, brochure design and illustration, lettering, logos and TV/film graphics. 40% of work is with print ads. 20% of freelance work demands knowledge of InDesign, Photoshop, QuarkXPress and Illustrator.

First Contact & Terms Send query letter and postcard-size or larger sample of work. Samples are filed. Will contact artist for portfolio review if interested. Pays for illustration by the project, $100-2,000. Rights purchased vary according to project.

☷ FOCUS COMMUNICATIONS, INC.

5739 Lovers Lane, Shreveport LA 71105. (318)219-7688. Fax: (318)219-7689. **President:** Jim Huckabay. Estab. 1976. Number of employees: 3. Specializes in corporate identity, direct mail design and full service advertising. Clients: medical, financial and retail. Professional affiliations: AAF.

Needs Approached by 5 freelancers/year. Works with 2 freelance illustrators and designers/year. Prefers local artists with experience in illustration, computer (Mac) design and composition. Uses

illustrators mainly for custom projects; print ads. Uses designers mainly for custom projects; direct mail, logos. Also uses freelancers for ad and brochure design and illustration, audiovisual materials, charts/graphs, logos, mechanicals and retouching. Needs computer-literate freelancers for design, illustration and production. 85% of freelance work demands skills in Photoshop, FreeHand and QuarkXPress.

First Contact & Terms Send postcard sample of work or send query letter with brochure, photocopies, photostats, slides, tearsheets and transparencies. Samples are filed. Will contact artist for portfolio review if interested. Portfolio should include b&w and color final art and slides. Pays for design by the hour, $40-75; or by the project. Pays for illustration by the project, $100-1,000. Negotiates rights purchased.

Tips Impressed by "turnkey capabilities in Macintosh design and finished film/proof composition."

N FORDESIGN GROUP

5405 South, 550 East, Ogden UT 84405-4771. (801)479-4002. Fax: (801)479-4099. E-mail: steven @fordesign.net. Web site: www.fordesign.net. **Owner:** Steven Ford. Estab. 1990. Specializes in brand and corporate identity, package and Web site design. Clients: corporations. Current clients include Sony, IBM, Cadbury Beverage, Carrs, MasterCard. Professional affiliations: AIGA, PDC.

Needs Approached by 100 freelancers/year. Works with 6-10 freelance illustrators and 4-6 designers/year. Uses illustrators mainly for brochures, ads. Uses designers mainly for corporate identity, packaging, collateral. Also uses freelancers for ad and brochure design and illustration, logos. Needs bright, conceptual designers and illustrators. 90% of freelance work demands skills in Illustrator, Photoshop, FreeHand and Dreamweaver.

First Contact & Terms Send postcard sample of work or send photostats, slides and transparencies. Samples are filed or returned by SASE if requested by artist. Will contact artist for portfolio review if interested. Portfolio should include b&w and color samples. Pays for design by the hour or by the project. Pays for illustration by the project.

Tips "We review *Showcase, Workbook*, etc. We are impressed by great work, simply presented. Save money on promotional materials by partnering with printers. Create a joint project or tie-in."

N ALAN FRANK & ASSOCIATES INC.

Dept. AM, 1524 South, 100 East, Salt Lake City UT 84105. (801)486-7455. Fax: (801)486-7454. **Art Director:** Scott Taylor. Serves clients in travel, fast food chains and retailing. Clients include KFC, A&W, Taco Bell and Tuffy Automotive.

Needs Uses freelancers for illustrations, animation and retouching for annual reports, billboards, ads, letterheads, TV and packaging.

First Contract & Terms Mail art with SASE. Responds in 2 weeks. Minimum payment: $500, animation; $100, illustrations; $200, brochure layout.

FREEASSOCIATES

2300 Westwood Blvd., Suite 105, Los Angeles CA 90064. (310)441-9950. Fax: (310)441-9949. E-mail: jfreeman@freeassoc.com. Web site: www.freeassoc.com. **President:** Josh Freeman. Estab. 1974. Number of employees: 4. Design firm. Specializes in marketing materials for corporate clients. Client list available upon request. Professional affiliations: AIGA.

Needs Approached by 60 illustrators and 30 designers/year. Works with 3 illustrators and 3 designers/year. Prefers freelancers with experience in top level design and advertising. Uses freelancers mainly for design, production, illustration; also for airbrushing, brochure design and illustration, catalog design and illustration, lettering, logos, mechanicals, multimedia projects, posters, retouching, signage, storyboards, technical illustration and Web page design. 30% of

work is with print ads. 90% of design and 50% of illustration demands skills in Photoshop, InDesign CS, Illustrator.

First Contact & Terms Designers: Send query letter with photocopies, photographs, résumé, tearsheets. Illustrators: Send postcard sample of work and/or photographs and tearsheets. Accepts Mac-compatible disk submissions to view in current version of major software or self-running presentations. CD-ROM OK. Samples are filed or returned by SASE. Will contact artist for portfolio review if interested. Pays for design and illustration by the project; negotiable. Rights purchased vary according to project. Finds artists through iSpot.com and other online resources, *LA Workbook*, *CA*, *PRINT*, *Graphis*, submissions and samples.

Tips "Designers should have their own computer and high-speed Internet connection; must have sensitivity to marketing requirements of projects they work on. Deadline commitments are critical."

⒩ FULLMOON CREATIONS INC.

100 Mechanic St., Doylestown PA 18901. (215)345-1233. E-mail: info@fullmooncreations.com. Web site: www.fullmooncreations.com. **Contact:** Art Director. Estab. 1986. Number of employees: 10. Specializes in new product ideas, new product concept development, product name generations, brand development, product design, packaging design, packaging structure design, packaging descriptive copy writing. Clients: Fortune 500 corporations. Current clients are top 1,000 manufacturers involved in new product and packaging development.

Needs Approached by 100-120 freelancers/year. Works with 5-15 freelance illustrators and 10-20 designers/year. Uses freelancers for ad, brochure and catalog design and illustration; airbrushing; audiovisual materials; book, direct mail and magazine design; logos; mechanicals; poster and P-O-P illustration. Needs computer-literate freelancers for design, illustration and production. 50% of freelance work demands knowledge of Illustrator, Photoshop, Adobe CS.

First Contact & Terms Send postcard sample of work, photocopies, résumé and URL. Samples are filed. E-mail links to Web site. Responds in 1 month with SASE. Will contact artist for portfolio review if interested. Portfolio should include b&w and color roughs, thumbnails and transparencies.

Tips "Fullmoon Creations, Inc. is a multi-dimensional creative development team, providing design and marketing services to a growing and diverse group of product and service organizations, and staffed by a team of professionals. Complementing these professionals is a group of talented, motivated (you) copywriters, illustrators, Web designers and programmers who are constantly challenging their creative skills, working together with us as a team. We are, above all, a professional service organization with a total dedication to our clients' marketing needs."

G2 PARTNERS

6 Spring St., Medway MA 02053-2156. (508)533-1223. E-mail: robert@g2partners.com. Web site: www.g2partners.com. **Creative Director:** Robert Greenebaum. Estab. 1975. Ad Agency. Specializes in business to business marketing communications (advertising, direct mail, branding and identity, Internet presence, corporate literature, investor relations) for a variety of regional, national and international clients, large and small.

Needs Uses freelancers mainly for advertising, direct mail and literature; also for brochure and print ad illustration.

First Contact & Terms Samples are filed or are returned by SASE if requested by artist. Responds only if interested. Pays for illustration by the project: $500-3,500. Finds artists through annuals and sourcebooks.

GARRITY COMMUNICATIONS, INC.

391 Lansing Station Rd., Lansing NY 14882-8606. (607)533-4536. Fax: (607)533-4543. E-mail: brandarmor@garrity.com. Web site: www.garrity.com. **Contact:** Art Director. Estab. 1978. Ad agency, AV firm. Specializes in trade ads, newspaper ads, annual reports, video, etc. Product specialties are financial services, food, higher education.

Needs Approached by 8 freelance artists/month. Works with 2 freelance illustrators and 1 freelance designer/month. Works on assignment only. Uses freelance artists mainly for work overflow situations, some logo specialization; also for brochure design and illustration, print ad illustration, TV/film graphics and logos. 40% of work is with print ads. 90% of freelance work demands knowledge of Photoshop, Illustrator, InDesign.

First Contact & Terms Send query letter with brochure and photocopies. Samples are filed and are not returned. Responds only if interested. Will contact artist for portfolio review if interested. Pays for design by the hour, $25-75. Pays for illustration by the project, $150-1,500. Rights purchased vary according to project. Finds artists through sourcebooks, submissions.

KERRY GAVIN STUDIOS

30 Brookwood Rd., Waterford NY 12188. (518)235-5630. E-mail: kerrygavin@kerrygavinstudios. com. Web site: www.kerrygavinsstudio.com. Specializes in publication design. Clients: corporations, companies. Client list available upon request.

Needs Approached by 6-10 freelancers/year. Works with 6-8 freelance illustrators and 1-2 designers/year. Uses illustrators mainly for assorted projects. Uses designers mainly for production. Also uses freelancers for magazine design. Freelancers should be familiar with InDesign, Illustrator and Photoshop.

First Contact & Terms Send postcard sample of work or photocopies and tearsheets. Samples are filed or returned. Responds only if interested. Portfolio review not required. Pays for design by the hour, $20-35. Pays for illustration by the project, $450 minimum. Buys one-time rights. Finds artists through sourcebooks, direct mailing, word of mouth and annuals.

Tips Impressed by "prompt response to query calls, good selection of samples, timely delivery."

GIRVIN STRATEGIC BRANDING AND DESIGN

1601 Second Ave., 5th Floor, Seattle WA 98101-1575. (206)674-7808. Fax: (206)674-7909. Web site: www.girvin.com. Estab. 1977. Number of employees: 34. Design firm. Specializes in corporate identity and brand strategy, naming, Internet strategy, graphic design, signage, and packaging. Current clients include Warner Bros., Procter & Gamble, Paramount, Wells Fargo, Johnson & Johnson, and Kraft/Nabisco.

Needs Works with several freelance illustrators, production artists and designers/year.

First Contact & Terms Designers: Send query letter with appropriate samples. Illustrators: Send postcard sample or other nonreturnable samples. Will contact for portfolio review if interested. Payment negotiable.

GOLD & ASSOCIATES INC.

6000-C Sawgrass Village Circle, Ponte Vedra Beach FL 32082. (904)285-5669. Fax: (904)285-1579. E-mail: gold@strikegold.com. Web site: www.strikegold.com. **Creative Director/President:** Keith Gold. Incorporated in 1988. Full-service multimedia, marketing and communications firm. Specializes in graphic design and advertising. Product specialties are entertainment, medical, publishing, tourism and sports.

Needs Approached by over 100 freelancers/year. Works with approximately 25 freelance illustrators/year. Works primarily with artist reps. Uses illustrators for annual reports, books, brochures, editorial, technical, print ad illustration; storyboards, animatics, animation, music videos. 65% of work is in print. 50% of freelance work demands knowledge of Illustrator, QuarkXPress, Photoshop or InDesign.

First Contact & Terms Contact through artist rep or send query letter with photocopies or tearsheets. Samples are filed. Responds *only* if interested. Will contact artists for portfolio review if interested. Follow up with letter after initial query. Portfolio should include tearsheets. Pays for illustration by the project, $200-7,500. Buys all rights. Finds artists primarily through sourcebooks and reps. Does not use freelance designers.

TOM GRABOSKI ASSOCIATES, INC.

4649 Ponce De Leon Blvd., Suite 401, Coral Gables FL 33146. (305)669-2550. Fax: (305)669-2539. E-mail: mail@tgadesign.com. Web site: www.tgadesign.com. **President:** Tom Graboski. Estab. 1980. Specializes in exterior/interior signage, environmental graphics, corporate identity, urban design and print graphics. Clients: corporations, cities, museums, a few ad agencies. Current clients include Universal Studios, Florida; Royal Caribbean Cruise Line; The Equity Group; Disney Development; Celebrity Cruises; Baptist Health So. Florida; City of Miami; City of Coral Gables.

Needs Approached by 20-30 freelance artists/year. Works with approximately 4-8 designers and draftspersons/year. Prefers artists with a background in signage and knowledge of architecture and industrial design. Freelance artists used in conjunction with signage projects, occasionally miscellaneous print graphics. 100% of design and 10% of illustration demands knowledge of Illustrator, Photoshop and QuarkXPress.

First Contact & Terms Send query letter with brochure and résumé. "We will contact designer/artist to arrange appointment for portfolio review. Portfolio should be representative of artist's work and skills; presentation should be in a standard portfolio format." Pays by the project. Payment varies by experience and project. Rights purchased vary by project.

Tips "Look at what type of work the firm does. Tailor presentation to that type of work. For this firm, knowledge of environmental graphics and detailing is a plus."

GRAPHIC DESIGN CONCEPTS

15329 Yukon Ave., El Camino Village CA 90260-2452. (310)978-8922. **President:** C. Weinstein. Estab. 1980. Specializes in package, publication and industrial design, annual reports, corporate identity, displays and direct mail. Current clients include Trust Financial Financial Services (marketing materials). Current projects include new product development for electronic, hardware, cosmetic, toy and novelty companies.

Needs Works with 15 illustrators and 25 designers/year. "Looking for highly creative idea people, all levels of experience." All styles considered. Uses illustrators mainly for commercial illustration. Uses designers mainly for product and graphic design. Also uses freelancers for brochure, P-O-P, poster and catalog design and illustration; book, magazine, direct mail and newspaper design; mechanicals; retouching; airbrushing; model-making; charts/graphs; lettering; logos; multimedia design; program and content development. 50% of freelance work demands knowledge of PageMaker, Illustrator, QuarkXPress, Photoshop or FreeHand.

First Contact & Terms Send query letter with brochure, résumé, tearsheets, photostats, photocopies, slides, photographs and/or transparencies. Accepts disc submissions compatible with IBM Windows. Samples are filed, or returned if accompanied by SASE. Responds in 10 days with SASE. Portfolio should include thumbnails, roughs, original/final art, final reproduction/product, tearsheets, transparencies and references from employers. Pays by the hour, $15-50. Considers complexity of project, client's budget, skill and experience of artist, how work will be used, turnaround time, and rights purchased when establishing payment.

Tips "Send a résumé if available. Send samples of recent work or *high-quality* copies. Everything sent to us should have a professional look. After all, it is the first impression we will have of you. Selling artwork is a business. Conduct yourself in a business-like manner."

GRETEMAN GROUP

1425 E. Douglas Ave., Wichita KS 67211. (316)263-1004. Fax: (316)263-1060. E-mail: info@grete mangroup.com. Web site: www.gretemangroup.com. **Owner:** Sonia Greteman. Estab. 1989. Number of employees: 24. Capitalized billing: $20 million. Creative agency. Specializes in corporate identity, advertising, annual reports, signage, Web site design, interactive media, brochures, collateral. Professional affiliations: AIGA.

Needs Approached by 20 illustrators and 20 designers/year. Works with 2 illustrators/year. 10% of work is with print ads. 30% of illustration demands computer skills in photoshop and illustrator.

First Contact & Terms Send query letter with brochure and résumé. Accepts disk submissions. Send EPS files. Samples are filed. Will contact for portfolio review of b&w and color final art and photostats if interested. Pays for illustration by the project. Rights purchased vary according to project.

GREY WORLDWIDE INC.

777 Third Ave., New York NY 10017. (212)546-2000. Fax: (212)546-2255. E-mail: jhorowitz@grey .com. Web site: www.grey.com. **Vice President/Art Buying Manager:** Jayne Horowitz. Number of employees: 1,800. Specializes in cosmetics, food and medical. Clients include Eli Lilly, Dairy Queen, Glaxo Smith Kline, Wyeth, and Platex. Professional affiliations: 4A's Art Services Committee.

• This company has 6 art buyers, each of whom makes about 50 assignments per year.

Needs Approached by hundreds of freelancers/year. Works with some freelance illustrators and few designers/year. Freelancers are needed mostly for illustration and photography, but also for model-making, fashion styling and lettering.

First Contact & Terms Works on assignment only. E-mail query with Web site link for initial contact. No flollow-up e-mails. Does not respond unless interested and appropriate project arises. Pays by the project. Considers client's budget and rights purchased when establishing fees.

Tips "Show your work in a neat and organized manner. Have sample leave-behinds or Web site link and do not expect to leave with a job."

GRIFFIN MARKETING SERVICES, INC.

802 Wabash Ave., Chesterton IN 46304-2250. (219)929-1616. Fax: (219)921-0388. E-mail: rob@gr iffinmarketingservices.com. Web site: www.griffinmarketingservices.com. **President:** Michael J. Griffin. Estab. 1974. Number of employees: 20. Approximate annual billing: $4 million. Integrated marketing firm. Specializes in collateral, direct mail, multimedia. Product specialty is industrial. Current clients include Hyatt, USX, McDonalds.

Needs Works with 20-30 freelance illustrators and 2-30 designers/year. Prefers artists with experience in computer graphics. Uses freelancers mainly for design and illustration; also for animation, model making and TV/film graphics. 75% of work is with print ads. Needs computer-literate freelancers for design, illustration, production and presentation. 95% of freelance work demands knowledge of PageMaker, FreeHand, Photoshop, QuarkXPress and Illustrator.

First Contact & Terms Send query letter with SASE or e-mail. Samples are not filed and are returned by SASE if requested by artist. Responds in 1 month. Will contact artist for portfolio review if interested. Pays for design and illustration by the hour, $20-150; or by the project.

Tips Finds artists through *Creative Black Book*.

GUERTIN ASSOCIATES

3703 W. Lake Ave., Glenview IL 60025. (847)729-2674, ext. 204. Web site: www.guertincomm unications.com. **Contact:** Russell Guertin. Estab. 1987. Marketing service agency. Specializes in P.O.S. materials, magazine ads, direct mail and business-to-business communications.

Product specialties are boating, gasolines, financial and pharmaceuticals. Current clients include Bank of America, GE Capital, Heinz, Kraft Foods, Sprint, Unilever. Client list available upon request.

Needs Approached by 50 freelancers/year. Works with 10 freelance illustrators/year. Prefers freelancers with experience in Mac Quark, Illustrator, Freehand, Photoshop, who can work off-site. Uses freelancers mainly for keyline and layout; also for billboards, brochure design, catalog design and illustration, logos, mechanicals, posters and signage. 10% of work is with print ads. Needs computer-literate freelancers for illustration and production. 90% of freelance work demands skills in FreeHand, Photoshop, QuarkXPress and Illustrator.

First Contact & Terms Send query letter with photocopies and résumé. Samples are not returned. Will contact artist for portfolio review if interested. Pays for design by the project, $100-1,000. Pays for illustration by the project. Buys all rights.

HAMMOND DESIGN ASSOCIATES, INC.

206 W. Main St., Lexington KY 40507. (859)259-3639. Fax: (859)259-3697. Web site: www.hamm onddesign.com. **Vice-President:** Grady Walter. Estab. 1986. Specializes in direct mail, package and publication design and annual reports, brand and corporate identity, display and signage. Clients: corporations, universities and medical facilities.

Needs Approached by 35-50 freelance/year. Works with 5-7 illustrators and 5-7 designers/year. Works on assignment only. Uses freelancers mainly for brochures and ads; also for editorial, technical and medical illustration, airbrushing, lettering, P-O-P and poster illustration, and charts/graphs. 100% of design and 50% of illustration requires computer skills.

First Contact & Terms Send postcard sample or query letter with brochure or résumé. Samples are filed or returned by SASE if requested by artist. Responds only if interested. Will contact artist for portfolio review if interested. Pays by the project.

HANSON/DODGE CREATIVE

220 E. Buffalo St., Milwaukee WI 53202-5704. (414)347-1266. Fax: (414)347-0493. E-mail: postma ster@hansondodge.com. Web site: www.hansondodge.com. **CEO:** Ken Hanson. Estab. 1980. Number of employees: 78. Approximate annual billing: $78 million. Specializes in active lifestyle-driven consumer marketing including brand planning, marketing communications, design, public relations, and technology solutions. Clients: corporations, agencies. Current clients include Trek Bicycle, Timex, T-Fal, Hushpuppies. Client list available upon request. Professional affiliations: AIGA, APDF, ACD.

Needs Approached by 30 freelancers/year. Works with 2-3 freelance illustrators, 2-3 designers and 5-8 production artists/year. Needs computer-literate freelancers for design, illustration and production. 90% of freelance work demands knowledge of Illustrator, Photoshop and InDesign.

First Contact & Terms Send letter of introduction and position sought with résumé and nonreturn-able samples to Hanson/Dodge Design, Attn: Claire Chin, or e-mail postmaster@hansondodge.c om. Résumés and samples are kept on file for 6 months. Responds in 2 weeks. Artist should follow up with call. Pays for design and illustration by the hour. Finds artists through word of mouth, submissions.

HARMON GROUP

807 Third Ave. S., Nashville TN 37210. (615)256-3393. Fax: (615)256-3464. E-mail: info@harmon grp.com. Web site: www.harmongrp.com. **President:** Rick Arnemann. Estab. 1988. Number of employees: 32. Approximate annual billing: $7.2 million. Specializes in luxury consumer products, brand identity, display and direct mail design and signage. Clients: consumer product companies, corporations, mid-size businesses. Current clients include Best Products, Service Merchandise, WalMart, Hartmann Luggage. Client list available upon request. Professional affiliations: Creative Forum.

Needs Approached by 20 freelancers/year. Works with 4-5 freelance illustrators and 5-6 designers/year. Uses illustrators mainly for P-O-P. Uses designers mainly for fliers and catalogs. Also uses freelancers for ad, brochure, catalog, poster and P-O-P design and illustration, logos, magazine design, mechanicals and retouching. 85% of freelance work demands skills in Illustrator, Photoshop and QuarkXPress.

First Contact & Terms Send photographs, résumé, slides and transparencies. Samples are filed. Will contact artist for portfolio review if interested. Portfolio should include color final art, roughs, slides and thumbnails. Pays for design and illustration by the project. Rights purchased vary according to project. Finds artists through sourcebooks and portfolio reviews.

HILL AND KNOWLTON, INC.

909 Third Ave., 10th Floor, New York NY 10022. (212)885-0300. Fax: (212)885-0570. E-mail: patrick.baird@hillandknowlton.com. Web site: www.hillandknowlton.com. **Graphic Designer:** Patrick Baird. Estab. 1927. Number of employees: 1,800 (worldwide). PR firm; full-service multimedia firm. Specializes in corporate communications, marketing communications, public affairs, health care/pharmaceuticals, technology. Creative services include reports, collateral materials, corporate identity, presentation design, signage and advertisements.

Needs Works with 0-10 freelancers/month. Works on assignment only. Uses freelancers for editorial, technical and medical illustration; also for storyboards, slide illustration, animatics, mechanicals, presentation design, retouching. 10% of work is with print ads. Needs computer-literate freelancers for illustration. Freelancers should be familiar with Adobe Creative Suite: Photoshop, Illustrator, InDesign, and Microsoft PowerPoint.

First Contact & Terms Send query letter with promo and samples. Samples are filed. Does not respond, in which case the artist should "keep in touch by mail—do not call." Call and drop-off only for a portfolio review. Pays freelancers by the project, $250-5,000. Negotiates rights purchased.

Tips Looks for "variety; unique but marketable styles are always appreciated."

THE HITCHINS COMPANY

22756 Hartland St., Canoga Park CA 91307. (818)715-0150. Fax: (775)806-2687. E-mail: whitchins @socal.rr.com. **President:** W.E. Hitchins. Estab. 1985. Advertising agency; full-service, multimedia firm.

Needs Works with 1-2 illustrators and 3-4 designers/year. Works on assignment only. Uses freelance artists for brochure and print ad design and illustration, storyboards, mechanicals, retouching, TV/film graphics, lettering and logo. Needs editorial and technical illustration and animation. 60% of work is with print ads. 90% of design and 50% of illustration demands knowledge of In Design, PageMaker, Illustrator, or FreeHand.

First Contact & Terms Send postcard sample. Samples are filed if interested and are not returned. Responds only if interested. Call for appointment to show portfolio. Portfolio should include tearsheets. Pays for design and illustration by the project, according to project and client. Rights purchased vary according to project.

BERNARD HODES GROUP

8270 Greensboro Dr., Suite 600, McLean VA 22102. (703)848-0810. Fax: (703)848-0895. Web site: www.hodes.com. **Creative Director:** Gregg Petermann. Estab. 1970. Ad agency; full-service, multimedia firm. Specializes in recruitment advertising and employment communications.

Needs Prefers artists with strong interactive design skils. Heavy emphasis on Flash, Dreamweaver, and HTML. Works on assignment only. Uses freelancers for illustration. 50% of work is with print ads. Freelance work demands knowledge of QuarkXPress, Illustrator, Photoshop or InDesign.

First Contact & Terms Send query letter with samples, CD of best work, or Web site link. Write for an appointment to show a portfolio.

HOLLAND ADVERTISING

700 Walnut St., Suite 300, Cincinnati OH 45202-2011. (513)721-1310. Fax: (513)721-1269. E-mail: holland@thinkresponsively. Web site: www.thinkresponsively.com. **Contact:** David Dreisbach. Estab. 1937. Number of employees: 17. Approximate annual billing: $12 million. Ad agency; full-service, multimedia firm. Professional affiliation: AAAA.

Needs Approached by 6-12 freelancers/year. Works with 5-10 freelance illustrators and 2-3 designers/year. Prefers artists with experience in Macintosh. Uses freelancers for brochure illustration, logos and TV/film graphics. 100% of freelance work demands knowledge of Photoshop, InDesign and Illustrator.

First Contact & Terms Send query letter with photocopies and résumé. Accepts submissions on disk. Samples are filed and are not returned. Will contact artist for portfolio review if interested. Portfolio should include b&w and color final art, photographs, roughs, tearsheets and thumbnails. Pays for design by the hour, by the project and by the day. Pays for illustration by the project. Rights purchased vary according to project.

HORNALL ANDERSON DESIGN WORKS, INC.

710 Second Ave., Suite 1300, Seattle WA 98104. (206)467-5800. Fax: (206)467-6411. E-mail: info@hadw.com. Web site: www.hadw.com. Estab. 1982. Number of employees: 100. Integrated branding firm. Specializes in full-range integrated brand and communications strategy, corporate identity, interactive and digital design, packaging, corporate literature, collateral, retail and environmental graphics. Current clients include Holland America Line, Widmer Brothers Brewery, Red hook Brewery, T-Mobile, CitationShares, Amgen. Professional affiliations: AIGA, Seattle Design Association, Art Directors Club.

● This firm has received numerous awards and honors, including the International Mobius Awards, London International Advertising Awards, ADDY Awards, Industrial Designers Society of America IDEA Awards, Communication Arts, Brand Design Association Gold Awards, AIGA, Clio Awards, Communicator Awards, Webby Awards, and Graphis Awards.

Needs Interested in all levels, from senior print and interactive design personnel to interns with design experience. Additional illustrators and freelancers are used on an as-needed basis in design and online media projects.

First Contact & Terms Designers: Send query letter with photocopies and résumé. Illustrators: Send query letter with brochure and follow up postcard. Accepts disk submissions compatible with FreeHand or Photoshop, "but the best is something that is platform/software independent (i.e., Director)." Samples are filed. Responds only if interested. Portfolios may be dropped off. Rights purchased vary according to project. Finds designers through word of mouth and submissions; illustrators through sourcebooks, reps and submissions.

HOWARD DESIGN GROUP

20 Nassau St., Suite 250W, Princeton NJ 08542. (609)924-1106. Fax: (609)924-1165. E-mail: diane@howarddesign.com. Web site: www.howarddesign.com. **Vice President:** Diane Savoy. Estab. 1980. Number of employees: 10. Specializes in Web sites, corporate identity, college recruitment materials and publication design. Clients: corporations, schools and colleges.

Needs Approached by 20 freelancers/year. Works with 10 freelance illustrators and 5 designers/year. Uses freelancers mainly for publication design; also for brochure design and illustration; catalog, direct mail, magazine and poster design; logos. Needs computer-literate freelancers for design and production. 100% of freelance work demands knowlege of Illustrator, Photoshop, FreeHand and QuarkXPress.

First Contact & Terms Send résumé. Samples are filed. Will contact artist for portfolio review if interested. Portfolio should include color final art, roughs and thumbnails. Pays for design and illustration by the project. Buys one-time rights. Finds artists through *Showcase*.

Tips Looks for "innovative design in portfolio."

HOWARD/FROST ADVERTISING COMMUNICATIONS

3131 Western Ave., #520, Seattle WA 98121. (206)378-1909. Fax: (206)378-1910. E-mail: bruce@ hofro.com. Web site: www.hofro.com. **Creative Director:** Bruce Howard. Estab. 1994. Number of full-time employees: 4. Ad agency. Specializes in media advertising, collateral, Web design, Web advertising and direct mail. Client list available upon request.

Needs Approached by 20-30 illustrators and 10-15 designers/year. Works with 10 illustrators and 2 designers/year. Works only with artist reps. Uses freelancers mainly for illustration, design overload; also for airbrushing, animation, billboards, brochure, humorous and technical illustration, lettering, logos, multimedia projects, retouching, storyboards, Web page design. 60% of work is with print ads. 60% of freelance design demands knowledge of PageMaker, FreeHand and Photoshop.

First Contact & Terms Designers: Send query letter with photocopies. Illustrators: Send postcard sample. Accepts disk submissions. Send files compatible with Acrobat, InDesign, Illustrator, Dreamweaver, Flash or Photoshop. Samples are filed and not returned. Responds only if interested. Art director will contact artist for portfolio review if interested. Pays for design and illustration by the project. Negotiates rights purchased.

Tips "Be patient."

HOWRY DESIGN ASSOCIATES

354 Pine St., Suite 600, San Francisco CA 94104. (415)433-2035. Fax: (415)433-0816. E-mail: info@howry.com. Web site: www.howry.com. **Principal/Creative Director:** Jill Howry. Estab. 1988. Full-service design studio. Number of employees: 10. Specializes in annual reports, corporate identity, print, advertising and multimedia. Clients: startups to Fortune 100 companies. Current clients include Del Monte, Affymetrix, Geron Corporation, McKesson Corp., First Republic Bank. Professional affiliations: AIGA.

Needs Works with 30 freelance illustrators, photographers and Web and print designers/year. Works on assignment only. Uses illustrators for "anything that applies." Uses designers mainly for newsletters, brochures, corporate identity. Also uses freelancers for production, programming, retouching, photography/illustration, logos and charts/graphs. 100% of design work, 10% of illustration work demands knowledge of InDesign, Illustrator or Photoshop.

First Contact & Terms Samples are filed. Responds only if interested. Portfolios may be dropped off every Thursday. Pays for design/production by the hour, or by the job, $25-60. Pays for photography and illustration on a per-job basis. Rights purchased vary according to project.

Tips Finds artists through sourcebooks, samples, representatives.

HUTCHINSON ASSOCIATES, INC.

1147 W. Ohio St., Suite 305, Chicago IL 60622. (312)455-9191. Fax: (312)455-9190. E-mail: hutch @hutchinson.com. Web site: www.hutchinson.com. **President:** Jerry Hutchinson. Estab. 1988. Number of employees: 3. Specializes in annual reports, corporate identity, capability brochures, direct mail, publication design and Web site design and development. Clients: small and large companies, associations and PR firms. Professional affiliations: AIGA.

● Work from Hutchinson Associates has been published in the following design books: *Graphis Design* (Graphis Publications); *Revival of the Fittest: Digital Versions of Classic Typefaces* (North Light Books); *Simpson Paper Show Catalog* (Simpson Paper, San Francisco); *Working with Computer Type*, Vols. 1-3 (Rotovision); *Context One* (Sappi Papers); *Logo Lounge*, Vols.

1-3 (Rockport); *1,000 Invitations* (Rockport); *Publication Design Workbook* (Rockport); *Letterhead and Logo Design 9* (Rockport).

Needs Approached by 5-10 freelancers/year. Works with 3-4 freelance illustrators and 5-15 designers/year.

First Contact & Terms Send postcard sample of work or send query letter with résumé, brochure, photocopies and photographs. Samples are filed. Request portfolio review in original query. Artist should follow up with call. Will contact artist for portfolio review if interested. Pays by the project, $100-10,000. Rights purchased vary according to project. Finds artists through sourcebooks, submissions and Illinois reps.

Tips ''Persistence pays off.''

ⓃⒻ ICON NICHOLSON, LLC

295 Lafayette St., New York NY 10012. (212)274-0470. Fax: (212)274-0380. E-mail: careers@icon nicholson.com. Web site: www.iconnicholson.com. **Senior Art Director:** Maya Kopytman. Estab. 1987. Specializes in design of interactive computer programs. Clients: corporations, museums, government agencies and multimedia publishers. Client list available upon request.

Needs Works with 3 freelance illustrators and 12 designers/year. Prefers local freelancers. Uses illustrators mainly for computer illustration and animation. Uses designers mainly for computer screen design and concept development; also for mechanicals, charts/graphs and AV materials. Needs editorial and technical illustration. Especially needs designers with interest (not necessarily experience) in computer screen design plus a strong interest in information design. 80% of freelance work demands computer skills.

First Contact & Terms Send query letter with résumé; include tearsheets and slides if possible. Samples are filed or are returned if requested. Will contact artist for portfolio review if interested. Portfolio should include thumbnails, original/final art and tearsheets. Considers complexity of project, client's budget, and skill and experience of artist when establishing payment. Rights purchased vary according to project. Interested in buying second rights (reprint rights) to previously published work. Finds artists through submissions/self-promotions and sourcebooks.

Ⓕ IDEA BANK MARKETING

701 W. Second St., Hastings NE 68902-2117. (402)463-0588. Fax: (402)463-2187. E-mail: sherma @ideabankmarketing.com. Web site: www.ideabankmarketing.com. **Creative Director:** Sherma Jones. Estab. 1982. Number of employees: 7. Approximate annual billing: $1,000,000. Ad agency. Specializes in print materials, direct mail. Product specialty is manufacturers. Client list available upon request. Professional affiliations: Advertising Federation of Lincoln.

Needs Approached by 2 illustrators/year. Works with 2 illustrators and 2 designers/year. Prefers local designers only. Uses freelancers mainly for illustration; also for airbrushing, catalog and humorous illustration, lettering. 30% of work is with print ads. 75% of design demands knowledge of Photoshop, Illustrator, FreeHand. 60% of illustration demands knowledge of FreeHand, Photoshop, Illustrator.

First Contact & Terms Designers/Illustrators: Send query letter with brochure. Send follow up postcard samples every 6 months. Accepts disk submissions compatible with original illustration files or Photoshop files. Samples are filed or returned by SASE. Responds only if interested. Will contact artist for portfolio review of b&w, color, final art, tearsheets if interested. Pays by the project. Rights purchased vary according to project and are negotiable. Finds artists through word of mouth.

Ⓝ IDENTITY CENTER

1110 Idaho St., Carol Stream IL 60188. E-mail: wk@genericsign.com. Web site: www.genericsign. com. **President:** Wayne Kosterman. Number of employees: 2. Approximate annual billing:

$250,000. Specializes in brand and corporate identity, print communications and signage. Clients: corporations, hospitals, manufacturers and banks. Professional affiliations: AIGA, American Center for Design, SEGD.

Needs Approached by 40-50 freelancers/year. Works with 4 freelance illustrators and 4 designers/year. Prefers 3-5 years of experience minimum. Uses freelancers for editorial and technical illustration, retouching and lettering. 50% of freelance work demands knowledge of QuarkXPress, Photoshop, Illustrator and Dreamweaver.

First Contact & Terms Designers: Send résumé and photocopies. Illustrators: Send postcard samples, color photocopies or other nonreturnable samples. To show a portfolio, send photocopies or e-mail. "Do not send samples you need back without checking with us first." Pays for design by the hour, $20-50. Pays for illustration by the project, $200-5,000. Considers client's budget, skill and experience of artist, and how work will be used when establishing payment. Rights purchased vary according to project.

Tips "Not interested in amateurs or part-timers."

IMAGE ASSOCIATES INC.

Keystone Office Park, 615 Davis Dr., Suite 600, Morrisville NC 27560. (919)876-6400. Fax: (919)876-7064. E-mail: carla@imageassociates.com. Web site: www.imageassociates.com. **President:** Carla Davenport. Estab. 1984. Number of employees: 35. Marketing communications group offering advanced Web-based solutions, multimedia and print. Visual communications firm specializing in computer graphics and AV, multi-image, interactive multimedia, Internet development, print and photographic applications.

Needs Approached by 10 freelancers/year. Works with 4 freelance illustrators and 4 designers/year. Prefers freelancers with experience in Web, CD-ROM and print. Works on assignment only. Uses freelancers mainly for Web design and programming; also for print ad design and illustration and animation. 90% of freelance work demands skills in Flash, HTML, DHTML, ASP, Photoshop and Macromind Director.

First Contact & Terms Send query letter with brochure, résumé and tearsheets. Samples are filed or are returned by SASE if requested by artist. Responds only if interested. To show portfolio, mail roughs, finished art samples, tearsheets, final reproduction/product and slides. Pays for assignments by the project, $100 minimum. Considers complexity of project, client's budget, and how work will be used when establishing payment. Rights purchased vary according to project.

☒ IMAGINASIUM, INC.

110 S. Washington St., Green Bay WI 54301-4211. (920)431-7872. Fax: (920)431-7875. E-mail: joe@imaginasium.com. Web site: www.imaginasium.com. **Executive Creative Director:** Joe Bergner. Estab. 1992. Number of employees: 18. Approximate annual billing: $2 million. Strategic marketing communications firm. Specializes in brand development, graphic design, advertising. Product specialties are business to business retail. Current clients include Wisconsin Public Service, Manitowoc Crane, Ansul. Client list available upon request. Professional affiliations: Green Bay Advertising Federation, Second Wind Network.

Needs Approached by 50 illustrators and 25 designers/year. Works with 5 illustrators and 2 designers/year. Prefers local designers. Uses freelancers mainly for overflow; also for brochure illustration and lettering. 15-20% of work is with print ads. 100% of design and 88% of illustration demands skills in Photoshop, QuarkXPress and Illustrator.

First Contact & Terms Designers: Send query letter with brochure, photographs and tearsheets. Illustrators: Send sample of work with follow up every 6 months. Accepts Macintosh disk submissions of above programs. Samples are filed and are not returned. Will contact artist for portfolio review of color tearsheets, thumbnails and transparencies if interested. Pays for design by the

hour, $50-75. Pays for illustration by the project. Rights purchased vary according to project. Finds artists through submissions, word of mouth, Internet.

IMPACT COMMUNICATIONS GROUP

18627 Brookhurst St., #4200, Fountain Valley CA 92708. (714)963-0080. E-mail: info@impactgrou p.com. Web site: www.impactgroup.com. **Creative Director:** Brad Vinikow. Estab. 1983. Number of employees: 15. Marketing communications firm; full-service multimedia firm. Specializes in electronic media, business-to-business and print design. Current clients include Yamaha Corporation, Prudential, Isuzu. Professional affiliations: IICS, NCCC and ITVA.

Needs Approached by 12 freelancers/year. Works with 12 freelance illustrators and 12 designers/ year. Uses freelancers mainly for illustration, design and computer production; also for brochure and catalog design and illustration, multimedia and logos. 10% of work is with print ads. 90% of design and 50% of illustration demands knowledge of Photoshop, QuarkXPress, Illustrator and Macro Mind Director.

First Contact & Terms Designers: Send query letter with photocopies, photographs, résumé and tearsheets. Illustrators: Send postcard sample. Samples are filed and are not returned. Will contact artist for portfolio review if interested. Portfolio should include b&w and color final art, photographs, photostats, roughs, slides, tearsheets and thumbnails. Pays for design and illustration by the project, depending on budget. Rights purchased vary according to project. Finds artists through sourcebooks and self-promotion pieces received in mail.

Tips "Be flexible."

N INK INC.

3137 32nd Ave. S., Suite 222, Fargo ND 58103-6159. (701)241-9204 or (800)736-0688. Fax: (701)239-1748. E-mail: info@inkinconline.com. Web site: www.directmailforprinters.com; www .Web sitesforprinters.com. **Contact:** Mike Stevens. Number of employees: 11. Approximate annual billing: $600,000. Newsletter printer and publisher; full-service multimedia firm. Specializes in direct mail advertising and newsletters. "We produce industry-specific newsletters that local printers re-sell to small businesses in their area." Current clients include more than 700 printers nationwide.

Needs Approached by 12-15 freelancers/year. Works with 5 freelance illustrators and 4 designers/ year. Uses freelancers mainly for illustration and line art; also for brochure design and illustration, lettering and logos. 80% of work is with newsletter design and advertisements. Knowledge of PageMaker and Photoshop helpful but not necessary.

First Contact & Terms Send query letter with photocopies. Samples are filed. "Will return if necessary." Responds in 1 month. Portfolio review not required. Pays for design and illustration by the project. Rights purchased vary according to project.

Tips "Do good work, be friendly, meet deadlines, and charge small-town prices. We can't afford New York City rates. We buy lots of artwork and design. Our artists love us because we're easy to work with and pay fast!"

INNOVATIVE DESIGN & GRAPHICS

1327 Greenleaf St., Evanston IL 60202-1152. (847)475-7772. Fax: (847)475-7784. E-mail: info@id gevanston.com. Web site: www.idgevanston.com. **Contact:** Tim Sonder. Clients: corporate communication and marketing departments.

Needs Works with 1-5 freelance artists/year. Prefers local artists only. Uses artists for editorial and technical illustration and marketing, advertising and spot illustration. Illustrators should be knowledgeable in Adobe Illustrator and Photoshop.

First Contact & Terms Send query letter with résumé or brochure showing art style, tearsheets, photostats, slides and photographs. Will contact artist for portfolio review if interested. Pays for

illustration by the project, $200-1,000 average. Considers complexity of project, client's budget and turnaround time when establishing payment. Interested in buying second rights (reprint rights) to previously published work.

Tips "Interested in meeting new illustrators, but have a tight schedule. Looking for people who can grasp complex ideas and turn them into high-quality illustrations. Ability to draw people well is a must. Do not call for an appointment to show your portfolio. Send nonreturnable tearsheets or self-promos, and we will call you when we have an appropriate project for you."

JUDE STUDIOS

8000 Research Forest, Suite 115-266, The Woodlands TX 77382. (281)364-9366. Fax: (281)364-9529. E-mail: jdollar@judestudios.com. Web site: www.judestudios.com. **Creative Director:** Judith Dollar. Estab. 1994. Number of employees: 2. Design firm. Specializes in printed material, brochure, trade show, collateral. Product specialties are industrial, restaurant, homebuilder, financial, high-tech business to business event marketing materials. Professional affiliations: Art Directors of Houston, AAF.

Needs Approached by 20 illustrators and 6 designers/year. Works with 10 illustrators and 2 designers/year. Prefers local designers only. Uses freelancers mainly for newsletter, logo and brochures; also for airbrushing; brochure design and illustration; humorous, medical, technical illustration; lettering, logos, mechanicals and retouching. 90% of design demands skills in Free-Hand, Photoshop, QuarkXPress. 30% of illustration demands skills in Illustrator and QuarkXPress.

First Contact & Terms Designers: Send brochure, photocopies, photographs, photostats, résumé, tearsheets. Illustrators: Send query letter with brochure, photocopies, photographs or tearsheets. Accepts disk submissions. Send TIFF, EPS, PDF or JPEG files. Samples are filed and are not returned. Art director will contact artist for portfolio review if interested. Pays by the project; varies. Negotiates rights purchased. Finds artists through *American Show Case*, *Workbook*, *RSVP* and artist's reps.

Tips Wants freelancers with good type usage who contribute to concept ideas. "We are open to designers and illustrators who are just starting their careers."

KAUFMAN RYAN STRAL INC.

650 N. Dearborn St., Suite 600, Chicago IL 60610. (312)649-9408. Fax: (312)649-9418. E-mail: lkaufman@bworld.com. Web site: www.bworld.com. **President/Creative Director:** Laurence Kaufman. Estab. 1993. Number of employees: 7. Ad agency. Specializes in all materials in print and Web site development. Product specialty is business-to-business. Client list available upon request. Professional affiliations: American Israel Chamber of Commerce.

Needs Approached by 30 freelancers/year. Works with 3 designers/year. Prefers local freelancers. Uses freelancers for design, production, illustration and computer work; also for brochure, catalog and print ad design and illustration, animation, mechanicals, retouching, model-making, posters, lettering and logos. 5% of work is with print ads. 50% of freelance work demands knowledge of QuarkXPress, FrontPage or Page Mill, Photoshop or Illustrator.

First Contact & Terms Send e-mail with with résumé and JPEGs. Responds only if interested. Will contact artist for portfolio review if interested. Portfolio should include b&w and color roughs and final art. Pays for design by the hour, $40-120; or by the project. Pays for illustration by the project, $75-8,000. Buys all rights. Finds artists through sourcebooks, word of mouth, submissions.

LARRY KERBS STUDIOS

3101 Old Pecos Trail, Unit 685, Santa Fe NM 87505-9547. (505)988-5904. Fax: (505)988-9107. E-mail: kerbscreative@earthlink.net. **Contact:** Larry Kerbs. Specializes in sales promotion design,

ad work and placement, annual reports, corporate identity, publications and technical illustration. Clients: industrial, chemical, medical, insurance, travel, PR.

Needs Works with computer production people, 1 illustrator and 1 designer/month. Uses artists for direct mail, layout, illustration, technical art, annual reports, trade magazine ads, product brochures and direct mail. Needs computer-literate freelancers; prefers those with strong design training. Needs editorial and technical illustration. Looks for realistic editorial illustration, montages, 2-color and 4-color.

First Contact & Terms Mail samples or call for interview. Prefers b&w or color line drawings, renderings, layout roughs and previously published work as samples. Provide business card and résumé to be kept on file for future assignments. Negotiates payment by the project.

Tips "Strengthen typographic knowledge and application; know computers, production and printing in depth to be of better service to yourself and to your clients."

KIZER INCORPORATED ADVERTISING & COMMUNICATIONS

4513 Classen Blvd., Oklahoma City OK 73118. (405)858-4906. E-mail: bill@kizerincorporated.com. Web site: www.kizerincorporated.com. **Principal:** William Kizer. Estab. 1998. Number of employees: 3. Ad agency. Specializing in magazine ads, print ads, copywriting, design/layout, collateral material. Professional affiliations: OKC Ad Club, AMA, AIGA.

Needs Approached by 20 illustrators/year. Works with 3 illustrators and 3 designers/year. 50% of work is with print ads. 100% of design demands knowledge of InDesign, FreeHand, Photoshop. 50% of illustration demands knowledge of FreeHand, Photoshop.

First Contact & Terms Designers: Send or e-mail query letter with samples. Illustrators: Send or e-mail query letter with samples. Accepts disk submissions compatible with FreeHand or Photoshop file. Samples are filed and are not returned. Responds only if interested. To show portfolio, artist should follow up with call. Portfolio should include "your best work." Pays by the project. Rights purchased vary according to project. Finds artists through agents, sourcebooks, online services, magazines, word of mouth, submissions.

KJD TELEPRODUCTIONS

30 Whyte Dr., Voorhees NJ 08043. (856)751-3500. Fax: (856)751-7729. E-mail: larry@broadcastcenterstudios.com. Web site: www.broadcastcenterstudios.com. **President:** Larry Scott. Estab. 2007. Ad agency; full-service multimedia firm. Specializes in magazine, radio and television. Current clients include Hartcourt Books, WCAU 10, Philadelphia, Cardinal Freight and Transport.

Needs Works with 10 freelance illustrators and 5 designers/year. Prefers freelancers with experience in TV. Works on assignment only. Uses freelancers for storyboards, animatics, animation, TV/film graphics; also for multimedia projects. 90% of freelance work demands knowledge of Adobe Creative Suite CS, Apple Final Cut Pro HD, including motion.

First Contact & Terms Mail query with DVD/CD as samples. Samples are filed or are returned by SASE. Accepts submissions on disk from all applications. Send EPS files. Responds only if interested. Pays for design and illustration by the project; rate varies. Buys first rights or all rights.

Ⓝ LEIMER CROSS DESIGN CORPORATION

12 Auli'i Dr., Makawao HI 96768. E-mail: kerry@leimercross.com. Web site: www.leimercross.com. **Creative Director:** Kerry Leimer. Principal: Dorothy Cross. Estab. 1983. Specializes in annual reports, publication design, marketing brochures. Clients: corporations and service companies. Current clients include Expedia, Gardenburger, Microsoft, U.S. Bancorp.

Needs Approached by 75 freelance artists/year. Works with 4-5 illustrators and 6-8 designers/year. Prefers artists with experience in working for corporations. Uses freelance illustrators mainly for annual reports, lettering and marketing materials. Uses freelance designers mainly for "layout per instructions," production; also for brochure illustration, mechanicals, charts/graphs.

First Contact & Terms Send query letter with résumé, tearsheets and photographs. Samples are filed. Responds only if interested. To show a portfolio, mail thumbnails, roughs, tearsheets and photographs. Pays for design by the hour or by the project. Pays for illustration by the project. Rights purchased vary according to project.

⃞Ⓝ ⃞Ⓘ LEKASMILLER

1460 Maria Lane, Suite 260, Walnut Creek CA 94596. (925)934-3971. Fax: (925)934-3978. E-mail: tina@lekasmiller.com. Web site: www.lekasmiller.com. **Production Manager:** Denise Fuller. Estab. 1979. Specializes in annual reports, corporate identity, advertising, direct mail and brochure design. Clients: corporate and retail. Current clients include Cost Plus World Market and Interhealth.

Needs Approached by 80 freelance artists/year. Works with 1-3 illustrators and 5-7 designers/year. Prefers local artists only with experience in design and production. Works on assignment only. Uses artists for brochure design and illustration, mechanicals, direct mail design, logos, ad design and illustration. 100% of freelance work demands knowledge of InDesign, Photoshop and Illustrator.

First Contact & Terms Designers/Illustrators: E-mail PDF or résumé and portfolio. Responds only if interested. Considers skill and experience of artist when establishing payment. Negotiates rights purchased.

⃞Ⓝ LUCY LESIAK DESIGN

575 W. Madison St., Suite 2809, Chicago IL 60661. (312)902-4533. Current clients include Scott Foresman, McGraw-Hill, World Book. Client list available upon request.

Needs Approached by 20 freelance artists/year. Works with 3-5 illustrators and 1-2 designers/year. Works on assignment only. Uses illustrators mainly for story or cover illustration; also editorial, technical and medical illustration. Uses designers mainly for text design; also for book design, mechanicals and logos. 100% of design work demands knowledge of Creative Suite 2.

First Contact & Terms Send postcard sample or query letter with photocopies, brochure and résumé. Accepts disk submissions compatible with Mac Illustrator 7.0 and QuarkXPress 4.1. Samples are filed. Will contact artist for portfolio review if interested. Portfolio should include final art, color tearsheets and transparencies. Pays for design by the hour, $30-50. Pays for illustration by the project, $30-3,000. Rights purchased vary according to project. Finds artists through agents, sourcebooks and self-promotions.

LIEBER BREWSTER DESIGN, INC.

740 Broadway, Suite 1101, New York NY 10003. (212)614-1221. Web site: www.lieberbrewster.com. **Principal:** Anna Lieber. Estab. 1988. Specializes in strategic marketing. Clients: small and midsize businesses, fortune 500s. Client list available upon request. Professional affiliations: Toastmasters, Ad Club-NY.

Needs Approached by more than 100 freelancers/year. Works on assignment only. Uses freelancers for HTML programming, multimedia presentations, Web development, logos, marketing programs, audiovisual materials.

First Contact & Terms Send query letter with résumé, tearsheets and photocopies. Will contact artist for portfolio review if interested.

⃞Ⓝ ⃞Ⓘ LIGGETT-STASHOWER

1228 Euclid Ave., Suite 300, Cleveland OH 44115. (216)348-8500. Fax: (216)736-8118. E-mail: artbuyer@liggett.com. Web site: www.liggett.com. **Art Buyer:** Tom Federico. Estab. 1932. Ad agency; full-service multimedia firm. Works in all formats. Handles all product categories. Current clients include Sears Optical, Forest City Management, Cedar Point, Crane Performance Siding, Henkel Consumer Adhesives, Ohio Lottery and Timber Tech.

Needs Approached by 120 freelancers/year. Works with freelance illustrators and designers. Prefers local freelancers. Works on assignment only. Uses freelancers mainly for brochure, catalog and print ad design and illustration, storyboards, slide illustration, animatics, animation, retouching, billboards, posters, TV/film graphics, lettering and logos. Needs computer-literate freelancers for illustration and production. 90% of freelance work demands skills in QuarkXPress, InDesign, FreeHand, Photoshop or Illustrator.

First Contact & Terms Send query letter. Samples are filed and are not returned. Responds only if interested. To show portfolio, mail tearsheets and transparencies. Pays for design and illustration by the project. Negotiates rights purchased.

Tips "Please consider that art buyers and art directors are very busy and receive at least 25 mailings per day from freelancers looking for work opportunities. We might have loved your promo piece, but chances of us remembering it by your name alone when you call are slim. Give us a hint—'it was red and black,' or whatever. We'd love to discuss your piece, but it's uncomfortable if we don't know what you're talking about."

LINEAR CYCLE PRODUCTIONS

P.O. Box 2608, North Hills CA 91393-0608. Phone/fax: (818)347-9880. E-mail: lcp@wgn.net. Web site: www.linearproductions.com. **Producer:** Rich Brown. Production Manager: R. Borowy. Estab. 1980. Number of employees: 30. Approximate annual billing: $200,000. AV firm. Specializes in audiovisual sales and marketing programs and also in teleproduction for CATV. Current clients include Katz, Inc. and McDave and Associates.

Needs Works with 7-10 freelance illustrators and 7-10 designers/year. Prefers freelancers with experience in teleproductions (broadcast/CATV/non-broadcast). Works on assignment only. Uses freelancers for storyboards, animation, TV/film graphics, editorial illustration, lettering and logos. 10% of work is with print ads. 25% of freelance work demands knowledge of FreeHand, Photoshop or Tobis IV.

First Contact & Terms Send query letter with résumé, photocopies, photographs, slides, transparencies, video demo reel and SASE. Samples are filed or are returned by SASE if requested by artist. Responds only if interested. To show portfolio, mail audio/videotapes, photographs and slides; include color and b&w samples. Pays for design and illustration by the project, $100 minimum. Considers skill and experience of artist, how work will be used, and rights purchased when establishing payment. Negotiates rights purchased. Finds artists through reviewing portfolios and published material.

Tips "We see a lot of sloppy work and samples; portfolios in fields not requested or wanted; poor photos, photocopies, graphics, etc. Make sure your materials are presentable."

LOHRE & ASSOCIATES

2330 Victory Pkwy., Suite 701, Cincinnati OH 45206. (513)961-1174. E-mail: chuck@lohre.com. Web site: www.lohre.com. **President:** Chuck Lohre. Number of employees: 8. Approximate annual billing: $1 million. Ad agency. Specializes in industrial firms. Professional affiliation: SMPS.

Needs Approached by 24 freelancers/year. Works with 10 freelance illustrators and 10 designers/year. Works on assignment only. Uses freelance artists for trade magazines, direct mail, P-O-P displays, multimedia, brochures and catalogs. 100% of freelance work demands knowledge of PageMaker, FreeHand, Photoshop and Illustrator.

First Contact & Terms Send postcard sample or e-mail. Accepts submissions on disk, any Mac application. Pays for design and illustration by the hour, $10 minimum.

Tips Looks for artists who "have experience in chemical and mining industry, can read blueprints, and have worked with metal fabrication." Also needs "Macintosh-literate artists who are willing to work at office, during day or evenings."

LOMANGINO STUDIO INC.

1042 Wisconsin Ave. NW, Washington DC 20007. (202)338-4110. E-mail: info@lomangino.com. Web site: www.lomangino.com. **President:** Donna Lomangino. Estab. 1987. Number of employees: 6. Specializes in annual reports, corporate identity, Web site and publication design. Clients: corporations, nonprofit organizations. Client list available upon request. Professional affiliations: AIGA.

Needs Approached by 25-50 freelancers/year. Works with 1 freelance illustrator/year. Uses illustrators and production designers occasionally for publication; also for multimedia projects. 99% of design work demands skills in Illustrator, Photoshop and QuarkXPress.

First Contact & Terms Send postcard sample of work or URL. Samples are filed. Accepts disk submissions, but not preferable. Will contact artist for portfolio review if interested. Pays for design and illustration by the project. Finds artists through sourcebooks, word of mouth and studio files.

Tips "Please don't call. Send samples or URL for consideration."

☙ LORENC & YOO DESIGN, INC.

109 Vickery St., Roswell GA 30075. (770)645-2828. Fax: (770)998-2452. E-mail: jan@lorencyoode sign.com. Web site: www.lorencyoodesign.com. **President:** Mr. Jan Lorenc. Specializes in architectural signage design; environmental, exhibit, furniture and industrial design. Clients: corporate, developers, product manufacturers, architects, real estate and institutions. Current clients include Gerald D. Hines Interests, MCI, Georgia-Pacific, IBM, Simon Property Company, Mayo Clinic. Client list available upon request.

Needs Approached by 25 freelancers/year. Works with 5 illustrators and 10 designers/year. Local senior designers only. Uses freelancers for design, illustration, brochures, catalogs, books, P-O-P displays, mechanicals, retouching, airbrushing, posters, direct mail packages, model-making, charts/graphs, AV materials, lettering and logos. Needs editorial and technical illustration. Especially needs architectural signage and exhibit designers. 95% of freelance work demands knowledge of QuarkXPress, Illustrator or FreeHand.

First Contact & Terms Send brochure, URL, or CD, résumé and samples to be kept on file. Prefers digital files as samples. Samples are filed or are returned. Call or write for appointment to show portfolio of thumbnails, roughs, original/final art, final reproduction/product and color photostats and photographs. Pays for design by the hour, $40-100; by the project, $250-20,000; by the day, $80-400. Pays for illustration by the hour, $40-100; by the project, $100-2,000; by the day, $80-400. Considers complexity of project, client's budget, and skill and experience of artist when establishing payment.

Tips "Sometimes it's more cost-effective to use freelancers in this economy, so we have scaled down permanent staff."

☙ JODI LUBY & COMPANY, INC.

808 Broadway, New York NY 10003. (212)473-1922. E-mail: jluby@jodiluby.com. Web site: www .jodiluby.com. **President:** Jodi Luby. Estab. 1983. Specializes in corporate identity, packaging, promotion and direct marketing design. Clients include magazines and corporations.

Needs Approached by 10-20 freelance artists/year. Works with 5-10 illustrators/year. Uses freelancers for production and Web production. 100% of freelance work demands computer skills.

First Contact & Terms Send postcard sample or query letter with résumé and photocopies. Samples are not filed and are not returned. Will contact artist for portfolio review if interested. Portfolio should include thumbnails, roughs, b&w and color printed pieces. Pays for production by the hour, $25 minimum; by the project, $100 minimum. Pays for illustration by the project, $100 minimum. Rights purchased vary according to project. Finds artists through word of mouth.

Todd LeMieux

An award-winning designer
on getting and keeping clients

Graphic designer Todd LeMieux says his first big break was losing his job. "I worked for a small ad agency whose owner suffered some serious health concerns. He abruptly closed the agency, and for the first time in my life I was unemployed. I called a handful of friends in the industry and a few small freelance clients I had on the side and told them, 'Hey, I have a lot more time on my hands if you need any graphic design work.' To my surprise, the jobs started coming in."

And they kept coming in. These days LeMieux keeps busy with clients who range from local businesses to Fortune 500 companies, and include everyone from Lego to Motorola to the Connecticut Lottery. He's also won several impressive awards, including an American Graphic Design Award for logo design, and awards from the Advertising Club of Western Massachusetts and the Hartford Ad Club.

LeMieux's career success is especially impressive considering he originally had not planned on working as a designer. "I had gone through two other majors in college," he says, "and I was taking a core (required) course that happened to be an art course. I loved it, and I was doing so well the instructor assumed I was an art major." It was that professor who helped LeMieux realize art was the right path for him. "She convinced me that I had what it took and encouraged me to join the Art Department. I did . . . and here I am!"

One of the exciting benefits of working as a graphic designer, says LeMieux, is the ability to work with an interesting variety of clients and in a wide variety of media. "My portfolio includes samples of advertising and design executed in just about every form of media, including print, outdoor and online. I feel equally comfortable designing for banks, colleges and insurance companies as I do for microbreweries, record labels and art festivals. My portfolio reflects my diverse client base."

As LeMieux has grown his business, he's developed many ways of reaching new clients and breaking into new types of markets for his design work. "I run advertisements; I send direct mail (postcards) and e-mail blasts; I cold call," he says. "I am fortunate to have benefited greatly from word of mouth and referrals, but also from doing some marketing for myself—online and in the 'real' world with traditional advertising and direct mail."

"But," emphasizes LeMieux, "the best thing you can do is network. Don't be a pest about it, but there is an art to networking that, if you learn it, can serve you well." While networking is a skill that many artists, especially those just beginning their professional careers, have difficulty with, LeMieux claims it is something anyone can do successfully. The trick, he believes, is talking to as many people as possible. "It's a numbers game to a degree," he says. "The more people you know, and the more business events and online resources you can participate in and plug into, the more likely you are to find out about possible projects,

and the more visible you will be when a potential client is thinking about who to call.''

And of course, timing is key. There is a right time to network, and a wrong time. ''I'm always open to networking possibilities,'' says LeMieux, ''but I try not to be pushy, greedy or forceful. I would not solicit business at a social function like a wedding.''

Many artists also find that once they start building a client list, they are able to grow their business by asking for referrals from people with whom they've worked. This is another way LeMieux has been able to expand his own clientele. ''I do occasionally ask or remind clients to refer me,'' he says, ''especially if they're particularly enthusiastic about my work. But I have to say I've been very lucky. I think success comes from a combination of the quality of your work, your personality, and how many people you know.''

So what is the best way to ask for referrals, especially for people who prefer doing their art over doing business? Besides the obvious, which is directly asking for referrals, LeMieux believes the answer is providing your clients with top-quality work. ''I'm sure in sales there's a proper 'technique' for getting referrals, but I can't say I have one or know of a certain way to get referrals. Be good at what you do and always strive to get better and learn more. Develop yourself (and not just your design skills, but yourself as an individual), because the more life experience you can bring into your work, the better it will be.''

LeMieux's own ability to serve his diverse clientele flows from broad sources of inspiration. ''Design is everywhere in our world,'' he says. Of course, it takes a lot of research and imagination to fulfill each individual client's needs.

When it comes to creating ads, logos and other designs for his clients, LeMieux takes the time to explore every design option that could possibly meet their business goals. ''I start with input from the client, getting the usual info about target audience, the purpose or goal for the piece being created, and various other specifics like quantity and budget. All of these elements affect design decisions,'' says LeMieux.

''Then I begin to research, gather image and style inspirations, and start to develop some visual directions to then work out various design solutions. Sometimes I sketch things out and make notes; sometimes I jump right to the computer.'' The Mac was just becoming part of the graphic design toolset when LeMieux was in college, so he knows how to work with paper and pen, or mouse. ''But ideas and thinking always come first,'' he says. ''The computer is a tool, and software features—all the bells and whistles and power that we have at our fingertips—are not graphic design or ideas; they are a means to an end.''

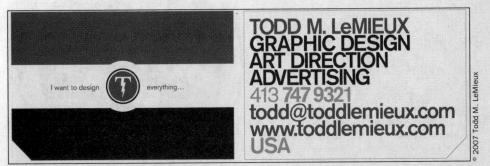

Todd LeMieux wanted his business card to stand out, so he made it slightly oversized; ''The little cut corner was another way of distinguishing it,'' he says. The lightning bolt ''T'' is his ''personal mark'' and was derived from a nickname he had in college.

LeMieux created this sexy design for a promotional event for a newspaper.

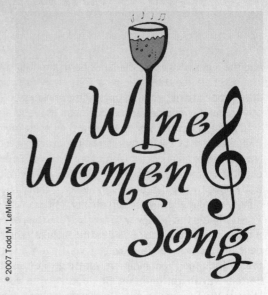

© 2007 Todd M. LeMieux

As he creates work for his clients, LeMieux sticks to a basic design philosophy, which has served him well. "I like to think my work is clean, simple, pure design. No extraneous 'stuff.' No design just for the sake of design. Less is more," he says. "I usually start with several different ideas/directions and continuously refine and narrow the focus, removing unnecessary elements until the final solution is the distillation of all the right elements."

During the creative process, LeMieux also takes time to investigate the market. "I do research not only to see what's out there for inspiration," he says, "but also to avoid creating something that may already exist. A unique solution is important, particularly when considering copyright issues."

Determining what fees to charge is part of the process, too. "I usually get as much information as possible about a project from the client and then provide an estimate based on that," says LeMieux. His own fees vary "depending on the project and the client," and he frequently consults The American Institute for Graphic Arts, which publishes an annual

LeMieux designed this logo for a small local business with a large customer base. "They were ready for something professional that would help brand them in the marketplace as they do a lot of advertising," says LeMieux. The logo was selected for inclusion in the book *Logo Lounge 3*, published by Rockport Publishers in association with LogoLounge.com.

© 2007 Todd M. LeMieux

salary survey for what rates are typical for different positions, types of work and regions of the country. And for some of his clients, LeMieux is willing to negotiate, especially if it's for a good cause. "I do a fair amount of pro bono work for causes I believe in, and I have donated or steeply discounted my fee for a startup business or a friend's business."

LeMieux's favorite job so far has been one that combined two of his loves: graphic design and music. For this project, he was hired to design a logo for a new record label [Cordless Recordings] owned by the Warner Music Group, as well as several music CDs for bands on the label. Seeing his own design work in public is "pretty cool," he says. "It's still really neat to see my work out there in the world. I've seen CDs I've designed in the racks at Tower Records, Virgin Megastores, Best Buy and other places that sell music. Sometimes I overhear someone comment favorably on the design. It's a great feeling, very validating."

Of course, when working with other people, sometimes things don't always go well. LeMieux has had encounters with a few challenging customers. "Generally speaking," he explains, "clients who don't know what they want are difficult to handle. When I hear 'I'll know it when I see it,' I cringe. A client who says that may not be sophisticated enough

"A happy dead fish. . . just the thing for an awesome, small local fish market," says LeMieux of his award-winning design. This logo won an American Graphic Design Award, and was thus selected for inclusion in the book *American Graphic Design Awards No. 4.*

yet to work with a professional graphic designer (which can be a lot of small or startup businesses), and/or they haven't done their homework in regards to defining a particular project, which only makes my job more difficult.''

When it comes to working with tough clients, LeMieux offers the following advice: ''Sometimes clients need education and explanation in order to 'see the light.' But you have to be open to input from a client, too. It can be invaluable, giving you another perspective, even if that perspective isn't backed by the same design experience you possess. If I feel strongly about it, I try to stand my ground by explaining the decision-making process that led me to a certain design choice and why I still think it's the best approach.''

Of course, there are times when clients either just don't get it or become too demanding to work with. When this happens, ''let them go,'' says LeMieux. ''They wouldn't hesitate to do the same to you if they weren't happy with something. Life is too short, and wasting time dealing with a difficult client has what's called an opportunity cost associated with it. You're potentially missing out on other opportunities while your energy and focus are directed toward that problem client/situation.''

One tough client he won't fire, jokes LeMieux, is himself. He creates all his own promotional material, including postcards and his Web site (www.toddlemieux.com), which is a valuable tool for potential clients. The site includes his résumé, several samples from his portfolio, and, most importantly, contact information. Yet working for himself is never easy, he says. ''Between being my own toughest critic and being too busy to do any work for myself, designing for my business can be challenging.''

But perhaps it is this high level of standards LeMieux has for himself that has helped him earn several awards from the design community. ''Hopefully, an original design solution made my work stand out,'' he says. ''It feels great to win, especially because it's usually a jury of my peers—people in the graphic design and advertising industries—making the selections. For fellow designers with presumably high standards to praise my work is very gratifying.''

LeMieux advises artists and designers who want to build a successful career in the advertising field to ''live your life to its fullest! Experience all that you can, and let your work be inspired by all those experiences. Find that inspiration everywhere, in everything, and from every person you meet. Design is all around us, from the pattern in the ceiling tiles to the newspaper on your desk, to the graphics on the instrument panel of your car, to the signs on the streets. It surrounds us. Take it all in and add it to your visual vocabulary.''

—Donya Dickerson

N I JACK LUCEY/ART & DESIGN

84 Crestwood Dr., San Rafael CA 94901. (415)453-3172. **Contact:** Jack Lucey. Estab. 1960. Art agency. Specializes in annual reports, brand and corporate identity, publications, signage, technical illustration and illustrations/cover designs, courtroom art (trial drawing). Clients: businesses, ad agencies and book publishers. Current clients include U.S. Air Force, California Museum of Art & Industry, ABC-TV, CBS-TV, NBC-TV, CNN, Associated Press. Client list available upon request. Professional affiliations: Art Directors Club; College of Marin Alumni, Academy of Art Alumni, San Francisco, CA.

Needs Approached by 20 freelancers/year. Works with 1-2 freelance illustrators/year. Uses mostly local freelancers. Uses freelancers mainly for type and airbrush; also for lettering for newspaper work.

First Contact & Terms Query. Prefers photostats and published work as samples. Provide brochures, business card and résumé to be kept on file. Portfolio review not required. Originals are

not returned to artist at job's completion. Requests work on spec before assigning a job. Pays for design by the project.

Tips "Show variety in your work. Many samples I see are too specialized in one subject, one technique, one style (such as air brush only, pen & ink only, etc.). Subjects are often all similar, too."

THE M. GROUP

2512 E. Thomas Rd., Suite 12, Phoenix AZ 85016. (480)998-0600. Fax: (480)998-9833. E-mail: gary@themgroupinc.com. Web site: www.themgroupinc.com. **Contact:** Gary Miller. Estab. 1987. Number of employees: 7. Approximate annual billing: $2.75 million. Strategic visual communications firm. Specializes in annual reports, corporate identity, direct mail, package design, advertising. Clients: corporations and small business. Current clients include American Cancer Society, BankOne, Dole Foods, Giant Industries, Motorola, Subway.

Needs Approached by 50 freelancers/year. Works with 5-10 freelance illustrators/year. Uses freelancers for ad, brochure, poster and P-O-P illustration. 95% of freelance work demands skills in Illustrator, Photoshop and QuarkXPress.

First Contact & Terms Send postcard sample or query letter with samples. Samples are filed or returned by SASE if requested by artist. Responds only if interested. Request portfolio review in original query. Artist should follow up. Portfolio should include b&w and color final art, photographs and transparencies. Rights purchased vary according to project. Finds artists through publications (trade) and reps.

Tips Impressed by "good work, persistence, professionalism."

TAYLOR MACK ADVERTISING

509 W. Spring #450, Fayetteville AR 72071. (479)444-7770. Fax: (479)444-7977. E-mail: Greg@TaylorMack.com. Web site: www.TaylorMack.com. **Managing Director:** Greg Mack. Estab. 1990. Number of employees: 16. Approximate annual billing: $3 million. Ad agency. Specializes in collateral. Current clients include Cobb, Jose's, Rheem-Rudd, and Bikes, Blues and BBQ. Client list available upon request.

Needs Approached by 12 illustrators and 20 designers/year. Works with 4 illustrators and 6 designers/year. Uses freelancers mainly for brochure, catalog and technical illustration, TV/film graphics and Web page design. 30% of work is with print ads. 50% of design and illustration demands skills in Photoshop, Illustrator and InDesign.

First Contact & Terms Designers: E-mail Web site link. Samples are filed or are returned. Responds only if interested. Art director will contact artist for portfolio review of photographs if interested. Pays for design by the project or by the day; pays for illustration by the project, $10,000 maximum. Rights purchased vary according to project.

MICHAEL MAHAN GRAPHICS

P.O. Box 642, Bath ME 04530-0642. (207)443-6110. Fax: (207)443-6085. E-mail: ldelorme@mahangraphics.com. Web site: www.mahangraphics.com. **Contact:** Linda Delorme. Estab. 1986. Number of employees: 5. Approximate annual billing: $500,000. Design firm. Specializes in publication design—catalogs and direct mail. Product specialties are furniture, fine art and high tech. Current clients include Bowdoin College, Bath Iron Works and College of the Atlantic. Client list available upon request. Professional affiliations: G.A.G., AIGA and Art Director's Club-Portland, ME.

Needs Approached by 5-10 illustrators and 10-20 designers/year. Works with 2 illustrators and 2 designers/year. Uses freelancers mainly for production; also for brochure, catalog and humorous illustration and lettering. 5% of work is with print ads. 100% of design demands skills in Photoshop and QuarkXPress.

First Contact & Terms Designers: Send query letter with photocopies and résumé. Illustrators:

Send query letter with photocopies. Accepts disk submissions. Samples are filed and are not returned. Responds only if interested. Art director will contact artist for portfolio review of final art roughs and thumbnails if interested. Pays for design by the hour, $15-40. Pays for illustration by the hour, $18-60. Rights purchased vary according to project. Finds artists through word of mouth and submissions.

MANGAN HOLCOMB PARTNERS

2300 Cottondale Lane, Suite 300, Little Rock AR 72202. (501)376-0321. Fax: (501)376-6127. E-mail: chip@manganholcomb.com. Web site: www.manganholcomb.com. **Creative Director:** Chip Culpepper. Number of employees: 12. Approximate annual billing: $3 million. Marketing, advertising and PR firm. Clients: recreation, financial, tourism, retail, agriculture. Current clients include Citizens Bank, Farmers Bank & Trust, The Wilcox Group.

Needs Approached by 50 freelancers/year. Works with 8 freelance illustrators and 20 designers/year. Uses freelancers for consumer magazines, stationery design, direct mail, brochures/flyers, trade magazines and newspapers. Needs computer-literate freelancers for production and presentation. 30% of freelance work demands skills in Macintosh page layout and illustration software.

First Contact & Terms Query with samples, flier and business card to be kept on file. Include SASE. Responds in 2 weeks. Call or write for appointment to show portfolio of final reproduction/product. Pays by the project, $250 minimum.

MARKEFXS

449 W. 44th St., Suite 4-C, New York NY 10036. (212)581-4827. Fax: (212)265-9255. E-mail: mark@mfxs.com. Web site: www.mfxs.com. **Creative Director/Owner:** Mark Tekushan. Estab. 1985. Full-service multimedia firm. Specializes in TV, video, advertising, design and production of promos, show openings and graphics. Current clients include ESPN and HBO.

Needs Prefers freelancers with experience in television or advertising production. Works on assignment only. Uses freelancers mainly for design production; also for animation, TV/film graphics and logos. Needs computer-literate freelancers for design, production and presentation.

First Contact & Terms E-mail your Web site link or mail DVD/CD. Coordinating Producer will contact artist for portfolio review if interested. Pays for design by the hour, $25-50. Finds artists through word of mouth.

▣ MARKETAIDE SERVICES, INC.

P.O. Box 500, Salina KS 67402. (785)825-7161. Fax: (785)825-4697. E-mail: our-team@marketaide.com. Web site: www.marketaide.com. **Contact:** Production Manager. Estab. 1975. Full-service ad/marketing/direct mail firm. Clients: financial, industrial and educational.

Needs Prefers artists within one-state distance who possess professional expertise. Works on assignment only. Needs computer-literate freelancers for design, illustration and Web design. 90% of freelance work demands knowledge of QuarkXPress, Illustrator and Photoshop.

First Contact & Terms Send query letter with résumé, business card and samples to be kept on file. Samples not filed are returned by SASE only if requested. Responds only if interested. Write for appointment to show portfolio. Pays for design by the hour, $15-75 average. "Because projects vary in size, we are forced to estimate according to each job's parameters." Pays for illustration by the project.

Tips "Artists interested in working here should be highly polished in technical ability, have a good eye for design, and be able to meet all deadline commitments."

▤ ▣ MARKETING ART AND SCIENCE

(formerly Pageworks Communication Design, Inc.), Two Tamarac Plaza, 7535 E. Hampden Ave., Suite 350, Denver CO 80231. (303)337-7770. Fax: (303)337-7780. E-mail: info@marketingartands

cience.com. Web site: www.marketingartandscience.com. **CEO/Creative Director:** Michael Guzofsky. Art Director: Marcie Fischer. Estab. 1981. Specializes in annual reports, corporate identity, direct mail, product development and packaging and publication design. Clients: corporations, associations. Clients include Pradera, Kemmons Wilson Communities, and Cell, Concert American Homes, Esprit Homes, Miller Global Properties, Loup Development Company.

Needs Approached by 50 freelance artists/year. Works with 5 illustrators and 5 designers/year. Prefers local artists with computer experience. Works on assignment only. Uses freelance designers and illustrators for brochure, catalog, magazine, direct mail and ad design; brochure, catalog and ad illustration; logos; and charts/graphs. Needs computer-literate freelancers for design, illustration and production. 90% of freelance work demands knowledge of QuarkXPress, Illustrator or Photoshop.

First Contact & Terms Send query letter with brochure, résumé, tearsheets and photocopies. Samples are filed and are not returned. Responds only if interested. Write for appointment to show portfolio or mail appropriate materials. Portfolio should include thumbnails, roughs, b&w and color tearsheets, printed samples. Pays for design and illustration by the hour, $20-50; or by the project. Negotiates rights purchased.

⃟ MARKETING BY DESIGN

2012 19th St., Suite 200, Sacramento CA 95818. (916)441-3050. Web site: www.mbdstudio.com. **Creative Director:** Joel Stinghen. Estab. 1977. Specializes in corporate identity and brochure design, publications, direct mail, trade shows, signage, display and packaging. Clients: associations and corporations. Client list not available.

Needs Approached by 50 freelance artists/year. Works with 6-7 freelance illustrators and 1-3 freelance designers/year. Works on assignment only. Uses illustrators mainly for editorial; also for brochure and catalog design and illustration, mechanicals, retouching, lettering, ad design and charts/graphs.

First Contact & Terms Send query letter with brochure, résumé, tearsheets. Samples are filed and are not returned. Does not respond. Artist should follow up with call. Call for appointment to show portfolio of roughs, color tearsheets, transparencies and photographs. Pays for design by the hour, $10-30; by the project, $50-5,000. Pays for illustration by the project, $50-4,500. Rights purchased vary according to project. Finds designers through word of mouth; illustrators through sourcebooks.

MARTIN THOMAS, INC.

42 Riverside Dr., Barrington RI 02806-3612. (401)245-8500. Fax: (866)899-2710. E-mail: contact@ martinthomas.com. Web site: www.martinthomas.com. **Contact:** Martin K. Pottle. Estab. 1987. Number of employees: 12. Approximate annual billing: $7 million. Ad agency; PR firm. Specializes in industrial, business-to-business. Product specialties are plastics, medical and automotive. Professional affiliations: American Association of Advertising Agencies, Boston Ad Club.

Needs Approached by 10-15 freelancers/year. Works with 6 freelance illustrators and 10-15 designers/year. Prefers freelancers with experience in business-to-business/industrial. Uses freelancers mainly for design of ads, literature and direct mail; also for brochure and catalog design and illustration. 85% of work is print ads. 70% of design and 40% of illustration demands skills in QuarkXPress.

First Contact & Terms Send query letter with brochure and résumé. Samples are filed and are returned. Responds in 3 weeks. Will contact artist for portfolio review if interested. Portfolio should include b&w and color final art. Pays for design and illustration by the hour and by the project. Buys all rights. Finds artists through *Creative Black Book*.

Tips Impress agency by "knowing industries we serve."

N i MCANDREW ADVERTISING

210 Shields Rd., Red Hook NY 12571. (845)756-2276. E-mail: robertrmca@aol.com. **Art/Creative Director:** Robert McAndrew. Estab. 1961. Number of employees: 3. Approximate annual billing: $200,000. Ad agency. Clients: industrial and technical firms. Current clients include chemical processing equipment, electrical components.

Needs Approached by 10 freelancers/year. Works with 2 freelance illustrators and 2 designers/year. Uses mostly local freelancers. Uses freelancers mainly for design, direct mail, brochures/flyers and trade magazine ads. Needs technical illustration. Prefers realistic, precise style. Prefers pen & ink, airbrush and occasionally markers. 30% of work is with print ads. Freelance work demands computer skills.

First Contact & Terms Query with business card and brochure/flier to be kept on file. Samples are not returned. Responds in 1 month. Originals are not returned. Will contact artist for portfolio review if interested. Portfolio should include roughs and final reproduction. Pays for illustration by the project, $35-300. Pays for design by the project. Considers complexity of project, client's budget, and skill and experience of artist when establishing payment. Finds artists through sourcebooks, word of mouth and business cards in local commercial art supply stores.

Tips Artist needs "an understanding of the product and the importance of selling it."

N MCCAFFERY GOTTLIEB LANE LLC

370 Lexington Ave., New York NY 10017. (212)706-8400. Fax: (212)490-1923. E-mail: hjones@mglny.net. Web site: www.mglny.com. **Senior Art Director:** Howard Jones. Estab. 1983. Ad agency specializing in advertising and collateral material. Current clients include General Cigar (Macanudo, Cohiba, Partagas, Bolivar, Punch, Excalibur), Bluefly.com, General Electric, Nature's Best.

Needs Works with 6 freelance artists/year. Works on assignment only. Uses artists for brochure and print ad illustration, mechanicals, retouching, billboards, posters, lettering and logos. 80% of work is with print ads.

First Contact & Terms Send query e-mail letter with PDFs. Responds only if interested. To show a portfolio, mail appropriate materials or drop off samples. Portfolio should include original/final art, tearsheets and photographs; include color and b&w samples. Pays for illustration by the project, $75-5,000. Rights purchased vary according to project.

Tips "Send mailers and drop off portfolio."

N MCCLEAREN DESIGN

1201 Gallatin Ave., Nashville TN 37206. (615)226-8089. Fax: (615)226-9237. E-mail: mcclearendesign@comcast.net. **Owner:** Brenda McClearen. Estab. 1987. Number of employees: 3. Specializes in display, music, package and publication design, Web sites, photography.

Needs Approached by 5-10 freelancers/year. Works with 5-7 freelance illustrators and designers/year. Uses freelancers for ad design and illustration, model-making and poster design. Needs computer-literate freelancers for design and illustration. 50% of freelance work demands knowledge of QuarkXPress and Macintosh.

First Contact & Terms Samples are filed. Will contact artist for portfolio review if interested. Pays by the project.

N SUDI MCCOLLUM DESIGN

3244 Cornwall Dr., Glendale CA 91206. (818)243-1345. Fax: (818)243-1345. E-mail: sudimccollum@earthlink.net. **Contact:** Sudi McCollum. Specializes in product design and illustration. Majority of clients are medium- to large-size businesses. "Specialty in home fashion accents." Clients: home furnishing and giftware manufacturers, advertising agencies and graphic design studios.

Needs Uses freelance production people either on computer or with painting and product design skills. Potential to develop into fulltime job.

THE BEST IN...

PRODUCT DESIGN: from cars to kitchen sinks, tires to televisions, we cover the new and notable

GRAPHIC DESIGN: breakout design in books, periodicals, brochures, annual reports, packaging, signage, and more

INTERACTIVE DESIGN: the latest games, websites, CD-ROMs, and software

ENVIRONMENTAL DESIGN: from restaurants and museums to schools, offices, and boutiques, you'll take a tour of the world's best environmental design

I.D. THE BEST IN DESIGN

First Contact & Terms Send query letter "with whatever you have that's convenient." Samples are filed. Responds only if interested.

MCGRATHICS

18 Chestnut St., Marblehead MA 01945. (781)631-7510. Web site: www.mcgrathics.com. **Art Director:** Vaughn McGrath. Estab. 1978. Number of employees: 4-6. Specializes in corporate identity, annual reports, package and publication and Web design. Clients: corporations and universities. Professional affiliations: AIGA, VUGB.

Needs Approached by 30 freelancers/year. Works with 8-10 freelance illustrators/year. Uses illustrators mainly for advertising, corporate identity (both conventional and computer); also for ad, brochure, catalog, poster and P-O-P illustration; charts/graphs. Computer and conventional art purchased.

First Contact & Terms Send postcard sample of work or send brochure, photocopies, photographs, résumé, slides and transparencies. Samples are filed. Responds only if interested. Portfolio review not required. Pays for illustration by the hour or by the project. Rights purchased vary according to project. Finds artists through sourcebooks and mailings.

Tips "Annually mail us updates for our review."

MCKENZIE HUBBELL CREATIVE SERVICES

5 Iris Lane, Westport CT 06880. (203)454-2443. Fax: (203)222-8462. E-mail: dmckenzie@mckenziehubbell.com or nhubbell@mckenziehubbell.com. Web site: www.mckenziehubbell.com. **Principal:** Dona McKenzie. Specializes in business to business communications, annual reports, corporate identity, direct mail and publication design. Expanded services include copywriting and editing, advertising and direct mail, marketing and public relations, Web site design and development, and multimedia and CD-ROM.

Needs Approached by 100 freelance artists/year. Works with 5 freelance designers/year. Uses freelance designers mainly for computer design. Also uses freelance artists for brochure and catalog design. 100% of design and 50% of illustration demands knowledge of QuarkXPress, Illustrator, InDesign and Photoshop.

First Contact & Terms Send query letter with brochure, résumé, photographs and photocopies. Samples are filed or are returned by SASE if requested by artist. Write to schedule an appointment to show a portfolio. Pays for design by the hour, $25-75. Pays for illustration by the project, $150-3,000. Rights purchased vary according to project.

MEDIA ENTERPRISES

1644 S. Clementine St., Anaheim CA 92802. (714)778-5336. Fax: (714)778-6367. Web site: www.media-enterprises.com. **Creative Director:** John Lemieux Rose. Estab. 1982. Number of employees: 8. Approximate annual billing: $2 million. Integrated marketing communications agency. Specializes in interactive multimedia, CD-ROMs, Internet, magazine publishing. Product specialty: high tech. Client list available upon request. Professional affiliations: Orange County Multimedia Association, Software Council of Southern California, Association of Internet Professionals.

Needs Approached by 30 freelance illustrators and 10 designers/year. Works with 8-10 freelance illustrators and 3 designers/year. Uses freelancers for animation, humorous illustration, lettering, logos, mechanicals, multimedia projects. 30% of work is with print ads. 100% of freelance work demands skills in PageMaker, Photoshop, Adobe InDesign, Illustrator, Director.

First Contact & Terms Send postcard sample and/or query letter with photocopies, photographs or URL. Accepts disk submissions compatible with Mac or PC. Samples are filed. Will contact for portfolio review of color photographs, slides, tearsheets, transparencies and/or disk. Pays by project; negotiated. Buys all rights.

MEDIA GRAPHICS

P.O. Box 820525, Memphis TN 38182-0525. (901)324-1658. Fax: (901)323-7214. E-mail: mediagra phics@devkinney.com. Web site: www.devkinney.com. **CEO:** J. Kinney. Estab. 1973. Integrated marketing communications agency. Specializes in all visual communications. Product specialties are financial, fundraising, retail, business-to-business. Client list available upon request. Professional affiliations: Memphis Area chamber, B.B.B.

- This firm reports they are looking for top illustrators only. When they find illustrators they like, they generally consider them associates and work with them on a continual basis.

First Contact & Terms Send query letter with résumé and tearsheets. Accepts disk submissions compatible with Mac or PC. E-mail 1 sample JPEG, 265K maximum; prefers HTML reference or small PDF file. Samples are filed and are not returned. Will contact artist for portfolio review on Web or via e-mail if interested. Rights purchased vary according to project.

Tips Chooses illustrators based on "portfolio, availability, price, terms and compatibility with project."

MEDIA LOGIC, INC.

One Park Place, Albany NY 12205. (518)456-3015. Fax: (518)456-4279. E-mail: swolff@mlinc.c om. Web site: www.mlinc.com. **Recruiter:** Suzanne Wolff. Director of Studio Services: Carol Ainsburg. (All submissions should be directed to Suzanne.) Estab. 1984. Number of employees: 85. Approximate annual billing: $50 million. Integrated marketing communications agency. Specializes in advertising, marketing communications, design. Product specialties are retail, entertainment. Current clients include education, business-to-business, industrial. Professional affiliations: American Marketing Associates, Ad Club of Northeast NY.

Needs Approached by 20-30 freelance illustrators and 20-30 designers/year. Works with 2 freelance illustrators and 2 designers/year. Prefers freelancers with experience in Mac/Photoshop. Uses freelancers for annual reports, brochure design, mechanicals, multimedia projects, retouching, Web page design. 30% of work is with print ads. 100% of design and 60% of illustration demands skills in Photoshop, QuarkXPress, Illustrator, Director.

First Contact & Terms Send submission via e-mail to Suzanne Wolff: swolff@mlinc.com. Candidates must be able to work onsite. Compensation via hourly rate.

MEDIA SERVICES CORP.

10 Aladdin Terrace, San Francisco CA 94133. (415)928-3033. Fax: (415)928-1366. E-mail: msc941 33@aol.com. **Design Director:** Betty Wilson. Estab. 1974. Number of employees: 4. Approximate annual billing: $750,000. Ad agency. Specializes in publishing and package design. Product specialties are publishing and consumer. Current clients include San Francisco Earthquake Map and Guide, First Aid for the Urban Cat, First Aid for the Urban Dog.

Needs Approached by 3 freelance artists/month. Works with 1-2 illustrators and 2 designers/ month. Prefers artists with experience in package design with CAD. Works on assignment only. Uses freelancers mainly for support with mechanicals, retouching and lettering. 5% of work is with print ads.

First Contact & Terms Designers: Send query letter with résumé. Illustrators: Send postcard sample. Samples are filed or are returned by SASE only if requested by artist. Responds only if interested. To show portfolio, mail tearsheets or 5×7 transparencies. Payment for design and illustration varies. Rights purchased vary according to project.

Tips Wants to see "computer literacy and ownership."

DONYA MELANSON ASSOCIATES

5 Bisson Lane, Merrimac MA 01860. (978)346-9240. Fax: (978)346-8345. E-mail: dmelanson@dm elanson.com. Web site: www.dmelanson.com. **Contact:** Donya Melanson. Advertising agency.

Amy Vangsgard works in painted clay relief, using polymer clay that is baked in an oven and then painted with acrylics; the final product is photographed and delivered to clients in digital format. She found the contact information for Media Graphics in *Artist's & Graphic Designer's Market* and sent them one of her promotional postcards. After working with the agency for a few years, some of her caricatures were chosen to illustrate a series of postcards for potential clients. This one of George W. Bush was sent out with the caption *If I only had a brain*. "Creating caricatures of political figures allows me to share my views with others and still maintain a sense of humor," Vangsgard says. She recommends having a strong Web presence and making your work easily accessible. "Send out regular mailings and provide a link to your Web site."

Number of employees: 1. Clients: industries, institutions, education, associations, publishers, financial services and government. Current clients include U.S. Geological Survey, Mannesmann, Cambridge College, American Psychological Association, Ladoca Enterprises and U.S. Dept. of Agriculture. Client list available upon request.

Needs Approached by 30 artists/year. Works with 3-4 illustrators/year. Most work is handled by staff, but may occasionally use freelance illustrators and designers. Uses artists for stationery design, direct mail, brochures/flyers, annual reports, charts/graphs and book illustration. Needs editorial and promotional illustration. 50% of freelance work demands skills in Illustrator, QuarkXPress, InDesign or Photoshop.

First Contact & Terms Query with brochure, résumé, photocopies, tearsheets or CD. Provide materials (no originals) to be kept on file for future assignments. Originals returned to artist after use only when specified in advance. Call or write for appointment to show portfolio or mail thumbnails, roughs, final art, final reproduction/product and color and b&w tearsheets, photostats and photographs. Pays for design and illustration by the project, $100 minimum. Considers complexity of project, client's budget, skill and experience of artist, and how work will be used when establishing payment.

Tips "Be sure your work reflects concept development. We would like to see more electronic design and illustration capabilities."

Ⓝ HOWARD MERRELL & PARTNERS

8521 Six Forks Rd., Suite 400, Raleigh NC 27615. (919)848-2400. Fax: (919)876-2344. E-mail: bibarnes@merrellgroup.com. Web site: www.merrellgroup.com. **Creative Director:** Billy Barnes. Estab. 1993. Number of employees: 60. Approximate annual billing: $90 million. Ad agency; full-service multimedia firm. Specializes in ads, collateral, TV, broadcast. Product specialties are industrial and hi-tech. Clients include Colonial Bank, Interton, Zilla.

Needs Approached by 25-50 freelancers/year. Works with 10-12 freelance illustrators and 20-30 designers/year. Uses freelancers for brochure design and illustration, catalog design, logos, posters, signage and P-O-P. 40% of work is with print ads. Needs computer-literate freelancers for design, illustration, production and presentation. 100% of freelance work demands knowledge of Photoshop, InDesign and Illustrator.

First Contact & Terms Send postcard sample of work or query letter with photocopies. Samples are filed. Request portfolio review in original query. Will contact artist for portfolio review if interested. Portfolio should include b&w and color final art. Pays for design by the hour, $25-65. Pays for design and illustrator by the hour or project.

Ⓝ Ⓣ MEYER/FREDERICKS & ASSOCIATES

333 N. Michigan Ave., #1300, Chicago IL 60601. (312)782-9722. Fax: (312)782-1802. E-mail: jbesse@meyerfredericks.com. Web site: www.meyerfredricks.com. Estab. 1972. Number of employees: 15. Ad agency, PR firm. Full-service multimedia firm.

Needs Prefers local freelancers only. Freelancers should be familiar with Photoshop 7.0, QuarkXPress 4.1 and Illustrator 8.

First Contact & Terms Send query letter with samples. Will contact artist for portfolio review if interested.

Ⓝ MILICI VALENTI NG PACK

999 Bishop St., 24th Floor, Honolulu HI 96813. (808)536-0881. Fax: (808)529-6208. E-mail: info@mvnp.com. Web site: www.mvnp.com. **Creative Director:** George Chalekian. Estab. 1946. Number of employees: 74. Approximate annual billing: $40,000,000. Ad agency. Serves clients in travel/tourism, food, finance, utilities, entertainment and public service. Current clients include First Hawaiian Bank, Aloha Airlines, Sheraton Hotels.

Needs Works with 2-3 freelance illustrators/month. Uses freelance artists mainly for illustration, retouching and lettering for newspapers, multimedia kits, magazines, radio, TV and direct mail. Artists must be familiar with advertising demands; used to working long distance through the mail and over the Internet; and familiar with Hawaii.

First Contact & Terms Send brochure, flier and tearsheets or PDFs to be kept on file for future assignments. Pays $200-2,000.

MITCHELL STUDIOS DESIGN CONSULTANTS

1810-7 Front St., East Meadow NY 11554. (516)832-6230. Fax: (516)832-6232. E-mail: msdcdesign @aol.com. **Principals:** Steven E. Mitchell and E.M. Mitchell. Estab. 1922. Specializes in brand and corporate identity, displays, direct mail and packaging. Clients: major corporations.

Needs Works with 5-10 freelance designers and 20 illustrators/year. "Most work is started in our studio." Uses freelancers for design, illustration, mechanicals, retouching, airbrushing, model-making, lettering and logos. 100% of design and 50% of illustration demands skills in Illustrator 5, Photoshop 5 and QuarkXPress 3.3. Needs technical illustration and illustration of food, people.

First Contact & Terms Send query letter with brochure, résumé, business card, photographs and photocopies to be kept on file. Accepts nonreturnable disk submissions compatible with Illustrator, QuarkXPress, FreeHand and Photoshop. Responds only if interested. Call or write for appointment to show portfolio of roughs, original/final art, final reproduction/product and color photostats and photographs. Pays for design by the hour, $25 minimum; by the project, $250 minimum. Pays for illustration by the project, $250 minimum.

Tips "Call first. Show actual samples, not only printed samples. Don't show student work. Our need has increased—we are very busy."

MIZEREK ADVERTISING, INC.

333 E. 14th St., Suite 7J, New York NY 10003. (212)777-3344. E-mail: mizerek@aol.com. Web site: www.mizerek.net. **President:** Leonard Mizerek. Estab. 1975. Specializes in catalogs, direct mail, jewelry, fashion and technical illustration. Clients: corporations, various product and service-oriented clientele. Current clients include A&B Jewelers, Frederic Sage, Sentinel Publishing.

Needs Approached by 20-30 freelancers/year. Works with 10 freelance designers/year. Works on assignment only. Uses freelancers for design, technical illustration, brochures, retouching and logos. 85% of freelance work demands skills in Illustrator, Photoshop and QuarkXPress.

First Contact & Terms Send postcard sample or query letter with résumé, tearsheets and transparencies. Accepts disk submissions compatible with Illustrator and Photoshop. Will contact artist for portfolio review if interested. Portfolio should include original/final art and tearsheets. Pays for design by the project, $500-5,000. Pays for illustration by the project, $500-3,500. Considers client's budget and turnaround time when establishing payment. Finds artists through sourcebooks and self-promotions.

Tips "Let the work speak for itself. Be creative. Show commercial product work, not only magazine editorial. Keep me on your mailing list!"

MNA CREATIVE, INC

(formerly Macey Noyes Associates, Inc.), 93 Lake Ave., 3rd Floor, Danbury CT 06810. (203)791-8856. Fax: (203)791-8876. E-mail: information@mnacreative.com. Web site: www.mnacreative.com. **Structural Design Director:** Tod Dawson. Estab. 1979. Specializes in corporate and brand identity systems, graphic and structural packaging design, retail merchandising systems, naming and nomenclature systems, Internet and digital media design. Clients: corporations (marketing managers, product managers). Current clients include Duracell, Norelco, Motorola, Pitney Bowes, Altec Lansing, Philips. Majority of clients are retail suppliers of consumer goods.

Needs Approached by 25 artists/year. Works with 2-3 illustrators and 5 designers/year. Prefers

local and international artists with experience in package comps, Macintosh and type design. Uses technical and product illustrators mainly for ad slick, in-use technical and front panel product. Uses designers for conceptual layouts and product design. Also uses freelancers for mechanicals, retouching, airbrushing, lettering, logos and industrial/structural design. Needs computer-literate freelancers for design, illustration and production. 40% of freelance work demands knowledge of QuarkXPress, Illustrator, Photoshop, Director, Flash and Shockwave.

First Contact & Terms Send query letter with résumé. Samples are filed or are returned by SASE if requested by artist. Responds only if interested. Will contact artist for portfolio review if interested. Portfolio should include thumbnails, roughs and transparencies. Pays for design by the hour, $30-75. Pays for illustration by the project, $100-2,500. Rights purchased vary according to project. Finds new artists through sourcebooks and agents.

MONDERER DESIGN, INC.

2067 Massachusetts Ave., 3rd Floor, Cambridge MA 02140. (617)661-6125. Fax: (617)661-6126. E-mail: stewart@monderer.com. Web site: www.monderer.com. **Creative Director:** Stewart Monderer. Estab. 1982. Specializes in annual reports, corporate identity, corporate communications, datasheets, and interactive solutions. Clients: corporations (technology, education, consulting, and life science). Current clients include Tufts University, Spotfire, Iron Mountain, Fluent, Thermo Electron, Northeastern University, Goslings Rum, Thermo Fisher Scientific, Metamatrix. Client list on Web site.

Needs Approached by 40 freelancers/year. Works with 10-12 illustrators and photographers per year. Works on assignment only.

First Contact & Terms Send query letter with brochure, tearsheets, photographs, photocopies or nonreturnable postcards. Will look at links and PDF files. Samples are filed. Will contact artist for portfolio review if interested. Portfolio should include b&w and color-finished art samples. Pays for design by the hour, $15-25; or by the project. Pays for illustration by the project, $250 minimum. Negotiates rights purchased. Finds artists through submissions/self-promotions and sourcebooks.

ℕ 🖹 RUTH MORRISON ASSOCIATES, INC.

246 Brattle St., Cambridge MA 02138. (617)354-4536. Fax: (617)354-6943. **Account Executive:** Cindy Simon. Estab. 1972. PR firm. Specializes in food, travel, design.

Needs Prefers local freelancers with experience in advertising and/or publishing. Assignments include logo/letterhead design, invitations and brochures, catalog, poster and print ad design. 5% of work is with print ads. 25% of freelance work demands computer skills.

First Contact & Terms Send query letter with photocopies. Samples are filed or returned by SASE if requested by artist. Does not reply. Pays for design and illustration by the project. Rights purchased vary according to project. Finds artists through colleagues, editorial credits, etc.

ℕ MRW COMMUNICATIONS

2 Fairfield St., Hingham MA 02043. (781)740-4525. Fax: (781)740-0042. E-mail: jim@mrwinc.com. Web site: www.mrwinc.com. **President:** Jim Watts. Estab. 1983. Ad agency. Specializes in ads, collateral. Web site development, online marketing. Product specialties are high tech, healthcare. Client list available upon request.

Needs Approached by 40-50 freelance illustrators and 40-50 designers/year. Works with 5-10 freelance illustrators and 2-5 designers/year. Prefers freelancers with experience in a variety of techniques; brochure, medical and technical illustration, multimedia projects, retouching, storyboards, TV/film graphics and Web page design. 75% of work is with print ads. 90% of design and 90% of illustration demands skills in FreeHand, Photoshop, QuarkXPress, Illustrator.

First Contact & Terms Designers: Send query letter with photocopies, photographs, résumé.

Illustrators: Send postcard sample and résumé, follow up postcard every 6 months. Accepts disk submissions compatible with QuarkXPress 7.5/version 3.3. Send EPS files. Samples are filed. Will contact for portfolio review of b&w, color final art if interested. Pays by the hour, by the project or by the day, depending on experience and ability. Rights purchased vary according to project. Finds artist through sourcebooks and word of mouth.

MSR ADVERTISING, INC.

P.O. Box 10214, Chicago IL 60610-0214. (312)573-0001. Fax: (312)573-1907. E-mail: info@msradv.com. Web site: www.msradv.com. **Art Director:** Lauren O'Flynn-Redig. Estab. 1983. Number of employees: 6. Approximate annual billing: $2.5 million. Ad agency; full-service multimedia firm. Specializes in medical, food, wines, spirits & beer, automotive, industrial and biotechnology. Current clients include AGCO Parts N.A., American Hospital Association, Illinois Biotechnology Industries Association, General Motors, Fosters Wine Estates, Barenger Wines, and Barton Beers.

 ● MSR's Tampa, Florida, office (including similar SIC represented industries and professions) has added insurance agencies, law firms and engineering firms to their growing list of clients.

Needs Approached by 6-10 freelancers/year. Works with 5-10 freelance illustrators and 5-10 designers/year. Prefers local artists who are "innovative, resourceful and hungry." Works on assignment only. Uses freelancers mainly for creative thought boards; also for brochure, catalog and print ad design and illustration, multimedia, storyboards, mechanicals, billboards, posters, lettering and logos. 30% of work is with print ads. 75% of design and 25% of illustration demands computer skills.

First Contact & Terms Send query letter with brochure, photographs, photocopies, slides, SASE and résumé. Accepts submissions on disk. Samples are filed or returned. Responds in 2 weeks. Write for appointment to show portfolio or mail appropriate materials—thumbnails, roughs, finished samples. Artist should follow up with call. Pays for design by the hour, $45-95. Buys all rights. Finds artists through submissions and agents.

Tips "We maintain a relaxed environment designed to encourage creativity; however, work must be produced in a timely and accurate manner. Normally the best way for a freelancer to meet with us is through an introductory letter and a follow up phone call a week later. Repeat contact every 2-4 months. Be persistent and provide outstanding representation of your work."

MYERS, MYERS & ADAMS ADVERTISING, INC.

938 N. Victoria Park Rd., Fort Lauderdale FL 33304. (954)523-6262. Fax: (954)523-3517. E-mail: pete@mmanda.com. Web site: www.mmanda.com. **Creative Director:** Virginia Myers. Estab. 1986. Number of employees: 6. Approximate annual billing: $2 million. Ad agency; full-service, multimedia firm. Specializes in magazines and newspaper ads; radio and TV; brochures; and various collateral. Product specialties are consumer and business-to-business. Current clients include Harley-Davidson, Wendy's and Embassy Suites. Professional affiliation: Advertising Federation.

Needs Approached by 10-15 freelancers/year. Works with 3-5 freelance illustrators and 3-5 designers/year. Uses freelancers mainly for overflow; also for animation, brochure and catalog illustration, model-making, posters, retouching and TV/film graphics. 55% of work is with print ads. Needs computer-literate freelancers for illustration and production. 20% of freelance work demands knowledge of PageMaker, Photoshop, QuarkXPress and Illustrator.

First Contact & Terms Send postcard-size sample of work or send query letter with tearsheets. Samples are filed and are returned by SASE if requested by artist. Will contact artist for portfolio review if interested. Portfolio should include b&w and color final art, roughs, tearsheets and thumbnails. Pays for design and illustration by the project, $50-1,500. Buys all rights. Finds artists through *Creative Black Book*, *Workbook* and submissions.

NAPOLEON ART STUDIO

420 Lexington Ave., Suite 3020, New York NY 10170. (212)692-9200. Fax: (212)692-0309. E-mail: scott@napny.com. Web site: www.napny.com. **Studio Manager:** Scott Stein. Estab. 1985. Number of employees: 40. Full-service multimedia firm. Specializes in storyboards, magazine ads, computer graphic art animatics. Product specialty is consumer. Current clients include "all major New York City ad agencies." Client list not available.

Needs Approached by 20 freelancers/year. Works with 15 freelance illustrators and 5 designers/year. Prefers local freelancers with experience in animation, computer graphics, film/video production, multimedia, Macintosh. Works on assignment only. Uses freelancers for airbrushing, animation, direct mail, logos and retouching. 10% of work is with print ads. Needs computer-literate freelancers for design, illustration, production and presentation. 80% of freelance work demands skills in Illustrator or Photoshop.

First Contact & Terms Send query letter with photocopies, tearsheets and ¾" or VHS tape. Samples are filed. Responds only if interested. Will contact artist for portfolio review if interested. Portfolio should include b&w and color thumbnails. Pays for design and illustration by the project. Rights purchased vary acording to project. Finds artists through word of mouth and submissions.

NEALE-MAY & PARTNERS

4151 Middlefield Rd., Palo Alto CA 94303. (650)328-5555. Fax: (650)328-5016. E-mail: info@nealemay.com. Web site: www.nealemay.com. Estab. 1986. Strategic communications and PR firm. Specializes in promotions, packaging, corporate identity, collateral design, annuals, graphic and ad design. Product specialties are Internet, hi-tech, computer systems and peripherals, medical and consumer packaged goods. Clients include eDiets.com, McAfee, PGP Corporation, TOA Technologies.

Needs Approached by 20 freelance artists/month. Works with 2-3 freelance illustrators and 2-3 freelance designers/month. Prefers local artists with experience in all areas of manual and electronic art capabilities. Works on assignment only. Uses freelance artists mainly for brochure design and illustration, print ad illustration, mechanicals, posters, lettering, logos and cartoons. Needs editorial and technical illustration for cartoons and caricatures. Needs freelancers for design, illustration, production and presentation.

First Contact & Terms Send query letter with "best work samples in area you're best in." Samples are filed. Responds in 2 weeks. To show a portfolio, mail thumbnails, roughs and color slides. Pays for design by the hour. Negotiates rights purchased.

NEIMAN GROUP

614 N. Front St., Harrisburg PA 17101. (717)232-5554. Fax: (717)232-7998. E-mail: fcoleman@neimangroup.com. Web site: www.neimangroup.com. **Executive Creative Director**: Jeff Odiorne. Estab. 1978. Full-service ad agency specializing in print collateral and ad campaigns. Product specialties are healthcare, banks, retail and industry.

Needs Works with 5 illustrators and 4 designers/month. Prefers local artists with experience in comps and roughs. Works on assignment only. Uses freelancers mainly for advertising illustration and comps; also for brochure design, mechanicals, retouching, lettering and logos. 50% of work is with print ads. 3% of design and 1% of illustration demands knowledge of Illustrator and Photoshop.

First Contact & Terms Designers: Send query letter with résumé. Illustrators: Send postcard sample, query letter or tearsheets. Samples are filed. Will contact artist for portfolio review if interested. Portfolio should include color thumbnails, roughs, original/final art, photographs. Pays for design and illustration by the project, $300 minimum. Finds artists through sourcebooks and workbooks.

Tips "Try to get a potential client's attention with a novel concept. Never, ever, miss a deadline. Enjoy what you do."

LOUIS NELSON ASSOCIATES INC.

P.O. Box 2021, New York NY 10013. (212)620-9191. Fax: (212)620-9194. E-mail: info@louisnelson.com. Web site: www.louisnelson.com. **President:** Louis Nelson. Estab. 1980. Number of employees: 12. Approximate annual billing: $1.2 million. Specializes in environmental, interior and product design and brand and corporate identity, displays, packaging, publications, signage and wayfinding, exhibitions and marketing. Clients: nonprofit organizations, corporations, associations and governments. Current clients include Stargazer Group, Rocky Mountain Productions, Wildflower Records, Port Authority of New York & New Jersey, Richter + Ratner Contracting Corporation, MTA and NYC Transit, Massachusetts Port Authority. Professional affiliations: IDSA, AIGA, SEGD, APDF.

Needs Approached by 30-40 freelancers/year. Works with 30-40 designers/year. Works on assignment only. Uses freelancers mainly for specialty graphics and 3D design; also for design, photo-retouching, model-making and charts/graphs. 100% of design demands knowledge of PageMaker, QuarkXPress, Photoshop, Velum, Autocad, Vectorworks, Alias, Solidworks or Illustrator. Needs editorial illustration. Needs design more than illustration or photography.

First Contact & Terms Send postcard sample or query letter with résumé. Accepts disk submissions compatible with Illustrator 10.0 or Photoshop 7.0. Send EPS/PDF files. Samples are returned only if requested. Responds in 2 weeks. Write for appointment to show portfolio of roughs, color final reproduction/product and photographs. Pays for design by the hour, $15-25; or by the project, negotiable.

Tips "I want to see how the artist responded to the specific design problem and to see documentation of the process—the stages of development. The artist must be versatile and able to communicate a wide range of ideas. Mostly, I want to see the artist's integrity reflected in his/her work."

ⓝ THE NEXT LEVEL MARKETING & CREATIVE LLC

1607 Pontius Ave., Los Angeles CA 90025. (310)477-2119. Fax: (310)477-2661. E-mail: deborah@tnlmarketing.com. Web site: www.tnlmarketing.com. **Creative Director:** Deborah Rodney. Estab. 2000. Number of employees: 5. Approximate annual billing: $800,000. Ad agency, design/integrated marketing communications firm. Specializes in health care, professional services, software, consumer products, financial services, nonprofits. Current clients include Portable Sound Laboratories, Orange County Federal Teachers Credit Union, QD Technology, Jewish Big Brothers/Big Sisters. Professional affiliations: MENG; Professionals Network Group.

Needs Approached by 100 + illustrators and 20 designers/year. Works with 6-8 illustrators and 2-3 designers/year. Works on assignment only. Prefers designers/illustrators with experience in animation and computer graphics (Macintosh). Uses freelancers mainly for illustration, photography, flash animation, Web programming; also for animation, brochure illustration, computer needs, direct mail. 35% of work is with print ads. 100% of design work demands skills in Illustrator, Photoshop, QuarkXPress. Illustration work demands knowledge of Illustrator and Photoshop.

First Contact & Terms Call or send samples. Prefers e-mail submissions with image files or link to Web site. Prefers Mac-compatible JPEG files. Samples are kept on file and are not returned. Responds only if interested. Will contact artists for portfolio review if interested. Portfolio should include b&w, color, finished art, photographs. Pays for illustration by the project. Pays for design by the hour or by the project. Rights purchased vary according to project; negotiated. Finds freelancers through agents/reps, submissions, Internet, *Workbook*, *The Black Book*.

NICOSIA CREATIVE EXPRESSO, LTD.

(NiCE Ltd.), 355 W. 52nd St., 8th Floor, New York NY 10019. (212)515-6600. Fax: (212)265-5422. E-mail: contact@niceltd.com. Web site: www.niceltd.com. **Principal/Creative Director:**

Davide Nicosia. Estab. 1993. Number of employees: 20. Full-service multicultural creative agency. Specializes in graphic design, corporate/brand identity, brochures, promotional material, packaging, fragrance bottles and 3D animations. Current clients include Estée Lauder Companies, Procter & Gamble, Dunhill, Gillette, Montblanc, Old Spice and Pantene.

Needs Approached by 70 freelancers/year. Works with 6 illustrators and 8 designers/year. Works on assignment only. Uses illustrators, designers, 3D computer artists and computer artists familiar with Illustrator, Photoshop, After Effects, Premiere, Macromedia Director, Flash and Alias Wavefront.

First Contact & Terms Send query letter and résumé. Responds for portfolio review only if interested. Pays for design by the hour. Pays for illustration by the project. Rights purchased vary according to project.

Tips Looks for "promising talent and the right attitude."

N NOSTRADAMUS ADVERTISING

884 West End Ave., Suite #2, New York NY 10025. (212)581-1362. E-mail: nos@nostradamus.net. Web site: www.nostradamus.net. **Creative Director:** B. Sher. Specializes in book design, Web design, fliers, advertising and direct mail. Clients: ad agencies, book publishers, nonprofit organizations and politicians.

Needs Works with 5 artists/year. Needs computer-literate freelancers for design and production. Freelancers should know Quark, Photoshop, Dreamweaver.

First Contact & Terms Send query letter with brochure, résumé, business card, samples and tearsheets. Do *not* send slides as samples; will accept "anything else that doesn't have to be returned." Samples not kept on file are not returned. Responds only if interested. Call for appointment to show portfolio. Pays for design and mechanicals by the hour, $30 average. Pays for illustration by the project, $100 minimum. Considers skill and experience of artist when establishing payment.

NOTOVITZ COMMUNICATIONS

15 Cutter Mill Rd., Suite 212, Great Neck NY 11021. (516)467-4672. E-mail: joseph@notovitz.com. Web site: www.notovitz.com. **President:** Joseph Notovitz. Number of employees: 4. Specializes in marketing communications (branding, annual reports, literature, publications, Web sites), corporate identity, exhibit signage, event design and writing. Clients: finance, real estate and industry. Professional affiliation: Specialty Graphic Imaging Association.

Needs Approached by 100 freelancers/year. Works with 10 freelance illustrators and 10 designers/year. Uses freelancers for brochure, poster, direct mail and booklet illustration; mechanicals; charts/graphs; and logo design. Needs computer-literate freelancers for design, illustration and production. 90% of freelance work demands expertise in InDesign, Illustrator and Photoshop. Needs pool of freelance Web developers with expertise in Flash, coding and design. Also collaborates on projects that writers and freelancers bring.

First Contact & Terms Send résumé and links to online examples of work. Responds "if there is fit and need." Pays for design and production work by the hour, $25-75. Pays for illustration by the project, $200-5,000.

Tips "Do a bit of research on the firm you are contacting. Send pieces that reflect the firm's style and needs. If we never produce book covers, book cover art does not interest us. Stress what you can do for the firm—not what the firm can do for you."

N I NOVUS VISUAL COMMUNICATIONS, INC.

121 E. 24th St., 12th Floor, New York NY 10010-2950. (212)473-1377. Fax: (212)505-3300. E-mail: novuscom@aol.com. Web site: www.novuscommunications.com. **President:** Robert Antonik. Vice President/Creative Director: Denis Payne. Estab. 1984. Creative marketing and com-

munications firm. Specializes in strategic planning, advertising, annual reports, brand and corporate identity, display, direct mail, fashion, package and publication design, technical illustration and signage. Clients include healthcare, telecommunications and consumer products companies.

Needs Approached by 12 freelancers/year. Works with 2-4 freelance illustrators and 2-6 designers/year. Works with artist reps. Prefers local artists only. Uses freelancers for ad, brochure, catalog, poster and P-O-P design and illustration, airbrushing, audiovisual materials, book, direct mail, magazine and newpaper design, charts/graphs, lettering, logos, mechanicals and retouching. 75% of freelance work demands skills in Illustrator, Photoshop, FreeHand, InDesign and QuarkXPress.

First Contact & Terms Contact only through artist rep. Send postcard sample of work. Samples are filed. Responds ASAP. Follow up with call. Pays for design by the hour, $15-75; by the day, $200-300; by the project, $200-1,500. Pays for illustration by the project, $150-1,750. Rights purchased vary according to project. Finds artists through *Creative Illustration*, *Workbook*, agents and submissions.

Tips "First impressions are important; a portfolio should represent the best, whether it's 4 samples or 12." Advises freelancers entering the field to "always show your best creative. You don't need to overwhelm your interviewer, and it's always a good idea to send a thank-you or follow up phone call."

N THE O'CARROLL GROUP

300 E. McNeese St., Suite 2-B, Lake Charles LA 70605. (337)478-7396. Fax: (337)478-0503. E-mail: pocarroll@ocarroll.com. Web site: www.ocarroll.com. **President:** Peter O'Carroll. Estab. 1978. Ad agency/PR firm. Specializes in newspaper, magazine, outdoor, radio and TV ads. Product specialty is consumer. Client list available upon request.

Needs Approached by 1 freelancer/month. Works with 1 illustrator every 3 months. Prefers freelancers with experience in computer graphics. Works on assignment only. Uses freelancers mainly for time-consuming computer graphics; also for brochure and print ad illustration and storyboards. Needs Web site developers. 65% of work is with print ads. 50% of freelance work demands skills in Illustrator and Photoshop.

First Contact & Terms Send query letter with résumé and paper or electronic samples. Samples are filed or returned by SASE if requested. Responds only if interested. Will contact artist for portfolio review if interested. Pays for design by the project. Pays for illustration by the project. Rights purchased vary according to project. Find artists through viewing portfolios, submissions, word of mouth, American Advertising Federation district conferences and conventions.

N ⚕ OAKLEY DESIGN STUDIOS

519 SW Park Ave., Portland OR 97205. (503)241-3705. E-mail: oakleyds@oakleydesign.com. Web site: oakleydesign.com. **Creative Director:** Tim Oakley. Estab. 1992. Number of employees: 1. Specializes in brand and corporate identity, display, package and publication design and advertising. Clients: ad agencies, record companies, surf apparel manufacturers, mid-size businesses. Current clients include TGF Productions, M3 Productions, Oregon State Treasury, Hui Nalu Brand Surf, Stona Winery, Kink FM 102. Professional affiliations: GAG, AIGA and PAF.

Needs Approached by 5-10 freelancers/year. Works with 3 freelance illustrators and 2 designers/year. Prefers local artists with experience in technical illustration, airbrush. Uses illustrators mainly for advertising. Uses designers mainly for logos. Also uses freelancers for ad and P-O-P illustration, airbrushing, catalog illustration, lettering and retouching. 60% of design and 30% of illustration demands skills in Illustrator, Photoshop and QuarkXPress.

First Contact & Terms Contact through artist rep or send query letter with brochure, photocopies, photographs, résumé and tearsheets. Accepts disk submissions compatible with Illustrator 9.0. Send EPS files. Samples are filed or returned by SASE if requested by artist. Responds in 6 weeks.

Request portfolio review in original query. Will contact artist for portfolio review if interested. Portfolio should include b&w and color final art, photocopies, photostats, roughs and slides. Pays for design by the project, $200 minimum. Pays for illustration by the project. Rights purchased vary according to project. Finds artists through design workbooks.

Tips "Be yourself. No phonies. Be patient and have a good book ready."

ODEN MARKETING & DESIGN

119 S. Main St., Suite 300, Memphis TN 38103-3677. (901)578-8055. Fax: (901)578-1911. Web site: www.oden.com. **Design Director:** Michael Guthrie. Estab. 1971. Specializes in annual reports, brand and corporate identity, design and package design. Clients: corporations. Current clients include International Paper, Federal Express.

Needs Works with 5-8 freelance illustrators and photographers/year. Works on assignment only. Uses illustrators mainly for collateral. 50% of freelance work demands knowledge of QuarkXPress, InDesign, Illustrator or Photoshop.

First Contact & Terms Send query letter with brochure, photographs, slides and transparencies. Samples are filed and are not returned. Responds only if interested. Portfolio review not required. Pays for illustration by the project. Rights purchased vary according to project.

Tips Finds artists through sourcebooks.

OMNI PRODUCTIONS

P.O. Box 302, Carmel IN 46082-0302. (317)846-2345. E-mail: winston@omniproductions.com. Web site: omniproductions.com. **President:** Winston Long. Estab. 1984. Full-service multimedia firm. Specializes in video, Intranet, CD-ROM and Internet. Current clients include "a variety of industrial clients, government and international agencies."

Needs Works on assignment only. Uses freelancers for brochure design and illustration, storyboards, slide illustration, animation, and TV/film graphics. Needs computer-literate freelancers for design, illustration and production. Most of freelance work demands computer skills.

First Contact & Terms Send résumé. Samples are filed and are not returned. Artist should follow up with call and/or letter after initial query. Pays by the project. Finds artists through agents, word of mouth and submissions.

ORIGIN DESIGN

20 E. Greenway Plaza, Suite 150, Houston TX 77046. (713)520-9544. Fax: (214)341-4682. E-mail: GrowWithUs@origindesign.com. Web site: www.origindesign.com. Design and marketing firm. Current clients include ExpressJet and Time Warner Cable. Professional affiliations: AIGA, AMA, NIRI, PRSA.

 • Recent Origin projects have been recognized in *HOW Magazine*, the national Summit Awards, the Dallas Society of Visual Communicators Annual Show, and the regional Addys.

First Contact & Terms Send query letter with résumé and samples.

OUTSIDE THE BOX INTERACTIVE LLC

150 Bay St., Suite 706, Jersey City NJ 07302-5917. (212)463-7160 or (201)610-0625. Fax: (212)463-9179. E-mail: theoffice@outboxin.com. Web site: www.outboxin.com. **Partner and Director of Multimedia:** Lauren Schwartz. Estab. 1995. Number of employees: 10. Full-service multimedia firm. "Our product mix includes Internet/intranet/extranet development and hosting, corporate presentations, disk-based direct mail, customer/product kiosks, games, interactive press kits, advertising, marketing and sales tools. We also offer Web hosting for product launches, questionnaires and polls. Our talented staff consists of writers, designers and programmers." Current clients include Columbia Pictures, eBay, Lucent Technologies, New York Academy of Sciences, Rolex USA.

Needs Approached by 5-10 illustrators and 5-10 designers/year. Works with 8-10 freelance illustrators and 8-10 designers/year. Prefers freelancers with experience in computer arts. Uses freelancers for airbrushing, animation, brochure and humorous illustration, logos, model-making, multimedia projects, posters, retouching, storyboards, TV/film graphics, Web page design. 90% of design demands skills in Photoshop, QuarkXPress, Illustrator, Director HTML, Java Script and any 3D program. 60% of illustration demands skills in Photoshop, QuarkXPress, Illustrator, any animation and 3D program.

First Contact & Terms Send query letter with brochure, photocopies, photographs, photostats, résumé, SASE, slides, tearsheets, transparencies. Send follow up postcard every 3 months. Accepts disk submissions compatible with Power PC. Samples are filed and are returned by SASE. Will contact if interested. Pays by the project. Rights purchased vary according to project.

OXFORD COMMUNICATIONS, INC.

11 Music Mountain Blvd., Lambertville NJ 08530. (609)397-4242. Fax: (609)397-8863. Web site: www.oxfordcommunications.com. **Creative Director:** Chuck Whitmore. Estab. 1986. Ad agency; full-service multimedia firm. Specializes in print advertising and collateral. Product specialties are retail, real estate and destination marketing.

Needs Approached by 6 freelancers/month. Works with 3 designers every 6 months. Prefers local freelancers with experience in Quark, Illustrator, InDesign and Photoshop. Uses freelancers mainly for production and design. 75% of work is with print ads.

First Contact & Terms E-mail résumé and PDF samples to solutions@oxfordcommunications.com. Samples are filed. Responds only if interested. Will contact artist for portfolio review if interested. Portfolio should include b&w and/or color photostats, tearsheets, photographs and slides. Pays for design and illustration by the project, negotiable. Rights purchased vary according to project.

PACE DESIGN GROUP

P.O. Box 31671, San Francisco CA 94131-0671. E-mail: info@pacedesign.com. Web site: www.pacedesign.com. **Creative Director:** Joel Blum. Estab. 1988. Number of employees: 6. Approximate annual billing: $1.2 million. Specializes in branding, advertising and collateral. Product specialties are financial services, high tech, Internet and computer industries. Current clients include Bank of America, Wells Fargo Bank, Allegiance Telecom, Bio-Rad Laboratories. Client list available upon request. Professional affiliations: AIP (Artists in Print).

Needs Approached by 100 illustrators and 75 designers/year. Works with 3-5 illustrators and 3-5 designers/year. Prefers local designers with experience in QuarkXPress, InDesign, Illustrator and Photoshop. Uses freelancers mainly for illustration and graphics; also for brochure design and illustration, logos, technical illustration and Web page design. 2% of work is with print ads. 100% of design and 85% of illustration demands skills in the latest versions of Photoshop, Illustrator, QuarkXPress and InDesign.

First Contact & Terms Designers: Send query letter with photocopies and résumé. Illustrators: Send query letter with photocopies, tearsheets, follow up postcard samples every 6 months. Accepts disk submissions. Submit latest version software, System OS X, EPS files. Samples are filed and are not returned. Will contact for portfolio review of color final art and printed pieces if interested. Pays for design by the hour, $35-65. Pays for illustration by the project. Rights purchased vary according to project. Finds artists through sourcebooks, word of mouth, submissions.

PAPAGALOS STRATEGIC COMMUNICATIONS

7330 N. 16th St., Suite B102, Phoenix AZ 85020. (602)279-2933. Fax: (602)277-7448. Web site: www.papagalos.com. **Creative Director:** Nicholas Papagalos. Specializes in advertising, bro-

chures, annual corporate identity, displays, packaging, publications and signage. Clients: major regional, consumer and business-to-business. Clients include Perini, American Hospice Foundation, Collins College, McMillan Fiberglass Stocks.

Needs Works with 6-20 freelance artists/year. Works on assignment only. Uses artists for illustration, retouching, design and production. Needs computer-literate freelancers, HTML programmers and Web designers for design, illustration and production. 100% of freelance work demands skills in Illustrator, QuarkXPress, InDesign or Photoshop.

First Contact & Terms Mail résumé and appropriate samples. Pays for design by the hour or by the project. Pays for illustration by the project. Considers complexity of project, client's budget, skill and experience of artist, how work will be used, turnaround time and rights purchased when establishing payment. Rights purchased vary according to project.

Tips In presenting samples or portfolios, "two samples of the same type/style are enough."

ⓝ PERSECHINI AND COMPANY

P.O. Box 656, Trinidad CA 95570. (310)455-9755. E-mail: sales@persechini.com. Web site: www. persechini.com. Estab. 1979. Multimedia design firm. Specializes in advertising, annual reports, brochures, collateral, corporate identity, events, packaging, publications and Web sites, signage. Current clients include The Bowman Group, Imax, UCLA, Universal Studios.

Needs Approached by 50-100 freelance artists/year. Works with 5-6 illustrators and 1 designer/year. Works on assignment only. Needs computer-literate freelancers for design, illustration, production and presentation. 99% of freelance work demands knowledge of QuarkXPress, Free-Hand, Photoshop, FinalCut or Director.

First Contact & Terms Send query letter with brochure, business card and photostats and photocopies. Responds only if interested. Pays for design by the hour, $15-25 average. Pays for illustration by the project, $150-3,000 average.

Tips "Most of our accounts need a sophisticated look for their ads, brochures, etc. Occasionally we have a call for humor."

ⓝ ⓘ PHOENIX LEARNING GROUP, INC.

2349 Chaffee Dr., St. Louis MO 63146. (314)569-0211 or (800)221-1274. Fax: (314)569-2834. E-mail: multimediasales@phoenixlearninggroup.com. Web site: www.phoenixlearninggroup.com. **VP/Operations & Management:** Erin Bryant. Number of employees: 50. Produces and distributes educational films. Clients: libraries, museums, religious institutions, U.S. government, schools, universities, film societies and businesses. Catalog available on Web site or by request.

Needs Works with 1-2 freelance illustrators and 2-3 designers/year. Prefers local freelancers only. Uses artists for motion picture catalog sheets, direct mail brochures, posters and study guides; also for multimedia projects. 85% of freelance work demands knowledge of PageMaker, QuarkXPress and Illustrator.

First Contact & Terms Send postcard sample and query letter with brochure (if applicable). Send recent samples of artwork and rates to director of promotions. "No telephone calls, please." Responds if need arises. Buys all rights. Keeps all original art, "but will loan to artist for use as a sample." Pays for design and illustration by the hour or by the project. Rates negotiable.

ⓝ ⓘ PICCIRILLI GROUP

502 Rock Spring Rd., Bel Air MD 21014. (410)879-6780. Fax: (410)879-6602. E-mail: micah@picgroup.com. Web site: www.picgroup.com. **Creative Director:** Micah Piccirilli. Estab. 1974. Specializes in design and advertising; also annual reports, advertising campaigns, direct mail, brand and corporate identity, displays, packaging, publications and signage. Clients: recreational sport industries, fleet leasing companies, technical product manufacturers, commercial packaging corporations, direct mail advertising firms, realty companies, banks, publishers and software companies.

Needs Works with 4 freelance designers/year. Works on assignment only. Mainly uses freelancers for layout or production. Prefers local freelancers. 75% of design demands skills in Illustrator and QuarkXPress.

First Contact & Terms Send query letter with brochure, résumé and tearsheets; prefers originals as samples. Samples are returned by SASE. Responds on whether to expect possible future assignments. To show a portfolio, mail roughs and finished art samples or call for an appointment. Pays for design and illustration by the hour, $20-45. Considers complexity of project, client's budget, and skill and experience of artist when establishing payment. Buys one-time or reprint rights; rights purchased vary according to project.

Tips "Portfolios should include work from previous assignments. The most common mistake freelancers make is not being professional with their presentations. Send a cover letter with photocopies of work."

POSNER ADVERTISING

30 Broad St., 9th floor, New York NY 10004. (212)867-3900. Fax: (212)480-3440. E-mail: pposner @posneradv.com. Web site: www.posneradv.com. **Contact:** VP/Creative Director. Estab. 1959. Number of employees: 85. Full-service multimedia firm. Specializes in ads, collaterals, packaging, outdoor. Product specialties are healthcare, real estate, consumer business to business, corporate.

Needs Approached by 25 freelance artists/month. Works with 1-3 illustrators and 5 designers/month. Prefers local artists only with traditional background and experience in computer design. Uses freelancers mainly for graphic design, production, illustration. 80% of work is with print ads. Needs computer-literate freelancers for design, illustration and production. 90% of freelance work demands knowledge of Illustrator, QuarkXPress, InDesign, Photoshop or FreeHand.

First Contact & Terms Send query letter with photocopies or disk. Samples are filed. Responds only if interested. Write for appointment to show portfolio. Portfolio should include thumbnails, roughs, b&w and color tearsheets, printed pieces. Pays for design by the hour, $15-35; or by the project, $300-2,000. Pays for illustration by the project, $300-2,000. Negotiates rights purchased.

Tips Advises freelancers starting out in advertising field to offer to intern at agencies for minimum wage.

R H POWER AND ASSOCIATES, INC.

9621 Fourth St. NW, Albuquerque NM 87114-2128. (505)761-3150. Fax: (505)761-3153. E-mail: info@rhpower.vom. Web site: www.rhpower.com. **Art Director:** Bruce Yager. Creative Director: Roger L. Vergara. Estab. 1989. Number of employees: 12. Ad agency; full-service multimedia firm. Specializes in TV, magazine, billboard, direct mail, marriage mail, newspaper, radio. Product specialties are recreational vehicles and automotive. Current clients include Kem Lite Corporation, Albany RV, Ultra-Fab Products, Collier RV, Nichols RV, American RV and Marine. Client list available upon request.

Needs Approached by 10-50 freelancers/year. Works with 5-10 freelance illustrators and 5-10 designers/year. Prefers freelancers with experience in retail automotive layout and design. Uses freelancers mainly for work overload, special projects and illustrations; also for annual reports, billboards, brochure and catalog design and illustration, logos, mechanicals, posters and TV/film graphics. 50% of work is with print ads. 100% of design demands knowledge of Photoshop 9.0, and Illustrator CS 12.

First Contact & Terms Send query letter with photocopies or photographs and résumé. Accepts disk submissions in PC format compatible with Illustrator 10.0 or Adobe Acrobat (PDF). Send PC EPS files. Samples are filed and are not returned. Will contact artist for portfolio review if interested. Portfolio should include b&w and color final art, roughs and thumbnails. Pays for design and illustration by the hour, $15 minimum; by the project, $100 minimum. Buys all rights.

Tips Impressed by work ethic and quality of finished product. "Deliver on time and within budget. Do it until it's right without charging for your own corrections."

🅽 🎨 POWERS DESIGN INTERNATIONAL

828 Producton Place, Newport Beach CA 92663. (949)645-2265. E-mail: sweepinfo@gmail.com. Web site: www.powersdesign.com. **President:** Ron Powers. Estab. 1974. Specializes in vehicle and product dessign development, corporate identity; displays; and landscape, interior, package and transportation design. Clients: large corporations. Current clients include Paccar Inc., McDonnell Douglas, Ford Motor Co. and GM. Client list available upon request.

Needs Works with varying number of freelance illustrators and 5-10 freelance designers/year. Prefers local artists only with experience in transportation design (such as those from Art Center College of Design), or with "SYD Mead" type abilities. Works on assignment only. Uses freelance designers and illustrators for brochure, ad and catalog design, lettering, logos, model making and Alias Computer Cad-Cam 16 abilities.

First Contact & Terms Call first for permission to submit materials and samples. Pays for design and illustration by the project.

🎨 PRECISION ARTS ADVERTISING INC.

57 Fitchburg Rd., Ashburnham MA 01430. (978)827-4927. Fax: (978)827-4928. E-mail: web@prec isionarts.com. Web site: www.precisionarts.com. **President:** Terri Adams. Estab. 1985. Number of employees: 2. Full-service Web/print ad agency. Specializes in Internet marketing strategy, Web site/print design, graphic design.

Needs Approached by 5 illustrators and 5 designers/year. Works with 1 freelance illustrator and 1 designer/year. Prefers local freelancers. 49% of work is with printing/marketing; 36% of work is Web design. Freelance Web skills required in Macintosh DreamWeaver and Photoshop; freelance print skills required in QuarkXPress, Photoshop, Illlustrator and Pre-Press.

First Contract & Terms Send résumé with links to artwork and suggested hourly rate.

🅽 🎨 PRINCETON MARKETECH

196 Princeton-Hightstown Rd., Building 2, Suite 15, Princeton Junction NJ 08550. (609)936-0021. Fax: (609)936-0015. E-mail: info@princetonmarketech.com. Web site: www.princetonmarketech .com. **Contact:** Creative Director. Estab. 1987. Ad agency. Specializes in direct mail, multimedia, Web sites. Product specialties are financial, computer, senior markets. Current clients include Citizens Bank, ING Direct, Diamond Tours. Client list available upon request.

Needs Approached by 12 freelance illustrators and 25 designers/year. Works with 2 freelance illustrators and 5 designers/year. Prefers local designers with experience in Macintosh. Uses freelancers for airbrushing, animation, brochure design and illustration, multimedia projects, retouching, technical illustration, TV/film graphics. 10% of work is with print ads. 90% of design demands skills in Photoshop, QuarkXPress, Illustrator and Macromedia Director. 50% of illustration demands skills in Photoshop, Illustrator.

First Contact & Terms Send query letter with résumé, tearsheets, digital files or sample disk. Send follow up postcard every 6 months. Accepts disk submissions compatible with QuarkXPress, Photoshop. Samples are filed. Responds only if interested. Pay negotiable. Rights purchased vary according to project.

🅽 PRO INK

2826 NE 19th Dr., Gainesville FL 32609-3391. (352)377-8973. Fax: (352)373-1175. E-mail: terry@ proink.com. Web site: www.proink.com. **President:** Terry Van Nortwick. Estab. 1979. Number of employees: 5. Specializes in publications, marketing, healthcare, engineering, development and ads. Professional affiliations: Public Relations Society of America, Society of Professional

Journalists, International Association of Business Communicators, Gainesville Advertising Federation, Florida Public Relations Association.

Needs Works with 3-5 freelancers/year. Works on assignment only. Uses freelancers for brochure/annual report illustration, airbrushing and lettering. 80% of freelance work demands knowledge of Illustrator, InDesign or Photoshop. Needs editorial, medical and technical illustration.

First Contact & Terms Send résumé, samples, tearsheets, photostats, photocopies, slides and photography. Samples are filed or are returned if accompanied by SASE. Responds only if interested. Call or write for appointment to show portfolio of original/final art. Pays for design and illustration by the project, $50-500. Rights purchased vary according to project.

N QUADRANT COMMUNICATIONS CO., INC.

161 Avenue of the Americas, Suite 904, New York NY 10013-1105. (212)352-1400. Fax: (212)633-6429. E-mail: re@quadrantny.com. Web site: www.quadrantny.com. **President:** Robert Eichinger. Number of employees: 4. Approximate annual billing: $850,000. Estab. 1973. Specializes in annual reports, interactive marketing, corporate identity, direct mail, publication design and technical illustration. Current clients include AT&T, Citibank, Morgan Stanley, Chase Manhattan Bank, Federal Reserve Bank and Polo/Ralph Lauren. Client list available upon request.

Needs Approached by 100 freelancers/year. Works with 6 freelance illustrators and 4 designers/year. Prefers freelancers with experience in publication production. Works on assignment only. Uses freelancers mainly for publications, trade show collateral and direct mail design; also for brochure, magazine Internet and intranet design; and charts/graphs. Needs computer-literate freelancers for design and production. 80% of freelance work demands knowledge of QuarkXPress, InDesign, Adobe Go Live or Illustrator and Photoshop.

First Contact & Terms Send query letter with résumé. Samples are filed. Responds only if interested. Call for appointment to show portfolio of tearsheets and photographs. Pays for design by the hour, $25-35. Pays for illustration by the project, $400-1,200. Rights purchased vary according to project.

Tips "We need skilled people. There's no time for training."

N QUALLY & COMPANY, INC.

2 E. Oak St., Suite 2903, Chicago IL 60611. (312)280-1898. Web site: www.quallycompany.com. **Creative Director:** Robert Qually. Specializes in integrated marketing/communication and new product launches. Clients: major corporations, high net worth individuals and think tanks.

Needs Works with 10-12 freelancers/year. "Freelancers must have talent and the right attitude." Works on assignment only. Uses freelancers for design, copywriting, illustration, retouching, and computer production.

First Contact & Terms Send query letter with résumé, business card and samples that can be kept on file. Call or write for appointment to show portfolio.

Tips Looking for "people with ideas, talent, point of view, style, craftsmanship, depth and innovation." Sees "too many look-alikes, very little innovation."

N QUARASAN

405 W. Superior St., Chicago IL 60610-3613. (312)981-2520. Fax: (312)981-2507. E-mail: info@quarasan.com. Web site: www.quarasan.com. **Contact:** Elizabeth Gomez. Estab. 1982. Full-service product developer. Specializes in educational products. Clients: educational publishers.

Needs Approached by 400 freelancers/year. Works with 700-900 illustrators/year. Prefers freelancers with publishing experience. Uses freelancers for illustration, books, mechanicals, charts/graphs, lettering and production. Needs computer-literate freelancers for illustration. 50% of freelance illustration work demands skills in Illustrator, QuarkXPress, Photoshop or FreeHand. Needs editorial, technical, medical and scientific illustration.

First Contact & Terms Send query letter with brochure or résumé and samples to be circulated and kept on file. Prefers "anything that we can retain for our files—photocopies, color tearsheets, e-mail submissions, disks or dupe slides that do not have to be returned." Responds only if interested. Pays for illustration by the piece/project, $40-750 average. Considers complexity of project, client's budget, how work will be used and turnaround time when establishing payment.
Tips Current job openings posted on Web site.

MIKE QUON/DESIGNATION, INC.

543 River Rd., Fair Haven NJ 07704. (732)212-9200. Fax: (732)212-9217. E-mail: mike@quondesi gn.com. Web site: www.quondesign.com. **President:** Mike Quon. Estab. 1982. Number of employees: 3. Specializes in corporate identity, collateral, packaging, publications and Web design. Clients: corporations (financial, healthcare) and ad agencies. Current clients include Pfizer, Bristol-Myers Squibb, American Express, Hasbro, Verizon, AT&T. Client list available upon request. Professional affiliations: AIGA, Society of Illustrators, Graphic Artists Guild.
Needs Approached by 10 illustrators and 10 designers/year. Works with 6 designers/year. Works on assignment only. Prefers graphic style. Uses artists for brochures, design and illustration, logos, charts/graphs and lettering. Especially needs computer artists with skills in QuarkXPress, Illustrator, Photoshop and InDesign.
First Contact & Terms E-mail résumé with Web site link or mail query letter with rèsumè and photocopies. Samples are filed and not returned. Responds only if interested. No portfolio drop-offs; mail only. Pays for design by the hour, depending on experience. Pays for illustration by the project, $100-500. Buys first rights.

N GERALD & CULLEN RAPP, INC.

420 Lexington Ave., Suite 3100, New York NY 10170. (212)889-3337. Fax: (212)889-3341. E-mail: info@rappart.com. Web site: www.rappart.com. Estab. 1944. Clients: ad agencies, corporations and magazines. Client list not available. Professional affiliations: GAG, SPAR, S.I.
Needs Approached by 500 freelance artists/year. Works exclusively with freelance illustrators. Works on assignment only. Uses freelance illustrators for editorial advertising and corporate illustration.
First Contact & Terms E-mail query letter with samples or Web site link. Will contact artist for portfolio review if intersted. Responds in 2 weeks. Pays for illustration by the project, $500-40,000. Negotiates rights purchased.

REALLY GOOD COPY CO.

92 Moseley Terrace, Glastonbury CT 06033. (860)659-9487. E-mail: copyqueen@aol.com. Web site: www.reallygoodcopy.com. **President:** Donna Donovan. Estab. 1982. Number of employees: 2. Ad agency; full-service multimedia firm. Specializes in direct response and catalogs. Product specialties are medical/health care, business services, consumer products and services. Current clients include The Globe Pequot Press, Wellspring, Danbury Hospital, Glastonbury Chamber of Commerce. Professional affiliations: Connecticut Art Directors Club, New England Mail Order Association.
Needs Approached by 40-50 freelancers/year. Works with 1-2 freelance illustrators and 6-8 designers/year. Prefers local freelancers whenever possible. Works on assignment only. Uses freelancers for all projects. "There are no on-staff artists." 50% print, 50% Web. 100% of design and 50% of illustration demands knowledge of QuarkXPress, Illustrator or Photoshop and HTML.
First Contact & Terms Designers: send query letter with résumé. Illustrators: send postcard samples. Accepts CD submissions, EPS or JPEG files only. Samples are filed or are returned by SASE, only if requested. Responds only if interested. Portfolio review not required, but portfolio should include roughs and original/final art. Pays for design by the hour, $50-125. Pays for illustration by the project or by the hour.

Tips "Continue to depend upon word of mouth from other satisfied agencies and local talent. I'm fortunate to be in an area that's overflowing with good people. Send two or three good samples—not a bundle."

PATRICK REDMOND DESIGN

P.O. Box 75430-AGDM, St. Paul MN 55175-0430. (651)646-4254. E-mail: agdm08@PatrickRedmo ndDesign.com. Web site: www.PatrickRedmondDesign.com. **Creative Director/Designer/ Owner:** Patrick M. Redmond. Estab. 1966. Number of employees: 1. Specializes in book cover design, logo and trademark design, brand and corporate identity, package, publication and direct mail design, Web site design, design consulting and education and posters. Has provided design services for many clients in the following categories: publishing, advertising, marketing, retail, financial, food, arts, education, computer, manufacturing, small business, healthcare, government and professions. Recent clients include independent publishers, performing artists, etc.

Needs Clients use freelancers mainly for editorial and technical illustration, publications, books, brochures and newsletters; also for Web site and multimedia projects. 80% of freelance work demands knowledge of Macintosh, QuarkXPress, Photoshop, Illustrator, InDesign (latest versions).

First Contact & Terms Send postcard sample and/or photocopies. Samples not filed are thrown away. No samples returned. Responds only if interested. "Artist will be contacted for portfolio review if work seems appropriate for client needs. Patrick Redmond Design will not be responsible for acceptance of delivery or return of portfolios not specifically requested from artist or rep. Samples must be presented by appointment only, unless other arrangements are made. Unless specifically agreed to in writing in advance, portfolios should not be sent unsolicited." Client pays for design and illustration by the project. Rights purchased vary according to project. Considers buying second rights (reprint rights) to previously published work. Finds artists through word of mouth, magazines, submissions/self-promotions, exhibitions, competitions, sourcebooks, agents and Internet.

Tips "Provide Web site address so samples of your work may be viewed on the Web. I see trends toward extensive use of the Internet and a broader spectrum of approaches to images, subject matter and techniques. Clients also seem to have increasing interest in digitized, copyright-free stock images of all kinds." Advises freelancers starting out in the field to "create as much positive exposure for your images or design examples as possible. Make certain your name and location appear with image or design credits. Photos, illustrations and design are often noticed with serendipity. For example, your work may be just what a client needs—so make sure you have name and URL in credit. If possible, include your e-mail address and Web site URL with or on your work. Do not send samples via e-mail unless specifically requested. At times, client and project demands require working in teams online, via Internet, sending/receiving digital files to and from a variety of locations. *Do not* send digital files/images as attachments to e-mails unless specifically requested. Provide names of categories you specialize in, Web site addresses where your work/images may be viewed."

RHYCOM STRATEGIC ADVERTISING

84 Corporate Woods, 10801 Mastin Blvd., Suite 950, Overland Park KS 66210. (913)451-9102. Fax: (913)451-9106. E-mail: rrhyner@rhycom.com. Web site: www.rhycom.com. **President:** Rick Rhyner. Multimedia, full-service integrated marketing communications agency. Clients: food, pharmaceutical, insurance, franchises.

Needs Works on assignment only. Uses freelancers for design, illustration, brochures, catalogs, books, newspapers, consumer and trade magazines, Web site design and development, P-O-P display, mechanicals, retouching, animation, billboards, posters, direct mail packages, lettering, logos, charts/graphs and ads.

First Contact & Terms Send samples showing your style. Samples are not filed and are not returned. Responds only if interested. Call for appointment to show portfolio. Considers complexity of project and skill and experience of artist when establishing payment. Buys all rights.

[N] [I] RICHLAND DESIGN ASSOCIATES

47 Studio Rd., Newton MA 02466. (617)965-8900. Fax: (617)796-9223. E-mail: judy@richland.com. Web site: www.richland.com. **President:** Judy Richland. Estab. 1981. Number of employees: 3. Approximate annual billing: $500,000. Specializes in annual reports, corporate identity, direct mail, Web design, video production and TV/film titling, and package design. Clients: corporations, museums, schools, state agencies. Current clients include Nynex Properties, Apple Computer, Integrated Computer Solutions, Simmons College. Client list available upon request. Professional affiliations: AIGA.

Needs Approached by 10 freelancers/year. Works with 5 freelance illustrators and 10 designers/year. Prefers local artists only. Uses illustrators mainly for annual reports. Also uses freelancers for ad, catalog and direct mail design. Freelancers should be familiar with QuarkXPress, Photoshop, Illustrator and InDesign.

First Contact & Terms E-mail query and link to your Web site. Samples are filed. Will contact artist for portfolio review if interested. Portfolio should include b&w and color photographs, slides and thumbnails. Pays for design and illustration by the project. Rights purchased vary according to project.

RIPE CREATIVE

1543 W. Apollo Rd., Phoenix AZ 85041. (602)304-0703. Fax: (480)247-5339. E-mail: info@ripecreative.com. Web site: www.ripecreative.com. **Principal:** Mark Anthony Muñoz. Estab. 2005. Number of employees: 5. Approximate annual billing: $500,000. Design firm. Specializes in branding, advertising, strategic marketing, publication design, trade-show environments. Current clients include Swing Development, PetSmart, Aon Consulting, Healthways, Hawk Hill Custom Hardware, Phoenix Art Museum. Client list available on request. Professional affiliations: Phoenix Advertising Club, National Organization of Women Business Owners, Arizona Hispanic Chamber of Commerce.

Needs Approached by 100 illustrators and 10 designers/year. Works with 10 illustrators and 3 designers/year. Works on assignment only. Uses freelancers mainly for illustration, graphic design, Web site design; also for animation, brochure design/illustration, direct mail, industrial/structural design, logos, posters, print ads, storyboards, catalog design and technical illustration. 15% of work is assigned with print ads. 100% of design work demands skills in InDesign, Illustrator, QuarkXPress and Photoshop. 100% of illustration work demands skills in Illustrator, Photoshop and traditional illustration media.

First Contact & Terms Designers: Send query letter with contact information, résumé, tearsheets, and URL if applicable. Illustrators: Send tearsheets, URL. Samples are returned if requested and SASE is provided. Designers and illustrators should attach PDF files and/or URL. Samples are filed or returned by SASE. Responds in 2 weeks. Company will contact artist for portfolio review if interested. Portfolio should include color finished art, photographs and tearsheets. Pays for illustration. Set rate negotiated and agreed to between RIPE and talent. Pays for design by the hour, $25-100. Rights purchased vary according to project. Finds artists through submissions, word of mouth, *Workbook*, *The Black Book*.

Tips "Cold calls are discouraged. When making first contact attempt, the preferred method is via mail or electronically. If interested, RIPE will follow up with talent electronically or by telephone. When providing samples, please ensure talent/rep contact is listed on all samples."

[N] [☆] ROBERTS COMMUNICATIONS & MARKETING, INC.

1715 E. Ninth Ave., Tampa FL 33605. (813)281-0088. Fax: (813)281-0271. E-mail: info@robertsco mmunications.com. Web site: www.robertscommunications.com. **Creative Director:** Sarah Tildsley. Art Director: Mike Beardlsy. Estab. 1986. Number of employees: 20. Ad agency, PR firm, full-service multimedia firm. Specializes in integrated communications campaigns using multiple media and promotion. Professional affiliations: AIGA, PRSA, AAF, TBAF and AAAAS.

Needs Approached by 50 freelancers/year. Works with 15 freelance illustrators and designers/ year. Prefers local artists with experience in conceptualization and production knowledge. Uses freelancers for billboards, brochure design and illustration, logos, mechanicals, posters, retouching and Web site production. 60% of work is with print ads. 80% of freelance work demands knowledge of Adobe Creative Suite 2, QuarkXPress 6.5.

First Contact & Terms E-mail query with samples in PDF files. Will contact artist for portfolio review if interested. Portfolio should include b&w and color final art, roughs and thumbnails. Pays for design by the hour, by the project, by the day. Pays for illustration by the project, negotiable. Refers to Graphic Artists Guild Handbook for fee structure. Rights purchased vary according to project. Finds artists through agents, sourcebooks, seeing actual work done for others, annuals (*Communication Arts*, *PRINT*, *One Show*, etc.).

Tips Impressed by "work that demonstrates knowledge of product, willingness to work within budget, contributing to creative process, delivering on-time."

[N] [🌐] SAATCHI & SAATCHI ADVERTISING WORLDWIDE

375 Hudson St., New York NY 10014-3620. (212)463-2734. E-mail: lynne.collins@saatchiny.com. Web site: www.saatchiny.com; www.saatchi-saatchi.com. **Contact:** Lynne Collins. Full-service advertising agency. Clients include Delta Airlines, Eastman Kodak, General Mills and Procter & Gamble.

● This company has 153 offices in 83 countries. See Web site for specific details of each location.

Needs Approached by 50-100 freelancers/year. Works with 1-5 designers and 15-35 illustrators/ year. Uses freelancers mainly for illustration and advertising graphics. Prefers freelancers with knowledge of electronic/digital delivery of images.

First Contact & Terms Send query letter and nonreturnable samples or postcard sample. Prefers illustrators' sample postcards or promotional pieces to show "around half a dozen illustrations," enough to help art buyer determine illustrator's style and visual vocabulary. Files interesting promo samples for possible future assignments. Pays for design and illustration by the project.

[N] SAI COMMUNICATIONS

15 S. Bank St., Philadelphia PA 19106. (215)923-6466. Fax: (215)923-6469. E-mail: info@saicom munications.com. Web site: www.saicommunications.com. Full-service multimedia firm.

Needs Approached by 5 freelance artists/month. Works with 3 freelance designers/month. Uses freelance artists mainly for computer-generated slides; also for brochure and print ad design, storyboards, slide illustration and logos. 1% of work is with print ads.

First Contact & Terms Send query letter with résumé. Samples are filed. Call to schedule an appointment to show a portfolio. Portfolio should include slides. Pays for design by the hour, $15-20. Pays for illustration by the project. Buys first rights.

[N] ARNOLD SAKS ASSOCIATES

350 E. 81st St., New York NY 10028. (212)861-4300. Fax: (212)535-2590. E-mail: afiorillo@saksde sign.com. Web site: www.saksdesign.com. **Vice President:** Anita Fiorillo. Estab. 1967. Specializes in annual reports and corporate communications. Clients: Fortune 500 corporations. Current clients include Alcoa, Wyeth, and Hospital for Special Surgery. Client list available upon request.

Needs Works with 1 or 2 computer technicians and 1 designer/year. "Technicians' accuracy and speed are important, as is a willingness to work late nights and some weekends." Uses illustrators for technical illustration and occasionally for annual reports. Uses designers mainly for in-season annual reports. Also uses artists for brochure design and illustration, mechanicals and charts/graphics. Needs computer-literate freelancers for production and presentation. All freelance work demands knowledge of QuarkXPress, Illustrator or Photoshop.

First Contact & Terms Send query letter with brochure and résumé. Samples are filed. Responds only if interested. Write for appointment to show portfolio. Portfolio should include finished pieces. Pays for design by the hour, $25-60. Pays for illustration by the project, $200 minimum. Payment depends on experience and terms, and varies depending upon scope and complexity of project. Rights purchased vary according to project.

ⓝ DON SCHAAF & FRIENDS, INC.

1313 F St. NW, Washington DC 20004. (202)965-2600. Fax: (202)965-2669. E-mail: donschaaf@aol.com. **Senior Designer:** Don Schaaf. Estab. 1990. Number of employees: 10. Approximate annual billing: $4.2 million. Design firm. Specializes in ads, brochures and print campaigns. Product specialty is high-tech communication. Current clients include AOL; MCI; Polycom; Legi-Slate. Client list available upon request. Professional affiliations: AIGA; Art Directors Club of Metropolitan Washington DC.

Needs Approached by 50 illustrators and 25 designers/year. Works with 20 illustrators/year. Uses freelancers for brochure illustration, multimedia projects, TV/film graphics and Web page design. 37% of work is with print ads. 90% of illustration demands skills in Photoshop, Illustrator and QuarkXPress.

First Contact & Terms Send postcard sample or query letter with follow up postcard every 3 months. Samples are filed. Responds only if interested. Portfolios of photographs may be dropped every Thursday and Friday. Pays for illustration by the project, $250-5,000. Rights purchased vary according to project. Finds artists through sourcebooks and word of mouth.

ⓝ ⓘ JACK SCHECTERSON ASSOCIATES

5316-251 Place, Little Neck NY 11362. (718)225-3536. Fax: (718)423-3478. **Principal:** Jack Schecterson. Estab. 1967. Ad agency. Specializes in 2D and 3D visual marketing, new product introduction, product, package, graphic and corporate design.

Needs Works direct and with artist reps. Prefers local freelancers. Works on assignment only. Uses freelancers for package, product and corporate design; illustration, brochures, catalogs, logos. 100% of design and 90% of graphic illustration demands skills in Illustrator, Photoshop and InDesign.

First Contact & Terms Send query letter with brochure, photocopies, tearsheets, résumé, photographs, slides, transparencies and SASE; "whatever best illustrates work." Samples not filed are returned by SASE only if requested by artist. Request portfolio review in original query. Will contact artist for portfolio review if interested. Portfolio should include roughs, b&w and color— "whatever best illustrates creative abilities/work." Pays for design and illustration by the project; depends on budget. Buys all rights.

ⓝ SCHROEDER BURCHETT DESIGN CONCEPTS

137 Main St., Unadilla NY 13849-3360. (607)369-4709. **Designer & Owner:** Carla Schroeder Burchett. Estab. 1972. Specializes in packaging, marketing and restoration. Clients: manufacturers.

Needs Works on assignment only. Uses freelancers for design, lettering and logos. 20% of freelance work demands knowledge of PageMaker or Illustrator. Needs technical and medical illustration.

First Contact & Terms Send résumé. "If interested, we will contact artist or craftsperson and

will negotiate." Write for appointment to show portfolio of thumbnails, final reproduction/product and photographs. Pays for design by the hour, $15 minimum. Pays for illustration by the project. "If it is excellent work, the person will receive what he asks for!" Considers skill and experience of artist when establishing payment. Finds artists through submissions and word of mouth.

Tips "Creativity depends on each individual. Artists should have a sense of purpose and dependability and must work for long- and short-range plans. Have perseverance. Top people still get in any agency. Don't give up."

THOMAS SEBASTIAN COMPANIES

(formerly ArtOnWeb), 508 Bluffs Edge Dr., McHenry IL 60051. (815)578-9171. E-mail: sebastiancompanies@mac.com. Web site: www.thomassebastiancompanies.com. **Creative Director:** Pete Secker. Owner: Thomas Sebastian. Estab. 1996. Number of employees: 10. Integrated marketing communications agency and Internet service. Specializes in Web site and graphic design for print materials. Client list available upon request.

Needs Approached by 12 illustrators and 12 designers/year. Works with 2-3 illustrators and 1-2 designers/year. Uses freelancers mainly for design and computer illustration; also for humorous illustration, lettering, logos and Web page design. 5% of work is with print ads. 90% of design and 70% of illustration demands knowledge of Photoshop, Illustrator, QuarkXPress.

First Contact & Terms Query via e-mail. Send follow up postcard samples every 6 months. Accepts Mac-compatible submissions on CD-ROM or DVD. Samples are filed and are not returned. Responds only if interested. Will contact artist for portfolio review if interested. Pays by the project. Negotiates rights purchased. Finds freelancers through *The Black Book*, creative sourcebooks, Internet.

N SELBERT-PERKINS DESIGN COLLABORATIVE

11 Water St., Arlington MA 02476. (781)574-6605. Fax: (781)574-6606. E-mail: lmurphy@spdeast .com. Web site: www.selbertperkins.com. Estab. 1980. Number of employees: 25. Specializes in annual reports, brand identity design, displays, landscape architecture and urban design, direct mail, product and package design, exhibits, interactive media and CD-ROM design and print and environmental graphic design. Clients: airports, colleges, theme parks, corporations, hospitals, computer companies, retailers, financial institutions, architects. Professional affiliations: AIGA, SEGD.

● This firm has an office at 200 Culver Blvd., Playa del Rey CA 90293. (310)822-5223. Fax: (310)822-5203. E-mail: nmartinez@spdwest.com.

Needs Approached by "hundreds" of freelancers/year. Works with 10 freelance illustrators and 20 designers/year. Prefers artists with "experience in all types of design and computer experience." Uses freelance artists for brochures, mechanicals, logos, P-O-P, poster and direct mail; also for multimedia projects. 100% of freelance work demands knowledge of Photoshop, Canvas, InDesign, Illustrator.

First Contact & Terms Send query letter with brochure, résumé, tearsheets, photographs, photocopies, slides and transparencies. Samples are filed. Responds only if interested. Portfolios may be dropped off every Monday-Friday. Artist should follow up with call and/or letter after initial query. Will contact artist for portfolio review if interested. Pays for design by the hour, or by the project. Pays for illustration by the project. Rights purchased vary according to project. Finds artists through word of mouth, magazines, submissions/self-promotions, sourcebooks and agents.

STEVEN SESSIONS INC.

5177 Richmond, Suite 500, Houston TX 77056. (713)850-8450. Fax: (713)850-9324. E-mail: Steven @Sessionsgroup.com. Web site: www.sessionsgroup.com. **President/Creative Director:** Steven

Sessions. Estab. 1981. Number of employees: 8. Approximate annual billing: $2.5 million. Specializes in annual reports; brand and corporate identity; fashion, package and publication design. Clients: corporations and ad agencies. Current clients are listed on Web site. Professional affiliations: AIGA, Art Directors Club, American Ad Federation.

Needs Approached by 50 freelancers/year. Works with 10 illustrators and 2 designers/year. Uses freelancers for brochure, catalog and ad design and illustration; poster illustration; lettering; and logos. 100% of freelance work demands knowledge of Illustrator, QuarkXPress, Photoshop. Needs editorial, technical and medical illustration.

First Contact & Terms Designers: Send query letter with brochure, tearsheets, CDs, PDF files and SASE. Illustrators: Send postcard sample or other nonreturnable samples. Samples are filed. Responds only if interested. To show portfolio, mail slides. Payment depends on project, $1,000-30,000/illustration. Rights purchased vary according to project.

N ☒ SIGNATURE DESIGN

727 N. First St., St. Louis MO 63102. (314)621-6333. Fax: (314)621-0179. E-mail: therese@therese mckee.com. Web site: www.theresemckee.com. **Owner:** Therese McKee. Estab. 1993. Interpretive graphic and exhibit design firm producing conceptual design, design development and project management for exhibits in museums, visitor centers and parks; interpretive signage for parks and gardens; and computer interactives and graphics for Web sites. Current clients include Bureau of Land Management, Missouri Botanical Garden, United States Post Office. Client list available upon request.

Needs Approached by 15 freelancers/year. Works with 1-2 illustrators and 1-2 designers/year. Prefers local freelancers only. Works on assignment only. 50% of freelance work demands knowledge of InDesign, Flash, Illustrator or Photoshop.

First Contact & Terms Send query letter with résumé, tearsheets and photocopies. Samples are filed. Responds only if interested. Artist should follow up with letter after initial query. Portfolio should include "whatever best represents your work." Pays for design by the hour. Pays for illustration by the project.

N ☒ SILVER FOX ADVERTISING

11 George St., Pawtucket RI 02860. (401)725-2161. Fax: (401)726-8270. E-mail: sfoxstudios@eart hlink.net. Web site: www.silverfoxstudios.com. **President:** Fred Marzocchi, Jr. Estab. 1979. Number of employees: 5. Approximate annual billing: $1 million. Specializes in package and publication design, logo design, brand and corporate identity, display, technical illustration and annual reports. Clients: corporations, retail. Client list available upon request.

Needs Approached by 16 freelancers/year. Works with 6 freelance illustrators and 12 designers/year. Works only with artist reps. Prefers local artists only. Uses illustrators mainly for cover designs; also for multimedia projects. 50% of freelance work demands knowledge of Illustrator, Photoshop, PageMaker and QuarkXPress.

First Contact & Terms Send query letter with résumé and photocopies. Accepts disk submissions compatible with Photoshop 7.0 or Illustrator 8.0. Samples are filed. Does not reply. Artist should follow up with call and/or letter after initial query. Portfolio should include final art, photographs, roughs and slides.

SIMMONS/FLINT ADVERTISING

33 S. Third St., Suite D, Grand Forks ND 58201. (701)746-4573. Fax: (701)746-8067. E-mail: YvonneRW@simmonsflint.com. Web site: www.simmonsflint.com. **Contact:** Yvonne Westrum. Estab. 1947. Number of employees: 90. Approximate annual billing: $5.5 million. Ad agency. Specializes in magazine ads, collateral, documentaries, Web design etc. Product specialties are agriculture, gardening, fast food/restaurants, healthcare. Client list available upon request.

• A division of Flint Communications, with 5 locations in North Dakota and Minnesota. See listing for Flint Communications in this section.

Needs Approached by 3-6 freelancers/year. Works with 3 freelance illustrators and 2 designer/year. Works on assignment only. Uses freelancers mainly for illustration; also for brochure, catalog and print ad design and illustration; storyboards; billboards; and logos. 10% of work is with print ads. 10% of freelance work demands knowledge of QuarkXPress, Photoshop, Illustrator.

First Contact & Terms Send postcard, tearsheets or digital submission. Samples are filed or are returned. Will contact artist for portfolio review if interested. Portfolio should include color thumbnails, roughs, tearsheets, and photographs. Pays for design and illustration by the hour, by the project, or by the day. Rights purchased vary according to project.

✠ SMITH & DRESS LTD.
432 W. Main St., Huntington NY 11743. (631)427-9333. Fax: (631)427-9334. E-mail: dress2@att.net. Web site: www.smithanddress.com. **Contact:** Abby Dress. Full-service ad firm. Specializes in annual reports, corporate identity, display, direct mail, packaging, publications, Web sites, trade shows and signage.

Needs Works with 3-4 freelance artists/year. Prefers local artists only. Works on assignment only. Uses artists for illustration, retouching, airbrushing and lettering.

First Contact & Terms Send query letter with brochure showing art style or tearsheets to be kept on file (except for works larger than 8½×11). Pays for illustration by the project. Considers client's budget and turnaround time when establishing payment.

SMITH ADVERTISING
321 Arch St., Drawer 2187, Fayetteville NC 28302. (910)222-5071. E-mail: gsmith@smithadv.com. Web site: www.smithadv.com. **CEO/President:** Gary Smith. Estab. 1974. Ad agency, full-service multimedia firm. Specializes in newspaper, magazine, broadcast, collateral, PR, custom presentations and Web design. Product specialties are financial, healthcare, manufacturing, business-to-business, real estate, tourism. Client list available upon request.

Needs Approached by 0-5 freelance artists/month. Works with 5-10 freelance illustrators and designers/month. Prefers artists with experience in Macintosh. Works on assignment only. Uses freelance artists mainly for mechanicals and creative; also for brochure, catalog and print ad illustration and animation, mechanicals, retouching, model-making, TV/film graphics and lettering. 50% of work is with print ads. Needs computer-literate freelancers for design, illustration, production and presentation. 95% of freelance work demands knowledge of QuarkXPress, Illustrator or Photoshop.

First Contact & Terms Send query letter with résumé and copies of work. Samples are returned by SASE if requested by artist. Responds in 3 weeks. Will contact artist for portfolio review if interested. Pays for design and illustration by the project, $100. Buys all rights.

SMITH DESIGN
P.O. Box 8278, 205 Thomas St., Glen Ridge NJ 07028. (973)429-2177. Fax: (973)429-7119. E-mail: laraine@smithdesign.com. Web site: www.smithdesign.com. **Vice President:** Laraine Blauvelt. Brand design firm. Specializes in strategy-based visual solutions for leading consumer brands. Clients: grocery, mass market consumer brands, electronics, construction, automotive, toy manufacturers. Current clients include Popsicle, Good Humor, Motts. Client list available upon request.

Needs Approached by more than 100 freelancers/year. Works with 10-20 freelance illustrators and 3-4 designers/year. Requires experience, talent, quality work and reliability. Uses freelancers for package design, concept boards, brochure design, print ads, newsletters illustration, POP display design, retail environments, Web programming. 90% of freelance work demands knowl-

edge of Illustrator, QuarkXPress, 3D rendering programs. Design style must be current to trends, particularly when designing for kids and teens. "Our work ranges from classic brands to cutting edge."

First Contact & Terms Send query letter with brochure/samples showing work, style and experience. Include contact information. Samples are filed or are returned only if requested by artist. Responds in 1 week. Call for appointment to show portfolio. Pays for design by the hour, $35-100; or by the project, $175-5,000. Pays for illustration by the project, $175-5,000. Considers complexity of project and client's budget when establishing payment. Buys all rights. (For illustration work, rights may be limited to a particular use TBD). Also buys rights for use of existing non-commissioned art. Finds artists through word of mouth, self-promotions/sourcebooks and agents.

Tips "Know who you're presenting to (visit our Web site to see our needs). Show work that is relevant to our business at the level and quality we require. We use more freelance designers and illustrators for diversity of style and talent."

N J. GREG SMITH

14707 California St., Suite 6, Omaha NE 68154. (402)444-1600. Fax: (402)444-1610. **Senior Art Director:** Greg M. Smith. Estab. 1974. Number of employees: 8. Approximate annual billing: $1.5 million. Ad agency. Clients: financial, banking, associations, agricultural, travel and tourism, insurance. Professional affiliation: AAAA.

Needs Approached by 1-10 freelancers/year. Works with 4-5 freelancers illustrators and 1-2 designers/year. Works on assignment only. Uses freelancers mainly for mailers, brochures and projects; also for consumer and trade magazines, catalogs and AV presentations. Needs illustrations of farming, nature, travel.

First Contact & Terms Send query letter with samples showing art style and/or photocopies. Responds only if interested. To show portfolio, mail final reproduction/product, color and b&w. Pays for design and illustration by the project: $500-5,000. Buys first, reprint or all rights.

SOFTMIRAGE

2900 Bristol St., Suite J103, Costa Mesa CA 92626. (714)546-7030, ext. 102. Fax: (714)546-3565. E-mail: steve@softmirage.com. Web site: www.softmirage.com. **Design Director:** Steve Pollack. Estab. 1995. Number of employees: 28. Approximate annual billing: $3 million. Visual communications agency. Specializes in architecture, luxury, real estate. Needs people with strong spatial design skills, modeling and ability to work with computer graphics. Current clients include Four Seasons Hotels, Ford, Richard Meier & Partners and various real estate companies.

Needs Approached by 15 computer freelance illustrators and 5 designers/year. Works with 6 freelance 3D modelers, and 10 graphic designers/year. Prefers West coast designers with experience in architecture, engineering, technology. Uses freelancers mainly for concept, work in process computer modeling; also for animation, brochure design, mechanicals, multimedia projects, retouching, technical illustration, TV/film graphics. 50% of work is renderings. 100% of design and 30% of illustration demands skills in Photoshop, 3-D Studio Max, Flash and Director. Need Macromedia Flash developers.

First Contact & Terms Designers: Send e-mail query letter with samples. 3-D modelers: Send e-mail query letter with photocopies or link to Web site. Accepts digital and video submissions. Samples are filed or returned by SASE. Will contact for portfolio review if interested. Pays for design by the hour, $15-85. Pays for modeling by the project, $100-2,500. Rights purchased vary according to project. Finds artists through Internet, AIGA and referrals.

Tips "Be innovative, push the creativity, understand the business rationale, and accept technology. Check our Web site, as we do not use traditional illustrators; all our work is now digital.

Send information electronically, making sure work is progressive, and emphasize types of projects you can assist with.''

SPECTRUM BOSTON CONSULTING, INC.

P.O. Box 689, Westwood MA 02090-0689. (781)320-1361. Fax: (781)320-1315. E-mail: gboesel@s pectrumboston.com. Web site: www.spectrumboston.com. **President:** George Boesel. Estab. 1985. Specializes in brand and corporate identity, display and package design and signage. Clients: consumer, durable manufacturers.

Needs Approached by 30 freelance artists/year. Works with 5 illustrators and 3 designers/year. All artists employed on work-for-hire basis. Works on assignment only. Uses illustrators mainly for package and brochure work; also for brochure design and illustration, logos, P-O-P design and illustration and model-making. 100% of design and 85% of illustration demands knowledge of Illustrator, QuarkXPress, Photoshop. Needs technical and instructional illustration.

First Contact & Terms Designers: Send query letter with résumé and photocopies. Illustrators: Send query letter with tearsheets, photographs and photocopies. Accepts any Mac-formatted disk submissions except for PageMaker. Samples are filed. Responds only if interested. Call or write for appointment to show portfolio of roughs, original/final art and color slides.

▓ SPIRIT CREATIVE SERVICES INC.

3157 Rolling Rd., Edgewater MD 21037. (410)956-1117. Fax: (410)956-1118. Web site: www.spirit creativeservices.com. **President:** Alice Yeager. Estab. 1992. Number of employees: 2. Approximate annual billing: $90,000. Specializes in catalogs, signage, books, annual reports, brand and corporate identity, display, direct mail, package and publication design, Web page design, technical and general illustration, photography and marketing. Clients: associations, corporations, government. Client list available upon request.

Needs Approached by 30 freelancers/year. Works with local designers only. Uses freelancers for ad, brochure, catalog, poster and P-O-P design and illustration, books, direct mail and magazine design, audiovisual materials, charts/graphs, lettering, logos and mechanicals; also for multimedia and Internet projects. 100% of design and 10% of illustration demands knowledge of Illustrator, Photoshop and PageMaker, A Type Manager, InDesign and QuarkXPress; also knowledge of Web design.

First Contact & Terms Send 2-3 samples of work with résumé. Accepts hardcopy submissions. Does not accept e-mail submissions. Samples are filed. Responds in 1-2 weeks if interested. Request portfolio review in original query. Portfolio should include b&w and color final art, tearsheets, sample of comping ability. Pays for design by the project, $50-6,000.

Tips ''Paying attention to due dates, details, creativity, communication and intuition is vital.''

SPLANE DESIGN ASSOCIATES

30634 Persimmon Lane, Valley Center CA 90282. (760)749-6018. E-mail: splane@pacificnet.net. Web site: www.splanedesign.com. **President:** Robson Splane. Specializes in product design. Clients: small, medium and large companies. Current clients include Lockheed Aircraft, Western Airlines, Liz Claiborne, Max Factor, Sunkist, Universal studios. Client list available upon request.

Needs Approached by 25-30 freelancers/year. Works with 1-2 freelance illustrators and 6-12 designers/year. Works on assignment only. Uses illustrators mainly for logos, mailings to clients, renderings. Uses designers mainly for sourcing, drawings, prototyping, modeling; also for brochure design and illustration, ad design, mechanicals, retouching, airbrushing, model making, lettering and logos. 75% of freelance work demands skills in FreeHand, Ashlar Vellum, Solidworks and Excel.

First Contact & Terms Send query letter with résumé and photocopies. Samples are filed or are returned. Responds only if interested. Will contact artist for portfolio review if interested. Portfolio

should include color roughs, final art, photostats, slides and photographs. Pays for design and illustration by the hour, $7-25. Rights purchased vary according to project. Finds artists through submissions and contacts.

ⓝ HARRY SPRUYT DESIGN

52 Kimball Hill, Putney VT 05346-8810. Specializes in design/invention, creating in aesthetic and functional (ergonomic) perspective delineations, mechanical control drawings and all model types; photography and grapichs. Clients: organizations and one-of-a-kind commissions for individuals. Client list available with description of HSD participations.

Needs Works on assignment only.

STEVENS BARON COMMUNICATIONS

Hanna Bldg., Suite 645, 1422 Euclid Ave., Cleveland OH 44115-1900. (216)621-6800. Fax: (216)621-6806. E-mail: pres@stevensbaron.com. Web site: www.stevensbaron.com. **President:** Edward M. Stevens, Sr. Estab. 1956. Ad agency. Specializes in public relations, advertising, corporate communications, magazine ads and collateral. Product specialties are business-to-business, food, building products, technical products, industrial food service, healthcare, safety.

Needs Approached by 30-40 freelance artists/month. Prefers artists with experience in food, healthcare and technical equipment. Works on assignment only. Uses freelance artists mainly for specialized projects; also for brochure, catalog and print ad illustration and retouching. Freelancers should be familiar with PageMaker, QuarkXPress, FreeHand, Illustrator and Photoshop.

First Contact & Terms Send query letter with résumé and photocopies. Samples are filed and are not returned. Responds only if interested. "Artist should send only samples or copies that do not need to be returned." Will contact artist for portfolio review if interested. Portfolio should include final art and tearsheets. Pay for design depends on style. Pay for illustration depends on technique. Buys all rights. Finds artists through agents, sourcebooks, word of mouth and submissions.

JOHN STRIBIAK & ASSOCIATES, INC.

1266 Holiday Dr., Somonauk IL 60552. (815)498-4900. Fax: (815)498-4905. E-mail: jsa@stribiak.com. Web site: www.stribiak.com. **President:** John Stribiak. Estab. 1981. Number of employees: 2. Approximate annual billing: $300,000. Specializes in corporate identity and package design. Clients: corporations. Professional affiliations: IOPP, PDC.

Needs Approached by 75-100 freelancers/year. Works with 20 freelance illustrators and 2 designers/year. Prefers artists with experience in illustration, design, retouching and packaging. Uses illustrators mainly for packaging and brochures. Uses designers mainly for new products. Also uses freelancers for ad and catalog illustration, airbrushing, brochure design and illustration, lettering, model-making and retouching. Needs computer-literate freelancers for production. 70% of freelance work demands skills in Illustrator, Photoshop and QuarkXPress.

First Contact & Terms Send postcard sample of work. Samples are filed. Will contact artist for portfolio review if interested. Portfolio should include b&w and color roughs and transparencies. Pays for design and illustration by the project. Rights purchased vary according to project. Finds artists through sourcebooks.

ⓘ STROMBERG CONSULTING

1285 Avenue of the Americas, 3rd floor, New York NY 10019. (646)935-4300. Fax: (646)935-4368. E-mail: lisa.fuhrman@ketchum.com. Web site: www.strombergconsulting.com. **Senior Recruiter:** Lisa Fuhrman. Specializes in direct marketing, internal and corporate communications. Clients: industrial and corporate. Produces multimedia presentations and print materials.

Needs Assigns 25-35 jobs/year. Prefers local designers only (Manhattan and its 5 burroughs)

with experience in animation, computer graphics, multimedia and Macintosh. Uses freelancers for animation logos, posters, storyboards, training guides, Web Flash, application development, design catalogs, corporate brochures, presentations, annual reports, slide shows, layouts, mechanicals, illustrations, computer graphics and desk-top publishing web development, application development.

First Contact & Terms "Send note on availability and previous work." Responds only if interested. Provide materials to be kept on file for future assignments. Originals are not returned. Pays hourly or by the project.

Tips Finds designers through word of mouth and submissions.

ℕ THE STRONGTYPE

P.O. Box 1520, Dover NJ 07802-1520. (973)919-4265. E-mail: richard@strongtype.com. Web site: www.strongtype.com. **Contact:** Richard Puder. Estab. 1985. Approximate annual billing: $300,000. Specializes in marketing communications, direct mail and publication design, technical illustration. Client history includes Hewlett-Packard, Micron Electronics, R.R. Bowker, Scholastic, Simon & Schuster and Sony. Professional affiliation: Type Directors Club.

Needs Approached by 100 freelancers/year. Uses designers mainly for corporate, publishing clients; also for ad and brochure design and illustration, book, direct mail, magazine and poster design, charts/graphs, lettering, logos and retouching. 100% of freelance work demands skills in Illustrator, Photoshop, FreeHand, Acrobat, QuarkXPress, Director, Flash, Fireworks and Dreamweaver.

First Contact & Terms E-mail with links and follow up with call, or send postcard sample, résumé and tearsheets. Samples are filed. Will contact artist for portfolio review if interested. Pays for design and production by the hour, depending on skills, $10-100. Pays for illustration by the job. Buys first rights or rights purchased vary according to project. Finds artists through sourcebooks (e.g., *American Showcase* and *Workbook*) and by client referral.

Tips Impressed by "listening, problem-solving, speed, technical competency and creativity."

STUDIO WILKS

2148-A Federal Ave., Los Angeles CA 90025. (310)478-4442. Fax: (310)478-0013. E-mail: richard @studiowilks.comWeb site: www.studiowilks.com. **Executive Creative Dirctor**: Richard Wilks. Estab. 1990. Specializes in print, collateral, packaging, editorial and environmental work. Clients: ad agencies, architects, corporations and small business owners. Current clients include Walt Disney Co., Target, Nokia, City of Cerritos, Major League Soccer and Yoga Works.

Needs Works with 6-10 freelance illustrators and 10-20 designers/year. Uses illustrators mainly for packaging illustration; also for brochures, print ads, collateral, direct mail and promotions.

First Contact & Terms Designers: Send query letter with brochure, résumé, photocopies and tearsheets. Illustrators: Send postcard sample or query letter with tearsheets. Samples are returned by SASE if requested by artist. Will contact artist for portfolio review if interested. Pays for design by the project. Buys all rights. Considers buying second rights (reprint rights) to previously published work. Finds artists through *Workbook* and word of mouth.

SWANSON RUSSELL ASSOCIATES

1222 P St., Lincoln NE 68508. (402)437-6400. Fax: (402)437-6401. E-mail: daveh@sramarketing.c om. Web site: www.sramarketing.com. **Managing Director:** Dave Hansen. Estab. 1962. Number of employees: 120. Approximate annual billing: $80 million. Integrated marketing communications agency. Specializes in collateral, catalogs, magazine and newspaper ads, direct mail. Product specialties are healthcare, agriculture, green industry, outdoor recreation. Current clients include Mercy Hospital, Physicians Mutual, Manna Pro, OPUS Medication Systems. Professional affiliations: PRSA, AIGA, Ad Club.

• Second location: 14301 FNB Parkway, Suite 312, Omaha NE 68154. (402)393-4940. Fax: (402)393-6926. E-mail: wesn@sramarketing.com. **Managing Director:** Wes Neuhaus.

Needs Approached by 12 illustrators and 3-4 designers/year. Works with 5 illustrators and 2 designers/year. Prefers freelancers with experience in agriculture, pharmaceuticals, human and animal health. Uses freelancers mainly for collateral, ads, direct mail, storyboards; also for brochure design and illustration, humorous and technical illustration, lettering, logos, mechanicals, posters, storyboards. 10% of work is with print ads. 90% of design demands knowledge of Photoshop 7.0, FreeHand 5.0, QuarkXPress 3.3. 30% of illustration demands knowledge of Photoshop, Illustrator, FreeHand.

First Contact & Terms Designers: Send query letter with photocopies, photographs, photostats, SASE, slides, tearsheets, transparencies. Illustrators: Send query letter with SASE. Send follow up postcard samples every 3 months. Accepts Mac-compatible disk submissions. Send self-expanding archives and player for multimedia, or JPEG, EPS and TIFF files. Software: Quark, FreeHand or Adobe. Samples are filed or returned by SASE. Responds within 2 weeks, only if interested. Art director will contact artist for portfolio review of final art, photographs, photostats, transparencies if interested. Pays for design by the hour, $50-65; pays for illustration by the project, $250-3,000. Rights purchased vary according to project. Finds artists through agents, submissions, word of mouth, *Laughing Stock, American Showcase.*

T-P DESIGN INC.

7007 Eagle Watch Court, Stone Mountain GA 30087. (770)413-8276. Fax: (770)413-9856. E-mail: tpdesign@mindspring.com. Web site: www.tpdesigninc.com. **Creative Director:** Charly Palmer. Estab. 1991. Number of employees: 3. Approximate annual billing: $500,000. Specializes in brand identity, display, package and publication design. Clients: corporations. Current clients include Georgia Pacific, Cartoon Network, General Mills, KFC.

Needs Approached by 4 freelancers/year. Works with 2 freelance illustrators and 2 designers/year. Prefers local artists with Mac systems, traditional background. Uses illustrators and designers mainly for comps and illustration on Mac; also for ad, brochure, poster and P-O-P design and illustration; book design, charts/graphs, lettering, logos, mechanicals (important) and page layout. 75% of freelance work demands skills in Illustrator, Photoshop, InDesign. "Knowledge of multimedia programs such as Director and Premier is also desirable."

First Contact & Terms Send query letter or photocopies, résumé and tearsheets. Accepts e-mail submissions to tpdesign@mindspring.com. Samples are filed. Will contact artist for portfolio review if interested. Portfolio should include b&w and color final art, roughs (important) and thumbnails (important). Pays for design and illustration by the project. Rights purchased vary according to project. Finds artists through submissions and word of mouth. Desires freelancers with Web design or Web programming experience and skills.

Tips "Be original, be creative and have a positive attitude. Need to show strength in illustration with a good design sense. A flair for typography is desirable."

⚡ TALCO PRODUCTIONS

279 E. 44th St., New York NY 10017. (212)697-4015. Fax: (212)697-4827. E-mail: alaw1@springmail.com. **President:** Alan Lawrence. Number of employees: 5. TV/film producer. Specializes in nonprofit organizations, industry, associations and PR firms. Produces videotapes, motion pictures. Professional affiliation: DGA.

Needs Works with 1-2 freelance illustrators and 1-2 designers/year. Prefers local freelancers with professional experience. 15% of freelance work demands skills in FreeHand or Illustrator.

First Contact & Terms Send query letter with résumé, brochure and SASE. Responds only if interested. Portfolio should include roughs, final reproduction/product, and color copies. Payment varies according to assignment. Pays on production. Originals almost always returned at

job's completion. Buys all rights. Considers complexity of project, client's budget and rights purchased when establishing payment.

JULIA TAM DESIGN

2216 Via La Brea, Palos Verdes CA 90274. (310)378-7583. Fax: (310)378-4589. E-mail: julia.tam@ verizon.net. **Contact:** Julia Tam. Estab. 1986. Specializes in annual reports, corporate identity, brochures, promotional material, packaging and design. Clients: corporations. Current clients include Southern California Gas Co., *Los Angeles Times*, UCLA. Client list available upon request. Professional affiliations: AIGA.

Needs Approached by 10 freelancers/year. Works with 6-12 freelance illustrators and 2 designers/year. "We look for special styles." Works on assignment only. Uses illustrators mainly for brochures. Also uses freelancers for catalog and ad illustration; retouching; and lettering. 50-100% of freelance work demands knowledge of QuarkXPress, Illustrator or Photoshop.

First Contact & Terms Designers: Send query letter with brochure and résumé. Illustrators: Send query letter with résumé and tearsheets. Samples are filed. Responds only if interested. Artist should follow up. Portfolio should include b&w and color final art, tearsheets and transparencies. Pays for design by the hour, $20. Pays for illustration by the project. Negotiates rights purchased. Finds artists through *LA Workbook*.

⚓ TASTEFUL IDEAS, INC.

7638 Bell Dr., Shawnee KS 66217. (913)722-3769. Fax: (913)722-3967. E-mail: john@tastefulideas .com. Web site: www.tastefulideas.com. **President:** John Thomsen. Estab. 1986. Number of employees: 4. Approximate annual billing: $500,000. Design firm. Specializes in consumer packaging. Product specialties are largely, but not limited to, food and foodservice.

Needs Approached by 15 illustrators and 15 designers/year. Works with 3 illustrators and 3 designers/year. Prefers local freelancers. Uses freelancers mainly for specialized graphics; also for airbrushing, animation, humorous and technical illustration. 10% of work is with print ads. 75% of design and illustration demands skills in Photoshop and Illustrator.

First Conact & Terms Designers: Send query letter with photocopies. Illustrators: Send non-returnable promotional sample. Accepts submissions compatible with Illustrator, Photoshop (Mac based). Samples are filed. Responds only if interested. Art director will contact artist for portfolio review of final art if interested. Pays by the project. Finds artists through submissions.

Ⓝ ⚓ BRANDON TAYLOR DESIGN

5405 Morehouse Dr., Suite 280, San Diego CA 92121. (858)623-9084. Fax: (858)452-6970. E-mail: dennis@brandontaylor.com. Web site: www.brandontaylor.com. **Principal:** Dennis Gillaspy. Estab. 1977. Specializes in corporate identity, displays, direct mail, package and publication design and signage. Clients: corporations and manufacturers. Client list available upon request.

Needs Approached by 20 freelance artists/year. Works with 15 freelance illustrators and 10 freelance designers/year. Prefers local artists. Works on assignment only. Uses freelance illustrators mainly for technical and instructional spots. Uses freelance designers mainly for logo design, books and ad layouts. Also uses freelance artists for brochure, catalog, ad, P-O-P and poster design and illustration, retouching, airbrushing, logos, direct mail design and charts/graphs.

First Contact & Terms Send query letter with brochure, résumé, photocopies and photostats. Samples are filed. Responds in 2 weeks. Write to schedule an appointment to show a portfolio, or mail thumbnails, roughs, photostats, tearsheets, comps and printed samples. Pays for design by the assignment. Pays for illustration by the project, $400-1,500. Rights purchased vary according to project.

CHUCK THOMAS CREATIVE, INC.

214 W. River Rd., St. Charles IL 60174. (630)587-6000. Fax: (630)587-6430. E-mail: branding@ctc reative.com. Web site: www.ctcreative.com. Estab. 1989. Integrated marketing communications agency. Specializes in consulting, creative branding, collateral. Product specialties: healthcare, family. Current clients include Kidspeace, Cook Communications, Opportunity International.

Needs Works with 1-2 freelance illustrators and 2-3 designers/year. Needs freelancers for brochure design and illustration, logos, multimedia projects, posters, signage, storyboards, TV/film graphics. 20% of work is with print ads. 100% of freelance design demands skills in Illustrator and InDesign.

First Contact & Terms Designers: Send query letter with brochure and photocopies. Illustrators: Send postcard sample of work. Samples are filed. Responds only if interested. Portfolio review not required. Pays by the project. Buys all rights.

J. WALTER THOMPSON COMPANY

10-B Glenlake Pkwy. NE, Atlanta GA 30328. (404)365-7300. Fax: (404)365-7399. Web site: www.j wt.com. **Executive Creative Director:** Carl Warner. Ad agency. Current clients include Domino's, Ford, HSBC, Kraft, Shell, Unilever.

- JWT has offices all over the world. See Web site for details.

Needs Works on assignment only. Uses freelancers for billboards, consumer and trade magazines and newspapers. Needs computer-literate freelancers for design, production and presentation. 60% of freelance work demands skills in Illustrator, Photoshop, InDesign, Flash, and Dreamweaver.

First Contact & Terms *Deals with artist reps only.* Send slides, original work, stats. Samples returned by SASE. Responds only if interested. Originals not returned. Call for appointment to show portfolio.

Tips Wants to see samples of work done for different clients. Likes to see work done in different mediums; variety and versatility. Freelancers interested in working here should "be *professional* and do top-grade work."

TOBOL GROUP, INC.

14 Vanderventer Ave., Port Washington NY 11080. (516)767-8182. Fax: (516)767-8185. E-mail: mt@tobolgroup.com. Web site: www.tobolgroup.com. **President:** Mitch Tobol. Estab. 1981. Ad agency. Product specialties are business to business and business to consumer.

Needs Approached by 2 freelance artists/month. Works with 1 freelance illustrator and 4 designers/month. Works on assignment only. Uses freelancers for brochure, catalog and print ad design and technical illustration, mechanicals, retouching, billboards, posters, TV/film graphics, lettering and logos. 45% of work is with print ads. 75% of freelance work demands knowledge of QuarkXPress, Illustrator, Photoshop or GoLive.

First Contact & Terms Send query letter with SASE and tearsheets. Samples are filed or are returned by SASE. Responds in 1 month. Call for appointment to show portfolio or mail thumbnails, roughs, b&w and color tearsheets and transparencies. Pays for design by the hour, $25 minimum; by the project, $100-800; by the day, $200 minimum. Pays for illustration by the project, $300-1,500 ($50 for spot illustrations). Negotiates rights purchased.

TOKYO DESIGN CENTER

703 Market St., Suite 252, San Francisco CA 94103. (415)543-4886. E-mail: info@tokyodesign.c om. Web site: www.tokyodesign.com. **Creative Director:** Kaoru Matsuda. Specializes in annual reports, brand identity, corporate identity, packaging and publications. Clients: consumer products, travel agencies and retailers.

Needs Uses artists for design and editorial illustration.

Subscribe to *The Artist's Magazine*… and get a FREE GIFT!

Every month, *The Artist's Magazine* provides you with painting techniques and tips from today's most accomplished international artists, delivered in spectacular full-color artwork and with clear, concise instruction. You'll find expert advice on how to:

- achieve stunning effects in watercolor, acrylic, oil, color pencil, pastel, gouache, pen and ink, and many other mediums
- recharge your creative reserves and break through artist's block
- choose and use your supplies, and get the most mileage from your materials
- keep up to date on current workshops, competitions, and exhibits
- and so much more!

Subscribe for one year (10 issues) for only $19.96—that's a 61% savings off the newsstand price—and you'll receive *Secrets for Successful Drawing* with your paid subscription.

RETURN THE ATTACHED POSTAGE-PAID CARD TODAY!

SUBSCRIBE TODAY & SAVE!

✓ *yes!* I want innovative painting ideas and creative inspiration delivered to my door! Please enter my 1-year subscription (10 issues) to *The Artist's Magazine* for the low rate of only $19.96. I understand that I will receive a **free gift**— *Secrets for Successful Drawing*—with my paid subscription. **Send no money now…we'll bill you later!**

NAME (PLEASE PRINT)

ADDRESS

CITY STATE ZIP

EMAIL *(to contact me regarding my subscription)*

☐ YES! ALSO E-MAIL ME *THE ARTIST'S MAGAZINE'S* FREE E-NEWSLETTER AND OTHER INFORMATION OF INTEREST. *(We will not sell your e-mail address to outside companies.)*

the artist's magazine

J7FAMK

Subscribers in Canada will be charged an additional US$10 (includes GST/HST) and invoiced. Please allow 4–6 weeks for first-issue delivery. Outside the U.S. and Canada, add $10 and remit in U.S. funds with this order. Annual newsstand rate: $49.90.

www.artistsmagazine.com

Subscribe to *The Artist's Magazine* Today and Save!
PLUS...GET A FREE GIFT WITH YOUR PAID SUBSCRIPTION!

Packed with innovative ideas, creative inspiration, and detailed demonstrations from the best artists in the world, *The Artist's Magazine* provides everything you need to be the best artist you can be. Here's just a sample of what you'll find inside...

- easy ways to paint dazzling light in watercolor
- simple tips for building alluring depth into your landscapes
- techniques for copying the masters with your own stylistic flair
- sure-fire solutions for still life painting success
- up-to-date information on materials and tools
- expert advice on the business side of being an artist
- and so much more!

YOUR FREE GIFT: You'll also receive the exclusive full-color booklet, *Secrets for Successful Drawing*. It's jam-packed with techniques from today's top artists. It's our gift to you—and it's yours free with your paid subscription!

SUBSCRIBE TODAY!

First Contact & Terms Send business card, slides, tearsheets and printed material to be kept on file. Samples not kept on file are returned by SASE, only if requested. Will contact artist for portfolio review if interested. Pays for design and illustration by the project, $100-1,500 average. Sometimes requests work on spec before assigning job. Considers client's budget, skill and experience of artist, turnaround time and rights purchased when establishing payment. Interested in buying second rights (reprint rights) to previously published work. Finds artists through self-promotions and sourcebooks.

THE TOMBRAS GROUP

630 Concord St., Knoxville TN 37919. (865)524-5376. Fax: (865)524-5667. E-mail: cpaul@tombra s.com. Web site: www.tombras.com. **Senior Production Manager:** Cheryl Paul. Estab. 1946. Number of employees: 68. Approximate annual billing: $75 million. Ad agency; full-service multimedia firm. Specializes in full media advertising, collateral, interactive. Current clients include National Highway Traffic, Safety Administration, Fred's Stores, Bristol Motor Speedway, Lowes Moter Speedway, Atlanta Motor Speedway, and Farm Bureau Insurance. Client list available upon request. Professional affiliations: AAAA, Worldwide Partners, AMA.

Needs Approached by 20-25 freelancers/year. Works with 20-30 freelance illustrators and 10-15 designers/year. Uses freelancers mainly for illustration and photography; also for brochure design and illustration, model-making and retouching. 60% of work is with print ads. Needs computer-literate freelancers for design and presentation. 25% of freelance work demands skills in InDesign, Photoshop and QuarkXPress.

First Contact & Terms Send query letter with photocopies and résumé. Samples are filed. Will contact artist for portfolio review if interested. Portfolio should include b&w and color samples. Pays for design by the hour, $25-75; by the project, $250-2,500. Pays for illustration by the project, $100-10,000. Rights purchased vary according to project.

Tips "Stay in touch with quality promotion. 'Service me to death' when you get a job."

A. TOMLINSON/SIMS ADVERTISING

250 S. Poplar St., Florence AL 35630. (256)766-4222. Fax: (256)766-4106. E-mail: atomlinson@a tsa-usa.com. Web site: www.atsa-usa.com. **President:** Allen Tomlinson. Estab. 1990. Number of employees: 9. Approximate annual billing: $5 million. Ad agency. Specializes in magazine, collateral, catalog, business-to-business. Product specialties are home building products. Client list available upon request.

Needs Approached by 20 illustrators and 20 designers/year. Works with 5 illustrators and 5 designers/year. Uses freelancers for airbrushing, billboards, brochure and catalog design and illustration, logos and retouching. 35% of work is with print ads. 85% of design demands skills in PageMaker, Photoshop, Illustrator and QuarkXPress. 85% of illustration demands skills in PageMaker, Photoshop, Illustrator and QuarkXPress.

First Contact & Terms Designers: Send query letter with brochure and photocopies. Illustrators: Send samples of work, photocopies and résumé. Samples are filed and are not returned. Does not reply; artist should call. Artist should also call to arrange for portfolio review of color photographs, thumbnails and transparencies. Pays by the project. Rights purchased vary according to project.

▣ TR PRODUCTIONS

209 W. Central St., Suite 108, Natick MA 01760. (508)650-3400. Fax: (508)650-3455. E-mail: info@trprod.com. Web site: www.trprod.com. **Creative Director:** Cary M. Benjamin. Estab. 1947. Number of employees: 12. AV firm; full-service multimedia firm. Specializes in collateral, multimedia, Web graphics and video.

Needs Approached by 15 freelancers/year. Works with 5 freelance illustrators and 5 designers/ year. Prefers local freelancers with experience in slides, Web, multimedia, collateral and video

graphics. Works on assignment only. Uses freelancers mainly for slides, Web, multimedia, collateral and video graphics; also for brochure and print ad design and illustration, slide illustration, animation and mechanicals. 25% of work is with print ads. Needs computer-literate freelancers for design, production and presentation. 95% of work demands skills in FreeHand, Photoshop, Premier, After Effects, Powerpoint, QuarkXPress, Illustrator, Flash.

First Contact & Terms Send query letter. Samples are filed. Does not reply. Artist should follow up with call. Will contact artist for portfolio review if interested. Rights purchased vary according to project.

TVN—THE VIDEO NETWORK

31 Cutler Dr., Ashland MA 01721-1210. (508)881-1800. Fax: (508)532-1129. E-mail: info@tvnvideo.com. Web site: www.tvnvideo.com. **Producer:** Gregg McAllister. Estab. 1986. Full-service multimedia firm. Specializes in video production for business, broadcast and special events. Product specialties "cover a broad range of categories." Current clients include Marriott, Digital, IBM, Waters Corp., National Park Service.

Needs Approached by 1 freelancer/month. Works with 1 illustrator/month. Prefers freelancers with experience in Mac/NT, 2D and 3D programs. Works on assignment only. Uses freelancers mainly for video production, technical illustration, flying logos and 3D work; also for storyboards, animation, TV/film graphics and logos.

First Contact & Terms Send query letter with videotape or computer disk. Samples are filed or are returned. Responds in 2 weeks. Will contact artist for portfolio review if interested. Portfolio should include videotape and computer disk. Pays for design by the hour, $50; by the project, $1,000-5,000; by the day, $250-500. Buys all rights. Finds artists through word of mouth, magazines and submissions.

Tips Advises freelancers starting out in the field to find a company internship or mentor program.

ULTITECH, INC.

Foot of Broad St., Stratford CT 06615. (203)375-7300. Fax: (203)375-6699. E-mail: comcowic@meds.com. Web site: www.meds.com. **President:** W. J. Comcowich. Estab. 1993. Number of employees: 3. Approximate annual billing: $1 million. Integrated marketing communications agency. Specializes in interactive multimedia, software, online services. Product specialties are medicine, science, technology. Current clients include large pharmaceutical companies.

Needs Approached by 10-20 freelance illustrators and 10-20 designers/year. Works with 2-3 freelance illustrators and 6-10 designers/year. Prefers freelancers with experience in interactive media design and online design. Uses freelancers mainly for design of Web sites and interactive CD-ROMS/DVDs; also for animation, brochure design, medical illustration, multimedia projects, TV/film graphics. 10% of work is with print ads. 100% of freelance design demands skills in Photoshop, QuarkXPress, Illustrator, 3D packages.

First Contact & Terms E-mail submission is best. Include links to online portfolio. Responds only if interested. Pays for design by the project or by the day. Pays for illustration by the project. Buys all rights. Finds artists through sourcebooks, word of mouth, submissions.

Tips "Learn design principles for interactive media."

UNICOM

9470 N. Broadmoor Rd., Bayside WI 53217. (414)352-5070. Fax: (414)352-4755. Web site: www.litteratibooks.com. **Senior Partner:** Ken Eichenbaum. Estab. 1974. Specializes in annual reports, brand and corporate identity, display, direct, package and publication design and signage. Clients: corporations, business-to-business communications, and consumer goods. Client list available upon request.

Needs Approached by 5-10 freelancers/year. Works with 1-2 freelance illustrators/year. Works

on assignment only. Uses freelancers for brochure, book and poster illustration, pre-press composition.

First Contact & Terms Send query letter with brochure. Samples are not filed or returned. Does not reply; send nonreturnable samples. Write for appointment to show portfolio of thumbnails, photostats, slides and tearsheets. Pays by the project, $200-3,000. Rights purchased vary according to project.

UNO HISPANIC ADVERTISING AND DESIGN

111 E. Franklin Ave., Suite 101, Minneapolis MN 55404. (612)874-1920. Fax: (612)874-1912. E-mail: luis@unoonline.com. Web site: www.unoonline.com. **Creative Director:** Luis Fitch. Marketing Director: Carolina Ornelas. Estab. 1990. Number of employees: 6. Approximate annual billing: $950,000. Specializes in brand and corporate identity, display, package and retail design and signage for the U.S. Hispanic markets. Clients: Latin American corporations, retail. Current clients include MTV Latino, Target, Mervyn's, 3M, Univision, Wilson's. Client list available upon request. Professional affiliations: AIGA, GAG.

Needs Approached by 33 freelancers/year. Works with 40 freelance illustrators and 20 designers/year. Works only with artists' reps. Prefers local artists with experience in retail design, graphics. Uses illustrators mainly for packaging. Uses designers mainly for retail graphics. Also uses freelancers for ad and book design, brochure, catalog and P-O-P design and illustration, audiovisual materials, logos and model making; also for multimedia projects (Interactive Kiosk, CD-Educational for Hispanic Market). 60% of design demands computer skills in Illustrator, Photoshop, FreeHand and QuarkXPress.

First Contact & Terms Designers: Send postcard sample, brochure, résumé, photographs, slides or tearsheets. Illustrators: Send postcard sample, brochure or tearsheets. Accepts disk submissions compatible with Illustrator, Photoshop, FreeHand. Send EPS files. Samples are filed. Will contact artist for portfolio review if interested. Portfolio should include color final art, photographs and slides. Pays for design by the project, $500-6,000. Pays for illustration by the project, $200-20,000. Rights purchased vary according to project. Finds artists through artist reps, *Creative Black Book* and *Workbook*.

Tips "It helps to be bilingual and to have an understanding of Hispanic cultures."

URBAN TAYLOR & ASSOCIATES

P.O. Box 571052, Miami FL 33257. (305)255-7888. Fax: (305)256-7080. E-mail: urbantay@netrun ner.net. Web site: www.gate.net/~urbantay. **President:** Alan Urban. Estab. 1976. Specializes in annual reports, corporate identity and communications, publication design. Current clients include University of Miami, Polaroid and Hughes Supply, Inc. Professional affiliation: AIGA.

Needs Approached by 10 freelancers/year. Works with 1-2 freelance illustrators and 1-2 designers/year. Works with artist reps and local freelancers. Looking for a variety of editorial, technical and corporate communications illustration styles, and freelancers with Mac experience. Works on assignment only. Uses illustrators mainly for brochures and publications. Also uses freelancers for lettering and charts/graphs. 100% of freelance work demands knowledge of QuarkXPress, FreeHand, Illustrator, Photoshop or Microsoft Word.

First Contact & Terms Send query letter with SASE and appropriate samples. Samples are filed. Will contact artist for portfolio review if interested. Pays for design by the project. "Payment depends on project and quantity printed." Rights purchased vary according to project. Finds artists through sourcebooks, direct mail pieces, referral from collegues, clients and reps.

UTOPIAN EMPIRE CREATIVEWORKS

P.O. Box 9, Traverse City MI 49864-0009. (231)943-5050 or (231)943-4000. E-mail: artists@Utopia nEmpire.com. Web site: www.UtopianEmpire.com. **Contact:** Ms. M'Lynn Hartwell. Estab. 1970.

Full-service multimedia firm. Specializes in corporate and industrial products, as well as TV and radio spots.

● This company also has a location in Hawaii: P.O. Box 458, Kapa'a HI 96746-0458.

Needs Works on assignment.

First Contact & Terms Send query letter with brochure, SASE and tearsheets. Samples are filed to review for project relevancy, or returned by SASE if requested by artist. Responds only if interested. To show portfolio, mail samples or CD/DVD media. Pays for design and illustration by the project, negotiated rate. Rights purchased vary according to project.

THE VAN NOY GROUP

3315 Westside Rd., Healdsburg CA 95448-9453. (707)433-3944. Fax: (707)433-0375. E-mail: jim@ vannoygroup.com. Web site: www.vannoygroup.com. **Vice President:** Ann Van Noy. Estab. 1972. Specializes in brand and corporate identity, displays and package design. Clients are consumer product, beverage, health and beauty, lawn and garden and decorative hardware companies. Client list available upon request.

Needs Approached by 1-10 freelance artists/year. Works with 2 illustrators and 3 designers/year. Prefers artists with experience in Macintosh design. Works on assignment only. Uses freelancers for packaging design and illustration, CS2 and Photoshop production and lettering.

First Contact & Terms Send query letter with résumé and photographs. Samples are filed. Will contact artist for portfolio review if interested. If no reply, artist should follow up. Pays for design by the hour, $35-100. Pays for illustration by the hour or by the project at a TBD fee. Finds artists through sourcebooks, self-promotions and primarily agents. Permanent positions available.

Tips "I think more and more clients will be setting up internal art departments and relying less and less on outside designers and talent. The computer has made design accessible to the user who is not design-trained."

VAN VECHTEN & COMPANY, INC.

P.O. Box 99, Boca Raton FL 33429. (561)620-2900. Fax: (561)620-2960. E-mail: lowell@vanvechte npr.com. Web site: www.vanvechtenpr.com. **President:** Lowell Van Vechten. Number of employees: 8. Approximate annual billing: $1.5 million. PR firm. Clients: medical, consumer products, industry. Client list available for SASE.

Needs Approached by 20 freelancers/year. Works with 4 freelance illustrators and 4 designers/ year. Works on assignment only. Uses artists for editorial and medical illustration, consumer and trade magazines, brochures, newspapers, stationery, signage, AV presentations and press releases. 100% of freelance work demands computer skills.

First Contact & Terms Send query letter with brochure, résumé, business card, photocopies. Samples are not returned. Responds only if interested. Pays for design and illustration by the project. Considers client's budget when establishing payment. Buys all rights.

Tips Advises freelancers starting out in the field to research agencies. "Find out what clients the agency has. Create a thumbnail sketch or original idea to get yourself in the door."

VIDEO RESOURCES

1809 E. Dyer Rd., #307, Santa Ana CA 92705. (949)261-7266. Fax: (949)261-5908. E-mail: writersb lock@videoresouces.com. Web site: www.videoresources.com. **Producer:** Brad Hagen. Number of employees: 15. Video and multimedia firm. Specializes in automotive, banks, restaurants, computer, health care, transportation and energy.

Needs Approached by 10-20 freelancers/year. Works with 5-10 freelance illustrators and 5-10 designers/year. Works on assignment only. Uses freelancers for graphics, multimedia, animation, etc.

First Contact & Terms Send query letter with brochure showing art style or résumé, business

card, photostats and tearsheets to be kept on file. Samples not filed are returned by SASE. Considers complexity of the project and client's budget when establishing payment. Buys all rights.

VISUAL CONCEPTS

1701 Kalorama Rd. NW, #307, Washington DC 20009-3508. **Owner:** John Jacobin. Estab. 1984. Service-related firm. Specializes in visual presentation, mostly for trade show exhibits and retail stores. Clients: retail stores, trade show industry, residential and commercial spaces.

Needs Approached by 15 freelancers/year. Works with 2 freelance designers/year. Assigns 10-20 projects/year. Prefers local artists with experience in visual merchandising and 3D exhibit building. Works on assignment only. Uses freelancers mainly for design and installation; also for editorial, brochure and catalog illustration, advertising design and layout, illustration, signage, and P-O-P displays. Prefers contemporary, vintage or any classic styles.

First Contact & Terms Contact through artist rep or send query letter with brochure showing art style or résumé and samples. Samples are filed. Pays for design per job. Rights purchased vary according to project.

VISUAL HORIZONS

180 Metro Park, Rochester NY 14623. (585)424-5300. Fax: (585)424-5313. E-mail: cs@visualhoriz ons.com. Web site: www.visualhorizons.com. Estab. 1971. AV firm; full-service multimedia firm. Specializes in presentation products, digital imaging of 35mm slides. Current clients include U.S. government agencies, corporations and universities.

Needs Works on assignment only. Uses freelancers mainly for catalog design. 10% of work is with print ads. 100% of freelance work demands skills in PageMaker and Photoshop.

First Contact & Terms Send query letter with tearsheets. Samples are not filed and are not returned. Responds if interested. Portfolio review not required. Pays for design and illustration by the hour or by the project, negotiated. Buys all rights.

WALKER DESIGN GROUP

421 Central Ave., Great Falls MT 59401. (406)727-8115. Fax: (406)791-9655. E-mail: info@walker designgroup.com. Web site: www.walkerdesigngroup.com. **President:** Duane Walker. Number of employees: 6. Design firm. Specializes in annual reports and corporate identity. Professional affiliations: AIGA and Ad Federation.

Needs Uses freelancers for animation, annual reports, brochure, medical and technical illustration, catalog design, lettering, logos and TV/film graphics. 80% of design and 90% of illustration demands skills in PageMaker, Photoshop and Illustrator.

First Contact & Terms Send query letter with brochure, photocopies, postcards, résumé, and/or tearsheets. Accepts digital submissions. Samples are filed and are not returned. Responds only if interested. To arrange portfolio review, artist should follow up with call or letter after initial query. Portfolio should include color photographs, photostats and tearsheets. Pays by the project; negotiable. Finds artists through *Workbook*.

Tips "Stress customer service and be very aware of deadlines."

WARKULWIZ DESIGN ASSOCIATES INC.

2218 Race St., Suite 300, Philadelphia PA 19103. (215)988-1777. Fax: (215)988-1780. E-mail: info@warkulwiz.com. Web site: www.warkulwiz.com. **President:** Bob Warkulwiz. Estab. 1985. Number of employees: 6. Approximate annual billing: $1 million. Specializes in annual reports, publication design and corporate communications. Clients: corporations and universities. Client list available upon request. Professional affiliations: AIGA

Needs Approached by 100 freelancers/year. Works with 10 freelance illustrators and 5-10 photographers/year. Works on assignment only. Uses freelance illustrators mainly for editorial and

corporate work; also for brochure and poster illustration and mechanicals. Freelancers should be familiar with most recent versions of QuarkXPress, Illustrator, Photoshop, FreeHand and Director.

First Contact & Terms Send query letter with tearsheets and photostats. Samples are filed. Responds only if interested. Call for appointment to show portfolio of "best edited work—published or unpublished." Pays for illustration by the project; "depends upon usage and complexity." Rights purchased vary according to project.

Tips "Be creative and professional."

⬛ WARNE MARKETING & COMMUNICATIONS

65 Overlea Blvd., Suite 112, Toronto ON M4H 1P1 Canada. (416)927-0881. Fax: (416)927-1676. E-mail: john@warne.com. Web site: www.warne.com. **Studio Manager:** John Coljee. Number of employees: 8. Approximate annual billing: $2.5 million. Specializes in business-to-business marketing and communications. Current clients include ACTRA Fraternal Benefits Society, 360 Athletics, Johnston Equipment, Leavens Aviation, and Virtek Vision. Professional affiliations: CIM, BMA, INBA.

Needs Works with 1-2 freelance illustrators and 1-3 designers/year. Works on assignment only. Uses freelancers for design and technical illustrations, advertisements, brochures, catalogs, P-O-P displays, posters, direct mail packages, logos and interactive. Artists should have "creative concept thinking."

First Contact & Terms Send query letter with résumé and photocopies. Samples are not returned. Responds only if interested. Pays for design by the hour, or by the project. Considers complexity of project, client's budget, and skill and experience of artist when establishing payment. Buys all rights.

WAVE DESIGN WORKS

P.O. Box 995, Norfolk MA 02056. (508)541-9171. E-mail: ideas@wavedesignworks.com. Web site: www.wavedesignworks.com. **Principal:** John Buchholz. Estab. 1986. Specializes in corporate identity and display, package and publication design. Clients: corporations, primarily biotech and software.

Needs Approached by 24 freelance graphic artists/year. Works with 1-5 freelance illustrators and 1-5 freelance designers/year. Works on assignment only. Uses freelancers for brochure, catalog, poster and ad illustration; lettering; and charts/graphs. 100% of design and 50% of illustration demands knowledge of QuarkXPress, Indesign, Illustrator or Photoshop.

First Contact & Terms Designers: send query letter with brochure, résumé, photocopies, photographs and tearsheets. Illustrators: send postcard promo. Samples are filed. Responds only if interested. Artist should follow up with call and/or letter after initial query. Portfolio should include b&w and color thumbnails and final art. Pays for illustration by the project. Rights purchased vary according to project. Finds artists through submissions and sourcebooks.

WEBSTER DESIGN ASSOCIATES, INC.

5060 Dodge St., Omaha NE 68132. (402)551-0503. Fax: (402)551-1410. E-mail: dwebster@websterdesign.com. Web site: www.websterdesign.com. **Contact:** Dave Webster. Estab. 1982. Number of employees: 12. Approximate annual billing: $16.3 million. Design firm specializing in direct mail, corporate identity, print communications, Web-interactive brochure/annual report design. Product specialites are telecommunications, Web design, corporate communications and human resources. Client list available upon request. Member of AIGA, Chamber of Commerce and Metro Advisory Council.

Needs Approached by 50 freelance illustrators and 50-75 freelance designers/year. Works with 12 freelance illustrators and 6 freelance designers/year. Prefers national and international artists

with experience in QuarkXPress, Illustrator and Photoshop. Uses freelancers mainly for illustration, photography and annual reports. 15% of work is with print ads. 100% of freelance design and 70% of freelance illustration requires knowledge of Aldus Freehand, Photoshop, Illustrator and QuarkXPress.
First Contact & Terms Designers: Send brochure, photographs and résumé. Illustrators: Send postcard sample of work. Send follow up postcard every 3 months. Accepts submissions on disk, Photoshop and Illustrator; EPS preferred in most cases. Sample are filed or returned. Responds only if interested. To show portfolio, artist should follow up with a call and/or letter after initial query. Portfolio should include b&w and color tearsheets, thumbnails and transparencies. Pays by the project. Rights purchased vary according to project. Finds artists through *Creative Black Book*, magazines and submissions.

WEST CREATIVE, INC.
9552 W. 116th Terrace, Overland Park KS 66210. (913)661-0561. Fax: (913)498-8627. E-mail: stan@westcreative.com. Web site: www.westcreative.com. **Creative Director:** Stan Chrzanowski. Estab. 1974. Number of employees: 8. Approximate annual billing: $600,000. Design firm; full-service multimedia firm. Client list available upon request. Professional affiliation: AIGA.
Needs Approached by 50 freelancers/year. Works with 4-6 freelance illustrators and 1-2 designers/year. Uses freelancers mainly for illustration; also for animation, lettering, mechanicals, model-making, retouching and TV/film graphics. 20% of work is with print ads. Needs computer-literate freelancers for design, illustration and production. 95% of freelance work demands knowledge of FreeHand, Photoshop, QuarkXPress and Illustrator; full-service Web design capabilities.
First Contact & Terms Send postcard-size sample of work or send query letter with brochure, photocopies, résumé, SASE, slides, tearsheets and transparencies. Samples are filed or returned by SASE if requested by artist. Responds only if interested. Portfolios may be dropped off every Monday-Thursday. Portfolios should include color photographs, roughs, slides and tearsheets. Pays for illustration by the project; pays for design by the hour, $25-60. "Each project is bid." Rights purchased vary according to project. Finds artists through *Creative Black Book* and *Workbook*.

WEYMOUTH DESIGN, INC.
332 Congress St., Boston MA 02210. (617)259-1421 or (617)542-2647. Fax: (617)451-6233. E-mail: gschelter@weymouthdesign.com. Web site: www.weymouthdesign.com. **Contact:** Graham Schelter. Estab. 1973. Number of employees: 16. Specializes in annual reports, corporate collateral, Web site design, CD-ROMs and multimedia. Clients: corporations and small businesses. Member of AIGA.
 • Second location: 600 Townsend St., San Francisco CA 94103. (415)487-7900. Fax: (415)431-7200. E-mail: bkellerman@weymouthdesign.com.
Needs Works with 3-5 freelance illustrators and/or photographers. Needs editorial, medical and technical illustration mainly for annual reports and multimedia projects.
First Contact & Terms Send query letter with résumé or illustration samples/tearsheets. Samples are filed or are returned by SASE if requested by artist. Will contact artist for portfolio review if interested.

DANA WHITE PRODUCTIONS
2623 29th St., Santa Monica CA 90405. (310)450-9101. E-mail: dwprods@aol.com. **President:** Dana C. White. AV firm. "We are a full-service audiovisual design and production company, providing video and audio presentations for training, marketing, awards, historical and public relations uses. We have complete in-house production resources, including computer multimedia, photo digitizing, image manipulation, program assembly, slidemaking, soundtrack production,

photography and AV multi-image programming. We serve major industries such as U.S. Forest Services; medical, such as Whittier Hospital, Florida Hospital; schools, such as University of Southern California, Pepperdine University; publishers, such as McGraw-Hill, West Publishing; and public service efforts, including fundraising."

Needs Works with 8-10 freelancers/year. Prefers freelancers local to greater Los Angeles, "with timely turnaround, ability to keep elements in accurate registration, neatness, design quality, imagination and price." Uses freelancers for design, illustration, retouching, characterization/animation, lettering and charts. 50% of freelance work demands knowledge of Illustrator, Free-Hand, Photoshop, Quark and Premier.

First Contact & Terms Send query letter with brochure or tearsheets, photostats, photocopies, slides and photographs. Samples are filed or are returned only if requested. Responds in 2 weeks, only if interested. Call or write for appointment to show portfolio. Pays by the project. Payment negotiable by job.

Tips "These are tough times. Be flexible. Negotiate. Your work should show that you have spirit, enjoy what you do, and that you can deliver high-quality work on time."

Ⓝ L.C. WILLIAMS & ASSOCIATES
150 N. Michigan Ave., Suite 3800, Chicago IL 60601. (312)565-3900. Fax: (312)565-1770. E-mail: dmeyers@lcwa.com. Web site: www.lcwa.com. **Creative Director:** Debra Myers. Estab. 2000. Number of employees: 28. Approximate annual billing: $3.5 million. PR firm. Specializes in marketing, communication, publicity, direct mail, brochures, newsletters, trade magazine ads, AV presentations. Product specialty is consumer home products. Current clients include Pergo, Ace Hardware, La-Z-Boy Inc. and Glidden. Professional affiliations: Chicago Direct Marketing Association, Sales & Marketing Executives of Chicago, Public Relations Society of America, Publicity Club of Chicago.

 • LCWA is among the top 15 public relations agencies in Chicago. It maintains a satellite office in New York.

Needs Approached by 50-100 freelancers/year. Works with 1-2 freelance illustrators and 2-5 designers/year. Works on assignment only. Uses freelancers mainly for brochures, ads, newsletters; also for print ad design and illustration, editorial and technical illustration, mechanicals, retouching and logos. 90% of freelance work demands computer skills.

First Contact & Terms Send query letter with brochure and résumé. Samples are filed. Does not reply. Request portfolio review in original query. Artist should call within 1 week. Portfolio should include printed pieces. Pays for design and illustration by the project; fee varies. Rights purchased vary according to project. Finds artists through word of mouth and queries.

Tips "Many new people are opening shop, and you need to keep your name in front of your prospects."

THE WILLIAMS MCBRIDE GROUP
344 E. Main St., Lexington KY 40507. (859)253-9319. Fax: (859)233-0180. E-mail: mail@williamsmcbride.com. Web site: www.williamsmcbride.com. **Partners:** Robin Williams Brohm and Kimberly McBride. Estab. 1988. Number of employees: 12. Design firm specializing in brand management, corporate identity and business-to-business marketing.

Needs Approached by 10-20 freelance artists/year. Works with 4 illustrators and 3 designers/year. Prefers freelancers with experience in corporate design, branding. Works on assignment only. 100% of freelance design work demands knowledge of InDesign, Photoshop and Illustrator. Will review résumés of Web designers with knowledge of Director and Flash.

First Contact & Terms Designers: Send query letter with résumé. Will review electronic portfolios or hardcopy samples. Illustrators: Send Web site link or postcard sample of work. Samples are filed. Responds only if interested. Pays for design by the hour, $50-65. Pays for illustration by

the project. Rights purchased vary according to project. Finds artists through submissions, word of mouth, *Creative Black Book*, *Workbook*, *American Showcase*, artist's representatives.

Tips "Keep our company on your mailing list; remind us that you are out there."

WISNER CREATIVE

18200 NW Sauvie Island Rd., Portland OR 97231-1338. (503)282-3929. Fax: (503)282-0325. E-mail: wizbiz@wisnercreative.com. Web site: www.wisnercreative.com. **Creative Director:** Linda Wisner. Estab. 1979. Number of employees: 1. Specializes in brand and corporate identity, book design, publications and exhibit design. Clients: small businesses, manufacturers, restaurants, service businesses and book publishers.

Needs Works with 3-5 freelance illustrators/year. Prefers experienced freelancers and "fast, accurate work." Works on assignment only. Uses freelancers for technical and fashion illustration and graphic production. Knowledge of QuarkXPress, Photoshop, Illustrator and other software required.

First Contact & Terms Send query letter or e-mail with résumé and samples. Prefers "examples of completed pieces that show the fullest abilities of the artist." Samples not kept on file are returned by SASE, only if requested. Will contact artist for portfolio review if interested. Pays for illustration by the hour, $30-45 average; or by the project, by bid. Pays for computer work by the hour, $25-35.

[N] [fig] MICHAEL WOLK DESIGN ASSOCIATES

31 NE 28 St., Miami FL 33137. (305)576-2898. Fax: (305)576-2899. E-mail: mwolk@wolkdesign.com. Web site: www.wolkdesign.com. **Chairman/Creative Director:** Michael Wolk. Estab. 1985. Specializes in corporate identity, displays, interior design and signage. Clients: corporate and private. Client list available on Web site.

Needs Approached by 10 freelancers/year. Works with 5 illustrators and 5 freelance designers/year. Prefers local artists only. Works on assignment only. Needs editorial and technical illustration mainly for brochures. Uses designers mainly for interiors and graphics; also for brochure design, mechanicals, logos and catalog illustration. Prefers "progressive" illustration. Needs computer-literate freelancers for design, production and presentation. 75% of freelance work demands knowledge of PageMaker, QuarkXPress, FreeHand, Illustrator or other software.

First Contact & Terms Send query letter with slides. Samples are not filed and are returned by SASE. Responds only if interested. To show a portfolio, mail slides. Pays for design by the hour, $10-20. Rights purchased vary according to project.

ERIC WOO DESIGN, INC.

733 Bishop St., Suite 1280, Honolulu HI 96813. (808)545-7442. Fax: (808)545-7445. E-mail: info@ericwoodesign.com. Web site: www.ericwoodesign.com. **Principal:** Eric Woo. Estab. 1985. Number of employees: 3. Approximate annual billing: $500,000. Design firm. Specializes in identities and visual branding, product packaging, print and Web design, environmental graphics and signage. Majority of clients are government, corporations and nonprofits. Current clients include NOAA, Paradise Water, University of Hawai'i, Western Pacific Regional Fishery Management Council, Alexander & Baldwin, Inc.

Needs Approached by 5-10 illustrators and 10 designers/year. Works with 1-2 illustrators/year. Prefers freelancers with experience in multimedia. Uses freelancers mainly for multimedia projects and lettering. 5% of work is with print ads. 90% of design demands skills in Photoshop, Illustrator, Quark, Flash, Dreamweaver and InDesign.

First Contact & Terms Designers: Send query letter with Web link. Illustrators: Send postcard sample of work or Web link. Pays for design by the hour, $20-50. Pays for illustration by the project. Rights purchased vary according to project.

Tips "Have a good sense of humor and enjoy life."

WORK

2019 Monument Ave., Richmond VA 23220. (804)358-9372. Fax: (804)355-2784. E-mail: cabel@worklabs.com. Web site: www.worklabs.com. **President/Chief Creative Director:** Cabell Harris. Estab. 1994. Number of employees: 10. Approximate annual billing: $44 million. Ad agency. Specializes in new product development and design, advertising, and strategic and creative problem solving. Current clients include Luck Stone, Snagajob.com, Macy's amd a variety of ad agencies. Client list available upon request. Professional affiliations: Advertising Club of Richmond, AIGA.

Needs Approached by 25 illustrators and 35-40 designers/year. Works with 2-3 illustrators and 6-7 designers/year. Works on assignment only. Prefers freelancers with experience in animation, computer graphics, Macintosh. Uses freelancers mainly for new business pitches and specialty projects; also for logos, mechanicals, TV/film graphics, posters, print ads, package design, and storyboards. 40% of work is with print ads. 95% of design work demands knowledge of Free-Hand, Illustrator, Photoshop and QuarkXPress. 20% of illustration work demands knowledge of FreeHand, Illustrator, Photoshop and InDesign.

First Contact & Terms Send query letter with photocopies, photographs, résumé, tearsheets, URL. Accepts e-mail submissions. Check Web site for formats. Samples are filed or returned. Responds only if interested. Request portfolio review in original query. Company will contact artist for portfolio review if interested. Portfolio should include b&w and color finished art, photographs, slides, tearsheets and transparencies. Pays freelancers usually a set budget with a buyout. Negotiates rights purchased. Finds freelancers through submissions, sourcebooks and word of mouth.

Tips "Send nonreturnable samples (JPEGs or PDFs) of work with résumé. Follow up by e-mail."

▓ WP POST & GRAPHICS

228 Pennsylvania, Wichita KS 67214-4149. (316)263-7212. Fax: (316)263-7539. E-mail: wppost@aol.com. Web site: www.wponline.com. **Art Director:** Kelly Flack. Estab. 1968. Number of employees: 4. Ad agency, design firm, video production/animation. Specializes in TV commercials, print advertising, animation, Web design, packaging. Product specialties are automative, broadcast, furniture, restaurants. Current clients include Adventure RV and Truck Center, The Wichita Eagle, Dick Edwards Auto Plaza, Turner Tax Wise. Client list available upon request. Professional affiliations: Advertising Federation of Wichita.

● Recognized by the American Advertising Federation of Wichita for excellence in advertising.

Needs Approached by 2 illustrators and 10 designers/year. Works with 1 illustrator and 2 designers/year. Prefers local designers with experience in Macintosh production, video and print. Uses freelancers mainly for overflow work; also for animation, brochure design and illustration, catalog design and illustration, logos, TV/film graphics, Web page design and desktop production. 10% of work is with print ads. 100% of freelance work demands knowledge of Photoshop, FreeHand and QuarkXPress.

First Contact & Terms Designers: Send query letter with résumé and self-promotional sheet. Illustrators: Send postcard sample of work or query letter with résumé. Send follow up postcard samples every 3 months. Samples are filed and are not returned. Responds only if interested. Art director will contact artist for portfolio review of b&w, color, final art, illustration if interested. Pays by the project. Rights purchased vary according to project and are negotiable. Finds artists through local friends and coworkers.

Tips "Be creative, be original, and be able to work with different kinds of people."

YASVIN DESIGNERS

P.O. Box 116, Hancock NH 03449. (603)525-3000. Fax: (603)525-3300. **Contact:** Creative Director. Estab. 1990. Number of employees: 3. Specializes in annual reports, brand and corporate identity, package design and advertising. Clients: corporations, colleges and institutions.

Needs Approached by 10-15 freelancers/year. Works with 6 freelance illustrators and 2 designers/year. Uses freelancers for book production, brochure illustration, logos. 50% of freelance work demands knowledge of Illustrator, Photoshop, and/or QuarkXPress.

First Contact & Terms Send postcard sample of work or send query letter with photocopies, SASE and tearsheets. Samples are filed. Responds only if interested. Request portfolio review in original query. Portfolio should include b&w and color photocopies, roughs and tearsheets. Pays for design by the project and by the day. Pays for illustration by the project. Rights purchased vary according to project. Finds artists through sourcebooks and submissions.

SPENCER ZAHN & ASSOCIATES

2015 Sansom St., Philadelphia PA 19103. (215)564-5979. Fax: (215)564-6285. E-mail: szahn@erols.com. **President:** Spencer Zahn. Business Manager: Brian Zahn. Estab. 1970. Number of employees: 10. Specializes in brand and corporate identity, direct mail design, marketing and retail advertising. Clients: corporations.

Needs Approached by 100 freelancers/year. Works with freelance illustrators and designers. Prefers artists with experience in Macintosh computers. Uses freelancers for ad, brochure and poster design and illustration; direct mail design; lettering; and mechanicals. Needs computer-literate freelancers for design, illustration and production. 80% of freelance work demands knowledge of Illustrator, Photoshop, FreeHand and QuarkXPress.

First Contact & Terms Send query letter with samples. Samples are not filed and are returned by SASE if requested by artist. Responds only if interested. Artist should follow up with call. Portfolio should include final art and printed samples. Buys all rights.

ZIPATONI

555 Washington Ave., St. Louis MO 63101-2019. (314)231-2400 or (314)345-4374. E-mail: chris.coffey@zipatoni.com. Web site: www.zipatoni.com. **Art Buyer:** Chris Coffey. Estab. 1984. Number of employees: 235. Approximate annual billing: $30 million. Sales promotion agency, creative/design service, event marketing agency. Specializes in new product development, brand extensions, promotional packaging and brand and corporate identity. Also maintains electronic design division that designs, develops and manages client Web sites; develops client intranets, extranets and CD-ROMs; and consults on Web marketing strategies, competitive analysis, and domain name research. Product specialties are food and beverage. Current clients include Purina, eBay, Levi's, Visa, Gerber, The Home Depot. Client list available on Web site.

- Also has locations in Chicago (312-782-7570) and San Francisco (415-820-8360).

Needs Approached by 200 illustrators and 50 designers/year. Works with 35 illustrators/year. Uses freelancers mainly for point-of-purchase displays, brochures; also for brochure design and illustration, model-making, posters and Web graphics.

First Contact & Terms Send query letter with brochure or photocopies and résumé. Send postcard sample of work with follow up postcard samples every 3 months. Accepts disk submissions. Samples are filed. Pays by the project, $300-8,000. Negotiates rights purchased. Finds illustrators through *American Showcase*, *The Black Book*, *Directory of Illustration* and submissions.

ZUNPARTNERS INCORPORATED

676 N. La Salle Dr., Suite 426, Chicago IL 60610-7253. (312)951-5533. Fax: (312)951-5522. E-mail: request@zunpartners.com. Web site: www.zunpartners.com. **Partner:** William Ferdinand. Estab. 1991. Number of employees: 9. Specializes in annual reports, brand and corporate identity, capability brochures, package and publication design, electronic and interactive. Clients: from Fortune 500 to Internet startup companies, focusing on high-impact service firms. Current clients include Deloitte, Baker and McKenzie, Bracewell and Giuliani. Client list available upon request. Professional affiliations: AIGA, ACD, LMA.

Needs Approached by 30 freelancers/year. Works with 10-15 freelance illustrators and 15-20 designers/year. Looks for strong personal style. Uses illustrators mainly for editorial. Uses designers mainly for design and layout. Also uses freelancers for collateral and identity design, illustration; Web, video, audiovisual materials; direct mail; magazine design and lettering; logos; and retouching. Needs computer-literate freelancers for design, illustration, production and presentation. 90% of freelance work demands knowledge of Illustrator, Photoshop, InDesign.

First Contact & Terms Send postcard sample of work or send query letter with brochure or résumé. Samples are filed. Responds only if interested. Portfolios may be dropped off every Friday. Artist should follow up. Portfolio should include b&w and color samples. Pays for design by the hour and by the project. Pays for illustration by the project. Rights purchased vary according to project. Finds artists through reference books and submissions.

Tips Impressed by "to-the-point portfolios. Show me what you like to do and what you brought to the projects you worked on. Don't fill a book with extra items (samples) for sake of showing quantity."

Stock Illustration & Clip Art Firms

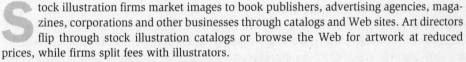

Stock illustration firms market images to book publishers, advertising agencies, magazines, corporations and other businesses through catalogs and Web sites. Art directors flip through stock illustration catalogs or browse the Web for artwork at reduced prices, while firms split fees with illustrators.

There are those who believe stock illustration hurts freelancers. They say it encourages art directors to choose ready-made artwork at reduced rates instead of assigning illustrators for standard industry rates. Others feel the practice gives freelancers a vehicle to resell their work. Marketing your work as stock allows you to sell an illustration again and again instead of filing it away in a drawer. That can mean extra income every time someone chooses the illustration from a stock catalog.

Stock vs. clip art

When most people think of clip art, they think of booklets of copyright-free graphics and cartoons, the kind used in church bulletins, high school newspapers, club newsletters and advertisments for small businesses. But these days, especially with so many digital images available online, perceptions are changing. With the popularity of desktop publishing, newsletters that formerly looked homemade now look more professional.

There is another crucial distinction between stock illustration and clip art. That distinction is copyright. Stock illustration firms do not sell illustrations. They license the right to reprint illustrations, working out a ''pay-per-use'' agreement. Fees charged depend on how many times and for what length of time their clients want to reproduce the artwork. Stock illustration firms generally split their fees 50-50 with artists and pay the artist every time his/her image is used. Some agencies offer better terms than others, so weigh your options before signing any contracts.

Clip art, on the other hand, generally implies that buyers are granted a license to use the image as many times as they want, and furthermore, they can alter it, crop it or retouch it to fit their purposes. Some clip art firms repackage artwork created many years ago because it is in the public domain, and therefore, they don't have to pay an artist for the use of the work. But in the case of clip art created by living artists, firms either pay the artists an agreed-upon fee for all rights to the work or negotiate a royalty agreement. Keep in mind that if you sell all rights to your work, you will not be compensated each time it is used unless you also negotiate a royalty agreement. Once your work is sold as clip art, the buyer of that clip art can alter your work and resell it without giving you credit or compensation.

How to submit artwork

Companies are identified as either stock illustration or clip art firms in the first paragraph of each listing. Some firms, such as Metro Creative Graphics and Dynamic Graphics, seem to

Stock Illustration

be hybrids of clip art firms and stock illustration agencies. Read the information under "Needs" to find out what type of artwork each firm wants. Then check "First Contact & Terms" to find out what type of samples you should send. Many firms accept samples in the form of slides, photocopies and tearsheets, but digital submissions are being accepted more frequently.

AFROCENTREX

P.O. Box 4375, Chicago IL 60680. (312)602-3301. E-mail: afrocentrex@comcast.net. Web site: www.afrocentrex.net. **Chief Executive Officer:** Keith Coleman. Estab. 1993. Clip art and digital media firm. Specializes in multicultural clip art (i.e., African-American and Hispanic-American), digital content, multicultural Web sites and cultural-specific mobile content (ringtones, videos and wallpapers). Distributes predominantly via Internet and stores.

Needs Approached by 5-10 illustrators/year. Buys from 2 illustrators/year. Prefers realistic illustrations, b&w line drawings and digital art.

First Contact & Terms Send cover letter with résumé, 3-5 samples (photocopies or tearsheets) and SASE. Samples are filed. Responds in 2 weeks. Write for appointment to show portfolio of final art. Pays flat fee: $25-150. **Pays on acceptance.** Negotiates rights purchased. Offers automatic renewal. Clip art firm owns original art and characters.

Tips Looks for "persistence, professionalism and humbleness."

⊕ ARTBANK®

London United Kingdom. E-mail: info@artbank.com. Web site: www.artbank.com. Estab. 1989. Picture library. "Artbank provides a platform where art can be displayed, promoted and sold, and the sellers have the right to protect their anonymity until a buyer wishes to contact them." Clients include advertising agencies, design groups, book publishers, calendar companies, greeting card companies and postcard publishers.

Needs Prefers 4×5 transparencies.

First Contact & Terms Register at www.artistbank.com.

DRAWN & QUARTERED LTD.

Metahqua, Oak Lane, Sewickley PA 15143. E-mail: red@drawnandquartered.com. Web site: www.drawnandquartered.com. **Contact:** Robert Edwards, chief executive.

 • See listing in Syndicates & Cartoon Features section.

Ⓝ DREAM MAKER SOFTWARE

P.O. Box 630875, Highlands Ranch CO 80163-0875. (303)350-8557. Fax: (303)683-2646. E-mail: sls@coolclipart.com. Web site: www.coolclipart.com. Estab. 1986. Clip art firm and computer software publisher serving homes, schools and businesses.

Needs Approached by 20-30 freelancers/year. Considers a variety of work, including cartoon-type and realistic illustrations suitable for publication as clip art with a broad market appeal. Also interested in small watercolor illustrations in styles suitable for greeting cards.

First Contact & Terms Send cover letter with 8-12 samples. Samples are not filed and are returned by SASE. Responds in 2 months, only if interested. Considers both traditional and computer-based (Illustrator) artwork. Does not accept initial samples on disk. Pays $10-50 flat fee on completion of contract. Typical contract includes artist doing 50-150 illustrations with full payment made upon completion and acceptance of work. Rights purchased include assignment of copyright from artist.

DYNAMIC GRAPHICS GROUP

A Jupiterimages™ division, 475 Park Ave. S., 4th Floor, New York NY 10016. (703)770-5350 or (800)764-7427. Fax: (703)770-5349. E-mail: photography@jupiterimages.com. Web site: www.d gusa.com. Distributes rights-managed and royalty-free stock images, clip art and animation to thousands of magazines, newspapers, agencies, industries and educational institutions.

- Publisher of *STEP inside design* (www.stepinsidedesign.com), *Dynamic Graphics* magazine (www.dynamicgraphics.com), and *LiquidTreat* (www.liquidtreat.com).

Needs Works with more than 50 freelancers/year. Prefers illustration, symbols and elements; color and b&w; traditional or electronic images. "We are currently seeking to contact established illustrators capable of handling b&w or color stylized and representational illustrations of contemporary subjects and situations."

First Contact & Terms Submit portfolio of at least 15 current samples with SASE. Responds in 2 weeks. **Pays on acceptance.** Negotiates payment. Buys all rights.

Tips "We are interested in quality, variety and consistency. Illustrators contacting us should have top-notch samples that show consistency of style (repeatability) over a range of subject matter. We often work with artists who are getting started if their portfolios look promising. Because we publish a large volume of artwork monthly, deadlines are extremely important, but we do provide long lead time (4-6 weeks is typical.) We are also interested in working with illustrators who would like an ongoing relationship. Not necessarily a guaranteed volume of work, but the potential exists for a considerable number of pieces each year for marketable styles."

GETTY IMAGES

601 N. 34th St., Seattle WA 98103. (800)462-4379 or (206)925-5000. Fax: (206)925-5001. Web site: www.gettyimages.com. Leading imagery company, creating and distributing the largest collection of images to communication professionals around the world. Getty Images products are found in newspapers, magazines, advertising, films, television, books and Web sites. Offers royalty-free and rights-managed images.

Needs Approached by 1,500 artists/year. Buys from 100 freelancers/year. Considers illustrations, photos, typefaces and spot drawings.

First Contact & Terms Visit http://contributors.gettyimages.com and click on "work with us" link.

INDEX STOCK IMAGERY™

23 W. 18th St., 3rd Floor, New York NY 10011. (212)929-4644 or (800)690-6979. E-mail: editing@i ndexstock.com. Web site: www.indexstock.com. Estab. 1992. Specializes in stock imagery for corporations, advertising agencies and design firms. Guidelines available on Web site.

Needs Approached by 300 new artists/year. Themes include animals, business, education, healthcare, holidays, lifestyles, travel locations, technology and computers.

First Contact & Terms "Ideally we would like to see a sample of 50 or more digital images that cover the range of subjects and styles of your work." Visit Web site; click on *For Artists Only* link at bottom of screen; click on *Initial Submission Evaluation* and then *Artists Questionnaire.* As instructed in guidelines, send completed questionnaire with your images for review (e-mail link to Web gallery or portfolio; e-mail low-res samples; or send low-res files on CD/DVD). "We do not return DVDs or CDs." Responds only if interested. Pays royalties of 40%. Negotiates rights purchased. Finds artists through *Workbook, Showcase, Creative Illustration*, magazines, submissions.

Tips "Index Stock Imagery likes to work with artists to create images specifically for stock. We provide 'Want' lists and concepts to aid in the process. We like to work with illustrators who are motivated to explore an avenue other than just assignment to sell their work."

[N] INNOVATIVE CLIP ART

4772 Betty Davis Rd., York SC 29745. (803)831-6727. Fax: (704)290-2056. E-mail: info@innovativ eclipart.com. Web site: www.innovativeclipart.com. **Owner:** David Dachs. Estab. 1985. Clip art publisher. Specializes in clip art for publishers, ad agencies, designers. Clients include Disney and *Time* Magazine.

Needs Prefers clip art, illustration, line drawing. Themes include animals, business, education, food/cooking, holidays, religion, restaurant, schools. 100% of design work demands knowledge of Illustrator.

First Contact & Terms Send samples and/or Macintosh disks (Illustrator files). Artwork should be saved as EPS files. Samples are filed. Responds only if interested. Pays by the project. Buys all rights.

METRO CREATIVE GRAPHICS, INC.

519 Eighth Ave., New York NY 10018. (212)947-5100. Fax: (212)714-9139. Web site: www.metroc reativegraphics.com. **Senior Art Director:** Darrell Davis. Estab. 1910. Creative graphics/art firm. Distributes to 7,000 daily and weekly paid and free circulation newspapers, schools, graphics/ ad agencies and retail chains. Guidelines available (send letter with SASE or e-mail art director on Web site).

Needs Buys from 100 freelancers/year. Considers all styles of illustrations and spot drawings; b&w and color. Editorial-style art and cartoons for syndication not considered. Special emphasis on computer-generated art for Macintosh. Send floppy disk samples using Illustrator 5.0 or Photoshop. Prefers all categories of themes associated with newspaper advertising (retail promotional and classified). Also needs covers for special-interest newspaper, tabloid sections.

First Contact & Terms Send query letter with non-returnable samples, such as photostats, photocopies, slides, photographs or tearsheets to be kept on file. Accepts submissions on disk compatible with Illustrator 5.0 and Photoshop. Send EPS or TIFF files. Samples returned by SASE if requested. Responds only if interested. Works on assignment only. **Pays on acceptance:** flat fee of $25-1,500 (buy out). Considers skill and experience of artist, saleability of artwork and clients' preferences when establishing payment.

Tips This company is "very impressed with illustrators who can show a variety of styles. When creating electronic art, make sure all parts of the illustration are drawn completely, and then put together. It makes the art more versatile to our customers."

MILESTONE GRAPHICS

303B Anastasia Ave., #140, St. Augustine FL 32080. (904)823-9962. E-mail: miles@aug.com. Web site: www.milestonegraphics.com. **Owner:** Jill O. Miles. Estab. 1993. Clip art firm providing targeted markets with electronic graphic images.

Needs Buys from 20 illustrators/year. 50% of illustration work demands knowledge of Illustrator. "Ability to draw people a plus, but many other subject matters needed as well. We currently have a need for golf and political illustrations."

First Contact & Terms Sample package should include nonreturnable photocopies or samples on computer disk. Accepts submissions on disk compatible with Illustrator on Mac. Send EPS files. All styles and media are considered. Mac computer drawings accepted (Illustrator preferred). Responds only if interested. Pays flat fee of $25 minimum/illustration, based on skill and experience. A series of illustrations is often needed.

MONOTYPE IMAGING, INC.

(formerly AGFA Monotype Typography), 500 Unicorn Park Dr., Woburn MA 01801. (781)970-6000. Fax: (781)970-6001. E-mail: allan.haley@fonts.com. Web site: www.fonts.com. **Typeface Review Board Chairman:** Allan Haley. Estab. 1897. Font foundry. Specializes in high-quality

Postscript and Truetype fonts for graphic design professionals and personal use. Clients include advertising agencies, magazines and desktop publishers. Submission guidelines available on Web site.

● Does not want clip art or illustrations—only fonts.

Needs Approached by 10 designers/year. Works with 5 typeface designers/year. Freelance work demands knowledge of Illustrator, Photoshop, QuarkXPress.

First Contact & Terms E-mail font samples as PDF or EPS files. Samples are not filed. Responds only if interested. Rights purchased vary according to project. Finds designers through word of mouth.

ONE MILE UP, INC.

7011 Evergreen Court, Annandale VA 22003. (703)642-1177. Fax: (703)642-9088. E-mail: gene@onemileup.com. Web site: www.onemileup.com. **President:** Gene Velazquez. Estab. 1988.

● Gene Velazquez told *AGDM* he is looking for aviation and military graphics. He does NOT use cartoons.

Needs Approached by 10 illustrators and animators/year. Buys from 5 illustrators/year. Prefers illustration.

First Contact & Terms Send 1-5 samples via e-mail with résumé and/or link to your Web site. Pays flat fee: $30-120. **Pays on acceptance.** Negotiates rights purchased.

STOCK ILLUSTRATION SOURCE

Division of Images.com, 1140 Broadway, 4th Floor, New York NY 10011. (212)849-2905 or (800)4-IMAGES. Fax: (212)691-6609. E-mail: daly@images.com. Web site: www.stockillustration source.com. **Acquisitions Manager:** Laura Daly. Estab. 1992. Stock illustration agency. Specializes in illustration for corporate, advertising, editorial and publishing industries.

Needs Conceptual and lifestyle imagery. Themes include corporate, business, education, healthcare, law, government, enviroment, family life and lifestyle.

First Contact & Terms Submissions guidelines available online at http://tools.images.com/about _submissions.shtml. Illustrators may send samples of work at any time by directing acquisitions manager to Web site, sending an e-mail with JPEG images or CD containing at least 20 low-resolution JPEG images. Stock Illustration Source offers exclusive representation on all accepted imagery along with competitive commission rates and individual artist promotion.

STOCKART.COM

155 N. College Ave., Suite 225, Fort Collins CO 80524. (970)493-0087 or (800)297-7658. Fax: (970)493-6997. E-mail: art@stockart.com. Web site: www.stockart.com. **Art Manager:** Matthew Lawrence. Estab. 1995. Stock illustration and representative. Specializes in b&w and color illustration for ad agencies, design firms and publishers. Clients include BBDO, Bozell, Pepsi, Chase, Saatchi & Saatchi.

Needs Approached by 250 illustrators/year. Works with 150 illustrators/year. Themes include business, family life, financial, healthcare, holidays, religion and many more.

First Contact & Terms Send at least 10 samples of work. Accepts hard copies, e-mail or disk submissions compatible with TIFF or EPS files less than 600K/image. Pays 50% stock royalty, 70% commission royalty (commissioned work artist retains rights) for illustration. Rights purchased vary according to project. Finds artists through sourcebooks, online, word of mouth. Offers "unprecedented easy-out policy: Not 100% satisfied, will return artwork within 60 days."

Tips "Stockart.com has many artists earning a substantial passive income from work that was otherwise in their file drawers collecting dust."

Syndicates & Cartoon Features

Syndicates are agents who sell comic strips, panels and editorial cartoons to newspapers and magazines. If you want to see your comic strip in the funny papers, you must first get the attention of a syndicate. They promote and distribute comic strips and other features in exchange for a cut of the profits.

The syndicate business is one of the hardest markets to break into. Newspapers are reluctant to drop long-established strips for new ones. Consequently, spaces for new strips do not open up often. When they do, syndicates look for a "sure thing," a feature they'll feel comfortable investing more than $25,000 in for promotion and marketing. Even after syndication, much of your promotion will be up to you.

To crack this market, you have to be more than a fabulous cartoonist—the art won't sell if the idea isn't there in the first place. Work worthy of syndication must be original, salable and timely, and characters must have universal appeal to attract a diverse audience.

Although newspaper syndication is still the most popular and profitable method of getting your comic strip to a wide audience, the Internet has become an exciting new venue for comic strips and political cartoons. With the click of your mouse, you can be introduced to *The Boiling Point* by Mikhaela Reid, *Overboard* by Chip Dunham, and *Strange Brew* by John Deering. (GoComics.com provides a great list of online comics.)

Such sites may not make much money for cartoonists, but it's clear they are a great promotional tool. It is rumored that scouts for the major syndicates have been known to surf the more popular comic strip sites in search of fresh voices.

HOW TO SUBMIT TO SYNDICATES

Each syndicate has a preferred method for submissions, and most have guidelines you can send for or access online. Availability is indicated in the listings.

To submit a strip idea, send a brief cover letter (50 words or less is ideal) summarizing your idea, along with a character sheet (the names and descriptions of your major characters) and photocopies of 24 of your best strip samples on $8^1/_2 \times 11$ paper, six daily strips per page. Sending at least one month of samples shows that you're capable of producing consistent artwork and a long-lasting idea. Never submit originals; always send photocopies of your work. Simultaneous submissions are usually acceptable. It is often possible to query syndicates online, by attaching art files or links to your Web site. Response time can take several months. Syndicates understand it would be impractical for you to wait for replies before submitting your ideas to other syndicates.

Editorial cartoons

If you're an editorial cartoonist, you'll need to start out selling your cartoons to a base newspaper (probably in your hometown) and build up some clips before approaching a syndicate.

Submitting published clips proves to the syndicate that you have a following and are able to produce cartoons on a regular basis. Once you've built up a good collection of clips, submit at least 12 photocopied samples of your published work along with a brief cover letter.

Payment and contracts

If you're one of the lucky few to be picked up by a syndicate, your earnings will depend on the number of publications in which your work appears. It takes a minimum of about 60 interested newspapers to make it profitable for a syndicate to distribute a strip. A top strip such as *Garfield* may be in as many as 2,000 papers worldwide.

Newspapers pay in the area of $10-15 a week for a daily feature. If that doesn't sound like much, multiply that figure by 100 or even 1,000 newspapers. Your payment will be a percentage of gross or net receipts. Contracts usually involve a 50/50 split between the syndicate and cartoonist. Check the listings for more specific payment information.

Before signing a contract, be sure you understand the terms and are comfortable with them.

Self-syndication

Self-syndicated cartoonists retain all rights to their work and keep all profits, but they also have to act as their own salespeople, sending packets to newspapers and other likely outlets. This requires developing a mailing list, promoting the strip (or panel) periodically, and developing a pricing, billing and collections structure. If you have a knack for business and the required time and energy, this might be the route for you. Weekly suburban or alternative newspapers are the best bet here. (Daily newspapers rarely buy from self-syndicated cartoonists.)

Helpful Resources

For More Info

You'll get an excellent overview of the field by reading *Your Career in Comics* by Lee Nordling (Andrews McMeel), a comprehensive review of syndication from the viewpoints of the cartoonist, the newspaper editor and the syndicate. *Successful Syndication: A Guide for Writers and Cartoonists*, by Michael H. Sedge (Allworth Press) also offers concrete advice to aspiring cartoonists.

Another great source of information is Stu's Comic Strip Connection at www.stus.com/index2.htm. Here you'll find links to most syndicates and other essential sources, including helpful books, courtesy of Stu Rees.

Syndicates

ARTIZANS.COM

11149 65th St. NW, Edmonton AB T5W 4K2 Canada. E-mail: submissions@artizans.com. Web site: www.artizans.com. **Submission Editor:** Malcolm Mayes. Estab. 1998. Artist agency and syndicate providing commissioned artwork, stock illustrations, political cartoons, gag cartoons, global caricatures and humorous illustrations to magazines, newspapers, Web sites, corporate and trade publications and ad agencies. Submission guidelines available on Web site. Artists represented include Jan Op De Beeck, Chris Wildt, Aaron Bacall and Dusan Petricic.

Needs Works with 30-40 artists/year. Buys 30-40 features/year. Needs single-panel cartoons, caricatures, illustrations, graphic and stock art. Prefers professional artists with track records who create artwork regularly, and artists who have archived work or a series of existing cartoons, caricatures and/or illustrations.

First Contact & Terms Send cover letter and copies of cartoons or illustrations. Send 10-20 examples if sending via e-mail; 24 if sending via snail mail. ''In your cover letter, tell us briefly

Artist Dusan Petricic was paid $300 for one-time use of this image to illustrate a review of a book about Nova Scotia in *The New York Times Book Review*. Petricic has been working regularly for *The Review* since he first sent samples to the art director 13 years ago. His cartoons are syndicated by Artizans.com, and he is also an award-winning illustrator of more than 20 books for children.

about your career. This should inform us about your training, what materials you use and where your work has been published." Résumé and samples of published cartoons would be helpful but are not required. E-mail submission should include a link to other online examples of your work. Responds in 2 months. Artist receives 50-75%. Payment varies depending on artist's sales. Artist retains copyright. "Our clients purchase a variety of rights from the artists."

Tips "We are only interested in professional artists with a track record. See our Web site for guidelines."

ATLANTIC SYNDICATION

4520 Main St., Kansas City MO 64111. (816)932-6600. Fax: (816)932-6669. E-mail: kslagle@atlant icsyndication.com. Web site: www.atlanticsyndication.com. **President:** Mr. Kerry Slagle. Estab. 1933. Syndicate representative servicing 1,700 daily and weekly newspapers and magazines. International, U.S. and Canadian sales. Recent introductions include *Pooch Cafe* and *Pepe*. Several of this syndicate's strips are offered in multiple languages. *Pepe* is offered in Spanish and English.

● Atlantic Syndication is the exclusive international representative for Universal Press Syndicate, which is listed separately in this section.

Needs Buys from 1-2 freelancers/year. Introduces 1-2 new strips/year. Considers comic strips, gag cartoons, caricatures, editorial/political cartoons and illustrations. Considers single, double and multiple panel, pen & ink. Prefers non-American themes. Maximum size of artwork: 11×17. Does not accept unsolicited submissions.

First Contact & Terms Send cover letter, finished cartoons, tearsheets and photocopies. Include 24-48 strips/panels. Does not want to see original artwork. Include SASE for return of materials. Pays 50% of gross income. Buys all rights. Minimum length of contract: 2 years. Artist owns original art and characters.

Tips "Look for niches. Study, but do not copy the existing competition. Read the newspaper!" Looking for "well-written gags and strong character development."

N ASHLEIGH BRILLIANT ENTERPRISES

117 W. Valerio St., Santa Barbara CA 93101. (805)682-0531. **President:** Ashleigh Brilliant. Estab. 1967. Syndicate and publisher. Outlets vary. "We supply a catalog and samples for $2 plus SASE."

● See additional listing in the Greeting Cards, Gifts & Products section.

Needs Considers illustrations and complete word-and-picture designs. Prefers single-panel. Maximum size of artwork: 5½×3½, horizontal only.

First Contact & Terms Samples are returned by SASE if requested by artist. Responds in 2 weeks. **Pays on acceptance:** minimum flat fee of $60. Buys all rights. Syndicate owns original art.

Tips "Our product is so unusual that freelancers will be wasting their time and ours unless they first carefully study our catalog."

CITY NEWS SERVICE, LLC

P.O. Box 39, Willow Springs MO 65793. (417)469-4476. E-mail: cns@cnsus.org. Web site: www.c nsus.org. **President:** Richard Weatherington. Estab. 1969. Editorial service providing editorial and graphic packages for magazines.

Needs Buys from 12 or more freelance artists/year. Considers caricatures, editorial cartoons, and tax and business subjects as themes; considers b&w line drawings and shading film.

First Contact & Terms Send query letter with résumé, tearsheets or photocopies. Samples should contain business subjects. "Send 5 or more b&w line drawings, color drawings, shading film or good line-drawing editorial cartoons." Does not want to see comic strips. Samples not filed are returned by SASE. Responds in 4-6 weeks. To show a portfolio, mail tearsheets or photostats. Pays 50% of net proceeds; pays flat fee of $25 minimum. "We may buy art outright or split percentage of sales."

Tips "We have the markets for multiple sales of editorial support art. We need talented artists to supply specific projects. We will work with beginning artists. Be honest about talent and artistic ability. If it isn't there, don't beat your head against the wall."

CONTINENTAL FEATURES/CONTINENTAL NEWS SERVICE

501 W. Broadway, Plaza A, PMB# 265, San Diego CA 92101. (858)492-8696. E-mail: continentalnewsservice@yahoo.com. Web site: www.continentalnewsservice.com. **Editor-in-Chief:** Gary P. Salamone. Parent firm established 1981. Syndicate serving 3 outlets—house publication, publishing business and the general public—through the *Continental Newstime* general interest news magazine. Features include *Portfolio*, a collection of cartoon and caricature art. Guidelines available for #10 SASE with first-class postage.

Needs Approached by up to 200 cartoonists/year. Number of new strips introduced each year varies. Considers comic strips and gag cartoons. Does not consider highly abstract, computer-produced or stick-figure art. Prefers single-panel with gagline. Maximum size of artwork: 8×10; must be reducible to 65% of original size.

First Contact & Terms Sample package should include cover letter and photocopies (10-15 samples). Samples are filed or are returned by SASE if requested by artist. Responds in 1 month, only if interested or if SASE is received. To show portfolio, mail photocopies and cover letter. Pays 70% of gross income on publication. Rights purchased vary according to project. Minimum length of contract is 1 year. The artist owns the original art and the characters.

Tips "We need single-panel cartoons and comic strips appropriate for English-speaking, international audience, including cartoons that communicate feelings or predicaments, without words. Do not send samples reflecting the highs and lows and different stages of your artistic development. CF/CNS wants to see consistency and quality, so you'll need to send your best samples."

CREATORS SYNDICATE, INC.

5777 W. Century Blvd., Suite 700, Los Angeles CA 90045. (310)337-7003. Fax: (310)337-7625. E-mail: info@creators.com. Web site: www.creators.com. **President:** Richard S. Newcombe. Director of Operations: Andrea Fryrear. Estab. 1987. Serves 2,400 daily newspapers, weekly and monthly magazines worldwide. Guidelines on Web site.

Needs Syndicates 100 writers and artists/year. Considers comic strips, caricatures, editorial or political cartoons and "all types of newspaper columns." Recent introductions: *Speedbump* by Dave Coverly; *Strange Brew* by John Deering.

First Contact & Terms Send query letter with brochure showing art style or résumé and "anything but originals." Does not accept e-mail submissions. Samples are not filed and are returned by SASE. Responds in a minimum of 10 weeks. Considers salability of artwork and client's preferences when establishing payment. Negotiates rights purchased.

Tips "If you have a cartoon or comic strip you would like us to consider, we will need to see at least four weeks of samples, but not more than six weeks of dailies and two Sundays. If you are submitting a comic strip, you should include a note about the characters in it and how they relate to each other. As a general rule, drawings are most easily reproduced if clearly drawn in black ink on white paper, with shading executed in ink wash or Benday® or other dot-transfer. However, we welcome any creative approach to a new comic strip or cartoon idea. Your name(s) and the title of the comic or cartoon should appear on every piece of artwork. If you are already syndicated elsewhere, or if someone else owns the copyright to the work, please indicate this."

DRAWN & QUARTERED LTD.

Metahqua, Oak Lane, Sewickley PA 15143. (412)749-9427. E-mail: red@drawnandquartered.com. Web site: www.drawnandquartered.com. **Chief Executive:** Robert Edwards. Estab. 2000. Syndicate serving over 100 weekly and monthly Internet sites, magazines, newsletters, newspapers and tabloids. Guidelines available.

• This company operates similarly to a stock agency. See their Web site for details.

Needs Considers celebrity caricatures, portraits, and single-panel editorial/political cartoons only. Prefers topical, timely, as-the-news-happens images; newspaper emphasis (i.e., political, sports, entertainment figures). Maximum size of artwork: 7″ height; artwork must be reducible to 20% of original size. Prefers to receive CDs or Zips of work, JPEGs or PNGs; b&w or RGB color; resolution 250-350 dpi.

First Contact & Terms Sample package should include cover letter, brochure, photocopies, résumé, contact information, tearsheets, 5-10 samples and self-caricature/portrait if possible. Samples are filed or returned by SASE if requested by artist. Portfolio not required. Pays 50% of net proceeds or gross income. Established average amount of payment: $20 per download. Pays on publication or downloads by client. Responds to submissions in 1 week. Minimum length of contract is 1 year. Offers automatic renewal. Artist owns copyright, original art and original characters.

Tips "Identify and date" samples.

PLAIN LABEL PRESS

P.O. Box 240331, Ballwin MO 63024. E-mail: mail@plainlabelpress.com. Web site: www.plainlabelpress.com. **Submissions Editor:** Laura Meyer. Estab. 1989. Syndicate serving over 100 weekly magazines, newspapers and Internet sites. Guidelines available on Web site.

Needs Approached by 500 cartoonists and 100 illustrators/year. Buys from 2-3 artists/year. Introduces 1-2 new strips/year. Strips introduced include *Barcley & Co.* and *The InterPETS!* by Todd Schowalter. Considers cartoons (single, double and multiple panel), comic strips, editorial/political cartoons and gag cartoons. Prefers comics with cutting edge humor, NOT mainstream. Maximum size of artwork: 8½×11; artwork must be reducible to 25% of original size.

First Contact & Terms Sample package should include cover letter, character descriptions, 3-4 weeks of material (18-24 samples on photocopies or disk, no original art) and SASE if you would like your materials returned. Samples are not filed and are returned by SASE if requested by artist. Pays on publication: 60% of net proceeds. Responds to submissions in 2-4 months. Contract

Todd Schowalter (www.studiotodd.com) began his professional cartooning career at the age of 14, when he became the youngest staff editorial cartoonist ever at the *St. Louis Sentinel*. Since then his work has been featured on television, in newspapers, magazines, books, advertisements, and on greeting cards nationwide. Schowalter's comic strip *Barcley & Co.* is syndicated by Plain Label Press and has appeared in newspapers and magazines since 1997. Its characters have been used in advertisements and on Web sites and merchandise. An active member of The National Cartoonists Society, Schowalter advises artists to "stick to your personal style and listen to your gut feelings," even when facing rejection. "It's the only way you'll build and maintain your own unique style," he says.

is open and may be cancelled at any time by the creator and/or by Plain Label Press. Artist owns original art and original characters.

Tips "Be FUNNY! Remember that readers *read* the comics as well as look at them. Don't be afraid to take risks. Plain Label Press does not wish to be the biggest syndicate, just the funniest. A large portion of our material is purchased for use online, so a good knowledge of digital color and imaging puts a cartoonist at an advantage. Good luck!"

TRIBUNE MEDIA SERVICES, INC.

435 N. Michigan Ave., Suite 1400, Chicago IL 60611. (312)222-4444. E-mail: submissions@tribune.com. Web site: www.comicspage.com. **Submissions Editor:** Tracy Clark. Managing Editor: Mary Elson. Syndicate serving daily domestic and international and Sunday newspapers as well as weeklies and new media services. Strips syndicated include *Broom-Hilda*, *Dick Tracy*, *Brenda Starr* and *Helen, Sweetheart of the Internet*. "All are original comic strips, visually appealing with excellent gags." Art guidelines available on Web site or for SASE with first-class postage.

• Tribune Media Services is a leading provider of Internet and electronic publishing content, including the WebPoint Internet Service.

Needs Seeks comic strips and newspaper panels, puzzles and word games. Recent introductions include *Cats With Hands* by Joe Martin; *Dunagin's People* by Ralph Dunagin. Prefers original comic ideas, with excellent art and timely, funny gags; original art styles; inventive concepts; crisp, funny humor and dialogue.

First Contact & Terms Send query letter with résumé and photocopies. Sample package should include 4-6 weeks of daily strips or panels. Send $8\frac{1}{2} \times 11$ copies of material, not originals. "Interactive submissions invited." Samples not filed are returned only if SASE is enclosed. Responds in 2 months. Pays 50% of net proceeds.

Tips "Comics with recurring characters should include a character sheet and descriptions. If there are similar comics in the marketplace, acknowledge them and describe why yours is different."

ⓝ UCLICK

Andrews McMeel Universal, 4520 Main St., Suite 500, Kansas City MO 64111. Web site: www.uclick.com. **Contact:** Acquisitions. Estab. 1995. Syndicate serving over 300 online clients daily. Specializes in Internet and mobile applications. Art guidelines available on Web site.

• See also listing for Universal Press Syndicate in this section.

Needs Approached by 200 cartoonists and 50 illustrators/year. Introduces about 15 new strips/year. Recent introductions include *Joe and Monkey*, *44 Union Avenue*, *The Norm* and *Bleeker the Rechargable Dog*. Considers caricatures, single- or multi-panel cartoons, comic strips, puzzles/games. Looking for conservative political cartoons; unique puzzles, games and quizzes.

First Contact & Terms Send cover letter, character sheets and finished cartoons. Prefers to see 2 weeks worth of samples. Samples are not filed and are returned by SASE if requested by artist. Responds in 6-8 weeks. Will contact artist for portfolio review if interested. Pays on publication. "Royalties are based on negotiated rates, fees or licenses depending on content and distribution channels." Rights are negotiated. Artist owns original art and characters. Minimum length of contract: 3-year term is preferred; offers automatic renewal.

Tips "Send samples that show the range of your talent in art, writing and style. Interactive content is becoming a growth area that creators should explore."

UNITED FEATURE SYNDICATE/NEWSPAPER ENTERPRISE ASSOCIATION

200 Madison Ave., New York NY 10016. (212)293-8500. Web site: www.unitedfeatures.com. **Contact:** Comics Editor. Syndicate serving 2,500 daily and weekly newspapers. Guidelines available on Web site.

• See also listing for parent company, United Media, in this section.

Needs Approached by 5,000 cartoonists/year. Buys 2-3 cartoons/year. Introduces 2-3 new strips/year. Strips introduced include *Dilbert, Luann* and *Over the Hedge*. Considers comic strips, editorial/political cartoons and panel cartoons.

First Contact & Terms Sample package should include cover letter and nonreturnable photocopies of finished cartoons; 18-36 dailies. Color Sundays are not necessary with first submissions. Responds in 4 months. Does not purchase one shots. Does not accept submissions via fax or e-mail.

Tips "No oversize packages, please."

UNITED MEDIA

200 Madison Ave., New York NY 10016. (212)293-8500. Web site: www.unitedfeatures.com; www.comics.com. **Contact:** Comics Editor or Editorial Submissions Editor. Estab. 1978. Syndicate servicing U.S. and international newspapers. "United Media consists of United Feature Syndicate and Newspaper Enterprise Association. Submissions are considered for both syndicates. Duplicate submissions are not needed." Guidelines available on Web site.

- See also listing for United Feature Syndicate/Newspaper Enterprise Association in this section.

Needs Introduces 2-4 new strips/year. Considers comic strips and single, double and multiple panels. Prefers pen & ink.

First Contact & Terms Send cover letter, résumé, finished cartoons and photocopies. Include 36 dailies; "Sundays not needed in first submissions." Do not send "oversize submissions or concepts without strips." Samples are not filed and are returned by SASE. Responds in 3 months. Payment varies by contract. Buys all rights.

Tips "Send copies, but not originals. Do not send mocked-up licensing concepts." Looks for "originality, art and humor writing. Be aware of long odds; don't quit your day job. Work on developing your own style and humor writing. Worry less about 'marketability'—that's our job."

UNIVERSAL PRESS SYNDICATE

Andrews McMeel Universal, 4520 Main St., Suite 700, Kansas City MO 64111. (816)932-6600. Web site: www.amuniversal.com/ups. **Acquisition Editor:** John Glynn. Estab. 1970. Largest independent newspaper and licensed propery syndicate in the world, serving 2,750 daily and weekly newspapers. Submission guidelines available on Web site.

- See also listing for uclick (Universal's digital/online division) in this section.

Needs Considers single-, double- or multiple-panel cartoons and comic strips; b&w and color. Requests photocopies of b&w, pen & ink, line drawings.

First Contact & Terms Send query letter with 4-6 weeks of samples. Include SASE for return of material. Do not send originals. Responds in 6-8 weeks. Pays on publication. Payment and rights are negotiated.

Tips "Be original. Don't be afraid to try some new idea or technique. Don't be discouraged by rejection letters. Universal Press receives 100-150 comic submissions a week and only takes on two or three a year, so keep plugging away. Talent has a way of rising to the top."

WASHINGTON POST WRITERS GROUP

1150 15th St. NW, 4th Floor, Washington DC 20071. (202)334-6375. E-mail: writersgrp@washpost.com. Web site: www.postwritersgroup.com. **Comics Editor:** Amy Lago. Estab. 1973. Syndicate serving over 1,000 daily, Sunday and weekly newspapers in U.S. and abroad. Submission guidelines available on Web site or for SASE with necessary postage.

Needs Considers comic strips, panel and editorial cartoons.

First Contact & Terms Send at least 24 cartoons. "You do not need to send color or Sunday cartoons in your initial submission; we will ask for those later if we require them. Of course if

you do include color work, we are happy to review it.'' No fax or e-mail submissions. Include SASE for reply or return of materials. Submissions without a SASE will not receive a reply. Responds in about 6 weeks.

Tips ''Use letter-sized paper for your submission. Make sure cartoons will reduce to standard sizes. Send only copies; never send originals.''

N WHITEGATE FEATURES SYNDICATE

71 Faunce Dr., Providence RI 02906. (401)274-2149. Web site: www.whitegatefeatures.com. **Talent Manager:** Eve Green. Estab. 1988. Syndicate serving daily newspapers, book publishers and magazines. Guidelines available on Web site.

● Send nonreturnable samples. This syndicate says they are not able to return samples, ''even with SASE,'' because of the large number of submissions they receive.

Needs Introduced Dave Berg's *Roger Kaputnik*. Considers comic strips, gag cartoons, editorial/political cartoons, illustrations and spot drawings; single, double and multiple panel. Work must be reducible to strip size. Also needs artists for advertising and publicity. Looking for fine artists and illustrators for book publishing projects.

First Contact & Terms Send cover letter, résumé, tearsheets, photostats and photocopies. Include about 12 strips. Does not return materials. To show portfolio, mail tearsheets, photostats, photographs and slides; include b&w. Pays 50% of net proceeds upon syndication. Negotiates rights purchased. Minimum length of contract: 5 years (flexible). Artist owns original art; syndicate owns characters (negotiable).

Tips Include in a sample package ''info about yourself, tearsheets, notes about the strip and enough samples to tell what it is. Don't write asking if we want to see; just send samples.'' Looks for ''good writing, strong characters, good taste in humor. No hostile comics. We like people who have cartooned for a while and are printed. Get published in local papers first.''

Record Labels

Record labels hire freelance artists to create packaging, merchandising material, store displays, posters and even T-shirts. But for the most part, you'll be creating work for CD booklets and covers. Your greatest challenge in this market will be working within the size constraints. Most CD covers are $4^3/_4 \times 4^3/_4$ inches, packaged in a 5×5-inch jewel case. Often there are photographs of the recording artist, illustrations, liner notes, titles, credit lines and lyrics all placed into that relatively small format.

It's not unusual for an art director to work with several freelancers on one project. For example, one freelancer might handle typography, another illustration; a photographer is sometimes used, and a designer can be hired for layout. Labels also turn to outside creatives for display design, promotional materials, collateral pieces or video production.

LANDING THE ASSIGNMENT

Check the listings in this section to see how each label prefers to be approached and what type of samples to send. Disk and e-mail submissions are encouraged by many of the companies. Check also to see what type of music they produce. Assemble a portfolio of your best art and design in case an art director wants to see more of your work.

Be sure your portfolio includes quality samples. It doesn't matter if the work is of a different genre—quality is key. If you don't have any experience in the industry, create your own CD package, featuring one of your favorite recording artists or groups. Send a cover letter with your samples, asking for a portfolio review. If you are not contacted within a couple of months, send a follow-up postcard or sample to the art director or other contact person.

Once you nail down an assignment, get an advance and a contract. Independent labels usually provide an advance and payment in full when a project is done. When negotiating a contract, ask for a credit line on the finished piece and samples for your portfolio.

You don't have to live in one of the recording capitals to land an assignment, but it does help to familiarize yourself with the business. Visit record stores and study the releases of various labels. Read industry publications such as *Billboard*, *Blender*, *Music Connection*, *Rolling Stone* and *Spin*.

- Every listing in this section includes the "new" icon **N** because last year's edition did not feature a Record Labels section.

N ACTIVATE ENTERTAINMENT

PMB 333, 11054 Ventura Blvd., Studio City CA 91604-3546. E-mail: jay@2activate.com. Web site: www.2activate.com. **President:** James Warsinske. Estab. 2000. Produces CDs and cassettes; rock & roll, R&B, soul, dance, rap and pop by solo artists and groups.

Needs Produces 2-6 solo artists and 2-6 groups/year. Uses 4-10 visual artists for CD and album/cassette cover design and illustration; brochure design and illustration; catalog design, layout and illustration; direct mail packages; advertising design and illustration. 50% of freelance work demands knowledge of PageMaker, Illustrator, QuarkXPress and Photoshop.

First Contact & Terms Send query letter with SASE, tearsheets, photographs, photocopies, photostats, slides and transparencies. Samples are filed. Responds in 1 month. To show portfolio, mail roughs, printed samples, b&w and color photostats, tearsheets, photographs, slides and transparencies. Pays by the project, $100-1,000. Buys all rights.

Tips "Get your art used commercially, regardless of compensation. It shows what applications your work has."

N AFTERSCHOOL PUBLISHING COMPANY

P.O. Box 14157, Detroit MI 48214-0157. (313)894-8855. **President:** Herman Kelly. Estab. 1978. Produces CDs and cassettes; rock, jazz, rap, R&B, soul, pop, classical, folk, educational, country/western, dance and new wave. Recent releases: *Enjoyment* by H. Kelly on M.C.P.; *Do You Remember What it Felt Like* by M.C.P.

Needs Produces 1 solo artist/year. Works with 10 freelance designers and 10 illustrators/year. Prefers professional artists with experience in all forms of the arts. Uses artists for CD cover design, cassette cover and advertising design and illustration, brochure design, multimedia projects and posters. 10% of freelance work demands computer skills.

First Contact & Terms Send query letter with brochure, résumé, SASE, bio, proposal and appropriate samples. Samples are filed or are returned by SASE. Responds in 1 month. Requests work on spec before assigning a job. To show portfolio, mail roughs, printed samples, b&w/color tearsheets, photographs, slides and transparencies. Pays by the project. Negotiates rights purchased. Interested in buying second rights (reprint rights) to previously published work. Finds artists through Michigan Artist Directory and Detroit Area.

Tips "Be on a local or national artist roster to work outside your hometown."

N ALBATROSS RECORDS; RN'D PRODUCTIONS

P.O. Box 540102, Houston TX 77254-0102. (713)521-2616. Fax: (713)529-4914. E-mail: rpds2405 @aol.com. Web site: www.rnddistribution.com. **Art Director:** Victor Ivey. National Sales Director: Darin Dates. Estab. 1987. Produces CDs, DVDs; country, jazz, R&B, rap, rock and pop by solo artists and groups. Recent releases: *I Love The Bay* by Too Short; *Gangsters and Strippers* by Too Short.

Needs Produces 22 releases/year. Works with 3 freelancers/year. Prefers freelancers with experience in Photoshop. Uses freelancers for cassette cover design and illustration; CD booklet design; CD cover design and illustration; poster design; Web page design; advertising design/illustration. 50% of freelance work demands knowledge of QuarkXPress, FreeHand, Photoshop.

First Contact & Terms Send postcard sample of work. Samples are filed and not returned. Will contact for portfolio review of b&w and color final art if interested. Pays for design by the project, $400 maximum. Pays for illustration by the project, $250 maximum. Buys all rights. Finds freelancers through word of mouth.

N ALEAR RECORDS

25 Troubadour Lane, Berkeley Springs WV 25411. (304)258-8314. E-mail: mccoytroubadour@aol .com. Web site: www.troubadourlounge.com. **Owner:** Jim McCoy. Estab. 1973. Produces CDs,

cassettes; country/western. Releases: *The Taking Kind* by J.B. Miller; *If I Throw away My Pride* by R.L. Gray; *Portrait of a Fool* by Kevin Wray.

Needs Produces 12 solo artists and 6 groups/year. Works with 3 freelancers/year. Works on assignment only. Uses artists for CD cover design and cassette cover illustration.

First Contact & Terms Send query letter with résumé and SASE. Samples are filed. Responds in 1 month. To show portfolio, mail roughs and b&w samples. Pays by the project, $50-250.

N ARIANA RECORDS

1312 S. Avenida Polar #A-8, Tucson AZ 85710. (520)790-7324. E-mail: jtiom@aol.com. Web site: www.arianarecords.net. **President:** Mr. Jimmi. Estab. 1980. Produces CDs, low-budget films; rock, funk, strange sounds, soundtracks for films. Recent releases: *Songs 4 Elevators & Answering Machines* by Scubatails; *The Cassette Demos* by Jtiom.

Needs Produces 4-6 music releases/year; 2 films/year. Prefers freelancers with experience in cover design. Uses artwork for CD covers, posters, flyers, T-shirts; design, illustration, multimedia projects. ''We are looking to work with new cutting-edge artists.''

First Contact & Terms Send postcard sample of work or link to Web site. ''Everything is filed. We will contact you if interested.'' Responds in 2-3 months. Pays by the project.

Tips ''Send your best! Simple but kool!''

N ART ATTACK RECORDINGS; MIGHTY FINE RECORDS

3305 N. Dodge Blvd., Tucson AZ 85716. (602)881-1212. **President:** William Cashman. Produces rock, country/western, jazz, pop, R&B by solo artists.

Needs Produces 12 albums/year. Works with 1-2 freelance designers and 1-2 illustrators/year. Uses freelancers for CD/album/cassette cover design and illustration; catalog design and layout; advertising design, illustration and layout; posters; multimedia projects.

First Contact & Terms Works on assignment only. Send postcard sample or brochure to be kept on file. Samples not filed are returned by SASE only if requested. Responds only if interested. Write for appointment to show portfolio. Original artwork is not returned. Pays for design by the hour, $15-25; or by the project, $100-500. Pays for illustration by the project, $100-500. Considers complexity of project and available budget when establishing payment. Buys all rights. Sometimes interested in buying second rights (reprint rights) to previously published artwork.

N ASTRALWERKS RECORDS

101 Avenue of the Americas, 10th Floor, New York NY 10013-1943. E-mail: sara.reden@astralwerks.com. Web site: www.astralwerks.com. **Contact:** Sara Reden. Estab. 1993. Produces CDs, DVDs, vinyl albums; alternative, progressive, rap, reggae, rock by solo artists and groups. Recent release: *Paper Tigers* by Caesars.

Needs Produces 60-100 releases/year. Works with 2 freelancers/year. Prefers local freelancers. Uses freelancers for CD booklet illustration, CD cover design and illustration. 90% of design work demands knowledge Illustrator, Photoshop, InDesign and QuarkXPress. 10% of illustration work demands knowledge of FreeHand.

First Contact & Terms Send postcard sample or query letter. Samples are filed. Responds only if interested. Request portfolio review in original query. Portfolio should include color finished and original art, photographs and roughs. Pays by the project, $100-500. Rights purchased vary according to project. Finds freelancers through word of mouth.

N ATLAN-DEC/GROOVELINE RECORDS

2529 Green Forest Court, Snellville GA 30078-4183. (770)985-1686. E-mail: atlandec@prodigy.net. Web site: www.atlan-dec.com. **Art Director:** Wileta J. Hatcher. Estab. 1994. Produces CDs and cassettes; gospel, jazz, pop, R&B and rap by solo artists and groups. Recent releases: *Stepping Into the Light* by Mark Cocker.

Needs Produces 2-4 releases/year. Works with 1-2 freelancers/year. Prefers freelancers with experience in CD and cassette cover design. Uses freelancers for album cover, cassette cover, CD booklet and poster design. 80% of freelance work demands knowledge of Photoshop.

First Contact & Terms Send postcard sample of work or query letter with brochure, photocopies, photographs and tearsheets. Samples are filed. Will contact for portfolio review of b&w, color, final art if interested. Pays for design by the project, negotiable. Negotiates rights purchased. Finds artists through submissions.

N BATOR & ASSOCIATES

31 State St., Suite 44D, Monson MA 01057. **Art Director:** Robert S. Bator. Estab. 1969. Handles rock and country.

Needs Buys 5,000 line drawings and logo designs/year. Needs full-color illustrations and line drawings for various advertising and books for adults and children. Also has special need for top-notch calligraphy. Works with freelancers on assignment only.

First Contact & Terms Slides and photostats welcome. Samples welcome. Responds in 5 days with SASE. Pays by the project. Buys one-time rights; other rights negotiable.

Tips "Send no originals, only your copies."

N ⊕ BIG BEAR RECORDS

P.O. Box 944, Birmingham B16 8UT United Kingdom. (0121)454-7020. Fax (0121)454-9996. E-mail: agency@bigbearmusic.com. Web site: www.bigbearmusic.com. **Managing Director:** Jim Simpson. Produces CDs and cassettes; jazz, R&B. Recent releases: *Hey Puerto Rico!* by King Pleasure and The Biscuit Boys; *The Marbella Jazz Suite* by Alan Barnes All Stars.

Needs Produces 4-6 records/year. Works with 2-3 illustrators/year. Uses freelancers for album cover design and illustration. Needs computer-literate freelancers for illustration.

First Contact & Terms Works on assignment only. Send query letter with photographs or photocopies to be kept on file. Samples not filed are returned only by SAE (include IRC if outside UK). Negotiates payment. Considers complexity of project and how work will be used when establishing payment. Buys all rights. Interested in buying second rights (reprint rights) to previously published work.

N BLACK DIAMOND RECORDS INCORPORATED

P.O. Box 222, Pittsburg CA 94565. (510)980-0893. Fax: (925)432-4342 or (510)540-0497. E-mail: blkdiamondrec@aol.com. Web site: www.blackdiamondrecord.com or www.blackdiamondrecords.snn.gr. **President:** Jerry J. Bobelli. Estab. 1988. Produces DVD movies; distributes DVDs, CDs and vinyl 12-inch records.

Needs Produces 2 solo artists and 2 groups/year. Works with 4 freelancers/year. Prefers freelancers with experience in album cover and insert design. Uses freelancers for CD/cassette cover and advertising design and illustration; direct mail packages; and posters. Needs computer-literate freelancers for production. 85% of freelance work demands knowledge of PageMaker and FreeHand.

First Contact & Terms Send query letter with résumé. Samples are filed or returned. Responds in 4 months. Write for appointment to show portfolio of b&w roughs and photographs. Pays for design by the hour, $100; by the project, varies. Rights purchased vary according to project.

Tips "Be unique, simple and patient. Most of the time success comes to those whose artistic design is unique and has endured rejection after rejection. Stay focused, stay humble."

N BOUQUET-ORCHID ENTERPRISES

P.O. Box 1335, Norcross GA 30091. (770)339-9088. **President:** Bill Bohannon. Estab. 1972. Produces CDs, cassettes; rock, country, pop and contemporary Christian by solo artists and groups.

Recent releases: *First Time Feeling* by Adam Day; *Just Another Day* by Bandoleers.

Needs Produces 6 solo artists and 4 groups/year. Works with 5-6 freelancers/year. Works on assignment only. Uses freelancers for CD/cassette cover and brochure design; direct mail packages; advertising illustration, logos, brochures. 60% of design work demands knowledge of PageMaker and QuarkXPress. 40% of illustration work demands knowledge of FreeHand.

First Contact & Terms Send query letter with photocopies and sample CD booklet. "I prefer a brief but concise overview of an artist's background and works showing the range of his/her talents." Include SASE. Samples are not filed and are returned by SASE if requested by artist. Responds in 1 month. Will contact artist for portfolio review if interested. Portfolio should include b&w and color photographs and tearsheets. Pays by the project, in line with industry standards for pay. Rights purchased vary according to project. Finds freelancers through agents, submissions and word of mouth.

Tips "Freelancers should be willing to work within guidelines and deadlines. They should be open to suggested changes and understand budgetary considerations. If we are pleased with an artist's work, we are happy to give repeat business."

CANTILENA RECORDS

1925 Fifth Ave., Sacramento CA 95818-3827. E-mail: llzz@aol.com. **Contact:** Laurel Zucker. Estab. 1992. Produces CDs; classical by solo artists. Recent releases: *J. Bach Flute Sonatas* and *Telemann Fantasies* by Laurel Zucker.

Needs Produces 3 releases/year. Works with 2-3 freelancers/year. Prefers artists with experience in CD design. Uses freelancers for CD cover design. 100% of design work demands knowledge of Illustrator, PageMaker, Photoshop, QuarkXPress.

First Contact & Terms Send query letter with sample CD booklets. Samples are not filed and not returned. Responds only if interested. Pays for design by the project. Buys all rights. Finds freelancers through submissions and word of mouth.

CHERRY STREET RECORDS, INC.

P.O. Box 52626, Tulsa OK 74152. (918)742-8087. Fax (918)742-8000. E-mail: ryoung@cherrystreetrecords.com. Web site: www.cherrystreetrecords.com. **President:** Rodney Young. Estab. 1991. Produces CDs and cassettes; rock, R&B, soul, country/western and folk by solo and group artists. Recent releases: *Land of the Living* by Richard Elkerton; *Find You Tonight* by Brad Absher; *RhythmGypsy* by Steve Hardin.

Needs Produces 2 solo artists/year. Approached by 10 designers and 25 illustrators/year. Works with 2 designers and 2 illustrators/year. Prefers freelancers with experience in CD and cassette design. Works on assignment only. Uses freelancers for CD/album/cassette cover design and illustration; catalog design; multimedia projects and advertising illustration. 100% of design and 50% of illustration demand knowledge of Illustrator and CorelDraw for Windows.

First Contact & Terms Send postcard sample or query letter with photocopies and SASE. Accepts disk submissions compatible with Windows '95 in above programs. Samples are filed or are returned by SASE. Responds only if interested. Write for appointment to show portfolio of printed samples, b&w and color photographs. Pays by the project, up to $1,250. Buys all rights.

Tips "Compact disc covers and cassettes are small; your art must get consumer attention. Be familiar with CD and cassette music layout on computer in either Adobe or Corel. Be familiar with UPC bar code portion of each program. Be under $500 for layout to include buyout of original artwork and photographs. Copyright to remain with Cherry Street; no reprint rights or negatives retained by illustrator, photographer or artist."

CORNELL ENTERTAINMENT GROUP (SUN DANCE RECORDS)

907 Baltimore St., Mobile AL 36605. (251)438-5756. E-mail: ceg4antoniop@hotmail.com. **President:** Antonio Pritchett. Estab. 1987. Produces CDs, CD-ROMs, cassettes; classical, country, folk,

gospel, jazz, pop, R&B, rap, reggae, rock, soul by solo artists and groups. Recent releases: *Bringing It* by Smoke Queen; *Luv of Money* by Da Force. Art guidelines available for SASE.

Needs Produces 37 releases/year. Works with 14 freelancers/year. Uses freelancers for animation, cover illustration and design, CD booklet illustration, CD cover design and illustration, CD-ROM packaging, poster and Web design, spot illustration. Illustration demands knowledge of FreeHand, Illustrator, InDesign, PageMaker, Photoshop, QuarkXPress.

First Contact & Terms Send query letter with brochure, photocopies, photographs, résumé, SASE, sample CD booklet. Samples are filed or returned by SASE. Does not reply. Artist should write a letter for an update on status. Company will contact artist for portfolio review if interested. Portfolio should include b&w and color finished art, original art, photographs, roughs, tearsheets. Pays by the hour, $8-19; by the project, $25-3,000. Rights purchased vary according to project. Finds freelancers through agents, submissions, magazines, word of mouth.

Tips "Your work is a statement of you, so put your best in everything you do."

N ⚅ EMI LATIN

1750 Vine St., Los Angeles CA 90028. E-mail: contacto@emilatin.com. Web site: www.emilatin.com. **Contact:** Art/Production Manager. Estab. 1989. Produces albums, CDs and cassettes; pop, rock, salsa, Merengue, regional Mexican and Tejano by solo artists and groups. Recent releases: *Para Que* by Oscar de la Hoya; *Nubes Y Claros* by Tam Tam Go.

Needs Produces 250 releases/year. Works with 10 designers/year. Prefers local designers. Uses freelancers for design of packages, CD and cassette covers, CD booklets, inlays and posters. 100% of design work demands knowledge of Illustrator, QuarkXPress, Photoshop.

First Contact & Terms Send postcard sample of work. Samples are filed. Responds only if interested. Pays for design by the project, $1,000-$1,500. Negotiates rights purchased. Finds artists through submissions.

N FOREFRONT RECORDS

P.O. Box 5085, Brentwood TN 37024-5085. E-mail: info@forefrontrecords.com. Web site: www.forefrontrecords.com. **Contact:** Creative Services Manager. Estab. 1989. Produces CDs, CD-ROMs, cassettes; Christian alternative rock by solo artists and groups. Recent releases: *Adios* by Audio Adrenaline; *If I Had One Chance to Tell You Something* by Rebecca St. James; *Portable Sounds* by Toby Mac.

Needs Produces 15-20 releases/year. Works with 5-10 freelancers/year. Prefers designers who own Macs and have experience in cutting edge graphics and font styles/layout, have the ability to send art via e-mail, and pay attention to detail and company spec requirements. Uses freelancers for cassette cover design and illustration; CD booklet design and illustration; CD cover design and illustration; CD-ROM design and packaging; poster design. 100% of freelance design and 50% of illustration demands knowledge of Illustrator, QuarkXPress, Photoshop.

First Contact & Terms Send postcard sample or query letter with résumé, photostats, transparencies, photocopies, photographs, slides, SASE, tearsheets. Accepts disk submissions compatible with Mac/Quark, Photoshop or Illustrator, EPS files. Samples are filed or returned by SASE if requested by artist. Responds only if interested. Will contact artist for portfolio review if interested. Payment depends on each project's budgeting allowance. Negotiates rights purchased. Finds artists through submissions, sourcebooks, Internet, reps, word of mouth.

Tips "I look for cutting edge design and typography along with interesting use of color and photography. Illustrations must show individual style and ability to be conceptual."

N HARD HAT RECORDS AND CASSETTE TAPES

519 N. Halifax Ave., Daytona Beach FL 32118-4017. (386)252-0381. Fax: (386)252-0381. E-mail: hardhatrecords@aol.com. Web site: www.hardhatrecords.com. **CEO:** Bobby Lee Cude. Produces

GET A FREE ISSUE OF HOW

From creativity crises to everyday technology, HOW covers every aspect of graphic design — so you have all the tools, techniques and resources you need for design success.

CREATIVITY idea-boosting tips from the experts and the inspiration behind some innovative new designs

BUSINESS how to promote your work, get paid what you're worth, find new clients and thrive in any economy

DESIGN an inside look at the hottest design workspaces, what's new in production and tips on designing for different disciplines

TECHNOLOGY what's happening with digital design, hardware and software reviews, plus how to upgrade on a budget

With this special introductory offer, you'll get a FREE issue of HOW. If you like what you see, you'll get a full year of HOW at our lowest available rate — a savings of 62% off the newsstand price.

I WANT TO TRY HOW.

Yes! Send my FREE issue and start my trial subscription. If I like what I see, I'll pay just $29.96 for 5 more issues (6 in all). If not, I'll write "cancel" on the invoice, return it and owe nothing. The FREE issue is mine to keep.

Name_____

Company_____

Address_____

City_____

State _____ ZIP_____

E-mail _____

❏ YES! Also e-mail me HOW's FREE e-newsletter and other information of interest.
(We will not sell your e-mail address to outside companies.)

SEND NO MONEY NOW.

In Canada: you'll be invoiced an additional $15 (includes GST/HST). Outside the U.S. and Canada: add $22 ($65 airmail) and remit payment in U.S. funds with order. Please allow 4-6 weeks for first-issue delivery. Annual newsstand rate $79.70.

www.howdesign.com

My business is best described as: (choose one)
○ Advertising Agency
○ Design Studio
○ Graphic Arts Vendor
○ Company (In-House Design Dept.)
○ Educational Institution
○ Other (specify)_____

My job title/occupation is: (choose one)
○ Owner/Management
○ Creative Director
○ Art Director/Designer
○ Advertising/Marketing Staff

○ Instructor
○ Student
○ Other (specify)_____

J7FAM1

You get three huge annuals:

SELF-PROMOTION — discover the keys to promoting your work and see the winners of our exclusive Self-Promotion Competition

INTERNATIONAL DESIGN — explore the latest design trends from around the world, plus the winning entries from the HOW International Design and HOW Interactive Design Competitions

BUSINESS — get the scoop on building your business and your portfolio, growing your career, and how your salary stacks up against others

Plus, get three acclaimed special issues — each focused on one aspect of design, so you'll get everything you need to know about Illustration, Typography and Creativity.

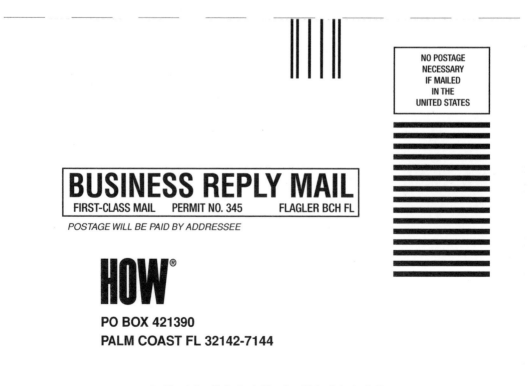

rock, country/western, folk and educational recordings by group and solo artists. Also publishes high school/college marching band arrangements. Recent releases: *Broadway USA* (3-volume CD program of new and original music); *Times-Square Fantasy Theatre* (CD release with 46 tracks of new and original Broadway-style music).

- Also owns Blaster Boxx Hits.

Needs Produces 6-12 records/year. Works with 2 designers and 1 illustrator/year. Works on assignment only. Uses freelancers for album cover design and illustration; advertising design; and sheet music covers. Prefers "modern, up-to-date, on the cutting edge" promotional material and cover designs that fit the music style. 60% of freelance work demands knowledge of Photoshop.

First Contact & Terms Send query letter with brochure to be kept on file for one year. Samples not filed are returned by SASE. Responds in 2 weeks. Write for appointment to show portfolio. Sometimes requests work on spec before assigning a job. Pays by the project. Buys all rights.

⃞ HOTTRAX RECORDS

1957 Kilburn Dr., Atlanta GA 30324. (770)662-6661. E-mail: hotwax@hottrax.com. Web site: www.hottrax.com. **Publicity and Promotion:** Teri Blackman. Estab. 1975. Produces CDs and cassettes; rock, R&B, country/western, jazz, pop and blues/novelties by solo and group artists. Recent releases include *Everythang & Mo'* by Sammy Blue; *No Regrets* by Bullitthead.

Needs Produces 2 solo artists and 4 groups/year. Approached by 90-100 designers and 30 illustrators/year. Works with 6 designers and 3 illustrators/year. Prefers freelancers with experience in multimedia and caricatures. Uses freelancers for CD/cassette cover, catalog and advertising design and illustration; posters. 25% of freelance work demands knowledge of PageMaker, Illustrator and Photoshop.

First Contact & Terms Send postcard samples. Accepts disk submissions compatible with Illustrator and CorelDraw. Some samples are filed. If not filed, samples are not returned. Responds only if interested. Pays by the project, $150-1,250 for design; $1,000 maximum for illustration. Buys all rights.

Tips "Digital downloads of single tracks have reduced the demand for CD artwork and graphics. It is our belief that this is only a temporary problem for artists and designers. Hottrax will continue to preserve this medium as an integral part of its album/CD production. We file all samples that interest us even though we may not respond until the right project arises. We like simple designs for blues and jazz, including cartoons/caricatures; abstract for New Age; and fantasy for heavy metal and hard rock."

⃞ ⃞ IDOL RECORDS

P.O. Box 720043, Dallas TX 75372. (214)321-8890. E-mail: info@idolrecords.com. Web site: www.idolrecords.com. **Contact:** Miles. Estab. 1993. Produces CDs; rock by solo artists and groups. Recent releases: *Movements* by Black Tie Dynasty; *The Man* by Sponge; *The Fifth of July* by Watershed.

Needs Produces 10-20 releases/year. Prefers local designers/illustrators. Uses freelancers for CD booklet illustration; cover design; poster design.

First Contact & Terms Send photocopies, photographs, résumé and sample CD booklet. Samples are filed and not returned. Responds only if interested. Will contact artist for portfolio review if interested. Pays by the project. Buys all rights. Finds freelancers through word of mouth.

⃞ IMAGINARY ENTERTAINMENT CORP.

P.O. Box 66, Whites Creek TN 37189. (615)299-9237. E-mail: jazz@imaginaryrecords.com. Web site www.imaginaryrecords.com. **Proprietor:** Lloyd Townsend. Estab. 1982. Produces CDs, cassettes and LPs; rock, jazz, classical, folk and spoken word. Recent releases: *Kaki* by S.P. Somtow;

Fifth House by The New York Trio Project; *Triologue* by Stevens, Siegel and Ferguson.

Needs Produces 1-2 solo artists and 1-2 groups/year. Works with 1-2 freelancers/year. Works on assignment only. Uses artists for CD/LP/cassette cover design and illustration.

First Contact & Terms Prefers first contact through e-mail with link to online portfolio; otherwise send query letter with brochure, tearsheets, photographs, and SASE if samples need to be returned. Samples are filed or returned by SASE if requested by artist. Responds in 3 months. To show portfolio, mail thumbnails, roughs and photographs. Pays by the project, $25-500. Negotiates rights purchased.

Tips "I always need one or two dependable artists who can deliver appropriate artwork within a reasonable time frame."

N K2B2 RECORDS
1748 Roosevelt Ave., Los Angeles CA 90006-5219. (213)732-1602. Fax: (213)731-2758. E-mail: Marty@k2b2.com. Web site: www.k2b2.com. **Art Director:** Marty Krystall. Estab. 1979. Produces CDs; jazz, classical by solo artists. Recent releases: *Across the Tracks* by Buellgrass; *Thelonious Atmosphere* by Buell Neidlinger Quartet; *Marty Krystall Quartet* by Marty Krystall.

Needs Produces 1 release/year. Approached by 20 designers and 25 illustrators/year. Works with 2 designers and 1 illustrator/year. Uses freelancers for CD cover and catalog design and illustration; brochure and advertising design. Needs computer-literate freelancers for design, illustration. 100% of freelance work demands knowledge of Adobe CS, Quark, Illustrator, Photoshop, Free-Hand, Painter.

First Contact & Terms Send query letter with brochure, résumé. Samples are filed and not returned. Responds only if interested. Artist should follow up with letter after initial query. Art Director will contact artist for portfolio review if interested. Portfolio should include color samples. Pays for design and illustration by the project, $500-1,500. Buys all rights.

Tips "I prefer line drawings and oil painting—real art."

N ⬙ KIMBO EDUCATIONAL
10 N. Third Ave., Long Branch NJ 07740. E-mail: kimboed@aol.com. Web site: www.kimboed.com. **Production Manager:** Amy Laufer. Educational CD company. Produces 8 CDs/year for schools, teacher-supply stores and parents—primarily early childhood/physical fitness.

Needs Works with 3 freelancers/year. Prefers local artists on assignment only. "It is very hard to do this type of material via mail." Uses artists for CD covers, catalog and flier design, and ads. Helpful if artist has experience in the preparation of CD cover jackets and booklets.

First Contact & Terms Send letter with photographs or actual samples of past work. Responds only if interested. Pays for design and illustration by the project, $300-500. Considers complexity of project and budget when establishing payment. Buys all rights.

Tips "The jobs at Kimbo vary tremendously. We produce material for various levels—infant to senior citizen. Sometimes we need cute 'kid-like' illustrations, and sometimes graphic design will suffice. We are an educational firm, so we cannot pay commercial CD art prices."

N LAMON RECORDS CORPORATION
P.O. Box 23625, Charlotte NC 28227. (704)282-9910. E-mail: cody@lamonrecords.com. Web site: www.lamonrecords.com. **Graphic Design Manager:** Cody McSwain. Produces CDs and cassettes; rock, country/western, folk, R&B and religious music by groups. Recent releases: *Play Fiddle* by Dwight Moody; *Western Hits* by Ruth and Ted Reinhart; *Now and Then* by Cathy and Dwight Moody.

Needs Works with 3 designers and 4 illustrators/year. Uses freelancers for album cover design and illustration, brochure and advertising design, and direct mail packages. Works on assignment only. 50% of freelance work demands knowledge of Photoshop.

First Contact & Terms Send brochure and tearsheets. Samples are filed and are not returned. Responds only if interested. Call for appointment to show portfolio or mail appropriate materials. Considers skill and experience of artist and how work will be used when establishing payment. Buys all rights.

Tips ''Include work that has been used on album, CD or cassette covers.''

🔢 LCDM ENTERTAINMENT

Box 79564, 1995 Weston Rd., Toronto ON M9N 3W9 Canada. E-mail: GuitarBabe@hotmail.com. Web site: www.liana.biz and www.indie-music-toronto.ca. **Producer:** L. DiMarco. Estab. 1991. Produces CDs, cassettes, publications (quarterly); pop, folk, country/western and original. Recent releases: ''Amazon Trail'' by LIANA; *Glitters & Tumbles* by Liana; *Indie Tips & the Arts* (publication); indie-music-toronto@yahoogroups.com (online newsletter).

Needs Prefers local artists but open to others. Uses freelancers for CD cover design, brochure illustration, posters and publication artwork. Needs computer-literate freelancers for production, presentation and multimedia projects.

First Contact & Terms Send query letter by snail mail with brochure, résumé, photocopies, photographs, SASE, tearsheets, terms of renumeration (i.e., pay/non-pay/alternative). No e-mail queries, submissions or solicitations. Samples are filed. Art director will contact artist for portfolio review if interested. Pays for design, illustration and film by the project. Rights purchased vary according to project.

Tips ''The best experience is attainable through indie labels. Ensure that the basics (phone/fax/ address) are on all of your correspondence. Seldom do indie labels return long distance calls. Include SASE in your mailings always. Get involved and offer to do work on a volunteer or honorarium basis. We usually work with artists who have past volunteer experience first.''

🔢 LMNOP

P.O. Box 15749, Chattanooga TN 37415. Web site: www.babysue.com and www.LMNOP.com. **President:** Don W. Seven. Estab. 1983. Produces CDs, cassettes and albums; rock, jazz, classical, country/western, folk and pop. Recent releases: *Bad Sisters* by The Stereotypes; *The Best and The Rest* by Lisa Shame.

Needs Produces 6 solo artists and 10 groups/year. Uses 5 freelancers/year for CD/album/cassette cover design and illustration, catalog design, advertising design and illustration, and posters. 20% of design and 50% of illustration demand computer skills.

First Contact & Terms Send postcard sample or query letter with SASE, photographs, photostats and slides. Samples are not filed and are not returned. Responds only if interested. To show portfolio, mail roughs, b&w and color photostats and photographs. Pays by the day, $250-500. Rights purchased vary according to project.

🔢 LUCIFER RECORDS, INC.

P.O. Box 263, Brigantine NJ 08203. (609)266-2623. **President:** Ron Luciano. Produces pop, dance and rock.

Needs Produces 2-12 records/year. Prefers experienced freelancers. Works on assignment only. Uses freelancers for album cover and catalog design; brochure and advertising design, illustration and layout; direct mail packages; and posters.

First Contact & Terms Send query letter with résumé, business card, tearsheets, photostats or photocopies. Responds only if interested. Original art sometimes returned to artist. Write for appointment to show portfolio, or mail tearsheets and photostats. Pays by the project. Negotiates pay and rights purchased.

JIM MCCOY MUSIC

25 Troubadour Lane, Berkeley Springs WV 25411. (304)258-8314. E-mail: mccoytroubadour@aol.com. Web site: www.troubadourlounge.com. **Owner:** Bertha McCoy. Estab. 1972. Produces CDs, cassettes; country/western. Recent releases: *Mysteries of Life* by Carroll County Ramblers.

Needs Produces 12 solo artists and 10 groups/year. Works on assignment only. Uses artists for CD cover design and illustration; cassette cover illustration.

MIA MIND MUSIC

259 W. 30th St., 12th Floor, New York NY 10001. (212)564-4611. Fax: (212)564-4448. E-mail: mimimus@aol.com. Web site: www.miamindmusic.com. **Contact:** Stevie B. "Mia Mind Music works with bands at the stage in their careers where they need CD artwork and promotional advertisements. The record label Mia Mind signs dozens of artists per year and accepts artwork through the mail; or call for appointment."

Tips "The weirder, the better. 'Extreme' sells in the music market."

MIGHTY RECORDS

BMI Music Publishing Co., Corporate Music Publishing Co., ASCAP, Stateside Music Publishing Co., BMI, 150 West End Ave., Suite 6-D, New York NY 10023. (212)873-5968. **Manager:** Danny Darrow. Estab. 1958. Produces CDs and cassettes; jazz, pop, country/western by solo artists. Recent releases: *Impulse* by Danny Darrow.

Needs Produces 1-2 solo artists/year. Works on assignment only. Uses freelancers for CD/cassette cover, brochure and advertising design and illustration; catalog design and layout; and posters.

First Contact & Terms Samples are not filed and are not returned. Rights purchased vary according to project.

NORTH STAR MUSIC INC.

22 London St., East Greenwich RI 02818. (401)886-8888. Fax: (401)886-8880. E-mail: info@northstarmusic.com. Web site: www.northstarmusic.com. **President:** Richard Waterman. Estab. 1985. Produces CDs; jazz, classical, folk, traditional, contemporary, world beat and New Age by solo artists and groups. Recent release: *Sundown* by Stewart Dudley.

Needs Produces 4 solo artists and 4 groups/year. Works with 2 freelancers/year. Prefers freelancers with experience in CD cover design. Works on assignment only. Uses artists for CD cover and brochure design and illustration; catalog design, illustration and layout; direct mail packages. 80% of design and 20% of illustration demand knowledge of QuarkXPress 4.0.

First Contact & Terms Send postcard sample or query letter with brochure, photocopies and SASE. Accepts disk submissions compatible with QuarkXPress 4.0. Send EPS or TIFF files. Samples are filed. Responds only if interested. To show portfolio, mail color roughs and final art. Pays for design by the project, $500-1,000. Buys first rights, one-time rights or all rights.

Tips "Learn about our label's style of music/art. Send appropriate samples."

OCP (OREGON CATHOLIC PRESS)

5536 NE Hassalo, Portland OR 97213-3638. E-mail: gust@ocp.org. Web site: www.ocp.org. **Creative Director:** Gus Torres. Estab. 1934. Produces liturgical music CDs, songbooks, missalettes and books.

 • OCP (Oregon Catholic Press) is a nonprofit publishing company, producing music and liturgical publications used in parishes throughout the United States, Canada, England and Australia. This company also has listings in the Book Publishers and Magazines sections.

Needs Produces 10 collections/year. Works with 5 freelancers/year. Uses freelancers for CD booklet illustration; CD cover design and illustration; also for spot illustration.

First Contact & Terms Send query e-mail with PDF samples only. Responds in 2 weeks. Will

contact artist if interested. Pays for illustration by the project, $35-500. Finds artists through submissions and the Web.

Tips Looks for attention to detail.

☒ ONE STEP TO HAPPINESS MUSIC

Jacobson & Colfin, P.C., 60 Madison Ave., Suite 1026, New York NY 10010-1666. (212)691-5630. Fax: (212)645-5038. E-mail: bruce@thefirm.com. Web site: www.thefirm.com. **Attorney:** Bruce E. Colfin. Produces CDs, cassettes and albums; reggae by solo artists and groups. Recent release: *Make Place for the Youth* by Andrew Tosh.

Needs Produces 1-2 solo artists and 1-2 groups/year. Works with 1-2 freelancers/year on assignment only. Uses artists for CD/album/cassette cover design and illustration.

First Contact & Terms Send query letter with brochure, résumé and SASE. Samples are filed or returned by SASE if requested by artist. Responds in 2 months. Call or write for appointment to show portfolio of tearsheets. Pays by the project. Rights purchased vary according to project.

☒ OPUS ONE

P.O. Box 604, Greenville ME 04441. (207)997-3581. **President:** Max Schubel. Estab. 1966. Produces CDs, LPs, 78s; contemporary American concert and electronic music.

Needs Produces 6 releases/year. Works with 1-2 freelancers/year. Prefers freelancers with experience in commercial graphics for CDs. Uses freelancers for CD cover and label design.

First Contact & Terms Send postcard sample or query letter with rates and sample of previous artwork. Samples are filed. Pays for design by the project. Buys all rights. Finds artists through meeting them in arts colonies, galleries or by chance.

Tips "Contact record producer directly. Send samples of work that relate in size and subject matter to what Opus One produces. We want witty, dynamic, colorful and dramatic work."

☒ PANDISC MUSIC CORP.

15982 NW 48th Ave., Miami FL 33014-6410. (305)557-1914. Fax: (305)557-9262. E-mail: beth@p andisc.com. Web site: www.pandisc.com. **Director of Production:** Beth Sereni. Estab. 1982. Produces CDs and vinyl; dance, underground/club, electronica, bass and rap.

Needs Produces 35-50 releases/year as well as some print ads and miscellaneous jobs. Works with a few freelancers and design firms. Prefers freelancers with experience in record industry. Uses freelancers for CD/album jacket design, posters, direct mail packages as well as print ads, promotional materials, etc. Needs computer-literate freelancers for design and production. 100% of freelance work demands computer knowledge, specifically QuarkXPress and the Adobe suites.

First Contact & Terms Send query letter with samples of work. Samples are filed if found to have potential. Art director will contact artist if interested. "Call for per-job rates." Buys all rights.

Tips "Must be deadline conscious and versatile."

☒ PPL ENTERTAINMENT GROUP

P.O. Box 261488, Encino CA 91426. (818)506-8533. Fax: (818)506-8534. E-mail: pplzmi@aol.c om. Web site: www.pplzmi.com. **Art Director:** Kaitland Diamond. Estab. 1979. Produces albums, CDs, cassettes; country, pop, R&B, rap, rock and soul by solo artists and groups. Recent releases: *Return of the Playazz* by JuzCuz; *American Dream* by Riki Hendrix.

Needs Produces 12 releases/year. Works with 2 freelancers/year. Prefers designers who own Mac or IBM computers. Uses freelancers for CD booklet design and illustration; CD/album/ cassette cover design and illustration; CD-ROM design and packaging; poster design; Web page design. Freelance work demands knowledge of PageMaker, Illustrator, Photoshop, QuarkXPress.

First Contact & Terms Send query letter with brochure, photocopies, tearsheets, résumé, photographs, photostats, slides, transparencies and SASE. Accepts disc submissions. Samples are filed

or returned by SASE if requested by artist. Responds in 2 months. Request portfolio review in original query. Pays by the project, monthly.

N PRAIRIE MUSIC LTD.

P.O. Box 492, Anita IA 50020. (712)762-4363. E-mail: bobeverhart@yahoo.com. **President:** Bob Everhart. Media Specialist: Sheila Everhart. Estab. 1967. Produces cassettes and CDs; folk, traditional, country and bluegrass. Recent releases: *Paid Our Dues* by Bob and Sheila Everhart; *Headed West* by Bobbie Everhart.

Needs Produces 2 solo artists and 2 groups/year. Prefers freelancers with experience in traditional rural values. Works on assignment only. Uses artists for album/cassette cover design/illustration and posters.

First Contact & Terms Send query letter with résumé, photocopies and photostats. Samples are filed. Responds in 4 months, only if interested. To show portfolio, mail b&w photostats. Pays by the project, $100-250. Buys one-time rights.

N R.E.F. RECORDING COMPANY/FRICK MUSIC PUBLISHING COMPANY

404 Bluegrass Ave., Madison TN 37115. (615)865-6380. E-mail: bob-scott-frick@juno.com. **Owner:** Bob Frick. Produces CDs and cassettes; southern gospel, country gospel and contemporary Christian. Recent releases: *Seasonal Pickin'* by Bob Scott Frick; *Righteous Pair*; *Pray When I Want To.*

Needs Produces 30 records/year. Works with 10 freelancers/year on assignment only.

First Contact & Terms Send résumé and photocopies to be kept on file. Write for appointment to show portfolio. Samples not filed are returned by SASE. Responds in 10 days, only if interested.

N ROCK DOG RECORDS

P.O. Box 3687, Hollywood CA 90078. (800)339-0567. E-mail: gerry.cannizzaro@att.net. Web site: www.rockdogrecords.com. **Vice President of Production:** Gerry North Cannizzaro. CFO: Patt Connolly. Estab. 1987. Produces CDs and cassettes; rock, R&B, dance, New Age, contemporary instrumental, ambient, and music for film, TV and video productions. Recent releases: *This Brave New World* by Brainstorm; *Fallen Angel* by Iain Hersey; *The Best of Brainstorm* by Brainstorm.

- This company has a second location: P.O. Box 884, Syosset NY 11791-0899. (516)544-9596. (516)364-1998. A&R, Promotion and Distribution: Maria Cuccia.

Needs Produces 2-3 solo artists and 2-3 groups/year. Approached by 50 designers and 200 illustrators/year. Works with 5-6 designers and 25 illustrators/year. Prefers freelancers with experience in album art. Uses artists for CD/cassette cover design and illustration, direct mail packages, multimedia projects, ad design and posters. 95% of design and 75% of illustration demand knowledge of Print Shop or Photoshop.

First Contact & Terms Send postcard sample or query letter with photographs, SASE and photocopies. Accepts disk submissions compatible with Windows 95. Send Bitmap, TIFF, GIF or JPEG files. Samples are filed or are returned by SASE. Responds in 2 weeks. To show portfolio, mail photocopies. Sometimes requests work on spec before assigning a job. Pays for design by the project, $50-500. Pays for illustration by the project, $50-500. Interested in buying second rights (reprint rights) to previously published work. Finds new artists through submissions from artists who use *Artist's & Graphic Designer's Market.*

Tips "Be open to suggestions; follow directions. Don't send us pictures, drawings, etc., of people playing an instrument. Usually we are looking for something abstract or conceptual. We look for prints that we can license for limited use."

N ROWENA RECORDS & TAPES

195 S. 26th St., San Jose CA 95116. (408)286-9840. E-mail: onealprod@sbcglobal.net. **Owner:** Jeannine O'Neal. Estab. 1967. Produces CDs, cassettes and albums; rock, R&B, country/western, soul, rap, pop and New Age. Recent releases: *Narrow Road* by Jeannine O'Neal; *Purple Jungle* by Jerry Lee.

Needs Produces 20 solo artists and 5 groups/year. Uses freelancers for CD/album/cassette cover design and illustration and posters.

First Contact & Terms Send query letter with brochure, résumé, SASE, tearsheets, photographs, photocopies and photostats. Samples are filed or are returned by SASE. Responds in 1 month. To show a portfolio, mail original/final art. "Artist should submit prices."

N SAHARA RECORDS AND FILMWORKS ENTERTAINMENT

10573 W. Pico Blvd. #352, Los Angeles CA 90064. (310)948-9652. E-mail: info@edmsahara.com. Web site: www.edmsahara.com. **Marketing Director:** Dwayne Woolridge. Estab. 1981. Produces CDs, cassettes; jazz, pop, R&B, rap, rock, soul, TV-film music by solo artists and groups. Recent releases: *Pay the Price* and *Rice Girl* film soundtracks; *Dance Wit Me* by Steve Lynn.

Needs Produces 25 releases/year. Works with 2 freelancers/year. Uses freelancers for CD booklet design and illustration; CD cover design and illustration; poster design and animation.

First Contact & Terms Contact only through artist rep. Samples are filed. Responds only if interested. Payment negotiable. Buys all rights. Finds artists through agents, submissions, *The Black Book* and *Directory of Illustration*.

N SILVER WAVE RECORDS

2475 Broadway, Suite 300, Boulder CO 80304. (303)443-5617. Fax: (303)443-0877. E-mail: valerie @silverwave.com. Web site: www.silverwave.com. **Art Director:** Valerie Sanford. Estab. 1986. Produces CDs and cassettes; Native American, New Age and World music. Recent releases: *Out of the Ashes* by Shelley Morningsong; *10 Questions for the Dalai Lama* by Peter Kater; GRAMMY winner *Dance With the Wind* by Mary Youngblood; *Johnny Whitehorse* by Johnny Whitehorse.

Needs Produces 4 releases/year. Works with 4-6 illustrators, artists, photographers/year. Uses illustrators for CD cover illustration.

First Contact & Terms Send postcard sample or query letter with 2 or 3 samples. Samples are filed. Will contact for portfolio review if interested. Pays by the project. Rights purchased vary according to project.

Tips "Develop some good samples and experience. I look in galleries, art magazines, *Workbook*, *The Black Book* and other trade publications. I visit artists' booths at Native American 'trade shows.' Word of mouth is effective. We will call if we like work or need someone." When hiring freelance illustrators, this company looks for a specific style for a particular project. "Currently we are producing contemporary Native American music and look for art that expresses that."

N STARDUST RECORDS; THUNDERHAWK RECORDS; WIZARD RECORDS

341 Billy Goat Hill Rd., Winchester TN 37398. (931)649-2577. Fax: (931)649-2732. E-mail: cbd@v allnet.com. Web site: www.stardustcountrymusic.com. **Contact:** Colonel Buster Doss. Produces CDs, cassettes and albums; rock, folk, country/western. Recent releases: *13 Red Roses Plus One* by Jerri Arnold; *It's the Heart* by Brant Miller.

Needs Produces 12-20 CDs and cassettes/year. Works with 2-3 freelance designers and 1-2 illustrators/year on assignment only. Uses freelancers for CD/album/cassette cover design and illustration; brochure design; and posters.

First Contact & Terms Send query letter with brochure, tearsheets, résumé and SASE. Samples are filed. Responds in 1 week. Call for appointment to show portfolio of thumbnails, b&w photostats. Pays by the project. Finds new artists through *Artist's & Graphic Designer's Market*.

N TAESUE ENTERTAINMENT LTD.

P.O. Box 804414, Chicago IL 60680. E-mail: taesue@taesue.com or etaylor@taesue.com. **Contact:** Eric C. Taylor, CEO; Dyrol Washington, Vice President. Estab. 1996. Produces videos, CDs, and media productions; gospel, pop, R&B, hip-hop and instructional media by solo artists. Recent releases: *The X Files* by Virtual X; *I've Got An Angel* by Virtual X; *The Biz* by The Company.

Needs Produces 4 releases/year. Works with 7 freelancers/year. Uses freelancers for CD and DVD cover design and illustration; cassette cover design and illustration; CD booklet design and illustration; poster design; Web page design. 70% of design and 70% of illustration demands knowledge of Illustrator, Photoshop, Flash, FreeHand.

First Contact & Terms Send query letter with brochure, résumé, photocopies, slides. Accepts disk submissions compatible with Mac or PC. Samples are filed or returned by SASE if requested by artist. Responds in 1 month. Art Director will contact artist for portfolio review of b&w, color, final art, photocopies, thumbnails if interested. Pays for design and illustration by the project; negotiable. Rights purchased vary according to project. Finds artists through *The Black Book* and magazines.

Tips "Record companies are always looking for a new hook, so be creative. Keep your price negotiable. I look for creative and professional-looking portfolio."

N T TANGENT RECORDS

P.O. Box 383, Reynoldsburg OH 43068-0383. (614)751-1962. Fax: (614)751-6414. E-mail: info@tangentrecords.com. Web site: www.tangentrecords.com. **President:** Andrew J. Batchelor. Estab. 1986. Produces CDs, DVDs, CD-ROMs, cassettes, videos; contemporary, classical, jazz, progressive, rock, electronic, world beat and New Age fusion. Recent releases: *Moments Edge* by Andrew Batchelor.

Needs Produces 20 releases/year. Works with 5 freelancers/year. Prefers local illustrators and designers who own computers. Uses freelancers for CD booklet design and illustration; CD cover design and illustration; CD-ROM design and packaging; poster design; Web page design; advertising and brochure design/illustration and multimedia projects. Most freelance work demands knowledge of Illustrator, QuarkXPress, Photoshop, FreeHand and PageMaker.

First Contact & Terms Send postcard sample or query letter with résumé, brochure, one-sheets, photocopies, tearsheets, photographs. Accepts both Mac- and IBM-compatible digital submissions. Send JPEG files on 3.5" diskette, CD-ROM or Superdisk 120MB. Samples are filed and not returned. Will contact artist for portfolio review if interested. Portfolio should include b&w, color, final art, photocopies, photographs, photostats, slides, tearsheets, thumbnails, transparencies. Pays by the project. "Amount varies by the scope of the project." Negotiates rights purchased. Finds artists through college art programs and referrals.

Tips Looks for "creativity and innovation."

N TOP RECORDS

4 Galleria del Corso, 20122 Milano Italy. (39)(02)76407175. Fax: (39)(2)76021141. E-mail: topdingo@toprecords.it. Web site: www.toprecords.it. **Managing Director:** Guido Palma. Estab. 1975. Produces CDs, albums; rock, rap, R&B, soul, pop, folk, country/western, disco by solo artists and groups.

Needs Produces 5 solo artists and 5 groups/year. Works with 2 freelancers/year on assignment only.

First Contact & Terms Send query letter with brochure. Samples are filed but not returned, unless requested and paid for by the artist. Responds in 1 month. Call for appointment to show portfolio or mail appropriate materials. Portfolio should include original/final art and photographs. Buys all rights.

Tips "Have a new and original idea."

ⓝ TOPNOTCH ENTERTAINMENT CORP.

P.O. Box 1515, Sanibel Island FL 33957-1515. (239)982-1515. E-mail: topnotch@wolanin.com. Web site: www.wolanin.com. **Chairman/CEO:** Vincent M. Wolanin. Estab. 1973. Produces aviation art, advertising layouts, logos, albums, CDs, DVDs, CD-ROMs, tour merchandise, cassettes; pop, progressive, R&B, rock, soul by solo artists and groups.

Needs Produces 6-8 unique designs/year. Works with 3-6 freelancers/year on work-for-hire basis. Prefers designers who use PC-based programs. Uses freelancers for design and illustration; animation; creative design and illustration; CD booklet design and illustration; CD cover design and illustration; CD-ROM design and packaging; poster design; Web page design. Also for outside entertainment projects like Superbowl-related events and aviation-related marketing promotions and advertising. 90% of design and illustration demands knowledge of PageMaker, Illustrator, QuarkXPress, Photoshop, FreeHand, Corel, FrontPage, Astound.

First Contact & Terms Send query e-mail or letter with brochure, résumé, photostats, transparencies, photocopies, photographs, slides, SASE, tearsheets. Also accepts links to artists' Web sites. Accepts disk or e-mail submissions compatible with IBM. Samples are filed. Does not report back. Artist should contact again in 1 year. Request portfolio review in original query. Artist should follow up with letter after initial query. Portfolio should include color, final art, photographs, slides, tearsheets. Pays for design and illustration by the project. Buys all rights.

Tips "We look for new ways, new ideas, eye catchers; let me taste the great wine right away. Create great work and be bold. Don't get discouraged."

ⓝ TOUCHE RECORDS CO.

P.O. Box 96, El Cerrito CA 94530. (510)524-4937. Fax (510)524-9577. **Executive Vice President:** James Bronson, Jr. Estab. 1955. Produces CDs, cassettes and LPs; jazz, soul, R&B and rap. Recent releases: *Happiness Is Takin' Care of Natural Business* by 'Al' Tanner.

Needs Produces 1-10 solo artists/year. Approached by 10 designers and 6 illustrators/year. Works with 3 designers and 1 illustrator/year. Works on assignment only. Uses artists for CD cover design and illustration; cassette cover illustration; brochure design and illustration; catalog design, illustration and layout; direct mail packages; advertising design and illustration; and posters.

First Contact & Terms Send query letter with brochure, résumé, photocopies and tearsheets. Samples are filed. Responds in 10 days. To show portfolio, mail portfolio of roughs. Pays for design by the project. Buys all rights.

Tips "All artwork gets my attention."

ⓝ TROPIKAL PRODUCTIONS; WORLD BEATNIK RECORDS

2787 Beverly Dr., Rockwall TX 75032. (972)771-3797. E-mail: tropikal@juno.com. Web site: www.tropikalproductions.com. **Contact:** Jimi Towry. Estab. 1981. Produces albums, CDs, cassettes; specializes in world beat, soca, jazz, reggae, hip-hop, Latin, Hawaiian, gospel. Recent releases: *Cool Runner, Alive Montage* and *The Island* by Watusi; *Inna Dancehall* by Ragga D.

Needs Produces 5-10 releases/year. Works with 5-10 freelancers/year. Prefers freelancers with experience in CD/album covers, animation and photography. "Note: The majority of our work is with 'Tropikal'-theme projects—island 'kulcha'." Uses freelancers for CD cover design and illustration; animation; cassette cover design and illustration; CD booklet design and illustration; poster design. 50% of freelance work demands knowledge of Illustrator, Photoshop.

First Contact & Terms Send brochure, résumé, photostats, photocopies, photographs, tearsheets. Accepts Mac- or IBM-compatible disk submissions. Send EPS files. "No X-rated material, please." Samples are filed or returned by SASE if requested by artist. Responds in 15 days. Will contact for portfolio review of b&w, color, final art, photocopies, photographs, roughs if interested. Pays by the project; negotiable. Rights purchased vary according to project; negotiable. Finds artists through referrals, submissions.

Tips "Show versatility; create theme connection to music."

🅽 📠 TRUE NORTH RECORDS; FINKELSTEIN MANAGEMENT CO. LTD.

260 Richmond St. W., Suite 501, Toronto ON M5V 1W5 Canada. (416)596-8696. Fax: (416)596-6861. E-mail: general_inquiries@truenorthrecords.com. Web site: www.truenorthrecords.com. **Director of Creative Services:** James Grimes. Estab. 1969. Produces CDs, cassettes and albums; rock and roll, folk and pop by solo and group artists. Recent releases: *The Charity of Night* by Bruce Cockburn; *Industrial Lullaby* by Stephen Fearing; *Bark* by Blackie and the Rodeo Kings; *Howie Beck* by Howie Beck.

Needs Produces 2 solo artists and 2 groups/year. Works with 4 designers and 1 illustrator/year. Prefers artists with experience in album cover design. Uses artists for CD/album/cassette cover design and illustration, posters and photography. 50% of freelance work demands computer skills.

First Contact & Terms Send postcard sample, brochure, résumé, photocopies, photographs, slides, transparencies with SASE. Samples are filed or are returned by SASE if requested by artist. Responds only if interested. Pays by the project. Buys all rights.

🅽 🎨 VALARIEN PRODUCTIONS

15332 Antioch St., #105A, Pacific Palisades CA 90272. (310)445-7737. Fax: (310)455-7737. E-mail: valarien@gte.net. Web site: www.valarien.com. **Owner:** Eric Reyes. Estab. 1990. Produces CDs; ambient, acoustic guitar, New Age, DJ/dance/electronica, film scores, progressive rock by solo artists.

Needs Produces 1-4 releases/year. Works with 1-2 freelancers/year. Prefers local freelancers who own Macs. Uses freelancers for CD/album cover design and illustration; animation; CD booklet design and illustration; advertising. 100% of freelance work demands knowledge of Illustrator, QuarkXPress.

First Contact & Terms Send postcard sample of work. Samples are filed and not returned. Will contact artist for portfolio review of b&w, color, final art if interested. Pays by the project. Rights purchased vary according to project. Finds artists through word of mouth, submissions, source-books.

🅽 VAN RICHTER RECORDS

100 S. Sunrise Way, Suite 219, Palm Springs CA 92262. (760)320-5577. Fax: (760)320-4474. E-mail: manager@vanrichter.net. Web site: www.vanrichter.net. **Label Manager:** Paul Abramson. Estab. 1993. Produces CDs; rock, industrial. Recent releases: *Nightmare* by Girls Under Glass.

Needs Produces 3-4 releases/year. Works with 2-3 freelancers/year. Prefers freelancers with experience in production design. Uses freelancers for CD booklet and cover design and illustration; posters/pop. 100% of freelance work demands knowledge of Illustrator, QuarkXPress, Photoshop.

First Contact & Terms Send postcard sample or query letter with brochure, tearsheets, photographs, print samples. Accepts Mac-compatible disk submissions. Samples are not filed and are returned by SASE if requested by artist. Will contact artist for portfolio review of final art if interested. Payment negotiable. Buys all rights. Finds artists through Internet and submissions.

Tips "You may have to work for free until you prove yourself/make a name."

🅽 VARESE SARABANDE RECORDS

11846 Ventura Blvd., Suite 130, Studio City CA 91604. (818)753-4143. Fax: (818)753-7596. E-mail: publicity@varesesarabande.com. Web site: www.varesesarabande.com. **Vice President:** Robert Townson. Estab. 1978. Produces CDs; film music soundtracks. Recent releases: *Shrek The Third* by Harry Gregson-Williams; *Evan Almighty* by John Debney; *Blood Diamond* by James Newton Howard; *Live Free or Die Hard* by Marco Beltrami; *Rush Hour 3* by Lalo Schifrin; *Grindhouse: Planet Terror* by Robert Rodriguez.

Needs Works on assignment only. Uses artists for CD cover illustration and promotional material.
First Contact & Terms Send query letter with photostats, slides and transparencies. Samples are filed. Responds only if interested. Pays by the project.
Tips "Be familiar with the label's output before approaching us."

N WARLOCK RECORDS, INC.

135 W. 26th St., Suite 3B, New York NY 10001. (212)206-0800. Fax: (212)206-1966. E-mail: fred@warlockrecords.com. Web site: www.warlockrecords.com. Estab. 1986. Produces CDs, cassettes and albums; R&B, jazz, rap and dance. Recent releases: *No Nagging* by Froggy Mit; *Lyrical Warfare* by Chocolate Bandit; *Just Be Free* by Christina Aguilera.
Needs Produces 5 solo artists and 12-15 groups/year. Approached by 30 designers and 75 illustrators/year. Works with 3 designers and 4 illustrators/year. Prefers artists with experience in record industry graphic art and design. Works on assignment only. Uses artists for CD/album/cassette cover design; posters; and advertising design. Seeking artists who both design and produce graphic art, to "take care of everything, including typesetting, stats, etc." 99% of freelance work demands knowledge of Illustrator 6.0, Quark XPress 4.0, Photoshop 4.0, Flight Check 3.2.
First Contact & Terms Send query letter with brochure, résumé, photocopies and photostats. Samples are filed and are not returned. "I keep information on file for months." Responds only if interested; as jobs come up. Call to schedule an appointment to show a portfolio, or drop off for a day or half-day. Portfolio should include photostats, slides and photographs. Pays for design by the project, $50-1,000; pays for illustration by the project, $50-1,000. Rights purchased vary according to project. Finds artists through submissions.
Tips "Create better design than any you've ever seen and never miss a deadline—you'll be noticed. Specialize in excellence."

N WATCHESGRO MUSIC, BMI—INTERSTATE 40 RECORDS—EDDIE CARR'S ENTERTAINMENT

9208 Spruce Mountain Way, Las Vegas NV 89134. (702)363-8506. **President:** Eddie Carr. Estab. 1975. Produces DVDs and CDs; rock, country/western, rap/hip-hop and country rock. Recent releases: *The Baby* by Blake Shelton; *Three Wooden Crosses* by Randy Travis; *I Will* by Chad Simmons; *Jude* by Judy Willis; *Sonny* by Sonny Marshall; *Deep in the South* by Sean O'Brien.
 • Watchesgro Music has placed songs in the following feature films: *Waitin' to Live*, *8 Mile*, *Die Another Day*, *Daredevil* and *DJ Domination*.
Needs Co-produces 8 solo artists/year. Works with 10 "top promoters in U.S. and European markets."
First Contact & Terms Send query letter with photographs. Responds in 1 week, only if interested. "We specialize in national releases of new artists."

N ♣ WATERDOG MUSIC

329 W. 18th St., #313, Chicago IL 60616-1120. (312)421-7499. E-mail: waterdog@waterdogmusic. com. Web site: www.waterdogmusic.com; www.ralphsworld.com. **Label Manager:** Rob Gillis. Estab. 1991. Produces CDs and manages Ralph Covert, The Bad Examples and Ralph's World. Recent release: *Good Examples of Bad Examples* by Ralph Covert.
Needs Produces 3-4 releases/year. Works with 2-3 freelancers/year. Prefers local freelancers with experience in CD design who own Macs. Uses freelancers for CD/album cover design and illustration; CD booklet design and illustration; poster design. 100% of design and 50% of illustration demands knowledge of QuarkXPress.
First Contact & Terms Send postcard sample or query letter with brochure, résumé. Samples are not filed. Portfolio review not required. Pays by the project. Buys all rights. Finds artists through referrals.

Artists' Reps

Many artists find leaving promotion to a rep allows them more time for the creative process. In exchange for actively promoting an artist's career, the representative receives a percentage of sales (usually 25-30%). Reps generally focus on either the fine art market or commercial market, rarely both.

Fine art reps promote the work of fine artists, sculptors, craftspeople and fine art photographers to galleries, museums, corporate art collectors, interior designers and art publishers. Commercial reps help illustrators and graphic designers obtain assignments from advertising agencies, publishers, magazines and other art buyers. Some reps also act as licensing agents.

What reps do

Reps work with artists to bring their portfolios up to speed and actively promote their work to clients. Usually a rep will recommend advertising in one of the many creative directories such as *Showcase* (www.showcase.com) or *Workbook* (www.workbook.com) so that your work will be seen by hundreds of art directors. (Expect to make an initial investment in costs for duplicate portfolios and mailings.) Reps also negotiate contracts, handle billing and collect payments.

Getting representation isn't as easy as you might think. Reps are choosy about who they represent—not just in terms of talent but also in terms of marketability and professionalism—reps will only take on talent they know will sell.

What to send

Once you've gone through the listings in this section and compiled a list of art reps who handle your type and style of work, contact them with a brief query letter and nonreturnable copies of your work. Check each listing for specific guidelines and requirements.

Learn About Reps

For More Info

The Society of Photographers and Artists Representatives (SPAR) is an organization for professional representatives. SPAR members are required to maintain certain standards and follow a code of ethics. For more information, write to SPAR, 60 E. 42nd St., Suite 1166, New York NY 10165, or visit www.spar.org.

FRANCE ALINE, INC.

E-mail: france@francealine.com. Web site: www.francealine.com. **Owner:** France Aline. Commercial illustration, photography and digital art representative. Estab. 1979. Specializes in logo design and advertising. Markets include advertising, corporations, design firms, movie studios, record companies. Artists include Jill Sabella, Craig Mullins, Ezra Tucker, Elisa Cohen, Justin Brandstater, Nora Feller, Peter Greco, Erica Lennand and Thomas Blacksedir.

Handles Illustration, photography.

Terms Rep receives 25% commission. Exclusive area representation is required. Advertises in *American Showcase*, *Workbook* and *The Black Book*.

How to Contact For first contact, send e-mail query. Responds in a few days.

N AMERICAN ARTISTS REP., INC.

353 W. 53rd St., #1W, New York NY 10019. (212)682-2462. Fax: (212)582-0090. Web site: www.a areps.com. Commercial illustration representative. Estab. 1930. Member of SPAR. Represents 40 illustrators. Markets include advertising agencies, corporations/client direct, design firms, editorial/magazines, paper products/greeting cards, publishing/books, sales/promotion firms.

Handles Illustration, design.

Terms Rep receives 30% commission. "All portfolio expenses billed to artist." Advertising costs are split: 70% paid by talent; 30% paid by representative. "Promotion is encouraged; portfolio must be presented in a professional manner—8×10, 4×5, tearsheets, etc." Advertises in *American Showcase*, *The Black Book*, *RSVP*, *Workbook*, medical and Graphic Artist Guild publications.

How to Contact Send query letter, direct mail flier/brochure, tearsheets. Responds in 1 week if interested. After initial contact, drop off or mail appropriate materials for review. Portfolio should include tearsheets, slides. Obtains new talent through recommendations from others, solicitation, conferences.

N ART IN FORMS (A Division of Martha Productions)

7550 W. 82nd St., Playa Del Rey CA 90293. (310)670-5300. Fax: (310)670-3644. E-mail: contact@ marthaproductions.com. Web site: www.artinforms.com. **President:** Martha Spelman. Commercial illustration representative. Estab. 2000. Represents 9 illustrators. Specializes in illustrators who create informational graphics and technical drawings, including maps, charts, diagrams, cutaways, flow charts and more.

- See listing for Martha Productions in this section.

ART LICENSING INTERNATIONAL INC.

7350 S. Tamiami Trail #227, Sarasota FL 34231. (941)966-8912. Fax: (941)966-8914. E-mail: artlicensing@comcast.net. Web site: www.out-of-the-blue.us. **President:** Michael Woodward, author of *Licensing Art 101*. Licensing agent. Estab. 1986. Represents fine artists, designers, photographers and concept designers. Handles collections of work submitted by artists for licensing across a range of product categories, such as fine art for interior design market, wall decor, greeting cards, stationery and gift products.

- See additional listings for this company in the Greeting Cards, Gifts & Products and Posters & Prints sections. See also listing for Out of the Blue in the Greeting Cards, Gifts & Products section.

Handles Prefers collections of art, illustrations or photography that have good consumer appeal.

Terms Send samples on CD (JPEG files) or color photocopies with SASE. Fine artists should send short bio. "Terms are 50/50 with no expenses to artist as long as artist can provide high-res scans if we agree on representation. Our agency specializes in aiming to create a full licensing program so we can license art across a varied product range. We are therefore only interested in collections, or groups of artworks or concepts that have commercial appeal."

Tips "Artists need to consider actual products when creating new art. Look at products in retail outlets and get a feel for what is selling well. Get to know the markets you are trying to sell your work to."

ART SOURCE L.A., INC.

2801 Ocean Park Blvd., # 7, Santa Monica CA 90405. (310)452-4411. Fax: (310)452-0300. E-mail: info@artsourcela.com. Web site: www.artsourcela.com. **Artist Liason:** Patty Levert. Fine art representative and consultant. Estab. 1984. Represents artists in all media in fine art and accessories. Specializes in fine art consulting and curating worldwide. Markets include architects, corporate collections, developers, hospitality, health care, public space, interior designers, private collections and government projects. Submission guidelines available on Web site.

- See additional listing in the Galleries section.

Handles Fine art in all media, including works on paper/canvas, giclées, photography, sculpture, and other accessories handmade by American artists. Genres include figurative, florals, landscapes and many others.

Terms Agent receives commission; amount varies (generally 50%). Exclusive area representation required in some cases. No geographic restrictions. Advertises in *Art in America*, *Gallery Guide*, *Art Diary*, *Art & Auction*, *Guild*.

How to Contact "Send minimum of 20 slides or photographs (laser copies are not acceptable) clearly labeled with your name, title and date of work, size and medium. Catalogs and brochures of your work are welcome. Also include a résumé, price list and SASE. We will not respond without a return envelope." Also accepts e-mail submissions. Responds in 6-8 weeks. Obtains new talent through recommendations, submissions and exhibitions. Finds artists through art fairs/exhibitions, submissions, referrals by other artists, portfolio reviews and word of mouth.

Tips "Be professional when submitting visuals. Remember—first impressions can be critical! Submit a body of work that is consistent and of the highest quality. Work should be in excellent condition and already photographed for your records. Framing does not enhance the presentation to the client."

N ARTISAN CREATIVE, INC.

1950 S. Sawtelle Blvd., Suite 320, Los Angeles CA 90025. (310)312-2062. Fax: (310)312-0670. E-mail: info@artisancreative.com. Web site: www.artisancreative.com. **Creative Contact:** Jamie Grossman. Estab. 1996. Represents creative directors, art directors, graphic designers, illustrators, animators (3D and 2D), storyboarders, packaging designers, photographers, Web designers, broadcast designers and flash developers. Markets include advertising agencies, corporations/client direct, design firms, entertainment industry.

- Artisan Creative has another location at 850 Montgomery St., C-50, San Francisco CA 94133. (415)362-2699. **Contact:** Wayne Brown.

Handles Web design, multimedia, illustration, photography and production. Looking for Web, packaging, traditional and multimedia-based graphic designers.

Terms 100% of advertising costs paid by the representative. For promotional purposes, talent must provide PDFs of work. Advertises in magazines for the trade, direct mail and the Internet.

How to Contact For first contact, e-mail résumé to Creative Staffing Department. "You will then be contacted if a portfolio review is needed." Portfolio should include roughs, tearsheets, photographs, or color photos of your best work.

Tips "Have at least two years' working experience and a great portfolio."

N ARTREPS

22287 Mulholland Hwy., Suite 133, Calabasas CA 91302-5157. (818)888-0825 or (800)959-6040. E-mail: info@artrepsart.com. Web site: www.artrepsart.com. **Art Director:** Phoebe Batoni. Fine

art representative, art consultant, publisher. Estab. 1993. Represents fine artists. Specializes in working with royalty publishers for posters, open editions, limited edition giclées; and galleries, interior designers and licensing agents. Markets include art publishers, corporate collections, galleries, interior decorators. Represents Barbara Cleary, Lili Maglione, Peter Colvine, Ann Christensen, Peter Wilkinson and Ron Peters.

● This agency attends Artexpo and DECOR Expo to promote its clients.

Handles Fine art: works on paper, canvas and mixed media; no sculpture.

Terms Negotiated on an individual basis. For promotional purposes, talent must provide "adequate materials."

How to Contact Send query letter with résumé, bio, direct mail flier/brochure, tearsheets, slides, photographs, photocopies or photostats and SASE (for return of materials). Will look at CD or Web site but prefers to review artwork in a tangible form. Responds in 2 weeks.

Tips "We're interested in fine art with universal mainstream appeal. Check out the kind of art that's selling at your local frame shop and fine art galleries or at retailers like Pier One Imports and Bed Bath & Beyond. Presentation counts, so make sure your submission looks professional."

ARTVISIONS℠

Bellevue WA. Web site: www.artvisions.com. Estab. 1993. Licenses fine art and professional photography.

Handles Fine art and professional photography licensing only.

Terms Royalties are split 50/50. Exclusive worldwide representation for licensing is required (the artist is free to market original art). Written contract provided.

How to Contact Review guidelines on Web site. "Not currently seeking new talent. However, we are always willing to view the work of top-notch established artists. If you fit this category, please contact ArtVisions via e-mail (from our Web site) and include a link to a Web site where your art can be seen. Or, you may include a few small samples attached to your e-mail as JPEG files."

Tips "To gain an idea of the type of art we license, please view our Web site. Artist MUST be able to provide either 4×5 transparencies or high-resolution, professionally made scans of artwork on CD."

ARTWORKS ILLUSTRATION

325 W. 38th St., New York NY 10018. (212)239-4946. Fax: (212)239-6106. E-mail: artworksillustra tion@earthlink.net. Web site: www.artworksillustration.com. **Owner:** Betty Krichman. Commercial illustration representative. Estab. 1990. Member of Society of Illustrators. Represents 30 illustrators. Specializes in publishing. Markets include advertising agencies, design firms, paper products/greeting cards, movie studios, publishing/books, sales/promotion firms, corporations/client direct, editorial/magazines, video games. Artists include Dan Brown, Dennis Lyall, Jerry Vanderstelt.

Handles Illustration. Looking for interesting juvenile images.

Terms Rep receives 30% commission. Exclusive area representation required. Advertising costs are split: 75% paid by artist; 25% paid by rep. Advertises in *American Showcase* and on theispot.c om.

How to Contact For first contact, send e-mail samples. Responds only if interested.

ASCIUTTO ART REPS., INC.

1712 E. Butler Circle, Chandler AZ 85225. (480)899-0600. Fax: (480)899-3636. E-mail: aartreps@c ox.net. **Contact:** Mary Anne Asciutto. Children's illustration representative. Estab. 1980. Specializes in children's illustration for books, magazines, posters, packaging, etc. Markets include publishing/packaging/advertising.

Handles Illustration only.

Terms Rep receives 25% commission. Advertising costs are split: 75% paid by talent; 25% paid by representative. For promotional purposes, talent should provide color prints or originals in an 8×11 size format.

How to Contact Send direct mail flier/brochure, tearsheets, photocopies and SASE. Responds in 2 weeks. After initial contact, send appropriate materials if requested. Portfolio should include original art on paper, tearsheets, photocopies or color prints of most recent work. If accepted, materials will be kept for scanning.

Tips "Be sure to connect with an agent who handles the kind of accounts you *want*."

CAROL BANCROFT & FRIENDS
P.O. Box 2030, Danbury CT 06813. (203)730-8270. Fax: (203)730-8275. E-mail: artists@carolbanc roft.com. Web site: www.carolbancroft.com. **Owner:** Joy Elton Tricarico. Founder: Carol Bancroft. Illustration representative for children's publishing. Estab. 1972. Member of Society of Illustrators, Graphic Artists Guild, SCBWI and National Art Education Association. Represents over 40 illustrators. Specializes in, but not limited to, representing artists who illustrate for children's publishing—text, trade and any children's-related material. Clients include Scholastic, Harcourt, HarperCollins, Random House, Penguin USA, Simon & Schuster. Artist list available upon request.

© Meryl Henderson. Reprinted with permission from Boyds Mills Press, Inc.

Children's book illustrator Meryl Henderson is represented by Asciutto Art Reps, Inc. Her realistic paintings are well suited to the types of books she works on, particularly historical biographies. No doubt her lifelike depictions of penguins will capture the attention of many young readers who adore the flightless birds.

Handles Illustration for children of all ages.

Terms Rep receives 25-30% commission. Advertising costs are split: 75% paid by talent; 25% paid by representative. For promotional purposes, artist should provide "Web address in an e-mail or samples via mail (laser copies, not slides; tearsheets, promo pieces, books, good color photocopies, etc.); 6 pieces or more; narrative scenes with children and/or animals interacting." Advertises in *RSVP, Picture Book, Directory of Illustration*.

How to Contact Send samples and SASE. "Artists may call no sooner than one month after sending samples."

Tips "We look for artists who can draw animals and people with imagination and energy, depicting engaging characters with action in situational settings."

BERENDSEN & ASSOCIATES, INC.

3940 Olympic Blvd., Suite 100, Erlanger KY 41018. (513)861-1400. Fax: (859)980-0820. E-mail: bob@illustratorsrep.com. Web site: www.illustratorsrep.com; www.photographersrep.com; www.designersrep.com; www.stockartrep.com. **Owner:** Bob Berendsen. Commercial illustration, photography, design representative. Incorporated 1986. Represents 70 illustrators, 15 photographers. Specializes in "high-visibility consumer accounts." Markets include advertising agencies, corporations/client direct, design firms, editorial/magazines, paper products/greeting cards, publishing/books, sales/promotion firms. Clients include Disney, CNN, Pentagram, F+W Publications. Additional client list available upon request. Represents Bill Fox, Kevin Torline, Judy Hand, Frank Ordaz, Wendy Ackison, Jack Pennington, Ursula Roma, John Sledd, Richard Cowdrey, Corey Wolfe, John Margeson, Paul Lopez and Tony Randazzo.

Handles Illustration, photography and Web design. "We are always looking for illustrators who can draw people, product and action well. Also, we look for styles that are metaphoric in content, and it's a plus if the stock rights are available."

Terms Rep receives 30% commission. Charges "mostly for postage, but figures not available." No geographic restrictions. Advertising costs are split: 70% paid by talent; 30% paid by rep. For promotional purposes, "artist can co-op in our direct mail promotions, and sourcebooks are recommended. Portfolios are updated regularly." Advertises in *RSVP, Creative Illustration Book, Directory of Illustration* and *American Showcase*.

How to Contact For first contact, send an e-mail with no more than 6 JPEGs attached; or send query letter and any nonreturnable tearsheets, slides, photographs or photocopies.

Tips Artists should have "a proven style" with at least 10 samples of that style.

BERNSTEIN & ANDRIULLI

58 W. 40th St., New York NY 10018. (212)682-1490. Fax: (212)286-1890. E-mail: artinfo@ba-reps.com. Web site: www.ba-reps.com. **Contact:** Louisa St. Pierre. Commercial illustration and photography representative. Estab. 1975. Member of SPAR. Represents 54 illustrators, 16 photographers. Markets include advertising agencies, corporations/client direct, design firms, editorial/magazines, paper products/greeting cards, publishing/books, sales/promotion firms.

Handles Illustration and photography.

Terms Rep receives a commission. Exclusive career representation is required. No geographic restrictions. Advertises in *American Showcase, The Black Book, Workbook, New York Gold, Bernstein & Andriulli International Illustration, CA Magazine, Archive*.

How to Contact Send query letter or e-mail with Web site or digital files. Call to schedule an appointment before dropping off portfolio.

JOANIE BERNSTEIN, ART REP

756-8 Aves, Naples FL 34102. (239)403-4393. Fax: (239)403-0066. E-mail: joanie@joaniebrep.com. Web site: www.joaniebrep.com. **Contact:** Joanie. Commercial illustration representative. Estab. 1984.

Handles Illustration. Looking for an unusual, problem-solving style. Clients include advertising, design, books, music, product merchandising, developers, movie studios, films, private collectors.

Terms Rep receives 25% commission. Exclusive representation required.

How to Contact E-mail samples.

Tips "Web sites are a necessity."

▣ BOOKMAKERS LTD.

P.O. Box 1086, Taos NM 87571. (505)776-5435. Fax: (505)776-2762. E-mail: gayle@bookmakersltd.com. Web site: www.bookmakersltd.com. **President:** Gayle McNeil. Estab. 1975. "We represent professional, experienced children's book illustrators. We welcome authors who are interested in self-publishing."

> • See additional listing in the Advertising, Design & Related Markets section.

BROWN INK ASSOCIATES

222 E. Brinkerhoff Ave., Palisades Park NJ 07650. (201)313-6081. Fax: (201)461-6571. E-mail: robert229artist@juno.com@juno.com. Web site: www.browninkonline.com. **President/Owner:** Bob Brown. Digital fine art publisher and distributor. Estab. 1979. Represents 5 fine artists, 2 illustrators. Specializes in advertising, magazine editorials and book publishing, fine art. Markets include advertising agencies, corporations/client direct, design firms, editorial/magazines, galleries, movie studios, paper products/greeting cards, publishing/books, record companies, sales/promotion firms.

Handles Fine art, illustration, digital fine art, digital fine art printing, licensing material. Looking for professional artists who are interested in making a living with their art. Art samples and portfolio required.

Terms Rep receives 25% commission on illustration assignment; 50% on publishing (digital publishing) after expenses. "The only fee we charge is for services rendered (scanning, proofing, printing, etc.). We pay for postage, labels and envelopes." Exclusive area representation required (only in the NY, NJ, CT region of the country). Advertising costs are paid by artist or split: 75% paid by artist; 25% paid by rep. Artists must pay for their own promotional material. For promotional purposes, talent must provide a full-color direct mail piece, an 11×14 flexible portfolio, digital files and CD. Advertises in *Workbook*.

How to Contact For first contact, send bio, direct mail flier/brochure, photocopies, photographs, résumé, SASE, tearsheets, slides, digital images/CD, query letter (optional). Responds only if interested. After initial contact, call to schedule an appointment, drop off or mail portfolio, or e-mail. Portfolio should include b&w and color finished art, original art, photographs, slides, tearsheets, transparencies (35mm, 4×5 and 8×10).

Tips "Be as professional as possible! Your presentation is paramount. The competition is fierce, therefore your presentation (portfolio) and art samples need to match or exceed that of the competition."

WOODY COLEMAN PRESENTS, INC.

490 Rockside Rd., Cleveland OH 44131. (216)661-4222. Fax: (216)661-2879. E-mail: woody@portsort.com. Web site: www.portsort.com. **CEO:** Laura Ray. Estab. 1978. Member of Graphic Artists Guild. Specializes in illustration. Markets include advertising agencies, corporations/client direct, design firms, editorial/magazines, paper products/greeting cards, publishing/books, sales/promotion firms, public relations firms. Provides referral to legal reference resources and materials.

Handles Illustration.

Terms Negotiates and invoices projects and receives 25% commission.

How to Contact Write, e-mail or call.

◪ CONTACT JUPITER

5 Laurier St., St. Eustache QC J7R 2E5 Canada. Phone/fax: (450)491-3883. E-mail: info@contactju piter.com. Web site: www.contactjupiter.com. **President:** Oliver Mielenz. Commercial illustration representative. Estab. 1996. Represents 12 illustrators, 6 photographers. Specializes in publishing, children's books, magazines, advertising. Licenses illustrators, photographers. Markets include advertising agencies, paper products/greeting cards, record companies, publishing/ books, corporations/client direct, editorial/magazines.

Handles Illustration, multimedia, music, photography, design.

Terms Rep receives 15-25% and rep fee. Advertising costs are split: 50% paid by artist; 50% paid by rep. Exclusive representation required. For promotional purposes, talent must provide portfolio pieces (8×10) and electronic art samples. Advertises in *Directory of Illustration*.

How to Contact Send query by e-mail with a few JPEG samples. Responds only if interested. After initial contact, e-mail to set up an interview or portfolio review. Portfolio should include b&w and color tearsheets.

Tips "One specific style is easier to sell. Focus, focus, focus. Initiative, I find, is very important in an artist."

CORNELL & McCARTHY, LLC

2-D Cross Hwy., Westport CT 06880. (203)454-4210. Fax: (203)454-4258. E-mail: contact@cmartr eps.com. Web site: www.cmartreps.com. **Contact:** Merial Cornell. Children's book illustration representative. Estab. 1989. Member of SCBWI and Graphic Artists Guild. Represents 30 illustrators. Specializes in children's books—trade, mass market, educational.

Handles Illustration.

Terms Agent receives 25% commission. Advertising costs are split: 75% paid by talent; 25% paid by representative. For promotional purposes, talent must provide 10-12 strong portfolio pieces relating to children's publishing.

How to Contact For first contact, send query letter, direct mail flier/brochure, tearsheets, photocopies and SASE. Responds in 1 month. Obtains new talent through recommendations, solicitation, conferences.

Tips "Work hard on your portfolio."

CWC INTERNATIONAL, INC.

611 Broadway, Suite 730, New York NY 10012-2649. (646)486-6586. Fax: (646)486-7622. E-mail: agent@cwc-i.com. Web site: www.cwc-i.com. **VP/Executive Creative Agent:** Koko Nakano. Estab. 1999. Commercial ilustration representative. Represents 23 illustrators. Specializes in advertising, fashion. Markets include advertising agencies, corporations/client direct, design firms, editorial/magazines, galleries, paper products/greeting cards, publishing/books, record companies. Artists include Jeffrey Fulvimari, Stina Persson, Chris Long and Kenzo Minami.

Handles Fine art, illustration.

Terms Exclusive area representation required.

How to Contact Send query letter with direct mail flier/brochure, photocopies (3-4 images) and résumé via postal mail or e-mail. Please put "rep query" as the subject of the e-mail. Responds only if interested.

Tips "Please do not call. When sending any image samples by e-mail, be sure the entire file will not exceed 300K."

LINDA DE MORETA REPRESENTS

1511 Union St., Alameda CA 94501. (510)769-1421. Fax: (510)892-2955. E-mail: linda@lindareps. com. Web site: www.lindareps.com. **Contact:** Linda de Moreta. Commercial illustration, handlettering and photography representative. Estab. 1988. Represents 10 illustrators, 2 photographers.

Markets include advertising agencies; design firms; corporations/client direct; editorial/magazines; paper products/greeting cards; publishing/books. Represents Chuck Pyle, Tina Healey, Monica Dengo, John Howell, Mike Newman, Shannon Abbey and Shannon O'Neill.

Handles Photography, illustration, lettering/title design, storyboards/comps.

Terms Commission, exclusive representation requirements and advertising costs are according to individual agreements. Materials for promotional purposes vary with each artist. Advertises in *Workbook*, *Directory of Illustration*, and on www.theispot.com.

How to Contact For first contact, e-mail samples or link to Web site; or send direct mail flier/brochure. "Please do *not* send original art. Include SASE for any items you wish returned." Responds to any inquiry in which there is an interest. Portfolios are individually developed for each artist.

Tips Obtains new talent through client and artist referrals primarily, some solicitation. "I look for great creativity, a personal vision and style combined with professionalism, and passion."

THE DESKTOP GROUP

420 Lexington Ave., Suite 2100, New York NY 10170. (212)916-0824. Fax: (212)867-1759. E-mail: jobs@thedesktopgroup.com. Web site: www.thedesktopgroup.com. Estab. 1991. Specializes in recruiting and placing creative talent on a freelance basis. Markets include advertising agencies, design firms, publishers (book and magazine), corporations, and banking/financial firms.

Handles Artists with Macintosh (and Windows) software and multimedia expertise—graphic designers, production artists, pre-press technicians, presentation specialists, traffickers, art directors, Web designers, content developers, project managers, copywriters, and proofreaders.

How to Contact For first contact, e-mail résumé, cover letter and work samples.

Tips "Our clients prefer working with talented artists who have flexible, easy-going personalities and who are very professional."

ROBERT GALITZ FINE ART & ACCENT ART

166 Hilltop Court, Sleepy Hollow IL 60118. (847)426-8842. Fax: (847)426-8846. E-mail: robert @galitzfineart.com. Web site: www.galitzfineart.com. **Owner:** Robert Galitz. Fine art representative. Estab. 1985. Represents 100 fine artists (including 2 sculptors). Specializes in contemporary/abstract corporate art. Markets include architects, corporate collections, galleries, interior decorators, private collections. Represents Roland Poska, Jan Pozzi, Diane Bartz and Louis De Mayo.

● See additional listings in the Galleries and Posters & Prints sections.

Handles Fine art.

Terms Agent receives 25-40% commission. No geographic restrictions; sells mainly in Chicago, Illinois, Wisconsin, Indiana and Kentucky. For promotional purposes, talent must provide "good photos and slides." Advertises in monthly art publications and guides.

How to Contact Send query letter, slides, photographs. Responds in 2 weeks. After initial contact, call for appointment to show portfolio of original art. Obtains new talent through recommendations from others, solicitation, conferences.

Tips "Be confident and persistent. Never give up or quit."

ANITA GRIEN REPRESENTING ARTISTS

155 E. 38th St., New York NY 10016. E-mail: anita@anitagrien.com. Web site: www.anitagrien .com. Representative not currently seeking new talent.

CAROL GUENZI AGENTS, INC.

DBA ArtAgent.com, 865 Delaware St., Denver CO 80204. (303)820-2599. E-mail: art@artagent.c om. Web site: www.artagent.com. **President:** Carol Guenzi. Commercial illustration, photogra-

phy, new media and film/animation representative. Estab. 1984. Represents 25 illustrators, 6 photographers, 4 film/animation developers, and 3 multimedia developers. Specializes in a "worldwide selection of talent in all areas of visual communications." Markets include advertising agencies, corporations/client direct, design firms, editorial/magazines, paper products/greeting cards, sales/promotions firms. Clients include Integer, BBDO, DDB Needham, TLP. Partial client list available upon request. Represents Christer Eriksson, Juan Alvarez, Michael Fisher, Kelly Hume, Capstone Studios and more.

Handles Illustration, photography. Looking for "unique style application."

Terms Rep receives 25-30% commission. Exclusive area representation is required. Advertising costs are split: 70-75% paid by talent; 25-30% paid by rep. For promotional purposes, talent must provide "promotional material; some restrictions on portfolios." Advertises in *The Black Book*, *Directory of Illustration, Workbook*.

How to Contact For first contact; e-mail PDFs or JPEGs with link to URL, or send direct mail flier/brochure. Responds only if interested. E-mail or call for appointment to drop off or mail in appropriate materials for review, depending on artist's location. Portfolio should include tearsheets, CD/DVD, photographs. Obtains new talent through solicitation, art directors' referrals, and active pursuit by individual artists.

Tips "Show your strongest style and have at least 12 samples of that style before introducing all your capabilities. Be prepared to add additional work to your portfolio to help round out your style. Have a digital background."

GUIDED IMAGERY DESIGN & PRODUCTIONS

2995 Woodside Rd., Suite 400, Woodside CA 94062. (650)324-0323. Fax: (650)324-9962. Web site: www.guided-imagery.com. **Owner/Director:** Linda Hoffman. Fine art representative. Estab. 1978. Member of Hospitality Industry Association. Represents 3 illustrators, 12 fine artists. Specializes in large art production; perspective murals (trompe l'oiel); unusual painted furniture/screens. Markets include design firms; interior decorators; hospitality industry.

Handles Looking for "mural artists (realistic or trompe l'oiel) with good understanding of perspectives."

Terms Rep receives 33-50% commission. 100% of advertising costs paid by representative. For promotional purposes, talent must provide a direct mail piece to preview work, along with color copies of work, and SASE. Advertises in *Hospitality Design*, *Traditional Building Magazine* and *Design Journal*.

How to Contact For first contact, send query letter, résumé, photographs, photocopies and SASE. Responds in 1 month. After initial contact, mail appropriate materials. Portfolio should include photographs.

Tips Wants artists with talent, references and follow-through. "Send color copies of original work that show your artistic style. Never send one-of-a-kind artwork. My focus is 3D murals. References from previous clients very helpful. Please, no cold calls."

PAT HACKETT, ARTIST REPRESENTATIVE

7014 N. Mercer Way, Mercer Island WA 98040. (206)447-1600. Fax: (206)447-0739. E-mail: pat@pathackett.com. Web site: www.pathackett.com. **Contact:** Pat Hackett. Commercial illustration and photography representative. Estab. 1979. Represents 12 illustrators, 1 photographer. Markets include advertising agencies; corporations/client direct; design firms; editorial/magazines.

Handles Illustration and photography.

Terms Rep receives 25-33% commission. Advertising costs are split: 75% paid by talent; 25% paid by representative. For promotional purposes, talent must provide "standardized portfolio, i.e., all pieces within the book are the same format. Reprints are nice, but not absolutely required." Advertises in *Showcase, Workbook*, and on theispot.com and portfolios.com.

How to Contact For first contact, send direct mail flier/brochure. Responds in 1 week, only if interested. After initial contact, drop off or mail in appropriate materials—tearsheets, slides, photographs, photostats, photocopies. Obtains new talent through "recommendations and calls/letters."

Tips Looks for "experience in the *commercial* art world, professional presentation in both portfolio and person, cooperative attitude and enthusiasm."

HOLLY HAHN & CO.

837 W. Grand Ave., Chicago IL 60622. (312)633-0500. Fax: (312)633-0484. E-mail: holly@hollyhahn.com. Web site: www.hollyhahn.com. Commercial illustration and photography representative. Estab. 1988.

Handles Illustration, photography.

How to Contact Send direct mail flier/brochure and tearsheets.

HANKINS & TEGENBORG, LTD.

501 Fifth Ave., Suite 1708, New York NY 10017. (212)755-6070. Fax: (212)755-6075. E-mail: dhlt@aol.com. Web site: www.htWeb site.com. Commercial illustration representative. Estab. 1980. Represents 35 illustrators. Specializes in realistic and digital illustration. Markets include advertising agencies; publishing/book covers/promotion.

Handles Illustration, computer illustration.

Terms Rep receives 25% commission. "All additional fees are charged per job if applicable." Exclusive area representation is required. Advertising costs are split: 75% paid by talent; 25% paid by representative. For promotional purposes, talent must provide digital files. Advertises on Web site.

How to Handle For first contact, e-mail with JPEGs attached or with Web site address to facilitate viewing work. Responds if interested.

BARB HAUSER, ANOTHER GIRL REP

P.O. Box 421443, San Francisco CA 94142-1443. (415)647-5660. E-mail: barb@girlrep.com. Web site: www.girlrep.com. Estab. 1980. Represents 8 illustrators. Markets include primarily advertising agencies and design firms; corporations/client direct.

Handles Illustration.

Terms Rep receives 25-30% commission. Exclusive representation in the San Francisco area is required.

How to Contact For first contact, "please e-mail. If you wish to send samples, please send no more than three very small JPEGs, but please note, I am not presently accepting new talent."

JOANNE HEDGE/ARTIST REPRESENTATIVE

1415 Garden St., Glendale CA 91201. (818)244-0110. Fax: (818)244-0136. E-mail: hedgegraphics @earthlink.com. Web site: www.hedgereps.com. **Contact:** J. Hedge. Commercial illustration representative. Estab. 1975. Represents 12 illustrators. Specializes in quality, painterly and realistic illustration, digital art and lettering; also vintage and period styles. Markets include packaging, especially food and beverage, advertising agencies, design firms, movie studios, package design firms and Web/interactive clients.

Handles Illustration. Seeks established artists compatible with Hedge Graphics Group.

Terms Rep receives 30% commission. Handles all negotiations and billing. Artist pays quarterly portfolio maintenance expenses. Advertising costs are split: 75% paid by talent; 25% paid by representative. For promotional purposes, talent should provide reprint flyer, CD, 4×5 or 8×10 copy transparencies, matted on 11×14 laminate mattes. Advertises in *Workbook*, *Directory of Illustration* and Web site.

How to Contact E-mail with samples attached or Web site address to view your work. Responds if interested.

Tips Obtains new talent after talent sees *Workbook* directory ad, or through referrals from art directors or other talent. "Have as much experience as possible and zero or one other rep. That, and a good-looking 8½×11 flier!"

Ⓝ HERMAN AGENCY

350 Central Park West, New York NY 10025. (212)749-4907. Fax: (212)663-5151. E-mail: hermana gen@aol.com. Web site: www.HermanAgencyInc.com. **Owner/President:** Ronnie Ann Herman. Commercial illustration representative. Estab. 1999. Member of SCBWI. Represents 33 illustrators, 3 photographers. Specializes in children's market. Artists include Seymour Chwast, Alexi Natchev, Joy Allen.

Handles Illustration. Looking for artists with strong history of publishing in the children's market.

Terms Rep receives 25% commission. Exclusive representation required. Advertising costs are split: 75% paid by the artist; 25% paid by rep. Advertises in direct mailing.

How to Contact For first contact, send bio, photocopies, SASE, tearsheets, list of published books. Responds in 4 weeks. Portfolio should include b&w and color tearsheets, copies of published books.

Tips "Check our Web site to see if you belong with our agency."

HK PORTFOLIO

10 E. 29th St., Suite 40G, New York NY 10016. (212)689-7830. Fax: (212)689-7829. E-mail: mela@h kportfolio.com. Web site: www.hkportfolio.com. **Contact:** Mela Bolinao. Commercial illustration representative. Estab. 1986. Member of SPAR, Society of Illustrators and Graphic Artists Guild. Represents 44 illustrators. Specializes in illustration for juvenile markets. Markets include advertising agencies; editorial/magazines; publishing/books.

Handles Illustration.

Terms Rep receives 25% commission. No geographic restrictions. Advertising costs are split: 75% paid by talent; 25% paid by representative. Advertises in *Picture Book*, *Directory of Illustration* and *Workbook*.

How to Contact E-mail query letter with Web site address or send portfolio with flier/brochure, tearsheets, published books if available, and SASE. Responds in 1 week. Portfolio should include at least 10-15 images exhibiting a consistent style.

Tips Leans toward "highly individual personal styles."

SCOTT HULL ASSOCIATES

4 West Franklin St., Suite 200, Dayton OH 45459. (937)433-8383. Fax: (937)433-0434. E-mail: scott@scotthull.com. Web site: www.scotthull.com. **Contact:** Scott Hull. Specialized illustration representative. Estab. 1981. Represents 25+ illustrators.

How to Contact Send e-mail samples or appropriate materials for review. No original art. Follow up with e-mail. Responds in one week.

Tips Looks for interesting talent with a passion to grow, as well as strong in-depth portfolio.

Ⓝ ICON ART REPS (A Division of Martha Productions)

7550 W. 82nd St., Playa Del Rey CA 90293. (310)670-5300. Fax: (310)670-3644. E-mail: contact@ marthaproductions.com. Web site: www.iconartreps.com. **President:** Martha Spelman. Commercial illustration representative. Estab. 1998. Represents 14 illustrators. Specializes in artists doing character design and development for advertising, promotion, publishing and licensed products.

- See listing for Martha Productions in this section.

THE INTERMARKETING GROUP

29 Holt Rd., Amherst NH 03031. (603)672-0499. **President:** Linda Gerson. Art licensing agency. Estab. 1985. Represents 8 illustrators. Licenses fine artists, illustrators. Markets include paper products/greeting cards, publishing/books, all consumer product applications of art. Artists include Tracy Flickinger, Marilee Carroll, Kate Beetle, Janet Amendola, Cheryl Welch, Loren Guttormson, Natalie Buriak and Doug Henry.

• See additional listing in the Greeting Cards, Gifts & Products section.

Handles Fine art, illustration.

Terms Will discuss terms of representation directly with the artists of interest. Advertising costs are paid by the artist. For promotional purposes, talent must provide color copies, biography.

How to Contact For first contact, send query letter with bio, direct mail flier/brochure, photocopies, SASE, tearsheets, "a good representation of your work in color." Responds in 3 weeks. Will contact artist for portfolio review if interested. Portfolio should include color tearsheets.

Tips "Present your work in an organized way. Send the kind of work you enjoy doing and that is the most representative of your style."

ⓝ VINCENT KAMIN & ASSOCIATES

Chicago IL 60610. (312)787-8834. Web site: www.vincekamin.com. Commercial photography, graphic design representative. Estab. 1971. Member of SPAR. Represents 6 illustrators, 6 photographers, 1 designer, 1 fine artist (includes 1 sculptor). Markets include advertising agencies.

Handles Illustration, photography.

Terms Rep receives 30% commission. Advertising costs are split: 90% paid by talent; 10% paid by representative. Advertises in *Workbook* and *Chicago Directory*.

How to Contact Send tearsheets. Responds in 10 days. After initial contact, call to schedule an appointment. Portfolio should include tearsheets.

ⓝ KIRCHOFF/WOHLBERG, ARTISTS REPRESENTATION DIVISION

866 United Nations Plaza, #525, New York NY 10017. (212)644-2020. Fax: (212)223-4387. Web site: www.kirchoffwohlberg-artistrep.com. **Contact:** Libby Ford. Estab. 1930. Member of SPAR, Society of Illustrators, AIGA, Associaton of American Publishers, Bookbuilders of Boston, New York Bookbinders' Guild. Represents over 50 illustrators. Specializes in juvenile and young adult trade books and textbooks. Markets include publishing/books.

Handles Illustration (juvenile and young adult).

Terms Rep receives 25% commission. Advertises in *American Showcase*, *Art Directors' Index*, *Society of Illustrators Annual*, *The Black Book*, children's book issues of *Publishers Weekly*.

How to Contact Please send all correspondence to lford@kirchoffwohlberg.com. "We will contact you for additional materials. Portfolios should include whatever you feel best represents your work."

CLIFF KNECHT—ARTIST REPRESENTATIVE

309 Walnut Rd., Pittsburgh PA 15202. (412)761-5666. Fax: (412)761-4072. E-mail: mail@artrep1.com. Web site: www.artrep1.com. **Contact:** Cliff Knecht. Commercial illustration representative. Estab. 1972. Represents more than 20 illustrators. Markets include advertising agencies, corporations/client direct, design firms, editorial/magazines, paper products/greeting cards, publishing/books, sales/promotion firms.

Handles Illustration.

Terms Rep receives 25% commission. No geographic restrictions. Advertising costs are split: 75% paid by the talent; 25% paid by representative. For promotional purposes, talent must provide a direct mail piece. Advertises in *Graphic Artists Guild Directory of Illustration*.

How to Contact Send résumé, direct mail flier/brochure, tearsheets, slides. Responds in 1 week.

After initial contact, call for appointment to show portfolio of original art, tearsheets, slides, photographs. Obtains new talent directly or through recommendations from others.

ANN KOEFFLER ARTIST REPRESENTATION

4636 Cahuenga Blvd. Suite #204, Toluca Lake CA 91602. (818)260-8980. Fax: (818)260-8990. E-mail: annartrep@aol.com. Web site: www.annkoeffler.com. **Owner/Operator:** Ann Koeffler. Commercial illustration representative. Estab. 1984. Represents 20 illustrators. Markets include advertising agencies, corporations/client direct, design firms, editorial/magazines, paper products/greeting cards, publishing/books, individual small business owners.

Will Handle Interested in reviewing illustration. Looking for artists who are digitally adept.

Terms Rep receives 25-30% commission. Advertising costs 100% paid by talent. For promotional purposes, talent must provide an initial supply of promotional pieces and a committment to advertise regularly. Advertises in *Workbook* and *Folio Planet*.

How to Contact For first contact, send tearsheets or send images digitally. Responds in 1 week. Portfolio should include photocopies, 4×5 chromes.

Tips "I only carry artists who are able to communicate clearly and in an upbeat and professional manner."

▨ SHARON KURLANSKY ASSOCIATES

192 Southville Rd., Southborough MA 01772. (508)460-0037. Fax: (508)480-9221. E-mail: lstock @charter.net. Web site: www.laughing-stock.com. **Contact:** Sharon Kurlansky. Commercial illustration representative. Estab. 1978. Represents illustrators. Markets include advertising agencies; corporations/client direct; design firms; editorial/magazines; paper products/greeting cards; publishing/books; sales/promotion firms. Client list available upon request. Represents Tim Lewis, Bruce Hutchison and Blair Thornley. Licenses stock illustration for 150 illustrators at www.laughing-stock.com in all markets.

Handles Illustration.

Terms Rep receives 25% commission. Exclusive area representation is required. Advertising costs are split: 75% paid by talent; 25% paid by representative. "Will develop promotional materials with talent. Portfolio presentation formated and developed with talent also."

How to Contact For first contact, send direct mail flier/brochure, tearsheets, slides and SASE or e-mail with Web site address/online portfolio. Responds in 1 month if interested. After initial contact, call for appointment to show portfolio of tearsheets, photocopies.

LANGLEY CREATIVE

333 N. Michigan Ave., Suite 1322, Chicago IL 60601. (312)782-0244. Fax: (312)782-1535. E-mail: s.langley@langleycreative.com or j.blasco@langleycreative.com. Web site: www.langleycreative .com. **Contact:** Sharon Langley or Jean Blasco. Commercial illustration representative. Estab. 1988. Represents 43 internationally acclaimed illustrators. Markets include advertising agencies; corporations; design firms; editorial/magazines; publishing/books; promotion. Clients include "every major player in the United States."

Handles Illustration. "We are receptive to reviewing samples by enthusiastic up-and-coming artists. E-mail samples and/or your Web site address."

Terms Rep receives 25% commission. Exclusive area representation is preferred. Advertising costs are split: 75% paid by talent; 25% paid by representative. For promotional purposes, talent must provide printed promotional pieces and a well organized, creative portfolio. "If your book is not ready to show, be willing to invest in a 'zippy' new one." Advertises in *Workbook*.

How to Contact For first contact, send samples via e-mail, or printed materials that do not have to be returned. Responds only if interested. Obtains new talent through recommendations from art directors, referrals and submissions.

© 2008 Tammy Shane

Illustrator Tammy Shane, represented by Langley Creative, painted "Ruffled Feathers" as a personal piece to be used on her promotional postcards. The whimsical image is an ideal representation of her style. Shane advises artists to send out a mailer every three to four months to the same companies. "It takes time for them to remember you," she says. "The more they see your work, the better chance of you getting a job from them." See more of Shane's work at www.theispot.com/artist/tshane.

Tips "You need to be focused in your direction and style. Be willing to create new samples. Be a 'team player.' The agent and artist form a bond, and the goal is success. Don't let your ego get in the way. Be open to constructive criticism, and if one agent turns you down, quickly move to the next name on your list."

LESLI ART, INC.

20558 Chatsboro Dr., Woodland Hills CA 91364. (818)999-9228. Fax: (818)999-0833. E-mail: lesliart@adelphia.com. Web site: www.LesliArt.com. **President:** Stan Shevrin. Fine art agent, publisher and advisor. Estab. 1965. Represents emerging, mid-career and established artists. Specializes in artists painting in oil or acrylic, in traditional subject matter in realistic or impressionist style. Also represents illustrators who want to establish themselves in the fine art market. Sells to leading art galleries throughout the U.S. Represents Tom Darro, Greg Harris, Christa

Kieffer, Roger LaManna, Dick Pionk, Rick Peterson and John Stephens. Licenses period costumed figures and landscapes for prints, calendars and greeting cards.

● See additional listing in the Posters & Prints section.

Terms Receives 50% commission. Pays all expenses including advertising and promotion. Artist pays one-way shipping. All artwork accepted unframed. Exclusives preferred. Contract provided.

How to Contact Send color prints or slides with short bio and SASE if material is to be returned. Material will be filed if SASE is not included. Responds in 1 month. Obtains new talent through "reviewing portfolios."

Tips "Artists should show their most current works and state a preference for subject matter and medium. Know what subject you're best at and focus on that."

MAGNET REPS

(310)733-1234. E-mail: art@magnetreps.com. Web site: www.magnetreps.com. **Director:** Paolo Rizzi. Commercial illustration representative. Estab. 1998. Represents 16 illustrators. Markets include advertising agencies, corporations/client direct, design firms, editorial/magazines, movie studios, paper products/greeting cards, publishing/books, record companies, character development. Represents Red Nose Studio and Shawn Barber.

Handles Illustration. "Looking for artists with the passion to illustrate every day, an awareness of cultural trends in the world we live in, and a basic understanding of the business of illustration."

Terms Exclusive representation required. Advertising costs are split. For promotional purposes, talent must provide a well-developed, consistent portfolio. Advertises in *Workbook* and others.

How to Contact Submit a Web link to portfolio, or 2 sample low-res JPEGs for review via e-mail only. Responds in 1 month. "We do not return unsolicited submissions." Will contact artist via e-mail if interested. Portfolio should include color printouts, good quality.

Tips "Be realistic about how your style matches our agency. We do not represent scientific, technical, medical, sci-fi , fantasy, military, hyper-realistic, story boarding, landscape, pin-up, cartoon or cutesy styles. We do not represent graphic designers. We will not represent artists that imitate the style of one of our existing artists."

MARLENA AGENCY

322 Ewing St., Princeton NJ 08540. (609)252-9405. Fax: (609)252-1949. E-mail: marlena@marlen aagency.com. Web site: www.marlenaagency.com. Commercial illustration representative. Estab. 1990. Member of Art Directors Club of New York, Society of Illustrators. Represents 28 illustrators from France, Poland, Germany, Hungary, Italy, Spain, Canada and U.S. "We speak English, French, Spanish, German, Flemish, Polish and Russian." Specializes in conceptual illustration. Markets include advertising agencies, corporations/client direct, design firms, editorial/magazines, publishing/books, theaters.

Handles Illustration, fine art and prints.

Terms Rep receives 30% commission; 35% if translation needed. Costs are shared by all artists. Exclusive area representation is required. Advertising costs are split: 70% paid by talent; 30% paid by representative. For promotional purposes, talent must provide slides (preferably 8×10 framed), direct mail pieces, 3-4 portfolios. Advertises in *American Showcase*, *The Black Book*, *Workbook*, *Alternative Pick*. Many of the artists are regularly featured in *CA* Annuals, The Society of Illustrators Annuals, American Illustration Annuals. Agency produces promotional materials for artists, such as wrapping paper, calendars, brochures.

How to Contact Send tearsheets or e-mail low-resolution images. Responds in 1 week, only if interested. After initial contact, drop off or mail appropriate materials. Portfolio should include tearsheets.

Tips Wants artists with "talent, good concepts—intelligent illustration, promptness in keeping up with projects, deadlines, etc."

MARTHA PRODUCTIONS, INC.

7550 W. 82nd St., Playa Del Rey CA 90293. (310)670-5300. Fax: (310)670-3644. E-mail: contact@ marthaproductions.com. Web site: www.marthaproductions.com. **President:** Martha Spelman. Commercial illustration representative. Estab. 1978. Represents 45 illustrators. Also licenses the work of illustrators. Specializes in illustration in various styles and media. Markets include advertising agencies; corporations/client direct; design firms; developers; editorial/magazines; paper products/greeting cards; publishing/books; record companies; sales/promotion firms.

 • See also listings for Art In Forms, Icon Art Reps and Retro Reps in this section.

Handles Illustration.

Terms Rep receives 30% commission. Advertising costs are split: 70% paid by talent; 30% paid by representative. For promotional purposes, talent must "have existing promotional pieces; also need to be on our Web site." Advertises in *Workbook* and *The Black Book*.

How to Contact For first contact, send query letter, direct mail flier/brochure and SASE. OK to e-mail a few small JPEG files. Responds only if interested. After initial contact, drop off or mail portfolio. Portfolio should include b&w and color tearsheets. Obtains new talent through recommendations and solicitation.

Tips "An artist seeking representation should have a strong portfolio with pieces relevant to advertising, corporate collateral or publishing markets. Check the rep's Web site or ads to see the other talent they represent to determine whether the artist could be an asset to that rep's group or if there may be a conflict. Reps are looking for new artists who already have a portfolio of salable pieces, some existing promos and hopefully some experience."

MASLOV-WEINBERG

608 York St., San Francisco CA 94110. (415)641-1285. Fax: (415)641-5500. E-mail: larryuu@aol.c om. Web site: www.maslov.com. **Contact:** Larry Weinberg. Commercial illustration representative. Estab. 1988. Represents 11 artists. Markets include advertising agencies, corporations/client direct, design firms, editorial/magazines, movie studios, paper products/greeting cards, publishing/books, record companies, sales/promotion firms. Artists include Mark Matcho, Mark Ulriksen, Pamela Hobbs.

Handles Illustration.

Terms Rep receives 25% commission. Exclusive representation required. Advertises in *American Showcase*, *Workbook*.

How to Contact Send query letter with direct mail flier/brochure. Responds only if interested. After initial contact, write to schedule an appointment.

MHS LICENSING

11100 Wayzata Blvd., Suite 550, Minneapolis MN 55305-5517. (952)544-1377. Fax: (952)544-8663. E-mail: artreviewcommittee@mhslicensing.com. Web site: www.mhslicensing.com. **President:** Marty H. Segelbaum. Licensing agency. Estab. 1995. Represents 14 fine artists, 1 photographer, and 12 illustrators or other artists and brands. Markets include paper products/greeting cards, publishing/books and other consumer products including giftware, stationery/paper, tabletop, apparel, home fashions, textiles, etc. Artists include Hautman Brothers, Judy Buswell, Kathy Hatch, Anne Ormsby, Cranston Collection, Darrell Bush, H. Hargrove, Jennifer O'Meara, Julie Ingleman, Luis Fitch, Robin Roderick and Ron King. Brands include Chester, Fred is Red, Karim Rashid, Smirk, Sock Monkey Circle, Speed Freaks and The Girls.

Handles Fine art, illustration, photography and brand concepts.

Terms Negotiable with firm.

How to Contact Send query letter with bio, tearsheets, approximately 10 low-res JPEGs via e-mail. See submission guidelines on Web site. "Keep your submission simple and affordable by leaving all the fancy packaging, wrapping and enclosures in your studio. 8½×11 tearsheets

(inkjet is fine), biography, and SASE are all that we need for review." Responds in 6 weeks. "No phone calls, please." Portfolio should include color tearsheets. Send SASE for return of material.
Tips "Our mutual success is based on providing manufacturers with trend-forward artwork. Please don't duplicate what is already on the market but think instead, 'What are consumers going to want to buy in nine months, one year, or two years?' We want to learn how you envision your artwork being applied to a variety of product types. Artists are encouraged to submit their artwork mocked-up into potential product collections ranging from stationery to tabletop to home fashion (kitchen, bed and bath). Visit your local department store or mass retailer to learn more about the key items in these categories. And, if you have multiple artwork styles, include them with your submission."

MORGAN GAYNIN INC.

194 Third Ave., New York NY 10003. (212)475-0440. Fax: (212)353-8538. E-mail: info@morganga ynin.com. Web site: www.morgangaynin.com. **Partners:** Vicki Morgan and Gail Gaynin. Illustration representatives. Estab. 1974. Markets include advertising agencies; corporations/client direct; design firms; magazines; books; sales/promotion firms.
Handles Illustration.
Terms Rep receives 30% commission. Exclusive area representation is required. No geographic restrictions. Advertising costs are split: 70% paid by talent; 30% paid by representative. Advertises in directories, on the Web, direct mail.
How to Contact Check Web site and click "submissions."

MUNRO CAMPAGNA

630 N. State St., Chicago IL 60610. (312)321-1336. Fax: (312)321-1350. E-mail: steve@munrocam pagna.com. Web site: www.munrocampagna.com. **President:** Steve Munro. Commercial illustration, photography representative. Estab. 1987. Member of SPAR, CAR (Chicago Artists Representatives). Represents 22 illustrators, 2 photographers. Markets include advertising agencies; corporations/client direct; design firms; publishing/books. Represents Pat Dypold and Douglas Klauba.
Handles Illustration.
Terms Rep receives 25-30% commission. Exclusive area representation is required. Advertising costs are split: 75% paid by talent; 25% paid by representative. For promotional purposes, talent must provide 2 portfolios. Advertises in *The Black Book*, *Workbook*.
How to Contact For first contact, send query letter, bio, tearsheets and SASE. Responds in 2 weeks. After initial contact, write to schedule an appointment.

THE NEWBORN GROUP, INC.

115 W. 23rd St., Suite 43A, New York NY 10011. (212)989-4600. Fax: (212)989-8998. Web site: www.newborngroup.com. **Owner:** Joan Sigman. Commercial illustration representative. Estab. 1964. Member of Society of Illustrators; Graphic Artists Guild. Represents 12 illustrators. Markets include advertising agencies, design firms, editorial/magazines, publishing/books. Clients include Leo Burnett, Penguin Putnam, Time Inc., Weschler Inc.
Handles Illustration.
Terms Rep receives 30% commission. Exclusive area representation is required. Advertising costs are split: 70% paid by talent; 30% paid by representative. Advertises in *Workbook* and *Directory of Illustration*.
How to Contact "Not reviewing new talent."
Tips Obtains new talent through recommendations from other talent or art directors.

PAINTED WORDS

310 W. 97th St., #24, New York NY 10025. E-mail: lori@painted-words.com. Web site: www.painted-words.com. Estab. 1993. Represents 20 illustrators. Markets include advertising agencies; design firms; editorial/magazines; publishing/books; children's publishing.

Handles Illustration and author/illustrators.

Terms Rep receives 25-30% commission. Cost for direct mail promotional pieces is paid by illustrator. Exclusive area representation is required. Advertising costs are split: 75% paid by talent; 25% paid by representative.

How to Contact For first contact, send non-returnable tearsheets, or e-mail a link to your Web site. Samples are not returned. "Do not phone, do not e-mail attachments; will contact if interested."

Tips Wants artists with consistent style. "We are aspiring to build a larger children's publishing division and specifically looking for author/illustrators."

CAROLYN POTTS & ASSOC. INC.

848 Dodge Ave. #236, Evanston IL 60202. (847)864-7644. E-mail: carolyn@cpotts.com. Web site: www.cpotts.com. **President:** Carolyn Potts. Commercial photography representative and marketing consultant for creative professionals. Estab. 1976. Member of SPAR; CAR (Chicago Artists Reps). Specializes in contemporary advertising and design. Markets include advertising agencies, corporations/client direct, design firms, publishing/books.

Handles Photography.

Terms Rep receives 30-35% commission. Artists share cost of their direct mail postage and preparation. Exclusive area representation is required. Advertising costs are split: 70% paid by artist; 30% paid by rep (after initial trial period wherein artist pays 100%). For promotional purposes, talent must provide direct mail piece and multiple portfolios.

How to Contact For first contact, send direct mail flier/brochure and SASE. Responds in 3 days. After initial contact, write to schedule an appointment. Portfolio should include tearsheets, photographs.

Tips Looking for artists with high level of professionalism, awareness of current advertising market, professional presentation materials (including a digital portfolio) and positive attitude.

CHRISTINE PRAPAS/ARTIST REPRESENTATIVE

8402 SW Woods Creek Court, Portland OR 97219. E-mail: christine@christineprapas.com. Web site: www.christineprapas.com. **Contact:** Christine Prapas. Commercial illustration and photography representative. Estab. 1978. Member of AIGA and Graphic Artists Guild. "Promotional material welcome."

GERALD & CULLEN RAPP—ARTIST REPRESENTATIVES

420 Lexington Ave., Penthouse, New York NY 10170. (212)889-3337. Fax: (212)889-3341. E-mail: info@rappart.com. Web site: www.rappart.com; www.theispot.com/rep/rapp. Commercial illustration representative. Estab. 1944. Member of SPAR, Society of Illustrators, Graphic Artists Guild. Represents 50 illustrators. Markets include advertising agencies, corporations/client direct, design firms, editorial/magazines, paper products/greeting cards, publishing/books, sales/promotion firms.

Handles Illustration.

Terms Rep receives 25-30% commission. Exclusive area representation is required. No geographic restrictions. Split of advertising costs is negotiated. Advertises in *American Showcase*, *Workbook*, *Graphic Artists Guild Directory*, and *CA* and *PRINT* magazines. Conducts active direct mail program and advertises on the Internet.

How to Contact Send query letter, direct mail flier/brochure or e-mail with no more than 1 image attached. Responds in 1 week. Obtains new talent through recommendations from others, solicitations.

REMEN-WILLIS DESIGN GROUP

2964 Colton Rd., Pebble Beach CA 93953. (831)655-1407. Fax: (831)655-1408. E-mail: remenwillis @comcast.net. Web site: www.annremenwillis.com. **Art Rep:** Ann Remen-Willis. Children's book illustration representative. Estab. 1984. Member of SCBWI. Represents 15 illustrators. Specializes in children's books trade and text. Markets include design firms, editorial/magazines, paper products/greeting cards, publishing/books.

Handles Illustration—children's books only; no advertising.

Terms Rep receives 25% commission. Advertising costs are split: 50% paid by artist; 50% paid by rep. Advertises in *Picturebook* and postcard mailings.

How to Contact For first contact, send query letter with tearsheets. Responds in one week. After initial contact, call to schedule an appointment. Portfolio should include b&w and color tearsheets.

Tips "Fill portfolio with samples of art you want to continue receiving as commissions. Do not include that which is not a true representation of your style and capability."

ⓝ REPERTOIRE

19424 Oak Meadow Circle, Tyler TX 75703. (903)839-4701. Fax: (903)839-4702. E-mail: info@rep ertoireart.com. Web site: www.repertoireart.com. **Contact:** Larry Lynch. Commercial illustration and photography representative and broker. Estab. 1974. Member of SPAR. Represents 3 illustrators and 3 photographers. Markets include advertising agencies, corporations/client direct, design firms, editorial/magazines. Artists include Marc Hauser, Gary John Norman, Gary Parker, Ambrose Rivera and Mike Robbins.

Handles Illustration, photography, design.

Terms Rep receives 25-30% commission. Exclusive area representation is required. Advertising costs are split; printing costs are paid by talent; distribution costs are paid by representative. Talent must provide promotion—both direct mail and a national directory.

How to Contact Send e-mail with link to Web site. Responds in 1 month. After initial contact, write for appointment or drop off or mail portfolio of tearsheets, slides, photographs. Obtains new talent through referrals, solicitations.

Tips Looks for "sense of humor, honesty, maturity of style, ability to communicate clearly, and relevance of work to our clients."

RETRO REPS (A DIVISION OF MARTHA PRODUCTIONS)

7550 W. 82nd St., Playa Del Rey CA 90293. (310)670-5300. Fax: (310)670-3644. E-mail: contact@ marthaproductions.com. Web site: www.retroreps.com. **President:** Martha Spelman. Commercial illustration representative. Estab. 1998. Represents 22 illustrators. Specializes in artists working in vintage or retro styles from the 1920s through 1970s.

- See listing for Martha Productions in this section.

LILLA ROGERS STUDIO

E-mail: info@lillarogers.com. Web site: www.lillarogers.com. **Agents:** Lilla Rogers, Ashley Lorenz, Susan McCabe. Commercial illustration representatives. Estab. 1984. Represents 20 illustrators. Markets include advertising agencies, corporations/client direct, design firms, editorial/ magazines, paper products, publishing/books, prints and posters, sales/promotion firms, children's books, surface design. Artists include Bonnie Dain, Diane Bigda and Jon Cannell.

- Lilla provides mentoring and frequent events for the artists, including classes and guest art director lunches.

Handles Illustration.

Terms Rep receives 30% commission. Exclusive representation required. Promotions include

Lilla Rogers Studio

*Agents who value and
inspire their artists*

L illa Rogers Studio (www.lillarogers.com) is a well-established agency in Massachu-
setts that represents commercial artists internationally. In business for over 23 years,
the Studio was founded by Lilla Rogers, a visual arts instructor as well as an interna-
tionally-known illustrator and painter. Susan McCabe and Ashley Lorenz are other key part-
ners. They work closely with the artists they represent and engage them in studio events.
Their artists' client lists include popular magazines, newspapers and other major compa-

Local artists gather at Lilla Rogers Studio for a 2007 social event. Pictured from left to right: artist Lisa
DeJohn, artist Ann Boyajian, artist Janell Genovese, former Studio employee Judy, and artist Jessica Allen.

Discover The Magic of Watercolor...
ABSOLUTELY FREE!

*I*f you're passionate about watercolor, acrylic, gouache or any other water-based media, you'll love *Watercolor Magic*—the #1 magazine for watermedia artists. Open an issue and you'll discover all the creative inspiration, excitement, and superior instruction of a professional art lesson. Here's just a sampling of what you'll find inside:

- step-by-step painting demonstrations showcased in spectacular full-color images

- fresh ideas and exercises for non-stop creative inspiration

- tips and technical advice from the best watermedia artists and instructors in the world, including Stephen Quiller, Frank Francese, Betsy Dillard Stroud, and Charles Reid

- the most up-to-date info on the best painting tools and materials

- and so much more!

Now's the time to develop your unique personal style to its fullest potential by taking advantage of this special offer in *Artist's & Graphic Designer's Market*.

Send for your free issue...
Return the attached postage-paid card today!

SEND MY RISK-FREE TRIAL ISSUE!

Yes! Send my FREE trial issue of *Watercolor Magic* and start my introductory subscription. If I like what I see, I'll get 5 more issues (6 in all) for just $19.96—that's a 44% savings off the newsstand price. If not, I'll write "cancel" on the bill, return it and owe nothing. The FREE ISSUE will be mine to keep!

Send no money now...we'll bill you later.

Name_____

Address_____

City _____

State_____ ZIP_____

Email_____
(to contact me regarding my subscription)

☐ **YES!** Also e-mail me *Watercolor Magic*'s FREE e-newsletter and other information of interest. (*We will not sell your e-mail address to outside companies.*)

Canadian orders will be billed an additional US$7 (includes GST/HST) and invoiced.
Outside the U.S. and Canada, add US$7 and remit payment in U.S. funds with this order.
Annual newsstand rate: $35.94. Please allow 4-6 weeks for first-issue delivery.

www.watercolormagic.com

J7FAM4

Get a *FREE ISSUE* of *Watercolor Magic*

From the Publishers of *The Artist's Magazine* and *Artist's and Graphic Designer's Market*

Packed with innovative ideas, creative inspiration, and detailed demonstrations from the best watermedia artists in the world, *Watercolor Magic* will offer you everything you need to take your art to the next level. You'll learn how to:

- Choose a great subject every time
- Capture light and shadows to add depth and drama
- Experiment by combining media
- Master shape, detail, texture and color
- Explore cutting-edge techniques and materials
- Get inspired and create breathtaking art!

See for yourself how *Watercolor Magic* will help you turn ordinary works into extraordinary art.

Mail the postage-paid card below for your FREE TRIAL ISSUE!

Artists at Lilla Rogers Studio's booth at SURTEX 2007 (www.surtex.com), an annual trade show for artists to sell and license art and design. Pictured from left to right: Bonnie Dain, Helen Dardik, Linda Ketelhut and Lisa DeJohn.

nies in a variety of industries. "We are unique in that we are strong in both advertising/editorial and licensing," says Rogers.

The idea of agenting was an "incredible, exciting, natural next step" for Rogers when she was first teaching years ago. Refusing illustration work because she was getting more assignments than she could handle, Rogers began passing those jobs on to her students. Her crop of artists continued to grow, and she now has more than two decades worth of contacts and clients. "Those clients trust our agency and know we've thoroughly vetted each artist for style and professionalism," says Rogers. "They also come to us knowing we've found the latest in trend."

Lorenz started out as Studio Manager about 10 years ago and eventually earned the promotion to Agent. After graduating from college with an Art History degree, she was seeking a job that would allow her to help working artists make a living. She was introduced to Lilla Rogers Studio through a friend and, though she knew nothing of illustration at the time, immediately fell in love with the agency and its artists. "We take on artists we love, that we are crazy about," she says.

McCabe joined the Studio in 2006. She had been an art director at magazines such as *Inc.* and *Harvard Business Review*, fell in love with illustration, and thought, "Wouldn't it

be fun to be an illustration rep?" A rep handles business aspects, such as job negotiations, contracts, billing, marketing and image management, allowing the artist to focus on being creative. "An agent can also guide a career," says Rogers. "An agent is an editor of the artist's work and can present the work in a brilliant way, showcasing the right pieces to the right art directors to get the very best work for the artist."

Because Rogers was a successful full-time illustrator, she understands the issues—both practical and emotional—of being an artist. In addition to mentoring her artists through classes and workshops, Rogers invites guest art directors to keep the artists fresh and stimulated. "As a teacher, she knows how to motivate and inspire her artists," says Lorenz.

Why have an agent?
Lilla Rogers Studio generally takes on only one new artist per year (out of more than a thousand submissions from around the world), but that shouldn't discourage you from

Lilla Rogers hugs artist Lisa DeJohn as they celebrate after a great day at SURTEX 2007. "I really love my artists!" says Rogers.

contacting the agency, especially if your style suits their requirements. "Currently, we're looking for someone with a 'design*sponge' (www.designsponge.blogspot.com) sensibility," says Rogers. The agency plans to include more information on their Web site in the future, but in the meantime interested artists can contact them at info@lillarogers.com. "Provide a link to your site, and tell us why you'd like an agent."

There are plenty of other reps listed in this section that are worth investigating as well. Most agents themselves strongly suggest artists research a variety of agencies before signing a contract. The idea is to find someone who understands your personal vision and needs, so that you can do your best work while having a comrade to guide you.

Here, some of the artists represented by Lilla Rogers Studio explain the value of working with an agent:

"With a good agency, you feel like you're part of a community, rather than struggling alone. They offer support and encouragement, see your work afresh, and therefore can make valuable suggestions and judgments. When the standard of work of the other illustrators that are represented is high, it can challenge you to produce new and (hopefully) ever-improving work. Most importantly, an agent frees you up to concentrate primarily on creating work (which is what we tend to be best at and enjoy most) and removes many of the day to day pressures of looking for work, negotiating fees and contracts, etc."

—*Trina Dalziel* (www.lillarogers.com/artists/trina/portfol.htm)

"I value immensely the feedback and encouragement I get from my agent. For me, she's a source of inspiration and positive energy."

—*Jessica Allen* (www.lillarogers.com/artists/jessica/portfol.htm)

"A rep is there to be your advocate. She knows the right questions to ask, gets top dollar for each job, and has my best interests as a priority. She knows the importance of balancing my work with other aspects of my life."

—*Susan Farrington* (www.lillarogers.com/artists/susan_3/portfol.htm)

"An agent can be in a unique position to give feedback, as she is constantly looking at and evaluating work. If you decide to go the agent route, it's important to respect your agent and her point of view and appreciate what she does for you. It's not a perfect world out there, and agents can't solve all of your problems, but that isn't their job.

It's a partnership. You give them high-quality work, delivered on time to your clients, and they give you the benefit of their expertise to keep finding new clients and opening new avenues for your work. This pushes you to constantly grow and improve as an artist, and ideally this works out to be a mutually beneficial relationship."

—*Sarajo Frieden* (www.lillarogers.com/artists/sarajogr/portfol.htm)

—*Catherine Overstreet*

PRINT Magazine, Design*Sponge blog, SURTEX trade show and other events; also runs extensive postcard direct mail campaigns.

How to Contact For first contact, e-mail 3-5 JPEGs or a link to your Web site. Responds only if interested.

Tips "It's good to check out the agency's Web site to see if you feel like it's a good fit. Explain in your e-mail why you want an agent and why you think we are a good match. No phone calls, please."

Ⓝ THE ROLAND GROUP

4948 St. Elmo Ave., Suite 201, Bethesda MD 20814. (301)718-7955. Fax: (301)718-7958. E-mail: info@therolandgroup.com. Web site: www.therolandgroup.com. Commercial illustration and

photography representative. Estab. 1988. Member of SPAR, Society of Illustrators, Ad Club, Production Club. Represents 20 illustrators and over 300 photographers. Markets include advertising agencies; corporations/client direct; design firms; editorial/magazines; paper products/greeting cards; publishing/books.

Handles Illustration and photography.

Terms Rep receives 35% commission. Exclusive and non-exclusive representation available. Also works with artists on a project-by-project basis. For promotional purposes, talent must provide 8½×11 promo sheet. Advertises in *American Showcase, Workbook, International Creative Handbook, The Black Book* and *KLIK*.

How to Contact For first contact, send query letter, tearsheets and photocopies. Responds only if interested. Portfolio should include nonreturnable tearsheets, photocopies.

ROSENTHAL REPRESENTS

3850 Eddingham Ave., Calabasas CA 91302. (818)222-5445. Fax: (818)222-5650. E-mail: elise@rosenthalrepresents.com. Web site: www.rosenthalrepresents.com. **Contact:** Elise Rosenthal. Commercial illustration representative and licensing agent. Estab. 1979. Member of SPAR, Society of Illustrators, Graphic Artists Guild, Women in Design and Art Directors Club. Represents 100 illustrators, 2 designers and 5 fine artists. Specializes in game packaging, personalities, licensing, merchandising art and storyboard artists. Markets include advertising agencies, corporations/client direct, paper products/greeting cards, sales/promotion firms, licensees and manufacturers.

Handles Illustration.

Terms Rep receives 30% as a rep; 50% as a licensing agent. Exclusive area representation is required. No geographic restrictions. Advertising costs are paid by talent. For promotional purposes, talent must provide 1-2 sets of transparencies (mounted and labeled) and 1-3 promos. Advertises in *American Showcase* and *Workbook*.

How to Contact Send direct mail flier/brochure, tearsheets, slides, photocopies, photostats and SASE. Responds in 1 week. After initial contact, call for appointment to show portfolio of tearsheets, slides, photographs, photocopies. Obtains new talent through seeing their work in an advertising book or at award shows, and by referrals.

LIZ SANDERS AGENCY

2415 E. Hangman Creek Lane, Spokane WA 99224. (509)993-6400. Fax: (509)466-5400. E-mail: liz@lizsanders.com. Web site: www.lizsanders.com. **Owner:** Liz Sanders. Commercial illustration representative. Estab. 1985. Represents 10 illustrators. Specializes in marketing of individual artists "within an ever-evolving illustration world." Markets include advertising agencies, corporations/client direct, design firms, editorial/magazines, juvenile markets, paper products/greeting cards, publishing/books, record companies, sales/promotion firms.

Handles Interested in illustration. "Looking for fresh, unique talent committed to long-term careers whereby the agent/talent relationship is mutually respectful, responsive and measurably successful."

Terms Rep receives 25-30% commission. Exclusive representation required. Advertises in *Picturebook, American Showcase, Workbook, Directory of Illustration*, direct mail material, traditional/electronic portfolio for agent's personal presentations; means to advertise if not substantially, then consistently.

How to Contact For first contact, send nonreturnable printed pieces or e-mailed Web address. Responds only if interested. After initial contact, call to schedule an appointment, depending on geographic criteria. Portfolio should include tearsheets, photocopies and digital output.

Tips "Concisely present a single, focused style supported by 8-12 strong samples. Only send a true portfolio upon request."

JOAN SAPIRO ART CONSULTANTS

4750 E. Belleview Ave., Greenwood Village CO 80121. (303)793-0792. Fax: (303)290-9204. E-mail: jsac@qwest.net. **Contact:** Kay Brouillette. Estab. 1980. Specializes in "corporate art with other emphasis on hospitality, health care and art consulting/advising to private collectors."

Handles All mediums of artwork.

Terms Artist must be flexible and willing to ship work on consignment. Also must be able to provide sketches, etc., if commission piece involved. No geographic restrictions.

How to Contact Send résumé, bio, direct mail flier/brochure, tearsheets, slides, photographs, price list (wholesale) and SASE. After initial contact, drop off or mail in appropriate materials for review.

Tips Obtains new talent through recommendations, publications, travel, research, university faculty.

THE SCHUNA GROUP

1503 Briarknoll Dr., Arden Hills MN 55112. (651)631-8480. Fax: (651)631-8426. E-mail: joanne@schunagroup.com. Web site: www.schunagroup.com. **Contact:** JoAnne Schuna. Commercial illustration representative. Represents 15 illustrators. Specializes in illustration. Markets include advertising agencies, corporations/client direct, design firms, editorial/magazines, paper products/greeting cards, publishing/books, record companies, sales/promotion firms. Represented artists include Cathy Gendron and Jim Dryden.

Handles Interested in reviewing illustration samples.

Terms Rep receives 25% commission. Exclusive representation required. Advertising costs are split: 75% paid by artist; 25% paid by rep. Advertises in various mediums.

How to Contact For first contact, send 2-3 digital samples via e-mail. "I will respond via e-mail within a few weeks at most if interested."

Tips "Listing your Web site in your e-mail is helpful, so I can see more if interested."

FREDA SCOTT, INC.

200 Brannan St., #411, San Francisco CA 94107. (415)348-9121. Fax: (415)348-9120. E-mail: info@fredascott.com. Web site: www.fredascott.com. **Contact:** Freda Scott. Commercial illustration and photography representative. Estab. 1980. Member of SPAR. Represents 14 illustrators, 17 photographers. Markets include advertising agencies, corporations/client direct, design firms, editorial/magazines, paper products/greeting cards, publishing/books, sales/promotion firms. Client list available upon request.

Handles Illustration, photography.

Terms Rep receives 25% commission. No geographic restrictions. Advertising costs are split: 75% paid by talent; 25% paid by representative. For promotional purposes, talent must provide "promotion piece and ad in a directory. I also need at least three portfolios." Advertises in *American Showcase*, *The Black Book*, *Workbook*.

How to Contact Send direct mail flier/brochure, tearsheets and SASE. If you send transparencies, responds in 1 week if interested. "You need to make follow-up calls." After initial contact, call for appointment to show portfolio of tearsheets, photographs (4×5 or 8×10). Obtains new talent sometimes through recommendations, sometimes solicitation.

Tips "If you are seriously interested in getting repped, keep sending promos—once every six months or so. Do it yourself a year or two until you know what you need a rep to do."

SUSAN AND CO.

8477 E. Leavenworth Rd., Leavenworth WA 98826. (206)232-7873. E-mail: susan@susanandco.com. Web site: www.susanandco.com. **Owner:** Susan Trimpe. Commercial illustration representa-

tive. Estab. 1979. Member of SPGA. Represents 19 illustrators. Markets include advertising agencies, corporations/client direct, design firms, publishing/books.

Handles Looks for "current illustration styles."

Terms Rep receives 25% commission. National representation is required. Advertising costs are split: 75% paid by talent; 25% paid by representative.

How to Contact For first contact, send e-mail letter and samples. Responds in 2 weeks, only if interested. After initial contact, call to schedule an appointment. Portfolio should "be representative of unique style."

▇▇ THREE IN A BOX INC.

862 Richmond St. W., Suite 201, Toronto ON M6J 1C9 Canada. (416)367-2446. Fax: (416)367-3362. E-mail: info@threeinabox.com. Web site: www.threeinabox.com. **Managing Director:** Holly Venable. Commercial illustration representative. Estab. 1990. Member of Graphic Artists Guild. Represents 53 illustrators, 3 photographers. Specializes in illustration. Licenses illustrators and photographers. Markets include advertising agencies, corporations/client direct, design firms, editorial/magazines, paper products/greeting cards, publishing/books, record companies, sales/promotion firms. Artists include Otto Steininger, Martin O'Neill and Peter Ferguson.

How to Contact For first contact, send query letter and URL to info@threeinabox.com. Responds in 1 week. After initial contact, rep will call if interested. Portfolio should include digital.

Tips "Try to specialize; you can't do everything well."

CHRISTINA A. TUGEAU: ARTIST AGENT

3009 Margaret Jones Lane, Williamsburg VA 23185. E-mail: chris@catugeau.com. Web site: www.catugeau.com. **Owner:** Chris Tugeau. Children's publishing market illustration representative (K-12). Estab. 1994. Member of Graphic Artists Guild, SPAR, SCBWI. Represents 35 illustrators. Specializes in children's book publishing and educational market and related areas. Represents Stacey Schuett, Larry Day, Melissa Iwai, Keiko Motoyama, Jason Wolff, Jeremy Tugeau, Priscilla Burris, John Kanzler, Martha Aviles, Ana Ochoa, Daniel J. Mahoney and Priscilla Burris.

Handles Illustration. Must be proficient at illustrating children and animals in a variety of interactive situations, backgrounds, full color/b&w, and with a strong narrative sense.

Terms Rep receives 25% commission. Exclusive USA representation is required. For promotional purposes, talent must provide direct mail promo(s), 8-10 good "back up" samples (multiples), 3 strong portfolio pieces.

How to Contact For first contact, e-mail a few JPEG samples or send direct mail flier/brochure, tearsheets, photocopies, books, SASE, "No slides! No originals." Responds within 2 weeks.

Tips "You should have a style uniquely and comfortably your own. Be a cooperative team player and be great with deadlines. Will consider young, new artists to the market with great potential and desire, and of course published, more experienced illustrators. Best to study and learn the market standards and expectations by representing yourself for a while when new to the market."

JAE WAGONER, ARTIST REPRESENTATIVE

P.O. Box 1259, Alta CA 95701. E-mail: services@jaewagoner.com. Web site: www.jaewagoner.com. **Contact:** Jae Wagoner. Commercial illustration representative. Estab. 1976. Represents 20 illustrators. Markets include advertising agencies, corporations/client direct, design firms, editorial/magazines, paper products/greeting cards, publishing/books, sales/promotion firms.

Handles Illustration.

Terms Agent receives 30% commission. Exclusive area representation required. For promotional purposes, talent must advertise once/year in major promotional book "exclusively with us." Advertises in *Workbook*.

How to Contact "By mail only—send copies or tearsheets for us to keep—do not call!" Samples are not returned. Responds only if interested.

Tips "We select first from submitted samples we can keep, that are mailed to us. The actual work determines our interest, not verbal recommendations or résumés. Sometimes we search for style we are lacking. It is *not* a good idea to call a rep out of the blue. You are just another voice on the phone. What is important is your work, *not* who you know, where you went to school, etc. Unsolicited work that needs to be returned creates a negative situation for the agent. It can get lost, and the volume can get horrendous. Also—do your homework—do not call and expect to be given the address by phone. It's a waste of the rep's time and shows a lack of effort. Be brief and professional." Sometimes, even if an artist can't be represented, Jae Wagoner provides portfolio reviews, career counseling and advice for an hourly fee. If you are interested in this service, please request this in your cover letter.

GWEN WALTERS

1801 S. Flagler Dr. #1202, West Palm Beach FL 33401. (561)805-7739. Fax: (561)805-5931. E-mail: artincgw@aol.com. Web site: www.gwenwaltersartrep.com. Commercial illustration representative. Estab. 1976. Represents 19 illustrators. Markets include advertising agencies; corporations/client direct; editorial/magazines; paper products/greeting cards; publishing/books; sales/promotion firms. "I lean more toward book publishing." Represents Gerardo Suzan, Fabricio Vanden Broeck, Resario Valderrama, Lave Gregory, Susan Spellman, Judith Pfeiffer, Yvonne Gilbert, Gary Torrisi, Larry Johnson, Pat Daris, Scott Wakefield, Tom Barrett and Linda Pierce. **Handles** Illustration.

Terms Rep receives 30% commission. Charges for color photocopies. Advertising costs are split: 50% paid by talent; 50% paid by representative. For promotional purposes, talent must provide direct mail pieces. Advertises in *RSVP*, *Directory of Illustration*.

How to Contact For first contact, send résumé, bio, direct mail flier/brochure. After initial contact, representative will call. Portfolio should include "as much as possible."

Tips "You need to pound the pavement for a couple of years to get some experience under your belt. Don't forget to sign all artwork. So many artists forget to stamp their samples."

Ⓝ WASHINGTON ARTISTS' REPRESENTATIVE INC.

22727 Cielo Vista #2, San Antonio TX 78255-9501. (210)698-1409. E-mail: artrep@sbcglobal.net. Web site: www.theispot.com. **Contact:** Dick Washington. Commercial illustration representative. Estab. 1983. Represents 12 illustrators.

How to Contact For first contact, send tearsheets or e-mail Web site or images. Responds in 2 weeks, only if interested. After initial contact, call for appointment to show portfolio of original art, tearsheets, slides. Usually obtains new talent through recommendations and solicitation.

Tips "Make sure that you are ready for a real commitment and relationship. It's an important step for an artist, and it should be taken seriously."

THE WILEY GROUP

1535 Green St., Suite 301, San Francisco CA 94123. (415)441-3055. Fax: (415)520-0999. E-mail: office@thewileygroup.com. Web site: www.thewileygroup.com. **Owner:** David Wiley. Commercial and fine art illustration and photography representative. Estab. 1984. Member of AIP (Artists in Print), Society of Illustrators, Graphic Artists Guild, Bay Area Lawyers for the Arts. Represents 12 illustrators. Clients include Coke, Pepsi, Microsoft, Forbes, Nestle. Client list available upon request.

Terms Rep receives 25% commission. No geographical restriction. Artist is responsible for all portfolio costs. Artist pays 75% of sourcebook ads, postcard/tearsheet mailings. Agent will reimburse artist for 25% of costs. Each year the artists are promoted using online agencies, bimonthly postcard mailings, and monthly e-cards (e-mail postcards).

How to Contact For first contact, e-mail Web site URL and one visual image representing your style. If interested, agent will call back to discuss representation.

Tips "The bottom line is that a good agent will get you *more* work at *better rates* of pay. Why? Because clients come to us knowing that we only represent serious professionals, and that we have a keen understanding of what the market will bear and what the art is truly worth."

DEBORAH WOLFE LTD.
731 N. 24th St., Philadelphia PA 19130. (215)232-6666. Fax: (215)232-6585. E-mail: inquiry@illustrationOnLine.com. Web site: www.illustrationOnLine.com. **Contact:** Deborah Wolfe. Commercial illustration representative. Estab. 1978. Represents 25 illustrators. Markets include advertising agencies, corporations/client direct, design firms, editorial/magazines, publishing/books.
Handles Illustration.
Terms Rep receives 25% commission. Advertises in *The Black Book*, *Workbook*, *Directory of Illustration* and *Picturebook*.
How to Contact For first contact, send an e-mail with samples or a Web address. Responds in 3 weeks.

Art Fairs

How would you like to sell your art from New York to California, showcasing it to thousands of eager art collectors? Art fairs (also called art festivals or art shows) are not only a good source of income for artists but an opportunity to see how people react to their work. If you like to travel, enjoy meeting people, and can do your own matting and framing, this could be a great market for you.

Many outdoor fairs occur during the spring, summer and fall months to take advantage of warmer temperatures. However, depending on the region, temperatures could be hot and humid, and not all that pleasant! And, of course, there is always the chance of rain. Indoor art fairs held in November and December are popular because they capitalize on the holiday shopping season.

To start selling at art fairs, you will need an inventory of work—some framed, some unframed. Even if customers do not buy the framed paintings or prints, having some framed work displayed in your booth will give buyers an idea of how your work looks framed, which could spur sales of your unframed prints. The most successful art fair exhibitors try to show a range of sizes and prices for customers to choose from.

When looking at the art fairs listed in this section, first consider local shows and shows in your neighboring cities and states. Once you find a show you'd like to enter, visit its Web site or contact the appropriate person for a more detailed prospectus. A prospectus is an application that will offer additional information not provided in the art fair's listing.

Ideally, most of your prints should be matted and stored in protective wraps or bags so that customers can look through your inventory without damaging prints and mats. You will also need a canopy or tent to protect yourself and your wares from the elements as well as some bins in which to store the prints. A display wall will allow you to show off your best framed prints. Generally, artists will have 100 square feet of space in which to set up their tents and canopies. Most listings will specify the dimensions of the exhibition space for each artist.

If you see the ☑ icon before a listing in this section, it means that the art fair is a juried event. In other words, there is a selection process artists must go through to be admitted into the fair. Many art fairs have quotas for the categories of exhibitors. For example, one art fair may accept the mediums of photography, sculpture, painting, metal work and jewelry. Once each category fills with qualified exhibitors, no more will be admitted to the show that year. The jurying process also ensures that the artists who sell their work at the fair meet the sponsor's criteria for quality. So, overall, a juried art fair is good for artists because it means they will be exhibiting their work along with other artists of equal caliber.

Be aware there are fees associated with entering art fairs. Most fairs have an application

fee or a space fee, or sometimes both. The space fee is essentially a rental fee for the space your booth will occupy for the art fair's duration. These fees can vary greatly from show to show, so be sure to check this information in each listing before you apply to any art fair.

Most art fair sponsors want to exhibit only work that is handmade by the artist, no matter what medium. Unfortunately, some people try to sell work that they purchased elsewhere as their own original artwork. In the art fair trade, this is known as "buy/sell." It is an undesirable situation because it tends to bring down the quality of the whole show. Some listings will make a point to say "no buy/sell" or "no manufactured work."

For more information on art fairs, pick up a copy of *Sunshine Artist* or *Art Calendar*, and consult online sources such as www.artfairsource.com, www.artcalendar.com and www.festival.net.

NORTHEAST & MIDATLANTIC

◪ ALLENTOWN ART FESTIVAL

P.O. Box 1566, Ellicott Station, Buffalo NY 14205-1566. (716)881-4269. E-mail: allentownartfestiv al@verizon.net. Web site: www.allentownartfestival.com. **Contact:** Mary Myszkiewicz, president. Estab. 1958. Fine arts & crafts show held annually 2nd full weekend in June. Outdoors. Accepts photography, painting, watercolor, drawing, graphics, sculpture, mixed media, clay, glass, acrylic, jewelry, creative craft (hard/soft). Slides juried by hired professionals that change yearly. Awards/prizes: $17,925 in 40 cash prizes; Best of Show. Number of exhibitors: 450. Public attendance: 300,000. Free to the public. Artists should apply by downloading application from Web site. Deadline for entry: January 31. Application fee: $15. Space fee: $225. Exhibition space: 13×10 ft. For more information, artists should e-mail, visit Web site, call or send SASE.
Tips "Artists must have attractive booth and interact with the public."

◪ ART IN THE HEART OF THE CITY

171 E. State St., Ithaca NY 14850. (607)277-8679. Fax: (607)277-8691. E-mail: phil@downtownith aca.com. Web site: www.downtownithaca.com. **Contact:** Phil White, office manager/event coordinator. Estab. 1999. Sculpture exhibition held annually in early June. Primarily outdoors; limited indoor pieces. Accepts photography, wood, ceramic, metal, stone. Juried by Public Arts Commission. Number of exhibitors: 28-35. Public attendance: 100,000 + . Free to the public. Artists should apply by submitting application, artist statement, slides/photos. Deadline for entry: May. Exhibition space depends on placement. For more information, artists should e-mail.
Tips "Be sure there is a market and interest for your work, and advertise early."

◪ ART IN THE PARK SUMMER AND FALL FOLIAGE FESTIVALS

(formerly Art in the Park Fall Foliage Festival), sponsored by the Chaffee Center for the Visual Arts. 16 S. Main St., Rutland VT 05701. (802)775-0356. Fax: (802)773-4401. E-mail: beyondmarket ing@yahoo.com. Web site: www.chaffeeartcenter.org. **Contact:** Sherri Birkheimer, event coordinator. Estab. 1961. Fine arts & crafts show held biannually: Art in the Park Summer Festival held 2nd weekend in August (Saturday and Sunday); Art in the Park Fall Foliage Festival held on Columbus Day weekend (Saturday and Sunday). Outdoors. Accepts photography, clay, fiber, floral, glass, wood, jewelry, soaps and baskets. Juried by a panel of 10-15 judges. Submit 3 slides (2 of artwork and 1 of booth display). Number of exhibitors: 130. Public attendance: 7,000-9,000. Public admission: voluntary donation. Artists should apply by visiting Web site for application. Deadline for entry: "Ongoing jurying, but to receive discount for doing both shows, March 31." Space fee: $135-310. Exhibition space: 10×12 ft. and 20×12 ft. For more information, artists should e-mail, visit Web site or call.
Tips "Have a good presentation and variety, if possible (in pricing also), to appeal to a large group of people."

⚑ ART'S ALIVE

200-125th St. & the Bay, Ocean City MD 21842-2247. (410)250-0125. Fax: (410)250-5409. E-mail: Bmoore@ococean.com. Web site: www.ococean.com. **Contact:** Brenda Moore, event coordinator. Estab. 2000. Fine art show held annually in mid-June. Outdoors. Accepts photography, ceramics, drawing, fiber, furniture, glass, printmaking, jewelry, mixed media, painting, sculpture, fine wood. Juried. Awards/prizes: Best of show, $2,000; Blue ribbon, $2,000; 6 judge's choices, $500 each; Mayor's Choice; people's choice. Number of exhibitors: 110. Public attendance: 10,000. Free to pubic. Artists should apply by downloading application from Web site, or call. Deadline for entry: February 28. Space fee: $75. Exhibition space: 12 × 12 ft. For more information, artists should e-mail, visit Web site, call or send SASE.

Tips "Apply early."

⚑ CHATSWORTH CRANBERRY FESTIVAL

P.O. Box 286, Chatsworth NJ 08019-0286. (609)726-9237. Fax: (609)726-1459. E-mail: lgiamalis@ aol.com. Web site: www.cranfest.org. **Contact:** Lynn Giamalis, chairperson. Estab. 1983. Arts & crafts show held annually in October. Outdoors. Accepts photography. Juried. Number of exhibitors: 200. Public attendance: 75,000-100,000. Free to the public. Artists should apply by sending SASE to above address. Deadline for entry: September 1. Space fee: $200. Exhibition space: 15 × 15 ft. For more information, artists should visit Web site.

CHRISTMAS CRAFT SHOW

5989 Susquehanna Plaza Dr., York PA 17406. (717)764-1155, ext. 1243. Fax: (717)252-4708. E-mail: joe.alfano@cumulus.com. Web site: www.warm103.com. **Contact:** Joe Alfano, director of special events. Estab. 1985. Arts & crafts show held annually in early December. Indoors. Accepts photography and all hand crafts. Number of exhibitors: 250. Public attendance: 3,000. Public admission: $3. Artists should apply by visiting Web site or calling or mailing for an entry form. Space fee: $95. Exhibition space: 10 × 10 ft. Average gross sales/exhibitor: $1,000-$2,000. For more information, artists should e-mail, visit Web site or call.

⚏ ⚑ CHRISTMAS CRAFTS EXPOS I & II

P.O Box 227, North Granby CT 06060. (860)653-6671. Fax: (860)653-6858. E-mail: acf@handmad einamerica.com. Web site: www.handmadeinamerica.com. **Contact:** Joanne McAulay, president. Estab. 1971. Fine arts & crafts holiday show held annually 1st 2 weekends in December. Indoors. Accepts photography, metal, fiber, pottery, glass, wood, jewelry, pen & ink. Juried by 6 product slides or photos, 1 booth photo, and 1 studio or shop photo (where the art is made). Number of exhibitors: 200. Public attendance: 10,000. Public admission: $7. Artists should apply by calling for an application or by downloading one from Web site. Deadline for entry: Applications are juried and space sold until sold out. Space fee: $420-$650. Exhibition space: 10 × 10 ft.; 10 × 15 ft.; 10 × 20 ft. For more information, artists should e-mail, visit Web site or send SASE.

Tips "Look at current market trends and economics. Have a unique and presentable booth. Be personable and friendly to customers."

CODORUS SUMMER BLAST

Codorus State Park, Hanover PA 17313. (717)764-1155, ext. 1243. Fax: (717)252-4708. E-mail: joe.alfano@cumulus.com. Web site: www.warm103.com. **Contact:** Joe Alfano, marketing/promotions. Estab. 2000. Arts & crafts show held annually in late June. Accepts photography and all crafts. Number of exhibitors: 50. Public attendance: 15,000. Free to the public. Artists should apply on Web site or through the mail. Space fee: $85. Exhibition space: 20 × 20 ft. Average gross sales/exhibitor: $1,000-2,000. For more information, artists should e-mail, visit Web site or call.

▟ COLORSCAPE CHENANGO ARTS FESTIVAL

P.O. Box 624, Norwich NY 13815. (607)336-3378. E-mail: info@colorscape.org. Web site: www.c olorscape.org. **Contact:** Peggy Finnegan, festival director. Estab. 1995. Fine arts & crafts show held annually the weekend after Labor Day. Outdoors. Accepts photography and all types of mediums. Juried. Awards/prizes: $5,000. Number of exhibitors: 80-85. Public attendance: 14,000-16,000. Free to the public. Deadline for entry: March. Application fee: $15/jury fee. Space fee: $150. Exhibition space: 12×12 ft. For more information, artists should e-mail, visit Web site, call or send SASE.

Tips "Interact with your audience. Talk to them about your work and how it is created. Don't sit grumpily at the rear of your booth reading a book. People like to be involved in the art they buy and are more likely to buy if you involve them."

▟ CRAFTS AT RHINEBECK

6550 Springbrook Ave., Rhinebeck NY 12572. (845)876-4001. Fax: (845)876-4003. E-mail: vimper ati@dutchessfair.com. Web site: www.craftsatrhinebeck.com. **Contact:** Vicki Imperati, event co-ordinator. Estab. 1981. Fine arts & crafts show held biannually in late June and early October. Indoors and outdoors. Accepts photography, fine art, ceramics, wood, mixed media, leather, glass, metal, fiber, jewelry. Juried by 3 slides of work and 1 of booth display. Number of exhibitors: 350. Public attendance: 25,000. Public admission: $7. Artists should apply by calling for application or downloading application from Web site. Deadline for entry: February 1. Application fee: $20. Space fee: $300-730. Exhibition space: inside: 10×10 ft. and 10×20 ft.; outside: 15×15 ft. For more information, artists should e-mail, visit Web site or call.

Tips "Presentation of work within your booth is very important. Be approachable and inviting."

▨ ▟ ELMWOOD AVENUE FESTIVAL OF THE ARTS, INC.

P.O. Box 786, Buffalo NY 14213. (716)830-2484. Fax: (716)885-2197. E-mail: directoreafa@aol.c om. Web site: www.elmwoodartfest.org. **Contact:** Joe DePasquale. Estab. 2000. Arts & crafts show held annually in late-August, the weekend before Labor Day weekend. Outdoors. Accepts photography, metal, fiber, ceramics, glass, wood, jewelry, basketry, 2D media. Juried. Awards/prizes: to be determined. Number of exhibitors: 170. Public attendance: 80,000-120,000. Free to the public. Artists should apply by e-mailing their contact information or by downloading application from Web site. Deadline for entry: April. Application fee: $20. Space fee: $200. Exhibition space: 150 sq. ft. Average gross sales/exhibitor: $2,700. For more information, artists should e-mail, visit Web site, call or send SASE.

Tips "Make sure your display is well designed, with clean lines that highlight your work. Have a variety of price points—even wealthy people don't always want to spend $500 at a booth where they may like the work."

▟ A FAIR IN THE PARK

Box Heart Gallery, 4523 Liberty Ave., Pittsburgh PA 15224. (412)687-8858. Fax: (412)687-6338. E-mail: boxheartexpress@earthlink.net. Web site: www.craftsmensguild.org. **Contact:** Nicole Capozzi, director. Estab. 1969. Contemporary fine arts & crafts show held annually the weekend after Labor Day. Outdoors. Accepts photography, clay, fiber, jewelry, metal, mixed media, wood, glass, 2D visual arts. Juried. Awards/prizes: 1 Best of Show and 4 Craftsmen's Guild Awards. Number of exhibitors: 115. Public attendance: 25,000+. Free to the public. Artists should apply by sending application with jury fee, booth fee and 5 slides. Deadline for entry: May 1. Application fee: $20. Space fee: $250-300. Exhibition space: 11×12 ft. Average gross sales/exhibitor: $900-3,000. For more information, artists should e-mail, visit Web site or call.

Tips "It is very important for artists to present their work to the public, to concentrate on the business aspects of their career. They will find that they can build a strong customer/collector

base by exhibiting their work and by educating the public about their artistic process and passion for creativity.''

ⓝ ⓥ FALL CRAFTS AT LYNDHURST

P.O. Box 28, Woodstock NY 12498. (845)331-7900. Fax: (845)331-7484. E-mail: crafts@artrider.com. Web site: www.craftsatlyndhurst.com; www.artrider.com. **Contact:** Laura Kandel. Estab. 1984. Fine arts & crafts show held annually in mid-September. Outdoors. Accepts photography, wearable and nonwearable fiber, metal and nonmetal jewelry, clay, leather, wood, glass, painting, drawing, prints, mixed media. Juried by 5 images of work and 1 of booth, viewed sequentially. Number of exhibitors: 325. Public attendance: 20,000. Public admission: $10. Artists should apply by downloading application from www.artrider.com (or apply online at www.zapplication.org). Deadline for entry: January. Application fee: $45. Space fee: $750. Exhibition space: 10×10. For more information, artists should e-mail, visit Web site or call.

ⓝ ⓥ FALL FINE ART & CRAFTS AT BROOKDALE PARK

Watchung Ave., Montclair NJ. (908)874-5247. Fax: (908)874-7098. E-mail: rosesquared@patmedia.com. Web site: www.rosesquared.com. **Contact:** Janet Rose, president. Estab. 1997. Fine arts & crafts show held annually in mid-October. Outdoors. Accepts photography and all other mediums. Juried. Number of exhibitors: 180. Public attendance: 14,000. Free to the public. Artists should apply by downloading application from Web site or calling for application. Deadline: 1 month before show date. Application fee: $15. Space fee: $310. Exhibition space: 120 sq. ft. For more information, artists should e-mail, visit Web site or call.

Tips "Create a professional booth that is comfortable for the customer to enter. Be informative, friendly and outgoing. People come to meet the artist.''

ⓝ ⓥ FALL FINE ART & CRAFTS AT NOMAHEGAN PARK

Springfield Ave., Cranford NJ. (908)874-5247. Fax: (908)874-7098. E-mail: rosesquared@patmedia.com. Web site: www.rosesquared.com. **Contact:** Janet Rose, president. Estab. 1986. Fine arts & crafts show held annually in October. Outdoors. Accepts photography and all other mediums. Juried. Number of exhibitors: 110. Public attendance: 12,000. Free to the public. Artists should apply by downloading application from Web site or calling for application. Deadline: 1 month before show date. Application fee: $15. Space fee: $310. Exhibition space: 120 sq. ft. For more information, artists should e-mail, visit Web site or call.

Tips "Create a professional booth that is comfortable for the customer to enter. Be informative, friendly and outgoing. People come to meet the artist.''

ⓝ ⓥ FINE ART & CRAFTS AT ANDERSON PARK

N. Mountain Ave., Upper Montclair NJ. (908)874-5247. Fax: (908)874-7098. E-mail: rosesquared@patmedia.net. Web site: www.rosesquared.com. **Contact:** Janet Rose, president. Estab. 1984. Fine arts & crafts show held annually in mid-September. Outdoors. Accepts photography and all other mediums. Juried. Number of exhibitors: 190. Public attendance: 16,000. Free to the public. Artists should apply by downloading application from Web site or calling for application. Deadline: 1 month before show date. Application fee: $15. Space fee: $310. Exhibition space: 120 sq. ft. For more information, artists should e-mail, visit Web site or call.

Tips "Create a professional booth that is comfortable for the customer to enter. Be informative, friendly and outgoing. People come to meet the artist.''

ⓝ ⓥ FINE ART & CRAFTS AT NOMAHEGAN PARK

Springfield Ave., Cranford NJ. (908)874-5247. Fax: (908)874-7098. E-mail: rosesquared@patmedia.com. Web site: www.rosesquared.com. **Contact:** Janet Rose, president. Estab. 1987. Fine arts

& crafts show held annually in early June. Outdoors. Accepts photography and all other mediums. Juried. Number of exhibitors: 110. Public attendance: 12,000. Free to the public. Artists should apply by downloading application from Web site or calling for application. Deadline: 1 month before show date. Application fee: $15. Space fee: $310. Exhibition space: 120 sq. ft. For more information, artists should e-mail, visit Web site or call.

Tips "Create a professional booth that is comfortable for the customer to enter. Be informative, friendly and outgoing. People come to meet the artist."

N: ☑ FINE ART & CRAFTS FAIR AT VERONA PARK

Verona Park NJ. (908)874-5247. Fax: (908)874-7098. E-mail: rosesquared@patmedia.net. Web site: www.rosesquared.com. **Contact:** Janet Rose, president. Estab. 1986. Fine arts & crafts show held annually in May. Outdoors. Accepts photography and all other mediums. Juried. Number of exhibitors: 140. Public attendance: 14,000. Free to the public. Artists should apply by downloading application from Web site or calling for application. Deadline: 1 month before show date. Application fee: $15. Space fee: $310. Exhibition space: 120 sq. ft. For more information, artists should e-mail, visit Web site or call.

Tips "Create a professional booth that is comfortable for the customer to enter. Be informative, friendly and outgoing. People come to meet the artist."

☑ GARRISON ART CENTER FINE ART & CRAFT FAIR

P.O. Box 4, 23 Camison's Landing, Garrison NY 10524. (845)424-3960. Fax: (845)424-3960. E-mail: gac@highlands.com. Web site: www.garrisonartcenter.org. Estab. 1969. **Contact:** Libby Turnock, executive director. Fine arts & crafts show held annually the 3rd weekend in August. Outdoors. Accepts all mediums. Juried by a committee of artists and community members. Number of exhibitors: 75. Public attendance: 10,000. Public admission: suggested donation of $5. Artists should call for application form or download from Web site. Deadline for entry: April. Application fee: $15. Space fee: $245; covered corner booth: $265. Exhibition space: 10×10 ft. For more information, artists should e-mail, visit Web site, call or send SASE.

Tips "Have an inviting booth and be pleasant and accessible. Don't hide behind your product— engage the audience."

N: ☑ HOLIDAY CRAFTS AT MORRISTOWN

P.O. Box 28, Woodstock NY 12498. (845)331-7900. Fax: (845)331-7484. E-mail: crafts@artrider.com. Web site: www.craftsatmorristown.com; www.artrider.com. **Contact:** Laura Kandel. Estab. 1990. Fine arts & crafts show held annually 3rd weekend in December. Indoors. Accepts photography, wearable and nonwearable fiber, metal and nonmetal jewelry, clay, leather, wood, glass, painting, drawing, prints, mixed media. Juried by 5 images of work and 1 of booth, viewed sequentially. Number of exhibitors: 165. Public attendance: 5,000. Public admission: $7. Artists should apply by downloading application from www.artrider.com (or apply online at www.zapplication.org). Deadline for entry: January. Application fee: $45. Space fee: $475. Exhibition space: 10×10 ft. For more information, artists should e-mail, visit Web site or call.

HOME, CONDO AND GARDEN ART & CRAFT FAIR

P.O. Box 486, Ocean City MD 21843. (410)524-7020. Fax: (410)524-0051. E-mail: oceanpromotions@beachin.net. Web site: www.oceanpromotions.info. **Contact:** Mike, promoter; Starr, assistant. Estab. 1984. Fine arts & crafts show held annually in March. Indoors. Accepts photography, carvings, pottery, ceramics, glass work, floral, watercolor, sculpture, prints, oils, pen & ink. Number of exhibitors: 125. Public attendance: 18,000. Public admission: $7/adults; $6/seniors & students; 13 and under free. Artists should apply by e-mailing request for info and application. Deadline for entry: until full. Space fee: $250. Exhibition space: 10×8 ft. For more information, artists should e-mail, visit Web site or call.

Art Fairs

MONTAUK POINT LIONS CLUB
P.O. Box 683, Montauk NY 11954. (631)668-5300. Fax: (631)668-1214. **Contact:** John McDonald, chairman. Estab. 1970. Arts & crafts show held annually Labor Day weekend. Outdoors. Accepts photography, arts and crafts. Number of exhibitors: 100. Public attendance: 1,000. Free to the public. Artists should apply by mail. Deadline for entry: Labor Day Saturday. Application fee: $125. Exhibition space: 100 sq. ft. For more information, artists should send SASE.

N: ☑ MOUNT GRETNA OUTDOOR ART SHOW
P.O. Box 637, Mount Gretna PA 17064. (717)964-3270. Fax: (717)964-3054. E-mail: mtgretnaart@ comcast.net. Web site: www.mtgretnaarts.com. **Contact:** Linda Bell, show committee chairperson. Estab. 1974. Fine arts and crafts show held annually 3rd full weekend in August. Outdoors. Accepts photography, oils, acrylics, watercolors, mixed media, jewelry, wood, paper, graphics, sculpture, leather, clay/porcelain. Juried by 4 professional artists who assign each applicant a numeric score. The highest scores in each medium are accepted. Awards/prizes: Judges' Choice Awards: 30 artists are invited to return the following year, jury exempt; the top 10 are given a monetary award of $200. Number of exhibitors: 260. Public attendance: 15,000-19,000. Public admission: $7; children under 12 free. Artists should apply via www.zapplication.org. Deadline for entry: April. Application fee: $15 jury fee. Space fee: $275. Exhibition space: 10×10 ft. For more information, artists should e-mail, visit Web site or call.

NORTH CONGREGATIONAL PEACH FAIR
17 Church St., New Hartford CT 06057. (860)379-2466. Estab. 1996. Arts & crafts show held annually in mid-August. Outdoors. Accepts photography, most arts and crafts. Number of exhibitors: 50. Public attendence: 500-2,000. Free to the public. Artists should call for application form. Deadline for entry: August. Application fee: $60. Exhibition space: 11×11 ft.
Tips ''Be prepared for all kinds of weather.''

☑ PAWLING ARTS & CRAFTS FESTIVAL
115 Charles Colman Blvd., Pawling NY 12564-1120. (845)855-5626. Fax: (845)855-1798. **Contact:** Verna Carey, chairman. Estab. 1991. Arts & crafts show held annually in late September. Accepts photography, handcrafts. No kit work. Juried.

☑ PETERS VALLEY CRAFT FAIR
19 Kuhn Rd., Layton NJ 07851. (973)948-5200. Fax: (973)948-0011. E-mail: pv@warwick.net. Web site: www.pvcrafts.org. **Contact:** Nancy Nolte, development director. Estab. 1970. Arts & crafts show held annually in late September. Indoors. Accepts photography, ceramics, fiber, glass, basketry, metal, jewelry, sculpture, printmaking, paper book art, drawing, painting. Juried. Awards/prizes: $1,300 in cash awards. Number of exhibitors: 200. Public attendance: 7,000-10,000. Public admission: $7. Artists should apply by downloading application from Web site. Deadline for entry: May 30. Jury fee: $25. Space fee: $350. Exhibition space: 10×10 ft. Average gross sales/exhibitor: $2,000-3,000. For more information, artists should e-mail, visit Web site, call or send SASE.
Tips ''Have fun, have an attractive booth design and a diverse price range.''

☑ QUAKER ARTS FESTIVAL
P.O. Box 202, Orchard Park NY 14127. (716)677-2787. **Contact:** Randy Kroll, chairman. Estab. 1961. Fine arts & crafts show held annually in September. Outdoors. Accepts photography, painting, graphics, sculpture, crafts. Juried by 4 panelists during event. Awards/prizes: over $10,000 total cash prizes. Number of exhibitors: 330. Public attendance: 75,000. Free to the public. Artists should apply by sending SASE. Deadline for entry: August. Space fee: $175. Exhibition space: 10×12 ft. For more information, artists should call or send SASE.

Tips "Have an inviting booth and be pleasant and accessible. Don't hide behind your product—engage the audience."

[N] [Z] SPRING CRAFTS AT LYNDHURST

P.O. Box 28, Woodstock NY 12498. (845)331-7900. Fax: (845)331-7484. E-mail: crafts@artrider.com. Web site: www.craftsatlyndhurst.com; www.artrider.com. **Contact:** Laura Kandel. Estab. 1984. Fine arts & crafts show held annually in mid-May. Outdoors. Accepts photography, wearable and nonwearable fiber, metal and nonmetal jewelry, clay, leather, wood, glass, painting, drawing, prints, mixed media. Juried by 5 images of work and 1 of booth, viewed sequentially. Number of exhibitors: 300. Public attendance: 20,000. Public admission: $10. Artists should apply by downloading application from www.artrider.com (or apply online at www.zapplication.org). Deadline for entry: January 4. Application fee: $45. Space fee: $750. Exhibition space: 10×10. For more information, artists should e-mail, visit Web site or call.

[N] [Z] SPRING CRAFTS AT MORRISTOWN

P.O. Box 28, Woodstock NY 12498. (845)331-7900. Fax: (845)331-7484. E-mail: crafts@artrider.com. Web site: www.craftsatmorristown.com; www.artrider.com. **Contact:** Laura Kandel. Estab. 1990. Fine arts & crafts show held annually in mid-March. Indoors. Accepts photography, wearable and nonwearable fiber, metal and nonmetal jewelry, clay, leather, wood, glass, painting, drawing, prints, mixed media. Juried by 5 images of work and 1 of booth, viewed sequentially. Number of exhibitors: 165. Public attendance: 5,000. Public admission: $7. Artists should apply by downloading application from www.artrider.com (or online at www.zapplication.org). Deadline for entry: January 4. Application fee: $45. Space fee: $475. Exhibition space: 10×10 ft. For more information, artists should e-mail, visit Web site or call.

[N] [Z] SPRING FINE ART & CRAFTS AT BROOKDALE PARK

Watchung Ave., Montclair NJ. (908)874-5247. Fax: (908)874-7098. E-mail: rosesquared@patmedia.net. Web site: www.rosesquared.com. **Contact:** Janet Rose, president. Estab. 1988. Fine arts & craft show held annually in mid-June. Outdoors. Accepts photography and all other mediums. Juried. Number of exhibitors: 180. Public attendance: 16,000. Free to the public. Artists should apply by downloading application from Web site or calling for application. Deadline: 1 month before show date. Application fee: $15. Space fee: $310. Exhibition space: 120 sq. ft. For more information, artists should e-mail, visit Web site or call.

Tips "Create a professional booth that is comfortable for the customer to enter. Be informative, friendly and outgoing. People come to meet the artist."

SPRINGFEST AND SEPTEMBERFEST

P.O. Box 677, Nyack NY 10960-0677. (845)353-2221. Fax: (845)353-4204. Web site: www.nyack-ny.com. **Contact:** Lorie Reynolds, executive director. Estab. 1980. Arts & crafts show held biannually in April and September. Outdoors. Accepts photography, pottery, jewelry, leather, clothing, etc. Number of exhibitors: 220. Public attendance: 30,000. Free to the public. Artists should apply by submitting application, fees, permits, photos of products and display. Deadline for entry: 15 days before show. Space fee: $175. Exhibition space: 10×10 ft. For more information, artists should visit Web site, call or send SASE.

[Z] WASHINGTON SQUARE OUTDOOR ART EXHIBIT

115 E. Ninth St. #7C, New York NY 10003. (212)982-6255. Fax: (212)982-6256. Web site: www.washingtonsquareoutdoorartexhibit.org. **Contact:** Margot J. Lufitg, executive director. Estab. 1931. Fine arts & crafts show held semiannually Memorial Day weekend and the following weekend, and Labor Day weekend and following weekend in September. Outdoors. Accepts photography,

oil, watercolor, graphics, mixed media, sculpture, crafts. Juried by submitting 5 slides of work and 1 of booth. Awards/prizes: certificates, ribbons and cash prizes. Number of exhibitors: 200. Public attendance: 200,000. Free to the public. Artists should apply by sending a SASE or downloading application from Web site. Deadline for entry: March, Spring Show; July, Fall Show. Application fee: $20. Exhibition space: 10×5 ft. For more information, artists should call or send SASE.

Tips "Price work sensibly."

☑ WESTMORELAND ART NATIONALS

252 Twin Lakes Rd., Latrobe PA 15650-3554. (724)834-7474. E-mail: info@artsandheritage.com. Web site: www.artsandheritage.com. **Contact:** Donnie Gutherie, executive director. Estab. 1975. Fine arts & crafts show held annually in July. Indoors. Accepts photography, all mediums. Juried: 2 jurors review slides. Awards/prizes: $5,000+ in prizes. Number of exhibitors: 200. Public attendance: 100,000. Free to the public. Artists should apply by downloading application from Web site. Application fee: $35/craft show; $25/fine art exhibit. Space fee: $325. Exhibition space: 10×10 ft. For more information, artists should visit Web site.

Tips "Sell the product; don't let the product sell itself."

☑ WILD WIND FOLK ART & CRAFT FESTIVAL

719 Long Lake, New York NY 12847. (814)723-0707 or (518)624-6404. E-mail: wildwindcraftshow @yahoo.com. Web site: www.wildwindfestival.com. **Contact:** Liz Allen or Carol Jilk, promoters. Estab. 1979. Fine arts & crafts show held annually the weekend after Labor Day. Barn locations and outdoors. Accepts photography, paintings, pottery, jewelry, traditional crafts, prints, stained glass. Juried by promoters. Submit 3 photos or slides of work plus 1 of booth if available. Number of exhibitors: 140. Public attendance: 8,000. Public admission: $5/adult; $3/seniors; 12 and under free. Artists should apply by visiting Web site and filling out application request, calling or sending a written request.

MIDSOUTH & SOUTHEAST

☑ APPLE ANNIE CRAFTS & ARTS SHOW

4905 Roswell Rd. NE, Marietta GA 30062. (770)552-6400, ext. 6110. Fax: (770)552-6420. E-mail: appleannie@st-ann.org. Web site: www.st-ann.org/appleannie. **Contact:** Show Manager. Estab. 1981. Arts & crafts show held annually the 1st weekend in December. Indoors. Accepts photography, woodworking, ceramics, pottery, painting, fabrics, glass. Juried. Number of exhibitors: 135. Public attendance: 5,000. Public admission: $2. Artists should apply by visiting Web site to print an application form, or calling to have one sent to them. Deadline: March 31. Application fee: $10 nonrefundable. Space fee: $120. Exhibition space: 72 sq. ft. For more information, artists should e-mail, visit Web site or call.

Tips "Have an open, welcoming booth and be accessible and friendly to customers."

☑ APPLE CHILL & FESTIFALL

200 Plant Rd., Chapel Hill NC 27514. (919)968-2784. Fax: (919)932-2923. E-mail: lradson@towno fchapelhill.org. Web site: www.applechill.com and www.festifall.com. **Contact:** Lauren Rodson, lead event coordinator. Estab. 1972. Apple Chill street fair held annually 3rd full weekend in April; Festifall street fair held annually 1st weekend in October. Estab. 1972. Outdoors. Accepts photography, pottery, painting, fabric, woodwork, glass, jewelry, leather, sculpture, tile. Juried by application process; actual event is not juried.

Art Fairs

ART FESTIVAL BETH-EL

400 S. Pasadena Ave., St. Petersburg FL 33707. (727)347-6136. Fax: (727)343-8982. **Contact:** Sonya Miller, chairwoman. Estab. 1972. Fine arts & crafts show held annually the last weekend in January. Indoors. Accepts photography, painting, jewelry, sculpture, woodworking. Juried by special committee on-site or through slides. Awards/prizes: $7,500 prize money; $100,000 Purchase Award. Number of exhibitors: 150-175. Public attendance: 8,000-10,000. Free to the public. Artists should apply by application with photos or slides; show is invitational. Deadline for entry: September. Space fee: $25. Exhibition space: 4×8 ft. (panels or wall space). For more information, artists should call.

Tips "Don't crowd display panels with artwork. Make sure your prices are on your pictures. Speak to customers about your work."

ART IN THE PARK

P.O. Box 1540, Thomasville GA 31799. (229)227-7020. Fax: (229)227-3320. E-mail: roseshowfest @rose.net. Web site: www.downtownthomasville.com. **Contact:** Felicia Brannen, festival coordinator. Estab. 1998-1999. Arts & crafts show held annually in April. Outdoors. Accepts photography, handcrafted items, oils, acrylics, woodworking, stained glass, other varieties. Juried by a selection committee. Number of exhibitors: 60. Public attendance: 2,500. Free to the public. Artists should apply by application. Deadline for entry: March 1. Space fee: $75, varies by year. Exhibition space: 20×20 ft. For more information, artists should e-mail or call.

Tips "Most important, be friendly to the public and have an attractive booth display."

BIG ARTS ART FAIR

900 Dunlop Rd., Sanibel FL 33957. (239)395-0900. Fax: (239)395-0330. E-mail: ncunnigham@big arts.org. Web site: www.bigarts.org. **Contact:** Natalie Cunningham, programs assistant. Estab. 1979. Fine arts & crafts show held annually the Friday and Saturday after Thanksgiving. Outdoors. Accepts photography, ceramics, graphics, painting, original wearable art, glass, jewelry, fiber, mixed media, sculpture, garden art. Juried by 1 judge, who changes annually. Awards/prizes: cash. Number of exhibitors: 80-90. Public attendance: 3,000-5,000. Public admission: $3. Artists should apply by visiting Web site or calling after June 1 for application. Deadline for entry: late September. Application/space fee: $150. Exhibition space: 10×10 ft. For more information, artists should e-mail, visit Web site or call.

CHERRY BLOSSOM FESTIVAL OF CONYERS

1996 Centennial Olympic Pkwy., Conyers GA 30013. (770)860-4190. Fax: (770)602-2500. E-mail: rebecca.hill@conyersga.com. **Contact:** Rebecca Hill, event manager. Estab. 1981. Arts & crafts show held annually in late March. Outdoors. Accepts photography, paintings. Juried. Number of exhibitors: 300. Public attendance: 40,000. Free to the public; $5 parking fee. Deadline for entry: January. Space fee: $125/booth. Exhibition space: 10×10 ft. For more information, artists should e-mail, visit Web site or call.

CHURCH STREET ART & CRAFT SHOW

P.O. Box 1409, Waynesville NC 28786. (828)456-3517. Fax: (828)456-2001. E-mail: downtownwa ynesville@charter.net. Web site: www.downtownwaynesville.com. **Contact:** Ronald Huelster, executive director. Estab. 1983. Fine arts & crafts show held annually 2nd Saturday in October. Outdoors. Accepts photography, paintings, fiber, pottery, wood, jewelry. Juried by committee: submit 4 slides or photos of work and 1 of booth display. Awards/prizes: $1,000 cash prizes in 1st, 2nd, 3rd and Honorable Mentions. Number of exhibitors: 100. Public attendance: 15,000-18,000. Free to the public. Deadline for entry: August 15. Application/space fee: $95-165. Exhibition space: 10×12 ft.-12×20 ft. For more information, artists should e-mail, call or send SASE.

Tips Recommends "quality in work and display."

N: Ⓜ FESTIVAL IN THE PARK

1409 East Blvd., Charlotte NC 28203. (704)338-1060. Fax: (704)338-1061. E-mail: festival@festiva linthepark.org. Web site: www.festivalinthepark.org. **Contact:** Julie Whitney Austin, executive director. Estab. 1964. Fine arts & crafts/arts & crafts show held annually the 3rd Thursday after Labor Day. Outdoors. Accepts photography, decorative and wearable crafts, drawing and graphics, fiber and leather, jewelry, mixed media, painting, metal, sculpture, wood. Juried by slides or photographs. Awards/prizes: $4,000 in cash awards. Number of exhibitors: 150. Public attendance: 85,000. Free to the public. Artists should apply by visiting Web site for application. Application fee: $20. Space fee: $350. Exhibition space: 10×10 ft. For more information, artists should e-mail, visit Web site or call.

GERMANTOWN FESTIVAL

P.O. Box 381741, Germantown TN 38183. (901)757-9212. E-mail: gtownfestival@aol.com. **Contact:** Melba Fristick, coordinator. Estab. 1971. Arts & crafts show held annually the weekend after Labor Day. Outdoors. Accepts photography, all arts & crafts mediums. Number of exhibitors: 400+. Public attendance: 65,000. Free to the public. Artists should apply by sending applications by mail. Deadline for entry: until filled. Application/space fee: $190-240. Exhibition space: 10×10 ft. For more information, artists should e-mail, call or send SASE.
Tips "Display and promote to the public. Price attractively."

Ⓜ HIGHLANDS ART LEAGUE'S ANNUAL FINE ARTS & CRAFTS FESTIVAL

1989 Lakeview Dr., Sebring FL 33870. (863)385-5312. Fax: (863)385-5336. E-mail: info@highland sartleague.com. Web site: www.highlandsartleague.com. **Contact:** Show Coordinator. Estab. 1966. Fine arts & crafts show held annually the 2nd weekend of November. Outdoors. Accepts photography, pottery, painting, jewelery, fabric. Juried based on quality of work. Awards/prizes: monetary awards up to $1,500 and Purchase Awards. Number of exhibitors: more than 100. Public attendence: more than 15,000. Free to the public. Artists should apply by calling or visiting Web site for application form after May 1. Deadline for entry: October. Application fee: $60 plus $15 jury fee. Exhibtion space: 10×14 ft. Artists should e-mail for more information.

Ⓜ HOLIDAY ARTS & CRAFTS SHOW

60 Ida Lee Dr., Leesburg VA 20176. (703)777-1368. Fax: (703)737-7165. E-mail: lfountain@leesbu rgva.gov. Web site: www.idalee.org. **Contact:** Linda Fountain, program supervisor. Estab. 1990. Arts & crafts show held annually the 1st weekend in December. Indoors. Accepts photography, jewelry, pottery, baskets, clothing, accessories. Juried. Number of exhibitors: 100. Public attendance: 4,000. Free to the public. Artists should apply by downloading application from Web site. Deadline for entry: August 31. Space fee: $100-150. Exhibition space: 10×7 ft. For more information, artists should e-mail or visit Web site.

Ⓜ HOLLY ARTS & CRAFTS FESTIVAL

P.O. Box 2122, Pinehurst NC 28370. (910)295-7462. E-mail: sbharrison@earthlink.net. Web site: www.pinehurstbusinessguild.com. **Contact:** Susan Harrison, Holly Arts & Crafts committee. Estab. 1978. Arts & crafts show held annually the 3rd Saturday in October. Outdoors. Accepts photography and crafts. Juried based on uniqueness, quality of product, and overall display. Awards/prizes: plaque given to Best in Show; 2 Honorable Mentions receive ribbons. Number of exhibitors: 200. Public attendance: 7,000. Free to the public. Artists should apply by filling out application form. Deadline for entry: March. Space fee: $60. Exhibition space: 10×10 ft. For more information, artists should e-mail, visit Web site, call or send SASE.

NEW SMYRNA BEACH FIESTA

210 Sams Ave., New Smyrna Beach FL 32168. (386)424-2175. Fax: (386)424-2177. Web site: www.cityofnsb.com. **Contact:** Kimla Shelton, program coordinator. Estab. 1952. Arts & crafts

show held annually the last full weekend in February. Outdoors. Accepts photography, oil, acrylics, pastel, drawings, graphics, sculpture, crafts, watercolor. Awards/prizes: $10,800 prize money; $1,000/category; Honorable Mentions. Number of exhibitors: 250. Public attendance: 14,000. Free to the public. Artists should apply by calling to get on mailing list. Applications are always mailed out the day before Thanksgiving. Deadline for entry: until full. Application/space fee: $133.13. Exhibition space: 10 × 10 ft. For more information, artists should send SASE.

◩ PANOPLY ARTS FESTIVAL, PRESENTED BY THE ARTS COUNCIL, INC.

700 Monroe St. SW, Suite 2, Huntsville AL 35801. (256)519-2787. Fax: (256)533-3811. E-mail: tac@panoply.org. Web site: www.panoply.org; www.artshuntsville.org. Estab. 1982. Fine arts show held annually the last weekend in April. Also features music and dance. Outdoors. Accepts photography, painting, sculpture, drawing, printmaking, mixed media, glass, fiber. Juried by a panel of judges chosen for their in-depth knowledge and experience in multiple mediums, and who jury from slides or disks in January. Awards/prizes: Best of Show: $1,000; Award of Distinction: $500; Merit Awards: 5 awards, $200 each. Number of exhibitors: 60-80. Public attendance: 140,000 +. Public admission: weekend pass: $10; 1-day pass: $5; children 12 and under: free. Artists should e-mail, call or write for an application form, or check online through November 1. Deadline for entry: January. Application fee: $30. Space fee: $175 for space only; $375 including tent rental. Exhibition space: 10 × 10 ft. Average gross sales/exhibitor: $2,500. For more information, artists should e-mail.

PUNGO STRAWBERRY FESTIVAL

P.O. Box 6158, Virginia Beach VA 23456. (757)721-6001. Fax: (757)721-9335. E-mail: pungofestival@aol.com. Web site: www.PungoStrawberryFestival.info. **Contact:** Janet Dowdy, secretary of board. Estab. 1983. Arts & crafts show held annually on Memorial Day Weekend. Outdoors. Accepts photography and all media. Number of exhibitors: 60. Public attendance: 120,000. Free to the public; $5 parking fee. Artists should apply by calling for application or downloading a copy from the Web site. Deadline for entry: March 1; applications accepted from that point until all spaces are full. Application fee: $50 refundable deposit. Space fee: $175. Exhibition space: 10 × 10 ft. For more information, artists should e-mail, visit Web site or call.

◩ RIVERSIDE ART FESTIVAL

2623 Herschel St., Jacksonville FL 32204. (904)389-2449. Fax: (904)389-0431. E-mail: rap@fdn.com. Web site: www.Riverside-Avondale.com. **Contact:** Bonnie Grissett, executive director. Estab. 1972. Fine arts & crafts show held annually the weekend after Labor Day. Outdoors. Accepts photography and all fine art. Juried. Awards/prizes: $10,000 cash. Number of exhibitors: 150. Public attendance: 25,000. Free to the public. Artists should apply by sending name and address or by e-mailing for an application. Deadline for entry: June 15. Jury fee: $25 (nonrefundable). Space fee: $175. Exhibition space: 10 × 10 ft. For more information, artists should call or e-mail.

◩ SANDY SPRINGS FESTIVAL

135 Hilderbrand Dr., Sandy Springs GA 30328-3805. (404)851-9111. Fax: (404)851-9807. E-mail: info@sandyspringsfestival.com. Web site: www.sandyspringsfestival.com. **Contact:** Christy Nickles, special events director. Estab. 1985. Fine arts & crafts show held annually in mid-September. Outdoors. Accepts photography, painting, sculpture, jewelry, furniture, clothing. Juried by area professionals and nonprofessionals who are passionate about art. Awards/prizes: change annually; usually cash with additional prizes. Number of exhibitors: 100 +. Public attendance: 20,000. Public admission: $5. Artists should apply via application on Web site. Application fee: $10 ($35 for late registration). Space fee: $125. Exhibition space: 10 × 10 ft. Average gross sales/exhibitor: $1,000. For more information, artists should visit Web site.

Tips "Most of the purchases made at Sandy Springs Festival are priced under $100. The look of the booth and its general attractiveness are very important, especially to those who might not 'know' art."

SPRINGFEST

P.O. Box 831, Southern Pines NC 28387. (910)315-6508. E-mail: spba@earthlink.net. Web site: www.southernpines.biz. **Contact:** Susan Harrison, booth coordinator. Estab. 1979. Arts & crafts show held annually the last Saturday in April. Outdoors. Accepts photography and crafts. Number of exhibitors: 200. Public attendance: 8,000. Free to the public. Artists should apply by filling out application form. Deadline for entry: March. Space fee: $60. Exhibition space: 10×12 ft. For more information, artists should e-mail, visit Web site, call or send SASE.

N̲: STOCKLEY GARDENS FALL ARTS FESTIVAL

801 Boush St., Norfolk VA 23510. (757)625-6161. Fax: (757)625-7775. E-mail: jlong@hope-house. org. Web site: www.hope-house.org. **Contact:** Jenny Long, development coordinator. Estab. 1984. Fine arts & crafts show held annually the 3rd weekend in October. Outdoors. Accepts photography and all major fine art mediums. Juried. Number of exhibitors: 150. Public attendance: 30,000. Free to the public. Artists should apply by submitting application, jury and booth fees, 5 slides. Deadline for entry: July. Application fee: $15. Space fee: $225. Exhibition space: 10×10 ft. For more information, artists should e-mail, visit Web site or call.

MIDWEST & NORTH CENTRAL

AKRON ARTS EXPO

220 S. Balch St., Akron OH 44302. (330)375-2835. Fax: (330)375-2883. E-mail: recreation@ci.akro n.oh.us. Web site: www.ci.akron.oh.us. **Contact:** Yvette Davidson, community events coordinator. Estab. 1979. Fine arts & crafts show held annually in late July. Outdoors. Accepts photography, 2D art, functional craft, ornamental. Juried by 4 slides of work and 1 slide of display. Awards/prizes: $1,600 in cash awards and ribbons. Number of exhibitors: 165. Public attendance: 30,000+. Free to the public. Deadline for entry: March 31. Space fee: $150-180. Exhibition space: 15×15 ft. For more information, artists should e-mail or call.

ALLEN PARK ARTS & CRAFTS STREET FAIR

16850 Southfield, Allen Park MI 48101. (313)928-1370. Fax: (313)382-7946. **Contact:** Allen Park Festivities Commission. Estab. 1981. Arts & crafts show held annually the 1st Friday and Saturday in August. Outdoors. Accepts photography, sculpture, ceramics, jewelry, glass, wood, prints, drawings, paintings. Juried by 3 photos of work. Number of exhibitors: 400. Free to the public. Artists should apply by requesting an application form by December 31 of the previous year. Application fee: $5. Space fee: $100. Exhibition space: 10×10 ft. For more information, artists should call.

AMISH ACRES ARTS & CRAFTS FESTIVAL

1600 W. Market St., Nappanee IN 46550. (574)773-4188. Fax: (574)773-4180. E-mail: jenniwyson g@amishacres.com. Web site: www.amishacres.com. **Contact:** Jenni Wysong, marketplace coordinator. Estab. 1962. Arts & crafts show held annually the 1st full weekend in August. Outdoors. Accepts photography, crafts, floral, folk, jewelry, oil, acrylic, sculpture, textiles, watercolors, wearable, wood. Juried. Submit 5 images, either 35mm slides or digital images e-mailed. Awards/ prizes: $10,000 cash including Best of Show and $1,500 Purchase Prizes. Number of exhibitors: 350. Public attendance: 70,000. Public admission: $6; children under 12 free. Artists should apply by sending SASE or printing application from Web site. Deadline for entry: April 1. Space fee:

10×10 ft.: $485; 15×12 ft.: $675; 20×12 ft.: $1,095; 30×12 ft.: $1,695. Exhibition space: 120-300 sq. ft. Average gross sales/exhibitor: $7,000. For more information, artists should e-mail, visit Web site, call or send SASE.

Tips "Create a vibrant, open display that beckons to passing customers. Interact with potential buyers. Sell the romance of the purchase."

☙ ANNUAL ARTS & CRAFTS ADVENTURE AND ANNUAL ARTS & CRAFTS ADVENTURE II

P.O. Box 1326, Palatine IL 60078. (847)991-4748 or (312)751-2500. E-mail: asoa@webtv.net. Web site: www.americansocietyofartists.org. **Contact:** American Society of Artists—"anyone in the office can help." Estab. 1991. Fine arts & crafts show held biannually in May and September. Outdoors. Accepts photography, pottery, paintings, sculpture, glass, wood, woodcarving. Juried. Send 4 slides or photos of your work and 1 slide or photo of your display; SASE (No. 10); a résumé or show listing is helpful. Number of exhibitors: 75. Free to the public. Artists should apply by submitting jury materials. If juried in, you will receive a jury/approval number. Deadline for entry: 2 months prior to show or earlier if spaces fill. Space fee: $80. Exhibition space: approximately 100 sq. ft. for single space; other sizes available. For more information, artists should send SASE, submit jury material.

• Event held in Park Ridge, Illinois.

Tips "Remember that when you are at work in your studio, you are an artist. But when you are at a show, you are selling your work."

☙ ANNUAL ARTS & CRAFTS EXPRESSIONS

P.O. Box 1326, Palatine IL 60078. (847)991-4748 or (312)751-2500. E-mail: asoa@webtv.net. Web site: www.americansocietyofartists.org. **Contact:** American Society of Artists—"anyone in the office can help." Estab. 1998. Fine arts & crafts show held annually in late July. Outdoors. Accepts photography, sculpture, jewelry, glass works, woodworking and more. Juried. Send 4 slides or photos of your work and 1 slide or photo of your display; SASE (No. 10); a résumé or show listing is helpful. Number of exhibitors: 50. Free to the public. Artists should apply by submitting jury materials. If juried in, you will receive a jury/approval number. Deadline for entry: 2 months prior to show or earlier if spaces fill. Space fee: $155. Exhibition space: approximately 100 sq. ft. for single space; other sizes available. For more information, artsits should send SASE, submit jury material.

• Event held in Chicago, Illinois.

Tips "Remember that when you are at work in your studio, you are an artist. But when you are at a show, you are selling your work."

☙ ANNUAL ARTS ADVENTURE

P.O. Box 1326, Palatine IL 60078. (847)991-4748 or (312)571-2500. E-mail: asoa@webtv.net. Web site: www.americansocietyofartists.org. **Contact:** American Society of Artists—"anyone in the office can help." Estab. 2001. Fine arts & crafts show held annually at the end of July. Outdoors. Accepts photography, paintings, pottery, sculpture, jewelry and more. Juried. Send 4 slides or photos of your work and 1 slide or photo of your display; SASE (No. 10); a résumé or show listing is helpful. Number of exhibitors: 50. Free to the public. Artists should apply by submitting jury materials. If juried in, you will receive a jury/approval number. Deadline for entry: 2 months prior to show or earlier if spaces fill. Space fee: $125. Exhibition space: approximately 100 sq. ft. for single space; other sizes available. For more information, artists should send SASE, submit jury material.

• Event held in Chicago, Illinois.

Tips "Remember that when you are at work in your studio, you are an artist. But when you are at a show, you are selling your work."

☑ ANNUAL CRESTWOOD ARTS & CRAFTS ADVENTURE

P.O. Box 1326, Palatine IL 60078. (847)991-4748 or (312)751-2500. E-mail: asoa@webtv.net. Web site: www.americansocietyofartists.org. **Contact:** American Society of Artists—"anyone in the office can help." Estab. 1979. Arts & crafts show held annually in June and August. Outdoors. Accepts photography, paintings, jewelry, glassworks, quilting, graphics, woodworking, paperworks and more. Juried. Send 4 slides or photos of your work and 1 slide or photo of your display; SASE (No. 10); a résumé or show listing is helpful. Number of exhibitors: 150. Free to the public. Artists should apply by submitting jury materials. If juried in, you will receive a jury/approval number. Deadline for entry: 2 months prior to show or earlier if spaces fill. Space fee: $160. Exhibition space: approximately 100 sq. ft. for single space; other sizes available. For more information, artists should send SASE, submit jury material.

• Event held in St. Louis, Missouri.

Tips "Remember that when you are at work in your studio, you are an artist. But when you are at a show, you are selling your work."

☑ ANNUAL EDENS ART FAIR

P.O. Box 1326, Palatine IL 60078. (847)991-4748 or (312)2500. E-mail: asoa@webtv.net. Web site: www.americansocietyofartists.com. **Contact:** American Society of Artists—"anyone in the office can help." Estab. 1995 (after renovation of location; held many years prior to renovation). Fine arts & fine selected crafts show held annually in mid-July. Outdoors. Accepts photography, paintings, sculpture, glass works, jewelry. Juried. Send 4 slides or photos of your work and 1 slide or photo of your display; SASE (No. 10); a résumé or show listing is helpful. Number of exhibitors: 50. Free to the public. Artists should apply by submitting jury materials. If juried in, you will receive a jury/approval number. Deadline for entry: 2 months prior to show or earlier if spaces fill. Space fee: $130. Exhibition space: approximately 100 sq. ft. for single space; other sizes available. For more information, artists should send SASE, submit jury material.

• Event held in Willamette, Illinois.

Tips "Remember that when you are at work in your studio, you are an artist. But when you are at a show, you are selling your work."

☑ ANNUAL HYDE PARK ARTS & CRAFTS ADVENTURE

(formerly Annual White Oaks Arts & Crafts Adventure), P.O. Box 1326, Palatine IL 60078. (847)991-4748 or (312)751-2500. E-mail: asoa@webtv.net. Web site: www.americansocietyofartists.org. **Contact:** American Society of Artists—"anyone in the office can help." Estab. 2001. Arts & crafts show held twice a year in late May/early June and September. Outdoors. Accepts photography, paintings, glass, wood, fiber arts, hand-crafted candles, quilts, sculpture and more. Juried. Send 4 slides or photos of your work and 1 slide or photo of your display; SASE (No. 10); a résumé or show listing is helpful. Number of exhibitors: 50. Free to the public. Artists should apply by submitting jury materials. If juried in, you will receive a jury/approval number. Deadline for entry: 2 months prior to show or earlier if spaces fill. Space fee: $135. Exhibition space: approximately 100 sq. ft. for single space; other sizes are available. For more information, artists should send SASE, submit jury material.

• Event held in Chicago, Illinois.

Tips "Remember that when you are at work in your studio, you are an artist. But when you are at a show, you are selling your work."

☑ ANNUAL OAK PARK AVENUE-LAKE ARTS & CRAFTS SHOW

P.O. Box 1326, Palatine IL 60078. (847)991-4748 or (312)751-2500. E-mail: asoa@webtv.net. Web site: www.americansocietyofartists.org. **Contact:** American Society of Artists—"anyone in the office can help." Estab. 1974. Fine arts & crafts show held annually in mid-August. Outdoors.

Accepts photography, paintings, graphics, sculpture, glass, wood, paper, fiber arts, mosaics. Juried. Send 4 slides or photos of your work and 1 slide or photo of your display; SASE (No. 10); a résumé or show listing is helpful. Number of exhibitors: 150. Free to the public. Artists should apply by submitting jury materials. If juried in, you will receive a jury/approval number. Deadline for entry: 2 months prior to show or earlier if spaces fill. Space fee: $160. Exhibition space: approximately 100 sq. ft. for single space; other sizes available. For more information, artists should send SASE, submit jury material.

• Event held in Oak Park, Illinois.

Tips "Remember that when you are at work in your studio, you are an artist. But when you are at a show, you are selling your work."

ART IN THE PARK

8707 Forest Court, Warren MI 48093. (586)795-5471. E-mail: wildart@wowway.com. Web site: www.warrenfinearts.org. **Contact:** Paula Wild, chairperson. Estab. 1990. Fine arts & crafts show held annually the 2nd weekend in July. Indoors and outdoors. Accepts photography, sculpture, basketry, pottery, stained glass. Juried. Awards/prizes: 2D and 3D monetary awards. Number of exhibitors: 115. Public attendance: 7,500. Free to the public. Deadline for entry: May 16. Jury fee: $10. Space fee: $100/outdoor; $150/indoor. Exhibition space: 12×12 ft./tent; 10×10 ft./pavilion. For more information, artists should e-mail, visit Web site or send SASE.

AN ARTS & CRAFTS AFFAIR, AUTUMN & SPRING TOURS

P.O. Box 184, Boys Town NE 68010. (402)331-2889. Fax: (402)445-9177. E-mail: hpifestivals@cox.net. Web site: www.hpifestivals.com. **Contact:** Huffman Productions. Estab. 1983. An arts & crafts show that tours different cities and states. The Autumn Festival tours annually October-November; Spring Festival tours annually March-April. Artists should visit Web site to see list of states and schedule. Indoors. Accepts photography, pottery, stained glass, jewelry, clothing, wood, baskets. All artwork must be handcrafted by the actual artist exhibiting at the show. Juried by sending in 2 photos of work and 1 of display. Awards/prizes: 4 $30 show gift certificates; $50, $100 and $150 certificates off future booth fees. Number of exhibitors: 200-430 depending on location. Public attendance: 12,000-40,000. Public admission: $6-7/adults; $5-6/seniors; 10 and under, free. Artists should apply by calling to request an application. Deadline for entry: varies for date and location. Space fee: $220-550. Exhibition space: 8×11 ft. up to 8×22 ft. For more information, artists should e-mail, visit Web site, call or send SASE.

Tips "Have a nice display, make sure business name is visible, dress professionally, have different price points, and be willing to talk to your customers."

ARTS EXPRESSIONS

(formerly Annual Northwoods Arts & Crafts Expressions), P.O. Box 1326, Palatine IL 60078. (847)991-4748 or (312)751-2500. E-mail: asoa@webtv.net. Web site: www.americansocietyofartists.org. Estab. 2003. Fine arts & crafts show held in summer. Outdoors. Accepts photography, paintings, graphics, sculpture, quilting, woodworking, fiber art, hand-crafted candles, glass works, jewelry, etc. Juried. Send 4 slides/photos representative of work being exhibited; 1 photo of display set-up; #10 SASE; résumé with 7 show listings helpful. Number of exhibitors: 50. Free to the public. Artists should apply by submitting jury material and indicating interest in this particular show. When you pass the jury, you will receive jury approval number and application you requested. Deadline for entry: 2 months prior to show or earlier if space is filled. Space fee: to be announced. Exhibition space: 100 sq. ft. for single space; other sizes are available. For more information, artists should send SASE to submit jury material.

• Event held in Chicago, Illinois.

Tips "Remember that when you are at work in your studio, you are an artist. But when you are at a show, you are selling your work."

☑ ARTS ON THE GREEN

2603 Curry Dr., Crestwood KY 40014. (502)243-9879. E-mail: judyanded2@peoplepc.com. Web site: www.oldhamcountyarts.com. **Contact:** Judy Wegenast, show coordinator. Estab. 2001. Fine arts & crafts show held annually the 1st weekend in June. Outdoors. Accepts photography, painting, clay, sculpture, metal, wood, fabric, glass, jewelry. Juried by a panel. Awards/prizes: Best of Show and category awards. Number of exhibitors: 100. Public attendance: 7,500. Free to the public. Artists should apply online or call. Deadline for entry: March. Application and space fees to be determined. Exhibition space: 12×12 ft. For more information, artists should e-mail, visit Web site or call.

Tips "Make potential customers feel welcome in your space. Don't overcrowd your work. Smile!"

Ⓝ ☑ AUTUMN FESTIVAL, AN ARTS & CRAFTS AFFAIR

P.O. Box 184, Boys Town NE 68010. (402)331-2889. Fax: (402)445-9177. E-mail: hpifestivals@cox.net. Web site: www.hpifestivals.com. **Contact:** Huffman Productions. Estab. 1986. Fine arts & crafts show held annually in October. Indoors. Accepts photography, pottery, jewelry, wood. All must be handcrafted by the exhibitor. Juried by 2 photos of work and 1 of disply. Awards/prizes: $420 total cash awards. Number of exhibitors: 300. Public attendance: 16,000. Public admission: $6. Artists should apply by calling for an application. Deadline: when full or by the end of September. Space fee: $400. Exhibition space: 8×11 ft. ("We provide pipe and drape plus 500 watts of power." For more information, artists should e-mail, visit Web site, call or send SASE.

Tips "Have a nice display; dress professionally; have various price points; be willing to talk to your customers; display your business name."

☑ BLACK SWAMP ARTS FESTIVAL

P.O. Box 532, Bowling Green OH 43402. (419)354-2723. E-mail: info@blackswamparts.org. Web site: www.blackswamparts.org. **Contact:** Tim White, visual arts committee. Estab. 1993. Fine arts & crafts show held annually the weekend after Labor Day. Outdoors. Accepts photography, ceramics, drawing, enamel, fiber, glass, jewelry, leather, metal, mixed media, painting, paper, prints, sculpture, wood. Juried by unaffiliated, hired jurors. Awards/prizes: Best in Show, 2nd Place, 3rd Place, Honorable Mention, Painting Prize. Number of exhibitors: juried: 110; invitational: 40. Public attendance: 60,000. Free to the public. Artists should apply by visiting Web site. Deadline for entry: juried: April; invitational: June or until filled. Application fee: juried: $225; invitational: $120. Exhibition space: 10×10 ft. For more information, artists should visit Web site, call (voicemail only) or e-mail.

Tips "Offer a range of prices, from $5 to $500."

☑ CAIN PARK ARTS FESTIVAL

40 Severance Circle, Cleveland Heights OH 44118-9988. (216)291-3669. Fax: (216)3705. E-mail: jhoffman@clvhts.com. Web site: www.cainpark.com. **Contact:** Janet Hoffman, administrative assistant. Estab. 1976. Fine arts & crafts show held annually the 2nd full week in July. Outdoors. Accepts photography, painting, clay, sculpture, wood, jewelry, leather, glass, ceramics, clothes and other fiber, paper, block printing. Juried by a panel of professional artists; submit 5 slides. Awards/prizes: cash prizes of $750, $500 and $250; also Judges' Selection, Director's Choice and Artists' Award. Number of exhibitors: 155. Public attendance: 60,000. Free to the public. Artists should apply by requesting an application by mail, visiting Web site to download application, or by calling. Deadline for entry: March. Application fee: $25. Space fee: $350. Exhibition space: 10×10 ft. Average gross sales/exhibitor: $4,000. For more information, artists should e-mail, visit Web site or call.

Tips "Have an attractive booth to display your work. Have a variety of prices. Be available to answer questions about your work."

CENTERVILLE/WASHINGTON TOWNSHIP AMERICANA FESTIVAL

P.O. Box 41794, Centerville OH 45441-0794. (937)433-5898. Fax: (937)433-5898. E-mail: america nafestival@sbcglobal.net. Web site: www.americanafestival.org. **Contact:** Patricia Fleissner, arts & crafts chair. Estab. 1972. Arts & crafts show held annually on the Fourth of July. Festival includes entertainment, parade, food, car show and other activities. Accepts photography and all mediums. "No factory-made items accepted." Awards/prizes: 1st Place; 2nd Place; 3rd Place; certificates and ribbons for most attractive displays. Number of exhibitors: 275-300. Public attendance: 70,000. Free to the public. Artists should send SASE for application form or apply online. Deadline for entry: June. "Main Street is usually full by early June." Space fee: $45. Exhibition space: 12×10 ft. For more information, artists should e-mail, visit Web site or call.

Tips "Artists should have moderately priced items, bring business cards, and have an eye-catching display."

COUNTRY ARTS & CRAFTS FAIR

N104 W14181 Donges Bay Rd., Germantown WI 53022. (262)251-0604. E-mail: stjohnucc53022@ sbcglobal.net. **Contact:** Mary Ann Toth, booth chairperson. Estab. 1975. Arts & crafts show held annually in September. Indoors and outdoors. Limited indoor space; unlimited outdoor booths. Accepts photography, jewelry, clothing, country crafts. Number of exhibitors: 70. Public attendance: 500-600. Free to the public. Artists should e-mail for an application and state permit. Space fee: $10 for youth; $30 for outdoor; $40 for indoor. Exhibition space: 10×10 ft. and 15×15 ft. For more information, artists should e-mail or call Mary Ann Toth or Amy Green, or send SASE.

⚑ CUNEO GARDENS ART FESTIVAL

3417 R.F.D., Long Grove IL 60047. Phone/Fax: (847)726-8669. E-mail: dwevents@comcast.net. Web site: www.dwevents.org. **Contact:** D & W Events, Inc. Estab. 2005. Fine arts & crafts show. Outdoors. Accepts photography, fiber, oil, acrylic, watercolor, mixed media, jewelry, sculpture, metal, paper, painting. Juried by 3 jurors. Awards/prizes: Best of Show; 1st and 2nd Places; and Honorable Mentions. Number of exhibitors: 100. Public attendance: 10,000. Free to the public. Artists should apply by downloading application from Web site. Deadline for entry: March 1. Application fee: $25. Space fee: $250. Exhibition space: 100 sq. ft. For more information, artists should e-mail, visit Web site or call.

Tips "Artists should display professionally and attractively, and interact positively with everyone."

⚑ DEERFIELD FINE ARTS FESTIVAL

3417 R.F.D., Long Grove IL 60047. Phone/Fax: (847)726-8669. E-mail: dwevents@comcast.net. Web site: www.dwevents.org. **Contact:** D & W Events, Inc. Estab. 2000. Fine arts & crafts show held annually in early June. Outdoors. Accepts photography, fiber, oil, acrylic, watercolor, mixed media, jewelry, sculpture, metal, paper, painting. Juried by 3 jurors. Awards/prizes: Best of Show; 1st and 2nd Places; and Honorable Mentions. Number of exhibitors: 120. Public attendance: 35,000. Free to the public. Artists should apply by downloading application from Web site. Deadline for entry: March 1. Application fee: $25. Space fee: $275. Exhibition space: 100 sq. ft. For more information, artists should e-mail, visit Web site or call.

Tips "Artists should display professionally and attractively, and interact positively with everyone."

Ⓝ ⚑ DELAWARE ARTS FESTIVAL

P.O. Box 589, Delaware OH 43015. (740-)363-2695. E-mail: info@delawareartsfestival.org. Web site: www.delawareartsfestival.org. **Contact:** Tom King. Estab. 1973. Fine arts & crafts show

held annually the Saturday and Sunday after Mother's Day. Outdoors. Accepts photography; all mediums, but no buy/sell. Juried by committee members who are also artists. Awards/prizes: ribbons, cash awards, free booth for the following year. Number of exhibitors: 160. Public attendance: 25,000. Free to the public. Artists should apply by visiting Web site for application. Application fee: $10. Space fee: $125. Exhibition fee: 120 sq. ft. For more information, artists should e-mail or visit Web site.

Tips "Have high-quality stuff. Engage the public. Set up a good booth."

FERNDALE ART SHOW
Integrity Shows, 2102 Roosevelt, Ypsilanti MI 48197. (734)216-3958. Fax: (734)482-2070. E-mail: mark@integrityshows.com. Web site: www.downtownferndale.com. **Contact:** Mark Loeb, president. Estab. 2004. Fine arts & crafts show held annually in September. Outdoors. Accepts photography and all fine art and craft mediums; emphasis on fun, funky work. Juried by 3 independent jurors. Awards/prizes: Purchase Awards and Merit Awards. Number of exhibitors: 90. Public attendance: 30,000. Free to the public. Application is available in March. Deadline for entry: July. Application fee: $15. Space fee: $250. Exhibition space: 10×12 ft. For more information, artists should e-mail or call.

Tips "Be enthusiastic. Keep a mailing list. Develop collectors."

FLORA AND FAUNA ART SHOW
Integrity Shows, 2102 Roosevelt, Ypsilanti MI 48197. (734)216-3958. Fax: (734)482-2070. E-mail: mark@integrityshows.com. Web site: www.integrityshows.com. **Contact:** Mark Loeb, president. Estab. 2006. Fine arts & crafts show held annually in September. Outdoors. Accepts photography and all fine art and craft mediums; 75% of each artist's work must be related to flora or fauna. Juried by 3 independent jurors. Awards/prizes: Purchase Awards and Merit Awards. Number of exhibitors: 50. Public attendance: 10,000. Public admission: suggested donation: $5. Application is available in March. Deadline for entry: July. Application fee: $15. Space fee: $200. Exhibition space: 12×15 ft. For more information, artists should e-mail or call.

Tips "Be enthusiastic. Keep a mailing list. Develop collectors."

FOUR RIVERS ARTS & CRAFTS HARVEST HOME FESTIVAL
112 S. Lakeview Dr., Petersburg IN 47567. (812)354-6808, ext. 112. Fax: (812)354-2785. E-mail: rivers4@sigecom.net. **Contact:** Denise Tuggle, program assistant. Estab. 1976. Arts & crafts show held annually the 3rd weekend in October. Indoors. Juried. Board of Directors are assigned certain buildings to check for any manufactured items. Crafts are not judged. Awards/prizes: $30-50; 3 display awards based on display uniqueness and the correlation of the harvest theme. Number of exhibitors: 200. Public attendance: 5,000. Free to the public; $2 parking fee. Artists should apply by calling with information. Application will be mailed along with additional information. Deadline for entry: July 30. Space fee: $55, 2 per applicant. Exhibition space: 10×10 ft. For more information, artists should call.

GOOD OLD SUMMERTIME ART FAIR
P.O. Box 1753, Kenosha WI 53141-1753. (262)654-0065. E-mail: kaaartfairs@yahoo.com. Web site: www.KenoshaArtAssoc.org. **Contact:** Karen Gulbransen, art fair coordinator. Estab. 1975. Fine arts show held annually the 1st Sunday in June. Outdoors. Accepts photography, paintings, drawings, mosaics, ceramics, pottery, sculpture, wood, stained glass. Juried by a panel. Photos or slides required with application. Awards/prizes: Best of Show, 1st, 2nd and 3rd Places, plus Purchase Awards. Number of exhibitors: 100. Public attendance: 3,000. Free to the public. Artists should apply by completing application form, and including fees and SASE. Deadline for entry:

April 1. Application/space fee: $60-65. Exhibition space: 12×12 ft. For more information, artists should e-mail, visit Web site or send SASE.

Tips "Have a professional display, and be friendly."

[N] [V] HIGHWOOD FINE ART FESTIVAL

3417 R.F.D., Long Grove IL 60047. Phone/Fax: (847)726-8669. E-mail: dwevents@comcast.net. Web site: www.dwevents.org. **Contact:** D&W Events, Inc. Estab. 2007. Fine arts & crafts show. Outdoors. Accepts photography, fiber, oil, acrylic, watercolor, mixed media, jewelry, sculpture, metal, paper, painting. Juried by 3 jurors. Awards/prizes: Best of Show; 1st and 2nd Places; and Honorable Mentions. Number of exhibitors: 75. Public attendance: 15,000. Free to the public. Artists should apply by downloading application from Web site. Deadline for entry: March 1. Application fee: $25. Space fee: $250. Exhibition space: 100 sq. ft. For more information, artists should e-mail, visit Web site or call.

Tips "Artists should display professionally and attractively, and interact positively with everyone."

[V] HINSDALE FINE ARTS FESTIVAL

22 E. First St., Hinsdale IL 60521. (630)323-3952. Fax: (630)323-3953. E-mail: janet@hindsdalech amber.com. Web site: www.hinsdalechamber.com. **Contact:** Jan Anderson, executive director. Fine arts show held annually in mid-June. Outdoors. Accepts photography, ceramics, painting, sculpture, fiber arts, mixed media, jewelry. Juried by 3 slides. Awards/prizes: Best in Show, Presidents Award and 1st, 2nd and 3rd Places in 7 categories. Number of exhibitors: 150. Public attendance: 2,000-3,000. Free to the public. Artists should apply by mailing or downloading application from Web site. Deadline for entry: March 2. Application fee: $25. Space fee: $250. Exhibition space: 10×10 ft. For more information, artists should e-mail or visit Web site.

Tips "Original artwork sold by artist. Artwork should be appropriately and reasonably priced."

[V] KIA ART FAIR (KALAMAZOO INSTITUTE OF ARTS)

314 S. Park St., Kalamazoo MI 49007-5102. (269)349-7775. Fax: (269)349-9313. E-mail: sjrodia@y ahoo.com. Web site: www.kiarts.org. **Contact:** Steve Rodia, artist coordinator. Estab. 1951. Fine arts & crafts show held annually the 1st Saturday in June. Outdoors. Accepts photography, prints, pastels, drawings, paintings, mixed media, ceramics (functional and nonfunctional), sculpture/ metalsmithing, wood, fiber, jewelry, glass, leather. Juried by no fewer than 3 and no more than 5 art professionals chosen for their experience and expertise. See prospectus for more details. Awards/prizes: 1st prize: $500; 2nd prize: 2 at $300 each; 3rd prize: 3 at $200 each. Number of exhibitors: 200. Public attendance: 40,000-50,000. Free to the public. Artists should apply by filling out application form and submitting 4 35mm color slides of their art and 1 color slide of their booth display. Deadline for entry: March 1. Application fee: $20, nonrefundable. Space fee: $110. Exhibition space: 10×12 ft. Height should not exceed 10 ft. in order to clear the trees in the park. For more information, artists should e-mail, visit Web site or call.

[N] [V] MASON ARTS FESTIVAL

P.O. Box 381, Mason OH 45040. (513)573-9376. E-mail: pgast@cinci.rr.com for City Gallery; mraffel@cinci.rr.com for outdoor art festival. Web site: www.masonarts.org. **Contact:** Pat Gastreich, City Gallery Chairperson. Fine arts & crafts show held annually in September. Indoors and outdoors. Accepts photography, graphics, printmaking, mixed media, painting and drawing, ceramics, metal sculpture, fiber, glass, jewelry, wood, leather. Juried. Awards/prizes: $3,000 +$. Number of exhibitors: 75-100. Public attendance: 3,000-5,000. Free to the public. Artists should apply by visiting Web site for application, e-mailing mraffel@cinci.rr.com, or calling (513)573-0007. Deadline for entry: June. Application fee: $25. Space fee: $75 for single space; $135 for

adjoining spaces. Exhibition space: 12×12 ft.; artist must provide 10×10-ft. pop-up tent.

● City Gallery show is held indoors; these artists are not permitted to participate outdoors and vice versa. City Gallery is a juried show featuring approximately 30-50 artists who may show up to 2 pieces.

Tips "Photographers are required to disclose both their creative and printing processes. If digital manipulation is part of the composition, please indicate."

MICHIGAN STATE UNIVERSITY HOLIDAY ARTS & CRAFTS SHOW

322 MSU Union, East Lansing MI 48824. (517)355-3354. Fax: (517)432-2448. E-mail: uab@hfs.msu.edu. Web site: www.uabevents.com. **Contact:** Kate Lake, assistant manager. Estab. 1963. Arts & crafts show held annually the 1st weekend in December. Indoors. Accepts photography, basketry, candles, ceramics, clothing, sculpture, soaps, drawings, floral, fibers, glass, jewelry, metals, painting, graphics, pottery, wood. Juried by a panel of judges using the photographs submitted by each vendor to eliminate commercial products. Judges will evaluate on quality, creativity and crowd appeal. Number of exhibitors: 220. Public attendance: 15,000. Free to the public. Artists should apply online. Application will be available in July. Application fee: $240. Exhibition space: 8×5 ft. For more information, artists should visit Web site or call.

MICHIGAN STATE UNIVERSITY SPRING ARTS & CRAFTS SHOW

322 MSU Union, East Lansing MI 48824. (517)355-3354. Fax: (517)432-2448. E-mail: artsandcrafts @uabevents.com. Web site: www.uabevents.com. **Contact:** Kate Lake, assistant manager. Estab. 1963. Arts & crafts show held annually in mid-May. Outdoors. Accepts photography, basketry, candles, ceramics, clothing, sculpture, soaps, drawings, floral, fibers, glass, jewelry, metals, painting, graphics, pottery, wood. Juried by a panel of judges using the photographs submitted by each vendor to eliminate commercial products. Judges will evaluate on quality, creativity and crowd appeal. Number of exhibitors: 329. Public attendance: 60,000. Free to the public. Artists can apply online beginning in February. Online applications will be accepted until show is filled. Application fee: $240. Exhibition space: 10×10 ft. For more information, artists should visit Web site or call.

ORCHARD LAKE FINE ART SHOW

P.O. Box 79, Milford MI 48381-0079. (248)684-2613. Fax: (248)684-0195. E-mail: patty@hotworks .org. Web site: www.hotworks.org. **Contact:** Patty Narozny, show director. Estab. 2002. Fine arts & crafts show held annually the 1st weekend in August. Outdoors. Accepts photography, clay, glass, fiber, wood, jewelry, painting, prints, drawing, sculpture, metal, multimedia. Juried by 3 art professionals who view 3 slides of work and 1 of booth. Awards/prizes: $2,500 in awards: 1 Best of Show: $1,000; 2 Purchase Awards: $500 each; 5 Awards of Excellence: $100 each. Free to the public; parking: $5. Artists can obtain an application on the Web site, or they can call the show director who will mail them an application. Deadline for entry: March. Application fee: $25. Space fee: starts at $300. Exhibition space: 12×3 ft. "We allow room on either side of the tent, and some space behind the tent." For more information, artists should e-mail, visit Web site, call or send SASE.

Tips "Be attentive to your customers. Do not ignore anyone."

RILEY FESTIVAL

312 E. Main St. #C, Greenfield IN 46140. (317)462-2141. Fax: (317)467-1449. E-mail: info@rileyfe stival.com. Web site: www.rileyfestival.com. **Contact:** Sarah Kesterson, office manager. Estab. 1975. Fine arts & crafts show held annually in October. Outdoors. Accepts photography, fine arts, home arts, quilts. Juried. Awards/prizes: small monetary awards and ribbons. Number of exhibitors: 450. Public attendance: 75,000. Free to the public. Artists should apply by download-

ing application on Web site. Deadline for entry: September 15. Space fee: $160. Exhibition space: 10×10 ft. For more information, artists should visit Web site.

Tips "Keep arts priced for middle-class viewers."

N ☑ SPRING FESTIVAL, AN ARTS & CRAFTS AFFAIR

P.O. Box 184, Boys Town NE 68010. (402)331-2889. Fax: (402)445-9177. E-mail: hpifestivals@cox.net. Web site: www.hpifestivals.com. **Contact:** Huffman Productions. Estab. 2007. Fine arts & craft show held annually in March. Indoors. Accepts photography, pottery, jewelry, wood. All must be handcrafted by the exhibitor. Juried by 2 photos of work and 1 of disply. Awards/prizes: $420 total cash awards. Number of exhibitors: 180. Public attendance: 6,000-8,000. Public admission: $5. Artists should apply by calling for an application. Deadline: when full or by mid-March. Space fee: $220. Exhibition space: 10×10 ft. "We provide pipe and drape." For more information, artists should e-mail, visit Web site, call or send SASE.

Tips "Have a nice display; dress professionally; have various price points; be willing to talk to your customers; display your business name."

N ☑ ST. CHARLES FINE ART SHOW

213 Walnut St., St. Charles IL 60174. (630)513-5386. Fax: (630)513-6310. E-mail: bethany@dtown.org. Web site: www.stcharlesfineartshow.com. **Contact:** Bethany McFarland, marketing coordinator. Estab. 1999. Fine art fair held annually in late May. Outdoors. Accepts photography, painting, sculpture, glass, ceramics, jewelry, nonwearable fiber art. Juried by committee: submit 4 slides of art and 1 slide of booth/display. Awards/prizes: cash awards of $2,500+ awarded in several categories. Purchase Award Program: $14,000 of art has been purchased through this program since its inception in 2005. Number of exhibitors: 100. Free to the public. Artists should apply by downloading application from Web site or calling for application. Deadline for entry: February. Jury fee: $25. Space fee: $200. Exhibition space: 12×12 ft. For more information, artists should e-mail, visit Web site or call.

☑ ST. JAMES COURT ART SHOW

P.O. Box 3804, Louisville KY 40201. (502)635-1842. Fax: (502)635-1296. E-mail: mesrock@stjamescourtartshow.com. Web site: www.stjamescourtartshow.com. **Contact:** Marguerite Esrock, executive director. Estab. 1957. Annual fine arts & crafts show held the 1st full weekend in October. Accepts photography; has 16 medium categories. Juried in March; there is also a street jury held during the art show. Awards/prizes: Best of Show—3 places; $7,500 total prize money. Number of exhibitors: 340. Public attendance: 275,000. Free to the public. Artists should apply by visiting Web site and printing out an application (or via www.zapplication.org). Deadline for entry: March. Application fee: $30. Space fee: $400-500. Exhibition space: 10×12 ft. For more information, artists should e-mail or visit Web site.

Tips "Have a variety of price points. Don't sit in the back of the booth and expect sales."

☑ STREET FAIRE AT THE LAKES

P.O. Box 348, Detroit Lakes MN 56502. (800)542-3992. Fax: (218)847-9082. E-mail: dlchamber@visitdetroitlakes.com. Web site: www.visitdetroitlakes.com. **Contact:** Sue Brown, artist coordinator. Estab. 2001. Fine arts & crafts show held annually the 1st weekend after Memorial Day. Outdoors. Accepts photography, handmade/original artwork, wood, metal, glass, painting, fiber. Juried by anonymous scoring. Submit 5 slides: 4 of work and 1 of booth display. Top scores are accepted. Number of exhibitors: 125. Public attendance: 15,000. Free to the public. Artists should apply by downloading application from Web site. Deadline for entry: January 15. Application fee: $150-175. Exhibition space: 11×11 ft. For more information, artists should e-mail or call.

SUMMER ARTS AND CRAFTS FESTIVAL

UW-Parkside, 900 Wood Rd., Box 2000, Kenosha WI 53141. (262)595-2457. E-mail: eichner@uwp .edu. **Contact:** Mark Eichner, coordinator. Estab. 1990. Arts & crafts show held annually the 3rd week in June. Outdoors. Accepts photography, painting, glass, sculpture, woodwork, metal, jewelry, leather, quilts. Number of exhibitors: 200. Public attendance: 4,000. Free to the public. Artists should apply by calling or e-mailing for an application form. Deadline for entry: May. Space fee: $100. Exhibition space: 10 × 10 ft. For more information, artists should e-mail or call. **Tips** "Items priced less than $100 are excellent sellers."

SUMMERFAIR

2515 Essex Place, Studio 243, Cincinnati OH 45206. (513)531-0050. Fax: (513)531-0377. E-mail: exhibitors@summerfair.org. Web site: www.summerfair.org. **Contact:** Christina Waddle. Estab. 1968. Fine arts & crafts show held annually the weekend after Memorial Day. Outdoors. Accepts photography, ceramics, drawing/printmaking, fiber/leather, glass, jewelry, painting, sculpture/ metal, wood. Juried by a panel of judges selected by Summerfair, including artists and art educators with expertise in the categories offered at Summerfair. Submit 5 slides of artwork, including artist's name, dimensions of work, and arrow indicating top of work. "Do not submit a booth slide." Awards/prizes: $10,000 in cash awards. Number of exhibitors: 300. Public attendance: 35,000. Public admission: $9. Artists should apply by downloading application from Web site (available in December) or by e-mailing for an application. Deadline: February. Application fee: $25. Space fee: $325, single; $650, double; $75 canopy fee (optional—exhibitors can rent a canopy for all days of the fair). Exhibition space: 10 × 10 ft. for single space; 10 × 20 for double space. For more information, artists should e-mail, visit Web site or call.

UPTOWN ART FAIR

1406 West Lake St., Suite LLC, Minneapolis MN 55408. (612)823-4581. Fax: (612)823-3158. E-mail: info@uptownminneapolis.com. Web site: www.uptownminneapolis.com. **Contact:** Cindy Fitzpatrick. Estab. 1963. Fine arts & crafts show held annually the 1st full weekend in August. Outdoors. Accepts photography, painting, printmaking, drawing, 2D and 3D mixed media, ceramics, fiber, sculpture, jewelry, wood. Juried by 4 images of artwork and 1 of booth display. Awards/ prizes: Best in Show in each category; Best Artist. Number of exhibitors: 350. Public attendance: 350,000. Free to the public. Artists should apply by visiting www.zapplication.com. Deadline for entry: March. Application fee: $30. Space fee: $450 for 10 × 10 space; $900 for 10 × 20 space. For more information, artists should call or visit Web site.

WINNEBAGOLAND ART FAIR

South Park Ave./South Park, Oshkosh WI 54902. (920)303-1503. E-mail: shelling1230@charter.n et. Estab. 1957. Fine arts show held annually. Outdoors. Accepts photography, watercolor, oils, acrylics, 3D large, 3D small, drawing, pastels. Juried. Applicants send in slides to be reviewed. Awards/prizes: monetary awards, Purchase, Merit and Best of Show awards. Number of exhibitors: 125-160. Public attendance: 5,000-7,000. Free to the public. Deadline for entry: April 30. Application fee: $60, but may increase next year. Exhibition space: 20 × 20 ft. For more information, artists should e-mail or call.
Tips "Have a nice-looking exhibit booth."

WYANDOTTE STREET ART FAIR

3131 Biddle Ave., Wyandotte MI 48192. (734)324-4505. Fax: (734)324-4505. E-mail: info@wyan. org. Web site: www.wyandottestreetartfair.net. **Contact:** Lisa Hooper, executive director, Wyandotte Downtown Development Authority. Estab. 1961. Fine arts & crafts show held annually the 2nd week in July. Outdoors. Accepts photography, 2D mixed media, 3D mixed media, painting,

pottery, basketry, sculpture, fiber, leather, digital cartoons, clothing, stitchery, metal, glass, wood, toys, prints, drawing. Juried. Awards/prizes: Best New Artist: $500; Best Booth Design Award: $500; Best of Show: $1,200. Number of exhibitors: 300. Public attendance: 200,000. Free to the public. Artists should apply online. Deadline for entry: February. Application fee: $10 jury fee. Space fee: $250/single space; $500/double space. Exhibition space: 10 × 10 ft. Average gross sales/exhibitor: $2,000-$4,000. For more information, artists should e-mail, visit Web site, call or send SASE.

SOUTH CENTRAL & WEST

◪ AFFAIRE IN THE GARDENS ART SHOW

Greystone Park, 501 Doheny Rd., Beverly Hills CA 90210-2921. (310)550-4796. Fax: (310)858-9238. E-mail: kmclean@beverlyhills.org. Web site: www.beverlyhills.org. **Contact:** Karen Fitch McLean, art show coordinator. Estab. 1973. Fine arts & crafts show held biannually the 3rd weekend in May and 3rd weekend in October. Outdoors. Accepts photography, painting, sculpture, ceramics, jewelry, digital media. Juried. Awards/prizes: 1st Place in category, cash awards, Best in Show cash award; Mayor's Purchase Award in October show. Number of exhibitors: 225. Public attendance: 30,000-40,000. Free to the public. Deadline for entry: end of February, May show; end of July, October show. Application fee: $25. Space fee: $300. Exhibition space: 10 × 12 ft. For more information, artists should e-mail, visit Web site, call or send SASE.

Tips "Art fairs tend to be commercially oriented. It usually pays off to think in somewhat commercial terms—what does the public usually buy? Personally, I like risky and unusual art, but the artists who produce esoteric art sometimes go hungry! Be nice and have a clean presentation."

◪ ART IN THE PARK

P.O. Box 247, Sierra Vista AZ 85636-0247. (520) 378-1763. E-mail: artinthepark@cox.net. Web site: www.huachuco-art.com. **Contact:** Vendor Committee. Estab. 1972. Fine arts & crafts show held annually the 1st full weekend in October. Outdoors. Accepts photography, all fine arts and crafts created by vendor. Juried by 3-6 typical customers. Artists submit 6 photos. Number of exhibitors: 222. Public attendance: 20,000. Free to the public. Artists should apply by calling, e-mailing or sending SASE between February and May. Deadline for entry: postmarked by May 30. Application fee: $10 included in space fee. Space fee: $175, includes jury fee. Exhibition space: 15 × 35 ft. For more information, artists should e-mail, call or send SASE.

◪ AVON FINE ART & WINE AFFAIRE

15648 N. Eagles Nest Dr., Fountain Hills AZ 85268-1418. (480)837-5637. Fax: (480)837-2355. E-mail: info@thunderbirdartists.com. Web site: www.thunderbirdsartists.com. **Contact:** Denise Colter, vice president. Estab. 1993. Fine arts & crafts show and wine tasting held annually in mid-July. Outdoors. Accepts photography, painting, mixed media, bronze, metal, copper, stone, stained glass, clay, wood, paper, baskets, jewelry, scratchboard. Juried by 4 slides of work and 1 slide of booth. Number of exhibitors: 150. Public attendance: 3,000-6,000. Free to the public. Artists should apply by sending completed application, fees, 4 slides of work, 1 slide of booth and 2 SASEs. Deadline for entry: March 27. Application fee: $20. Space fee: $360-1,080. Exhibition space: 10 × 10 ft.-10 × 30 ft. For more information, artists should visit Web site.

◪ CALABASAS FINE ARTS FESTIVAL

26135 Mureau Rd., Calabasas CA 91302. (818)878-4225. E-mail: artcouncil@cityofcalabasas.com. Web site: www.cityofcalabasas.com. Estab. 1997. Fine arts & crafts show held annually in late April/early May. Outdoors. Accepts photography, painting, sculpture, jewelry, mixed media.

print

Subscribe and save 68%

Every issue of *PRINT*

- explores the art, influence, power and passion of visual communication

- takes you beyond the beauty and style to the ideas and points of view that drive today's designers

- connects you to the past, present and future of graphic design

Every issue of *PRINT* makes you a better designer

Use the post-paid card below to get a year of *PRINT* for only $37, the lowest rate available.

Subscribe now and save 68% off the newsstand price.

You'll get these 2 special issues...

A $39 value!

PLUS...

Your subscription includes 4 more issues covering everything from international graphics to the work of today's hottest talent in illustration, design, photography, and more. Issue after issue, you'll explore a broad spectrum of topics that demonstrate the significance of design and visual communication in our world today.

PRINT's Regional Design Annual
The most comprehensive yearly profile of graphic design in America, packed with the best, most current work in the country.

PRINT's European Design Annual
A portfolio of the finest work being created across the Continent, with commentary on national styles and international trends.

Get all 6 spectacular issues — a full year of *PRINT* — at the introductory rate of just $37. (Annual newsstand rate $116.85.)

Juried. Number of exhibitors: 250. Public attendance: 10,000+. Free to the public. For more information, artists should visit Web site or e-mail.

☒ CHUN CAPITOL HILL PEOPLE'S FAIR

1290 Williams St., Denver CO 80218. (303)830-1651. Fax: (303)830-1782. E-mail: chun@chunden ver.org. Web site: www.peoplesfair.com; www.chundenver.org. Estab. 1971. Arts & crafts show held annually the 1st weekend in June. Outdoors. Accepts photography, ceramics, jewelry, paintings, wearable art, glass, sculpture, wood, paper, fiber. Juried by professional artisans representing a variety of mediums and selected members of fair management. The jury process is based on originality, quality and expression. Awards/prizes: Best of Show. Number of exhibitors: 300. Public attendance: 250,000. Free to the public. Artists should apply by downloading application from Web site. Deadline for entry: March. Application fee: $35. Space fee: $300. Exhibition space: 10×10 ft. For more information, artists should e-mail, visit Web site or call.

☒ EDWARDS FINE ART & SCULPTURE FESTIVAL

15648 N. Eagles Nest Dr., Fountain Hills AZ 85268-1418. (480)837-5637. Fax: (480)837-2355. E-mail: info@thunderbirdartists.com. Web site: www.thunderbirdsartists.com. **Contact:** Denise Colter, vice president. Estab. 1999. Fine arts & sculpture show held annually in late July. Outdoors. Accepts photography, painting, drawing, graphics, fiber sculpture, mixed media, bronze, metal, copper, stone, stained glass, clay, wood, baskets, jewelry. Juried by 4 slides of work and 1 slide of booth presentation. Number of exhibitors: 115. Public attendance: 3,000-6,000. Free to the public. Artists should apply by sending completed application, fees, 4 slides of work, 1 slide of booth, and 2 SASEs. Deadline for entry: March 29. Application fee: $20. Space fee: $360-1,080. Exhibition space: 10×10 ft.-10×30 ft. For more information, artists should visit Web site.

☒ EVERGREEN ARTS FESTIVAL

P.O. Box 3931, Evergreen CO 80437-3931. (303)679-1609, option 1. E-mail: info@evergreenartists .org. Web site: http://www.evergreenartists.org/Shows_Festivals.htm. **Contact:** EAA Arts Festival Coordinator. Estab. 1966. Fine arts & crafts show held annually the last weekend in August. Outdoors. Accepts photography, fiber, oil, acrylic, pottery, jewelry, mixed media, ceramics, wood, watercolor. Juried by 5 jurors that change yearly. Artists should submit 4 slides of work and 1 of booth display. Awards/prizes: Best of Show; 1st, 2nd, 3rd Places in each category. Number of exhibitors: 96. Public attendance: 3,000-6,000. Free to the public. Deadline for entry: April 15. Application fee: $25. Space fee: $275-325. Exhibition space: 10×10 ft. For more information, artists should call or send SASE.

Tips "Have a variety of work. It is difficult to sell only high-ticket items."

N ☒ FOURTH AVENUE SPRING STREET FAIR

329 E. Seventh St., Tucson AZ 85705. (520)624-5004. Fax: (520)624-5933. E-mail: www.kurt@fou rthavenue.org. Web site: www.fourthavenue.org. **Contact:** Kurt Tallis, event director. Estab. 1970. Arts & crafts fair held annually in March. Outdoors. Accepts photography, drawing, painting, sculpture, arts and crafts. Juried by 5 jurors. Awards/prizes: Best of Show. Number of exhibitors: 400. Public attendance: 300,000. Free to the public. Artists should apply by completing the online application. Deadline for entry: December. Application fee: $35. Space fee: $425. Exhibition space: 10×10 ft. Average gross sales/exhibitor: $3,000. For more information, artists should e-mail, visit Web site, call or send SASE.

N ☒ FOURTH AVENUE WINTER STREET FAIR

329 E. Seventh St., Tucson AZ 85705. (520)624-5004. Fax: (520)624-5933. E-mail: www.kurt@fou rthavenue.org. Web site: www.fourthavenue.com. **Contact:** Kurt Tallis, event director. Estab.

1970. Arts & crafts fair held annually in December. Outdoors. Accepts photography, drawing, painting, sculpture, arts and crafts. Juried by 5 jurors. Awards/prizes: Best of Show. Number of exhibitors: 400. Public attendance: 300,000. Free to the public. Artists should apply by completing the online application. Deadline for entry: September. Application fee: $35. Space fee: $425. Exhibition space: 10×10 ft. Average gross sales/exhibitor: $3,000. For more information, artists should e-mail, visit Web site, call or send SASE.

HOME DECORATING & REMODELING SHOW

P.O. Box 230699, Las Vegas NV 89105-0699. (702)450-7984 or (800)343-8344. Fax: (702)451-7305. E-mail: spvandy@cox.net. Web site: www.nashvillehomeshow.com. **Contact:** Vandy Richards, manager member. Estab. 1983. Home show held annually in September. Indoors. Accepts photography, sculpture, watercolor, oils, mixed media, pottery. Awards/prizes: Outstanding Booth Award. Number of exhibitors: 300-350. Public attendance: 25,000. Public admission: $8. Artists should apply by calling. Marketing is directed to middle and above income brackets. Deadline for entry: open until filled. Space fee: $850 + . Exhibition space: 9×10 ft. or complement of 9×10 ft. For more information, artists should call.

⚑ KINGS MOUNTAIN ART FAIR

13106 Skyline Blvd., Woodside CA 94062. (650)851-2710. E-mail: kmafsecty@aol.com. Web site: www.kingsmountainartfair.org. **Contact:** Carrie German, administrative assistant. Estab. 1963. Fine arts & crafts show held annually Labor Day weekend. Accepts photography, ceramics, clothing, 2D, painting, glass, jewelry, leather, sculpture, textile/fiber, wood. Juried. Number of exhibitors: 135. Public attendance: 10,000. Free to the public. Deadline for entry: January 30. Application fee: $10. Space fee: $100 plus 15%. Exhibition space: 10×10 ft. Average gross sales/exhibitor: $3,000. For more information, artists should e-mail, visit Web site, call or send SASE.

⚑ LAKE CITY ARTS & CRAFTS FESTIVAL

P.O. Box 1147, Lake City CO 81235. (970)944-2706. E-mail: jlsharpe@centurytel.net. Web site: www.lakecityarts.org. **Contact:** Laura Sharpe, festival director. Estab. 1975. Fine arts/arts & crafts show held annually in mid-July. One-day event. Outdoors. Accepts photography, jewelry, metal work, woodworking, painting, handmade items. Juried by an undisclosed 4-member jury. Prize: Winners are entered in a drawing for a free booth space in the following year's show. Number of Exhibitors: 85. Public Attendance: 500. Free to the public. Deadline for entry: May 1. Application fee: $75. Exhibition space: 12×12 ft. Average gross sales/exhibitor: $500-$1,000. For more information, artists should visit Web site.

Tips "Repeat vendors draw repeat customers. People like to see their favorite vendors each year or every other year. If you come every year, have new things as well as your best-selling products."

⚑ LITCHFIELD LIBRARY ARTS & CRAFTS FESTIVAL

101 W. Wigwam Blvd., Litchfield Park AZ 85340. (623)935-5053. E-mail: tinalibrary@qwest.net. **Contact:** Tina Norwalk, administrator. Estab. 1970. Fine arts & crafts show held annually the 1st weekend in November. Outdoors. Accepts photography and all mediums. Juried. Number of exhibitors: 300. Public attendance: 125,000. Free to the public. Artists should apply by calling for application. Deadline for entry: April. Space fee: $300. Exhibition space: 10×15 ft. For more information, artists should call.

Tips "Have professional display and original art."

⚑ MID-MISSOURI ARTISTS CHRISTMAS ARTS & CRAFTS SALE

P.O. Box 116, Warrensburg MO 64093. (660)747-6092. E-mail: bjsmith@iland.net or rlimback@il and.net. **Contact:** Beverly Smith. Estab. 1970. Holiday arts & crafts show held annually in Novem-

ber. Indoors. Accepts photography and all original arts and crafts. Juried by 3 good-quality color photos (2 of the artwork, 1 of the display). Number of exhibitors: 50. Public attendance: 1,000. Free to the public. Artists should apply by e-mailing or calling for an application form. Deadline for entry: November. Space fee: $50. Exhibition space: 10×10 ft. For more information, artists should e-mail or call.

Tips ''Items under $100 are most popular.''

N ☑ NEW MEXICO ARTS & CRAFTS FAIR

5500 San Mateo NE, Suite 106, Albuquerque NM 87109. (505)884-9043. Fax: (505)884-9084. E-mail: info@nmartsandcraftsfair.org. Web site: www.nmartsandcraftsfair.org. **Contact:** Kristin Schuetz, office manager. Estab. 1962. Fine arts & craft show held annually in June. Indoors and outdoors. Accepts photography, ceramics, fiber, digital art, drawing, jewelry, printmaking, sculpture, wood, mixed media. **Only New Mexico residents 18 years and older are eligible.** Juried by 5 slides; 5 New Mexico artists are chosen each year to jury. Awards/prizes: total cash awards exceed $4,500; Best of Show: $1,500; First Lady's Choice; Jury Awards; Artist's Choice Award; Creativity Award; First-Time Exhibitor Award. Number of exhibitors: 220. Public admission: $10 for 3-day adult and senior pass; $5 for adult and senior daily admission; free to youth 12 and under. Artists should apply by downloading application from Web site or e-mailing for application. Deadline: January. Application fee: Jury fee of $25 per category entered. Space fee: 10×10 ft. (outdoor): $25; 10×10 ft. (indoor): $375; 10×10 ft. (outdoor, 2 exhibitors): $400; 10×10 ft. (indoor, 2 exhibitors): $450. For more information, artists should e-mail, visit Web site or call.

N ☑ OFFICIAL TEXAS STATE ARTS & CRAFTS FAIR

4000 Riverside Dr., Kerrville TX 78028. (830)896-5711. Fax: (830)896-5569. E-mail: fair@tacef.org. Web site: www.tacef.org. **Contact:** Penni Carr. Estab. 1972. Fine arts & crafts show held annually on Memorial Day weekend. Outdoors. Accepts photography, ceramics, fiber, glass, graphics/drawing, jewelry, leather, metal, mixed media, painting, sculpture, wood. Juried by a panel of professional artists and college art professors. Number of exhibitors: 160+. Public attendance: 16,000. Public admission: $10 for a 4-day pass. Artists should apply by downloading application from Web site. Deadline: December. Application fee: $20. Space fee: $300-600. Exhibition space: 10×10. ft. and 10×20 ft. For more information, artists should visit Web site.

Tips ''Market and advertise.''

☑ PASEO ARTS FESTIVAL

3022 Paseo, Oklahoma City OK 73103. (405)525-2688. Web site: www.ThePaseo.com. **Contact:** Lori Oden, executive director. Estab. 1976. Fine arts & crafts show held annually Memorial Day weekend. Outdoors. Accepts photography and all fine art mediums. Juried by 3 slides or CD. Awards/prizes: $1,000, Best of Show; $350, 2D; $350, 3D; $350, Best New Artist. Number of exhibitors: 75. Public attendance: 50,000-60,000. Free to the public. Artists should apply by calling for application form. Deadline for entry: March 1. Application fee: $25. Space fee: $250. Exhibition space: 10×10 ft. For more information, artists should visit Web site, call or send SASE.

☑ SANTA CALI GON DAYS FESTIVAL

P.O. Box 1077, Independence MO 64051. (816)252-4745. Fax: (816)252-4917. E-mail: tfreeland@independencechamber.org. Web site: www.santacaligon.com. **Contact:** Teresa Freeland, special projects assistant. Estab. 1940. Market vendors show held annually Labor Day weekend. Outdoors. Accepts photography, all other mediums. Juried by committee. Number of exhibitors: 240. Public attendance: 225,000. Free to the public. Artists should apply by requesting application. Application requirements include completed application, application fee, 4 photos of product/

art and 1 photo of display. Deadline for entry: March 6-April 7. Application fee: $20. Space fee: $330-430. Exhibition space: 8×8 ft.-10×10 ft. For more information, artists should e-mail, visit Web site or call.

N. ⚑ SAUSALITO ART FESTIVAL

P.O. Box 10, Sausalito CA 94966. (415)332-3555. Fax: (415)331-1340. E-mail: artfestonel@aol.com. Web site: www.sausalitoartfestival.org. **Contact:** Joseph Lillis, executive director. Estab. 1952. Fine arts & crafts show held annually Labor Day weekend. Outdoors. Accepts photography, 2D and 3D mixed media, ceramics, drawing, fiber, functional art, glass, jewelry, printmaking, sculpture, woodwork. Juried. Jurors are elected by their peers from the previous year's show (1 from each category). They meet the 1st weekend in April and give scores of 1, 2, 3, 4 or 5 to each applicant (5 being the highest). Awards/prizes: $500 for each 1st and 2nd Place in each category; optional $1,000 for Best in Show. Number of exhibitors: 270. Public attendance: 40,000. Public admission: $20; seniors (age 62+): $10; children (under 6): $5. Artists should apply by visiting Web site for instructions and application (http://www.sausalitoartfestival.org/artists.html). Deadline for entry: March. Application fee: $50. Space fee: $950-2,600. Exhibition space: 100 or 200 sq. ft. Average gross sales/exhibitor: $14,000. For more information, artists should visit Web site.

⚑ SIERRA MADRE WISTORIA FESTIVAL

78 W. Sierra Madre Blvd., Sierra Madre CA 91024. (626)355-5111. Fax: (626)306-1150. E-mail: info@sierramadrechamber.com. Web site: www.SierraMadrechamber.com. Estab. 100 years ago. Fine arts, crafts and garden show held annually in March. Outdoors. Accepts photography, anything handcrafted. Juried. Craft vendors send in application and photos to be juried. Awards/prizes: Sometimes newspapers will want to do special coverage of a particular artist. Number of exhibitors: 175. Public attendance: 12,000. Free to the public. Artists should apply by sending completed and signed application, 3-5 photographs of their work, application fee, license application, space fee and 2 SASEs. Deadline for entry: November 30. Application fee: $15. Space fee: $177. Exhibition space: 10×10 ft. For more information, artists should e-mail, visit Web site or call.

Tips "Have a clear and simple application. Be nice."

⚑ SOLANO AVENUE STROLL

1563 Solano Ave., #PMB 101, Berkeley CA 94707. (510)527-5358. E-mail: saa@solanoave.org. Web site: www.solanoave.org. **Contact:** Allen Cain, executive director. Estab. 1974. Fine arts & crafts show held annually the 2nd Sunday in September. Outdoors. Accepts photography and all other mediums. Juried by board of directors. Jury fee: $10. Number of exhibitors: 140 spaces for crafts; 600 spaces total. Public attendance: 300,000. Free to the public. Artists should apply online after April 1, or send SASE. Deadline for entry: June 1. Space fee: $10. Exhibition space: 10×10 ft. For more information, artists should e-mail, visit Web site or send SASE.

Tips "Artists should have a clean presentation; small-ticket items as well as large-ticket items; great customer service; enjoy themselves."

⚑ ST. GEORGE ART FESTIVAL

86 S. Main St., George UT 84770. (435)634-5850. Fax: (435)634-0709. E-mail: leisure@sgcity.org. Web site: www.sgcity.org. **Contact:** Carlene Garrick, administrator assistant. Estab. 1979. Fine arts & crafts show held annually Easter weekend (March or April). Outdoors. Accepts photography, painting, wood, jewelry, ceramics, sculpture, drawing, 3D mixed media, glass. Juried from slides. Awards/prizes: $5,000 Purchase Awards. Art pieces selected will be placed in the city's permanent collections. Number of exhibitors: 110. Public attendance: 20,000/day. Free to the

public. Artists should apply by sending completed application form, non-refundable application fee, slides or digital photos of 4 current works in each category and 1 of booth, and SASE. Deadline for entry: January 6. Application fee $20. Space fee: $125. Exhibition space: 10×11 ft. For more information, artists should e-mail.

Tips "Artists should have more than 50% originals; have quality booth and set-up to display art in best possible manner; be outgoing and friendly with buyers."

STRAWBERRY JUNCTION ARTS & CRAFTS SHOW

13858 N. Pumpkin Hollow, Proctoe OK 74457-3236. (918)456-0113. **Contact:** Cleva Smith, coordinator. Estab. 1985. Arts & crafts show held annually at various times throughout the year. Indoors. Accepts handmade arts and crafts and some photography. Juried by 3 photos. Number of exhibitors: 30-80. Free to the public. Artists should apply by contacting the coordinator. Deadline for entry: until full. Application fee: $60. Space fee: $160 per 10×10 ft. Exhibition space: 10×10 ft.-10×20 ft. Average gross sales/exhibitor: $800-1,500. For more information, artists should call or send SASE.

SUN FEST, INC.

P.O. Box 2404, Bartlesville OK 74005. (918)914-2826. Fax: (918)331-3351. E-mail: lhigbee@tctc.org. **Contact:** Laura Higbee, chair of board. Estab. 1982. Fine arts & crafts show held annually in early June. Outdoors. Accepts photography, painting and other arts and crafts. Juried. Awards/prizes: $2,000; Best of Show receives free booth rental for the following year. Number of exhibitors: 95-100. Number of attendees: 25,000-30,000. Free to the public. Artists should apply by e-mailing or calling for an entry form, or visiting Web site. Application fee: $125 ($150 for late application). Exhibition space: 10×10 ft. For more information, artists should e-mail, call or visit Web site.

TILLES ARTS & CRAFT FESTIVAL

9551 Litzsinger Rd., St. Louis MO 63124. (636)391-0922, ext. 12. Fax: (636)527-2259. E-mail: toconnell@stlouisco.com. Web site: www.stlouisco.com/parks. **Contact:** Tonya O'Connell, recreation supervisor. Fine arts & crafts show held biannually in May and September. Outdoors. Accepts photography, oil, acrylic, clay, fiber, sculpture, watercolor, jewelry, wood, floral, basket, print, drawing, mixed media. Juried by a committee. Awards/prizes: $100. Number of exhibitors: 90-100. Public attendance: 5,000. Public admission: $1. Deadline for entry: March, spring show; May, fall show. Application fee: $15. Space fee: $75. Exhibition space: 10×10 ft. For more information, artists should call.

TUBAC FESTIVAL OF THE ARTS

P.O. Box 1866, Tubac AZ 85646. (520) 398-2704. Fax: (520) 398-1704. E-mail: artfestival@tubacaz.com. Web site: www.tubacaz.com. Estab. 1960. Fine arts & crafts show held annually in early February. Outdoors. Accepts photography and considers all fine arts and crafts. Juried. A 7-member panel reviews applicants' slides and artists' statements. Jury process is blind—applicants' names are withheld from the judges. Average number of exhibitors: 170. Public attendance: 50,000. Free to the public; parking: $5. Deadline for entry: mid-October. Application fee: $25. Space fee: $575. Exhibition space: 10×10 ft. For more information, artists should e-mail, visit Web site, call or send SASE.

TULSA INTERNATIONAL MAYFEST

321 S. Boston #101, Tulsa OK 74103. (918)582-6435. Fax: (918)587-7721. E-mail: comments@tulsamayfest.org. Web site: www.tulsamayfest.org. Estab. 1972. Fine arts & crafts show annually held in May. Outdoors. Accepts photography, clay, leather/fiber, mixed media, drawing, pastels,

graphics, printmaking, jewelry, glass, metal, wood, painting. Juried by a blind jurying process. Artists should submit 4 slides of work and 1 of booth set-up. Awards/prizes: Best in Category and Best in Show. Number of exhibitors: 120. Public attendance: 350,000. Free to the public. Artists should apply by downloading application from Web site in late November. Deadline for entry: January 16. Application fee: $35. Space fee: $300. Exhibition space: 10×10 ft. For more information, artists should e-mail or visit Web site.

NORTHWEST & CANADA

⚏ ANACORTES ARTS FESTIVAL

505 "O" St., Anacortes WA 98221. (360)293-6211. E-mail: info@anacortesartsfestival.com. Web site: www.anacortesartsfestival.com. **Contact:** Mary Leone. Fine arts & crafts show held annually the 1st full weekend in August. Accepts photography, painting, drawings, prints, ceramics, fiber art, paper art, glass, jewelry, sculpture, yard art, woodworking. Juried by projecting 3 images on a large screen. Works are evaluated on originality, quality and marketability. Each applicant must provide 3 high-quality digital images or slides—2 of the product and 1 of the booth display. Awards/prizes: over $4,000 in prizes. Number of exhibitors: 250. Artists should apply by visiting Web site for online submission or by mail (there is a $25 processing fee for application by mail). Deadline for entry: early March. Booth fee: $300. For more information, artists should see Web site.

⚏ ANNUAL ARTS & CRAFTS FAIR

Pend Oreille Arts Council, P.O. Box 1694, Sandpoint ID 83864. (208)263-6139. E-mail: art@sandpoint.net. Web site: www.ArtinSandpoint.org. Estab. 1962. Arts & crafts show held annually in August. Outdoors. Accepts photography and all handmade, noncommercial works. Juried by 8-member jury. Number of exhibitors: 100. Public attendance: 5,000. Free to the public. Artists should apply by sending in application. Deadline for entry: May 1. Application fee: $15. Space fee: $150-230, no commission. Exhibition space: 10×10 ft. or 10×15 ft. For more information, artists should e-mail, visit Web site, call or send SASE.

⚏ ART & JAZZ ON BROADWAY

P.O. Box 583, Philipsburg MT 59858. **Contact:** Sherry Armstrong at hitchinpost@blackfoot.net or (406)859-0366, or Liz Willett at kokopellilane@mac.com or (406)859-3189. Estab. 2000. Fine arts/jazz show held annually in August. Outdoors. Accepts photography and handcrafted, original, gallery-quality fine arts and crafts media made by selling artist. Juried by Flint Creek Valley Arts Council. Number of exhibitors: 75. Public attendance: 1,500-2,000. Public admission: donation to Flint Creek Valley Arts Council. Artists should e-mail or call for an entry form. Application fee: $45. Exhibtion space: 10×10 ft. For more information, artists should e-mail or call.

Tips "Be prepared for temperatures of 100 degrees or rain. Display in a professional manner. Friendliness is crucial; fair pricing is essential."

⚏ THE CRAFTSMEN'S CHRISTMAS ARTS & CRAFTS SHOW

P.O. Box 494, Black Eagle MT 59414-0494. (406)453-3120. E-mail: giskaasent@bresnan.net. **Contact:** Sue Giskaas, owner/promoter. Estab. 2005. Arts & crafts show held annually the 1st Friday and Saturday in November. Indoors. Accepts photography, anything handmade, no resale. Juried by management selects. Number of exhibitors: 85. Public attendance: 5,000. Public admission: $2. Artists should apply by sending SASE to above address. Deadline for entry: October 1. Space fee: $125. Exhibition space: 10×10 ft. For more information, artists should e-mail, call or send SASE.

STRAWBERRY FESTIVAL

2815 Second Ave. N., Billings MT 59101. (406)259-5454. Fax: (406)294-5061. E-mail: lisaw@dow ntownbillings.com. Web site: www.strawberryfun.com. **Contact:** Lisa Woods, executive director. Estab. 1991. Fine arts & crafts show held annually the 2nd Saturday in June. Outdoors. Accepts photography. Juried. Number of exhibitors: 76. Public attendance: 15,000. Free to the public. Artists should apply by application available on Web site. Deadline for entry: April 14. Exhibition space: 12 × 12 ft. For more information, artists should visit Web site.

TULIP FESTIVAL STREET FAIR

P.O. Box 1801, Mt. Vernon WA 98273. (360)226-9277. E-mail: dwntwnmv@cnw.com. Web site: www.downtownmountvernon.com. **Contact:** Executive Director. Estab. 1984. Arts & crafts show held annually the 3rd weekend in April. Outdoors. Accepts photography and original artists' work only. No manufactured work. Juried by a board. Jury fee: $10 with application and prospectus. Number of exhibitors: 215-220. Public attendance: 20,000-25,000. Free to the public. Artists should apply by calling or e-mailing. Deadline for entry: January 30. Application fee: $10. Flat fee: $300. Exhibition space: 10 × 10 ft. Average gross sales/exhibitor: $2,500-4,000. For more information, artists should e-mail, visit Web site, call or send SASE.
Tips "Keep records of your street fair attendance and sales for résumé. Network with other artists about which street fairs are better to return to or apply for."

WHITEFISH ARTS FESTIVAL

P.O. Box 131, Whitefish MT 59937. (406)862-5875. Fax: (406)862-3515. Web site: www.whitefish artsfestival.org. **Contact:** Rachael Knox, coordinator. Estab. 1979. Fine arts & crafts show held annually the 1st full weekend in July. Outdoors. Accepts photography, pottery, jewelry, sculpture, paintings, woodworking. Juried. Art must be original and handcrafted. Work is evaluated for creativity, quality and originality. Awards/prizes: Best of Show awarded half-price booth fee for following year with no application fee. Number of exhibitors: 100. Public attendance: 3,000. Free to the public. Deadline for entry: April 14. Application fee: $20. Space fee: $195. Exhibition space: 10 × 10 ft. For more information, artists should e-mail, visit Web site or call.
Tips Recommends "variety of price range, professional display, and early application for special requests."

Grants

State, Provincial & Regional

A rts councils in the United States and Canada provide assistance to artists in the form of fellowships or grants. These grants can be substantial and confer prestige upon recipients; however, **only state or province residents are eligible**. Because deadlines and available support vary annually, query first (with a SASE) or check Web sites for guidelines.

UNITED STATES ARTS AGENCIES

Alabama State Council on the Arts, 201 Monroe St., Montgomery AL 36130-1800. (334)242-4076. E-mail: staff@arts.alabama.gov. Web site: www.arts.state.al.us.

Alaska State Council on the Arts, 411 W. Fourth Ave., Suite 1-E, Anchorage AK 99501-2343. (907)269-6610 or (888)278-7424. E-mail: aksca_info@eed.state.ak.us. Web site: www.eed. state.ak.us/aksca.

Arizona Commission on the Arts, 417 W. Roosevelt St., Phoenix AZ 85003-1326. (602)771-6501. E-mail: info@azarts.gov. Web site: www.azarts.gov.

Arkansas Arts Council, 1500 Tower Bldg., 323 Center St., Little Rock AR 72201. (501)324-9766. E-mail: info@arkansasarts.com. Web site: www.arkansasarts.com.

California Arts Council, 1300 I St., Suite 930, Sacramento CA 95814. (916)322-6555. E-mail: info@caartscouncil.com. Web site: www.cac.ca.gov.

Colorado Council on the Arts, 1625 Broadway, Suite 2700, Denver CO 80202. (303)892-3802. E-mail: online form. Web site: www.coloarts.state.co.us.

Connecticut Commission on Culture & Tourism, Arts Division, One Financial Plaza, 755 Main St., Hartford CT 06103. (860)256-2800. Web site: www.cultureandtourism.org.

Delaware Division of the Arts, Carvel State Office Bldg., 4th Floor, 820 N. French St., Wilmington DE 19801. (302)577-8278 (New Castle County) or (302)739-5304 (Kent or Sussex Counties). E-mail: delarts@state.de.us. Web site: www.artsdel.org.

District of Columbia Commission on the Arts & Humanities, 2901 14th St. NW, 1st Floor, Washington DC 20010. (202)724-5613. E-mail: cah@dc.gov. Web site: www.dca rts.dc.gov.

Florida Division of Cultural Affairs, R.A. Gray Building, 3rd Floor, 500 S. Bronough St., Tallahassee FL 32399-0250. (850)245-6470. E-mail: info@florida-arts.org. Web site: www. florida-arts.org.

Georgia Council for the Arts, 260 14th St. NW, Suite 401, Atlanta GA 30318. (404)685-2787. E-mail: gaarts@gaarts.org. Web site: www.gaarts.org.

Guam Council on the Arts & Humanities, P.O. Box 2950, Tiyan GU 96932. (671)475-2242. E-mail: arts@ns.gov.nu. Web site: www.guam.net.

Hawai'i State Foundation on Culture & the Arts, 250 S. Hotel St., 2nd Floor, Honolulu HI 96813. (808)586-0300. E-mail: ken.hamilton@hawaii.gov. Web site: www.state.hi.us/sfca.

Idaho Commission on the Arts, P.O. Box 83720, Boise ID 83720-0008. (208)334-2119 or (800)278-3863. E-mail: info@arts.idaho.gov. Web site: www.arts.idaho.gov.

Illinois Arts Council, James R. Thompson Center, 100 W. Randolph, Suite 10-500, Chicago IL 60601. (312)814-6750. E-mail: iac.info@illinois.gov. Web site: www.state.il.us/agency/iac.

Indiana Arts Commission, 150 W. Market St., Suite 618, Indianapolis IN 46204. (317)232-1268. E-mail: IndianaArtsCommission@iac.in.gov. Web site: www.in.gov/arts.

Iowa Arts Council, 600 E. Locust, Des Moines IA 50319-0290. (515)281-6412. Web site: www.iowaartscouncil.org.

Kansas Arts Commission, 700 SW Jackson, Suite 1004, Topeka KS 66603-3761. (785)296-3335. E-mail: kac@arts.ks.gov. Web site: http://arts.state.ks.us.

Kentucky Arts Council, 21st Floor, Capital Plaza Tower, 500 Mero St., Frankfort KY 40601-1987. (502)564-3757 or (888)833-2787. E-mail: kyarts@ky.gov. Web site: www.artscouncil.ky.gov.

Louisiana Division of the Arts, P.O. Box 44247, Baton Rouge LA 70804. (225)342-6083. E-mail: arts@crt.state.la.us. Web site: www.crt.state.la.us/arts.

Maine Arts Commission, 193 State St., 25 State House Station, Augusta ME 04333-0025. (207)287-2724. E-mail: MaineArts.info@maine.gov. Web site: http://mainearts.maine.gov.

Maryland State Arts Council, 175 W. Ostend St., Suite E, Baltimore MD 21230. (410)767-6555. E-mail: msac@msac.org. Web site: www.msac.org.

Massachusetts Cultural Council, 10 St. James Ave., 3rd Floor, Boston MA 02116-3803. (617)727-3668. E-mail: mcc@art.state.ma.us. Web site: www.massculturalcouncil.org.

Michigan Council for Arts & Cultural Affairs, 702 W. Kalamazoo St., P.O. Box 30705, Lansing MI 48909-8205. (517)241-4011. E-mail: artsinfo@michigan.gov. Web site: www.michigan.gov/hal/0,1607,7-160-17445_19272---,00.html.

Minnesota State Arts Board, Park Square Court, Suite 200, 400 Sibley St., St. Paul MN 55101-1928. (651)215-1600 or (800)866-2787. E-mail: msab@arts.state.mn.us. Web site: www.arts.state.mn.us.

Mississippi Arts Commission, 501 N. West St., Suite 701B, Woolfolk Bldg., Jackson MS 39201. (601)359-6030. Web site: www.arts.state.ms.us.

Missouri Arts Council, 815 Olive St., Suite 16, St. Louis MO 63101-1503. (314)340-6845 or (866)407-4752. E-mail: moarts@ded.mo.gov. Web site: www.missouriartscouncil.org.

Montana Arts Council, 316 N. Park Ave., Suite 252, Helena MT 59620-2201. (406)444-6430. E-mail: mac@mt.gov. Web site: http://art.mt.gov.

Resources

National Assembly of State Arts Agencies, 1029 Vermont Ave. NW, 2nd Floor, Washington DC 20005. (202)347-6352. E-mail: nasaa@nasaa-arts.org. Web site: www.nasaa-arts.org.

Nebraska Arts Council, 1004 Farnam St., Plaza Level, Omaha NE 68102. (402)595-2122 or (800)341-4067. Web site: www.nebraskaartscouncil.org.

Nevada Arts Council, 716 N. Carson St., Suite A, Carson City NV 89701. (775)687-6680. E-mail: online form. Web site: http://dmla.clan.lib.nv.us/docs/arts.

New Hampshire State Council on the Arts, 2½ Beacon St., 2nd Floor, Concord NH 03301-4974. (800)735-2964. Web site: www.nh.gov/nharts.

New Jersey State Council on the Arts, 225 W. State St., P.O. Box 306, Trenton NJ 08625. (609)292-6130. Web site: www.njartscouncil.org.

New Mexico Arts, Dept. of Cultural Affairs, P.O. Box 1450, Santa Fe NM 87504-1450. (505)827-6490 or (800)879-4278. Web site: www.nmarts.org.

New York State Council on the Arts, 175 Varick St., New York NY 10014. (212)627-4455. Web site: www.nysca.org.

North Carolina Arts Council, 109 East Jones St., Cultural Resources Building, Raleigh NC 27601. (919)807-6500. E-mail: ncarts@ncmail.net. Web site: www.ncarts.org.

North Dakota Council on the Arts, 1600 E. Century Ave., Suite 6, Bismarck ND 58503. (701)328-7590. E-mail: comserv@state.nd.us. Web site: www.state.nd.us/arts.

Commonwealth Council for Arts and Culture (Northern Mariana Islands), P.O. Box 5553, CHRB, Saipan MP 96950. (670)322-9982 or (670)322-9983. E-mail: galaidi@vzpacifica.net. Web site: www.geocities.com/ccacarts/ccacwebsite.html.

Ohio Arts Council, 727 E. Main St., Columbus OH 43205-1796. (614)466-2613. Web site: www.oac.state.oh.us.

Oklahoma Arts Council, Jim Thorpe Building, 2101 N. Lincoln Blvd., Suite 640, Oklahoma City OK 73105. (405)521-2931. E-mail: okarts@arts.ok.gov. Web site: www.arts.state.ok.us.

Oregon Arts Commission, 775 Summer St. NE, Suite 200, Salem OR 97301-1280. (503)986-0082. E-mail: oregon.artscomm@state.or.us. Web site: www.oregonartscommission.org.

Pennsylvania Council on the Arts, 216 Finance Bldg., Harrisburg PA 17120. (717)787-6883. Web site: www.pacouncilonthearts.org.

Institute of Puerto Rican Culture, P.O. Box 9024184, San Juan PR 00902-4184. (787)724-0700. E-mail: www@icp.gobierno.pr. Web site: www.icp.gobierno.pr.

Rhode Island State Council on the Arts, One Capitol Hill, Third Floor, Providence RI 02908. (401)222-3880. E-mail: info@arts.ri.gov. Web site: www.arts.ri.gov.

American Samoa Council on Culture, Arts and Humanities, P.O. Box 1540, Office of the Governor, Pago Pago AS 96799. (684)633-4347. Web site: www.prel.org/programs/pcahe/PTG/terr-asamoa1.html.

South Carolina Arts Commission, 1800 Gervais St., Columbia SC 29201. (803)734-8696. E-mail: info@arts.state.sc.us. Web site: www.southcarolinaarts.com.

South Dakota Arts Council, 711 E. Wells Ave., Pierre SD 57501-3369. (605)773-3301. E-mail: sdac@state.sd.us. Web site: www.artscouncil.sd.gov.

Tennessee Arts Commission, 401 Charlotte Ave., Nashville TN 37243-0780. (615)741-1701. Web site: www.arts.state.tn.us.

Texas Commission on the Arts, E.O. Thompson Office Building, 920 Colorado, Suite 501, Austin TX 78701. (512)463-5535. E-mail: front.desk@arts.state.tx.us. Web site: www.arts. state.tx.us.

Utah Arts Council, 617 E. South Temple, Salt Lake City UT 84102-1177. (801)236-7555. Web site: http://arts.utah.gov.

Vermont Arts Council, 136 State St., Drawer 33, Montpelier VT 05633-6001. (802)828-3291. E-mail: online form. Web site: www.vermontartscouncil.org.

Virgin Islands Council on the Arts, 5070 Norre Gade, St. Thomas VI 00802-6872. (340)774-5984. Web site: http://vicouncilonarts.org.

Virginia Commission for the Arts, Lewis House, 223 Governor St., 2nd Floor, Richmond VA 23219. (804)225-3132. E-mail: arts@arts.virginia.gov. Web site: www.arts.state.va.us.

Washington State Arts Commission, 711 Capitol Way S., Suite 600, P.O. Box 42675, Olympia WA 98504-2675. (360)753-3860. E-mail: info@arts.wa.gov. Web site: www.arts.wa.gov.

West Virginia Commission on the Arts, The Cultural Center, Capitol Complex, 1900 Kanawha Blvd. E., Charleston WV 25305-0300. (304)558-0220. Web site: www.wvculture. org/arts.

Wisconsin Arts Board, 101 E. Wilson St., 1st Floor, Madison WI 53702. (608)266-0190. E-mail: artsboard@arts.state.wi.us. Web site: www.arts.state.wi.us.

Wyoming Arts Council, 2320 Capitol Ave., Cheyenne WY 82002. (307)777-7742. E-mail: ebratt@state.wy.us. Web site: http://wyoarts.state.wy.us.

CANADIAN PROVINCES ARTS AGENCIES

Alberta Foundation for the Arts, 10708 - 105 Ave., Edmonton AB T5H 0A1. (780)427-9968. Web site: www.cd.gov.ab.ca/all_about_us/commissions/arts.

British Columbia Arts Council, P.O. Box 9819, Stn. Prov. Govt., Victoria BC V8W 9W3. (250)356-1718. E-mail: BCArtsCouncil@gov.bc.ca. Web site: www.bcartscouncil.ca.

The Canada Council for the Arts, 350 Albert St., P.O. Box 1047, Ottawa ON K1P 5V8. (613)566-4414 or (800)263-5588 (within Canada). Web site: www.canadacouncil.ca.

Manitoba Arts Council, 525-93 Lombard Ave., Winnipeg MB R3B 3B1. (204)945-2237 or (866)994-2787 (in Manitoba). E-mail: info@artscouncil.mb.ca. Web site: www.artscounci l.mb.ca.

New Brunswick Arts Board (NBAB), 634 Queen St., Suite 300, Fredericton NB E3B 1C2. (506)444-4444 or (866)460-2787. Web site: www.artsnb.ca.

Newfoundland & Labrador Arts Council, P.O. Box 98, St. John's NL A1C 5H5. (709)726-2212 or (866)726-2212. E-mail: nlacmail@nfld.net. Web site: www.nlac.nf.ca.

Nova Scotia Department of Tourism, Culture, and Heritage, Culture Division, 1800 Argyle St., Suite 601, P.O. Box 456, Halifax NS B3J 2R5. (902)424-4510. E-mail: cultaffs@gov.ns. ca. Web site: www.gov.ns.ca/dtc/culture.

Ontario Arts Council, 151 Bloor St. W., 5th Floor, Toronto ON M5S 1T6. (416)961-1660 or (800)387-0058 (in Ontario). E-mail: info@arts.on.ca. Web site: www.arts.on.ca.

Prince Edward Island Council of the Arts, 115 Richmond St., Charlottetown PE C1A 1H7. (902)368-4410 or (888)734-2784. E-mail: info@peiartscouncil.com. Web site: www.peiart scouncil.com.

Québec Council for Arts & Literature, 79 boul. René-Lévesque Est, 3e étage, Québec QC G1R 5N5. (418)643-1707 or (800)897-1707. E-mail: info@calq.gouv.qc.ca. Web site: www.calq. gouv.qc.ca.

The Saskatchewan Arts Board, 2135 Broad St., Regina SK S4P 1Y6. (306)787-4056 or (800)667-7526 (Saskatchewan only). E-mail: sab@artsboard.sk.ca. Web site: www.artsbo ard.sk.ca.

Yukon Arts Section, Cultural Services Branch, Dept. of Tourism & Culture, Government of Yukon, Box 2703 (L-3), Whitehorse YT Y1A 2C6. (867)667-8589 or (800)661-0408 (in Yukon). E-mail: arts@gov.yk.ca. Web site: www.btc.gov.yk.ca/cultural/arts.

REGIONAL GRANTS AND AWARDS

The following opportunities are arranged by state since most of them grant money to artists in a particular geographic region. Because deadlines vary annually, check Web sites or call for the most up-to-date information.

California

Flintridge Foundation Awards for Visual Artists, 1040 Lincoln Ave., Suite 100, Pasadena CA 91103. (626)449-0839 or (800)303-2139. Fax: (626)585-0011. Web site: www.flintridge foundation.org. *For artists in California, Oregon and Washington only.*

James D. Phelan Award in Photography, Kala Art Institute, Don Porcella, 1060 Heinz Ave., Berkeley CA 94710. (510)549-6914. Web site: www.kala.org. *For artists born in California only.*

Connecticut

Martha Boschen Porter Fund, Inc., 145 White Hallow Rd., Sharon CT 06064. *For artists in northwestern Connecticut, western Massachusetts and adjacent areas of New York (except New York City).*

Idaho

Betty Bowen Memorial Award, % Seattle Art Museum, 100 University St., Seattle WA 98101. (206)654-3131. Web site: www.seattleartmuseum.org/bettybowen/. *For artists in Washington, Oregon and Idaho only.*

Illinois

Illinois Arts Council, Artists Fellowship Program, James R. Thompson Center, 100 W. Randolph, Suite 10-500, Chicago IL 60601. (312)814-6750. Web site: www.state.il.us/agency/ iac/Guidelines/guidelines.htm. *For Illinois artists only.*

Kentucky

Kentucky Foundation for Women Grants Program, 1215 Heyburn Bldg., 332 W. Broadway, Louisville KY 40202. (502)562-0045. Web site: www.kfw.org/grants.html. *For female artists living in Kentucky only.*

Massachusetts

See Martha Boschen Porter Fund, Inc., under Connecticut.

Minnesota

McKnight Photography Fellowships Program, University of Minnesota Dept. of Art, Regis Center for Art, E-201, 405 21st Ave. S., Minneapolis MN 55455. (612)626-9640. Web site: www.mcknightphoto.umn.edu. *For Minnesota artists only.*

New York

A.I.R. Gallery Fellowship Program, 511 W. 25th St., Suite 301, New York NY 10001. (212)255-6651. E-mail: info@airnyc.org. Web site: www.airnyc.org. *For female artists from New York City metro area only.*

Arts & Cultural Council for Greater Rochester, 277 N. Goodman St., Rochester NY 14607. (585)473-4000. Web site: www.artsrochester.org.

Constance Saltonstall Foundation for the Arts Grants and Fellowships, P.O. Box 6607, Ithaca NY 14851 (include SASE). (607)277-4933. E-mail: info@saltonstall.org. Web site: www.saltonstall.org. *For artists in the central and western counties of New York.*

New York Foundation for the Arts: Artists' Fellowships, 155 Avenue of the Americas, 14th Floor, New York NY 10013-1507. (212)366-6900, ext. 217. E-mail: nyfaafp@nyfa.org. Web site: www.nyfa.org. *For New York artists only.*

Oregon

See Flintridge Foundation Awards for Visual Artists, under California.

Pennsylvania

Leeway Foundation—Philadelphia, Pennsylvania Region, 123 S. Broad St., Suite 2040, Philadelphia PA 19109. (215)545-4078. E-mail: info@leeway.org. Web site: www.leeway.org. *For female artists in Philadelphia only.*

Texas

Individual Artist Grant Program—Houston, Texas, Cultural Arts Council of Houston and Harris County, 3201 Allen Pkwy., Suite 250, Houston TX 77019-1800. (713)527-9330. E-mail: info@cachh.org. Web site: www.cachh.org. *For Houston artists only.*

Washington

See Flintridge Foundation Awards for Visual Artists, under California.

Residencies & Organizations

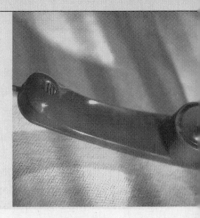

RESIDENCIES

Artists' residencies (also known as communities, colonies or retreats) are programs that support artists by providing time and space for the creation of new work. There are over 250 residency programs in the United States, and approximately 200 in at least 40 other countries. These programs provide an estimated $36 million in support to independent artists each year.

Many offer not only the resources to *do* artwork, but also to have it *seen* by the public. While some communities are isolated in rural areas, others are located near urban centers and may provide public programming such as workshops and exhibitions. Spending time as a resident at an artists' community is a great way to network and cultivate relationships with other artists.

Alliance of Artists Communities: www.artistcommunities.org
Offers an extensive list of international artists' communities and residencies.

Anderson Ranch Arts Center: www.andersonranch.org
Nonprofit visual arts community located in Snowmass Village, Colorado.

Arrowmont School of Arts & Crafts: www.arrowmont.org
Nationally renowned center of contemporary arts and crafts education located in Gatlinburg, Tennessee.

The Bogliasco Foundation/Liguria Study Center for the Arts & Humanities:
www.liguriastudycenter.org
Located on the Italian Riviera in the village of Bogliasco, the Liguria Study Center provides residential fellowships for creative or scholarly projects in the arts and humanities.

Fine Arts Work Center: www.fawc.org
Nonprofit institution devoted to encouraging and supporting young artists, located in Provincetown, Massachusetts.

Hall Farm Center: www.hallfarm.org
A 221-acre retreat in Townshend, Vermont, that offers residencies, workshops and other resources for emerging and established artists.

Kala Art Institute: www.kala.org
Located in the former Heinz ketchup factory in Berkeley, California, Kala provides exceptional facilities to professional artists working in all forms of printmaking, photography, digital media and book arts.

Lower Manhattan Cultural Council: www.lmcc.net

Creative hub for connecting residents, tourists and workers to Lower Manhattan's vast and vibrant arts community. Provides residencies, studio space, grants and professional development programming to artists.

The MacDowell Colony: www.macdowellcolony.org

A 100-year-old artists' community consisting of 32 studios located on a 450-acre farm in Peterborough, New Hampshire.

Pouch Cove Foundation: www.pouchcove.org

Not-for-profit organization in Newfoundland, Canada, providing retreat for artists from around the world.

Santa Fe Art Institute: www.sfai.org

Located on the College of Santa Fe campus in Santa Fe, New Mexico, SFAI is a nonprofit organization offering a wide range of programs to serve artists at various stages of their careers.

Vermont Studio Center: www.vermontstudiocenter.org

The largest international artists' and writers' residency program in the United States, located in Johnson, Vermont.

Women's Studio Workshop: www.wsworkshop.org

Visual arts organization in Rosendale, New York, with specialized studios in printmaking, hand papermaking, ceramics, letterpress printing, photography and book arts.

Yaddo: www.yaddo.org

Artists' community located on a 400-acre estate in Saratoga Springs, New York, offering residencies to professional creative artists from all nations and backgrounds

ORGANIZATIONS

There are numerous organizations for artists that provide resources and information about everything from industry standards and marketing tips to contest announcements and legal advice. Included here are just a handful of groups that we at *Artist's & Graphic Designer's Market* have found useful.

American Association of Editorial Cartoonists: http://editorialcartoonists.com

Professional association concerned with promoting the interests of staff, freelance and student editorial cartoonists in the United States.

American Institute of Graphic Arts: www.aiga.org

AIGA is the oldest and largest membership association for professionals engaged in the discipline, practice and culture of designing.

Art Dealers Association of America: www.artdealers.org

Nonprofit membership organization of the nation's leading galleries in the fine arts.

The Art Directors Club: www.adcglobal.org

The ADC is the premier organization for integrated media and the first international creative collective of its kind. Founded in New York in 1920, the ADC is a self-funding, not-for-profit membership organization that celebrates and inspires creative excellence by connecting visual communications professionals from around the world.

Artists Unite: www.artistsunite-ny.org

Nonprofit organization dedicated to providing quality arts programming and to helping artists of all genres collaborate on projects.

Resources

The Association of Medical Illustrators: www.ami.org
International organization for anyone interested in the highly specialized niche of medical illustration.

The Association of Science Fiction and Fantasy Artists: www.asfa-art.org
Nonprofit association organized for artistic, literary, educational and charitable purposes concerning the visual arts of science fiction, fantasy, mythology and related topics.

Association International du Film d'Animation (International Animated Film Association): www.asifa.net
International organization dedicated to the art of animation, providing worldwide news and information on chapters of the group, as well as conferences, contests and workshops.

Association Typographique Internationale: www.atypi.org
Not-for-profit organization run by an elected board of type designers, type publishers, graphic and typographic designers.

Canadian Association of Photographers and Illustrators in Communications: www.capic.org
Not-for-profit association dedicated to safeguarding and promoting the rights and interests of photographers, illustrators and digital artists working in the communications industry.

Canadian Society of Children's Authors, Illustrators and Performers: www.canscaip.org
This organization supports and promotes all aspects of children's literature, illustration and performance.

College Art Association: www.collegeart.org
CAA promotes excellence in scholarship and teaching in the history and criticism of the visual arts and in creativity and technical skill in the teaching and practices of art. Membership is open to all individuals with an interest in art, art history or a related discipline.

The Comic Book Legal Defense Fund: www.cbldf.org
Nonprofit organization dedicated to the preservation of First Amendment rights for members of the comics community.

Friends of Lulu: www.friends-lulu.org
National organization whose main purpose is to promote and encourage female readership and participation in the comic book industry.

Graphic Artists Guild: www.gag.org
National union of illustrators, designers, production artists and other creatives who have come together to pursue common goals, share experiences and raise industry standards.

Greeting Card Association: www.greetingcard.org
Trade organization representing greeting card and stationery publishers, and allied members of the industry.

International Comic Arts Association: www.comicarts.org
Member-driven organization open to anyone with a love and appreciation of the comics art form and a desire to help support and further promote the industry.

National Cartoonists Society: www.reuben.org
Home of the famed Reuben Awards, this organization offers news and resources for cartoonists interested in everything from caricature to animation.

New York Foundation for the Arts: www.nyfa.org
NYFA offers information and financial assistance to artists and organizations that directly

serve artists, by supporting arts programming in the community, and by building collabo-
rative relationships with others who advocate for the arts in New York State and through-
out the country.

Society of Children's Book Writers and Illustrators: www.scbwi.org
With chapters all over the world, SCBWI is the premier organization for professionals in
children's publishing.

Society of Graphic Designers of Canada: www.gdc.net
Member-based organization of design professionals, educators, administrators, students
and associates in communications, marketing, media and design-related fields.

The Society of Illustrators: www.societyillustrators.org
Since 1901, this nonprofit organization has been working to promote the interests of
professional illustrators through exhibitions, lectures, education, and by fostering a sense
of community and open discussion.

Type Directors Club: www.tdc.org
Organization dedicated to raising the standards of typography and related fields of the
graphic arts through research, education, competitions and publications.

United States Artists: www.unitedstatesartists.org
Provides direct financial support to artists across all disciplines. Currently offers one grant
program: USA Fellows.

US Regional Arts Organizations: www.usregionalarts.org
Six nonprofit entities created to encourage development of the arts and to support arts
programs on a regional basis. Funded by the NEA, these organizations—Arts Midwest,
Mid-America Arts Alliance, Mid Atlantic Arts Foundation, New England Foundation for
the Arts, Southern Arts Federation, and Western States Arts Federation—provide technical
assistance to their member state arts agencies, support and promote artists and arts organi-
zations, and develop and manage arts initiatives on local, regional, national and interna-
tional levels.

Resources

Publications, Web sites & Blogs

I n addition to the thousands of trade publications written for visual artists, there are now countless Web sites, blogs and online artists' communities intended to connect, inspire and support artists in their careers. Listed here are just a handful of books, magazines and online resources to get you started; most will lead to additional sources, especially Web sites that provide links to other sites.

BOOKS

AIGA Professional Practices in Graphic Design: The American Institute of Graphic Arts, edited by Tad Crawford (Allworth Press)

Art Marketing 101: A Handbook for the Fine Artist by Constance Smith (ArtNetwork)

Business and Legal Forms for Fine Artists by Tad Crawford (Allworth Press)

Business and Legal Forms for Graphic Designers by Tad Crawford and Eva Doman Bruck (Allworth Press)

Business and Legal Forms for Illustrators by Tad Crawford (Allworth Press)

The Business of Being an Artist by Daniel Grant (Allworth Press)

Career Solutions for Creative People: How to Balance Artistic Goals with Career Security by Dr. Ronda Ormont (Allworth Press)

Children's Writer's & Illustrator's Market, edited by Alice Pope (Writer's Digest Books, F + W Publications)

Comics and Sequential Art by Will Eisner (Poorhouse Press)

Creativity for Graphic Designers: A Real-World Guide to Idea Generation—From Defining Your Message to Selecting the Best Idea for Your Printed Piece by Mark Oldach (North Light Books, F + W Publications)

Design Basics for Creative Results by Bryan L. Peterson (HOW Books, F + W Publications)

The Fine Artist's Guide to Marketing and Self-Promotion by Julius Vitali (Allworth Press)

Fingerprint: The Art of Using Handmade Elements in Graphic Design by Chen Design Associates (HOW Books, F + W Publications)

A Gallery Without Walls: Selling Art in Alternative Venues by Margaret Danielak (ArtNetwork)

Graphic Artists Guild Handbook: Pricing & Ethical Guidelines (Graphic Artists Guild)

The Graphic Designer's and Illustrator's Guide to Marketing and Promotion by Maria Piscopo (Allworth Press)

The Graphic Designer's Guide to Clients: How to Make Clients Happy and Do Great Work by Ellen Shapiro (Allworth Press)

Graphic Storytelling & Visual Narrative by Will Eisner (Poorhouse Press)

Guide to Getting Arts Grants by Ellen Liberatori (Allworth Press)

How to Draw and Sell Comics by Alan McKenzie (IMPACT Books, F + W Publications)

How to Survive and Prosper as an Artist: Selling Yourself Without Selling Your Soul by Caroll Michels (Owl Books)

Inside the Business of Illustration by Steven Heller and Marshall Arisman (Allworth Press)

Legal Guide for the Visual Artist by Tad Crawford (Allworth Press)

Licensing Art 101: Publishing and Licensing Artwork for Profit by Michael Woodward (ArtNetwork)

Licensing Art & Design: A Professional's Guide to Licensing and Royalty Agreements by Caryn R. Leland (Allworth Press)

Logo, Font & Lettering Bible: A Comprehensive Guide to the Design, Construction and Usage of Alphabets and Symbols by Leslie Cabarga (HOW Books, F + W Publications)

Making Comics: Storytelling Secrets of Comics, Manga and Graphic Novels by Scott McCloud (HarperCollins)

Starting Your Career as a Freelance Illustrator or Graphic Designer by Michael Fleishman (Allworth Press)

Successful Syndication: A Guide for Writers and Cartoonists by Michael Sedge (Allworth Press)

The Word It Book: Speak Up Presents a Gallery of Interpreted Words, edited by Bryony Gomez-Palacio and Armin Vit (HOW Books, F + W Publications)

MAGAZINES

Advertising Age: www.adage.com
Weekly print magazine delivering news, analysis and data on marketing and media. Web site provides a database of advertising agencies as well as daily e-mail newsletters: *Ad Age Daily*, *Ad Age's Mediaworks* and *Ad Age Digital*.

Art Business News: www.artbusinessnews.com
Monthly magazine that reports on art trends, news and retailing issues. Offers profiles on emerging and established artists, as well as in-depth articles on merchandising and marketing issues.

Art Calendar: www.artcalendar.com
Business magazine devoted to connecting artists with income-generating opportunities and resources for a successful art career.

Resources

Art in America: www.artinamericamagazine.com
"The World's Premier Art Magazine," covering the visual art world both in the U.S. and abroad, but concentrating on New York City. Provides news and criticism of painting, sculpture, photography, installation art, performance art, video and architecture in exhibition reviews, artist profiles, and feature articles. Every August issue is the *Annual Guide to Museums, Galleries and Artists.*

ART PAPERS: www.artpapers.org
Dedicated to the examination, development and definition of art and culture in the world today.

ARTFORUM: www.artforum.com
International magazine widely known as a decisive voice in its field. Features in-depth articles and reviews of contemporary art, as well as book reviews and columns on cinema and popular culture.

The Artist's Magazine: www.artistsmagazine.com
Features color reproductions, interviews with artists, practical lessons in craft, and news of exhibitions and events.

ARTnews: www.artnews.com
Oldest and most widely circulated art magazine in the world. Reports on the art, personalities, issues, trends and events shaping the international art world.

Artweek: www.artweek.com
Offers critical reviews of West Coast exhibitions, as well as news, feature articles, interviews and opinion pieces focusing on contemporary art. Includes a comprehensive listing of regional, national and international competitions; classified ads for job opportunities, studio space, artists' services, supplies and equipment; exhibition listings of over 200 gallery and museum spaces.

Communication Arts Magazine: www.commarts.com
Leading trade journal for visual communications. Showcases the top work in graphic design, advertising, illustration, photography and interactive design.

Create Magazine: www.createmagazine.com
Quarterly publication offering creative professionals an insider's perspective on the people, news, trends and events that influence the advertising and creative production industries.

Creativity: http://creativity-online.com
Monthly magazine about the creative process. Web site features what its editors believe to be the best video, print and interactive ads.

Eye: The International Review of Graphic Design: www.eyemagazine.com
Published in the United Kingdom, this quarterly print magazine is for anyone involved in graphic design and visual culture.

Grafik: www.grafikmagazine.co.uk
Based in London, this monthly magazine serves the international design community with essential information, independent-minded editorial, unflinching reviews and outspoken opinion from industry personalities.

Graphic Design USA: www.gdusa.com
News magazine for graphic designers and other creative professionals.

Greetings etc.: www.greetingsmagazine.com

Official publication of the Greeting Card Association, featuring timely information for everyone doing business in the greeting card, stationery, and party goods markets.

HOW: www.howdesign.com

Provides graphic design professionals with essential business information; covers new technology and processes; profiles renowned and up-and-coming designers; details noteworthy projects; provides creative inspiration; and publishes special issues featuring the winners of its annual competitions. Web site is a trusted source for business advice, creative inspiration and tools of the trade.

I.D.: www.idonline.com

America's leading critical magazine covering the art, business and culture of design. Published seven times/year, including the Annual Design Review (America's oldest and most prestigious juried design-recognition program).

JUXTAPOZ: www.juxtapoz.com

Monthly art and culture magazine based in San Francisco, California. Features profiles and exhibition announcements of "lowbrow" or "underground" artists—art establishment conventions do not apply here.

PRINT: www.printmag.com

Bimonthly magazine about visual culture and design that documents and critiques commercial, social and environmental design from every angle.

Target Marketing: www.targetmarketingmag.com

The authoritative source for hands-on, how-to information concerning all direct response media, including direct mail, e-mail and the Web. Readers gain insight into topics such as using databases and lists effectively, acquiring new customers, upselling and cross-selling existing customers, fulfillment strategies and more.

WEB SITES & BLOGS

The Alternative Pick: www.altpick.com

"The best source for creatives on the Web." Allows artists to display samples of their work that can be searched by art buyers and directors. Offers industry news, classifieds, job postings and more.

Animation World Network: www.awn.com

Comprehensive and targeted coverage of the international animation community has made AWN the leading source of animation industry news in the world. It provides an industry database, job postings, education resources, discussion forums, newsletters and a host of other resources covering everything related to animation.

Art Deadlines List: www.artdeadlineslist.com

Great source for calls for entries, competitions, scholarships, festivals and plenty of other resources. Subscription is free, or you can purchase a premium edition for $24/year.

The Art List: www.theartlist.com

Offers an extensive listing of art contests, competitions and juried art shows, as well as other resources for visual artists looking for income opportunities or to gain exposure for their work. An annual subscription to The Art List's monthly e-mail newsletters is only $15. Each newsletter includes a link to a searchable database of art contests, competitions, residencies, fellowships, calls for public art, and juried exhibition announcements.

Resources

Art Schools: www.artschools.com

Free online directory with a searchable database of art schools all over the world. Also offers information on financial aid, majors and lots more.

Artbusiness.com: www.artbusiness.com

Provides art appraisals, art price data, news, articles and market information for art collectors, artists and fine arts professionals. Also consults on marketing, promotion, public relations, Web site construction, Internet selling, and career development for artists at all stages.

Artdeadline.com: www.artdeadline.com

"The Professional Artist's Resource," offering thousands of income and exhibition opportunities and resources for artists of all disciplines. Subscriptions start at $24/year, or you can get a 20-day trial for $14.

Artist Career Training: www.artistcareertraining.com

Offers valuable information to help you market your art and build your career. Sign up for a monthly newsletter and weekly tips.

Artist Help Network: www.artisthelpnetwork.com

Designed to help artists take control of their careers, the network assists artists in locating information, resources, guidance and advice on a comprehensive range of career-related topics.

Artists Network: http://forum.artistsnetwork.com

Interactive artists' community and forum for discussions of art-related topics including business tips and inspiration. Connect to *The Artist's Magazine*, *Watercolor Artist* (formerly *Watercolor Magic*) and *Pastel Journal*, as well as fine art book clubs and lots of other helpful resources.

Artleby: www.artleby.biz

Online arts exhibition space, run by artists for artists. A one-year subscription, payable in monthly installments of $5, provides you with a Web site to display up to 50 images as well as résumé, biography, artist's statement, etc. The ability to create multiple portfolio categories according to media, themes, etc., allows you to direct your work to a specific audience/market.

Artlex Art Dictionary: www.artlex.com

Online dictionary that provides definitions, examples and cross-references for more than 3,600 art terms.

Artline: www.artline.com

Offers news and events from 7 reputable art dealer associations: Art Dealers Association of America, Art Dealers Association of Greater Washington, Association of International Photography Art Dealers, Chicago Art Dealers Association, International Fine Print Dealers Association, San Francisco Art Dealers Association, and The Society of London Art Dealers.

Children's Illustrators: www.childrensillustrators.com

Online networking community for children's illustrators, agents, publishing houses, advertising agencies and design groups from around the world.

The Comics Reporter: www.comicsreporter.com

Offers an overview of the history of comics, as well as resources and information about publishing comic books and syndicating comic strips.

Creative Talent Network: www.creativetalentnetwork.com
Online networking community of experienced animators, illustrators, designers, Web creators, production artists and other creatives.

The Drawing Board for Illustrators: www.members.aol.com/thedrawing
Information and resources for illustrators, including pricing guidelines, marketing tips, and links to publications, organizations and associations.

EBSQ: Self-Representing Artists: www.ebsqart.com
Online art association whose members represent their own work to the public. Membership is open to artists at all stages of their careers, and all media and styles are welcome.

Illustration Friday: www.illustrationfriday.com
Online forum for illustrators that offers a weekly challenge: a new topic is posted every Friday, and then participants have a week to submit an illustration of their own interpretation.

Theispot.com: www.theispot.com
Widely recognized as "the world's premier illustration site," allowing illustrators from all over the world to showcase and market their work.

The Medical Illustrators' Home Page: www.medartist.com
A site where medical illustrators can display and market their work.

The Nose: www.the-nose.com
A place for caricature artists to showcase their work.

Portfolios.com: www.portfolios.com
The first searchable creative directory on the Web. Through the Portfolios.com Partner Network, you can set up and manage one portfolio, but have it appear on multiple Web sites for one low price.

Starving Artists Law: www.starvingartistslaw.com
Start here for answers to your questions about copyright registration, trademark protection and other legal issues.

TalkAboutComics.com: www.talkaboutcomics.com
Provides a comprehensive list of all things comics related on the Web, as well as audio interviews with online comics creators.

Talkabout Design: www.talkaboutdesign.com
Online forum and blog for the design community.

UnderConsideration: www.underconsideration.com
A network of blogs (Speak Up, Brand New, Quipsologies, The Design Encyclopedia) dedicated to the progress of the graphic design profession and its practitioners, students and enthusiasts.

Volunteer Lawyers for the Arts: www.vlany.org
Provides education and other services relating to legal and business issues for artists and arts organizations in every discipline.

WetCanvas!: www.wetcanvas.com
Largest online community of visual artists, offering forums, critiques, art lessons and projects, marketing tools, a reference image library and more—all for FREE!

Glossary

Acceptance (payment on). An artist is paid for his/her work as soon as a buyer decides to use it.

Adobe Illustrator®. Drawing and painting computer software.

Adobe InDesign®. Revised, retooled version of Adobe PageMaker.

Adobe PageMaker®. Page-layout design software. Product relaunched as InDesign.

Adobe Photoshop®. Photo manipulation computer program.

Advance. Amount paid to an artist before beginning work on an assigned project. Often paid to cover preliminary expenses.

Airbrush. Small pencil-shaped pressure gun used to spray ink, paint or dye to obtain gradated tonal effects.

Anime. Japanese word for animation.

Art director. In commercial markets, the person responsible for choosing and purchasing artwork and supervising the design process.

Artist's Statement. A short essay, no more than a paragraph or two, describing an artist's mission and creative process.

Biannual. Occurring twice a year. See also semiannual.

Biennial. Occurring once every two years.

Bimonthly. Occurring once every two months.

Biweekly. Occurring once every two weeks.

Book. Another term for a portfolio.

Buyout. The sale of all reproduction rights (and sometimes the original work) by the artist; also subcontracted portions of a job resold at a cost or profit to the end client by the artist.

Calligraphy. The art of fine handwriting.

Camera-ready. Art that is completely prepared for copy camera platemaking.

Capabilities brochure. A brochure, similar to an annual report, outlining for prospective clients the nature of a company's business and the range of products or services it provides.

Caption. See gagline.

Carriage trade. Wealthy clients or customers of a business.

CD-ROM. Compact disc read-only memory; nonerasable electronic medium used for digitized image and document storage and retrieval on computers.

Collateral. Accompanying or auxiliary pieces, such as brochures, especially used in advertising.

Color separation. Photographic process of separating any multi-color image into its primary component parts (cyan, magenta, yellow and black) for printing.

Commission. 1) Percentage of retail price taken by a sponsor/salesman on artwork sold. 2) Assignment given to an artist.

Comprehensive. Complete sketch of layout showing how a finished illustration will look when printed; also called a comp.

Copyright. The exclusive legal right to reproduce, publish and sell the matter and form of a literary or artistic work.

Consignment. Arrangement by which items are sent by an artist to a sales agent (gallery, shop, sales rep, etc.) for sale with the understanding that the artist will not receive payment until work is sold. A commission is almost always charged for this service.

Direct mail package. Sales or promotional material that is distributed by mail. Usually consists of an outer envelope, a cover letter, brochure or flier, SASE, and postpaid reply card, or order form with business reply envelope.

DPI or dpi. Dots per inch. The unit of measure used to describe the scanning resolution of an image or the quality of an output device. See also resolution.

Dummy. A rough model of a book or multi-page piece, created as a preliminary step in determining page layout and length. Also, a rough model of a card with an unusual fold or die cut.

Edition. A set of identical prints published of one piece of art.

Engraving. A print made by cutting into the printing surface with a point. See also etching.

Environmental graphic design (EGD). The planning, designing and specifying of graphic elements in the built and natural environment; signage.

EPS. Encapsulated PostScript—a computer format used for saving or creating graphics.

Estimate. A ballpark figure given to a client by a designer anticipating the final cost of a project.

Etching. A print made by the intaglio process, creating a design in the surface of a metal or other plate with a needle and using a mordant to bite out the design.

Exclusive area representation. Requirement that an artist's work appear in only one outlet within a defined geographical area.

Finished art. A completed illustration, mechanical, photo or combination of the three that is ready to go to the printer. Also called camera-ready art.

Gagline. The words printed with a cartoon (usually directly beneath); also called a caption.

Giclée. Method of creating limited and unlimited edition prints using computer technology in place of traditional methods of reproducing artwork. Original artwork or transparency is digitally scanned, and the stored information is manipulated on screen using computer software (usually Photoshop). Once the image is refined on screen, it is printed on an Iris printer, a specialized ink-jet printer designed for making giclée prints.

GIF. Graphics Interchange Format—a computer format used for saving or creating graphics.

Gouache. Opaque watercolor with definite, appreciable film thickness and an actual paint layer.

Halftone. Reproduction of a continuous tone illustration with the image formed by dots produced by a camera lens screen.

Honorarium. Token payment—small amount of money and/or a credit line and copies of the publication in which an artist's work appears.

Informational graphics. Information, especially numerical data, visually represented with illustration and text; charts/graphs.

IRC. International Reply Coupon; purchased at the post office to enclose with artwork sent to a foreign buyer to cover his/her postage cost when replying.

Iris print. Limited and unlimited edition print or giclée output on an Iris or ink-jet printer (named after Iris Graphics of Bedford, Massachusetts, a leading supplier of ink-jet printers).

JPEG. Joint Photographic Experts Group—a computer format used for saving or creating graphics.

Keyline. An outline drawing on completed art for the purpose of indicating its shape, position and size.

Kill fee. Portion of an agreed-upon payment an artist receives for a job that was assigned, started, but then canceled.

Layout. Arrangement of photographs, illustrations, text and headlines for printed material.

Licensing. The process whereby an artist who owns the rights to his or her artwork permits (through a written contract) another party to use the artwork for a specific purpose for a specified time in return for a fee and/or royalty.

Linocut. A relief print made from linoleum fastened to a wooden block. See also relief.

Lithograph. A print made by drawing on fine-grained porous limestone or on a zinc plate with greasy material, then wetting the stone or plate and applying greasy ink, which will adhere only to the drawn lines. Dampened paper is applied to the stone and is rubbed over with a special press to make the final print.

Logo. Name or design of a company or product used as a trademark on letterhead, direct mail packages, in advertising, etc., to establish visual identity.

Mechanicals. Preparation of work for printing.

Mezzotint. A method of engraving in which the artist works from dark to light. The entire painting surface is first covered with a regular fine scratching made by using a rocking tool called a cradle. This takes the ink and appears as a black background. The design is burnished onto it, does not take the ink and therefore appears in white.

Multimedia. A generic term used by advertising, public relations and audiovisual firms to describe productions involving a combination of media such as animation, video, Web graphics or other visual effects. Also, a term used to reflect the varied in-house capabilities of an agency.

Offset. Printing process in which a flat printing plate is treated to be ink-receptive in image areas and ink-repellent in nonimage areas. Ink is transferred from the printing plate to a rubber plate, and then to the paper.

On spec. Abbreviation for "on speculation." See also speculation.

Overlay. Transparent cover over copy, on which instruction, corrections or color location directions are given.

Panel. In cartooning, the boxed-in illustration; can be single panel, double panel or multiple panel.

PDF. Portable Document Format—Adobe® file format for representing documents in a manner that is independent of the original application software, hardware and operating system used to create those documents.

P-O-P. Point-of-purchase; in-store marketing display that promotes a product.

Print. An impression pulled from an original plate, stone, block screen or negative; also a positive made from a photographic negative.

Production artist. In the final phases of the design process, the artist responsible for mechanicals and sometimes the overseeing of printing.

Publication (payment on). An artist is not paid for his/her work until it is actually published, as opposed to payment on acceptance.

QuarkXPress. Page layout computer program.

Query. Letter to an art director or buyer eliciting interest in a work an artist wants to illustrate or sell.

Quote. Set fee proposed to a client prior to commencing work on a project.

Relief. 1) A composition or design made so that all or part projects from a flat surface. 2) The impression or illusion of three dimensions given by a painting.

Rendering. A drawn representation of a building, interior, etc., in perspective.

Resolution. The pixel density of an image, or the number of dots per inch a device is capable of recognizing or reproducing.

Retail. The sale of goods in small quantities directly to the consumer.

Roughs. Preliminary sketches or drawings.

Royalty. An agreed percentage paid by a publisher to an artist for each copy of a work sold.

SASE. Self-addressed, stamped envelope.

Self-publishing. In this arrangement, an artist coordinates and pays for printing, distribution and marketing of his/her own artwork and in turn keeps all ensuing profits.

Semiannual. Occurring twice a year. See also biannual.

Semimonthly. Occurring twice a month.

Semiweekly. Occurring twice a week.

Serigraph. Silkscreen; method of printing in which a stencil is adhered to a fine mesh cloth stretched over a wooden frame. Paint is forced through the area not blocked by the stencil.

Simultaneous submission. Sending the same artwork to more than one potential buyer at the same time.

Speculation. Creating artwork with no assurance that a potential buyer will purchase it or reimburse expenses in any way; referred to as work "on spec."

Spot illustration. Small illustration used to decorate a page of type or to serve as a column ending.

Storyboard. Series of panels that illustrate a progressive sequence or graphics and story copy of a TV commercial, film or filmstrip. Serves as a guide for the eventual finished product.

Tabloid. Publication whose format is an ordinary newspaper page turned sideways.

Tearsheet. Page containing an artist's published illustration, cartoon, design or photograph.

Thumbnail. A rough layout in miniature.

TIFF. Tagged Image File Format—a computer format used for saving or creating graphics.

Transparency. A photographic positive film such as a color slide.

Type spec. Type specification; determination of the size and style of type to be used in a layout.

Unsolicited submission. Sample(s) of artwork sent to a buyer without being requested.

Velox. Photoprint of a continuous tone subject that has been transformed into line art by means of a halftone screen.

Wash. Thin application of transparent color or watercolor black for a pastel or gray tonal effect.

Wholesale. The sale of commodities in large quantities usually for resale (as by a retail merchant).

Woodcut. A print made by cutting a design in side-grain of a block of wood, also called a woodblock print. The ink is transferred from the raised surfaces to paper.

Geographic Index

INDIANA

IOWA

KANSAS

TRY *THE PASTEL JOURNAL*...ABSOLUTELY FREE!

And Get Pastel Painting Inspiration Delivered To Your Door!

Take a look at *The Pastel Journal*—the leading magazine for pastelists of all skill levels—and discover why artists worldwide enjoy this one-of-a-kind publication packed with awe-inspiring information and inspiration, plus spectacular full-color artwork. Send for your **FREE** trial issue today!

Inside each bi-monthly issue you'll find:

- *in-depth articles featuring expert tips and techniques that inspire your own art style*
- *insightful interviews with renowned pastel artists like Albert Handell, Elizabeth Mowry, Daniel E. Greene, and many more*
- *reproductions of gorgeous artwork from leading artists*
- *extensive listings of workshops and contests*
- *expert advice on how to market your artwork*
- *product reviews to help you choose the best art materials*
- *and much, much more!*

Take advantage of this special trial offer in *Artist's & Graphic Designer's Market* and discover *The Pastel Journal*—absolutely **FREE!**

The Pastel Journal

Get a FREE ISSUE of The Pastel Journal

Discover **The Pastel Journal** today–absolutely **FREE!** Inside you'll find a wealth of information and inspiration from today's leading pastel artists, as well as spectacular full-color demonstrations of their artwork. You'll also find invaluable advice, priceless creative inspiration, and exciting new painting techniques that take your talent to the next level. Just take a peek inside:

- *You'll learn how an exciting array of artists use pastel in creating breathtaking landscapes, still lifes, portraits, wildlife art, and more.*

- *You'll discover concrete, useful information about methods and materials, such as how to frame your artwork; how to shoot professional slides; and how to build your own Web site.*

- *You'll explore opportunities and resources through regular columns on marketing, comprehensive workshop and exhibition listings, sources for supplies and services, and much more.*

Find out why **The Pastel Journal** is the leading magazine for pastel artists!

Send in the postage-paid card below and request your FREE TRIAL ISSUE today!

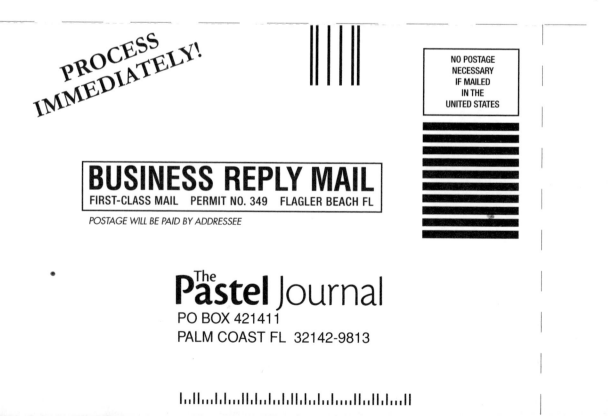

Geographic Index

Niche Marketing Index

The following index can help you find the most apropriate listings for the kind of artwork you create. Check the individual listings for specific information about submission requirements.

Cartoons

Children's Publications/Products

Informational Graphics

Licensing

Religious/Spiritual

General Index